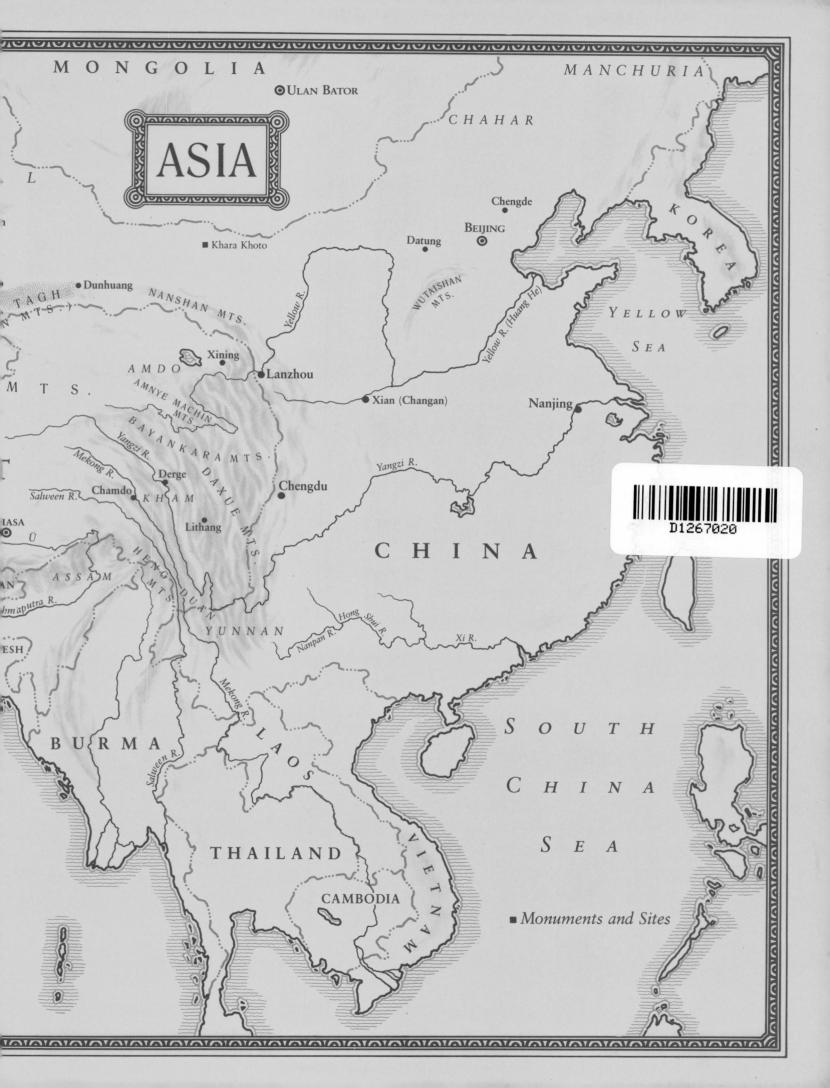

ASIA

MONGOLIA

MANCHURIA

⊙ Ulan Bator

CHAHAR

■ Khara Khoto

Chengde

Datung

BEIJING ⊙

KOREA

NANSHAN MTS.

● Dunhuang

N TAGH

MTS.)

Yellow R.

WUTAISHAN MTS.

YELLOW SEA

Yellow R. (Huang He)

AMDO

Xining

AMNYE MACHIN MTS.

● Lanzhou

Xian (Changan) ●

Nanjing ●

M T S.

BAYANKARA MTS.

Mekong R.

Yangzi R.

Yangzi R.

Salween R.

Derge ●

DAXUE MTS.

Chengdu ●

Chamdo ●

KHAM

Lithang ●

CHINA

IASA

Ü

ASSAM

HENG DUAN MTS.

hmaputra R.

YUNNAN

Nanpan R.

Hong Shui R.

Xi R.

ESH

Mekong R.

Nanpan R.

SOUTH

BURMA

LAOS

CHINA

Salween R.

SEA

THAILAND

VIETNAM

CAMBODIA

■ Monuments and Sites

ཤེས་རབ་དང་

སྤྱིང་རྗེའི་

རོལ་པ།

ཤེས་རབ་དང་

སྙིང་རྗེའི་

རོལ་པ།

WISDOM
AND
COMPASSION

THE
SACRED ART
OF TIBET

Expanded Edition

Marylin M. Rhie
Robert A. F. Thurman

Principal photography by John Bigelow Taylor

Tibet House New York

in association with

Abradale Press

Harry N. Abrams, Inc., Publishers

Published on the occasion of the third incarnation of *Wisdom and Compassion: The Sacred Art of Tibet*, an exhibition originated by Tibet House New York, originally with the Asian Art Museum of San Francisco, for venues in 1991–1992, and reorganized and enlarged by Tibet House New York for venues in 1996–1997

First incarnation:
 Asian Art Museum of San Francisco
 April 17–August 18, 1991

 IBM Gallery of Science and Art, New York City
 October 15–December 28, 1991

Second incarnation:
 Royal Academy of Art, London
 September 18–December 13, 1992

Third incarnation:
 Kunst- und Ausstellungshalle der Bundesrepublik Deutschland, Bonn
 May 9–August 25, 1996

 Fundacio "la Caixa," Barcelona
 October 1, 1996–January 14, 1997

 Tobu Museum of Art, Tokyo
 February–April 1997

 The Yamaguchi Prefectural Museum of Art, Yamaguchi City
 May–July 1997

 Chiba City Museum of Art, Chiba City, Japan
 August–September 1997

Tibet House New York
 Robert A. F. Thurman, President
 Philip Glass, Vice-President
 Marylin M. Rhie, Co-Curator
 Robert A. F. Thurman, Co-Curator
 Jeffrey Jordan, Director of Exhibitions

Harry N. Abrams, Inc.
 Julia Moore, Editor
 Jisho Cary Warner, Manuscript Editor
 Maria Learmonth Miller, Designer

The Library of Congress has cataloged the Abrams edition as follows:
 Rhie, Marylin M.
 Wisdom and compasssion : the sacred art of Tibet / Marylin M. Rhie,
 Robert A. F. Thurman ; principal photography by John Bigelow Taylor.—
 Expanded ed.
 p. cm.
 This ed. was created in connection with a reconstituted exhibition at the
 Kunst- und Ausstellungshalle der Bundesrepublik Deutschland, Bonn, Germany.
 Includes bibliographical references and index.
 ISBN 0–8109–3985–1 (cloth)
 1. Art, Buddhist—China—Tibet. 2. Buddhist art and symbolism—China
 —Tibet. 3. Art, Tibetan. I. Thurman, Robert A. F. II. Taylor, John Bigelow.
 III. Kunst- und Ausstellungshalle der Bundesrepublik Deutschland. IV. Title.
 N8193. T5R47 1996
 704.9'48943923'09515074435518—dc20 95–39484
 Abradale ISBN 0–8109–8204–8
Text copyright © 1991 Harry N. Abrams, Inc.
Text copyright © 1996 Tibet House New York
Illustrations except as otherwise noted copyright © 1991,1996 John Bigelow Taylor

Printed and bound in Japan

CONTENTS

MESSAGES • 7

ACKNOWLEDGMENTS • 10

OVERVIEW • 12
Marylin M. Rhie and Robert A. F. Thurman

NOTE ON TRANSCRIPTIONS AND TERMINOLOGY • 14

WISDOM AND COMPASSION: THE HEART OF TIBETAN CULTURE • 17
Robert A. F. Thurman

TIBET, ITS BUDDHISM, AND ITS ART • 20
Robert A. F. Thurman

TIBETAN BUDDHIST ART: AESTHETICS, CHRONOLOGY, AND STYLES • 39
Marylin M. Rhie

THE SACRED ART OF TIBET: CATALOGUE • 67
Marylin M. Rhie and Robert A. F. Thurman
Gennady Leonov, Gilles Béguin, Kira Samosyuk, Richard Kohn, Terese Tse Bartholomew

TIBETAN SACRED HISTORY • 70
I. Shakyamuni Buddha: Life and Lives • 72
II. Arhats • 102
III. Bodhisattvas • 120
IV. Great Philosophers and Great Adepts • 146
V. Dharma Kings • 156

TIBETAN BUDDHIST ORDERS • 164
VI. Nyingma Order • 166
VII. Sakya Order • 199
VIII. Kagyu Order • 236
IX. Geluk Order • 262

TIBETAN PERFECTED WORLDS • 310
X. Cosmic Bodhisattvas • 313
XI. Cosmic Buddhas • 334
XII. Pure Lands • 361

TECHNIQUES OF TIBETAN PAINTING AND SCULPTURE • 385
Gilles Béguin

GLOSSARY • 389

BIBLIOGRAPHY • 394

INDEX • 398

CREDITS • 406

SUPPLEMENT • 408

BIBLIOGRAPHY TO SUPPLEMENT • 485

INDEX TO SUPPLEMENT • 486

CREDITS TO SUPPLEMENT • 488

His Holiness the Dalai Lama

MESSAGES

Independent Tibet was not a developed country in the modern, material sense. Yet, it had a highly developed civilization and culture. Many centuries back, Tibet, like most other nations, was using violent warfare and conquest to expand her territory and to enrich herself with material treasures. The Tibetans then encountered the teachings of the Buddha, which slowly persuaded them that it was more important to conquer their own hearts than to conquer the whole world.

The peaceful, contented heart does not emerge all of a sudden. Rather, it comes from deep understanding, contentment, and genuine love. These in turn are caused by the conquest of ignorance, greed, and hostility. For an entire nation to make such education, discipline, and insight the center of its life takes painstaking development of a higher, truly human civilization. The Tibetans had to struggle to transform a rough, earthy culture of warriors into a gentle, literate culture of saints and sages. We are still far from perfect. Nevertheless, we can display what we have accomplished so far.

I was happy in 1991 that this exhibition of Buddhist sacred art of Tibet was conceived by Marylin Rhie and Robert Thurman for Tibet House New York, and that the Asian Art Museum of San Francisco organized it so that many people in the United States and England were able to see some of our finest works for themselves. I am delighted that Tibet House New York has reorganized and enlarged the exhibition so that the people of Germany, Spain, and Japan can now have the same opportunity during the coming years. It is good that this book is being enlarged and republished in English, and also translated into German, Spanish, Catalan, and Japanese so that we can better share our precious culture. It is my hope that the new exhibition and book will help to clarify some of the misconceptions and confusions still lingering about the sacred art forms of Tibet.

Art expresses the perceptions of a people. Sacred art reveals their deepest insights and their highest aspirations. So, to encounter our works of sacred art is to experience for yourself some of our most profound visions. Some of these visions come from our greatest masters, who looked deep into the human soul, confronted the stark realities of human passions, and discovered the human capabilities of wisdom and love.

If only a few of these works of art bring pleasure, stimulate curiosity, and provoke new insights to even a small number of those who see and study them, then the exhibitions and the editions of this book will have accomplished their purpose. We have treasured them for centuries in Tibet and are deeply moved that they are now beginning to be treasured by the open-minded people of the whole world.

Dharamsala, India
October 1995

Robert A. F. Thurman
Co-Founder and President, Tibet House New York

As one of the founders and the current President of Tibet House New York, I am extremely pleased to present a reincarnated and expanded exhibition and book, *Wisdom and Compassion: The Sacred Art of Tibet,* to all those who are interested in Tibetan civilization, with its profound spiritual knowledge and its exquisite art. It is especially wonderful that the people of Germany, Spain, and Japan will now have the opportunity to visit the "sacred mandala space" of this exhibition as it is presented in their countries and read about Tibetan civilization and these outstanding works in their own languages.

I began my study of Tibetan civilization thirty-three years ago and first met His Holiness the Dalai Lama and the Tibetan refugee community in Dharamsala, India. On leave from Harvard College and wandering in search of higher truth, I sensed in the Tibetans traces of an age-old, "higher"—in the sense of most gentle, intelligent, and cheerful—culture. I then determined to dig into it to find the lost philosophy of life and enlightenment for which I felt such an urgent need. With the help first of the late Venerable Geshe Wangyal, and soon of His Holiness himself, my intensive, five-year study of Tibetan philosophy began. This involved meditation and critical analysis, along with linguistic, psychological, and philosophical studies. In my enthusiasm I became a Buddhist monk and returned to Harvard for the long haul to become a professor, the university being modern culture's next best thing to a monastery. Thirty-three years later, Tibetan civilization has brought me gifts of inestimable value for my life and spirit, and I look forward to enjoying a continued exploration of the vast treasures hidden in the Tibetan traditions.

My approach for the first ten years or so was primarily philosophical and spiritual. While sensitive to and comfortable with Tibetan art, I paid it little heed. Only in the last twenty years did I begin to discover the extraordinary richness of the Tibetan aesthetic. So when, in 1979, in Houston, Texas, His Holiness asked several American friends to think about establishing a Tibet House in America—a long-term institution to preserve the cultural traditions of his people—we readily accepted the challenge.

I then began to find out about the extreme devastation of Tibetan material culture, first by the Chinese military invasion and occupation of Tibet and then by the program of "thought reform" that tried to eradicate all traces of Tibetan religiosity and culture. This program reached a height during the infamous "Cultural Revolution" from 1966 to 1979. The once broad river of living culture, the ongoing performance of ancient Tibetan artistic traditions, can now only be found in tiny trickles in the exile communities and in private museum collections around the world. In fact, the job of founding Tibet House was so daunting that it took another eight years to assemble enough supporters to fund the institution. During that period, Marylin Rhie and I managed an exhibition of Tibetan sacred arts, *From the Land of Snows,* at the Mead Art Museum at Amherst College in 1984.

In 1987, under the auspices of His Holiness the Dalai Lama, 1989 Nobel Peace Prize Laureate, Tibet House New York was founded in order to present to the modern world the ancient traditions of Tibetan art and culture, to preserve and restore the spectrum of Tibet's unique cultural heritage, and to share with the world Tibet's practical techniques of spiritual philosophy, human development, nonviolence, and enlightenment. His Holiness has said, "I feel that Tibetan culture, with its special heritage—born of the efforts of many human beings of good spirit, of its contact with Indian, Nepalese, Persian, and Chinese cultures, and of its unique natural environment—has developed a kind of energy which is very helpful towards cultivating peace of mind and a joyful life. . . . In this way I feel very strongly that Tibetan culture will have a role to play in the future of humanity."

Mr. Tenzin Thethong, then the American representative of His Holiness, Mr. Richard Gere, the famous actor and disciple of His Holiness, and Mr. Philip Glass, the noted composer and Buddhist practitioner, were instrumental in getting Tibet House started. Dr. Steven Rockefeller made a generous leadership gift that enabled us to create a full-scale international art exhibition, *Wisdom and Compassion: The Sacred Art of Tibet,* that definitively revealed the world-class aesthetic brilliance of Tibetan culture. We decided to make the exhibition the central element of the International Year of Tibet in 1991–92, which was created to introduce to an ever-widening circle of people the intense beauty and spiritual value of Tibet. Our dream is to see a restored Tibet, wherein the transmission of artistic and spiritual tradition from generation to generation will once again be honored and secure, providing a suitable resolution of the present political situation.

In the exhibition or in these pages, you will encounter the Buddhas and Bodhisattvas, saints, adepts, kings, lamas, gods and goddesses mild and fierce, from the heavens and from nature, including the realms beyond death, and amazing landscapes from the Tibetan imagination. These persons, deities, and places have all contributed to Tibetan civilization. They originally created it, long preserved it, and it is believed that they work invisibly to ensure its continuance. It has been our privilege to assemble the art that reflects their nobility, beauty, wisdom, and compassion. We hope your eyes will be delighted and your hearts buoyantly uplifted, and that you will join us in our prayers and wishes for the Tibetan civilization to remain with us, contributing to the future of our world and enriching our emerging global culture.

New York, New York
October 1995

Rand Castile
Director, Asian Art Museum of San Francisco

Wenzel Jacob
Director, Kunst- und Ausstellungshalle
der Bundesrepublik Deutschland

The Westerner's view of Tibet, like an early motion picture, is two-dimensional, flickered with light and relieved by no reality. It is as though we were shut out, as though Tibet itself was made almost imperceptible and inaudible to us by distance and by a permanent snow that mingled with all atoms and filled the space of Tibet. The bright snow is a scrim behind which a vaguely discerned Tibet is occasionally glimpsed.

It is our fond hope that the exhibition and this publication will bring us closer to the people and culture of Tibet through the illustration and discussion of its great and religious art. Our undertaking is ambitious; the subject is large, it is ancient, it is supremely complex, and it is alive in practice in several areas of the world.

The exhibition is inspired by the concept of the mandala. On a simple level, the mandala represents a paradise, a divine universe, the home of a god. Seen more deeply, it symbolizes the divine nature of our own world.

The art in the exhibition spans the millennium from the ninth through the nineteenth centuries. In theme, however, it starts from a more distant historical point—the time of Shakyamuni Buddha, some twenty-five hundred years ago. In the exhibition one moves forward in time, past the early days of Buddhism to the introduction of the doctrine into Tibet. Deeper into the exhibition, one surpasses time per se and enters the symbolic realm of the mandala, and, ultimately, one ends among the powerful images of the Pure Lands of the Buddhas. In sculpture and in painting we find an equally strong and colorful Tibetan art. The rank of imagination and artistic skill here is among the highest one can encounter in religious art. Western work of comparable power might be best seen in the richest mosaics of the Byzantine Church or in the early stained-glass art of French cathedrals. In these, as in the Tibetan tangkas of the exhibition, color, form, and iconography meet in unparalleled enthusiasm.

This publication and the exhibition have benefited from the exalted leadership of His Holiness the Dalai Lama. His early and keen interest in the project inspired and sustained the many who worked on *Wisdom and Compassion*, and, on behalf of us all, may I express here our profound thanks and appreciation. May I also thank Richard Gere, of Tibet House New York, for it was he who came to me with the idea of an important exhibition treating Tibetan art. His dedication to the project did much to ensure its success.

San Francisco, California
September 1990

With the exhibition *Wisdom and Compassion: The Sacred Art of Tibet*, the Kunst- und Ausstellungshalle der Bundesrepublik Deutschland in Bonn directs its attention for the first time toward the cultural realm of Asia. Our present knowledge of Tibet has increased considerably beyond the old notions of Tibet as a mystical and distant paradise; our fascination, however, remains as vital as ever. Many scholarly publications have explained the Tibetans' way of life, their history, and their religion, but no narrative can substitute for the face-to-face exposure to the original relics of Tibetan culture. Therefore, we are delighted that the combined efforts of Marylin M. Rhie and Robert A. F. Thurman have made it possible to show an extraordinarily rich and beautiful selection of Tibetan religious artworks. We are also grateful to Tibet House New York for organizing this show for our institution. It is our deep wish and hope that this exhibition will increase public interest in Tibet and provide its audience with enthusiasm for the treasure that is Tibetan culture.

Bonn, Germany
1996

Yasuo Yuzawa
Director, Arts and Cultural Events Department
Cultural Projects Division
The Asahi Shimbun

It is our great pleasure to hold the exhibition *Wisdom and Compassion: The Sacred Art of Tibet*. Born in India, Buddhism came to Japan by way of China and became a national religion of Japan. However, *Tibetan* Buddhism never came to Japan in the true sense, and Japan has had few exposures to it. *Wisdom and Compassion* is a comprehensive compilation of Tibetan Buddhist painting and sculpture representing the core essence of Tibetan Buddhism over ten centuries. It is our belief that this high-quality show will provide an opportunity for Japanese people to promote understanding about Tibet and its Buddhism and that it will foster mutual trust and friendship. We would like to express our special thanks to Tibet House New York for organizing such a fabulous exhibition and to its curators, Dr. Marylin M. Rhie and Dr. Robert A. F. Thurman.

Tokyo, Japan
1996

ACKNOWLEDGMENTS

Tibet House New York is extremely grateful to the individuals and institutions who have graciously loaned the treasures of their collections for the third incarnation of this exhibition: The British Museum, The Trustees of the Victoria and Albert Museum, A. and J. Speelman, Ltd., and Spink and Son, Ltd., London; American Museum of Natural History, The Asia Society, and Doris Wiener Gallery and Nancy Wiener Gallery, New York City; The Asian Art Museum of San Francisco, San Francisco; The Cleveland Museum of Art, Cleveland, Ohio; Mr. and Mrs. Willard G. Clark; Mr. and Mrs. John L. Eastman; G. W. Essen, Hamburg; Folkens Museum Etnografiska, Stockholm; Mr. and Mrs. John Gilmore Ford; Mr. and Mrs. Lionel Fournier; Dr. Wesley and Mrs. Carolyn Halpert; Mr. William M. Hitchcock; Los Angeles County Museum of Art, Los Angeles; Mr. Michael McCormick; Musée Guimet, Paris; The Newark Museum, Newark, New Jersey; Museum Rietberg-Zurich, Zurich; Rose Art Museum, Brandeis University, Waltham, Massachusetts; Royal Ontario Museum, Toronto; Donald and Shelley Rubin; Arthur M. Sackler Museum, Harvard University, Cambridge, Massachusetts; The State Hermitage Museum, St. Petersburg; The Zimmerman Family; and other private collectors in Europe and the United States.

1991 Acknowledgments

We would like to thank from the depths of our hearts the host of people whose support, encouragement, and contributions of works of art, funds, time, and energy made this exhibition and book possible: His Holiness the Dalai Lama, whose strong encouragement of our original proposal got us going and kept us moving over the last six years; Richard Gere, whose vision, devotion to the Tibetan people, enthusiasm for Tibetan culture, generosity, good humor in tight spots, and persistence in the face of obstacles were indispensable at every step of the way; Professor Steven C. Rockefeller, whose early and continued, strong and intelligent encouragement and support were crucial; Elizabeth Avedon, who has been inspiring and supportive at all times, especially at the beginning when the goal seemed most remote; Paul Gottlieb, who felt instinctively at ease with the Tibetan aesthetic and whose unstinting enthusiasm and support were crucial at many points during the journey; Rand Castile, who caught the vision instantly and took the courageous stand that Tibetan civilization merited wide appreciation; John Bigelow Taylor and Dianne Dubler, who from the very beginning gave full support from the heart and persevered with magnificent generosity of time, energy, and loving skill to render the beauty of Tibetan sacred art with a new level of vividness and clarity; Porter McCray, who opened many doors of understanding and opportunity and gave key advice on many occasions; Elsie Walker, who translated her enthusiasm into constant dedication and hard labor without losing initiative and courage, especially during the most difficult times; Laurance Rockefeller, who shared his vision of lighting the way to peace and justice with the lamp of culture and gave key support; Anna Souza, who contributed her knowledge of Tibetan art and culture, her special gift of bringing people together for the best purpose (and then bringing out the best in each of them), her flair and eye for quality, and when she became Tibet House's coordinator of the whole process, took responsibility for really making it happen; Robert Hatfield Ellsworth, John and Berthe Ford, and Jack and Muriel Zimmerman, not only because their love of beauty and of Tibet impelled them to find and preserve some of the greatest treasures in the exhibition, but also because they gave such wise advice, such enthusiastic support, and such steadfast faith

in the project over a long period of time; Gennady Leonov, for his longtime friendship and generous spirit of support; Julia Moore, for her insight, editorial skill, patience, and creativity in taking hold under the pressure of the complexities of this large project, and for coming up with a clear vision of the beautiful book in it; Nena von Schlebrugge-Thurman and Young H. Rhie, whose devotion, diplomacy, insight, patience, and hard work were crucial, unfailingly helpful, constant, and utterly indispensable.

With heartfelt appreciation, we thank the institutions and individuals who have been crucial supporters and partners along the way: The National Endowment for the Humanities, The Threshold Foundation, The Luce Foundation, and The Merck Foundation.

At Tibet House, Matthew Buckley, Chimi Thonden, Johnnie Chace, William Sterling, and the entire board and staff have our deepest gratitude. At the Asian Art Museum of San Francisco, we thank Clarence Shangraw, Terese Tse Bartholomew, Richard Kohn, Hal Fischer, and Libby Ingalls. At the IBM Gallery of Science and Art, our special thanks to Cynthia Goodman, Richard Berglund, and Robert Murdock.

We also want to acknowledge our colleagues who served on the advisory committee, those who so graciously contributed to earlier versions of this manuscript, and those who were consulted informally at various stages over the years: Venerable Gelek Rinpoche, Venerable Pema Wangdak, Venerable Tulku Thondup, Lobsang P. Lhalungpa, Harold Talbott, Heather Stoddard-Karmay, and Valrae Reynolds; the late Venerable Hiroshi Sonami, Tartse Ngor Khenpo, Venerable Pema Losang Chögyen, Professor Pramod Chandra, Professor Elliot Sperling, and Paul Nietupski.

Also, we are grateful to Edwin Bernbaum, Thomas J. Pritzker, Martin Brauen, and Young H. Rhie for sharing their superb personal photographs; to Anna Souza and Lobsang Lhalungpa for their translations; and to others who helped in various ways, with typing, proofreading, photography, and other supports: Richard Fish, Sonya Rhie, Nancy Braxton, Beata Tikos, Janice Leoshko, Denise Leidy, Robert Mowry, and many others. Caroline D. Warner has our admiration for her sharp-eyed, intelligent, and good-humored polishing of the text of this book, and Maria Miller deserves great credit for her elegant and sensitive design.

M.M.R. and R.T.

1996 Acknowledgments

We gratefully acknowledge His Holiness the Dalai Lama for encouraging us to move forward with effort and enthusiasm to reincarnate the *Wisdom and Compassion* exhibition.

We thank Rand Castile, former Director of the Asian Art Museum of San Francisco, for giving blessing to our efforts to reorganize the exhibition. For their advice and kind cooperation, we thank Hal Fischer, Terese Tse Bartholomew, Richard Kohn, and Libby Ingalls. We are thankful to Mark Gotlob, Marie-Therese Brincard, and Sarah Fogel at the American Federation of Arts for their expert advice on the complex organization process and for assuring the highest-caliber registrarial procedures for the present exhibition.

We are sincerely grateful to publisher Paul Gottlieb at Abrams for his faithful support in publishing this book in its expanded form in English. We also give special thanks to Julia Moore, Maria Miller, Margaret Chace, and Toula Ballas for their exacting and patient efforts in producing this volume.

We wish to express our sincere gratitude to Robert Hatfield Ellsworth, Jack and Muriel Zimmerman, John and Berthe Ford, and Kira Samosyuk for continuing to help us obtain works for the exhibition. We also appreciate the helpful cooperation of Deborah Klimburg-Salter, Jane Casey Singer, Steven Kossak of the Metropolitan Museum of Art, and the kind assistance given by Fabio Rossi, Moke Mokotoff, Stuart Perrin, and Nik Douglas.

To Ryuichi Abe, Ryuju Abe, and Hiroko Sakomura, we extend our gratitude for their tireless, thoughtful efforts in getting the international exhibition started. We are also very thankful to Uma Thurman for encouragement and participation in the early phases of negotiation.

We are immensely fortunate to have had the perseverance and perceptive assistance of Nena von Schlebrugge Thurman, Treasurer and board member of Tibet House New York, through the entire project. Profound thanks go to Jeffrey Jordan, Director of Exhibitions at Tibet House, without whose skillful, determined, industrious, and courageous efforts the exhibition would not have been possible. To our dear friends Nancy Braxton, attorney-at-law, and Beata Tikos, Administrative Director of Tibet House New York, and to all the board members, staff, and volunteers, especially John Morgenegg, we offer heartfelt thanks. Finally, we would like to acknowledge the continuous and unflagging help and understanding of numerous other friends and associates, particularly Young Rhie, whose insights and guidance have sustained us during the long process.

M.M.R. and R.T.

Marylin M. Rhie
and Robert A. F. Thurman

OVERVIEW

As an exhibition, *Wisdom and Compassion: The Sacred Art of Tibet* seeks to fulfill the important responsibility of making Western audiences more acutely aware of Tibetan sacred art. Just as important, it is the first exhibition that has attempted both to demonstrate the function of this quintessentially religious art within its sacred context and to present its qualities as a distinctive body of fine art. As the guest curators, we have felt both the awe of the pilgrim and the delight of the treasure hunter in the long process of finding the one hundred sixty paintings, sculptures, tapestries, and other works presented here. They are some of the rarest masterpieces of all Tibetan Buddhist art from museums and private collections in North America, Europe, and the Soviet Union.

In choosing the works that comprise *Wisdom and Compassion*, and in writing this book, our goal has been twofold: to introduce Tibet's compelling and mysterious art *on its own terms* to those with little or no background in either Buddhism or Tibetan Buddhist art, and to add new scholarship on the subject of Tibetan art that reveals its independent tradition, rich imagination, high refinement, and profound and universal significance. Satisfying both objectives has been an immense challenge. The art itself is highly sophisticated—both iconographically and artistically—and it is a seamless expression of Tibet's complex culture, which is a completely spiritual one.

Because one cannot approach the art of Tibet without considerable grounding in Tibetan Buddhist thought, practice, and history, this book, written with the collaboration of an international team of scholars and curators to illuminate the exhibition, is likewise unprecedented in its interweaving of the religious and artistic content of Tibetan sacred art. Organized as a progressive journey, it begins with basic concepts of Buddhist thought and art and moves on through specific details about the individual works. The brief opening essay, "Wisdom and Compassion: The Heart of Tibetan Culture," is a kind of experiential hand-in-hand walk through one of the most difficult images for Westerners to comprehend: a father-mother union manifestation of the Buddha that, on first view, is both fearsome and erotic. By confronting this image on several levels—symbolic, aesthetic, psychological, and spiritual—we hope to make the beholder aware of the possibilities inherent in all the works of art that follow.

"Tibet, Its Buddhism, and Its Art," which comes next, is a broad-brush introduction to historical Tibet, Buddhist thought (and specifically Tibetan Buddhist thought and practice), and Tibetan Buddhist art from a religious point of view. All of the religious and symbolic concepts encountered in the catalogue

section are introduced here: Tibet's secular and religious history, its pantheon of deities, and its particular tantric synthesis of all the varieties of Buddhism; its four main monastic orders and their contributions; and Tibet's view of itself as one of the Buddhist Pure Lands and as a millennial nation. This essay also articulates an important theory of Tibetan sacred art in terms of modern depth psychology.

"Tibetan Buddhist Art: Aesthetics, Chronology, and Styles," is an art historical essay and, together with the preceding essays, provides a solid foundation, preparation, and context for the catalogue section. It uses the chronological framework of Tibet's thirteen-hundred-year artistic tradition to present ideas of the aesthetics of Tibetan art, a more exact chronology, and an analysis of the regional styles and complex stylistic sources of the art. It shows how Tibetan art holds a unique and high position among the Buddhist arts of Asia, and how it is an expression of a most profoundly developed Buddhist thought depicted in a form and style that are harmonious with the traditions of the other great Buddhist civilizations, yet rises to special eminence because of its distinctive qualities of vivid clarity, kinetic vitality, and spiritual realism. A summary overview of the techniques of Tibetan tangka painting and sculpture by the eminent French scholar of Tibetan art Gilles Béguin follows the catalogue section.

In "The Sacred Art of Tibet," as the catalogue section is titled, the entries for each of the one hundred sixty works of art synthesize all the approaches just described. Building upon the pioneer studies of previous Western scholars and writers, and drawing on Tibet's own developed traditions of religious and aesthetic scholarship, we have combined religious and aesthetic insights in the hope of offering a new, more accurate and complete, understanding of the nature, development, and sources of this spectacular art. In the religious dimensions, we focus on the iconography of the images, discussing its symbolism, meaning, and function in religious practice. In the artistic aspects, we emphasize style in terms of aesthetics as it relates to the religious ideal, and we present dating and regional factors while tracing the particular sources associated with each work. We have been aided in this endeavor by colleagues Gennady Leonov, Curator of the Tibetan and Mongolian Collection, State Hermitage, Leningrad; Gilles Béguin, Conservateur, Tibetan Art, Musée Guimet, Paris; Kira Samosyuk, Curator of Chinese Art and the Khara Khoto Collection, State Hermitage, Leningrad; Terese Tse Bartholomew, Curator of Indian and Tibetan Art, Asian Art Museum of San Francisco; and Richard Kohn, Associate Curator of Tibetan Art, Asian Art Museum of San Francisco.

The study of Tibetan art is still a new field in the West. We trust that by using a multifaceted approach we have helped clarify the profound religious thought behind these works of art, at the same time familiarizing viewers with the distinctive sense of beauty grounded in that thought. Also, the significant new materials, translations, and theories presented here offer valuable resources for the study of Tibetan art. It is our hope that *Wisdom and Compassion,* both the exhibition and the book, will bring a heightened public awareness of this precious cultural expression of the Tibetan people and that it will encourage more study and greater appreciation of Tibet's unique religion, art, and civilization.

The plan of *Wisdom and Compassion* is symbolically meaningful. It centers on, and takes its governing principle from, the mandala of the Wheel of Time (Kalachakra mandala), the mystic mansion that embodies the perfected history and cosmos of the Buddhas. In its extended function, the mandala (literally, "sphere of spiritual nurture") is a total purified universe which can be used to transform our environment, our country, our planet Earth, or our own minds. Thus the exhibition has woven the works of art into an iconographic design of a sacred time and space, which unfolds to the imagination of the viewer. One begins with the outer halls of the mandala-palace, representing the realms of the historical Buddha of our times, the Buddha Shakyamuni, and the various teachers, upholders, and protectors of his teaching (the Dharma), including the Arhats, Bodhisattvas, philosopher-saints, and Great Adepts, and the Dharma Kings, royal protectors of the Dharma. One then enters the middle halls of the mandala-palace, which represent the practices of Tibetan Buddhism by its four major orders: in historical order, the Nyingma, Sakya, Kagyu, and Geluk orders, with their eminent founders and teachers and some of their archetype deities (*yidam*). One comes finally into the inner halls of the mandala-palace, there to meet the highest forms of the transcendent Bodhisattvas and Buddhas in their celestial and earthly Pure Land paradises, and to see how the Tibetan nation and civilization became transfigured through connection with those realms.

The Pure Land dimension of Tibet can be seen as the key to Tibet's mysterious fascination, as it revitalizes our dreams of the mandalic, sacred aspect of Earth itself and its ultimate potential as a paradise. It keeps alive our hopes for understanding the fundamental truth, present in all the world's spiritual traditions, that the goal reality—nirvana, liberation, salvation, enlightenment, and transfiguration—are really here and now, at hand within the core of our existence.

One of the highest art forms for Tibetan Buddhists is presented in the innermost chamber of the mandala-palace. It is the creation of the color particle sand mandala by the monk-artists of His Holiness the Dalai Lama's Namgyal Monastic University. This exquisite and unique art form attests to the vitality of the Tibetan Buddhist artistic tradition in the present. It provides the living context within which the ancient masterpieces come to life.

Each section of the exhibition seeks to suggest the qualities, mood, and character of its subject, and, as a secondary principle, to reflect as much as possible the chronological sequence of the art within that section. Where feasible, the regional characteristics and the hierarchical order of religious practice are also observed. The presentation of the four main orders with their archetype deities offers new insights into the iconography of practice of each order, and into the artistic styles that may be associated with particular monasteries and orders. An awareness of simulating the settings within Tibetan temples also appears in the groupings and arrangement of the pieces. In this way the exhibition offers the viewer a full sense of the Tibetan Buddhist vision, as well as a varied way of understanding each individual work, with its pure aesthetic qualities, in its own religious and historical setting.

NOTE ON TRANSCRIPTIONS AND TERMINOLOGY

In order to make this catalogue as accessible as possible to the general public, we have avoided diacritical marks, even where specialists might expect them. Thus, Sanskrit long and short vowels have not been differentiated, and sibilant and retroflex *sh*'s, various *n*'s, dentals and retroflex dentals, and so forth have been conflated (as they are by the nonspecialist even when diacriticals are used). Tibetan words have been rendered as phonetically close as the English alphabet will get them to their pronunciation in Lhasa speech. *Th* has not been used for the Tibetan aspirated dental, since English *t* is already aspirated, and since the American reader reads *th* as in *the*, which sound does not occur in Tibetan. Tibetan names and terms often have been transliterated in modified Library of Congress convention when italicized in parentheses. Chinese words have been given in Pinyin transcription. In transcribing all three languages, we have made exceptions to our system in a few conventionally well-established cases. The Sanskrit form is given in the first occurrence of a term, but thereafter the English translation is generally used. Italicized terms in parentheses are generally Sanskrit, unless otherwise noted, except in places where Tibetan terms occur in exclusively Tibetan contexts.

In dating, we have departed from the Western usage of Before Christ and Anno Domini. We have followed a convention much in use in Asia and in writings of adherents of the other world religions: namely, Before the Common Era (BCE) and Common Era (CE).

To avoid anachronisms, we have recognized countries of origin as they existed during the time the works of art were created. Thus, Tibet is the country of origin for most of the works, with a few made in Mongolia and some made in China. By "Western Tibet" we mean mainly the areas of Guge, Ngari, Spiti, Zanskar, and Ladakh, the last three regions now part of India. By "Eastern Tibet" we mean the provinces of Kham and Amdo (currently mostly incorporated into the Chinese provinces of Qinghai, Gansu, Sechuan, and Yunnan). And by "central regions of Tibet" we mean the provinces of Ü and Tsang. All dates and regional attributions in the entry headings are the authors' and reflect the analyses given in the entry texts.

There is a glossary of terminology at the end of the book. Several terms should be mentioned here as well. The Three Vehicle terminology is not well established in Western Buddhist scholarship, as it emerges mainly from the late Indian (no longer extant) and Tibetan traditions, where all three are accepted as fully valid teachings of the Buddha; and thus they must be synthesized into a usable whole. We translate the Sanskrit terms Hinayana, Mahayana, and Vajrayana, respectively, as Individual Vehicle, Universal Vehicle, and Apocalyptic Vehicle, in that monastic (Individual Vehicle) Buddhism facilitates the individual's focus on his or her own liberation, messianic (Universal Vehicle) Buddhism encourages the individual to undertake the universal liberation of all beings, and esoteric, tantric (Apocalyptic Vehicle) Buddhism aims to liberate all beings immediately, putting an end to the ordinary time of the world of suffering in the apocalyptic revelation of the enlightened universe.

Finally, we are quite pleased with our translation of the Tibetan *yidam* (Sanskrit *ishtadevata*) as "archetype deity." These *yidam* include some of the most beautiful and spectacular of the tantric Buddhaforms, some erotic, some terrific, all benign and compassionate, however fierce the exterior. Previous scholars have tried various terms for *yidam*, and some have retained the Tibetan word. The tendency is to think of them as some sort of external deity, that is, some elaboration of Buddhahood into something utterly alien from the calm, contemplative, humanlike Buddha under the bodhi tree. The fact is, these Buddha forms are chosen (*ishta*) by tantric yogis as templates for visualization, forms that artistically express the powerful feelings of insight and breakthrough, exaltation, bliss, and clarity. Jung insightfully discerned the mythic archetypes in the collective mind, archetypes that can serve as vehicles for deep, repressed emotions to surface and be integrated in healthy awareness. The psychological and healing connotations of his term are completely appropriate for the tantric embodiments of enlightenment.

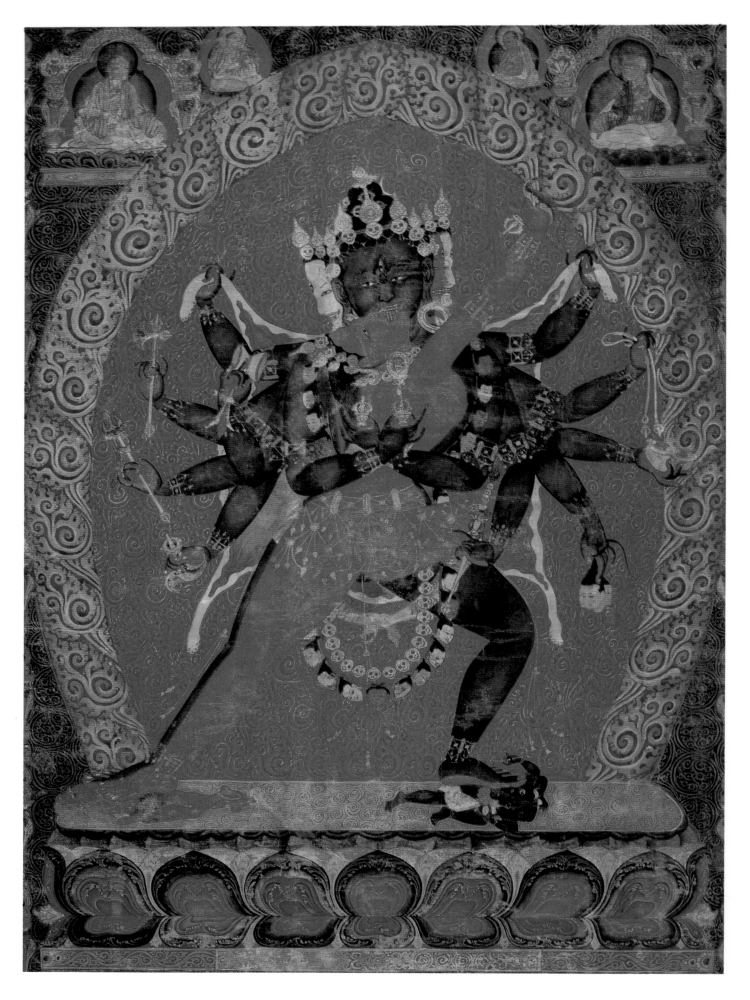

Detail from *Paramasukha-Chakrasamvara Father-Mother*, No. 70

WISDOM AND COMPASSION: THE HEART OF TIBETAN CULTURE

Robert A. F. Thurman

In Tibet, the Buddhist Land of Snows, art flows into life, and virtually all the arts are sacred. Art finds its way onto all the surfaces of the Tibetan world: onto teacups and lamps, tables and carpets, onto hems and hats and boots, onto saddles and tents, and most conspicuously onto Tibet's magnificent temples and monasteries. Tibetans create art to open windows from the ordinary, coarse world we know onto the extraordinary realm of pure wisdom and compassion. To the artists who create these objects, and to those who behold them, they are the point of transition from the earthly world to ultimate and sacred realities. The contemplation of icons, called tangkas, and of sculptures and mandalas enables Tibetans to reach into realms beyond their normal command, just as these art forms enable their deities' compassion to come shining through into this world of woe and trouble.

Quite deliberately, *Wisdom and Compassion: The Sacred Art of Tibet* begins with this startling image that shows the Buddha—the same Buddha most often represented as a fatherly monk—in father-mother union form, in an aspect that is electrifyingly physical. This father-mother union image of the Buddha as Supreme Bliss Wheel Integration (Paramasukha-Chakrasamvara), which is No. 70 in the catalogue section of this book, is not an example of erotic art. Yet if seen only at the "ordinary" level of physical union, the imagery of this tangka might seem to confirm so many of our longstanding misperceptions of Tibetan Buddhism as a "primitive" mix of Buddhism and an indigenous animistic religion, as a corrupt and degenerate form of Buddhism, or as evidence of a culture in which rites and practices are based on, or even legitimize sexual extremes.

Nothing could be further from the truth. The father-mother union is a manifestation of the Buddha's highest spiritual essence, of enlightenment as the union of wisdom and compassion. More than metaphorical, to the devout Tibetan this image is concrete evidence of the existence of great spiritual attainment. The female (mother), Vajravarahi, represents transcendent wisdom: the direct awareness of reality as the Buddha experienced it and taught it. The male (father), Shamvara, represents compassion for all beings, which is the natural expression of such wisdom. Wisdom knows the ultimate nature of reality, its absolute freedom and total relativity. To Buddhists, the "root of all evil" is our desperate clinging to self-image and self-satisfaction. Wisdom comes through experiencing the perfect "transparency" of the self, which leads to utter freedom from self-concern. Such transparency of self gives a clear view of others; such freedom from self-concern makes room for concern for others. Wisdom is the bliss of seeing through the delusion of self-preoccupation to reveal the underlying dimension of freedom. Compassion is the expression of such bliss to others.

Compassion is also sensitivity to others' suffering. It sees them imprisoned in self-involvement, and reaches out to show them the way to freedom. The quintessential Buddhist art, in the broadest sense, is the liberating of all beings from suffering; its fruition is the discovery of truth, beauty, goodness, and the capacity for bliss inherent in enlightened life.

As modern depth psychology has come to recognize, images like this Paramasukha-Chakrasamvara represent the deepest archetypes of the unconscious, integrating the powerful, instinctual energies of life into a consciously sublimated and exalted state. And if we look at it this way, we will be able to appreciate one of Tibet's most precious gifts to civilization.

We will see that the Tibetans have given us a method for transmuting even the darkest, most dread-filled phenomena of the human psyche—such as the fear of death and the drives to lust and hate—into creative energy that can triumph over them and turn them into the highest spiritual enlightenment. (This notion is elaborated in the essay "Tibet, Its Buddhism, and Its Art.")

Let us for a moment lay aside our ordinary perceptions of reality and follow the Tibetans in their meditation on this father-mother union image, allowing it to become an image of ourselves as the embodiment of enlightenment. If we let ourselves observe and experience this image as Tibetans do, we can be inspired about the possibility of attaining enlightenment for ourselves. But the liberative potential of this image can be fully realized in our imagination only if we try to feel the texture of the goal state—if we imagine ourselves to be both this male and this female in union, in such an embrace, with these arms, these legs, these faces and eyes, with these adornments, and holding these symbols. This is, in fact, what Tibetan adepts do. It is the inner secret of tantric meditation.

Thus as Shamvara (who embodies compassion), we embrace transcendent wisdom (seen as the goddess Vajravarahi) as an impassioned lover—feeling the ecstatic, all-pervading bliss in balance with the peaceful connectedness of physical union. Our front face is black with the direct experience of the perfection of ultimate reality, and we look adoringly at the face of the beloved, whose exquisite body is flaming red with the solar intensity of passion. Without moving from the absolute freedom, calm, and confidence of this indivisible bliss-void, we feel a pure and passionate love for the myriad forms of all creation. Our expression is alive with the intensity of a delight so great that it borders on ferocity, totally unobstructed by any holding back, suffering, or lack of joy. We look out of three eyes—the usual two that reveal the binary world of yes and no, of love and hate, and the eye in the center of the forehead that beholds the deeper realities of the spiritual. At the same time that we are absorbed with the beloved one, we feel fully present to all that is happening around us in the world, looking right and behind and left with our three other faces—the red one to the right aroused with awareness of all beings, seeing the exquisiteness of their individuality; the yellow one behind entranced in the joyous exaltation of full awareness of the abundance of life; and the left one white and peaceful, mindful that even external forms that fascinate us mirror the perfection of the absolute.

The intense bliss of our heart surges to embrace all life, exploding out through complex shoulders, extending to six strong arms on each side. Our first pair of arms embrace the beloved, holding her delicately in full contact and holding behind her back a vajra scepter in our right hand and a vajra bell in our left. The vajra scepter at the basic level symbolizes compassion, the bell wisdom. At a higher level, they symbolize magic body and clear light—the inconceivable, fully enlightened body and mind blissfully at one with ultimate reality. The scepter and bell signify that unity, the state of Buddhahood, is the goal—the union of relative and absolute, love and wisdom, life and death, creativity and security.

We have ten more arms that reach out to touch all beings, bringing them to their highest potential of wisdom and joy. One pair of arms hold a freshly flayed elephant hide across our back, symbolizing the conquest of our own elephant of ignorance—the heavy mind that insists on the habitual perceptions and conceptions of ordinary reality. These two arms stretch the bloody hide across our back, ecstatically expanding our chest as it bursts free from all heavy encumbrance. The hide is also a symbol of our utter fearlessness. The beast we have conquered is our ordinary, fearful self. Our "presence" encompasses death and has found ecstatic life within death. We have nothing more to fear.

Our next pair of arms hold a *damaru* drum in the right hand and a vajra-tipped *khatvanga* staff in the left. The double-faced *damaru* has two small clappers on strings that hit the drum's surfaces when we twist it quickly back and forth. Its rapid rattling sound teaches impermanence, summons the angelic female deities known as Dakinis, and celebrates the triumph over misery that is achieved by practice of the secret arts of the Unexcelled Yoga tantras. These are the most advanced tantras, or technologies, for yoking every atom of our being to the experience and expression of enlightenment. The *khatvanga*, a ceremonial staff symbolizing mastery of the subtle body and its energies, has an eight-faceted shaft; its top has a small vase of immortality, topped by a vajra cross, symbolizing the union of wisdom and the art of compassion. Above the cross are stacked a moist human head, a dried human head, and a dried skull. Together they symbolize our conquest of the three poisons (greed, hate, and delusion); our mastery of the three channels of the subtle body; and our transmutation of the life cycle of death, the state between death and rebirth, and life into the Three Bodies of Buddhahood—the Truth Body, the Beatific Body, and the Emanation Body. (These concepts are explained in the next essay; they are mentioned here only to convey the icon's symbolic range.)

Our next pair of arms hold a battle ax and a blood-filled skull bowl, symbolizing the conquest of all demonic forces and the transmutation of the lifeblood of ordinary evil into the elixir of immortality. Our fifth pair of arms hold a vajra chopper and a lasso. The chopper symbolizes the severing of the ordinary false, habitual imagination. The lasso symbolizes the enlightened ability to bind negativity and harness it to the positive. Our last pair of arms hold a trident and a severed four-faced head of Brahma, the Indian creator god. The trident symbolizes the powers derived from mastery of the three channels of the yogic subtle nervous system that Buddhist yogis visualize in their meditations as a ball of energy fibers wound around a blue central spinal channel.

The severed head of the Indian creator god Brahma is a complex symbol. It is our own head, and it represents the Buddha's triumph over the temptation to become a god. It also symbolizes the harnessing of creativity toward the transformation of the universe of selfishness and insufficiency into a paradise of selfless generosity and abundance. Its being held aloft symbolizes the power of the truly loving individual, who is beyond all danger of being overawed by oppressive authority or dominating power. Our legs, standing in the pose of warrior challenge on the backs of male and female universe-destroying deities (these too are our own emanations), symbolize that the indivisible bliss-void transcends the forms of ordinary, self-centered sexuality.

We also can become Vajravarahi, the beloved, burning with the unrestrained passion of love that experiences, indivisibly, individual satisfaction and the happiness of all beings. Being wisdom ourselves, as Vajravarahi, we see our compassion-

consort as the absolute in action. We embrace him as if he were the universe itself, as if he were vast networks of galactic energies spread infinitely throughout the endless void, a creative darkness bursting with the brilliant light of power and beauty. And at the same time responding as Shamvara, we feel Vajravarahi as the absolute at peace. We embrace wisdom as our true home, a calm so vast and free that it can be delicate and sensitive, the tender creative matrix. In union as wisdom and compassion, we are blissful in a sustained and sustaining way, radiating light streams of healing energy to all beings.

This image, and many others like it, are familiar to all Tibetans. Its vision of personal energy, altruistic dedication, and total fulfillment reveal and express the core ideal of the Tibetan way of life. While only a few can hope in their present life to succeed in the evolutionary enterprise of becoming a Buddha, all are aware of the possibility. All feel that the most advanced beings among them can, and have, attained such enlightenment. To the Tibetan, it is only logical that such enlightened beings should return as reincarnations to assist those who have not yet achieved this goal state. None feel that such fruition is very far away. Few Tibetans feel that

their daily lives and actions have lost sight of Buddhism's highest evolutionary goal. At the same time most Tibetans recognize that individual progress depends on ability and opportunity. Tibetan lovers and domestic couples are aware of the virtues of celibacy and the desirability of monastic life, but, perhaps unconsciously, they must feel exonerated in their mortal passions. After all, even the Buddhas emanate in father-mother union form.

Thus Tibetan culture holds transcendent wisdom as its highest and most relevant ideal. All cultural forms are lit up from within by a cultivated spirit of karmic kinship and connectedness with all living beings. Compassion is in the air—in the open Tibetan smile, in the familial look that falls even upon strangers. It is in their gentleness toward children and old people and animals, in the kindness of monks and nuns, saints, and beggars. The living union of wisdom and compassion is shown by the remarkable Tibetan tendency to focus on the most otherworldly concerns with the most colorful and energetic earthiness. *Wisdom and Compassion: The Sacred Art of Tibet* explores this transcendent yet earthy aesthetic of one of the most spiritually developed of all the Buddhist civilizations.

TIBET,
ITS
BUDDHISM,
AND
ITS
ART

Robert A. F. Thurman

The Tibetan highland is an enormous land mass sitting above the rest of Asia. Geologically it results from the Indian tectonic plate burrowing under the Asian plate and pushing its southern rim skyward. Under Tibet, the earth's crust is twice as thick as at most other places on the planet (see map of Asia at the front of this book).

Traditional Tibet covers an area of more than a million square miles, about a quarter the size of the United States. Its highland plateau has an average altitude of 16,000 feet and is rimmed with high mountain ranges: the Himalayas in the south, the Karakoram in the west, the Kunlun and the Altyn Tagh in the north, and the Bayankara and the Amnye Machin in the east. It is rather dry—the clouds get over the mountains with difficulty—and the climate, at least in the central area, is more mild than popularly thought. The high mountain passes are almost always under snow, and melting glaciers provide a permanent flow of waters to irrigate the cultivated valleys. The great northern plain, the Jangtang, can be bitter cold in winter, so the herders go to the southern valleys during that season. The Jangtang is a rich area for pastoralism, and that most productive of creatures, the yak, brings great wealth to Tibetan nomads. The southern and eastern river valleys have a milder climate and a reliable irrigated agriculture. The dry climate and pure air make it possible to store surplus grains for years without spoilage. While Tibetan living has tended to be simple and somewhat spartan, Tibetans have never experienced a famine in their recorded history, except during a few short periods of military occupation.

Tibet's glacial waters give rise to most of the major rivers of Asia: the Sutlej, the Indus, and their tributaries, the Ganges, the Brahmaputra, the Salween, the Mekong, the Yellow River, and the Yangzi. Some of the mythic dimensions of Tibet's image may come from its central position within Asia. The gods of the Hindu pantheon are believed to dwell in the heavens above its peaks, as are the immortals of traditional China and the mountain deities of the Central Asian peoples. The Tibetans themselves have a myth that the land is a great, fierce mother goddess lying on her back, supporting the towns and people on her torso.

The historical origins of the Tibetan people are obscure, although there is some evidence of continuous occupation for fifty thousand years, with clear evidence of Late Stone Age settlements about 1600 BCE. Some anthropologists have associated the Tibetans with the vast belt of nomadic pastoral peoples that stretches across Asia and Africa from Siberia to South Africa, including the tribes occupying the Arabian peninsula. These tribes all exhibit some similarities of culture, the presence of various forms of shamanism being an important linking trait. This huge region of steppes is suitable for the breeding of cattle, which causes very diverse peoples to exhibit similarities of lifestyle. But there are a number of special factors about Tibet that must be considered to get a sense of the particular nature of the Tibetan people, the majority of whom are not nomads.

Besides being just beyond the fringe of this nomadic belt, Tibet also lies beyond the outer reaches of the great civilizations of Iran, India, Southeast Asia, and China—not quite belonging to any of them. There is no typical set of facial characteristics, body and head measurements, or genetic pattern that is uniformly Tibetan. The all-important southern valleys are agricultural, and there a type of agronomy is practiced similar to that of the Iranian plateau—dependent on

sophisticated irrigation, conservative patterns of land tenure, careful crop rotation, and maintenance of a balanced population. The Tibetan inhabitants of these southern valleys racially tend to resemble the peoples on the other side of the high passes: the Thais, Burmese, and Yunnanese in the east, the Nepalis and north Indians in the middle, and the Dards (Indo-Iranians with a dash of Greek) in the west. The northern Tibetans, who are seminomadic, tend to resemble the Turks, the Mongols, and the Indo-European Scythians, who have ranged on the other side of the Altai mountains. Relatively few Tibetans resemble the peoples of central China, and both peoples have an instinctive sense of foreignness toward each other.

All these regional types of Tibetans seem to have incorporated racial strains from the peoples beyond the mountain walls. Most probably individuals and small groups periodically went over the passes to higher and less accessible terrain in order to remove themselves from the main migration routes and populated areas. Tibet seems always to have attracted spiritual seekers, people willing to go high up, farther and farther away from steppes and river valleys to escape struggles for wealth and territory. They have been willing to deal with the wind, the altitude, and the general sparseness of the high country, perhaps in order to avoid worse problems posed by human society. They have legends that their first king escaped from the genocidal wars recounted in the great epic of India, the *Mahabharata*, suggesting that they are refugees from the south. Other legends of the descent of a divine king from the sky may indicate origins in the great steppes to the north. Thus the prehistoric beginnings of the "nation" of Tibet may lie in the mingling of all these peoples in the central valleys, where Tibetan civilization emerged. In any case, by the time of the early empire, traditionally traced to the 5th century BCE, and evidenced by impressive royal burial mounds, the nomads supplied meat and military strength and the agriculturalists provided food surpluses and stable patterns of social organization.

The modern Tibetans are a hardy breed, strongly individualistic and self-reliant, inclined to think for themselves and tolerant of diversity. From their nomadic component comes a certain toughness and adaptability, and from the sedentary component comes a fun-loving and playful cheerfulness. They are not as insular as might be expected, given the inaccessibility of their land. Their culture is organized in sophisticated patterns that are highly structured by secular systems of law, social and political organization, and economic order, and by spiritual systems of the scientific ordering of knowledge, religious articulation of belief, and monastic systematization of education. Yet it is one of the world's most relaxed and flexible societies about social hierarchy, sexuality, marriage arrangements (both polyandry and polygamy occur in Tibet), and ideological systems.

The Tibetan language is presently considered to belong to the Bodic branch of the Sino-Tibetan language family, with closest connections to the Burmic branches. Classical Tibetan and classical Chinese have certain similarities, but the modern languages are completely different. The Tibetan alphabet and grammar were developed from the Sanskrit alphabet and grammar, which makes Tibetan an interesting hybrid of the Sino-Tibetan and Indo-European language families. What is distinctively Tibetan is the complex integration of diverse elements from its cultural environment.

ANCIENT TIBETAN WORLDVIEWS

It is safe to say that the prehistoric Tibetans were animistic in their view of the world. Animism holds that everything is alive, with little sense of boundary between sentient beings and insentient nature. The primitive Tibetans' world was filled with gods and with ancestors and spirits of nature: of the sky, the earth, and the underworld. Before there was any central government authority, each regional tribe or clan probably had a chief and a high priest or shaman, the former to regulate the visible, social forces that govern life, the latter to deal with the invisible, spiritual forces that control the natural environment. The chief probably commanded the sacrifices, communications from human society to the spirit world; and the shaman-priest performed the divinations and healings, the spirit world's communications to society. The chief was concerned with maintaining the social order, the shaman with preserving the degree of disorder needed for individual health. Earliest Tibet was no doubt similar in these respects to other developing or nonurban societies.

Tibet began the transition from tribal society to dynastic state around 400 BCE, according to traditional accounts. The first king of the Tibetan nation, King Nyatri Sangpo, came from the Yarlung valley. Legend has it that he miraculously descended from the sky onto the top of a mountain near present-day Tsetang. When he passed away he climbed back up a ladder into the heavens. His first seven successors climbed down the same ladder to serve the people, going back up to heaven when their work was done. A hymn to the first heavenly king is worth quoting for the flavor of these ancient times.

He came from the heights of the heavens, descendant of the six lords, the ancestral gods, who dwell above the mid-heaven, three elder brothers and three younger. . . . He came as lord-protector on the face of the earth, came as rain which covers the face of the earth. He came to the holy mountain, Gyang-do, and the great massy mountain bowed low, bowed low. . . . He came as Lord of the six parts of Tibet . . . this center of heaven, this core of the earth, this heart of the world, fenced round by snow, the headland of all rivers, where the mountains are high and the land is pure . . . O King, whose religion is equalled by none, who is saluted by worshipping cranes, and who takes the light as his cloak. Those who are his nobles are clad in lordly garments. Their greatness and nobility are all derived from him. Of all trees the pine is the tallest, of all rivers the Yarlung the bluest, and Yarlha Shampo is god supreme! (Snellgrove and Richardson, 1968, p. 24)

Around 100 BCE, so the Tibetans say, the ninth king of this Yarlung dynasty, King Pudegungyal (the first to be born after the heavenly ladder was cut and hence the first to die on earth), instituted a court religion called Bon. This religion, perhaps derived from Iranian models, adapted elements of animistic beliefs and rites to the support of the divine legitimacy of an organized state. The two most prominent features of this dynastic religion were the great sacrificial rituals relating to the state, especially coronation and burial rites, and the oracular rites derived from the folk religion, especially magical possessions and healings that required the priests to exhibit shamanic powers. The symbol of the king was the mountain, connoting stability, durability, and axiality. The symbol of the shaman was the sky, all-pervading yet formless. To achieve his vocation, or even to exercise his profession, the shaman had at all times to be willing to

disintegrate, to be torn into pieces visionarily or psychically. He thus fused with the disordering tendency of nature, going beyond the visible to bring a new source of energy back to the social world, as society's health depended on the right balance between freedom and integration. The royal and shamanic functions fit together and balanced each other. This is particularly clear at the death of a king, when, in a sense, the mountain shatters and flies apart into the sky until a new return is effected by the shaman's intercession, and a successor is crowned. The Bon religion of that time was somewhere between the primitive animism of predynastic Tibet, and the Bon still practiced in Tibet in modern times—which has changed enormously during its thirteen-hundred-year-long competition with Buddhism.

In the 7th century CE, Tibet burst on the international scene with the advent of its first international conqueror, King Namri Songtsen, the thirty-second king of the Yarlung dynasty. His son Songtsen Gambo (r. 627–649) truly earned the status of emperor by unifying all of Tibet and extending its boundaries throughout Central Asia. He defeated the armies of Tang China, controlled the Tarim basin Silk Route trade cities, and dominated Nepal, Ladakh, and large areas of what are now northeast India and northern Burma. This great expansion brought the Tibetans into close contact with Buddhism, which was present all around Tibet, from India to China. In the conquered Tarim basin cities there were Christians and Manicheans, besides Taoists and Hindu traders. The great whirlwind of Islam, just beginning in Arabia, was soon to sweep through all the peoples of the steppes. So the Tibetan emperors had no dearth of "great traditions" to draw from as they worked to develop their civilization in the international arena. The Bon religion lacked texts at this time, as far as we know, and was not well suited to the complex imperial society. The main thing that held the new dynasty together at first was the dynamism of war and the economic benefits from the military unity that was needed to bring home the spoils.

But the strain on the central figure in such times was too great, and the danger of intrigue and dissension too constant, for an intelligent ruler to remain content with such a situation, no matter how glorious the temporary successes. Emperor Songtsen thus looked for models to those empires that manifested the greatest magnificence and stability at the time, the Pala of India and the Tang of China. Both prominently fostered Buddhism. So he decided he must import Buddhism in order to secure a source of long-lasting, universalistic, spiritual legitimation. Or, as the traditional Buddhist historians would argue, he was himself a Buddhist incarnation and so was easily converted to the truth and benefit of Buddhism's institutions, teachers, and teachings.

Along with Buddhism, he imported many aspects of the more developed civilization of India. The first of these was writing. This made possible a national language, a national literature, an official system of belief, law, and ethics, and an effective administrative bureaucracy. Emperor Songtsen sent the scholarly noble Tönmi Sambhota with a delegation to India to learn Sanskrit grammar, to devise a writing system for the Tibetan language, and to collect texts for translation. He began to promote a national myth, building a system of temples to the Buddhas, designed on geomantic principles to tame the spirits of the land. He collected and treasured religious texts. He promulgated an official code of law based on the Buddhist version of the ten commandments: not to kill, not to steal, not to lie, and so forth. He assumed the role of Dharmaraja, King of Truth, thus giving his dynasty international legitimacy and a stronger place of permanence and honor in the hearts of his people.

His successors for the most part continued his policies. They fought with and defeated several of the Tang emperors, exacting tribute in the form of rolls of silk from the mid-660s until late in the 8th century, after which peace treaties between Tibet and China were concluded and carved on stone pillars in 783 and 821 (these pillars can still be seen today). During the reign of Emperor Trisong Detsen (r. 755–797), the first Buddhist monastery was constructed at Samye, and Tibetans began to adopt monastic vocations. Buddhism became so powerful by the 9th century that nobles and Bon priests reacted against it, and a large-scale persecution against it began in 836.

From the 7th century on, the Tibetans became more and more interested in Buddhism. Their own histories credit the Buddhist movement with giving them a whole new way of thinking, feeling, and acting that eventually transformed their personal and social lives. It turned their society from a fierce, grim world of war and intrigue into a peaceful, colorful, cheerful realm of pleasant and meaningful living.

THE BASICS OF BUDDHISM

Before continuing the historical background, we must look into the basic ideas and feeling of Buddhism. Buddhism is correctly thought of as one of the major world religions. It is also an important current in human intellectual history and a powerful social movement that has transformed every civilization that has embraced it. Buddhism was founded in the 6th century BCE by Siddhartha of the Gautama clan, crown prince of the Shakya kingdom, in a region that today spans the India-Nepal border. After becoming a Buddha, an Enlightened One, he was known as the Sage of the Shakya, or Shakyamuni.

Shakyamuni Buddha was roughly contemporary with the pre-Socratics, Isaiah, Zoroaster, Confucius, and Lao-tzu. He grew up in a time when Eurasia was filled with bustling city-states. Kings were striving for empires, with devastating effects on their subjects and neighbors. Priests were trying to hang on to the old rites and myths, while the growing population was becoming skeptical and alienated. Merchants were prospering, with new technologies of production and travel, and were feeling the need of new ethics and educational systems that would be more consonant with their new perspective. From Greece to China, philosophers arose to meet these needs, asking new questions and finding new answers. They sought to discover the nature of reality, the key to peace of mind, and the meaning of life. They were usually persecuted by kings, feared by priests, and, fortunately, appreciated by the ever-practical merchants.

Prince Siddhartha was one such philosopher, one who was dissatisfied with the state of knowledge, art, and social practice of his day. At twenty-nine he was happily married and the father of a beautiful son; he had wealth, and he was about to assume the throne of his nation. Suddenly, shaken by encounters with sickness, death, and old age, and lured by the promise of philosophy and asceticism, he left his astonished father and family. He promised them only that he was going

to find out if there was something more to life than following the conventional path from birth to death. Renouncing his home, family, property, body, and even identity, he went into the forest to meditate until he might find the truth or die in the attempt.

In Indian culture, it was not considered enough just to think about the great questions. Philosophy was not merely academic; it was an enterprise both religious and scientific. It was a yoga—a yoking of one's self to one's understanding—what we call empiricism, the idea that one must test one's ideas in experience. Understanding counted for nothing if it did not transform the self. One had to undertake the investigation of reality by yoking the mind and emotions, the body and the soul, to the aim of one's quest. One had not only to learn about the truth through rational inquiry, but had to further test that truth by becoming it, by experiencing it in the deepest levels of one's being. To achieve that, the seeker of enlightenment had to learn the arts of concentration and meditation, to take the art of the thought experiment to the ultimate levels.

Often, these Indian philosopher-yogis became so intent on their quests that they ignored or even mortified their bodies. Siddhartha lived among such philosophical ascetics for six years, fasting and mortifying his flesh until he was skin and bones. He mastered the techniques of psycho-physical trances and achieved deep absorption in the higher realms of pure form, boundless light, love, joy, and equality, and even in the formless realms of infinite space, infinite consciousness, absolute nothingness, and the realm beyond all imagination. Still he was not satisfied.

At the age of thirty-five, he renounced asceticism, as he had previously renounced the self-indulgence of the worldly life. He accepted normal food and returned to a more moderate lifestyle. Then, he took his seat under the great bodhi tree and proclaimed he would not budge until he fully understood everything, until he had transformed himself into a Buddha. By dawn of the following day he had attained perfect enlightenment, defined by him as complete freedom from all suffering, full experiential knowledge of the exact nature of reality, and comprehensive awareness of all its dimensions. He declared that he had discovered the reality of all things to be ultimate selflessness, or voidness, or freedom, and ultimate relativity. By selflessness or freedom he meant that things lack any independent self and are naturally free of any intrinsic identity, unrelated essence, or isolated substance, and by ultimate relativity that there is no source of the universe that is not relative.

When people hear about these things, they tend to feel intimidated, sure only that they cannot understand them. But Buddhist freedom and relativity are not particularly mysterious. The Buddha had been looking for freedom from suffering, and he discovered that freedom was inherent in the very fabric of reality. Finding himself already truly free, he no longer felt trapped in an unfree world, and he was able to accept wholeheartedly a creative involvement in relativity. He became aware of the precise way he had previously been a prisoner of ignorance, and he noticed that others, still imprisoned, could find their own ways out.

Buddha held that the vicious cycle of suffering starts from our not knowing our own freedom, because ignorance conditions us to feel ourselves as separate entities pitted against a hostile universe. Feeling hemmed in by over-whelming opposition, we crave freedom, supposing it to be some state of relief outside of the world. We struggle ever harder against things to win that freedom. We may break the cycle by cultivating critical wisdom through investigation of the reality of self and universe. We may systematically overcome ignorance by seeing through the illusion of being a separate "self" and of the universe being an objective "other." We realize that everything is free of any intrinsic status, there is no real self to be trapped, no real universe that traps, and also no real off-world isolated state of freedom. Free of the "self" delusion, we become free of self-concern. Free of self-concern, we become free to interact unselfishly with others. Free to interact unselfishly, we no longer experience interaction as suffering; we become able to experience all things happily.

In reaching such an enlightenment himself, the Buddha declared that he had achieved the purpose of evolution, the ultimate fulfillment of human and even divine potential. He also declared that all living beings could eventually reach and experience for themselves the same ultimate bliss. And he pledged his newly acquired, inexhaustible energies toward helping them do so. And this experience of turning around in the depth of the self from self-delusion and self-obsession to freedom and concern for others has been the fountain of the energy of the entire Buddhist movement through history.

An important Sanskrit word for "truth," "reality," and also the "teaching" that leads to understanding them is *dharma*, coming from the verbal root *dhr*, meaning "to hold." The Buddha said that every intelligent being could understand the truth, that such understanding would lead to direct experience of reality, and that such experience would result in freedom, happiness, and transformation. The greatest gift one could give others thus was teaching; it could help others come to understanding, freedom, and happiness. The most effective teacher is a Buddha, since a Buddha has personally attained the understanding for himself or herself. And Shakyamuni Buddha proceeded to spend the next forty-five years teaching his new Dharma, far and wide.

In most religions, truth is thought of as something to be believed, in the sense of adopted as a correct proposition, embraced as a credo, or submitted to as a command. The Buddha's Dharma could not help its adherents much just by being believed. To be content with believing in it was to confuse its verbal propositions with the reality it pointed to. To encounter the reality and be transformed by the encounter, one had to understand it, not just believe it. To understand something requires a process of inquiry, examination, and experimentation—in fact, a process of education that is a yoga of self-transformation. To make such a process available to his contemporaries and to posterity, the Buddha had to found a new educational institution, a school for people to learn about the Dharma and a community for people to live in the Dharma. He called this new community the Sangha. The school central to this community had the strict requirements of celibacy, nonviolence, generosity, and honesty, which together served as the foundation of its effective transformative discipline and earned it the respect of the larger Indian society. It created the first monasteries and nunneries in human history.

As the Buddhist movement grew, these three—the Buddha, the Dharma, and the Sangha (the Enlightened Teacher, the Teaching, and the Community)—became known as the Three

Jewels. It was thought that the discovery of the evolutionary possibility of being a Buddha, of the reality and teaching that make that possible, and of the community that makes it practical was like finding precious jewels to purchase freedom from suffering, understanding of reality, and the happiness of good relationships with others. The representation of these Three Jewels can be seen in the center of the traditional Tibetan flag, upheld by the two snow lions, guardians of the Land of Snows.

The Buddha taught a great variety of people in many different places over many years, though tradition has it that he wrote no texts. Still, an enormous number of texts purport to record his words, and these texts register important differences among them. A vast literature has emerged in Buddhist civilizations that attempts to reconcile these differences in various ways. But here it is more important to focus in greater depth on the quintessential core of all the teachings. As already mentioned, the Buddha called his fundamental insight "selflessness." His enlightenment was the realization that the sense of possessing an independent, central self at the core of one's being is a delusion. It is the delusion that causes all the suffering in life and death, the delusion that "I" and the universe are two utterly different things and hence that "I" must wage a battle against the universe, which can only end in me being crushed. It is the delusion that anchors all the negative notions and emotions of egotism, fanaticism, pride, anger, greed, and envy. This selflessness has often been misunderstood as meaning that we do not exist at all. But we can easily correct this misapprehension. The Buddha would have to have been a fool or a madman to have experienced his own annihilation and then told the world he was not there. And the millions of people who found truth and release, beauty, and joy in his Dharma would have to have been just as mad and foolish to accept such a preposterous assertion. Clearly, selflessness is a description of the experienceable condition of the living self, which obviously does exist, and obviously is not a static, independent, isolated, or alienated entity. Obviously it exists as a living, changing, thoroughly relational, totally interconnected being.

This is so easy to understand at the intellectual level, we might wonder if it could be the whole story. But Buddhism assures us it is the whole story, and that the truth is just that simple. What is difficult is to take hold of that intellectual understanding, concentrate on it one-pointedly, and make it a visceral realization. We are so habituated to organizing our lives, perceptions, and reactions around the sense of a static, aloof self-center that it takes a lot of doing to transform that habit. When we succeed in doing so, it is like a revolution in our perceptions, feelings, and emotions, completely changing the quality of our lives.

Seeing through the false sense of rigid self releases a person from the imprisoning sense of alienation from the universe and all the painful reactions that alienation leads to. It replaces the sense of isolation with a sense of connectedness. It is no longer "I" against "you" or "it." It is "we" in a play of relation and interaction. Such experiential selflessness frees us for the ethical selflessness of altruistic action that brings joy to self and others. The Buddha's wisdom, his experience of selflessness, released his compassion and energy toward the transformation of his society. He devised a host of methods and techniques to assist people to realize their own selflessness, freedom, and compassion. These became the

Buddhist arts, the ways of opening doorways for others to move out of their prisons, of manifesting a vision enabling others to see beyond their habitual delusion-dominated world of egocentric suffering into the wisdom-liberated world of selfless pleasure.

During the centuries they were working to "liberate" the people of India, Indian Buddhists developed three vehicles to carry people to freedom. The first was the Monastic or Individual Vehicle (corresponding to but not just the same as today's Theravada Buddhism), so called because it provided institutional, doctrinal, and contemplative methods for individuals to liberate themselves from egocentric delusion. The persons who successfully attained Nirvana and freed themselves from suffering were called Arhats (saints). These were quite numerous in Buddhist India and were highly respected for their holiness and benevolence, exemplifying the virtues of selflessness and gently revolutionizing society. The Individual Vehicle was emphasized for roughly the first five hundred years of Indian Buddhism, since the free space for selfless individuals had to be created within the rather communalistic and rigidly controlled early Indian society. It was during that period that Buddhism spread outside of India mainly to Sri Lanka and to the Iranian world.

The second was a messianic social vehicle, called the Universal Vehicle (corresponding to today's Mahayana Buddhism), because it fostered the messianic resolve to liberate all beings by transforming the entire universe into a realm of peace, abundance, and happiness. A person who cultivates such a resolve is called a Bodhisattva (literally, an enlightenment hero or heroine). A Bodhisattva only accepts freedom for himself or herself when all other beings have been freed, so Buddhahood becomes a transformation of the universe of others as well as a transformation of the self. Such a universe-transforming Buddhahood is vividly depicted in the extraordinary scriptures (sutras) of the Universal Vehicle, wherein the universe is poetically described as a multidimensional realm of boundless possibility. An individual's messianic resolve to save the whole world is considered realistic due to the limitless amount of time available to the individual in the endless continuum of lives. Life after life, the individual gradually works on the ability to understand and benefit the world. Eventually, after limitless efforts, these abilities become limitless and all beings can be saved. This vehicle was predominant in India during the second five-hundred-year period after the Buddha. During this period, Buddhism spread outside of India mainly to Central Asian Silk Route kingdoms, China, and the various states of Southeast Asia.

The third vehicle, which we are calling the Apocalyptic or Tantric Vehicle, is really the esoteric aspect of the second. It is a magical vehicle, also called the Diamond, Thunderbolt (Vajra), and Technology (Tantra) Vehicle, because of its irresistible, swift power and its technological sophistication. (This Tantric Vehicle is also called the Esoteric Vehicle.) It was developed for those whose messianic resolve becomes too intense for them to bear waiting for limitless eons before becoming able to free others from suffering. Their prayer for magical means to accelerate the evolutionary path to Buddhahood was answered by the promulgation of the tantric technology. Those enlightenment heroes and heroines who successfully practiced the tantras attained the state of being Great Adepts (Mahasiddhas), great individuals who have become perfect Buddhas in their subtle mystic bodies, yet continue to

manifest through their old, "coarse" bodies in order to remain present to their societies and help their fellow beings.

The essence of the tantric technology is a shift from gross to subtle realities of the universe, a reality wherein evolutionary change can be immeasurably accelerated, wherein matter can be instantaneously reshaped by imagination. The progress achieved within the subtle reality is then "inconceivably" transferred into the gross reality in order to deliver the benefits to other beings. To make this "inconceivability" a tiny bit intelligible, we can consider the realm of dreams and its relationship and effect on the waking world. In a dream, one can realistically undergo various deaths, transmutations of one's body, the opening up of unforeseen pleasures, the overcoming of terrors, and other experiences usually inaccessible to the waking self. With careful attention, the psychological development gained from these experiences can be applied to one's waking personality with beneficial results. The tantric technology operates in a similar way, by shifting levels of reality.

This has to be understood within the framework of the Buddhist cosmology of multiple lives. The Apocalyptic Vehicle is not differentiated from the exoteric Universal Vehicle from the point of view of wisdom. Transcendent Wisdom (Prajnyaparamita) is still its goal. In terms of compassion, technique, and art, in the widest sense, it focuses on developing the Buddha body, as much as on developing the Buddha mind. It is the art of reconstructing the self and universe on the basis of enlightened wisdom, after overcoming the ordinary self and universe built up by countless lives steeped in ignorance.

Thinking of enlightenment as the goal of Buddhism, we tend to think of it as something mental, as a kind of higher understanding. But Buddhahood is just as much a physical transformation. The Bodhisattva goes through a long physical evolution, developing his or her mind through wisdom and contemplation, and developing the body through compassion and deeds of liberative art. The Tantric Vehicle is primarily intended to accelerate the cultivation of compassion, although in that process there is an immeasurable deepening of understanding. Tibetans say that the tantric practitioner approaches the same objective—voidness, the ultimate reality—with a different subjectivity, a subtle one compared to which the ordinary mind is coarse. And that subtle subjectivity is great bliss (*mahasukha*) itself, mobilized as a subatomic awareness focused upon voidness. Such extremely subtle, indivisible bliss-void intuitive wisdom is the key energy of the Apocalyptic Vehicle. This vehicle is also known as the "quick and easy path," which is properly understandable only within the karmic vision of the individual's evolution as covering a vast span of eons. The Bodhisattva has to go through three evolutions, "up from pre-Cambrian slime," so to speak, and not as a race or a species, but individually. The Bodhisattva has to evolve from life to life to finally become a Buddha.

The tantras developed a huge literature in India, with many scriptures purporting to record the revelatory teachings of Shakyamuni Buddha. There are four categories of tantras, called Action (Kriya), Performance (Charya), Yoga, and Unexcelled Yoga tantras. All four of these teach practices to accelerate progress toward complete Buddhahood by using visualizations of archetype deity embodiments. The Unexcelled Yoga tantras are for the most advanced practitioners: they consist of a creation stage, on which the art of visualization is developed to the highest degree, and a perfection stage, whereon the yogi or yogini actually practices the death process, uses out-of-body experiences (similar to dream-body experiences as in lucid dreaming) to accelerate the development of wisdom and compassion, experiments with the actual reincarnation procedures, and goes through the final processes of becoming a complete Buddha.

The Unexcelled Yoga tantra claims that Buddhahood is possible within a single human lifetime, meaning within a single coarse-body lifetime. Unexcelled Yoga is a yoga of dying and reincarnation—for the Buddha body cannot be attained without at least the experience of death, without many deaths and resurrections. It is very precise, very technically analyzed and practically laid out. It has the yoga of the death-dissolutions, the yoga of arresting the breath, the yoga of venturing out from the coarse body into the dream state and then being reborn back into that same coarse body. This is the art of reaching Buddhahood using the magic body, the subtle mystic body, and the clear light, the clear experiential reality of voidness. It is the realm of the Apocalyptic Vehicle's subtle acceleration of evolution. The scientific possibility of this approach based on the individual karmic biological theory of Buddhism is hard to entertain, given the conventional wisdom of our materialistic culture. Perhaps the best we can do at first is to understand the tantric process as a discipline of depth therapy using the artistic imagination.

However we approach it, whether as an art of therapeutic visualization or as an art of subtle, depth-imaginational, genetic engineering, we need some sense of this context to understand the terrific and erotic Buddha forms used in the tantric arts of Tibet. They were originally developed in India, as the Tantric Vehicle became more and more emphasized during the final five-hundred-year period of Indian Buddhism (around 500 to 1000 CE), as the greatest fruition of the Individual and Universal Vehicles. During this period, while Tantrism spread widely throughout all the lands that were already Buddhist, all three vehicles of Buddhism together spread to new territories, mainly in Tibet, Korea, Japan, Cambodia, and Indonesia. Of these countries, Tibet was located nearest to the Indian Buddhist heartland. This explains why Tibetan Buddhism today is closest to the final, three-vehicles-in-integration form of Indian Buddhism, preserving the full set of rules of the monastic order, implementing the full curriculum of the Indian monastic university, and keeping the law of the land as close as possible to the messianic Buddhist social ethic, as well as keeping alive in individual practice the vast array of contemplative technologies and ritual arts of the Tantric Vehicle.

In sum, Buddhism is a social, religious, and philosophical scientific movement founded on the Buddha's discovery of a happy way of living, a way of living as a relational and flexible self, free of the exaggerated egocentrism derived from a habitually static and rigid self-image. As a social movement, it has provided Asian societies with peaceful ethics, institutions, and educational literatures. As a religious movement, it has provided them with a spiritual perspective giving human life special value and meaning, and improving their ability to enjoy life and to allow others to enjoy it. As a philosophical science and technology, it has developed knowledge and arts of understanding and transforming mind and body that are

unparalleled in any other psychological tradition in the world. These developments within the Indian cultural sphere of influence greatly benefited the civilizations of the subcontinent, helping them to achieve the most gentle, refined, gracious, colorful, and liberated culture in the world during the first millennium CE. Such gentleness made India vulnerable to less gentle peoples from the Central Asian steppes. Major waves of Turkic invasions penetrated India from the 9th to the 12th centuries. The rigid personalities of these conquerors and the intolerance of their recently acquired Islamic ideology impelled them to destroy the most refined and gracious elements of the society that had attracted them. Almost all the Buddhist monasteries and their libraries were destroyed; the monks were slaughtered; the lay Bodhisattvas were forced to adopt the conquerors' ideology, and the adepts left the country or went underground. Fortunately, many of the great scholars, saints, sages, and adepts were able to flee up over the Himalayan wall into Tibet, carrying their institutions, texts and teachings, and personal lineages of practice. These flourished in the Land of Snows until the Chinese communist invasion of 1950, which forced the Dalai Lama and the Tibetan community in exile to bring the teachings and lineages back to India. In the West, Tibetan Buddhism is just beginning to be appreciated as more than a religion—as a cultural and civilizational force with many aspects. It is especially valued by leaders of other world religions for its meditational arts, and by philosophers and psychologists for its sophisticated "inner science," or "science of the mind."

THE FOUR GREAT WAVES OF BUDDHISM IN TIBET

With the basics of Buddhism in mind, we can return to Tibet and pick up the story of its thirteen-hundred-year-long journey from warrior empire to monastic Buddhist nation. By 600 CE, Indian Buddhism was like a great ocean, filled with teachings and practices, scriptures, technologies, and institutions that had proliferated over a thousand years in response to the needs of the Indian subcontinent's many different peoples. A large arm of this ocean had developed in Central Asia, which became a channel for the waters of Indian Buddhism to flow to China and the rest of East Asia. The highland of Tibet was an island little touched by this ocean for many centuries. When, at last, the Dharma reached Tibet, it swept over the highland in four main waves. These resulted in four religious movements that in modern times have been considered the four main orders of Tibetan Buddhism. These are called the Nyingma (the Ancient), Sakya (named after the head monastery), Kagyu (Oral Tradition), and Geluk (Virtue Tradition) Orders.

In previous writings on Tibet, these orders were often called sects. But "sect" is a term derived from the history of Protestantism, and implies a history of a major doctrinal or institutional divergence from an established religion that has created a splinter group, a body that considers itself radically different from its originating religion and usually is so considered by the members of the earlier group. The Tibetan waves, however, had no such major doctrinal or institutional divergences. They all were devoted to the Three Jewels—the Buddha, his Teaching, and the Community. They all upheld the Three Vehicles: Individual, Universal, and Apocalyptic. Their differences lie in the histories of the founders, in the lineages of teachers, in the particular texts each prefers, and

most importantly in the tantric technologies they favor. Thus, as institutions they more resemble the Benedictines, Franciscans, and so on, than the Methodists, Quakers, and the like, making "order" a better term than "sect."

The Nyingma Wave

Each of the orders had a period in which it was the dominant Buddhist movement in Tibet. In the case of the Nyingma, during its period of dominance, it was the only order. It dates to the late 8th century, when the learned Indian abbot Shantarakshita, was invited by Emperor Trisong Detsen to build the first monastery at Samye. When emperor and abbot had trouble with the local deities, they had to call on the Great Adept Padma Sambhava to "tame" the national psyche and bring the Dharma to life in Tibet. Padma did tame all the important national deities, got the monastery built, started the process of translating Buddhist teachings, and gave his deepest esoteric instructions to twenty-five major disciples. This process continued for another half century with strong imperial patronage. Many Tibetans attained high realizations. The Buddhist ethic began to spread around the country, and monasticism began to show its benefits to the Tibetan population: education, the superior Buddhist medical technology, the pageantry of Buddhist religious festivals and rituals, and the zones of gentleness that inevitably develop around monastic establishments.

In fact, Buddhism gained so much popularity under the emperors following Trisong Detsen, and Buddhist monks gained so much prominence, that a reaction set in among Tibetan nobles and Bon priests. In 836, King Tri Relwajen was assassinated, and his older brother, Lang Darma, came to the throne to begin a vigorous persecution of Buddhism, destroying temples and texts, killing monks or forcing them to flee. The next century saw a revival of Bon and probably the beginning of Bon's remarkable development of a written canon of sacred scripture in competition with Buddhism. It is hard to know clearly what happened during this period, because the imperial dynasty collapsed, foreign possessions were lost, and Tibet itself broke into a number of regional kingdoms.

As we have said, during the dynastic period in Tibet, Nyingma Buddhism was the only Buddhism. Only after the restoration of Buddhism in the 10th and 11th centuries was the Nyingma formulated as an order, one of a number of Buddhist movements. It was, and remains, distinctive in a number of ways. It adheres to the traditions associated with the textual translations and practice transmissions preserved from the 9th century. Institutionally, it relies primarily on lay masters rather than monks to preserve and propagate its teachings, though in recent centuries, it has built and maintained a large number of important monasteries. It maintains a special tradition of treasure finders (T. *tertön*), spiritual adepts who recover texts and teachings magically hidden by Padma Sambhava in order to survive times of persecution. Above all, it has a special focus on the Great Perfection (*Dzogchen*) tantras, sophisticated spiritual technologies of the most advanced type, leading directly to the essence of Buddhahood without much reliance on visualizations and central channel yogas.

The Nyingma teaching from the beginning contained all the teachings of the Three Vehicles, laying a firm foundation for Tibetan monasticism, spreading the messianic ethic of the Universal Vehicle, and initiating leading intellectuals in the

highest esoteric practices of the Apocalyptic Vehicle, especially the supreme teaching of the Great Perfection. One must admire the achievement of Padma Sambhava and Shantarakshita and their disciples, for it must have been difficult to persuade the rough warrior population of Tibet that nonviolence is the way to live, that self-conquest is more important than military conquest, that enlightened humanity is more important than national gods, and that the purpose of life is evolutionary merit and transcendent wisdom, not power and pleasure.

During the period of the later waves, the Nyingma traditions were collected and preserved by many scholars, although because of its relative paucity of monasteries the order remained a minority movement. Then, in the 14th century, it too caught the monastery fever and built six major centers around Tibet. The greatest of its lamas in this period was the incomparable Longchen Rapjam Tsultim Lodrö (1308–1363), considered a direct incarnation of the Bodhisattva Manjushri. He synthesized the whole Buddhist teaching into a systematic path leading up to the Great Perfection. His numerous works are among Tibet's greatest treasures and have served as the foundation and summit of the Nyingma curriculum until the present day.

In the early 10th century, the king of Ngari in Western Tibet, Yeshe Ö, became a strong patron of Buddhism, sending translators to India, rebuilding temples, and building new monasteries. The great translators Rinchen Sangpo (958–1055), Lhodrak Marpa (1012–1096), and Drokmi (992–1072) began major new works of cultural transmission. Several important monks returned from exile in Eastern Tibet, bringing ancient texts and practices. A number of Indian masters entered Tibet, the most important of whom was Atisha (982–1054), whose coming in 1042 is thought to signal the beginning of the Second Transmission, the revival of Buddhism in Tibet after the great persecution of the 9th century. His disciple, the layman Drom (1008–1064), founded Ratreng monastery in 1056, Drokmi's descendant Konchok Gyalpo (1034–1102) founded Sakya in 1073, Milarepa's disciple Gampopa (1079–1153) founded Dakla Gampo in 1122. From this time on through the 12th and 13th centuries, there was a powerful spread of Buddhist movements throughout Tibet. There was no central dynasty as before, but regional noble families aligned themselves with new monasteries founded by charismatic translator-yogis. These translators traveled to India to study and transform themselves in the "land of the Holy Ones." As the pioneers of the new society, they brought back teachings and practices, which Tibetans took up with great enthusiasm.

The Sakya Wave

While all the orders developed enormously at this time, the Sakya Order can be counted as the second wave, because it led in the development of the texts and monastic institutions that grounded the new Buddhist teachings of the Second Transmission. The Sakya spiritual lineages were begun by the translator Drokmi, who came from the noble Khon family of the southern Tsang province. The Khon numbered among their ancestors one of the twenty-five select disciples of Padma Sambhava. After a settlement of disciples gathered at the valley called Sakya (after the yellow-grey soil of the region), Konchok Gyalpo founded the Sakya monastery in 1073. The monastery was soon thriving with numerous monks and supporters who were translating books, studying them, contemplating profoundly, and practicing the advanced tantric techniques of the Path and Fruition teachings. These teachings were derived by the Great Adept Virupa from the *Laughing Vajra (Hevajra) Tantra,* a particularly effective combination of tantric contemplative technique and fundamental Buddhist mind-training. Numerous people attained high realizations, and the monastery gradually became the focus of the life of the region. The monastery sheltered and supported the labors of the many scholarly religious who were thus able to translate the entire Indian canon of scriptures and treatises, to put into practice all the intellectual and artistic traditions that had matured for centuries in the Indian monastic universities, and to sustain their meditative retreats until they attained solid realizations.

The Khon family united with the monastery in an innovative pattern. The abbacy of the monastery was given to a spiritually developed member of each generation of the family, who lived a monastic life, except for marrying and producing children who would inherit the leadership of the order. It was believed that various celestial Bodhisattvas, such as Manjushri, Bodhisattva of wisdom, would regularly reincarnate in the family as the monastic leader of the order. This early experiment in the union of spiritual and political power was put to the test in the 13th century, with the emergence of the Mongol empire. In 1244, the Sakya Pandita (a title meaning "scholarly sage") Kunga Gyaltsen (1182–1251), considered an incarnation of Manjushri, was invited to the camp of Prince Godan (second son of Emperor Ogodei) as the representative of all Tibet. Taking with him his nephew, Pakpa (1235–1280), he surrendered Tibet to the worldwide Mongol empire to avoid invasion and inevitable loss. But he greatly impressed the Mongol warlord with his honesty and charismatic power. He began to teach Buddhism to tame the Mongols' violent ways. He was honored and recognized as a great spiritual leader, and the Mongolian-Tibetan relationship of "patron and priest" was begun. In 1253, Pakpa became the court priest of Prince Khubilai, and in 1260, when Khubilai became emperor, Pakpa became imperial preceptor and was given the administrative responsibility for all of Tibet.

The Sakya Order practiced the teachings of the Three Vehicles just as had the Nyingma, which coexisted at the same time, and maintained the traditions of the ancient period. The broadening of the Buddhist movement within Tibetan society required the Sakyapas to develop a broader curriculum, to establish many monasteries, and to engage its rising number of scholars in researching Indian literature, translating it more extensively, and reviving a greater variety of contemplative practices. The new monasteries founded in the 11th to 13th centuries offered a growing population of religious, both monastic and lay, the opportunity for higher education, something very few had had access to previously. With their sophisticated, literate, and bureaucratic social organization, the Sakya thus transformed the whole society.

Around the time when Atisha was visiting Tibet (1042–1054) and Konchok Gyalpo was founding Sakya, the lay master-translator from Lhodrak, Marpa (1012–1096), was energetically active. He journeyed to India several times, studied all the branches of Buddhist learning, and practiced successfully the profound teachings of the *Esoteric Communion (Guhyasamaja), Laughing Vajra (Hevajra),* and *Supreme Bliss (Shamvara)* tantras. In India he met his chief spiritual

teacher, the Great Adept Naropa, one of the most important of the eighty-four Great Adepts. After arduous preparatory discipline, Naropa gave Marpa his most precious teachings. Marpa returned to Tibet to practice in retreat until he mastered these teachings; and then he spread them widely.

The Kagyu Wave

Marpa was a layman who taught out of his personal residence, instead of in an organized monastery. He had hundreds of important disciples, forming the new Kagyu (Oral Tradition) Order. He translated and taught a number of important texts and contributed much to the literary traditions of the new wave. But his order took its name from the transmission of precious esoteric instructions from Naropa to him, instructions that illumined the practice of the various tantric technologies. His four major disciples were the "four pillars," known as Ngok, Tsur, Mes, and Milarepa (1040–1123). Mes and Ngok received responsibility for the teachings of the Mother tantras *Hevajra, Vajrapanjara, Chatuhpita,* and *Mahamaya.* Tsur received responsibility for the Father tantra *Guhyasamaja,* along with all its associated secret precepts and perfection-stage yogic instructions. And Milarepa received responsibility for the supreme Mother tantra, the *Paramasukha-Chakrasamvara,* along with the essential precepts of Naropa, known as the Six Yogas. These are the yogas of fury-fire, dream, between-state, clear light, soul-ejection, and body-switching.

Milarepa became the most famous of Marpa's main disciples. He is sometimes thought of as the first ordinary Tibetan to become a perfect Buddha in one lifetime. His autobiography is one of the great classics of world literature. His father died when Milarepa was young, and he, his mother, and his sister were cheated of their inheritance by a wicked uncle. Milarepa learned black magic to gain revenge, which he did successfully, killing all his uncle's heirs. He then repented and went to Marpa to practice the Buddha Dharma. Marpa put him through terrible ordeals, refusing to teach him until he had single-handedly constructed a nine-story stone tower four times, taking the first three towers apart himself, stone by stone. Finally initiated, Milarepa took Marpa's advice to heart and spent the rest of his long life in meditative retreat high in the snowy mountains, keeping himself warm with the fury-fire yoga and fed with the offerings of the faithful who found him in the wilderness. He was profoundly gifted as a singer and poet, and he gave innumerable Buddhist teachings in the form of Tibetan folk songs. His collected songs became a widely beloved Tibetan classic. Given Milarepa's origin in a peasant family and his sufferings and sins as a youth, his tremendous progress through practice and the miraculous signs of his complete evolutionary transformation into Buddhahood were an inspiration to all Tibetans.

Milarepa had thousands of disciples, women as well as men, who were mostly like their master in being cotton clad, which is practically naked considering the Tibetan climate. It is said that the psychic light of the contemplations of all these yogis and yoginis lit up the Himalayas so brightly that day and night became indistinguishable. Late in his life, he met a monk physician, Dakpo Lhajey Gampopa, who attained great realization and to whom he transmitted all the precepts and the responsibility for carrying on the order. Gampopa (1079–1153) was responsible for the institutional development of the order. He founded a head monastery and created a curric-

ulum to undergird the advanced esoteric precepts, which he developed from his previous study and mastery of the Kadam curriculum at Ratreng monastery (see below).

The enlightened disciples of Gampopa numbered in the hundreds, the major ones known as the "sixteen great sons." They spread out and founded monasteries of their own, beginning the "four major and eight minor" branches of the Kagyu Order. The three most important were Pakmodru, Dusum Kyenpa, and Gompa. Pakmodru (1110–1170) founded the monastery Til in 1158; of his disciples, Jigten Gompo (1143–1212) founded Drigung in 1179, Taklung Tangpa founded Taklung in 1178, and Yeshe Dorje founded Druk in 1180. Dusum Kyenpa (1110–1193) became the first Karmapa, and founded Tsurpu in 1189. He also founded the first line of formal reincarnations in Tibet, beginning a practice that made an unique contribution to Tibetan civilization—the practice of formally recognizing reincarnations of a great lama and inviting those reincarnations to assume the authority of leadership of an order. Gompa (1116–1169) had a disciple named Shang, who founded Tsal in 1187.

This is not the place to list all the suborders with their leaders and monasteries. The essence of this third, Kagyu, wave is the intensely bright and colorful spiritual light generated by those who practiced the contemplative technologies with their hearts. Marpa and his sons, Milarepa and his naked yogis and yoginis, Gampopa and his many disciples—all of them braved physical hardship, emotional trials of going into their own unconscious depths, and mental agonies of experiencing real deaths and voyages through the death-rebirth between-states. They attained the great evolutionary fruition of freedom from their instinctual drives and delusions and the corresponding voluntary control over their life processes to manifest lives that benefited others. Inspiring the people with their charisma, the eloquence of their teachings, the efficacy of their medicines, and the beauty of their arts and rituals, they spread all over Tibet. They allied themselves with noble families of different regions, established monasteries, and gave teachings in an ever-widening circle in Tibet, Mongolia, and China.

The political authority during the Sakya hegemony had been vested in the Sakya hierarchy and its bureaucracy, which ran the thirteen administrative provinces of Tibet at that time, with the Dharma King function exercised from the outside by the Mongolian emperors. A number of the Kagyu foundations served as administrative centers for those regions, especially the Pakmodru, the Drigung, and the Taklung monasteries. The succession of Pakmodru, for example, was controlled by the Lang family in the pattern initiated earlier by the Sakyas; one brother in each generation was made monastic hierarch of the Pakmodru Order, and another layman was administrator of the associated Nedong estates. This style of authority was favored by most of the suborders. As the Mongolian emperors were losing their hold in China during the 1340s and 1350s, the Pakmodru ruler, the layman Jangchup Gyaltsen (1302–1364), rose up against the Sakya-dominated Tibetan adminis-tration, and after some years of struggle and diplomacy, took responsibility for the government of Tibet in 1358. He had become known as a reformer while governor of Nedong, and he continued this for the entire country. He also restored the traditions of the ancient Tibetan dynasty, meeting the desire among Tibetans not to pay lip service to any outside rulers. When the Ming emperors established themselves in China in

1368, they were unable to develop the patron-priest relationship with any Tibetan lamas on the pattern established by the Mongols.

During this third wave, an innovation in the pattern of religious authority developed among the Karma Kagyu suborder based at Tsurpu. Thirteen years after the death in 1193 of the first Karmapa, Dusum Kyenpa, a remarkable child was born in 1206 in eastern Tibet. He was duly recognized as the actual reincarnation of the Karmapa Lama. He was enthroned and established as the second Karmapa, Karma Pakshi. From then on the Karma Kagyu suborder was headed by a Karmapa Lama reincarnation, whose birth was not restricted to any particular family. The Karmapa Lamas were born in various regions and families, thus broadening the order's contacts and supporters. They developed good relations with various Mongol rulers and, after the fourth Karmapa Deshin Shekpa's 1407 visit to the Ming emperor Yongle, with the Ming emperors of China. The Ming, however, were not an international empire like the Mongols, and they were never able to install the Karmapa incarnations as hierarchs of Tibet, in parallel with the Sakyapas earlier. From the 14th to the 17th centuries, the political authority remained in the hands of the Pakmodrupa ruler, slowly passing to the Rinpung family in Shigatse, and then to the regents in Tsang. The Tibetan polity was troubled now and then during this time as various rulers contended for power. Throughout, the Karmapa Lamas, like the Sakya hierarchs, were combinations of scholar-saint monks and Great Adepts. Their charismatic travels through the length and breadth of Tibet and Mongolia spread this third wave of Tibetan Buddhism very widely.

The fourth and final wave began at the same time as the second and third, with the coming of Atisha to Tibet in 1042. His disciple Dromton Gyalway Jungnay founded the Kadam (Oral Instruction) Order at Ratreng monastery in 1056. The Kadam institutions in the 11th and 12th centuries established a curriculum based on Atisha's teachings, producing numerous enlightened persons. Sonam Drakpa of the Sakya Order, Gampopa and Taklung Tangpa of the Kagyu Order, and many lamas of all orders studied in the Kadam monasteries. The Kadampas assiduously avoided involvement with political matters, as the Sakya and Kagyu orders took responsibility for Tibetan national life. The Kadampas kept their mission on the social level of the spiritual needs of the people of various regions. Thus they remained a powerful current under the crests of the second and third waves.

The Geluk Wave

Tsong Khapa, the founder of the New Kadam, or Geluk, Order, was born in 1357 in Amdo in the far northeast of Tibet, at the very beginning of the Pakmodrupa revival of Tibetan national feeling after the receding of the Mongol empire. The great scholars of the Kadam, Nyingma, Sakya, and Kagyu orders had developed the canon of translations, the curricula of monasteries, and the climate for contemplatives that enabled him to spend his lifetime in study, practice, writing, and teaching. Tsong Khapa's native genius made effective use of the creative and comprehensive works of his predecessors; he made the greatest contribution of any Tibetan lama up to that time. His first teacher, the Kadampa Rinchen Döndrup, was led by dreams and oracles to Tsong Khapa's family, and took him as disciple at the age of three. He was ordained soon thereafter as a novice monk by the fourth Karmapa Lama, Deshin Shekpa. He went to the central regions of Tibet in 1372, and spent twenty years studying with Nyingmapa, Sakyapa, Kagyupa, and Kadampa teachers, mastering all the important Buddhist studies of the day. By the mid-1380s he was an acknowledged master, having had advanced spiritual realizations and having written major works of critical scholarship and insight. In the early 1390s he began a more mystical phase, spending seven years in semiretreat, reportedly in daily conference with the celestial Bodhisattva Manjushri. In 1398 he achieved complete enlightenment, and soon began his work (his "four major deeds") to renew the course of Buddhism in Tibet, to bring the fourth wave to its crest.

He began by refurbishing a famous temple of Maitreya, the future Buddha, at Dzingji. During a year of miracles, pilgrims from all over Tibet came there and had extraordinary visions, while Tsong Khapa and his friends reconstructed the temple. His second deed was to convene a great council of all the orders to review the monastic Discipline (Vinaya) that provides the blueprint for Buddhist religious communities. This resulted in a new wave of monastic renewal that affected all of Tibet. His third major deed was to establish, in 1409, a New Year's festival in Lhasa around the Jokhang, the national shrine built in the 7th century by Songtsen Gambo. This Great Prayer Festival lasted several weeks, commemorating the fortnight of miracles performed by Shakyamuni Buddha before the assembled nations of India. For those weeks, there was no difference between monk and layperson; the nation's business was to pray and celebrate. (The original event was a time when Buddha opened a visionary door for the whole society into the world of enlightenment, and the Lhasa festival served the same function for the Tibetans.) During that time, histories report, everyone could feel ordinary time stand still, and the whole society was lifted for a while into the realm of perfection, the Buddha Land, where wisdom and compassion were fully manifest to everyone. The crowning moment of the festival came when Tsong Khapa offered the Jowo Rinpoche statue of Shakyamuni elaborate, expensive jeweled ornaments, symbolizing the eternal presence of the Buddha at the heart of the Tibetan nation. Tsong Khapa's fourth great deed was the construction in 1415 of three three-dimensional mandalas (perfect universes) of these Buddhas: Guhyasamaja, Paramasukha-Chakrasamvara, and Vajrabhairava—a remarkable feat of scholarship, contemplative virtuosity, artistic skill and creativity, and spiritual devotion. He allowed his Ganden hermitage to be built up into a major monastery for the express purpose of sheltering these precious mandalas. The disciples of the new Geluk Order were so numerous that a second monastery near Lhasa was built at Drepung in 1416 and a third at Sera in 1419.

After Tsong Khapa's passing away in 1419, the renewed Kadam, or Geluk, Order began immediately to spread widely through Tibet. Tsong Khapa's disciple Jamchen Chöjey accepted the Ming emperor's invitation to visit Beijing, where he built a major monastery. The three new Lhasa monasteries grew into the largest of any religion in the world, housing around four thousand, seven thousand, and ten thousand monks respectively. The work of establishing monasteries and their curricula in order to produce ever greater numbers of educated and enlightened persons expanded greatly throughout the 15th and 16th centuries.

One of the most charismatic successors of Tsong Khapa, the monk Gendun Drubpa (1391–1474), founded Tashi Lhunpo in 1447, and spread the teachings vastly. A few years after his death, a child born in 1475 gave signs of being his reincarnation, was eventually recognized by his followers, and was given the name Gendun Gyatso. He lived a long and fruitful life and passed away in 1542 after helping many disciples and establishing more monastic foundations. His reincarnation was born in 1543, was soon found, and was named Sonam Gyatso. Sonam Gyatso was invited in 1577 to visit Altan Khan of the Tumed Mongols. After a difficult journey, he reached the Mongol camp at Chahar in Mongolia and began what was to be a fruitful relationship with the Mongols. The Mongols were converted en masse from their shamanistic practices to Buddhism, and Altan Khan proclaimed Sonam Gyatso to be a Dalai Lama (Oceanic Master). The new Third Dalai Lama (his two previous incarnations were retroactively recognized as First and Second) visited Kham, where he founded Lithang monastery in 1580, and then went to the birthplace of Tsong Khapa in Amdo, where he established the Kumbum monastery. Sonam Gyatso passed away in Mongolia in 1588. Several years later, an expedition went back to Mongolia to find his reincarnation, who was eventually recognized among the grandchildren of Altan Khan, an exceptional boy born in 1589. Brought back to Tibet in 1601, he was enthroned in Drepung as Yönden Gyatso, the Fourth Dalai Lama. Perhaps due to the high altitude, perhaps due to the stressful nature of the times, he died prematurely in 1617.

The fourth wave of the Geluk Order completed the efforts of the other three in the work of bringing Buddhism into the absolute center of Tibetan national life. The special flavor of the Geluk lies in its comprehensiveness, its collecting into one coherent system all the vast array of Buddhist teachings and practices, a system with many entries, one for each type and level of person. Tsong Khapa spent his life trying to fulfill what Atisha had called the Four Square Path of putting Buddha's teaching into practice: "All Buddha's Discourse should be understood as free of contradiction; all his teachings take effect as practical instructions; his inner intent is thus easily discovered; and thereby one is safe from the abyss of the condemnation of Dharma." The Gelukpa lamas had rededicated themselves to living simply according to the monastic Discipline. Their charismatic energy was enormous, and many new people were inspired to support more and larger foundations all over Tibet. Peoples outside of Tibet, aware of its importance as a spiritual center, were attracted and inspired by the apparent renaissance taking place there.

At the beginning of the movement, political authority over Tibet was effectively wielded by the Pakmodru rulers from Nedong, who supported the yearly festival in Lhasa and the fervor of monastic renewal through the land. Within Tibet during the 15th century, the Pakmodru regime was challenged by the Rinpung family. The Rinpungs in turn lost power to the Tsangpa regents during the 16th century. And from outside Tibet, various Mongol and Chinese rulers periodically got involved as patrons of various lamas and orders. Thus, the continuing Gelukpa spread of religious practice and monastic institutions was frequently disturbed by political interference and unrest. Things reached a crisis point by the end of the 16th and the beginning of the 17th centuries, during the brief and troubled times of the Fourth Dalai Lama. Historians point to the rivalry between the Karma Kagyu Red Hats and the Geluk Yellow Hats, the former supported by the Tsangpa regents and the latter patronized, but not effectively supported, by the more and more nominal Pakmodru kings. There was some rivalry between the orders, and undeniable conflicts between the affiliated princes. But this level of historical view is superficial, like looking at the small splashes caused by cross currents as one wave subsides and its waters are swept up even more powerfully in the next big breaker. What was really happening was that Tibet was going through a much more radical transformation, something hard for historians to recognize, because it was something unique to Tibet. The sum achievement of the four waves, working both together and in close succession, was the creation of a completely monasticized nation.

A BUDDHIST NATION

Almost exactly one thousand years after the time of Emperor Songtsen Gambo, the Fifth Dalai Lama incarnation was found in 1619 in Chongyay, the valley of the ancient Tibetan kings. The exceptional child was born in late 1617, what the Tibetans call the year of the fire snake. Due to the severe military suppression of the Geluk monasteries by the Tsang regent, his presence was kept secret at first. This political tension eased somewhat in 1622, when the old Tsang regent died and the sixteen-year-old Karma Tenkyong Wangpo took his place. But the new child Dalai Lama was on dangerous ground, as it soon became apparent that the new regent, Tenkyong Wangpo, was planning to totally eradicate the Geluk Order. During the next twelve years, the new ruler made alliances with the Bonpo king of Beri, a country east of Tibet, and a Chogtu Mongol chieftain in order to destroy the Gelukpas. The advisers of the Fifth Dalai Lama heard of this and approached other Mongol chieftains to protect the order. A special relationship developed between Gushri Khan of the Qoshot Mongols and the young Dalai Lama. When the Chogtu Mongols started the invasion of the central regions of Tibet, they were stopped and defeated by Gushri Khan and his allies. Gushri Khan came to Lhasa in 1638 and publicly proclaimed his support for the Dalai Lama, an act that only intensified the Tsangpa ruler's plans to eliminate the Geluk Order and its Dalai Lama. Gushri Khan eventually went to Beri and destroyed the king of Beri's army. The khan then went on the offensive against the Tsangpa ruler in 1641, and conquered him in 1642. In that year, he officially proclaimed the twenty-four-year-old Fifth Dalai Lama the spiritual and temporal ruler of Tibet, from Tachienlu in the east to Ladakh in the west, from Kokonor in the north to the Himalayas in the south.

This story is usually told as just another series of political events. In fact, it has a much deeper significance. In assuming this responsibility, the Fifth Dalai Lama was departing from the Buddha's original example, set when he abandoned his throne for the monastic life, and from established Tibetan tradition, which would have had him serving as a spiritual hierarch in cooperation with a lay ruler of the secular sphere. Instead, he absorbed the role of Dharma King into his own person as monk-sage and tantric adept rolled into one. Publicly recognized as a reincarnation of Avalokiteshvara, the celestial Bodhisattva of great compassion, he became a union, in one person, of the founders of Tibetan Buddhism, Shantarakshita, Padma Sambhava, and Trisong Detsen: abbot,

Great Adept, and king. In 1645 he began to build a new palace on the Red Mountain, mythic site of Avalokiteshvara's contemplations and historic site of Songtsen Gambo's palace of one thousand years before. He built the magnificent Potala that we see today, a monument that is at least three buildings rolled into one—monastery, sacred mandala temple, and fortress seat of government. He set up a unique new form of government, employing monastic and lay officials to work side by side. After the turbulence of centuries of struggle had calmed, he reduced military institutions to the absolute minimum. As the whole land was ritually offered to him as the incarnation of Avalokiteshvara, he was able to create a situation where the Tibetan aristocracy held its privileges not by private military prowess but by service to the government. Each family was required to station its leading members in Lhasa to work for the nation, receiving their ancestral estates as salary for their service of the government. He relied on diplomacy to settle border problems, and he exerted his influence to preserve peace throughout Asia. The Ming dynasty collapsed two years after his enthronement, and the Manchus, a non-Chinese people from the forests north of Korea, conquered China. The Dalai Lama made an alliance based on equality with the Manchu emperor. The Manchus honored the Tibetan ruler greatly, not only because of his religious sanctity but also because they needed his help to keep the Mongols well disposed toward the Manchus.

Intriguingly, it was around the very same century, the 17th, that the seeds of most modern nations around the world were being planted. Louis XIV built Versailles, Peter the Great planned St. Petersburg, the Manchus developed Beijing into a multinational imperial capital, the Tokugawa shogunate was developing Edo, the Mughal and Ottoman empires were at their height, the Spanish and Portuguese were rich with treasure from the New World, and the British were going through revolutionary changes at home, while developing possessions in North America. Newton, Descartes, and Galileo were laying the groundwork for materialistic, mechanistic Western modernity, as Luther and Calvin had prepared the way for Protestant Europe to bring the Industrial Revolution that would conquer the entire planet.

In Europe and Japan, the transformation of the balanced, medieval world into the dynamic, progressive modernity on the march required that the militarily focused secular states swallow all sacred institutions with their monastic focus. The shogunate destroyed Buddhist monasticism in Japan in the late 16th century, and the Protestants destroyed Catholic monasticism in Britain and northern Europe during that same period. According to the well-established analysis of the sociologist Max Weber, the disenchantment of the world by the process of secularization was the ideological engine of the utilitarian, capitalistic, engineering rationalism that created the modern world. In fact, this kind of secularized society living in the material world is the only form of modernity we can imagine. All other societies are simply lumped together as premodern, or non-Western, not to speak of underdeveloped, backward, and so forth.

But the case of Tibet poses a real challenge to this Eurocentric outlook. At the very same moment that the West was finalizing its secular form of rational modernity, the Fifth Dalai Lama was taking steps to transform the inner Asia of Tibet and Mongolia in the precisely opposite direction. There the sacred institutions swallowed the secular state and its

military. Tsong Khapa's followers had developed the enlightenment-oriented, millennial worldview essential to undergird a spiritualistic, organic modernity. The Karmapa Lama and Dalai Lama incarnations of Avalokiteshvara prepared the way for Tibet and Mongolia to complete the monastic revolution and to "industrialize" the Buddhist educational program of self-conquest. Thus the Tibetan worldview dating from this period can be understood as a kind of alternative modernity, a spiritualistic or interior modernity in contrast with the Western materialistic or exterior modernity we are familiar with. It is this different kind of modern quality that makes Tibetan civilization and its arts so fascinating to us, and so worthy of our study and emulation.

To return to the Dalai Lama saga, the Sixth, Tsangyang Gyatso (1683–1707), surprisingly decided to upset all the organization and stability created by his predecessor, refusing to be ordained as a monk, and renouncing his palace for the streets of Lhasa and the life of a romantic poet. He was forcibly removed from office and died in mysterious circumstances on his way to exile. The next Dalai Lama, found after some controversy, was Kelsang Gyatso (1708–1757), a great leader, author, and teacher, although his political authority was more circumscribed than that of the Great Fifth. The Eighth Dalai Lama, Jambel Gyatso (1758–1805), was also a remarkable spiritual leader, and he continued to play a diplomatic role in keeping the peace in Central Asia.

The 19th century was unhappy for Tibet, as for the rest of colonialized Asia, though Tibet long escaped invasion by any colonial power. From 1805 to 1875, there was a series of Dalai Lamas who never reached maturity and the country was governed by regents in conjunction with Manchu ambassadors. The Manchus became more assertive with the Tibetans once the great Qianlong emperor was gone (after 1796) and Mongol power was less of a concern. The Manchu strategy was to keep Tibetans and Mongolians isolated from the outside world, in order to use their vast lands as backward buffer zones and to lessen the risk of their learning about modern weaponry or forming alliances with the Russians or the British. This was the real reason for Tibet's recent isolation, and not, as some have thought, Tibetan aversion to outsiders.

The Great Thirteenth Dalai Lama, Tupten Gyatso (1876–1933), came to power in 1895. Early in his reign, he saw the necessity for Tibet to establish its identity among the modern nations. With the help of one of his tutors, the Buryat Mongol Ngawang Dorje, he corresponded with Czar Nicholas of Russia, seeking protection from the British and the Manchus and assistance to develop Tibet. He began sweeping reforms in all areas of Tibetan society. However, the British, with their fear of Russian designs on India, were troubled by the friendship between the czar and the Dalai Lama, and so sent Colonel Younghusband to invade Tibet in 1904. The Dalai Lama fled to Mongolia, then visited Beijing in hopes of gaining more recognition for Tibet. The British forces soon withdrew from Lhasa, after imposing a treaty upon Tibet. And then, with the death of the Manchu Dowager Empress, the Dalai Lama had to flee again from the hostile designs of her successor. In 1909, a Manchu army invaded Tibet from the east in pursuit of the Dalai Lama, who fled to India, this time to the protection of the British. The two years he spent as the guest of the British Raj were very informative for him, firming his resolve to modernize Tibet before it was too late.

With the collapse of the Manchus in 1911, the Dalai Lama returned to Lhasa, evicted the remaining Manchu garrison, and proclaimed independence in the modern sense. For the next twenty years, he worked hard to establish Tibet in the eyes of the world, but to his frustration the British would not reliably support Tibet when it counted, not backing Tibet's attempt to enter the League of Nations, for example. On the other hand, Sir Charles Bell, the British plenipotentiary for Central Asia, became a personal friend of the Dalai Lama and tried to help him modernize Tibet. From 1921, the Dalai Lama tried to establish a secular school system, a defense force, a mint, a postal system, and other minimal institutions of a modern nation, with only limited success. Eventually, he became discouraged and, after the Russian communist destruction of Buddhism in Mongolia in the early 1930s, he wrote a testament to his people, in which he predicted the eventual loss of Tibetan Buddhist culture in Tibet itself. Some Tibetans believe that he then consciously died fifteen years earlier than necessary. They report him as saying that he was dying ahead of time in order to be reborn and to grow old enough by the time of the doom of Tibet, to be able to help his people through their ultimate trial. He died in 1934, after foretelling the circumstances of his reincarnation. The new Dalai Lama was fourteen when the Chinese Red Army invaded Tibet in 1949, twenty-four when crisis forced his flight to India in 1959. The Chinese communist attempt to destroy Tibetan civilization, eradicating all Buddhist institutions and practices, brought a terrible fulfillment of the prediction of the Great Thirteenth.

The fourteenth Dalai Lama, Tenzin Gyatso, was born near the birthplace of Tsong Khapa in northeastern Tibet in 1935. After the first phase of his spiritual education, on November 17, 1950, he assumed political responsibility in order to deal with the increasingly difficult situation with China. With massive numbers of Chinese troops then in Tibet, the Dalai Lama had no choice but to try to cooperate with the Chinese program of modernization.

Tibet was a vast territory—it now accounts for more than a third of the land mass of the People's Republic of China. It had a great store of artistic wealth and undeveloped resources, as well as an important strategic position. Tibetan treasures were expropriated, its cultural institutions destroyed. In the ensuing years, some millions of ethnic Chinese would be relocated in its traditional territory. By 1959, Tibetans were in open revolt, despite their religious ethic and the Dalai Lama's calls for restraint. Fearing that his people would lose their last chance if he were to come to harm, the Dalai Lama fled to India. With the hospitality of Pandit Nehru, he set about preserving Tibetan culture and helping the more than one hundred thousand refugees who followed him. At the same time, he implemented in the exile community the modernizing and reform measures his predecessor had attempted in Tibet proper.

The Dalai Lama has never despaired of the value of the Buddha's teaching, finding time to engage in intensive studies of the most profound philosophies during the sixties and the contemplative and ritual arts of the tantras in the seventies. In keeping with his Buddhist practice, he does not manifest hatred of the Chinese. He adheres to the Buddhist precepts that the enemy is the greatest teacher, and that hatred does not end by hatred, but only by love. Nevertheless, in the secular realm, the Dalai Lama never hesitates to speak out against

Chinese rule. He always speaks compassionately for the individual human being, and calls upon nations to adhere to the same law and morality in the global community that they require of their own individual citizens. He is well informed and appreciative of technology and actively concerned about the abuse of nature. He was deeply respected by Nehru and other important figures in India from their first contacts, and now his circle of acquaintance among world leaders is vast. His maturity as a philosopher and as a religious leader was signaled in 1989, when he was awarded the Nobel Peace Prize. Since then he has become a major voice for world peace and justice.

Tibetans have a myth, the myth of Shambhala from the *Kalachakra (Time Machine) Tantra,* that gives them the resources to understand the historical tragedy they are suffering. Shambhala is a magical country somewhere in the polar regions, shielded from other nations by a forcefield of invisibility. Its agents work invisibly for the welfare of humanity, reincarnating where needed, but the nation as a whole remains hidden until the barbaric impulse for war and destruction will have abated and the world becomes one community. After this, true decentralization becomes possible within an international moral and legal framework, and a new golden age commences. The Tibetans expect all this to happen after about three more centuries; the prophecy is very vivid for most. It gives us a clue to their sense of identity and mission in the present. They can understand their present holocaust as part of the agonizing process of the unification of the world.

The Tibetans see the individual's role as that of working in his or her own heart and immediate circle of influence to manifest enlightened principles in living, with the strong hope that this work will not be lost in a nuclear holocaust. They see technology as basically useful, but only as good as the wisdom and compassion of those who wield it. And, most importantly, they see the planet itself as having a positive destiny, not as a mere staging-ground for a heavenly ascent, and not as a mere random accident in a galactic chemical ocean. They see it as an emerging Buddha land, a land of enlightenment and compassion, in which it is crucial that those who can see through the sometimes horrific surface appearances work to help others see that it is only fear and hatred that cause sufferings, and not some fundamental inadequacy of life and its environment. And they readily acknowledge that ultimately some higher power must intervene, when people's hearts and minds are ready. Their optimism is amazing, and they are rarely discouraged in their small individual efforts, however hopelessly insufficient they may appear to be.

PURE LANDS IN THE TIBETAN IMAGINATION

The third major section of *Wisdom and Compassion* focuses on the Tibetan vision of a purified and perfected reality, the Pure Lands or Buddha lands, vividly described in Buddhist scriptures. The Indian vision of the cosmos has always included a strong imagination of heavenly environments. In the simplest form of the Buddha legend, he is presented as descending from the highest heaven of the realms of pure form to the Joyous (Tushita) Heaven of the realm of sense, even before being conceived in his mother's womb. The future Buddha, Maitreya, is believed to dwell in Tushita Heaven right now, waiting for his turn to come into the world. There is an Indian "Mount Olympus," called Mount Meru, where a

divine city flourishes, and from which various gods descend now and then to play among us humans. Yogis and yoginis of all religions can fairly easily attain contemplative trances, in which they can experience the various heavenly realms. And good people when they pass away may realistically hope to enter a pleasant heaven realm, though in most of the Indian religions, heaven can never be a final resting place—only another, rather pleasant, temporary way station in the endless round of rebirths.

With the emergence of the Universal Vehicle scriptures from the 2nd and 1st centuries BCE, the concept of a Buddha field or Buddha land (*buddha-kshetra*) became popular in India and throughout Asia. A Buddha land is the environment of a Buddha. As such, it expresses the Buddha's universal compassion in the artistry of its design as a universe in which every being can find the answer to his or her individual needs. It is a vision of Buddhahood as achieved by a world as a whole, not just by an individual alone. It is made possible in Buddhist physics by the absolute reality of voidness; since the objective reality of things is not intrinsically fixed in any one way, since it is merely relative, the collective imagination's power to shape things is unlimited. For Buddhists, the "strong force" within the atoms of matter is mind, the collective imagination; the collectivity includes Buddhas, Bodhisattvas, gods, and angels along with humans and lower animals. Thus as a Bodhisattva evolves toward Buddhahood, life after life through history, a being interacts with innumerable other beings, bit by bit turning lives, deeds, words, and imaginations away from ignorance and selfishness toward wisdom and compassion. Since one keeps this process up throughout "three immeasurable eons" of lifetimes, the Buddhist view is that one's own final perfection of Buddhahood will involve a final perfection of one's whole universe; one turns into a being who perfectly expresses wisdom and compassion, and one's environment turns into a land that perfectly expresses them too.

The first and most famous Buddha land is the "western paradise" known as the Land of Bliss (Sukhavati), presided over by the celestial Buddha Amitabha (Infinite Light). This Buddha is ninety million miles tall, manages a vast, galactic land beyond as many universes to the west as there are grains of sand in sixty-two Ganges riverbeds. The brilliant rays of his compassionate grace reach like magnetic beams into all galaxies throughout the multiverse to draw the souls of the faithful to his blissful land. Once installed there on one's own jewel lotus, with a perfect body drawing all its sustenance effortlessly from the enriched atmosphere, one can study the Dharma directly with Amitabha Buddha, contemplate in an ideal environment, and make rapid progress toward one's own Buddhahood. The compassion of Buddha Amitabha is so great, his grace so universal, that even a grave sinner need only turn his or her mind toward him for a moment, call upon his name with true sincerity, and he or she is whisked to the Land of Bliss after death. The Blissful Land Sutra describes the magnificent jeweled environment in vivid, colorful detail. The Buddhist faithful commissioned vast murals in temples, on cave walls, in texts and paintings, and the popular imagination was kindled with the splendor of this better universe, the one they could reach through faith after breathing their last in this land of suffering, this grimy world of ours.

As the centuries went by, other Buddha lands became well known, notably the Land of Delight (Abhirati) of Buddha Akshobhya in the east. Scriptures such as the Vimalakirti, Lotus, and Garland sutras, in which Shakyamuni Buddha miraculously reveals an underlying Buddha-land reality in this world, were much contemplated and enjoyed. As the tantric literature developed, the mandala concept entered more commonly into Buddhist art. Mandala means a protected environment, a realm where the mind is free to manifest its highest imagination. Thus the Buddha mind, with its compassion, creates mandala environments wherein the environment itself brings beings out of suffering and exalts each in the joy of the experience of his or her own highest fruition. In the esoteric technology of the tantras, the mandala perfected universe can be established immediately, without evolving through infinite eons, by imaginally shifting into a subtle, timeless dimension. A more powerful insight into voidness releases a more powerful imagination, which can magically bring into reality whatever it visualizes. Thus the Buddha land possibility became more accessible to people in a more immediately revelatory, or apocalyptic, way.

Further, the many great Bodhisattvas who operate in this world environment to benefit beings here—sort of Buddhist archangels manifesting ideal virtues in the midst of the world—became better known during the early centuries of the common era. Their literature associates them with various earthly environments magically hidden here in this world, though guarded and inaccessible to all but the faithful. Thus, Avalokiteshvara and Tara, male and female angelic Bodhisattvas, got their mythic starts in the far-away dimension of Amitabha's Land of Bliss. They came to dwell in a land hidden on a mountaintop by the sea on the southwest coast of India, a magic land called Potalaka (Safe Haven), and from there they ventured forth to help beings all over the world. Avalokiteshvara in particular took mythic vows to help the "barbaric" Tibetans, denizens of the Land of Snows, helping them evolve away from violence and ignorance into a happy nation living in compassion and wisdom. The Bodhisattva Manjushri, archangel of wisdom, took his vow to help the people of China, feeling sympathy for them in that the blessing of the Shakyamuni incarnation had occurred in India, far away from them. His magical Pure Land was then mythically established among the Five Mountains (Ch. Wutaishan) of northwest China, where pilgrims still go to the many temples and monasteries hoping for a vision of the real Pure Land there, invisible to all but those purified in vision. The Great Adept Padma Sambhava is believed to dwell in the Glorious Copper Mountain Pure Land somewhere in west Asia or perhaps Africa. The female Buddhas, the Vajradakinis ("diamond angels") have their own Pure Land hidden away somewhere in the Hindu Kush. And the *Kalachakra Tantra* reports the Pure Land of Shambhala hidden in the polar regions (see above), where every citizen has become a Bodhisattva, and whence in the final crisis of this cycle of history help will come to bring wisdom and compassion to triumph over the forces of ignorance and violence. This tantra was originally taught to a vast host of gods, adepts, and visiting Shambhalans, in a vast dimension within the great stupa monument Dhanyakataka, at Amaravati in South India. And in general, the major sites of Shakyamuni's life—the Lumbini garden where he was born, Bodhgaya where he attained enlightenment under the bodhi tree, the Deer Park at Sarnath where he taught the Monastic Vehicle, Vulture Peak where he taught the Universal Vehicle, Shravasti where he

performed two weeks of miracles, Kushinagara where he manifested Parinirvana, and so forth—all are considered Pure Lands in their own right. So they have a powerful attraction for the pilgrim.

Thus by the time Buddhism reached Tibet, a rich landscape and "heavenscape" was well established in the Buddhist imagination. The Tibetans, who had always lived mythically close to the heavens just above the tops of their snowy mountain peaks, were overjoyed to discover a spiritual geography so full of benevolent power. In addition, because the mandala artistic traditions and associated spiritual high technology of the tantras were by then so central to Indian Buddhism, they found tools for their own enterprise of transforming not only themselves, but also the land of Tibet itself.

In believing in the legend of the future Buddha Maitreya —who is present in Tushita Heaven now and constantly intervenes to improve the day, while waiting to emanate as a Buddha far in the future in order to help those who have failed to reach enlightenment in this cycle of history—the Tibetans demonstrate their long-term hope for a positive outcome to their evolutionary struggles. In their devotion to the myth of Avalokiteshvara's vow to protect the Tibetans, they uphold their covenant with a powerful archangel of total benevolence. They need only put the Buddha Dharma of wisdom and compassion into practice as much as possible in their personal lives and social institutions, and the Bodhisattva will tirelessly come to their aid in all their difficulties. In the sense of planetary spiritual environment, Tibetans feel the continuing presence of Padma Sambhava alive on his copper mountain, of Manjushri dwelling on his five peaks, and of the Vajradakinis in their magic land to the west. In the midst of being invaded and troubled by difficulties in the world, they feel Shakyamuni still radiant from the holy land of India, and they feel the vigilant presence of Shambhala in the north, waiting for the time to turn the world around toward goodness and sanity.

In the sense of boundlessness of life that goes along with the model of reality based on individual reincarnation, Tibetans feel the continuing attention of the great beings who have lived throughout history. They reenvision their own history: the dynastic kings are remembered as incarnations of the great Bodhisattva of compassion, the queens as incarnations of the female celestial Bodhisattva Tara. Their most learned guiding scholars, Longchenpa, Sakya Pandita, and Tsong Khapa are understood as incarnations of Manjushri, the archangelic Bodhisattva of wisdom. The Karmapa Lamas are revered as Avalokiteshvaras, and many of the Tibetan heroes of times of danger are recognized as incarnations of Vajrapani, the archangelic Bodhisattva of Buddha power. Since the millennial movement of Tsong Khapa, Tibetans have more and more expected an end to negative history. They see this coming in the Dalai Lamas' assumption of political responsibility, the founding of the Ganden (Tibetan for Tushita) palace government, and the assurance that the competent powers of wisdom and compassion are operating at full force in their lives. In any spiritual tradition, the peoples' sense of their highest spiritual power and model being actually in office and caring for their lives is millennial in every way. It goes along with the individual's feeling that real problems are not caused by shortcomings in external reality, but must instead be caused by deficiencies of one's own merit, wisdom, compassion, and visionary purity. Thus, the energy of response to such

problems should logically be directed inward, toward one's inner obstructions. And so the Tibetans thus find the educational system of vast and numerous monasteries, hermitages, and holy places most directly relevant to their perceived needs. Furthermore, life in such a millennial environment becomes a constant practice, a permanent pilgrimage. Every mountain has been a hermitage for many saints, every valley the seat of important monasteries, every river the abode of helpful deities. The major city of Lhasa is a god ground (T. *lha-sa*), in the center of which an ancient icon of Shakyamuni called the Jowo has a special spiritual force to represent his undying wisdom and compassion.

Looming over it is the residence of the living messiah, Avalokiteshvara himself, called the Potala after the southern Pure Land Potalaka. Within it are concentrated monastic sanctity, messianic dedication, and tantric high technology of world transformation. The Wheel of Time (Kalachakra) mandala is permanently manifest, as in Shambhala to the north, and before 1959 there was a year-round series of festivals transforming the lives of even the simplest peasants and pilgrims into a fruitful practice of the Dharma. Pure Land visions were made yearly as multistory floats of colored butter and paraded through the towns with great joy and merriment. Dancers and chanters represented deities and historical figures to reconfirm the ancient virtues through drama. Clowns and buffoons used humor to show the foolishness of following ordinary negative emotions and notions.

The Tibetan landscape everywhere is filled with *mani* stones, flat rocks with the mantra of compassion, OM MANI PADME HUM ("OM! the jewel in the lotus [itself a symbol of the union of compassion and wisdom, male and female, and so on] HUM"). There are stupas (*chöten*)—monuments to the eternal Buddha presence—everywhere, ranging from a simple pile of stones heaped up on a high pass in the wilderness to huge architectural structures serving as city gates or many-roomed temples, and many-ton sarcophagi of gold and silver studded with precious stones. In the streams there are water wheels turning huge cylinders filled with *mani* prayers. On the hillsides there are wind wheels doing the same. People turn hand wheels as they circumambulate holy spots. There are giant Buddha icons on cliff faces. Most important, there are living Buddha icons, reincarnations walking around all over the country. The child in anyone's womb could be such a one, the infant on the herdswoman's back, the urchin in the city. In short, Tibet itself becomes thought of as a Pure Land, the Buddha land of the deity of great compassion, and her people become a chosen people with specially meaningful lives and opportunities. In *Wisdom and Compassion: The Sacred Art of Tibet,* the masterpieces of painting, sculpture, and ritual particle mandala painting demonstrate the special Tibetan way of envisioning the enlightened sacredness of their own environment.

THE BUDDHIST APPROACH TO ART

Given Buddhism's basis in Shakyamuni Buddha's discovery of the viability, usefulness, and happiness of the enlightened life, it is not surprising that Buddhism inspired the arts in India and in all the civilizations it touched. For the enlightened person, life has no purpose other than art in the broadest sense, since his or her life itself is nothing but an art that communicates the vision of enlightenment that inspires others

to find their own relief and happiness. In Universal Vehicle terms, enlightenment is the full development of wisdom in the deep experience of selflessness, the open transparency of the self. This naturally becomes compassion, since others are fully experienced through the openness of the self, and compassion spontaneously responds to remove their sufferings. For a fully enlightened being there is no drive other than the art (*upaya*) of liberating others.

In Universal Vehicle Buddhism, the seeds of a theory of art are contained in the central doctrine of the Three Bodies of a Buddha. When one becomes a Buddha, the ordinary mind and body are transformed into these Three Bodies. The first is called the Truth Body (Dharmakaya), defined as ultimate reality personally experienced as one's own body/mind, the fulfillment of all individual aims, the perfection of wisdom, inexpressible, transparent and more, and is sometimes analyzed into "reality" and "wisdom" aspects. The second is called the Beatific Body (Sambhogakaya), defined as relative reality experienced as universal bliss (due to its nonduality with ultimate reality), the fulfillment of all altruistic aims, being an irresistible energy of love that cannot fail to make others happy, the perfection of compassion, inconceivable, magical, and more. The third is called the Emanation Body (Nirmanakaya) and is a reflex of the second, since bliss by itself—on the boundary of the formless absolute—is not manifest to unenlightened beings, and thus cannot communicate to them and educate them on how to find the happiness of enlightenment. To communicate to beings, then, one emanates more solid forms, adopting Buddha bodies, incarnating as various beings and things. The Emanation Body is analyzed into three categories, called Supreme, Incarnational, and Artistic. The Supreme Emanation Body consists of emanations such as Shakyamuni Buddha, the creation of a Buddha life out of the artistry of compassion in order to help beings find release from suffering. The Incarnational Emanation Body consists of emanations of teachers, companions, even animals or inanimate objects such as lands, houses, bridges, planets, and so forth, becoming beings and things that people who are not ready for a Buddha life can relate to and that will satisfy their needs and inspire them to attain enlightenment. The Dalai Lamas and other Tibetan reincarnations are examples of this form of the Emanation Body, as are undoubtedly many other unrecognized persons and things. The Artistic Emanation Body is defined as all icons of Buddhas, Bodhisattvas, incarnations, environments or anything that represents enlightenment to beings, in addition to the artists who create them, during the time they are doing so. This last category gives the key to the place of art and its uses in Buddhist civilization, most specifically in Tibet.

The beginning of the adventure on the path toward enlightenment comes with the first glimmer of imagining the very possibility of enlightenment. As long as the imagination is trapped in the routinized perceptions of ordinary culture, one will think one's unenlightened awareness is the only possible awareness. As long as one's culture convinces one that life is created and controlled by some inscrutable authority, or that life is an accidental conglomeration of atoms, that nothing matters after death, that there is no other way to be than the way one is, and so forth, there is no chance even to aspire to evolve to any higher being. Therefore, Buddha's task as a teacher could not even begin until works of art had opened people's imaginations to the possibility of a new perception.

Thus in the Buddhist scriptures, almost every discourse is preceded by some sort of miracle, some dramatic revelation of an extraordinary perception that releases the audience's imagination. Once the Buddha himself was no longer there, those who remembered him began to make icons of his liberating presence, though at first the memory of his extraordinary qualities was so vivid no representation would do justice, and he would be represented in a scene by a tree of enlightenment, a wheel of teaching, or some other symbol. The stupa, originally a royal funerary monument, came to represent the omnipresence of the Buddha's mind, arranging symbols of the elements of the world in such a way as to symbolize architecturally their infusion with the Buddha presence.

Literature is a most important medium for the art of manifesting freedom and compassion. The Buddhist vision of biology includes karmic evolution, wherein individual beings evolve through various life forms, where man has been monkey and can become monkey again if his deeds are not intelligent, is communicated by the artful reworking of folktales into the Former Life stories, the Jataka. These are then illustrated in visual arts, in stupa carvings, in cave murals, in book illustrations. In the Universal Vehicle texts, the broadening imagination of other dimensions comes through in the elaborate descriptions of other worlds. Numerous cosmic Buddhas from other universes, magnificent Bodhisattvas, female as well as male, all these became inspirational icons, examples of the Artistic Emanation Body. And with the tantras, the representations of enlightenment went even deeper, going into the deepest archetypal images in the unconscious to find the enlightening possibilities.

Tibetan art is justly famous for its erotic and terrific images. In the Paramasukha image of the frontispiece, the Buddha is dramatically revealed as two beings, a male and a female, in ecstatic sexual union. In the Yamantaka images in the Geluk section, the Buddha is revealed in a ferocious form, his main head like that of an Indian water buffalo, with gnashing fangs, with many arms and many legs. There are even combinations, such as Yamantaka in male-female union, that are simultaneously erotic and terrific. All of these are considered transcendent Buddhas. We have discussed the erotic, semi-terrific Paramasukha form as the union of wisdom and compassion (see essay, "Wisdom and Compassion: The Heart of Tibetan Culture"). We made the main point that it has a special spiritual purpose: it evokes for the practitioner a state of enlightenment that has integrated the unconscious, instinctual energies of life into a consciously sublimated exalted state of enlightenment. In the last century, before depth psychologies had been developed in the West (outside of monastic institutions), these images were frightening and disgusting to Westerners, provoking them to denounce Hinduism and Indo-Tibetan forms of Buddhism as obscene, vulgar, and demonic. Still today, some people from other cultures, even Buddhist cultures, are so disturbed by these icons that they denounce Tibetan Buddhism as a degenerate form. Therefore, we must focus on these images from a modern perspective, in order to clear away any lingering stigma and to appreciate one of the most useful achievements of Tibetan civilization.

Freud and Jung cannot be ignored by any thinking person today. One is unlikely to agree with everything they said; there has been a great deal of further development in depth psychology since their time. But there is no question that they rediscovered a primal instinctual dimension of human life, a

dimension wherein an important portion of every healthy person's life energy is bound up in a normally unconscious area of instinctual drives, especially in the realms of eros and thanatos, desire and aggression. When this energy is too strenuously suppressed, when its existence is denied, it cripples a person, creating the mental and physical disorders Freud and his colleagues were trying to treat. The process of healing involves bringing these energies to awareness by observing and cultivating dreams, attending to messages communicated in verbal free association, art work, and so forth. Having brought them to awareness, they can then be integrated in the conscious personality through sublimation, and the considerable liberated energy can be put to useful purposes.

In the case of the Tibetan depth psychology of the tantras, the healing process is designed to achieve a much more radical goal, not only normality as freedom from crippling disease, but the total well-being and drastically expanded creativity of enlightenment. The instincts must be totally transmuted into creative energy. Thus there are Buddha forms that totally transvalue eros and thanatos, transmuting selfish lust into selfless compassion that seeks happiness for all others and transmuting destructive aggression into analytic wisdom that critically sees through all appearance of self-existence to penetrate the core freedom that is the reality of the universe. But the erotic and terrific Buddha forms do not only operate on their optimal level. They affect each person on the level needed. The person just trying to get along in mundane society can find in them a sense of relief in their reflection of one's inner reality. While ego transcendence may be the ultimate goal, ego reinforcement can occur by making the ego more open to the unconscious dimensions of the person. And actually, contrary to popular notions about enlightenment, the supreme ego transcendence of enlightenment does not amount to ego loss, but rather undergirds the strongest possible, that is the ultimately resilient, ego; what the tantras call the "diamond self of selflessness."

It will be helpful here to consider in detail one of the most terrific Buddha forms, that of Vajrabhairava, the Diamond Terrifier, alias Yamantaka, the Death Exterminator. He is a Buddha form of Manjushri, a Bodhisattva on one level but really the god of wisdom and the personification of the concentrated wisdom of all the Buddhas. According to his myth, in his paroxysm of insight he traveled all the way to the underworld to seek out Yama, the God of Death, who dwells with all his minions in the sixteen sealed-up iron cities of hell. Yama appears in Indian mythology with the head of a water buffalo. To tame Yama, Manjushri adopted the same form, adding to it eight other faces symbolizing other dimensions of awareness beyond Yama's ken, sprouting thirty-four arms, each holding instruments of fearsome power and knowledge, sprouting sixteen legs symbolizing his groundedness in the sixteen emptinesses, and assembling around himself a vast host of Buddhas and Bodhisattvas in terrific forms. As a Buddha, Manjushri draws on the boundless life of ultimate voidness or freedom. To confront Death, the archetype of boundedness, limitation, terminality, he manifested the form of Death magnified to infinity. Death, a single, egocentric god, was overwhelmed by the god of selflessness. Death saw himself endlessly mirrored back to himself, infinitely outnumbered by himself. Death was literally scared to death; but the killing of death means the granting of endless life, even to him.

Thus the yogi who meditates through the archetype deity form Yamantaka is using artistic modeling—genetic imagination—to develop a sense of identity strong enough to face down death, and the fear and anger that attend upon it. His wisdom transforms into Yamantaka to conquer his denial of his own mortality, his fear of cessation, his anger toward a universe that would count him out, and so forth. Each head, each limb, each attribute, symbol, and ornament expresses the total mobilization of the faculties of enlightenment needed for this ultimate confrontation. For example, the nine heads are the nine branches of the Buddha's teachings. The thirty-four arms and brain, throat, and heart centers are the thirty-seven faculties of enlightenment, faith, mindfulness, wisdom, contemplation, and so forth. The sixteen legs are the realizations of the sixteen varieties of freedom. Further, since the realm of tantric imagination is a realm of multivalence of symbolism, there are ways of understanding the Yamantaka form as encoding patternings of sensitivity in the subtle nervous system, or programming sequences of contemplative unfoldments and so forth.

The erotic and terrific deities of Tibetan art and culture express the Tibetan mastery and further development of the sophisticated depth psychology they inherited from Indian Buddhist civilization, anticipating discoveries in psychology made only recently in the West. And it is in this area, traditionally known as inner science (adhyatma-vidya), that Tibetan civilization has something else of its own, unique and of extreme value, to contribute to humanity. In the context of Tibetan society, the number of practitioners who fully mastered the high technology of the tantric path was probably quite small in most eras. Yet it seems that the public sense of the presence of such adepts and the atmosphere generated by the presence of such powerful imagery affected for the better the attitudes common about life and death, about sexuality and violence, good and evil. Tibetans on the whole were not tense, but were easygoing, cheerful even in stress, nonviolent though vigorous in expressing emotions, and very adaptable under conditions of great hardship. During the recent Tibetan holocaust, mass exile, and cultural dislocation, there have been relatively few cases of mental illness, murder, or suicide. And the simplest Tibetans treasure their icons and images so fondly, turn to their lamas so devotedly—in spite of intensive propaganda efforts to disillusion them and reform their minds—and look to their monasteries as the source of health and happiness with such determination that one cannot help but think the Buddhist arts and sciences have benefited them.

THE TIBETAN USES OF ART

Art for the Tibetans is well accepted as a precious window into an alternative reality, into the enlightened dimension. In a special sense, it is not human-made, but is a gift of enlightened beings themselves. For example, it was said that when Tsong Khapa and his disciples were making the gold and silver three-dimensional mandalas in 1415, the artisans never had to consecrate or even polish a single statue. As soon as the iconography of the image was correct, following both the traditional iconometry of the texts and the visionary styling of the master, the images would begin to shine by themselves, as what the tantras call "wisdom duplicates" of the actual deities descended from their heavenly abodes and merged within the icons. Every Tibetan was quite aware of the difference between an icon and a real Buddha or Bodhisattva, and many

experienced frequent visions of them. Still, due to the sense that even icons are by extension part of the actual Body of Buddha, Tibetans feel that icons transmit a living presence. They feel that this can be ritually and contemplatively enhanced by rituals of consecration and even by the attention of an accomplished lama.

For the Tibetans, art can exercise its liberating and delighting function through any medium. The highest medium is life itself, the living material of an incarnation. Tibetans believe that their reincarnate lamas have achieved the highest stage of Buddhahood, that they have become free of the selfish instinct to grasp for life and have already experienced the supreme peace of nirvana. Thus their returning incarnate among the people is itself the highest artistic act. The circumstances of their births, the qualities of their bodies, their deeds, teachings, and creations—all these are for the sake of the beholders. Encountering such an incarnation is the highest aesthetic experience for the Tibetan. The living incarnation is thus far superior to the icon made of gold, or gems, or wood, or stone. Of course, there are many examples of inanimate icons talking and acting to help beings; and there are incarnations whose mummified bodies remain perfect and confer liberation upon those who behold them. The boundaries are vague in this realm because of the fundamental Tibetan sense of the inconceivable generosity and abundance of enlightened beings.

The next important medium is literature, the enlightened word being a direct route to the imagery of the human imagination. Great authors are high artists most appreciated by the educated. The Great Adepts like Milarepa, Drukpa Kunlek, Tangtong Gyalpo, as well as the Sixth Dalai Lama and others who adapted the Dharma to the form of the Tibetan folk song, are most appreciated by the simple people. The Tibetans have epics and songs, rhymes and riddles, tales and legends—in all, an immense native literature in addition to the vast, treasured canon of translations from the Sanskrit.

Music is important; its harmonies and vibrations are able to affect the heart and emotions of the listener directly. Tibetan monastic chants are extraordinary in their ability to communicate the wisdom of selflessness in pure sound. Some Tibetan monks have the ability to sing a note in such a way that multiple overtones are produced, setting up a resonance in the tone that is considered capable of opening the heart centers of the listeners. There are a wide variety of chants accomplishing other effects such as healing or inspiring, as well as ballads and folk songs intended simply to delight.

Architecture is a major medium, and here the learned lamas are the masters, seeking to imbed in public buildings the forms from the tantric mandalas that are believed to convey the architectonics of the enlightened sensibility. To be in a lofty, well-adorned space of precisely determined proportions is believed to instill a sense of exaltation, security, and delight in a person's central nervous system. Archetype deities are visualized by yogis within precisely and elaborately defined architectures. Thus the architecture of the Potala expresses to the beholder that it is the residence of the Bodhisattva of compassion: It is powerful and inviting, secure and stable, yet fantastic and delightful. The highest of the architectural arts is, of course, the construction of three-dimensional mandalas, which are made of mind, wood, metal, clay, butter, dough, and even thread, and elaborately decorated with gems and precious cloth. The highest of these are those made of mind-

stuff in pure imagination, and they are the paradigms of all others. An adept yogi or yogini on the creation stage of Unexcelled Yoga can visualize so precisely and so stably that he or she can hold firmly in mind every architectural and ornamental feature of a luminous mandalic mansion, from within and without, from above and below, for several hours. It is said that a person with even a fraction of this ability to visualize finds all mandalas made in coarser media dull and disappointing, though such a person will create them anyway as triggers for the imaginations of others.

The sculptural arts are treasured as a way of energizing the visualization of oneself as an archetype Buddha. These icons, too, are made of mind, gems, metal, wood, clay, dough, and butter, with the highest being mind. The tantric practice of melting one's ordinary sense of body into voidness and revisualizing oneself as an archetype Buddha deity, such as Yamantaka with his many heads and faces and arms and legs, affects the central nervous system even more powerfully than the architectural visualization (actually the two go together, as one visualizes the deity within mandalic space). The Buddha art of incarnation is thus learned in the tantric art of visualization. The belief is that in life one rehearses the self-creation of bodily forms (those that ideally express compassion) in sustained contemplation, developing extreme stability of visualization and full control of normally unconscious imagery processes. Then after death, in the between-state, where image can fluidly shape subtle matter without the resistance of coarse forms, one can adopt the archetype deity form for real, thereby engineering an acceleration toward perfect enlightenment in forms of compassion as well as in depth of wisdom. Thus every tantric yogi is a sculptor of the subtle stuff of imagination. The sculptors in the coarse materials are aware of this highest form of their art and so take their direction from such lamas. The icons placed in temples and holy places are intended to remind ordinary Tibetans of the limitlessly abundant and beautiful manifestations of enlightened beings and inspire them about their own potential to achieve such states. The sculptor following traditional proportions in making a Buddha statue is conscious of being part of the Artistic Emanation Body and of being a vessel of the Buddha activity.

The two-dimensional painted icons and the particle mandalas made on a flat surface are connected to the same range of approaches as the art forms just described. Again, the picture should be a window on the enlightened dimension. If an archetype deity were to be painted incorrectly, Tibetan artists believe it could plant a distorted image in a viewer's unconscious and damage him or her genetically during a future rebirth process. As His Holiness the Fourteenth Dalai Lama once remarked in a lecture on quiescence meditation, "It's best to use a small Buddha image as the object of focus for this concentration; it plants a good seed for your own future Buddhahood. But make sure you have a well-made Buddha image; if you meditate a lot on a crooked Buddha image, there's a danger you will one day become a crooked Buddha!" He burst into gales of laughter, but the Tibetan mind takes these things seriously.

The artist has to be a person who is open enough to enlightenment to serve as a selfless vessel for its manifestations; who has to participate in the creation of a work of art out of dedication to the higher realm, and not primarily for fame or profit. It is an anonymous art. Rarely do we find

the names of the artists or architects of tangkas, statues, temples, and monasteries.

The beholder also has to bring openness to the encounter with the work of art; the beholder's faith is in a very real sense a co-creator of the work of art. There is the famous story of the young peasant who went to Lhasa to trade, promising to bring his mother a relic from the Jowo statue of Shakyamuni. He had such a good time in Lhasa that he forgot all about it until he was a few miles from home. So ashamed was he that he picked up a tooth from a dead dog's skull lying in the ditch by the road, wrapped it in some elegant silk, put it in a relic box, and presented it to his mother. The old woman was delighted and prayed to it constantly. Soon she was regaling the neighbors with tales of the blessings she was receiving from the fine relic her son had brought her. The son was embarrassed and also felt guilty about deceiving her. One holiday he was washing down by a stream, and he decided to confess his trick and disabuse the old woman of her delusion. The moment he came to this resolve, he looked up and saw the Jowo statue standing before him. The Buddha statue said to the awestruck peasant, "Young man, do not think your mother does not have a real relic. You forgot, but I remembered, and the dog's jaw was my manifestation. If you don't believe me, go quietly home and observe your mother's prayers!" The son went home directly and quietly went in to his mother's shrine where she was praying. The reliquary was open and the silk unfolded. The tooth was shining with brilliant rainbow rays of light.

TIBETAN BUDDHIST ART: AESTHETICS, CHRONOLOGY, AND STYLES

Marylin M. Rhie

Tibetan art is first and foremost Buddhist art. It can best be comprehended and appreciated when both its religious meaning and its high artistic quality are well understood. The religious dimension has been expounded in the preceding essay, "Tibet, Its Buddhism, and Its Art." The artistic aspects will be developed here in terms of the unique aesthetics of Tibetan art and its varied styles throughout its history. These two essays thus will prepare the reader to experience the subtle and complex content of Tibetan art. In fact, these two essays are conceived as a pair of essential pillars standing before the entrance to the mandala of Tibet's sacred art, in which religious and artistic analyses are combined in explication of the masterworks of Tibetan art presented.

The aesthetics of Tibetan Buddhist art is based upon revealing the Buddhist understanding of the way things truly are. Because of this, Tibetan art, expressed primarily in terms of deities and their settings, possesses an intensity, a power, and a reality that appear more penetrating, more beautiful, and greater than ordinary. Deities whose forms have been revealed to those whose minds have a purified, clear vision are portrayed to assist others in attaining this same vision and thereby become acquainted with the possibility of complete enlightenment.

Iconography becomes a critical element in Tibetan art because of the importance of these manifestations in the practice of the Vajrayana Buddhist path. Despite the strange or awesome appearance of many of the deities, all are, without exception, manifestations of that deity's wisdom and compassion, which are the expressions of the enlightened mind for the benefit of all beings. These images are, in most cases, visions of the Beatific Body (Sambhogakaya), the projections of the Buddha's enlightened mind into the more perfected realms and minds of phenomena, like those of the Pure Lands or the accomplished adepts. In the styles of early Tibetan art, the deities are presented with a complete immediacy that impacts the viewer without hindrance; in later Tibetan art, the deity and its world dwell in an idealized harmony that draws us into their realm. In both cases, the reality of the enlightened sphere seems to become one with our plane of ordinary reality.

Utmost care is taken in the precise depiction of these emanations of wisdom and compassion, yet without loss of spontaneity. The art seems to break the "veil of illusion" and offer a complete, instantaneous vision of the radiant beauty and power of pure reality. The way in which this vision is presented naturally varies from artist to artist, from region to region, and from time to time. There is also a complex interweaving of elements from varied sources and traditions within Tibet and from the major cultures surrounding it. The uniquely Tibetan result is an art that shows a genius for clear, pristine vision and that possesses a quality of energy and vitality wedded to gentleness and beauty.

The study of Tibetan art is quite new in the West, and the field awaits extensive study. But the aesthetics, general chronological movements, interesting regional distinctions, and some of the complex sources of styles and motifs are beginning to be understood. The following essay is a brief presentation of some of these topics within a historical, chronological, and regional context. Further study will certainly continue to reveal the true importance of Tibetan art, with its impassioned yet controlled vigor, its astonishingly detailed yet evocative realism, its brilliant gemlike color and skillful linear techniques, and its profoundly positive, religious

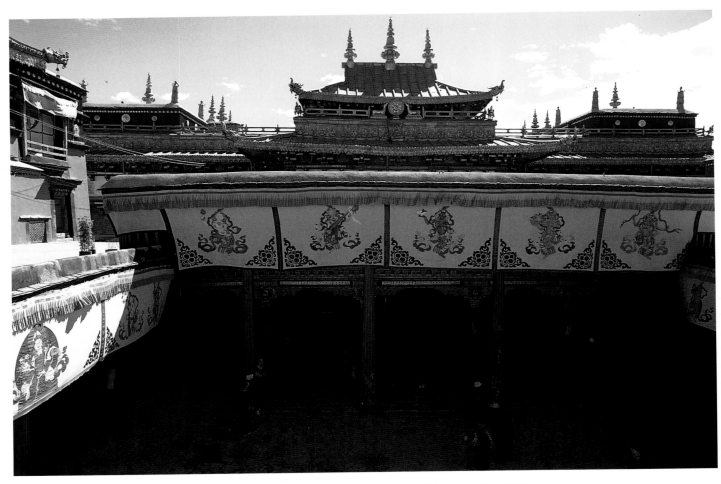

Fig. 1. The Jokhang Temple, Lhasa. Founded ca. 640s by Songtsen Gambo. (photo: John Bigelow Taylor, 1981)

content. This magnificent yet fragile country has created, fostered, and developed within its rare cultural environment an inspiring art that is a sublime and joyous treasure.

THE PERIOD OF THE RELIGIOUS KINGS: 7TH TO 9TH CENTURY

In 627 CE Songtsen Gambo (r. ca. 627–649) became the thirty-third king of the Yarlung dynasty of Tibet, unifying the factious regions into the first Tibetan empire. It is said that the emperor's marriages to both a princess of the Chinese imperial family and one of the Nepalese royal family led to his acceptance of Buddhism, and he became known as the first of the Religious Kings. With these two queens he built two temples in Lhasa in the 640s to house the Buddha statues they brought to Tibet. The Ramoche was built for the Chinese queen's Shakyamuni Buddha statue, called Jowo, and the Jokhang (fig. 1) for the Nepalese queen's Akshobhya Buddha. Later the two images were switched, and the Jokhang became the temple of the Jowo Shakyamuni, honored and worshiped throughout the centuries as the most revered sacred image in Tibet, seen in fig. 2.

The structure of the Jokhang, which became the main national temple in Lhasa, has its roots in Indian Buddhist architecture. Such elements as the entrance through a columned portico into an open courtyard surrounded by columned corridors, and a main hall bordered by many small shrine rooms can still be found in the 5th-century Buddhist cave temples of Ajanta in western India. Even the details of

some of the carved wooden doorways with pillars and vine motifs, and the massive wooden columns with large brackets carved with flying celestials resemble forms known in the Ajanta caves. Remains from the oldest portions of the Jokhang also reveal figured carvings whose style is related to 6th-century Nepalese sculpture. In the late 17th to early 18th century, during the period of the Sixth Dalai Lama, shrine roofs of copper impregnated with gold were added, creating the distinctively impressive, magical sight that this temple inspires to this day (fig. 1).

Although other small Buddhist temples were built by Songtsen Gambo and some of his successors, it is not until the time of the second of the three Religious Kings, Trisong Detsen (r. ca. 755–797), that the first large-scale Buddhist teaching monastery was built. Under the advice of his Indian Buddhist teacher, Shantarakshita, the king invited the renowned Buddhist tantric yogi Padma Sambhava from India in order to help overcome the powerful negative forces opposing the development of Buddhism at that time. Together the three founded the monastery of Samye, built upon a mandala made by Padma Sambhava for his meditation to purify the site. Its circumference walls follow the circular plan of the sacred mandala and its main temple building rises three stories in the center of the compound (see No. 150). The architecture is eclectic, combining styles, it is said, of China, India, and Tibet as well as being modeled on the famous monastery of Odantapuri in northeast India.

Literary records tell of the embellishments of temples with statues and paintings, especially during the reigns of Trisong

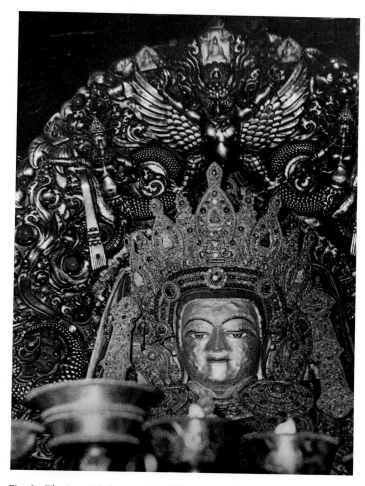

Fig. 2. *The Jowo Shakyamuni Buddha,* main hall of the Jokhang, Lhasa; brought to Tibet by Princess Wencheng ca. 641 and bejeweled by Tsong Khapa in 1409. Photographed by Vladimir Sis and Jan Vanis, 1953–55.

cross-balance of weights that imparts a lifelike naturalism to the statue, his left arm supports his body while his left leg is relaxed; on his right the roles are reversed. With equally masterful artistry the drapery shows the naturalism of varied weights and textures: the fluid form of the light silken scarf that falls from his shoulders over his lap contrasts with the heavy drapery folds on his legs and arms and with the sharply cut, angular creases around his belt. The layers of overlapping garments are clasped at the waist by a special wide belt of square plaques. Interestingly, it is reminiscent of belts seen in statues of Persian kings from the 3rd century CE, and in the famous portrait statues of the Kushans of northern India, particularly that of King Kanishka (1st to 2nd century CE), who, like Songtsen Gambo, was the first great Buddhist king of his people.

An indication of Tibetan painting of this time may be gathered from some remains from the Buddhist cave temple site at Dunhuang on the Central Asian Silk Route in northwest China. This strategic military outpost, flourishing commercial center, and renowned Buddhist sanctuary was controlled by Tibetans from ca. 781 to the mid-9th century. Most of the art at Dunhuang executed during this period is Chinese in style, including a notable wall painting depicting a Tibetan king (cave 159, ca. 820). Other wall paintings reveal an Indo-Nepalese-Tibetan style (caves 161 and 14; Tonkō Bumbutsu Kenkyūjo, 1980–82, IV, figs. 91, 144, 169).

Among the treasures of Dunhuang are paintings on silk and framed in brocade known as banner paintings, vertical paintings that were held up in processions and placed in temple halls. Some of the banner paintings brought early in

Detsen and Tri Relwajen (r. ca. 815–836), the third Religious King, but little has apparently survived. The most impressive and important extant work may well be the group of life-size painted stucco sculptures now preserved in the Potala palace in Lhasa in the room known as Songtsen Gambo's private meditation chamber. Among them is a portrait statue of Songtsen Gambo accompanied by statues of his Nepalese and Chinese queens. Although variously dated by scholars and slightly repaired, these three sculptures appear to be basically genuine and to stylistically relate to the international styles of Asian sculpture of the early 9th century. This triad, which in later centuries was to be repeated many times, survives as a remarkable early example of royal portraiture, rare in all Asian art (Rhie, 1988).

Statues of King Songtsen Gambo are known in literary records to have been made during the period of the Religious Kings. This life-size figure, one of the finest images in Tibetan art, is a masterwork of naturalism and meaningful symbolism (fig. 3). Seated in the graceful, relaxed posture of royal ease, the figure has a sense of articulation and solid mass complemented by complex and elegantly executed drapery configurations. Wearing a turban with the head of Buddha Amitabha on top—probably a later addition but clearly an allusion to his identification with Avalokiteshvara, Bodhisattva of Compassion, who always appears with this Buddha in his crown—he turns slightly to the side, gazing outward with an open, gentle, and friendly expression. In a skillfully realized

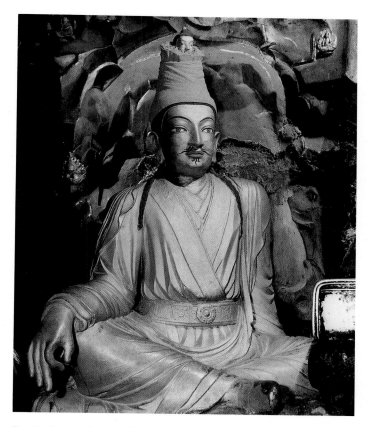

Fig. 3. *Portrait Statue of Songtsen Gambo,* The Potala, Lhasa. Ca. 830s. Stucco (recent repainting). H. 61″ (155 cm). (From Jigmei et al, *Tibet,* New York, McGraw-Hill Book Company, 1981, fig. 10, with permission of McGraw-Hill, Inc.)

this century from Dunhuang to the West—to the Musée Guimet in Paris by Paul Pelliot and to the British Museum in London by Sir Aurel Stein—bear Tibetan inscriptions or are executed in a style that may be Tibetan (Whitfield, 1982, figs. 15–17, 46–47; 1983, figs. 47–49). The Vajrapani in No. 20 is one of the Dunhuang banner paintings in Tibetan style; it also has a Tibetan inscription. The fully revealed and solid, slightly stiff body, the brightly colored striped textile designs, the heavy, even line, and the intense outward gaze of the figure are distinct, probably Tibetan, style characteristics. They are very different from the contemporary Chinese style of well-draped figures executed with fluid line and generally softer coloring.

Tibet entered a period of repression and persecution of Buddhism, marking the decline of the Yarlung dynasty, after the assassination of the devout Religious King Tri Relwajen in 836 by his elder brother Lang Darma. Even though Lang Darma, who usurped the throne, was himself slain by a Buddhist monk in 842, Buddhism was effectively extinguished in the central regions of Tibet for about seventy years. During those dark years, some monks were able to keep the Buddhist teachings and ordinations alive in remote areas of Eastern Tibet, while a branch of the royal Yarlung family fled to the Ngari region of Western Tibet and established the dynasty known as the Guge. The rulers of this dynasty were instrumental in promoting a renewal of Buddhism from the third quarter of the 10th century. This resurgence of Buddhism, which initially took place mainly in Western Tibet but from around the mid-11th century developed in the central regions of Tibet with great impetus, is known as the Second Transmission of Buddhism in Tibet. It inaugurated a period of tremendous expansion of Tibetan Buddhism and its art.

THE PERIOD OF THE SECOND TRANSMISSION

This is undoubtedly one of the most interesting, yet most complex and difficult, periods in Tibetan art. There are few dated works to chart the course of developments, and the multiplicity of diverse traditions are not easy to unravel. Practically nothing is known about the art in Eastern Tibet, but fairly distinct regional differences appear between the art of Western Tibet and that of the central regions of Tibet (Ü and Tsang), both of which are quite prolific. In Western Tibet the artistic traditions of Kashmir are particularly strong, while in the central regions the heritage of the art of the Pala dynasty of India (8th to mid-12th century) and Nepalese art of the Pala lineage provide the primary artistic inspirations. This style is often referred to as Indo-Nepalese. Other sources are apparent as well, such as South India and Central Asia, especially the major Buddhist centers of Khotan and Dunhuang.

Western Tibet: Mid-10th to Early 13th Century

Tsenpo Khore, king of the Guge dynasty in Western Tibet and better known by his Buddhist name, Yeshe Ö, recognizing the dire state of Buddhist studies in Tibet, took two momentous actions. He sent twenty-one young Tibetans to Kashmir to be trained as Buddhist monks, and later he invited the renowned Indian Buddhist scholar and teacher Atisha Dipamkara (982–1054) to come from Vikramashila monastery in central India. Atisha, finally accepting a second invitation, arrived in Western Tibet in 1042, after the death of Yeshe Ö. Of the twenty-one men sent to Kashmir, only two survived the

arduous journeys to return in 978, the date taken as the beginning of the restoration of Buddhism in Tibet. One of them, Rinchen Sangpo (958–1055) is known as the Great Translator and as the founder of some fifteen monasteries in Western Tibet, including Tabo and Tholing, the latter founded together with Yeshe Ö. He made three journeys to India over seventeen years and returned with numerous texts and also with some thirty-two artisans, who were undoubtedly instrumental in the execution of newly founded temples and their art. The Vairochana texts, some of which were translated by Rinchen Sangpo, formed the basis of many of the iconographic themes in the cycles of wall paintings and sculpture adorning the temples related to him.

The art of Kashmir and Himachal Pradesh were the dominant sources for Western Tibetan art through the 11th century, although the roles of Pala art from India and Nepalese art are also apparent. The standing sculpture of Shakyamuni Buddha now in the Cleveland Museum of Art (fig. 4) is an important example of Kashmiri-style imagery (probably made in Kashmir) from the early phase of the revival in Western Tibet. The inscription in Tibetan on its base states it to be the personal image of the monk Nagaraja, probably the second son of Yeshe Ö (H. Karmay, 1975, pp. 29–30), thereby dating this remarkable historical and artistic work to around 1000 CE. In the grace of the free and open posture, the elegance of its proportions with a somewhat small head and long, slender limbs, and in the sensitive muscular

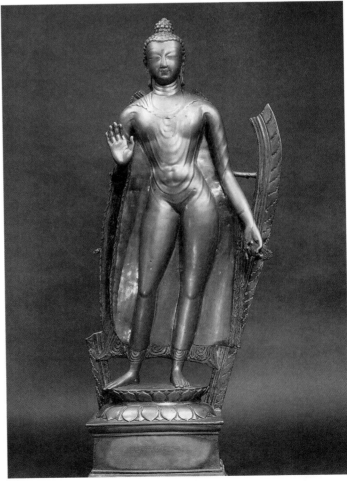

Fig. 4. *Shakyamuni Buddha*. Kashmiri style. Ca. 1000. Brass, H. 38⅝" (98 cm). The Cleveland Museum of Art. John L. Severance Fund (66.30)

modeling of the athletically shaped torso with broad shoulders and slim waist, it perfectly reflects styles associable with the best of the Kashmiri sculptural traditions. The monk's robe fits close to the body and stretches behind the figure, offsetting and revealing the figure's shape. In an interesting variant of older Indian styles, the drapery ripples in softly modulated folds across the torso and upper arms but fits smoothly to the arms and legs. This style combines and transforms the modes of the Indian Mathura and Sarnath sculptural traditions to create a fresh and inspired, if mannered, naturalism.

Similar vitality and an elegant, slightly mannered naturalism appear in the great cycles of wall paintings that fortunately still survive in some temples of Western Tibet, including regions of Spiti and Ladakh, both presently part of India. Works from the temples at Mangnang, Tabo, and Alchi are of such quality and beauty that they clearly represent the 11th-century link in the chain of great Indian and Central Asian Buddhist wall paintings. They were made known by the writings of the pioneer historian and expert of Tibetan Buddhism, art, and culture, Guiseppi Tucci, in the 1930s and 1940s. The paintings at Mangnang are probably among the oldest, from the early part of the 11th century. The figural style is stunningly bold, with strong modeling and thick, even, and powerful line drawing defining full, muscular figures with sweet, round faces (Tucci, 1973, figs. 113–122). The wall paintings of the Dukhang (main hall) of Tabo monastery in Spiti, probably dating a little later in the 11th century, possibly ca. the 1040s,[1] fully exemplify the continuation of this style, observable in the Bodhisattva in fig. 5. The round face with strongly delineated features (a style related to 10th-century wall paintings in Dunhuang), the long, smoothly muscular torso and swelling shoulders, and the rather flat but thickly fashioned arms and legs all create a firm and solid yet flexible figure. It is delicately though richly ornamented with a profusion of intricate jewels. The patterned scarves and textiles are painted with subdued colors and interestingly varied geometric designs. The combination of powerful line and form with delicacy of modeling and ornament elevate these figures to a pinnacle of strong yet subtle naturalism.

Iconographically, the Dukhang at Tabo monastery presents one of the oldest complete cycles of paintings in Tibet. It reveals the systematic planning of the design and the complexity of the interwoven ideas of Buddhism. For example, paintings and sculptures within the rectangular hall illustrate themes from the three major phases of Buddhist teachings, the so-called three turnings of the wheel of Dharma. On the lower registers are scenes depicting the life of the Buddha, which refer to the early phase of Buddhism (the Individual Vehicle tradition), and scenes from the Avatamsaka Sutra showing the fifty-three stages to enlightenment of the pilgrim Sudhana. The latter illustrate the so-called Sutra Tradition of the Universal Vehicle, the second phase of Buddhist teaching. Most prominent of all in the Dukhang, however, are the deities associated with the Vairochana mandala, a part of the Tantric Tradition of the Universal Vehicle—the Apocalyptic Vehicle or Vajrayana, the third phase of Buddhism—which are portrayed on the middle and upper levels. The thirty-two major deities of the mandala appear as stucco high-relief sculpture midway on the walls; around and above them are the painted Buddhas and Bodhisattvas of which fig. 5 is one example.

The iconography of Vairochana and the theme of wisdom and compassion permeate the art in the Dukhang and the

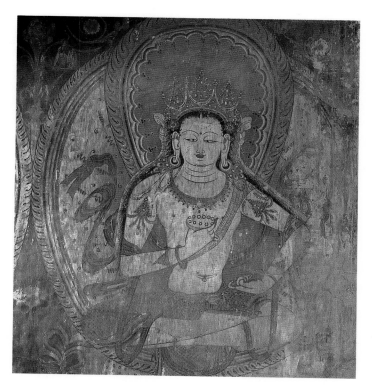

Fig. 5. *Bodhisattva*, wall painting in the Dukhang, Tabo monastery, Spiti (Himachal Pradesh). Ca. 1st half of the 11th century, possibly 1040s. (photo: Thomas J. Pritzker)

Sumtsek, the two major early halls at Alchi monastery in Ladakh, founded ca. mid-11th century.[2] Stylistically, the wall paintings of the Dukhang, the earlier of the two halls, reveal a change from the Tabo figures in showing generally less elongated and more regularly proportioned bodies, simpler ornamentation, and a distinct trend toward playful emphasis on linearity and slightly distorted proportions, such as the small hands and feet and pinched waists of the female figures. The rare contemporary statue of the Eleven-Faced, Six-Armed Avalokiteshvara in No. 127 reveals a similar style in sculpture. Both continue to reflect the Kashmiri stylistic heritage.

The tendency toward imaginative distortion is developed to bold and dazzling heights in the superbly vigorous paintings in the Sumtsek, probably dating to the third quarter of the 11th century. One of the most stunning figures among the prolific array of wall paintings in this three-storied hall is the female goddess of the Perfection of Wisdom sutras, Prajnyaparamita, represented as Green Tara (fig. 6). Interestingly, female deities are greatly emphasized in the painting cycles of these two early halls at Alchi. Here Prajnyaparamita, identified by her six arms, takes an unusual dual form with Green Tara, the green-colored female Bodhisattva of compassionate activity, thus meaningfully fusing wisdom and compassion in one female figure.

This image, like the other paintings of this hall, seems to dance with joyously vivid color and sprightly energized line. The posture is vivacious, and its shape and proportion have the charming distortions typical of this style, notably in the tiny waist and strangely emphasized muscle configurations of the abdomen. Light, deft lines create an animated face with tiny mouth, aquiline nose, and long, projecting eyes. The body is strongly modeled with light and shade, creating the impression of a mystical, unspecified, and glowing internal light. The drapery patterns tend to flatten and dissolve the

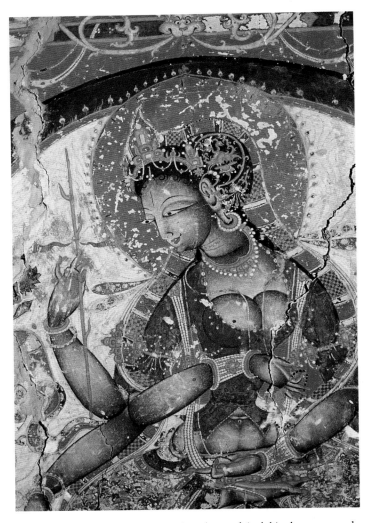

Fig. 6. *Green Tara as Prajnyaparamita,* alcove of Avalokiteshvara, ground floor of the Sumtsek hall at Alchi monastery, Ladakh. Ca. 3rd quarter of the 11th century

figure into particles of color, creating a vibrantly coloristic, abstract effect. This combining of the cubistic abstraction of modeled form, which seems to heighten the three-dimensional aspects of the body, with the intricately colored patterns of textiles, which shatter reality into two-dimensional colored particles, testifies to the supreme skill of the artists of the Sumtsek wall paintings. In a unique way this Prajnyaparamita-Tara painting stunningly expresses the Buddhist aesthetics of Tibetan art: two seemingly opposite states become simultaneously coexistent. Here, the contradictory elements of the two-dimensional and the three-dimensional worlds, and realistic and abstract styles, are visually integrated into one unified, believable whole. Furthermore, the image is executed with such élan that the beholder continually marvels at its near magical beauty, radiance, and life. It is this coexistence of two worlds and the spirit of energized life that infuse the best of Tibetan art.

The incredible array of wall paintings in the Sumtsek expounds a profoundly religious iconographic scheme. It is based on several major themes, such as the expression of the perfection of body, speech, and mind to become those of a Buddha's Emanation Body (Nirmanakaya), the visible form taken to teach in this world; a Buddha's Beatific Body (Sambhogakaya), visible to those of purified vision; and a Buddha's Truth Body (Dharmakaya), synonymous with com-

plete, perfect enlightenment. These are represented respectively by three colossal stucco statues of Manjushri, Avalokiteshvara, and Maitreya Bodhisattvas that reach from the first up into the second floor of the hall. In the alcove of each of the colossal Bodhisattvas and on the walls of the first, second, and third stories are painted appropriate accompanying deities, the thousand Buddhas, mandalas and paradises of the Five Transcendent Buddhas, and many other figures, in an amazingly complex rendering of the interwoven themes of wisdom and compassion. Other temples of Western Tibet at this time, such as Sumda and Mangyu, have beautiful wall paintings as well, but none surpass Alchi for completeness, profundity, and beauty.

There is great diversity apparent among the sculptures of Western Tibet from the latter half of the 11th to the 12th century. Some fully exemplify the marvelous Sumtsek style, like the Cleveland Museum's rare wooden seated Buddha in No. 136, dating about the same time as the Sumtsek and possibly from the Ladakh region. The statue of Shakyamuni in the Zimmerman collection (No. 2) and the standing Avalokiteshvara in the Ellsworth collection (No. 28) also relate to the Sumtsek statues and paintings, but probably date slightly later. The Avalokiteshvara sculpture displays a shape, stance, and wiry linear style that is apparent in some Sumtsek paintings (second floor, back right wall; Pal, 1982, S 66–68). In addition, however, the torso and facial style relate to figures in the Manjushri Lhakhang hall at Alchi, probably dating some years later than the Sumtsek (*ibid.,* ML 1–4). While the Buddha in No. 2 represents both the sophisticated Pala Indian and the Kashmiri stylistic traditions of Western Tibet, the Avalokiteshvara may be a work related to the Himachal Pradesh stylistic tradition.

The difficulties of understanding the complex strands of Western Tibetan styles and chronology of the 12th century is compounded by a severe lack of securely datable works. It would appear that images in the Kashmiri stylistic lineage continue, but at the same time styles characteristic of art in the central regions of Tibet are being assimilated. An example of the Kashmiri-related style is the Newark Museum's Vajrakumara (No. 53).

The other trend, the intermixing of styles from the central regions, is aptly illustrated by the seated Buddha, probably of the early 12th century, in the Ellsworth collection (No. 137). It possesses the naïve qualities of proportion and alert posture typical of the indigenous Western Tibetan styles, mingled with a sophisticated poise, smooth planes, and pedestal design more typical of contemporaneous sculpture from the central regions (fig. 7). Similar combinations appear in the wall paintings of two halls at Alchi monastery, the Lotsawa Lhakhang and the Lhakhang-soma (Pal, 1982, LL 1–6, LS 1–37), both possibly dating from the second half of the 12th to the 13th century (with the entrance-wall paintings of the Lhakhang-soma probably executed in the 14th century). Two superb, rare early archetype deity (T. *yi dam*) sculptures in the Zimmerman collection, one of the two-armed Shamvara with Vajravarahi (No. 68) and the other a Hayagriva (No. 54) relate stylistically to the wall paintings of the Lhakhang-soma. Their naïve charm and stocky bulk may suggest a Western Tibetan provenance; however, in certain elements they both also relate to 12th-century works from the central regions (fig. 11).

The art of Western Tibet played a major role in this early period of the Second Transmission of Buddhism in Tibet,

with respect to both its unsurpassed wall paintings and its stylistically diverse and spirited sculptures. Although there appears to be a more or less steady production of sculpture and some paintings during the 13th and 14th centuries in Western Tibet, it is not until the second half of the 15th century, during the Guge revival, that Western Tibet experiences again a magnificent flowering of its art on a scale comparable to that of the 11th century.

The Central Regions of Tibet: 11th to 13th Century

In 1045, after spending three years in Western Tibet, Atisha came to the central regions of Tibet, where he became the spiritual founder of the Kadam Order and the major impetus in the rejuvenation of Buddhism in the provinces of Ü and Tsang. His main disciple, Drom Tonpa (d. 1064), established the first Kadampa monasteries after Atisha's death in 1054. In the latter half of the 11th and into the 12th century, various other orders and their monasteries were established throughout the central regions. From Milarepa (1040–1123) and his teacher Marpa (1012–1095) grew the branches of the Kagyupa; from Drokmi (992–1072) and the Khon family the Sakyapa developed, with their main monasteries in Tsang. These orders, along with the Nyingma Order, whose roots stem from the period of the Religious Kings, established a firm Buddhist monastic foundation in Tibet, translated sacred texts, and assimilated the practices and art of the major Indian and Nepalese Buddhist sources.

Many of the venerated sites of Buddhism as well as the great Buddhist monastic universities were in the central and eastern regions of India, particularly the region under the rule of the Palas. These areas of India were linked to the central regions of Tibet by the main trade routes passing through Nepal. The primary inspirational sources of the Buddhist art for these central regions of Tibet thus became the central and northeastern areas of India, and Nepal. However, there are other sources as well, which complicate the situation, so usually they must be ascertained on an individual basis for nearly every work. Because of such diversity, it is difficult to define the art of this period in one all-inclusive way. Although further studies are needed to clarify this complex period, a few important works can provide some indication of the different styles among the sculpture and painting of the central regions, which are in many ways quite distinct from those of Western Tibet.[3]

In the sculpture of the 11th to 13th century in the central regions, there are a number of different stylistic groups, of which four will be discussed here in chronological sequence. In most cases the styles relate to sources from the art of the Pala dynasty (ca. 750–1155) in northeastern India, and their successors, the Senas (mid-12th to mid-13th century), but one major group shows apparent links to the art of Khotan, on the southern Silk Route in Central Asia.

The standing Maitreya Bodhisattva (fig. 7) photographed at Narthang monastery in Tsang in the 1950s and said to be dated 1093 (Liu, 1957, fig. 65) is a prime early sculpture of the central regions. The smooth, well-unified body in its gentle, composed stance contrasts with the wiry and alert characteristics of most Western Tibetan sculptures, as seen for instance in No. 28; it contrasts also with the slightly elongated figures with naturalistic muscular definition of the Western Tibetan Alchi style as seen in the Cleveland

Museum's Avalokiteshvara (No. 127) and seated Buddha (No. 136). Ornamentation is elaborate but refined, and the face is sculpted with a sharpness and perfection unlike either the usually softer Kashmiri style or the somewhat mystical strangeness of the Himachal Pradesh-type Western Tibetan style of No. 28. Stylistically, this Maitreya statue derives from the 5th-century Sarnath sculpture of the Gupta period in central India, but is also related to such Pala styles as that of the 9th-century Sylhet Bodhisattva (Asher, 1980, p. 253) and Nepalese sculpture of the 10th to 11th century. In its plain simplicity it is also strikingly similar to figures in early Tibetan tangkas of the central regions (fig. 11).

A few extraordinary sculptures carved in a fine black or yellow sedimentary stone, usually marked with Tibetan inscriptions, have appeared in recent years. Some are closely related to Pala sculpture of the 11th to 12th century, though there is no certainty as to the carver or place of origin.[4] The Tara stele and the Mahakala in the Ellsworth collection (Nos. 22, 52) are superlative examples of these. The exceptional and unique Tara stele is a particularly interesting representation of religious practice embodied in art: There is one Tara for each of the twenty-one verses in praise of Tara from the popular *Tara Tantra* text. What may be one of the oldest sculptural

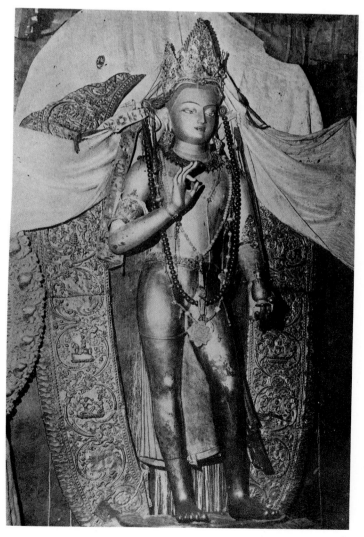

Fig. 7. *Maitreya Bodhisattva*, Narthang monastery, Tsang, in the central regions of Tibet. Ca. 1093. (photo: Liu I-se, ed., *Xizang fojiaoishu*, Beijing, Wenwu chubansha, 1957, fig. 65)

representations of a Tibetan lama yet known also appears in this stele. The complementary harmony between the prominent, smooth volumes of the form and the intricately but richly fashioned details of the ornamentation in both of these stone sculptures is characteristic of the naturalism based on Pala styles of this time.

The remarkably rendered yogi statue in fig. 8, probably dating in the 12th century, has some stylistic similarities to the two stone images, but has a slightly more abstract quality. It is possibly the depiction of a Great Adept (Mahasiddha), perhaps Padampa Sangyey, taken by Tibetans as one of the Great Adepts (see No. 38). The impression of controlled and concentrated inner energy makes this work particularly expressive of the Tibetan genius for articulating the powers of the yogi. So effectively captured in many later examples throughout Tibetan art, the powerful concentration of the yogi is here dramatically rendered in the smooth swelling volumes and intense facial expression of this distinctive early example, perhaps the oldest yet known in Tibetan sculpture. Along with the emphasis on the figure's internal concentration, there is an equal stress on the external. His wide-open eyes and spiky locks of hair seem to radiate energy from within. This statue is a superlative example of the intense yet composed quality that characterizes Tibetan art.

A number of metal sculptures, mostly small and mostly of Bodhisattvas, form another important group in this period. They are generally closely related to the Pala-Sena Indian images, especially those from Bengal.[5] One example, the Avalokiteshvara in No. 29, shows characteristics pertaining to sculptures from both the central regions and Western Tibet.

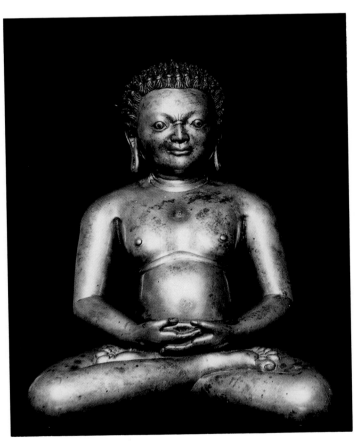

Fig. 8. *Yogi* (Padampa Sangyey?). Central regions of Tibet. 12th century. Brass, H. 12½″ (31.8 cm). Robert Hatfield Ellsworth Private Collection. (photo: Young H. Rhie)

Its dominant relation with the Pala-Sena styles, probably of the 12th century, indicate that the image is most likely a work from the central regions. It is also similar to a bronze sculpture photographed by Tucci in Zinchi monastery in Ü (Tucci, 1973, fig. 161). The figure's grace in posture and proportion and the heavy ornamentation are typical of the Pala lineage, but certain elements are also related to Western Tibetan forms, such as the asymmetrical positioning of the lower garment with its central hems pulled to one side, and the sheets of long, curled hair, similar to the Manjushri Lhakhang images at Alchi. Such complexity is endemic to the study of Tibetan art, especially in these early periods.

Among the most intriguing and magnificent works of this time are the monumental sculptures at Iwang and Nesar monasteries in Tsang (fig. 9). They appear to be rare remains reflecting an influential artistic relationship with the art of Khotan in Central Asia. Inscriptions at Iwang state the presence of "Indian and Khotanese" styles. Tucci, who first photographed and studied these images, surmised that the unusual style of the drapery of the Buddha and Bodhisattva statues probably represented a Khotanese style.[6] This is most likely the case, although the evidence is scant and little is known about Khotanese art.

Khotan was a flourishing oasis city along the southern Silk Route through Central Asia. It was noted for its large Mahayana Buddhist centers from early times and was especially prosperous during the Tang period (618–906). As known from literary records, Tibet had a special relation with Khotan from the period of the Religious Kings. Artists are said to have come to Tibet from Khotan to help build the Buddhist monasteries and make the Buddhist images. Most of the ancient art of Khotan no longer survives and we are left mainly with Chinese writings that speak of the marvelous qualities of its art. The Khotanese style is especially noted for its figural representations showing masses of light drapery distinguished by closely parallel soft pleats. The Khotanese style had considerable influence on Chinese Buddhist art from as early as the 7th century, but from around the late 12th through the 14th century it became a major style in Chinese Buddhist art.[7]

Several elements of the Iwang and Nesar sculptural style seem to support a Khotanese stylistic source and a late 12th- to 13th-century dating for these special sculptures. The narrow parallel clusters of limpid drapery folds seen in the magnificent Buddha in fig. 9 suggest the descriptions of the special Khotanese drapery style and relate to a certain extent to images in Chinese art also associated with the Khotanese style, except the Chinese variants usually show more movement. Furthermore, some elements relate to Kashmiri-style sculptures from the 11th to 12th century. For example, the medallion designs in raised stucco on the garments of some of the Iwang and Nesar figures (Tucci, 1973, figs. 159, 162–163; L. G. Govinda, 1979, I, pp. 45–46) suggest parallels with the silver and copper inlay designs known in Kashmiri-style metal sculptures from the 9th to 12th century, though most prominently in the 11th- and 12th-century examples probably associable with Western Tibet. Also, the types of crowns with large U-shaped supports are related to those appearing in Kashmiri-style sculpture, particularly of the 11th to 12th century.[8] While these elements help to suggest a possible late-12th-century dating for the Iwang and Nesar images, they also indirectly indicate a possible source for these

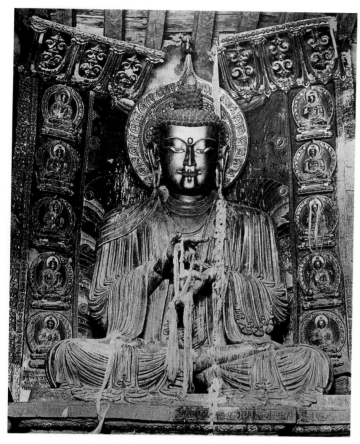

Fig. 9. *Buddha,* main image of the central chapel, Iwang monastery, Tsang, in the central regions of Tibet. Ca. late 12th to early 13th century. Stucco. Photographed by Li Gotami Govinda in 1947. (photo: Lama and Li Gotami Foundation, Munich, Germany)

motifs in Khotanese art. Both Tibet and Kashmir, being in close contact with Khotan, could have received similar influences from Khotan.

Although there does not seem to have been a continuation of this special style in Tibet, elements of the style, such as the raised medallion designs, appear in other sculptures like those at Kyangphu monastery of the 13th century (L. G. Govinda, 1979, I, pp. 41–43; Tucci, 1989a, III, figs. 25, 26, 29, 30, 31). However, this unusual and splendid group of stucco images from Iwang and Nesar forms an important, distinctively different ingredient among the other sculptural styles predominantly related to Indian and Nepalese art during this early period of the Second Transmission in the central regions.

Paintings from the central regions of Tibet of this period are some of the finest masterworks of Tibetan art. Though most survive as tangkas, a few wall paintings are known. Some tangkas just recently coming to light may date from the late 11th century, and in the Jokhang temple in Lhasa there are a few exceedingly rare wall paintings that may be among the earliest remains of wall paintings in the central regions, possibly dating in the late 11th or early 12th century (fig. 10). The remains are scant and the evidences for dating few and far between. However, a group of Tibetan style paintings from the Central Asian site of Khara Khoto now in the collection of the Hermitage in Leningrad provide invaluable materials for this period, especially in relation to the painting of the central regions of Tibet.

The early Jokhang wall paintings provide important remains for distinguishing and defining the painting styles of the central regions. They demonstrate not only a general stylistic compatibility with Western Tibetan painting of the time but also clearly reveal the special character of the central regional style. Although distinctly different from Western Tibetan paintings, the style of these central Tibetan Jokhang paintings generally relates to the graceful, slow curves apparent in the linear style of the Tabo wall paintings of ca. the 1040s, but without the heavy line of the Tabo style (fig. 5). Similarly, certain elements relate to the paintings in the Sumtsek at Alchi, but with far less interest in the minute details of textiles and jewelry (Pal, 1982, S66). The Jokhang paintings also have some similarities to motifs in Chinese Buddhist art. The style of the background flowers, for example, relates to the flower designs painted on the ceiling of the Lower Huayansi (Hua-yen ssu) in Datong, northern Shansi, near the Chinese border with Mongolia, dated 1038 (Sekino and Takeshima, 1934–1944, I, fig. 47). A distinctive style of the central regions emerges in these early Jokhang paintings. The unified, elegant simplicity of the full and regularly proportioned bodies complemented by the restrained curves of the relatively plain ornaments especially characterizes this style, which clearly represents the major elements of the distinctively sophisticated styles of painting in the central regions as they develop in the 12th century.

Closely related to the style of the Jokhang wall paintings, but with more refinement and increased elaboration, which suggests a slightly more developed style, are the Green Tara in No. 24 and the lama portrait in No. 95, both in the collection of Mr. and Mrs. John Gilmore Ford, as well as the Vairochana tangka recently acquired by the Cleveland Museum (fig. 11). They all probably date from the 12th century. The style of the

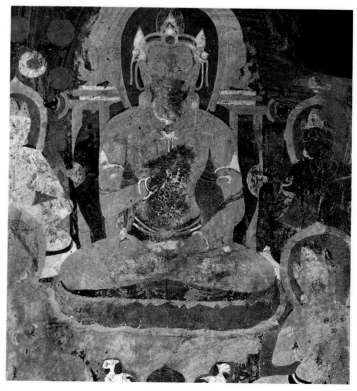

Fig. 10. *Bodhisattva,* wall painting, Jokhang, Lhasa. Ca. late 11th to early 12th century. (photo: Xizang gongye qianchu kanze shejuyuan, *Dazhaosi,* Beijing, 1985, fig. on p. 77)

Green Tara, with its delicate, thin planes of color, and long lotus stalk base with softly delineated leaves and petals, relates to examples in Pala period sculpture, especially from the Eastern Bengal region (Asher, 1980, pls. 131, 248, 250), suggesting one possible stylistic source in the art of that region for this tangka. The strong probability that Atisha and Drom Tonpa are represented in this Green Tara painting (just above Tara) suggests an association with the Kadam Order. A Shamvara and Vajravarahi painting that has a style similar to the Ford Green Tara may also be linked to the Kadampa (Pal, 1984a, pl. 12). However, this style may not have been limited to this order. Judging from the Los Angeles County Museum's famous huge Amitayus, which is probably part of a set,[9] possibly datable to the late 12th century (Pal, 1983, p. 134), more freedom is exercised in the interpretive shaping of the body when compared with the earlier paintings.

Understanding the developments in paintings from the central regions requires careful analysis of details in each tangka with regard to degrees of subtle modeling, types of jewels, arrangements and sizes of figures, and so on. As such detailed analysis is not feasible here, only an outline of the typical components of these tangkas will be noted. Tangka paintings of this period generally follow a formal compositional style probably derived from Indo-Nepalese sources that

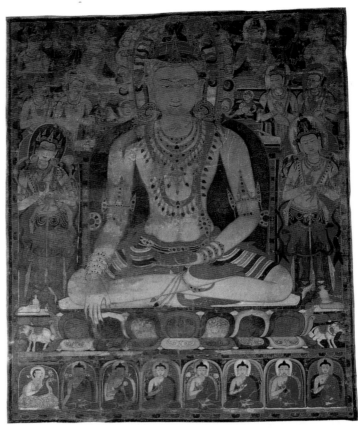

Fig. 12. *Akshobhya Buddha and Bodhisattvas*. Central regions of Tibet. Late 12th to early 13th century. Tangka; gouache on cotton. Private collection. (photo: Young H. Rhie)

emphasizes the central deity, who appears as a large, monumental figure symmetrically flanked by smaller attendants, with rows, above and below, and sometimes to both sides, of other smaller figures—Bodhisattvas, lamas, Great Adepts, archetype deities, and protectors (figs. 11, 12). Each surrounding figure is given a discrete, usually equal, space primarily defined by the halo and pedestal. The main image, however, is by far the largest, and is the dominant focus of the paintings. The image is presented frontally and the face is usually broad and rectangular or ovoid. The eyes possess the distinctive central Indian (Pala) style of curved upper lid (fig. 11), the nose is long, and the thin mouth has red coloring, generally only on the lower lip. Red usually stains the palms and soles of the feet as a mark of beauty. The backgrounds tend to be solid dark blue sprinkled with flowers, imparting a clearly two-dimensional setting for the deities.

Thrones are depicted in the Indian style: They have cushions, often decorated with a scroll pattern, and also a structural backing, sometimes partly covered with a cloth, creating a triangular shape behind the image. Also, this back may have a decorative animal figure, usually a goose (*hamsa*) or the fantastic composite fish-crocodile-elephant (*makara*), perched at the ends of the top crossbar. The head halos are elongated and often encompassed by a lotus petal, tree, or foliated scroll-like design descended from styles known in Pala and Nepalese art. The individual petals of the main image's lotus seat are generally large, subtly modeled and portrayed in several alternating colors. Frequently, the lotus seats are placed on a structural pedestal or part of the throne that may have border patterns of large jewels, also in alternating colors.

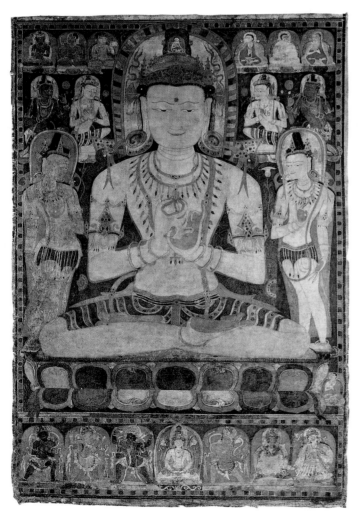

Fig. 11. *Vairochana(?) and Bodhisattvas*. Central regions of Tibet. 2nd half of the 12th century. Tangka; gouache on cotton, 43¾ × 28¾" (111 × 73 cm). The Cleveland Museum of Art. Mr. and Mrs. William H. Marlatt Fund (89.104)

Sometimes they are the same as the jewel patterns framing the whole painting (figs. 11, 12).

The main attendant Bodhisattvas are particularly interesting in these early paintings. Several distinct stylistic types are apparent and are even utilized concurrently within a single set of tangkas. One type, which appears strongly Indian (fig. 11), typically portrays the Bodhisattvas with willowy posture, curvaceous contours, unusually large feet and hands, squarish faces shown in three-quarter view, and a tall crown of hair (*jatamukuta*) rising from the back of the head. They wear diaphanous garments that disclose the shapes of their legs as clearly as though they were uncovered, a style known in sculpture from the Bengal regions of the 9th-century Pala period and in the paintings of the Dunhuang caves of the 9th century as well (Tonkō Bumbutsu Kenkyūjo, 1980–82, IV, fig. 169). The somewhat strangely mannered, languorous posture, not typical of Pala art, is related to figures of ca. 1000 in central India, such as the sculptures at Khajuraho. Another type of attendant appears garbed in twisting scarves and heavier, long, pleated skirts that obscure the shape of the legs (fig. 12). This style may draw its inspiration from Central Asian art; it is very similar to some paintings in the caves at Dunhuang from the mid-10th century, such as the Bodhisattvas in cave 220 (*ibid.*, V, fig. 20).

The exceptionally beautiful, rare tangkas in figs. 11 and 12 were probably originally parts of sets of the Five Transcendent Buddhas, which was a popular theme during this period in the central regions of Tibet (see XI. Cosmic Buddhas). The Akshobhya in fig. 12 is part of a set from which another tangka survives (see Pal, 1984a, pl. 9), probably dating in the late 12th to early 13th century; it is a little later than the Cleveland tangka in fig. 11, probably of Vairochana, judging from the image's teaching gesture, which is typical for Vairochana. The depiction of a tiny vajra held by the tips of Vairochana's right fingers is an unusual feature, but not unknown in paintings of this period (see No. 135, where a vajra appears in front of the Buddha). Another unusual feature is the presence of a small lama figure above the head of the main image. The presence in the top row at the left of small figures of (from left to right) Vajradhara and the Great Adepts Tilopa and Naropa could indicate that this work is Kagyupa. It may be that the lamas on the upper right are, from left to right, Marpa, Milarepa (in a white robe), and Gampopa.

In some wall paintings, tangkas, and tapestries of this period a special kind of stylized, tall, and narrow rocky mountain appears. These spiky forms are depicted in various alternating colors and are stacked side by side to form a row that is used to divide areas of the composition. Examples occur in the Mangnang monastery wall paintings (Tucci, 1973, fig. 113), in the Ford Green Tara (No. 24), in some *kesi* silk tapestries of the late 12th century (Xizang Tangjia, 1985, pls. 62, 102), and in some of the paintings and the *kesi* tapestry (No. 23) from Khara Khoto now in the Hermitage collection. It is an imaginative design for mountains, known in Indian sculpture since the second century CE and later in Indian and Nepalese manuscripts (Pal, 1984a, pl. 5). An interesting example also appears in several early 7th-century Korean tiles (fig. 13), indicating that such forms may have been part of an international landscape style by that time. This motif reaches its full development in Tibetan painting by the 13th to 14th century, and soon thereafter loses popularity, being detectable only sporadically as a much reduced and

Fig. 13. Ceramic tile with design of mountain landscape, from Puyo, Paekche kingdom, southwest Korea. 1st half of the 7th century. 11⅝ × 11¾″ (29.7 × 29.8 cm). National Museum of Korea, Seoul.

slightly more naturalistic motif by the middle to second half of the 15th century, as seen in Nos. 3 and 48.

Paintings from the site of Khara Khoto in Central Asia form a significant group especially related to Tibetan paintings of the central regions of this period. In Inner Mongolia in northwestern China, Khara Khoto (Ch. Heishuicheng) was controlled by the Uighurs until it was captured by the Tanguts around the mid-11th century and became a garrisoned city of the Tangut Xi Xia dynasty (ca. 990–1227). The Xi Xia rulers supported Buddhism and are known to have sponsored many Buddhist works, including numerous paintings and sculptures at the cave temples of Dunhuang. It is also known from literary sources that Tibetan lamas were present at the court of the Xi Xia. One reference records that in 1159 Tsang Sopa (gTsang soba), a disciple of Dusum Kyenpa (1110–1193), the first Black Hat Karmapa, was invited by the Xi Xia king Renzong Lirenxiao and received from him the honorific title of Shangshi, Supreme Teacher (Tonkō Bumbutsu Kenkyūjo, 1980–82, V, p. 157; Roerich, 1988, p. 517). In 1227 the forces of Genghis Khan destroyed Khara Khoto and the Xi Xia kingdom. The royal family fled to the northern part of the Tsang region in Tibet, where they established the Jang (T. Byang) family (H. Karmay, 1975, pp. 20, 35). These and other references indicate a close connection between Tibet and the Xi Xia (also see excerpts by K. Samosyuk in the introductions to II. Bodhisattvas and XI. Cosmic Buddhas).

Major discoveries were made early in this century by the Russian explorer P. K. Kozlov at the famous *suburgan* (Mongolian name for stupa) southeast of the ruined city of Khara Khoto. It is generally believed that the materials discovered there, including many paintings, predate the devastating invasion of 1227. These paintings comprise works of various styles, many from the Chinese and Tibetan stylistic and iconographic traditions. Most of the paintings executed in Tibetan styles relate to the early paintings of the central

regions of Tibet. However, in the Khara Khoto paintings the colors tend to be sharper and the drawing is less refined in some cases. Eight of these rare works of Tibetan style from the Hermitage collection of Khara Khoto materials are presented in this book: Nos. 21, 91, 92, 93, 128, 133, and 135, which are paintings, and No. 23, a tapestry of Green Tara in the *kesi* technique.

There is considerable stylistic variation among the Tibetan group of Khara Khoto paintings. This probably indicates that there were many different hands working over several generations as well as diverse stylistic sources for the art. One of the most powerful and important examples is the female Buddha deity Vajravarahi in No. 93, possibly the most amazing representation of this deity yet known. The big-bodied red image, garbed only in bone jewels, dances before a flickering red halo of flames, brandishing the skull bowl and the vajra chopper. The style of her massive body, as well as the profuse and refined ornamentation, depicted with gossamer white lines, clearly relates to styles seen in the 12th- to mid-13th-century sculpture of Orissa, in Eastern India, and in the temple sculptures of the same period made under the Hoysala dynasty at Belur and Halebid, in Karnataka, South India. Since most of the Khara Khoto Tibetan-style paintings seem to relate to the painting styles from the central regions of Tibet, this may indicate the presence of Orissan and Hoysalan styles in the art of the central regions as well. However, with regard to the Khara Khoto paintings, sources other than the central regions of Tibet cannot be ruled out: for example, Nepal or possibly Eastern Tibet, about which as yet we have little knowledge. It is also interesting to note that the particular Orissan and Hoysalan style mentioned in reference to the Vajravarahi in No. 93 seems to be continued in later works, such as some of the Yongle period (1403–1425) sculptures made in China in the early 15th century (No. 76) and in many spectacular paintings of the mid-15th century from the central regions of Tibet, such as No. 104. In these cases we see the art from Orissa and South India, rather than from the Pala dynasty in northeastern India, apparently being an influential part in some Tibetan-style art.

The Bodhisattva attendant in No. 21 of the Khara Khoto group, a repaired fragment from a once-larger painting, exhibits the willowy, curved body and charming simplicity typical of many of the attendant figures in 12th-century tangkas from the central regions of Tibet (fig. 11). The expression of the face, with its broad and slightly angular mouth, is a type common to the Pala images of ca. the 11th to 12th century, especially of the Bengal region. This figure also closely matches figures in the wall paintings at Iwang, in the hall with the large stucco images (Tucci, 1973, fig. 124), thus lending further credence to a probable late 12th-century dating for that important temple hall and its images.

Finally, the Khara Khoto Medicine Buddha tangka (No. 133) has an interesting representation of the Black Hat Karmapa in the lower left corner. Since the first Black Hat Karmapa is said to have received the special black hat worn only by him from the Dakinis (Skywalkers) at the time of his enlightenment (ca. 1160), it would indicate a dating for this painting after that time and make this work particularly important for chronological data. Not only is the Khara Khoto group of Tibetan-style paintings a treasure from a Central Asian kingdom that had a relation with Tibetan Buddhism at this time, it is also a rich resource for helping to establish the stylistic dating and iconographic types of Tibetan art during this difficult but consequential early period.

THE 13TH TO 14TH CENTURY IN THE CENTRAL AND WESTERN REGIONS OF TIBET

This period is an active one, internally and externally, for Tibet and for Tibetan art. The Buddhist monastic institutions established during the previous two centuries were flourishing and most of the sacred writings had been translated. Internationally, the rise of the Mongols, which transformed Asia in the 13th century, also involved Tibet, though not as disastrously as other regions of Asia. During the 13th century Tibet had increased relations and communications with China, especially through the Mongols and with the Mongol Yuan dynasty (1279–1368). Several noted Tibetan lamas became personal preceptors to the Mongol leaders, such as Sakya Pandita (1182–1251), Tibet's great Sakyapa scholar (see No. 66), to Godan Khan, and Pakpa, Sakya Pandita's nephew, to Khubilai Khan. Though relations between Tibet and China declined after the early 14th century, the contacts with China had a decided, if as yet limited, impact on Tibetan Buddhist art.

A number of remaining monuments, paintings, and sculptures that are of Tibetan style from the 13th to the 14th century in China testify to the influence Tibetan Buddhism and its arts had on the culture of the Yuan dynasty in China. To cite one example, in Hangzhou, in southern China, numerous Tibetan-style images were carved in the cliffs and grottoes of the Feilaifeng mountain in the late 13th century and a great wood-block edition of the Tripitaka (the Buddhist canon) in Tibetan style was made there in ca. the early 14th century. The famous Juyong Guan gate dated 1345, in the mountains north of Beijing, capital of the Yuan, is decorated with monumental relief sculptures in Tibetan style of the mandalas of the Five Transcendent Buddhas. In the city of Beijing the well-known landmark of the Beita pagoda was built by the famous Nepalese artist Aniko (1245–1306), who had been personally recommended by Pakpa and had established a flourishing workshop in Beijing that also produced sculptures. In China's northwest, some of the last major caves executed at Dunhuang (caves 465 and 113) and some wall paintings in other caves in the Gansu province area further attest to the considerable impact of Tibetan Buddhist art in China during this time.

Tibet in the second half of the 14th century was ruled by thirteen myriachies (small, basically autonomous, kingdoms), with the principal ones in the hands of the Pakmodrupa, a subsect of the Kagyupa. In Western Tibet the Nepalese Kasiya-Malla, who had exerted control over much of the region since the 12th century, were collapsing by the late 14th century as some regions of Western Tibet were becoming autonomous kingdoms. In Tibetan art the dominant styles continued to be related to the Indo-Nepalese traditions, but the infusion of Chinese artistic elements begins to appear from the mid-14th century with some regularity and importance, mostly in the central regions. This is especially noticeable with respect to the theme and style of the Arhats, enlightened Buddhist monks who remain in this world to maintain the Buddhist teachings until the time of the next Buddha. Chinese elements also appear in landscape depiction and in figure styles utilizing loosely draped garments unlike the tightly fitted or simply draped ones of the Indo-Nepalese styles.

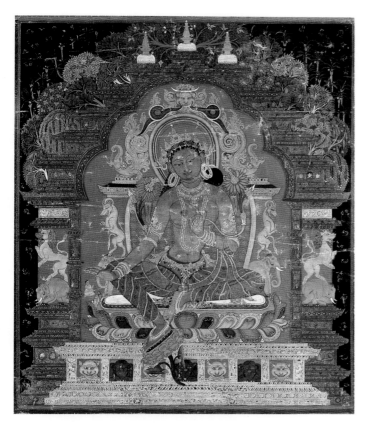

Fig. 14. *Green Tara*. Central regions of Tibet. Late 12th to 1st half of the 13th century. Tangka; gouache on cotton. 20⅛ × 16⅞" (51.1 × 43 cm). The Cleveland Museum of Art. Purchase from the J. H. Wade fund by exchange (70.156)

Paintings with Indo-Nepalese Stylistic Elements

Painting related to the Indo-Nepalese stylistic tradition, the predominant source for the earlier painting in the central regions, continues in full flower during this period. There are evidences of superb wall paintings in such monasteries as Narthang, Shalu, and Jonang in the Tsang region (Liu, 1957, figs. 32, 27), but these still await more complete documentation and study. They appear to relate primarily to the Indo-Nepalese styles and probably date from the 13th and 14th centuries. The style of painting on the British Museum manuscript cover (No. 122), probably from a Sakyapa monastery, seems to relate to the style of some of the wall paintings. The line is smooth and even; the patterning of the textiles is rich and refined; the color is astonishingly vivid. The proportions of the figures are elegant, with occasional use of prominent modeling. This style is close to some Nepalese painted manuscripts of the late 12th to early 13th century and probably represents one major trend in Tibetan painting of the 13th century.

Two masterworks of the Indo-Nepalese stylistic tradition typical of this period are the Cleveland Museum's famous Green Tara (fig. 14), probably dating around the first half of the 13th century, and the Shamvara and Vajravarahi in No. 69, from the late 14th century. Both utilize the large central figure format and an essentially two-dimensional spatial plane stressing beautiful pattern and vivid, brilliant coloration.

The iconic beauty of this style is nowhere more masterfully portrayed than in the Cleveland Green Tara. She sits within a templelike jeweled shrine reminiscent of Indian architectural modes with finely detailed decor as seen in 12th- to mid-13th-century Orissan and Hoysalan temples. The interior glows a brilliant crimson red, startlingly offsetting the olive green coloring of her firm, graciously bending body. Green Tara, the compassionate female Bodhisattva, is a little mysterious, which is implied here by the forest setting and nighttime sky, charmingly sprinkled with flowers. The style has gemlike color, precise and even line, and fascinating detail. The jewels and textiles have a precision and clarity that make the image seem real.

Despite the strongly two-dimensional aspect of the painting, it appears utterly realistic and immediately apprehendable, approachable, and present. It seems as though we could touch the image with no barrier between us, even as we realize her iconic, perfect nature. She is seemingly from another world yet she is totally in ours, representing the amazing simultanity of the mundane reality of our world with that of the Beatific Body (Sambhogakaya) of the transcendent or Pure Land realms. Once again, the masterful success of Tibetan Buddhist painting is this ability to function completely and believably as both transcendent and real at the same time, expressing the reality of the Buddhist view—the nondualistic simultaneous interpenetration of all realms.

Image after image achieves this same impact, perhaps none more dramatically and meaningfully than the male-female deities in father-mother (*yab-yum*) union, supremely represented by the large, late 14th-century tangka in No. 69. The big, powerful forms exude an energy of primordial essence and become more than mere religious icons—they seem to live and act infused with a superhuman drama and spirit. All this is translated to us through the power of Tibetan belief, which becomes the basis of the compelling magnetism of Tibetan aesthetics.

The characteristic leaflike, flame-edged halo of the main deities and the use of precise rows of figures along the borders are typical of the clear compositional structure of this major style. Although persisting for at least another three hundred years as a kind of "classic" type of composition, this style emerges in its most monumental grandeur during the 14th and 15th centuries. Some renderings around 1400 and the first half of the 15th century also incorporate a fantastic stylization, like the magnificent Mahakala (Pal, 1984a, pl. 24), and the Vaishravana and Raktayamari in Nos. 44 and 77.

An important stylistic group, possibly related to a particular Sakyapa monastery, can be formed around the Zimmerman collection Raktayamari mandala (No. 75), which is datable to the late 14th century. The precision and vitality of the scroll-like filling designs, the thick, olive green leafy vine *rinceau* with circular vignettes and the almost penlike sharpness and selectivity of the line, along with the strong modeling on some figures and the deep tonality, density, and smooth texture of the colors, typify this style. Others of this group include a Guhyasamaja mandala in the Zimmerman collection, and the Vairochana (Acc. No. 67.861) and pair of Sakya lamas in the Museum of Fine Arts, Boston (Pal and Tseng, 1969, no. 27). The monumental tangka of Shamvara and Vajravarahi in No. 69 can also be associated with this group.

Another distinctive style related to the Sakyapa, and to Nepalese sources in particular, occurs in the splendid series of paintings represented by the Zimmerman collection mandalas in the Vajravali series (No. 73), datable by inscription to ca. 1400. Colors with a brilliance like gems, a dominant bold red, crystalline clarity of forms, and a highly decorative beauty

mark this style. It represents one of the major stylistic idioms of this time and is an apogee of the intense, decorative, two-dimensional style related to Nepalese painting of the time.

Paintings with Chinese Stylistic Elements

In Tibetan art the representation of the Arhats was strongly affected by models from China, where the Arhats were a popular theme in painting from the 8th century (see the introduction to II. Arhats). Examples from the 14th to the early 15th century presented in this book, probably all from the central regions of Tibet, are some of the finest surviving early Tibetan Arhat paintings (Nos. 12–14). They offer a fascinating glimpse into the Tibetan process of assimilation and adaptation of complex stylistic elements from varied sources to create their own unique style.

The Arhat in the Los Angeles County Museum's early masterpiece (No. 12) continues the typical monumental central figure configuration with the essentially unnatural, scroll-filled space of the Indo-Nepalese tradition. Touches of landscape break into the two-dimensional plane in spurts, creating interesting, fanciful areas of spatial dimension proportionately unrelated to each other. The particular floral, plant, and rock motifs relate to forms known in Chinese Yuan dynasty painting. Nevertheless, they are strongly tempered by and incorporated with the more traditional Indo-Nepalese idioms to create a uniquely Tibetan style. The same is true of the Arhat himself. He is endowed with a strongly individualistic characterization typical of the well-established Arhat tradition in China and follows a form similar to figures by the famous early Yuan figure painter Yan Hui (Tokyo National Museum, 1975, fig. 53), but the particularly vivid coloring and the engaging, potent gaze have a spirit and intensity that are thoroughly Tibetan.

The blue-eyed Arhat Vanavasin in No. 13, probably dating in the late 14th to the first quarter of the 15th century, still follows the monumental compositional plan, but here he is presented in a more spatially oriented three-quarter view, amplified by the large shrine behind him. The landscape, though more profuse, remains basically intuitive and fanciful—more related to Indo-Nepalese than to Chinese forms. In spite of the elaborate robes worn loosely in the Chinese way, the strong modeling and rich designs are closer to earlier Tibetan art at Tabo and to the Indo-Nepalese manner, again indicating a synthesis that may be considered characteristically Tibetan.

By the first quarter of the 15th century, as witnessed in the British Museum set of Arhats obtained from Shigatse in Tsang (No. 14), elements of Chinese painting are more common, as in the more naturalistic proportioning of the Arhat within a consistent, unified landscape setting. The style utilizes the Chinese "blue-green" coloration in the layering of rocks, and the figures are superbly executed with typically Chinese calligraphic ease of line and loose, fluid draperies. However, the condensing of the landscape into an essentially two-dimensional plane, despite the setting of a frontal ground plane and single viewpoint, is characteristically Tibetan. The strangely twisted tree and the layers of craggy, gold-outlined rocks, which are motifs from Chinese painting, are imbued here with a naïve, mystical life of their own. All this bespeaks a uniquely Tibetan interpretation.

Some important 14th-century tangkas reportedly at the Drigung monastery in Ü (Liu, 1957, figs. 20, 21, 22, 24) also

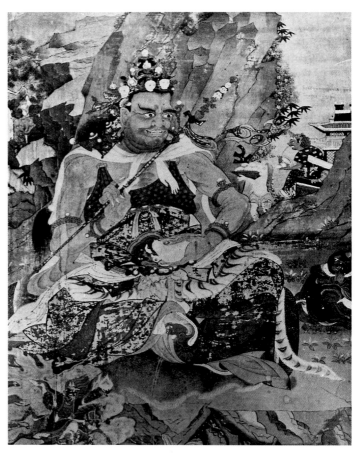

Fig. 15. *A Protector* (?), Drigung monastery, Ü, central regions of Tibet. 14th century. Tangka; gouache on cotton. (photo: Liu I-se, ed., *Xizang fojiaoishu*, Beijing, Wenwu chubansha, 1957, fig. 22)

contain large figures of monumental appearance, portrayed within landscapes of large trees, rocky ledges, swift waterfalls, and some selective yet prominent architectural elements (fig. 15). Overlapping banks suggest some recession on a ground plane, but, like the Arhats discussed above, the main focus remains on a fastidiously realistic, firmly outlined, large main image, with the landscape acting as a somewhat ambiguous but nevertheless important setting. These semiunified landscape elements, the commanding position of the large figure on the ground plane, the details of the figure style, such as the large, bony body of the image in fig. 15, and the manner of portraying the robes showing the beauty of the sweeping curves and angles, are all elements clearly seen in Yuan dynasty Buddhist painting (Siren, 1958, VI, pls. 6, 7). They are, however, transformed here into a marvelous, fresh view that delights in a freedom of unrestrained, even unnatural, juxtaposition of elements in space and in presenting all elements with an unambiguous clarity of shape and detail.

Finally, the rare painting of Padma Sambhava in the Ford collection (No. 46) provides a further example of the mingling of Chinese and Indo-Nepalese elements. His robes suggest a Tibetan adaptation of the Chinese loose style of garment. The overlapping layers of the garments, especially as they fall in triangular flaps over the legs, are also related to some 14th-century sculptures in the Drigung monastery in Ü (Liu, 1957, figs. 59, 60). Although the main figure of Padma Sambhava seems to partake of new modes in drapery depiction, the remainder of the painting strongly adheres to the traditional schematic composition of the Indo-Nepalese styles. The

attendant figures, though related to the willowy figures of the 12th- and 13th-century paintings of the central regions (fig. 11), incorporate a slightly Chinese-style fluid garment style. This tangka probably relates most strongly to the central regions and may well indicate a school associated with a Nyingmapa monastery in the late 14th to early 15th century.

Sculpture

In the central regions the sculpture of this time, like the painting, is characterized by a diversity of styles. The Padma Sambhava and Amitayus sculptures at the Drigung monastery (Liu, 1957, figs. 59, 60) are important remains of large-sized sculptures, possibly dating in the early part of the 14th century. The figures, which are big and well proportioned, reveal an assimilation of Chinese drapery modes similar to that seen in the tangkas of the same monastery (fig. 15) and in the Buddha paintings on the entrance wall of the Lotsawa Lhakhang at Alchi, probably dating to the 14th century (Pal, 1982, LL6). The delicately textured raised stucco borders on the robes of the Amitayus statue are similar to those decorating the hems of the ca. mid-14th-century Arhat in No. 12.

Both examples of Arhat sculptures included in this book (Nos. 15, 16) are probably of Chinese origin. They reveal two different stylistic types prevalent in the 14th century. The Arhat Bhadra (No. 15) shows the Khotanese-style drapery configuration with its distinctive close, parallel, soft, and wavy folds. This striking style was noted earlier in relation to the Khotanese-style sculptures of Iwang and Nesar monasteries. It was a popular style in the late 13th to early 14th century in China, the probable date for this beautiful small sculpture. The Arhat Kalika (No. 16), however, reveals the powerful chunky forms of Chinese sculpture appearing in the late 14th century, in the early years of the Ming dynasty.

The period of the 13th to the early 15th century offers some of the most remarkable Tibetan sculptures of the Great Adepts (Mahasiddhas) and archetype deities (*yi dam*). Such works as Nos. 38, 55, and 78, as well as fig. 16, all possess a powerful inner vitality radiating from the solid, rather abstract volumes characteristic of this time. The Ford Vajrapani (No. 55), probably dating in the late 13th to early 14th century, lunges with greater force in its smooth and bulging form than earlier sculptures such as the Zimmerman Shamvara in No. 68 of ca. the late 12th to early 13th century. There is also increased linear decorative interpretation of the facial features in the Vajrapani. The strong outlining and somewhat masklike appearance of the face of the Padampa Sangyey (No. 38) from the mid-14th century appears as a further developed style in the Zimmerman Milarepa statue (No. 78), which closely relates in its broad planes and selective linear style to the figures in the Raktayamari mandala datable to the end of the 14th century (No. 75). The sense of mass in the Milarepa statue is concordant with those developments in the late 14th century that culminate in the grand colossal sculptures of the Kumbum at Gyantse of ca. the second quarter of the 15th century (fig. 18).

The Virupa statue in fig. 16, probably dating late 14th to early 15th century, combines a strong masklike appearance in the face and decorative touches in the depiction of the hair with a heightened awareness of volume in the chunky, rounded, cubic body. It also reveals an increased naturalism in the mobile stretching of the large mouth and the wiry flexing of the arm muscles. This superb sculpture, probably from the

Tsang region, contains the essence of the 14th-century abstract power, while drawing toward the naturalistic styles apparent in the sculptures of the Peljor Chöde at Gyantse from the second quarter of the 15th century. It affords an instructive contrast with the Yongle period (1403–1425) sculptural style as represented by the large gilt Virupa statue in the Cleveland Museum (Béguin et al, 1977, p. 104).

Several excellent gilt Bodhisattva statues photographed at Shalu monastery testify to the beautiful style of gilt Bodhisattva statues of this period in the Tsang region (Henss, 1981, p. 141, figs. 47, 48), the fig. 47 image probably dating in the 14th century and the image in fig. 48 to the early 15th century. Although they both reveal clear stylistic links to contemporary Nepalese sculpture, they have an intensity and sharp clarity of line that is typically Tibetan.

Western Tibet during the 13th to early 15th centuries produced some of Tibet's most interesting and distinctive sculptures, many of which portray the iconography of the Five Transcendent Buddhas. These represent probably the most concentrated examples in sculptural form of the Five Transcendent Buddhas, which was a theme equally popular in painting in the 12th- to early 13th-century tangkas of the central regions. Sculptures Nos. 138, 139, 140, 142, and 143 in the Cosmic Buddha section, together with the Newark Museum Vajrasattva (No. 131), partially demonstrate a

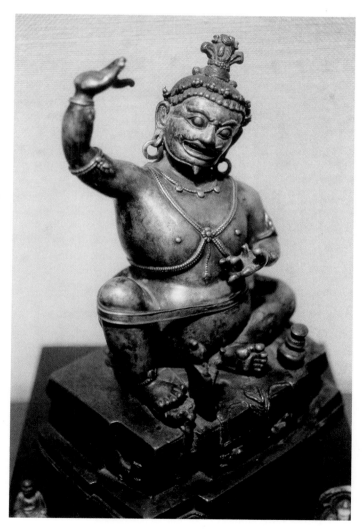

Fig. 16. *Virupa*. Early 15th century. Brass, H. 10½″ (26.6 cm). Private collection. (photo: Marylin M. Rhie)

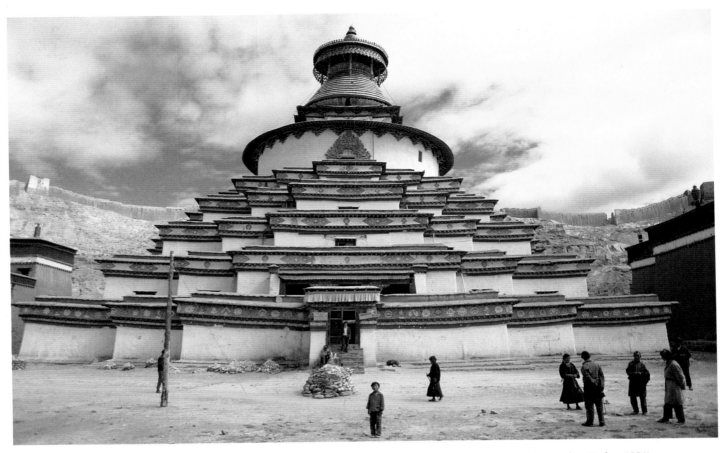

Fig. 17. The Kumbum, Gyantse, Tsang, central regions of Tibet. Ca. 2nd quarter of the 15th century. (photo: John Bigelow Taylor, 1981)

chronological development during this period. A number of other important examples can be found in the Hermitage, the Essen collection in Hamburg (Essen and Thingo, 1989, figs. I-4, 5, 7), and in various private collections (von Schroeder, 1981, figs. 34B, 35B and D–G, 36D, 39B and D–F). Increased application of inlay and inset jewels and a growing sophistication in delicate details mark the examples of the 13th to early 15th century. As a whole the group exhibits an elegant as well as earthy and unusual charm. Rather than suggesting power through mass, these images exude a more mysterious, almost ethereal essence, which is complemented by the sinuous lines of the jewel chains, the strange stiffness of the scarves, and the generally tall hairdos and crowns.

THE 15TH CENTURY

The 15th century was a relatively peaceful era in Tibetan history and it is characterized by momentous achievements in Tibetan Buddhism and its art. A central figure in this period was Tsong Khapa (1357–1419), Tibet's most illustrious lama and a profound clarifier of the Buddhist doctrine. He is considered the founder of the Geluk Order and was active in establishing many meaningful and lasting institutions for Tibetans. He inaugurated the national Monlam New Year and prayer festival in 1409, and at that time he bejeweled the Jowo Shakyamuni statue in the Jokhang (fig. 2), transforming it into a Beatific Body image. In the same year he also founded the great monastery of Ganden northwest of Lhasa, which became a main teaching monastery of the Geluk Order.

Some of the early Ming emperors of China took an interest in Tibetan Buddhism and invited various lamas to visit China,

including Tsong Khapa, who declined. The fifth Black Hat Karmapa Lama, however, became a close friend of the Ming emperor and a relationship between the Karmapa and Ming China seems to have continued for several centuries. The emperor of the Yongle period (1403–1425) is recorded as sending gifts to a number of high Tibetan lamas, which included the famous Yongle Buddhist sculptures.

The most prolific and important remains of sculpture and painting are found primarily in the central regions, especially Tsang, and in Western Tibet, which experienced a renaissance during the middle and second half of the 15th century.

The Central Regions of Tibet

The Gelukpa became very active in founding monasteries in the Ü and Tsang regions during the first half of the 15th century. Two of Tsong Khapa's disciples founded Drepung and Sera monasteries on the outskirts of Lhasa in Ü, in 1416 and 1419, respectively. Each of these monasteries eventually came to house thousands of monks. A few decades later, in 1447, the Gelukpa lama Gendun Drubpa (1391–1474), later recognized as the First Dalai Lama and also a disciple of Tsong Khapa, established Tashi Lhunpo monastery near Shigatse in Tsang. Now the monastery of the Panchen Lama, it houses the tallest colossal Maitreya statue in Tibet—eighty-six feet (26.2 m) tall and made of gold-plated bronze.

Not far from Shigatse in the flourishing commercial town of Gyantse, on the main route to Nepal and India, another great edifice was built in the early 15th century. It is the multistoried temple and stupa called the Kumbum, literally meaning "the hundred thousand images" (fig. 17). Chapels with wall paintings and sculptures on each of the stories

afford a progression toward higher and higher practice as one moves from the lower to the upper stories. Some of the greatest *in situ* treasures of Tibetan Buddhist art are found in this magnificent edifice and in the Peljor Chöde monastery adjacent to the Kumbum. Though both are nonsectarian, they have strong Gelukpa and Sakyapa connections. The Peljor Chöde was built between 1414 and 1424 by a local lord, Rapten Kunsang Pakpa; the Kumbum, dated ca. 1439 (some sources say dedicated in 1427), was built by Pakpa Rinchen (Jigmei et al, 1981, p. 203; Tucci, 1989a, p. 81).

Colossal stucco, lacquered, and polychromed statues in the Kumbum, such as those of the Five Transcendent Buddhas and their attendants, present a grand and imposing sight (fig. 18). Monumental in scale, their massive bodies, thick limbs, broadly proportioned torsos, and squarish heads with large features create figures of great dignity and an enormous sense of power, despite the tendency toward inflated grandiosity. Their bulky mass is lightened by draperies that glide with smooth and fluttering ease and by ornamentation that is elaborate, refined, and minutely detailed. Their halos display a rich patterning of flames whose textured lines frame and offset the great images. The style appears to be an assimilation of the Indian and Nepalese styles of massive form and delicate

jewelry, combined with beautiful fluid drapery derived from Chinese sources, possibly like those of Yongle period sculptures, such as the Manjushri in No. 30.[10]

The wall paintings of the Kumbum reveal a similar combination: an Indo-Nepalese-related style in the forms, ornamentation, and textile designs, but an astonishingly beautiful naturalism in the drapery, garments, and scarves based on Chinese modes (fig. 19). The pristine sharpness and clarity, the sophisticated complexity of detail, and the masterful control of colors and patterns produce gracious yet animated deities of extraordinary beauty of proportion, bright color, fluid line, and refined patterns. A similar grandeur and elegance appear in some independent tangkas of this time and region as well, such as the Amitayus and the Raktayamari in the Museum of Fine Arts in Boston (Nos. 77, 145). Landscape scenes and elements in the Kumbum wall paintings occur as basically discrete, highly patterned two-dimensional representations depicted in the typical registration format of the Nepalese tradition. This tradition is different from the somewhat freer, more natural, and unified spatial concepts present in the earlier Drigung tangkas (fig. 15).

The same sublime strength and gentle elegance witnessed in the wall paintings of the Kumbum also occur in numerous

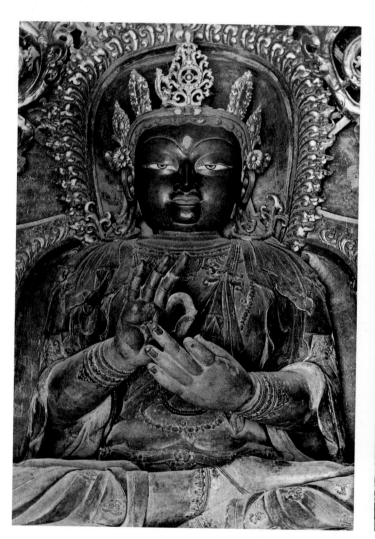

Fig. 18. *Vairochana*, colossal statue in the Kumbum at Gyantse, Tsang. Ca. 2nd quarter of the 15th century. Painted stucco. Photographed by Li Gotami Govinda in 1947. (photo: Lama and Li Gotami Foundation, Munich, Germany)

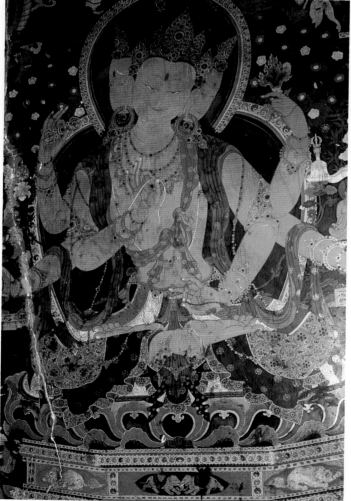

Fig. 19. *Maitreya Bodhisattva*, wall painting on the first level, chapel 16 in the Kumbum at Gyantse, Tsang. Ca. 2nd quarter of the 15th century. (photo: Edwin Bernbaum, 1983)

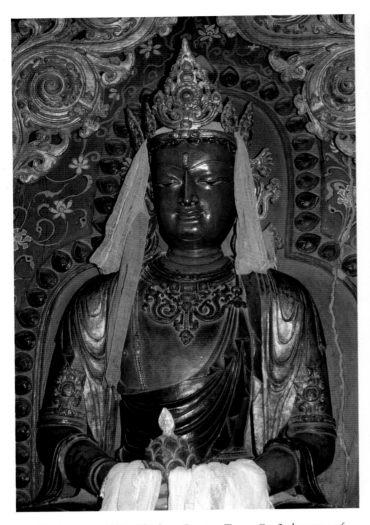

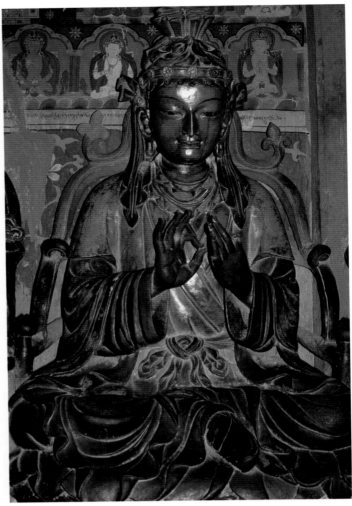

Fig. 20. *Amitayus,* Peljor Chöde at Gyantse, Tsang. Ca. 2nd quarter of the 15th century. (photo: Edwin Bernbaum, 1983)

Fig. 21. *King Trisong Detsen,* ground floor, right chapel, Peljor Chöde at Gyantse, Tsang. 2nd quarter of the 15th century. (photo: Edwin Bernbaum, 1983)

sculptures of the Peljor Chöde, which are among the finest expressions in Tibetan art. The full, quiet forms of the Bodhisattvas and Buddhas possess a noble and lofty presence, while the drapery flows over the figures with unrivaled beauty of line (fig. 20). In this masterful style the gentle yet tense folds carry an energetic spirit combined with a limpid and relaxed grace. The same is true of the sculptures of the Three Religious Kings in the Maitreya chapel of the Peljor Chöde, whose stately countenance and composure is enlivened by the coherent, curvilinear masses of their thick and spreading garments (fig. 21). The freedom of linear expression in the drapery is distinctly different from the earlier statue of Songtsen Gambo (fig. 3).

In the portrait-type images of Arhats, lamas, and Great Adepts in the Peljor Chöde, the Tibetan artists achieve a peak of dynamic naturalism. Solid, tough forms convey the sense of muscle and sinew, and faces become animated, with sensitive human character and expression (fig. 22). These sculptures are splendid examples of a new, full-blown naturalism, which, however, does not mature further at this time. Rather, some features of this naturalistic style are gradually mingled and assimilated with the more hieratical, traditional styles to produce interesting new variations in works of the later 15th and early 16th century.

Shortly after the founding of the Gyantse Kumbum, the

Sakyapa Ngor monastery was established in Tsang in 1429, by Kunga Sangpo (1382–1444). It is famous for the style of its wall paintings and tangkas, such as the grand lama in No. 61, whose monumental proportions and human qualities certainly affirm a dating near the time of the Gyantse works. It is interesting to note that this lama exhibits an uncanny resemblance to some early Renaissance paintings in Italy, such as seen in the frescoes of San Marco in Florence of the 15th century, especially in regard to the subtle pastel coloration and the broadly handled yet volumetric modeling of the large hands and face. Although this could be coincidental, it is more likely to be indicative of the probable communications between the West and Tibet through the well-traveled networks of east-west trade routes, with which the Tibetans were well acquainted. This is an intriguing subject for further investigation. It also should be noted that this particular style seems to be short-lived and does not appear to have had any further development in Tibetan art. This splendid lama remains an interesting but possibly isolated case at present.

Paintings that incorporate Chinese elements yet retain a strong connection to the Gyantse style, such as the British Museum Shakyamuni Buddha and Arhats (No. 3), also appear in the mid-15th century, a very rich and diverse period. Perhaps most prominent in the middle and second half of the 15th century, however, are the paintings that continue the

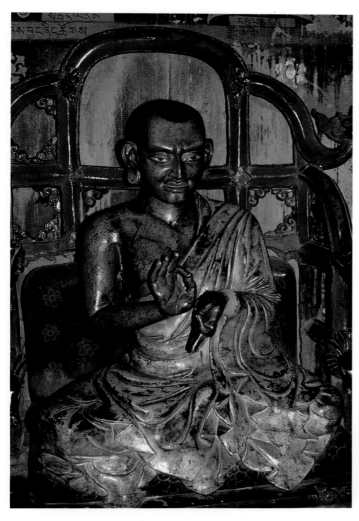

Fig. 22. *Sakya Lama,* upper floor, left chapel, Peljor Chöde at Gyantse, Tsang. Ca. 2nd quarter of the 15th century. (photo: Edwin Bernbaum, 1983)

particularly in the splendid products of the monasteries of Tsang. The works of the Kumbum and the Peljor Chöde are landmarks in the history of Tibetan art and served as inspiring models for more than a century to come. The fusion of the Indo-Nepalese styles and the more naturalistic styles filtering in from Chinese sources begins at this time, though it takes another century before its potential begins to be fully realized and developed.

Western and Eastern Tibet

In some respects the true inheritor of the Gyantse Kumbum style, especially in painting, seems to be the great temple wall paintings and tangkas produced in Western Tibet around the middle and second half of the 15th century. Tucci was the first to introduce to the West these magnificent works of the revived Guge dynasty in Western Tibet with its capital at Tsaparang.[11] The refined epitome of the elegant Gyantse style combined with the ethereal and charming styles characteristic of the Western Tibetan tradition that had flowered so brilliantly in the 11th century can be discerned in the wall paintings of the Red Temple and in many of the tangkas Tucci himself acquired at Tsaparang.

The wall paintings of the Red Temple, as well as those in Tholing (fig. 23) and in the Serkhang hall at Tabo in Spiti, show a sophisticated, monumental style related to that of the

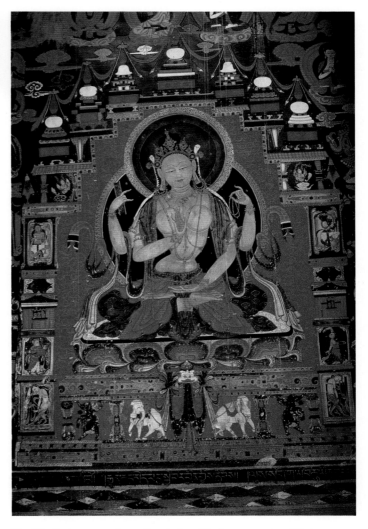

Fig. 23. *Prajnyaparamita,* wall painting, Tholing monastery, Western Tibet. 2nd half of the 15th century. (photo: Edwin Bernbaum, 1988)

Indo-Nepalese style, probably mostly in Sakyapa monasteries. These paintings reveal a marked tendency toward dramatic simplification, with the incorporation of some elements of naturalism, especially in the modeling of the main figures. Examples like the Yamantaka in No. 104 employ the two-dimensional, hieratical composition with a frontal, dominant central figure. But elements like the strong, effective modeling in the Yamantaka figure and his vigor of movement make him stand out more forcefully and dramatically and a little more naturalistically against the stylized background of flame patterns. These factors indicate the gradual changes underway in this "classical" style.

Other paintings of a slightly later date, such as the father-mother Shamvara and Vajravarahi in No. 70, reveal a similar interest in modeling as witnessed in the Yamantaka, but present images with a slim, sophisticated elegance of proportion, more refined ornamentation, and a greater sense of easy articulation in their movement. The beautiful painting on silk of Hevajra and consort in the Musée Guimet (Béguin et al, 1977, p. 51), probably dating into the 16th century and executed in China or Eastern Tibet, partakes of a developed variant regional interpretation of the same tendencies displayed in the Shamvara tangka (No. 70).

Tibetan art from this middle period in its history reached a high point, both in terms of output and in monumentality,

Gyantse Kumbum, but they also incorporate some of the delightful distortions characteristic of the Western Tibetan style (L. G. Govinda, 1979, II, pp. 168–69; J. Huntington, 1972, pls. LIX right and LX left). In this book tangkas Nos. 4, 6, 129, and 151 probably date from the middle to the second half of the 15th century, during the early phase of the remarkable "renaissance" under the Guge, which lasted from the 15th to mid-17th century. They are characterized by a delicate, almost brittle, line, by subtle colors usually dominated by deep reds and blues, by strictly two-dimensional surfaces with little landscape, and by precise, delicate patterns. Many motifs are related to the traditional Indo-Nepalese features, such as shrine-type thrones, and to the Kumbum styles, such as the halos. They have a monumental grandeur integrated with a sublime, ephemeral essence that is tempered by subtle touches of earthy charm. They offer one of the last major vital creations within the Tibetan Indo-Nepalese stylistic tradition before the irrevocable tide toward greater naturalism in the 16th and 17th centuries.

Sculptures of the Eight Medicine Buddhas in the Red Temple at Tsaparang (fig. 24) display an interesting new ideal, distinct from the colossal images of the Gyantse Kumbum. Tall, shapely forms, slender limbs, and ovoid faces with long eyes and sweetly smiling mouths create sensitive, engagingly humanistic images. The thin robes with very delicate

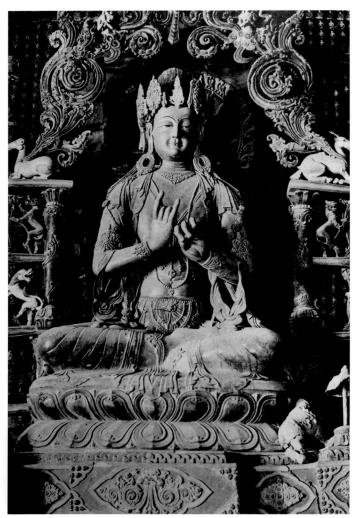

Fig. 25. *Vairochana Buddha,* White Temple, Tsaparang, Western Tibet. 1st half of the 16th century. Stucco. Photographed by Li Gotami Govinda in 1948. (photo: Lama and Li Gotami Foundation, Munich, Germany)

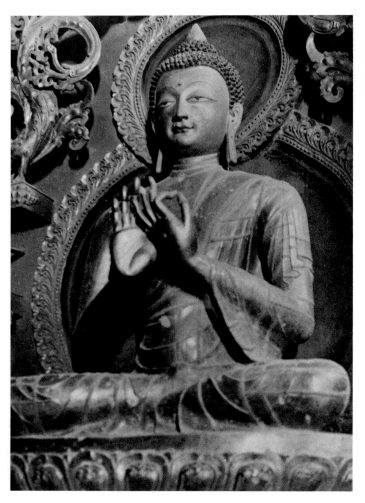

Fig. 24. One of the *Eight Medicine Buddhas,* Red Temple, Tsaparang, Western Tibet. 2nd half of the 15th century. Stucco. Photographed by Li Gotami Govinda in 1948. (photo: Lama and Li Gotami Foundation, Munich, Germany)

lineaments cling lightly, though a little stiffly, to the figures, enhancing the fragile, ethereal effects of the form. The unusual sculpture of Padma Sambhava in the Zimmerman collection (No. 47) is a magnificent example of this style, revealing the especially mystical character achieved by the Western Tibetan schools.

In the White Temple at Tsaparang, which probably dates to the first half of the 16th century (Petech, 1980, p. 105), the sculptures reach stunningly imaginative heights with their boldly conceived figures, elongated far beyond the ordinary and decorated with garments and ornaments whose disparate, angular, and scattered effects create an aura of the fantastic and otherworldly (fig. 25 and Aschoff, 1989, pp. 139, 140, 144). In the merging of the mystical and the human, these sculptures and paintings offer a glorious, slightly strange, yet sublime and humanistic portrayal of Buddhist ideals. As unique and distinctive as this group of images may seem, they are also important in understanding the less pronounced components of this style that appear in many works of the late 15th to early 16th century. Together with the art in the Gyantse Kumbum and Peljor Chöde, these sculptures and paintings in the Red and White Temples at Tsaparang are among the most important remains from this middle period in the history of Tibetan art.

Although it is assumed that Buddhist monasteries and art were developing in Eastern Tibet during this period, little concrete evidence about them is available yet. However, brief mention should at least be made of important developments in Tibetan painting which seem to be taking place in Eastern Tibet or China that show a strong inspirational source from painting of the early part of the Ming period (1368–1644). Two Arhat paintings, possibly Eastern Tibetan, both in private collections,[12] clearly exhibit the use of 15th-century Ming style landscape for the settings of the Arhat figures. The paintings present a closeup, unified, single landscape view, and provide an ample foreground plane for the main subject, the seated Arhat, who is asymmetrically rather than centrally placed and is in moderately natural proportion to the ambient landscape. The elements of trees, flowers, and rocks are executed with decoratively beautiful and profuse naturalistic details. The overlapping rocky precipices are clearly related to the styles exhibited by the Drigung tangkas of the 14th century (fig. 15). However, they are utilized with the early Ming sense of the illusion of atmospheric distance, while actually stressing a two-dimensional clarity and patterning.[13] The eastern areas of Tibet must surely be credited with fostering the employment of naturalistic landscape as an appropriate setting for Buddhist subjects, perhaps as illustrated by these Arhat paintings—a particularly challenging feat that comes to preoccupy the artists and dominate the developments in Tibetan art from the late 16th century.

THE 16TH CENTURY

Art works are known from all three of the main regions of Tibet from this period, reflecting a wide variety of styles. In Western Tibet, including Guge, Ladakh, and Zanskar, there is considerable activity, and numerous wall paintings and some excellent tangkas testify to the prosperity of the Buddhist monasteries there. In Eastern Tibet the rise of the Karma Gadri style of painting, known from written sources as a major Tibetan artistic style and associated with the Karmapa branch of the Kagyu Order, arises in the second half of the 16th century. Most prolific, however, are the central regions, which seem to have the most complex stylistic trends. Many styles are associated with the Sakyapa, but several interesting variants, probably attributable to the Drigung Kagyupa and the Nyingmapa, also appear. The clear regionalization in the art of this period reflects a similar political disunity, yet despite this, there is some interrelationship among the regions as the art in general moves in various ways toward the expression of a more powerful naturalism.

Painting in Western Tibet

Buddhism and Buddhist art continued to flourish in Western Tibet throughout the 16th and into the mid-17th century. Wall paintings and tangkas survive in quite large numbers from Ladakh and surrounding regions, such as those from the monasteries of Basgo, Piyang, Likir, and Lamayuru, as well as from Karsha and Phugtal monasteries in Zanskar.[14] From the Guge, the rare, probably contemporaneous, portrait painting of the Third Dalai Lama (No. 97) is a fine representative from the middle phase of the Guge renaissance. Since the painting can be confidently dated to ca. the third quarter of the 16th century (see entry, No. 97), it is of major importance not only in understanding the developments in Western Tibetan painting,

but also in dating paintings from other regions, such as the Gayadhara (No. 64) from the central regions.

In certain ways this painting of the Third Dalai Lama is related to painting styles from the earlier phase of the Guge renaissance of ca. the middle and second half of the 15th century, particularly in the fine linear qualities and predominantly deep blue and red coloring. However, important developments are apparent. The depiction of the loosely folded layers of delicate drapery has acquired greater complexity and a generally more naturalistic, three-dimensional quality. The scenes surrounding the main figure, who appears slightly set back into the picture plane, are imbued with spatial awareness through the simple mountain settings and the architectural arrangements, which are more profuse than in the earlier examples utilizing schematic registers (No. 6). The developments probably reflect movements already underway in painting of the central regions and Eastern Tibet, but it is this painting that provides the dated evidence of these important changes occurring around the third quarter of the 16th century in Tibetan art. The wall paintings at Tsaparang in the White Temple and the Yidam Temple from the first half of the 16th century (Aschoff, 1989, pp. 152 right–155) stylistically predate this Third Dalai Lama tangka, while those from the Scholar's Temple (*ibid.*, pp. 136–37) date stylistically into the early 17th century. The Guge tangkas and sequence of wall paintings from Tsaparang and Tholing form one of the most important series of major works showing evolving local styles from the mid-15th to the mid-17 century.

Painting in Eastern Tibet

Although documentation for art in Eastern Tibet still remains scarce, some paintings that incorporate Chinese stylistic elements, particularly landscape, are considered most likely to be connected with this region. It is known that the Karmapas, a subset of the Kagyupa, had close relations with the early Ming emperors in the early 15th century (H. Karmay, 1975, pp. 75–80), and the development of the Karma Gadri style from the second half of the late 16th century in Eastern Tibet is related both to the Karmapas and to strong Chinese stylistic elements. Most of the major artists working in this style, noted for its "distinctive colors and shading," were Karma Kagyupas in Kham and Amdo (L. Chandra, 1970, pp. 44–46). The main themes of Eastern Tibetan painting appear to be the Arhats, Great Adepts, and Jatakas, the stories of the former lives of Shakyamuni Buddha.

Two examples probably indicative of developments in the latter half of the 16th or early 17th century are the Dharmatala in the Museum of Fine Arts in Boston (No. 17) and the pair of Great Adepts in the Ford collection (No. 39). Both employ a well-unified composition with significant landscape components. The former, profusely utilizing the brilliant malachite green popular in works from this area, stresses an elaborate tree and pastel clouds. Although these features are known in Ming Buddhist painting from the 15th century, they are also seen in paintings of the middle (ca. 1500–1580) and late Ming (ca. 1580–1644), with which this painting has most in common. In the Ford painting, the fantastic rock shapes, the focus on a few naturalistically portrayed plants, and the advanced naturalism of the figural style clearly reflect styles of mid-Ming period painting.[15]

A superb example of the naturalism of the mid-Ming style is apparent in the impressive Musée Guimet painting of

Kubera, the god of wealth, riding a dapple-grey horse (No. 45). The handsome figure of Kubera, garbed in military attire and holding his jewel-spouting mongoose, rides through masses of pastel clouds. He is accompanied by other generals and ogres (*yakshas*), who are skillfully, and somewhat freely, drawn and modeled. The most stunning feature, however, is the masterfully rendered horse, whose solid form and sensitively drawn and textured face are so well portrayed that the creature seems to be alive. It is possibly the most accomplished portrayal of a horse in surviving Chinese and Tibetan painting of the Ming period.

The British Museum Jataka painting (No. 7), whose place of origin is unclear, but which is most likely to be a product of the eastern schools, affords important evidence for painting around 1600.[16] It is part of a set that was possibly commissioned by, or at least once belonged to the collection of, the Wan-li period emperor of China (r. 1573–1620), whose period of reign is inscribed in Chinese characters at the bottom. It not only utilizes rather profuse and developed elements of landscape and freely placed architecture, but also presents a lively, sketchy figural style in the small figures within the surrounding, well-integrated scenes. The main image displays a curvaceously athletic figure whose elegant, loosely folded drapery reveals a considerable advance in naturalistic depiction. The earthy coloration of the landscape, with its cone-shaped peaks and sensitively modulated outlines, and the plain dark colors of the halos represent only some of the stylistic elements in this important dated work that become standard motifs in the paintings of the 17th century and later.

Painting in the Central Regions of Tibet

In the central regions of Tibet at this time political control was largely in the hands of prominent families supported by various religious orders. The most powerful ones controlled the Lhasa and Tsang areas; the former usually associated with the Geluk Order and the latter backed by the Karmapa line of the Kagyupas. The late 16th and 17th century is also a period marked by increasingly close ties between the Gelukpa and the Mongolians, who at this time were independent. The Third Dalai Lama died in 1588 in Eastern Tibet on an extended trip to Mongolia, during which he converted Altan Khan of the Mongols, and founded Lithang monastery in Eastern Tibet and the famous Kumbum monastery in Amdo at the birthplace of Tsong Khapa. The Fourth Dalai Lama, reincarnated in the family of the Mongol rulers, did not return to Tibet until 1601, when he was twelve years old.

The trends in painting in the central regions in the 16th century are complex, yet they tend to show two main directions. One, which is strong in the first half of the 16th century but declines towards the latter half, continues the style of the 15th century as exemplified mainly in the works of the Indo-Nepalese-related style and was produced largely, it would seem, by Sakyapa monasteries. The other trend, which becomes stronger as the century progresses, shows the gradual assimilation of naturalistic landscape elements and figural styles (possibly from Eastern Tibet), especially the widespread assimilation of the Chinese-type loose drapery style. The Sakyapa were apparently major producers of these new developments as well, although there is some evidence of a style associated with the Drigungpa, a subsect of the Kagyu Order, and another with the Nyingmapa.

Among the diverse stylistic groups that are distinguishable, a few can be noted here. One style is exemplified by the set of paintings of Sakyapa lineage masters of which the Zimmerman collection Gayadhara (No. 64) is part, dating ca. the third quarter of the 16th century.[17] This style represents possibly the last major stage of the brilliantly colorful, two-dimensional patterning and the traditional formalized composition derived from Indo-Nepalese heritage. However, this set of paintings also incorporates some elements of loose drapery style. Another trend appears in other sets of Sakyapa lama paintings, which manifest the adoption of a wider color scheme, including malachite green, and more floral elements, but are still conservatively two-dimensional, such as the pair of Sakya lamas in the Los Angeles County Museum (Pal, 1984a, pl. 35; Pal, 1983, p. 82). A third stylistic group of paintings, also associated with Sakyapa works, uses a distinctly earthy color tonality and a simple landscape for Sakyapa lamas as well as for major deities (Pal, 1984a, pls. 64, 65). The landscape has a unified view but loses its impact because it is mostly covered by the numerous isolated deities. These deities are no longer arranged in static rows, but are slightly asymmetrically positioned, as though floating in the spatial setting. This style represents a definite new direction in Tibetan painting in the central regions and a number of important tangkas demonstrate it, including the magnificent Sakyapa Mahakala in the Zimmerman collection (No. 71).

A fourth distinctive style can be seen in the Drigungpa lama in No. 87. This style, which may be associable with the Drigung Order whose main monastery is in Ü, emphasizes a simple but fairly prominent landscape and use of a naturalistic tree behind the lama instead of the traditional shrine motif. The line is exquisitely refined and there is a dominance of red color and gold dotting in the garments. The rather free effects are related to the style of the Jataka painting in No. 7, dating ca. 1600.

Finally, the unusual style in the Zimmerman tangka of Padma Sambhava in the Palace of the Glorious Copper Mountain Paradise in No. 50, probably dating in the late 16th to early 17th century, may offer evidence of a style associated with a Nyingma monastery, probably in the central regions. Its delicacy and refinement, rich coloring, and usage of architectural motifs suggest some stylistic relation to Nepalese painting and to Western Tibetan Guge styles. It may be one of the earliest known depictions of Padma Sambhava's paradise.

The way in which these various stylistic groups present themselves suggests that artistic styles of this period may have a rather clear association with a particular order, or a certain monastery or artistic school. Many of the painters were monks, a factor which would tend to produce a tradition within a monastery from generation to generation, as taught by the artist monks to their disciples. Also, artists frequently came from families of painters who for generations would be associated with a certain area, so a traditional style would tend to continue in that area. This undoubtedly contributed to the strongly conservative tendency in Tibetan art. Nevertheless, the evidence of new stylistic innovations and the movement of motifs and stylistic trends from one region to another, particularly from Eastern Tibet to the central regions and from the central regions to Western Tibet during this period, also reveals the movement of artists and works of art (tangkas, sketchbooks, small statues, and so forth are easily transportable) from region to region, oftentimes within a particular

order. As Tibetan art is studied more, these fascinating movements and associations will undoubtedly become clearer.

Sculpture

With regard to sculpture, there is often difficulty in ascertaining the specific region of its make, although it is becoming possible to detect several specific stylistic groups. One group seems to reflect elements of the naturalism of the early 15th-century Gyantse Kumbum sculpture and to stylize it slightly in angular or curved patterns that are flattened against the form, as displayed in the Western Tibetan sculpture in the White Temple at Tsaparang (fig. 25). These sculptures, largely dating from the late 15th into the first half of the 16th century, also employ rich patterns of chased (engraved) designs, many of which appear in lama portrait sculptures (Nos. 62, 86, 88). Other notable examples are in the British Museum and the Essen collection in Hamburg.[18] These works are probably mostly from the central regions, but the Hermitage lama in No. 88 is probably from Eastern Tibet.

The Vajradhara and Vajravarahi sculptures in the Newark Museum (Nos. 147, 113) also relate to late 15th- to 16th-century styles and are probably from the central regions. Both reflect some relation to Nepalese sculptural styles. Nevertheless, the former has elements of the elongated, ethereal styles of Western Tibetan sculpture of the late 15th century as well as elements of drapery style descended from the Yongle sculptures (No. 30). The stiff turning of the scarves is a style seen in the small figures in the Shamvara tangka of the late 15th to early 16th century (No. 70). The latter has a particularly sensitive facial expression, which seems to relate to the style appearing in the Zimmerman collection tangka in No. 50 of the late 16th century.

Correspondences between painting and sculpture in this period are a major and particularly helpful factor in determining the date and stylistic region of independent sculptures. In fact, it may be possible with further study to link certain groups of sculptures and tangkas together as belonging to the same monastery or local regional artistic school. The rare Nairatmya sculpture in the Los Angeles County Museum (No. 74), for example, seems stylistically closely related to some secondary figures in the Sakyapa Gayadhara tangka dating ca. the third quarter of the 16th century (No. 64). This could indicate a similar date, region, and artistic school for the two works.

Many lama portrait sculptures from this period offer a fascinating study in themselves. Among the numerous variant styles, two examples in this book readily reveal two clearly different types from around the middle part of the 16th century. The Zimmerman collection Sakya Lama Sonam Lhundrub (No. 63) is executed in a gorgeous, traditional style of the central regions (probably Tsang), with tight-fitting robes displaying some of the fluid grace of line descended from the Gyantse Kumbum sculptural tradition. On the other hand, the Karma Dudzi image in the Los Angeles County Museum (No. 89), probably from Eastern Tibet and dating later in the 16th century, is also related to some styles of the Gyantse Kumbum sculpture, but nevertheless reveals a more forceful naturalism in its heavy robes, which are full of tension and mass. Though both of these sculptures possess a sturdy form, the latter's naturalism projects an added power and immediacy through the stunning layers of thick, folded robes and the forcefully individualistic characterization.

The stage is now set for a synthesis of the fully assimilated schematic traditions of the older Indo-Nepalese traditions with the powerful naturalism that was developing in spurts during the 15th and 16th century in the central regions and from the Chinese-related Eastern Tibetan schools. It is in the 17th century that this synthesis comes to fruition and matures, producing a major new, uniquely Tibetan style that flowers to the present day.

THE 17TH CENTURY

The 17th century was a climactic period historically and artistically in Tibet. The locus of power in the central regions of Ü and Tsang at the beginning of the century was roughly divided between the Karmapa in Tsang and the Gelukpa in Ü. With the rise of the Fifth Dalai Lama (1617–1682), backed by Gushri Khan of the Qoshot Mongols, power became consolidated in 1642 in the hands of the "Great Fifth." From this time the Dalai Lamas became the political leaders of Tibet as well as being the head of the Geluk Order, which spread to all parts of Tibet under the Fifth Dalai Lama and subsequently became the most powerful religious order in Tibet. In 1645 the Fifth Dalai Lama began the construction of the Potala palace in Lhasa, raising it on the remains of the palace of Songtsen Gambo, Tibet's first great Religious King, on Marpori, the Red Mountain, overlooking Lhasa (fig. 26). This awesome edifice, with its towering tapered walls, thousand windows, and monumental zigzag staircases, is one of the grandest and most powerful architectural structures in the world. The residence of the Dalai Lamas and the Namgyal monastery and university until the 1950s, it remains today an unparalleled reminder of the Tibetan religion embedded within the secular, material world.

Painting in the Central Regions of Tibet

Several datable tangkas indicate the course of developments in painting for this period in the central regions: the Ford collection Penden Lhamo, dated before 1642 (No. 115), the Newark Museum's Ngor Sakya Sonam Gyatso, probably dating ca. 1667 (Reynolds et al, 1986, II, pp. 154–55), and the Los Angeles County Museum's Kunga Tashi, dating ca. 1675 (No. 65).

The Ford Penden Lhamo is unquestionably one of the most significant works to appear in recent years. Not only is it a major piece of evidence for tracing the genre of the "black tangka," which appears to have come to full flower by the second half of the 17th century, but it is also an example of a principal new direction in painting, which stresses boldly powerful naturalistic figures portrayed with a masterful, thick, even line. The firm line and energetic force of this new style can also be observed in the Ellsworth collection Vajrapani (No. 58), probably from the first half of the 17th century, and in the Zimmerman collection Yamantaka of the late 17th century (No. 105), the latter which possesses a roaring, dynamic power created by solid masses in movement and by a thick, masterful line.

The style of these tangkas may be associated with the emergence of the "New Menri" style, which is said to have been initiated by Chöying Gyatso (active 1620–1665), who worked for the first Panchen Lama and later became the painter for the Fifth Dalai Lama in Lhasa, where this style flourished. The style generally associated with the fully developed New Menri

Fig. 26. The Potala, Lhasa, built by the Fifth Dalai Lama, 1645–1694. Photographed by Leslie Weir ca. 1930.
(reprinted with permission from *Tibet: The Sacred Realm,* published by Aperture, 1983, New York)

style is represented in some wall paintings in the Potala palace in Lhasa (Deng, 1982, figs. 44, 51) as well as in the portrait tangka of Sakya Lama Kunga Tashi of ca. 1675 (No. 65). According to Tibetan texts, the New Menri style is characterized as "stylized realism," stressing rich and thick colors, attention to detail, patterns of elegant brocade garments, individually painted petals and leaves, and a grace and flow in the style (L. Chandra, 1970, p. 46). In comparison with the Newark Museum's Sakya lama portrait of ca. 1667, the features of this new style are readily apparent. Although the Newark lama has a boldly fashioned, lavish garment that is fully consonant with contemporary developments, the setting continues a conservative 16th-century style. But the Kunga Tashi painting displays the new style's emphasis on rich orange and green coloration, its usage of architecture and landscape elements to create dimension in the setting, and the vigorous push and pull of space between deities and setting. Rather than the traditional Indo-Nepalese-style niche-shrine formulation, a fully developed style of foliage and flowers is utilized as a backing for the main subject. The floral backing, probably inspired by Chinese paintings, was seen in its earlier stages in the Drigung lama in No. 87.

The sense of reality in the Kunga Tashi tangka seems solid and indisputable, and includes celestial visions and earthly phenomena with equal force. This is unquestionably one of Tibet's major artistic styles and marks a culminating point in the long evolution of Tibetan painting. Emerging at the time when the Fifth Dalai Lama was asserting commanding leadership for Tibet in the political, religious, and cultural spheres, it developed not only into a national Tibetan style, but eventually into an international one.

This major Tibetan style, not only in painting but also in sculpture and other arts, attained such a high degree of autonomous character and widespread influence that even Chinese and Mongolian Buddhist art followed the Tibetan lead, becoming practically indistinguishable from Tibetan works except as regional variations. This Tibetan international style, rooted in Tibetan Buddhist art primarily of the central regions, but spreading throughout the northern Buddhist world, produced probably the finest Buddhist art in Asia during the 17th and 18th centuries.

The special genre of the black tangkas, the potent, highly mystical paintings portraying shimmering, brilliant forms appearing out of a translucent darkness, also comes to full fruition in the second half of the 17th century in the central regions. In addition to the Ford collection Penden Lhamo noted above, three other works are particularly pertinent for understanding the developments of this extraordinary type of painting. One is the secret vision manuscript of the Fifth Dalai Lama, illustrated between 1674 and 1681 (S. Karmay, 1988, figs. 1–18). Another is the Butön tangka datable to the late 17th century in the Asian Art Museum of San Francisco (No. 67). The Butön tangka comes from Shalu monastery in Tsang and so it is also important for indicating the regional style. The third is the Mahakala tangka in No. 112. It most likely also comes from Tsang, as it was purchased in Gyantse by Tucci from Tashi Lhunpo monks. Though this Mahakala painting is undated, its stylistic closeness to the illustrations in the Fifth Dalai Lama's manuscript is instrumental in dating it to approximately the third quarter of the 17th century. The strength of the drawing and the vigor of the forms further suggest this early date when compared to the Butön tangka, which shows considerable development toward refinement and idealization, a trend that continues into the mid-18th century.

The Raktayamari black tangka in the Museum of Fine Arts, Boston (No. 107), relates so closely to the Butön tangka in the

beauty of its pastel colors and elegant, refined nuances of shading and line executed with a deft, light touch that it may also be considered to date in the late 17th century and possibly to come from Shalu monastery as well. The black tangka in the Newark Museum (No. 59) was obtained in Kham and may be an Eastern Tibetan variant of the black tangka. It is a work of the Nyingmapa, which was experiencing a resurgence at this time, and also stylistically belongs to this early grouping of extraordinary black tangkas, which conjure up the mysterious, brilliant worlds of the transcendent.

Painting in Western and Eastern Tibet

Splendid achievements in painting also occurred in Western and Eastern Tibet during the 17th century, both of which also reached climactic levels at this time. The Western Tibetan schools assimilated elements of spatial setting and more naturalistic figural styles in the first half of the 17th century, represented by the Pure Land of Amitayus in the Virginia Museum of Fine Arts (Tucci, 1949, pl. 39). In the magnificent, large Padma Sambhava tangka in the Ellsworth collection (No. 49), probably dating in the late 16th to the first half of the 17th century, the marvelous mysterious qualities of the Western Tibetan style are retained in the somber, dark tonality, but the freer style of the surrounding scenes reveals the adoption of techniques known in the Jataka tangka of ca. 1600 (No. 7). The bold gold patterns of Padma Sambhava's robes are akin to the style of the Newark Museum's Sakya lama of ca. 1667, while the strong drawing is related to developments occurring in the central regions around the mid-17th century, which may indicate a dating for the Padma Sambhava tangka toward the mid-17th century.

The Eastern Tibetan schools, the most famous of which is the Karma Gadri, which developed in the late 16th century and is said to have flourished in the 17th and 18th centuries (L. Chandra, 1970, pp. 44–46), are intimately related to painting movements in China. This allows the chronology of Chinese painting to become a useful reference in understanding Tibetan painting of this region. Nevertheless, it is a complicated matter, not the least because of the complexity within middle and late Ming painting. It is also apparent that elements from painting in north India affect the Eastern Tibetan schools in particular at this time (No. 8), although the impact becomes more pronounced in the 18th century. Some architectural features in the famous set of Great Adept paintings in Tibet House, New Delhi (Pal, 1969, nos. 16, 17) exhibit elements of Indian painting as seen in the early Mughal manuscript painting of the *Tuti-nama*, dating ca. the 1560s (P. Chandra, 1976). Also, out of veneration, as well as an interest in spreading and continuing famous traditions, there is a tendency to retain older elements or to copy, usually with some modifications, famous older paintings or even whole sets of paintings, such as the Arhats, Jatakas, or lineage portraits (see note 12). In these cases the date must be judged by detecting the most advanced element in a style that may contain many older features.

Although dated materials continue to be lacking for the Eastern Tibetan schools, it seems probable that paintings such as the Ellsworth collection Eight-Armed Green Tara (No. 123), the Ford Arhat Angaja (No. 18), the Sarasvati in the Los Angeles County Museum (No. 27), and the Shamarpa lama (No. 90) and the Arhat Rahula (No. 19) in the Musée Guimet may all be ascribed to this period by virtue of the fact that

they possess a number of elements related to late Ming period (ca. 1580–1644) painting. The Ming style is most apparent in the two Musée Guimet works. The spacious landscape setting in the Shamarpa portrait painting, with its deep perspective and delicate individual plants, suggests early 17th-century Chinese styles. The Rahula, with its fantastic craggy rock, clearly dates after the work of the late Ming painter Wu Bin (active ca. 1568–1626), whose fantastic mountains are a model for the kind of daring shapes seen in this Rahula painting and appearing in 18th-century works such as the Zimmerman collection Gampopa (No. 84). The strong deep blue and red coloring of Rahula's robes, also seen in the Ford Jataka (No. 8), seems to be a style of ca. the late 17th or early 18th century, which may be the date of this splendid large Arhat painting.

The special success of the Eastern Tibetan style, superbly represented by these five somewhat different works, lies in the harmonious integration of the main figures into a naturalistic setting. In the case of the Green Tara (No. 123), possibly from the early 17th century, the space, though limited, is nevertheless clearly defined by the planes of the architecture, and so the deity seems to occupy the spacious courtyard in front of her palace, whose mysterious wooded setting is suggested by the large trees close behind. In the Ford Arhat (No. 18), despite the fact that the splendor of the Arhat somewhat isolates him from the landscape, the setting has become an engagingly realistic force to balance the gorgeously robed figure. Though space in this painting is somewhat ambiguous, the ample ground plane and the manipulations of scale induce a uniquely fascinating, if arbitrary, realism that effectively draws the viewer into the scene. In both cases, our world and that of the sacred figure become one, and we are induced to enter into it rather than be outside observers or receivers as in earlier Tibetan painting.

The full potential of the Eastern Tibetan school is achieved in the Los Angeles County Museum's Sarasvati (No. 27), in which deity and landscape are so compatible as to be inseparable and completely believable. The deity and our natural world coexist as credible, naturally integrated entities, thereby becoming a truly apt expression of the highest ideal of Buddhist art. By effectively utilizing gradations of subtle color to create an atmospheric illusion of space in conjunction with sparsely but tenderly portrayed ducks, birds, gentle waves, and a few distant, strangely individualistic peaks, the landscape achieves a slightly fantastic vision of nature, which completely and readily draws the viewer into its depths as easily as does the calm and lovely grace of Sarasvati. It is in this idyllic naturalism, so compatible with the beauty of the deities, that the Eastern Tibetan school is eminently successful. By the late 17th and through the mid-18th century, this idealism becomes a factor controlling most of Tibetan painting.

Sculpture

Some trends in sculpture continue the Indo-Nepalese-related styles, as in the White Tara in No. 26 and the Manjushri in No. 31, which probably dates earlier, possibly in the 16th century. Rich and ornate with gilding, inlaid with gems and turquoise, the figures display a distinct quality of opulence, which does not, however, obscure their quality of human naturalism. Other sculptures related to this same Indo-Nepalese tradition have more elements associated with the Chinese Yongle sculptures, such as the Asian Art Museum's

Shamvara and Vajravarahi (No. 102). The couple's slender bodies seem to carry with supernatural ease the ornate strands of jewels they wear, which are portrayed in the manner of the Yongle images like the Raktayamari in No. 76—a style probably ultimately derived from South Indian idioms of the 12th to 13th century, as noted earlier. Other sculptures, such as the two beautiful ones of Tsong Khapa and the first Panchen Lama from Tashi Lhunpo monastery near Shigatse in Tsang (Liu, 1957, figs. 76, 78, the latter reversed), reveal the blend of naturalism and growing idealization that becomes the strength of later 17th-century sculpture.

The fully developed qualities of idealistic naturalism appear in the Rose Art Museum's statue of the Fifth Dalai Lama (No. 98), which also exhibits elements of a new movement toward a slightly mannered abstraction. The marvelously portraitlike face and sense of solid body reinforce the naturalism of the figure, and the refined beauty of line and chasing designs contribute to the idealized effects and enliven the decorative aspects. On the other hand, the strong, animated shaping of the angular, crinkled robes creates a stunning yet slightly mannered mass that, by its very beauty, tends to draw as much attention as the powerful character of the face. This style, descended from the purer naturalism seen, for example, in the Karma Dudzi statue in No. 89, and descended also from the style of subtly elegant drapery folds as in the Tashi Lhunpo Tsong Khapa statue, evolves by the late 17th to early 18th century into a style stressing the captivating power of manipulated, angular shapes whose mannered, antinaturalistic beauty creates a tension that is in balance with the naturalistic elements.

It is probably during the 17th century that some of the large gilt and jeweled images of the Jokhang and Potala were installed.[19] A parallel to these monumental temple sculptures is offered by the splendid large images brought to Sweden from Chahar, Inner Mongolia, by the Swedish explorer and geographer Sven Hedin in the 1930s (Nos. 1, 35, 36, 96). Their grandeur, coupled with their beautiful linear and planar patterns, solid, rounded form, and jeweled magnificence, not only suggests their dating ca. 1700, but also typifies the qualities of the monumental sculptures of the time.

Some other splendid works that exemplify the flourishing Mongolian, as well as Chinese, schools of the Tibetan international style Buddhist art in the 17th to early 18th centuries include a number of sculptures from the Prince Ukhtomsky collection in the Hermitage in Leningrad (Nos. 5, 120, 124), the Royal Ontario Museum's Green Tara and Mahakala (Nos. 25 and 111), and the Rose Art Museum's Penden Lhamo (No. 116). The sublime Maitreya Bodhisattva from the Sackler Museum at Harvard (No. 32) is an especially important sculpture of this style, which can be quite definitely identified as Mongolian of the late 17th century. It reveals a beauty of body and line that is descended from such early Tibetan styles as seen in the Maitreya in fig. 7. It also combines a remarkable Indo-Nepalese flavor in the body and face with a Chinese-like consciousness of flexible line. This sculpture confirms, along with the recently published works of the 17th-century Mongolian lama-sculptor Zanabazar, the prime importance of the Mongolian school during this period (Tsultem, 1982).

The international Tibetan style of art is also significant in the Buddhist art of China, especially from the 17th and 18th centuries. This art has generally been called Sino-Tibetan or lamaist art in the past, both of which are misleading. In this book we are introducing the term Tibeto-Chinese as a stylistic designation for those images whose style and iconography are predominantly derived from sources in Tibetan Buddhism and its art, basically as the term "Greco-Roman" is used in Western art history. Sino-Tibetan, on the other hand, refers here to images whose iconography and style are predominantly in Chinese Buddhism and its art, as in the case of some Arhat paintings.

Tibeto-Chinese sculptures of this period in this book include both benign and wrathful manifestations. The Royal Ontario Museum's Green Tara (No. 25) of ca. the mid-17th century is one of the most beautiful of the Chinese interpretations of this Tibetan-style benign deity, with her soft contouring, sweet grace, and flurry of rich and light textures. The wrathful deities, on the other hand, whose overriding iconographic links with Tibetan art seem to predispose the style to be concomitantly sharp and vigorous in the Tibetan manner, seem practically indistinguishable stylistically from their Tibetan prototypes (Nos. 111, 114, 116, 120). However, the energy and naturalism displayed in both these benign and wrathful deities assure their place at the high point of Tibeto-Chinese styles, before the stiffness and formalism of the mid- and later 18th century sets into the works of those schools.

THE 18TH AND 19TH CENTURIES

The 18th century was marked by the long reigns of the Seventh Dalai Lama (1708–1757) in Tibet and of the Qing dynasty Manchu emperor Qianlong (r. 1735–1796) in China. With the greater unity in Tibet under the direction of the Dalai Lamas, increased homogeneity in artistic styles occurred as regional distinctions become much less pronounced than in former times. While Tibetan painting in particular developed generally to a peak of complexity and idealization, the Tibetan-inspired sculpture of the Mongolians and the Chinese, especially during the Qianlong period, began to exhibit the signs of a rigid and dry formality, but without a complete loss of vigor.

The style of the famous illustrations in the Narthang wood blocks of the Tanjur and the Kanjur, the Tibetan sacred canon, of ca. the second quarter of the 18th century,[20] with which the Newark Museum's Sakya Pandita is closely related stylistically (No. 66), aptly exemplifies the main midcentury developments in painting. The style tends to be rich in landscape detail, with full assimilation of complex spatial relations, exquisitely refined patterning (usually in gold) of the textiles, highly idealized facial depictions, mannered elongation and mild distortions of the figural forms, and an exceedingly elegant and fluid linear style. The combination creates a sense of a highly perfected figure with supernatural, ethereal overtones set within a realistic yet somewhat fantastic and spatially diverse landscape. Although regional distinctions are sometimes difficult to judge in these later periods, it is likely that the Newark Museum's Sakya Pandita is an example from the central regions of Tibet. The Zimmerman collection Ushnishasitatapattra (No. 125) and the Ellsworth collection Vajradhara (No. 148), on the other hand, because of the brighter and more pastel palette of color and joyously light, ecstatic quality of the mood, may be representations from the Eastern Tibetan region of a generally similar style and period, although the Vajradhara is probably the earlier of the two.

In the second half of the 18th century and into the early 19th century, paintings of Pure Lands become more prevalent; they are filled with details of palaces and deities presented as if viewed from a high vantage point, with perspective-suggesting architecture (Nos. 149, 153). Lineage tangkas, such as that of the Refuge Tree of Tsong Khapa (No. 154), begin to assume the formality of well-established compositional types, but they are still portrayed with vigor and finesse. The art produced in China of Tibetan style, especially during the Qianlong period (1735–1796), is quite profuse, but it begins to show increasing formalization. Despite the tendency to rigidity and repetitive lack of inspiration, the art is not without great beauty in its delicate detail and solid sense of power and grandeur, as shown in Nos. 100, 106, 126, and 134.

In the 19th century, painting develops many diverse trends with a wide range of iconography. Generally, the styles of the 19th century continue with some modifications and elaborations toward a settled formality that stresses a new reality based on the idealism of the 18th-century styles. Paintings such as the splendid set of Milarepa tangkas in Stockholm of the late 18th to early 19th century (Nos. 82, 83, 152) and the Parinirvana tangka from the Asian Art Museum (No. 9) reveal how successful and beautiful this formalism can be: the idealism of the 18th century is fashioned into a new, unique kind of reality by the sheer force of pristine clarity of forms, graceful line, and vivid colors, thus creating a world at once far from our own but nevertheless echoing it in a paradisiacal way. The Sertrap in No. 121, possibly from Eastern Tibet, continues the powerful styles known in the 17th century with a stronger and harsher coloration that makes it burst forth with a forced yet intriguing energy. The Virginia Museum of Fine Arts's King of Shambhala (No. 43) represents a style that stresses the lyrical whimsy of line, and the Royal Ontario Museum's Temples of Lhasa (No. 155) illustrates the dominance of landscape and architecture in a panoramic view of the sacred monasteries of Lhasa. The genre of grand vista incorporating many scenes or elements also appears in the final two paintings of the book: the Shambhala and the Offerings to Mahakala (Nos. 157 and 158), two popular themes of 19th-century Tibetan art. They exemplify the tendency to incorporate narrative idioms and to portray symbols as part of the formalistic trends of the time. The

monumental size of these paintings increases their spectacular and dramatic attraction, and the sacred symbols and holy places assume an abstract, timeless identity and power over the viewer.

Throughout its course, Tibetan Buddhist art has striven for the integration of the phenomenal and the transcendent as its ultimate aesthetic principle. This has perhaps been most successfully achieved in masterworks of painting, where the style itself portrays this integration. In the early styles of painting developed from the Indo-Nepalese artistic traditions, the transcendent world of the deity is depicted as two-dimensional space, making it basically unreal or otherworldly to us. In contrast, the deities and figures are rendered in such a way that they represent the phenomenal: They are so sensitively and realistically portrayed as to seem immediate and totally real. These deity-forms project outward into our world, where they appear astonishingly active and compelling. The vivid realism of the figures and the abstract, simple, unreal, two-dimensional world of pure color are compatibly fused to create an undifferentiated unity of the transcendent and the phenomenal.

In the later styles of Tibetan painting, which developed from assimilating elements of the Chinese artistic traditions, the approach is different, though the idea of integration is the same. The phenomenal world is now represented by a three-dimensional setting, which is easily equatable with our own world. But we do not readily conceive of the deity as residing in our world, so the three-dimensional setting is idealized or made fantastic in order to harmonize more closely with the conception of the deity in the transcendent realm. At the same time the deity is made more humanlike by its more naturalistic, less hieratic proportioning with respect to the setting and by increasing the naturalism of its form and its loose and fluttering garments. In this way the idealized naturalistic beauty of the deity is made to harmonize with the idyllic beauty of the landscape setting. The resulting compatibly integrated deity and landscape readily draw the viewer into their world, into a sublime and uplifting unity with what seems to be the perfected universe—the Pure Land of the Buddhist vision—of which we become a welcome and intimate part.

NOTES

1. The Dukhang of Tabo is generally accepted as founded ca. 996 or 1008 (Klimburg-Salter, 1982, pp. 157–64). Pritzker (1989, pp. 39–41) suggests a dating of ca. 1042 for the wall paintings, reflecting the "renovations" of Jang Chup Ö, as stated in an inscription in the Dukhang.

2. Alchi monastery was founded in the mid-11th century by Kelden Sherap, a follower of Rinchen Sangpo, and the monk Tsultrim Sherap (Snellgrove and Skorupski, 1977, pp. 30–31, 47–48; Pal, 1982, pp. 11–17).

3. Tibetan histories, such as *Kongtrul's Encyclopedia of Indo-Tibetan Culture,* describe two major styles in early Tibetan art: the Kashmiri Kache style and the Nepalese Beri style, each of which is said to have three substyles (L. Chandra, 1970, p. 42). Without detailed descriptions and actual works as references, it is difficult to utilize this classification at present except in a qualified and tentative way. One of the clearest subtypes of the Nepalese Beri style is called the Sarthun, referring to the Pala art of India, which, as can be seen in numerous examples, was a major source for the art of the central

regions in the early period. (See also S. and J. Huntington, 1989, pp. 40–41.)

4. They usually have Tibetan inscriptions, so they are clearly made and/or used by Tibetans. S. and J. Huntington place this group in their Sarthun early-period classification, and they believe these works were carved by Tibetans because of certain stylistic elements not found in Pala Indian sculpture (*ibid.*, pp. 40–41).

5. Examples of this group include: Tucci, 1973, figs. 143, 151–153, mostly from Sakya; Essen and Thingo, 1989, fig. 36.

6. Tucci, 1973, figs. 159, 162, 163; Tucci, 1949, I, figs. 75–77; L. G. Govinda, 1979, I, pp. 44–47.

7. The Khotanese style has been known from Chinese sources from at least the 7th century, when it was made popular in China by the famous Khotanese painter Weizhi Yiseng (Wei-chih I-seng). From the 8th century it continued in Chinese art as a special style, but in the late 12th to early 14th century it became a dominant style in both sculpture and painting, possibly due to some impetus from Central Asian art of the time. The Tibetan version as seen in Iwang and

Nesar, as well as the sculpture reported and photographed by Tucci at Kyangphu and Dranang (Tucci, 1989a, III, figs. 19–21, 25–32; Tucci, 1956, figs. opp. p. 158) seems to have the earmarks of the Khotanese style, as far as we can determine it at present. Judging from comparable Chinese works, these images appear to date stylistically between the late 12th and early 14th centuries. There is also a stylistic relationship with the "Chinese style" paintings from Khara Khoto, dating before ca. 1227. Elements of this style appear in Nepalese sculpture as well, particularly of the late 13th to the 14th century—possibly as a reflection of this powerful and impressive array of sculptures and paintings in the monasteries of the southern Tsang region.

8. Examples for both the inlay medallions and the crowns include the magnificent standing Avalokiteshvara at the Asia Society, New York, which, as discussed in a recent article by Chandra Reedy, is probably a work of the 11th century in Kashmiri style, made in Western Tibet (Reedy, 1987, pp. 84, 90); a statue on the altar at Sakya monastery (Tucci, 1973, fig. 157); and the Vajrapani in the Musée Guimet (Pal, 1975, pl. 98). Although the medallion is a well-known Persian motif in earlier periods, its resurgence in the 11th to 13th centuries may be linked to Central Asian popularity and usage.

9. Tangkas photographed by Pt. Rahula Samkrityayana in 1928–29 and 1934 in monasteries in Tsang interestingly show, despite poor reproduction and retouching, several tangkas of a similar style (Pathak, 1986, pls. 5, 6, 7, and 11).

10. According to Chinese records, gifts of images and texts were sent at least six times between 1408 and 1419 from Emperor Chengzu to certain high Tibetan lamas (H. Karmay, 1975, pp. 79–80). Although the Yongle period sculptures reveal a strong Tibetan style and iconography, there are characteristics that are clearly Chinese as well. In particular, the movement and fluid linear depiction of the drapery appears to be Chinese. Since these sculptures were in Tibet during the period of the making of the Peljor Chöde and the Kumbum, whose images reflect this same style of drapery, it may be that these Yongle images provided some artistic inspiration for those great works.

11. According to Tucci, the Red Temple at Tsaparang was built by the wife of the king of Guge, Losang Rapten, "a contemporary of Nag dban gragpa, the apostle of the dGelugs pa in Western Tibet and a disciple of Tson K'a pa (1357–1419)." Tucci therefore ascribes the Red Temple to around the end of the 15th century (Tucci, 1949, p. 359). This same king, Losang Rapten, rebuilt Tholing monastery and installed Ngawang Drakpa as head abbot there. Later, probably in the first half of the 16th century, the king's nephew, Jigten Wangchuk, built the White Temple and the Vajrabhairava Temple at Tsaparang and presented many offerings to Gedun Gyatso (1475–1542), the Second Dalai Lama (from the *Vaidurya Serpo*; see Tucci, Tibetan notes, *Harvard Journal of Asiatic Studies*, 1949, 12, pp. 483–85, 487). The sculptures and paintings from these temples, dating from ca. the second half of the 15th to the first half of the 16th century constitute not only major remains of Buddhist art of the same time but also art that is related to the Geluk Order during an earlier phase.

12. Pal, 1984a, pls. 58, 59. Interestingly, these two paintings appear to have been copied in later times as part of a set of eighteen Arhats. One such set, probably dating from the 18th century, is in the Yonghegong in Beijing (published only in postcards). Although certain changes have been made and the style is Qing rather than Ming, they clearly follow the earlier prototypes, at least as far as these two examples are concerned. Copies of sets of famous Arhat paintings are a well-known tradition in Chinese painting history, such as the famous set by Guan Xiu (late 9th century), which has been copied many times.

13. Though utilizing Chinese elements, the style is basically not Chinese. The more naïve two-dimensional employment of landscape and the stress on brilliant color and clarity of line are more Tibetan than Chinese. Since these paintings are unlikely to have been done in China or in the central regions of Tibet or Western Tibet, it seems most reasonable to attribute them to Eastern Tibet, even though more positive evidence is lacking at present.

14. Genoud, 1982: Basgo (figs. 1, 4–6, 13, 18); Piyang (figs. 1–9); Copeland, 1980, pp. 28, 32, 60, 62, 64, 68, 72; Council of Religious Affairs of H. H. the Dalai Lama, 1982, pp. 12, 68–72, 75; Snellgrove and Skorupski, 1980, color pl. V..

15. The style of rocks and the composition in the Ford collection Great Adepts tangka relate to some middle and late Ming paintings, such as those by the major painters of the 16th century—Wen Zhengming, Tang Yin, and Qiu Ying (Ch'iu Ying)—and by Wu Bin (ca. 1568–1626) and Sheng Maoye (1594–1637). The Dharmatala painting has many stylistic elements that relate to the paintings of the late Ming professional artist Ding Yunpeng (Ting Yün-p'eng, 1547–1638), as well as others of the late Ming, such as Yu Zhiding (Yü Chih-ting). These elements include the figure style as well as the landscape features, particularly the trees and rocks (Siren, 1958, VI, pls. 310, 311, 335). In both cases, these tangkas do not appear to be Chinese; they have the Tibetan style of figures and the characteristic Tibetan clarity and precision of form and line.

16. A wall painting photographed in 1980 by M. Henss (1981, p. 244) in a deserted Gelukpa monastery at Dawu in Kham in Eastern Tibet, though of a later date (probably 19th century), shows a number of features that seem descended from the style of this British Museum painting. This may indicate a stylistic tradition in this part of Eastern Tibet to which this British Museum Jataka could be related.

17. Others from this set are in the Ford collection (Lauf, 1976a, pl. 25), the Rijksmuseum voor Volkenkunde in Leiden (Béguin et al, 1977, fig. 16), the Essen collection (Essen and Thingo, 1989, I-75), and the Los Angeles County Museum (Pal, 1983, p. 154). The set may also include two paintings in a private collection (Pal, 1984a, pls. 39, 40).

18. Zwalf, 1985, fig. 186 (British Museum); Essen and Thingo, 1989, I-3, 29, 35, 39, 65, 71, 73, 76; Reynolds et al, 1986, III, p. 101.

19. Jigmei et al, 1981, figs. 170, 172; Deng, 1982, figs. 65–68; Xizang gongye qianchu kanze shejiyuan, 1985, figs. 44–45, 54.

20. The Narthang wood blocks of the Tanjur and Kanjur were commissioned in 1732 and 1742. Examples of the famous illustrations appear in Tucci, 1949, II, text figs. 90–100.

THE
SACRED
ART
OF
TIBET

CATALOGUE

Marylin M. Rhie and Robert A. F. Thurman

Gennady Leonov Gilles Béguin Kira Samosyuk

Richard Kohn Terese Tse Bartholomew

1

Vajrapani

Chahar, Inner Mongolia

Circa 1700

Gilt brass, with lacquer and pigments,
inset with gems

H. 73″ (185.4 cm)

Folkens Museum Etnografiska, Stockholm

Lit.: Tsultem, 1982.

Vajrapani is a complex deity with various forms. For the exhibition *Wisdom and Compassion: The Sacred Art of Tibet,* he functions as a protector figure. As the companion of the Buddha, he is a familiar figure in early Mahayana Buddhist texts. In art he is a major Bodhisattva (spiritual hero), distinguished by his holding of the vajra (scepter of compassion's power). In tantric Mahayana tradition, Vajrapani is most frequently encountered in his fierce emanation, in which he is a powerful protector and remover of obstacles. It is also said that Vajrapani will become the last Buddha to appear in this world cycle. In the Geluk Order in particular, which was influential in Mongolian Buddhism, Vajrapani is often grouped with Avalo- kiteshvara and Manjushri. The three celestial Bodhisattvas are thought of as archangelic protectors, representing the power (Vajrapani), compassion (Avalo- kiteshvara), and wisdom (Manjushri) of all the Buddhas of past, present, and future. In fact, this image, brought to Sweden from Chahar, Inner Mongolia, by the famous geographer and explorer Sven Hedin, is part of such a group; the others appear in this book as Nos. 35 and 36. In honor of his role as the fiercely compassionate protector of the Teaching, Vajrapani is designated as the first of the one hundred sixty works of Tibetan art in this book, just as he is frequently found near the entrance to the shrine halls in Tibetan and Mongolian temples.

The massive body of this Vajrapani is balanced with spirit and poise in the "warrior's pose." His right arm thrusts upward in the direction his body moves, the right hand lightly clasping a vajra scepter. The left arm crosses his stomach, with the hand alertly poised in the threatening gesture. Under each foot he controls a live snake. His dress and ornamentation include some of the usual features of wrathful deities, such as the long snake necklace and the tiger-skin loincloth (with the face depicted on the back). But generally his ornaments are those of the benign Bodhisattvas, that is, jeweled five-part crown, elaborate earrings, armbands, bracelets, necklaces, and anklets. Interestingly, a half vajra also appears in his hair, probably in reference to his special attribute. The ribbons from his crown and the long scarves that pass around his shoulders and flutter to the sides create a swirling frame of movement, complementing the active posture of his body. Similar agitation is provided by the sheets of his red hair, standing on end, by the flamelike forms of his eyebrows and mustache, and by his tightly curled red beard. The individualistic features of his face are engagingly lifelike: three popping eyes, a short, furrowed nose (with a wart on the end), and a wildly roaring mouth rimmed with lacquered red lips. A curling red tongue is glimpsed between the two rows of his gaping nutcracker teeth. His appearance is mighty, spirited, colorful,

and shows a balance of naturalism and stylization.

This work dates from the later phase of Tibetan art when it had penetrated deeply into the cultures of China, Manchuria, Inner and Outer Mongolia, and parts of Soviet Siberia, such as Buryat. Though the art has often been termed "Sino-Tibetan," since Chinese workshops were especially active in producing for the Tibeto- Mongolian-Manchu market, little study has yet appeared to clarify the distinctions among the regional schools of this "international" Tibetan-style art. This image, and the others from this set, can be taken as indicative of the Mongolian school around 1700. Elements of this sculpture such as the smooth, sleek, and broad planes of the body, the rather large yet selective and varied types of colorful jewel insets, the particular scroll patterns of the gilded ornament depictions, and the somewhat mild, youthful, and glowing aspect of this fierce deity are characteristics of Mongolian Buddhist sculpture of this time. These elements are also apparent in works related to the famous Mongolian lama sculptor Zanabazar, who was active in the late 17th century. The grandeur of this Vajrapani conveys the awesome aura conjured by the large images found at the entrances and on the altars of Buddhist temples in Tibet and all the regions devoted to this international Tibetan Buddhist style.

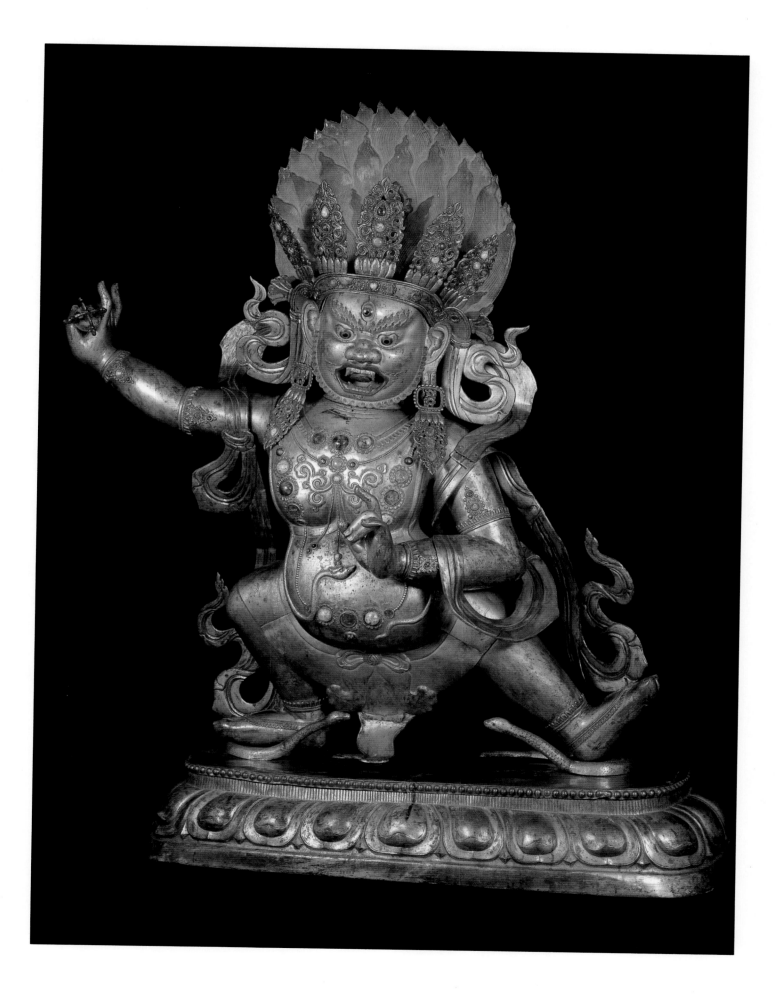

བོད་ཀྱི་

ཚོས་འགྱུར་དང་

འབྲེལ་བའི་

སྐུ་རྫས།

TIBETAN

SACRED

HISTORY

The Tibetan sense of history has become completely intertwined with Buddhism during the last thirteen hundred years. Even the Tibetan cosmogonic myths originate in the Buddhist scriptures. Within the general Buddhist context of the beginninglessness of life, these myths teach that universes evolve and devolve in a cycle of eons (*kalpas*). Tibetans believe we now are in the Excellent Eon of the Thousand Buddhas, during which one thousand Buddhas will appear in our world. Shakyamuni, our historical Buddha (563–481 BCE), is the fourth of these, and Maitreya Buddha, the Buddha of the future (around 100,000 CE), will be the fifth.

In one way, our present time is viewed as an age of degeneration because it is so far from the revelatory time of Shakyamuni Buddha's life. In another way it is viewed as an age of fruition, because the Buddha's legacy still lives, especially in Tibetan civilization, due to the special virtues of the esoteric teachings of the tantras. Tibetans feel that their special role in history is to preserve the Buddha Dharma until the advent of the kingdom of Shambhala, an earthly Buddhist paradise that lies hidden in the arctic regions of the planet. There is a prophecy that several centuries from now the king of Shambhala will restore the liberating Buddhist practice to the whole world and prolong the duration of the Buddha's Teaching by many centuries.

Such a powerful Tibetan faith in history is daily reinforced by the pervasive presence of icons of historic and mythic ancestors in homes, monasteries, and temples. In a society where historically both the illiterate and the highly educated cultivated the memory and the visual imagination, the oral and the pictorial traditions held a powerful position. The art of graphically portraying history was richly developed; the icon not only represented an individual Buddha, deity, angel, saint, scholar, adept, or king, but often told the story of his or her life, accomplishments, and liberation. These icons taken as a group contain the record of the secular and sacred history within which the Tibetan nation still lives and finds its meaning.

This section presents icons of the historical Buddha Shakyamuni, both those connected to his life's work as a Buddha and those that chronicle his lifetimes of evolution toward Buddhahood. It also presents representative icons of the Arhats (saints); the Bodhisattvas (messianic spiritual heroes and heroines), both mundane and celestial; the national treasure philosophers (Mahapanditas); the Great Adepts (Mahasiddhas); and the Dharma Kings (Dharmarajas) of Indo-Tibetan Buddhist history.

I.
Shakyamuni Buddha:
Life and Lives

Shakyamuni is the Buddha of our historical period. To understand the omnipresence of his icon in Tibetan culture, we must understand what "Buddha" (T. *sangs-rgyas*) means to Tibetans. A Buddha is a being—both human and divine, either male or female—who has "awakened" (*sangs*) from the sleep of ignorance and has purified all evil, a being who has "expanded" (*rgyas*) limitlessly the power of his or her compassion and accomplished all goodness. A Buddha is a form of life that has achieved the highest evolutionary perfection possible. He or she is perfect wisdom (the experience of the exact nature of reality) and perfect compassion (the embodiment of the will to others' happiness). Buddhahood transcends suffering and death and incorporates the perfected abilities to experience and communicate happiness to all living beings.

A Buddha is not a creator god, so Tibetans do not blame Buddhas for the evil in the world. Evil is part of the existing order of things, produced by bad habits and persisting since beginningless time. Its root is ignorance or misknowledge of the nature of reality, which is the self's misperception of its own status as absolute, its own position as central, its essence as ultimately separated from others. This misknowledge leads to greed and hate, as one wants to take things away from others and fears that they will take things away from oneself. Greed and hate cause negative evolutionary actions, such as stealing and killing, and these inevitably cause suffering both to perpetrator and victim. For Buddhists, evil is suffering and good is happiness. The purpose of life is to get rid of all suffering and find real happiness.

Buddhism holds that ignorance can be eliminated by the wisdom that totally understands reality, described as freedom from the rigid self in total relativity. This wisdom experiences the self as interrelated with others. This understanding of reality leads to generosity and love, as one feels enriched by others' fortune and enjoys their happiness. Generosity and love cause positive evolutionary actions, such as saving lives, and these bring happiness to all. The highest good, the greatest happiness, the supreme beauty, and the most powerful

dynamism of good action—these constitute Buddhahood, a state that all of us can (and eventually will) attain. Of all forms of life, human beings are the most favorably endowed for this attainment. Even the gods, Tibetans believe, cannot as easily gain enlightenment.

Not an ordinary being with an ordinary body, a Buddha is said to have three bodies: a Truth Body, a Beatific Body, and an Emanation Body. The Truth Body is Reality itself: omnipresent, quiescent, and serene; it is absolute fulfillment and contentment. The Beatific Body is the bliss that streams subtly throughout Reality, radiant with the delight of that fulfillment. Ordinary beings cannot perceive Truth and Beatific bodies. But from their union, the union of wisdom and bliss, the Emanation Body emerges, manifesting limitless forms to interact with and enfold suffering beings into its own perfectly safe and happy condition. In a very real sense, the Emanation Body itself is the primal Buddhist art. Its works are inspired by the Buddha's love and convey the ultimate aesthetic pleasure to living beings, to lift them above their habitual routines, to exalt them beyond themselves, and to lead them toward a fulfillment beyond their richest dreams.

The Emanation Body has three forms, Supreme, Incarnational, and Artistic. Shakyamuni and other Teaching Buddhas are Supreme Emanations. Teaching is thought to be the supreme art, since the only door of liberation for each being is his or her own free understanding. Tibetans consider many historical figures, both mundane and celestial, to be Incarnational Emanations. They represent a Buddha's efforts to reach out to beings not yet fortunate enough to be born at the time of a Supreme Emanation Teacher. Tibet's famous reincarnate lamas, such as His Holiness the Dalai Lama, are Incarnational Emanations. Finally, any valid (correctly inspired, designed, and consecrated) icon in any medium (along with its creator during the work of creation) is considered an Artistic Emanation Body Buddha. For such inspired works of art can reach out to a wider circle of living beings to communicate the aesthetic experience of enlightenment. And this third category places the Tibetan

sacred arts in an extraordinary and powerful context.

A Supreme Emanation, such as Shakyamuni Buddha, always descends to the human realm at a historical moment when beings will be able to take advantage of his presence. Shakyamuni Buddha's biography is schematized in what are called Twelve Deeds: 1) descent from the Akanishita to the Tushita Heaven, 2) conception, 3) birth, 4) education, 5) marriage and play, 6) renunciation, 7) asceticism, 8) sitting at the tree of enlightenment, 9) defeating the devil, 10) perfect enlightenment, 11) turning the wheel of Dharma, and 12) attaining Final Nirvana (Parinirvana). There are many sets of Tibetan icons depicting these twelve deeds. Among them the teaching (turning the wheel of Dharma) deed is particularly rich in depictions.

A second genre of depictions is the Former Life stories (Jatakas), which portray the Buddha in his former lives when he was a Bodhisattva. These stories illustrate how, even when in a hell or in lives of animals, gods, or demons, the Bodhisattva turned hate to love, greed to generosity, and ignorance to wisdom. With each deed, he developed in evolutionary form toward the exalted state he would achieve as a Buddha. These stories function in Tibetan culture much like the moral fables of Aesop or, closer to home, of Walt Disney. They exemplify basic virtues such as kindness, courage, loyalty, justice, and generosity on a simple and basic level. In the Tibetan imagination, the Buddha-to-be is the ideal representative of perfect goodness and the hero of the moral adventure.

Buddha Shakyamuni and other monastic Buddhas, such as the future Buddha Maitreya, are generally portrayed wearing monks' robes, covering one or both shoulders. They are shown with at least some of the thirty-two characteristic marks (lakshanas) of a Buddha, such as a golden complexion, long arms, the mark of a thousand-spoked wheel on palms and soles, and a white hair curl (urna) between the eyebrows, which is often said to emit miraculous rays of light. The Buddha's elongated earlobes reflect his royal origins, coming from wearing heavy earrings in his youth. His cranial

protuberance (ushnisha) is considered indicative of his enlightened state. Usually, he is depicted with his hands making symbolic gestures (mudras), the three most common being the gestures of manifesting enlightenment, giving teachings, and contemplation. In the enlightenment, or earth-witness (bhumisparsha), gesture, he places his right hand palm down over his right knee and touches the earth with his middle finger, calling upon the Mother Earth goddess to witness his evolutionary right to enlightenment. In the teaching or Dharma-wheel-turning (dharmachakra-pravartana) gesture, he holds both hands at heart level with thumbs and index fingers making two circles touching together, extending the other three fingers of each hand. In the contemplation (dhyana) gesture, both hands lie flat in his lap, the right laid evenly over the left and the thumb tips touching.

Tibetan paintings of Shakyamuni typically show him attended by his two great disciples, Shariputra and Maudgalyayana, or by two Bodhisattvas. Often surrounding this centrally placed triad are formally arranged depictions of the Thirty-five Buddhas of Confession and/or the patriarchs (Sthaviras) and saints (Arhats), as seen in several important early examples in this book (Nos. 3, 4, 6). Other paintings depict scenes from the Buddha's life or from previous lives. They may focus on a single event, as does the Parinirvana painting (No. 9), or they may present a series of scenes, usually five or ten Former Life tales (Jatakas), each with its own narrative sequence (Nos. 7, 8). The Former Life paintings frequently include scenes of his animal as well as human lives. The oldest surviving depictions of the Shakyamuni life in Tibetan art appear to be the wall paintings of the 11th century at Tabo monastery in Spiti (now in northern India but historically Western Tibet). From the 16th century on, the Buddha Life and Former Life paintings show increasing interest in the development of landscape as a setting for the various scenes. These developments are particularly successful in paintings from the eastern (Kham and Amdo) regions, where portrayals of figures in landscape reached unsurpassed heights of idealistic and imaginative beauty (No. 8).

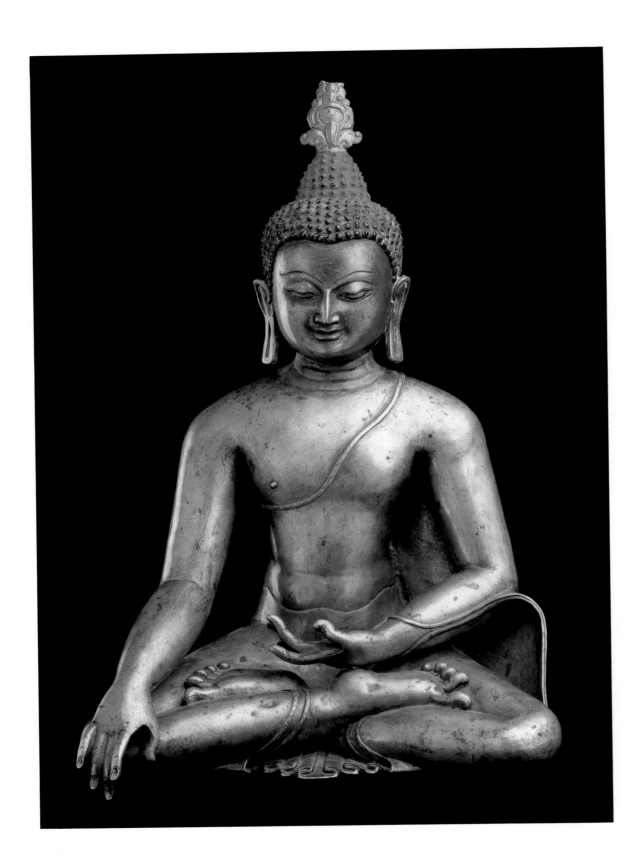

2
Shakyamuni Buddha

Western Tibet

Mid-11th to 12th century

Brass, with traces of blue pigment in the hair; sealed with relics inside

H. 16″ (40.6 cm)

The Zimmerman Family Collection

Lit.: Rhie and Thurman, 1984, no. 77; von Schroeder, 1981, p. 184.

A masterwork of power and grace, this image is a brilliant example of the rare early Tibetan sculptures of our historical Buddha. It is one of the most significant and popular portrayals of Shakyamuni—at the moment of his full enlightenment under the bodhi tree at Bodhgaya. Seated with legs crossed in the adamantine (diamond) posture and garbed in a simple robe, Shakyamuni touches the earth with the tip of the middle finger of his right hand, responding to the devil Mara's challenge to his right to enlightenment. He calls upon Mother Earth herself to bear witness to his long evolutionary struggle, over billions of lifetimes, to come to this moment. Typical for the portrayal of a Buddha, this image also has a cranial protuberance (*ushnisha*), a curl of hair (*urna*) between his eyebrows, a golden complexion, tightly curled hair, and elongated earlobes.

The sculpture is finely proportioned, with broad shoulders, subtly muscular torso, and a slender waist. It projects a combination of youthful vigor and controlled composure that befits a representation of a Buddha at the moment of enlightenment. Nowhere do the swelling volumes of the form slacken, and every part of the body appears to radiate with inner life. The attenuated fingers, sensitively curved and naturalistically molded, are poised with the confidence and power of dauntless inner will. Even the toes seem to sparkle with the energy that courses through the figure. Above the triple-lined neck—a mark of beauty—the round and beaming face with its curved and softly molded features seems both outwardly aware and self-contained.

Fitting the body like a skin, the garment reinforces and heightens the vitality of the figure, especially in the swift and sinuous curves of its slightly raised hems. Lightly scored in a zigzag pattern of double incised lines, these hems stretch with a skillful balance of ease and tension around chest, legs, and arms. In a striking show of gravity-defiance, the edge of the garment leaps into the air off the left arm and, in ascribing an elliptical arc, artistically complements the large and small para-bolic shapes that are seen throughout the figure.

Although the image is derived from Kashmiri and Pala Indian Buddhist sculpture of the 10th and 11th centuries, it has a warmth and unreserved forthrightness characteristic of Tibetan art that is different from the sharp sophistication of Pala art or the rich beauty of Kashmiri works. Descended from the famous Sarnath style perfected in 5th-century Gupta India as transmitted and revitalized in the Buddhist sculpture of the Pala dynasty (8th to 12th century), this sculpture represents yet another fresh interpretation of that powerful and fruit-ful tradition. Notable for its spirit of naturalism and free of any stricture of formality, this image communicates its superhuman essence with a directness that clearly reflects the vigor and enthusiasm of this early period of Tibetan Buddhism.

Some stylistic elements relate to the sculptures and wall paintings of the early to middle 11th century in Western Tibet, especially those at Tabo and Mangnang (Tucci, 1973, figs. 113–22). These include the round shaping of the face with its softly contoured features; the vigorous mobility and simplicity of the line; the flat, curvilinear fold patterns under the feet; and the square shape of the distended earlobes. The style is quite distinct from the harder, sleeker, and slightly more elaborate interpretations of it that appear in the late 14th to 15th century. The specific zigzag linear pattern in the hems can also be seen in wall paintings from the Sumtsek at Alchi in Ladakh dating about the third quarter of the 11th century. These factors, as well as a close similarity to some early sculptures published by Tucci from Luk monastery in Guge, Western Tibet (Tucci, 1973, fig. 155, which he dates to the 12th to 13th century), strongly suggest an attribution to the general western Tibetan region. The stylistic associations with all these images, as well as the clear lineage from 10th- to 11th-century Pala sculpture, point to a dating ca. the middle of the 11th century or a little later. Certain features, such as the slightly cone-shaped *ushnisha* and the smoothly curved, plain surfaces of the body, also appear in some Buddha paintings from the Khara Khoto group, generally dating before 1227 (No. 135). These lend support for a mid-11th- to 12th-century date for this superlative sculpture, which surely represents one of the major early styles of Western Tibet.

3

Shakyamuni Buddha
with Two Disciples
and the Eighteen Arhats

Central Regions, Tibet; probably Tsang

Mid-15th century

Tangka; gouache on cotton

36½ × 31¼″ (92.8 × 79.4 cm)

The British Museum, London

Lit.: Béguin et al., 1977, p. 113; Béguin et al., 1984, p. 17.

Within this single tangka the genius of the Tibetan artist has created a highly synthesized and eclectic work by incorporating multiple artistic traditions. This complex and unusual painting centers on Shakyamuni and his two great disciples, Shariputra and Maudgalyayana, who are famous for their intellectual and mystical powers, respectively. The triad is presented within an elaborate throne structure composed of a broad pedestal supporting a large screenlike backing on three sides. The large figure of Shakyamuni dominates the scene. He sits cross-legged, making the earth-witness gesture and holding a monk's bowl, whose white center creates a strong visual focus. From within the quiet realm provided by the throne enclosure, he seems to emerge as a beautiful golden figure with a broadly proportioned body, round face, and massively full, curved shoulders, arms, and hands. The patterns of his burgundy-red robe, whose patches are bordered with gold delicately laced with raised lines in gold-covered gesso, echo in smaller size the rigid geometric structure of the throne panels. Together with the flat, golden body of the Buddha these panels form the basis for the controlled calmness in the center of the painting.

The figural style of the Buddha can be traced to 13th- to 14th-century prototypes, especially from the central regions (Ü-Tsang), such as seen in some tangkas from Narthang (Akiyama et al, 1969, fig. 215). But the figure is not presented in such a monumental way and the style in general has undergone the process of refinement and elaboration characteristic of painting in the second half of the 15th century. The face of the Buddha is superbly rendered with flat gold and even red lines of great skill and control (3.1). The curved eyelids and rounded mouth are indicative of the Pala stylistic lineage and are distinct from the Guge style of Western Tibet of this time with its straight eyes and sharper mouth, as seen in Nos. 4 and 6. Yet the robe style and the broad body proportions are similar to those appearing in the wall paintings of Tabo monastery in Western Tibet from around the middle and second half of the 15th century. These factors suggest a wide distribution of artistic styles at this time, particularly between the central and western regions.

Behind the Buddha, transparent washes create unusual, strangely fluid waves of light for the body halo. This style is reminiscent of some 9th-century halos seen in the cave paintings at Dunhuang, the ancient oasis center on the northwest border of China with Central Asia. The minute foliate pattern that fills the center of the head halo is more traditional and is especially popular in Tibetan paintings of the 14th to 16th centuries. The refreshing beauty of the malachite green used in the head halo, and sparingly but effectively in a few other places in the painting, imparts a touch of transcendence to the otherwise earthy tonality of the painting. Adorning the outer border of the halos are fine lines in raised gold, a technique known as early as the third quarter of the 11th century in the wall paintings of the Sumtsek at Alchi in Ladakh but especially popular in tangkas and wall paintings from the Tsang region in the first half of the 15th century. The two attendant disciples, though small in size, are drawn with charm and verve. Each holds a monk's staff and alms bowl. They stand out by virtue of their bright orange robes, which are lined in gold and bordered in dark blue (3.2). The voluminous pleats of these heavy robes are modeled with slightly darkened color along their fold lines, a shading technique well known in paintings from the Tsang region, especially since the 14th century. These pleats seem to merge visually with the Buddha's body halo, effectively creating waves of movement around the immediate static center of the Buddha.

The throne backing, a particularly special feature of this painting, is intricately fashioned with decorated panels and a cusped-arch rim, which is adorned with alternating projecting dragon heads and flaming "bliss-swirl" (T. *gakyil*) jewels. This bliss-swirl design, which occurs at all the junctures of the inset panels as well, is symbolic of enlightenment's joyful integration of all dualistic opposition. Related to the Indian swastika and the Chinese yin-yang, it frequently appears in Tibetan art of later centuries, especially of the eastern regions. Thrones of this kind are prevalent in Chinese paintings of monks and Arhats from the 12th to 14th century. The origin of this type in China dates back to the late 6th and 7th centuries, as seen in examples from the paintings at Dunhuang and sculptures at the Lung-men cave temples.

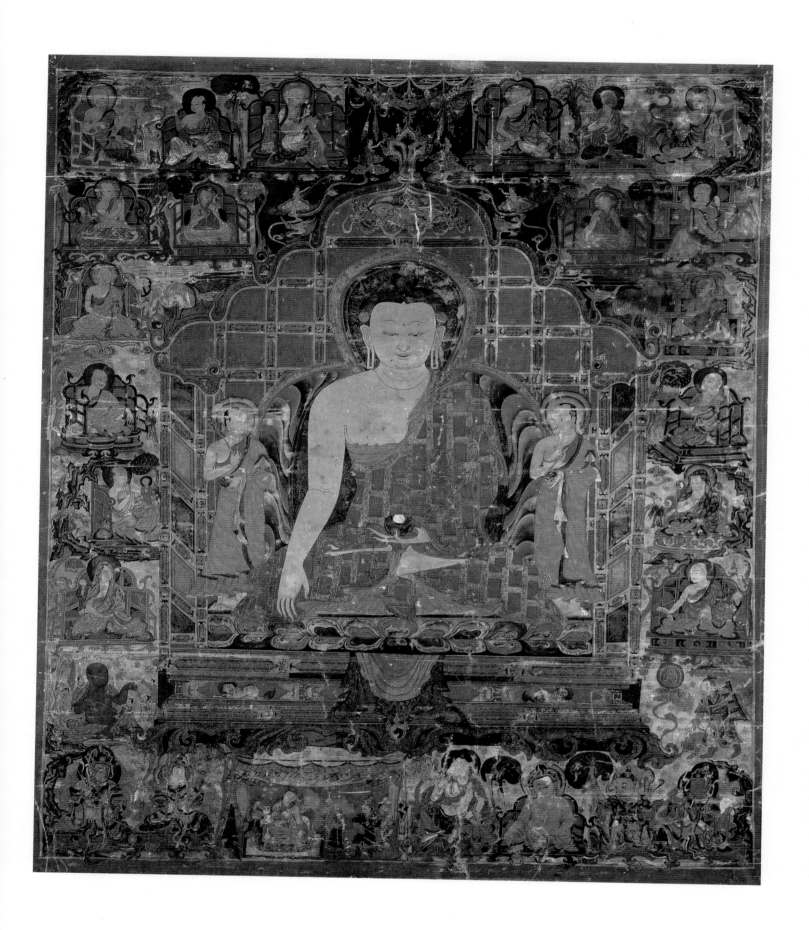

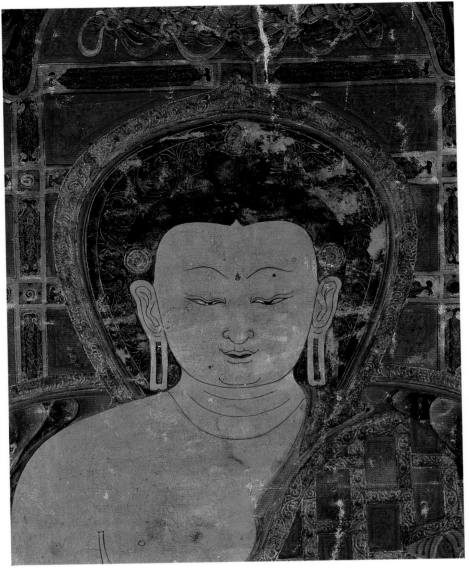

3.1

order described in the great collection of evocations (*sadhanas*) revised by Sakya Kunga Rinchen (see introduction to II, Arhats). Beginning with the Arhat Rahula at the top, the sequence moves from one side to the other rather than in serial order (see diagram): 1) Rahula, the son of Shakyamuni, holding a diadem; 2) Chudapanthaka, in meditation; 3) Pindolabharadvaja, with a book and alms bowl; 4) Panthaka, holding a book; 5) Nagasena, holding a libation vase and a staff; 6) Gopaka, holding a book in his right hand; 7) Abheda, holding a stupa given to him by the Buddha when he went to the country of the demon deities (*yakshas*); 8) Angaja, holding a fly whisk and incense burner; 9) Kanakabharadvaja, in meditation; 10) Vanavasin, holding a fly whisk (3.2); 11) Kalika, holding one or two earrings; 12) Vajriputra, with a fly whisk (3.2); 13) Bhadra, with right hand in the teaching gesture and left hand palm up in his lap; 14) Kanakavatsa, holding the precious lasso (3.2); 15) Ajita, in meditation with his garment pulled over his head; and 16) Bakula, holding a jewel-spouting mongoose in his left hand. This set is especially important because it is an early complete example of one of the main cycles of Tibetan Arhats, possibly one associated with the Sakya Order, and each figure closely conforms to the established iconographic type. In addition, each Arhat is presented as an interesting, spirited personage, accompanied by a disciple and seated in a thronelike chair, each with its own distinctive style. With loosely draped garments associated with the Chinese type, fancy chairs, and unusual rocky settings, this style of Arhat depiction derives in large part from the painting traditions of Chinese Buddhist art of the Southern Song period, such as those known in the famous scroll painted by Zhang Shengwen and dedicated by the king of Yunnan in 1180 (Chapin and Soper, 1972, pls. 12–16, 19–23).

Hvashang (17) and Dharmatala (18), both special adjuncts to the group of Arhats in Tibetan art since at least the late 14th or early 15th century and usually numbered as the seventeenth and eighteenth Arhats (see Nos. 14 and 17), appear to the left and right above the pairs of richly bedecked Heavenly Kings of the Four Directions at each of the bottom corners (19, 20, 24, 25). Hvashang, the chubby dark attendant, is joyfully encumbered with numerous children. Dharmatala, the messenger of the Arhats, carries a backpack of books and is accompanied by his tiger as a small figure of Amitabha, the Buddha of Infinite Light, floats in a circle above. In the center at the

These, however, clearly reveal a derivation from Southeast Asian and Indian throne types. It would appear that this type of chair-throne style has made a circuit, over time and with some stylistic changes, from India and Southeast Asia through China to Tibet. A similar kind appears with some sculptures dating to the second quarter of the 15th century in the Peljor Chöde at Gyantse in Tsang (text fig. 22).

A gauzelike canopy appears in front of the upper panel of the throne above the Buddha's head. To each side, on light clouds silhouetted against the dark sky of deep blue clouds, a tiny celestial goddess appears holding a minuscule canopy. Two more goddesses flank the throne's pinnacle, below another canopy of delicate swags and pearl festoons. They are kneeling on red clouds and pouring water over the Three Jewels (Triratna) emblem at the pinnacle of the throne. Except for the unusual scroll design of the base, the pedestal is derived from styles known in 14th- to 15th-century Tibetan paintings related to

Nepalese styles. The multistage, bejeweled platform with its crouching lions is covered, like the throne backing, with threadlike gold lines in extremely delicate floral patterns of the highest refinement—an especially notable feature of this painting.

By the geometric clarity of its structure, beauty of solid color, and delicate linear designs, this intricate throne ensemble not only affords a controlled, though actually spaceless, center for the main triad, but also creates a stark contrast with the nervous, fluctuating movements, muted color tonalities, and naturalistic settings of the encompassing scenes of Arhats, guardians, auspicious deities, and donors. Almost as in another world, the Arhats spread around the central group above and to the sides in rather large, individual square spaces defined by surrealistically mobile and sharp rock formations and simple yet individualistic trees (3.2). Although there is some slight variation, this cycle of Arhats appears to follow the

bottom is the donor, a prominent seated figure accompanied by a servant and three standing figures in distinct dress with broad-brimmed, cone-shaped peaked hats (21). To the right of this donor panel are Ganesha (22), the auspicious white elephant-headed god, and Kubera (23), the plump, square-faced golden god of wealth, squeezing jewels from his mongoose. Two lamas (26, 27), one holding a rosary, appear seated in chairs like the Arhats just above the back of the Buddha's throne.

In its sophisticated elegance, this painting is compatible with the artistic style of the middle and second half of the 15th century associated with some of the developments during and following the embellishments of the Kumbum and Peljor Chöde at Gyantse (Tsang). Because of the inclusion of stylistic elements of Nepalese and Chinese derivation, this work is stylistically complicated. The color scheme relates to the tradition of paintings from Tsang, and the popularity of both Chinese and Nepalese elements in the art of that region would further tend to suggest that area as the likely provenance for this work. The presence of the "Chinese"-style Arhats in the Tsang region is attested not only by written accounts but also by surviving works, such as the Arhat sculptures at the Peljor Chöde from around the second quarter of the 15th century. The style of skillful, penlike brush-line drawing, besides being related to the paintings of the Gyantse Kumbum of the same date, is also close to that seen in the sketchbooks of artists with strong Nepalese artistic background, such as the book of Jivarama dated 1435 in the Neotia collection, Calcutta (Lowry, 1977). This sketchbook adds further evidence for a dating in the middle of the 15th century for this unusual, intricate, and important painting.

5	3	1		2	4	6
7	26				27	8
9						10
11						12
13						14
15						16
17						18
19	20	21	22	23	24	25

3.2

4

Shakyamuni Buddha
and Two Bodhisattvas

Western Tibet; Guge

Second half of the 15th century

Tangka; gouache on cotton

40½ × 34½″ (103 × 87.5 cm)

Virginia Museum of Fine Arts, Richmond.
The Nasli and Alice Heeramaneck Collection.
Gift of Paul Mellon

Lit.: Tucci, 1949, p. 363; Pal, 1987, pp. 58–63; J. Huntington, 1972.

Within the formal, highly symmetrical structure of this tangka, the central figure of Shakyamuni Buddha clearly governs the composition. His right hand in the earth-witness gesture and his left holding a monk's bowl, he sits in calm and lordly grandeur, his full but gracefully delineated golden body garbed in robes of orange-red with dark blue-green lining and borders. Delicate designs in fine yellow lines embellish the robe, defining the patches and ornamenting them with an unusual and delightfully free-flowing curvilinear vine motif. Small flowers decorate the underlining; wispy cloud motifs on the outer borders have a delicacy typical of the Guge-school paintings, of which this is a fine example. Behind the body the round, flower-bordered halo has an intricate, naturalistically rendered floral scroll pattern used as a filling design and executed in the same delicate and precise manner. The moonlike face of the Buddha with the crisp, linear drawing of the straight-edged lowered eyes and slightly smiling mouth contrasts with a plain dark halo edged in lacy flames. Orange-red henna, a mark of beauty, decorates the palms and soles of the Buddha's feet, a feature of long tradition in Indian paintings of the Buddhas and Bodhisattvas.

To left and right stand gracefully bending Bodhisattvas, their heads inclined toward the Buddha and their hands holding lotus stalks that carry their symbolic attributes. The pale yellow figure with sword and book on the Buddha's left

is Manjushri, representing the profound (wisdom) lineage of the Teaching. The orange figure with the vase at the Buddha's right is Maitreya (mistakenly identified as Samantabhadra by Giuseppi Tucci), representing the magnificent (love and compassion) lineage. Both wear the jewels, scarves, and garments that are typical of Bodhisattvas, leaving the upper body bare. Decorating the striped cloth of Maitreya are depictions of four tiny Great Adepts (Mahasiddhas), masters of the Buddhist tantras (4.1).

Surrounding this triad is the portrayal of an elaborate shrine, quite different from the throne-backing type seen in No. 3. Two-stage pillars rise from the backs of elephants, hold a lion and leogryph (*shardula*, with lion body, horns, and wings) pair at midlevel, and support on the uppermost platform large fantastic *makaras* (composite beasts with elephant-crocodile heads and fish bodies), whose scaly skin and scroll-like "feathers" ornamentally outline an arch that terminates at the apex in a small, lionlike "face of glory" (*kirtimukha*). The red interior of the shrine, which splendidly offsets the prominent shape of the Buddha and his gold-tipped, rather small, circular halos, is covered with a faint "shadow" pattern of beautifully naturalistic linear floral scrolls punctuated only by three tiny circles containing deities (Amitayus and Vajradhara) and a lama wearing a yellow hat (possibly Atisha).

This general form of shrine depiction—

well known in Indian, Nepalese, and Tibetan art for centuries—is continued here with as much freshness, ingenuity, and fascination for detail as at any time in its long and fertile history. In Tibet this particular type of shrine motif is associated with art of the Indian (including Kashmiri) and Nepalese styles. Although a popular motif in all the schools of Tibetan art, it was perhaps most prevalent among the various schools that were executing paintings under the patronage of the Sakya Order during the 14th to 17th centuries in the central regions (especially Tsang). Its usage in the Guge school of Western Tibet of the 15th to 16th century can probably be considered an indication of the assimilation of some elements from the painting style of the central regions into the continuing developments within the Western Tibetan traditions.

Balancing the shrine is the lotus seat, its mostly dark green petals punctuated by a few orange ones, the whole creating a dark contrast to the brighter shrine area above. Below the rows of petals with their gold-tipped, crenellated edges, vines with floral tendrils encircle lions and a male and a female Gandharva, half-human half-bird celestials of the heavenly slopes of Mount Meru. Two small Nagas (underwater serpent deities), also male and female, lend support to the lotus stalk that rises from the pool below. Fish, ducks, geese, conch shells, and some auspicious symbols mingle among the stylized waves of the pool as deer look on from the banks (4.1).

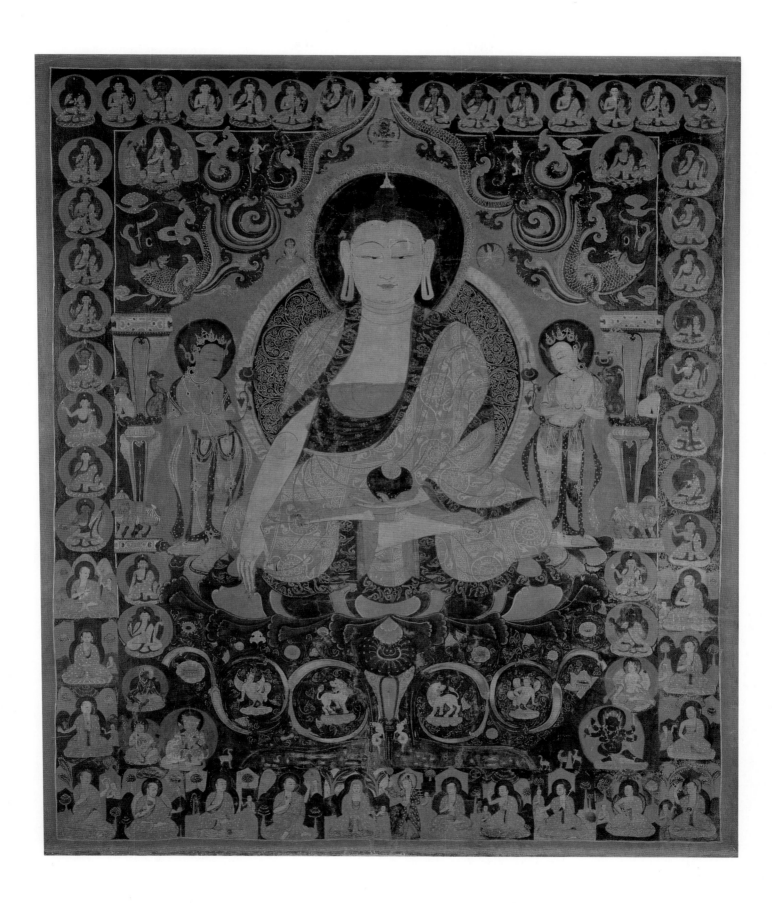

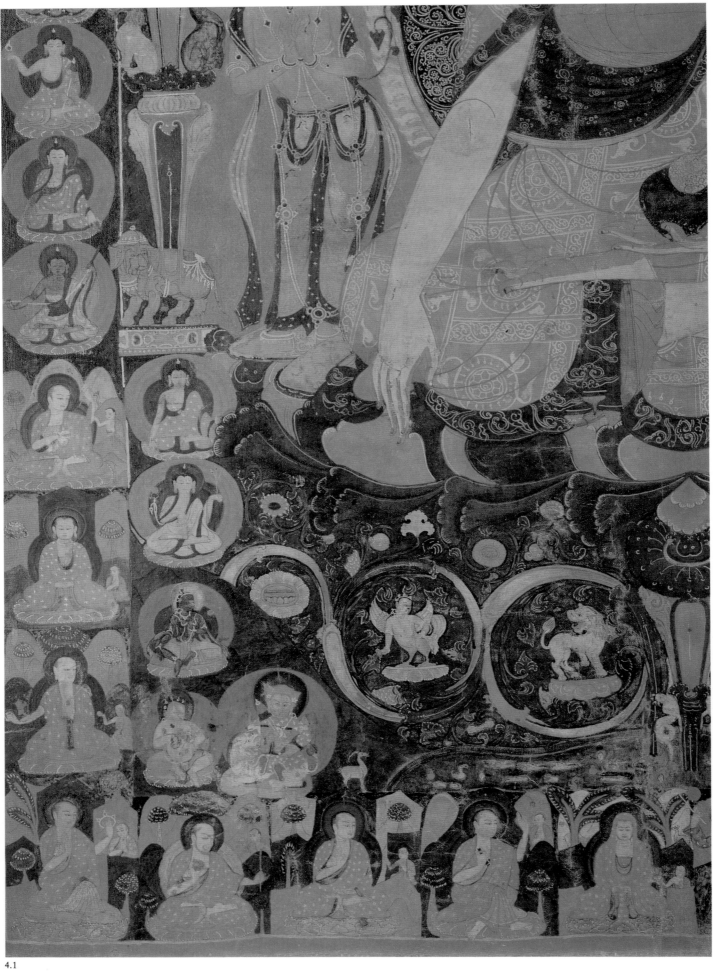

4.1

Above the shrine, in the corners of the inner frame, are two small triads, one of unidentified lamas (right side) and the other of Tsong Khapa (1357–1419), founder of the Geluk Order, wearing the yellow philosopher's hat, accompanied by his two main disciples. The appearance of Tsong Khapa indicates that this painting is in some way connected with the Geluk Order. It is one of the few such paintings known from the early period of this order. Small flowerlike clouds waft around the shrine against the blue-green sky and two tiny figures can be seen dancing among the clouds and tendrils of the swirling ornament. In the lower corners of the inner zone (4.1) are four of the Thirty-five Buddhas of Confession (two on each side) and several "archetype deities" (T. *yi dam*), a Green Tara, a White Tara (both female Bodhisattvas of Compassion), a Jambhala (wealth deity), a Vaishravana (World Protector) and a six-armed Mahakala (terrific archetype deity). In the outer border on the top and upper portion of the sides are the rest of the Thirty-five Buddhas of Confession (only a total of thirty-four are depicted; the Buddha Shakyamuni is the thirty-fifth). The Thirty-five Buddhas comprise a kind of spatial mandala encompassing all existence in the four main, four secondary, and twenty-four intermediate directions, together with the center, zenith, and nadir. Along the bottom and the lower parts of each side are the sixteen Arhats, the enlightened monks who remain in this world to continue to teach the Buddha's doctrine until the arrival of the next Buddha. The sequence of the Arhats here is different from that in No. 3 and conforms closely to the order according to Atisha's lineage, which begins with Angaja as the first Arhat (see introduction to II. Arhats). This factor and the presence of Tsong Khapa would seem to indicate a Kadampa-Gelukpa connection in this tangka.

In this painting the sixteen Arhats are divided into two sections, separated by the standing figure of Dharmatala carrying a small load of books on his back in the center of the bottom line (4.1). His presence as the seventeenth, adjunct, Arhat (and the lack of Hvashang, the eighteenth, adjunct, Arhat) reveals this to be a

seventeen-Arhat tangka, a rarer version, but one noted in a treatise on the Arhats by the Fifth Dalai Lama (see introduction to II. Arhats section). This set begins on the left side (see diagram and 4.1) with 1) Angaja, 2) Kanakabharadvaja, 3) Vanavasin, 4) Kalika, 5) Vajriputra, 6) Bhadra, 7) Gopaka, and 8) Ajita. It continues on the right side with 9) Bakula, 10) Rahula, 11) Chudapanthaka, 12) Pindolabharadvaja, 13) Panthaka, 14) Nagasena, 15) Kanakavatsa (?), and 16) Abheda (see No. 3 for the attributes of each). This representation along with those in Nos. 3 and 6 in this book is important evidence of complete sets of Arhats in 15th-century Tibetan art. They clearly reveal that the forms, *mudras*, and attributes were already well formulated by that time. In style the Arhats in this tangka appear to conform more closely to Indo-Nepalese-Tibetan rather than to Chinese characteristics. Each figure is rendered differently and is a delightful miniature portrait, but they do not have the prominence and freedom seen in the Arhat portrayal in the British Museum tangka in No. 3. The landscape settings show rocky mountains related to earlier portrayals as seen in Nos. 23 and 24, but considerably simplified and less stylized.

Although the color scheme of this painting is limited, it is unusual. Reddish orange and blue-green predominate, rather than the more common primary colors of red and blue. They do, however, create an aura of potency, like a fresh spring landscape. Yellow, white, and the sparse dark blue are sensitively alternated to create as much variety and contrast as possible. Color tends to be applied in flat, solid, sometimes translucent planes without modeling. Line plays a role equally essential to that of color; it is at all times an evenly drawn line of precision and lyrical beauty. Executed with a brush, it has an astonishing combination of unflagging energy and delicate lightness. It varies from the superbly curved lines indicating the folds of the Buddha's robe to intricate patterns of vines, flowers, and clouds on the robes and halo of the Buddha. From the Buddha down to the smallest figures nestled among the scroll patterns, clouds, or waters, the execution of line is fastidious, subtle, intense, and

disarmingly free. Within the seeming restraint is a subtle playfulness that delights in hints of distortion, as in the bending torsos of the Bodhisattvas, or in purely calligraphic line, as in the zigzag of the garment folds on the Buddha's left arm. Almost passing unnoticed, these small touches enliven the rather sober and deep tonality of the colors and the strong two-dimensional patterning and clear formality of the rigid structural layout.

This tangka was acquired by Giuseppi Tucci in Western Tibet. It is one of the splendid paintings from the Guge dynasty of Western Tibet, which experienced a "renaissance period" from around the middle of the 15th to the middle of the 17th century. Several other masterworks of this "Guge school," as it was termed by Tucci, appear in this book (Nos. 6, 97, 129, 151). In Tucci's view, this example belongs to the "ripe period of the Guge school." The somewhat fluid and even quality of the line, some of the light, curvilinear floral patterns, and the sleek smoothness of the forms and color would seem to relate the style to the wall paintings of the Chakrasamvara chapel and of the Red Temple at Tsaparang, both dating around the second half of the 15th century. The iconography of the Arhats, however, may indicate an early dating in the Guge group, possibly in the second quarter of the 15th century (see No. 13). On many accounts, this tangka becomes one of the especially important works of the Guge renaissance.

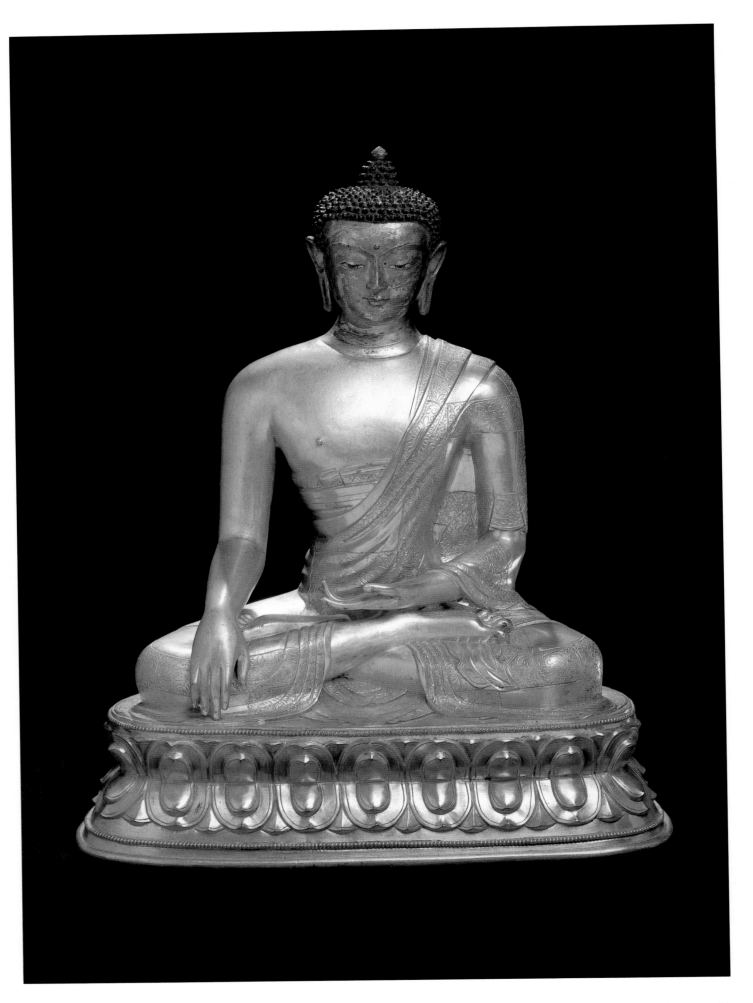

5
Shakyamuni Buddha

Tibeto-Chinese

Late 17th century

Gilt brass, with chasing, cold gold paste,
and pigments; sealed with relics inside

H. 16⅛″ (41 cm)

The State Hermitage, Leningrad.
Kozlov Collection

Buddha Shakyamuni is shown here in his most popular and widespread iconographic form: sitting cross-legged in *padmasana* (the lotus or diamond posture) with his right hand in the earth-witness gesture and his left hand in contemplation. His garment is like that of the first members of the Buddhist community, who wore clothes made of wornout rags sewn together. Marks of circles (*chakras*), one of the *lakshanas* (auspicious marks of the Buddha's body), are engraved on his palms and soles. Unlike the *lakshanas* of the *urna* and *ushnisha*, which one can find in almost every Buddha sculpture, *chakras* are rarely depicted.

This image belongs with the group of Tibeto-Chinese sculptures of the Chinese early Qing period (1644–1912). There are many elements of the Qing style in this figure, such as the particular ornamental floral design on the borders of the garment and on the borders of each patch, the characteristic "triangle" design on the borders of the garment, and the typical pleat folds of the drapery over the Buddha's chest.

Although undoubtedly of Qing origin, this sculpture shows the signs of an early stage in the development of Qing style. Double lotus petals surround the throne of the Buddha, leaving no empty space at the back of the sculpture, as is usual in 18th-century Qing bronzes. At the same time the number of lotus petals here is uneven (twenty-one) while the number on Ming bronzes is almost always even.

The face of the Buddha is very unusual for Qing bronzes. It is squarish and is more reminiscent of a Central Asian (possibly Tibetan) ethnic type than the uniform, chubby faces associated with Qing lamaist images. Perhaps this sculpture was made in China by a Tibetan master who chose to portray the face in this way; or it could have been made with the idea of making the image especially for Tibetans.

In any case this sculpture has been used by Tibetans. There are two Tibetan words scratched in capital letters on the upper surface of the throne below the Buddha's

knees; "dru" (?) at his right knee and "tshes brgyad" at his left knee. The meaning of *dru* is obscure. Possibly it is a mistake or an abbreviation from *drug,* "six," or from *drung,* "beside" or "near to," or even from *drung 'khor,* "retinue." The last two variants may have a connection with *tshes brgyad,* which means "the eighth day." The eighth day of a lunar month in the Tibetan calendar is one of the three so-called Buddha's Days, namely, the day of the Medicine Buddha Bhaishajyaguru. It is quite possible that this image of Buddha Shakyamuni had been used by Tibetans in rituals connected with this holiday.

The State Hermitage possesses one of the world's largest collections of Tibetan art. It includes more than five thousand tangkas, bronze sculptures, ritual objects, wood blocks, and textiles. The basis of this collection was compiled by Prince Esper Ukhtomsky (1861–1921), one of the most prominent Russian orientalists of his day. Following his graduation from St. Petersburg University, Prince Ukhtomsky took a keen interest in Asian culture, primarily that of Central Asia. He started his collection in the mid-1880s after making several trips to Kalmuck and Buryat in northeastern USSR. Over the years he made numerous trips to those regions as well as to China and Mongolia, where he made many friends among Buddhist lamas, noble families, and also common people. Being a prominent Russian noble and for many years the publisher and editor-in-chief of the main Russian official newspaper, *The St. Petersburg Record,* Ukhtomsky was an influential person in the capital. He used his position to advance his liberal views, especially in regard to the problem of nationalities within the empire. Since he favored establishing more equality for the smaller nations of Russia, he acquired a reputation as a protector of the Russian Buddhists. Because of this, he had the unique opportunity to collect his Buddhist art directly from the people rather than through dealers, auctions, and conventional acquisition means. At that

time he also had practically unlimited choice of objects, so his collection reflects high quality and great range as well as his own particular knowledge and taste. The remains of his personal archives reveal that he thoroughly studied nearly all the important European publications on Tibet, Buddhist art, and Buddhism of that time. His knowledge directed him to collect works that would reflect the entire picture of the development of art in Tibet as well as in the adjacent areas.

The collection consists mainly of objects from the northern and eastern regions of the area influenced by Tibetan culture. Other Western collections usually reflect southern and western regional sources. So while there may be a lack of Nepalese or Kashmiri bronzes, this collection is probably richer in the 18th- to 19th-century Chinese and Mongolian bronzes than most other collections in the West. Interestingly, Ukhtomsky was also one of the first to recognize the importance of tangkas and bronzes as a source equally as important as texts for the study of Tibetan culture. Scholars began to recognize the value of his collection, and in 1900 the noted German scholar A. Grünwedel wrote his famous book *Mythologie des Buddhismus in Tibet und der Mongolie* utilizing the Ukhtomsky collection. This book was exhibited in the Paris Exhibition of 1900, where it was awarded a Great Gold Medal.

Subsequently, in 1902, Ukhtomsky gave his collection to the Ethnographical Department of the Russian Museum in St. Petersburg and continued to add objects. For example, in 1905, with the assistance of the famous Agvan Dorjiev, he commissioned Buryat masters to make a complete Paradise of Amitabha, which he gave to the Russian Museum. In 1933 the Ukhtomsky collection was divided into two parts: the larger one was given to the Oriental Department of the Hermitage and the other to the Museum of the History of Religion (in Leningrad). Some years later the Hermitage collection was enlarged by the collection of P. Kozlov, which he compiled in his numerous trips to Central Asia.

G. Leonov

6

Shakyamuni Buddha
with Scenes of His Life

Western Tibet; Guge

Second half of the 15th century

Tangka; gouache on cotton

40 × 32″ (101.5 × 81.3 cm)

Robert Hatfield Ellsworth Private Collection

Lit.: Tucci, 1949, pp. 351–59, pls. 24–28;
J. Huntington, 1972.

This painting is one of the masterpieces of the Guge school of Western Tibet, which flourished from the second half of the 15th to ca. the middle of the 17th century. It glorifies the image of Shakyamuni and his two great disciples, Shariputra and Maudgalyayana, in the center of the painting. Above the central triad are small figures of Maitreya and Manjushri, as Bodhisattvas respectively representing the magnificent (compassion) and profound (wisdom) lineages. The circular halos and layered pedestal—both elaborately ornamented—as well as the varicolored lotus with its crenellated edges, complete the definition of the central zone. Around it are series of figures and illustrative scenes.

This Buddha and his two disciples are among the most masterfully painted figures of the Guge renaissance style, and are notable especially for the subtlety and vividness of the color and the controlled sharpness and alert spirit of the line. The reverberations of orange and yellow against the lavender-reds and dark blues create a refreshing and idealized beauty; the linear components with their crisp yet fragile lightness create a taut, fanciful, yet lyrical counterpoint (6.1). Like strings of the finest piano wire, these lines almost seem to create an ethereal melody in harmony with the translucent colors, yielding a beauty apparently beyond the real and in the realm of the purely aesthetic. Yet humanness glows within: the perfectly rounded faces with their long eyes and gently smiling mouths, the playfully long, curling fingers, and the slightly chubby, weightless feet. Despite the overriding emphasis on ethereal beauty, an inner human warmth is projected with lightness and wit. It becomes an apt expression of the Buddha's transcendent

perfection coordinated with a lively sensitivity to our world. The Guge renaissance period painting has a unique and meaningful style that aptly expresses the Buddhist ideal.

The upper portions of the painting are filled with two rows of the depiction of thirty-four of the thirty-five Buddhas of Confession (Shakyamuni is the Thirty-fifth), each one seated on a lion pedestal. Just below are the sixteen Arhats with Hvashang and Dharmatala, the two "adjuncts," making an eighteen-Arhat representation (6.2). Tucci has listed the names of all the individual Buddhas of Confession, which encompass all directions of space, but he did not identify the Arhats, although each has its own inscription. These Arhats form another interesting group along with those of Nos. 3 and 4. Though presented differently from No. 4, this group also appears to follow the sequence associated with Atisha. On the left side are (see diagram): 1) Angaja, 2) Ajita, 3) Vanavasin, 4) Kalika, 5) Vajriputra, 6) Bhadra, 7) Kanakavatsa, and 8) Kanakabharadvaja with 18) Hvashang (called Ahorsha in the inscription [Tucci, 1949, p. 561]). On the right are 9) Bakula, 10) Rahula, 11) Chudapanthaka, 12) Pindolabharadvaja, 13) Panthaka, 14) Nagasena, 15) Gopaka, 16) Abheda, and 17) Dharmatala. The landscape setting is similar to that of No. 4, but slightly more elaborate. The figures are mildly elongated and, though small in size, are rendered with spirit and engaging individuality (6.2).

In the lower sections compact scenes of the Buddha's life, each accompanied by an inscription, unfold from left to right, beginning in the middle of the left side. The scenes move counterclockwise through five registers to the large lower section and

continue up the right side with eight registers of scenes terminating in the eight great stupas containing the relics of the Buddha after his Parinirvana. These life scenes are the most elaborate and complete series within one tangka that is known from the earlier centuries of Tibetan art. It rivals in smaller scale similar series known in temple wall paintings.

Two palaces begin the life sequence at the middle of the left side (6.1). They depict Shakyamuni in the Tushita Heaven before his birth on earth and show his transmission of the Buddha lineage to his successor, Maitreya, the next Buddha of this earth. Below is the scene where he is conceived by his mother, Queen Maya, who lies on a jeweled couch. His birth from Maya's right side in Lumbini garden is seen at the far left of the next panel, while the appearance of marvelous signs and the scene of his lustration by the gods is center and right in the same panel. In the fourth level the baby Buddha is shown taking his seven steps (marked by lotuses

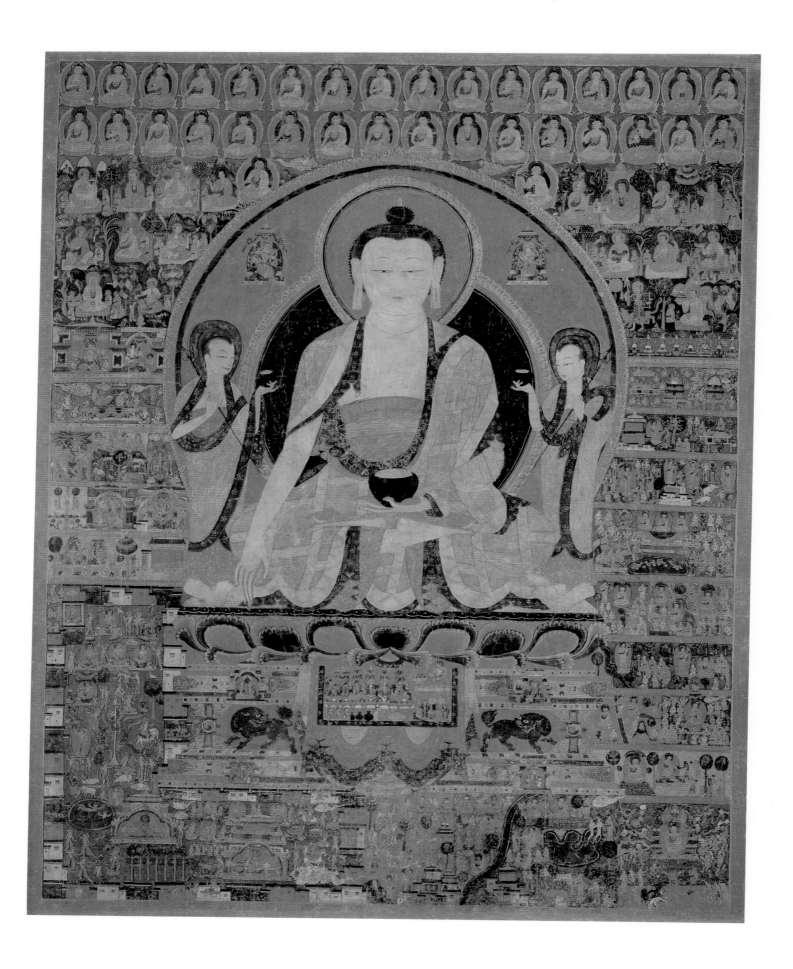

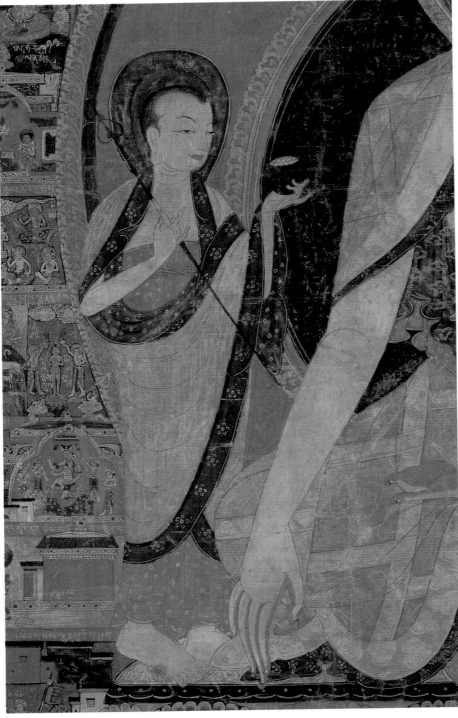

6.1

four occasions, when he saw for the first time in his sheltered life the actuality of old age, sickness, and death. On the fourth encounter, he saw a monk. Reflecting on these encounters, he finally determined to seek the truth of the suffering he had perceived, to see if there is a way to freedom. He is shown leaving the palace stealthily by night on his white horse, Kanthaka, whose hooves are supported by deities to muffle the sound. With this act, his youth in the palace at Kapilavastu came to an end. In this painting this entire sequence is bounded by the dwellings of the palace and city.

Unfolding further along the bottom are the events of cutting off his hair, becoming an ascetic, receiving food (cooked milk and rice) from the maiden Sujata, and his subsequent meditation at Bodhgaya, where after forty-nine days he achieved enlightenment with the defeat of Mara. This is illustrated in the large scene in the lower right corner where the hosts of Mara are shown threatening the Buddha, who is seated in meditation above the rocky ground. From this point, in eight registers, unfold events following his enlightenment. These include: the offering of the four bowls (which Shakyamuni turned into one) by the merchants; the teaching to the five ascetics at Sarnath (the turning of the wheel of the Law); the being sheltered from a downpour by the hooded snake; the descent from the heaven of the Thirty-three Gods (the Indian Olympus), where he went to teach his mother, who had died three days after his birth; an ordination of nuns taking vows in the garden of Venuvana; his preaching the Transcendent Wisdom on Mount Grdhrakuta; the miracle of the multiplication of images; teaching and defeating of the heretics who are cast into the lake; the begging for alms and subduing of the mad elephant Nalagiri in Rajagrha; the monkey's offering of honey, an act for which the monkey was reborn in a heaven; and Shakyamuni's final illness. The sequence ends with the Parinirvana and cremation in a self-created fire with the eight stupas containing the divided relics portrayed above. With charm and descriptive genius these multiple scenes are arranged with little setting and executed with a light touch and bold coloring of reds, green, and gold against a deep blue background. The somber tonality is characteristic of the style and creates a heavy, serious tone quite suitable for the subject.

This tangka was part of the group of paintings acquired by Tucci in Tsaparang, the capital of the Guge dynasty in Western Tibet. Although having many stylistic

in a mandala pattern in the center and four directions). The scene at the center shows him "honored by the eight mothers." At the right the sage Asita examines the baby and tells his father, King Shuddhodhana, that his son will be either a universal monarch (Chakra-vartiraja) or a fully enlightened Buddha. The last scene in this registered sequence shows the prince being taken to a temple and honored by the gods (6.1). Interestingly, the style of this scene seems to relate to that of paintings from the Western Indian Mewar school of the 16th century.

In the entire lower left section are a

number of well-known scenes from the prince's youth, including various sports contests and the throwing of the elephant's carcass. Moving along the bottom, the first scene shows the First Concentration. While witnessing the spring plowing festival, the prince was distressed to see the birds eating the worms and bugs. He sat beneath a rose-apple tree and spontaneously went into meditation, reaching the high contemplative level known as the First Concentration. Thereafter, there is the scene of the prince in the palace with his wife and the palace ladies. Then there are his encounters when leaving the palace on

elements in common with tangka No. 4, this painting is larger, more complex, and has a significantly different color scheme. According to Tucci, it is very similar to some wall paintings he saw in the Red Temple at Tsaparang, which was founded by the wife of the Guge king, himself a contemporary of the Gelukpa missionary monk Ngawang Gyatso. This monk was a disciple of Tsong Khapa (1357–1419), the founder of the Geluk Order, so his dates may be assumed to be the earlier half of the 15th century, with his missionary work in the later phase. These associations suggest a date for the Red Temple around the middle to second half of the 15th century. Certainly the style of this tangka also relates in many ways to the wall paintings in the Kumbum at Gyantse in Tsang (ca. the second quarter of the 15th century), as well as to the Guge renaissance-period wall paintings of the Tabo monastery, located to the west of Tsaparang in present-day Spiti. These three great cycles of wall paintings in Tsang, Tsaparang, and Tabo, all probably dating in the period from the second quarter to the end of the 15th century, have stylistic correspondences that can also be seen in this tangka, suggesting a probable date in the middle to latter half of the 15th century. Its well-preserved condition heightens its preeminence as an exemplary work of the Guge school, and as a representative in tangka form of the great Guge cycle of wall paintings.

6.2

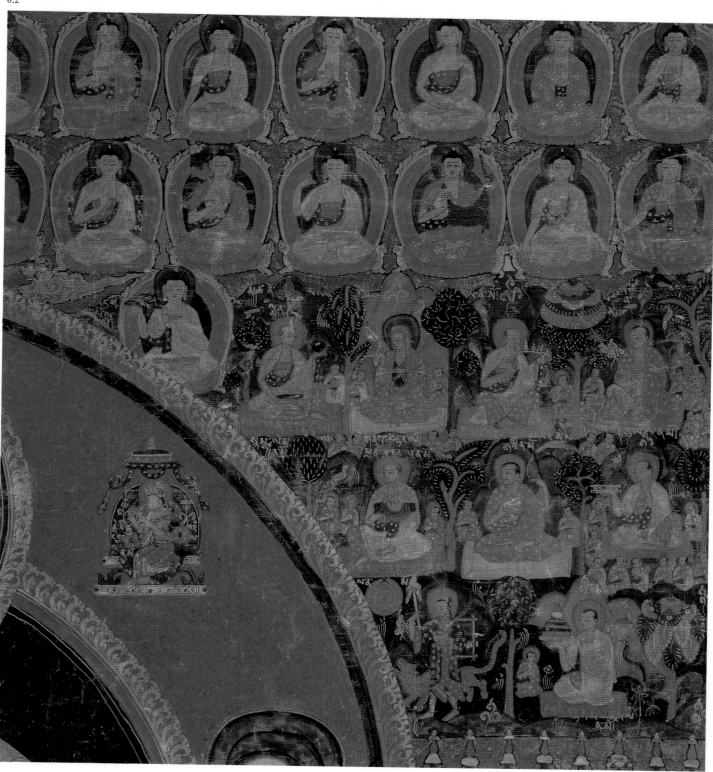

7

Shakyamuni Buddha with Scenes of His Former Lives

Eastern Tibet (?)

Dated to the Wanli period (1573–1620)

Tangka; gouache on cotton

27⅞ × 18⅝″ (70.8 × 47.5 cm)

The British Museum, London

Lit.: Pal, 1969, p. 136; Bryner, 1956;
Speyer, 1982, pp. 172–291.

A solitary figure of Shakyamuni is centrally positioned within an array of scenes illustrating a series of ten of his Former Lives (Jatakas). Seated slightly higher than midway in the composition with his right hand in the earth-witness gesture and his left resting contemplatively in his lap, the image is effectively silhouetted against dark blue (lightly lined with thin gold rays) and green halos. The contrasting golden shape of the exposed part of the Buddha's body, outlined with only the thinnest of lines, underscores the style of expanding and contracting curves of the small head, narrow neck, extremely broad shoulders, and slim waist. These proportions suggest the ideal of an athletic, youthful figure, in sharp contrast to the more gentle and sedate ideal of the renaissance period of the Guge school of Western Tibet (Nos. 4, 6). Reinforcing the taut dynamics of the body are the lively rhythmic arcs of the drapery that loosely but energetically enfold the figure. Above the inner robe of red is a pale silk robe latticed with red patches lined with dark dots. The sweeping and fluid curves of the hems and folds, controlled in short bursts of energy, constitute one of the distinguishing features of this style. It contrasts with the more brittle, sustained, and delicate lines of the Guge renaissance style as seen in Nos. 4 and 6 and reflects the changing styles of the late 16th century, which also affect the late phase of the Guge style, as seen in No. 97. Under the white moon seat is a broad lotus whose curled golden edges echo the curvilinear flourishes throughout the painting. The dark leaves of the lotus are simply and naturalistically depicted in two shades of green, a feature typical of Chinese flower painting.

Moving clockwise from the upper right corner is a series of scenes, each one accompanied by an inscription and a number (written under the semicircle at the end of each inscription). The numbers run from twenty-one to thirty, indicating

that this painting is the third in a series, each of which contains ten scenes. They illustrate ten Former Life stories from the popular text of Aryashura's lyrical Sanskrit poem, *The Garland of Former Life Stories (Jatakamala)*, probably written in the 1st to 3rd century CE. Although many of the stories also appear in the earlier Pali series, some are different. Tibetan representations of these stories generally follow the work of Aryashura. Former Life stories demonstrate the virtuous and heroic deeds of a Bodhisattva through eons of lives in various forms, showing how one evolves toward Buddhahood. Stories twenty-one through thirty illustrate the transcendent virtue of patience (*kshanti*). Although some inscriptions in this tangka are partly illegible, the readable ones, combined with the illustrations and compared with the text, allow sure identification of the scenes. Beginning with scene twenty-one, we offer a free translation of the inscription and then comment on the original text, while relating it to the scenes in the painting (see diagram). The stories are as follows (inscription translations are by Lobsang Lhalungpa):

1) No. 21: The Shuddhabodhi Life Story

*The ascetic (Bodhisattva Shuddhabodhi),
after renouncing the worldly life, was living
 in a forest.
He was assaulted by a lecherous king.
Yet the sage subdued his own anger
and remained patient and concerned even for
 his enemy.*

This is the Former Life story that tells of the Bodhisattva, born as a noble named Shuddhabodhi, who, together with his wife, renounces that life (a) to become an ascetic in the forest (b, c). One day a king comes to the forest and, noticing the beauty of the hermit's ascetic wife, takes her by force for his harem (d). However, on noticing the sage's patient freedom from anger at even this great crime (e), the king returns his wife and becomes the sage's disciple (7.1).

2) No. 22: The Mahahamsa Life Story

*Through his fame as compassionate protector
 (of his flock),
and his gift of Dharma teaching,
he won the heart of King Brahmadatta of
 Benares.
The King placed (the Bodhisattva) on a
 jeweled throne.
He then gave the King a religious discourse.*

This section illustrates the Mahahamsa Jataka, which relates the Buddha's birth as king of the geese (*hamsa*). He is tempted to leave his abode on Lake Manasa to see a splendid lake built by the king of Benares, although it is against the advice of his wise counselor and companion, the future Ananda, who nevertheless accompanies him on his flight to see the lake. Unknown to the birds, the king had made the lake especially to entrap these famous birds. The king's fowler watches the flock (a) as they come with their leader. The Bodhisattva is caught in the fowler's snare and he warns the flock to fly away (b). His companion comes and begs the fowler to let him take the place of

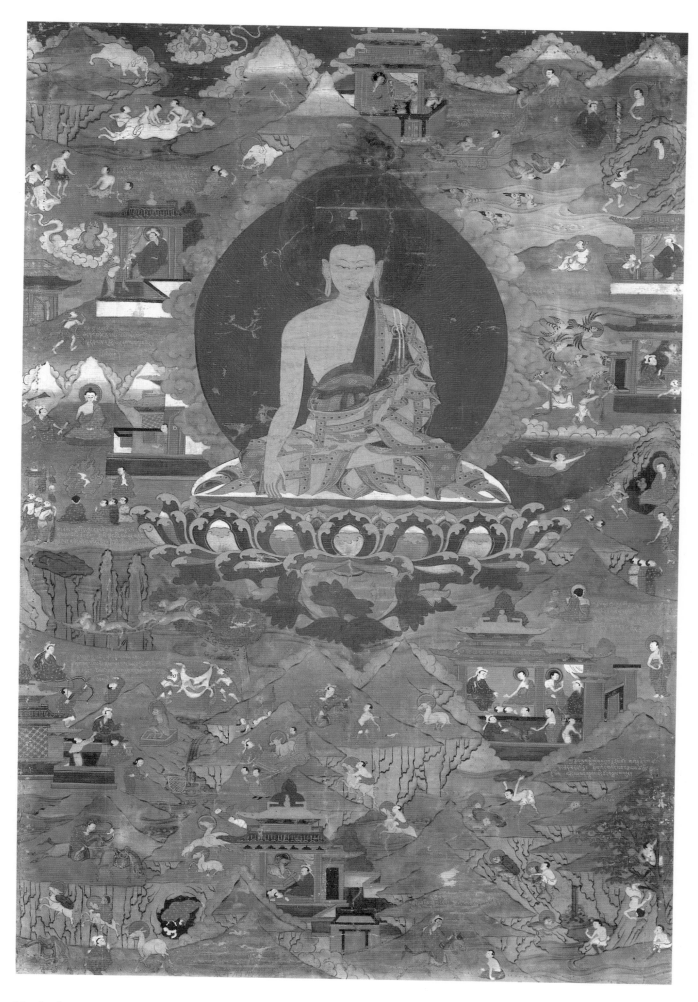

7.1

*he was entrapped by an evil man and sucked
into the jaws of Death.
The man shamelessly tried to kill him.
Homage to (the Bodhisattva) who thereupon
liberated him, thus repaying evil with
kindness.*

In this life the Bodhisattva was a great,
noble-minded ape living alone in the
forests of the Himalaya mountains. Once a
man who was chasing a lost cow came to
a secluded area where there was a fruit
tree overhanging a waterfall and a steep
precipice. Being hungry, the man eats the
fruit and then climbs the tree to reach
more fruit on a limb overhanging the
precipice (a). The branch breaks and he
falls into the chasm (b). Unable to scale
the steep walls, he despairs. The great ape
comes to the chasm and sees the man (c).
Filled with pity, the ape throws him some
fruit. Then, in order to rescue the man, he
practices climbing with a large stone on
his back (d). When he feels able, he
descends into the chasm and takes the man
on his back and with extreme difficulty
carries him out (d). Being exhausted, the
ape lies down to rest on a rock. As he is
sleeping, the man wickedly thinks to kill
him for food. He lifts a huge stone to let
it drop on the ape, but because he is weak,
he trembles and the stone only grazes the
ape's head (e). Jumping up, the ape realizes
what the man has done, but still has
compassion for him and shows him the
way out of the forest. Full of remorse, the
man is later afflicted with leprosy and
despised. Seen by a king passing by on a
horse, the man relates to him his story,
cautioning him to hold fast to virtue (f)
(7.2).

5) No. 25: Sharabha Deer Life Story

*When the Bodhisattva was born as a
sharabha deer,
the enemy who tried to kill him with a
dangerous arrow
was helped and protected from disaster.
(The Bodhisattva) could not bear the death
(of that enemy)
and came back and saved him.
Homage to (the Bodhisattva)!*

This tale relates the life of the Bodhi-
sattva as a splendid *sharabha* (a fabulous
deer) who lived in a remote forest.
Separated from his retinue, the king spies
the *sharabha* and gives chase (a). The great
deer readily jumps a deep gulch, but the
king's horse stops short, flinging the king
headlong into the steep depression (b).
Realizing what has happened, the deer
turns back. Feeling compassion for the
hurt king trapped in the gulch without
shade or water, the deer offers to help the
king. The king is astonished by the deer's
kindness. He expresses his thanks and then

the captured leader. Moved by this action,
the fowler (the Buddha's future disciple
Channa) releases the Bodhisattva and, at
the request of the companion, escorts both
birds unbound to the king. Overjoyed by
the sight and behavior of the wonderful
birds, the king listens to the Bodhisattva
teach the wisdom of the Buddhist way (c),
and then releases both to return to their
home on Lake Manasa (7.1).

3) No. 23: The Mahabodhi Life Story

*When the Bodhisattva, as a prince, was
wandering about,
he used his miraculous weapon of reasoning
to move the hearts of his opponents.
He guided the King and brought peace
and well-being to the kingdom.*

In this story, the Bodhisattva becomes a
wandering ascetic renowned for his
knowledge and skills in conversing. A
king, hearing of his fame, makes a special
palace and invites the ascetic to stay (a).

However, the king's ministers become
jealous and turn the king's mind against
him so that even the king's dog barks in a
hostile way at the ascetic (b). Realizing the
unfavorable situation, the ascetic, despite
protestations from the king, leaves the
palace for a forest retreat, where he attains
great powers (c). By his clairvoyance, he
sees that the ministers of the king are
leading him astray with dangerous
immoral doctrines. Feeling compassion for
the king, he conjures up the form of a
monkey skin (d), in which he robes
himself and goes to the king (e). Using the
ruse of this monkey skin, he is able to
show the errors in each of the ministers'
false doctrines and sets the king onto the
path of virtue (f). He then flies through the
air back to his forest retreat (g) (7.2).

4) No. 24: The Great Ape Life Story

*When the Bodhisattva was incarnated as an
ape,*

his shame for his previous attack on such a pure being. The deer exercises with a heavy stone on his back until he is strong enough to carry the king out of the gulch on his back (c). Out of gratitude the king invites the deer to his capital, but the deer declines, asking only that the king desist from hunting animals, which, though stupid, have the same feelings as humans and are worthy of compassion (d).

6) No. 26: The Ruru Deer Life Story

Living as a ruru deer, the great Bodhisattva (saw) a man being swept away by a turbulent river,
and saved him from certain death.
This Bodhisattva showed kindness to a man who wished him ill.

This scene depicts the story of the Bodhisattva's life as a ruru deer of jewel-spotted colors who rescues a man from drowning in a river only to have the man later treacherously lead the king of Benares to capture him. As a man is drowning in the swift river, the Bodhisattva as the ruru deer hears his cries, swims into the river, and saves the man on his back (a). The man is grateful and, at the deer's request, promises not to tell anyone of the incident. Meanwhile, the queen of Benares has a dream of the fabulous deer and tells the king about it. The king issues a proclamation of reward for information on the whereabouts of the rare deer. Finally enticed by the rich reward, the man reneges on his promise to the deer and reveals his whereabouts to the king. As he points out the hiding place of the deer to the king, his right hand falls off (b). The king is about to shoot the deer, but in a human voice the deer speaks out and tells the king about saving the man's life in the raging river and the promise not to reveal him. Angry at the treacherous man, the king turns to shoot him, but the deer, feeling compassion for the man, intercedes on his behalf (c). Completely amazed by the noble-minded deer, the king gives him freedom within his realm and takes him to his palace, where the deer teaches the wisdom of the Dharma in a beautiful human voice (d) (7.2).

7) No. 27: The Monkey King Life Story

When the Bodhisattva was the leader of a monkey troop,
he could not bear its fear of being hunted down by enemies.
(The Bodhisattva) formed a bridge with his own body and saved (the troop).
Homage to him who delights in facing adversity
and performs wonderful deeds!

This is the popular Monkey King Life Story, which relates the Buddha's life as

leader of a tribe of monkeys who feed from a banyan tree with marvelous fruit more delicious than ripe mangoes. Even though he has warned his monkeys not to drop a single fruit lest it be discovered and coveted by others, eventually one escapes the eyes of the monkeys and drops into the water. It floats down the river and is discovered by women of a king's harem as they swim. Entranced by the wonderful smell and flavor of the fruit, they take it to the king (a). Wishing for more, the king goes with his royal army to find the tree. Spying the great tree filled with monkeys, the angry king orders his men to shoot and drive them away. The monkey chief, the future Buddha, perceiving the panic in his troop, ties his feet to a tree and stretches out his own body as a bridge across the precipice for the monkeys to escape (b). Running across his body, all are saved, but the monkey king is trampled and broken. Amazed by the valor and self-sacrifice of the monkey chief, the king orders a canopy to be held beneath him to catch his fall (c). Before he dies, the Bodhisattva teaches the king the wisdom of the virtuous ruler in selflessly desiring the welfare of his subjects: "Though my body is broken, O king . . . my mind is come to a state of the greatest soundness, since I removed the distress of those over whom I exercised royal power for a long time" (d).

8) No. 28: The Kshantivada Life Story

When (the Bodhisattva) was the ascetic Kshantivada,
a king, enraged by ugly rumors about his queens paying him a visit,
had (the Bodhisattva's) body cut into pieces.
Yet, the ascetic triumphantly remained calm and immobile like a mountain.

This scene represents the Kshantivada Life Story, when the Bodhisattva was an ascetic practicing the virtue of patience in a forest. One day the king brought his harem to the same forest, and while the king was taking a nap after bathing, the women roamed about. They come upon the ascetic, who subsequently delights them with his conversation. Meanwhile, the king, who has awakened, misses his female companions. Upon finally finding them with the ascetic, he becomes so enraged that he draws his sword and cuts off the limbs, ears, and nose of the ascetic, who, despite this horrendous ordeal, maintains his patience and composure (a). Afterward, as he dies, the earth opens up and engulfs the cruel king in flames while his attendants look on (b).

9) No. 29: The Brahma Deity Sage Life Story

Living as a divine master of meditation and morality,

The Bodhisattva exercised his compassion for King Angadinna,
and released him from his addiction to desire and wrong views.
He lifted him up to the noble path.

In this tale, the Bodhisattva miraculously comes down from his contemplative life in the Brahma Heaven to teach a stubborn and deluded king who has become addicted to evil actions by adopting a nihilistic view about the existence of future lives. Manifesting as a divine apparition, the Bodhisattva convinces the king about the inevitable consequences of his actions, and establishes him on the noble path (a) (7.3).

10) No. 30: The White Elephant Life Story

When (the Bodhisattva) was an elephant roaming about in the wilderness,
He could not bear the sufferings of a hundred travelers who had lost their way.
He fed them with his own flesh and blood; he consoled them and gave them his own life.
Homage to the Bodhisattva!

This sequence tells the tale of the Elephant Life Story, which recounts the Bodhisattva's life as a white elephant. Hearing the cries of a hundred starving people who had been exiled and were lost in the wilderness, the elephant comes and tells them to go to a spot near a lake where they will find the body of an elephant for sustenance (a). As they depart, the elephant runs around by another path and reaches the place before them. Thinking that any merit for his action should be for the attainment of Buddhahood for the sake of all beings, he casts himself over the steep mountain cliff as deities look on (b). The people come and discover his body. Gratefully taking the flesh for food and his intestines as bags to carry water (c), they then cross the wilderness to safety, recognizing and honoring the life-giving sacrifice of the splendid white elephant (7.3).

This series of Former Life stories is presented in such a way that there appears to be a fluid interaction and cohesive unity to the composition. They are dispersed within a simple and somewhat realistic landscape in which mountains, lakes and valleys, rocks, and trees create a naïve but plausible three-dimensional setting for the lively figures of the various tales. Without interruption and with apparent ease, one story moves on to another and the animated figures, predominantly white or red, seem to dart and flicker with sharp intensity amid the somber green and brown color washes of the landscape. Here and there palaces in red and dark green

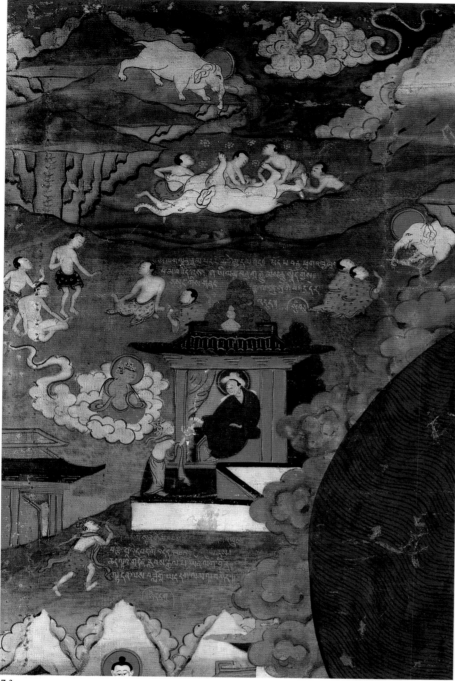

7.3

very unusual linear style in Tibetan painting seems related to a style of line known in Chinese painting from the Southern Song period as most successfully used by the famous painter Ma Hezhi (1131–1162). It has the characteristic of a flower and later comes to be called, in its various interpretations in Chinese painting and in Japanese Buddhist painting of the 15th century in particular, the orchid flower line. In this painting it is utilized as a foil for the colored washes and even line drawing of the architecture and figures. This soft and fluctuating line provides an ebb and flow of expanding and contrasting bursts of energy, like the rhythm of a beating heart. These pulses of energy throughout the painting, generated not only by the fluctuating linear elements but also by the contrasts of light and dark and the solid velvety reds and lightning flashes of white amid the somber deep blue and green and transparent muted washes, skillfully coordinate to create the extraordinary lively energy of this painting.

Written in red on the bottom edge are the Chinese characters "Ta Ming Wanli nianhao" (year period of Wanli of the Great Ming). This period corresponds to 1573 to 1620. At least one other painting of the same set with the same inscription is known in the Zimmerman collection (Pal, 1986, fig. 14, p. 180). Although the inscription could have been added later, the color red appears to be the same as that used in the painting. It seems to have been written by a Chinese hand. Pal has suggested that this set may have been commissioned by the Wan-li emperor; this is a probable explanation, considering the content of the inscription. The linkage with China indicated by this inscription is also borne out to a certain extent by some elements of the style of the painting, which, besides the Chinese brush style in the landscape, also reflects a Chinese style in the Buddha's drapery. However, the energetic tempo and character of the painting is typically Tibetan and it would appear to have been painted by an artist who was trained in the Tibetan style but who was familiar with Chinese painting as well. These factors may suggest an Eastern Tibetan stylistic school for the work. Overall, the style is consistent with a Wan-li period dating, as it has certain similarities with such late 16th-century Tibetan paintings as No. 97. Besides being one of the finest early Jataka paintings, it is especially important as a dated painting in tracing the development of architectural and landscape elements in Tibetan art as well as for the figural styles. It helps to date a number of other major works to the same period, such as Nos. 50 and 58.

offer interesting counterpoint relief to the triangular green hills, snow-capped peaks and weathered rocks, crevices, and ravines. Solid, scalloped clouds in muted neutral tones enframe Shakyamuni's halos and the occasional peaks and hills. In each sequence the Bodhisattva can be easily picked out by a red halo, whether he is animal or human. The vivid gestures, postures, and clothing of the figures are all typical of Tibetan paintings, and are here portrayed with a charming simplicity and verve. There is a keen sense of the tonal dynamics of light and dark, of the rich versus the delicate, and of the dense contrasted with the transparent—characteristics that can be associated with

Chinese styles reflecting the yin-yang principle of contrasting opposites.

The architectural elements are simple, with only touches of decor. Gateways, roofs, walls, and chambers, placed judiciously within the overall scheme, do not dominate but form a geometric relief of solid colors for the more variegated washes and modulated line of the landscape sections. Besides the finely graded washes—from greens to light earthen tones—most extraordinary is the fluctuating line of the hills and rocky banks. This line is soft and wavy, sensitively changing from thick to thin in undulating pulses that border on the imaginative rather than the realistic. This

Shakyamuni Buddha with Scenes of His Former Lives

Eastern Tibet

Late 17th to early 18th century

Tangka; gouache on cotton

26 × 16½″ (66 × 42 cm)

Mr. and Mrs. John Gilmore Ford

Lit.: Pal, 1984b, no. 133
(for another in the same series).

A springlike aura pervades this lovely painting illustrating five scenes from Shakyamuni's past lives. Sensitive graded washes of pale green spread across the tilted picture plane, which depicts an idyllic verdant landscape of rolling hills dotted with rivers, layered rocks, blue cliffs, flowering trees, palaces, and snow-capped mountains. Figures in realistic scale and with a mixture of rich and pale colors add to the generally joyful tone of the painting, despite the drama of the events unfolding in each scene. The Buddha is set back within the landscape. He makes the earth-witness gesture, and is colorfully garbed in brilliant red, orange, and pink robes. He is seated on a finely decorated pedestal and is surrounded by two halos and a large, transparent, encompassing aura.

All elements, including the central Buddha, are so integrated with the landscape as to become a single, indivisible unit. Nevertheless, each of the five scenes surrounding the Buddha skillfully revolves within its own space, generally in a circular pattern of action incorporating a number of scenes in a narrative sequence. Each is separated from the others by seemingly natural but in fact subtly contrived barriers of rocks, rivers, or clusters of trees. The Former Life tales presented here are Jatakas 24 to 28 of Aryashura's *Jatakamala* and are the same as those in No. 7, except that here there are only five and they are presented in a different order (see accompanying diagram). For a more complete explanation of the stories, refer to entry No. 7.

1) The scenes begin at the upper left with the Great Ape Life Story, identified by an inscription on the large rock. The man falls off the tree (a) into the swift river (b) and is rescued by the great ape, who first practices with a rock the weight of the man (c, d). The ape gives the man food (e) and then lies on a rock to rest. While he sleeps the man tries to kill the ape for food with a big stone (f). He later meets a king riding by and tells him of his regret at turning against his ape bene-factor, an act that led to his dismal lot as a leper (g).

2) The upper right shows the Sharabha Deer Life Story (identified by a worn inscription on the bank near the water). A king is shown chasing the fabulous deer (a), who jumps a gulch. The king's horse, refusing to jump, throws the king into the gulch, from which he cannot escape (b). The *sharabha* takes pity on him and rescues the king, for which the king expresses his gratitude (c).

3) Across the center is the Ruru Deer Life Story. The ruru deer saves a man from drowning in the river (a, b). Later, the man leads the king to the deer's hiding place and as he points to the deer his right arm falls off (c). The king is going to shoot the man for his treachery after he hears the whole story from the deer, but the deer intercedes (d). The ruru deer is taken in the king's chariot to the palace (e), where he teaches people in a melodious human voice.

4) At the lower left appears the Monkey King Life Story. The monkeys are being shot at in their fabulous banyan fruit tree (a). A cloth is held up to catch the monkey king (b), who falls fatally exhausted after having made his body a bridge so the monkeys could escape to safety. Before he dies he teaches the king on the virtuous mind of a ruler toward his subjects (c).

5) In the lower right is the Kshantivada Life Story (also identified by an inscription as "The Sage of Patience"). The king sleeps in the park after his festivities (a). His harem women wander in the park and come across the patient ascetic in his cave and he teaches them (b). The king, in a fit of anger at finding his women with the ascetic, cuts off the limbs of the ascetic, who maintains his composure as he dies (c).

There are three inscriptions on the back: "Om sarvavidya svaha" ("Hail universal knowledge!"), "Om vajra-ayushe svaha" ("Hail diamond life-span!"), and "Om ye dharma hetu . . ." and so on, the famous epitome of the Buddha's teaching ("That all things arise from causes, what those causes are, and what their cessation—hail to that Doctrine of the Great Sage!")

This painting represents the fully evolved Tibetan-style landscape incorporating figures with many scenes. The style, probably developed by the Eastern Tibetan Karma Gadri school, incorporates some elements well known from Chinese painting, especially of the Ming period (1368–1644), such as the layered blue rocks, the stylized wave patterns of the water, and the tightly clustered leafy trees executed with bright blue-green colors. Especially interesting in this painting, which is one from a set—six of which are in the Ford collection and another in the Walters Art Gallery in Baltimore—are the long, wavy, "texture strokes" delicately modeling the hills and rocks. This technique had been used since the 8th century in Chinese painting, but usually in relation to the monochrome style of painting and not with color as seen here. The usage in the color medium enhances the beauty and naturalism of this landscape. Such elements as the flowering trees and the colorful architectural elements, though known in Ming period Chinese Buddhist painting, also have a distinct kinship to Mughal Indian painting of the 17th century. These kinds of subtle combinations, executed with judicious restraint, the presence of a spirited élan in the figures, and the quality of the ethereal beauty in the color, all signal the special character of this school of Tibetan painting, of which this tangka is a parti-cularly beautiful and refined example.

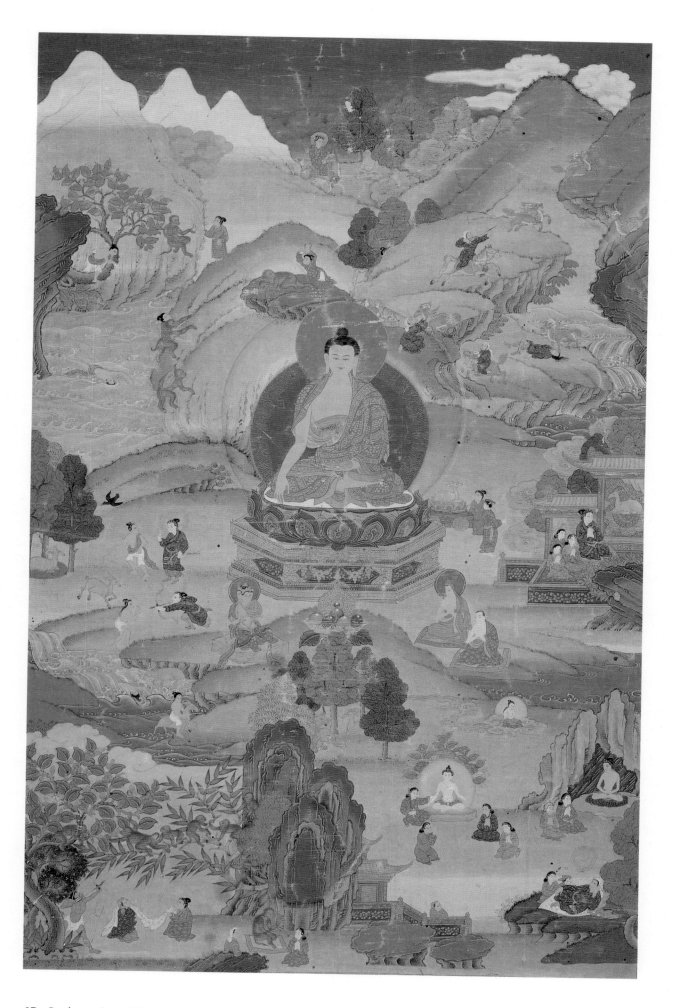

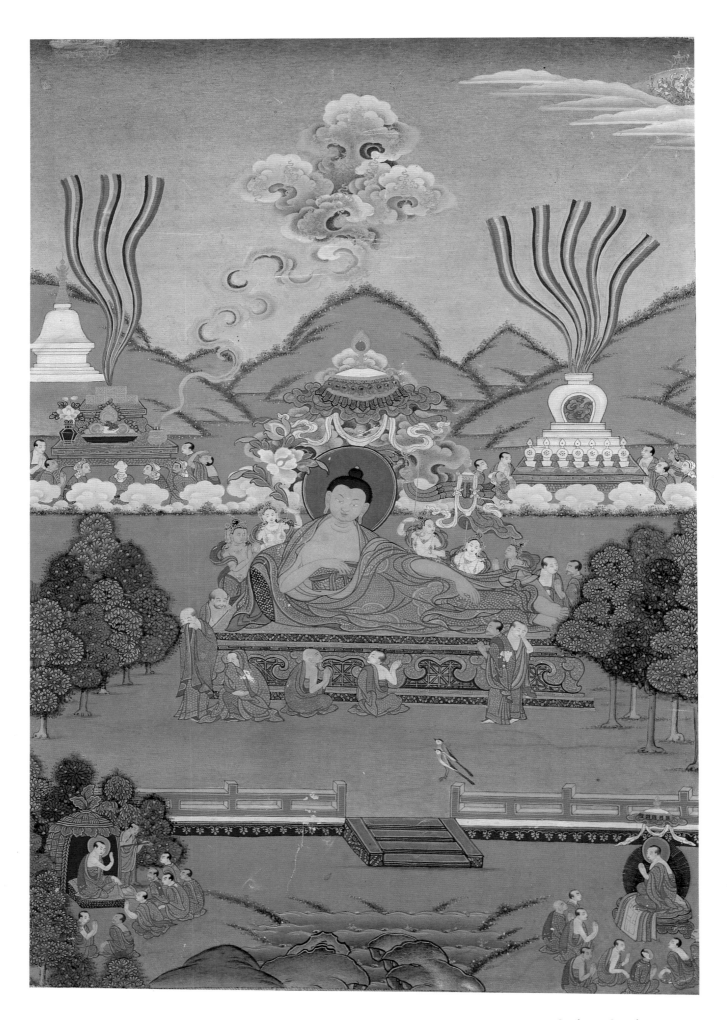

9
Shakyamuni Buddha Attaining Parinirvana

Central Regions, Tibet, or Eastern Tibet

Late 19th to early 20th century

Tangka; gouache on cotton

17⅞″ × 12½″ (45.4 × 31.8 cm)

Asian Art Museum of San Francisco.
The Avery Brundage Collection

Lit.: Rahula, 1962, xvi; Pal, 1984b, pp. 124–25; Rhys-Davids, 1977, pp. 11, 150, 146, 177–78, 185; Foucher, 1963, p. 241.

The Buddha passed away at the age of eighty near Kushinagara, the capital of the ancient kingdom of the Mallas in what is today the Indian state of Uttar Pradesh. Lying down in a grove, between two shala trees, he preached his last sermon: "All composite things are by nature impermanent. Work out your salvation with diligence." The Mahaparinibbana Sutra, a standard Pali canonical account, recalls the deathbed scene. The gods Brahma and Indra recited poems. Gods and men wept. "Too soon has the exalted one died!" they cried. "Too soon has the Happy One passed away! Too soon has the light gone out of the world!" Only the Arhats, the saints who had passed beyond all worldly sorrow, retained their composure. Although doubtless rooted in later traditions, this recent Tibetan tangka reflects this optimistic and triumphant view.

The scene is vernal—unseasonably, the sutra tells us—with deep green fields and flowering trees. Rainbows play overhead. Five green hills rise in the distance, their edges strewn with tiny multicolored flowers. To the left, flowers are scattered on the forest floor. Beneath the bier, a pair of gaily colored birds sound a cheerful note. The Buddha reclines, at peace with his impending departure from the world. His body, a deep and rich ocher, seems not to sink in the heaviness of death, but to rise in a graceful lilting dance. How wonderful, remarked Ananda during his master's illness, that the color of the skin of the Exalted One should be so clear, so exceedingly bright. The Buddha is surrounded by fourteen figures. Above the Blessed One, Brahma recites verses of praise and a group of serene deities bear lotuses, banners, and other insignia. By their side, a tranquil pair of monks salute the Buddha with folded palms.

Below, the central figures are as calm as those above: three monks who mutely salute their master. Two are seated on the ground. One perhaps is Subhadra, the Buddha's final convert, who is often shown meditating in front of the bier of his new-found master. The figures elsewhere betray quite a different reaction. Framing the group, two distraught monks press their cheeks on their palms and stare mutely into space. One clutches the edge of the palanquin for support. Another pair, their backs bent in sorrow, weep into the folds of their robes. For them, the moment of the Buddha's passing is as Ananda described it: "Then there was terror! Then stood the hair on end! Then he endowed with every grace, the supreme Buddha, passed away!"

On the seventh day after his passing, eight chiefs of the Mallas came to claim the body of the Blessed One. They bore his remains to a tribal shrine outside the town gates and there cremated the body. Although the chiefs vied for the honor of lighting the pyre, they were unable to do so until the monk Mahakashyapa arrived and the pyre spontaneously burst into flames.

The upper right corner shows the crematorium, which is in the shape of a stupa. Flames swirl within it. Above it, five rainbows rise. Below, seven offerings of food and seven offerings of water rest on the altar. Around the altar, a group of seven attend the ceremony. Three are monks. The four in princely garb are perhaps the four Malla princes whom the sutra records as attending the ceremony. When the Buddha's death became known, seven other powers vied with the Mallas of Kushinagara for possession of his relics. Tradition credits a brahman named Drona with the Solomon-like wisdom of suggesting that the relics be divided into eight parts.

The eight golden boxes of relics sit on an altar table. Three rainbows rise from them. Below the relics, the offerings of the five senses are arrayed on a lower altar. From a bowl of incense, the traditional offering to the sense of smell, a cloud of smoke wafts heavenward through the center of the painting, bringing with it a scintillating multitude of auspicious symbols painted in gold. Groups of eight figure elsewhere in the painting. At both the lower left and right, a saintly monk preaches to a group of eight respectful and attentive monks. At the upper left, four monks and four princes worship eight boxes of the Buddha's relics. The number eight is also prominent in the sutra: eight chiefs carry the Buddha's bier, eight kings vie for his remains. Several days before the Buddha's death, Ananda, the Buddha's cousin and closest disciple, asked him what should be done with his earthly remains. The Buddha replied that like those of a king, the remains of a Tathagata should be enshrined in a stupa.

The sutra records his reasoning: "At the thought, Ananda: 'This is the stupa of that Exalted One, of that Able Awakened One,' the hearts of many shall be made calm and happy; and since they there had calmed and satisfied their hearts they will be reborn in the happy realms of heaven. It is on account of this circumstance, Ananda, that a Tathagata, an Able Awakened One, is worthy of a stupa." Above the division of the relics, we see the original stupa represented by a modern Tibetan stupa, or *chöten* (T. *mchod rten*). To this day, the circumambulation of *chötens* figures prominently in the popular religion of Tibet.

In the upper right-hand corner, three deities holding a ritual flask, an umbrella, and a golden banner nest in a bank of pink and green clouds. Perhaps they herald the advent of the Buddha's mother, who is often portrayed descending to her son's deathbed surrounded by an angelic cohort. The Buddha wrote no books, nor during his lifetime did his disciples commit his words to paper. Before his death, however, he declared that he should not leave this world until his disciples, carrying the doctrinal books in their memory, would be able to tell others of it, preach it, make it known, establish it, open it, minutely explain it, and make it clear. In the succeeding centuries, his followers did just that; at a series of councils they established the definitive canon and later preserved it in writing.

At the bottom of the painting, two scenes illustrate the survival and continuation of the Noble Doctrine. In each, a saintly monk teaches the Dharma to a group of disciples. The figure on the left sits in a thatched shelter made of woven mats, suggestive of the warm climate of India. He has an orange halo, attesting his saintly character. Around him, alert and respectful, sits a group of disciples. Behind him, a scribe poses with pen in hand, recording the words of the Buddha as the monk recites them from memory. The group on the right shows another moment in the spread of the doctrine. As in the earlier scene, a saintly monk instructs a group of attentive listeners. Here, however, the monk's halo is green like that of the Buddha himself and a nimbus of radiant light emerges from his body, both signs of exalted spiritual status. He may represent a later saint, perhaps even a Tibetan. He is shaded by an umbrella and seated on a throne. The latter is a luxury forbidden monks by the Buddha himself, but it became a customary way of showing reverence to lamas in Tibet.

R. Kohn

10
Maitreya, the Future Buddha

Kashmiri style, with Pala elements

10th to 11th century

Bronze, with cold gold paste and pigments

H. 8″ (20 cm)

The State Hermitage, Leningrad.
Prince Ukhtomsky Collection

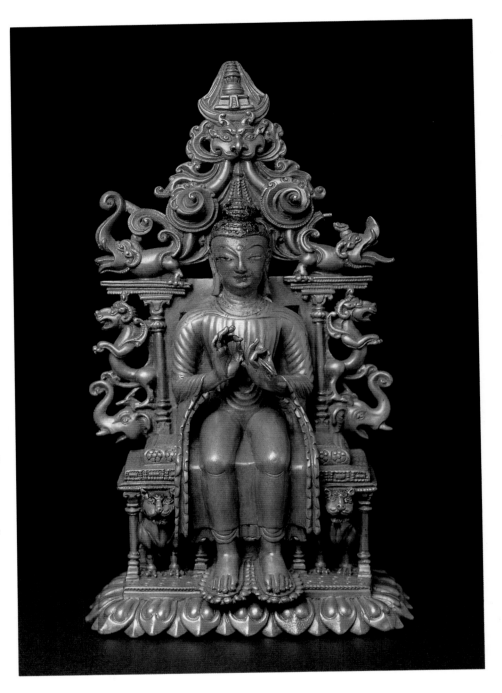

This sculpture is an interesting mixture of Kashmiri and Pala traditions. Some of its features show unmistakably the influence of the Pala art tradition, such as the complex composition of the back of the throne with its pronounced animal forms and a miniature stupa on its top, as well as the base of the throne with two lions and bifurcated lotus petals. At the same time some details point to Kashmiri origins. Not only is the figure of the future Buddha Maitreya sitting in the extended-leg benevolence posture (*bhadrasana*)—a pose especially popular with Kashmiri artists but seldom seen in Pala art—but even some formal elements of the style are related to Kashmiri prototypes, such as the treatment of the hair, the soft riblike folds of the garment, a typical "puffy" shaped face, and six-petaled engraved rosettes covering the edges of the cushion. By the time this sculpture was made, certain early traditions in the rendering of Buddhas' clothes seem to have changed; this is possibly why the edge of the robe that Maitreya holds in his hand seems to resemble an object more than mere cloth.

A small pin protruding from the left side of Maitreya's chest and connecting with his hands is interesting evidence of the technical problems confronting the sculptor. It appears that this piece was solid-cast and this pin was necessary for the molten metal to flow into the clay model. This detail suggests a link with techniques and developments in other Himalayan Buddhist art, such as the bronzes of Western Tibet.

A very interesting detail that supports an early date for this sculpture is the presence of a rectangular hole ¹⁰⁄₁₆ × ¾

inches (1.8 × 3 cm) and 2 inches (5 cm) deep in the base. It has evidently been made for the insertion of relics inside the sculpture. At the same time, its inner walls are plain and in no way does the cavity have the appearance of the large cavities seen in later sculptures that repeat the outline of the image and resemble the

shape of the human body. This rectangular hole may serve as an indication of a very early period in the development of the rite of consecration in Tibet when the procedure of consecration had not been as worked out and elaborated as it became by the 14th century.

G. Leonov

11
Maitreya Buddha

Eastern Tibet, or Central Regions, Tibet

Mid-18th century

Tapestry; silk and gold brocade appliqué with couching and silk embroidery

135 × 75½″ (343 × 191.7 cm)

Mr. and Mrs. John Gilmore Ford

Lit.: Pal, 1984b, no. 179.

This elegant, large tapestry of silk and brocade appliqué depicts the future Buddha Maitreya seated on a lotus in the teaching gesture. He wears a brocaded yellow and blue patched robe with gold floral patterns. On his head appears a tiny golden stupa, his special attribute, and on the lotus flowers at his side are a water vessel and a wheel. The Buddha, whose facial and garment style is strongly related to Chinese modes, sits before blue and pink halos that are encompassed by a wreath of pastel and red flowers in full bloom. A landscape of broadly defined areas spreads before and behind the Buddha. Two deer recline before the pedestal—a reference to the tradition that the first teaching of all Buddhas, including Maitreya, takes place in the Deer Park at Benares. Other animals, birds, and dragons appear throughout the land and sky. The two importantly dressed lamas seated in the clouds can be identified as Tsong Khapa (with sword and book) and the Seventh Dalai Lama, shown in gold-threaded robes. Below, at the lower right corner, kneels the donor monk, who is mentioned in the inscription as the abbot Jamyang Döndrup. He pays homage to Maitreya by offering the Wheel of the Teaching. In the center is the golden-bodied Kubera, god of wealth, and at the lower left, next to a three-storied temple building, stands the Nechung oracle dressed in armor and holding a banner and bow.

Along the bottom edge is embroidered an inscription that recounts the dedication of this tapestry for the long life of Kelsang Gyatso, the Seventh Dalai Lama, who lived from 1708 to 1757. The monastery Zab-yang Khyilpa (T. *zab yangs 'kyhil pa*); possibly the famous Tashi Kyil Labrang of northeast Tibet), presumably the monastery of the donor abbot, is also mentioned. Clearly this work was made during the lifetime of the Seventh Dalai Lama. Its perfect condition makes it a particularly handsome example of the spectacular large tapestries that are customarily displayed by Tibetan temples during religious festivals.

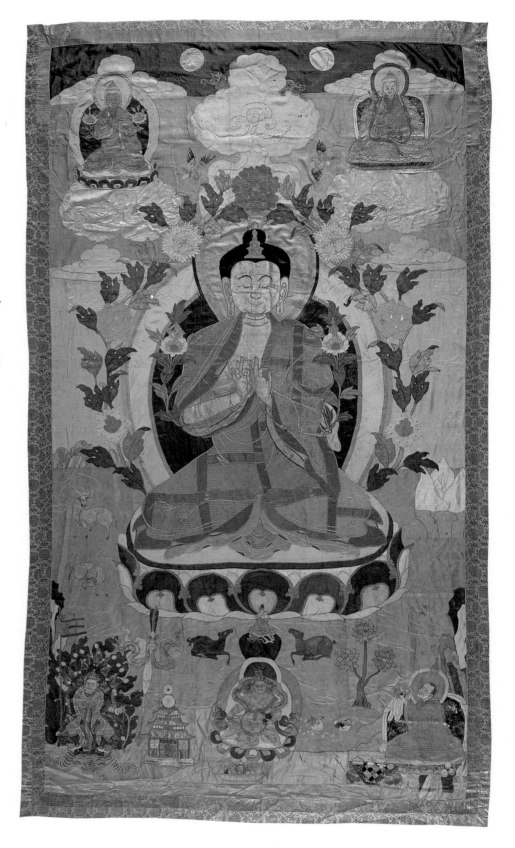

II.
Arhats

The Sanskrit word *arhat* may be derived from the verb *arh* to be worthy; or it may derive from the combination of *ari* plus *han,* meaning "one who has conquered one's enemy." In either case, the Arhats are the saints of Buddhism. They are followers of the Buddha who have attained freedom from ignorance and suffering. In early monastic, or Individual Vehicle, Buddhism they appear quite similar to Buddha himself. Arhats were his major Apostles (Shravakas) and served as patriarchs (Sthaviras) of the Buddhist Order (Sangha) over the centuries after the Parinirvana. In India and Tibet they were celebrated in literature as immortal patriarchs, ideal exemplars of liberation, though the corresponding visual art traditions are not clearly traceable. In Universal Vehicle Buddhism, they are still highly regarded, though as ideal types they are eclipsed by the messianic Bodhisattvas, who seek not only their own freedom from suffering but also strive to save the whole world. The most famous Arhats are probably considered as moving beyond the state of personal freedom to join the Bodhisattva enterprise in their own way. Thus emerges the tradition of a number of "immortal" Arhats, sixteen in India, eighteen in China, and sixteen, seventeen, and eighteen in Tibet. They use their magical powers to remain alive indefinitely, in order to preserve the Buddha's Teaching even in times of social disintegration and religious corruption.

The various traditions of the group of Arhats are complex. From literary sources, the Indian tradition of Nandimitra lists the group of sixteen Arhats, but we have no surviving artistic evidence of the Indian Arhat tradition. In China the sixteen Arhats are known in literary evidence from the 5th century CE and in surviving art as sets of sixteen and/or eighteen from the Tang period (618–906). They became especially popular along with the five hundred Arhats in the Song (960–1279) and Yuan (1279–1368) periods and remained a major subject in Chinese art thereafter. From at least the 11th century onward the Arhats have been a presence in Tibet as well, and Tibetan art has produced some of the most beautiful examples of the Arhat theme in all Asian art.

In Tibet the earliest liturgical tradition is traced to Atisha and two of his disciples in the middle of the 11th century. This tradition, which in its ordering of the Arhats begins with Angaja as the first Arhat, was supported by the famous scholar Chimton Namkadrak of Narthang, a center of the

Arhat cult. Another tradition, which lists Rahula as the first Arhat, appears in the great collection of *sadhanas* (collections of evocations) written by Chödrak Gyaltsen and revised by Sakya Kunga Rinchen (Tucci, 1949, p. 560). Examples from both systems appear here (Nos. 3, 4, 6). In both systems, as well as that of Nandimitra, the individuals in the group of sixteen Arhats are the same; only the order varies. Variations in the ordering evolve around liturgical practice and the structuring of the Arhats by different masters according to a kind of spatial mandala based on where the Arhats are said to reside.

It is not clear at what juncture the Tibetan tradition adopted the seventeenth Arhat, Dharmatala, and the eighteenth, Hvashang. In surviving art they are known from at least the late 14th to early 15th century (possibly Dharmatala is known a little earlier—in the wall paintings of the Guru Lhakhang in Ladakh). Although generally counted with the Arhats, they are laypersons and not monks like the Arhats. They appear to be primarily a distinctly Tibetan addition to the Arhats. Each has some resemblance to a well-known Central Asian or Chinese figure (see Nos. 14 and 17), but they are different from the two Arhats generally added in the early Chinese tradition of eighteen Arhats. A treatise by the Fifth Dalai Lama recognizes the tradition of seventeen Arhats in Tibet, which is the customary sixteen with the addition of Dharmatala. Several Guge Western Tibetan paintings present the seventeen Arhats, including No. 4, which dates from the second half of the 15th century. Most depictions of the Arhats in Tibet, however, are of the eighteen Arhats.

With regard to pictorial style of the Arhats in Tibetan art, Tibetan literary sources mention several early sources, mostly traced to China. Perhaps the most interesting is the set of sixteen Arhats with Dharmatala and Hvashang said to have been brought by the monk Lumey (T. Klu-mes, 10th century) from China. These were placed in the temple of Yerpa (near Lhasa), and it is said that Atisha's disciples introduced a liturgy from India for these paintings. The treatise of the Fifth Dalai Lama says that the Kadampa took the Yerpa representations as models (Tucci, 1949, pp. 556–57, 563). The Tibetan text revised by Sakya Kunga Rinchen (noted above) mentions three major stylistic traditions for Arhat portrayal: Indian, Chinese, and Tibetan. These three traditions are

discussed by Pal (1990, pp. 68–71), who suggests that the Indian tradition of Arhat portrayal, of which no extant examples are known, may have been like the early lama representations such as the one in the Ford tangka (No. 95). The Indian style is said to have been introduced by one of the three pandits who accompanied Atisha (Tucci, 1949, p. 562). A major point of distinction between the Indian and Chinese portrayals suggested by the Kunga Rinchen text is that the Indian Arhats are drawn as monks with three garments in blue, red, and yellow, while the Chinese style portrays them in "ample silken robes" of somber hue, like scholars. Landscape settings for the Arhats are mentioned in this same text for all three traditions. The Chinese style includes "palaces ornamented with lattice work" (Tucci, 1949, p. 562), a feature that appears in some early Tibetan Arhat paintings such as No. 13.

In China several famous stylistic traditions for the Arhats emerged, some of which seem to have had a bearing on the Tibetan Arhat tradition. One is associated with the late Tang painter Guan Xiu (832–912), who monumentalized them as magnificent but often bizarre figures with Taoist overtones. He presented them at close view with few indications of a natural setting. Elements of this tradition, mainly the lofty monumentality and the forceful characterization, as reinterpreted in Yuan period Buddhist painting, may be seen in the earliest known Tibetan Arhat paintings, two of which are Nos. 12 and 13. But whereas Guan Xiu's Arhats were essentially monochromatic and used landscape sparingly, the Tibetan examples employ brilliant color and more landscape as well as some Indo-Nepalese elements, creating a stunning and successful new interpretation of the Arhat theme.

Another major tradition of Arhat painting in China stems from the style of the master painter Li Gonglin (d. 1106), who was famous not only for his landscape and figure painting, but also for his Buddhist painting. Arhat paintings by Chinese professional and academic painters in the late 12th to 13th century combined color with the masterfully fluid drawing style of Li Gonglin, especially skillful in the portrayal of masses of flowing drapery. They also included richly formulated landscape elements, which had developed to a high point in Song-period painting. The incorporation of this tradition, as it evolved through Yuan and early Ming painting,

can be seen in Tibetan art in such paintings as the set of Arhats from the late 14th to early 15th century from Shigatse now in the British Museum (see text to No. 14).

In the later periods of Tibetan art there is a close correspondence between developments in Chinese painting and the schools in Eastern Tibet, such as the famous Karma Gadri school, which began in the second half of the 16th century. The styles of Eastern Tibetan painting in turn seem to impact on the art of the central regions. An indication of the complex styles in the Eastern Tibetan schools from the 16th to the 18th century can be seen in the three later Arhat paintings, Nos. 17, 18, 19. In general, these developments show a change from landscapes of great clarity, delicacy, beauty, and naturalism with a somewhat artificial placement of the main Arhat as if unrelated to his setting (No. 17) to a better integrated coordination between the primary figures and the landscape, which becomes either more fantastic (No. 19) or more spacious (No. 18).

There are a number of ways in which the Arhats are presented in Tibetan painting. Usually they appear singly in a set of eighteen individual tangkas, or in groups of four or more in one painting within the series. Some depict specialized scenes, such as the coming of the Arhats over the sea (related to the tale of Hvashang). In a number of 15th-century paintings they appear grouped with Shakyamuni Buddha (Nos. 3, 4, 6). There is one interesting example of the seventeen Arhats with Tsong Khapa in a mid-15th-century painting (Tucci, 1949, pl. 13). These are especially valuable for depicting the sequence, characterization, and attributes of the Arhats at an early stage of their evolution in Tibetan art. Two factors usually stand out with regard to Arhat paintings: the personality of the Arhat himself and the landscape setting. Certainly Arhat paintings contributed to the development of portraitlike representation and to the depiction of landscape in Tibetan art.

In sculpture there are several famous sets of Arhats, such as those at the Peljor Chöde in Gyantse from around the second quarter of the 15th century (Liu, 1957, pls. 69–72) and another at Sera monastery in Lhasa (text fig. 22; Jigme, 1981, pl. 186). They are also popular as sets of small bronze sculptures, particularly in China, which is probably the origin of the two remarkable examples presented here (Nos. 15, 16).

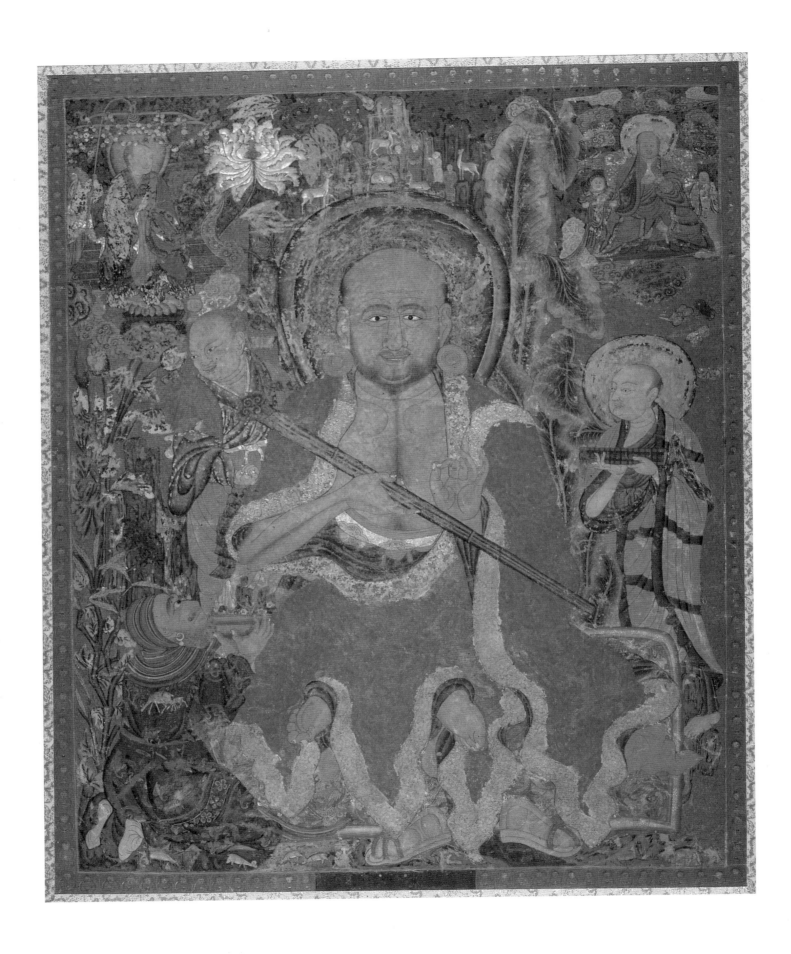

12
Arhat

Central Regions, Tibet; probably Tsang

Mid-14th century

Tangka; gouache on cotton

25½ × 21¼" (64.8 × 54 cm)

The Los Angeles County Museum of Art,
Los Angeles. From the Nasli and Alice
Heeramaneck Collection. Museum Associates
Purchase. M.77.19.9

Lit.: Pal, 1983, pp. 136–38; Pal, 1990,
pp. 66–78.

The identity of this Arhat is not yet clear, although Pal has most recently suggested the probability that it is Kanakavatsa. The attribute that this Arhat holds is not customary for any of the Tibetan Arhats, and the Chinese Arhat depictions are so diverse that there is no regularly established set of attributes to help identify this one. Secondary elements offer indications, but of a tentative nature. For example, the presence of the banana tree in this painting could suggest a southern climate for the Arhat's dwelling place, in which case his identity as Vajriputra, who lived in Sri Lanka, could be considered. However that may be, along with the Arhat in the Ellsworth collection (No. 13), this extraordinary work ranks among the most magnificent of all Tibetan Arhat paintings. Although both assimilate some elements of Chinese and Indo-Nepalese artistic styles, they display a power and unique quality in interpretation and execution that clearly separates them from either tradition and reveals a distinctively Tibetan creativity.

In this tangka the result is a stunningly individualistic main figure embedded in an imaginative amalgam of prominent, though secondary, personages. These figures are interspersed with glimpses of a rocky landscape dotted with figures, animals, plants, and flowers of varied species and with brightly colored clusters of fantastic clouds. Each element is prominent and fascinating in its rich coloring, carefully tinted zones of shading, and artfully elegant, evenly drawn, red and black lines. The master of the scene, however, is the Arhat. His grand figure, enlarged by the spread of his magnificent red robe, practically fills the frontal plane. The robe's dark green lining with its strong black shading acts as a foil for the glimmering stream of the sumptuous gold border. Both the red robe and its gold border are patterned with minute designs: the robe in a red shadow pattern and the

border by threadlike lines in raised gold, imparting a fine, grainy texture to the surface. Asymmetrically encircling the body and rippling over his feet with a silken lightness, the gold border becomes a major element contributing a lively movement to the otherwise frontally rigid image.

From this cascade of colorful cloth the body and head of the Arhat emerge, distinguished by delicate flesh-colored tints, refined brushstrokes for the dark grey hair, and by a firm, even red line defining the contours and facial features (12.1). He has a broad cranium, a wide, long face with a big nose, and smiling lips slightly parted to reveal his teeth. Most forcefully, however, his eyes directly engage us in pointed and unwavering sharpness, animating the believable presence of an extraordinary person. Careful and controlled, the spare lines and refined shading conjure more than the rudiments of a human being. This Arhat is not remote or self-absorbed. He speaks directly to us, not from some other world, but from and in our own space. Typical of the Tibetan artistic genius in the early phases of Tibetan art is this ability to present such a stark and forceful reality in terms of unreal space and extraordinary color and form. This is a key to the power of this representation and to the power of much of Tibetan art. The Arhat is completely in our world and in so being is completely, naturally, Buddhist. His wisdom, his teaching is not for himself alone; it is for everyone. As shown graphically by this painting, it speaks of an ultimate nondistinction between the supermundane and the mundane worlds.

Around the monumental figure of the Arhat, various intriguing figures and small scenes are portrayed with an astonishing realism, but with a lack of naturalistic scale or spatial awareness. Tiny deer, so small they seem from the land of Lilliput, gather around the Arhat's shoes and his

printed sitting mat. Continuing the small scale, in a minuscule landscape above the Arhat's halo some people and more deer are in rapt attention beneath a fantastic right-angled tree. The tall, rectangular rocks with rounded corners seen at various points in the painting have a modeled naturalism and rounded edges, but they lack spatial dynamics. They differ from the stylized rocks of the early Tibetan paintings (No. 24) and from those seen in later times (Nos. 3, 18, 19). Though fairly distinct, the shape and modeling style relate most closely to rock depictions in some late Xi Xia wall paintings of ca. late 12th century at the Yulin caves near Dunhuang in northwest China (Shih Chin-po et al., 1988, fig. 31) and in some Yuan dynasty (1279–1368) Chinese painting (Siren, 1958, VI, pls. 5, 9). Wide, naturalistically portrayed banana leaves with well-articulated stems and veins arch around the left side of the Arhat. In asymmetrical balance on the Arhat's right is a beautiful white peonylike flower with red-outlined edges. The sensitive realism of the detail of the plants is related to Chinese flower-painting styles from the late Southern Song (1127–1279) and early Yuan periods. The plants, too, are woven into the tapestry of the design without the nuance of space.

Each upper corner has a small figure, possibly other Arhats, in distinctive, contrasting robes and settings. The figure in the upper right, garbed in somber-colored robes and attended by two adoring acolytes, is surrounded by a group of fantastic flowerlike clouds of red, yellow, and blue. In contrast, the figure in the upper left, wearing brilliant blue and red garments and seated in three-quarter view on an elaborate seat with a pedestal, is attended by a servant who shades him with a broad, open canopy decorated with ball-like jewels. The contrasts between the two figures, a characteristic frequently seen in Chinese painting as an expression

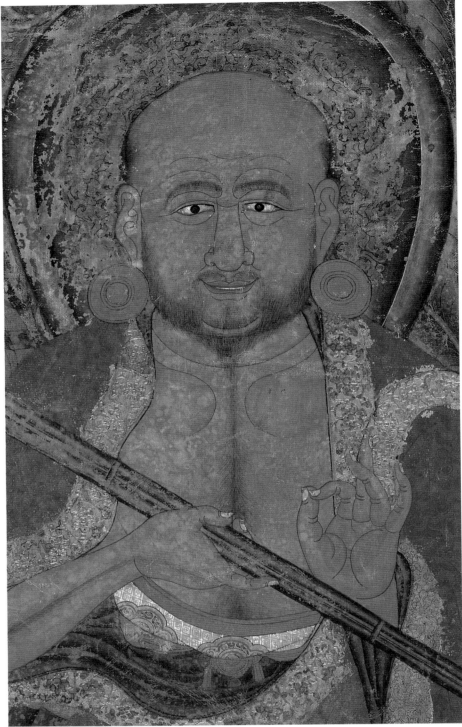

12.1

of the Arhat, the loose folds of the silken garments relate to the Chinese type of monk's robe, which is worn very loosely and droops low over the chest, exposing much of the upper chest. This probably conforms to the Chinese style noted in the early Tibetan text mentioned in the introduction to II. Arhats. In figure style, the Arhat is related to the impressive large figure seen in one of the tangkas probably dating in the 14th century from the Drigung monastery, northeast of Lhasa (text fig. 15). The monumental figural style, besides being in part derived from the Guan Xiu Arhat tradition, is also a feature of some Yuan dynasty Arhat paintings (Siren, 1958, VI, pl. 7).

One of the closest comparisons, not in iconography or landscape, but in the pose of the figure, linear execution, and in the style of the garment portrayal, is with a painting of Shakyamuni attributed to the famous early Yuan artist Yan Hui and now in the Rokuō-in in Kyoto (Tokyo National Museum, 1975, fig. 53). The style of the main attendant monks is related to Chinese monk depictions. One pertinent example that compares closely with the monk on the Arhat's right can be seen in the large early Yuan period wall painting from the Xinghua temple now in the Royal Ontario Museum in Toronto (Siren, 1958, VI, pl. 2). The even line drawing, though known in China and used in the Yan Hui example cited above, is not as favored in China for Arhat depictions as the modulated line or the free-flowing line of the Li Gonglin tradition. Tibetan painting was well adapted to the usage of the even line by the 14th century. The rich coloring is known in Chinese Arhat paintings of the Southern Song and Yuan, but it is also equally if not more related to the Indo-Nepalese traditions. Nearly all the vividly colored areas of the painting are either strongly modeled or are patterned with exquisite shadow designs. These create a mildly granular texture to the surface but do not dominate the color-borne clarity of the shapes or the wiry power of the line. Such modeling and patterns are a prime feature of Nepalese painting of this period and are not typical of Chinese painting. It is interesting to note for the sake of future investigations that this complex and important painting also seems to be representative of a style prefiguring the dynamic Mughal painting that produced the Hamzanama folios of ca. 1563–67. Finally, it should be noted that the outer border of tiny seated Buddhas, each holding a bowl, is a rare border design, indicating, like the extensive use of gold, the costly and meticulous nature of this masterpiece.

of the yin-yang contrast of opposites, is also carried through in the larger figures of the monks asymmetrically flanking the sides of the main Arhat. One monk moves toward the master, offering a book; the other, already close, turns away to look down at the large bearded man kneeling in the lower left corner. This latter figure is an extraordinary character wearing an animal-patterned, dark blue robe and striped headgear. He makes a symbolic offering of the universe, represented as a coral landscape in a bowl, to the great Arhat. As a type he is akin to the char-

acteristic Chinese image of the "foreign" man of the West. This type, especially in the realistic head, is also seen in East Asian depictions of Bodhidharma, a popular figure in Chinese art of this period.

In this work, the mingling of traditions from Indo-Nepalese and, more prominently, from Chinese sources creates a unique and highly successful Tibetan style that in the final analysis is different from the other artistic traditions. In the landscape elements the derivation appears to be primarily from late Southern Song and Yuan period painting. In the drapery

13
Arhat Vanavasin

Central Regions, Tibet; probably Tsang

Second half of the 14th to early 15th century

Tangka; gouache on cotton

28 × 21" (71.1 × 53.3 cm)

Robert Hatfield Ellsworth Private Collection

Lit.: de Visser, 1923; Tucci, 1949, pp. 560–69; Béguin et al, 1984.

This painting is one the most important and splendid of the early Arhat paintings in Tibetan art. The large image of a cheerfully smiling, blue-eyed Arhat, seemingly animated in discourse, looms from an impressive shrinelike throne. He is garbed in a patched red outer robe of exceptional beauty, executed with consummate skill (13.1). The patches, each with an intricate floral design in a darker shade of red, are carefully aligned to create a radiating and flowing movement over the figure. The robe is framed and offset by green hems and a purple lining that is sparingly but interestingly revealed with darkly modeled, double-lined parallel creases. An ultramarine blue undergarment, also with a purple lining, is pulled high above the waist and tied with a narrow cord. It falls over the exposed right leg in broad folds of artfully modeled and erratically curved and pointed shapes. His right hand, with thumb and middle finger touching, lies casually palm up on his knee. With his left hand he gracefully holds the golden staff of his

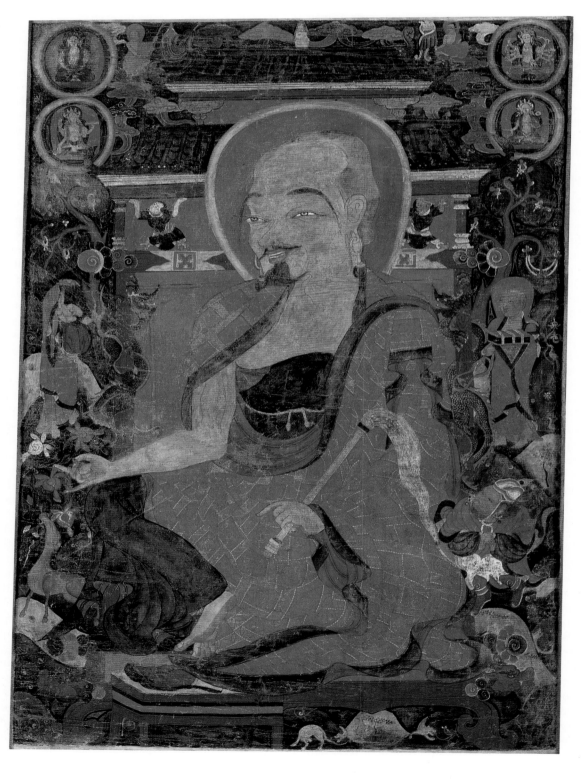

yak-tail fly whisk, whose delicate hairs wave like a thin, transparent veil across his robe and echo the soft texture of his own light hair. His hands are unusually delicate and small, and they contrast dramatically with his large head, the most riveting and dominating element in the painting. The head's size, light coloring, and angular contours combine with his striking features to create a uniquely individualistic portrait. Clear, bright blue eyes, narrowed to a squint by his smile, flash out from crescent-shaped lids. A short, pointed nose slopes jauntily down toward his red lips, which are parted in a perky smile showing two rows of gleaming teeth. His wavy, smoky-grey beard, pointed and trim mustache, and long, drooping eyebrows (a particularly Chinese feature) add to his alert, if somewhat bizarre, appearance. This is an immediately likable Arhat. Despite his obvious older age, there is a wiry, almost youthful energy in his slender arms and bony face. A touch of naïveté in the perspective of the head and body adds to the somewhat improbable air of this painting. A plain red halo with yellow and pink border stripes encircles his head and merges with the red of the robe and the panels of the throne back to create the dominant central focus.

Surrounding the mass of red at the center are primarily the blue and green of the shrinelike backdrop for the Arhat and a fantastic landscape setting. Different kinds of birds and animals and pinwheel-shaped flowers dot the dark and light green rolling hills. Two monkish attendants, one holding a book and the other stretched up in an unusual posture, flank the Arhat. They are subordinated by being unnaturally small in comparison to the Arhat, as is the strangely dressed figure near the Arhat's left elbow. This figure, perhaps a foreigner or type of deity, appears to be lightly tripping across a hill as he bends around with hands overlapped to look up at the Arhat (13.1). He is partly balanced visually on the opposite side by a large tapir-looking deer, which stretches its head up toward the hand of the Arhat. On the lower borders there is a simple footstool on which rest the dark-colored shoes of the Arhat. Fanciful Miró-like flowers, lavender birds, and jewel chains float and drift over the hills and adorn the globe-shaped trees.

In the upper reaches of the painting, the splendid structure of the shrine throne captures the attention. It has a double-storied roof covered with well-modeled dark green and blue tiles. Two boyish, or perhaps *yaksha*, figures appear to hold up the eaves of the lower roof. They stand on the thick lintel, which is decorated with elaborate gold ornaments whose sharply notched shapes act to strengthen the focus on the Arhat's head. Mischievous dragons with blue scales, red backfins, and green beards coil up the posts. A small monk holding a banner kneels at each side of the upper roof on stacks of multicolored curly clouds wafting up from below. A pair of female deities, each in a large rainbow-colored circle, effectively frame and strengthen the upper corners.

Though similar in many ways to the Los Angeles County Museum Arhat (No. 12), in particular with respect to reflecting the monumental compositional style of Yuan dynasty Buddhist painting, the style of this painting is somewhat different. There is more emphasis on solid planes of color, a reduction in the prominence of the attendant figures, and a somewhat more limited palette. However, the line technique, compositional style, and modeling in both are basically similar. The care for detail in the patches of the red robe, fly whisk, and cord belt reflects the same interest in fidelity to realistic details seen in the Los Angeles County Museum Arhat. Here, however, it is limited to the most important areas of the painting and is not carried into every component. Probably this painting dates slightly later than the Los Angeles County Museum Arhat, perhaps around the later part of the 14th century or into the early years of the 15th century. There is a degree of simplicity and abstraction that suggests developments at the end of the 14th century as seen in the Raktayamari painting (No. 75) datable to the end of the 14th century. There is also an intriguing mixture of Chinese and Indo-Nepalese elements, although the end result is strikingly Tibetan. The simple, rounded hills and tree forms outlined in dark, thick lines are related to Indo-Nepalese styles of landscape painting and are not part of the Chinese tradition of landscape painting. The "further eye" that projects beyond the cheek line of the face is a style well known in Indian art from the 8th century, and appears in the wall paintings of the Sumtsek at Alchi in Ladakh, from around the third quarter of the 11th century (text fig. 6). One of the most notably Chinese elements is the Arhat's robe in loose flowing folds, but the modeling technique and interesting shapes are not so characteristic of the Chinese mode of portrayal, nor is the shadow patterning. The appearance of Chinese-type architectural forms in the shrine-type throne is especially interesting. This may be the "palaces with lattice work" noted in the Tibetan text edited by Sakya Kunga Rinchen (see introduction to II. Arhats) as a feature of the Chinese style in Tibetan Arhat depiction. Two other paintings are known from this same Arhat series: one represents Bhadra (in the Zimmerman collection: Pal, 1986 p. 179) and the other, of Kanakavatsa, is in the Los Angeles County Museum (Pal, 1983, pl. 14). In both of these appear not only the "palace with lattice designs" shrine type but also the pairs of encircled deities at the corners, a special feature of this series.

The Ellsworth Arhat is most probably Vanavasin (T. Nagnane). Of the three Arhats who are commonly shown holding a fly whisk, it is Vanavasin who corresponds most closely to the figure in this painting. He is said in the book revised by Sakya Kunga Rinchen to hold a fly whisk in his left hand and to have his right hand in the *tarjani mudra* (threatening gesture with the hand held up and its index finger pointing upward). The gesture displayed by this Arhat is unusual; it is not the standard form for the *tarjani* gesture, nor is it any other typical gesture. In the series of Arhats depicted in 15th-century paintings, most of them Guge, Vanavasin appears with the customary *tarjani mudra* with the up-pointing index finger in most examples (see Nos. 3 and 6 in this book and one in the Los Angeles County Museum of Art [Pal, 1987, fig. 20]). There is, however, one clear and pertinent exception: the Shakyamuni tangka from the Virginia Museum of Fine Arts (No. 4). In the Virginia tangka, Vanavasin's index finger does not point upward; his thumb and index fingers touch. The hand is not held upward, nor is it resting on the right knee; it is slightly elevated, palm up, above the knee (see 4.1). Vanavasin's right-hand posture in the Virginia tangka is not precisely in the position of the Ellsworth Arhat, whose thumb and middle finger touch, hand resting palm up on the knee, but it is a relatively close comparison. Perhaps the Virginia Vanavasin is a "transitional" form between the depiction in the Ellsworth Arhat and the fully developed *tarjani mudra* seen in the other tangkas noted above (see 3.2 and 6.2). There may be the suggestion of a dating sequence here, the Virginia tangka dating later than the Ellsworth Arhat but earlier than the more developed style and iconographic portrayals represented by Nos. 3 and 6. This, incidentally, would suggest an interesting early dating within the Guge school for the Virginia tangka. In the British Museum set of Arhats from Shigatse (see No. 14), the figure of Vanavasin shows his right hand in a raised position in front of his chest with the thumb and middle finger touching and the

13.1

index finger slightly bent upward. This may be a subsequent transitional stage in the development following the Virginia example but before the fully developed *tarjani mudras* seen in the portrayals of Nos. 3 and 6.

Vanavasin is known from the texts as the Arhat who dwells in the forest. He is generally said to reside in the forest near Mount Saptaparna (T. Loma Dun) in Shravasti, in central India. In Atisha's hymn he is said to reside in Videha, one of the four great continents surrounding our universe (Tucci, 1949, pp. 158, 560, 566). Shakyamuni Buddha found him in the forest and ordained him a monk. The forest setting with animals in the Ellsworth tangka agrees with this. The Buddha called Vanavasin his "best hermit monk."

Although there is a little restoration to some parts of the tangka, notably around the worn areas on the left side, this painting remains one of the great treasures of early Arhat depiction in Tibetan art.

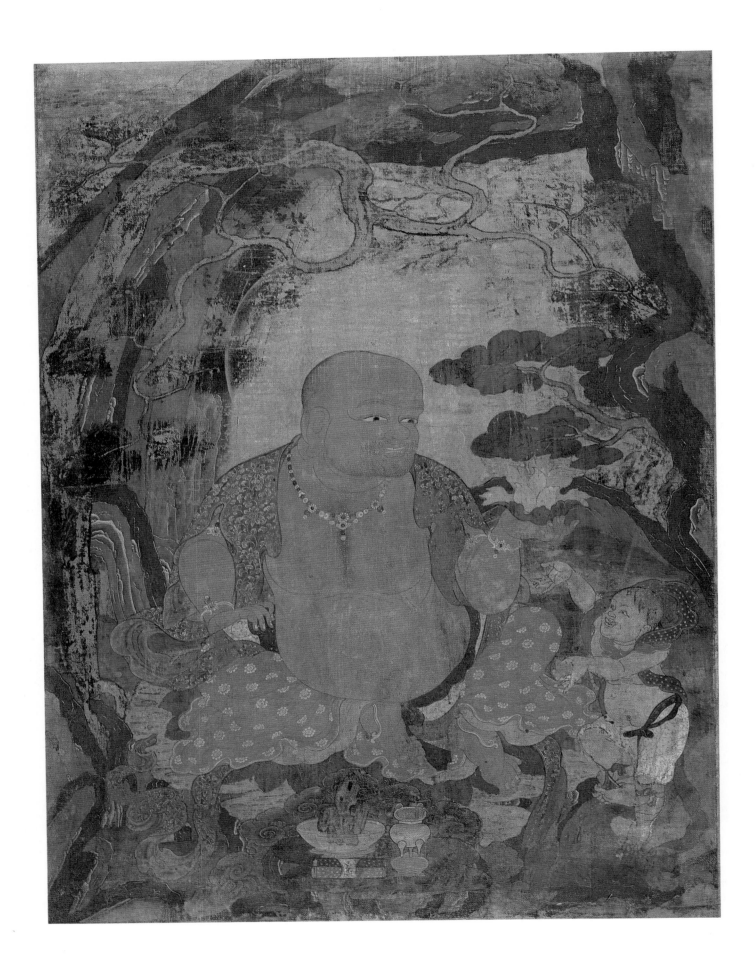

14

Hvashang

Central Regions, Tibet; said to have come from a ruined temple in Shigatse in Tsang

Early 15th century; probably ca. 1425

Tangka; gouache on cotton

25 × 18½" (63.5 × 47 cm)

The British Museum, London

Lit.: Tucci, 1949, pp. 556–62; Béguin et al, 1984; de Visser, 1923.

Hvashang is one of the "supporters," or adjuncts, of the sixteen Arhats. He, together with Dharmatala (No. 17), are Tibetan additions to the original set of sixteen. Neither is mentioned in the original lists of Arhats from India and from Atisha. It is not certain when they first appeared in Tibet, but Hvashang may have appeared later than Dharmatala (Tucci, 1949, pp. 558–61). They are usually counted as the seventeenth and eighteenth Arhats in the Tibetan tradition, even though they are lay figures rather than monks. Hvashang has his own special character, is rotund and jocular, and is often depicted as the friend of children. He resembles the Chinese Chan (J. Zen) character Budai, a popular figure since the 10th century in Chinese art, whose identity later became merged with a form of laughing Buddha associated with Maitreya. These characters have slightly differing interpretations and popular traditions, but they all center around a similar figure with chubby body and good-hearted personality.

This example is part of a set of the sixteen Arhats (only twelve of the Arhat tangkas now remain) with the two supporters and the Four Heavenly Kings that was obtained in Shigatse, in Tsang, early in this century by one Colonel French of the British army. The set was presented to the British Museum in 1955. It is a rare surviving, nearly complete set of the Arhats from an early date and may well be the oldest set of individual tangkas with the figures of Dharmatala and Hvashang. The tangkas in this set are in generally excellent condition, although most have undergone slight repair, presumably in early times, in the form of retouching worn-out areas and occasional redrawing of black lines. Each example has

a cartouche at the bottom with a lengthy, though worn, inscription (in Tibetan *ume* script) that is difficult to decipher.

The portly but shapely golden brown figure of Hvashang sits in a relaxed pose on a mat of gold-edged pointed leaves atop a flat boulder. Unlike the two earlier Arhat paintings (Nos. 12, 13) Hvashang is set back into the midground area, which imparts a new element of spaciousness and naturalism to the composition. A faint, transparent green halo surrounds his head. In front, silhouetted against the dark cloud that separates it from the rocky mass, there is a glass bowl containing a rock, a small Chinese-style tripod vessel, and two volumes of books bound together by a ribbon. These objects are Chinese in character and undoubtedly reflect the description in the Tibetan text revised by Sakya Kunga Rinchen (see introduction to II. Arhats), which describes the Chinese style of Arhats as having Chinese books, dishes, and so on.

Hvashang, his eyes wrinkled and his mouth smiling to show his small white teeth, gazes with pleasure at a floral offering that he holds up in his left hand. It has apparently just been presented to him by the gleefully delighted boy at his left. (Some overpainting, probably done at a later time when this set was being repaired, reveals an attempt to alter somewhat the position of this boy's left leg and foot.) Only these two figures are present in the forest, whose dark coloring offsets the fairly large figure of Hvashang. He is ornamented with a necklace and armbands of yellow and blue gems outlined in red. His elaborate red skirt and green shawl are both decorated with fine brocadelike gold floral designs. These designs differ from those in the earlier Tibetan Arhat tangkas, but are related to designs appearing in the portrait of Lang Ösung (ca. 14th century) from Drigung monastery northeast of Lhasa (Liu, 1957, fig. 24). The naturalistic style of these draperies with their loose, fluttering edges and twisting ends, which seem to curl and turn in some unseen draft, is generally associated with well-known Chinese stylistic traditions for example, those seen in the early Yuan period wall paintings at Dunhuang, such as those of Cave 3 (Tonkō Bumbutsu Kenkyūjo, 1982, V, pls. 163, 167, 170, 174, 176). From this time on, this style of drapery depiction becomes a pervasive motif in Tibetan paintings,

particularly after the 17th century.

The figure of Hvashang is masterfully drawn. The lines, drawn in dark red (except for the eyelid), have an even, fluid grace and pliancy unlike the more brittle and sharp quality of line in Nos. 12 and 13. Such resiliency of line and the somewhat softened tone as well as the calligraphic fluency are characteristic of Chinese painting and would indicate that in this case the artist was at least trained in Chinese painting methods. The drawing easily suggests foreshortening in the arms, hands, and face, without awkward naïveté. With little or no modeling to suggest the rounded mass of the body, this superb line ably creates a body full of solid and curvaceously shaped mass. In addition, there is subtle sensitivity in the lyrical movement of curve and countercurve. The linear movement is fairly naturalistic and restrained, without the baroque flourishes that appear in later paintings. Clearly this painting, along with the others in this remarkable set, is an early example of a skillfully naturalistic style of drawing in Tibetan art. That is, the drawing itself suggests the natural characteristics of weight, movement, and mass.

Despite the strange stylization of the twisted trees and the flat layers of gold-edged blue, green, and brown rocks, the landscape in this tangka affords a more consistently naturalistic spatial setting for the figures than the preceding two Arhat tangkas (Nos. 12, 13). Compared to these same two tangkas, the early Ming Chinese lineage of the landscape elements in this tangka seems clear, though they are handled with a studied intensity and a distinct tendency to flatten the shapes that is decidedly Tibetan in character. This type of large, interestingly twisted tree is known in Chinese painting of the Yuan and early Ming (Tokyo National Museum, 1975, fig. 60; Cahill, 1978, figs. 3, 4, 12). Some of the other Arhats in this series show comparable features in figure style (especially in the portrayals of the faces) with figures in the wall paintings of the Kumbum at Gyantse dating around the second quarter of the 15th century (text fig. 19). This factor, as well as the early Ming character of the paintings and the apparently transitional feature of the *mudra* of the Arhat Vanavasin from this set (see text to No. 13) all strongly suggests a dating for this unique set of Arhats around 1425.

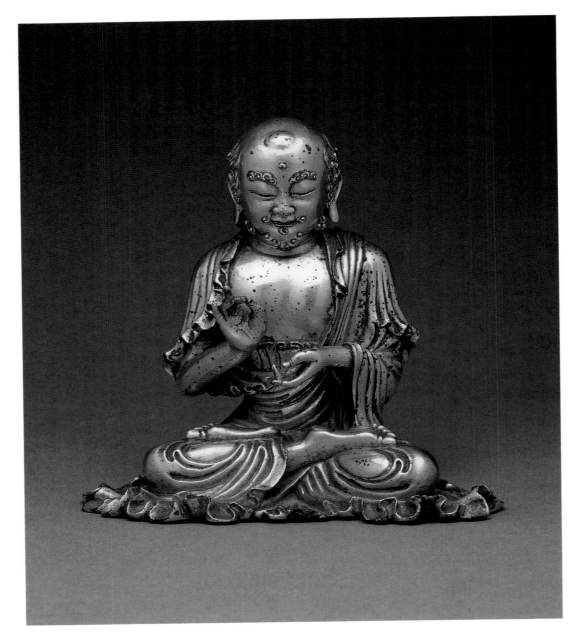

15

Arhat Bhadra

China

14th century

Gilt bronze

H. 4⅜" (11.2 cm). Shown actual size

Musée Guimet, Paris

Lit.: Béguin et al, 1977, p. 106.

The Arhat Bhadra (T. Sangpo) was born in Kapilavastu, the native land of the Buddha Shakyamuni. He is portrayed here teaching on the shores of the Jamuna River.

Made in China, this very fine piece is reminiscent of the molded clay statues manufactured at the monastery of Evam in southern Tibet during the second half of the 14th century. Similarities can also be seen to several smaller statues dated by specialists from the end of the 14th century or early 15th century. The Ming dynasty emperor of the Yongle period (1403–1425) in particular contributed personally to the development of the imperial workshops of Buddhist bronzes. The pieces that came out of these workshops, however, seem more geometric in form and more "Nepalese" in their ornamentation than this statue from the Musée Guimet, which may, in fact, be earlier.

G. Béguin

16
Arhat Kalika

China

Late 14th century

Gilt bronze

H. 6½″ (16.5 cm)

The Los Angeles County Museum of Art, Los Angeles. From the Nasli and Alice Heeramaneck Collection. Purchased with funds provided by the Jane and Justin Dart Foundation. M.81.90.18

Lit.: Pal, 1983, pp. 225–26; Béguin et al, 1977, p. 107; Pal, 1990.

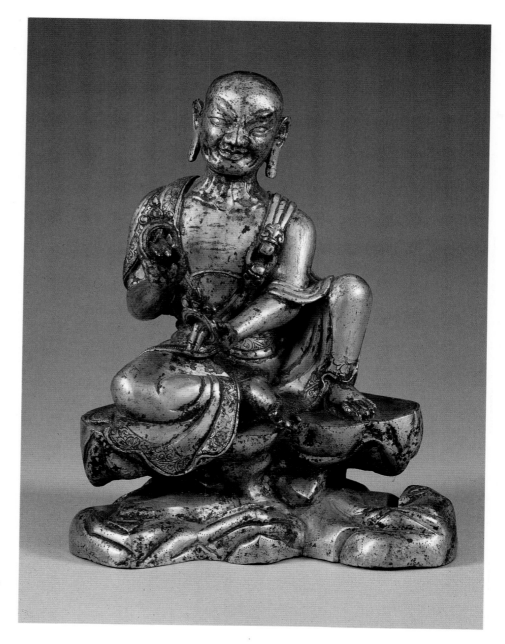

This powerful image of the Arhat Kalika (T. Duden) shows him seated on a rocky pedestal holding two earrings, a mark of his identity. Once, when teaching the gods of the Desire Realm Heaven, they presented him with their ornaments, which he transformed into a pair of gold earrings.

The chunky image of the Arhat is fashioned as a tough and solid figure, twisting with a forceful yet contained movement. The dynamics of the body are superb; even though he is quietly seated, the arms and legs seem to thrust into space, and the torso and head turn with firm, bold command. Just as the inner tension and outer movement balance each other, so do the solid volumes of the masses balance with the simple but effective movements of the drapery. While the body seems to project in one direction, the drapery folds pull in a counter-direction. Such use of counterbalancing forces shows the yin-yang principle of opposites (the opposing forces and dualistic characteristics of nature) typical of Chinese artistic style. Part of his outer robe is held at the left side by a clasp, often seen in Chinese representations of the monk's robe. Chased floral patterns boldly decorate the borders of the garment.

The powerful bald head of the Arhat emerges from a neck of straining sinews. The features of the smiling face, though coarse, define a magnetic and strong personality. He has thick lips and wide-open, sharply contoured eyes. His sloping eyebrows and jutting nose, together with the solid mass of cheeks, cranium, and jowls, intensify the power of form that is so characteristic of this style. The craggy rock pedestal supports the dramatic effect.

It is layered with a constricted center and is naturalistically fashioned in angular but smooth shapes. Minute perforations in lines along the edges of the lumpy shapes are somewhat unusual, possibly indicating texture. Naturalistic rocky pedestals for the Arhats have been a feature of Chinese Arhat depiction since the Tang dynasty.

The style of this image is consistent with that of 14th-century Chinese sculpture (Yuan to early Ming). The vigor and tension of dramatic movement in both form and drapery are features of Yuan sculpture, but the slightly rigid chest and the controlled clusters of folds with their curved patterns relate most closely to the early Ming style as represented by the

statue of Guanyin (Kuanyin) dated 1385 in the Metropolitan Museum of Art in New York (Bachhofer, 1947, fig. 78). The naturalistic yet patterned design of the rocky pedestal is seen in this same statue and in other Chinese Buddhist sculptures of the late 14th century. In many ways this statue is not unlike the Arhat figures from the series of No. 13 and may date around the same time. This powerful image of Kalika also affords an interesting contrast with the delicate Arhat Bhadra in the Musée Guimet sculpture (No. 15), probably of the early 14th century and of a different stylistic type, employing the soft, closely parallel, wavy folds associated with the Khotanese style.

17
Dharmatala

Eastern Tibet (?)

Second half of the 16th century

Tangka; gouache on cotton

31½ × 20⅛″ (80 × 51 cm)

Museum of Fine Arts, Boston

Lit.: Tucci, 1949, pp. 556–62; Béguin et al, 1984; de Visser, 1923.

Like Hvashang (No. 14), Dharmatala often accompanies the sixteen Arhats as a servant, but he appears to have a special function as a messenger. Both are called laymen (*upasaka*) and are not monks like the Arhats, but they are usually counted as the seventeenth and eighteenth Arhats in the Tibetan tradition. Dharmatala is always depicted carrying a load of books on his back and accompanied by a tiger, who was miraculously created, it is said, to frighten away spirits. He was apparently a devotee of Amitabha Buddha, so customarily a small figure of that Buddha appears on a cloud nearby. The depiction of Dharmatala resembles in many ways the "traveling figure" found among the paintings and drawings of the 9th and early 10th century from Dunhuang on China's Central Asian frontier. The identity of this figure has been puzzling, but in one tradition in China it became associated with the famous Chinese pilgrim Xuan Zhuang, who in the 7th century had traveled to India for fifteen years and returned with many sutras, images, and a diary of all his travels. Some scholars suggest the figure is a Khotanese deity protector of travelers (Whitfield, 1983, pl. 59, pp. 336–37). Both Hvashang and Dharmatala seem to have incorporated some elements from popular Chinese figures, but, unlike the Chinese and Central Asian examples from which they seem largely derived, the Tibetans have given them a special, prominent, and specific place and function with the Arhats.

In this painting, Dharmatala is positioned near the middle on a fairly broad, level plane. He is shown walking on a bright red and gold carpet that forcefully defines his space and contrasts markedly with the predominantly green surroundings. He is dressed in subdued but elegant long robes of dark blue, green, and white. A white cloth is belted around his waist; it is fastened with a gold-edged sash whose ends drift off to the side. In his hands he holds a delicate fly whisk and a golden ewer with a tall lid and curved spout. His parasol has a dark green lining and a border of black and white stripes that seem to imitate the stripes of Dharmatala's white companion tiger. A small white incense burner hangs from the outer edge of the canopy and dangles gently beside his face. On his back, his heavy load of books is stacked in a bamboo rack. His face and hands are unusually pale; they are hardly distinct from the white cloth of his headgear and undergarment. Delicate lines describe his small facial features and light beard, which complete the impression of a gentle, rather than a rugged, figure.

Although Dharmatala remains the primary focus of the painting, he is not as monumental within the setting as the Arhats of 14th- and early 15th-century paintings (Nos. 12, 13, 14), and the landscape itself plays a far greater role. Yet, despite the increased interest in landscape, its spatial function, and its atmospheric properties, the landscape does not have the power observed in the earlier examples. It is far more delicate and subdued, and recedes farther into the distance. The dominant color is malachite green; its cool and inviting tonality draws the viewer into the setting. We move readily from object to object in a zigzag path from the lower left, where a mysterious "foreign"-type male figure offers up to Dharmatala two blue jewels from his place beneath rocky ledges and a lavender cloud. Another large lavender cloud and a beautiful leafy tree reinforce the central position of Dharmatala. From here we are drawn through the breaks in the rocks to the deities and clouds that float in the pale, murky sky. An offering deity in brilliant garb hovers above the white-robed Amitabha. Overall, the pale tones and refined style create the ethereal atmosphere of an ideal world.

This kind of landscape—with beautifully detailed naturalistic elements (such as the large tree), the spatial composition and ground plane, and the pastel coloring of the clouds and green landscape—is related to Chinese Buddhist painting of the Ming dynasty (1368–1644), particularly of the 16th century. The atmospheric illusions in the painting seem to suggest a relationship with middle Ming period painting, before the crisper clarity of the late Ming ushers in a more precise definition of space, as seen in the Ford tangka (No. 18). Despite the similarities with Chinese painting, the distinctively Tibetan artistic style emerges in the clarity and sharpness of the primary figures and the latent power of the two-dimensional representation, which injects its own potent kind of reality. It gives the ethereal landscape a vigor and intensity more Tibetan than Chinese. The painting does reveal, however, a fortuitous merging of the Chinese styles with the Tibetan expression. This tendency appears most often in the eastern regions of Kham and Amdo, where there were many important Tibetan temples, most never well known in the West, now mostly destroyed. This painting was one of a series of Arhats; another two examples are also in the collection of the Museum of Fine Arts in Boston (Acc. Nos. 08.373 and 08.374). All are exceptionally fine works of great delicacy, refined detail, and beauty of color.

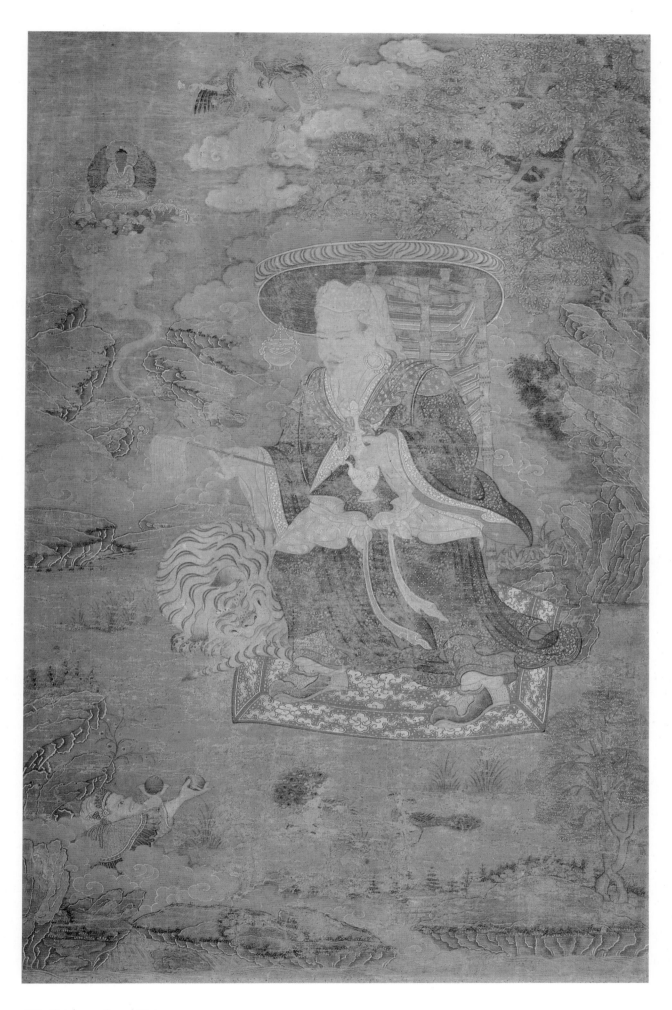

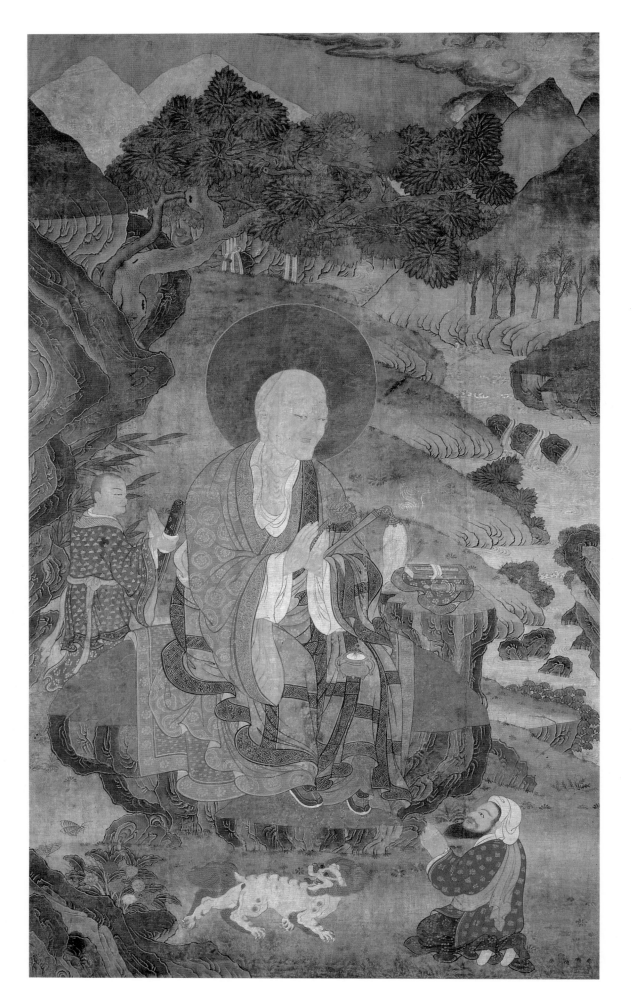

18
Arhat Angaja

Eastern Tibet

17th century

Tangka; gouache on cotton

38 × 22⅜″ (96.5 × 57 cm)

Mr. and Mrs. John Gilmore Ford

Lit.: Lauf, 1976a, pp. 66–67.

Angaja, who according to tradition dwells on Mount Kailash, is the first in the set of sixteen Arhats, according to Atisha's ordering. He is shown as an aged man, fragile and expressive. He carries his characteristic implements, an incense burner and a yak-tail fly whisk. He gently holds the dragon-headed staff of the fly whisk and the incense burner hangs by a chain over his left arm. It is said that the children of the gods made offerings to him after they received his blessings, and that all the other offerings, one by one, were merged into these two implements. His blessing is said to have a special power to protect from suffering and disease.

Angaja is seated on a blue flat-topped rock with a solid blue halo. He is garbed in full, elegant robes of soft colors that harmonize with the neutral tones of much of the landscape. Each of his robes is carefully patterned with a variety of designs in gold. He gazes at the bearded man dressed in white turban and brocade robes kneeling in front of him. Nearby, a delightfully brisk, orange-maned white snow lion, possibly an allusion to Angaja's domain on Mount Kailash, scampers across the front, turning its head as it runs. A book-bearing disciple steps behind the Arhat, his robes gracefully suggesting his movement. A volume of the Prajnyaparamita Sutra and a rolled-up scroll rest on a rocky projection at the Arhat's left. The book is a Chinese-style volume, but the title is written in Tibetan letters. Both books and scroll are tied with cloth bands that seem to be a little different from the Chinese type.

The landscape and the Arhat seem perfectly integrated and in naturalistic proportions. Even the viewpoint seems consistent with the viewer's eye-level progression into the distance, although there are surprises, such as the collapse of the space in the elements around the right side of the stream. Landscape elements seen in their infancy in Tibetan art, as in No. 14, and developed with more three-dimensional design, as in No. 17, are here fully realized, and there is a clarity and harmony among all the elements. The Arhat is the central focus of the foreground. Behind him, emphasizing his importance, a cone of serried riverbanks funnels back between a pale, refreshing stream on the right and a diagonally layered cliff at the left. At the middle ground the view becomes blocked by the heavy mass of the overspreading tree, which draws our attention back to the Arhat it protects and covers. Beyond the barrier of the tree, we catch just a glimpse of the background.

The play of contrasts between the left and right sides of the little valley discloses the subtle use of the yin-yang principle of composition, which Tibetan artists skillfully employed in landscapes of Arhat paintings in later periods. The style here, however, is Tibetan. The clarity of form, the strength of the line, and the tendency to make elements into distinct, two-dimensional shapes—all are characteristic of Tibetan art. The face of the Arhat is rendered with refined sensitivity in a line more delicate than that used for the garments and landscape, a technique used since the Southern Song period in Chinese Buddhist portraits. Here, however, it reveals the steady, even clarity of a Tibetan style rather than the fluctuating softness of a Chinese hand. The painting probably dates to the latter half of the 17th century, as the landscape corresponds to some late Ming styles. Another example from this same set is also in the Ford collection (Lauf, 1976a, pl. 14). This exquisite series is a forerunner of the set reproduced by Tucci (1949, pls. 156–70), which probably dates in the 18th century. Both are important works for understanding the development of the Eastern Tibetan schools from the 16th to the 19th centuries, a subject that still needs much clarification.

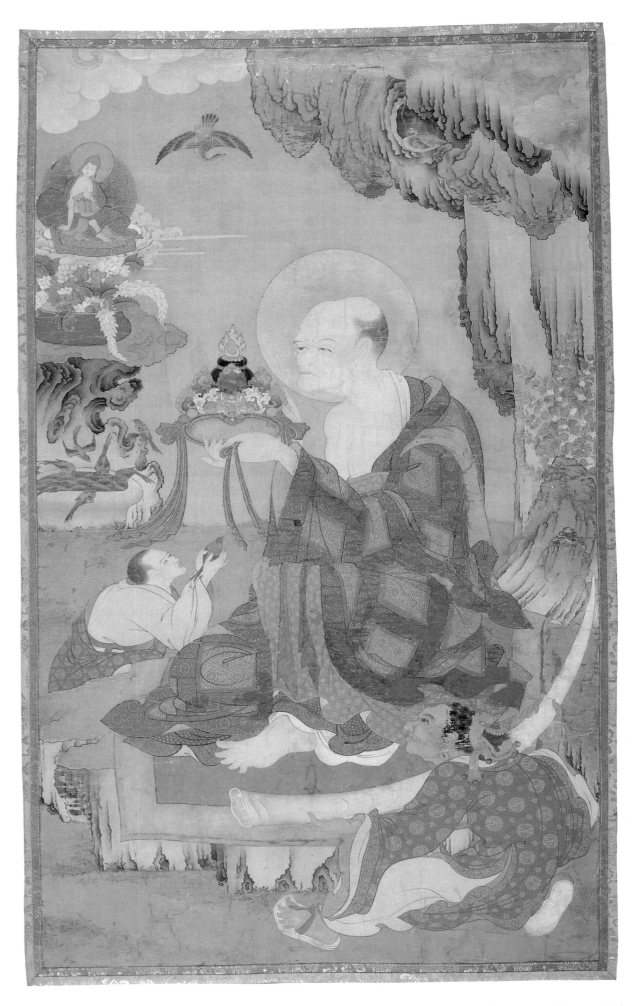

19
Arhat Rahula

Eastern Tibet or China; Sino-Tibetan

17th to early 18th century

Tangka; gouache on cotton

43¼ × 25¼″ (110 × 64 cm)

Musée Guimet, Paris

The Arhat Rahula (T. Dragchenzin) was the only son of the Buddha, and was said to have attained enlightenment just by walking into the presence of his father. According to legend, he teaches in the Olympus-like Heaven of the Thirty-three Gods (Trayastrimsa), especially to their children. In return, they give him presents of richly wrought jewel tiaras. The great Indian master Shantarakshita, who built and dedicated the Samye monastery in Tibet in the 8th century, was considered the spiritual reincarnation of the Arhat Rahula.

This work, executed according to Tibetan techniques and perhaps made for a Chinese monastery, shows strong influences of the decorative painting of the Ming period (1368–1644): the impressive overhanging rock, birds (one in in flight, another nesting, and some around a small pool), and the flower element (19.1). By the subtle use of shading, the painter evokes the modulations of the traditional wash technique. The figure of Rahula himself appears as a successful synthesis between two well-known methods of illustrating Arhats in Chinese art. The expressive face is reminiscent of Guan Xiu (832–912), and the noble attitude as well as the magnificence of the environment, of Li Longmian (ca. 1040–1106).

G. Béguin

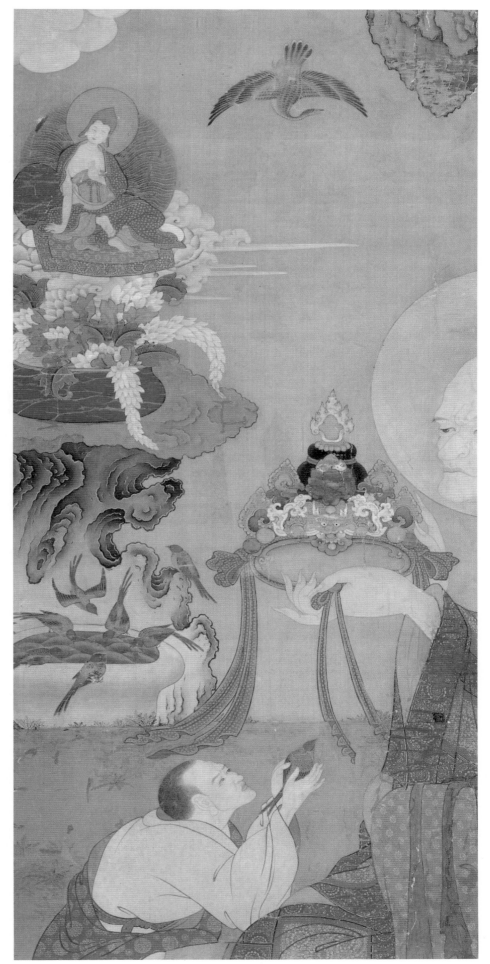

19.1

III.
Bodhisattvas

"Bodhisattva" means "hero" (*sattva*) of "enlightenment" (*bodhi*). It refers to any person, male or female, human, animal, or divine, who has conceived the will to unexcelled perfect enlightenment in order to save all beings from suffering, and has vowed to persist in that quest for as many lifetimes as it takes to accomplish it. It is said that counting from the moment he conceived the spirit of enlightenment (*bodhichitta*), Shakyamuni Buddha took three immeasurable eons of lifetimes to attain Buddhahood. Bodhisattvas are truly messianic figures, spiritual heroes and heroines willing to sacrifice themselves for others life after life. At the same time, they are keen to develop the wisdom that understands reality and the art to be effective in saving beings. The Universal Vehicle (Mahayana) sutras that began to emerge in India from the 1st century BCE elevate the messianic ideal of the Bodhisattva above the Individual Vehicle (Hinayana) ideal of the self-liberated Arhat or saint.

Some Bodhisattvas are still ordinary beings, ones who maintain the spirit of enlightenment. Other Bodhisattvas have become highly developed. Their goodwill toward beings drives them to develop godlike powers, so that they become almost indistinguishable from a Buddha in their ability to benefit others. We can refer to these as human or historic Bodhisattvas and celestial or angelic Bodhisattvas, respectively.

This section describes paintings and sculptures of a few of the most prominent and popular Bodhisattvas active in Tibetan Buddhist history and art, including Vajrapani, Green and White Tara, Avalokiteshvara, Manjushri, and Maitreya. The works are from various regions and from periods that range from the 9th through the 18th century.

The array of sculptures presented here is intended to suggest a Tibetan temple altar and to offer a wide range of stylistic and regional examples from both inside and outside Tibet. In the early sculpture of the 11th to the 13th century there are pronounced regional styles that depend largely on the lineages of schools of Indian art, notably those of the Pala dynasty in northeast India and of Kashmir. Sculptures from Western Tibet during the 10th to the 12th century possess particularly distinctive styles, usually related to the Kashmiri and Himachal Pradesh sculptural traditions. Images of Pala

inspiration seem more common to the central regions, but little is yet known about the sculptures from this area during these early centuries. Old photographs of Tibetan temple altars taken by Tucci show a profusion of imported sculptures of this period. Some of the works in this section were made outside of Tibet, but in some way, by either style, iconography, or usage, are strongly associated with Tibet. They reveal the complexity of the interrelationships between Tibet and neighboring Buddhist lands.

A few works in this section specifically point to Tibet's relationship with China. The Yongle sculptures (No. 30), for example, were gifts to prominent Tibetan lamas by the third Ming emperor, ruling during the Yongle period (1403–1425). Mongolia and China became increasingly important in Tibetan history during the 16th to the 18th century. Two excellent Maitreya Bodhisattvas (Nos. 32, 33) reflect the Mongolian and Tibeto-Chinese styles of the late 17th and mid-18th centuries respectively. The huge sculptures brought by Sven Hedin from Inner Mongolia offer spectacular examples of the impressively large altar images characteristic of Tibetan temples (Nos. 35, 36).

Paintings in this part focus on a few especially fine examples from the central regions of Tibet (No. 24) and Eastern Tibet (No. 27) from the early and later periods, respectively. The Ford Green Tara painting is not only exquisite in style, but its subject matter singles it out from other surviving early paintings from the central regions, in which Bodhisattvas are scarcely seen as the main image in surviving paintings. More than likely it can be considered to be a tangka of the Kadam Order. Also, certain important works in Indo-Tibetan style from places outside Tibet proper, but under Tibetan cultural influences, are represented. These include the rare examples from Dunhuang (No. 20) of the 9th century and from Khara Khoto (No. 21) of ca. late 12th century. Both sites were important Buddhist centers on the Central Asian borders of China. Khara Khoto was a garrison town of the Xi Xia kingdom from the latter part of the 11th century until it was razed by the forces of Genghis Khan in 1227. The works from Khara Khoto were recovered early in this century by P. K. Kozlov and are now a part of the State

Hermitage in Leningrad (see text below by K. Samosyuk). The rarely seen Bodhisattva painting No. 21, although a fragment, is a well-preserved, superb example of a large Bodhisattva in the Khara Khoto Indo-Tibetan style, which relates to tangkas and wall paintings in the central Tibetan regions in the 12th century. The *kesi* silk tapestry (No. 23) from the same site, one of a rare few of its kind, was, along with all the other works from the State Hermitage collection in this book, shown for the first time in the United States in 1991 in *Wisdom and Compassion: The Sacred Art of Tibet*.

M. Rhie and R. Thurman

The Soviet collection of Tangut cultural relics was brought to Russia by P. K. Kozlov, an explorer and scholar who made two expeditions to Central Asia, in 1907 and 1924. Both times he worked in the ruined city of Khara Khoto (Ch. Heshui-cheng, in Gansu province). After the third decade of the 11th century, this garrison city was part of the Tangut kingdom of Xi Xia (982–1227), a hostile neighbor of Song dynasty China. It also shared a border with Tibet to the south and with the Uighur kingdoms to the west. Tibet linked the Tanguts with eastern India and Nepal while the Uighurs played the role of international mediators in Central Asia. Determined to establish an independent state, the Tanguts turned to two powerful cultural traditions: the Chinese and Indo-Tibetan. They created their own written language in 1036, and in 1039 by imperial order parts of the Buddhist canon were translated from Chinese into the Tangut language. Translations were also made from Sanskrit and, more rarely, from Tibetan. The Xi Xia state was multinational; in addition to Tanguts, it was inhabited by Chinese, Tibetans, and Uighurs. Until the Tanguts conquered Khara Khoto, the city was under Uighur control.

Corresponding to the ethnic composition of the state, the Buddhist communities (sanghas) were Tangut, Tangut-Chinese, and Tibetan. E. I. Kychanov hypothesized that Tangut Buddhism leaned toward Chinese Buddhism, because of the close proximity of major Chinese Buddhist centers such as

Dunhuang and others in the Gansu area, as well as Wu Tai Shan. The city was on the Silk Route and was visited by Marco Polo after the Mongols conquered it in 1227.

At Khara Khoto, Kozlov discovered a buried treasure in a *suburgan* (Mongolian for stupa), which was later given the epithet "the famous or great *suburgan*." The manuscripts and books from the stupa, printed in Chinese, Tangut, and Tibetan, currently make up the Tangut collection of the Institute of Oriental Studies of the Academy of Science in Leningrad. The paintings, sculpture, and prints are kept in the State Hermitage in Leningrad, which has a total of thirty-five hundred articles from Khara Khoto, including about three hundred paintings (of which more than half are in good condition), about twenty prints and drawings, about seventy sculptures made of clay, wood, and bronze, and other items such as fabric, paper currency, coins, Yuan dynasty (1279–1368) fragments of porcelain, and various utensils. These materials became the basis for a new school of oriental studies known as Tangut studies, founded by A. N. Nevsky. No other museum in the world has such a complete collection of Tangut cultural materials and art of medieval Central Asia.

S. F. Oldenburg, the first to study the Indo-Tibetan icons, has noted the Chinese and Tibetan artistic traditions in the paintings of Khara Khoto. We might also add the Central Asian and local Khara Khoto traditions. The latter—a kind of amateurish or primitive style—is extremely important for understanding the collection's heterogeneity. Some are executed according to Chinese models, some, Tibetan. Others combine both traditions, suggesting that over a long period Khara Khoto religious painters were familiar with both artistic schools. It is hard to say where these works were painted—by Tibetan artists in Tibet, or by Tibetans or their Tangut students in Xi Xia. Although the icons are not presented here in the context of Tangut culture, they are appropriate in a book on Tibetan art. *Tuhui Baochien*, a Chinese work of 1365, mentions that by the beginning of the 11th century Tanguts produced art and that the emperor was a patron of the arts. The same work notes that northeastern Tibetans studiously painted Buddhas and used cotton cloth (Oldenburg, 1914, p. 73; Hirth, 1896, p. 45).

K. Samosyuk

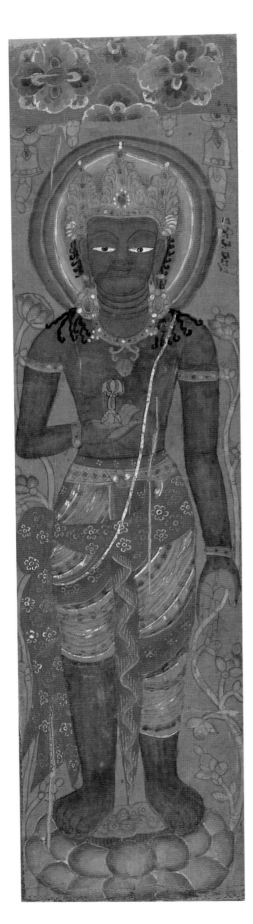

20

Vajrapani

Dunhuang, northwest China

9th century

Banner; ink and colors on silk

21½ × 5¾″ (55 × 14.5 cm)

The British Museum, London

Lit.: Whitfield, 1982, p. 334; H. Karmay, 1975, pp. 8–17; Klimburg-Salter et al, 1982, p. 132, pl. 58.

This rare fragment of a silk banner painting was obtained by Sir Aurel Stein in 1906 at the Dunhuang caves in northwest Gansu province on the border of China and Central Asia. It was a part of the famous cache of paintings and texts he found in cave 17, which had apparently been walled up in the middle of the 10th century to safeguard these precious treasures during a time of instability. The British Museum and the National Museum in New Delhi, the two museums that shared the works brought back by Stein, have several other paintings of a similar type, date, and style (Whitfield, 1982, pls. 46, 47). All are Bodhisattvas; all date to the 9th century; and all are uncharacteristic of the prevailing Chinese Buddhist painting style of that time. As has been recognized by a number of scholars, they appear clearly to relate to an Indo-Nepalese-Tibetan tradition of painting, most likely Tibetan. At present, however, there is no hard evidence to confirm this. There is a six-letter inscription that has long been a mystery in the painting above the figure's left shoulder. Professor Elliot Sperling has determined that the letters are Tibetan, but they appear to be written in reverse, possibly indicating an inscription on the back that has leaked through the silk to the front. The letters are phonetic Tibetan (Pa-ja-ra-pa-ra-ne) for Vajrapani. Tibetan inscriptions exist on some Dunhuang paintings of this period, including works that are painted in the Chinese stylistic tradition, apparently by Tibetan artists. Tibetans occupied the strategic oasis of Dunhuang from ca. 781 to 848, during the time of their ascendancy in most of Central Asia. It is likely that these paintings belong to this period, that of the Yarlung dynasty of the Religious Kings of Tibet. Thus they can reasonably be con-

sidered valuable materials reflecting the art of this early period in Tibetan history.

We can identify the image as Vajrapani, symbol of the power of compassion, by the blue vajra that he holds upright in his right hand, the vajra being the diamond or "thunderbolt" scepter. The lowered left hand holds the stalk of a lotus bud while a full-flowering lotus rises behind the figure on his right side. The frame of this banner fragment is narrow and the standing figure barely fits within its confines. He stands straight, frontal, and barefoot on a lotus pedestal tinted with a rose red graded wash. His body is rather firm and simply shaped. Its olive green color handsomely offsets the bright yellow, red, and blue print of his kilt, his white-flowered red hip sash, and his elaborate, triple-pointed golden crown and other jewels. Strands of curly black hair stick out from his head and lie scattered across his shoulders. His large head has an ample jaw, a tiny mouth, and arched eyebrows. The whites of his large eyes make such a startling setting for the pupils that they become the focal point in the painting. This bold contact with the viewer is as distinctly non-Chinese as it is typically Tibetan. It is seen in many art works, such as in the 14th-century Arhat (No. 12) from the central regions of Tibet. The multicolored, striped textile derives from India rather than China, along with the strong and brilliant coloring, the sturdy proportions, and the fully rounded shaping of the body. A round halo completes the figure. Above, we see part of a border of flowers and hanging bells. The figure is placed against a plain silk background and is outlined in even, firm, red and black lines. Overall, the boldness and strength of form, color, and line come together in a powerful, if broad and simple, style.

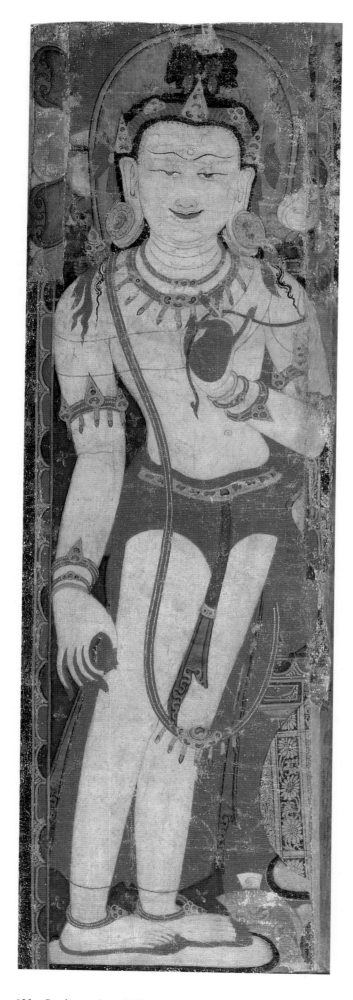

21

Padmapani Bodhisattva

Khara Khoto, Central Asia

Before 1227

Tangka; gouache on cotton

29½ × 9½″ (75 × 24 cm)

The State Hermitage, Leningrad

Lit.: Oldenburg, 1914, p. 18

An exceptionally fine work, this Padmapani-Lokeshvara was believed by Oldenburg to be the proper right side of a large icon. All that remains of the central figure—about which we can only speculate—is a lotus petal and a rich black garment with intricately executed gold designs covering the remaining knee. This surviving fragment is composed of several pieces. In the upper left corner a patch of cloth with parts of painted lotuses has been attached. There is another narrow patch at the upper right and another in the middle right side. This patching, as well as the worn and fragmentary condition, may suggest that this work is very old— possibly executed before the 12th century.

This fragment is unique among the paintings in the Khara Khoto collection. It is the only example in which the figure standing to the right of the unpreserved central image (Bodhisattva?) is depicted *en face*. The upper body of the figure turns toward the viewer, but the legs are depicted in profile. The Bodhisattva is white, with one head and two arms. The right arm is lowered in an indeterminate *mudra* and the left hand holds the delicate stem of a white lotus. The figure is richly ornamented with flowers in the hair, a necklace and earrings, bracelets, and a long cord extending below the knees. The necklace, bracelets, and the transparent scarf—thrown across the chest nearly horizontally and tied at the left shoulder— have analogies in the paintings of Ladakh. It has not yet been possible to find a similar hairstyle or head ornamentation. Although the exact origins of the style of this image are not known, they are probably not Indian or Nepalese.

K. Samosyuk

22

Twenty-one White Tara Stele

Tibet (?)

Second half of the 11th century

Yellow sedimentary silt stone, with pigments

15¼ × 10½ × 3″ (38.7 × 26.7 × 7.6 cm)

Herbert and Florence Irving Collection

Lit.: Mullen, 1980; Willson, 1988.

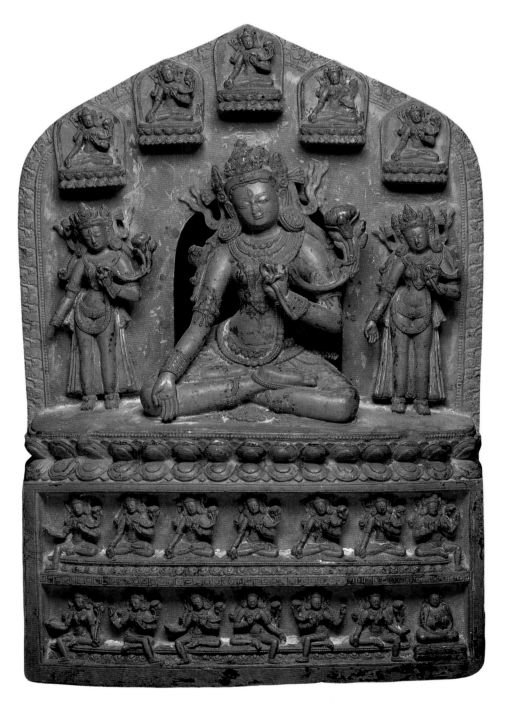

Tara's name means One Who Saves. Her compassion for living beings, her desire to save them from suffering, is said to be stronger than a mother's love for her children. As Manjushri is the celestial Bodhisattva who represents the wisdom of all Buddhas and Avalokiteshvara is the one who represents all their compassion, Tara is the Bodhisattva who represents the miraculous activity of all the Buddhas of past, present, and future. She is seen here in her White Tara form in one of the most extraordinary sculptures to survive from the early periods of Buddhist art in Tibet. It is carved like a stele from a rare, fine-grained yellow silt stone and shows twenty-one forms of Tara. They represent the Taras invoked in "Twenty-one Verses in Praise of Tara" recited by Vairochana Buddha in chapter three of the thirty-five-chapter *Tara Tantra*. Indeed, the grouping of the figures seems to follow that text quite precisely, so that each Tara corresponds to one of the verses of the text.

Some versions of the praises begin with the root mantra of Tara (magical syllables that evoke the goddess): OM TARE TUTTARE TURE SVAHA! Then follow the twenty-one verses of praise, which are variously grouped as to subject by different scholars, who also differ as to which form of the goddess is evoked by which verse. One tradition (Mullen, 1980) considers that the first seven verses praise her legendary aspects, the second seven praise her fierce forms, and the final seven praise her enlightened activities. This tradition is associated with Atisha (982–1054), the great Bengali Buddhist master who followed Tara's prophecy and went to Tibet to renew Buddhism in 1042. In that tradition, all the twenty-one Taras appear very much alike, with the gesture and posture of White Tara, though they are evoked and praised from different perspectives.

The first verse is especially memorable: "Homage! Tara, swift, heroic! With a glance like flashing lightning, born from a blooming lotus sprung from the tears on the face of the Lord of the World!" This verse refers to one of Tara's legends. Avalokiteshvara was looking down from his heaven on the world of suffering beings, and he wept to see that more and more of them were in pain no matter how many he delivered. From the tears streaming down his face two Taras were born, a peaceful white one from the left and a fierce green one from the right. As the quintessence of the miraculous activities of all Buddhas, they gave him courage not to give up striving in his impossible task.

The succeeding verses praise 2) her symbolic attributes, 3) her hand gestures, 4) her holiness, as revered by Buddhas and Bodhisattvas, 5) her overcoming unharmonious conditions, 6) her worship by worldly gods, and 7) her destroying external threats. Verse 15 praises her as the ultimate reality, the Truth Body of the Buddhas. It stands apart from the other verses, seeing her as the immovable source from which the miraculous saving activities emerge. "Homage! Happy, good, and peaceful! She the calm Nirvana realm! Full of the inspiration and salutation of the final end of sin!"

It is possible to see that the composition of the images on the stele corresponds to the divisions of the text. On the bottom row, six Taras are seated in variants of the posture of royal ease on a single elongated lotus seat. This group seems to correspond to the six verses of Part III in Mullen's translation, which evoke her miraculous activities. They praise 16) her peaceful and wrathful mantras, 17) her shaking the three worlds, 18) her dispelling the effects of poison, 19) her eliminating conflicts and nightmares, 20) her curing diseases, and 21) her overcoming ghosts and demons. The monk at the right end of the row is undoubtedly the practitioner of the Tara practice and the donor of the sculpture.

The seven Taras in the row above (five cross-legged in diamond posture and two with one leg pendant) seem to correspond to the seven verses of Part II, which evoke the triumphant fierceness of her saving deeds. They praise 8) her excellence in removing Maras and the two obstructions, 9) the symbols in her two hands, 10) her crown, smile, and laughter, 11) her activating the Ten World Gods, 12) her head ornaments, 13) her wrathful posture, and 14) her magic syllable HUM, which radiates light.

The remaining portion, that on the top of the stele, is more difficult to decipher. The large central Tara is a typical White Tara. She is the Tara of verse 1, born from the tears of Avalokiteshvara, and also the Tara of verse 15, the Truth Body Tara. Though her image has lost its original color, she is in the iconographic attitude of White Tara. Her body is seen by the practitioner as dazzling white as a thousand autumn moons. She has a third eye on her forehead, symbolizing her direct vision of the unity of ultimate reality simultaneous with her two eyes seeing the dualistic relative world of beings. Her right hand is extended down in the boon-granting gesture, with another eye in its palm, symbolizing that her gen-erosity is always accompanied by perfect wisdom. Her left hand is raised in the gesture of granting refuge in the Three Jewels of Buddhism—the Buddha (Teacher), the Dharma (Teaching), and the sangha (Community). She holds the stem of a triple lotus, its bud, bloom, and closed flowers symbolizing the Buddhas of past, present, and future. Her crossed legs signify her immovability from contemplative union with Nirvana, while the eyes in the soles of her feet symbolize her continuing awareness of living beings' plight. She has an elaborate jeweled crown and full royal ornaments, her naked torso alert and majestic in a pose of power gracefully at its ease. In Tibet, White Tara is associated with the 7th-century Tang princess Wen Cheng, the wife of King Songtsen Gambo, who brought the famous Jowo statue of Shakyamuni to Tibet and was instrumental in constructing the Jokhang, the great temple in Lhasa (text figs. 1, 2).

The two standing Taras on either side are her own emanations who serve as her attendants. And the five Taras seated above seem to be positioned like the Five Transcendent Buddhas (representing the five elements, the five passions, the five wisdoms, and so forth) normally seen in Pala dynasty Buddhist sculptures. The central Tara and these seven may be addressed in common by the verses 2 through 6. Certainly it seems clear that this stele is a remarkably graphic expression of the practice of the "Twenty-one Verses in Praise of Tara" text.

On the back of the stele, a rectangular hole has been dug out to serve as a handle for ease of carrying. It appears that, as Robert Ellsworth suggests, this stele was a traveling shrine. Incised into the plain surface of the back are the syllables OM, AH, HUM, repeated seven times in positions corresponding to the seven Taras grouped around the main Tara on the front. The back of the main Tara is partly carved in the round and is visible through the cut-out arch around her. Behind the main image, there are more elaborately formed syllables in Sanskrit script: a large OM above her and a large HUM below her. Inside the hollowed-out handle are many small inscriptions of OM, AH, HUM, presumably corresponding to each of the small Taras in the two lower rows. Most of the remaining color (bright blue, green, and orange-red) seems to have been added later, but the remains of some white underpainting in some crevices may be original.

In style, this piece is closely allied to the Pala dynasty sculpture of northeast India, particularly of the Nalanda school of ca. the 11th to the early 12th century. The monk in the lower register, however, is Tibetan; it is one of the oldest known sculptures of a Tibetan monk. His chubby form and smooth, lively planes are very close to the style of some Liao dynasty monk sculptures of the second half of the 11th century in northern China (one in the Royal Ontario Museum, Toronto). It is also close in style to a Korean monk image dated 1022 (Chin, 1983, fig. 165). These correspondences suggest that the stele may date from around the middle to the second half of the 11th century. Some features seen in 12th-century tangkas from the central regions of Tibet also appear in this stele, such as the border pattern of square and round flat jewels (seen in the dividing edge between the two lower rows), and the clinging drapery of the lower garment. In the standing images to either side of the main Tara, the drapery billows behind the legs, making them appear uncovered. The style is also close to that of the Narthang Maitreya Bodhisattva statue, said to date to 1093 (text fig. 7).

The individual figures are carved in high relief. Full-bodied and shapely, their surfaces are smooth and their limbs plump. The main figure has heavy ornate jewelry similar to that of Pala stone sculptures of the 10th to the early 12th century. The thick points of the crown are not unlike those seen in even earlier works such as the crown of the 9th-century Vajrapani (No. 20). The wide multilayered pearly bracelet worn by the main Tara is a kind seen on the famous Tara painting in the Sumtsek at Alchi from around the third quarter of the 11th century (text fig. 6) and on certain female sculptures from the Kashmiri school of ca. the 10th to the 11th century (Pal, 1975, nos. 68, 69, pp. 182–85). Although there are regional differences, the Zimmerman collection Buddha (No. 2) has facial features that closely resemble those of this stele's main Tara. All these elements suggest a dating for this stele around the second half of the 11th century or early 12th century. The stone, according to Ellsworth, is typical of southwest China, but it is difficult to say where this work was carved and who the carver was. Certainly it seems that this stele was commissioned and used by a Tibetan monk in the early days of the period of the Second Transmission of Buddhism in Tibet, near the time of Atisha. The fact that Tara was one of Atisha's favorite deities undoubtedly contributed to her popularity in Tibet and in other areas influenced by Tibetan Buddhism, as the next two works (Nos. 23, 24) also suggest.

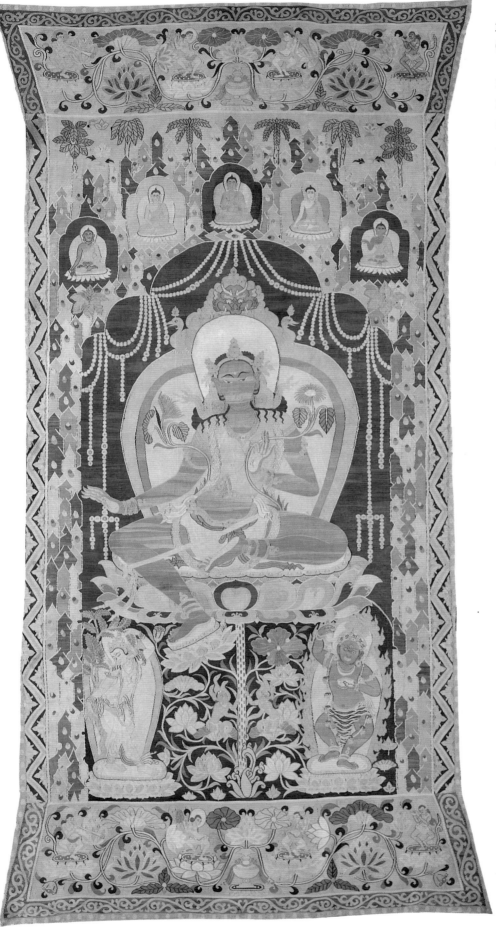

23
Green Tara

Khara Khoto, Central Asia

Before 1227

Silk tapestry; *kesi* technique

39¾ × 20¼″ (100.9 × 51.5 cm)

The State Hermitage, Leningrad

Lit.: Béguin, 1977, p. 80.

Green Tara sits on a blue lotus (*utpala*), her right leg extending beyond the throne and leaning on the lotus. Her left leg is bent in the pose of ease (*lalitasana*). Her right hand is extended to the side in an elegant gesture, and her left holds a blue lotus. Another lotus appears from behind the right side of the goddess (23.1). Her nimbus and encompassing mandorla are white and the mandorla has two borders. Above the nimbus are two geese (*hamsa*) and on top is the head of a lionlike face of glory (*kirtimukha*). Pearl beads are hung above the throne. The lotus throne is supported on a long stem, which is held up by Nagas (serpent deities). Tara is depicted against a blue background surrounded by mountains. The interpretation of the mountains is identical to the mountains in other icons of the Khara Khoto "Tibetan"—or rather Indo-Nepalese-Tibetan—school. The Five Transcendent (Dhyani) Buddhas appear above the throne. Just under the top border are six trees of three different types. It is possible that these are the campaka, ashoka, and parijataka trees, which are described in the *Sadhanamala* (in SM 116, in de Mallman, 1975, p. 369). Overall, however, *Sadhana* SM 116 is different from this icon.

Below and to the right of Tara is Ashokakanta (yellow two-armed form of Marichi, Goddess of the Dawn), standing under a tree. Blue Ekajata is to Tara's left; she holds a skull bowl (*kapala*) in her left hand and a curved knife (*kartri*) in her right. She wears a tiger skin on her hips. Wide strips of cloth are sewn to the top and bottom of the icon on which four Dakinis (Skywalkers, powerful female divinities, usually enlightened) dance among the lotuses and play musical instruments: the horn, flute, and conch shell. The instrument in the hand of the second figure from the left on both panels is not clear.

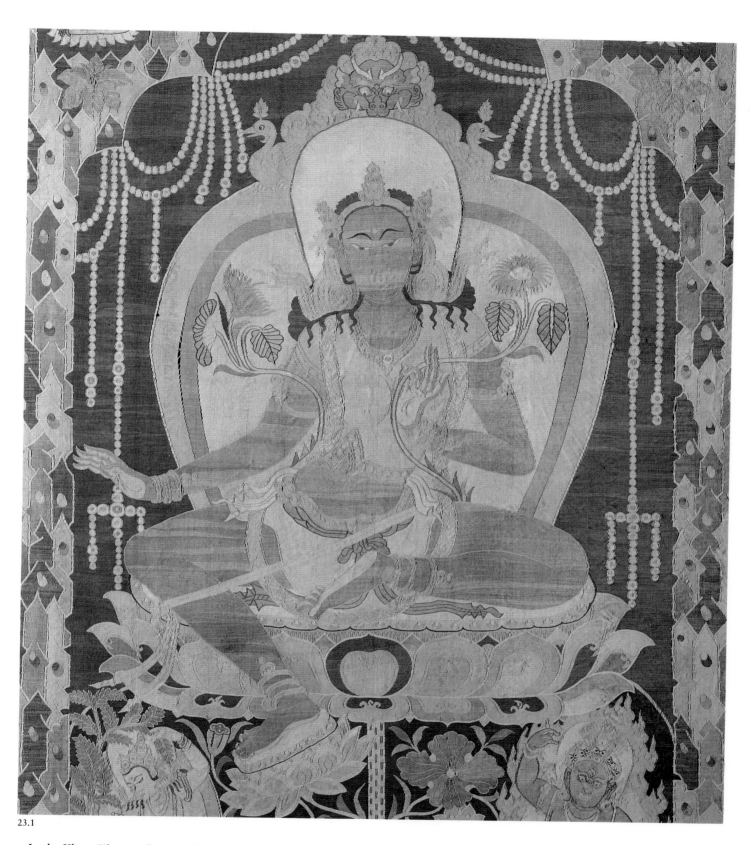

23.1

In the Khara Khoto collection there is one more small fragment executed in the *kesi* silk technique. This technique, based on a tapestrylike weaving of threads, can be seen in wool fabrics from the Near East. It was apparently borrowed by the Chinese living among the nations of Central Asia and applied to silk. Pieces of silk are woven separately and then sewn together so that all the seams are clearly seen when held up to the light. The Tara tapestry was first thought to be a Chinese work, but after Professor Kychanov found a reference in Tangut texts to studios working in the technique of *kesi* in Xi Xia, it was considered to be a Tangut work.

The icon is distinguished by an elegance of composition and drawing, subtlety of coloration, and exquisite execution. It is one of the masterpieces of the State Hermitage collection.

K. Samosyuk

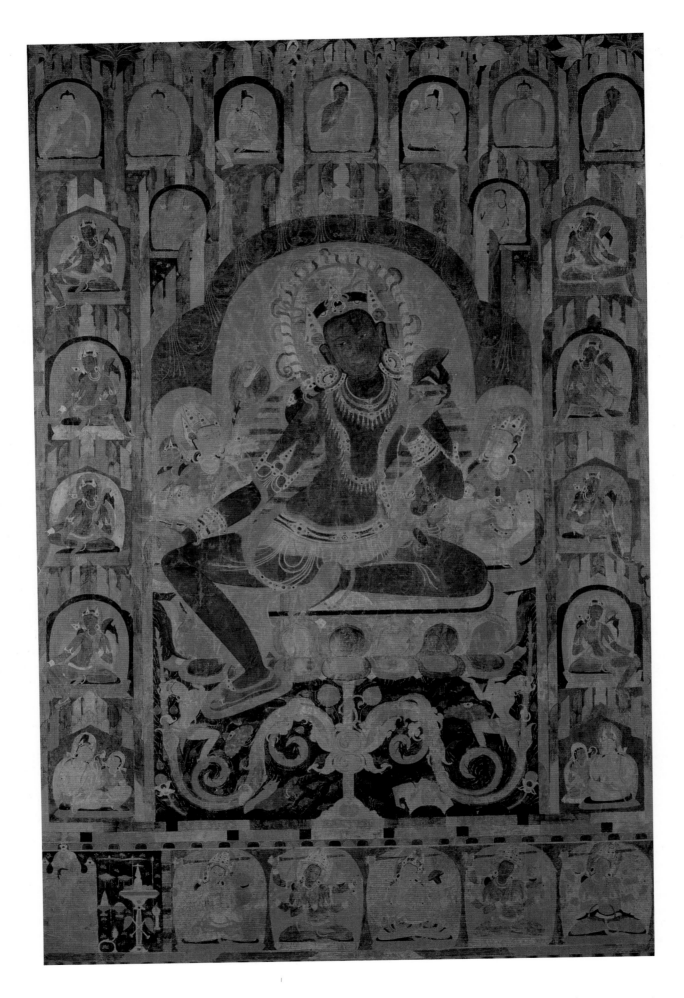

Green Khadiravani Tara

Central Regions, Tibet

Circa first half of the 12th century

Tangka; gouache on cotton

48¼ × 31½" (122.5 × 80 cm)

Mr. and Mrs. John Gilmore Ford

Lit.: Pal, 1984a, pp. 224–25.

Green Tara is Tara's most dynamic manifestation. Her green body color signifies her association with the Buddha clan of Amoghasiddhi, the Transcendent Buddha of the north. He transmutes the poison of envy and turns it to the positive energy of all-accomplishing wisdom. Thus Green (*shyama*, sometimes translatable as "dark blue" or "black") Tara, here presented as Khadiravani, "dweller in the Khadira tree forest," is a semiterrific manifestation, and is propitiated in order to overcome obstacles, to save one from dangers, and to deal with evil in general. There is a hymn composed by the First Dalai Lama (1391–1474), for whom she was a favorite deity (Willson: 1988: p. 301ff. [selections, slightly modified for our context]), that fortuitously suits this work:

> Through the magic of Lokeshvara's compassion,
> The three times Buddhas' wisdom, love, and power
> Appear in the lovely form of the Goddess of Action,
> Who saves us all from want — at Tara's feet I bow!

In this form and in this painting she is depicted in a posture of ease with the right leg extended, signifying readiness to go into action, and the left folded in the contemplative position on the lotus pedestal, the two together thus symbolizing the integration of wisdom and art (*prajnyopayadvaya*). Her left hand, in the gesture of granting refuge in the Three Jewels, holds the stem of a blue lotus that floats over her left shoulder as a symbol of purity and power. With her right hand she makes the boon-granting gesture (in an apparently unusual version with the hand partly raised and palm turned down, as also seen in the Khara Khoto tapestry No. 23 and the famous Green Tara in the Cleveland Museum of Art (text fig. 14). Another blue lotus, its fully opened form facing us, floats over her right shoulder. She is youthful and beautiful and has the

power to inspire energy and enthusiasm in her devotees. As the First Dalai Lama describes his vision of her:

> On a lotus seat, standing for realization of voidness,
> (You are) the emerald-colored, one-faced, two-armed Lady,
> In youth's full bloom, right leg out, left drawn in,
> Showing the union of wisdom and art — homage to you!
>
> Like the outstretched branch of the heavenly turquoise tree,
> Your supple right hand makes the boon-granting gesture,
> Inviting the wise to a feast of supreme accomplishments,
> As if to an entertainment — homage to you!
>
> Your left hand gives us refuge, showing the Three Jewels;
> It says, "You people who see a hundred dangers,
> Don't be frightened — I shall swiftly save you!"
> Homage to you!
>
> Both hands signal with blue utpala flowers,
> "Samsaric beings! Cling not to worldly pleasures,
> Enter the great city of liberation!"
> Flower-goads prodding us to effort — homage to you!

In Tibet she is associated with Bhrkuti, the Nepalese queen of Tibet's first great religious king, Songtsen Gambo (d. 649). Tara also adopted this form to serve as a tutelary Bodhisattva of Atisha (982–1054). In fact, in this early and exceptionally rare painting, the small figures of a monk in red hat and robes and a man in layman's clothing (24.1), located to left and right just above the arched shrine of Tara, almost certainly are Atisha and his most prominent disciple, the layman Drom Tonpa (d. 1064). Together, they were the founders of the Kadam Order, which was one of the main orders from this time until it was reformed by Tsong Khapa in the early 15th century and was renamed Geluk. Their presence

here would seem to assure this tangka to be Kadampa.

The mysterious and intriguing nature of Green Tara is marvelously captured in this painting by the setting and coloring (24.2). The slender, long-proportioned body of the goddess is a dusky olive green in color. Her coloring reverberates against the striped cushion of her throne back, the golden head-halo bordered by wavy striped and semicircular patterns and by the large red-orange encompassing mandorla. Behind her is a midnight blue sky against which fine tendrils of hanging red jewels create a delicately decorative effect.

This shrinelike abode is surrounded by a rocky mountain fastness created by rows of imaginatively stylized peaks in alternating red, yellow, olive, and malachite green. The source of this motif appears to be India; similar rocks appear in manuscript paintings of the 11th century and in stone sculpture as early as the Kushana period (1st–3rd century CE), such as from Sanghol (Srivastava, 1990, central pl., p. 85). They are prevalent also in Nepalese manuscripts of the 11th to 12th century and in the Indo-Tibetan style paintings from Khara Khoto of the late 12th to early 13th century. Interestingly, similar stylized mountain shapes also appear in late 6th- to early 7th-century Korean landscape tiles (text fig. 13). This was clearly a widely disseminated motif over a fairly long period and from an early time. The rocky mountain shapes in this tangka act as a frame not only for Tara's shrine but for all the secondary images of the painting, creating an overall fanciful, joyful, and highly decorative landscape setting for the entire painting. Midnight and mountains seem to fit the mysterious energy of Green Tara.

She is dressed in a gauzy orange skirt, which, though it covers the legs, does not appear to do so (24.2). It is a style common in Tibetan paintings from the central regions during the early period and also occurs in sculptural representations of the time (No. 22). Beautiful golden, red

24.1

and green jewels adorn her. Her jewelry includes wide bracelets, several necklaces with many pendant gems, and a multi-stringed, long jewel chain that sinuously falls around her body and over her right arm. This type of chain is prevalent in tangkas dating ca. late 12th century, such as those from monasteries in Tsang, photographed by M. R. Samkrityayana during the 1920s and 1930s (Pathak, 1986, pls. 5–7). Her delicate girdle sways lightly with gossamer gold chains. Pointed arm-bands, circular plug earrings, rings on her toes and fingers, and a three-pointed crown festooned with narrow red ribbons complete her rich adornment. As the First Dalai Lama sees her ornaments and atmosphere:

Ruby-colored Amitabha holds in meditation
An alms bowl full of elixir,
And, granting immortality, adorns your
crown,
Subduing the lord of death—homage to you!

Though Green Tara is associated with Amoghasiddhi, Khadiravani has in her crown a living Amitabha Buddha, Lord of Immortality, since the meditator is propitiating her to remove obstacles to his life. Note that the tradition tends to reserve the crown Buddha for the vision, not including it in the painting.

In a heavenly mansion shaped by the artist of
the gods,
Inconceivable celestial wish-granting gems,
Most beautiful, wrought into fascinating
ornaments,
Fully adorn you—homage to you!

Like an emerald mountain clothed in
rainbows,
Your upper body is draped in heavenly silks,
Your lovely supple, slender waist supports
A skirt of five bright colors—homage to you!

She is attended by four figures, all female (24.2). Behind each of the two seated golden figures wearing short floral red blouses is a wrathful figure. On Tara's right side the wrathful figure is red Marichi with a sow's head, wearing an olive green blouse. The peaceful golden figure in front holds the bright blue ashoka flower in her left hand and a vajra in her right hand. The vajra lies flat in the palm, a style seen also in the Khara Khoto paintings (No. 135). These are the attributes of Ashokakanta, the two-armed form of Marichi. It appears that the two figures together represent Marichi-Ashokakanta, one wrathful, the other peaceful. On Tara's left is the dark olive green Ekajata wearing an orange print blouse and a tiger-skin skirt, part of which is visible on her raised knee. She holds her usual attributes: the curved knife and the skull bowl. Her eyebrows are wrinkled in the fancy scalloped design typical of wrathful images of the 12th century in India (Sena period) and in Tibet (No. 68). Ekajata also customarily accompanies Khadiravani Tara. The golden figure in front of Ekajata is more difficult to interpret. The figure seems to hold a peacock feather in the palm of her right hand and possibly a snake in her left hand. These do not agree with attributes of Ekajata, but they suggest the attributes of Mahamayuri and Arya Janguli, two Bodhisattvas who, in addition to Marichi and Ekajata, usually accompany the Mahashri Tara (also green). These attendant images have head halos backed by a plain red-orange surrounding mandorla like the Tara. The ensemble around Tara is compact yet precisely and delicately detailed.

On your right, Marichi of the ashoka,
Peaceful, golden, radiating sunlight.
On your left, Ekajata, sky-blue, fierce
But loving and bright, O Beauty—to you
I bow!

Skilled in musical songs and gorgeous
dances,
Holding white parasols, chowries, vinas,
flutes,
And endless offering objects, hosts of
goddesses,
Filling space, make offering—homage to you!

Two golden, gracefully shaped Nagas (serpent deities) with small snakes appearing above their heads stand on the scrolling branches of Tara's lotus seat. Along with the tall central stalk that emerges from the dark landscape below, they help support her lotus, which is rimmed by varicolored delicately drawn and shaded petals. Silhouetted here against the background of her dark and mysterious world, the scattered lotus leaves and small animals among the hills below seem fragile yet perfect. The style of this pedestal is especially characteristic of Pala period art from the Bengal area of eastern India—Atisha's original home.

The dominating red tones add a lively fervor to the mood of the painting. Tara herself, with her long, smooth limbs, slim

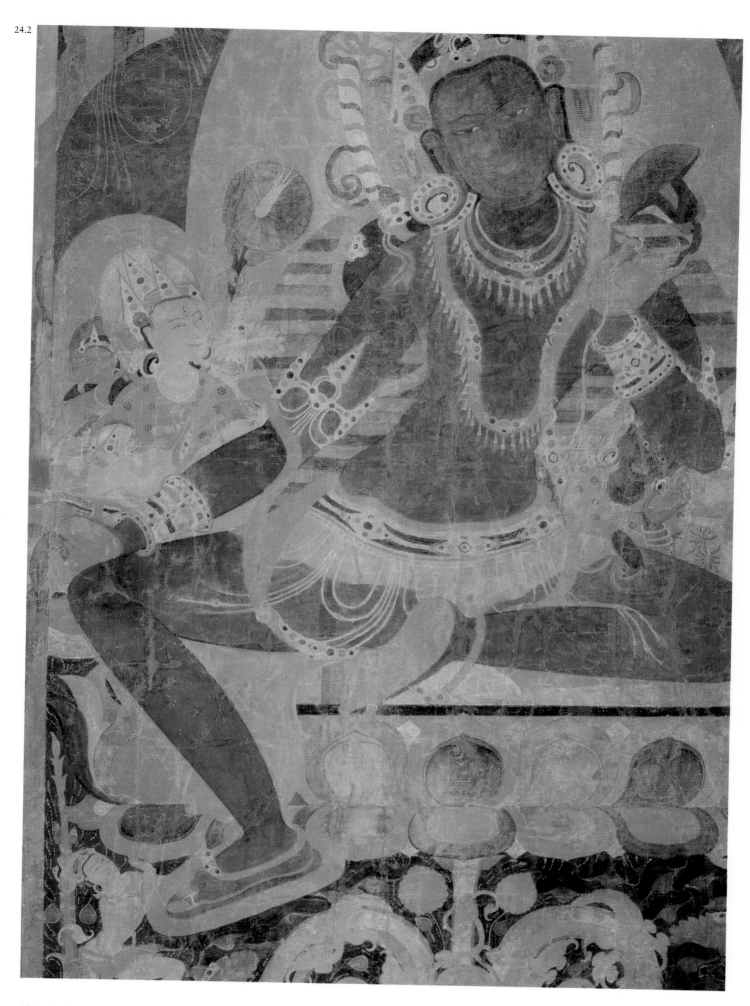

body, and long face with delicately curved features and serious expression (24.2), seems calm and poised yet ready for action. The painting technique is extremely refined, the pigment flat and thin, and it does not emphasize linear outlining except in the most subtle way. This delicacy seems to relate to the painting style in the Sumtsek at Alchi, although the figure type and painting techniques are different.

You have found peace; yet moved by
* compassion,*
Your loving hands are quick to save
Sentient beings sunk in a sea of sufferings—
Mother perfect in mercy, homage to you!

Your calming, increasing, taming, and
* destroying deeds,*
Like ocean tides are never at wrong times,
You engage in them without strain or
* interruption;*
Mother perfect in action—homage to you!

The eight disasters, harm by evil spirits,
Emotional and cognitive obscurations—
You save us from these dangers the instant of
* our prayer;*
Mother perfect in power—homage to you!

The eight manifestations of Green Tara are seated four on each side in various postures. They stand for her miraculous activities as savior from the eight dangers, which have both mundane and spiritual referents. As the Dalai Lama puts it, just by being called to help, she instantaneously saves the faithful from attacks by 1) lions and pride, 2) wild elephants and delusions, 3) forest fires and hatred, 4) snakes and envy, 5) robbers and fanatical views, 6) prisons and avarice, 7) floods and lust, and 8) demons and doubts. Some of the halos of these figures have tiny jewel decorations similar to those seen in some of the Khara Khoto paintings (Nos. 128, 135).

Around the top is a row of the Five Transcendent Buddhas, with Amoghasiddhi, the lord of Tara's Buddha clan, in the central position, flanked by two Bodhisattva attendants. Palm trees, animals, and some figures appear along the top border of the vertical mountain rocks. This kind of charming border also occurs in some fragments from the Khara Khoto collection in the Hermitage that date before 1227. At the lower corners of the main part of the painting bounded by the rim of rocks, there is a niche with a seated Bodhisattva and attendant. Along the bottom, in their own space separated from the main part by a border of alternating square and cone-shaped jewel designs, are seated five terrific deities. They are all six-armed, female, and carry a long sword in one of their hands. They are probably either connected with the fierce Buddha of Amoghasiddhi's clan, Amrtakundali, or else fierce forms of Green Tara herself. At the far left, the donor in Tibetan monk's garb sits before his ritual offerings.

The style of this painting is a refinement of a style that appeared in the 9th-century Vajrapani from Dunhuang (No. 20). The use of solid color, even outline, and clean, well-revealed, smooth shape is similar. However, precision, delicacy, and exquisite elaboration have replaced the earlier bold vigor of line and the brusque, sketchy washes of color. Because of the presence of Atisha and Drom in this tangka, it probably dates after their time. The monk donor is most likely a disciple in their lineage, possibly of the next generation. This would suggest the earliest probable dating around the last quarter of the 11th century. The stylistic proximity with some of the wall paintings at the Sumtsek at Alchi of ca. the third quarter of the 11th century would tend to favor this early dating, as would the compatibility with some of the early surviving wall paintings in the Jokhang in Lhasa (text fig. 10). Certainly this tangka would not date later than the late 12th century. In general it has elements in common with the twenty-one Tara stele (No. 22) and with the standing Avalokiteshvara in No. 28, both considered stylistically to date ca. the late 11th or early 12th century. This work is unquestionably one of the finest, rarest, and most important of the early paintings from the central regions of Tibet. Few survive with a Bodhisattva as the main image and with such certain linkage with the Kadam school of Atisha and Drom Tonpa.

25
Green Tara

Tibeto-Chinese

Mid-17th century

Gilt brass, with inset gems and pigments

H. 14½″ (36.8 cm)

Royal Ontario Museum, Toronto.
The George Crofts Collection

Green Tara is revealed in this charming sculpture as a girl of age sixteen, as described in her meditational text and in eulogies. Green Tara is revered as the miraculous savior who rescues all beings from suffering, particularly from the eight calamities mentioned above (in No. 24). She is honored as the "Mother of the Buddhas of all three times" (*Tara Tantra*). This statue shows her poised and alert, with her head tilted slightly and one leg drawn up onto the lotus seat and one inclined over the side in her customary posture of royal ease. With her right hand she graciously extends her palm in the boon-granting gesture (*varada mudra*), holding the stem of a blue lotus. Another flowering blue lotus is held by her left hand as she makes the three-refuge gesture by extending three fingers upward. The two flowers frame her arms with a luxurious flurry of realistically fashioned leaves and petals. The almost rococo delicacy of the flowers heightens the feeling of blossoming beauty. The wiry movements of her fancy, pearl-lined jewelry and light, twisting scarves energize her supple, slender body, suggesting her active nature. A few of the original inset jewels remain, creating points of color that add to the richness of the gilt surfaces. Even the pedestal, with its multilayered, curling lotus petals, seems to bloom.

Although the style relates somewhat to the late 16th- to early 17th-century wooden goddess statues in the Kumbum monastery in the Amdo region in northeastern Tibet, now the Qinghai province of China, this figure has an ornate and florid style more closely related to Chinese sculpture of the middle of the 17th century. The light and mobile line, the soft textures, and the sweet and mild face suggest that this Green Tara sculpture is probably a Chinese work in the Tibetan iconographic and stylistic tradition. The rich and prominent pair of lotus flowers appears in other Chinese and Tibetan sculptures of this time. A slightly later and less vigorous rendering appears in the Tsong Khapa statue from Inner Mongolia (No. 96).

26
White Tara

Central Regions, Tibet

17th century

Silver, with gold and inlays of copper and semiprecious stones

H. 6¾″ (17.1 cm). Shown actual size

The Asia Society, New York. Mr. and Mrs. John D. Rockefeller 3rd Collection

Lit.: Rhie and Thurman, 1984, no. 38.

In contrast with the fluttering liveliness of the Tibeto-Chinese Green Tara (No. 25), which is of similar date, this White Tara of the Indo-Nepalese stylistic lineage of Tibet proper is solid and luxurious. She has a queenly demeanor befitting her nature, which is to offer peace, prosperity, long life, health, and good fortune. Like Green Tara, she is the female companion of the Bodhisattva of Compassion, Avalokiteshvara. With her right hand she makes the boon-granting gesture and with her left she holds a triple white lotus (missing), with one bud, one full bloom, and one closed bloom. She sits with both legs raised and crossed in the diamond pose. An eye in her forehead and in the palm of each hand signifies her ability to see the sufferings in every corner of the world. As explained more fully in No. 22, she is the Mother of Buddhas and the compassionate savior of all beings.

This image has a magnificence beyond her small size. Tara's sparkling silver body, gold embellishments, and inset semiprecious stones radiate opulence. Strings of pearls and jewels wrap over her body and wind around her legs. Her tight-fitting garments are embossed with large, rich floral designs. A heavy crown of five jeweled plaques encircles her head. Her hair falls in thick masses and curls on her forehead and shoulders.

The rich style, related to Indo-Nepalese styles, is characteristic of the central regions of Tibet, particularly of the Lhasa area, in the 17th century, a time when Tibetan Buddhist art was reaching a peak of creative brilliance. It is, in effect, a small version of the large silver images of White Tara that grace the halls of the Potala palace, built above Lhasa over the ancient ruins of Songtsen Gambo's castle by the Great Fifth Dalai Lama, beginning in 1645.

27

Sarasvati

Eastern Tibet

17th century

Tangka; gouache on cotton

14³⁄₁₆ × 9⁵⁄₈″ (36.1 × 24.4 cm)

The Los Angeles County Museum of Art, Los Angeles. From the Nasli and Alice Heeramaneck Collection. Museum Associates Purchase. M.84.32.6

Lit.: Pal, 1983, p. 160.

Sarasvati is the goddess of learning and music, a goddess beloved by Hindus and Buddhists alike. Her popularity spreads far beyond the borders of India to Tibet, China, Korea, and Japan. This tangka, though small, is one of the loveliest of Sarasvati in surviving Tibetan art. She is white in color, seated on a simply drawn, large white lotus. Her legs are drawn up in an unusual cross-ankled posture with her knees raised, presumably a posture for musical performance. Her delicately long fingers hold a *vina,* a classical musical instrument of India. Her ornaments are simple and restrained, but a narrow, dark green scarf creates a flurry of movement around the figure. It floats in an arc behind her slightly tilted head, then winds around her arms and drifts off in a circular maze to left and right. The chalky white of the body with its pale outlining of the features contrasts with the more colorful orange, pink, and green stripes of the skirt and its red-orange and pink overhang. A plain, peach-colored halo like the setting sun broadly encircles the entire figure. Its pastel color provides a perfect setting for the image, while the unusual dark green shading that outlines the orb gives it a sense of substance and prominent definition.

An outstanding feature of this tangka is the style of the landscape. It is spacious, atmospheric, and idealized, creating an idyllic yet naturalistic setting for the goddess. In alternating horizontal layers of green and pink washes, the eye moves back through this charming scene along a unified level plane, approximating a naturalistic three-dimensional space rarely seen in Tibetan painting. A gentle rock and grassy shoreline with two groups of lamas define the foreground. From here the landscape moves readily to the midground over an expanse of gently rippling water with charming details of white lotuses, pairs of ducks (one with a small family of baby ducks), and two red-crested cranes. Beyond, in the background, are several oddly shaped peaks and a pale pink sky with blue clouds that then fades into blue darkness. Above the clouds, three lamas float as though hovering in the air. This landscape readily assimilates the deity, with no duality between the perfect and otherworldly goddess and the worldly reality of the spacious landscape. This harmony of the worldly and the divine seems to express the Buddhist belief that the ordinary and the transcendent, samsara and nirvana, are one beautifully balanced reality. For an analysis of the dating, see the essay "Tibetan Buddhist Art: Aesthetics, Chronology, and Styles." Another painting, of White Tara, in this same style and possibly by the same artist or even from the same series, is in the collection of the American Museum of Natural History in New York. They were probably produced in Eastern Tibet and may be related to the Karma Gadri schools of that region.

28
Avalokiteshvara

Western Tibet

Late 11th to early 12th century

Bronze, with copper and silver inlay

H. 22″ (55.8 cm)

Robert Hatfield Ellsworth Private Collection

Lit.: Pal, 1978, no. 107.

Avalokiteshvara is the archangelic Bodhisattva of Great Compassion. His vast vows to save all beings are said by the texts to be inconceivable. With his special mantra, OM MANI PADME HUM ("Hail the jewel in the lotus!"), he travels to all realms of the universe in his tireless quest to deliver beings from suffering. In one of his special sutras, the Jewel-Casket Array (Karandavyuha), he actually descends to the hells of Yama. From the fingers of his thousand arms, magic waters flowed and cooled the flames of the molten iron realm. The Tibetans believe that the White Lotus of Compassion Sutra (Karunapundarika) records how he took a special vow to free the Tibetans, to tame them and turn them away from their violent ways, and to turn their land of barbaric savagery into a land bright with happiness. With his female colleagues, Tara and Bhrkuti, and his fierce form Hayagriva, the Horse-Necked One, as well as many other forms, this Bodhisattva is probably the most universally beloved divine figure in Mahayana Buddhism.

This bronze sculpture is a handsome, relatively large standing figure. He can be identified as Avalokiteshvara by the small image of Amitabha Buddha in his crown (supposed to be a miniature emanation of the actual Amitabha) and by the full-blooming lotus he holds. In the Indian fashion, the lotus springs from the pedestal and is held lightly in his left hand. His right hand, which, like the crown, has become a little bent, is in the fear-not gesture (*abhaya mudra*), in which the hand is held up in front of the chest, palm out. In this representation he wears an antelope skin tied around his chest. It is knotted in front, with the head of the hide covering his left shoulder. Along with his vigorous posture, the antelope skin imparts a slightly wild appearance to the gentle Bodhisattva, indicative of his ascetic qualities as a yogi (somewhat like Shiva, the Hindu yogic god). He also wears the usual crown and jewels of a Bodhisattva, including a long, double-stranded chain, which encircles the image like a wiry

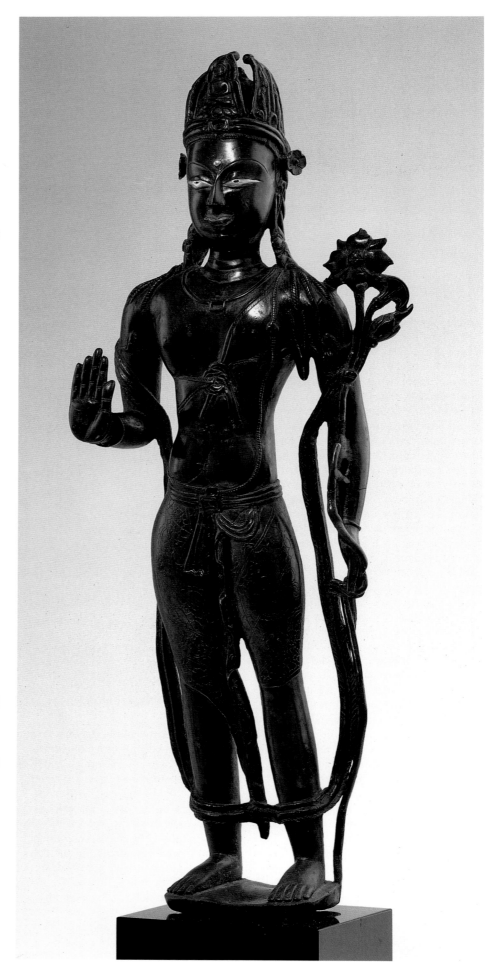

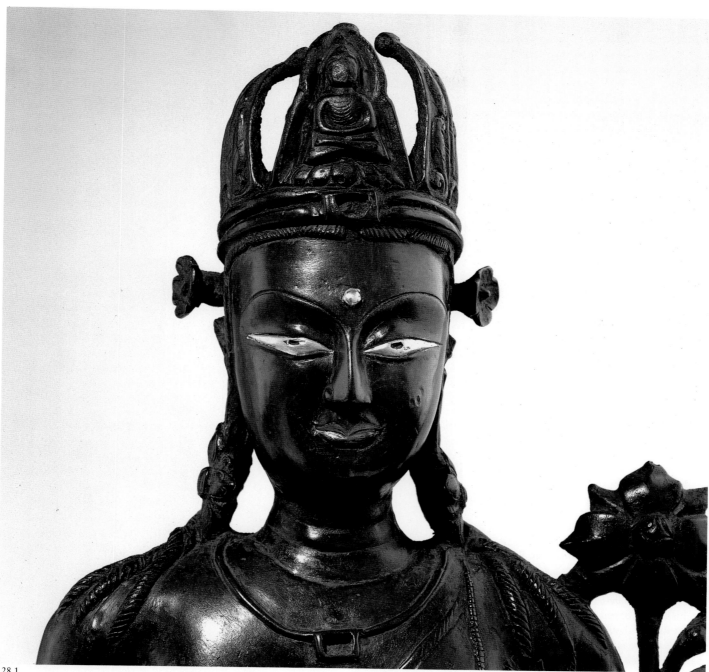

28.1

frame from shoulders to ankles. The empty sockets in the center of the crown and necklace suggest that jewels were originally inset in those places. The lower garment, lightly patterned with engraved floral designs, is simply belted with a narrow double cord. It fits tightly to the body and hangs with the hems falling in a zigzag pattern between the legs, typical of images of this period.

From its style, it is clear that the image comes from Western Tibet and probably dates around the second half of the 11th or early 12th century. Although it is noticeably a part of the Kashmiri and Himachal Pradesh sculptural style (see Pal, 1975, figs. 68, 70), the figure was very probably made by artists in Western Tibet.

Its bold and vigorous strength and air of forthright immediacy is somewhat naïve and unlike the smooth sophistication typical of Kashmiri works. The tight, muscular body and disproportionately long torso are characteristic of the Western Tibetan style in general. They are also features of some figures in the wall paintings of the Sumtsek Hall (second floor, rear wall) at Alchi in Ladakh, which dates around the third quarter of the 11th century. The narrow waist, the linear markings of the pectoral muscles, and the alert, broad-shouldered upper chest coincide with the vigorous, strongly linear yet interestingly modeled style in the Sumtsek wall paintings. Even the long, large eyes, heightened by their gleaming

silver inlay, have their counterpart in the sharply shaped eyes of the Sumtsek figures (text fig. 6). The clear linear demarcations of the face, the unusual proportions of the body, and the large rectangular head are all somewhat bizarre. The astonishingly large eyes, a feature shared by the Dunhuang Vajrapani (No. 20), and the broad, slightly smiling copper lips add to his captivating intensity (28.1). It is unquestionably one of the most fascinating and excellent of the few rare sculptures to survive from the vital early years of the Second Transmission of Buddhism that took place in Western Tibet in the late 10th and 11th century under the guidance of King Yeshe Ö, the translator Rinchen Sangpo, and the Indian sage Atisha.

29
Avalokiteshvara

Central Regions (?), Tibet

12th century

Brass, with cold gold paste and pigments

H. 13¾″ (34.8 cm)

The Zimmerman Family Collection

This gracious image of Avalokiteshvara, the Bodhisattva of Compassion, closely adheres to the Pala tradition of Indian Buddhist sculpture. The regular proportions of the fully revealed figure reflect the full, perfect body of a youth. Heavy, carefully chiseled ornaments stand out against the smooth, languorous form. His head supports a heavy crown. His face has been painted in later times with cold gold paste, a common practice in Tibet. Cold gold paste is powdered gold mixed with a binding agent. It is fragile and oxidizes easily, requiring frequent renewal. Features are usually painted on top of it.

Avalokiteshvara's bow-shaped, slanted eyebrows, curved and rather open eyes, sharp nose, and full mouth with pouting underlip are typical of Pala sculptural style. Avalokiteshvara holds a curving lotus stalk, with flowers in bud, fully open, and already closed (symbolizing his manifesting the compassion of the Buddhas of past, present, and future). There is a long jewel chain, which is captivatingly looped over his belt and hip sash. Both objects elegantly echo the sinuous curves of the figure's thrice-bent (*tribhanga*) pose. Rich locks of blue-colored hair are piled on his head (topped by a lotus bud) and flow over his shoulders in luxurious curls. The ideal here is a completely human naturalism, not the mysterious strangeness and wiry vigor of the Western Tibetan image (No. 28). That such widely disparate ideals occur in the same general period is largely a result of differing regional tastes and stylistic lineages.

The style of this image relates to Indian Pala images of the 10th to early 12th centuries, especially those from the Nalanda area. The Pala tradition had a marked influence on early Tibetan art, especially in the central regions. Old photographs taken by Tucci and others, which show Pala as well as Kashmiri images on Tibetan temple altars, suggest that many sculptures were imported from India in the early period. This particular image, which appears to be neither Indian nor Nepalese, is one of the finest in the Pala tradition, possibly made in Tibet in close imitation of the Indian prototypes.

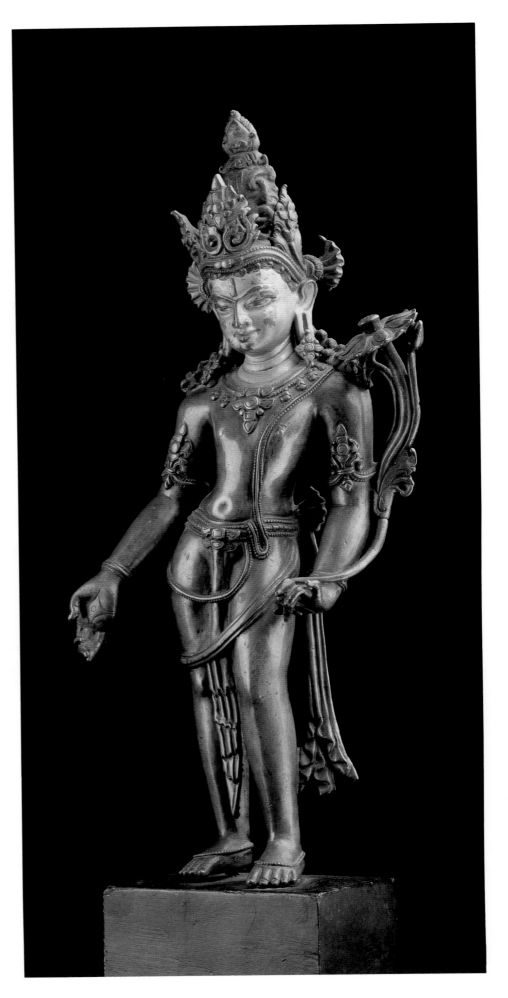

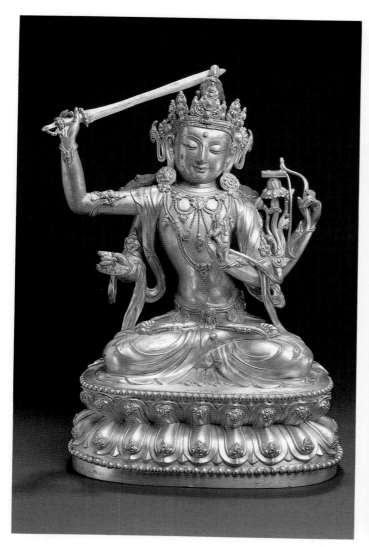
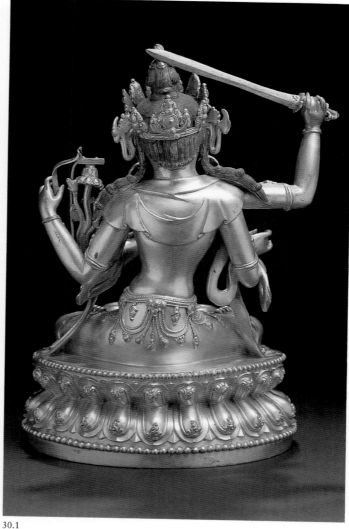

30.1

30
Four-Armed Manjushri

China

Yongle period (1403–1425), by inscription

Gilt brass; cast in several parts, with cold gold paste and pigments

H. 9⅞″ (25.2 cm)

The State Hermitage, Leningrad. Prince Ukhtomsky Collection

Lit.: W. Zwalf, 1985, pp. 211–12, n. 308.

The Bodhisattva of Wisdom holds his main attributes in his two main hands—the sword in the right and the lotus flower with the volume of the Prajnyaparamita Sutra on top of it in the left. The second left hand holds a bow, and the second right originally held the arrow that goes with it; they are traditional Buddhist symbols of the weapons of meditation and wisdom directed against the evil of egotism.

This sculpture is a typical example of Yongle images. An almost identical Manjushri that differs from this one only in size and in a few minute details belongs to the British Museum. There is a Tikshna-Manjushri in the W. E. Clark catalogue of the Qianlong collection (Clark, 1965b: p. 201, fig. 6A42/406; p. 264, fig. 157/405), with identical hand implements in the four arms. For a back view of this superb image see 30.1.

G. Leonov

31

Manjushri

Central Regions, Tibet

16th century

Gilt bronze, with inset semiprecious gems

H. 12¼″ (31 cm)

The Zimmerman Family Collection

Manjushri is an ancient Buddha who vowed to emanate throughout the universe as the always youthful, princely Bodhisattva of Transcendent Wisdom. His special purpose is to lead the audiences of the Buddha in the inquiry into the self, to discover the true nature of reality. He is usually depicted holding the text of the Transcendent Wisdom (Prajnyaparamita) Sutra in his left hand and the double-edged sword of analytic discrimination, which cuts through all delusions, in his right. Here, his attributes are resting on open lotuses, one at each side of the figure (the sword is broken in this example). Manjushri raises his hands in front of his heart in the teaching gesture. He sits comfortably in the pose of ease atop an ornate lotus pedestal whose base is decorated with winding vines and cavorting lions, probably a reference to the lion mount he sometimes rides. He is a chunky figure with chubby limbs, his rounded face and cherubic smile giving him a healthy, friendly, and energetic appearance. His sumptuous ornamentation with inset gems of turquoise, crystal, and semiprecious stones, many of which still remain, adds to his prosperous air. Even his garment is encrusted with rows of pearl chains and clusters of jewels. Amid his royal splendor, he carries himself with a frank, good-natured innocence.

Stylistically, the figure is related to Indian sculptural styles, especially those that developed in South India from the

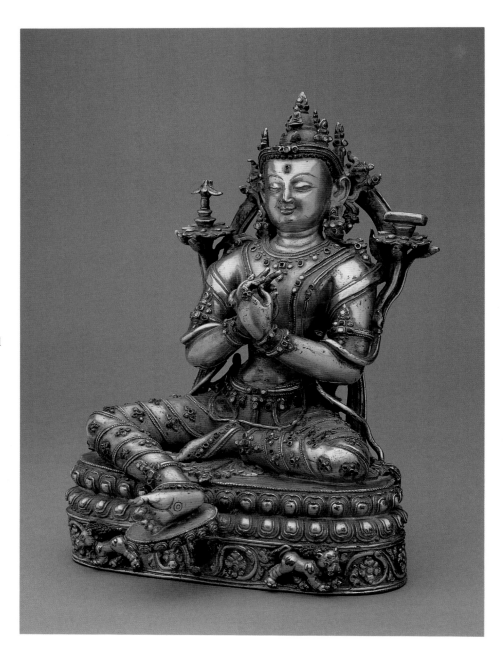

13th to the 16th centuries. It also shows remnants of the Pala lineage, especially in the head and facial features. Since it seems closely related to certain large sculptures in the Jokhang temple and Sera monastery that were probably made during the 16th to 17th centuries (Liu, 1957, figs. 74, 75), it is likely that this sculpture dates to the same period, and may have come from the Lhasa area as well.

Maitreya Bodhisattva

Mongolia

Late 17th century

Gilt bronze, with traces of pigments

H. 24⅝" (62.4 cm)

Harvard University. Arthur M. Sackler Museum, Cambridge, Massachusetts. Gift of John West

Lit.: Pal, 1969, no. 47; Tsultem, 1982.

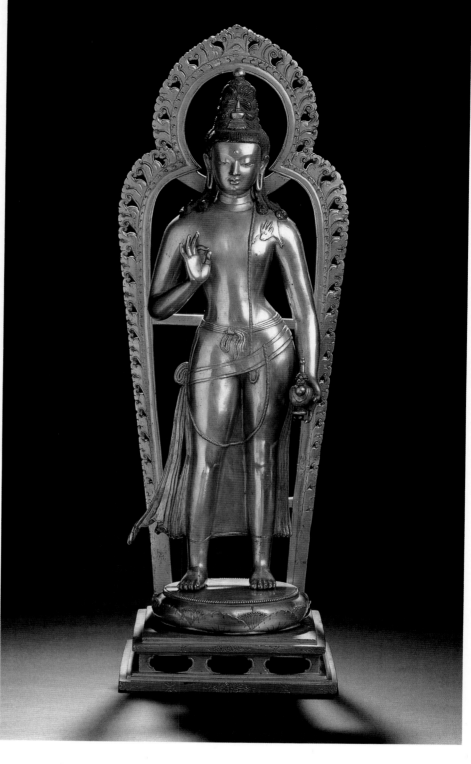

Maitreya, the future Buddha, is presented in this standing sculpture as a Bodhisattva. The stupa in his hair and vase of elixir of immortality that he holds in his left hand have been characteristic features of this Bodhisattva since the earliest known sculptures of the Gandharan school of Buddhist art of the 1st to 3rd centuries CE. His right hand is in the discerning gesture (*vitarka mudra*, with thumb and one finger touching), which indicates the belief that he will constantly be giving teachings at his residence in the Tushita Heaven until the time he descends into this world as the next Buddha.

Here we see Maitreya as a youthful figure garbed in a simple lower garment that clings smoothly to his legs, revealing their shape and making narrow, undulating pleats at the sides. A wide sash is draped diagonally across his hips. In a subtle asymmetry, its ends merge with the garment pleats on his right side. The knotted strands at the waist and the thin jewel chain that loops engagingly over the sash make asymmetrical linear patterns on the smooth planar surfaces. His full face and serene expression heighten the quality of sublime perfection engendered by the extraordinarily smooth body. His hair is piled up high in the matted-lock coiffure (*jatamukuta*), falling in heavy ringlets onto the shoulders. Its blue pigment contrasts with the predominantly golden image. The perfection of the halo and pedestal reinforces the sense of fully idealized beauty in the image.

This striking sculptural image seems to be descended from earlier representations of Maitreya that were no doubt popular in Tibet, such as the Maitreya dated 1093 in Narthang monastery (text fig. 7). This style, also prevalent in Nepalese sculpture, traces its lineage to the famous Sarnath school of Gupta India. But it seems clear from recent publication of material related to the famous Mongolian sculptor Lama Zanabazar that the work is Mongolian of the same school, if not actually a work by Zanabazar himself. Stylistically, in all the features of the image as well as the

pedestal, it relates to a Maitreya image of the same type now in the Gandan Tegchilin monastery in Ulan Bator, Outer Mongolia (Tsultem, 1982, fig. 44). This and other works attributed to Lama Zanabazar are datable to ca. the end of the 17th century (a record notes the production of certain images by him around 1683). Particular to this "Zanabazar" Mongolian style is the soft sleekness of the form and the calm, gentle demeanor of the face and body. The

characteristic Tibetan sharpness is lacking and the Chinese emphasis on movement of line is not as pronounced. The image is an important work revealing the high quality of the Mongolian school, in which there are distinct attributes of the Indo-Nepalese style as well as a relation to Tibetan sculpture. This work illustrates the vitality and inspiration of Tibetan Buddhist art on the art of surrounding regions in later centuries under the potent influence of Tibetan Buddhism.

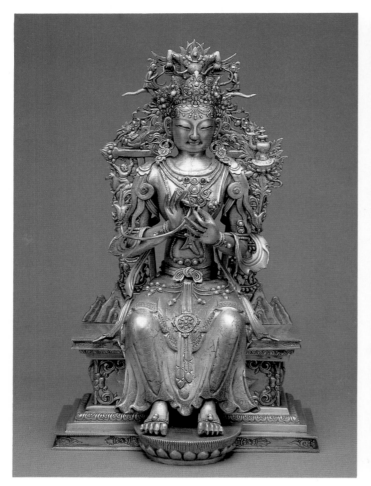
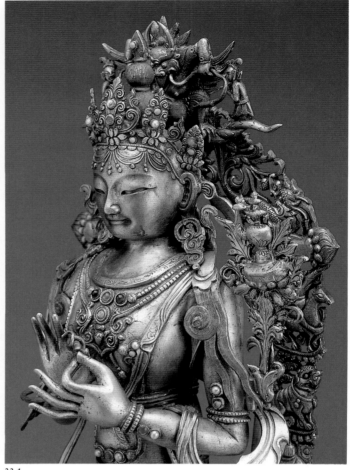

33.1

33
Maitreya Bodhisattva

China, with elements of Pala stylistic tradition

Mid-18th century

Embossed silver; assembled from several parts, with chasing, and pearl, turquoise, coral, and smalt inlay

H. 11¼" (28.6 cm)

The State Hermitage, Leningrad.
Prince Ukhtomsky Collection

Here the future Buddha Maitreya is represented as a Bodhisattva richly decorated with various ornaments. He sits in *bhadrasana*, the benevolence pose, with both legs pendant, resting on a small support. Both hands are held in front of his chest in the Dharma-wheel-turning, or teaching, gesture (*dharmachakra-pravartana mudra*). His attributes are two lotus flowers supporting a vessel (*kundika*) at his left shoulder and a wheel (*chakra*) at his right shoulder. (The upper part of this attribute has been lost.)

The sculpture presents an interesting case of an obvious replica of an old Indian style executed by a Chinese master. The throne of the sculpture, especially because of its back, seems to be borrowed from eastern Indian specimens. The composition of this part of the sculpture is basically the same as seen, for example, in the image of the 10th-century Maitreya from the Hermitage collection (No. 10). The master's attempt to reproduce a truly ancient image can be seen even in the design of bifurcated lotus petals chased on

one level of the throne's base.

At the same time all the elements of the back of the throne taken separately are absolutely Chinese. The lions are typical Chinese Shizi. The faces of the *yakshas* riding on deer are those of boys in Chinese folk paintings. Obscure *makaras* (composite crocodile and elephant creatures) have been replaced by dragons, obviously more familiar to the master than Indian sea monsters, and traditional Chinese mountains appear at the lower part of the back of the throne.

As for the image of Maitreya, it is executed in the traditions of Qing lamaist art without any signs of Indian influence. Here we see a complete set of all the necessary elements of the Qing style such as a standard Qing design of the plaques of the crown, three long hair locks on the shoulders of the deity with one lock curled up (33.1), a shawl making two loops at Maitreya's elbows, and a bow in the middle of the waistband. This last detail became almost obligatory in Qing images by the middle of the 18th century.

34
Eleven-Faced, Eight-Armed Avalokiteshvara

China

17th century

Tangka; gouache on cotton

90 × 52⅝″ (229 × 133.8 cm)

Museum of Fine Arts, Boston

This handsome and impressive painting depicts one of the most powerful forms of the Bodhisattva Avalokiteshvara, the archangel of compassion in Mahayana Buddhism. In this form, the Bodhisattva has eight arms. His first two hands are held in front of his solar plexus, holding the magic wish-granting gem, which stands for the spirit of enlightenment that consists of love and wisdom. Two of his remaining three right hands hold a rosary for reciting OM MANI PADME HUM and a wheel of combined spiritual teaching and benevolent governance; the third reaches out in the boon-granting gesture. His left hands hold a white lotus in full bloom, symbolizing that the flowering of enlightenment lies in compassionate activity, a bow and arrow symbolizing meditation and wisdom, and a vase of elixir of immortality, symbolizing that enlightenment results in boundless life. His enormously elongated head has ten faces: front, right, and left faces on three levels, and a topmost front face. These faces symbolize that Avalokiteshvara has mastered all ten of the Bodhisattva stages, each face representing an attitude dominant on a particular stage. Three of the faces are loving, three are peaceful, and four are fierce. On top of the whole stack there is a small separate head of Buddha Amitabha himself, symbolizing that Avalokiteshvara is really a Buddha, that in fact he is the compassion of all the Buddhas. This magnificent head expresses the multidimensionality of the Bodhisattva's compassionate awareness, that he can "manifest whatsoever needed to tame whomsoever," as his many arms express his extensive power to help beings become free from the sufferings of samsara, or egocentric existence. The skin of an antelope is draped around his chest, referring to his ascetic experience. Otherwise, his garments and ornaments are typical of royal or celestial Bodhisattvas. The various layers of his skirtlike cloth have detailed designs in gold—auspicious symbols on the upper part, and over the legs, coiling dragons.

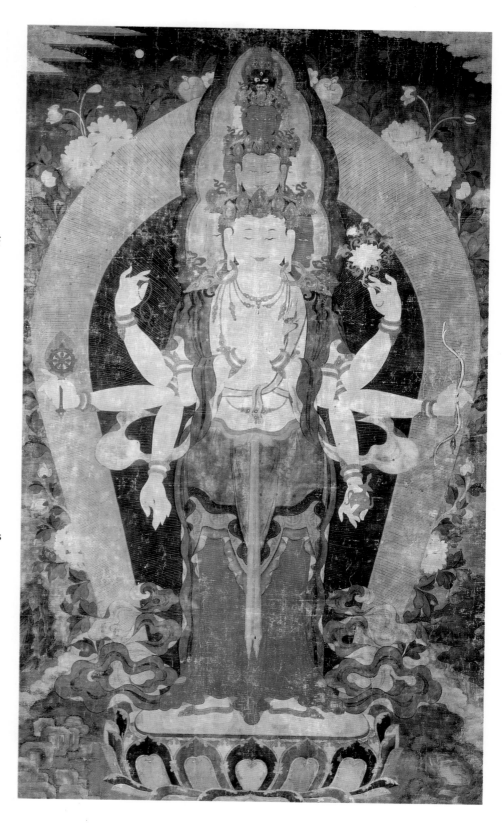

Symmetrical and monumental, Avalokiteshvara is portrayed in a gentle style with predominantly pastel colors. This and the refined detail of the flowers, the oddly shaped gemlike rocks, and the form of the pedestal and halo suggest styles of the late Ming period (early 17th century). This work is Chinese, and is generally related to the Tibetan Buddhist art of this time. This Tibetan-related style is probably the most vital form of Chinese Buddhist art in the Ming and Qing periods. Several Ming and all the Manchu Qing emperors had a strong interest in Tibetan Buddhism. The imperial and temple workshops employed many Tibetan and Nepalese artists, who often directly taught their Chinese colleagues and disciples. Hence this style of art can usually be included in both Chinese and Tibetan traditions.

35 and 36
Manjushri
and
Shadakshari Avalokiteshvara

Chahar, Inner Mongolia

Circa 1700

Gilt brass, with lacquer and pigments, inset with gems

Both H. 71″ (180.3 cm)

Folkens Museum Etnografiska, Stockholm

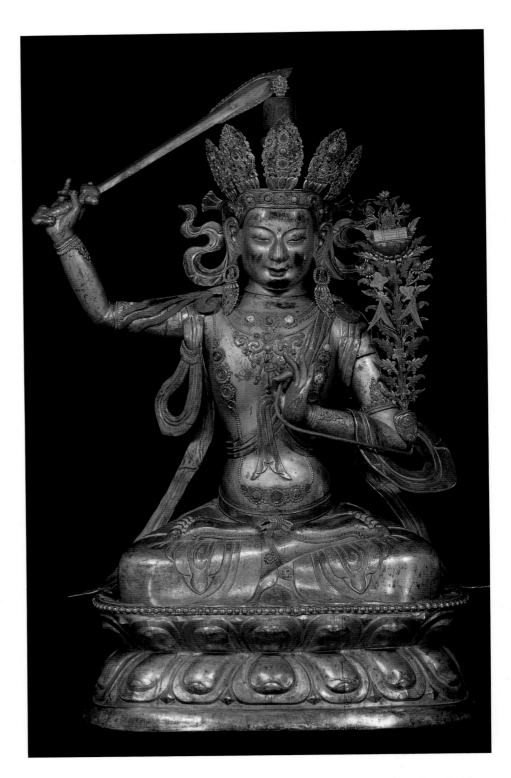

These two magnificent, monumental sculptures come from a temple in Chahar, Inner Mongolia. They were brought to Sweden in the 1930s by Sven Hedin, the pioneer Swedish adventurer and geographer of Central Asia. Chahar was made famous in 1578 by the momentous visit of the Third Dalai Lama, which led to the final phase of the conversion of the Mongols to Tibetan Buddhism. As the Bodhisattvas of Wisdom and Compassion respectively, Manjushri and Avalokiteshvara embody the essence of enlightenment and the theme of this book.

Manjushri, the Prince of Wisdom, holds the sword of discriminating intelligence and the stem of a lotus that supports the text of the Transcendent Wisdom Sutra. Avalokiteshvara's Shadakshari (The Six-Syllable One) form personifies the liberating blessing of the mantra OM MANI PADME HUM ("Hail the jewel in the lotus!"). This magical sound is believed to reverberate throughout the entire universe as the triumphant power of freedom, emerging from the Bodhisattva's infinite vow to save all beings. He has one face, four arms, and two legs crossed in

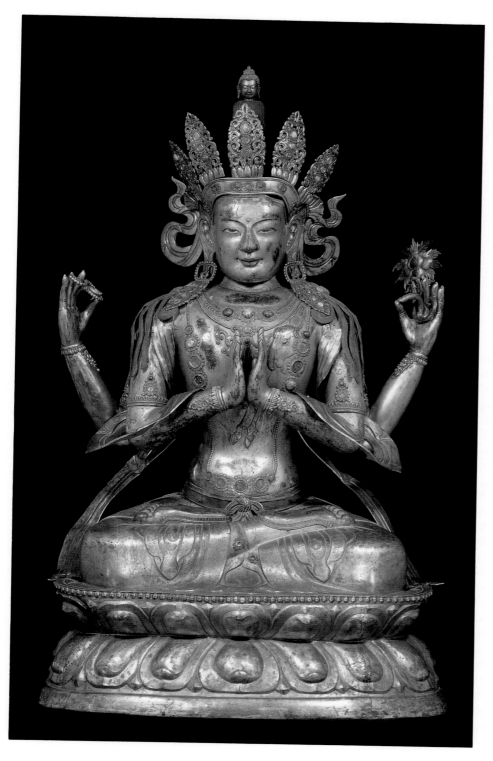

contemplative posture. His two front hands hold the wish-granting gem (missing here) at his heart, his rear hands holding a rosary and a lotus. It is said that the Dalai Lamas are manifestations of this form of Avalokiteshvara.

These grand statues are made of beaten brass and are lacquered, gilded, painted, and adorned with semiprecious jewels. They impart the impressive aura of the large images that were once lined up on the altars of great Tibetan and Mongolian temple halls. Their proportions are regular, their faces gentle with large features and

Indian eyes. Their forms are full and subtly delineated; their garments are flat yet delicately creased; their jewelry is rich yet refined. All these elements combine to produce pleasing and gently animated sculptures. Though the formality of the 18th-century style begins to appear, the beauty of individual elements is not sacrificed. The effect is balanced and harmonious, lively yet composed, simple yet grand. The style is strongly in the Tibetan tradition, while elements forecast developments seen in Chinese Buddhist art of the Qianlong period (1735–1796).

IV.
Great Philosophers
and Great Adepts

As Sir William Jones, the father of Indian studies in the West, noted in 1787, India has always had its Homers, Platos, and Pindars (Mukherjee, 1968, p. 116). During the more than a thousand years from Shakyamuni until Songtsen Gambo, Buddhism was developed and spread in the Indian subcontinent by numerous great individuals. The Tibetans have a literary tradition of biographies and an artistic tradition of portraits of some of the most outstanding of these great teachers and philosopher-saints (Mahapanditas), such as the Six Ornaments and Two Superiors. These are Nagarjuna (ca. the 1st century BCE to the 2nd century CE), Aryadeva (ca. the 2nd to the 3rd century CE), Asanga (ca. the 4th century), Vasubandhu (ca. the 4th to the 5th century), Dignaga (5th century), Dharmakirti (ca. the 6th to the 7th century), Gunaprabha (ca. the 5th to the 6th century) and Shakyaprabha (ca. the 7th century). The first six were major saints, teachers, writers, and founders of institutions. The last two were major teachers of ethics and reformers of monastic orders and their universities. Their combined collected works number in the hundreds of volumes, including major treatises on all the sciences of the ancient world, which were more developed in India than anywhere else. Their successors were equally prolific, geniuses such as Sthiramati (ca. the 6th century), Chandrakirti (ca. the 7th century [No. 37], Shantideva (ca. the 7th century), Shantarakshita (the 8th to the 9th century), Atisha (the 11th century), and Naropa (the 11th century).

Numerous libraries housed their works. Destroyed during the Turkish invasions around the end of the first millennium, they can be thought of as the Indian equivalents of the Library of Alexandria. From the 8th until the 14th century, the Tibetans conducted an unparalleled work of translation, resulting in two massive collections they treasure, the Kanjur and the Tanjur. Of the more than five thousand works they contain, only about five percent remain outside of Tibet in their original Sanskrit versions. About fifteen percent, mostly the religious texts, were translated into Chinese. The rest, but for the Tibetans, would have been lost to the world.

Like the figure of Chandrakirti in No. 37, the only one of these great philosopher-saints represented in here by an individual entry, these great teachers are usually depicted in a formal debate gesture, usually with left arm raised and right arm stretched forward in a vigorous gesture of retort or in the discerning gesture. To this day, formal debate is an important part of the Indo-Tibetan intellectual tradition. Sets of portraits of these philosophers invariably hung in the study and debate halls of the great monastic universities of Tibet, nowadays reconstructed and flourishing in India.

The Great Adept, or Mahasiddha, is the ideal figure for the Apocalyptic or Tantric Vehicle, as the individualistic Arhat is for the Monastic Vehicle and the messianic Bodhisattva is for the Universal Vehicle. Each figure personifies the goal to be

attained by the practitioner of that vehicle of Buddhism. The Great Adepts are often wrongly understood as alternatives to Arhats and Bodhisattvas, rebels against their individualistic monasticism and universalistic messianism, respectively. But the Great Adepts are Arhats and they are Bodhisattvas—but they are also living Buddhas. Using the refined spiritual technologies of the tantras, they have found a way to live as perfect Buddhas on the subtle plane, within their old ordinary bodies, within their old societies, and within their old universe. The Great Adepts included women as well as men. They were sometimes great scholars and writers, but often they maintained ordinary occupations, such as king, wife, merchant, farmer, or were outcastes.

They are exemplars of the tantric acceleration of evolution all the way to Buddhahood, not accepting the inevitability of the flow of time of ordinary history. Thus their vehicle is truly apocalyptic, in the sense of immediate, or revelatory. They are mystics in the Western sense of the term. Beyond conventional religious denominations, some of them are considered saints of Hinduism, with slight variations in biography. They undoubtedly influenced the Chan movement in China, the legendary Bodhidharma clearly being one of them. The Chan patriarchs maintained the Great Adepts' direct mind-to-mind transmission, their apocalyptic immediacy of attainment, and their insistence on a goal of total enlightenment—Arhat, Bodhisattva, and Buddha all in one. The Great Adepts were

also doubtless a major influence on the development of Sufism within Islam. Al-sindhi ("the Indian") was one of the lineage ancestors of early Sufism, and the Muslims who settled in India were exposed to Great Adepts at all levels of society.

The Great Adepts in this book are some of the traditional eighty-four Indian Adepts, and some are Tibetan additions, notably Padampa Sangyey (No. 38) and the great Milarepa (shown in the Kagyu section, Nos. 78 to 83). The Great Adepts, by their nature and life experiences, lend themselves to imaginative, powerful portraiture and biographical representation. Though they have antecedents in Indian art, they truly are a Tibetan art form, even more than the Arhats, and Tibetan painting and sculpture convey their forceful personalities more mystically and compellingly than the art of any other country. Delightful in their bizarre appearance and often surrealistic behavior, they are always represented as awesome in their accomplishments. The idealized representations of the Karma Gadri school of Eastern Tibet are probably the most beautiful (Nos. 39, 41). In groups of spiritual ancestors, they sometimes accompany major con-templative deities in paintings (No. 75). Some of them are repeatedly seen in conjunction with the lineage masters of the various orders, the Nyingma favoring Padma Sambhava; the Sakya, Virupa and Saraha; the Kagyu, Tilopa, Naropa, and Milarepa; and the Geluk, Nagarjuna, Luyipa, Ghantapa, Lalita, and others.

37

Chandrakirti

Tibeto-Chinese

First half of the 18th century

Bronze with chasing, cold gold paste, and pigments

H. 7½″ (19.1 cm)

The State Hermitage, Leningrad. Prince Ukhtomsky Collection

This image presents a number of problems, most of which have remained without a suitable solution. To begin with, the design of the lotus petals surrounding the throne relates to sculpture of the Qing tradition. This is supported by typical Qing flowers chased on Chandrakirti's garment. The even number of petals (eighteen in this case) also occurs in early Qing Buddhist bronzes. The puzzling detail is the size of the central petal at the back of the throne.

Does this number—eighteen—have any symbolic or iconographic meaning? Is it connected in any way with the particular person in the sculpture? Or does it just relate the sculpture to a certain artistic school or workshop? Not all these problems have been settled yet so we can only pose these questions.

Another problem is the Chinese inscription. Several characters are carved on the inside of the throne behind Chandrakirti's right foot. The first one from the left is a triangle with a dot in the center, then the Chinese character *san* (three), then two vertical parallel lines, then the characters *er* (two) and *wu* (five). These characters leave no doubt about the Chinese origin of the sculpture. It is almost certain that these characters were carved by the master who executed the image (they were not cast into the clay image before casting, but were chiseled rather deeply into the metal after casting and certainly before consecration, when the bottom was sealed). But the meaning of the inscription is obscure. Does it signify the number of the sculpture in a set, as in the Medicine Buddha mandala (No. 134)? If so, what was this set? Or does this inscription indicate the number of images produced by the master (or by the workshop) in a certain period of time? Unfortunately, we cannot give any suitable answer to these questions either.

One more problem concerns the subject of the sculpture. There is a Tibetan inscription carved around the side and back of the throne above the lotus petals. It reads "dpa la ldan zla grags la na mo" ("Hail to the glorious Zla-grags!") There is a little mistake in the inscription: it should be *dpal ldan* instead of *dpa la ldan*. So this sculpture is an image of Zla-grags or Zla-ba grags-pa: Chandrakirti. He wears the so-called Atisha's hat with three stripes (T. *jo zhva gling gsum*). According to the drawing reproduced by Tucci, this hat reminds one more of Padma Sambhava's hat (T. *Pad-ma-sam-zhwa*), worn only by abbots (T. *mkhan-po*) and incarnate lamas (T. *sprul-sku*), or the other Nyingmapa while expounding the doctrine (Tucci, 1980, p. 125). His hands are in what is called the debate position.

According to Western scholars, there are two Chandrakirtis in the Tibetan Buddhist pantheon, although Tibetans consider them one and the same. The first one was a great Indian Mahayana philosopher, the abbot of Nalanda, who lived in the 6th century (Tucci, 1949, p. 214). Waddell listed Chandrakirti among "other Indian saints of the Mahayana school who are most worshipped by the Lamas" (Waddell, 1972, p. 378). This is Chandrakirti the Mahapandita, the great philosopher-teacher. Another Chandrakirti is one of the eighty-four (or eighty-five) Mahasiddhas who, according to Tucci, lived "approximately, about the end of the 9th century" (Tucci, 1949, p. 214) and is considered to be an incarnation of Manjushri (Schmid, 1958, p. 100).

Although in Tibet there were numerous Chandrakirtis in sets of National Ornament philosophers, there are four images of Chandrakirti well known in the West. The first one is included in the pantheon of the three hundred gods (Oldenburg, 1903, p. 8, no. 22). He wears the usual monk's hat, his left hand rests on his left knee, and his right hand is raised to his breast in the discerning gesture (*vitarka mudra*). He is placed in the beginning of the series of Indian teachers, and it is most likely that this Chandrakirti is the Indian philosopher.

We find another Chandrakirti in the pantheon of three hundred sixty gods (Clark, 1965a, II, p. 227, no. 9). The

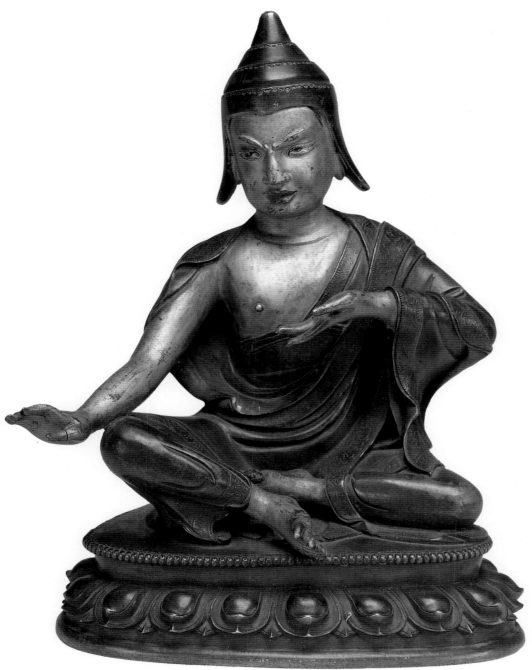

drawing here has more similarity to the Hermitage sculpture, though the hat is not the Atisha type of pandit hat either. Although this Chandrakirti is also placed among Indian philosophers, his face has a rather angry expression, and he is probably best placed among the Mahasiddhas.

The image of Mahasiddha Chandrakirti published in the well-known book by Toni Schmid has nothing in common with the Hermitage sculpture. He is depicted there with two serpents. His head is covered with a piece of textile, and he is bearded and clad in a patched monk's gown (Schmid, 1958, pl. X). Another image of this Mahasiddha is reproduced in the Lhasa edition of Ashtasahasrika. This fourth representation of Chandrakirti wears the Atisha type of pandit's hat but holds a book in his right hand and shows the discerning gesture with his left (Vira and Chandra, 1967, part 16, pl. 35a).

The iconography of the Hermitage sculpture does not coincide in many details with any of the above-mentioned images and it is difficult to decide which of the two Chandrakirtis, the Mahapandita or the Mahasiddha, is presented here. On the one hand a strained expression on his face (rather rare for a Qing sculpture) fits the image of a Mahasiddha—a Great Adept. On the other hand the debate position of Chandrakirti's hands does not contradict the image of a philosopher—a Mahapandita. It reminds one also of Chandrakirti's seven-year-long dispute with Chandragomin, an Idealism (Vijnyanavada) philosopher and the author of a Sanskrit grammar popular in Tibet (*Chandravyakarana*). As the result of this dispute Chandrakirti was defeated and went to South India while Chandragomin became the abbot of Nalanda (Vasiliev, 1857, I, pp. 207–08).

G. Leonov

38
Great Adept Nagpopa
(Padampa Sangyey)

Central Regions (?), Tibet

Mid-14th century

Bronze, with copper and silver inlay

H. 8¾″ (22.2 cm)

The Los Angeles County Museum of Art, Los Angeles. From the Nasli and Alice Heeramaneck Collection. Museum Associates Purchase. M.70.1.5

Lit.: Pal, 1983, p. 220; Pal, 1990; Roerich, 1988.

Padampa Sangyey was a great Buddhist yogi and the Great Adept who came to Tibet from India in the second half of the 11th century. There are many legends about him, including that, centuries earlier, he had gone to China, had become well known as Bodhidharma, and had founded an order of Adepts known as Chan. Later, he became a famous scholar at Vikramashila monastery in northeast India. He was noted for teaching the Chö, or Spiritual Self-Dissection method of meditation. This was a powerful, somewhat shamanistic method of taking apart the old ego-centered mind and body and reassembling it in the patterns of wisdom and compassion. It was followed by many schools in Tibet. With his major disciple, the Tibetan female saint Machig Ladrön, Padampa founded his own order, known as the Shije Order. He is included as one of the Great Adepts (six Tibetan and two Indian) added by the Tibetans to the original group of eighty-four.

In this almost completely symmetrical statue, Padampa Sangyey is presented seated in a squatting position that indicates his practice of the "inner heat" (T. *dumo*) yoga. He is garbed only in a printed lower garment. Its sharp folds echo the curves of his chest muscles and provide the only asymmetrical touch in the work. Flat spiral earrings stand out as starkly as his wide open eyes, which are inset with silver and copper. His wiry necklace reflects the short curling contours of his beard. The band of flowers on his head seems incongruous on this powerful and magnetic head, but they are reflected by the large floral, leafy patterns of his garment. The condensed and chunky quality of the body and the controlled energy of its contours create an image seeming to hold in balance intense contending forces. In this way, this simple yet masterful sculpture conveys the yogic powers of the figure.

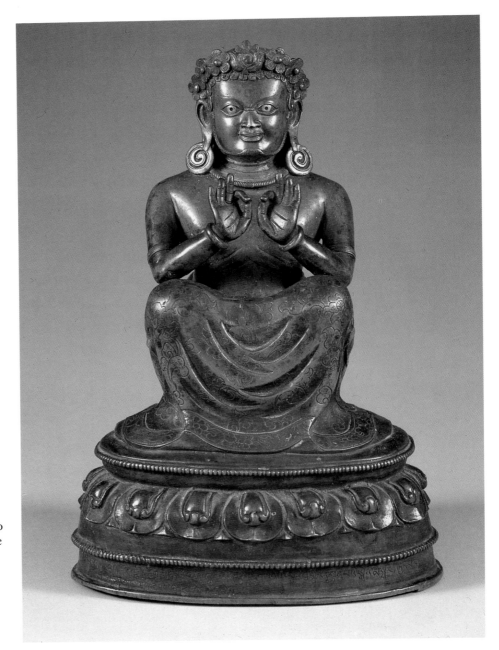

An inscription on the statue states: "Headed by the nun, the disciples have set up this holy image as a support for faithful prayers for the memorial service of the glorious Lama (Palden Lama). By its merit may all creatures attain Buddhahood. Good luck, Good fortune." Pal and Richardson (Pal, 1983, pp. 220, 263)

suggest that "Palden Lama" may be Palden Sengge (Penden Sengey, d. 1342). Stylistically, the sculpture suggests a mid-14th-century date. It has some of the clear-cut strength seen in the 14th-century Arhat paintings (Nos. 12, 13). It has a particularly well-defined side and back view.

Great Adepts Shavaripa and Dharikapa

Eastern Tibet

Late 16th century

Tangka; gouache on cotton

25¾ × 15″ (65.5 × 38.1 cm)

Mr. and Mrs. John Gilmore Ford

Shavaripa was a hunter of antelopes, but was shown his mistaken ways by Avalokiteshvara, who appeared to him as another hunter and challenged him to a contest of deer slaying. With his magical power, he completely amazed Shavaripa by slaying five hundred deer with one arrow. He then showed Shavaripa and his wife a vision of themselves in hell, where their professional killing would land them. Thus stimulating their religious zeal, he initiated them into the mystic circle (mandala) of Paramasukha-Chakrasamvara (Supreme Bliss Wheel Integration). Thereafter Shavaripa gave up killing animals and practiced tantric meditation for twelve years. He finally achieved Buddhahood in his lifetime.

Also called Wearer of the Peacock Plume, he is shown in this painting with a great peacock-feather cape billowing behind him as he dances in the air holding a bow and pointing to a fleeing antelope, who dives headlong into the rocks (39.1). He presents a rather astonishing figure with a Pinocchio nose and tight leggings with leather knee-capped guards. Below is a hunter, presumably himself before his conversion, carrying a slain black antelope and accompanied by his wife, who holds his quiver of arrows. Above the springing deer two peacocks perch on a branch and an image of Vajrasattva glows from the blue slanted rocks.

The scene below shows the Great Adept Dharikapa. Once a king, after meeting the Great Adept Luyipa he gave up his kingdom and became a disciple. In the course of his service he was sold to the main dancer of a temple. He was her slave for twelve years. One night the dancer, Dharima, saw him sitting on a levitating throne, teaching the spiritual technology of the tantra. She begged his pardon for having held him in her service, and she forthwith became his disciple. His name, Dharikapa, comes from his being the servant of this famous dancer. He is depicted here with beard and crown. He holds a peacock feather and a vajra scepter in his right hand and a bell in his left. He is regal and magnificent, wearing a black

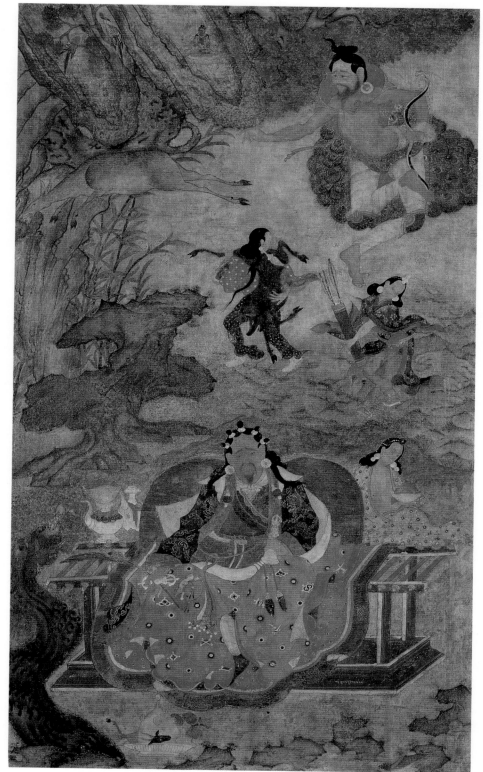

39.1

cloak with dragon designs. An orange lap cloth spreads over him and part of his dark blue throne. It seems to be a racklike bed, probably the simple cot he slept on in Dharima's servant quarters. Behind stand a victory vase (without spout), with cloth vestment and conch-shell covering cup, and an action vase (with spout), used to pour holy water during rituals. A loosely dressed woman, who is probably Dharima, stands behind him. She holds a skull bowl heaped with the inner offering (transmuted body substances), which identifies her symbolically as his yogic consort.

These two scenes are set within a landscape that has little depth and no clear horizon line. Both figures and landscape elements are relatively large and are viewed at close range. The lively beauty of the wiry, curvilinear figures is matched by the interesting shapes and sensitive color modeling of the rocks, trees, and water. The high degree of informal naturalism, with individual distinctness of each element and a strong stylization of the rocks, relates to paintings of the late Ming period. It suggests a dating for this work in the late 16th century.

Another Great Adept painting possibly from the same set is in the Ford collection (Lauf, 1976a, pl. 23). These are early examples of the Eastern Tibetan school of painting, which seems to have gained momentum by the late 16th century and is particularly noted for its assimilation of Chinese landscape styles. The Great Adepts in Tibet House, New Delhi (Tibet House Museum, 1965, pls. 5–6, 11–15) are another distinctive, but later (17th-century) style of Eastern Tibetan painting, and the Milarepa tangkas in Stockholm (Nos. 82, 83, 152) are yet another, and even later (late 18th- to early 19th-century) development in the Eastern school. Whether or not all of these distinctive styles can be equated with the so-called Karma Gadri style has yet to be resolved. Certainly the paintings in this set are masterworks of refined technique and the skillful balance of sensitive naturalistic and stylized elements.

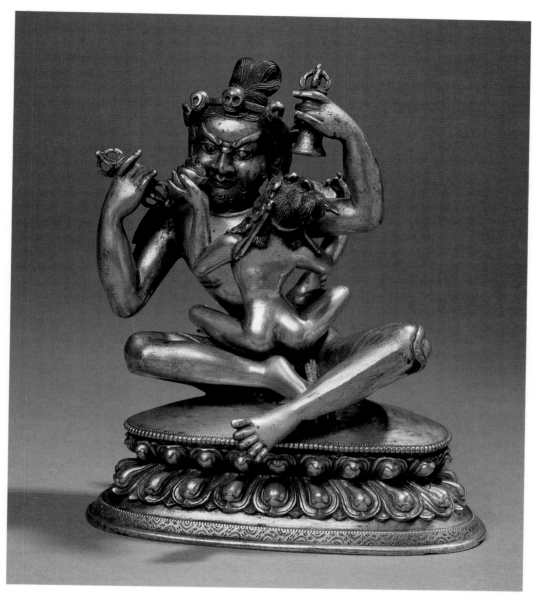

40
Great Adept Ghantapa and Consort

Tibet

Second half of the 16th to early 17th century

Gilt bronze

H. 8¹⁵⁄₁₆" (22.7 cm)

Trustees of The Victoria and Albert Museum, London

Lit.: Lowry, 1973, p. 33.

Ghantapa was a celibate monk-scholar of the famous Nalanda monastic university in northeast India. When he refused an invitation to come to the palace of King Devapala (r. ca. 809–849), on the grounds of the king's insincerity, the king became angry and put a price on his celibacy. To win the substantial reward, a local courtesan sent her beautiful daughter to seduce him. The girl eventually succeeded and the two became a couple. When she had borne Ghantapa a child, the king came to take revenge. With a large retinue, he confronted Ghantapa with accusations. Ghantapa smashed the baby and his gourd of wine upon the ground. The earth opened and a flood of water gushed forth. Baby and gourd were transformed into a vajra and bell, which Ghantapa took up in his hands. Transforming into Paramasukha-Chakrasamvara Buddha, Ghantapa rose into the air with his consort, who transformed into Vajravarahi. Avalokiteshvara appeared to rescue Devapala and his retinue from the flood. They prayed for pardon and were initiated by Ghantapa into the magic Circle of Great Bliss.

Ghantapa and his consort are shown in union as Paramasukha-Chakrasamvara and Vajravarahi. His legs are drawn up onto the sloping pedestal and he balances his petite consort on his lap, possibly in the moment of rising into the air. The pair presents a complex and engaging sight. Strong diagonal movements of the Mahasiddha's legs, body, and arms are complemented by the alert and bending body of his consort. He holds up his vajra of compassion and bell of wisdom. She holds aloft a vajra chopper and skull bowl, implements of Vajravarahi, symbolizing her personification of sharp-edged wisdom and its transmutation of ordinary substance into the ambrosia of enlightenment. She appears to be his smaller counterpart both in pose and movement. Except for their skull crowns and earrings, and his animal-skin loincloth, both are naked; the sleek planes of their bodies create a smooth, golden surface. The expression on each one's face is serious and intent. This is undoubtedly one of the most masterful sculptures of a Great Adept and consort. The slightly heavy quality of the limbs and bodies would appear to relate the work to the late 16th or early 17th century.

41

Great Adepts Virupa, Naropa, Saraha, and Dombi Heruka

Eastern Tibet

18th century

Tangka; gouache on cotton

32½ × 22″ (82.4 × 55.8 cm)

Museum of Fine Arts, Boston

In an unnaturally perfect but sumptuous "landscape" are positioned four highly realistic and compelling Great Adepts, each with his own clearly demarcated setting that is only tenuously related to the landscape. Nevertheless, the two harmonize by virtue of their beauty of color, which, almost by itself, lifts the painting to a plane of pure aesthetics. It is not merely a naturalistic idealism such as that of the earlier Sarasvati (No. 27). This painting goes a step beyond, to a point where the ideal has become formalized and completely real.

In the lower right sits the corpulent, dark, and naked Virupa, clearly identified by his well-known scene, in which he is surrounded by wine jars and bedecked in garlands of flowers and a yogic meditation strap. From his right index finger shoots a ray of golden light, sent to stop the sun in its tracks so he would not have to pay his wine bill, which he had promised to pay when the sun set. At the lower left, seated on a lavender lotus rising from a lake, sits Naropa, with his consort in his lap. This depicts the scene that occurred after Naropa outraged the citizens of Sarnath by wandering naked with his consort. They burned the couple at the stake with a mountain of firewood. Yet when the citizens returned to the scene in the morning, Naropa and his consort were sitting blissfully on a giant lotus that sprang from a lovely lake that had replaced the bonfire. Each partner holds a gleaming white skull bowl, symbolizing their great bliss wisdom that contains the essential elixir of insight into voidness.

At the upper left is Saraha, the maker of arrows, identified by inscription as one who attained success while dwelling on Mount Glory (Shri Parvata). He is shown as an aged man on a large, lightly tinted blue cloud holding the symbol of his trade. In front of him is his female yogi. Saraha is famous for his marvelous verses, of which the example below is taken from David Snellgrove's translation (Conze et al, 1964, pp. 227–39):

Where vital breath and mind no longer roam
 about,
Where sun and moon do not appear,
There, O man, put your thought to rest,
This is the precept taught by Saraha.
Do not discriminate, but see all things as one,
Make no distinctions of clans or castes,
Let the whole of the universe be as one
In the exaltation of great passion.
Here there is no beginning, middle, or end,
Neither samsara nor nirvana.
In this state of supreme bliss,
There is neither self nor other. . . .
I have visited in my wanderings shrines and
 other places of pilgrimage,
But I have not seen another shrine blissful
 like my own body. . . .
The fair tree of the void abounds with flowers,
Acts of compassion of many kinds,
And fruit for others appearing spontaneously,
For this joy has no actual thought of another.
So the fair tree of the void also lacks
 compassion,
Without shoots or flowers or foliage,
And whoever imagines them there, falls down,
For branches there are none.
The two trees spring from one seed,
And for that reason there is but one fruit.
He who thinks of them as indistinguishable,
Is released from samsara and nirvana.

In the upper right-hand corner Dombi Heruka, also identified by inscription, rides a growling tiger. Garbed in flayed skins, with snakes wound around his arm and body, he sports his consort on his knee. Formerly, he was a king of Magadha in the Ganges plain who was initiated by his Guru and practiced tantra while remaining on his throne. Eventually, he became a Great Adept and began to behave unconventionally. His subjects became indignant when he took a consort from the outcaste class. He then left the throne and went to dwell in bliss in the forest with his outcaste queen. When his subjects became unhappy without his presence and realized their loss, they requested his return. He and his consort rode out of the forest on the back of a pregnant tiger. As a condition for his return, the king requested that he and his consort be put to the test of purification through fire, from which they both emerged inside a lotus bud.

From behind the diagonal slopes of the smooth, dense, green hills come half-revealed groups of splendid palaces with yellow-gold, orange-gold, and aqua roofs and deep red walls. Though somewhat patterned and formalistic in the approach to landscape elements, all the parts seem to vibrate with a sparkling life, from the eddies of the water to the lilting rhythms of the mountain peaks. The plain areas provide just enough relief for the details to show their best. It is an almost perfect work, probably related to the fully developed phase of the Karma Gadri style of Eastern Tibet.

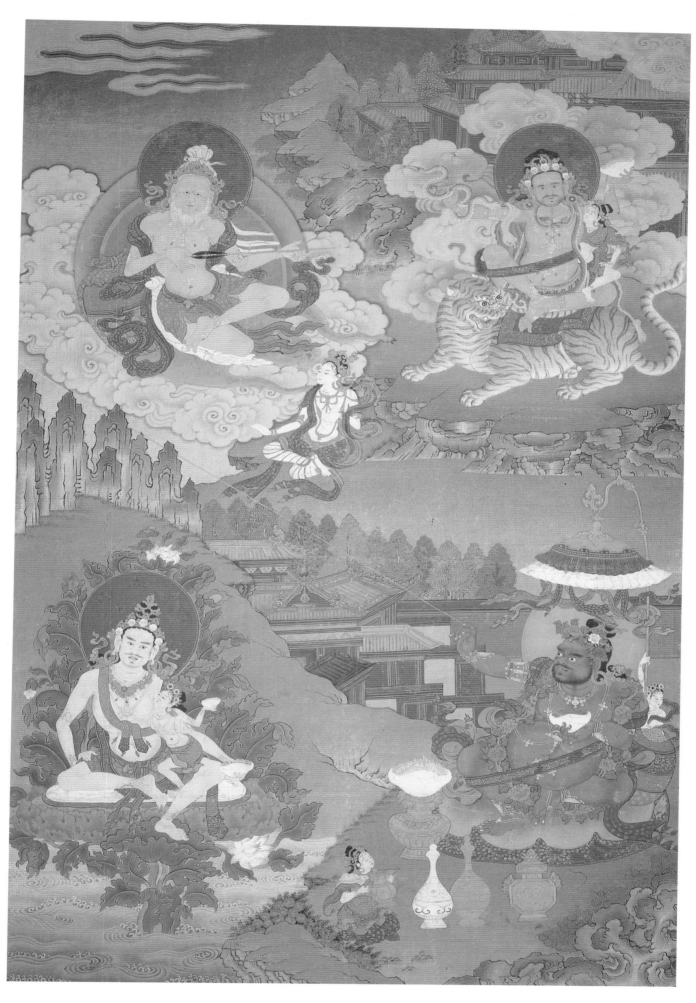

V.
Dharma Kings

In Shakyamuni Buddha's day, the kings of the Gangetic city states, such as Bimbisara of Magadha and Prasenajit of Kosala, became famous as the patrons of the newly founded order. Emperor Ashoka (3rd century BCE) of the Maurya dynasty became a paradigm of a Dharma King. He made it the overriding purpose of his rule, as memorialized in numerous rock-carved pillar edicts, to support religious persons in general, and especially the Buddhist educational community. In many Buddhist countries since then, kingship has drawn its legitimacy from the ruler's patronage of the people's spiritual pursuits. He supports their renunciation of mundane concerns, their joining of the order, their rituals of offering and honoring at stupas and *chaityas*—sanctuaries or assembly halls, usually containing a stupa—and their supporting and learning from the monks and nuns of the order. The Buddhist ideal of Dharma kingship is clearly conveyed by the Buddhist custom that, although such a king or queen is the most honored and most powerful figure in society, he or she should bow down to the simplest monk or nun, signifying the superiority of the sacred over the mundane.

Certain Dharma Kings—some worldly, some mythical, and some heavenly—are especially famous in Tibetan Buddhism as protectors of the Dharma, the Buddhist teachings. Most renowned among the human Dharma Kings in Tibet are the three great Religious Kings of the early Yarlung period, or Period of the Religious Kings. They ruled from the 7th to the 9th century in Tibet. They were Songtsen Gambo (r. ca. 627–649), believed to be the incarnation of Avalokiteshvara; Trisong Detsen (r. ca. 755–797), believed to be the incarnation of Manjushri; and Tri Relwajen (r. ca. 815–836), believed to be the incarnation of Vajrapani.

There is the mythical King Gesar of the Tibetan oral epic, known as Gesar of Ling. Gesar is a Tibetan national hero who fights for his people against all sorts of enemies, though, like almost every other aspect of Tibetan culture, the cycle of tales has absorbed Buddhism so completely that Gesar's defense of Tibet against the forces of evil becomes a drama of defense of the Buddha Dharma.

Then there are celestial kings adopted from Indian mythology, known as the Four Heavenly Kings. These kings are believed to live on the slopes of the axial mountain, Meru (the Indian equivalent of Olympus), and to confer great wealth, success, and victory on their worshipers.

Finally, there is a set of thirty-two religious kings of the mythical country of Shambhala, believed to exist magically hidden in the arctic region until a future apocalyptic era three or four centuries from now. The history and prophecies about Shambhala are recounted in the literature of the *Kalachakra Tantra*. The first of these kings was King Suchandra, who came with his subjects from Shambhala to India in magical airships. They received the teaching of the *Kalachakra Tantra* directly from Shakyamuni Buddha at the great stupa of Shri Dhanyakataka in South India. Tibetans believe we are presently in the realm of the twenty-ninth king of Shambhala, and that the new golden age of world freedom and enlightenment will dawn after a terrible technological war during the reign of the thirty-second king, King Rudrachakrin.

A few examples from these popular groups appear here. Generally, they occur in Tibetan art as complete sets of paintings and sculptures. The Four Heavenly Kings oftentimes accompany a set of the sixteen or eighteen Arhats. These iconographic sets seem most prevalent in the central regions of Ü and Tsang and in Eastern Tibet; they seem rarely to appear in Western Tibetan painting before the 17th century. The Religious Kings and the Kings of Shambhala are especially popular with the Geluk Order.

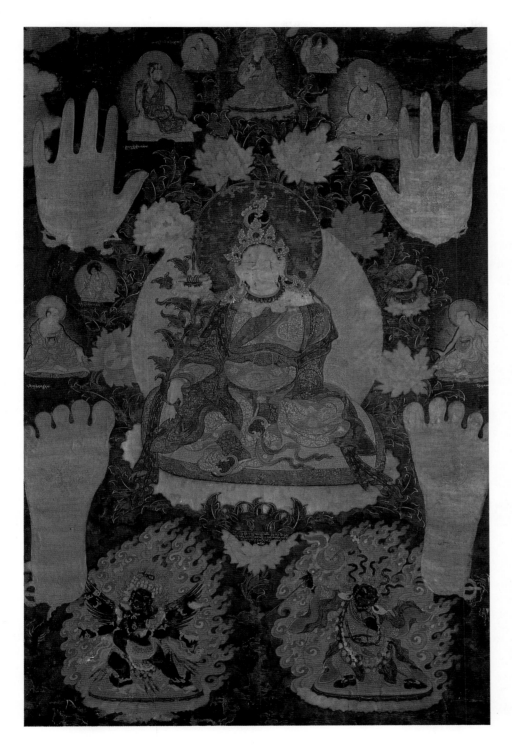

42
King Trisong Detsen

Tibet

Circa 1700

Tangka; gouache on cotton

30½ × 19⅝″ (77.5 × 50 cm)

Musée Guimet, Paris

In the center of the composition is the figure of King Trisong Detsen (r. 755–797). This king was the royal patron of Samye, the first Buddhist monastery in central Tibet (around 779), and shortly afterward he proclaimed Buddhism the official religion of the nation. His reign marks the zenith of the period of the Religious Kings (7th to 9th centuries).

This tangka belongs to a famous series representing the successive reincarnations of the Bodhisattvas Avalokiteshvara, Manjushri, and Vajrapani as the temporal and spiritual rulers of Tibet, culminating with the Buddhocratic rule of the Dalai Lamas. The Musée Guimet has three other paintings in this series. Each of the tangkas has handprints and footprints of a particularly important ruler decorating the work. Handprints or footprints frequently appear on the backs of paintings, but rarely, as here, on the front, made during the consecration ceremony.

The four pieces from the Musée Guimet are executed in a particular style common in the Gelukpa monasteries from the 17th century. The dark background, a blue-green becoming almost brown, the extremely meticulous drawing, certain contours redone in gold, perfectly assimilated Chinese motifs (clouds, roofs, ornamental flowers), and the delicate floral decor of the clothing are all characteristics that are comparable to the works of the great mural cycles in the Red Palace of the Potala, executed under the patronage of the regent Sangyey Gyatso from 1692–1705.

G. Béguin

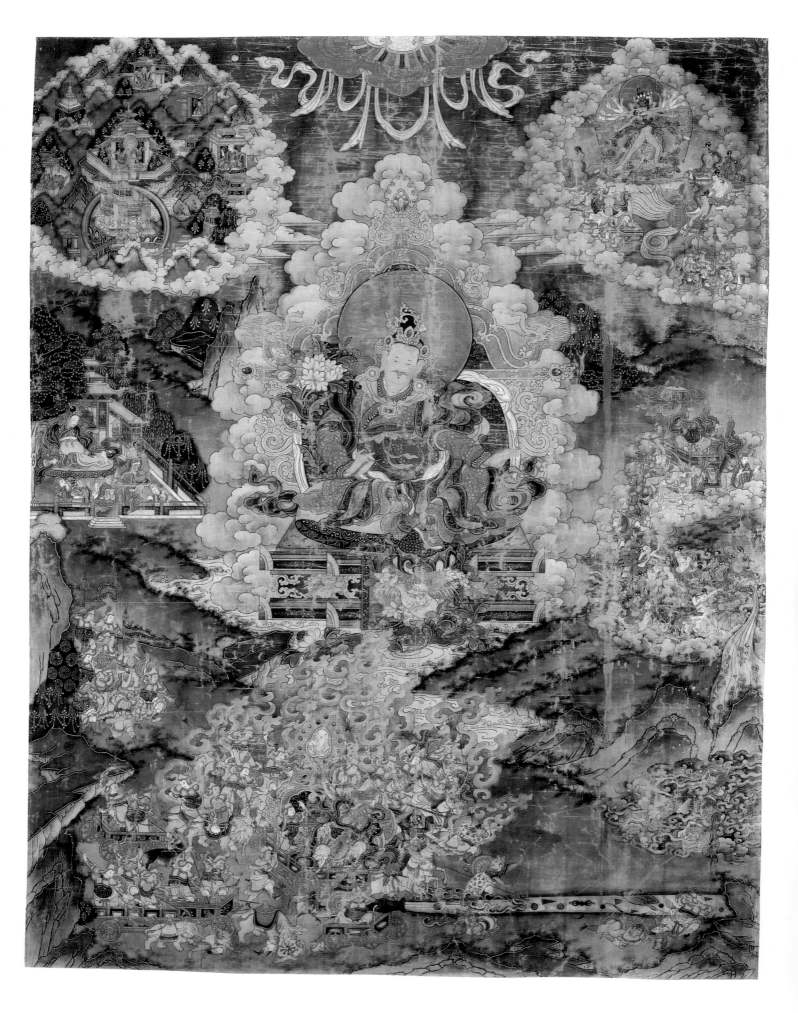

Rudrachakrin,
the Last King of Shambhala

Eastern Tibet(?)

Late 18th to early 19th century

Tangka; gouache on cotton

31⅞ × 24″ (81 × 61 cm)

Virginia Museum of Fine Arts, Richmond. Gift of Shoji Yamanaka in memory of Alan Priest

Beneath a brilliant red canopy with flying white streamers appears a fantastic ruddy cloud holding the throne of the gorgeously robed celestial king Rudrachakrin, the last king of Shambhala, the mythical kingdom of the north (see introduction to V, Dharma Kings). Other visions and scenes appear amid masses of pastel clouds that are interspersed against the dark blue sky. Among the jade green hills appear clusters of trees strung with jewels and stylized blue and brown jagged rocks. To the upper right appears the realm of Buddha Kalachakra (Time Machine), contemplative deity of the *Kalachakra Tantra,* which expounds the technology of a Buddha's triumph over time, and contains the apocalyptic legend of Shambhala. The miniature forms of the Buddha and his consort Vishvamata (All-Mother) are surrounded by Great Adepts, female Dakinis, a figure of the king of Shambhala in his general's uniform with adoring soldiers beside him, a wheel of power emitting mystical rays, and another group of soldiers standing in the clouds. In the upper left segment, a simplified map of the kingdom of Shambhala is depicted with a number of palatial buildings representing the various provinces. The palace of the king appears in the center. Below it in the garden is the famous three-dimensional mandala of Kalachakra, encircled by a rainbow. In the middle sections of the painting to left and right of the central figure appear respectively the palace of a queen and a scene with the king, riding in a horse-drawn cart with a canopy overhead. He is accompanied by his army as they survey the events taking place below where fierce Dakinis riding animals attack a cluster of hungry ghosts and demons enmeshed in the dark cloud underneath. From an open box a rain of hail and *purba* daggers—ritual daggers symbolizing wisdom's ability to stop and to subjugate demons—are released upon the hapless demons. At the bottom left and center is the major battle between the forces of good under Rudrachakrin and

those of evil that had enslaved the world (43.1). A fierce general (Rudrachakrin?) thrusting a long spear leads the army of Shambhala with their war carts drawn by elephants and horses. An attendant holds the flag of Shambhala (a peacock feather framing a plaque of snowy mountains), above him. The army attacks the enemy with various weapons, including a fantastic futuristic cannon whose lazerlike rays shoot arrowheads, bullets, and vajra thunderbolts. It is said that Rudrachakrin's victory will inaugurate an unprecedented golden era of peace in world history. The Buddhist teaching of selflessness and the practice of nonviolence and compassion will flourish, and many yogis and yoginis will become adepts in the *Kalachakra Tantra.*

The entire painting projects an air of light fantasy through the warm color tones of the prominent cloud groups, which create islands of otherworldly scenes

43.1

contrasting with the darker tonality of the earth and sky. The lighthearted mood engendered by the coloring is only increased by the swift and free movements of the line, which tend toward an abandon not witnessed in earlier Tibetan art. Such light coloring, mannered freedom, and mild distortions appear in Tibetan painting around the late 18th to early 19th century. They are especially notable in the paintings from the eastern regions. There is a touch of improbability in this style, a fresh and delightful, if somewhat sweet, aura of playful unconstraint and conscious prettiness. These, however, remain acceptable because of the spirited, engaging, and colorful drama of the scene. It is an interesting stylistic variant contrasting with other paintings of the period (No. 153), as well as to the Tsong Khapa tangka in the Museum of Fine Arts, in Boston, dated to the early 19th century (Pal and Tseng, 1969, no. 32).

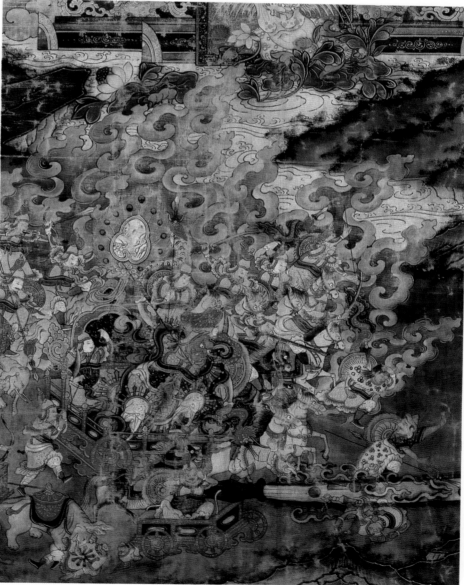

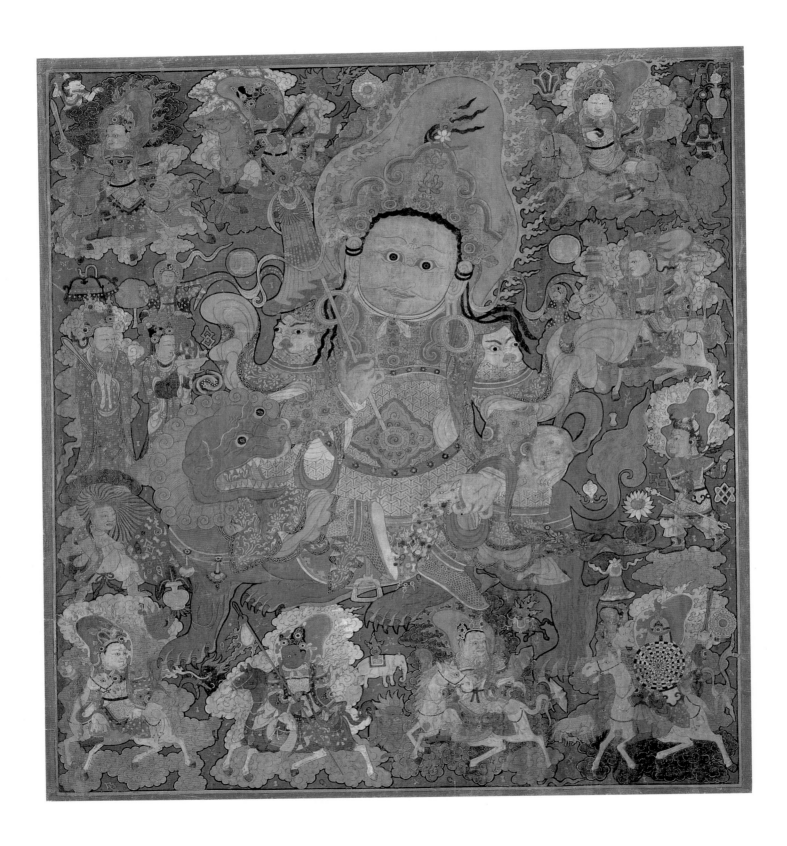

44

Vaishravana

Central Regions, Tibet

First half of the 15th century

32 × 29″ (81.3 × 73.7 cm)

Tangka; gouache on cotton

Robert Hatfield Ellsworth Private Collection

Lit.: L. Chandra, 1974 II, 171–73.

The great Dharmapala (Protector of the Teaching) Vaishravana, guardian deity of the north and god of wealth, sits astride a ravishing blue snow lion holding a victory banner and a plump, jewel-spouting mongoose (who symbolizes generosity, as it conquers the snakes of avarice). He is a chubby, broad, stunningly armored figure with a huge, square, smiling face. His large round eyes, though rimmed in red, are nevertheless mild. The large snow lion, its beautiful aqua mane reflecting the color of Vaishravana's halo, turns its big head around toward its master as he strides among the clouds and surrounding figures. Everything seems to swirl over the surface without any structural or artificial impediments, so there is a certain degree of fluidity to the otherwise compact, strongly two-dimensional surface.

Large figures on horseback accompany Vaishravana; they are the eight demon lords: white Jambhala, (east); yellow Purnabhadra, (south); red Manibhadra, (west); dark Kubera, (north); yellow Samprajana, (southeast); black Guhyatana, (southwest); canary Pancikaye, (northwest); and white Picikundali, (northeast). Each has a name and special color and each carries the mongoose in his left hand and another identifying symbol in his right hand. Scattered around these demon generals are their demon armies. Also among the various clouds are the eight lucky symbols (wheel, fish, knot, vase, banner, jewel, conch, and lotus) and the seven royal necessities (precious wheel, queen, wish-granting jewel, minister, elephant, horse, and general). At the left side appears a brown, corpulent, laughing figure, looking like Hvashang, gleefully emptying a bag of riches, which 'fall like magical toys throughout the sky and over the figures below (44.1).

Each of the individual figures is well drawn in the crisp, even line of this style. The color is flat and brilliant, with a predominance of dark ultramarine blue. The delightful turquoise blue imbues the painting with a joyful spirit. Turquoise

color is generally used sparingly in Tibetan art until later centuries. Here it is used quite lavishly for an early work and brings a special beauty to the painting.

In general, the style seems to be most closely related to the art of the central regions of the early 15th century, especially as known from the wall paintings of the Kumbum at Gyantse in Tsang, dating around the second quarter of the 15th century. The shape of Vaishravana's halo, as though the flames are blown in the wind, is a style seen in the halos of the guardians of the Shigatse tangkas in the British Museum (1955.4–

44.1

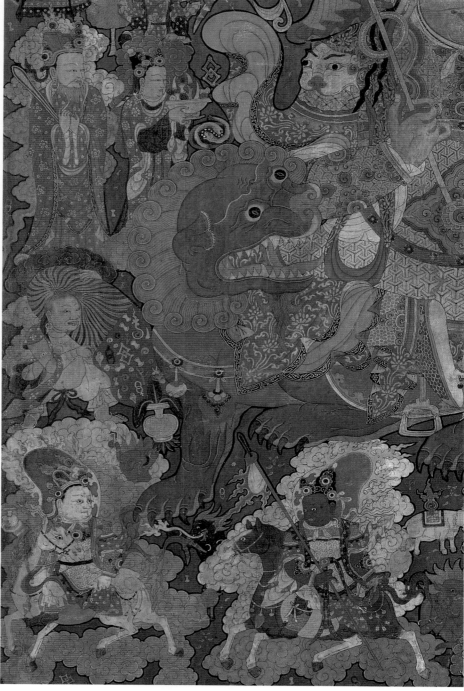

6.038/.039) of about the same date, although there is greater simplicity here. This unusual and special painting is probably one of the earliest surviving examples of this form of Vaishravana on the snow lion in Tibetan art. Although Vaishravana wearing the general's armor is common within the traditional Central Asian and Chinese depictions from early centuries CE, the representation of Vaishravana riding the snow lion is most prevalent in Tibet. One of the earliest of the Tibetan-related examples appears in the Khara Khoto group (Béguin et al, 1977, pp. 80, 84).

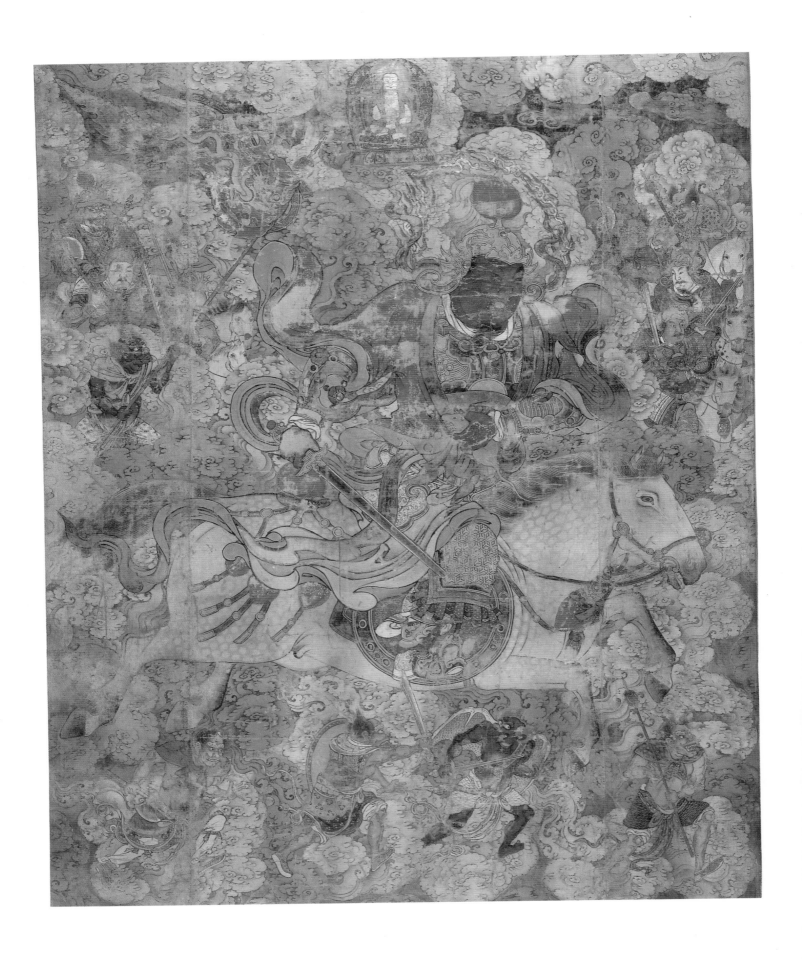

45
Kubera

Eastern Tibet or China

Second half of the 16th to first half of the
17th century

Tangka; gouache on cotton

47⅝ × 38¼″ (121 × 97 cm)

Musée Guimet, Paris

Lit.: Béguin, 1989, pp. 106–07.

Vaishravana is accompanied by eight
generals, the Eight Masters of the Horses,
among whom Kubera is one of the most
important. They are all emanations of
Vaishravana. Among them Kubera can be
found in the north. Dark-skinned, he
brandishes a sword, and in his left hand
he holds the mongoose with jewels
streaming from its mouth. The extreme
refinement of this huge panel, possibly cut
on the right-hand side, is somewhat
reminiscent of a work from the end of the
Ming period (1368–1644). Detail 45.1
shows part of the right section with the
lively and realistically drawn and modeled
yakshas and the superbly rendered dapple-
grey horse.

G. Béguin

45.1

བོད་ཀྱི་

རང་བའི་

ཚོས་བཀྲུད།

TIBETAN

BUDDHIST

ORDERS

After the ocean of Buddhism broke through to the Himalayas in the late 8th century, it flowed across the Tibetan highland in a succession of four great waves, called the four main orders of Tibetan Buddhism: Nyingma (the Ancients), Sakya (after the site of the head monastery), Kagyu (Oral Tradition), and Geluk (Virtue Tradition). (Each order is described in some detail in the essay, "Tibet, Tibetan Buddhism, and Its Art.") As in the famous Buddhist paradox, the Buddhist ocean and the order-waves are neither the same nor different; in another sense, all four waves are both the same *and* different. They are perceived as different varieties of the common Buddhist vision, contemplation, and action. All four base their philosophies, meditations, and ethical codes on the Monastic, Universal, and Apocalyptic Vehicles of Indian Buddhism, and rarely are they seen as mutually exclusive. While there have been very occasional conflicts between them, these have always involved political factions aligned with one or another "regional" institution, sometimes both of the same order. No philosophical or religious differences are major enough to be the true cause of serious conflict.

The Nyingma Order was founded in the 8th century on the legacy of the first Buddhist pioneers in Tibet. It has the power and simplicity characteristic of all foundational institutions, and there is a saying among modern Tibetans that the Nyingma teachings were for near-Buddhas. Certainly the early Nyingmapas were almost superhuman in intelligence, energy, and dedication. Padma Sambhava and other Nyingma masters were the first to tame the nature deities of Tibet, and probably because of that, Nyingma rites are still used directly and indirectly by the other orders in their efforts to remain in harmony with the environment.

The Sakya Order, which rose toward the middle of the 11th century, was critical to the Second Transmission of Buddhism in Tibet. Its founders were descended from the earliest disciples of the Indian masters Padma Sambhava and Shantarakshita. The Sakyapas were outstanding not only for their goodness and sanctity, but also for their depth of realization and breadth of scholarship. The order's founders stemmed from a ruling family, the Khons of the southern Tsang region, who brought great organizational ability to the Sakyapas' early administration. The Sakya contribution has been enormous in terms of educating monks and nuns, translating and editing numerous Buddhist classics, writing insightful and compellingly beautiful treatises, commissioning important works of art, and even, during the perilous times of the Mongol empire, governing with prudence and compassion.

The Kagyu Order was founded in the 11th century by the translator Marpa (1012–1098) and the Tibetan poet-saint Milarepa (1040–1123) on the esoteric and contemplative teachings descended from the Indian Mahasiddhas Tilopa and Naropa. Its great appeal thus lies in the power of its yogic traditions and the brilliant charisma of its masters. (The same modern Tibetan saying cited above goes on to say that the Sakya and Kagyu teachings are for Bodhisattvas.) From Gampopa (1079–1153) onward, the Kagyu Order developed a solid monastic institutional base and spread throughout Tibet, branching into numerous suborders. The Kagyupas originated the distinctively Tibetan Buddhist pattern of leadership by reincarnate lamas of special holiness, thus breaking the pattern of domination by a traditional ruling family and making possible its broad regional spread.

The Geluk Order is sometimes called the New Kadam, a recognition that its founder, the active visionary Tsong Khapa (1357–1419), considered himself to be the renewer of the dispensation of the great 11th-century Bengali master, Atisha. Inspired by the future Buddha Maitreya, Tsong Khapa made every effort to ensure that the Buddhist Teaching would continue to serve an ever-widening public. His teachings are noted for their comprehensiveness, drawing as they do from the practical teachings of all previous Tibetan orders. The Gelukpas created a systematic curriculum that allows lay people and monastics to progress on the path to enlightenment from whatever their starting point. (The modern Tibetan saying concludes that the Geluk teachings were designed to accommodate the most ordinary people.) The Geluk Order caused an explosion of monastery building in the 15th through the 17th century and greatly expanded the practice of rule by reincarnate lamas. One of the reincarnational lama lines of its Drepung monastic university became the succession of Dalai Lamas, who, from the 17th-century Great Fifth to the present Fourteenth Dalai Lama, have provided honored and effective leadership for the entire Tibetan Buddhist world.

VI.
Nyingma Order

The Nyingma Order was founded upon the exoteric teachings of Shantarakshita and Kamalashila, two great masters from Nalanda monastery in India, and upon the esoteric teachings of Padma Sambhava, the legendary Great Adept. Under the patronage of the Tibetan king Trisong Detsen (r. 755–797), Shantarakshita founded the first Tibetan monastery at Samye around the middle of the 8th century, ably assisted by Padma Sambhava, who had to tame the native deities of Tibet and bind them to the service of Buddhism. Other Indian masters, such as Vimalamitra and the translator Vairochana, helped in the long and arduous work of collection, translation, and transmission of much of the sacred lore and hard science of ancient India. This work was carried on at Samye during the first half of the 9th century. The Dharma kings Trisong Detsen and Tri Relwajen (r. ca. 815–836) were the bountiful patrons of these extensive projects.

During this initial heyday, the Nyingma tradition was the whole of Tibetan Buddhism. In the middle of the 9th century, Buddhism was persecuted by King Lang Darma (r. 836–842), who took the throne after the assassination of the Dharma King Tri Relwajen. When Lang Darma in turn was assassinated by a Buddhist adept, Lhalung Pelgyi Dorje, the Yarlung dynasty was thrown into chaos, and the country soon split into poorly coordinated regions. Buddhist monks fled to the outer provinces. The recently translated Buddhist texts were destroyed or hidden. The Buddhist temples and monasteries were unable to function for a long time.

From the middle of the 10th century, the Dharma began to return to the central regions. At the same time, later forms of Indian Buddhism entered Tibet through the work of numerous Tibetan translators and Indian masters. Around this time, the Nyingma was formed into a distinctive order; it was based on the spiritual lineages preserved in the families of the • descendants of the disciples of Padma Sambhava, on the sacred texts in the "old" translations done in the Samye period, and on the monastic traditions descended from Shantarakshita. Its primary teachers were lay masters, so it became a minority order compared to the newer monastic orders founded by Atisha, Drokmi, and Gampopa during the 11th and 12th centuries. In the 17th century, it experienced a renaissance under the patronage of the Fifth Dalai Lama, who was profoundly influenced by the Nyingma teachings. He revived the liturgies of various Nyingma deities in the Namgyal Dratsang, his personal monastery in the Potala. He also supported the construction of the important Nyingma monasteries of Mindröling and Dorje Drak. In the last three centuries, a number of important masters flourished in the Kham region of Eastern Tibet, writing important works, founding monasteries, and training numerous enlightened disciples. A number of superb and unusual tangkas and sculptures of Padma Sambhava from the 14th to 17th century, all probably from the central regions of Ü and Tsang and Western Tibet, are presented in the pages that follow.

Padma Sambhava can be depicted in many ways, such as in

his eight main manifestations; or with his twenty-five main Tibetan disciples; with his life stories; or in his Glorious Copper Mountain Pure Land. Generally, he is shown with his two consorts: Mandarava, the Indian princess, and Yeshe Tsogyal, a Tibetan queen, both of whom are ranked as Great Adepts. Although there are variations in his attire, customarily he is garbed with the robes of a prince: a white silken undergarment covered by a blue-green patterned silk overgarment, over which is thrown a dark red-brown woolen robe. He wears a hat of his place of birth (Uddiyana, usually equated with present-day Swat in northern Pakistan), which has lappets and an eagle's feather, an ancient symbol of penetrating vision. In his right hand he holds the vajra, symbol of compassion's power. In his left hand he holds a skull bowl of blood, symbolic of the purification of egotism. In the crook of his left arm rests an adept's staff (khatvanga), at the apex of which are three heads in varied stages of decay: one freshly severed head, one shrunken head, and one skull, symbolizing the conquest of desire, hate, and ignorance, respectively.

Some of the major archetype deities (ishtadevata) of the Nyingma Order are Hayagriva with horse's head (No. 54), Vajrakila (Dorje Purba) (Nos. 53, 57), and Vajrapani (Nos. 55, 56, 58) in various forms. Mahakala (No. 52) is an important protector deity. These are terrific manifestations of strange and awesome appearance, not meant to frighten, but to help the practitioner undertake and achieve the task of clearing away the obstructions to enlightenment. The power of these archetype deities, when assimilated by the practicing adept, lets him or her penetrate the barriers of ignorance. For it is only delusion, mistaken conceptions, and the negative egotistic instincts that impede the pure mind of enlightenment in each being from manifesting itself. The six sculptures of fierce manifestations in this section show a good cross section of the stylistic developments of this type from the late 11th to the 16th century.

A special type of tangka prevalent among the Nyingmapas is the so-called Bardo or between-state depiction, described in detail in the famous *Tibetan Book of the Dead*. Bardo paintings (No. 60) show the various forms of the deities who manifest themselves to the subtle consciousness of the person during the between state after death and before rebirth. This book, well known in Tibet, can be a helpful guide to understand and train the mind, to prepare for the after-death process, and to aid in obtaining a good rebirth. Such practices are quite advanced, however, and presuppose a broad and firm foundation in the principles and the path to liberation as taught in the Buddhist tradition.

Much Nyingma Buddhist art has a somewhat mysterious and somber aspect, a kind of strong and sensitive power. It also seems—although more evidence is needed to be certain— that a distinctive painting style was evolving in the late 14th to the 15th century that may be associated with the Nyingma Order in particular. Tangkas No. 46 and 48 appear to indicate such a school, possibly in the central regions of Tibet.

46
Padma Sambhava

Central Regions (?), Tibet

14th century

Tangka; gouache on cotton

41 × 31⅜″ (104 × 79.5 cm)

Mr. and Mrs. John Gilmore Ford

The legend of Padma Sambhava begins in the Sukhavati paradise, not long after Buddha Shakyamuni's time. Avalokiteshvara looks down toward earth and notices that the king of Uddiyana in northwest India has threatened to destroy all the religions in his kingdom if he cannot have a son. The Bodhisattva fears for the people and asks Amitabha Buddha if there isn't something more that can be done for them. Amitabha replies by extending his tongue, which emits a rainbow-trailing meteor that shoots straight down to Uddiyana, landing in the middle of a lotus lake. A few days later, the prime minister discovers a giant lotus there, with a beautiful eight-year-old boy sitting radiantly upon it. When he asks the boy who he is, he replies, "I have no name and no country but the kingdom of the Dharma. My father is compassion and my mother perfect wisdom." The boy was called Padma Sambhava, Lotus-born, and he was adopted by the king. Padma had a pleasant childhood, but soon disturbed people with his unconventional behavior. Eventually he left society and went off to become a Buddha, which he soon accomplished. He then left the monkhood and became an adept, going around India to meditate in cemeteries and wildernesses. He tamed many demons, converted many barbaric kingdoms to Buddhism, and accomplished the power of longevity. About a thousand years later, he was invited to Tibet by Shantarakshita and King Trisong Detsen, who were being prevented by the Tibetan tribal deities from building the first Buddhist monastery at Samye.

Padma Sambhava is thus a direct emanation of Amitabha Buddha and a terrific colleague of Avalokiteshvara; sometimes he is associated with the Hayagriva archetype Buddha. To the Tibetans, he serves the mythic function of comprising in his person all the attributes of the Buddha, the Bodhisattvas, and all the eighty-four Great Adepts. He thus personifies the power of all the divine benevolence directed toward the Tibetan people. His image is everywhere evident in Tibet, and his name and mantra—OM AH HUM VAJRA GURU PADMA SIDDHI HUM—is often on the lips of Tibetans.

This rare and unusual painting is one of the earliest known tangkas of Padma Sambhava. Although depictions are known in early wall paintings, such as the one in the Lhakhang-soma of Alchi of ca. the late 12th to early 13th century, tangkas of Padma Sambhava are relatively scarce until the 16th century and later. Here the Great Adept is seated in a five-fold arched shrine attended by his two consorts. On his right stands the Bengali princess Mandarava, dressed in diaphanous clothing emulating the styles of Bodhisattvas seen in 11th- to 13th-century paintings from the central regions. On his left stands Yeshe Tsogyal, the Tibetan queen turned yogini, dressed in long, heavy robes typical of those seen in Western Tibetan works of the 15th to 17th centuries. Both make offerings to Padma Sambhava. He holds the vajra scepter in his right hand, raised in the threatening gesture. In his left he holds the white skull bowl symbolizing the realization of absolute voidness, in which there is a vase of elixir of immortality, symbolizing his being a manifestation of Amitabha/Amitayus (Infinite Light and Life). Held by his forearm and leaning on his left shoulder is the *khatvanga*, the adept's staff, surmounted by the vajra cross (symbolizing the union of wisdom and compassion), the vase of elixir, the three heads (wet, shrunken, and skull, symbolizing conquest of the three poisons), and the trident, symbolizing the mastery of the three central channels of the yogic subtle nervous system. His robes and ornaments show his royal status. He wears a form of adept's hat unique to him, surmounted by an eagle's feather, barely visible in this example as it crosses over the golden rim of the halo.

He presents a rather gentle figure in his loose robes, thin loop earrings, and tall hat. His face, quite long but full and flat, reveals a naïvely simple rendering of his features. The round eyes seem intently fixed and the broad lips are slightly parted (46.1). The pink coloring of his skin is in marked contrast to the generally subdued colors of his plain moss green and dark blue halos and the lighter green, soft brown, and dark red of his garments. The borders and linings of blue, white, and gold enliven the image with flashes of light and dark. Decorative accents are added by the strips of tiger skin glimpsed beneath his outer robe. Flaming jewels, starlike, and floral designs of various kinds are carefully drawn on the red and brown robes. His vajra, earrings, and halo borders are done in gilded raised relief, a technique especially prevalent in the 14th and 15th centuries. These details contribute to making Padma Sambhava the most interesting figure in the painting, which otherwise is characterized by opaque planes of solid coloring. Against the red background of the shrine his two consorts are emphasized by their prominent light blue halos. This color, used sparingly and in a softer tone elsewhere in the painting, is relatively unusual prior to the 17th century. It is seen in early works, such as the 12th-century Mahakala in No. 52 and in some Nepalese manuscript paintings of around the same time. In the late 14th and early 15th centuries it appears to be popular again (Nos. 44, 75).

Organized in rows around the central shrine are roundels, bordered by a simple vine motif and containing individual figures. They include the original seven monks ordained by Shantarakshita, some of the hundred and eight translators sent to India by King Trisong Detsen, and all the twenty-five main disciples of Padma Sambhava. Of these, the monks wear the red pandit's hat, red garment, and brown

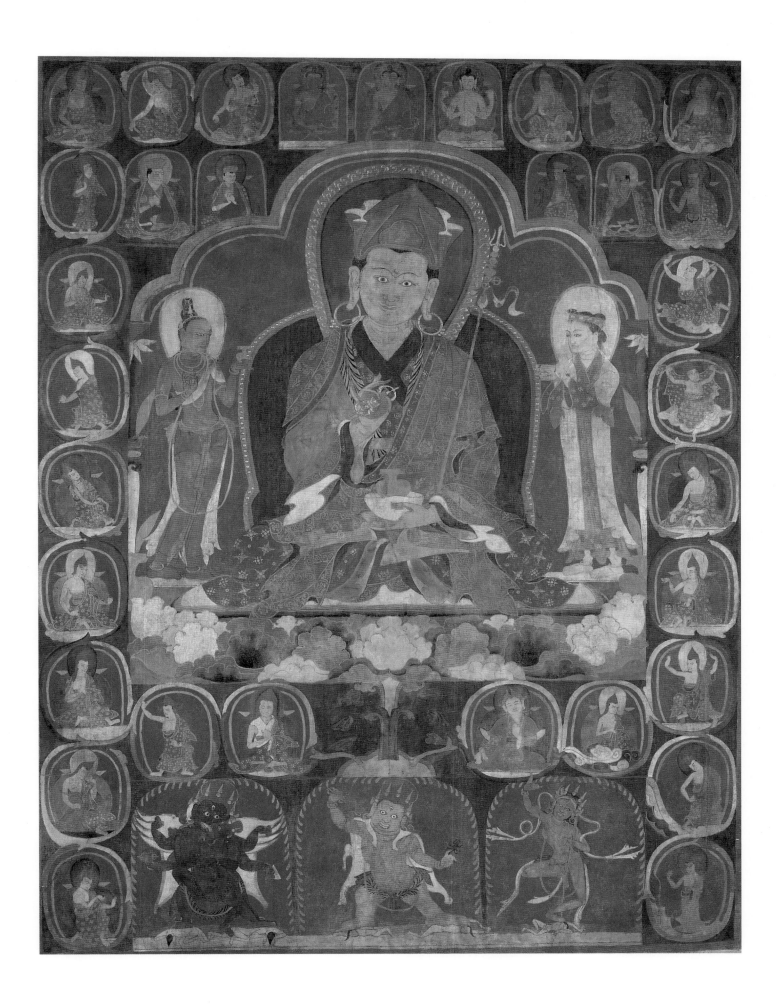

46.1

outer robe. Their lively postures are quite individualized. The twenty-five major disciples of Padma Sambhava were: King Trisong Detsen himself, Queen Yeshe Tsogyal, and the translator-monk Vairochana; the monks Gyalwa Chogyang, Namkay Nyingpo, Yeshe Shönu, Yeshe Yang, Yeshe De, Tsemang, Kawa Peltsek, Gyalwa Lodrö, Drog Kichung, Tenpa Namka, Ma Rinchenchok, Queen Yeshe Tsogyal's brother Pelgyi Dorje, and Gyalwa Jangchub; the laymen Nubchen Sangyey Yeshe, Drog Pelgyi Yeshe, Lang Pelgyi Sengey, Dorje Dujom, Sogpo Hapal (a Mongolian), Pelgyi Wangchuk, Pelgyi Sengey, another Pelgyi Wangchuk, and the minister Konchok Jungnay. At the top center is Shakyamuni Buddha, with Padma's progenitors, Amitayus on his right and Shadakshari Avalokiteshvara on his left. Below the pedestal, to left and right respectively on either side of the lotus stalk, are the Indian master Shantarakshita and King Trisong Detsen. On the lowest row in the center are three large archetype deities who are prominent in Nyingma practice: a black Chemchok Heruka with three faces, six arms, four legs, and white wings holding a blue consort, a red fierce Padma Sambhava, called Guru Drakpo, who holds a vajra and a scorpion, and the azure female archetype Tutob Dagmo,

with one face and two arms in a dancing pose (46.2). An archetype deity is a form of an enlightened being that expresses particular energies that the practitioner seeks to experience, and thus is a physical paradigm of a particular type of enlightenment experience. A Heruka is a fierce, heroic, male form of an enlightened deity.

This tangka is unusual in many ways. It has an intriguing blend of apparent naïveté and sophistication, and it appears to combine diverse stylistic traditions. In most instances these traditional elements are rendered in a rather plain, unelaborated way. This is especially noticeable in the depictions of the vine, lotus, halo, and shrine motifs. The terrific deities are portrayed in a style well known since the 12th century in the central regions. However, the figures of Padma Sambhava and the disciples reveal an advanced style of drapery, clearly utilizing elements of Chinese loose drapery depiction. The figure of Padma Sambhava in particular seems to prefigure styles appearing in more developed form in the wall paintings of the Kumbum in Gyantse dating from the second quarter of the 15th century. This is a primary factor in attributing this tangka to the central regions and to a pre-Kumbum dating. The consort figures are an interesting portrayal

of simplified traditional style (for Mandarava) and forms seen in Western Tibet later in the 15th century (for Tsogyal). The florallike form of the lotus petals is known in other tangkas from the first half of the 15th century, but they are portrayed in a simpler, though very sensitive, manner in this work. Elements such as the vine roundels and the pillar style of the shrine derive from the Indo-Nepalese stylistic tradition as seen in tangkas and wall paintings of the central regions of this time; but again, the simpler rendering is quite distinctive. This tangka is certainly a forerunner of the style seen in No. 48, which shows more elaboration in most features and a more formal treatment of the face of Padma Sambhava. These two tangkas may represent a stylistic trend or school within the Nyingmapa of the 14th to 15th century from the central regions. As such they are important works representing a stylistic tradition other than the ones associated with Sakyapa, and other prominent monasteries in Tsang in particular at this time. There has been slight restoration in this tangka to some worn areas and there is a patch in the lower left side, but this does not detract from the uniqueness and importance of this rare early painting of Padma Sambhava.

46.2

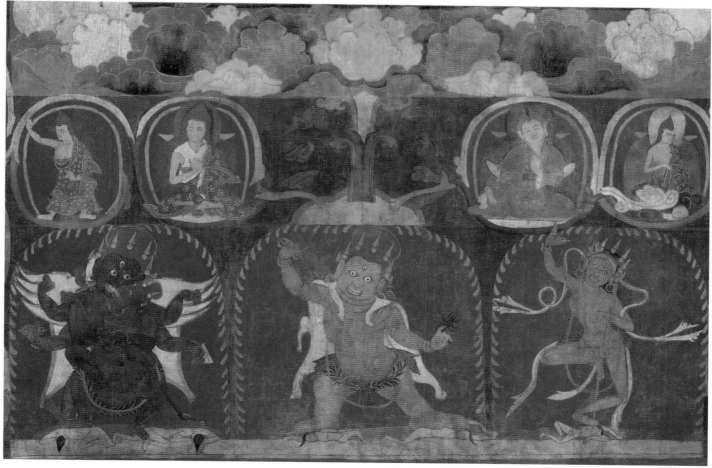

47

Padma Sambhava

Western Tibet

Second half of the 15th century

Brass, with copper and silver inlay

H. 24″ (61 cm)

The Zimmerman Family Collection

This sculpture of Padma Sambhava is one of the most extraordinary in all Tibetan art, not by virtue of dynamic mass or powerful line, but because of its supremely mystical gentleness. A face of compassionate understanding gazes seriously upon the world, its sensitivity suggested by the slight tilt of the head and the delicate carving of the features, hair, and ornaments. A tall and slender body, rather stiffly poised, lifts the figure higher than normal. Folded garments cover the body, their thin, parallel, broken folds adding a touch of improbability and lightness to the figure. The eyes are inlaid with silver and the mouth with copper, imparting a sense of realism to the somewhat stylized features of the intent face. Of his usual implements, the vajra is held in his right hand, which makes the three-refuge gesture, and the skull bowl rests on his left hand, which lies flat in the contemplation gesture; a hole for fixing the *khatvanga*

staff (now missing) is seen in the upper left arm. A fine pattern of chased flowers decorates the robes; they are similar to patterns seen in Western Tibetan paintings of the 15th and 16th centuries. The subtle distortions of the figure and the flat folds of the stiffly curved drapery are also related to Western Tibetan Guge styles of this time, especially the sculpture of the Red Temple at Tsaparang, dating around the second half of the 15th century (text fig. 24). The overall delicacy of the style, and the mystical mood of the image are also generally consistent with the Western Tibetan style.

The image is separate from the pedestal, and is secured to it by rivets that have bliss-swirl (T. *gakyil*) designs on their heads. The style of the pedestal seems related to certain stupa pedestals photographed by Tucci in the Sakya monastery in Tsang (Tucci, 1973, fig. 167). The front of the base is stepped-back

with panels along it. The central panel has a large vajra, on each side of which are two of the Four Heavenly Kings—from left to right: Vaishravana (north), Dhrtarashtra (east), Virudhaka (south), and Virupaksha (west). There is an inscription along the lower rim on the back of the pedestal that reads: "Namo Guru Padmaye! The king Miwang Kunga Gyalpo [commissioned] this image of the great Master Padma Sambhava, which grants successes to those who behold it, in order to venerate the Buddhist Teaching and its upholders, in order to expand the fortune of his reign and his subjects, and especially to fulfill the wishes of his father and mother—such is his wondrous intention of pure altruistic resolve!" (The inscription is partially effaced, but that is its gist.) Miwang Kunga Gyalpo is not yet identified, though it seems likely he was a provincial ruler of one of the small kingdoms of Western Tibet.

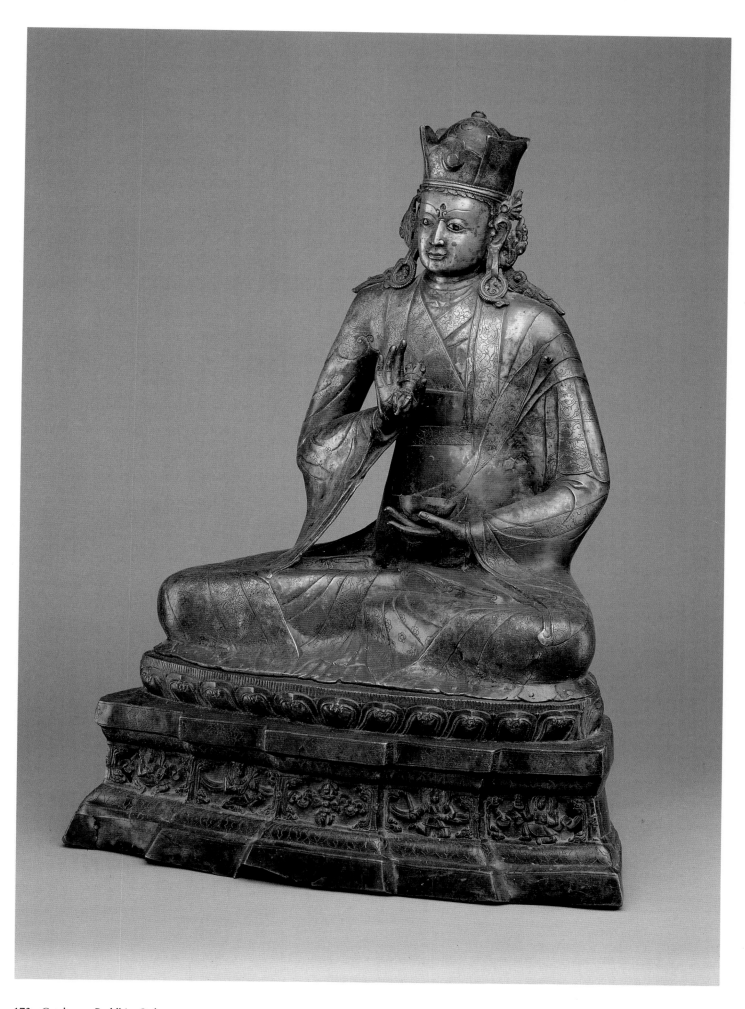

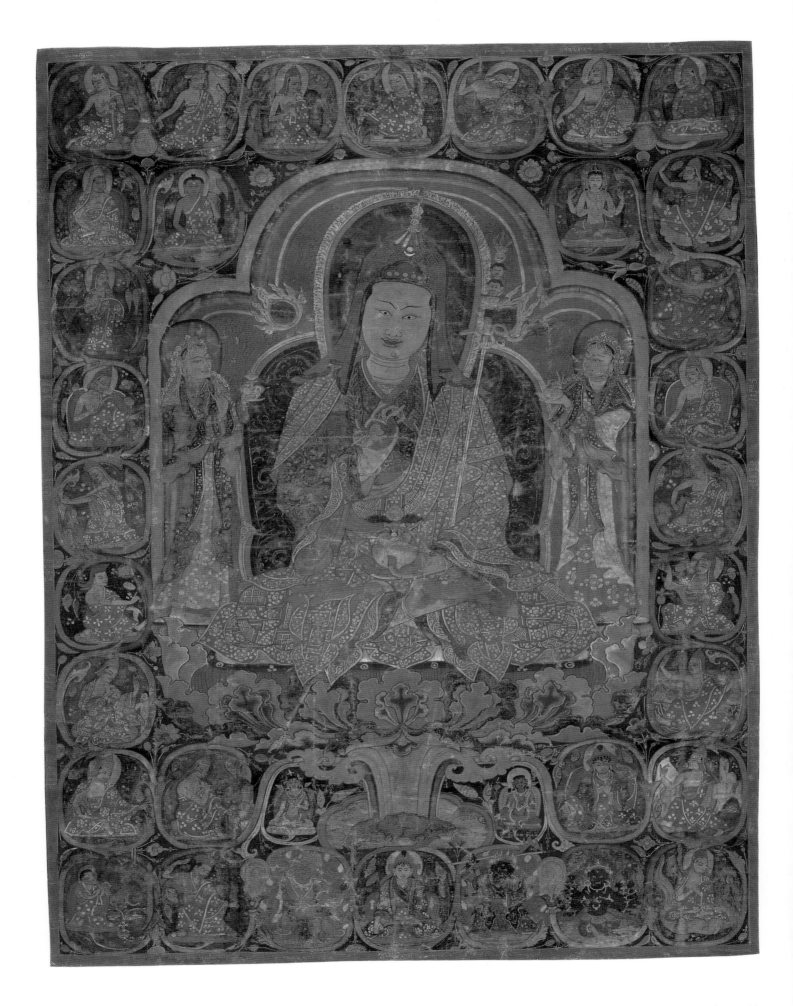

48

Padma Sambhava
and the Twenty-five Adepts

Central Regions (?), Tibet

Second half of the 15th century

Tangka; gouache on cotton

22½ × 17″ (57 × 43.2 cm)

Trustees of The Victoria and Albert Museum, London

Lit.: Lowry, 1973, p. 63.

Padma Sambhava sits in a trefoil-arched shrine with his two consorts, Mandarava and Tsogyal, standing to his right and left respectively. Surrounding the center group, within individual circular vignettes fashioned by a swirling vine, are Padma Sambhava's twenty-five most famous Tibetan disciples: seven on top, eight down each side, and two more next to the two bottom left side figures. Each of them is accompanied by an inscription in the border. The disciples are portrayed in lively postures, some in debate, some flying through the air, some teaching, and so on. The stylized rocks seen in some early works of the central regions (No. 24) and Khara Khoto (No. 23) reappear here in a later form in a mountain background, behind the second figure up from the bottom on the right (48.1). Simplified renderings, similar to the portrayal in this tangka, appear in some of the Guge tangkas of the second half of the 15th century (Nos. 4, 6). At the bottom are a few archetype (*yidam*) and protector deities: a red fierce figure left of center, which the inscription says is Guru Drakpo, a fierce archetype form of Padma Sambhava; an unidentified, seated royal figure in the center; a protector in long robes called Maning Drakpo right of center; and on the right a blue multiarmed Naga (a serpentlike dragon) with water spouting from its tail (48.1). Unlike the fully enlightened archetype deities, whom the practitioner seeks to become, the protectors are powerful defenders of the Buddhist Teaching and its followers. Often, they have previously been mundane gods who were tamed and bound in service by Buddhist masters. Small figures of White and Green Tara sit to the left and right of the stem of Padma Sambhava's lotus pedestal, which rises from a red-rimmed lake. Next to Green Tara sits King Trisong Detsen, holding the sword of wisdom and the Transcendent Wisdom

book, attributes of an incarnation of Manjushri (48.1). He is usually included among Padma Sambhava's disciples. Above the side parts of the shrine are a red Amitabha, the progenitor of Padma Sambhava, and a four-armed white Shadakshari Avalokiteshvara, who sometimes represents a Beatific Body counterpart to Padma Sambhava as Emanation Body.

The Great Adept Padma Sambhava sits in his customary cross-legged pose holding vajra scepter, *khatvanga* staff, and skull bowl. He wears green silken robes covered with a red robe and a brown outer patched robe. All are embellished with gold designs. The edges of a tiger skin appear next to the wide borders of the robe lapping over his chest. His Uddiyana-style hat is dark red, with rows of geometric patterns and long kerchieflike lapels that hang over his shoulders. An eagle feather rises from a golden vajra at the apex. His face is unusual, being long and full with rounded cheeks and jowls. This seems to be a special type for Padma Sambhava; it also appears in No. 46. His eyes, with their staring black pupils, are especially effective. The compelling and finely executed face with its sharp linear drawing is somewhat abstract. It stands out next to the more naturalistic folds of the drapery, which is related to Chinese styles and to No. 46. Large flaming jewels project from the intersections of his two

halos. Similar ornaments appear in the British Museum Shakyamuni (No. 3). The dark blue body halo is filled with a fine linear scroll pattern that is quite abbreviated, light, and sketchy. His consorts are garbed in long coatlike garments and rather heavily jeweled head kerchiefs. Unlike No. 46, both consorts are similarly dressed. Most of the disciples wear red monastic robes with large patterns of four-petal gold flowers. Within the deep and somber mood of the tangka, the active gestures of the small figures, the dots of gold, and Padma Sambhava's penetrating eyes set in his gentle, compassionate face combine to give this painting its special vitality and charm.

The color tonality is dark green and red with gold highlights and touches of white. This color scheme became prevalent in the 17th century, but this painting appears to mark an early stage in its usage. Is it possible that this tangka could be related to the 15th-century Menri style, now known only from literary description, which became important in the 17th century as the New Menri style? This tangka probably dates from the second half of the 15th century and is most likely from the central regions. The style of Padma Sambhava and the type of shrine arch seem to be related to those of the earlier tangka No. 46. Perhaps the two paintings represent a Nyingmapa stylistic tradition in a certain area.

48.1

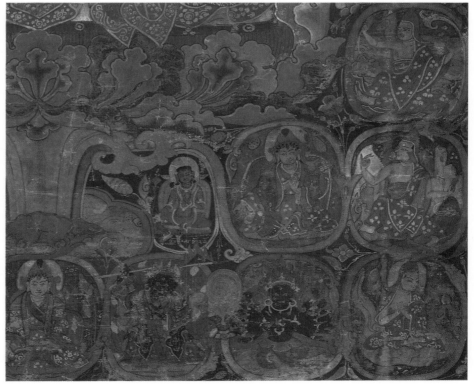

49

Padma Sambhava
and Scenes from His Life

Western Tibet; Guge

Late 16th to first half of the 17th century

Tangka; gouache on cotton

56 × 38″ (142.3 × 96.5 cm)

Robert Hatfield Ellsworth Private Collection

Lit.: Tucci, 1949, pp. 373–86.

This dark and mysterious painting shows Padma Sambhava and his two consorts surrounded by scenes from his fabled life. The somber tonality, punctuated by flickering gold, seems to echo the mystical aura surrounding the master of yogic practices. Mandarava and Yeshe Tsogyal, garbed in Indian and Tibetan dress respectively, stand as small attendants to the dominating figure of Padma Sambhava, looming large in the center of the painting. The awesome figure, realistic and remarkably gentle, is one of the most amazing representations of Padma Sambhava in all Tibetan art. He appears set back in the picture plane. The rudimentary landscape and architectural settings of the various surrounding scenes create fluid and ambiguous spatial nuances. His robes flow around him with a natural ease, and we can sense beneath them the solid substance of his body. His halos, rather than the customary ethereal floral patterns or plain colors, are dark spaces shattered by the finest golden rays. Every feature is extraordinary. From his golden face, his large, round, dark-orbed eyes appear simultaneously to sink inward and penetrate outward to the viewer. Evenly drawn red lines define his face and, in contrast, delicate, wispy strokes fashion his light and curling hair, eyebrows, mustache, and goatee. His somber-colored robes are patterned not just with small flowers, cloud motifs, and closely set geometric

patterns in gold, but with an uncommon, large, and bold kaleidoscopic design on the outer brown robe. The spectacular broad bands of gold offset the midnight blue and reddish browns.

The scenes of his biography unfold around him in a translucent dark atmosphere. The clouds are smoky lavender, blue, and red. Gold edges the brown rocks; the buildings are dull brown and orange. Beginning at the top center (see diagram) with a triad (1) of Amitabha in his paradise (49.1), the scenes move counterclockwise around the central configuration. The left half of the painting shows his life in India, the right half, his life in Tibet. In the upper left corner (2), a large scene portrays the events attending his birth—being found as a child of eight years seated on a lotus in the center of a lake in the kingdom of Uddiyana. The people take him in a cart to King Indrabhuti, who accepts him as his son. Golden rays from Amitabha touch both the figure of Padma Sambhava on the lotus and the king seated within his palace (49.1). Another scene (3) portrays him attaining yogic powers and defeating demons in the cemetery of Silwatsal, where, according to the inscription, he obtains the name Nyimay Özer, Sun Rays (49.2). Below, images of Vajrapani and Vajradakini appear before flame halos (4), and beneath them Padma Sambhava undertakes ascetic practice in the cemetery

of Tsogpa, where he has a vision of Vajra-varahi and gets the name Dorje Drakpo, Fierce Vajra. Continuing, we come to Padma Sambhava meeting the monk Shakyamitra in front of a stupa (5) (49.2). The next scene (6) shows Padma Sambhava conversing in a cave with the saint Prabhahastin, his teacher of tantric texts, and he gets the name Simhanada, (Lion's Roar). Next, he gets the name Loden Choksey (Supreme Genius) in the presence of many ascetics (7), an episode of a struggle between a Bonpo—a priest of Bon, the pre-Buddhist religious tradition in Tibet—and a shepherd, according to Tucci. He discourses with monks (8), and he

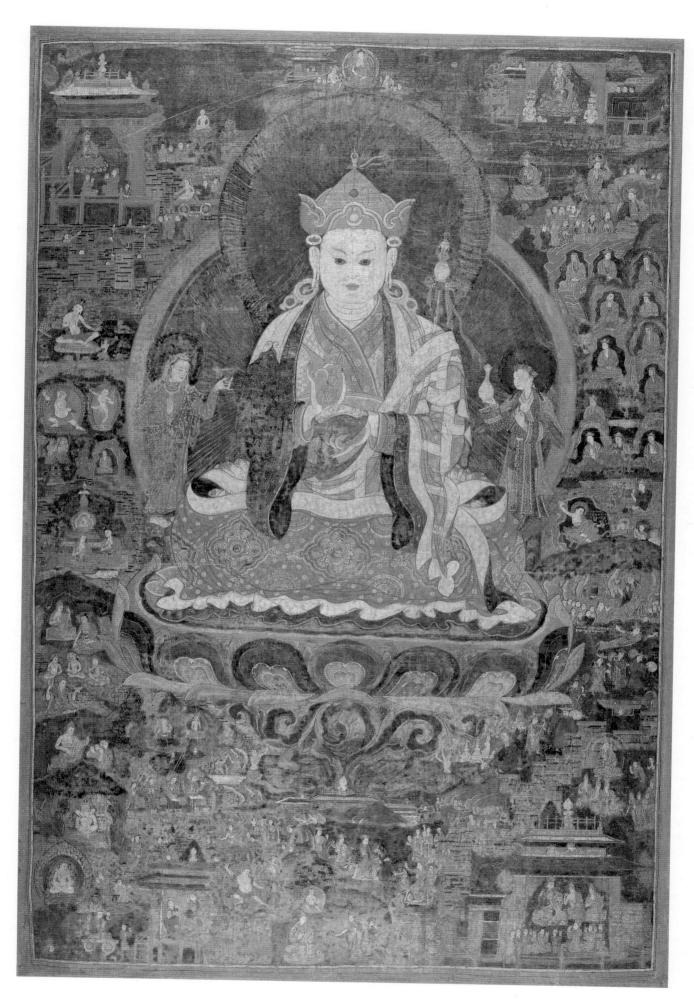

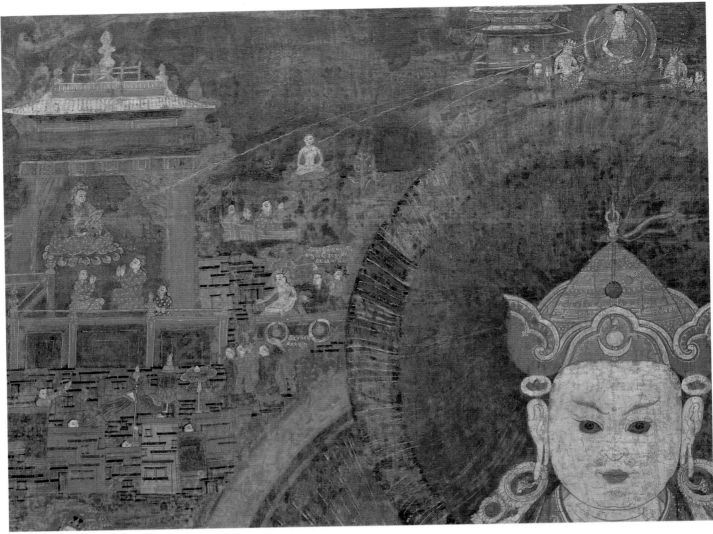

49.1

attains a mystical revelation of Amitayus in the Marati cave (9). To the right are the donors, two men and two women sitting before tables holding dishes of offerings (10). The last episodes of his life in India are shown in the lower left corner with a sequence of events with his Indian consort, Mandarava (11 and 12). The most prominent scene is the famous episode where, in the words of the inscription, he "arrived in Zahor (Bengal) and being burnt in the fire (with Mandarava), he worked a miracle by turning the fire into a lake" (Tucci, 1949, pp. 384–85). The following scenes show Padma and Mandarava in a cart and Padma teaching in a palace. A fierce figure, probably Padma Sambhava destroying heretics who planned to kill him, and a small figure of Vajrakila, whom Padma Sambhava saw in a vision and from whom he received the mystic revelation of the *Vajrakila Tantra,* bring this part of his biography to a close.

The lower center section begins the story of his invitation to Tibet by King Trisong Detsen. The king's emissary, Lama Jnyanakumara, is shown coming before the seated figure of Padma Sambhava, who

was residing at Nalanda university at that time. Jnyanakumara carries a bundle on his back and is accompanied by two servants (13). Above is the meeting of Padma Sambhava and the king in Tibet, both of whom are on horseback (14). The scene just below is Samye monastery with deities dressed in armor, one of whom is Pehar, the special protector of Samye (15). In the lower right corner is a large scene of Padma Sambhava and two lamas teaching. One of the lamas is the famous abbot of Samye, Shantarakshita, teacher of King Trisong Detsen. Above, in a palace, Padma Sambhava speaks to a woman (16), and above this, in a large monastic setting, Padma Sambhava is seen translating (17). The scenes continue up the right side, showing Padma Sambhava flying (18), and teaching the king in the cave of Chimpu at Samye after the death of the princess Padmagyal (19). Padma Sambhava, as Dorje Drölö, sits on a tiger and lifts a vajra in a gesture of exorcism (20). In a large area above this, Padma Sambhava appears in a series of caves, representing the places (each one labeled) where he hid the "treasure texts" (T. *terma*), or where

he left his handprints or footprints in stone (21). The final scenes show Padma Sambhava taking leave of the king (22) to go to the land of the cannibal trolls (*rakshasas*); and, in the upper right corner, we see him seated in his palace flanked by two Naga deities and cannibal trolls.

From the inscription at the bottom of the tangka, Tucci surmised that it was the first in a series, of which the others are not known. Its connections with the Guge style in composition and in some details, especially in the small scenes, indicate a provenance in Western Tibet. Stylistically, this painting appears to fall between the time of the Sonam Gyatso tangka (of the Guge school), dating in the third quarter of the 16th century (No. 97), and the painting of Kunga Tashi of about a hundred years later, ca. 1675 (No. 65). Although certain 16th-century Guge school elements continue, such as the architectural forms, the new emphasis on naturalism suggests a 17th-century date. The magnetism of the portrayal and the mystical atmosphere of the work create one of the most unusual masterpieces in Tibetan art.

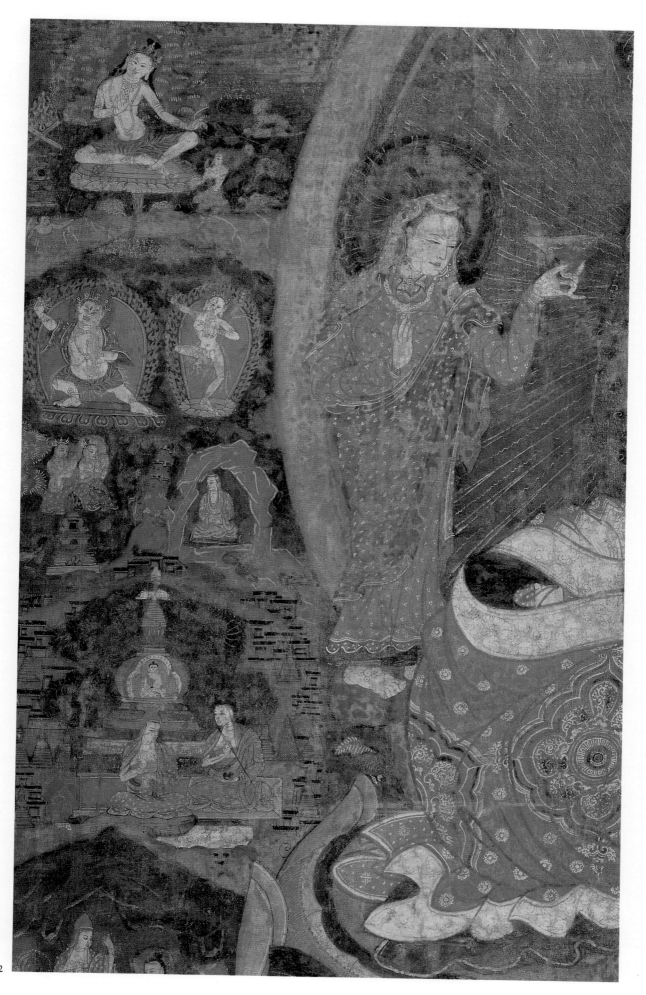

49.2

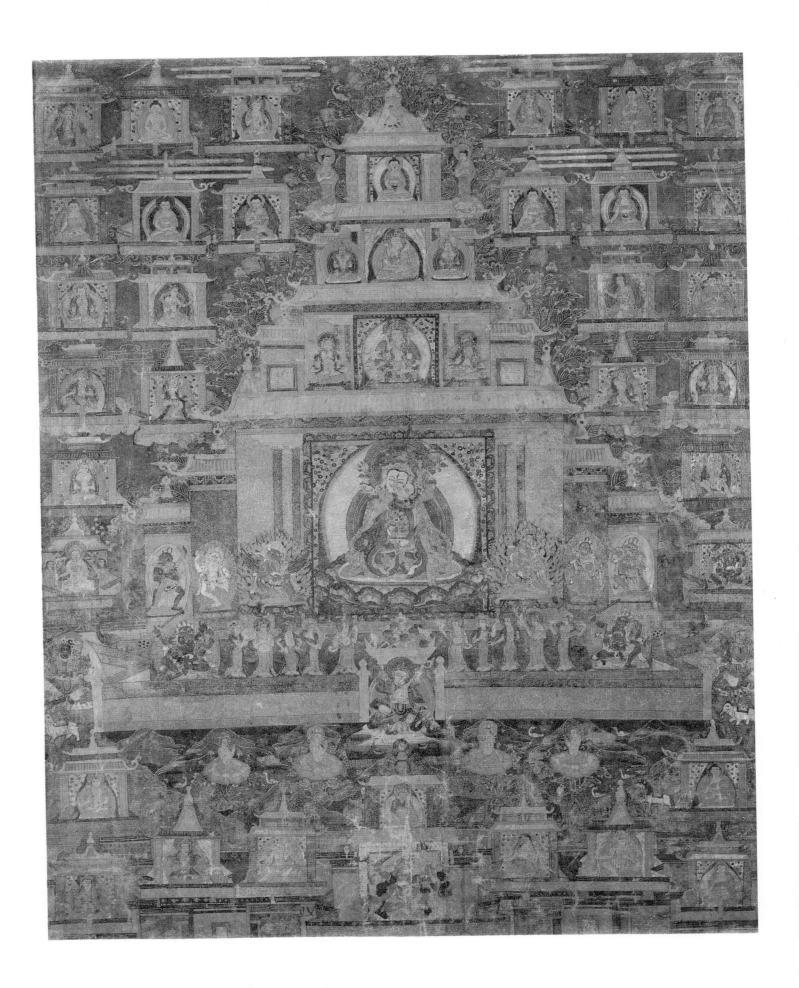

Padma Sambhava in the Palace of the Glorious Copper Mountain Paradise

Central Regions, Tibet

Late 16th to early 17th century

Tangka; gouache on cotton

28½×23″ (72.4×58.4 cm)

The Zimmerman Family Collection

This extraordinarily delicate and detailed painting shows Padma Sambhava in his Glorious Copper Mountain Paradise on a continent to the southwest of India. He is said to reign here until the end of time, protecting beings of the southern continent from the harmful influences of sky demons and jungle trolls. The paradise is said to be on the Chamara (Yak-Tail) Island, one of two said to flank India, and it is known as the domain of the cannibal trolls (*rakshasas*). In the center of the continent is a great sea from which rises a mountain with a palace on top, where Padma Sambhava in various forms teaches the sutras, reveals the tantras, performs initi-

ations, and explains the deeds that bind beings to evolution and those that set them free (Tucci, 1949, p. 617, note 295).

In this painting the palace is unusual in that it has four stories, rather than the usual three. A three-storied palace is called a Three-Buddha-Body Mansion, as the first story symbolizes the Emanation Body, the second, the Beatific Body, and the top, the Truth Body. Here, we have this symbolism in the upper three stories above Padma Sambhava, who is seated with his consort on the lowest level, perhaps indicating his incorporation of all three Bodies in himself. The palace is surrounded by a wall whose gates are

guarded by the Four Heavenly Kings, with only three visible; Dhrtarashtra of the east holding the lute in the central position, Virudhaka of the south with the flaming sword at the left gate, and Vaishravana of the north at the right with banner and mongoose. Inside the courtyard are ten Dakinis dancing and playing heavenly music. In the first level of the palace Padma Sambhava appears with his consort Yeshe Tsogyal in sexual union (50.1). One of Padma's eight manifestations is Tsokyey Dorje (Saroruha Vajra), a couple archetype Buddha, the male blue and the female white. But a sexual union depiction of Padma Sambhava in his heavenly palace is

50.1

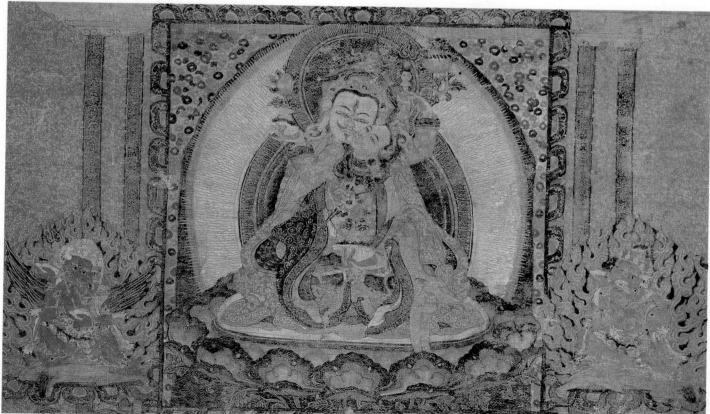

50.2

extremely unusual (compare Essen and Thingo, 1989, I, p. 200, where the first story has the usual Padma figure without consort). He is holding a vajra chopper (a curved-bladed knife) in his right hand and a skull bowl containing a vase of immortality in his left hand; she holds a red lotus with a book, and a skull bowl containing a vase and flower. To their left and right are various archetype deities in individual shrines; to his right: a three-faced, two-armed winged Heruka couple, a three-faced fierce Dakini, and a one-faced, two-armed blue Chakrasamvara and red Vajravarahi couple (50.3); to his left: a red fierce Hayagriva (?) couple, a three-faced dancing red Dakini, and a two-armed red fierce couple. Below, in the courtyard is a four-armed fierce deity couple, probably forms of Mahakala. On the second story of the palace, Avalo-kiteshvara appears in union with his

consort, flanked by two seated god-desses, symbolizing the Emanation Body manifestation. On the third stoy, an esoteric Amitayus couple appears in union, expressing the Beatific Body level. On the topmost story, a monastic Amitabha Buddha flanked by Pratyeka Buddhas appears as a representation of the Truth Body. Flowering leafy foliage surrounds the palace (50.2), which is placed above a mountain, rendered as small hills and a cliff above the waters where four Dakinis on red and white lotus flowers offer homage to the abode of the great Guru Rinpoche, Padma Sambhava (50.3).

Rows of shrines containing important deities are positioned on both sides of the upper part of the palace. There are twenty-four shrines, twelve on each side. On the left side (50.2) from left to right appear on the top row Padma Sambhava, the Primordial Buddha Samantabhadra, and

Vajrasattva; in the second row: Ratna-sambhava, Amitabha, and Amoghasiddhi; in the third row: Manjushri and White Tara; in the fourth row: Green Tara and Indrabhuti Dakini; in the fifth row: a two-armed white Avalokiteshvara with a red Buddha head on top; in the sixth row: a figure with a red hat and a white robe. This figure has the only inscription in the painting, but it is virtually illegible. At the right from left to right on the top row are Vajradhara, Vairochana, and Akshobhya; in the second row: Akshobhya or Shakyamuni (?), Bhaishajyaguru, and Amitayus (?); in the third row: a lama, and Shakyamuni shielded by the snake Muchilinda; in the fourth row: Manjushri and Shadakshari; in the fifth row: Vajrapani; in the sixth row: a four-armed Mahakala couple. At the bottom are represented the eight shrines at the cardinal and intermediate directions,

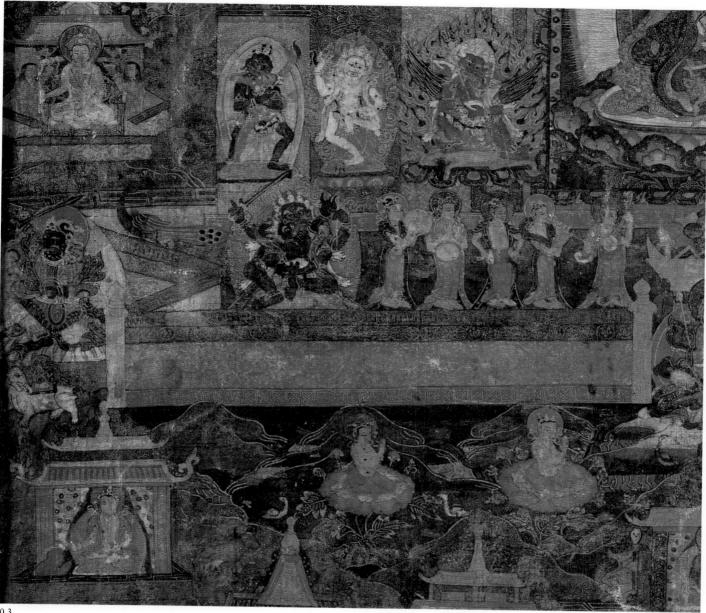

50.3

where Padma Sambhava manifests in various forms and tames the trolls (50.3). On the central axis at the main gate to the island is an eleven-headed guardian, perhaps a form of Rahu. Above him sits Padma Sambhava in a pavilion. A stack of three heads—one fresh-cut, one shrunken, and one just a skull—appears on the roof above Padma Sambhava, as if a giant *khatvanga* staff were built into the pavilion in which he sits. Interspersed about the landscape are some auspicious elements, such as a horse and two elephants. Ducks, conch shells, a bull, and long-necked storks appear as charming accents within the delicate and subtle renderings of the simple landscape (50.3).

Dark blue is the main background color, harmonizing with the rose red of much of the architecture and dress of the figures. The delicately elegant ornamentation of the buildings and the designs of the

clothing, mostly of gold, is a strong feature of the style and has an obvious relation to designs appearing in Indian painting of both the Mughal and Rajput schools (such as that of Bundi) from the 16th to 17th century in particular. The touches of landscape relate to styles seen in late 16th-century paintings (Nos. 7 and 97), a feature that helps to date this work. In figure style there is some resemblance to Nepalese delicacy, but the loose drapery, like that in the previous two Padma Sambhava tangkas, is related to Chinese styles that by this time were thoroughly assimilated in Tibetan art. This eclectic mixture indicates that this exquisite painting probably comes from the central regions.

This rare painting appears to be an important early work of this particular theme, with the distinctive feature of portraying the deities in sexual union on

the first three stories. There is a later rendering of the same theme in the Essen collection in Hamburg (Essen and Thingo, 1989, I, pp. 200–01). It may be that this compositional format, which does not emphasize the mountain but has rows of shrines, was developed in one area at least by the late 16th century and continued as a particular type. According to Thingo Rinpoche's interesting suggestion, this type presents a vision of the Glorious Copper Mountain Paradise meant to orient the close-to-death believer who seeks to be reborn there. It is different from another, more familiar rendering of this theme that emphasizes the large copper mountain and its setting without the rows of individual shrines, as seen in the painting from the Newark Museum (No. 149). This latter type has a more cosmological thrust, and may represent a different regional variant, possibly from Eastern Tibet.

51
Nyingma Lama

Central Regions, Tibet, or Eastern Tibet

Late 17th to early 18th century

Tangka; gouache on cotton

31 × 22¾″ (78.8 × 57.8 cm)

Mr. and Mrs. John Gilmore Ford

Lit.: Lauf, 1976a, p. 114.

Dominating the center of a bright red field of color, an impressive Nyingma lama sits in three-quarter view. Except for him and the donor, every figure in the painting is labeled with an inscription. Around the lama, images of his previous incarnations and/or lineage masters create a sense of movement like flickering lights. With his right hand the lama makes a teaching gesture and in his left hand he gracefully holds a blue-covered book. The Tibetan words written on the cover (partly hidden by the lama's fingers) read, "The profound path is here." Directly above his halo is White Tara, and above her, Manjushri Bodhisattva. On the top row from left to right are Karwa Tongtsen, Maudgalyayana (one of Shakyamuni's main disciples), Manjushri, Shri Simha, and Shantarakshita. The second row from left to right consists of Gyiso Dawa, Dorje Dujom, Mitub Dawa, Lodrö, Luyi Gyaltsen, and Lobpön Tsemo. The four lamas down the left side are Tsungyen Drakpa, Tegchen Rinpoche, the famous Longchen Rapjam, and Ludrup Gyatso. The three lamas down the right side are Sonam Gyaltsen, Gau (?) Rabjom, and Dorje Denpa. At the bottom, in the left corner, the donor lama sits before three gleaming jewels. In the center, the fierce protector goddess Penden Lhamo

(Palden Lhamo) rides through the clouds. In the right corner, an esoteric form of Jambhala (a god of wealth) holds his jewel-spouting mongoose and strikes a warrior pose over the corpse of avarice. Some scholars have speculated that this lama is one of the more recent incarnations of the previous head of the Nyingma Order, Dujom Rinpoche. It is certain at least that the background figures are most likely previous incarnations of the main lama, as there is no obvious teaching that would link such diverse and well-known figures in a specific teaching lineage.

Touches of landscape—hills, waterfalls, and trees—appear; but, like all the elements of the painting, they are practically subsumed in the overall red field characteristic of this special genre of tangka. We have not yet found any written source that specifies the meaning of the use of the red background. However, red is the color of powerful rituals and deeds. It is the color of passion, transmuted in the lotus Buddha clan of Amitabha to discriminating wisdom—of the five wisdoms, perhaps that most closely associated with universal compassion. While Manjushri, the archetype deity of wisdom, is at the top center of the

painting, Tara, archetype deity of compassionate and powerful activities, is directly above the lama's head. It is probable, then, that the red genre of tangka is used to convey a powerful association of compassion and energy, as a special tribute to the beneficial contribution of a particular lama or lineage.

The master lama is stunning at the center. His body is big and his face is powerful, edged with a trim black beard. His eyes are gentle, yet they shine intensely from the stark white ground. His face has an incisive, commanding sharpness that totally controls his surroundings. The few touches of black, white, and blue throughout the painting capture the eye all the more by their sparsity.

This tangka appears to be quite early in the development of the "red style" and is one of the most effective examples. It has a restrained use of gold and the line is lively and relatively free. The bunching of the lama's outer robe is a typical feature in late 17th- to 18th-century paintings. The simplified scalloped-edged lotus petals descend from the more complex 15th- and 16th-century examples. Its masterful drawing, the rarity of its iconography, and its fine condition make this tangka a singularly beautiful work.

52
Mahakala

Tibet (?)

12th century

Black sedimentary silt stone

7½ × 4½ × 1½″ (19 × 11.5 × 3.8 cm)
Shown actual size

Robert Hatfield Ellsworth Private Collection

Mahakala is one of the most popular of all the terrific deities in Tibet. While there is a legend of his taming by Manjushri and Avalokiteshvara, he is sometimes considered a terrific manifestation of the Bodhisattva of Compassion. Mahakala can be approached as an archetype deity, functioning as an enlightened being with whom the practitioner identifies, or, alternatively, as a fierce protector, a guardian of the Dharma and its adherents. He figures as an archetype deity in his own *Mahakala Tantra* literature, associated with the Great Adept Shavaripa. More commonly in Tibet in recent times, he is propitiated as a major spiritual protector deity. Practice oriented to Mahakala as an archetype deity was particularly prevalent in Western Tibet in the late 10th to the 12th century, based on the revelation of Mahakala attained by the great translator Rinchen Sangpo (958–1055), who brought the texts of this deity from India to Tibet. This sculpture of the four-armed seated Mahakala is one of the rare works in stone from the early phase of Tibetan art, probably from the late 11th or 12th century. It is strongly Indian in style, and may have been carved by an Indian artist, but it has a Tibetan inscription (which is unintelligible) carved on the back, so it appears to have been commissioned and/or used by Tibetans. It retains much of its apparently original paint, a rare occurrence. Its bright red and gold, olive green, flesh color, and turquoise hues, close in shade to pigments seen in contemporary manuscript paintings, give a decided cheerfulness and richness to the work.

Mahakala appears to be master of his environment: stocky, almost jovial, and self-assured, with his large square head, huge hands, and chubby, red-soled feet. With his two main hands he holds a vajra chopper over a skull bowl, symbolizing the sharp edge of wisdom shredding all materialistic negative attitudes within the skull vessel of the understanding of voidness. His second pair of hands holds a broad-bladed sword of wisdom in the right and a trident-tipped *khatvanga* staff (representing power over the subtle nervous system) in the left. As a terrific manifestation, Mahakala has the power to conquer addictive emotions and to dispel inner, spiritual obstacles. He has a horrific face, with wiry, curled eyebrows and mustache, and three bloodshot, yellow, bulging eyes. His jaw is forcefully set, accented by his tightly curled beard, though his calm mouth only slightly reveals the fanglike teeth that gnash to symbolize his grinding away all delusive resistances of evil. His body is massive and squat, his abdomen swells with inner power. He wears terrific ornaments. His crown of five skulls represents the five main afflictions of anger, greed, pride, envy, and ignorance, transmuted into five wisdoms—ultimate reality, and discriminating, equalizing, all-accomplishing, and mirror wisdoms. Live snakes writhe as bindings of his headdress, and he wears them as earrings, as a brahman's cord, and as bracelets and anklets. A garland of fifty severed heads symbolizes the conquered mental functions of lust, pretense, aggression, spite, hypocrisy, and so forth. A tiger skin is tied around his

waist, its legs tied behind his back and its head lying over his right knee. His hair, yellowish red in color and coiled in tight ringlets, stands on end, flaring from his head like supernova flames. His features somehow frightening and charming at the same time, he sits with calm composure in the pose of royal ease, on the prostrate, flesh-colored body of the devil of selfishness. Richly detailed jewels, flying ribbons, and scarves impart a decorative and animated aspect to this superbly carved sculpture.

A pointed arch-shaped frame surrounds the figure, its edge carved in flame patterns. The back is cut through, so the shape of Mahakala's nicely detailed body can be seen from the back. A one-line Tibetan inscription, which may have been written at a later time, is carved on the back below the perforation. The lotus seat, rimmed with large pearl shapes, has well-carved layered petals in alternating colors. The base is stepped back in a form similar to, though simpler than, many pedestals on Pala sculptures. On the bottom a rectangular trough ⅞ inches deep has been carved out, presumably to allow a grip for ease of carrying. With its engaging, refined detail and massive body, the sculpture relates to Pala Indian style of c. the 11th to the 12th century. This sculpture is one of the most perfect, handsome, and rare stone images from Tibet of ca. 12th century. It is distinctly different from Western Tibetan sculpture of the 11th and 12th centuries, and from the more ornate and sumptuous style seen in the large stone Mahakala dated 1292 (Stoddard, 1985).

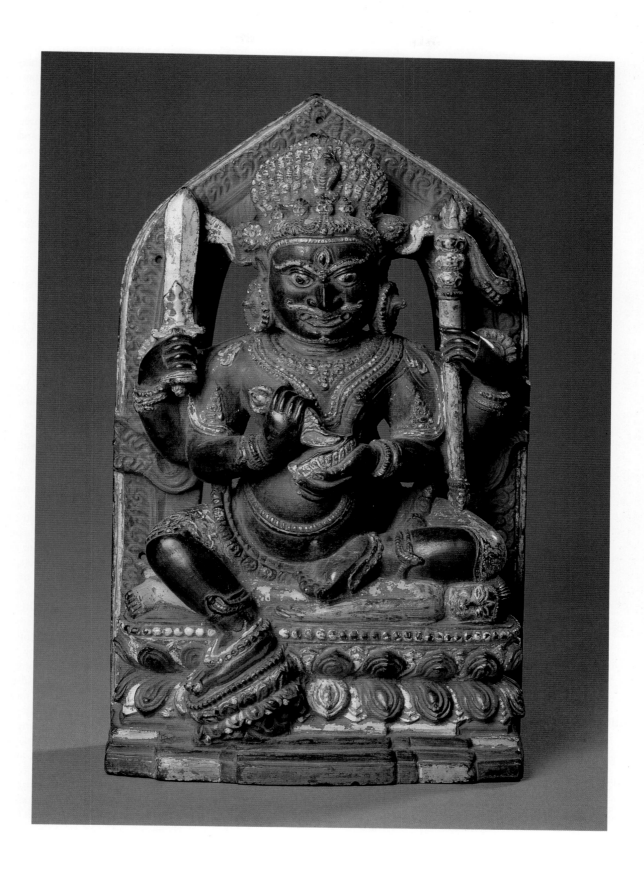

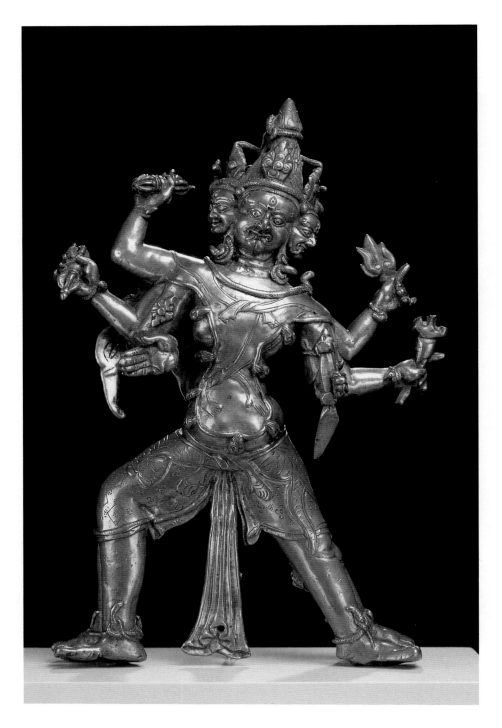

and subtle inner modeling of the central nervous system, opening the yogi's sensibility and clearing the obstructions to inner energy flows. This allows the yogi to attain spiritual insights into the deep self and to incorporate powerful energies otherwise locked away in the normally unconscious regions of the mind.

Vajrakumara presents quite an astonishing sight here, with three heads, six arms, and four legs. His hands, except for the right front one, which makes a gesture of granting boons with open palm to the side, grasp large objects: two vajras, one with five and the other with nine prongs, a flaming three-refuge jewel, a trident, and the *purba* dagger that is his symbol. Covering his back is the freshly flayed skin of the elephant of ignorance, whose legs are tied in front. A human skin is tied diagonally across his chest, the hands lying flat on his stomach. A rope ripples over his torso, dangling severed heads hanging by their hair. A knee-length loincloth with printed floral and rectilinear designs winds around his belly, belted with a tiger skin complete with tail, claws, and head. The vertical lines of the hems give the awkwardly bending and thrusting figure a stabilizing central axis.

Like the Mahakala in No. 52, this diety wears live snakes as earrings (coiled with the head jutting out), bracelets, anklets, a brahman cord, and a hair ornament. His faces are roundish and small compared to the gangly, tall frame of his body. Despite the obvious, large fangs and strongly outlined popping eyes, he has a rather likable, pleasant demeanor, probably engendered by the soft, chubby cheeks and the naïve vigor in the posture. This naïveté is a characteristic feature of early Western Tibetan sculptures, of which this is probably an example. It is closely related stylistically to the Kashmiri tradition, as has been noted by V. Reynolds, but its strange proportions, short, uncoordinated arms, and the rather rough fashioning of the back indicate a Western Tibet origin in the late 11th to 12th century. The snake earrings, the loose garland of widely spaced, severed heads, the soft facial features, and the rather gentle posture of the legs are all features of early Tibetan bronzes, especially those that derive from 9th- to 11th-century Kashmiri styles. This sculpture and another of the same icon, stylistically dating in the 12th century and now in the Los Angeles County Museum of Art (Pal, 1983, p. 209), are two of the most striking sculptures of this deity from the early phase of Tibetan art.

53
Vajrakumara (Vajrakila)

Central Regions, Tibet, or Western Tibet

Late 11th to 12th century

Brass

H. 10¾" (27.4 cm)

Collection of The Newark Museum, Newark, New Jersey. Gift of Mr. and Mrs. Jack Zimmerman in honor of Eleanor Olson, 1970

Lit.: Reynolds et al, 1986, pp. 77–78.

Vajrakumara (T. Dorje Shönu) is the deity of the magic *purba* dagger, a symbol of the sharp point of wisdom fixed immobile on goodness by the power of one-pointed concentration. He is one of the favorite tantric archetype deities used in Nyingma practice on the Mahayoga and Anuyoga levels. It must be understood that this archetype has a precise yogic use, and is not merely considered an external deity to be worshiped or manipulated in ritual activities. His unusual form is carefully visualized by the yogi or yogini until they can imaginatively adopt his form at will. This deeply affects the coarse self-image

54
Hayagriva

Western Tibet (?)

Late 12th to early 13th century

Dark bronze, with cold gold paste and pigments

H. 13½″ (34.3 cm)

The Zimmerman Family Collection

Lit.: Rhie and Thurman, 1984, no. 112; Béguin et al, 1977, p. 183.

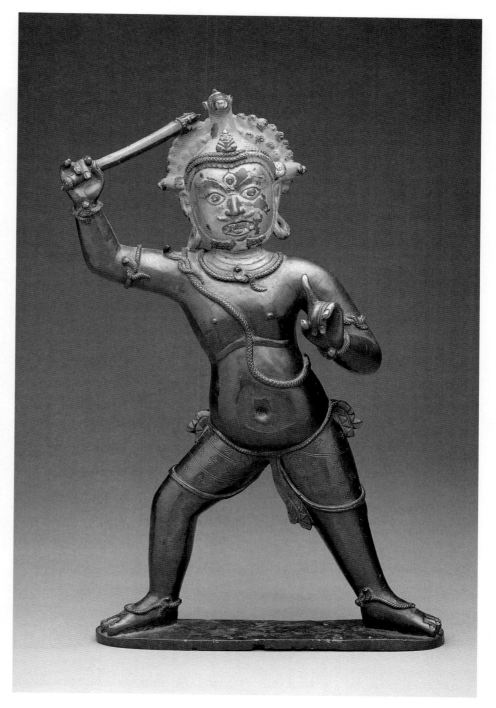

Hayagriva is one of the main archetype deities (*yidam*) of Tibetan Buddhism. He has been especially favored by the Nyingma Order from its earliest days. He is considered to be the terrific form of Avalokiteshvara. As such, he is the archetype of fierce compassion and thus is connected with Padma Sambhava's manifestation as well. One of his origin mantras, occurring in the *Guhyasamaja Tantra,* is OM HRIH PADMA SAMBHAVA HUM. He has many forms, often with three faces, six arms, and four legs, and sometimes with huge wings. He is always recognizable by the small horse's head that surmounts his main fierce deity head and gives him his name Hayagriva, Horse-Necked One. The horse's head neighs loudly, and the sound is said to pierce all false appearances of substantiality, revealing the shining reality of freedom.

Here Hayagriva is depicted in his one-faced, two-armed, two-legged form, the form the yogi identifies with between contemplation sessions and during ritual sequences. Everything about him is terrific—his scowling face with three glaring eyes, his roaring mouth with protruding fangs, his pose of warrior's aggressiveness, his broad belly bulging with inner energy, his sword raised threateningly in his right hand, his left hand raised in the threatening gesture, and his live snake ornaments. This terrific aspect expresses compassion's fierce determination to help us overcome inner egotistic addictions and outer obstructions. Anger transmuted into reality-penetrating wisdom is indispensable for overcoming deep-seated wrong views and other addictions, such as lust, hate, pride, and envy, which cause all misfortunes and sufferings. This example shows Hayagriva's integration of love with ferocity by portraying all his terrific qualities within a whole that appears childlike and innocent.

This sculpture is one of the earliest surviving Tibetan sculptures of this important deity. It can be dated to around

the second half of the 12th century or early 13th century by virtue of its strong stylistic associations with the paintings of the Lhakhang-soma at Alchi in Ladakh. It is difficult to pinpoint the regional provenance of the work. Because of the flat face, stiff quality, and closeness to the Lhakhang-soma works, it may be from Western Tibet. However, the patterns of the cloth and the style of the hems relate to forms seen in paintings and sculptures from the central regions around the late 12th century.

Its solid, smooth mass offers a unitary base for the controlled curves of the

serpent ornaments and the hemlines of the short skirt. This style of line is reminiscent of that seen in the early Shakyamuni statue (No. 2). The simple, stylized features of his flat, broad face, however, resemble the styles seen in terrific figures in 12th-century painting. Interestingly, in this early piece Hayagriva does not have the crown of skulls; the ornamentation is simple. The pigments and cold gold paste are later additions, typical of images worshiped in Tibet. The firmness of mass and simplicity and power of the curves and lines create an abstract purity in this delightful yet highly iconic image.

55
Vajrapani

Central Regions, Tibet

Second half of the 13th to early 14th century

Brass, with remains of pigment

H. 11½″ (29.2 cm)

Mr. and Mrs. John Gilmore Ford

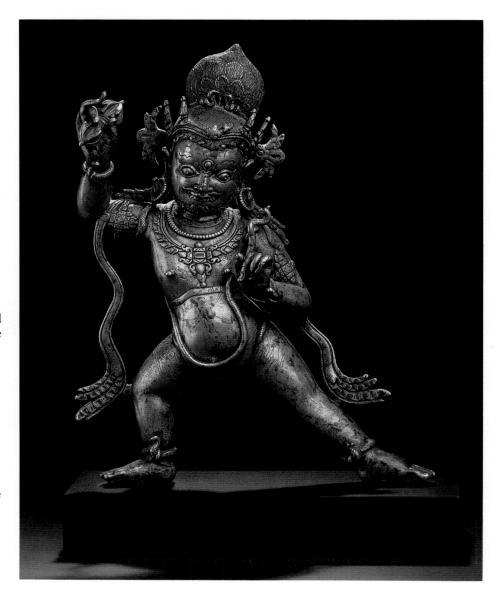

On the popular level, Vajrapani, Holder of the Thunderbolt Scepter (symbolizing the power of compassion), is the angelic Bodhisattva who represents the power of all the Buddhas, just as Avalokiteshvara represents their great compassion, Manjushri their wisdom, and Tara their miraculous deeds. For the yogi, Vajrapani is an archetype deity of fierce determination and symbolizes unrelenting effectiveness in the conquest of negativity. This tough, vigorous, yet elegant sculpture of Vajrapani reflects a style later than the early naïve bronzes of terrific figures in the late 11th to 12th century (Nos. 53, 54, 68). Stylistically, the decor, the facial form, and greater flexibility of mass relate it to examples of the famous Tibeto-Chinese style sculptures dating in the late 13th century at the Feilaifeng near Hangzhou in southern China. The particular form of the hair, like a large leaf-shaped plaque, is similar to some headgear of the Xi Xia (dating before 1227). Although later, the large Vajrapani in No. 1 is the same form of Vajrapani as this one—a fierce archetype deity and remover of obstacles. As such, this icon brandishes a vajra in an exorcising gesture in his right hand, and with his left hand makes the threatening gesture with index finger pointed up. His taut posture is the active warrior pose (*pratayalidha*), based on an archer's stance but resembling the *en garde* position in Western fencing. In this Vajrapani, a diaphanous, floral-patterned scarf and a tiger-skin loincloth (its hems have been broken between the legs) are delicately etched into the surface. This concern for the beauty of contrasting textures is also a feature of 12th- to 13th-century tangkas and sculptures from the central regions. The same is true of the treatment of the face, which is bright and alert and yet also beautifully patterned with thin, scalloped eyebrows, twisted mustache, and short, curling beard.

There is a joyous élan to the sculpture that imbues it with a human quality quite different from the mystical, iconic character of the earlier indigenous style (Nos. 53, 54, 68). The large head and hands, both masterfully portrayed, seem to reflect the Indian style seen in the stone Mahakala (No. 52). Along with its slightly ornate appearance, this suggests an origin in the central regions, probably Tsang. A superb example of the transition period between the early phase and the developments of greater naturalism and monumentality in the 15th century, this work provides a much-needed missing link in the chronology of Tibetan sculpture. It is certainly one of the most important sculptures of a terrific deity from the period of the 13th to 14th century to surface in recent years.

56
Mahachakra Vajrapani
and Consort

Central Regions, Tibet

First half of the 15th century

Brass, with cold gold paste and pigments

H. 15¼" (37.6 cm)

The Zimmerman Family Collection

Intense energy infuses and radiates from this pair. This fierce yet erotic form of the Bodhisattva Vajrapani with three faces and six arms is mainly associated with the subduing of Nagas (the subterranean and suboceanic serpentlike dragon beings). His consort has one face and two arms, otherwise closely resembling him. He embraces her in sexual "father-mother" (T. yab-yum) union, her right leg pressed against his left leg from thigh to foot, her left leg raised over his right thigh. They hold a dancer's balance, trampling forcefully upon the flattened bodies of figures who represent the ignorance and evil of untamed dragons. This work is an extremely difficult sculptural feat, but the two deities are successfully coordinated in balanced union, pervaded by a marvelous sense of dynamic action. Limbs and bodies are poised and energized. The stiff but forceful movements of the skirt, scarves, jewel girdles, and even of the snake that passes through Vajrapani's mouth and ear, complement their vigor and intensity.

Stylistically, the work is more developed than the Hayagriva (No. 54) and Vajrapani (No. 55) presented above. These three images offer a glimpse of the main chronological developments in Tibetan sculpture from the 12th to the 15th century. The sense of movement, inner energy, and advanced realism, appearing especially in the properties and definition of the faces and limbs of Vajrapani and his consort, relate to sculpture of the early 15th century. It is similar to the wiry, resilient style seen in some of the sculptures of the Gyantse Peljor Chöde monastery of ca. the second quarter of the

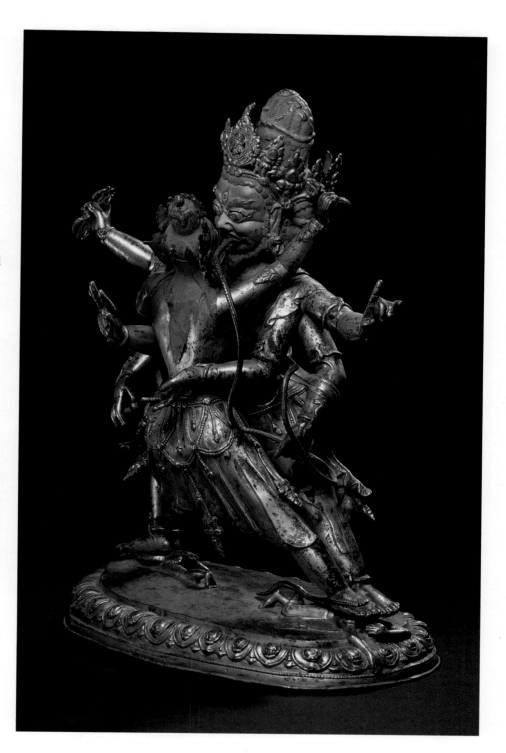

15th century. The pedestal has fairly elaborate lotus petals, typical of the type prevalent in the 15th century. The remains of cold gold paste on the heads and red

paint on the hair of both figures are later additions. The image is superb from all sides, including a powerfully conceived back for Vajrapani.

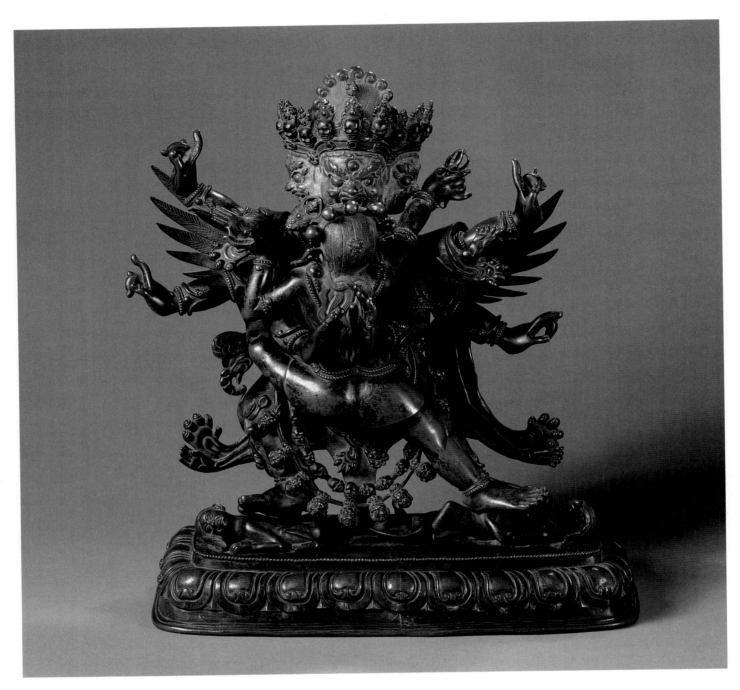

57

Vajrakumara (Vajrakila)

Central Regions, Tibet

16th century

Dark bronze, with cold gold paste and pigments

H. 15½″ (39.4 cm)

Mr. and Mrs. John Gilmore Ford

This winged Heruka archetype deity with three faces and six arms is probably Vajrakumara (also known as Vajrakila). He is shown in terrific union with his wisdom (*prajnya*) consort. Together they represent the union of wisdom (female) and artful method (male), which is compassion's action. They stand on prostrate figures, one male and one female, symbolizing their triumph over delusion. Marks of his status as a terrific Heruka include the flayed skin of an elephant and of a human being, both of which are stretched over his back as two separate pieces. He wears the long garland of fifty severed heads, representing the negative attitudes severed and turned into ornaments by wisdom. He also wears over each face a five-skull crown, representing

the five addictions transmuted into the five wisdoms. His consort (cast as a separate piece) is one-faced and two-armed and holds the vajra chopper and skull bowl. She is dressed in a leopard-skin skirt, wears the five-skull crown, and has a flower on the back of her hair.

Heavy and forceful, this sculpture is one of the finest representations of this class of deity. With its emphasis on realistic, heavy masses, it contrasts with the slimmer, stiffer dynamics and less complicated masses seen in the earlier Vajrapani couple (No. 56). In this later work, probably dating from the 16th century, a convincing realism removes the barrier of abstraction from the archetype; one accepts it as real, as a live possibility. Therein lies its enormous power.

58

Four-Armed Vajrapani

Central Regions, Tibet

First half of the 17th century

Tangka; gouache on cotton

38 × 25½″ (96.5 × 64.8 cm)

Robert Hatfield Ellsworth Private Collection

Lit.: Tucci, 1949, p. 403.

A vigorous, four-armed terrific Vajrapani stands in the warrior pose on a chalk-white, four-armed, prostrate deity (his own emanation in that form), who holds in his right hands a *damaru* drum and vajra chopper, and in his left hands a trident and a skull bowl. The main figure was identified by Tucci as Bhutadamara Vajrapani, judging by his pose and hand implements, even though this form is more often dark blue. He stands here as the great eliminator of obstacles to the path of realization. His huge square face, lumpy limbs, and massive body are golden-white. His terrific features skillfully drawn, he radiates the overwhelming force of a sumo wrestler. His outstretched right hand brandishes a vajra and his left hand deftly holds a lasso—with which to bind demons. His other two hands are crossed in front in the diamond HUM-sound gesture (*vajrahumkara mudra*), indicating his triumph over the triple universe. A fluffy mass of light hair with lavender-red

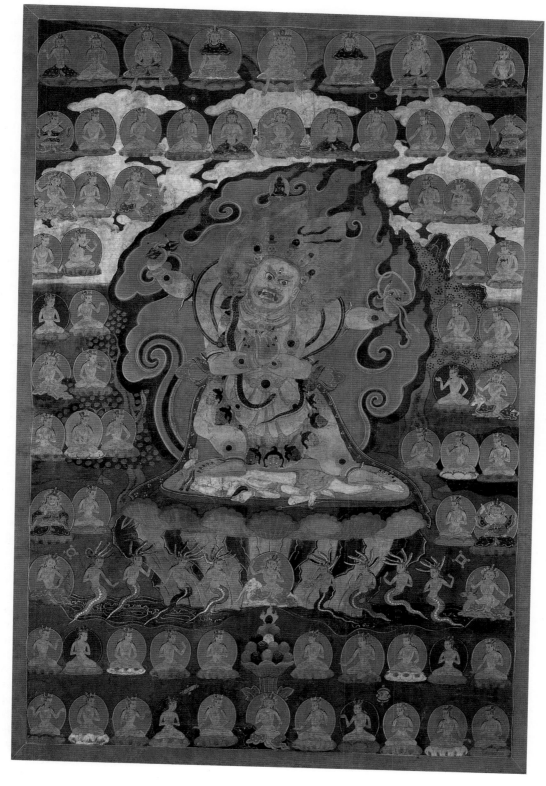

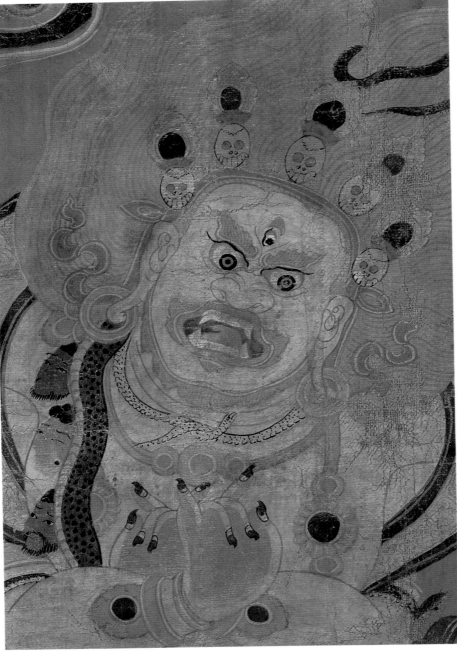

58.1

strands wafts behind him, barely distinguishable from the solid, rosy color of his extraordinary swirling halo. This halo, with its unique arabesques of mystic flames, dominates the configuration. Within the halo, just above Vajrapani's flaring hair, sits a small blue Akshobhya Buddha, lord of his Buddha clan, symbolizing the transmutation of anger into ultimate-reality-perfection wisdom. A wide, semicircular white scarf with faint cloud patterns creates a strong, curved structure for the upper body. Its dark green ends drape along the legs, silhouetting the lower body. Against the white of the body, the predominantly dark blue-green, orange, and lavender-red ornaments create an aesthetically pleasing ensemble. In addition to the fearful

ornaments—the five-skulled crown, the garland of large moist heads, a fat, blue-green, polka-dotted snake entwined loosely over his body, and a small white snake around his neck—he has a heavy set of necklaces with pendants that act as a girdle. His eyebrows, mustache, beard, and hair blaze with apocalyptic flames. His huge mouth snarls, showing his strong teeth and curling tongue, and wrinkling his nose. His three bloodshot eyes glare with fierce determination. His features are drawn with consummate skill and power, the red lines used to heighten the hot, bright aspect of the figure (58.1).

From a blue lake surrounded by plain, dark green hills, a mountain of blue and tan vertical striped rocks supports Vajrapani's orange and lavender-red lotus

pedestal. On either side, somewhat hidden behind his halo and attendant Great Adept figures, are two trees, whose style is as unusual as the halo. The one at his right, with lavender trunk and orange blossoms, is set against a blue ground, and the one at his left, with blue flowers, is an amorphous lavender-pink shape.

In symmetrical alignment around the main image are many small deities of Vajrapani's retinue, placed against a background of solid green hills, occasional rocks, dark blue sky, a mass of brilliant white clouds, and a lavender-red and blue-green "jet stream" in the upper reaches. Most of them are white and their halos have the same bright color scheme that is such a prominent feature of this extraordinary painting. Along the central vertical axis from top to bottom are: Sarvavid Vairochana (four-headed form of Vairochana, the Buddha patron of the eradication of ignorance); the great god Brahma on a goose; and the dark blue figure of Akshobhya Buddha in a halo. Below the pedestal are Indra on a white elephant; a dish of jewel offerings; and a seated white deity on a black boar (perhaps a form of Vishnu). On either side of Vairochana on the top row are the other four Transcendent Buddhas, two on each side, and the four elemental Mother Buddhas, two in each corner. The Four Heavenly Kings appear at the outer edges (second row from the top and fourth row from the bottom). Eight female dragon queens (Naginis), with writhing snake crowns and serpentine lower bodies, rise from the lake on either side of the Indra figure (58.2). Figures on animal mounts, distributed symmetrically around the main figure, are the great world gods of India. There are numerous adepts of the practice lineage scattered throughout.

The combination of dark and bright, but subtle, colors, especially lavender-red and orange, is seen in paintings in the Western Tibetan schools of the Guge renaissance. However, the strength of the line drawing of the central figure is associated with styles in the central regions of the 17th century (No. 115). Some features, such as the delicate small deities and the double-lined edges of the rather simple drapery, are similar to those seen in tangkas from Ü province in central Tibet (No. 87) and also from the eastern regions (No. 7) from the late 16th to early 17th century. The complex mixture of styles indicates that this work is probably from the central regions. Its realism, simplicity, and power, as well as stylistic similarities with Nos. 7, 87, and 115, suggest a dating during the first half of the 17th century for this spectacular work.

58.2

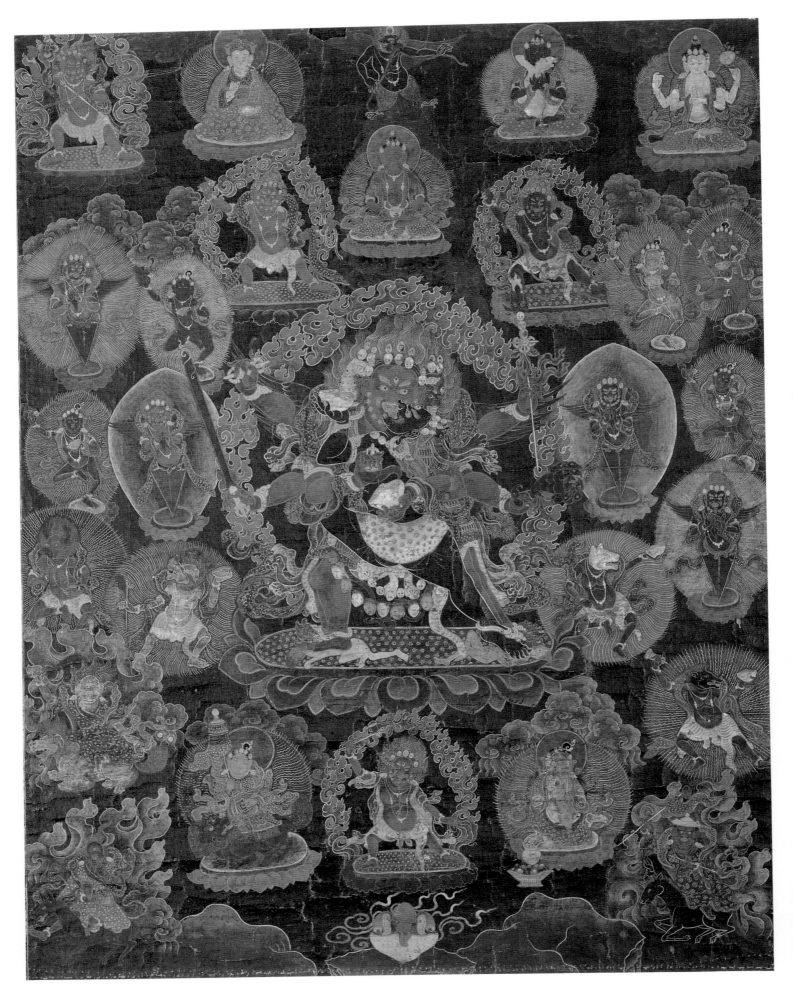

59

Guru Drakpoche

Central Regions, Tibet, or Eastern Tibet;
obtained in Kham

Late 17th to early 18th century

Tangka; gouache on cotton

31 × 25″ (78.4 × 64.0 cm)

Collection of The Newark Museum, Newark,
New Jersey. Gift 1911, Edward N. Crane
Memorial Fund

Lit.: Reynolds et al, 1986, III, pp. 185–87;
Olson, 1950–70, III, pp. 54–55.

Tangkas with a black background like
this one form a special category of
contemplative paintings. They are a highly
mystical and esoteric type, usually reserved
for advanced practice. Black is the color
of hate, transmuted by the alchemy of
wisdom into the ultimate-reality-perfection
wisdom. It is not that darkness is the
absolute—the void is not nothingness.
Darkness represents the imminence of the
absolute, the threshold of the experience.
The absolute itself is rather the clear light
transparency within which all relative
forms and vulnerable living things are
sustained. But the dark connotes death,
which enlightenment converts into the
Body of Truth. It is used for terrific ritual
actions, the radical conquest of evil in all
its forms—conquest not by annihilating,
but by turning even evil into good. Thus,
in the black paintings (T. *nagtang*) the
black ground casts forth deities in
luminous visions of translucent color. By
the 18th century this style had become
common in Tibet, and it was certainly
gaining prominence by the middle of the
17th century. Early examples are Nos. 115
and 112 in this book and the paintings
in the gold manuscript of the Fifth Dalai
Lama dating between 1674 and 1681
(S. Karmay, 1988).

The main figure in this tangka is central
in Nyingma practice, apparently relating
to a vision of the Tertön Padma Lingpa
(1450–1521), according to D. I. Lauf
(Reynolds et al, 1986, p. 187). Here
Padma Sambhava takes the form of Guru
Drakpoche, a fierce Heruka archetype
deity embracing his consort in sexual
union. He appears as orange-brown in
color, with three faces, the right one
white, the left one green, and the front one
orange-brown, four legs, and six arms. His
right hands hold a vajra chopper, sword,
and vajra; his left hands hold a skull bowl,
a black scorpion with seven eyes, and a
trident-tipped *khatvanga* staff. His consort
lifts a skull bowl in her left hand, offering

sips of its elixir to her lord, and holds a
vajra chopper in the right hand, out of
sight behind his neck. She wears a
leopard-skin skirt, which contrasts with
her gold-outlined black body. Both are
adorned with the ornaments typical of the
fierce deities and are surrounded by an
arched halo of flames as they stand on
symbolic conquered deities of ignorance
lying on the decorated sun disc above the
lotus pedestal. The style of the halo is
similar to those appearing on some of the
sculptures from the Hermitage collection
(Nos. 72, 117, 120). It may be a type
prevalent in the eastern as well as the
central regions, as some other examples
may suggest (No. 123).

Around the central pair drift numerous
discrete figures with varied halos and
pedestals. They offer a visual feast of
deities from lamas and highest archetype
deity forms to protectors and
protectresses. On the bottom, above a
rocky ground with a skull bowl of
offerings, are the major protectors and
gods of wealth. The middle zone has four

animal-headed Dakini protectors; four
Kila dagger deities, whose lower bodies
are in the shape of that mystical stake; and
five wisdom Dakinis, the colors of the five
wisdoms, who are dancing (59.1). Just
above the main figure is a red Amitayus
Buddha with a *garuda* (eagle of wisdom)
above him, flanked by two fierce Herukas.
On the top row from the left corner are
another Heruka figure and a usual Padma
Sambhava figure; to the upper right, there
is a blue, peaceful form of the primordial
Buddha of the Nyingma practice,
Samantabhadra, in union with a white
wisdom Samantabhadri, and in the corner,
there is the four-armed Bodhisattva
Avalokiteshvara. The fine drawing, the
subdued tones of the deities, and the
subtle modeling create one of the most
effective of the black tangkas, probably
dating late in the 17th or early in the 18th
century. The delicacy of the style is rather
close to the manuscript of the Fifth Dalai
Lama (ca. 1674–1681) and may indicate a
dating for this exceptional tangka during
the period of the Fifth Dalai Lama.

59.1

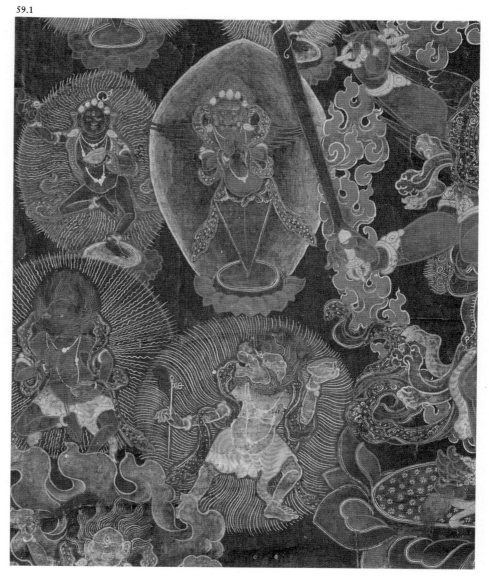

60
Chemchok Heruka
with Fierce and Tranquil Deities
of the Bardo

Eastern Tibet (?)

19th century

Tangka; gouache on cotton

28½ × 19″ (72.4 × 48.3 cm)

Collection of The Newark Museum, Newark,
New Jersey. Purchase 1969, The Members' Fund

Lit.: Reynolds et al, 1986, p. 177; Olson, 1950–
70, III, p. 55; Gordon, 1939, pp. 97–101.

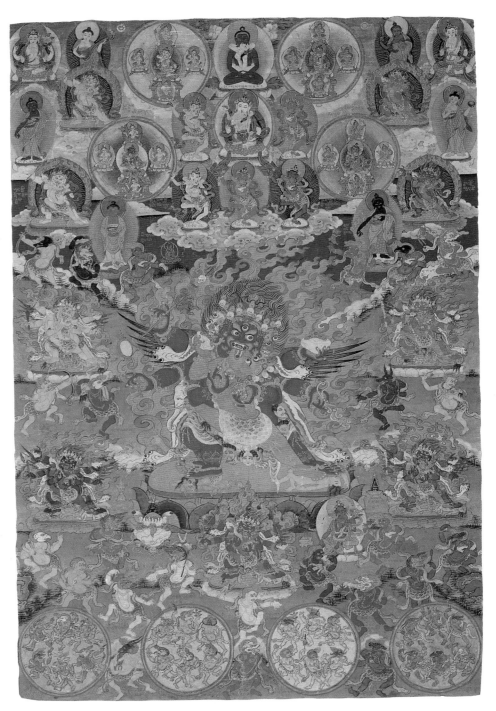

The dark, reddish brown winged
Chemchok Heruka with three faces, six
arms, and four legs embraces his bright
red consort in sexual union. He is the
terrific form of Samantabhadra, the
primordial Buddha form of the Nyingma
Order, who appears at top center in
peaceful father-mother (*yab-yum*) form.
Against a rudimentary landscape appear
numerous deities and circular realms
related to the transmigratory visions in the
Bardo or Between-State—the period
between death and rebirth. These visions
appear from the consciousness, according
to the teachings of the *Bardo Thodol*, the
*Book That Liberates When Heard in the
Between*, popularly known in the West as
The Tibetan Book of the Dead. In the
upper zones appear the tranquil deities,
visions of whom are said to appear early
in the after-death state. In the circles are
the abbreviated mandalas of four of the
Five Transcendent Buddhas. Other deities
outside the circles include the six standing
Buddhas of the six migratory realms, the
five knowledge-holding deities, and four
fierce *yab-yum* herukas.

In the center, around the central Heruka
archetype deity are the five Heruka
Buddhas as fierce winged deities with their
consorts, eight Kerimas (female deities that
appear in the Bardo) in human form, four
animal-headed protectors, and eight
animal-headed Dakini goddesses. Dakinis
are "skywalkers"; they are powerful
females, usually divine and usually
enlightened, with mundane counterparts.
At the bottom are four circles, each
containing six deities, the Female Power
Deities (T. Wangchukma), animal-headed

goddesses of the four quarters. Outside
these circles are four animal-headed
protectors. These terrific deities occur later
in the between-state experience than the
tranquil ones.

The brilliant, fresh color with bright
green and strong ultramarine blue, and the
lively, vibrant forms of the protectors
relate stylistically to paintings of the 19th
century, probably from the eastern regions

of Tibet. These esoteric paintings of the
Between are a special class of tangka, used
for contemplative preparation for the after-
death experience. Highly iconographic in
content, they place strong emphasis on
vivid portrayal of the deities, which pack
the picture plane with a dazzling array of
visionary forms. This tangka, according to
D. I. Lauf, is also of the Tertön Padma
Lingpa (1450–1521) tradition.

VII.
Sakya Order

The Sakya Order began with the founding of Sakya monastery in 1073 by Khon Konchok Gyalpo (1034–1102). The Sakya Order adheres to the basic principles of all three Vehicles of Buddhism, as do the other orders. The special flavor of Sakyapa teachings came from their implementing the monastic and scholarly traditions brought to Tibet from Vikramashila monastery in India by the translator Drokmi (992–1072) and the Indian masters such as Atisha (982–1054), keeping their knowledge in the practice framework provided by the esoteric lineages of the Path and Fruition (T. lam-'bras) teaching derived from the Great Adept Virupa and based on the *Hevajra Tantra* literature. The Sakyapa were among the most active scholarly orders during the early period, collecting enormous numbers of texts, commissioning numerous translations, implementing an effective curriculum designed by the famous Sakya Pandita, and founding numerous monasteries. During the Mongol period, the order was designated to rule over all Tibet, and devoted Mongol emperors made lavish offerings to the Sakya hierarchs. Thus the Sakyapas were able to commission numerous works of art, bringing artists from all over the Buddhist world. Their combination of vast textual research and intensive spiritual experience enabled them to maintain precise and authentic artistic traditions and also to refine them to a very high degree. They are credited with producing some of Tibet's greatest Buddhist art.

The Sakya monasteries of the Tsang region are renowned for their spectacularly successful paintings in the Pala style Indo-Nepalese traditions. They were also associated with the early incorporation of Chinese Buddhist art styles, especially in the 14th century. The great Sakyapa monasteries on the north and south banks of the Drum River as well as Ngor are among the most famous institutions of the Sakya Order, but there are many more. Though it is tempting to identify certain styles, especially in painting, as Sakyapa, it is probably too soon in the study of Tibetan art to take such a designation as definitive. Other orders used similar styles, and even within a single monastic tradition different lineages can be found. Until documentation becomes more complete, it is probably safer at present to identify styles by their lineages or general regions; or, when it is possible, to group works around well-established monuments, such as the Kumbum and Peljor Chöde at Gyantse.

Part VII reveals some of the broad range of styles seen in the paintings and sculptures of the Sakya tradition from the late 12th to the middle of the 18th century. The paintings range from monumental, two-dimensional works reminiscent of the humanism of Giotto and much early 15th-century Renaissance painting (No. 61), to the brilliantly colorful style that relates to Indo-Nepalese traditions (Nos. 64, 69, 70, 73, 75, 77). The rich, rococo style of the late 17th century (No. 65) is also represented, as is the ethereal, idealistic realism of the late 17th to mid-18th century (Nos. 67, 66). The six sculptures in this part range from the late 12th to the early 17th century, and although not large, they are some of the choicest icons in Tibetan art. They include the superb early Paramasukha-Chakrasamvara (No. 68), the stunning "gold" Raktayamari (No. 76) from the Yongle group (1403–1425), two lama portraits that show contrasting styles (Nos. 62, 63), the rare sculpture of the goddess Nairatmya (No. 74), and the special form of Mahakala known as Brahmanarupa (No. 72). Most of these works come from the central regions, probably Tsang, the stronghold of the Sakya Order.

The Sakyapa meditate on many different archetype deities. This section has examples of Paramasukha-Chakrasamvara and the terrific Raktayamari, the archetype goddess figures of Nairatmya and the Pancharaksha goddesses, and the popular spiritual protector Mahakala in several forms favored by the Sakyapa (Nos. 71, 72). They are presented here in hierarchical, rather than strictly chronological, order. Known as a particularly scholarly order, the Sakyapa also reveal themselves to be prolific masters of Buddhist art. This section offers a few of the many masterpieces associated with the splendid and renowned Sakya tradition.

61
Sakya Lama Kunga Nyingpo

Ngor monastery, Tsang, Tibet

Circa 1429

Tangka; gouache on cotton

45 × 37″ (114.3 × 94 cm)

Robert Hatfield Ellsworth Private Collection

Lit.: Tucci, 1949, p. 333; Chogay Rinpoche, 1983.

This magnificent large tangka was obtained by Tucci from Ngor monastery in Tsang, founded in 1429. According to Tucci, the founder, Gyalwa Dorje Chang Kunga Sangpo (1382–1457), invited artists to adorn the chapels. His biography mentions his ordering a set of "paintings of the masters of the transmission of the verbal plane." Tucci considered it probable that this tangka was one of that set, and he thought it was one of the most important paintings in his own collection.

This is a portrait of Sachen Kunga Nyingpo (1092–1158), the first of the five great early masters of the Sakya Order. His father, Khon Konchok Gyalpo, had established the Sakya monastery in 1073 as a new order based on the Path and Fruition teachings of Virupa, as transmitted by Gayadhara to the translator Drokmi. Konchok Gyalpo had established the succession of abbots of the Sakya monastery to be within the hereditary lineage of the noble family of Khon, so the Sakya tradition has both lay and monastic lineages. Kunga Nyingpo was said to have been an incarnation of the Bodhisattva Avalokiteshvara. He received special guidance from the Bodhisattva Manjushri and the Great Adept Virupa, who appeared to him in his dark brown form for one month during a critical period in his spiritual development.

The august, kindly, elderly figure of this famous Sakya lama sits cross-legged on a red and green lotus seat, supported by an ornate double-tiered base with designs in raised gesso relief covered in gold. His hands are in the teaching gesture, each holding the delicate stems of a blue lotus. The lotus at his right supports a vajra (mystic symbol of adamantine power and compassion), and the one on his left supports a bell (*ghanta,* mystic symbol of wisdom). These ritual implements, which, used together, have the meaning of the union of wisdom and compassion, are also raised in relief with gilded gesso. Kunga Nyingpo wears a pale greyish blue robe belted with a light band composed of tight geometric designs in gold (61.1). A wheat-colored soft sitting-robe with dark grey fur lining lightly encases his body within its fluid, symmetrical shape. This kind of outer robe is a Tibetan invention—a *dagam*—a sort of sleeping bag for sitting up, used for meditating in the cold climate. The coloring and delicate floral decoration of both garments are more subdued and restrained than those generally encountered in 14th- and early 15th-century paintings. A red halo and nimbus with a filling of intricate floral scroll patterns contrast with the flesh-colored tints of the image and the subdued tones of his humble clothing. Above the head of the image floats a parasol of peacock feathers with fluttering white ribbons below and flat-bottomed surrealistic white clouds above. The offering deity on each side of the clouds closely follows the style of the celestial attendant angels (*apsaras*) commonly seen in the wall paintings of earlier times at the Buddhist cave temples of Dunhuang in northwest China.

The dark ultramarine blue background of the painting is decorated by lively, loose, and delicately naturalistic flowers, leaves, and stems. A series of circular vignettes float to the left and right of Kunga Nyingpo, containing depictions of lamas, Great Adepts, and deities, all of which are named by inscription. These are Kunga Nyingpo's teachers (see diagram): 1) Dorje Denpa, 2) Shangton Konrap, 3) Rahula, 4) Manjushri (61.2), 5) Delpo Jnyana, 6) Burang Lochang, 7) Ngok Lotsawa (translator), 8) Drangti Darma Nyingpo, 9) Kyang Rinchen Drak, 10) Bari Lotsawa, 11) Khon Gyichuwa, 12) Virupa, 13) Lama Namkapa, 14) Khon Konchok Gyalpo, 15) Semkar Chungwa, 16) Mal Lotsawa Lodrö Drakpa, 17) Ganjusemba A, and 18) Mezin Chey. Virupa, main Great Adept of the Sakya lineage, particularly related in his brown form to Kunga Nyingpo, and Manjushri, the Bodhisattva of Wisdom, who appeared to Kunga Nyingpo when he was twelve years old and gave him a special verse, have a prominent position just above the lama's vajra and bell. In the lower corners of the painting on each side are: 19) the seven ornaments of the world ruler, and 20) the eight lucky signs. They appear as a "tree" of tiny circles with minuscule figures and symbols sprouting from a vase.

The grandeur of the central figure and the human character of the portrait dominate the painting. This contrasts with the ornateness of the lotus seat and jeweled

1	2		10	11
3	4		12	13
5				14
6				15
7				16
8				17
9				18
	19			20

61.1

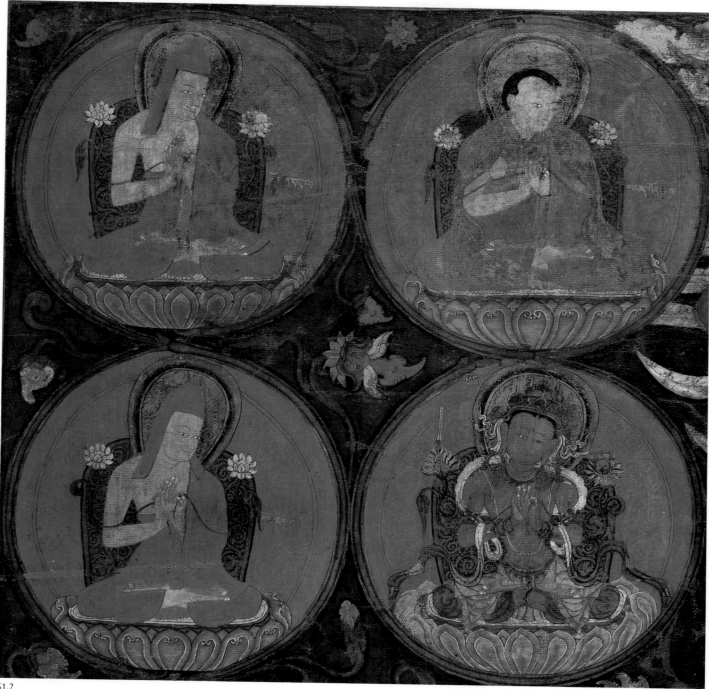

61.2

pedestal in gilded raised relief, the formal
patterns of the circular vignettes with their
strong red background, and the delicacy of
the floral motifs. Despite these disparate
elements, the painting maintains harmony
and unity. One of the most outstanding
features of the work is the remarkable
naturalism and human appeal of the main
figure (61.1). His large head, hands, and
feet emphasize his generosity and gentle-
ness. The subtle modeling of these
features, especially the hands, produces
the kind of solid, soft, naturalistic effect
that appears in paintings of the early
Renaissance in Italy, just beginning in
the mid-15th century. The unusual

coloring of the pale blue and muted mustard
yellow of Kunga Nyingpo's robes is also
more typical of early Italian Renaissance
painting than of traditional Tibetan
painting. Considering the meetings be-
tween Tibetans and Europeans that had
occurred during the Mongol empire, the
wide range of ongoing Tibetan trading
contacts throughout India, Nepal, China,
and Central Asia, and the Tibetan knack
of assimilating useful elements from other
cultures, it would not be impossible for
Tibetan art to be inspired not only by art
from its immediate neighbors, but also by
art from the West brought to Asia. This
tangka is, however, quite a rare example

among currently known works. It did not
seem to foster a school that developed this
"Renaissance" style further. As a work
datable around 1429, it is an important
evidence in the chronology of Tibetan
painting and parallels in a tangka the style
of the wall paintings in the Kumbum at
Gyantse of the second quarter of the 15th
century. In its monumentality, use of even
red lines to draw the features, and the
particular "further-eye" projection, it still
has some links with the early Arhat
representations, especially the set asso-
ciated with No. 13. As a monumental
portrait from the middle periods in
Tibetan art, this work is unsurpassed.

62
Sakya Lama Sonam Tsemo

Central Regions, Tibet; probably Tsang

Late 15th to early 16th century

Copper alloy, with pigments

H. 7¼″ (18.4 cm)

The Los Angeles County Museum of Art,
Los Angeles. Gift of Doris and Ed Wiener.
M.72.108.3

Lit.: Pal, 1983, p. 228.

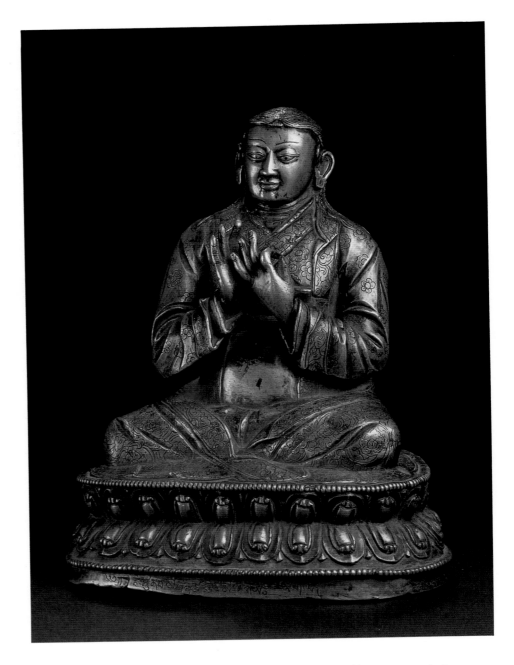

This sturdy and bold portrait sculpture is of Sonam Tsemo (1142–1182), one of the early Sakya hierarchs. It is identified by the inscription on the front side at the bottom of the pedestal. Sonam Tsemo was the son of Kunga Nyingpo (No. 61) and received his early teaching from him. He is depicted here in robes and a jacket, showing his lay status within the Sakya lineage, which accommodates both lay and monastic lamas in its hierarchy. He was noted as a great scholar and collector of texts.

The figure is big, broad, and impressive, but at the same time without pretense or hauteur. There is a natural ease in the gentle expression that contrasts with the agitation created by the crinkled clothing. With its deep, slashing grooves and the sharp, sudden angles of its borders, the robes become a vehicle of dynamic vigor. Although in certain details they resemble the drapery in the 14th-century image of Padampa Sangyey (No. 38) and of Padma Sambhava from the second half of the 15th century (No. 47), the robes here are not as selective and restrained as the groovelike folds of the former nor as flat as the angular folds of the latter. These have a pronounced naturalism: the drapery is independent from the shape of the body, and yet at the same time it seems to take account of the body beneath, indicating a greater awareness of natural form. The boldly incised floral patterns complement the energetic folds. The enormous hands, held in the teaching position, sustain the sense of largeness of the figure. These hands are reminiscent of the large hands seen in the Lhakhang-soma paintings at Alchi (ca. late 12th to 13th century) and of the Sakya Kunga Nyingpo painting in No. 61, but they are more sinuous, in keeping with the greater naturalism of the figure as a whole. The clarity and shape of its features and the inlay of copper and silver relate to the Padma Sambhava in No. 47, but the square head shows greater solidity and massiveness.

Although related in a number of ways to earlier artistic styles, this work, by its eclecticism, the increased naturalism of its mass, and the daring freedom of its drapery, probably dates to the late 15th to early 16th century. Certainly, it is prior to the more highly developed naturalism seen in the late 16th-century statue of Karma Dudzi (No. 89).

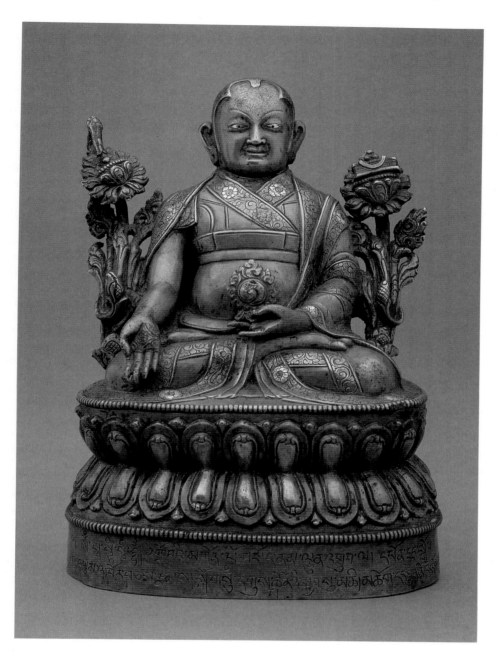

63

Sakya Lama Sonam Lhundrub

Central Regions, Tibet; probably Tsang

Mid-16th century

Brass, with copper, silver, and turquoise inlay

H. 7⅞" (20 cm)

The Zimmerman Family Collection

Lit.: Béguin et al, 1977, p. 152.

An inscription in two lines on the front of the base identifies the lama as Sonam Lhundrub (1456–1532), who lived in Lowo in Mustang, and the donors as Pondrung Drolma, a local noble family. It reads, "Om! May all be well! [We of] Pondrung Drolma, man and wife and retinue, all respectfully go for refuge with body, speech, and mind to the protector of beings, Sonam Lhundrub. May he grant [us] common and supreme success!"

This work is an unusually colorful sculpture of the lama. It is handsomely inlaid with copper and silver, not only in the face, but also in the floral designs on his robes. Pieces of turquoise adorn the flaming bliss-swirl jewel (T. *gakyil*) that he holds in his left palm. With his right hand he makes the boon-granting gesture. To either side is a rich, naturalistically portrayed lotus, reminiscent of the Pala Indian styles, with realistically fashioned stalks, leaves, buds, and open flowers, which hold the symbols of the book and sword, now broken. His robes are worn tightly and neatly; they conform to the chunky mass of his body and flow over his legs with a graceful, unhindered, but slightly sluggish curvilinear rhythm.

Stylistically, this sculpture is related to the Buddhashri statue (No. 86), but its soft naturalism and dense mass are more advanced, as seen in later 16th-century sculptures, such as that of Karma Dudzi (No. 89). Since the massive body and tightly fitting but flowing drapery resemble the main sculptures of the Gyantse Kumbum, it is likely that this work is from the Tsang region, where there are many famous Sakya monasteries. Another statue of this lama, of similar style and date, is in the Essen collection (Essen and Thingo, 1989, II, p. 105).

The Indian Pandit Gayadhara, Guru of the Sakya Order

Central Regions, Tibet; probably Tsang

Second half of the 16th century

Tangka; gouache on cotton

31 × 26″ (78.8 × 66 cm)

The Zimmerman Family Collection

Lit.: Roerich, 1988, p. 204 ff.

An inscription in Tibetan at the bottom of this well-preserved painting identifies this lama as Gayadhara, a Kashmiri pandit, or master, who was an important teacher of the translator Drokmi (992–1072), one of the founders of the Sakya Order. The inscription reads, "Highly skilled in all knowledge, in command of all samadhis, the tamer of the Land of Snows—Homage to Gayadhara! By which virtue, may the Buddha Teaching long endure and all short-term obstacles and injuries be eradicated! Good luck to all!" Gayadhara is recorded in the *Blue Annals* as passing away a short time after Drokmi.

The master makes the teaching gesture with his right hand and with his left hand holds on his lap a book wrapped in printed blue cloth with aqua lining. He wears a red pandit's hat that has rows of delicate geometric designs and long lappets that fall over his shoulders. His red floral-printed undergarment is tied with a wide yellow band. A loosely draped white outer robe spreads around and over his body in undulating folds of some weight. The artist's consummate draftsmanship is revealed in the beauty of the calligraphic lines of this robe. Touches like the whorl pattern of the hem under the feet add a glimmer of fanciful charm to the otherwise strongly geometric and formal quality of this painting.

The face of the lama is soft and mild as he looks directly outward at the viewer with his serious brown eyes and very slight smile. Because of the purity of the solid coloring and the pale tone of the lines describing the features, the face appears highly two-dimensional. It forms, along

with the rest of the figure, a perfectly fashioned pattern on the same plane as the blue and green halos, which are exquisitely, if a little formalistically, executed with the traditional shadow scroll patterning. The style of these halos strongly resembles those seen in Guge paintings of the second half of the 15th and the 16th century (Nos. 4, 6, 97), but probably traces back to the style seen in the great cycle of paintings in the Kumbum at Gyantse. The same shadow patterning appears on the red ground of the background shrine. By the time of this work, this type of shrine backing has become a time-honored motif, often simplified into a cusped arch supported by double-stage pillars rising from a base in the form of a vase, as seen in this work.

The flat, dark blue ground surrounding the lama's shrine is filled with forty-two individual, vividly executed images in formal rows. Each figure has its own halo and is identified by a label in Tibetan. They are as follows (see diagram): 1) Vajradhara, 2) Saraha, 3) Aryadeva, 4) Chandrakirti, 5) Viravajra, 6) Vajrapani, 7) Nagarjuna, 8) Kanhapa, 9) Önton Peldzin, 10) Drokmi, 11) Guhyasamaja-Akshobhya, 12) Amitabha (?), 13) Amitayus (?), 14) Manjushri, 15) Meton, 16) Sherton, 17) Amitayus, 18) Amitabha, 19) Amitayus, 20) Amitayus, 21) Kunga Nyingpo, 22) Sonam Tsemo, 23) Dakpa Gyaltsen, 24) Sakya Pandita, 25) Chögyal Pakpa, 26) Konchokpel, 27) Dakpukba, 28) Penden Lama, 29) Penden Tsultrim, 30) Buddhashri, 31) Ngorchen, 32) Jamchöpa Kunlo, 33) Kedzun Pelgyal, 34) Nuchen Namka Pelzang, 35) Chunda, 36) Nyangen Mepaipel, 37–40) Özer Jenma (Dakinis, two with pig heads, connected to Marichi), 41) Jambhala, and 42) Konchok Lhundrub. Clusters of flowers decorate the red-painted border of this precise and brilliant painting.

On the back of the tangka there are also prayer inscriptions in Tibetan. Each image, small and large, has a consecratory OM AH HUM on the back, symbolizing the presence of the Buddha body, speech, and mind within the icon. Then there is a pyramid of dedicatory mantras and pious Buddhist verses: "All things arise from

causes . . ." and so on; "To tame one's mind is the Buddha's teaching . . ." and so on; "To control body, speech, and mind is the best of vows . . ." and so on. At the end, there are mantric salutations to Mahakala, Vaishravana, Jambhalajalendra, and Vasudhara.

This painting appears to be one of a set of Sakya lamas, as noted by Pal and others. A number of other tangkas in the set are known, such as those in the collections of Mr. and Mrs. John Gilmore Ford, Michael Henss, and the Los Angeles County Museum of Art. The style, which is related to the Indo-Nepalese stylistic traditions but has become thoroughly Tibetan, indicates a provenance from the central regions. More than likely, it comes from Tsang, where this tradition was sustained for centuries, especially in painting schools related to the many Sakya monasteries in that region.

The particular style of this work is fairly restrained, stressing an almost dry perfection of color and line. The incredible skill of line and the naturalistic beauty of the white robe, however, save it from pure formalism. Although the red, orange, and lavender-red colors brighten the pallet, they are somewhat muted in tonality, and they are different from the astonishingly bright and saturated colors seen, for example, in No. 73. Stylistically, the tangkas from this set would appear to date around the time of the Third Dalai Lama painting (No. 97), in the third quarter of the 16th century.

9	8	7	6	1	2	3	4	5
10	11	12				13	14	15
16	17	18			19		20	21
22								23
24								25
26								27
28								29
30								31
32								33
34	35	36	37	38	39	40	41	42

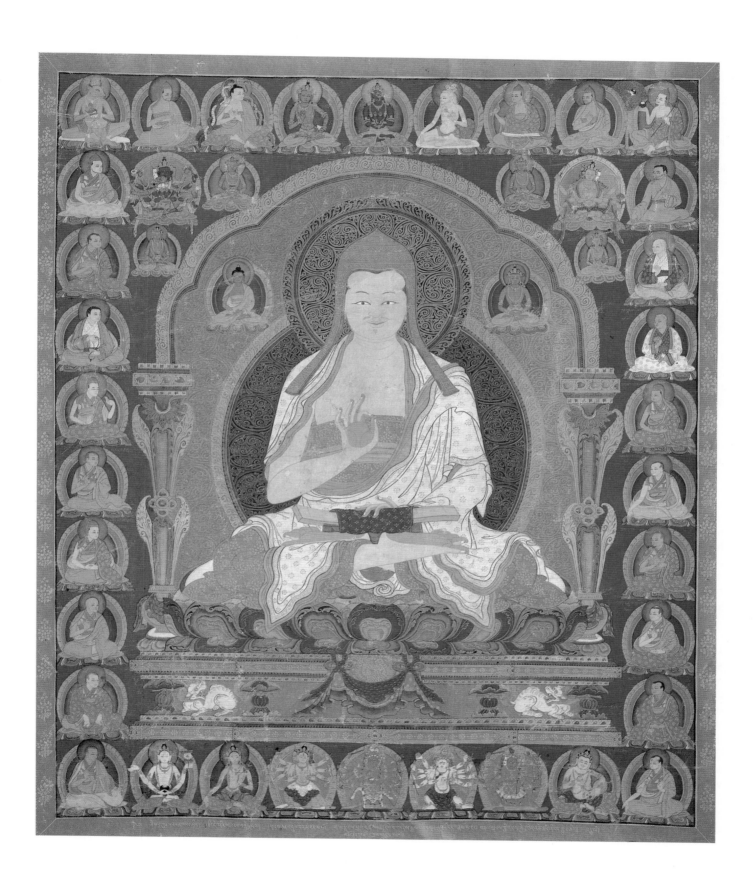

65

Kunga Tashi

Central Regions, Tibet; probably Tsang

Last quarter of the 17th century

Tangka; gouache on cotton

37 × 27¼" (94 × 69.2 cm)

The Los Angeles County Museum of Art, Los Angeles. From the Nasli and Alice Heeramaneck Collection. Museum Associates Purchase. M.83.105.16

Lit.: Tucci, 1949, pp. 372–73; Pal, 1983, pp. 156–57.

This painting is especially important for a number of reasons: first, because it can probably be dated to the period ca. 1675–1700 (Pal, 1983, p. 157), and second, because it reflects the newly flourishing style of painting of the period of the Fifth Dalai Lama (1617–1682), as seen in some of the wall paintings in the Potala in Lhasa. This tangka was acquired by Tucci at Sakya, the site of the large main Sakya monastery in Tsang.

The main subject of the painting, one Kunga Tashi of the Sakyapa, is a little hard to identify definitely. Tucci believed him to be the lama mentioned in the biography of the Fifth Dalai Lama as a contemporary "confirmed on his see in the year 1668." Pal and Richardson suggest other possibilities, including that he may be Kunga Tashi (1349–1425), who was the thirty-second abbot of Sakya monastery (Pal, 1983, pp. 157, 261–62). He is shown here accompanied by scenes from his life and by important archetype deities: above him to his right and left are Manjushri (Bodhisattva of Wisdom) and Tara (Female Bodhisattva of Miraculous Activity), embodiments of the factors of enlightenment. Directly over his head is another Sakya lama, undoubtedly of great significance in the lineage of the main image, and at the pinnacle is a small image of Vajradhara, representing the essence of all Buddhas. While the three deities above him are all white in color, the terrific deities below are all dark. In the center is Mahakala as Lord of the Pavilion, the special spiritual protector of the Sakyapa. He is flanked by two different forms of the black fierce female protector Penden Lhamo (Palden Lhamo). Seated on either side of the offering table at the foot of the lama's throne are the two donors of the painting who "pray to obtain the Lama's favor."

The figure of Kunga Tashi is asymmetrically positioned, imparting the illusion of being set slightly high and back into the picture plane. This is a distinctly different compositional configuration from the traditional symmetrical, strictly frontal format frequently encountered in earlier portrait paintings (Nos. 61, 64). Although integrated into the surroundings and relatively small in size, he nevertheless remains the largest figure and the center of attention. He sits in a relaxed and easy pose on a simply draped, arch-backed throne. Behind him, a flowering tree peony with dark flowers and gold-edged leaves provides a setting that is reminiscent of Chinese Buddhist painting. This marks a clear departure from the traditional shrine type of setting derived from the Indo-Nepalese tradition so prevalent in earlier Sakyapa paintings. In his left hand the lama holds an exquisite vase of immortality, the kind generally associated with the Buddha Amitayus. His right hand holds the stem of a lotus flower that in turn supports a book on which there is a flaming sword, both associated with Manjushri. He wears the hat associated with the Sakyapa; its red and gold colors, like the color theme in the whole painting, are strikingly offset by a plain green halo. He presents a personable figure, with a gently inclined head, and a slightly wistful and abstracted gaze. In style, it marks a transition between the linearity of 16th-century portraits (Nos. 64, 97) and the more idealistic styles of the late 17th to early 19th centuries (Nos. 66, 67, 82, 83).

His gorgeous robes are composed of thick layers of magnificent red and orange cloth, decorated with gold and lined and laced with dark and light green, blue, and lavender. The folds, full and free in movement, seem to have little relation to the form of the body beneath, as they descend on either side of him. The free curves and eccentric mannerisms of the hooked strokes and repetitive clusters of folds are elements of the daring and rapidly changing stylistic developments of 17th-century Tibetan art. Perhaps independently, the emphasis on movement and the lush beauty of the surroundings seem to parallel the Baroque-Rococo styles developed in European art at about the same time.

The scenes from the life of this lama are placed in richly graphic architectural settings, which lend a distinct touch of dimensional perspective to the painting. From the upper right in clockwise direction, the scenes (see diagram), as

suggested by the accompanying inscriptions, show him: 1) together with his treasurer, commissioning the making of a statue, which the lama is shown receiving; 2) offering gems to Kubera, the god of wealth, accompanied by a prominent donor (a monk in the clothing of Eastern Tibet, according to Tucci), who sits behind stacks of various offerings; 3) preaching the doctrine at the famous Throne of Dharma Temple on the banks of the Drum River in Tsang; 4) riding among a great entourage with packs of offerings and ritual objects "going to Yangtse for a divine ceremony"; 5) at the Puntsok Yangtse temple; and, 6) in the upper left, at the great Sakya monastery (whose distinctive huge inner courtyard can be distinguished), which is being repaired, presumably under the direction of Kunga Tashi.

The painting as a whole is powerful and active. Though there are pastel touches of mauve, pale green, and pale yellow, the dominant color scheme of green and orange-red effectively controls and unifies the painting. This style also marks the wall paintings in the Potala at this time, indicating its prevalence in the central regions. Even though there are many landscape elements, such as clouds and trees, landscape essentially acts only as a filling element and is not an equal partner with the architecture and figures as it is in the Eastern Tibetan schools at this time. The increased freedom in the placement of forms in a slightly more plausible perspective is provided primarily by the architectural settings in the painting. The beauty of this style lies in its powerful dynamism, its sumptuously rich color and decor, and its greater sense of realism, which involves the viewer very directly and intimately.

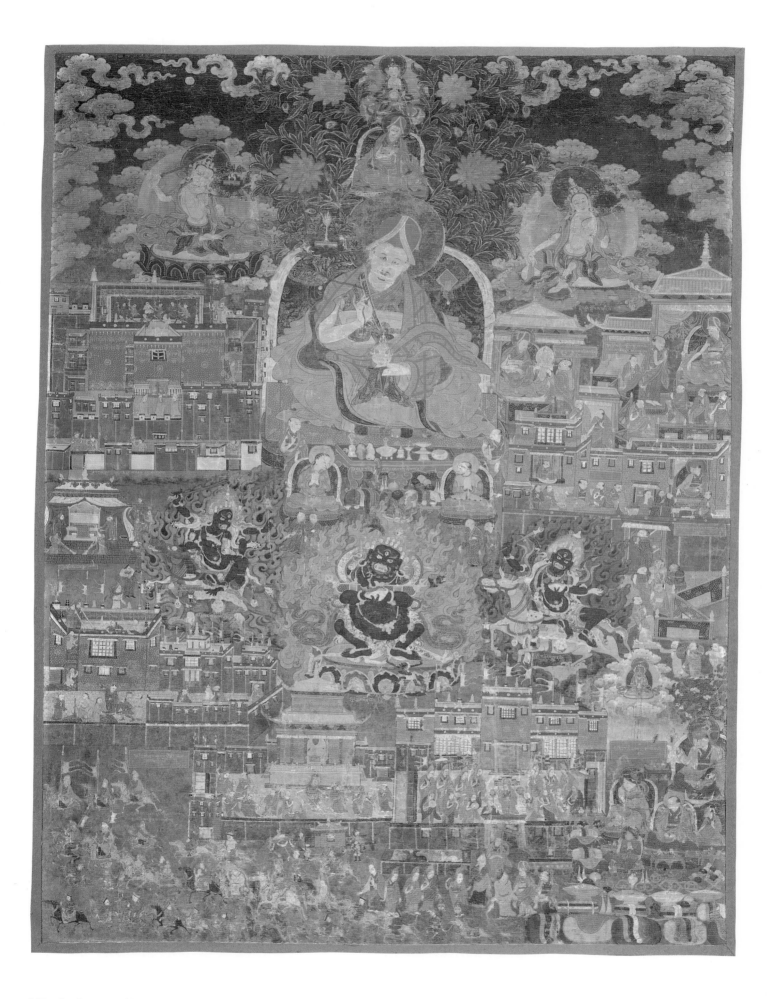

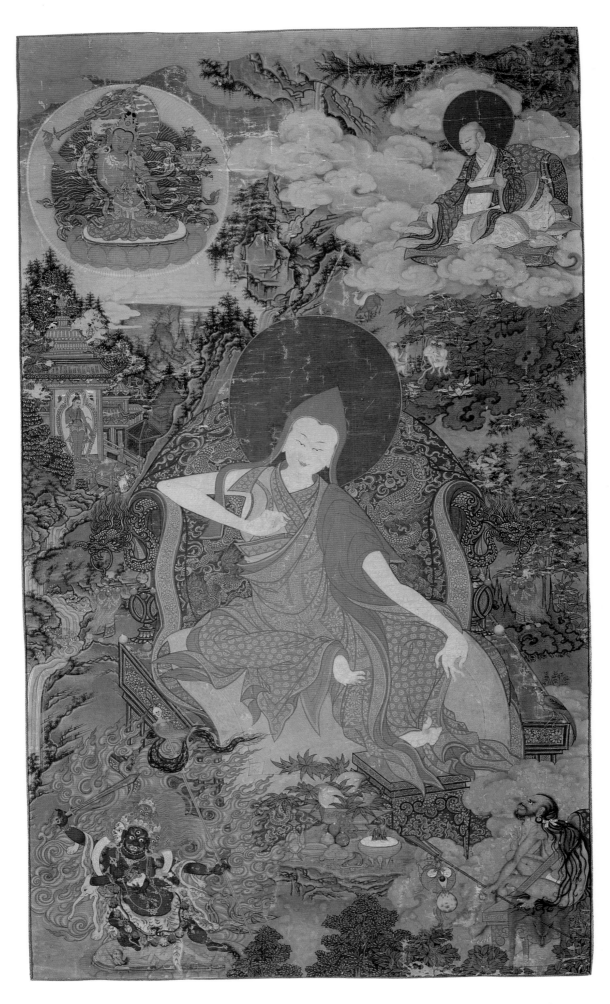

66
Sakya Pandita

Central Regions, Tibet; probably Tsang

Mid-18th century

Tangka; gouache on cotton

24½ × 14″ (62.3 × 35.6 cm)

Collection of The Newark Museum, Newark, New Jersey. Purchase 1969, Felix Fuld Bequest Fund

Lit.: Reynolds et al, 1986, pp. 158–60.

Sakya Pandita (1182–1251) is one of Tibet's most revered lamas. He is believed to be an incarnation of the Bodhisattva Manjushri, the embodiment of the wisdom of all Buddhas. He is renowned for his consummate skills in language and debate as well as in the ten branches of learning, which were perfected before he was twenty-seven years old. In Nepal, on his return to Tibet from study in India, he met and defeated in debate a prominent Hindu brahman yogi, Harinanda (depicted in the lower right corner of this tangka). The brahman became his disciple and returned to enter his monastery, but died before reaching Tibet.

In 1240, at the eve of further Mongol conquests across Asia, a main ruler of the Mongols, Godan Khan, invaded Tibet. He requested that Sakya Pandita, the most revered lama of his time, come to him in Lanzhou, in northwest China. Sakya Pandita did go, arriving in 1247 together with his young nephew, Pakpa. Sakya Pandita had a positive effect on Godan Khan, persuading him to stop casting the Chinese into the Yellow River and not to destroy any more Buddhist countries. He was the first Tibetan lama to create a priest-patron relationship with a powerful non-Tibetan ruler. This tradition was continued by Pakpa later in the 13th century, when he became the spiritual preceptor of Khubilai Khan.

Sakya Pandita is also considered an incarnation of the Panchen Lama lineage and as such he often appears in sets of Panchen Lama incarnation paintings, following the prototype established by the famous Narthang woodblocks of 1737. This painting is probably from such a set. With its relatively secure dating and regional affiliation, this painting is an important document and an excellent example of a major style.

In general layout the painting is rather symmetrical, with Sakya Pandita in the center and two figures in each corner. However, the lush profusion of landscape

and the numerous diagonals within the composition create an engaging asymmetry and a feeling of movement and depth. Sakya Pandita is the graceful center, made prominent by his position, size, and energetic posture. The plain circle of his halo creates a quiet focal point amid the maze of detail. He is seated on an ample throne, which is covered with brocaded cloth whose designs seem to merge into the texture of the rocky landscape behind him. He is dressed in beautifully patterned yellow and red robes, and he wears the red hat of an Indian Buddhist pandit, similar to that of Gayadhara (No. 64). He sits so intently in the posture of formal debate that his hands and fingers, and even feet and toes, are curling with the force of his passion to deliver his reasoning precisely to the brahman ascetic squatting down below him. Like an archer drawing his bow, his torso twists with controlled power beneath his robes, totally focused on aiming the arrow of his liberating wisdom at its target of delusive notions. His body is tall and his limbs slim, exaggerated in their length and elegance. His face seems idealized in its perfection, lifted calmly above his active body. The mannered distortion of the figure heightens his mystical aura, while at the same time his naturalistic liveliness emphasizes his engaged interaction with his surroundings. Drapery and body are made into beautiful abstractions of line and shape. This particular realistic style, juxtaposing manneristic, idealistic, and mystical elements, comes into full flower by the mid-18th century and continues as a main style for the next century or more.

Although Sakya Pandita may appear sublime, the landscape around him and the other figures, birds, and monkeys appear highly realistic. The orange Arapachana Manjushri is in the upper left corner, holding the sword and book. Lama Dakpa Gyaltsen, the predecessor and main teacher of Sakya Pandita, is in the upper right corner. The four-faced, four-armed

Mahakala stands in the lower left, and the brahman Harinanda squats naked with long matted hair, meditation cord, and ascetic's staff, in the lower right corner, gazing up at Sakya Pandita. The landscape, colored in natural tones of greens, browns, and some blues, creates a rich tapestry effect with its minutely detailed and textured rocky cliffs, rushing streams and waterfalls, dense pine forests, leafy trees, and thick pastel cloud banks. At the left, the zigzag course of a stream leads the eye back to a large shrine, and beyond it one catches glimpses of distant peaks and overlapping rocks. These elements, completely out of logical perspective, create a mixture of concave and convex "warped" spaces and masses that almost seem to anticipate the modern theories of relativity and chaos. In 17th-century Chinese landscape painting, this kind of space-mass effect is known in the theories of Dong Qichang as the use of concavity and convexity to create "momentum." Here the realistic detail makes these strange intuitive landscapes so acceptable, we hardly realize their incongruity. They provide the inner dynamics of the painting and readily incorporate the manneristic style of the main figure. This subtle play of the real and the surreal is so skillfully done that we are able to accept the merging of two incompatible worlds as perfectly real. It is a masterful artistic counterpart of the traditional Buddhist practice of the reconciliation of dichotomies (yamaka-vyatyastahara). We can learn directly from this art, as a visual teaching by-passing the difficulty of words, about the Buddhist insight into the nondual nature of reality. It is fitting that this message should come so clearly in this portrayal of Sakya Pandita, the incarnation of the god of wisdom, in the act of using critical reason to communicate the true nature of reality. It is an interesting coincidence that the movements of masses and the refined details of this painting style are not unlike the rich Rococo style of European art.

67
Butön Rinchen Drup

Shalu monastery, Tsang, Tibet

Late 17th century; painted by Kyenrab Jamyang

Tangka; gouache on cotton

34¾ × 24¼″ (88.3 × 61.6 cm)

Asian Art Museum of San Francisco.
The Avery Brundage Collection

Lit.: Bartholomew, 1987; Tucci, 1949; Pal, 1983; Ruegg, 1966.

This portrait of Butön Rinchen Drup stands out both for its artistic merit and historical significance. Butön Rinpoche (1290–1364) was an abbot of Shalu monastery. Located in Tsang, Shalu is southeast of Tashi Lhunpo. This non-sectarian temple is small in size but distinctive. Originally constructed by the princes of Shalu in the 11th century, the temple was restored in 1333 while Butön Rinpoche was abbot in residence. Butön was a remarkable man and the restoration of Shalu is only a small part of his achievement. His genius lies in his revision of the entire religious literature of Tibet, compiling and organizing it into the two great canonical works, the Kanjur and Tanjur. His own writings cover nearly every aspect of Buddhism. His treatises on the tantras describe the mandalas of the various cycles with such precision that they served as the foundation for iconographic schemes followed by painters of later generations.

This tangka is from Shalu itself. It is one of the rare paintings depicting this great master. It is large, almost three feet in height, painted on a black background. It is mounted with the customary Chinese brocade, in this case part of a dragon robe. A large figure of Butön Rinpoche dominates the painting. He sits in meditation on a lotus pedestal above an elaborate lion throne. His hands, in the gesture of teaching the Dharma, hold the stems of a pair of lotuses that float at shoulder level. The red lotus at his right carries a vajra scepter, while a bell rests on the white lotus at his left. Butön Rinpoche wears the elaborate robes of a lama and a yellow hat. A green halo shines behind his head. Fine lines of gold emanate from his body, forming a golden aureole around him that separates him from the rest of the composition.

A total of fifty-eight figures surround the central image. The late Venerable Sonam Gyatso, Thartse Abbot of Ngor monastery, has kindly identified them as follows (see accompanying diagram):

Butön Rinpoche (1) is flanked by two of his disciples. The one on the right (2) is Dratsepa Rinchen Namgyal, 1318–1388, a great scholar who held Butön's lineage of teachings and authored his biography. The other disciple on the left (3) has not been identified. The primordial Buddha Vajradhara (4) surmounts the tangka (67.1). He is accompanied by the Buddha Shakyamuni (5), an Arhat (8), the future Buddha Maitreya (6), and the Bodhisattva of Compassion, Avalokiteshvara (7). A snake-hood canopy identifies the monk on the right as Nagarjuna (9), the famous Indian philosopher of the 1st to 2nd century CE. He is grouped with one yogi and several Indian pandits and lamas. Toward the bottom, we find the great Indian teacher Atisha (10), who once resided at Shalu, and his student Drom Tonpa (11). The Great Adept Tilopa (12) sits on the left, holding a fish and surrounded by Indian yogis, pandits, and monks (67.1). The monk in the lower left corner (13) is Tsong Khapa (1357–1419), the great reformer of Tibetan Buddhism and founder of the Geluk Order. The sword and book he holds indicate that he is considered an emanation of Manjushri, Bodhisattva of Wisdom. The group below Butön Rinpoche is headed by (14) the Fifth Dalai Lama, Losang Gyatso (1617–1682), shown with his characteristic mustache and holding the wheel of the Law. To his right is Panchen Losang Chögyen (15). The figure below the Fifth Dalai Lama, carrying a lotus and a vase of long life, can be identified as the Sixth Dalai Lama, Rinchen Tsangyang Gyatso (16). In the lower right-hand corner, the lama with an unusual hat (17) is probably Gyalwa Ensapa, a famous mystic and previous incarnation of the Panchen Lama. The first Panchen Lama was considered the fruition of a tradition of contemplative (T. ensapa) lamas, who would spend much of their lives on retreats and are identified by this type of hat.

This is an idealized portrait of Butön (67.1); he is usually shown as an older and thinner man. Although the teaching gesture is associated with his image, the attributes of a vajra and bell are unusual. In fact, such an image is easily confused with that of Sakya master Ngorchen Kunga Sangpo, who makes the same gesture and carries a vajra and bell. Only the accompanying figures and the inscription on the back of the painting positively identify the image as Butön Rinpoche.

The dedicatory inscription on the back of this tangka is of considerable historical interest. Anonymity is the rule in Tibetan paintings; this is one of the rare occasions when the artist's name is mentioned. As translated by the late Venerable Sonam Gyatso, the main painter was Kyenrab Jamyang, who worked with several assistants. Manga Ratna was the benefactor of the painting. The inscription further states that this tangka is the first of a collection of eleven that depict the lineage, deities, and Dharma protectors of the teachings propagated by the Shalu school founded by Butön Rinpoche. Both benefactor and painter express their wish that the benefit resulting from the work help spread the teachings of the school.

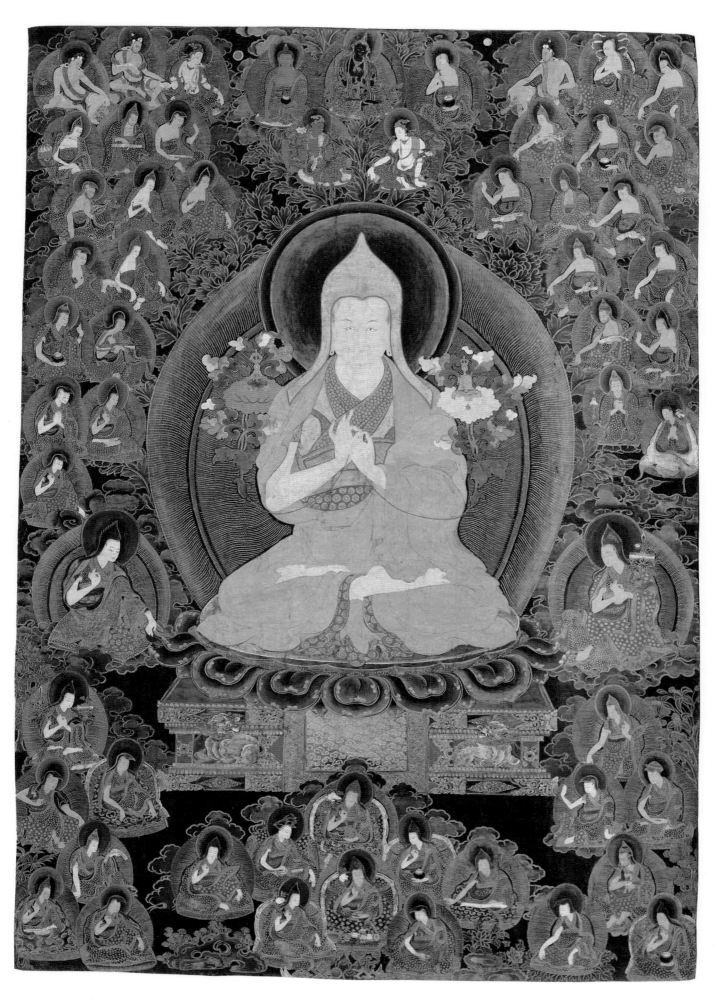

67.1

Above the inscription are two hand prints, made by the unknown lama who consecrated this tangka.

The tangka is not dated, nor are the names of the artist and benefactor otherwise known to us. However, the presence of the Fifth and Sixth Dalai Lamas suggest a date of late 17th century. As a sign of respect, it was customary to include the spiritual figures of the time holding auspicious objects, in this case the wheel of the Dharma held by the Fifth Dalai Lama and the long-life vase carried by the Sixth.

The back of the mounting provides further evidence that the central figure is Butön Rinpoche. An embroidered inscription is sewn on the very top, so that it is in full view when the tangka is rolled up. It reads: "gtso bo thams cad mkhyen pa." Tamjey Kyenpa, or Omniscient One, is a well-known epithet of Butön Rinpoche, and Tsobo, meaning Principal One, refers to Butön Rinpoche as the principal founder of the school. This important tangka is the first among the eleven paintings by Kyenrab Jamyang alluded to in the inscription.

T. Bartholomew, with the assistance of the late Venerable Sonam Gyatso

Shamvara Paramasukha-Chakrasamvara

Central Regions, Tibet, or Western Tibet

12th to early 13th century

Brass, with silver inlay and remains of cold gold paste and pigment

H. 13″ (33 cm)

The Zimmerman Family Collection

Lit.: Rhie and Thurman, 1984, p. 22; Pal, 1986, p. 168.

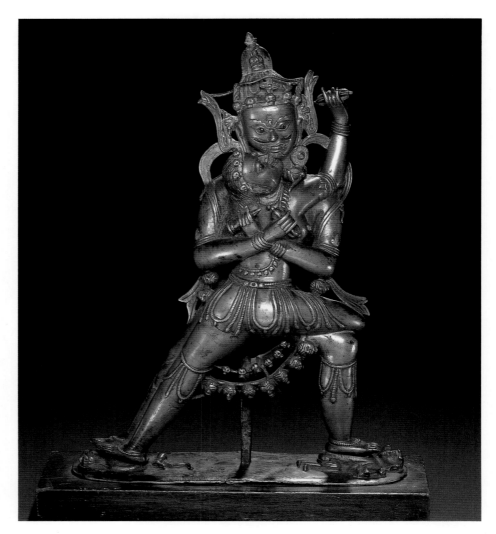

This unusual and powerful sculpture is one of the rarest to survive from the early period of Tibetan art. It is a one-faced, two-armed, father-mother form of the tantric archetype deity Paramasukha (Supreme Bliss) Chakrasamvara (Wheel Integration). Western scholars have become accustomed to call this deity Samvara or Chakrasamvara, but the Tibetans always prefer *bDe-mchog*, which translates the Supreme Bliss (Paramasukha) part of his name. The confusion arose perhaps because the word *shamvara* (not *samvara*) can be a synonym of *paramasukha*. Here we usually refer to this archetype as either Shamvara or Paramasukha-Chakrasamvara. The *Supreme Bliss Wheel Integration Tantra* is considered the ultimate Mother tantra, in that its literature has the most developed technology of contemplative cultivation of the clear light of freedom (*shunyata-prabhasvara*). The myth is that the Buddha emanated the mandala-palace and adopted this archetype deity form to teach the tantras to Shiva and Parvati on top of Mount Kailash at the headwaters of the Ganges in southwestern Tibet.

Here we see Shamvara in mystic union with his female aspect, Vajravarahi (Diamond Sow), symbolizing the blissful union of compassion and wisdom that is the actuality of enlightenment. His face is highly intense. His furrowed, scallop-lined brows are rippling. His mouth stretches wide, exposing his fangs which grind up the false world appearing to materialistic perceptions. The third eye that always sees ultimate reality directly is positioned vertically between his brows. He has a beard and swept-up mustache. Both the mustache and principal eyes are inlaid with silver. His unusual circular earrings with a star pattern apparently once held an inset gem. His two arms embrace Vajravarahi. His small hands cross behind her back in the diamond HUM-sound gesture, simultaneously holding a vajra and a bell, symbols of wisdom and compassion, or

clear light and magic body. She also has an expression of fierce passion. Her main eyes are also inlaid with silver. She encircles his neck with her left arm, the skull bowl in her left hand reaching around his neck to the front. Turning slightly to her right, she raises her right arm above his shoulder, brandishing a vajra. She follows his vigorous warrior's pose, but folds her right leg around his thigh. They emanate small deity images that symbolize ordinary maleness and femaleness, and hold these deities under their feet, thus showing that there is no ordinary greed or delusion in their transcendent passion. Both have the flaming red hair (the paint may be later remains) characteristic of the terrific archetype deities. Small five-skull diadems frame their foreheads. Crown ribbons arch stiffly upward on either side of Shamvara's head. He has a high, unusually plain topknot with a jewel ornament, in front of which sits a small figure of Vairochana Buddha. Usually Shamvara's clan lord is Akshobhya Buddha. But since Vairochana is clan lord of his consort Vajravarahi, possibly he wears Vairochana in deference to her or to acknowledge or underline the Mother

tantra aspect. He wears two long garlands, one of small skulls and the other of freshly severed heads. These stand for the negative attitudes obstructing liberation from the binding forces of self-conception. They are worn here, as by all fierce deities, as decorations.

The bodies of these figures are smooth and sleek. Somewhat incongruously, they appear both sturdy and delicate at the same time. The small and fragile appearance of the hands and chubby feet contrasts with the thick legs and torso, making the figure at once heavy and light. Shamvara's stiff and plain scarf reinforces the delicacy of the sculpture, but the jewels, hung in loops as leg ornaments and as a girdle for Vajravarahi, have a thick and soft effect as they adhere to the body surfaces. This particular style of jewelry can be seen on figures in 12th-century tangkas from the central regions (text fig. 11) and in some deities in the wall paintings of the Lhakhang-soma at Alchi in Ladakh (ca. late 12th to early 13th century), correspondences that suggest a similar dating for this rare early statue of one of the most important tantric deities in Tibetan Buddhism.

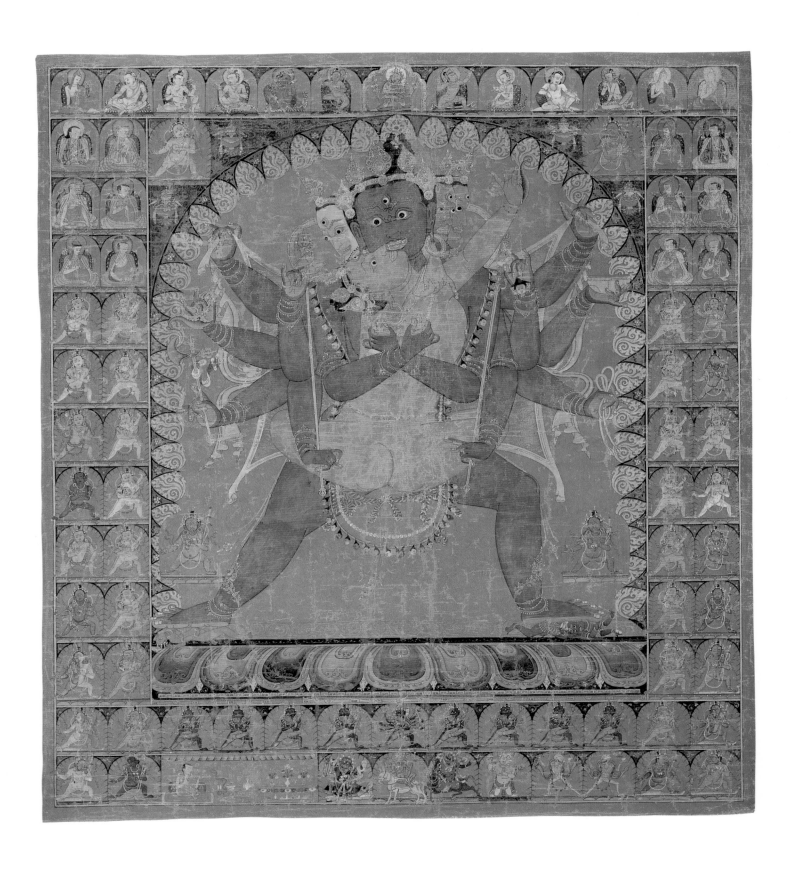

Paramasukha-Chakrasamvara Father-Mother

Central Regions, Tibet

Late 14th to early 15th century

Tangka; gouache on cotton

31½ × 29″ (80 × 73.7 cm)

Robert Hatfield Ellsworth Private Collection

Lit.: Tucci, 1949, p. 332.

A work of powerful grandeur and precise detail, this painting is one of the most magnificent large tangkas to survive from early Tibetan Buddhist art. It represents the tantric archetype deity Buddha Shamvara (see Nos. 68, 70, 92, and the essay "Wisdom and Compassion: The Heart of Tibetan Culture," for more explanation). The contemplative sciences of the Shamvara literature focus on internal practices designed to develop mastery of the clear-light-mind. His tantra is studied by all four orders, being particularly popular with the Kagyu, Sakya, and Geluk orders. It is difficult to be exact as to the precise style of visualization underlying this tangka. According to the Venerable Tara Tulku, it is the mandala emanated by Vajradhara (represented in this tangka directly above the main pair) onto the top of Mount Kailash in order to control Ishvara (Shiva). The dark blue male with green female consort, both with eight arms, located in the center of the row just below the main pair are probably Shiva and his consort. The extra twelve deities (beyond the usual sixty-two) in the assembly, and the main Mother's posture with both legs around the Father's waist are unusual features. In this remarkable and richly symbolic manifestation, both the male and female are the Buddha. They appear simultaneously united and independent, like the complex relationship of sameness and difference between wisdom (female) and compassion (male) in the enlightened state.

Elephantlike, ponderous, energetic forms confront the viewer in this stunning portrayal. Balancing in the warrior's pose, Shamvara embraces the massive red body of his consort Vajravarahi, holding in his twelve hands various implements symbolic of his triumph over ignorance and evil. She is adorned in a delicately jeweled five-skull diadem, a coiffure gem, and wears bone earrings, necklace, armlets, bracelets, and anklets, and an almost imperceptibly thin bone girdle. A jeweled waistband is a rarely seen added ornament. She gazes rapturously and intently at her consort with her head thrown back, heightening their electrifying aura. Her right arm is thrust upward, the hand grasping a vajra chopper. Her left arm winds tightly around Shamvara's neck, her left hand coming all the way around to pass over her own right shoulder, while holding a skull bowl. Both are symbolic implements for destroying and transmuting the deep-seated egotistic processes within us. He has four faces, blue (front), yellow (right), red (back), and green (left), which symbolize four of the Buddha wisdoms. His three red-rimmed eyes glare intensely and his open mouth shows a curling tongue and four small fangs. In contemplative visualization, the practitioner circumambulates the deity, who stands in the center of the mandala-palace.

Each implement in Chakrasamvara's twelve hands is distinctly portrayed. His first two arms embrace his consort, his hands holding a vajra and a bell while making the diamond HUM-sound gesture with crossed wrists. With the next pair of arms, held uppermost, he stretches the flayed skin of the mad elephant of ignorance, portrayed in rose red with a textured design and a gold border. Two hands behind his consort's hips hold vertical staffs, the right one a vajra trident, and the left one a *khatvanga* staff, crowned with three heads in different stages of decomposition and a small vajra. His other right hands hold a drum, a small ax, and a vajra chopper, and his other left hands hold a four-faced Brahma head, a skull bowl filled with devil blood, and a lasso. The twelve arms symbolize the twelve links of dependent origination, and the implements symbolize the experience of overcoming specific obstructions inherent in self-centered consciousness. Encircling his broad shoulders and falling between his legs is a long garland of freshly severed heads representing his conquest and transformation of egotistic mental processes. A more delicate garland of tiny skulls dangles from around her neck. The tied ends of his tiger-skin loincloth stretch between his thighs.

Behind the figures glow the flames of a crimson aura, its filigree edges patterned into stylized clusters like a rim of heat-radiant gold leaves. Four of the fierce female Buddhas who dwell in the great bliss circle in the center of his mandala-palace are depicted in the four directions: blue Dakini by his right foot, green Lama by his left foot, red Khandarohi over his left shoulder, and yellow Rupini over his right. Four initiatory vases float in the murky sky patterned with delicate floral vines, and tiny flower clusters are interspersed between leaflike flames within the dark outline of the mandorla. Under Shamvara's chunky, red-soled feet lie the prostrate bodies of his own emanated deity forms, a four-armed red female Kalaratri and a four-armed blue male Bhairava. He stands on them to show his conquest of even the most divine forms of egotism, even the most heavenly forms of ordinariness. The broad lotus base is painted with five alternating colors; each petal is outlined with the thin, crisp, sleek, and dexterous black line that characterizes the linear style of this tangka. The thin and delicate style of the petals is similar though less elaborate than that in the slightly later Raktayamari tangka in No. 77. The gold and jeweled ornaments of the main pair are more sumptuous than the adornments of the Khara Khoto Shamvara, which can be dated to before 1227 (No. 92), and they prefigure the style seen in the Gyantse Kumbum images in the second quarter of the 15th century. The broad planes of color, using little or no modeling, are bold, dense, and stark.

Numerous images related to the Shamvara lineage and mandala appear in serial form around the central realm of the Buddha couple with their four inner goddesses (see diagram). The first circle around that inner, great bliss, circle is the mind circle, with sixteen blue deities in eight couples. The next circle out is the speech circle, with eight red deity couples. The outer circle is the body circle, with eight white couples. There is a fifth circle outside the three wheels (the blue, red, and white circles) called the commitment circle, where important bicolored fierce deities are located. From left to right (see diagram) working downward from the top left corner (69.1) there are: 1–5) Mahasiddha figures, the first a monk Great Adept and the fifth the Great Adept Virupa, recognizable by his brown color, 6) a red Indrabhuti Dakini, 7) Vajradhara, 8) a red Maitri Dakini, 9–11) three Great

1	2	3	4	5	6	7	8	9	10	11	12	13
14	15										16	17
18	19										20	21
22	23										24	25
26	27										28	29
30	31										32	33
34	35										36	37
38	39										40	41
42	43										44	45
46	47										48	49
50	51										52	53
54	55	56	57	58	59	60	61	62	63	64	65	66
67	68	69	70	71	72	73	74	75	76	77	78	79

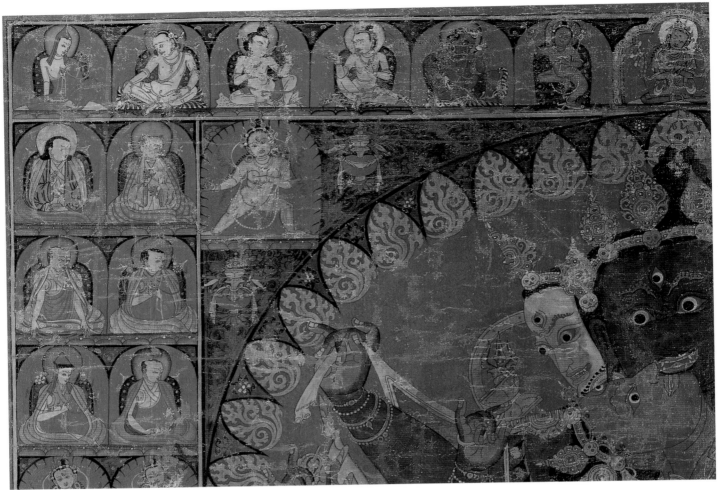

69.1

Adepts, 12 and 13) two lamas; on the second row: 14–17) four lamas, two on the left and two on the right, some lay and some monastic from the Sakya Order; and on the third and fourth rows: 18–25) four lamas on each side, all monastic. From the fifth row down on both sides are deities from the mandala: down the left outside, 26, 30, 34, 38, 42, 46) six Hero Yogi deity figures, white, white, red, blue, red, blue, respectively; down the left inside, 27, 31, 35, 39, 43, 47), four white body-circle Hero-Heroine couples and two red speech-circle Hero-Heroine couples; down the right inside, 28, 32, 36, 40, 44, 48) four white body-circle Hero-Heroine couples and two red speech-circle Hero-Heroine couples; and down the right outside, 29, 33, 37, 41, 45, 49) six Yogini figures, red, blue, white, yellow, blue, blue. The eleventh row down has: 50) a half-blue, half-yellow Yamadadhi southeast female protector, 51 and 52) red speech-circle Hero-Heroine couples, 53) a half-red, half-green Yamadamshtri northwest female protector, 54) a half-yellow, half-red Yamaduti southwest female protector, 55 and 65) two red speech-circle Hero-Heroine couples, and 66) a half-green,

half-blue Yamamathani northeast female protector. Along the top layer of the bottom (69.2) are: 56–59) four blue mind-circle Hero-Heroine couples, 60) a multiarmed blue deity couple, probably a form of Shiva and his consort Parvati, and 61–64) four blue mind-circle Hero-Heroine couples (69.3). Finally, along the bottom layer of the bottom, there are (69.2): 67) a yellow Sukarasya southern female protector, 68) a black Kakasya eastern female protector, 69–71) the donor monk with offering tables before him, 72) Black-Cloaked Mahakala, 73) four-armed mule-mounted Shri Devi, 74) another horse-mounted, robed deity, perhaps Jambhala, 75) white Mahakala, 76 and 77) the Kinkara skeleton couple, special protectors of the Shamvara lineage, 78) a green Ulukasya northern female protector, and 79) a red Shvanasya western female protector (69.3). Every one of these figures is superbly portrayed, each against a similar stark red halo set against a blue ground. The predominance of red in this painting, together with the large halo, puts the great blue figure of Shamvara with his red wisdom consort in a dominating position.

Although it utilizes the stylistic traditions of 14th-century Nepalese Buddhist art, this painting is nevertheless thoroughly Tibetan in its juxtaposition of powerful masses and vivaciously energized, yet controlled and crisp, firm line. There is an urgency and drama in the forms that is characteristically Tibetan. Its monumental scale, as noted by Tucci, relates it to some of the major wall paintings seen in the Gyantse Kumbum temple of the early 15th century. However, the clear stylistic similarities with the Raktayamari tangka in the Zimmerman collection (No. 75), datable to the second half of the 14th century, suggest a more positive dating around that time. In fact, it may be from the same stylistic school or monastery as the Raktayamari and other tangkas associated with this distinctive style. The presence of early Sakya hierarchs such as Kunga Nyingpo would affirm its Sakyapa association. It is of major significance as a late 14th-century monumental work prior to the Gyantse wall paintings of the second quarter of the 15th century, and for the definition of an obviously important artistic style associated with the Sakyapas in the second half of the 14th century.

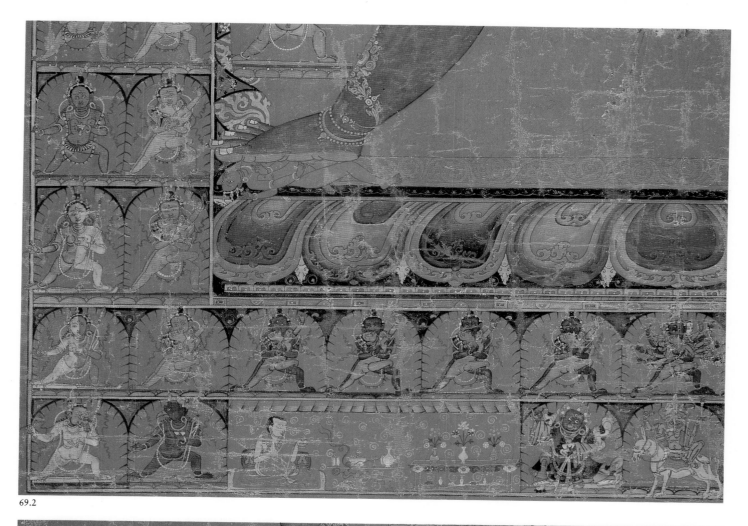

69.2

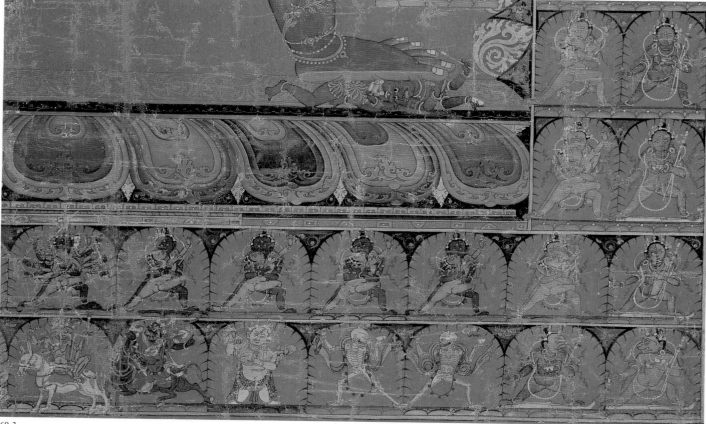

69.3

70

Paramasukha-Chakrasamvara
Father-Mother
(Variant Face Style)

Central Regions, Tibet; probably Tsang

Late 15th to early 16th century

Tangka; gouache on cotton

24 × 18″ (61 × 45.8 cm)

Robert Hatfield Ellsworth Private Collection

This tangka is the same tantric archetype Buddha as sculpture No. 68 and tangka No. 69. One of the loveliest paintings of this icon in Tibetan art, it is a perfect archetype image of the ecstatic union of wisdom and compassion (see full discussion in the essay "Wisdom and Compassion: The Heart of Tibetan Culture"). It is, in most respects, the usual Fruitional Emanation Body form of Shamvara, in union with his bright red female wisdom, Vajravarahi. In variation from the usual Shamvara, who has (clockwise from the front) dark blue, yellow, red, and green faces, in this tangka his front face is storm-cloud blue-black; his right face, white; back face, yellow (seen in two dimensions as behind his left face); and left face, red (detail, jacket front). The three eyes of his front face gaze adoringly at the upturned face of his consort and look out cheerfully at us. He is smiling, and his teeth seem to gleam with energy. His dark blue body is the strongest element in the painting. The sensitive modeling of the shapely limbs and youthful face compels our attention. The modeling does not follow the dictates of external light; instead, light seems to radiate from the body itself, heightening the muscular shaping and imparting a mildly rounded dimension and substantial reality to the figure. Each implement that Shamvara holds in his hands is portrayed in perfect clarity. His front two arms

embrace his consort, the hands holding a vajra scepter and bell while making the diamond HUM-sound gesture. His next right hands hold a *damaru* drum, a vajra chopper, a trident, and an ax. His next left hands hold a *khatvanga* staff, a severed, four-faced Brahma head, a skull bowl, and a lasso. With his back two hands he lifts up the freshly flayed skin of the elephant of ignorance, which spreads behind him like a cape. The customary garlands of skulls and heads and the five skull crowns are also present, and one catches a glimpse of his tiger-skin loincloth.

His partner, Vajravarahi, is beautiful in appearance and expression with a shapely and energetic form. She is an appealing red color, without modeling. Her hair is black and she wears the finest gossamer strands of carved white bone in her girdle, as well as in her bracelets and anklets. Shamvara is also delicately adorned with similar light jewelry, whose style seems to descend from the jewelry fashions of Orissan art of the 13th century. From eastern India, this style passes through Nepalese art. This jewelry style is but one of a number of features this tangka has in common with Nepalese art, another being the stunning modeling style noted earlier. A flame halo with a background of red on red is rimmed by large flames shaded vividly with orange, pink, and yellow, each flicker outlined in dark red. The pedestal has an orange surface that represents the

solar disc of spiritual energy. Delicately shimmering transparent planes and lines of yellow, light blue, orange, and lavender form the intricately detailed lotus and pedestal base. A border of rose red with gold-lined flowers completes the tangka. The artist's black line drawing of a flame pattern that appears in the upper left margin was originally covered by the cloth frame, but revealed when this was removed.

Continuing the predominating pale tonality accented with bright colors, rows of Sakya lamas line the lower sides and bottom around the main central panel, and Mahasiddhas line the upper sides and top. Two large and two small lamas are seen to left and right above the deities' encompassing halo. A monk kneeling in worship before the deity in the lower left corner is probably the donor. Jambhala, god of wealth, sits next to him, with his jewel-spouting mongoose. Each of these figures sits under a trefoil-arched shrine with a red interior and elaborate pillars typical of paintings of the late 15th and early 16th centuries. The drapery of these small figures is remarkably loose and free, in the Chinese mode, although this has become thoroughly assimilated as a Tibetan style. Similarities with the sophisticated styles seen in the Kumbum monastery of Gyantse of earlier date suggest a similar regional affiliation for this elegant tangka.

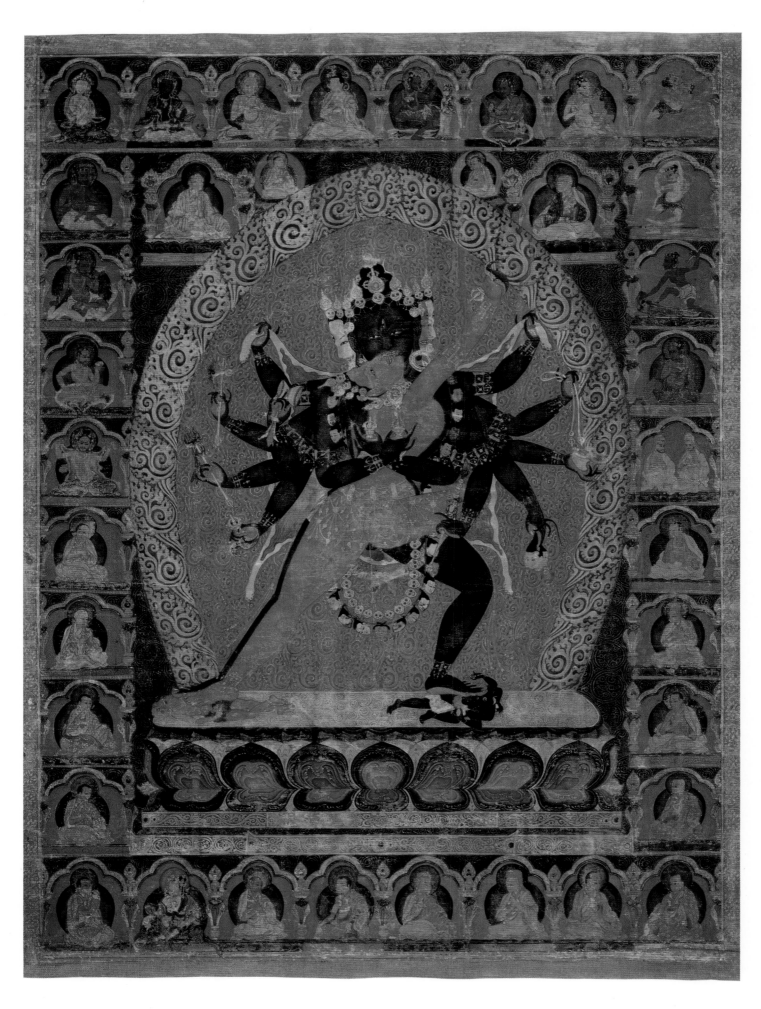

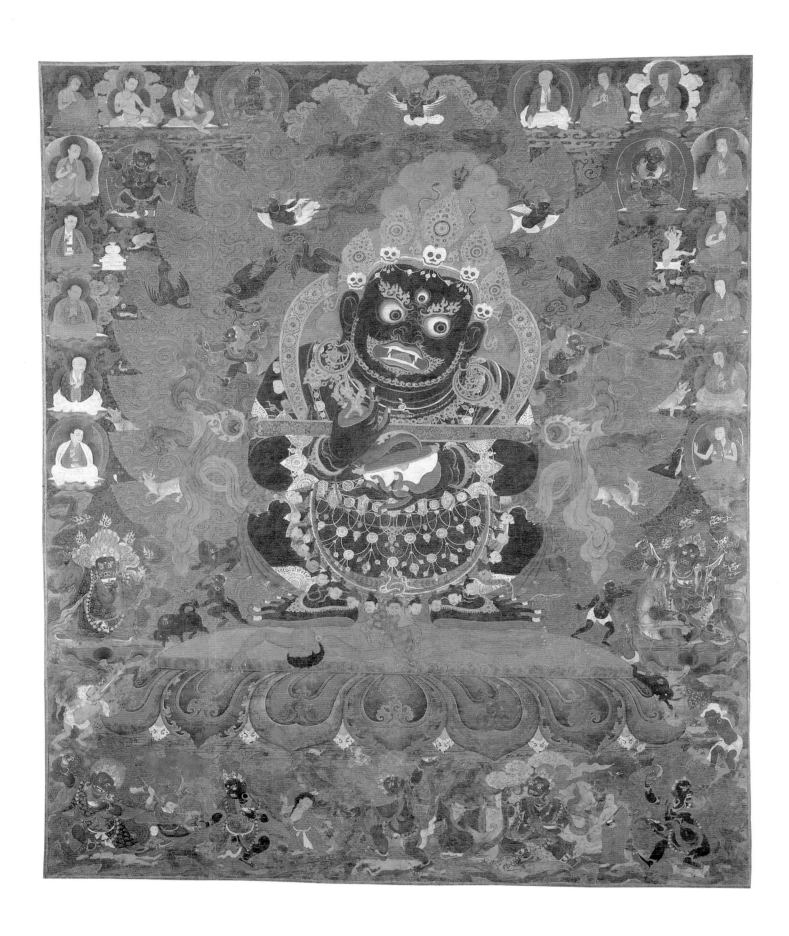

71
Mahakala Panjaranatha (Lord of the Pavilion)

Central Regions, Tibet; probably Tsang

First half of the 16th century

Tangka; gouache on cotton

63½ × 53½″ (161.6 × 136 cm)

The Zimmerman Family Collection

Grinning wildly and fiery eyed, this monumental image of the Great Black One stands heavily on the body of a corpse. He holds before him a huge vajra chopper and a large white skull bowl full of the blood and guts of demons turned into elixir. He carries across the crooks of his elbows an ornamented wooden *gandi* gong, used in Buddhist monasteries to call the monks to assemblies, symbolizing his vow to protect Nalanda monastic university and by extension all Buddhist monasteries. In his immediate environment he is surrounded by hags, jackals, a flock of crows, birds, and other animals of prey. Parts of bodies floating in the sky contribute to the frenzied action within a kind of smoky, twilight world. The ornaments worn so elegantly on his chubby black body and gigantic head include jewel-encrusted gold crown, scarf, necklace, earrings, and anklets, accompanied by an equally elaborate set of delicately detailed armbands, legbands, bracelets, and a netlike skirt, all of carved human bone. Garlands of severed heads and snakes and the chalk-white five-skull crown complement the bone ornaments and his glowing eyeballs and gleaming teeth. Each of these specifically symbolizes the conquest of a particular type of obstruction of enlightenment. Mahakala takes a terrific form and conquers the most horrible realms of existence. As a fierce manifestation of Avalokiteshvara, the Bodhisattva of Compassion, Mahakala helps beings overcome all negative elements, especially spiritual ones, personified and symbolized by the panoply of fearsome creatures over which he becomes lord. He wears his grisly ornaments to show his indefatigable determination to redeem even the horrible.

71.1

This particular form of Mahakala, easily recognized by the wooden gong he carries across his arms, is a favorite protector deity of the Sakya Order.

Around the upper borders are several Indian Mahasiddhas and Tibetan lamas of the Sakya Order (71.1), including Sachen Kunga Nyingpo and Sakya Pandita on the upper right. At the four corners of the halo and pedestal are other forms of Mahakala, including Brahmanarupa with a thighbone trumpet. Along the bottom, from left to right, are five large members of Mahakala's retinue interspersed with smaller figures representing various classes of people (71.2).

Though large and imposing in scale, this painting is fairly subdued in color. The blues, greens, reds, and browns that predominate emit a gentle, earthy, naturalistic aura rather than the strongly celestial allusions created by the brilliant colors seen in some other examples of Sakyapa art (Nos. 70, 73). Despite a considerable degree of stylization characteristic of the 15th century in general and the wall paintings of the great Kumbum at Gyantse in particular, there is an increased

71.2

awareness of the rotundity of form and a
loosening of the rigidity of planes of color
that suggests the beginnings of a slightly
naturalistic space. A freer curvilinear
shaping of the figures and animals imparts

a sense of freedom of movement and
space. These changes indicate a date into
the 16th century, while the ties with the
Gyantse school of painting suggest the
continued potency of that lineage and a

provenance around the Tsang region. Its
well-preserved condition, its evident drama
and charm, and its astonishing size make
this painting a rare masterpiece of this
popular deity.

Mahakala Brahmanarupa

Tibet

Late 16th century

Brass; cast in several parts (the pedestal cast
by mold in two parts), with cold gold paste
and pigments

H. 8¼″ (21 cm)

The State Hermitage, Leningrad.
Prince Ukhtomsky Collection

Surrounded by tongues of flame, Mahakala
stands in the warrior posture, trampling
with both feet on a prostrate human
figure. He holds a trumpet made of a
human thighbone in his right hand and a
skull bowl in his left hand. With his left
arm he holds a lance, and a skull rosary
hangs around his left elbow. From this
large rosary dangle a sword and a vase. He
is decorated with a long garland of severed
human heads. According to a Tibetan
legend referred to by Getty, it was in this
form of a "protector in the form of a
Brahmana" that Mahakala appeared to the
famous Sakya Lama Pakpa (1235–1280),
to help him explain the meaning of the
Hevajra Tantra to the Mongol emperor
Khubilai Khan (Getty, 1914, pp. 144–45).

This sculpture and the Hermitage
Simhavaktra (No. 117) are two from a
set of twelve images of peaceful and terrify-
ing deities from the Prince Ukhtomsky
Collection. Besides Mahakala Brah-
manarupa and Simhavaktra, presented
here, this set also includes Ratnasambhava,
Vasudhara, Yama, Vajrapani, Lhamo, Four-
and Six-Armed Mahakalas, Begtse, and
some other deities. Most likely they are a
part of a whole set of images made in the
same workshop after the same pattern
(Fisher, 1974, p. 26). All the sculptures are
made with the same techniques and have
similar elements of style. The deities either
stand or sit on their lotus thrones, each of
which is placed on a rectangular pedestal
supported by three stylized legs. The
pedestals were cast from a mold in two
parts (front and back) and joined together.
In the center of the front of this statue's
pedestal, there is an openwork relief panel
with a human figure, two lions, and four
stupas that support the upper level of the
pedestal. This relief with its tiny images is
reminiscent of Eastern Indian prototypes
of the so-called nongilt schools of
sculpture in Tibetan art. It is known that
Tibetan masters belonging to these schools
were trying to reproduce the basic
composition as well as some elements of
style of the Pala bronzes in their

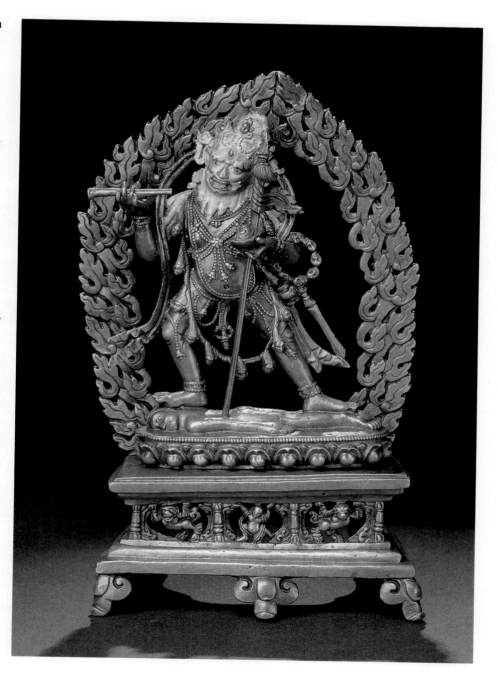

sculptures. These sculptures provide rare
examples of the borrowing of an entire
compositional motif—the front relief of
the pedestal—which increases the Indian
nature of the images. A certain stiffness of
the images is also evident, especially in the
slightly stereotyped ornaments, tongues of
flame, and lotus petals, all of which
suggest a late 16th-century date.

G. Leonov

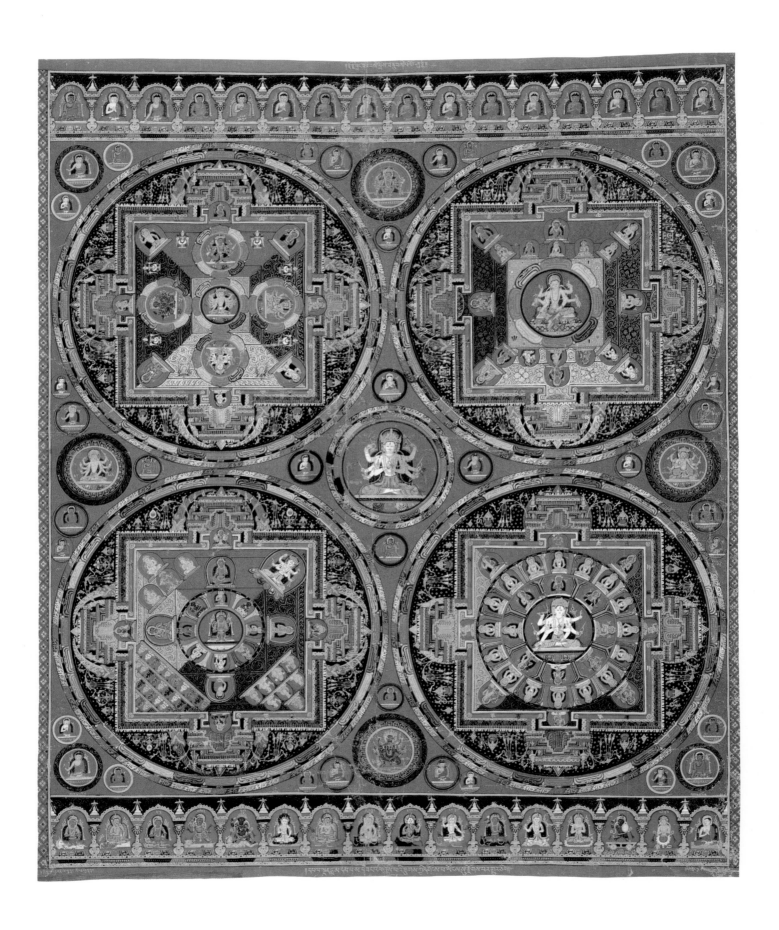

73
Four Mandalas of the
Vajravali Series

Central Regions, Tibet; probably Tsang

Circa 1390s

Tangka; gouache on cotton

35 × 29″ (89 × 73.7 cm)

The Zimmerman Family Collection

An inscription at the center of the top border identifies this tangka as the "fourteenth painting of the Vajravali," a major text in the Tibetan Tanjur. Along the bottom border are three sets of inscriptions. Those at the far left are two mantras. The central inscription reads: "May the heart's intent of the holy glorious Lama Sasang Pakpa be fulfilled." The right inscription reads: "Bless the monk Kunga Sangpo." It appears that this set of Vajravali paintings was donated immediately after the death of the great pandit Sasang Pakpa, by the monk Kunga Sangpo. Sasang Pakpa was a Sakya lama famous as the author of a book on the composition of poetry, and as a teacher of poetics to the young Tsong Khapa. He died in approximately the 1380s, so this set of tangkas, two of which are presently in the Zimmerman collection, can be confidently dated to the end of the 14th century. Considering the severe lack of dated materials for this period, this exceptionally beautiful work gains particular prominence and importance.

This incredibly detailed and vivid mandala painting depicts an ingenious scheme incorporating four individual mandalas, each with its own special goddess, as well as an all-encompassing mandala of the Five Pancharaksha Goddesses. With the assistance of Venerable Losang Chögyen, mandala expert of Namgyal monastery in

Dharamsala, we were able to identify the mandalas in this painting from a text written by Jangkya Hutuktu Ngawang Chönden (vol. *ga*, ff. 133a–141a).

The upper left is a mandala of the Five Pancharaksha Goddesses, known as the Mahapratisara Thirteen-Deity Mandala (73.1). The Pancharaksha goddesses are popular deities for protection against sickness, misfortune, and calamity. In the center of this mandala is the twelve-armed golden goddess Mahapratisara. The other four goddesses, in blue, red, green, and white colors, appear in the four directions around her. There are four goddesses in the corners and four in the doorways, bringing the total number to thirteen. This mandala is the only one of the four that is included in the Vajravali text. The other three are included in this painting since they are associated with the granting of initiation in the Vajravali set of visualizations. They are drawn from the set of initiations included in the pandit Darpanacharya's Kriyasamucchaya set, according to Jangkya Hutuktu's text.

The upper right mandala depicts the six-armed golden goddess of wealth, Vasudhara (73.2), accompanied by eighteen deities, all associated with wealth and prosperity. The lower right mandala portrays the three-faced, eight-armed white goddess Ushnishavijaya (73.3), surrounded by eight Ushnisha deities derived from the Buddha clans on the

inner lotus, sixteen deities derived from the sixteen voidnesses on the outer lotus, four Ushnisha goddesses in the doorways, and four long-life goddesses in the corners. This whole mandala is associated with long life.

The mandala at the lower left is that of the Bhagavati Mahavidya, who is white and two armed and sits in the northeast (upper right) corner of the mandala (73.4). In the center are nine planetary deities associated with the ancient Indian solar system of seven planets, including the sun and the moon, and positive and negative lunar nodes. A two-armed red form of Surya, the sun, is in the middle, with the moon, Mercury, Mars, Saturn, Venus, Rahu, Jupiter, and Kalagai on an eight-petaled lotus around him, clockwise from the bottom. In the lower left corner are the twenty-seven lunar mansions. In the upper left corner are the four *yaksha* ogres. In the upper right is the Planet Mother, Mahavidya. On the lower right are the seven planetary deities in alternate forms. In the four gates are the Four Heavenly Kings, guardians of the directions. This entire mandala is associated with protecting the initiate from negative planetary influences.

Interwoven around the four mandalas in the main field is another, floating mandala scheme consisting of the Five Pancharaksha Goddesses appearing at the four cardinal directions and the center. They are

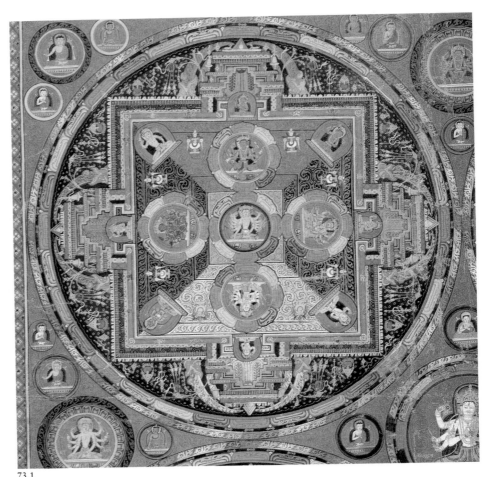

73.1

73.4

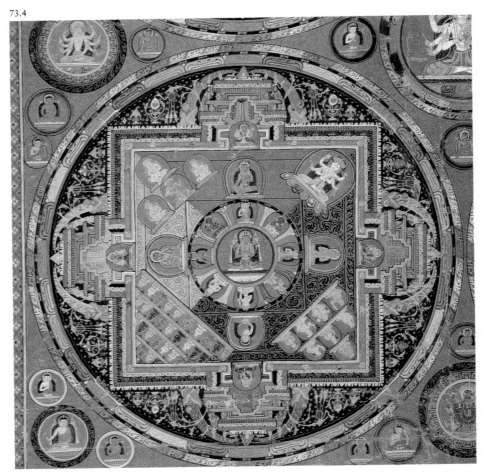

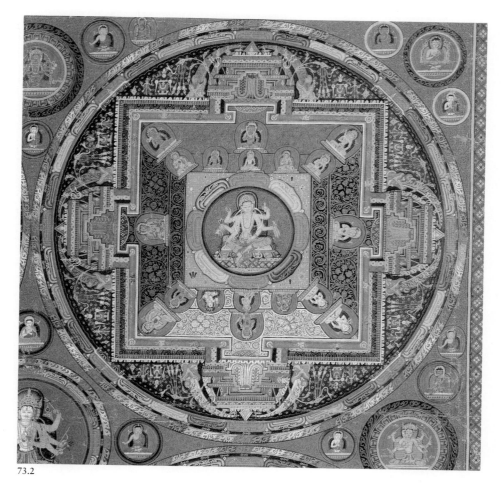

73.2

73.3

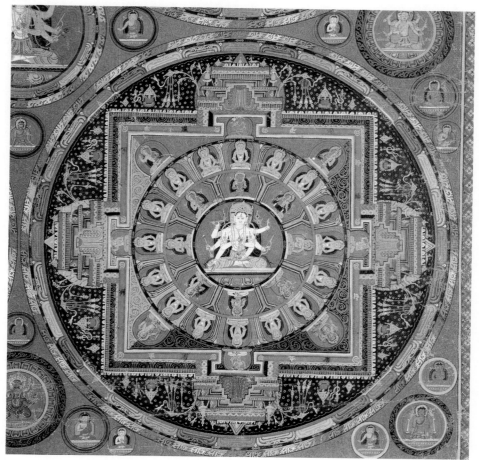

identified by inscriptions as 1) Mahasahas-rapramardani (at the bottom, the east, blue in color); 2) Mahamayuri (at the left, the south, yellow in color); 3) Mahaman-trausarini (at the top, the west, red in color); 4) Mahasitavati (at the right, the north, green in color); and 5) Mahapratisara (in the center, white in color). Surrounding these goddesses and at the four corners of the tangka are small Buddhas, thirty-five in total. These are the Thirty-five Buddhas of Confession, as noted in the two small inscriptions in the lower left and right corners just above the border.

Along the topmost border are sixteen seated Buddhas in niches, each inscribed and executed with flawless precision in coloring and drawing (see full image). The Five Transcendent Buddhas open the line at the left: Akshobhya, Vairochana, Ratnasambhava, Amitabha, and Amoghasiddhi. They are followed by a golden Shakyamuni, and then the Ten Direction Buddhas alternating red and golden in color. According to the inscriptions, they are in the order: east, south, west, north, northeast, southeast, southwest, northwest, zenith, and nadir. Balancing this highly symmetrical composition at the bottom is a row of sixteen seated figures. Buddhist forms of the World Gods are identified by inscriptions (left to right) as Indra, Garuda, Agni, Yama, Yaksha, Varuna, Vayu, Kubera, Ganesha, Shiva, Surya, Chandra, Brahma, Vemachitra, and Prthividevi. The last figure is the donor lama, Kunga Sangpo, identified by the inscription below him as Gelong Kunga Sangpo la Jinjila Sasang.

All the figures are portrayed with fastidious care and a bold spirit. The saturated brilliance of the flat, thickly applied primary colors, especially noticeable in the crimson reds, coupled with touches of strong modeling, and the clear, lively line impart dramatic life to this predominantly schematic design. The strongly formal tendencies of this style, its stiffness of forms and jewellike hardness of color, differ from the softer and simpler style of the Raktayamari mandala (No. 75), which also dates from the late 14th century. Clearly they represent two distinct schools of painting, both in Sakya institutions, at the end of the 14th century. The one represented by this Vajravali series relates to a prominent school of Nepalese painting prevalent in the 14th and 15th centuries, of which there are numerous examples, one of the best being the Vishnu mandala dated 1420 in the Los Angeles County Museum of Art (Pal, 1985, pl. 62).

74
Nairatmya

Central Regions, Tibet

Second half of the 16th century

Gilt brass, with turquoise insets and pigment

H. 9¼″ (23.5 cm)

The Los Angeles County Museum of Art, Los Angeles. From the Nasli and Alice Heeramaneck Collection. Museum Associates Purchase. M.70.1.4

Lit.: Pal, 1983, p. 213.

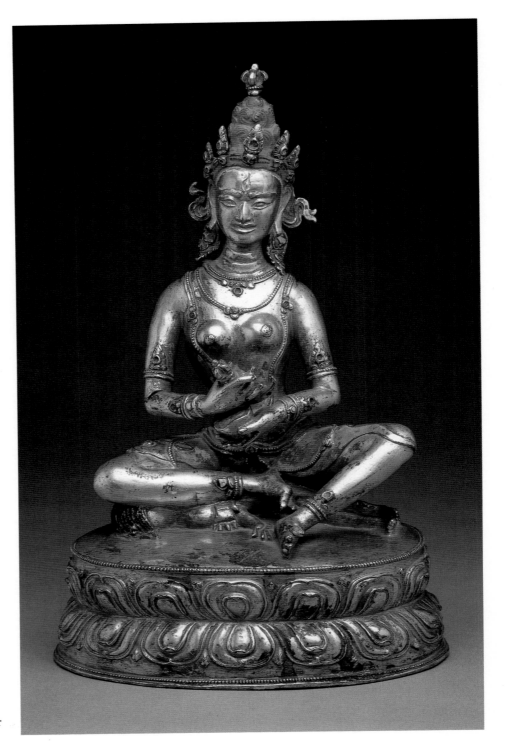

The sculpture is of Nairatmya, whose name means "selflessness" (often Vajranairatmya, Diamond Selflessness). She is the personification of freedom; and as such, she is a terrific archetype deity in her own right. She is also the consort of Hevajra, a major male archetype Buddha. Both deities were popular in the Sakya Order. Here she is an independent figure seated on the prostrate conquered deity of egotistic attitudes. Like many of the terrific deities, she holds a vajra chopper and a skull bowl, symbolizing the chopping up of the misperceptions and misconceptions that block the realization of emptiness.

Her slim and lithe body with gracefully curved torso, adorned with a few light jewels in which a few turquoise insets still remain, indicates her benign and beautiful nature. Her terrific aspect is indicated by her third eye, her slightly fierce face, crown of small skulls, symbolic implements, and tiger-skin skirt. She also has the red hair synonymous with these forms. Her tall chignon, bunched into two tiers, is topped by a five-pronged vajra, an unusual hair ornament for an archetype deity, though common for a protector.

The pedestal is rimmed with a delicate row of pearls, and the lotus petals are tightly edged with simple, unelaborated rims. This lotus-petal style is seen on other images of the late 15th to 16th century in particular, such as the Vajradhara in No. 147. Stylistic elements, such as the slender body and style of jewelry, are similar to figures in tangkas of ca. the second half of the 16th century and probably from the Tsang region, such as No. 64. This would seem to indicate a similar dating and provenance for this statue. An interesting recent technical study by Chandra Reedy strongly confirms a provenance in the central regions of Tibet for the work (Reedy, 1987, p. 94).

Typical of Tibetan art, the whole configuration in this uncommon and lovely statue has a restrained yet lively quality, and is both strong and refined. This sculpture is a particularly meaningful image, as it seems to integrate a forthright earthiness with an ethereal lightness. Such integration expresses the heart of the Buddhist vision of the absolute coincidence of existence and emptiness, relativity and freedom. Not only iconographically, but also in style, Tibetan art works like this sculpture express fundamental aspects of Buddhism. The greatness of Tibetan art lies to a large degree in this skillful artistic manifestation of Buddhist ideals.

Raktayamari Mandala

Central Regions, Tibet

Late 14th century

Tangka; gouache on cotton

24 × 21″ (61 × 53.4 cm)

The Zimmerman Family Collection

Not only is this small masterpiece incredibly perfect in execution, it is an extremely important datable work that has significant impact on establishing the chronology and character of certain regional schools of the late 14th century. The inscription in black ink on the back says it was "done for the meditation of the Holy Hermit of Jangpukpa, Lama Khedzun Kunga Lekpa." Kunga Lekpa lived in the latter half of the 14th century and was one of the teachers of the great master Tsong Khapa (1357–1419). Since it is stated to be his own personal meditation tangka, it can be dated to within his lifetime. It was also probably made in the Tsang region where this lama lived. More than likely the lama portrayed in the lower

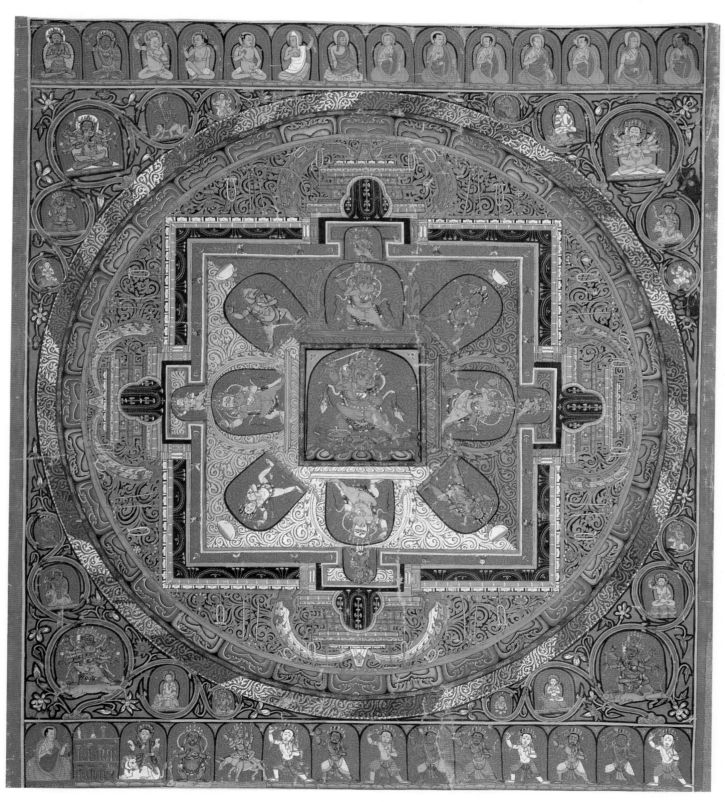

left corner is meant to be Kunga Lekpa making offerings.

Raktayamari is a popular archetype deity in the Sakya and Geluk orders. Tsong Khapa is known to have practiced this deity for a specific period in order to overcome dangers to his health and to lengthen his life span. He is the red form of Yamantaka, sometimes approached also as a protector deity.

This mandala is the essence of the realm of Raktayamari. It is presented as though we are gazing into the palace of the deity all at once, but in actual practice one would usually visualize entrance through the gates and then into the various chambers, finally reaching the innermost central room where Raktayamari and his consort in the bliss of union are the embodiment of the union of wisdom and compassion in the enlightened state. His palace is divided into four zones, each a different color (east white, south yellow, west red, north green) and each presided over by a Yamari couple of different color. The intermediate areas in between have single goddesses, white Charchika with chopper and skull bowl in the southeast, dark blue, boar-headed Varahi with a vajra scepter and skull bowl in the southwest, red Sarasvati with chopper and bowl in the northwest, and green Gauri with chopper and bowl in the northeast. Tiny Yamantaka guardian couples appear in each gateway. The square walls of the palace have goblins holding up the base, festoons of jewels against a black background, a blue wall, and finally the

top wall with its embattlements. At the gates, red *makara* heads spout flame-edged prongs that arch over the decorated multilayered gate roofs and appear like giant vajras. There is a pair of deer flanking a Dharma wheel on the top roof level, a common sight above Tibetan temple entrances. The design of scrolling vines filling the interior spaces of the palace is strongly rendered with superb clarity and vigor. Encircling the palace are the protecting zones of lotuses, vajras, and stylized flames in alternating colors.

Outside the sacred zone, entwined with thick moss green vines edged in mustard yellow and sprouting pink and white buds and flowers, are various tantric deities: the larger ones are Guhyasamaja (upper left, detail 75.1), Guhyamanjuvajra (upper right), blue Yamari (lower left), and Krishnayamari (lower right). Around the circle, the smaller globes contain the World Gods, beginning in the lower left of center and proceeding clockwise, Vishnu on his peacock, Indra on an elephant, Agni on a goat, red Surya, white Chandra, Yama on a bull, Nairrti on a man, Brahma on a swan, red Vemachitra, white Varuna on a sea monster; a grey figure holding a rope and sitting on a yellow deer (?), probably Vayu; Ganesha on a rat; a blue figure holding a sword and sitting on a white horse (?), possibly a fierce deity in the retinue of Kubera; Kubera sitting on three pots; Shiva on his bull; and Prthividevi. Across the top, left to right (75.1), are blue Vajradhara, red Vajradharma, the Mahasiddha Shridhara

with a dog's head, two other Great Adepts (probably Lalita and Baro Dongdum), a white-robed and hatted Indian pandit, a red-robed pandit, five hatless lamas, a red-hatted lama, and a hatless lama. Across the bottom after the lama with his offering assemblage in the left corner are Vaishravana, Mahakala as Lord of the Pavilion, four-armed Penden Lhamo, and nine two-armed fierce figures brandishing swords, vajras, axes, and other implements.

The style of the figures is charming, bright, and dominantly linear, although modeling is skillfully employed in a few places. The black line, though sparingly used, is firm, a little stiff, sharp, and incisive. There is a disarming simplicity but an unusual strength and boldness so characteristic of Tibetan painting. A fairly thick black line outlines the vine motif in the corners, making it stand out almost as in relief. The utter precision, strong colors, and sense of life in the line are unsurpassed in this work, clearly by a master. It is historically important as a datable painting from the late 14th century, a period severely lacking in dependably dated materials. It can readily provide evidence to date other works to the same period, such as the statue of Milarepa in No. 78, the pair of Sakya lamas in the Museum of Fine Arts in Boston (Pal and Tseng, 1969, fig. 27), and the magnificent Chakrasamvara in No. 69. These works appear to be one major school, probably in the Tsang region in the late 14th century, possibly associated with a particular monastery or artistic school.

75.1

76
Raktayamari Father-Mother

China; Tibeto-Chinese

Dated by inscription Yongle period
(1403–1425)

Copper and gold (about 40 percent); cast in
several parts, with pigments; sealed with relics
still inside the pedestal

H. 6¾″ (17.2 cm)

The State Hermitage, Leningrad. Prince
Ukhtomsky Collection. Later given Kozlov
Collection number

Lit.: H. Karmay, 1975, pp. 72–103.

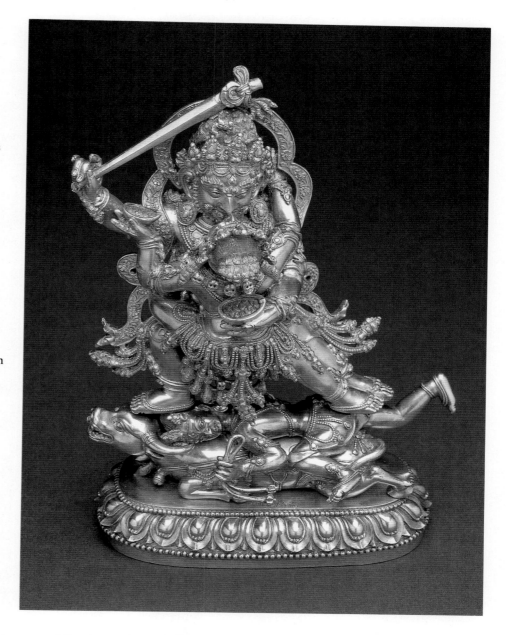

Rakta (red) Yamari (enemy of Yama) is
one of the forms of the Conqueror of the
Lord of Death, Yamantaka, a terrific
archetype Buddha form of Manjushri, the
Bodhisattva of Wisdom. He embraces
Vajravetali (Diamond Zombie), his wisdom
consort, with his left arm, his hand
holding a skull bowl. With his right hand
he brandishes a rod of punishment.
Vajravetali holds a vajra chopper in her
right hand and a skull bowl in her left
hand. Both the deities trample on a
crowned figure (the Hindu god of death,
Yama) who lies on a buffalo holding a
lasso in his left hand, and a short club (?)
in his right.

Besides the inscription, the sculpture
possesses inevitable marks of the Ming
style: a peculiar type of earring and other
decorations of the deities; two strings of
pearls surrounding the pedestal; a specific
Ming form for the lotus petals and their
number (there are an even number of
petals on the pedestals of Ming sculptures,
unlike those of Qing bronzes).

There are seven sculptures with the
Yongle date inscribed on their pedestals in
the Hermitage collection, and this gold
image of Raktayamari is certainly one of
the best in the whole collection. But it is
not only the precious material of the
sculpture that matters (although it must be
noted that golden images are not very
common in Tibetan art in general or

among Ming images in particular). A very
high level of craftsmanship is shown in
this image. It is rather high even in
comparison with the generally recognized
gracefulness of Ming images. Here the
master demonstrates almost a jeweler's
skill in rendering the finest details of the
deities' decorations and garments.

At the same time there are not any
special new inventions either in

iconography or in style in this icon. It is
enough to compare Raktayamari with
another Ming sculpture from the
Hermitage collection—that of Manjushri
(No. 30)—to be convinced that the artist
of the Raktayamari uses the stereotypes
usual for Ming images. It is the master's
skill that puts this sculpture far beyond
ordinary Ming bronzes.

G. Leonov

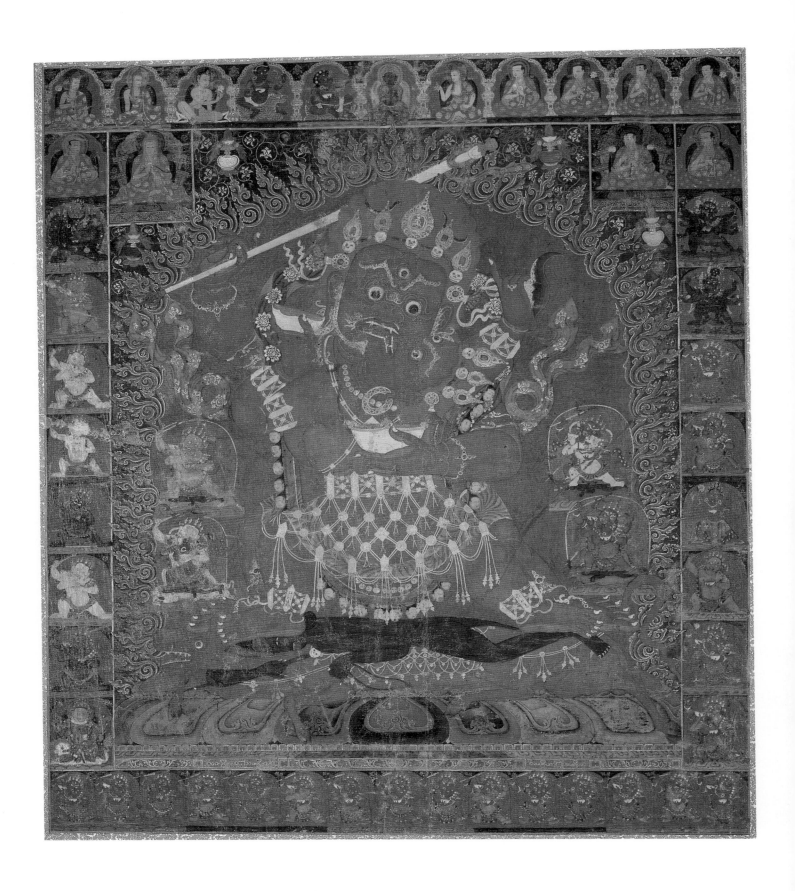

Raktayamari Father-Mother

Central Regions, Tibet; probably Tsang

Second quarter of the 15th century

Tangka; gouache on cotton

32⅜ × 28¼″ (82.4 × 71.7 cm)

Museum of Fine Arts, Boston.
Gift of John Goelet

Lit.: Pal and Tseng, 1969, no. 36.

This grand painting depicts the herculean figure of Raktayamari together with his consort, Vajravetali. They are the main archetype deities of what is apparently a form of the Thirteen-Deity Raktayamari mandala. Raktayamari, the red form of Manjushri as Yamantaka, is a terrific archetype Buddha, personifying enlightenment as the conquest of death. The legend is that Manjushri, as the Bodhisattva embodying the absolute wisdom of all Buddhas, decided that Death was causing human beings too much trouble, cutting short their precious human lives within which they had the unique opportunity to attain enlightenment. So he went down to the windowless iron fortresses of Yama, Lord of Death, and he annihilated the deadliness of death, he became the Terminator (*antaka*), or Opponent (*ari*) of Death (*yama*). Of course, the death of death, the annihilation of nothingness, is the prize of immortality, the preservation of everything. Although Yamantaka is a completely transcendent archetype deity —his practice aiming solely at supreme enlightenment—it is thought that his devotees gain the incidental gift of freedom from any obstructions to their lives and from premature death.

Here Raktayamari and his consort seem to swell over the surface of the painting as gigantic figures dominating their realm. Refined jewels, fluttering light scarves, a smoldering flame halo, shimmering, flat lotus petals, and a deep midnight blue sky sprinkled with vases and flowering vines lightly embellish the space. However, the main impression is of the overwhelming massiveness of the divine couple. He brandishes his rod and skull bowl, and she holds a skull bowl and a vajra chopper. In powerful union, they flatten the form of deadly egotism, pressed down on the back of their elongated red bull mount. Around the main pair in the central space are four directional Transcendent Buddhas as Yamari Father-Mothers in the interior directions of the mandala; the eastern white Mohayamari,

the southern yellow Matsaryayamari, the western red Ragayamari, and the northern green Irshyayamari. At the upper corners of the central space are the two main lamas, one without a hat, perhaps Sakya Pandita on the left and Pakpa on the right.

Around the borders outside the center are lamas and deities. Across the top from left to right are two lamas, three Mahasiddhas, Vajradhara (the esoteric form of the essence of all Buddhas), and five lamas, one with a cap. On the side panels are an assortment of protectors, including Vajrabhairava and Vaishravana (who are the top and bottom figures on the left side). Eight of the protectors are depicted with consorts; they are the eight door and corner guardians of the mandala, which, together with the five icons in the central space, comprise the basic figures of the thirteen-deity mandala. The other protectors, without consorts, are the Yamarajas, the forms of the Lord of Death who became protectors of practitioners. Across the bottom are fifteen repetitions of Raktayamari with his consort, who are the Fifteen World Gods transformed into Raktayamari in order to attend upon and enjoy the Raktayamari mandala-universe.

This majestic painting descends stylistically from late 14th-century paintings, such as the Shamvara in No. 69 and

the Raktayamari mandala in No. 75. It parallels the style of the Kumbum wall paintings at Gyantse (ca. the second quarter of the 15th century). It is also somewhat related to the style of the British Museum Shakyamuni in No. 3, probably dating around the middle of the 15th century. The steady and powerful but sharp drawing of the figures, combined with the smoothly luminous modeling, is characteristic of some of the finest works of the late 14th- to middle 15th-century paintings in Tibet. Touches of malachite green are precisely used, as in No. 3 and other paintings around the first half of the 15th century. This special coloring effectively resonates with the overall dark tonalities in these paintings, imparting a touch of mystical beauty and lightness. The flame patterns are especially fine, with consummate care given to variegated color and modeling of the oak-leaf-shaped outer flames, which add dimension to the halo. Particularly outstanding details are the refined linear work in the bone ornaments and the gold filigree of the flower patterns of the flying scarf and of Raktayamari's lacy eyebrows, mustache, and beard (77.1). Though the work is stylized, one readily senses the pulsating, exhilarating aliveness of these figures, and their drama, which operates on a heroic and mythic scale.

77.1

VIII.
Kagyu Order

The Kagyu Order is known for its radiant yogi saints and profound meditative teachings, which descended from the Great Adepts of India. The order was also an energetic founder of monasteries and an educational institution that produced many enlightened persons. Its traditions of fine arts were an integral part of the great Kagyupa lamas' visionary practices and experiences, and the Kagyupa cultivated a highly refined visionary aesthetic as a means to, and expression of, enlightenment. A number of the Karmapa Lamas, leaders of an important branch of the order, were themselves prolific and distinguished artists, who regarded the artistic re-creation of visionary experience as a spiritual path, a way to give people easy access to their inner world of meditative visualization.

The works selected here emphasize the figure of Milarepa (1040–1123), one of the most universally beloved saints of Tibet, whose autobiography ranks with Saint Augustine's *Confessions* as one of the great testaments of spiritual transformation in world literature. His life was an epic of betrayal and vengeance, repentance, transcendence, liberation, and enlightenment. Even with all that, there runs in him a strand of earthy humor and an enchanting pattern of magic and miracle. Of the numerous statues and paintings of this popular figure in varied styles from different regions and periods, a selection of a few of special significance are presented here.

Milarepa's two main disciples, Rechungpa and Gampopa, were called the moon and sun of his contemplative lineage. Gampopa, who is represented in tangka No. 84, founded the main orders of the monastic branch of the Kagyupa. Many suborders soon developed, and lamas of a number of the more prominent ones are also represented. Several of these suborders also had their own different styles of painting and sculpture. The Drigung Kagyu in the 16th century and the Taklung Kagyu in the 18th century, for example, each seem to have produced a distinct style of tangka painting. The suborders with flourishing schools in Eastern Tibet developed a major style of painting that emphasized landscape. This style is generally associated with the Karma Kagyu, and is called the Karma Gadri style. These same Eastern Tibetan schools also seem to have developed an important realistic style of portrait sculpture in the second half of the 16th century, of which No. 89 is a prime example. In their refined sense of naturalism of figure and drapery, these sculptures rival the great realistic sculptures of the Song period in China and the Kamakura period in Japan.

Like the other orders, the Kagyupas frequently depicted Buddhas, Arhats, Bodhisattvas, Great Adepts, and Dharma Kings. A number of the tangkas in these categories appearing here are probably works produced by Kagyupa artists (Nos. 27, 39). In general, Kagyupa art exhibits mildness, gracious beauty, ecstatic vision, and a keen sense of humor about the human condition. Such moods pervade the set of paintings of Milarepa's life in the collection of the Folkens Museum Etnografiska, Stockholm (Nos. 82, 83, 152).

With regard to the main archetype deities of the Kagyu, Paramasukha-Chakrasamvara Father-Mother and Vajravarahi as a powerful independent figure are singled out. Though it is not certain that the works represented here were produced by or for the Kagyupas, they may justly be considered as representative of Kagyupa archetype deities. They are all rare masterpieces of their kind. The Khara Khoto painting (No. 93) and the Musée Guimet sculpture of the Indrabhuti Vajradakini (No. 94), for example, are among the most powerful representations of this deity in all Asian art. There are three paintings from the famous Khara Khoto group from the Hermitage in this part, including an unidentified lama (No. 91), primarily because of the known relation between the Xi Xia and the Karmapas, especially after 1159. The Xi Xia king Renzong Lirenxiao, who was a learned Buddhist, in 1159 invited Tsang Sopa (gTsang-so-ba), one of the main disciples of the first Karmapa, Dusum Kyenpa, and conferred on him the title of Shang Shi, Supreme Teacher (Tonkō Bumbutsu Kenkyūjo, 1980–82, V, p. 157; Roerich, 1988, p. 517). It is quite likely that at least some of the Tibetan-style Khara Khoto paintings, several of which depict the Black-Hat Karmapa (No. 133), are connected with this order.

78
Milarepa

Central Regions, Tibet; probably Tsang

Late 14th to early 15th century

Brass, with pigments

H. 18″ (45.7 cm)

The Zimmerman Family Collection

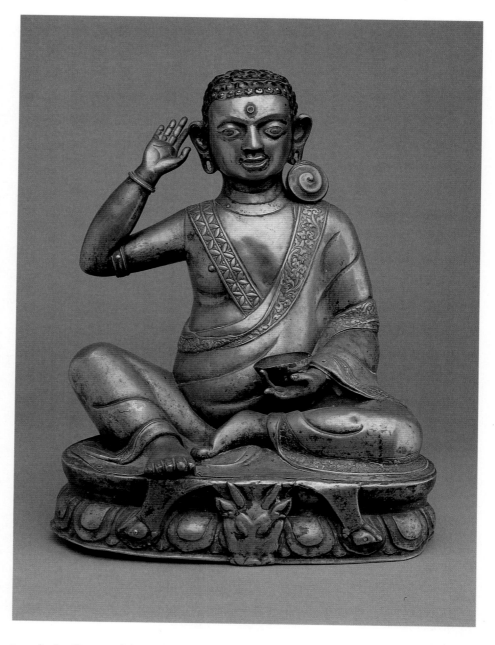

Tibet's Buddhist poet-saint-yogi Milarepa lifts his right hand to his ear in a gesture that has become his trademark. As though listening to the voice of inspiration, he sings the song of the Buddha Dharma, teaching his listeners through the poetic beauty of vernacular Tibetan. As a yogi, he sits on the skin of an antelope, which is draped over the broad-petaled lotus seat with its horned head in front. His pose is relaxed, with the right leg slightly raised. He is garbed in the white cotton cloth that he wore even during the bitter cold of the Himalayan winters. A large earring with a swirl design hangs prominently from his left ear (the right one is missing), and his right arm has some simple ornaments. A meditation belt, used during long sessions of meditation to keep the body upright, is slung across his right shoulder. It may be that the small thin bowl held in his left hand is the famous nettle-shell bowl. During the early years of his contemplation practice, Milarepa survived by eating the nettles he found growing outside his cave. One day, when his clay cooking pot broke, it revealed a nettle shell that had formed from the dried nettle soup. It was later kept by his followers as a relic of his austerities. Near the bowl on the border of his robe is a pin, probably for holding some other symbol, such as a nettle. He has the curly hair and *urna* typical of Buddhas. The interior of this statue was filled with numerous interesting consecration items, which have been kept in the Zimmerman collection.

This statue, made of large riveted pieces of brass, is an especially important work, not only for its unusual size, but because it

is undoubtedly one of the earliest known representations of Milarepa. The long, sloping torso with narrow shoulders and swelling abdomen and the few curved grooves of the thick drapery correspond stylistically to the lama figures in the Zimmerman Raktayamari mandala painting, which dates to the late 14th century (No. 75), and to some of the sculptures in the Peljor Chöde at Gyantse from ca. the second quarter of the 15th century. The face, with its strongly formed, abstract, and naïvely rendered features, falls between the style of the Padampa Sangyey (No. 38) of ca. the mid-14th century and that of the colossal sculptures of the Gyantse Kumbum of ca. 1427. With its smooth, swelling planes, this Milarepa sculpture also seems to prefigure the monumentality that is a major part of the style of the great Kumbum statues (text fig. 18). The wide bands of

ornate, raised relief relate both to trends of the 14th century, as seen in the Arhat (No. 12), and to the 15th-century Kumbum sculptures (L. G. Govinda, 1979, II, p. 82). Unquestionably, this great sculpture, appearing so innocent, alert, and grandly simple, serves as an important landmark for documenting the sculptural developments between the solid, stiff forms of the mid-14th century and the bold monumentality of the colossal Kumbum sculptures of the early 15th century. This period was one of the most exciting in Tibetan history, because it was the time of the master Tsong Khapa and the religious and artistic renaissance ushered in by his founding of the Great Prayer Festival in Lhasa. Together with the Raktayamari tangka (No. 75), this sculpture gives a definite indication of the development of artistic styles during this still-uncharted but flourishing period in Tibetan art.

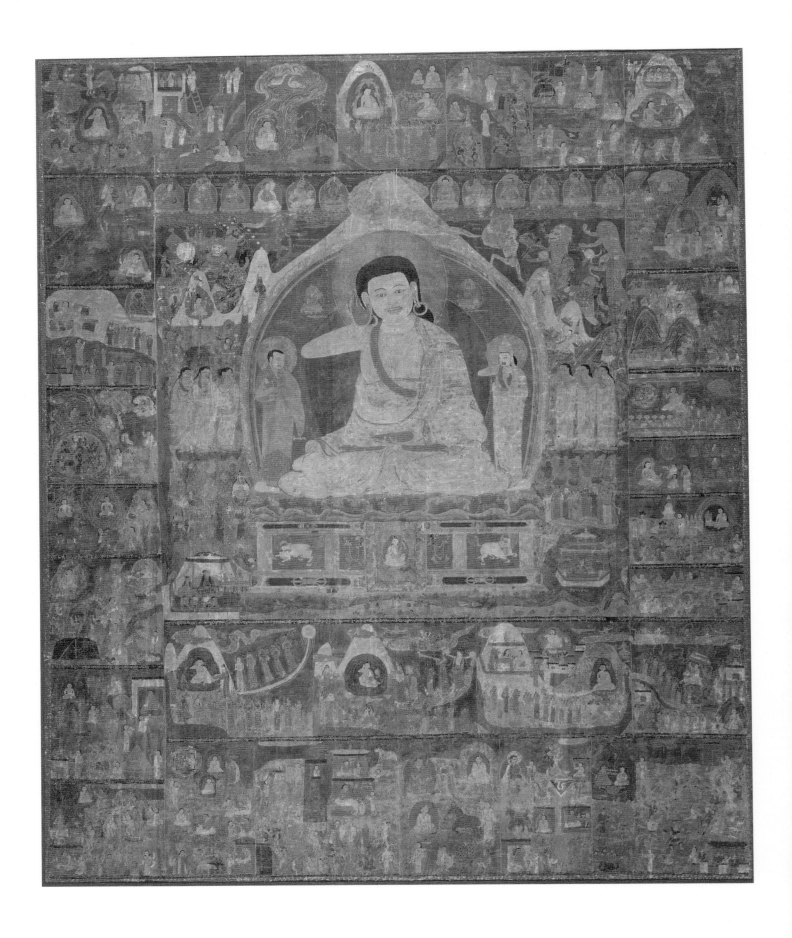

Milarepa and
Scenes from His Life

Western Tibet

Second half of the 15th century

Tangka; gouache on cotton

51½ × 41½" (130.8 × 105.4 cm)

The Los Angeles County Museum of Art, Los Angeles. From the Nasli and Alice Heeramaneck Collection. Purchased with funds provided by the Jane and Justin Dart Foundation. M.81.90.2

Lit.: Pal, 1983, p. 148–49.

Flanked by his two great disciples, Rechungpa in white on his right and Gampopa in red on his left, the poet-saint Milarepa sits clad in his white cotton robes, surrounded by scenes of his life, all identified by inscriptions. He sits singing his teaching, his right hand held up to his ear, perhaps the better to hear the inspiration of his master and the Dakinis. Encircled by a grey cloud, the snow-covered peak of a Himalayan mountain arches behind his halos of blue, green, and red. Like his listening gesture and his cotton robe, the Himalayan environment is a characteristic element of paintings of this Tibetan yogi. He spent his adult life in Himalayan caves, meditatively trans-forming the stark, otherworldly landscape into a sacred realm of spiritual attainment. Tibetans especially revere Milarepa as the first ordinary Tibetan to become an Arhat, a Bodhisattva, and even a Great Adept— that is to say, a perfectly enlightened Buddha in one lifetime.

The figure of Milarepa is portrayed here in a gentle, relaxed manner with broad face and expressive though stylized features stiffly and carefully drawn. His robes are loose and light and their folds are sensitively naturalistic and profuse. The drapery is particularly remarkable in this painting as a unique early rendering, obviously by Tibetan hand but in-corporating elements of Chinese style. The style appears to be descended from paintings such as the British Museum Arhats of ca. early 15th century from Shigatse in Tsang (No. 14) and the Gyantse Kumbum paintings. Milarepa's hair is a refined version of the type seen in the Zimmerman collection Milarepa statue (No. 78), and the manner of painting the eyes relates to both the British Museum Arhat style (No. 14) and the Padma Sambhava in the Victoria and Albert Museum (No. 48). The rather dramatic characterization and strong patterning of

79.1

the faces of the disciples are known in 13th- to 14th-century paintings, such as the pair of lamas in the Cleveland Museum (Acc. No. 87.146). This striking facial style has, however, a longer history. It appears in the 9th-century Buddhist wall paintings of Bazaklik near Turfan in eastern Central Asia. Styles and motifs often travel from one area in the Buddhist world to another in quite surprising ways. Tibetan Buddhist art frequently embodies in its style many such diverse elements, often creating complex combinations and variations.

The mystical realities of Milarepa's life are suggested in this tangka by imaginative details (79.1) like the free shapes of the mountains and caves and the childlike forthrightness of the demons and the rows of Dakinis standing on a boat of mystical light, which seems to sail down from the moon. There is an expressive freedom in the rocks, mountains, trees, and figures that reminds one of the works of some modern Western painters. For example, the usage of solid colors, like dark blue, green, and orange, seems like that of Henri Matisse's *La Danse* paintings in the Hermitage in Leningrad. The drifting, childlike character of the figures reminds one of the paintings of Marc Chagall, while the evocative colors and strange shapes of the womblike caves conjure the same deep nuances of feeling as the works of Edvard Munch. The details are executed with such matter-of-fact understatement and minuscule scale, however, that they are easy to miss.

While containing a number of elements relating to painting of the central regions in the 15th century, the tangka appears to be predominantly Western Tibetan in character. The combination of earthy, muted colors, fanciful touches, mild distortions, elongated figures, and naïve biographical scenes and landscape elements is characteristic of the Western Tibetan style of painting, particularly during the middle and second half of the 15th century. Landscape, though important here as the background of the biographical scenes, is nevertheless not very naturalistically developed and remains, typical for Western Tibetan painting of the time, primarily abstract and suggestive. Nevertheless, it is an important example in charting the evolution of landscape in Tibetan painting. The regimentation of the picture plane by the formal structure of separate rec-tangular zones, or registers, is a feature that generally gives way to a more integrated scheme by the end of the 16th century. This painting is a particularly interesting example of the early adjustment to the use of landscape within the rigid format inherited from the Indo-Nepalese traditions, which still held sway in many of the works of the 15th century. Remarkable for the expressive power of its figures and landscape, for a uniquely moving portrayal of Milarepa, and for the beauty of the budding naturalism in the depiction of his robe, this tangka is prob-ably the finest early example of the genre depicting Milarepa and scenes of his life.

80
Milarepa

Chinese stylistic tradition

16th century

Carved ivory, with cold gold paste

H. 3″ (7.6 cm). Shown actual size

The State Hermitage, Leningrad.
Prince Ukhtomsky Collection

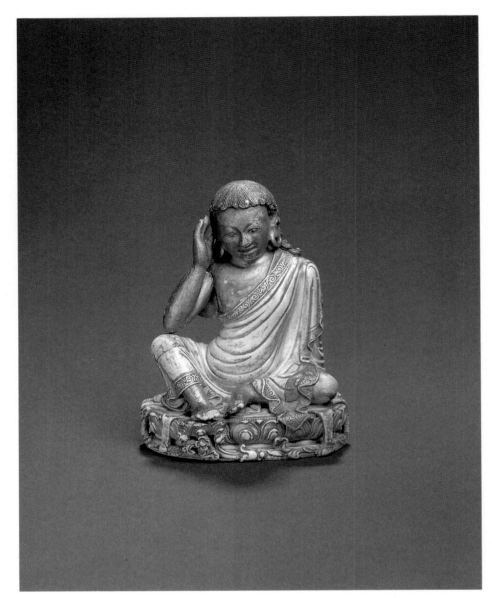

Milarepa is shown here sitting in the pose of royal ease on an antelope skin covering a lotus throne. His right hand is raised to his ear. The meaning of this gesture is explained differently by various authors, some of whom consider it to be "the attitude of singing his songs of realization" (Batchelor, 1987, p. 420). Others say that "it may signify his listening to the sounds of nature or refer to his use of the secret, oral doctrines that were not written down but passed verbally from master to disciple" (Fisher, 1974, p. 26). Images of Milarepa are easily recognizable by this distinctive gesture of his right hand. However, the Hermitage ivory Milarepa has certain details that distinguish it from the usual representations. The Tibetan iconographic tradition usually depicts Milarepa with his left hand resting on his lap, either empty or holding a *kapala* skull bowl (some scholars consider this attribute to be a bowl but not a skull bowl). Here, however, his left hand leans on the throne behind his body. The prayer belt usually over his right shoulder is absent here. These differences are too important from the iconographic point of view to be mere inventions of the artist. It is more likely that a certain pattern was followed.

Rather similar representations of Milarepa can be found among Chinese images. One example belongs to the pantheon of the Baoxiang (Pao-hsiang) Lou temple in Beijing (Clark, 1965a, II, p. 17, N 1A35). Here the famous Tibetan ascetic is made to resemble Chinese images of Maitreya as a big-bellied, smiling personage. As in the Hermitage ivory Milarepa, he sits on an antelope skin and his left hand leans upon his throne.

Another 18th-century Chinese image of Milarepa is in the Musées Royaux d'Art et d'Histoire in Brussels (von Schroeder, 1981, no. 156D, pp. 548–49). On the whole, the sculpture looks as though it was made in the Tibetan stylistic tradition, but the position of the left hand is the same as in the Baoxiang Lou's Milarepa.

It is very likely that this type of Milarepa image goes back to a Chinese prototype, namely to the images of big-bellied Maitreya. The style of this sculpture, to say nothing of its ivory

material, supports a Chinese provenance for the Hermitage Milarepa. The ornament, the folds of the garment, and the design of the flower under Milarepa's right foot suggest a 16th-century date. The image has been pieced in several places and glued together (the right arm at the shoulder level, and the right knee). The bottom has a carved-out cavity about 1⅜ inches deep. A small scroll with a Tibetan text written with black ink in ordinary script was found inside.

G. Leonov

81
Milarepa

Eastern Tibet or Central Regions, Tibet

First half of the 17th century

Dark bronze, with cold gold paste and pigments

H. 7″ (17.8 cm)

The Los Angeles County Museum of Art,
Los Angeles. Gift of Doris and Ed Wiener.
M.72.108.1

Lit.: Pal, 1983, p. 230.

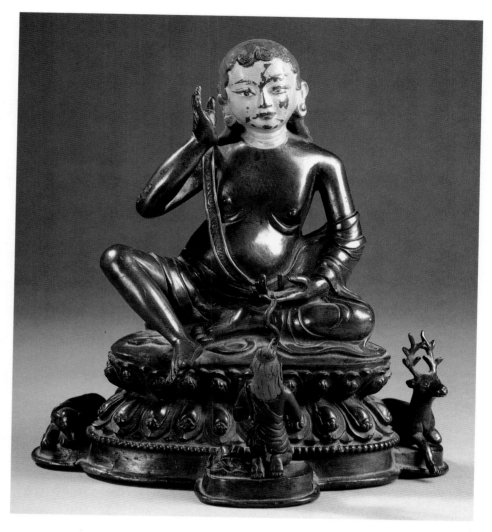

This lovely sculpture portrays the saintly
yogi with a gentle grace and a sublimely
sweet expression. Before him kneels the
hunter Kyiwara Gonbo Dorje (Chirawa
Gwunbo Dorje), with a spotted black deer
and a red dog sitting quietly on either
side. Milarepa's biography recounts how
one day he was sitting in meditation on a
large boulder on Nyi Shang Gur Da
Mountain. The deer was fleeing for its life
from the dog and the hunter. Roused by a
great compassion for all three, who were
caught in the life-and-death drama of
samsara (the ego-driven life cycle), Mila-
repa spoke to the deer, and calmed its fear:

Listen to me, you deer with sharp antlers!
Because you want to escape
From something in the outer world,
You have no chance to free yourself
From inner blindness and delusions.

Then the wild red hunting dog ran up
and charged angrily at the deer, but Mila
said to her in turn:

Whatever you see, you deem it to be your foe;
Your heart is full of hatred and ill thoughts.
Because of your bad Karma you were born a
* bitch,*
Ever suffering from hunger, and agonized by
* passion.*
If you do not try to catch the natural mind
* within,*
What good is it to catch prey outside?
The time has come for you to capture your
* natural mind;*
Now is the time to renounce your fury,
And with me sit here restfully.

The dog was moved by these words, and
she lay down peacefully with the deer.
Soon the hunter came upon the scene: "As
he dashed up, one could hear his breath
coming in suffocating gasps and see
streams of sweat pouring down his face,
almost choking him to death." In his
frenzy, seeing the dog and deer beside the
yogi, he became angry at Milarepa and
shot at him with an arrow. But the arrow
was magically deflected. Mila sang to him:

Men say the human body is most precious,
* like a gem;*

There is nothing that is precious about you,
You sinful man with a demon's look!
Though you desire the pleasures of this life,
Because of your sins, you will never gain them.
But if you renounce desires within,
You will win the Great Accomplishment.
It is difficult to conquer oneself
While vanquishing the outer world;
Conquer now your own natural mind.
To slay this deer will never please you,
But if you kill the Five Poisons within,
All your wishes will be fulfilled.
If one tries to vanquish foes in the outer
* world,*
They increase in greater measure.
If one conquers his natural mind within,
All his foes soon disappear.

The hunter was thunderstruck by Mila's
calm and moved by his words. He felt
great faith in this powerful yogi. He
offered up the deer, the dog, his hunter's
robe, his goatskin clothes, and his bow
and arrows, and he became Milarepa's
disciple. Thereafter he was known as Kyira
Repa—the cotton-clad huntsman. It is said
that the deer and dog were "forever
removed from the Path of Sorrow," and
that the bow and arrows still remain in the
cave at Nyi Shang Gur Da Mountain on
the border of Tibet and Nepal.

(Translations from Chang, 1977, I,
pp. 225–86.)

The slender and beautiful body of this
statue expresses a naturalistic aesthetic that
seems consonant with movements in art
around the late 16th to early 17th century.
Although many features of the style have
been known since the early 15th century,
such as the drapery configurations (close
to those of the sculptures in the Peljor
Chöde in Gyantse), the narrative elements
(as seen in the Virupa statue of the early
15th century in text fig. 16), and the
delicate fashioning of the face in the
Shamvara of No. 70, they appear here as
well-assimilated elements. Most of the
them relate to features from Tsang
regional styles, but the special emphasis on
the grace and delicacy of the style could
indicate an origin in Eastern Tibet, close
to the source of Chinese lyrical naturalism.
This stylistic tradition can also be seen in
some of the Hermitage sculptures (Nos.
72, 80). The cold gold paste, the bright
blue pigment in the hair, and the touches
of red seem to be later additions. This
sculpture is surely one of the most pleasing
and delightful of all Tibetan statues of
Milarepa.

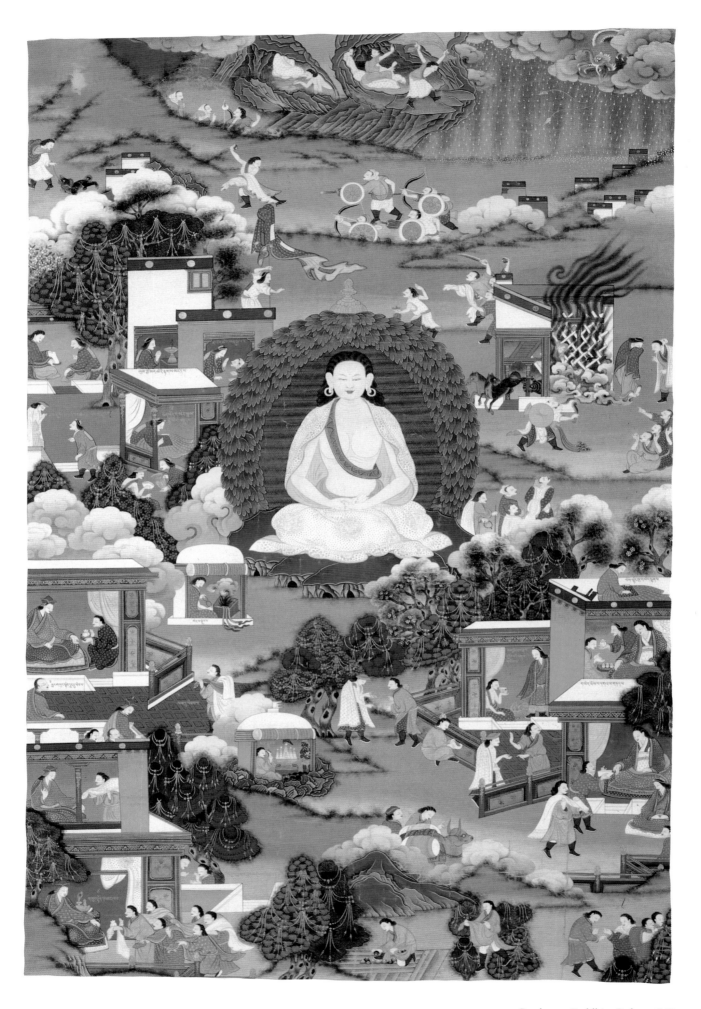

Milarepa and
Scenes from His Life

Eastern Tibet

Late 18th to early 19th century

Tangka No. III in a series; gouache on cotton

32⅞ × 21⅞″ (83.5 × 55.5 cm)

Folkens Museum Etnografiska, Stockholm

Lit.: Schmid, 1952, pp. 36–40.

This sophisticated and elegant painting comes from a famous series of nineteen tangkas on the life of Milarepa obtained in Beijing in 1930 by the Sven Hedin expedition. This set follows the biographical details preserved in the *Life of Milarepa* and the *Collected Songs of Milarepa*. It represents a high point in the development of one of the major styles of Tibetan biographical painting, seen in several earlier examples, such as Nos. 97, 49, and 65. In this style, the image of the lama or adept is placed in the center of the painting as a large hierarchical figure, surrounded by the unfolding scenes from his or her life presented within a landscape setting.

Here, in the third tangka of this series, Milarepa is shown seated in front of a leafy cave bower, his hands laid flat in his lap in the contemplation gesture. His white cotton robes, decorated with gold floral designs, flow with a dexterous and fluid line over his perfectly proportioned body. His face is portrayed with an exceptionally lyrical and idealistic beauty. The quality of line and color tends to lift the entire painting beyond the realm of the real, but the vivid action of the figures and the engrossing narrative details of the events unfolding in each scene surrounding Milarepa counteract the idealized aspect of the style and keep the work rooted in reality. This reflects a constant principle in Buddhist art; like the Teaching itself, it does not forsake this world but freely chooses to engage with it.

Each scene is clearly labeled, and the events flow and unfold with a compelling rhythm, generally following a compositional scheme starting from the lower left and moving to the top. The scenes here, as worked out in Toni Schmid's masterful study, depict a period in Milarepa's life before he embarked on his Buddhist practice. Mila's father died when he was only seven. Mila's mother and her two children were then cheated out of their inheritance by a greedy paternal uncle and his wife. Eventually, Mila's mother sent him to learn black

magic in order to take revenge. Mila was successful in his sorcery, and as the right side of the tangka shows, he destroys the family house, in which his uncle's son is having his wedding feast. He conjures up a scorpion, which frightens the horses, who in their fright kick the pillars, causing the house to collapse and kill most of the uncle's family (82.1). When the villagers still threaten his mother, he produces a hailstorm that destroys one of his uncle's fields. The action is seen here on two separate planes: Mila in his small cell performing the charm in the lower left and the resulting hailstorm taking place in the upper right. Mila and a friend go to watch the hailstorm from a cave nearby, but he is recognized by the angry villagers, who take up arms and come to get him. These acts of black magic later caused Milarepa much remorse. Convinced that he would be punished for them in hell, he sought spiritual guidance with a firm resolve. After he found his primary master, the

translator Marpa, he dedicated himself totally to practice.

Figures, landscape, and houses all freely commingle to create the story elements. Green and pink clouds, blue and green hills edged in gold, and groups of trees help to separate the various scenes. Simple but colorful architecture and smoothly graded washes of green create the shadowless planes of the spacious setting. The lyrical beauty of the fluid line combines with the sharp reality of clear, brilliant color and the harmonious juxtaposition of figures and landscape to create the beautiful synthesis that characterizes this style. It is generally associated with the Karma Gadri style of painting of Eastern Tibet. A similarity in style with the painting of the Tree of Divine Assembly dated 1795 in the Museum of Fine Arts, Boston (Pal and Tseng, 1969, no. 17), suggests a late 18th- to early 19th-century dating. It appears that at least two different hands executed the paintings in this marvelous set.

82.1

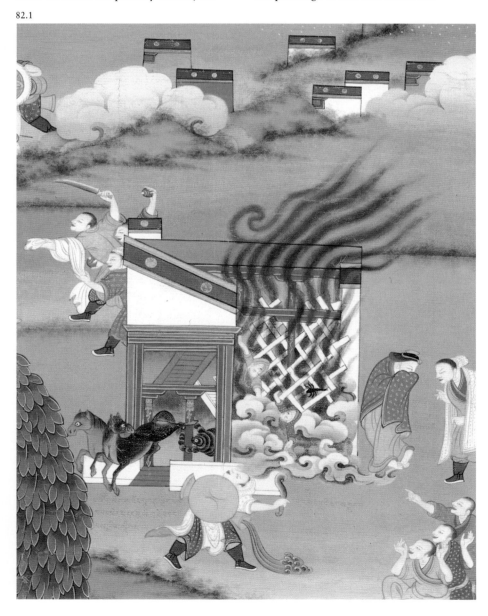

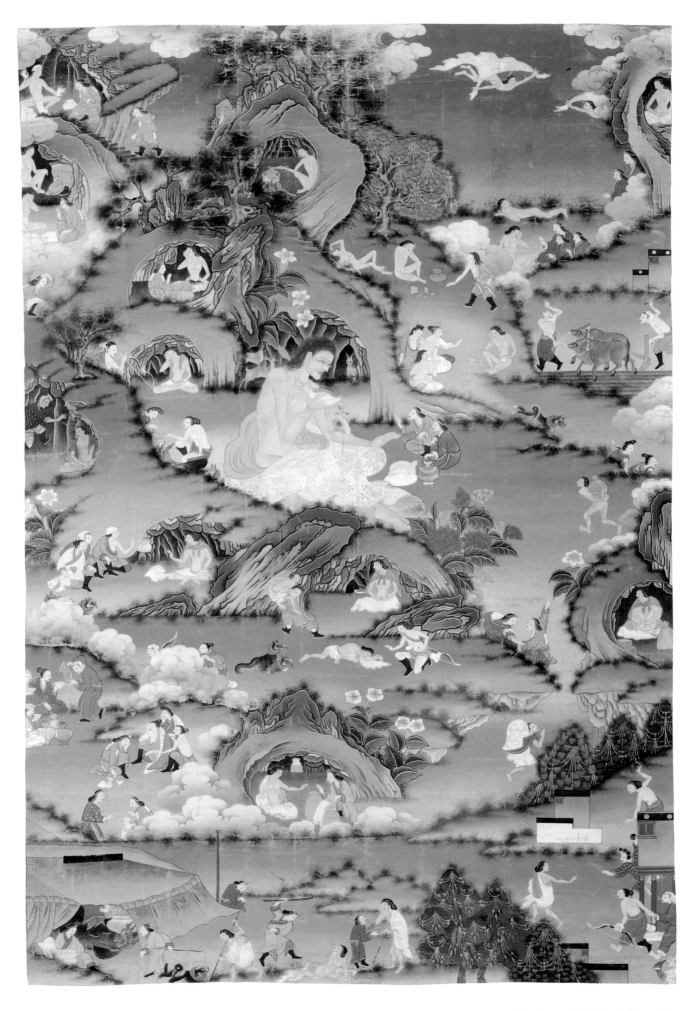

83
Milarepa and
Scenes from His Life

Eastern Tibet

Late 18th to early 19th century

Tangka No. IX in a series; gouache on cotton

32⅞ × 21⅞″ (83.5 × 55.5 cm)

Folkens Museum Etnografiska, Stockholm

Lit.: Schmid, 1952, pp. 62–65.

From the same set as No. 82, this painting depicts scenes of Milarepa's intense contemplative practice of the teachings he received from Marpa. The large central figure of Milarepa, positioned with slight asymmetry, reflects the circumstances of this stage in his life. He is shown as a gaunt ascetic with grey-green skin (83.1), a shade resulting from his diet of nettle soup, which was the only food he took during a period in his early meditation retreats.

Scenes from this interesting time of Milarepa's life in the caves are set within the criss-crossing diagonals of the hilly composition. Summarizing the sequence and description presented by Toni Schmid (1952, pp. 63–64), they unfold as follows (see diagram), beginning at the lower left. At this juncture, Mila is about to begin an important meditation period. He has left the house of his teacher, Marpa, and has returned to his home region, where he has found that his mother has died and that his family's home and religious books are in dismal neglect. He is destitute and begs for food. In his wandering he comes upon the tent of his aunt, where he is beaten up and bitten by a dog (1). Later he goes to his uncle's house and is chased away by his uncle, who tries to shoot him with a bow and arrow (2). Following this, Mila spends some time in a cave (3 and 4), where he is given some provisions by his remorseful aunt (3). She asks for his property and he gives it to her. In a series of scenes at the center left, various hunters and thieves come upon him during his two years' meditation in the cave (5). His sister, who has not seen him for years and who herself has become destitute, hears about Mila and goes to see him. A sequence of scenes in the upper left corner portray his meetings with her (6). When she first saw him she was frightened, thinking she saw a ghost. Horrified by his nakedness, on a later occasion she brings him cloth. He makes coverings for his hands and feet from the cloth. As he shows her these strange garments, he tries to convert her by telling her one need not be ashamed of

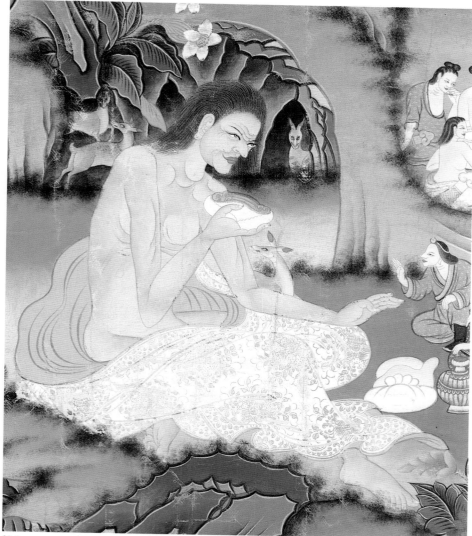

83.1

nakedness, but of evil thoughts and deeds. It is during this period that Mila opens the scroll Marpa gave him at parting. Following its instructions, he makes advances in his meditation and attains the ability to fly (7). Below, he is seen flying by a relative plowing his field. As Mila leaves the caves of this formative period in his life, he drops his clay pot and the nettle shell rolls out (8).

Brilliant green dominates the color scheme of this tangka and affords a contrast to others in the series that utilize more architectural forms. The small figures, as in each of the paintings of this series, are done with characteristic graphic liveliness, skillful execution of line, and bright coloration. The rocks and hills have become somewhat formalized over the centuries of this stylistic tradition's development, but they nevertheless retain freshness, vigor, and flair. The sense of space, a feature that came to Tibetan painting primarily from Chinese sources, has become a well-assimilated part of the composition, and is equal in importance to the figures. The dynamic energy, the vivid

realism, and the intense beauty of fluid line and brilliant color—in this case probably associable with the Karma Gadri school of Eastern Tibet—are the special hallmarks of the Tibetan artistic genius.

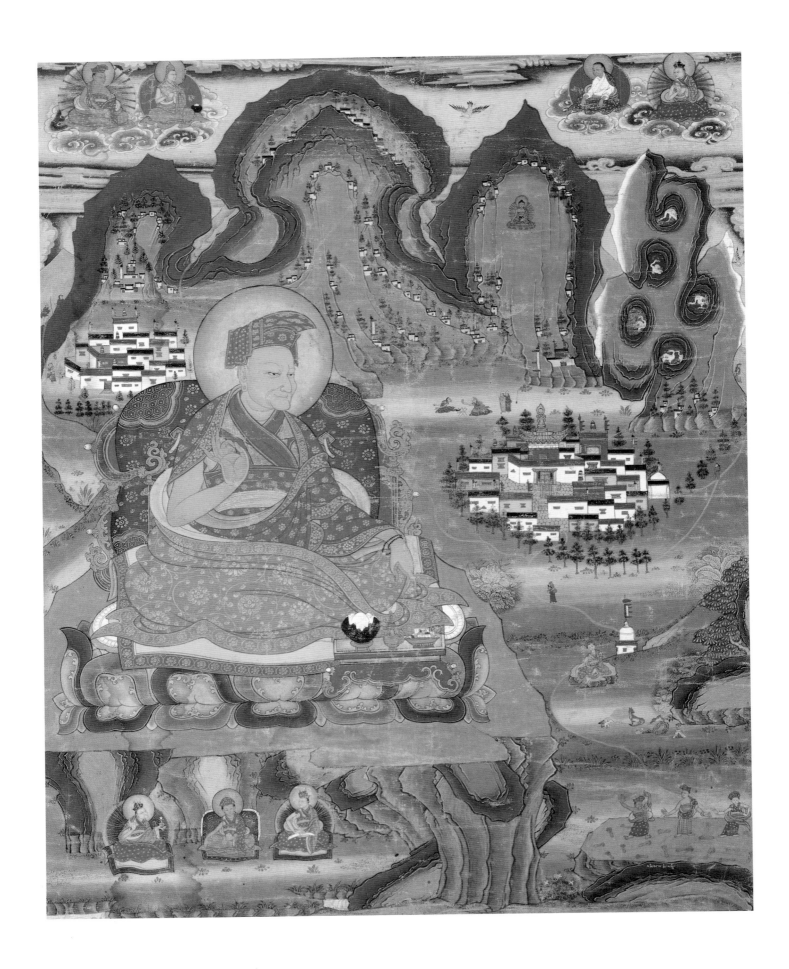

84

Gampopa

Central Regions, Tibet

18th century

Tangka; gouache on cotton

24 × 20″ (61 × 50.8 cm)

The Zimmerman Family Collection

Gampopa (1079–1153), the Physician from Dakpo (Dakpo Lhajey), was the foremost monastic disciple of Milarepa. He founded the main monastic traditions of the Kagyu Order, integrating the mystic contemplative teachings of Milarepa with the monastic curriculum of the Kadam Order, in which he had received his Buddhist higher education. He had many noted disciples, a number of whom founded the most important suborders of the Kagyupa. This painting of Gampopa, identified by an inscription on the back, comes from a set of lineage masters of the Taklung Order of the Kagyupa, which founded its main monastery in the late 12th century at Taklung.

In this portrait, Gampopa is depicted as an old man with a broad, bony face and a big body amply swathed in red and yellow robes brightly dotted with gold designs. He sits on a low-backed curvilinear throne atop a lotus pedestal with orange, pink, green, and dark blue petals. A small painted table with offerings seems to hover in front of him. The asymmetrical placement of the main figure allows a view past the rocky outcropping that supports his pedestal and into the valley beyond. Small figures and a stupa are visible on the plain in front of the monastery, whose

main hall has a golden roof. The buildings are clustered in front of an impressive array of imaginatively conceived blue mountains edged in gold. Behind the monastery a debate is taking place. Farther back and to the left, we glimpse a second, slightly smaller monastery over the lama's throne. Small figures are climbing the mountain nearby on a path, which appears to run around the mountain and the monastery. Other figures emerge from the mountain on the far right. Dotting the sharp cliffs are numerous small hermitages for meditation. A figure of Akshobhya Buddha appears in the sheer face of the sharpest peak. Five circular cave nests, inhabited by what seem to be vultures, appear in the fantastic convoluted cliff at the upper right corner.

In the sky above, filled with horizontal cloud masses, sit four small figures of lamas, each identified by an inscription. From left to right they are Jey Gontsul, with the red hat of the Shamarpas (see No. 90); Atisha, with a *khatvanga* staff and bowl beside him; Drom Tonpa, Atisha's lay disciple; and Dusum Kyenpa, the first Karmapa, wearing the black hat of the Karmapas. They are an interesting combination of Karmapa and Kadampa lamas, two lineages that had a close re-

lation to Gampopa. Inscriptions accompany other groups of figures throughout the painting, but they are difficult to decipher. The group at the lower right seems to be making or exclaiming about footprints in the rock; the inscription calls them "three men of Mamspa." At the lower left are a red-hatted Shamarpa and black-hatted Karmapa flanking, presumably, a Taklung lama.

The control of space and the boldness of the fantastic rocks suggest a date of at least the 17th, but more likely the 18th, century. The tonality of the color is subdued and earthy, in keeping with color schemes frequently seen in the western and central regions. It is quite likely that the set was painted in the area of Taklung monastery. The strength of the abstract patterning and the refreshing lack of over-elaborate detail show another side of 18th-century Tibetan painting, one that places more reliance on simplicity and strength than on overt refinement and elegance. This set, of which ten tangkas are in the Zimmerman collection, one in the Ford collection (Lauf, 1976a, pl. 37), and another in the Los Angeles County Museum (Pal, 1983, p. 94), is an important and excellent example of a particular local genre style.

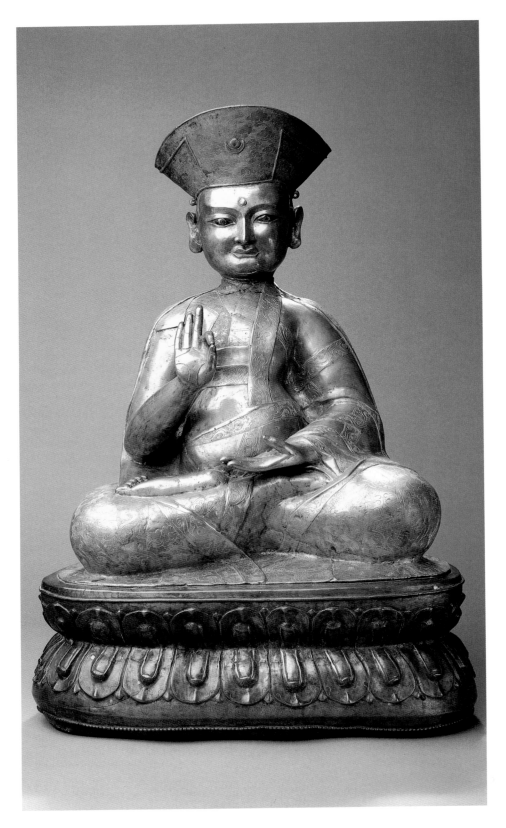

Drukpa Lama Gyalwa Gotsangpa Gonpo Dorje

Western Tibet

15th century

Brass, with copper and silver inlay, and pigments

H. 26″ (66 cm)

Collection of The Newark Museum, Newark, New Jersey. Purchase 1969, The Members' Fund

Lit.: Reynolds, 1978, no. 208; Reynolds et al, 1986, pp. 102–03.

The lama sits fully garbed in clinging robes and an impressively broad hat, presenting an imposing and massive figure. His right hand makes the discerning gesture, and his eyes, inlaid with silver and copper, gaze intently at us. The noticeable asymmetry and distortion of the figure, rather than being a distraction, serve to affirm his human qualities. His distinctive character is immediately grasped from his broad face and large features. The powerful volumes of his limbs reinforce his appearance of strength, while his chubby midsection and gently sloping, narrow shoulders suggest a gentle nature within. Lama Gotsangpa (1189–1258) was a mystic and a disciple of the founder of the Druk Order of the Kagyu. This order was well established in Western Tibet, the probable provenance of this sculpture. The Gotsang Drubdeh hermitage (near the famous Drukpa monastery of Hemis in Ladakh) is mentioned in the inscription on the bottom of the pedestal.

The mass of the figure, together with a broad face and well-outlined large features, seems consonant with the monumental sculptural style of the main images of the Gyantse Kumbum, dating around 1427 (text fig. 18). The technique of overlapping flat layers of cloth and exposing the general shape of the body also seems consistent with other sculptures from the 15th century, such as No. 47. The flowery details in the chasing and the inlaid copper along the border of the inner vestment add some ornamental touches to the rather plain, smooth surfaces of the figure. The pedestal, which is darker than the image that is attached to it, has a gently convex upper surface and a double row of slightly raised, simple, but strongly delineated lotus petals. With its impressive bulk, expressive use of distortion, and powerful yet gentle humanity, this lama sculpture is one of the finest and largest known in Western collections.

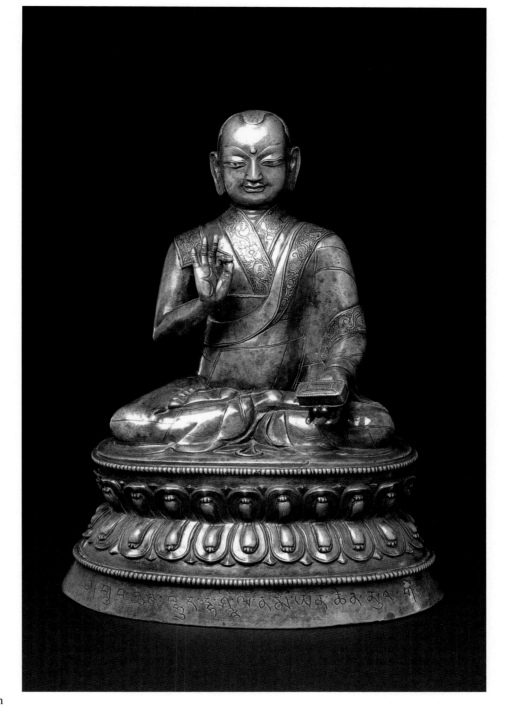

Buddhashri

Central Regions, Tibet; probably Tsang

Late 15th to early 16th century

Brass, with copper and silver inlay

H. 7¾″ (19.9 cm)

Trustees of The Victoria and Albert Museum, London

Lit.: Lowry, 1973, p. 36–37; Roerich, 1988, pp. 708 ff, 1056, 1068–70.

There is an inscription on the front and back of the pedestal of this sculpture that reads: "Homage to the Great Adept, Buddhashri! By the great patron Mul [or Mula], this was made as the truth of the father. The Chos-lung palace." According to the *Blue Annals*, Buddhashri lived from 1173 to 1225. He was a Mahasiddha from Jagatala in Eastern India. He later went to Tibet, where he visited Lhasa, Samye, and other places. When he was twenty-five years old, he was invited to Tropu in central Tibet by Tropu Lotsawa, who was one of his two great disciples. In 1212 he constructed a large Maitreya temple in Tropu. Tropu Lotsawa escorted him out of Tibet when he went to Kashmir, where he instigated a revival.

In this statue, Buddhashri sits in the diamond pose with his bare feet exposed. He makes the teaching gesture with his right hand and holds a small book with an elaborate cover in his left hand. He presents a strong and rather mature appearance with his serious face and slightly protruding abdomen, his alert posture and small hands and feet adding a subtle touch of youthfulness.

This small but handsome work shows an interesting mixture of smooth planes with touches of the looser drapery and the regular, naturalistic proportioning seen in the sculptures from the Peljor Chöde at Gyantse, dating in the second quarter of the 15th century (text figs. 21, 22). In addition, the stress on the beauty and power of the figure is characteristic of the art of the central regions. The smooth, fluid surfaces, the controlled patterns of the curved folds, and the touches of rich floral design on the robe's borders reveal a consciously selective principle of proportioning, patterning, and balancing. The silver inset eyes, copper lips, and copper hair heighten the sense of reality and punctuate the beauty of the thinly curved lines, the smooth swelling of the masses, and the gently folded pleats. The pedestal is close in style to that of Lama Gotsangpa (No. 85), except that it has the slightly heavier and thicker appearance typical of sculpture from the central regions. A lama sculpture of similar but earlier style is in the Essen collection (Essen and Thingo, 1989, II, p. 102, no. 221). Both are likely to be related to the Taklung monastery in northern Tsang.

87
The Drigung Kagyu Lama Chetsang Rinpoche

Central Regions, Tibet; probably Ü

Late 16th century

Tangka; gouache on cotton

21 × 17″ (53.4 × 43.2 cm)

The Zimmerman Family Collection

It is probable that this lama is one of the Chetsang Rinpoches of the Drigung Kagyu Order. The Chetsang Rinpoches are the reincarnations of one of the major disciples of Jigten Sumgon, the founder of the Drigung Order. Along with the Chung-tsang Rinpoches, they have headed the order since the 14th century. The Drigung is a major suborder of the Kagyu, tracing its lineage from Jigten Sumgon (1143–1212), a disciple of Gampopa and founder of the main Drigung monastery in 1179 in the Ü region, northeast of Lhasa. The Drigung is a strongly mystical order, particularly famous for its cultivation of the practices associated with the Six Yogas of Naropa, especially the yoga of life transference (T. *'pho ba*). As a social institution, the order was a political ally and sometimes a rival of the Sakya Order during the 13th-century period when Tibetan monastic institutions were protecting Tibet from the Mongol empire while trying to keep the peace within Tibet. The Drigungpas have been active missionaries.

This painting is a portrait of an important lama that has a specially sacred status due to its presenting the mystical images of hand prints and footprints of the lama. For the Tibetan devotee, it is almost like a reliquary in blessing power, since it received direct contact with the lama's physical body while he was alive. The palms of the mystical hand prints and the soles of the footprints show the sign of the wheel of the Dharma, indicating that the lama is believed to be a living incarnation of an actual Buddha. The lama has prominent cheeks and dark skin. He sits in a dark blue chair, his hands in the teaching gesture. He is not very large in scale. The large golden hand prints and footprints tend to overwhelm the painting, with its delicate style and dark, subdued tonalities.

The placement of the secondary figures is highly symmetrical. Above the main figure's triumphal canopy sits a red Vajradharma, a form of the Buddha as tantric master associated with the mystic teachings of the Vajrayogini. Four lamas with bright red halos flank this figure, two on each side, representing the lineage through which the main lama received the transmission. At the level of the main lama and between the hand print and footprint on that side, there is a red Amitayus at the left and a red Indrabhuti-style Vajrayogini at the right. In front of the main figure there is an offering table, and below that, a wheel of the Dharma stands on a mound of jewels, with a lama and two disciples on the left and a protector figure, called Sherma in the inscription, but resembling the Gonpo Bernak, Black-Cloaked Mahakala. At the bottom is a dark pool with ducks swimming in it. Dark rocks with subtle naturalistic shading and jagged edges back the golden feet, and barely discernible blue rocks back the golden hands. Perhaps these are reminders to the believer of a famous set of footprints and hand prints left in rock by the lama. Dusky, brick red clouds divide the malachite green ground from the dark blue sky, which flickers with the curling golden threadlike lines of clouds. Behind the main lama is a tree with golden fruit. It is an early usage of the tree motif, replacing the shrine backing of the traditional styles. The lamas' clothing is predominantly red, with small dots of gold. The strong accent of red enlivens the otherwise somber and quiet setting.

This delicate and refined painting has a very distinctive style. Since it can be associated with the Drigungpas, possibly from the Ü region, it is especially important to the understanding and categorizing of developments that comprise the complex artistic style of this period. Stylistically it is comparable with other works of the late 16th century, such as No. 97 from Western Tibet and Nos. 7 and 39, both probably from Eastern Tibet. Landscape elements like the tree and the pond with ducks swimming in it relate to eastern styles. Both the Jataka of ca. 1600 (No. 7) and the Sarasvati of the 17th century (No. 27), for example, have similar, although more developed, duck pond motifs. All of these paintings may be related to Kagyupa sources, a possible indication of a cross-fertilization in art between monasteries of similar affiliation from differing regions. In contrast to those eastern works, this Drigungpa tangka reveals some prominent regional differences in paintings of this era. In the Western Tibetan painting (No. 97) there is little reliance on landscape. On the other hand, contemporaneous Eastern Tibetan paintings, closer to sources of Chinese painting, incorporate even more landscape and spatial dimension than do paintings of the central regions like this one.

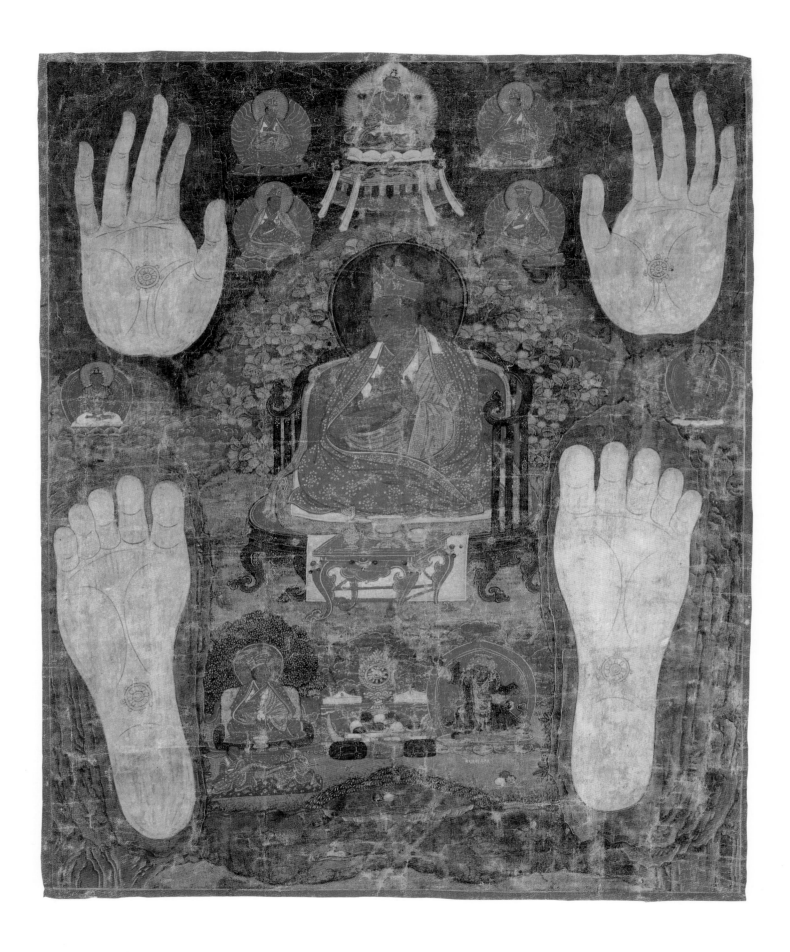

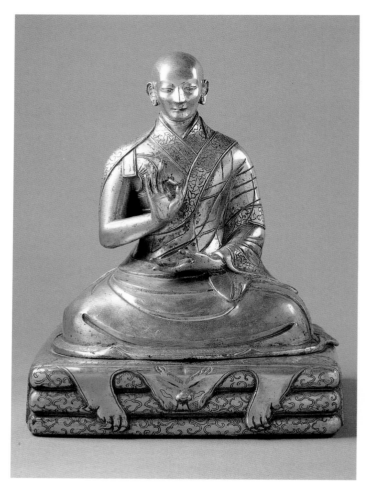
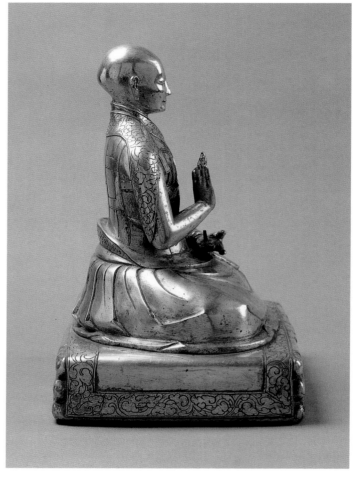

88

Lama

Eastern Tibet

Late 15th to early 16th century

Gilt brass; cast in several parts, with chasing, cold gold paste, and pigments

H. 12¼″ (31 cm)

The State Hermitage, Leningrad. Kozlov Collection

This majestic image of a lama is one of the best examples of portrait sculpture in the Hermitage collection of Tibetan art. Not overloaded with details, the image concentrates all the attention of the spectator on the powerful head of the lama. The protruding back of the head, thin determined lips, and sharp chin distinctly indicate the attempt of the artist to render the real portrait features of this unknown Tibetan lama.

The iconography of the sculpture is very simple. The lama's right hand makes the discerning gesture, and his left hand lies flat on his lap in the contemplation gesture. It possibly held an object, and one finger is delicately arched. The cushion type of pedestal indicates that the sculpture was made during his lifetime, since it is apparently customary for portraits made either within the lifetime or within living memory, to depict the lama seated on cushions rather than on a lotus pedestal. The cushions are covered by a tiger skin, indicating that the lama was an adept and yogi. However, none of these details enables us to know his name, in the absence of an inscription.

G. Leonov

89
Lama Karma Dudzi

Eastern Tibet

Second half of the 16th century

Gilt bronze, with pigments

H. 11¼″ (28.6 cm)

The Los Angeles County Museum of Art, Los Angeles. Gift of Christian Humann. M.77.152

Lit.: Pal, 1983, p. 220.

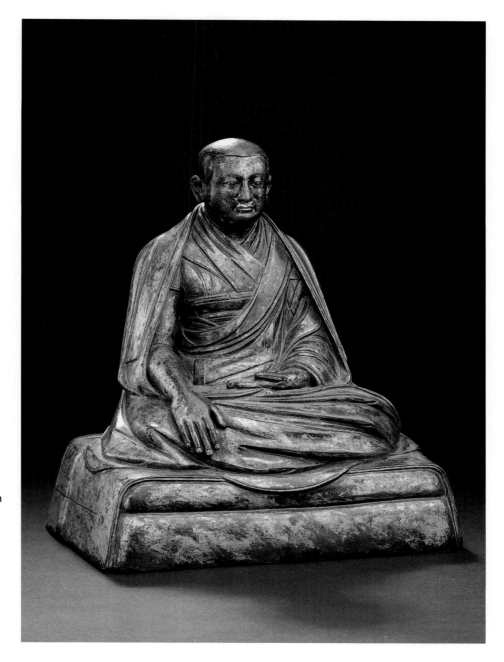

An inscription on the back of the pedestal states that this sculpture is "a portrait image for the bedroom of the late Lama Rinpoche Karma Dudzi." Hugh Richardson, who translated the inscription, notes that there was a Karmapa lama of this name living in the 16th century (Pal, 1983, p. 263). Although the inscription indicates that the lama is deceased, it also suggests it was made by his close associates or disciples, within living memory of the lama.

Clearly, this is one of the most powerful realistic portrait sculptures in Tibetan art. Although there is great emphasis on solidity of form and sensitive human presence, as seen in other portrait sculpture of the 15th and 16th centuries, such as the large statue of Gotsangpa from Western Tibet (No. 85), the style is nevertheless quite different. The Karma Dudzi image gives equal consideration to the firm mass of the body and to the lama's heavy, naturalistically portrayed robes. These robes, rather than being thin layers, are a spectacular mass of tensely drawn planes and thickly creased folds. The layers and folds wrap around his body, flow in deeply gouged creases over his legs, and frame the arms with severely tense, taut edges that impart a sense of the inner life and power of the figure beneath. As dramatic in composition and mass as the folds of his robes may be, however, the sturdy, regularly shaped body of the lama ably supports them. The square face, with its firmly set features, and the exposed arm, with the hand turned palm down on the knee, reveal the same solid, heavy mass and bulk that is implied beneath the thick drapery.

This image is especially important in establishing the existence at this time, probably in Eastern Tibet, of a stylistic tradition emphasizing a high degree of naturalism in the representations of drapery, body, and personality. The influence of Chinese naturalism in the drapery is more apparent here than in areas more affected by the Indian and Nepalese traditions. This seems to be a major style of portraiture for the central regions by the end of the 17th century, as seen in a number of surviving sculpture portraits of the Fifth Dalai Lama (No. 98). The lama sculpture from the Hermitage (No. 88), which seems stylistically to date with the Buddhashri statue (No. 86) from the central regions of the late 15th to early 16th century, may represent a somewhat earlier stylistic phase in the development of this Eastern Tibetan naturalistic portrait sculpture.

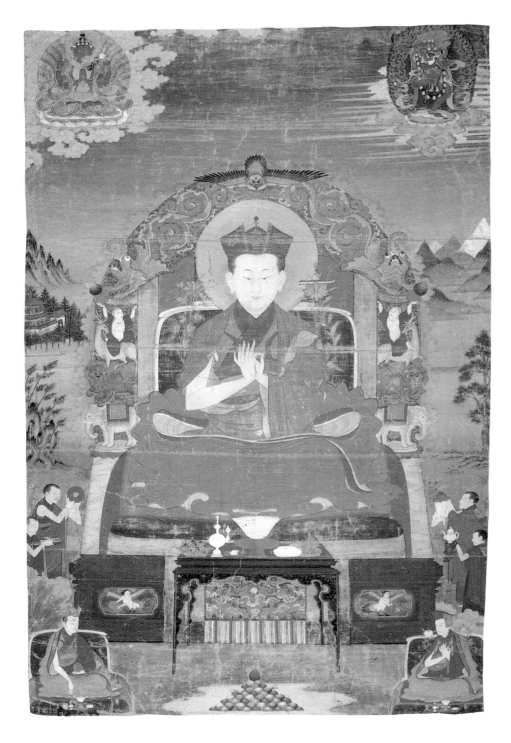

90
Eastern Tibetan
Kagyu Lama, Shamarpa

Eastern Tibet or China

First half of the 17th century

Tangka; gouache on cotton

50⅜ × 32¼″ (128 × 82 cm)

Musée Guimet, Paris

The shape of the headdress is typical of the Karma Kagyu Order, and the red color indicates it is one of the Shamarpa Lamas, a lineage dating back to the first Shamarpa, Trakpa Sengey (1283–1349). His hands are held in the teaching gesture, each holding the stem of a lotus. A red one floats at his right shoulder, supporting a sword, and a blue one floats at his left shoulder, holding a Transcendent Wisdom book, itself supporting a sacred bell of wisdom. He sits on a beautifully ornate throne, in a contemplative's sitting bag (*dagam*) that hides his knees and feet. Before him is an offering table with a vase and a skull bowl, flanked by two other red-hatted lamas in the bottom corners. In the upper left corner, the four-armed red Bodhisattva Shadakshari Avalokiteshvara sits in union with his white consort; this indicates the lama's role as a lineage holder of the Ocean of Victors (Gyalwa Gyatso) tantric form of this deity. In the upper right corner, the two-armed red female protector Simhavaktra dances on one leg, indicating her guardianship of this lama's ministry.

The landscape is subtle and spacious, with a deep perspective. It is clearly inspired by the Chinese landscape tradition. The pastel coloring and the effects of shading seem inspired by paintings on silk.

The Ming emperors (1368–1644) had a close relationship with the Karmapas and other lamas close to them. Some of the later emperors were instrumental in the development of the Kagyu orders. This painting most likely dates to the last decades of their reign in the first half of the 17th century.

G. Béguin

91

Lama (Portrait of a Monk)

Khara Khoto, Central Asia

Before 1227

Tangka; gouache on cotton

15 × 10½″ (38 × 27 cm)

The State Hermitage, Leningrad

Lit.: Oldenburg, 1914, p. 145.

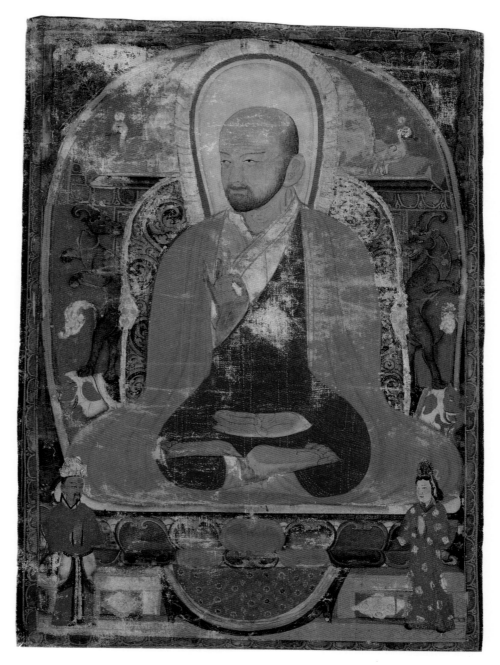

A monk, portrayed as a teacher, sits on a throne on a moon-disc cushion that is in turn on top of a multicolored lotus. A carpet is hung from the throne, which is typical of Central Asia, with a crosspiece at the top supported by dark blue, golden-tailed, goatlike leogryphs (shardulas) that are each standing on an elephant. There are yellow geese above the crosspiece. The monk sits in the diamond pose. His right hand makes the discerning gesture, and his left hand lies flat in his lap in the contemplation gesture. His inner robe is yellow, his outer robe is lilac-brown, and his outermost sitting robe is orange-red.

From Tangut sources translated by Prof. E. I. Kychanov, we know that Tangut monks' robes could be yellow, black, red, and violet. Only occasionally is it possible to explain the meaning of the differences of color, as they refer to adherence to a particular order or to hierarchy of rank within an order. There were three sanghas (Buddhist communities) in Xi Xia: Tangut, Tibetan, and mixed Tangut-Chinese. (It is not yet known if there was a mixed Tangut-Tibetan sangha.) In texts currently known in Tangut studies, there is no mention of antagonism among the various sanghas. The people of Xi Xia could not wear red or yellow clothing. An exception was made for monks, but it did not extend to outer wear; a monk could not wear a yellow outermost robe. The abbot wore red clothing, and someone dressed in yellow was lower in the hierarchy than someone dressed in red or violet. The offense of wearing red or violet clothing was punished by removal from office (Kychanov, 1982, pp. 30, 40, 48, 49). Unfortunately, this information rarely seems to correspond to the depiction of monks in the tangkas.

Below are patrons in rich robes and headpieces, a male on the left and a female on the right. Oldenburg believed that they are Uighurs; however, they may be Tanguts. There are analogous women's hairstyles—a high knot of hair covered with a golden net—depicted in other icons from Khara Khoto with Tangut inscriptions. From Tangut writings we know that portraiture existed as a genre in Xi Xia. (Portraiture of patrons in Khara Khoto is a fertile topic for research). Portraits of teachers are known both in Chinese Buddhist and Tibetan traditions. This one bears more resemblance to Tibetan works, although it is not possible to link it with a particular personage.

K. Samosyuk

Paramasukha-Chakrasamvara Father-Mother, Luyipa Mandala

Khara Khoto, Central Asia

Before 1227

Tangka; gouache on cotton

31½ × 26″ (80 × 66 cm)

The State Hermitage, Leningrad

Lit.: Béguin et al, 1977, no. 30; Oldenburg, 1914.

Paramasukha-Chakrasamvara—Shamvara for short—is the most important archetype Buddha of the Mother tantra class of Unexcelled Yoga tantras. He purposefully resembles tantric forms of Shiva in the Indian pantheon. He is related to the Hevajra Buddha form, another important Mother tantra archetype deity. In the icons of Khara Khoto he is depicted either alone or with his consort Vajravarahi. His cult was popular among the Tanguts. This icon, like the Khara Khoto Vajravarahi (No. 93), can be regarded as a mandala of deities. Despite the absence of a geometric composition and projection of a mandala-palace in the plan, this icon is organized by quadrants of the world in mandalic concept.

In the center is blue Shamvara with four faces and twelve arms. He is standing on a red solar disc on a multicolored lotus, against the background of an aura of red tongues of flame. The central face turned to the front (east) is blue; to the right, facing south, is a yellow face; to the left, facing north, is a green face; and behind him, facing west, is a red face. His hair is gathered in a high knot and decorated with a moon crescent, a double vajra, and jewels. A five-skull diadem rests on his brow. Around his neck is a necklace of beads made from human bones and a garland of heads. He is adorned with the bone ornaments of an adept, and wears a tiger skin on his hips. He holds a freshly flayed elephant skin held across his back by his two uppermost hands. His other right hands hold, top to bottom, a *damaru* drum, an ax, a vajra chopper, a trident, and, behind his consort's back, a vajra. His other left hands hold, top to bottom, a *khatvanga* staff, a skull bowl, a lasso, a four-faced head of Brahma, and, behind his consort's back, a bell. His right foot rests on a rose-colored Kalaratri goddess; his left, on a blue figure of the deity Bhairava.

Shamvara is depicted in the embrace of his consort, Vajravarahi. She is red, with one face and three eyes. She is adorned with bone ornaments, a five-skull diadem, and the other attributes of an adept Yogini. She stands with her left leg against her consort's right leg, her right leg raised athletically, winding around his left thigh. Her left hand embraces his neck, holding a skull bowl (out of sight), and her right hand brandishes her vajra chopper in the air. The square space behind the flame mandorla is pale blue, filled in with scenes from the eight cemeteries, specially sacred cremory burning grounds (*shmashana*) in ancient India. (They have become symbols of the ordinary life world from the tantric perspective and are located in the eight directions around a mandala.) The interpretation of the burning grounds is analogous to that of the Vajravarahi painting (No. 93). The iconographic depiction of the cemeteries is not very precise.

Around the central field—in frames—are the depictions of the deities of the Luyipa Sixty-two Deity Mandala, with two additional deities, all on a background of flames (see diagram). The deities in the upper left corner have been lost, but we can tell what they were from the iconographic pattern. Numbering them left to right, and down from the top left corner, they are: 1) a Yamaduti, half-yellow, half-red fierce female protector of the southwest; 2) one of the eight white body-circle Vira-Yogini couples; 3) a blue mind-circle Hero-Heroine couple; 4) a red Shvanasya, dog-faced female protector of the west; 5) a blue mind-circle Hero-Heroine couple; 6) a white body-circle Hero-Heroine couple; 7) a half-red, half-green northwest female protector, Yamadamshtri; 8) yellow Rupini, the southern Yogini of the inner great bliss circle; 9) a red speech-circle Hero-Heroine couple; 10) a white body-circle Hero-Heroine couple; 11) a one-faced, two-armed lone blue Shamvara Heruka; 12) a white body-circle Hero-Heroine couple; 13) a red speech-circle Hero-Heroine couple; 14) a red Khandarohi bliss-circle western Yogini; 15) a white body-circle Hero-Heroine couple; 16) a white body-circle Hero-Heroine couple; 17) a red speech-circle Hero-Heroine couple; 18) a red speech-circle Hero-Heroine couple; 19) a yellow pig-faced Sukarasya fierce southern female protector; 20) a green owl-faced Ulukasya fierce northern female protector; 21) a blue mind-circle Hero-Heroine couple; 22) a blue mind-circle Hero-Heroine couple; 23) a red speech-circle Hero-Heroine couple; 24) a red speech-circle Hero-Heroine couple; 25) a blue Dakini bliss-circle Yogini; 26) a blue mind-circle Hero-Heroine couple; 27) a red speech-circle Hero-Heroine couple; 28) a one-faced, four-armed blue Achala, protector of the mandala as a whole; 29) a red speech-circle Hero-Heroine couple; 30) a blue mind-circle Hero-Heroine couple; 31) a green lama bliss-circle Yogini; 32) a half-blue, half-yellow Yamadadhi fierce southeast female protector; 33) a white body-circle Hero-Heroine couple; 34) a blue mind-circle Hero-Heroine couple; 35) a blue Kakasya crow-faced fierce eastern female protector; 36) a blue mind-circle Hero-Heroine couple; 37) a white body-circle Hero-Heroine couple; and 38) a half-blue, half-green Yamamathani fierce northeast female protector.

Oldenburg identified the deity in the center of the second row from the bottom as blue Achala, with one head and four arms. He was identified by the cord in his hair and his implements: his main arms hold a cup of blood, his secondary right arm holds a sword, the left holds a staff with skulls. Here Achala, who has no special connection with the Shamvara mandala, plays the role of protector—in an apparently unique pairing of Shamvara with Achala. They do not appear together in published visualization manuals, or *sadhanas*. Overall, the icon corresponds exactly with the visualization manual of the Luyipa Sixty-two Deity Shamvara Mandala, with the exception of the one-faced, two-armed blue Heruka above the main figure, and the Achala below.

Comparison of this painting of Shamvara with the Hermitage Vajravarahi from Khara Khoto (No. 93) reveals that they belong to different artistic studios. Both were executed by professional, competent artists. The interpretation of the tongues of flame, the lotus petals, and the manner in which the severed heads are tied to the cord of the garland is different in these two paintings. In the Shamvara, the green and gold nimbus is noteworthy. This green color does not appear in any other icon from Khara Khoto.

K. Samosyuk

1	2	3	4	5	6	7
8	9	10	11	12	13	14
15						16
17						18
19						20
21						22
23						24
25	26	27	28	29	30	31
32	33	34	35	36	37	38

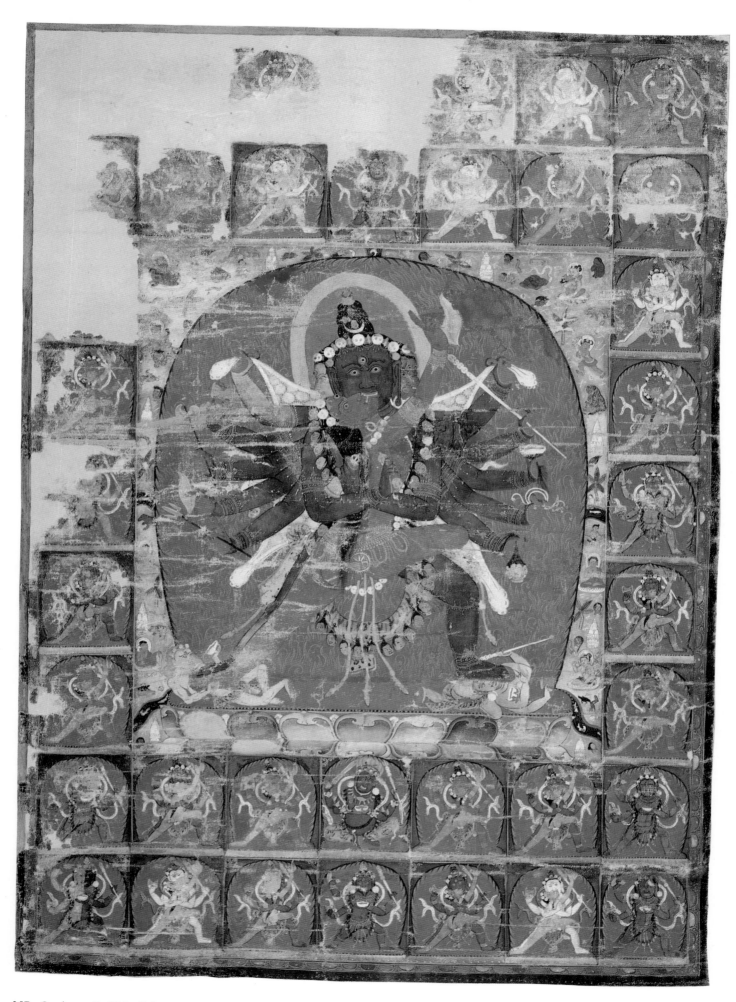

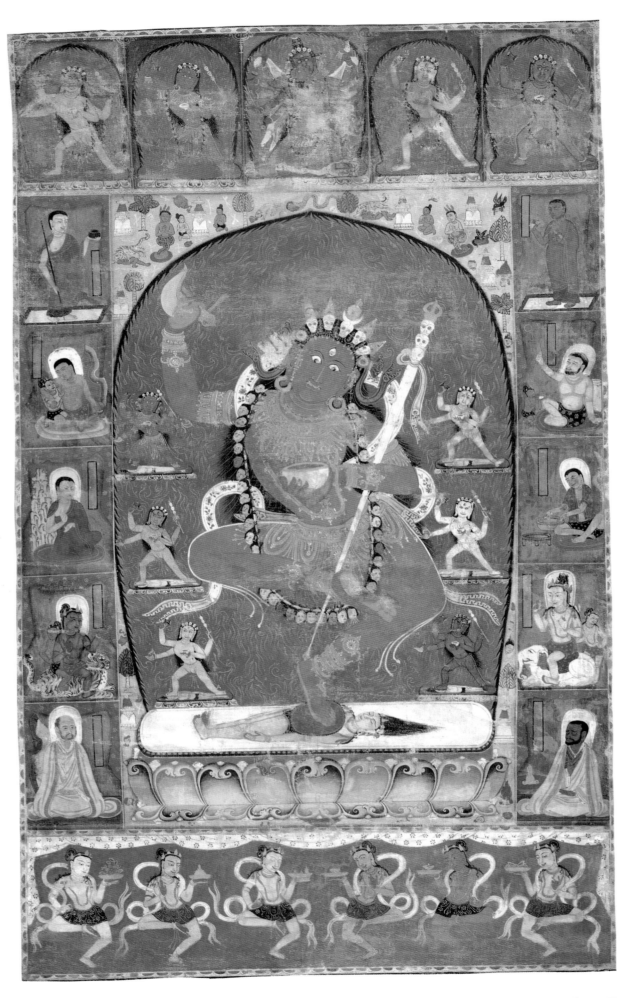

Vajravarahi

Khara Khoto, Central Asia

Before 1227

Tangka; gouache on cotton

43½ × 27″ (110.5 × 68.5 cm)

The State Hermitage, Leningrad

Lit.: Béguin et al, 1977, no. 28; Oldenburg, 1914, pp. 140–41.

Vajravarahi—the Diamond Sow (Dorje Pakmo)—belongs to the community of Shamvara deities. In Khara Khoto she is depicted either alone or with her retinue, against the background of a cemetery or without it. She is the female incarnation of the archetype Buddha, Shamvara.

Here red Vajravarahi stands on her left leg in a dancing pose, on the yellow reclining body of Bhairava, whose head is turned slightly to his left. The goddess wears a crown of skulls; on the central skull a wheel of the Dharma is depicted lying on a half-moon (93.2). To the right of her face is the head of a blue sow, badly worn. She wears a white flowered scarf and a garland of heads. She has gold earrings and gold ornaments on her arms, wrists, hips, and ankles. Fine bone ornaments also adorn her body, including an apron and a grand necklace. Her right hand holds a vajra chopper; the left holds a skull bowl before her breast. She carries a *khatvanga* staff, surmounted by three skulls and a vajra, in the crook of her left arm. She stands on a red disc on top of

Bhairava, who lies on the white oval moon disc, supported by a multicolored lotus blossom with a double row of petals. The figure is surrounded by a mandorla with tongues of flame. Against the background of the mandorla are six figures—Vajravarahi's retinue. The three on her right are red, green, and blue, and the three on her left are yellow, white, and dark blue (93.1). They all lunge to the right, trampling exactly the same figure as Vajravarahi. All except the red figure have

one face and four arms; they hold in their right hands a *damaru* drum and a vajra chopper, and in their left hands a *khatvanga* staff and a skull bowl. The red figure is different: she is three-faced and six-armed. Her right hands hold a *damaru* drum, a goad, and a vajra chopper; her left hands hold a *khatvanga* staff, a lasso, and a skull bowl. These six escorts may be the personification of the syllables in Vajravarahi's mantra. The flame mandorla is depicted against the background of eight

93.1

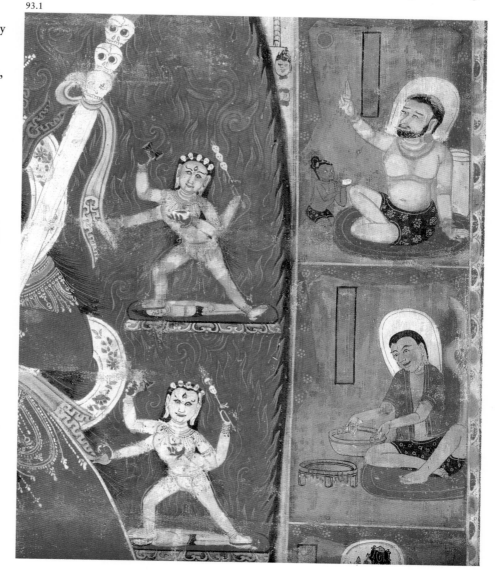

1		2
3		4
5		6
7		8
9		10

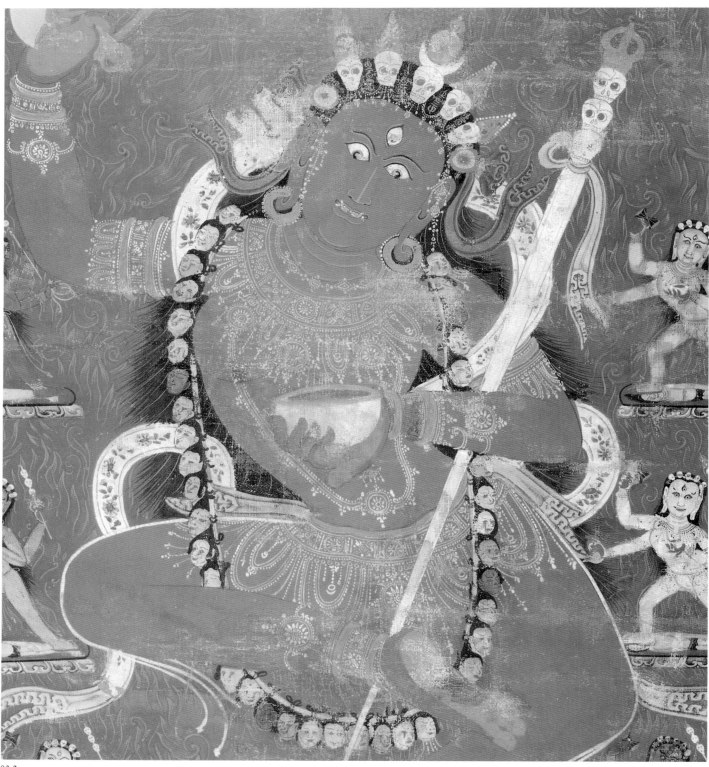

93.2

cemeteries represented by the eight stupas, eight trees, severed limbs, and praying figures. Bones, skulls, and beasts eating corpses are dispersed about the cemeteries.

A Shamvara couple stands on the top row in the center, flanked by a pair of four-armed Dakinis on each side. Five pairs of figures are positioned vertically along the two sides, each in a frame defined by gold-flowered red drapery (93.1). The red cartouches accompanying each figure are empty. From top to bottom, left to right, appear (see diagram): 1–2) monks; 3) a Great Adept with a consort; 4) a Great Adept, probably Virupa, pointing his finger at the red sun disc as a small person kneels at his side (93.1); 5) a Great Adept in brown monk's robes, sitting in front of cliffs with very unusual forms that may be unique to paintings from Khara Khoto; 6) a Great Adept preparing fish (Luyipa, according to the hypothesis of Oldenburg; 93.1); 7) a Bodhisattva or a god on a tiger (Vishnu or Brahma [?]); 8) a Bodhisattva or a god, possibly Indra, sitting atop a white elephant; and 9–10) monks. It is interesting that dark and light faces alternate both vertically and horizontally.

Six dancing women bearing gifts are depicted on the bottom against a plain red background. A pulled-up curtain of blue-flowered white cloth frames the group, creating the impression of the isolation of a stage.

K. Samosyuk

94
The Indrabhuti Vajradakini

Tibet (?)

Circa 1700

Gilt copper, with traces of pigments

H. 49⅝″ (126 cm)

Musée Guimet, Paris

Lit.: Béguin, 1989, pp. 168–69.

This statue is the most impressive and well-known object in the fine Tibetan collections of the Musée Guimet. The many different parts of the statue were assembled from over thirty-four pieces of gilded copper, worked with the repoussé method, and then riveted or welded together. Traces of the welding are visible on the neck, the pelvis, and on the arms. A belt and jewelry, now lost, used to hide these joints entirely. The hands, separately attached, were made by using the lost wax method.

The female deity, with the three eyes of the terrific deities, dances with only one foot on the ground. She must have originally trampled on the prostrate form of her own emanation as a secondary deity whose name is Nairrti. She must also have been attired with an adept's bone apron as we see the traces of it on the left thigh, with a belt, a necklace, and a crown of skulls. The fastener of this last piece is still visible on the forehead. She has lost her symbolic implements. The position of the fingers lets us suppose that this Dakini held a vajra chopper and a skull bowl, with a long *khatvanga* staff crooked in her left arm. An old photograph shows a hole in the front of the left shoulder where the staff once rested. This was covered during restoration.

In the absence of any iconographic context, a precise identification is difficult. This female deity has often been described as a Vajradakini, a female form of Buddha. There are three main Vajradakini forms, given by revelation to Indrabhuti, Maitripa, and Naropa. From her posture, she can be identified as the Indrabhuti Vajradakini.

Provenance and dating of this piece are problematic. Her acquisition from a longtime owner in Saigon early in this century suggests an eastern origin. Her coiffure is somewhat unusual, possibly indicating an Eastern Tibetan source. However, a more northern place of origin, whence the statue might have been moved as a result of the Boxer pillaging in the Beijing region, could also be possible.

G. Béguin

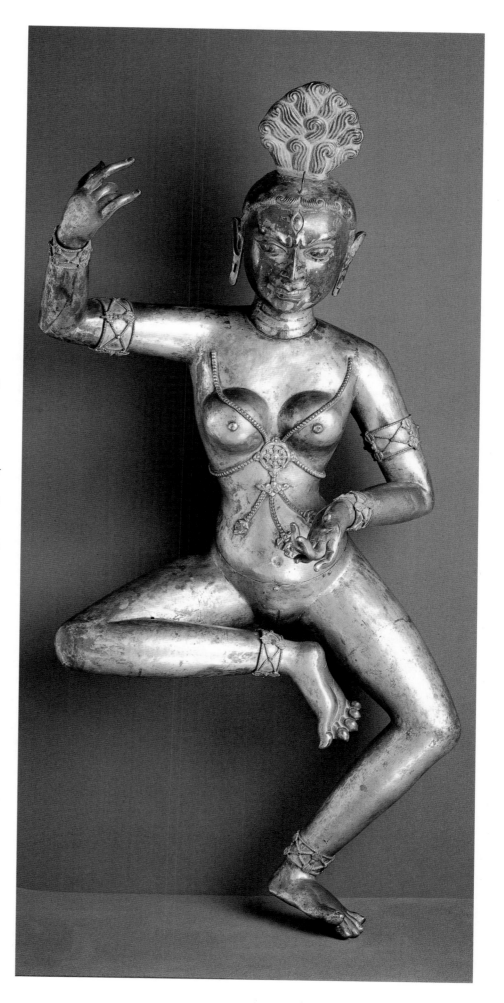

IX.
Geluk Order

The Geluk Order has been perhaps the most prolific of all in sheer volume of works during the last five centuries. As it became the majority order throughout the country, its lamas and lay patrons refurbished old temples and commissioned countless works for the thousands of new monasteries. The Mongol khans, from the 16th century on, and the Manchu emperors, starting in the 17th century, were devoted to Tsong Khapa, to the Dalai Lamas and the major reincarnations of Tibet, and to the Mongolians, such as the Panchen Lama, the Khalkha Jetsun Dampa, and the Jangkya Hutuktu. These rulers used their considerable wealth to commission massive numbers of high quality works.

Perhaps the most creative peak ever reached by Tibetan sacred art was gained in the 17th and 18th centuries under the patronage of the Fifth and Seventh Dalai Lamas. This patronage focused on Nyingma as well as Geluk themes, and inspired a new level of creativity in the other orders. The reality of this world was brought into sharpest focus as a simultaneous manifestation of the pure lands of Avalokiteshvara, of the Transcendent Buddhas, and of the tantric archetype and protector deities. This special combination of paradisiacal beauty and this-world earthiness was Tibet's supreme artistic achievement.

The period from the 15th to the 18th century reflected the glory of the civilization as a whole, toward the end of its first millennium (600–1600) of dedication to Buddhism. The Great Fifth Dalai Lama concretized the architectonics of Tibetan Buddhist civilization with the building of the magnificent Potala palace from around 1645 to the mid-1690s. In Europe at around the same time, the Sun King, Louis XIV, built Versailles, and Peter the Great built St. Petersburg. In Asia, the Manchus set up the Qing dynasty in China, the Mughals of India reached the pinnacle of their reign, and the Tokugawa shogunate was set up in Japan. In a thought-provoking parallel to Tibet, the cultural syntheses that provided the foundations for the modern nation states were being accomplished in many parts of the world.

The art of this period in Tibet becomes more than ever a doorway for revelation. Tibetans felt that their faith in the all-encompassing compassion of Avalokiteshvara was well rewarded. With the nationwide peace ushered in by the reign of the Fifth Dalai Lama, a millennial atmosphere pervaded the life of the people. They felt as if a sun of love and compassion had arisen in their land, by the blessings of Avalokiteshvara and the Three Jewels. This was not something newly invented by the Geluk Order. The Gelukpas gratefully inherited the treasuries of wisdom and art from all the preceding establishments. The Gelukpa sages and artists were merely able to articulate the fruition of the inspired and reverent labors of ten centuries of Tibetan Buddhists.

Central in the art of the Gelukpas is the towering figure of Tsong Khapa and the lineage of the Dalai Lamas. Though there are many examples of these figures in Tibetan art, only a few special examples are presented here: a large brass altar sculpture of Tsong Khapa from Chahar, Mongolia (No. 96), a very important datable portrait painting of the Third Dalai Lama from the Guge renaissance period in Western Tibet (No. 97), and a superb portraitlike statue of the Fifth Dalai Lama (No. 98). The Panchen Lama lineage (No. 99) is represented by a painting from the first half of the 19th century, and there is a portrait statue of the influential Mongolian lama Jangkya Hutuktu Rolway Dorje (1717–1786) (No. 100), the most prominent lama of Beijing and preceptor of the Qianlong emperor of China (r. 1735–1796). These latter works as well

as the large Tsong Khapa statue reflect the strong Chinese and Mongolian involvement with Tibetan Buddhism and the Geluk Order in particular in these later centuries.

Considerable prominence is given in this part to the archetype and protector deities of the Gelukpa. Included are a spectacular group of the tantric archetype deities: Kalachakra, the various Yamantakas, Guhyasamaja, Shamvara, and the Vajrayogini. The Protectors of the Teaching, the Dharmapalas, are represented by Yama, Mahakala, Shri Devi (Penden Lhamo), and the popular god of wealth Vaishravana, as well as by protectors such as Begtse and Sertrap. These deities are a potent and powerful, but by no means complete, group from the astonishing numbers of these deities known and propitiated by many Tibetans as well as favored by the Gelukpa.

A few of the paintings predate the emergence of the Gelukpas, but they are included to show the connections with the earlier Kadam Order of Atisha and Drom Tonpa and the importance of the Sakya Order as being a major source of the scholarly traditions of the Gelukpa in general and of Tsong Khapa in particular. Art that is definitely identifiable as Gelukpa is scarce from the first century or so following Tsong Khapa. Some of the Guge renaissance paintings appear to reflect Gelukpa patronage, such as Shakyamuni Buddha in No. 4, but it is with the superb portrait of the Third Dalai Lama from the third quarter of the 16th century that Gelukpa attributions become more definite and more numerous. The Penden Lhamo painting in the Ford collection (No. 115) is a spectacular new piece, introduced here for the first time. It provides datable evidence of developments in Gelukpa painting ca. the 1630s (before 1642), in the genre of the black tangka, and also possibly of the New Menri style, which evolved about this time. It shows the bold linear drawing of this

dramatically powerful style that emerged in the 17th century and that came to full flower in paintings such as the Yamantaka from the Zimmerman collection (No. 105). Select examples of the complex styles of paintings from the late 17th through the 19th century, when the Geluk Order was the dominant religious and secular power in Tibet, show the exquisite refinement of the black tangkas (Nos. 112 and 107), popular with all orders, and the brilliant, slightly formalized yet free style of the early 19th century (No. 121).

As a result of the Third Dalai Lama's conversion of the Mongols in the late 1570s and the Manchu imperial interest in Tibetan Buddhism, especially by the Qianlong emperor in the 18th century, the Chinese and Mongolian production of Tibetan art became an important factor in 17th- to 19th-century developments in the Tibetan Buddhist world. A number of works presented here belong to that international Tibetan artistic tradition. Some are made in Mongolia (No. 96), and others are probably made in China, such as the embroidery (No. 109), the Yamantaka of the Qianlong period (No. 106), and Nos. 100 and 101. Those so-called Sino-Tibetan images whose stylistic and iconographic sources are predominantly from Tibetan Buddhism and its artistic tradition are termed Tibeto-Chinese in this book (see essay "Tibetan Buddhist Art"). The considerable quantity of Mongolian and Chinese Buddhist art in the Tibetan stylistic and iconographic tradition makes these works a major part of later Tibetan Buddhist art, and much of it is related to the dominating influence of the Gelukpa in these regions. Tibetan art, like Tibetan Buddhism, became international by the 18th century, and this is reflected in the wide variety of the art of this Gelukpa section. In its overall aspect the art of this section is characterized by a dramatic sense of power.

95

Lama (possibly Atisha or an Early Kadam Lama)

Central Regions, Tibet

12th century

Tangka; gouache on cotton

13⅞ × 10¾″ (35.3 × 27.4 cm)

Mr. and Mrs. John Gilmore Ford

A solitary lama sits in the exact center of the painting, his head slightly turned to the side, revealing his mild and gentle character. It has been suggested that he may be the great Indian pandit Atisha Dipamkara Shrijnyana (982–1054). He accepted the invitation of the Western Tibetan kings Yeshe Ö and Jangchup Ö to visit Tibet and renew the teaching and practice of the Buddha Dharma. He arrived in 1042 and began a twelve-year teaching career that left a profound impact on all the orders of Tibetan Buddhism, which were just beginning to take shape at around that time, at the beginning of the Second Transmission of Buddhism in Tibet. This early portrait differs from the usual later ones in which the master has an Indian-style red abbot's hat, and has a stupa and a traveling sack behind him. That it may be Atisha is indicated by the fact that the donor is an ordained layperson who is holding up an offering lamp. His long hair indicates that he is a layman, while his monk's robes show him to be ordained (ordained laity being allowed to wear such robes on certain occasions). The principal disciple of Atisha was Drom Tonpa (d. 1064), an ordained layman (*upasaka*), who, it is said, lit an offering lamp when he first met Atisha in 1042 and kept it burning continuously for the next twelve years, until Atisha's death in 1054. Drom Tonpa founded the Ratreng monastery in 1057, which became the head monastery of the Kadam Order. If it is not Atisha, it is probably a later Tibetan abbot of Ratreng, such as Potowa or Sharabha. One support for this attribution is the stiff orange Tibetan sitting robe (T. *dagam*), in which the master sits in the meditative diamond pose. This indicates that this master was an adept in contemplative practice, known for his frequent retreats. The main clue to this being the portrait of a Kadampa master lies in the selection of deities around the borders. Atisha and his early successors were often helped in their religious work by, and felt

extremely close to, Avalokiteshvara and the two main Taras, as well as the fierce archetype deity Achala. It is fitting to begin the Geluk section with the portrait of this master, whichever one it turns out to be. Tsong Khapa considered himself a renewer of Atisha's Kadampa teaching. He had many visions of Atisha and wrote his major work at Ratreng monastery. The Geluk Order itself is sometimes also called the New Kadam.

In this rare and superb early painting, the master is surrounded by a series of curvilinear flat planes of contrasting solid colors. Layer after layer contrasts between light and dark but harmonizes in the arching curves of the shapes. Most brilliant is the white halo silhouetting the head and the white moon-disc cushion on top of the lotus, which makes the figure appear to float. The bright yellow and red of the lama's two monastic robes offset the pale flesh tone and establish a vivid contrast with the orange sitting robe, which balloons around the figure, creating the most compelling shape in the painting. The dark green seat-back cushion, the encompassing red halo, and the dark blue background all continue the rhythms of the alternating flat planes. The delicate flowers floating in the sky, the golden ducks, and the scroll-pattern back of the seat as well as the sensitively modeled broad petals of the unusual single-layered lotus seat all add light, restrained, and decorative touches to the simple format of the painting. This very simplicity allows the beauty of the subtle modeling, the variation of color, and the fine line to emerge with distinction. The exceedingly refined line is full of controlled tension, especially beautifully executed in the red lines of the robes.

Shakyamuni and the blue-bodied Medicine Buddha are seen respectively to the left and right above the lama within the main central zone. Bordering the upper part are the Five Transcendent Buddhas — from the left, Ratnasambhava, Akshobhya, Vairochana, Amitabha, and Amoghasiddhi — and a four-armed golden female Buddha, who most likely is the Goddess Prajnyaparamita, Mother of all Buddhas. Below, in six spaces from left to right are: 1) a monk with long hair holding up an offering lamp, 2) an offering complex including a mandala representation of the universe and objects of sense pleasure, 3) a White Tara, 4) a four-armed white Shadakshari Avalokiteshvara, 5) a Green Tara, and 6) a dark blue Achala holding

up a sword. The whole painting and the top and bottom rows of deities are framed with a painted design of green, red, and dark blue gems. These designs are typical of many of the early tangka paintings of the central regions, probably from as early as the 11th century but certainly prevalent during the 12th to 14th centuries.

Although there has been some minor restoration in a few places, overall the style is completely consistent with that of other early paintings now becoming known. This work clearly predates the harder and more elaborated styles of the 14th century. It is more consistent with the style of the Green Tara that is also in the Ford collection (No. 24). The style of the lama is related to that seen in the Twenty-one White Tara Stele (No. 22) and in the British Museum painted manuscript cover in No. 122. The style of the small accompanying images seems to relate to some of the surviving wall paintings (probably of the late 11th to the 12th century) in the Jokhang in Lhasa and to reflect an earlier stage in the style seen utilized with a freer abandon in the wall paintings of the Lhakhang-soma at Alchi (probably dating late 12th to 13th century). The resemblance to the Khara Khoto examples, such as No. 135, is also clear, and adds further evidence for a 12th-century dating.

This painting also affords an interesting comparison with the Hermitage Lama portrait from the Khara Khoto group (No. 91). Clearly the latter has Tangut and Chinese elements, especially in the style of the donors and in the line drawing of the lama's face, which reflect Chinese styles well known since at least the Tang dynasty. Although the Khara Khoto example has been retouched (before burial in the 13th century in the famous *suburgan* discovered by Kozlov), the repainting is easily distinguished by its thick and darker color and its lack of skill when compared with the original line. The very presence of repair, which occurs in a number of Khara Khoto works, indicates that the original probably already had considerable age before the date of ca. 1227 or, possibly, as some scholars are presently investigating, a little later in the 13th century. Certainly this easily suggests a 12th-century or even earlier date for the original, showing that forms such as the seat with ducks and leogryphs and the jewel border were already well-established pictorial elements at that time, even beyond the central regions of Tibet.

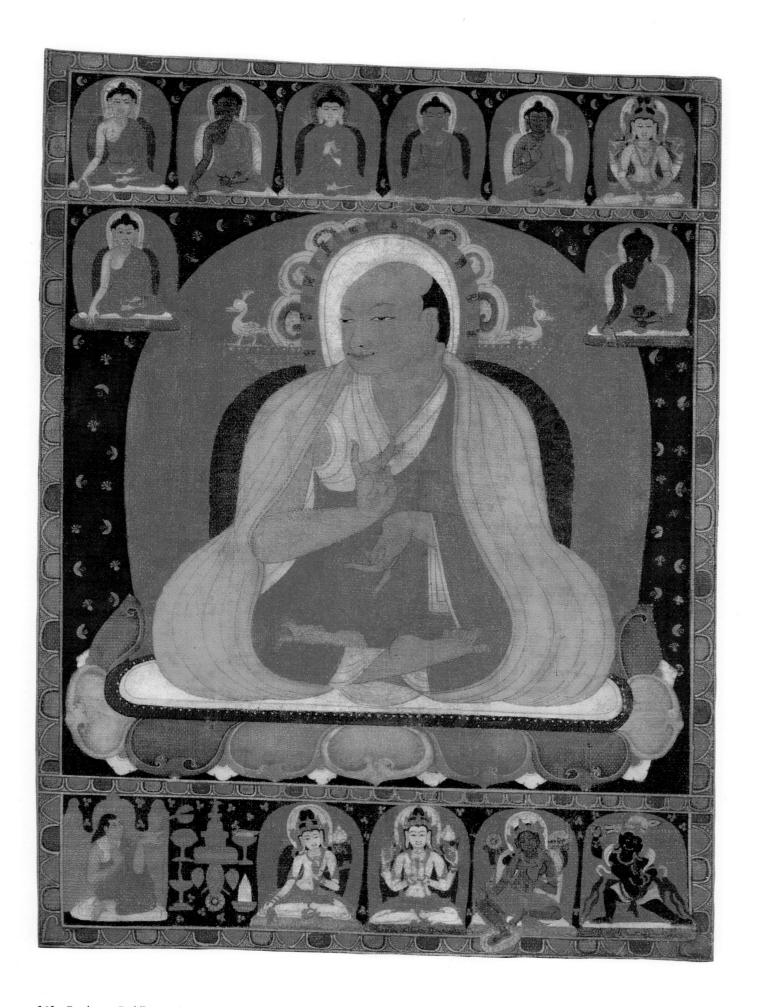

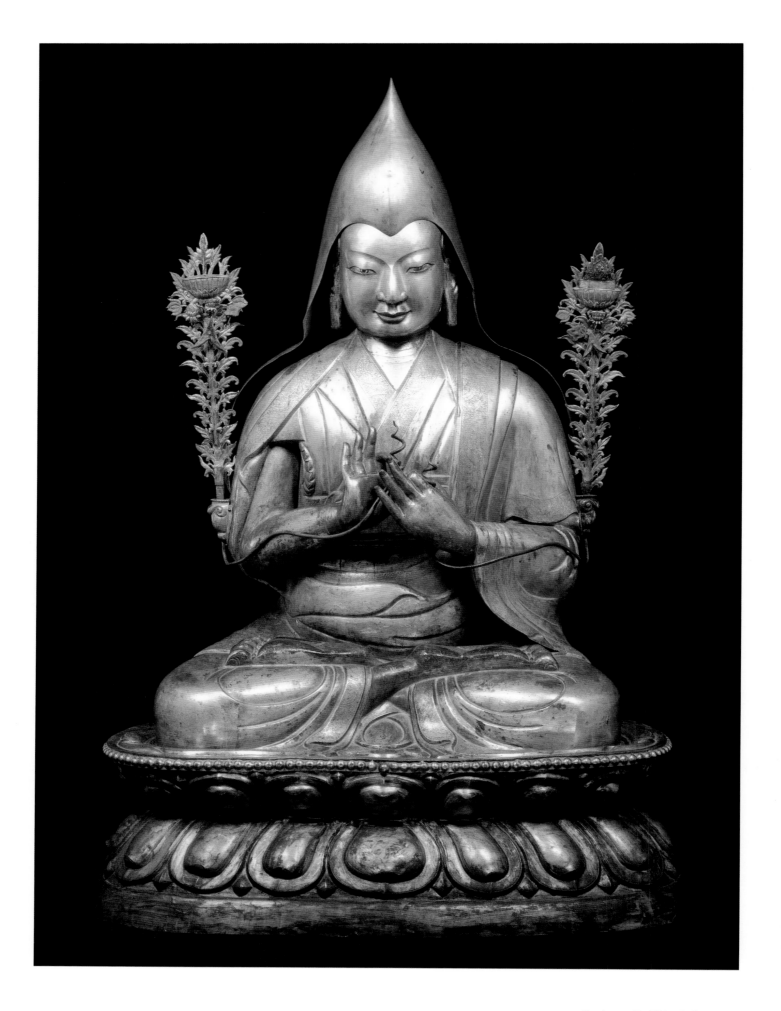

Tsong Khapa

Chahar, Inner Mongolia

Circa 1700

Gilt brass, with pigments

H. 51″ (129.5 cm)

Folkens Museum Etnografiska, Stockholm

Tsong Khapa (1357–1419) was one of the greatest lamas of Tibet. He was revered as a consummate clarifier of Shakyamuni Buddha's Teaching and as an energetic renewer of its practice. He was especially inspired by the heritage of Nagarjuna and Chandrakirti, which he aimed to uphold in both his Dialectical Centrist philosophical method and his Unexcelled Yoga tantra contemplative and artistic traditions. Tsong Khapa is also regarded as the founder of the Geluk Order, though he considered himself merely the renewer of the early Kadam Order founded by master Atisha and Drom Tonpa in the middle of the 11th century. Following the example of Tsong Khapa's far-reaching activities, his disciples, especially the early Dalai Lamas, spread his teachings widely. The order prospered to such a degree that, by the time of the Fifth Dalai Lama (1617–1682), it had become the majority religious order in Tibet and the stimulus to increased expansion in all the other orders. Tsong Khapa was revered as a national hero, an incarnation of the Bodhisattva Manjushri. His charismatic movement was centrally responsible for the religious renaissance that made Tibet's uniquely sacred modern culture possible.

This monumental statue of Tsong Khapa was brought from the area of Chahar in northeastern Inner Mongolia early in this century by the Swedish explorer and geographer Sven Hedin. The Mongolians were an important element in Tibetan history from the 13th century on. By the end of the 16th century, they had become major adherents of Tibetan Buddhism, due to the conversion of Altan Khan in 1578. His lama was Sonam Gyatso (1543–1589), upon whom the khan bestowed the title of Dalai Lama, meaning Oceanic Master. (The master on whom the title of Dalai Lama was originally conferred, Sonam Gyatso, is counted as the Third Dalai Lama; the First and Second were earlier incarnations in his lineage, to whom the title of Dalai Lama was given posthumously.) In fact, it was at Chahar, the original site of this sculpture, that

Altan Khan met the Third Dalai Lama in 1578. Since that time, Mongolia has been strongly influenced by Tibetan culture and artistic traditions. After the Manchu conquest of China in the 17th century, Mongolia developed closer ties with China. These were also a source of cultural and artistic inspiration for the Mongolians, especially since aspects of Manchu culture were simultaneously being influenced by Tibetan Buddhism. The close interweaving of the four areas—Tibet, Mongolia, Manchuria, and China—with respect to Buddhist art is probably the most vital development in Asian Buddhist art history from the 17th century onward. The interrelationships were so close that the Buddhist art of this time can almost be treated as one unified tradition with regional distinctions in style. Just as the Great Fifth Dalai Lama was the supreme spiritual leader of all three non-Chinese nations in this group at this time, Tibetan Buddhism was the main inspirational source for the Buddhist artistic traditions of the Manchu Qing empire. This statue, although from Inner Mongolia, belongs to the Tibetan international cultural-artistic tradition. It is also tinged with elements of Chinese artistic influence and possibly even shows Chinese workmanship. It is a complicated mixture, which cannot be entirely unraveled without further intensive study of the art of this period.

This magnificent monumental statue probably graced the central altar of the temple hall of a large monastery. Tsong Khapa is shown wearing a lama's formal robes and the yellow Indian pandit's hat. This hat was reserved for him and, subsequently, for the heads of the order, the Ganden Throne-holders, and the charismatic heads of state, the Dalai Lamas. Monks of the Geluk Order also wear yellow hats, though theirs are quite different in shape, a practice that has led to this order being popularly dubbed the Yellow Hats. Tsong Khapa is shown here with the gestures and implements that came to typify him in representations. He is making the teaching gesture, each hand

holding the stem of a lotus between thumb and forefinger. The lotus stalks rise behind him, with green and gold leaves alternating up to the lotus flowers. They support, respectively, a volume of the Transcendent Wisdom Sutra on his left and the sword of wisdom on his right (missing here). These two attributes indicate that Tsong Khapa is an incarnation of Manjushri.

This image of Tsong Khapa has a strongly naturalistic appearance. In expression, he has a calm composure and a kind, smiling demeanor. There is smooth but rather deep modeling of the broad, Mongolian-type face, with its big nose and generous mouth. The sleek planes of the wide cheeks and forehead are echoed in the smooth curves of the pointed hat, which arches over his forehead, reflecting the lines of the eyebrows and nose. A solid, massive body is indicated beneath the layers of his robes. The drapery, which seems thick and heavy, fits snugly around the torso and shows the ovoid shape of the legs and left arm. It falls relatively loosely, with large, heavy, swollen folds over the shoulders and upper arms, and with curved tension over the crossed legs. Certain interesting touches enliven the drapery: an unusual bending of the hems, the symmetrical curves, and the circular pattern created by the folds around the ankles. The thick robes are embellished with beautifully executed chased patterns of semicircular lotus medallions and floral motifs in the borders. In this statue the hat, the lotus branches, and the sword and book symbols were all cast separately. There is green pigment on the flowers and leaves; remains of red pigment appear inside his hat and on his mouth; and there are remnants of blue on his hair. His eyes are shaped with the curving eyelid of the Indian tradition. They are painted with black, white, and a touch of pink, and the irises are yellow (the left one is a little worn out). This sculpture is one of the finest known large statues of Tsong Khapa. With its excellent craftsmanship, it has an eminently dignified monumentality and an effective naturalistic, human presence.

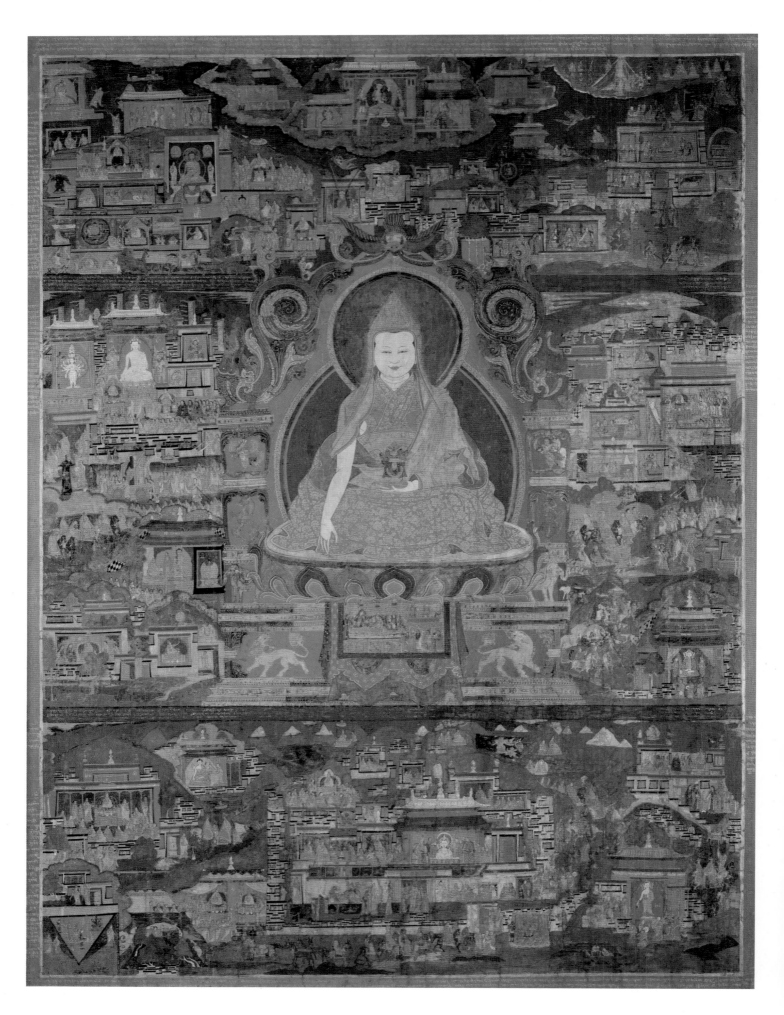

Sonam Gyatso, the Third Dalai Lama, and Scenes from His Esoteric Biography

Western Tibet; Guge

Third quarter of the 16th century

Tangka; gouache on cotton

48½ × 36¾" (123.2 × 93.3 cm)

Robert Hatfield Ellsworth Private Collection

Lit.: Tucci, 1949, pp. 392–99.

This tangka is an especially beautiful and important painting. It centers on the portrait figure of the Third Dalai Lama, Sonam Gyatso (1543–1589). He is famous in Tibetan history as the converter of the Mongols under Altan Khan in 1578, and as the founder in 1582 of the Kumbum monastic university at the site of Tsong Khapa's birthplace in Amdo, now Qinghai province. This portrait would appear to be a good likeness, judging from the individual expression, the charming smile, and the small, cheerful eyes (97.2). Numerous scenes from Sonam Gyatso's life are also presented. Mainly drawn from his esoteric biography, they are not usually encountered in paintings because of their esoteric nature.

The tangka was obtained by Tucci in Luk, a major city in Western Tibet, and it is painted in the Guge renaissance style of that region. In his extensive discussion of this tangka, Tucci suggests that the royal donors portrayed on the overhang of the cloth on the lotus pedestal are the members of the Guge ruling family. They may have commissioned this painting after a documented visit with Sonam Gyatso in 1555 by one of the princes. However, it is also known that Sonam Gyatso visited Western Tibet shortly before leaving on his historic trip to Mongolia in 1577. So it is also possible that it was painted around that time. In either case, this painting was quite certainly executed around the third quarter of the 16th century. As such it is very significant. It is a virtually contemporary portrait of the Third Dalai Lama, and a rare example of portrait painting from the Guge school. It is also a painting of the highest quality that provides important data for the chronological, regional, and religious study of Tibetan art—a field in great need of important works of established date and region.

Robed in light garments in subtle shades of lavender, brown, and red, decorated with fine designs in gold, the main figure of the lifelike lama is like an exquisite flower. He is presented in relatively small

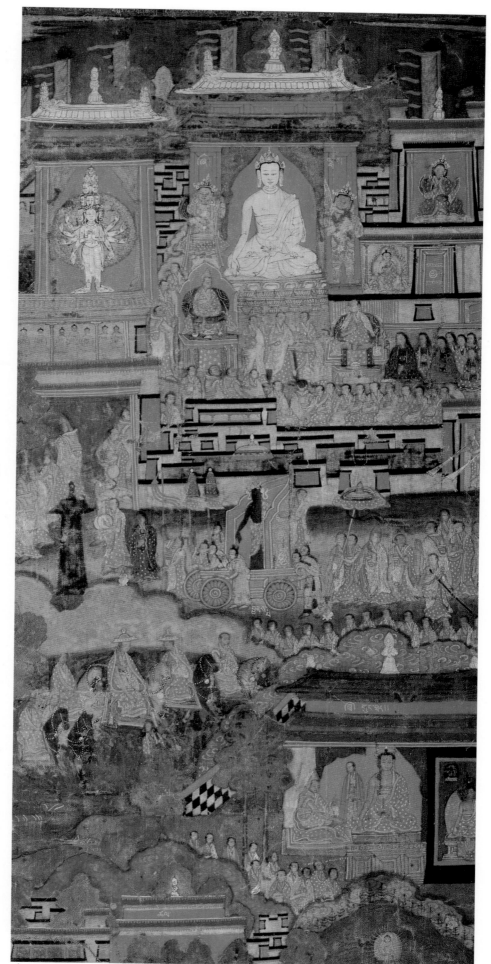

97.1

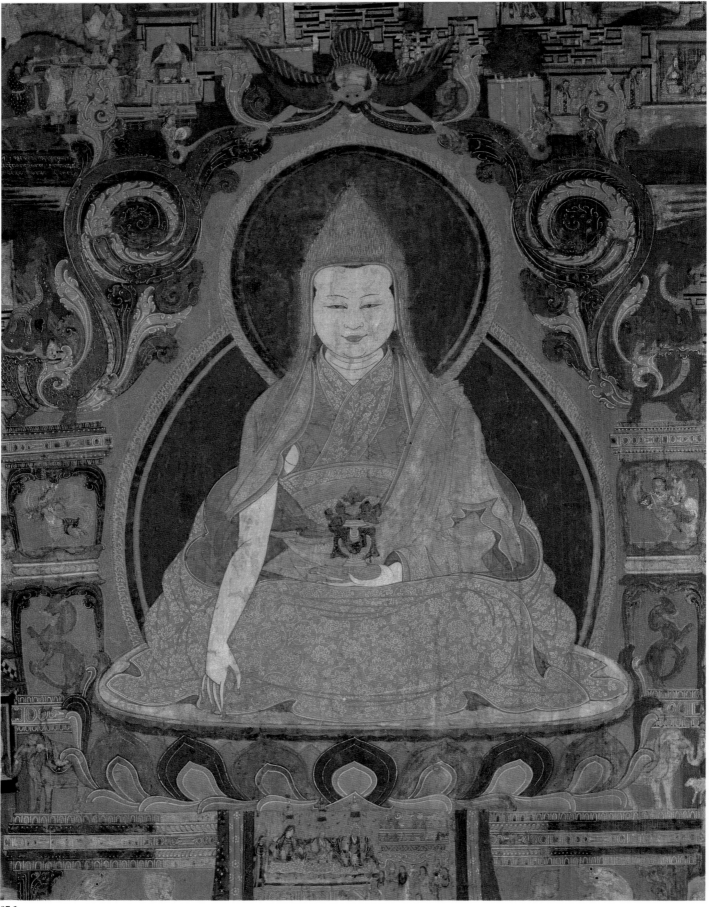

97.2

97.3

scale, sitting on a lion throne with a lotus seat and side panels adorned with animals (97.2). In his left hand he holds the vase of immortality, the symbol of Amitayus, the Buddha of Infinite Life. Behind him, the shrine backing with scrolling tails of *makaras* (fantastic composite beasts, part fish and part crocodile) forms the overhead arch. Many elements are traditional and are related to the Indo-Nepalese artistic styles especially fostered by the monasteries in Tsang and Guge during the 15th century. However, the lightness of line, the elongation of the body—especially evident in the long right arm making the earth-witness gesture—and the subdued, muted color tones appear to be distinctive elements in the Western Tibetan schools of the 16th century. The light, loose folds of the robes, with their distinctive, sweeping curves, indicate the incorporation of some elements of Chinese stylistic inspiration, as also seen in the robes of figures in paintings from the central regions of this time and in the Buddha in a nearly contemporary work probably from the eastern regions (No. 7).

Around the central figure are many scenes, most of them depicting events that are connected with visions, dreams, and teachings concerning the Dalai Lama's spiritual practice. Inscriptions on the borders and within the painting identify, where still legible, each of the scenes. For example, those at the upper left involve his between-state experience (after the death of his previous incarnation and before his reincarnation in 1543), which is reported in his biography. His subtle body first visited the Tushita Heaven and saw the Bodhisattva Maitreya. From there it went on to the Sukhavati Buddha land, and then to Padma Sambhava's Glorious Copper Mountain paradise, before returning to reincarnate in Tibet. Other scenes depict the Third Dalai Lama's visits to various monasteries, such as Sera, Samye, and Ganden, the latter shown in the large scene in the center at the bottom (97.3). There are a number of temples depicted with statues, such as at the left side, where the Eleven-Faced Avalokiteshvara is seen in a small shrine to the left of a large shrine with Shakyamuni Buddha (97.1). Below

this there is a procession of monks transporting a Maitreya Buddha statue in a wagon.

The profusion of monastic settings makes architectural forms the primary compositional factor. The various buildings are highly two-dimensional, but there is such variety, attention to detail, and beauty of color that there is no sense of overburdened repetition. The white walls, the black woodwork of the windows and doors, the occasional brilliant orange of some of the buildings, and the gold of the roofs all reverberate against the predominantly blue background. The architecture creates a pleasing tapestry of delicate, translucent, and abstract color planes. With gentle simplicity the subdued landscape elements of mountains, trees, dark blue sky, and clouds serve to separate the architectural scenes into groupings. The refinement and sensitivity of this magically beautiful setting, where heavenly and earthly forms float with transcendent lightness, create an inspired and suitable atmosphere for the mystical events of the Dalai Lama's biography.

98
Ngawang Losang Gyatso,
the Great Fifth Dalai Lama

Central Regions, Tibet

End of the 17th century

Gilt bronze

H. 7⅞″ (20 cm)

Rose Art Museum, Brandeis University, Waltham, Massachusetts. Gift of N. and L. Horch to the Riverside Museum Collection

Lit.: Rhie and Thurman, 1984, p. 9.

Ngawang Losang Gyatso, known as the Great Fifth Dalai Lama, is one of the central figures of Tibetan history. He was born in 1617 as the fifth reincarnation of the Dalai Lama. His father was a famous Nyingmapa lama of aristocratic lineage. During his youth, Tibet was torn by strife instigated by various aristocratic factions, which aligned themselves with various orders. These troubles were resolved in his twenty-fifth year, and he was elevated to become the supreme spiritual teacher and secular ruler of Tibet. He was a charismatic figure for both the Geluk and Nyingma orders. As ruler of all Tibet, he sought to distance himself from being narrowly identified with the Geluk Order. On the twenty-fifth day of the third month of the Wood-Bird year (1645), he began construction of the Potala palace on the Red Mountain in Lhasa, the site of the original palace of Songtsen Gambo, the first Religious King of Tibet. He then moved out of the Drepung monastic university and took up residence there. The Potala stands unsurpassed today as the foremost monument of distinctively Tibetan architecture. A combination of fort, monastery, palace, and temple, it has become the universally recognized emblem of the Tibetan nation and its Buddhist civilization.

An inscription on the back of this statue (on the upper two cushions) identifies the image as the Fifth Dalai Lama. It reads: "Ngagi Wangchuk [short name of the Fifth

Dalai Lama, added to his titles in 1638 when he was twenty-one years old and took his monk's vows]. May the family and descendants of the donor Ngödrup [dNgos Grub] with his wife and followers effortlessly attain their desired aims and ultimately be exalted in the highest good."

He is seated in a voluminous array of robes on three square cushions, each decorated with a different floral or geometric pattern. His left hand, in his lap, probably once held a wheel (both of the Teaching and of royal rule). With his right hand he makes the discerning gesture. In his belt appears the head of a *purba*, the ritual three-cornered dagger used in tantric rituals, especially those of Vajrakila, a Nyingmapa archetype deity that the Great Fifth highly favored. This statue exhibits a portrait likeness of this Dalai Lama, judging from the similarity in facial features of this statue with another known by inscription to have been made during the lifetime of the Great Fifth ca. 1679 and now part of the collection of the Boston Museum of Fine Arts (MacDonald, 1977). His rounded head is striking for its pointed chin and distinctive features. He has a long, sharp nose, a somewhat stern but sensitive bow-shaped mouth, and closely set walnut-shaped eyes whose lids taper smoothly to high, angular brows. Though less than eight inches tall, this sculpture reveals his great dignity and his strong presence through the bearing of his head, the sharp delicacy of his features,

and the sturdy mass of his body.

A special elegance is imparted to the figure by the masterfully shaped drapery folds. Their sleek, curvilinear movements and incisive, angular, crinkled creases impart dynamic rhythms around the entire figure. Delicate chased designs heighten the beauty but do not detract from the sense of inner energy coursing through the layers of thick robes.

Stylistically, the image closely resembles the figure of Kunga Tashi (No. 65), which helps to date this statue to the period of the late 17th century, possibly during the lifetime of the Great Fifth. Antecedents for this style appear as early as the late 16th century, in such works as the Karma Dudzi statue, probably from Eastern Tibet (No. 89), and some 17th-century statues from Tashi Lhunpo (Liu I-se, 1957, figs. 76, 78). The close relation to the latter works may also indicate that this Dalai Lama statue is a product of the central regions. This sculpture is distinguished, however, by a marked development in the conscious attempt to create a surrealistic beauty by a willful and mannered expressiveness of line and a sharpened clarity of form. This injects an abstract, otherworldly aura into the work, not seen in the more earthy naturalism of the earlier statues, such as that of Karma Dudzi. Though relatively small, this work is one of the most artistic, sensitive, and personable statues known of the Great Fifth Dalai Lama.

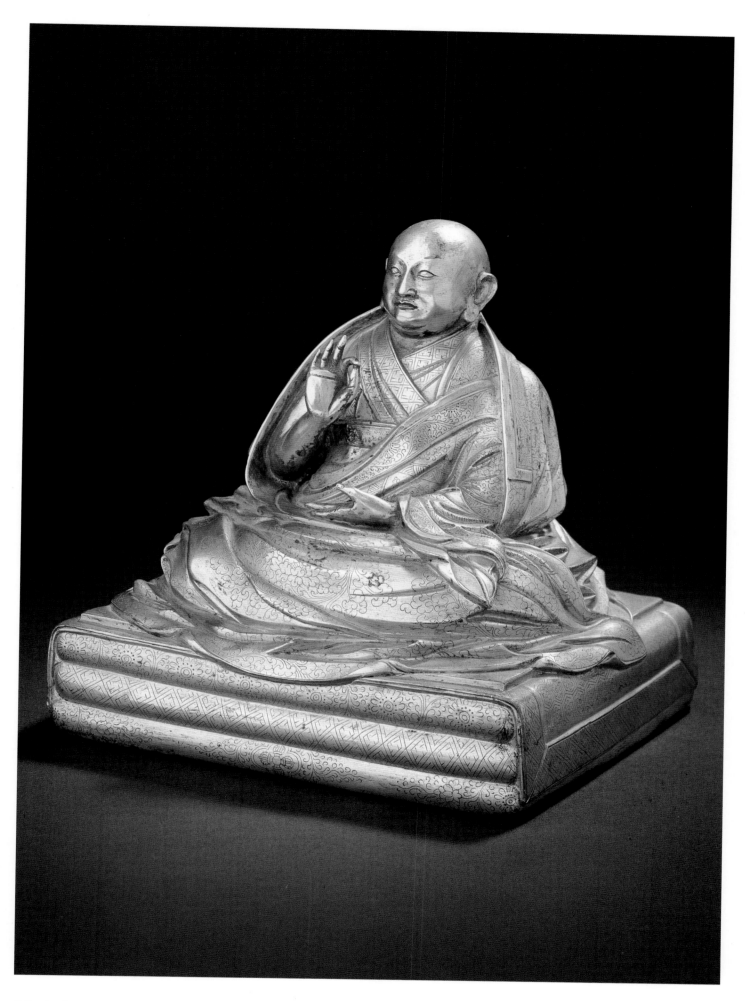

The Panchen Lama and His Reincarnation Lineage

Central Regions, Tibet

First half of the 19th century

Tangka; gouache on cotton

28½ × 15½″ (72.4 × 39.4 cm)

The American Museum of Natural History, New York. From the collection of the late Baron A. von Stael-Holstein. 70.2/753.

The Geluk Order had an adepts' esoteric, oral transmission lineage (T. *dGa ldan snyan brgyud*), which descended from Manjushri through Tsong Khapa and his foremost tantric disciple, Kedrup Gelek Pelsangpo (1385–1438). The fourth lama in this lineage was Losang Chökyi Gyaltsen (1570–1662). He was the main teacher of the Great Fifth Dalai Lama, who achieved a vision of him as indivisible from Amitabha Buddha himself. The Dalai Lama gratefully enthroned Losang Chökyi Gyaltsen and his reincarnations as the Panchen Lamas, abbots of Tashi Lhunpo monastery, founded by the First Dalai Lama in 1447. The Panchen Lamas were popularly believed to be the emanations of Amitabha Buddha, the heavenly guru of Avalokiteshvara, who is believed to emanate as the Dalai Lamas. The last Panchen Lama passed away in 1989, and was considered by many Tibetans to have been a close colleague of the present Dalai Lama. He suffered greatly, having been imprisoned and tortured for fourteen years, and worked to champion the Tibetans from within their Chinese-occupied land, as the Dalai Lama works to champion them from without.

The main figure of the present painting is the fourth Panchen Lama, Losang Tenpay Nyima (1782–1853), the latest incarnation at the time of the painting. Around him are arranged the lineage of previous incarnations of Amitabha Buddha as the Panchen Lama. The series begins with the group to left and right immediately above the main figure (see diagram). This is the group of his foreign spiritual predecessors: 1) Subhuti, a disciple of Shakyamuni Buddha; 2) King Yashas, the seventh king of Shambhala, who abridged the *Kalachakra Tantra* into its present form; 3) Bhavaviveka, a renowned debater and commentator of the Madhyamika school of philosophy; and 4)

Abhayakaragupta, a great scholar from Orissa, in India, who was chief abbot of the Bodhgaya, Vikramashila, and Nalanda universities under King Ramapala in the 11th century. To the left and right below the main figure are the early Tibetan incarnations of the Panchen Lama: 5) the translator Gö, who visited India three times, studied under seventy-two scholars, was ordained by Gayadhara (see No. 64), and became a disciple of Atisha; 6) Sakya Pandita (see No. 66), the most famous debater and scholar of his day, who became preceptor of Godan Khan of the Mongols; 7) Yungdrön Dorje Pel (b. 1284), who went to China and was one of the four main disciples of Butön (see No. 67); 8) Kedrup Jey, the tantric disciple of Tsong Khapa, who wrote a voluminous commentary on the *Kalachakra Tantra* and a biography of Tsong Khapa and became the second abbot of Ganden monastery; 9) Sonam Choklang (b. 1438), considered the first reincarnation after Kedrup Jey; and 10) Losang Döndrup (b. 1505), the second reincarnation after Kedrup Jey.

The scheme then shifts to the top of the painting, where the figures are: 11) Losang Chökyi Gyaltsen, first given the title of Panchen Lama and the abbacy of Tashi Lhunpo monastery by the Fifth Dalai Lama; 12) Losang Yeshe (1663–1737), the second Panchen Lama; 13) Losang Penden Yeshe (1738–1780), the third Panchen Lama; 14) the fourth Panchen Lama; and 15) the Buddha Amitayus. The female protector Penden Lhamo appears at the bottom (16). A set of wood blocks of this series (Tucci, 1949, II, text figs. 90–105) facilitates the identification of these figures; this tangka is a simplified composite of all the incarnation figures in one painting.

The particular style of this tangka utilizes strong colors, clear, simple forms, and lively details. The line is powerful and is forcefully employed in outlining,

especially in the gold edges of the leaves and the black flames of the Penden Lhamo figure. There is a vigor and simplicity compared to the refined mid-18th-century style known from the Narthang wood blocks, to which No. 66 is related stylistically, but this tangka seems nevertheless to be derived from that tradition. The energy in the line and figures, distinct from the gentler Chinese style, suggests a Tibetan hand, but it is also possible that this tangka was painted in China. In some ways the style is related to the Milarepa tangkas in Stockholm (Nos. 82, 83, 152), which may date around the same general period. Because the fourth Panchen Lama is included as the main figure, the tangka can be dated to the first half of the 19th century. Including a complete lineage and executed in a fresh style, this tangka is one of the most interesting portrayals of the Panchen Lamas.

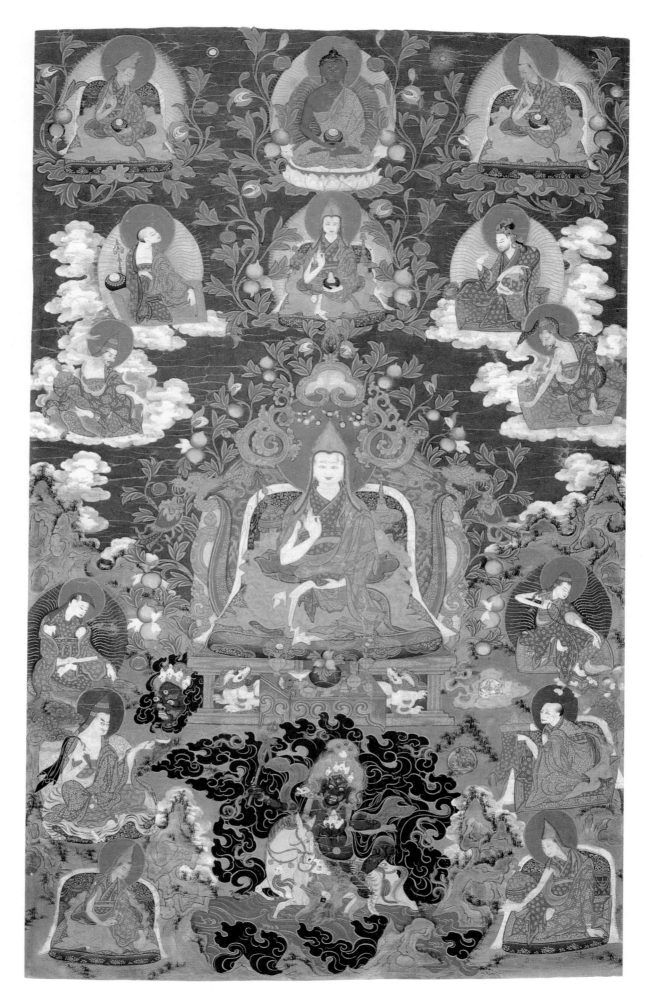

100

Rolpay Dorje, the Jangkya Hutuktu

Tibeto-Chinese

Second half of the 18th century

Gilt brass; cast in several parts, with chasing, cold gold paste, and pigments

H. 6½″ (16.5 cm)

The State Hermitage, Leningrad.
Prince Ukhtomsky Collection

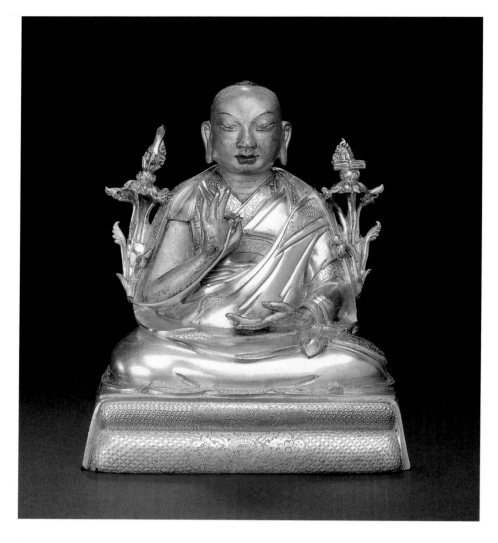

The story of the rise to power in Beijing of the Jangkya incarnation began at the time of the Qing emperor Kangxi (1662–1722). In 1680, Ngawang Losang Chönden (1642–1714), a Tibetan lama from the Gonlung monastery in Amdo, was appointed to the position of the head court lama in Beijing. He was given the responsibility for religious affairs in all Mongolian principalities and for the diplomatic relations of the Qing court with the Mongolian princes. The Sharasuma monastery was built for the new hierarch in Dolonnor in 1701. He lived in Beijing in the winter and in Dolonnor during the summer. He traveled in Inner Mongolia and Amdo, organized the building of new monasteries, and distributed the Manchu emperor's donations among the lamas and monasteries. In 1706, Kangxi granted Ngawang Losang Chönden a golden seal and the title of Imperial Tutor (Hutuktu in Mongolian). After that, all Mongolian lamas received their authority to run religious affairs from the hands of the Beijing Jangkya Hutuktus (Gerasimova, 1971, p. 11).

Emperor Yongzhen (r. 1723–1735) confirmed the title and the authority of the hierarchy to the reincarnation of Ngawang Losang Chönden, the second Jangkya Hutuktu, Rolpay Dorje (1717–1786). A spiritual history of fourteen of his previous incarnations was established, beginning with the Arhat Chunda and the lay sage Vimalakirti. It also includes such eminent persons in Tibetan history as Langri Tangpa (1054–1123), the founder of the Kadampa monastery of Langtang, the famous Sakya lama Pakpa Lodrö Gyaltsen (1235–1280), and Tsong Khapa's disciple Jamchen Chöjey Shakya Yeshe (1354–1435), the founder of Sera monastery (Vostrikov, 1962, pp. 211–12).

Rolpay Dorje is said to have known Emperor Qianlong (1735–1796) from his childhood, as they attended the palace school together. This acquaintance later enabled him to take a leading role in the propagation of Tibetan Buddhism from

the capital of the Qing empire. His accomplishments helped make Beijing an important center of Tibetan Buddhism in Central Asia. He supervised the editing and publishing of a new Beijing edition of the Tibetan Kanjur and Tanjur canons in Tibetan, a set of three hundred fifty volumes containing over five thousand works. He also directed the translation of the Tanjur into Mongolian and the Kanjur into Manchu, and had the Qianlong emperor himself review the editing of the latter. He prepared a remarkable set of multilanguage Buddhist terminological dictionaries, based on the critical writings of Gelukpa scholars. He organized printing houses in Beijing to print these treatises in Mongolian, Manchu, and Tibetan. In addition, he established a Beijing school of tangka painting. He compiled the famous album with drawings of three hundred of the deities of the Tibetan Buddhist pantheon that served as the main reference book for generations of Tibetan scholars (Pander, 1890; Grünwedel, 1890; Oldenburg, 1903). According to A. von Stael-Holstein, Rolpay Dorje is also the possible author of another important source of Buddhist iconography, the album

"Three Hundred Sixty Gods" (Clark, 1965a, I, p. x).

Like Tsong Khapa, the Jangkya Hutuktu Rolpay Dorje was considered an incarnation of Manjushri. That is why he is depicted with the symbols of this Bodhisattva; a sword and a book supported by lotus flowers at his shoulders. His right hand with the end of a stem of the lotus flower is raised to his heart in the discerning gesture, while his left hand rests on his lap in the contemplation gesture, holding a vase of elixir of immortality (missing). This is how he is represented in the "Three Hundred Gods" catalogue. (Oldenburg, 1903, p. 18, no. 53).

The image of the second Jangkya Hutuktu included here possesses an interesting detail—a kind of lipoma on his right cheek. According to oral testimony of Tibetans, disfigurements of eminent personages were never allowed to be depicted in images, and this particular feature of Rolpay Dorje's face cannot be seen in his drawing in the catalogues he compiled. We also failed to find it in any of the other images of the second Jangkya Hutuktu known to us.

G. Leonov

Guhyasamaja Akshobhyavajra Father-Mother

Tibeto-Chinese

15th or 16th century

Gilt bronze

H. 26″ (66 cm)

Asian Art Museum of San Francisco.
The Avery Brundage Collection

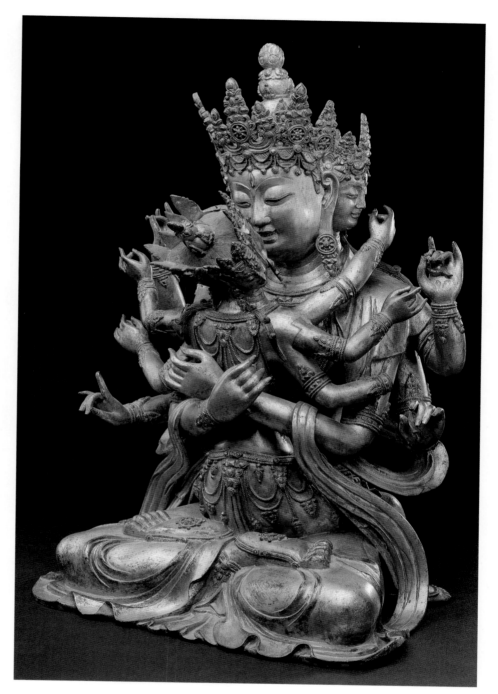

Over two feet in height, this sculpture of Guhyasamaja is an impressive statue. It has a relaxed grace typical of Ming dynasty Tibeto-Chinese bronzes. The central face is broad and somewhat sinicized. There is a hint of heaviness about the cheeks and jowls. The flesh on the neck hangs in soft folds, a traditional sign of beauty. The full lips curl sinuously, exposing a row of human yet menacing teeth. The folds of drapery behind the ears suggest an early Ming style, as do the projections that frame the central diadem of the crown. Newari (Nepalese) artists worked in the Ming court, and both features can be traced to Newari sculpture.

Guhyasamaja's name means Secret Union or Assembly of the Secret Ones (T. Sangwa-dupa). In Tibet, he is particularly favored by the Geluk Order, most likely for the antiquity of his texts. Translated in the 8th century, the *Guhyasamaja Tantra* was one of the first Sanskrit works to be translated into Tibetan (Snellgrove, 1987, p. 183). One tradition has it that Shakyamuni Buddha himself proclaimed the tantra the morning after his enlightenment (Lessing, 1942, p. 73). Other traditions claim that Maitreya taught the tantra in the Tushita Heaven, and that the Indian scholar Asanga brought it to the human world in the 4th century (Bhattacharyya, 1967, p. xxxiv). Like other deities of the Unexcelled Yoga tantra tradition, Guhyasamaja is associated with the Buddha Akshobhya (Snellgrove, 1987, p. 204). Many texts, including the *Guhyasamaja Tantra* itself, simply call him Akshobhya or Akshobhyavajra.

Guhyasamaja is dark blue in color. He has three faces: the central one is blue and fierce; the right face is peaceful white; and the left one is red. He is considered Lord of the Diamond Body, Speech, and Mind of All the Tathagatas (Tucci, 1934–35, p. 342). He gently holds his consort, Sparshavajra, in an intimate embrace. The goddess has six hands and three faces, and is "like her consort," in the words of an early ritual (Wayman, 1977, p. 127).

Sparshavajra gazes upward in rapture, meeting Guhyasamaja's downward glance. The goddess projects an energy and ferocity that contrasts with the serene countenance of her mate.

Being "of the same nature," the divine pair possess similar hand implements. The implements in this piece are missing, but we can easily reconstruct them. The central pair of hands should hold, right and left, a vajra scepter and a bell; the upper pair, a wheel and a blazing jewel; the lower pair, a lotus and a sword. The vajra scepter and bell symbolize, among other things, the vajra Buddha clan of Akshobhya. The wheel symbolizes the mirror-wisdom clan of Vairochana, the lotus the discriminating wisdom clan of

Amitabha, the jewel the equality wisdom clan of Ratnasambhava, and the sword the all-accomplishing wisdom clan of Amoghasiddhi. Thus Guhyasamaja Buddha symbolically represents the union of all the Buddha clans. The blazing jewel that Guhyasamaja once held in his upper left hand is of particular interest. Unlike examples from Tibet and later Chinese pieces, where the jewel is mounted on a sticklike handle or held directly in the palm, here it is on a curving lotus stem (Clark, 1937, p. 44). Similar mounting can be seen in an iconographic drawing of Guhyasamaja dated 1410 from the Yongle period of the Ming dynasty (see H. Karmay, 1975, pp. 55–56, 57, pl. 36).

R. Kohn

102

Paramasukha-Chakrasamvara and Vajravarahi

Tibeto-Chinese

17th century

Gilt bronze

H. 12″ (30.5 cm)

Asian Art Museum of San Francisco.
The Avery Brundage Collection

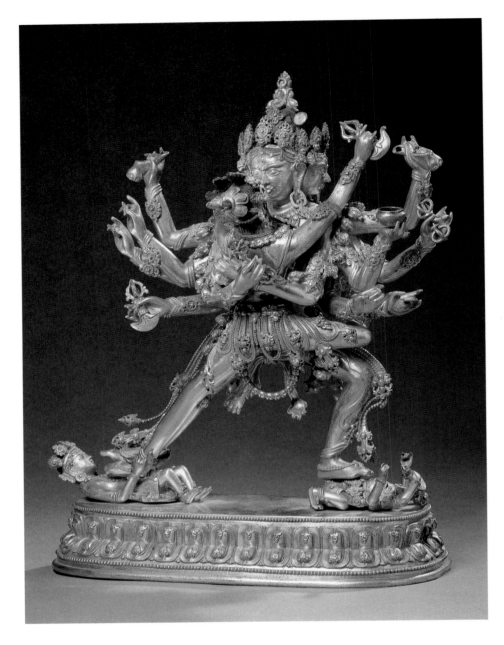

Rendered with the meticulous finish typical of Ming period Tibeto-Chinese bronzes, this 17th-century depiction of the god Shamvara and his consort Vajravarahi is a work of electrifying intensity. Shamvara's brow is knitted in anger; flames issue from the corners of his sharp-fanged mouth. Typical of the Heruka type of deity, his expression is midway between peace and wrath; although his brow is furled and his fangs protrude, he lacks the bulging eyes and gaping jaw of a full-fledged wrathful deity.

Shamvara has four faces and twelve arms. His first two arms are wrapped in passionate embrace around his consort, Vajravarahi. The first two hands, holding a vajra scepter and a bell, make the diamond HUM-sound gesture.

A motif of foliate wheels and vajras decorates the skull crowns the god and goddess wear, a motif repeated on his arm-

bands and bracelets and on her earrings. The statue's superbly finished back has been fashioned to suggest a chest for the god's fourth, backward-facing head (102.1).

Shamvara's hair is arranged in the coif of a yogi and is decorated with a lunar crescent, a reminder that he was first worshiped by the wandering ascetics of medieval India, and that although he is a thoroughly Buddhist deity, he shares some attributes with Shiva, the Hindu god of yogis. His name, for example, is related to Shamba (Fortunate), an epithet of Shiva. In Buddhist myth, Shamvara dwells atop Mount Meru—Mount Kailash—the traditional abode of Shiva.

Several forms of Shamvara are known. The *Sadhanamala*, a 12th-century manual of iconography, identifies this form as Chakrasamvara. In Tibet, Chakrasamvara is a deity particularly associated with the Kagyu Order, although he is important to

the Geluk and Sakya as well (Beyer, 1973, p. 52).

The name Shamvara, or Shambara, itself means Supreme Bliss, the bliss that is the fruit of tantric meditation. Similarly, Chakrasamvara, literally "joined to the Wheel," may be interpreted as "joined to the wheel of wisdom and bliss." Equal to a Buddha, Shamvara is beyond the extremes of samsara and nirvana. To signal this, his right foot presses down on the goddess called Night of Time, Kalaratri, who represents nirvana. His left foot rests on Bhairava, The Terrifier, who represents samsara (Snellgrove, 1987, pp. 153–54).

Shamvara is a deity of the *yidam* class, which are personal deities of Buddhist meditation. A *yidam* is at once the embodiment of a philosophical view and a role model, for the meditator, of the Buddha he aspires to become. A *yidam* is a "pure appearance," a vision of purity.

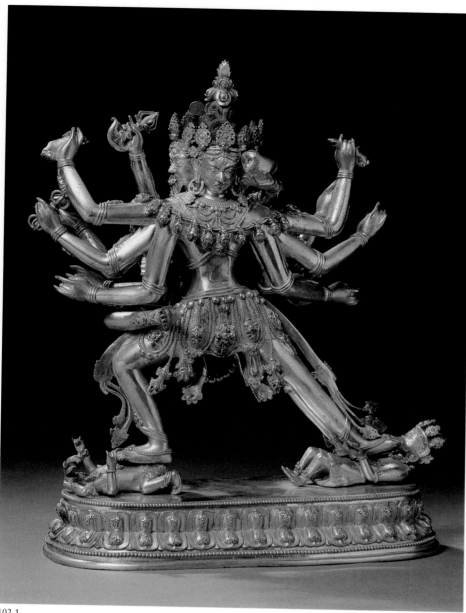

102.1

Tibetans say that rather than having an ordinary physical form, such a deity is a congerie of pure symbolic elements. The bell that Shamvara holds in his left hand, for example, symbolizes wisdom, and the vajra scepter that he wields in his right represents skillful method. In the poetical language of tantra, the god's bell is wisdom itself. Thus, the deity's attributes are of paramount importance: they are clues to his identity and to his function in meditation and ritual (translation from Snellgrove, 1987, p. 154):

His body is blue, indicating that he does not diverge from the (celestial) Dharma-sphere. Each face has three eyes, indicating that he sees the (whole) threefold world and that he knows the substance of the three times (past, present and future). He has twelve arms indicating that he comprehends the evolution and reversal of the twelvefold causal nexus and eliminates these twelve stages of transmigration.

Corresponding to the usual iconography of Chakrasamvara, this piece has twelve arms, each of which once held a characteristic implement. Some of these, however, were cast separately and are now missing.

The tantric text called *Clarifying the Order of the Rite* [sadhana] *of the Circle of the Mandala of Sricakrasamvara*, quoted above (translated by Dawa Samdup in Arthur Avalon, *Tantric Texts*, VII, as cited in Snellgrove, 1987, p. 154), explains the meaning of each implement. The first pair of hands holds, right and left, a vajra scepter and a bell, symbolizing the union of skillful means and wisdom. The second pair rends the elephant of illusion and stretches its hide out like a cape. The drum in the third right hand (missing) shows that Shamvara's "voice resounds joyously." The third left hand holds the *khatvanga* staff that represents "the blissful Thought of Enlightenment." His fourth

right hand brandishes the ax (missing) that "cuts off birth and death at the roots." The skull bowl of blood in his fourth left hand shows that he "has cut away discrimination between existence and non-existence." His fifth right hand wields the vajra chopper that "cuts off the six defects, pride and the rest." The vajra lasso in his fifth left hand binds beings to wisdom from life to life. The trident (missing) in his sixth right hand signals that he has "overcome the evil of the threefold world." The severed head of the god Brahma dangles from his sixth left hand, showing that Shamvara "avoids all illusion."

In this piece, the vajra lasso is worth looking at carefully. In standard iconography, a vajra lasso is shown as a rope with a half or full vajra decorating the end. Here, however, this artist has depicted the lasso as a rope twisted into the shape of a vajra.

R. Kohn

103
Lotus Mandala with Paramasukha-Chakrasamvara

Tibeto-Chinese

17th century

Gilt bronze

Closed: 9½ × 5″ (24.2 × 12.7 cm)

Open: 10 × 8″ (25.5 × 20.3 cm)

The British Museum, London.
Given by Miss Humphreys in memory of
Edward Humphreys, Esq.

Lit.: Zwalf, 1985, p. 215.

103.1

The mandala of the tantric archetype deity
Shamvara, or Paramasukha-Chakrasamvara
(Supreme Bliss Wheel Integration Buddha),
is fashioned in the shape of a globular
lotus. When opened, the eight petals of the
lotus hold an array of twenty standing
deities (103.1 and 103.3). Near the center
the four fierce female Buddhas—Dakini,
Lama, Khandarohi, and Rupini—alternate
with four pillar stands holding skull
caldrons. This is the arrangement of the
inner part of a Shamvara mandala, known
as the great bliss circle. Alternatively, these
four plus the central couple are the five
deities of the abbreviated mandala. On
each of the two back positions of each
petal stands an offering goddess, holding
offerings or playing musical instruments.
Each figure stands on an individual cloud.
In the exact center Chakrasamvara and his
consort Vajravarahi stand in sexual union
on top of a lotus pedestal that rests on a
curved platform simulating the lotus calyx
but appearing like the shape of a cloud.

When closed, the globe, looking like a
pomegranate, emerges from three layers of
thick, leafy petals, the top layer of which
has incised veins. This upper section is
lifted up on an eight-sided pillar, which
rises from a circular, triple-tiered base.
Each side of this pillar is decorated with a

103.2

103.3

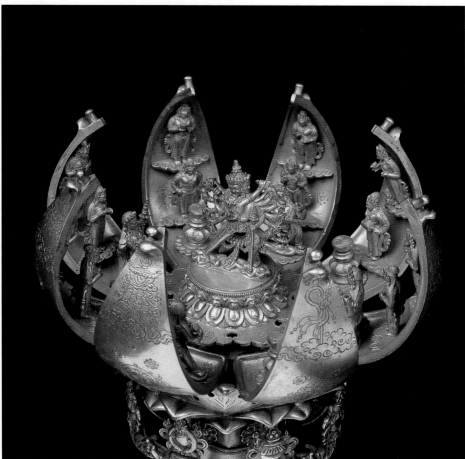

rosette in relief, and there is a spectacular projecting rim composed of eight leafy lotus pedestals linked together. These pedestals each hold a small sculpture, either of the auspicious symbol of the vase (with the Three Jewels on top) or of the pair of fish. An ingenious internal mechanism allows the globe to open when the pillar-stem is moved upward by moving this projecting rim.

The theme of the seven treasures of the universal monarch appears in incised drawings on the bulging middle of the globe. Including a representation of the monarch (or possibly the minister in this case), these symbols (moving clockwise from the king or minister) are the faithful queen, the wish-granting jewel, the wheel of universal sovereignty, a vase (not usually included, but it is perhaps either a substitute for the minister or simply a filling for the eighth petal), the general, the horse, and the elephant (the latter two each with a flaming jewel on its back). Each figure appears on a cloud and has a pair of flower rosettes above, positioned like the sun and the moon. Another set of incised linear symbols appears near the peak of the closed globe. Moving clockwise from the same petal containing the monarch (or minister), they are the mirror on a lotus, a canopy, a victory banner, a bowl holding the sun and moon emblems, another canopy, a tied ribbon, a vase holding a jewel, and a canopy raised over a building (103.2). These seem to be mixtures of various auspicious symbols and do not follow a standardized version.

This work is a handsome example, probably of Chinese make, of this specialized form of mandala. It is a type well known from earlier times in Indian sculpture, particularly of the Pala dynasty (ca. mid-8th to late 12th century). It has a grandeur and heaviness that suggest a date possibly in the late Ming dynasty. The sculptured figures have power and a quality of dramatic movement that may be equated with sculptures of the 17th century. The jewel decor is rather stiff and simple, but prominent and well fashioned, much like some images from 17th century. The line drawings, in their freedom, simplicity, and naturalism, seem similar to figures appearing in some 17th-century tangkas.

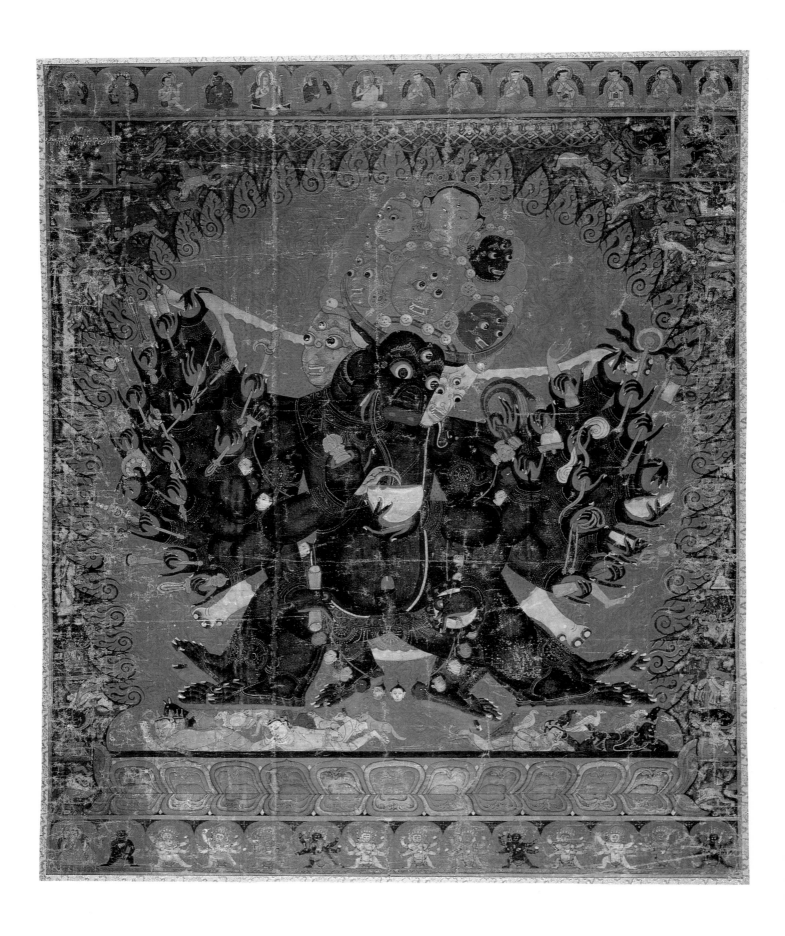

Yamantaka Vajrabhairava Ekavira (Rva Lotsawa Form)

Central Regions, Tibet

Mid-15th century

Tangka; gouache on cotton

38⅜ × 31½″ (97.5 × 80 cm)

The Los Angeles County Museum of Art, Los Angeles. From the Nasli and Alice Heeramaneck Collection. Museum Associates Purchase. M.77.19.8

Lit.: Pal, 1983, p. 146.

Yamantaka is one of the most important of all Gelukpa archetype deities, representing the adamantine wisdom of ultimate reality in triumph over evil, suffering, and death. This painting is one of the earliest tangkas known of this figure. He is the terrific form of the Bodhisattva Manjushri, whose benign princely head appears in gold color with crown and earrings at the top of Yamantaka's stack of heads. In order to conquer Death, the compassionate Bodhisattva assumes the buffalo-headed form of Yama, Lord of Death. With his other eight faces, sixteen legs, and thirty arms, he expresses the many facets of his inconceivable enlightenment, and manifests a power far greater than Yama. Thus overwhelming Yama, he stops his killing activity and becomes the Terminator of Death (*yama-antaka*). This archetype deity was highly significant in the life of Tsong Khapa (who was believed to be an incarnation of Manjushri). It thus became especially favored by the Geluk Order.

In Tibetan Buddhist practice, there are three main forms of Yamantaka: the red Yamantaka, Raktayamari; the black Yamantaka, Krishnayamari; and the Vajrabhairava Yamantaka, the Diamond Terrifier. Of these three, the multicolored Diamond Terrifier form, in this and the next two images, is by far the best known. Bhairava forms are awesome, terrifying figures from Hinduism, and the vajra is the symbol of ultimate reality manifesting as compassion. So the Vajrabhairava stands up in selfless ultimate reality, where the powers of the Bhairava forms are magnified unimaginably, so as to move the viewer through terror to transcendence.

This portrayal of Vajrabhairava without consort, in what is called the Lone Hero form, is tremendously powerful. The tight, muscular, blue body, modeled daringly with blue-grey highlights and dark blue shadows, has a tough reality that sets it apart from the more linear, decorative, and two-dimensional character of the rest of the painting. Each arm fights for individuality in the compact crowd of arms and red-palmed hands holding various symbols and weapons. The legs cluster together, appearing like thick supports for the wayward and spreading array of arms. His erect phallus has a bright red tip. His two main hands hold the familiar skull bowl and vajra chopper (104.1), and behind him he spreads the bloody hide of the flayed elephant of ignorance. He wears the characteristic ornaments of the wrathful deities—the garland of severed heads (symbolizing the conquered egotistic instincts) and the crown of skulls (the five wisdoms, made of the transmuted poisons of the five addictions). He wears the jeweled girdle, and ankle, leg, arm, wrist, and neck ornaments, all executed with gossamer white lines, a style known from as early as the late 12th century (No. 93) and seeming to have stylistic connections with art of Eastern India (Orissa). His enormous buffalo's head is truly fearsome, with its gaping jaws, thick neck, sweeping horns, three red-rimmed, popping eyes, and red nostrils (104.1). Its energy is augmented by the explosion of the mass of top-heavy, chunky, brown, white, black, red, blue, and yellow faces circling around, with blood-red and yellow heads stacked

104.1

above. The great clusters of limbs and heads create an awesome, even if cumbersome, effect. Despite the decorative character of this painting in the Nepalese stylistic tradition, the Tibetan infusion of a quality of deep primordial power emanates without restraint from this mesmerizing figure, striking to the heart of one who witnesses it.

Beneath the feet lie subdued gods and animals, and around the halo drift scenes from the sacred burning grounds. Above, there is a latticed canopy of flayed human skins. Along the top border are Bodhisattvas, Great Adepts, Indian pandits, and lamas. The lowest border has many Yamantaka manifestations of the World Gods and in the left corner is a black Kubera and a seated monk. This painting is an extraordinary work of the Rva Lotsawa form from a fairly early period. Its closeness to the paintings of the Kumbum in Gyantse and to the Nepalese-style works prevalent in the Tsang region in the 15th century clearly indicates a Tsang provenance for the work. The stylization of some elements is similar to that seen in No. 44. The unusual motif of clusters of gold circles, at the upper corners of the throne cushions of some of the small figures on the top row, appears in an early painting of Tsong Khapa (Tucci, 1949, pl. 13), probably also dating around the mid-15th century.

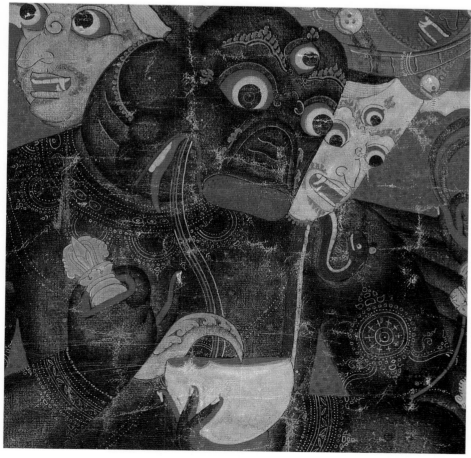

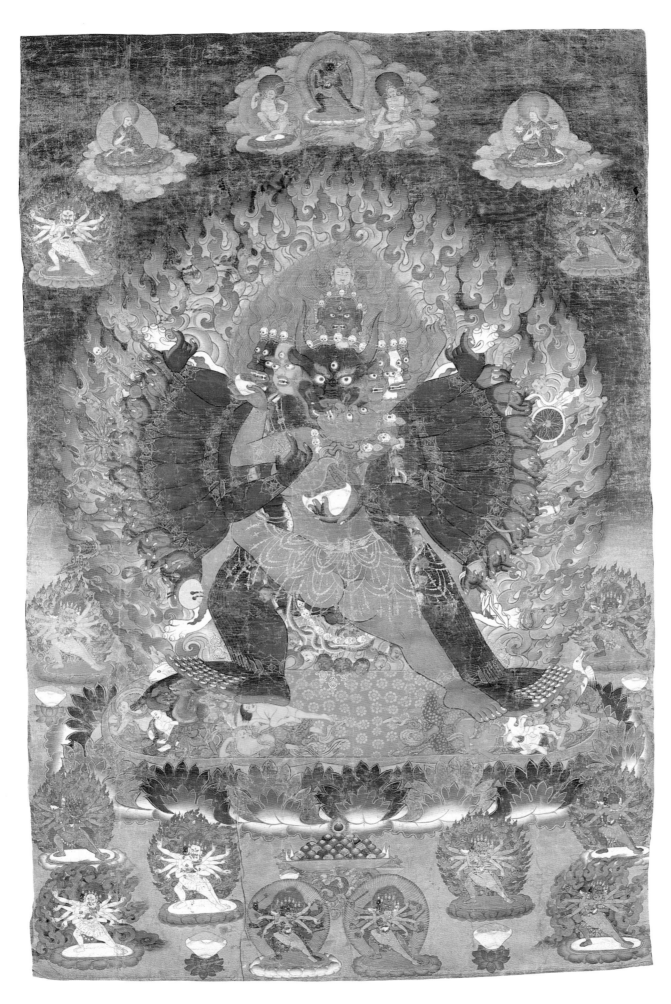

105
The Thirteen-Deity Yamantaka Father-Mother

Central Regions, Tibet; possibly Ü

Late 17th to early 18th century

Tangka; gouache on cotton

60 × 48″ (152 × 122 cm)

The Zimmerman Family Collection

Floating against the amorphous setting of a pale green ground that fades indistinctly into a horizonless ultramarine blue sky is the giant figure of the sixteen-legged, thirty-four-armed buffalo-headed blue Yamantaka Vajrabhairava, the Death Tamer, the Diamond Terrifier. In this most powerful manifestation he holds his pale blue consort, Vajravetali, the Diamond Zombie, in the blissful union that symbolizes the union of compassion and wisdom. They are encircled by a potent ring of flames shaded from light yellow to orange to red, and edged in gold lines. Beneath their feet are skillfully portrayed figures of humans and animals (105.1). Accompanying the main pair are twelve other Yamantaka couples in various colors positioned below and to the sides, representing the other twelve deity couples

that accompany this form of Yamantaka in his mandala: four Transcendent Buddhas, Mohayamantaka (Vairochana as Yamantaka), Matsaryayamantaka (Ratnasambhava), Ragayamantaka (Amitabha), and Irshya-yamantaka (Amoghasiddhi); four female Buddhas with male consorts, Charchika, Mamaki, Sarasvati, and Gauri; and four guardians, Mudgarayamantaka, Danda-yamantaka, Padmayamantaka, and Khadgayamantaka. Above, a two-armed, one-faced blue Yamantaka couple appears on green clouds. To their sides appear the Jnyanadakini (a female Buddha who revealed the Yamantaka teaching) on the left, and the Great Adept Lalitavajra, who first received the teachings from her, on the right. Next to Lalita appears Tsong Khapa, holding sword and book, and on the left next to the Jnyanadakini appears a

lama (probably the Fifth Dalai Lama) in the teaching gesture and holding a book. A large bowl of jewel offerings beneath the leafy lotus pedestal and four skull bowls on lotus pedestals positioned at the four quarters to the front and sides complete the well-unified, perfectly symmetrical composition.

The grandeur of its size, the intense energy of the figures, and the potency of the color make this amazing tangka one of the most spectacular known of this important deity. It rivals in power and scale the depictions of the great wall paintings in Tibetan temples, most now irrevocably lost. Stylistically, it is close to some wall paintings in the Drepung monastery in Lhasa, which may indicate that this painting comes from that area at about the same period (Council of

105.1

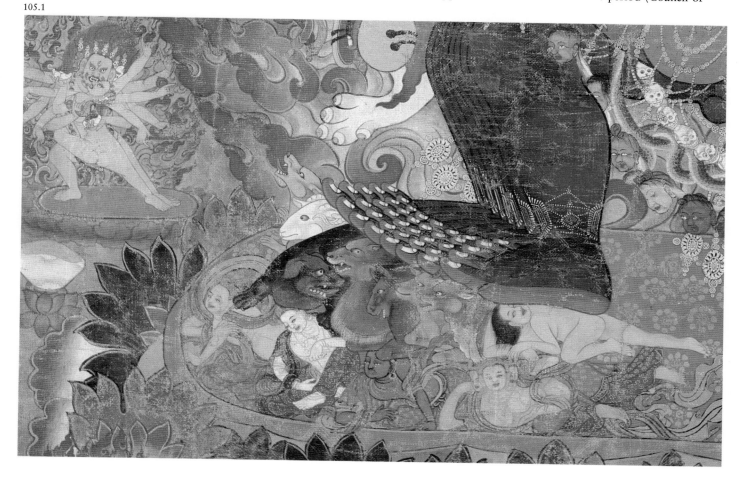

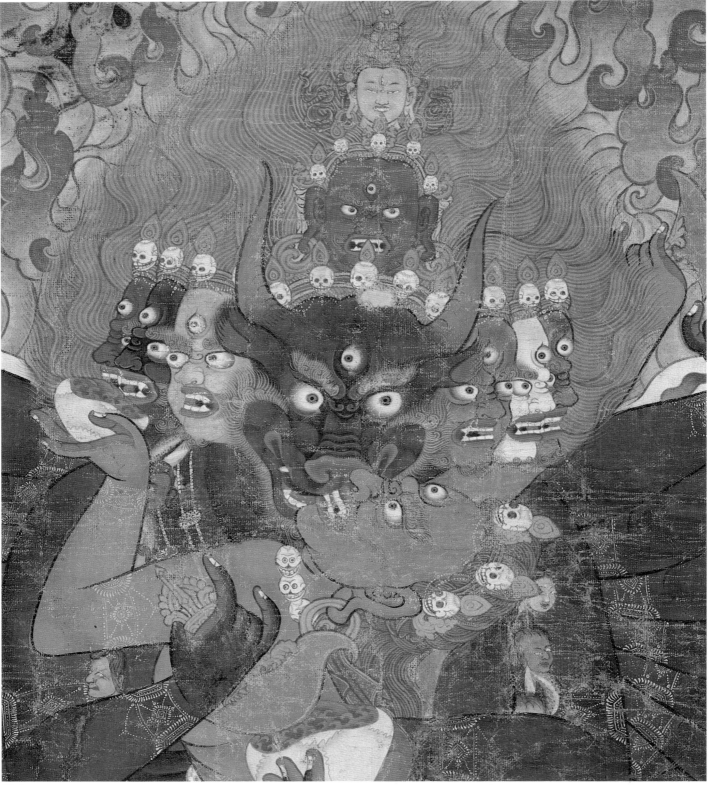

105.2

Religious Affairs of H. H. the Dalai Lama, 1982, p. 40). Both the Drepung wall paintings and this work utilize the power of simple, broadly handled shapes and tough, thick, even, outline drawing (105.2). This style of line and drawing seems to descend from the style seen in the Penden Lhamo from the Ford collection, which can be dated to before 1642 (No. 115). It is quite probable that this

Yamantaka is a developed example of the New Menri style, which came to dominate the painting of the Lhasa area during the time of the Great Fifth, in the second half of the 17th century. Effective techniques like the glowing whites for the undersides of the lotus petals, the rows of toenails, (101.1), the skulls, and the intensely glaring eyes of Yamantaka, are characteristics of this style as well. This whole

painting and its engagement with the viewer are totally controlled by the central power of Yamantaka's buffalo head (105.2). The projection of massive power is a main characteristic of painting of the central regions at this time; it is clearly distinguished from the more earthy and subdued styles of Western Tibet and the joyously bright and atmospheric styles of the eastern regions of this time.

106

Yamantaka Vajrabhairava Ekavira

Tibeto-Chinese

18th century; dated by inscription to the Qianlong period (1735–1796)

Brass; cast in several parts, with chasing, cold gold paste, and pigments

H. 18¾″ (47.5 cm)

The State Hermitage, Leningrad. Prince Ukhtomsky Collection

Yamantaka—the Conqueror of Yama, Lord of Death—belongs to both the archetype (*ishtadevata*) and protector (*dharmapala*) groups of deities. As an archetype Buddha, he is especially important in the Geluk Order.

Yamantaka is a terrific form of the Bodhisattva of Wisdom, Manjushri, who took this form in order to conquer the Lord of Death. Thus Yamantaka symbolizes the victory of Wisdom over Death, death being associated with ignorance by Buddhists.

Also known as Vajrabhairava, the Diamond Terrifier, this form of Yamantaka has associations with the Hindu deity Mahabhairava, himself the special form of Shiva, who destroys the universe at the end of the eon. The Buddhist Yamantaka tantras combine aspects of both deities (Yama and Shiva) into the one cult of Vajrabhairava-Yamantaka, which developed great importance in Tibetan Buddhism.

This sculpture of the terrifying god presents his very complex iconography. He is shown with his nine faces, including the central buffalo head, his thirty-four arms, and his sixteen legs, with which he tramples on birds and animals lying on top of human forms of deities and demons. His main implements are the vajra chopper and skull bowl, which he holds in his main hands at his breast.

The image was commissioned by the Manchu emperor Qianlong, which is evident from the Chinese inscription cast on the front part of the throne. It reads: "Respectfully produced at the time of Qianlong of the Great Qing" (Ch. "da qing qian long nian jing zao").

G. Leonov

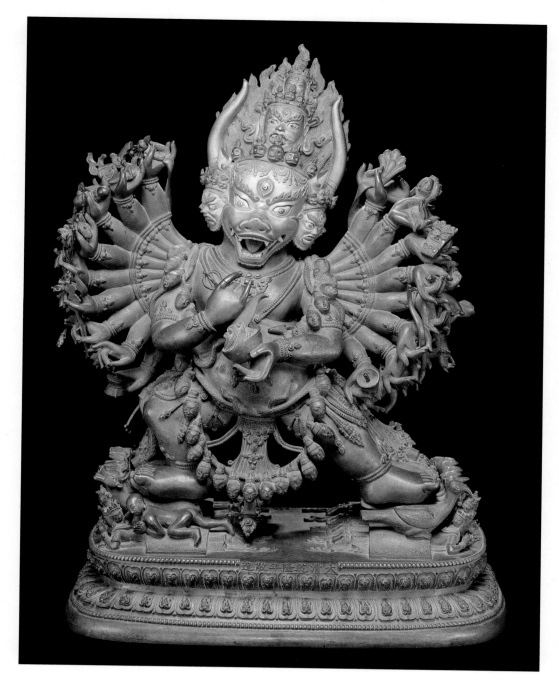

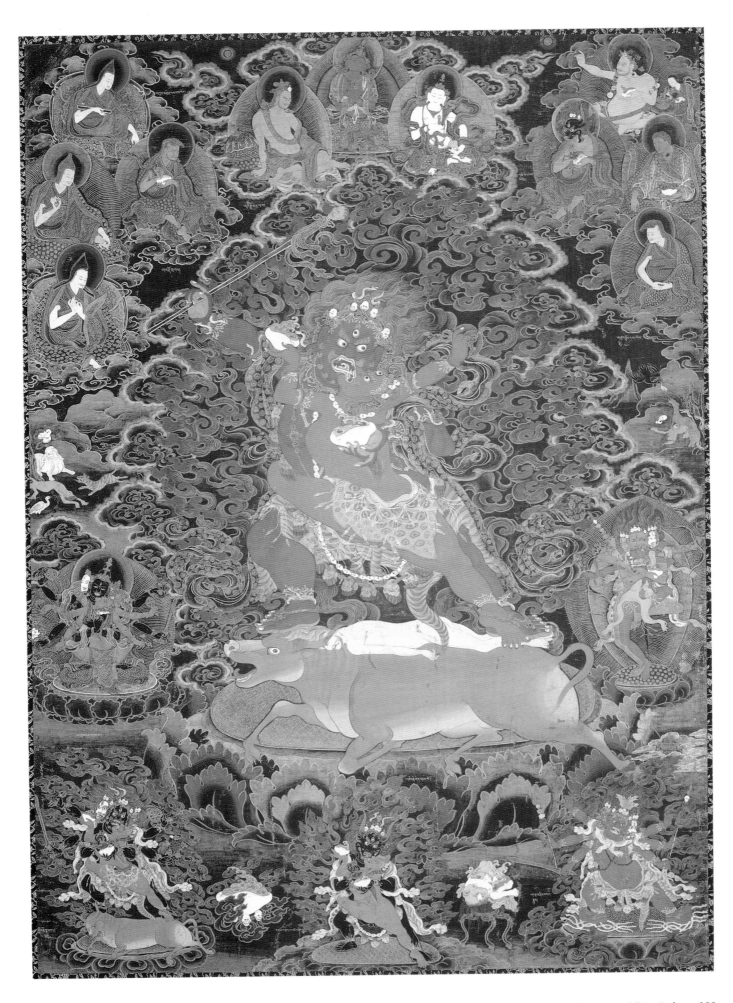

107

Raktayamari Father-Mother

Central Regions, Tibet; probably Tsang

Late 17th to first half of 18th century

Tangka; gouache on cotton

34⅝ × 24½″ (87.7 × 62 cm)

Museum of Fine Arts, Boston

Gossamer planes and lines of blues and reddish pinks create an atmosphere of sheer beauty against the translucent black space. The beautiful color washes and delicate lines of this painting create the mystical world of the secret black tangka of Raktayamari, the Red Conqueror of Death, as full-fledged Buddha archetype deity. It is the same deity as in the mandala in No. 75, the sculpture in No. 76, and the 15th-century tangka in No. 77, seen in full display with his consort in the blissful union of wisdom and compassion. They stand on the red buffalo of death, trampling beneath their feet the prostrate body of the god of egotism. To the left of the buffalo appears Guhyasamaja Buddha Father-Mother, and to the right at the same level is an unusual sky blue form of Shamvara Father-Mother. Across the bottom, left to right, appear a black Yamari Father-Mother, a two-armed buffalo-headed Yama Father-Mother, and a six-armed, three-headed red Hayagriva. Blue Vajradhara and white Vajrasattva appear directly above with a Mahasiddha, probably Lalita, to Vajradhara's right. At the upper left are three lamas, including Rva Lotsawa and Dorje Drakpo as well as the Great Adept Dombi Heruka. Virupa appears in the upper right corner (107.1). All together there are seven lamas, identified by inscriptions: one with a buffalo head, others probably of the Geluk oral tradition lineage and its precursors (107.1). Glimpses of animals, skull bowls brimming over with blood, entrails, palace buildings, and vistas of mountains appear here and there amidst the profusion of light blue clouds and yellow and pink coiling flames.

This painting, with its special coloristic beauty and refinement, is a remarkable example of the mystical black tangkas, which seem to have been universally popular among all the orders from the 17th century on. This work appears especially similar to late 17th- to early 18th-century paintings produced at the Shalu monastery, Butön Rinpoche's famous monastery in the Tsang region, as seen in No. 67. The black tangka in No. 112, bought by Tucci from monks of the

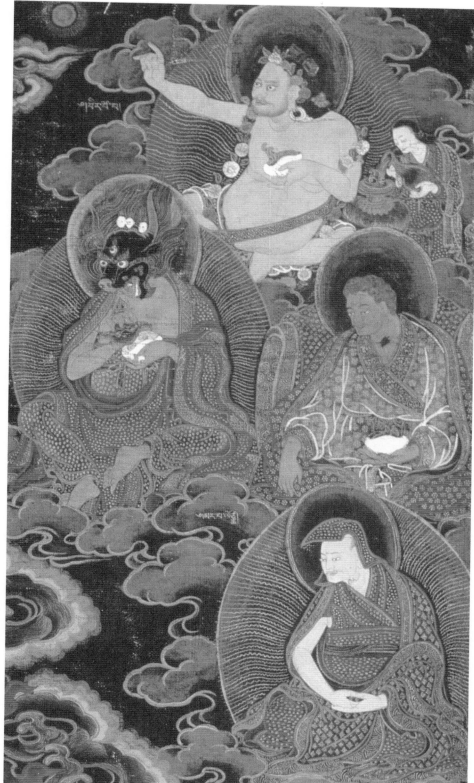

107.1

Gelukpa monastery of Tashi Lhunpo near Shigatse in Tsang, is also of a similar style, possibly dating a little earlier. It would appear that this was a prevalent style in the Tsang region at this time. The delicate technique, the ease of figural movement, and the precision of the drawing and modeling impart a much greater sense of realism to the figures, compared to the styles of earlier times. A rippling, incessant movement pervades the entire painting as though a kind of cosmic wind were blowing. The sophistication and refinement of the technique are amazing. The extraordinary ability of the Tibetan artistic genius to capture the mind with exquisite color and line and an improbable coordination of strength and delicacy is evident in this painting. It succeeds in making us aware of realms beyond the ordinary.

108
The Outer Yama Dharmaraja

Central Regions, Tibet

Mid-17th century

Tangka; gouache on cotton

27 × 18″ (68.6 × 45.7 cm)

The Zimmerman Family Collection

Yama Dharmaraja (Yama King of the Law) is the sometimes buffalo-headed Lord of Death of ancient Indian mythology, who judges the soul at the gates of hell, and whose minions come for us when our days are done. In Buddhist myth, Manjushri has brought this most fearsome god under control as a Dharma protector (Dharmapala) and as such he is a major protector deity in Tibetan Buddhist practice. He is especially important for the Gelukpas, because of Tsong Khapa's special association with Manjushri, the Conqueror of Yama. At top center, there is an image of Tsong Khapa, the only peaceful figure in the painting. This identifies the work as from the Geluk Order.

Archetype and protector deities can have outer, inner, secret, and sometimes ultimate forms. The Outer Yamaraja, with his buffalo head, is the form normally represented. He confronts outer obstacles and seeks to protect practitioners and monasteries from droughts, bandits, and other misfortunes. There is also an Inner Yamaraja, a similar form usually represented with a human-type terrific face. The true spiritual obstacles in one's life are not outer circumstances, but inner defilements such as fear, hate, pride, and jealousy; so the Inner Yamaraja is invoked to destroy them. He is a protector on an emotional, spiritual plane. There is also the Secret Yamaraja, who works in the instinctive wellsprings of one's being and brings correspondingly deep positive energy out from those inner realms. Finally, there is the Ultimate Yamaraja, the encounter with death. In the moment of death the mind experiences the self as obliterated, but as it meets nothingness it sees that instead of obliteration it has reached selflessness, the inexorable web of relativity. So death is a gateway, and the mind opens to enlightenment.

It is said that Tsong Khapa achieved a direct vision of the Inner Yamaraja. In his famous poem, translated below (R.

Thurman, unpublished), he describes this inner experience of his great ally in terms of the outward manifestation of Yama:

The slightest stamp of your extended and drawn-back feet destroys the world with its four elements,
Your intensely fierce buffalo face blazes extremely and your great roar fills the three realms.
O Lord Yamantaka, terrible form manifested to tame the evil by Manjushri, sole father of Buddhas,
Having bowed reverently to you, I now praise Yamaraja—it is time for all demons to go on alert!
Continuously sounding the great roaring sound that shatters mountains and shakes up oceans,
Great mass of fierce flames embraced by blackening smoke like lightning flashing in a thunderhead,
Your head shines with heat, unbearably hot to touch, surrounded with a wreath of rainbow light
Upon a triangle blackened as if smeared by a million fogs, filled with a swirling ocean of blood and grease.
Straddling the prostrate form of a black ogre, lying on a solar disc, O Yamaraja,
Your short thick body black as kohl, right leg stretched out, left drawn up, in the stance that shakes the earth,
Your hair flaming up earthy yellow, adorned with five-skull diadem, crown adorned with fierce vajra,
Your neck hung with blood-smeared fresh-severed head garlands, your three eyes flash and bulge and dart about.
Your mouth gapes with sharp fangs gnashing, your breath panting constantly like the poisonous vapors of snakes.
Your right hand brandishes the blazing chopper knife to mash the brains of the demon host, and your left hand plays with the bloody skull bowl that it holds.
Your tiger-skin skirt manifests your great fury—swiftly remember what you have vowed to Lord Yamantaka, never waver, never waver, and accomplish all that I, the yogi, do command!

With black body lunging wildly across the back of his bull mount, Yama waves a bone-white skull-headed club and lasso. He glares into the face of his consort, the blond-haired Chamundi, who is also black, and who straddles the haunches of the bull and Yama's left leg. She holds a trident and offers Yama a skull bowl full of demon-blood elixir. Both have three eyes and five-skull crowns; his is topped by a fierce vajra, symbolizing his having been tamed and bound to an oath of benevolent service by Manjushri Yamantaka. The

vajra and his strong, short horns stand out against his solid mass of black- and gold-lined earth-colored hair wafting out behind him with strangely parallel regularity. He has an enormous necklace of moist, severed heads. The skin of a spotted grey antelope covers her back. Both are naked, but their black bodies sparkle with the sharp slashes of delicate, threadlike, human-bone jewels. The moss green bull copulates with the stricken white body of ignorant life beneath his bellowing form.

This horrific scene is intensified in its drama by a naturalistic mass of dense flames blowing behind the central configuration and by the frenzied retinue cavorting amid billowing smoky clouds and white-hot flames. Twelve of Yama's minions appear around the top edges, each holding a different symbol and wearing the skins of various wild animals. On the right side of the bull mount is a black Inner Yama with a demon face; on the left is a red, buffalo-headed Secret Yama, the long-life Yama with skull bowl and jewel. Across the bottom are two dancing figures dragging little white human figures to their dooms, and two figures, Kali Devi and Shri Devi, who ride grey-brown and palomino asses.

The dark green and orange-red colors, as well as the wild and potent nature of the painting, appear to be similar to wall paintings seen in the Drepung monastery in Lhasa, possibly dating around the second half of the 17th century (Council of Religious Affairs of H. H. the Dalai Lama, 1982, p. 63). The figure of Tsong Khapa is stylistically close to the painted figures in the gold manuscript of the secret visions of the Fifth Dalai Lama dated ca. 1674–1681 (S. Karmay, 1988, fig. 8, on p. xi). The bold depiction of Yama's face and the specific manner of portraying the teeth, eyebrows, eyes, and so on closely resemble those of the Penden Lhamo in the Ford collection dated to before 1642 (No. 115). This painting is probably one of the finest of the Yama tangkas known. The broadly handled forms, though imparting a bold simplicity, are nevertheless masterfully controlled with ease and power. The flickering jewels and flames, done with a deft and delicate touch, increase the lively drama of the scene while adding sparkle. Even though it is serious, and even frightening, in subject and tone, one cannot help being enchanted by the spectacle of this world of the Lord of Death.

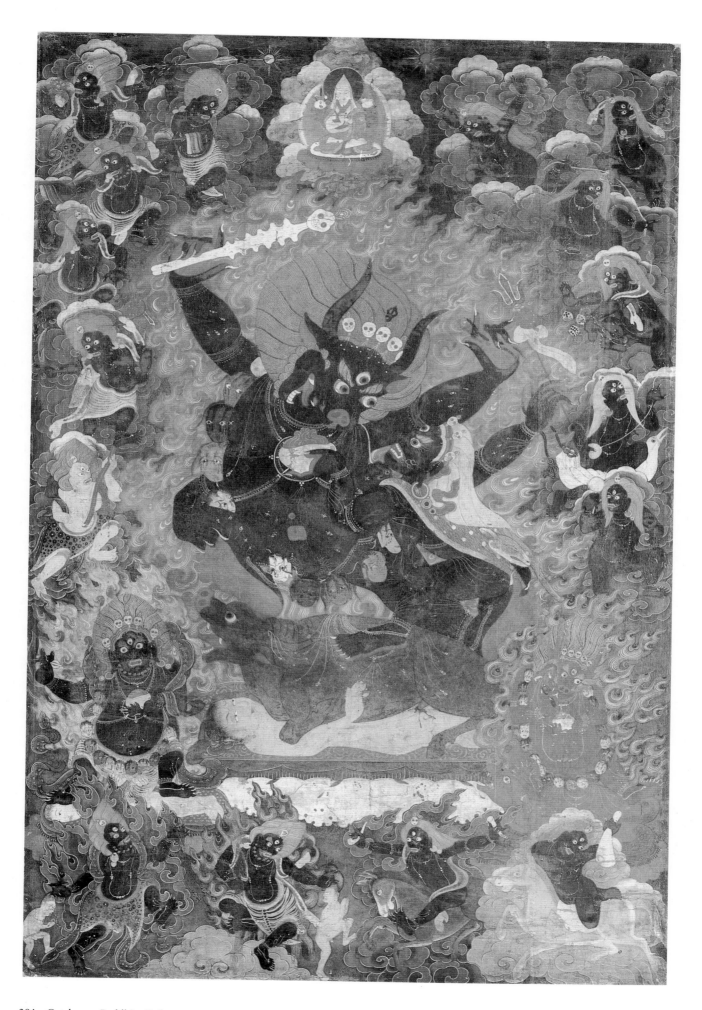

109
Yama Dharmapala

Tibeto-Chinese

18th century

Silk embroidery

26 × 18″ (66 × 45.7 cm)

The British Museum, London

Yama, the Lord of Death, the same figure as seen in No. 108, is presented here alone astride his bull. With alacrity and a kind of fearsome grace he lunges to the side, flourishing a skull-headed club in his right hand and a lasso in his left. A beautiful yellow and grey silken scarf with rippling edges flutters loosely around his shoulders, loops with delicate lightness around his outstretched leg and drifts to the side. A heavy pearl chain crosses his chest in an X and is held by a large jewel clasp with three pendants. The curves of the pearl chain echo the semicircular shapes prevalent in the figures. It is a major motif in the composition, giving a stable, balanced focus in the center of the painting. The apparent disorder of the wild flames, leaping behind Yama and licking around the pedestal in a highly unusual portrayal, provides a chaotic counterpoint for the bold, blue body of Yama and for the awful drama of the rape of the dying person by the bull. There is, however, a sophisticated compositional control based on X-crossed diagonals underlying the chaos. The flames seem to leap wildly to each side, but are diagonally crossed, actually providing the stable matrix behind the figure of Yama.

Despite the terrible aspects of the scene, this silk embroidery is superbly elegant. Primarily using only varied shades of blue and yellow (four shades of each) in addition to the grey, white, black, and flesh colors, the color scheme achieves a harmony and a contrast that are subtle and pleasing. The exquisite silk embroidery techniques produce both strong modeling and skillfully graded nuances, such as appear in the flowing

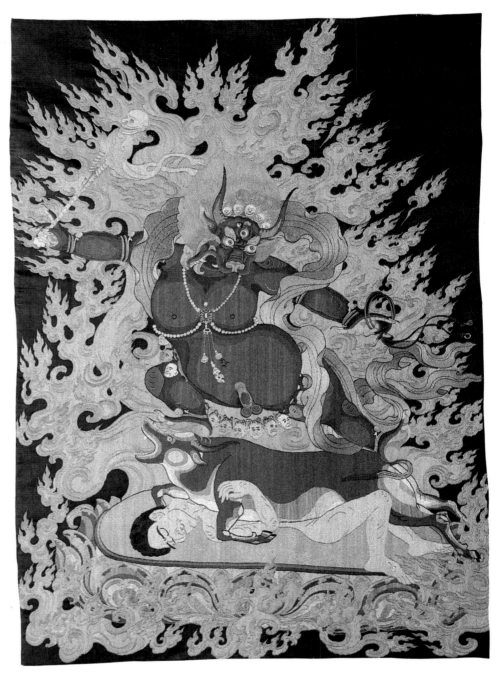

yellow hair of Yama. They also create a naturalistic dimension for the flames. This finely executed and well-preserved work is probably from the famous embroidery workshops of southern China. The less fierce tenor of the portrayal and the com-

positional stress on complex repetitive curved lines seem Chinese in style. Some features are, however, related to elements seen in the 17th-century White Vajrapani (No. 58), such as the spiral whorl patterns in the halo.

110
Standing White Mahakala

Eastern Tibet or Mongolia (?)

17th century

Tangka; gouache on cotton

23¼ × 14⅞″ (59 × 37.8 cm)

Mr. and Mrs. John Gilmore Ford

Lit.: Lauf, 1976a, pp. 150–51; Tsultem, 1982.

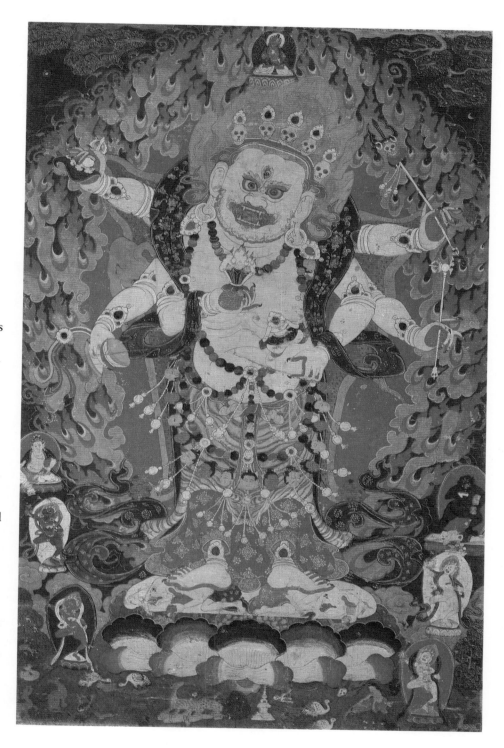

A skillfully drawn, intriguing, and stocky six-armed White Mahakala stands in an animated frontal posture, holding in his two front hands a flaming jewel and the skull bowl with an initiatory vase. His other right hands hold a drum with streaming ribbons and a vajra chopper; his other left hands hold an iron goad and a trident-tipped *khatvanga* staff. The back two hands also hold up the hide of an elephant, portrayed in subdued tones of purple and grey, and he stands on two prostrate emanations of himself as Ganesha, the elephant-headed Hindu wealth god. He wears a handsomely painted tiger skin spread broadly across his lower body below his bulging stomach. He is quite lavishly ornamented with swaying gold girdle chains, strings of round beads, and richly gilded and jeweled armbands, anklets, earrings, and the five-skull crown. As with the ornaments, gold is used to brighten the eyebrows of all three of his eyes, his flaming mustache, and his beard (110.1). A small figure of a red Vajrasattva sits above his fluffy and soft, streaming two-tone reddish hair. Even though stationary in his stance, a lively movement is imparted through the agitated postures of his arms, the jaunty swinging of his girdle, and the "Art Nouveau" curves of his floating scarves, whose dark blue and green coloring is tastefully decorated with naturalistically drawn floral motifs in delicate gold lines. The figure is complemented by the orange-red flames of the halo, rendered with clarity and curvilinear grace against the smoky grey clouds, the midnight blue sky, and the dark leafy trees leaning out horizontally overhead as if coming from nowhere. A simple ground plane, its horizon obscured by grey clouds, is the field for the image's bright red-, blue-, and green-tipped white lotus pedestal and, below it, a smattering of wildlife, including various scavenging animals and birds. Completing the lower section are four Dakinis (green, red, yellow, and white) in dance posture, and, above them, two Kuberas, deity of wealth, in his typical white form on one side and on the other side in his dark esoteric form.

The White Mahakala is more unusual than the customary black form (No. 112). He is especially popular in Mongolia as the main protector deity of Mongolia, given such distinction by the Third Dalai Lama. The presence of Kubera in this painting in his usual as well as his black esoteric form is also common in Mongolian iconography of this deity. This, as well as the particular color scheme of somber tones of dark green, blue, and grey, may favor a Mongolian or Eastern Tibetan-related provenance for this exquisite tangka. Mongolian Buddhist art was highly influenced by that of Tibet and also of China. From the time of the Third Dalai Lama's conversion of Altan Khan in the late 1570s, Mongolian Buddhism was intimately connected to Tibet. Stylistically, the art does have its own regional peculiarities and in general lacks the keen sharpness or force of the Tibetan styles (No. 58). It favors instead a softer, less vigorous line, darkish colors that tend to contrast with acid sharpness, forms that are more placid than wild, and a quality of heavy richness. There has as yet been very little study of Mongolian art and it is vastly underestimated. It is a major artistic tradition, particularly in the 17th century, which produced extraordinarily beautiful paintings and sculptures (No. 32). There is also a close stylistic affinity between this tangka and the Royal Ontario Museum's sculpture of Mahakala (No. 111), probably a Tibeto-Chinese work of the 17th century. The grey and dark green coloring is a feature appearing as well in the Zimmerman Yama painting (No. 108) and the tree forms are related to those appearing in some Eastern Tibetan works of the 17th century.

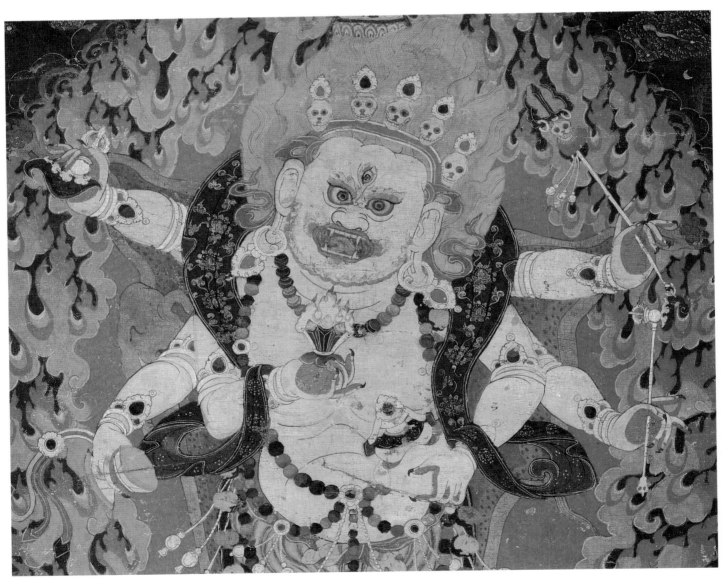

110.1

111
Mahakala

Tibeto-Chinese

17th century

Gilt brass; cast as two separate pieces, with pigments and gems

H. 13⅞″ (35.2 cm)

Royal Ontario Museum, Toronto

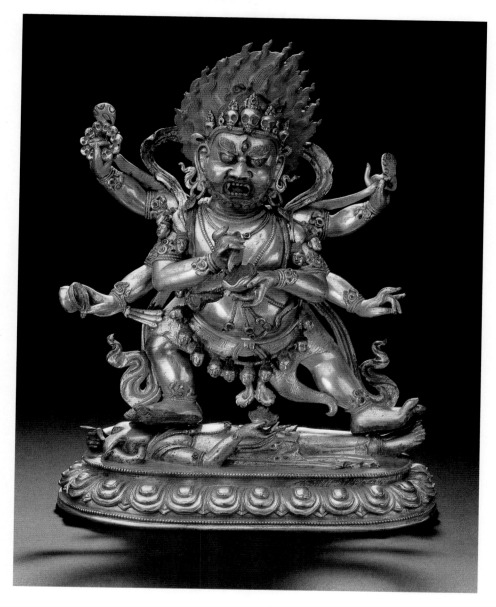

Mahakala is one of the most popular terrific protectors in Tibetan Buddhism. He frequently appears at the inner entrance of a temple or is afforded a special shrine. His myth speaks of his having been tamed by Avalokiteshvara. He is sometimes even considered to be a fierce form of that Bodhisattva of Compassion.

This handsome, fairly large, gilded sculpture shows the six-armed manifestation. With his two central arms he holds his characteristic vajra chopper and skull bowl, symbolizing the destruction and transmutation of inner addictive and outer demonic obstructions of one's quest for enlightenment. His other right hands hold a rosary of skulls and a *damaru* drum, his left hands usually hold a trident and a lasso (missing here). The two upper hands also hold the feet of the freshly flayed elephant skin he drapes across his back. A tiger-skin skirt is tied around his huge belly, which bulges with power. His other adornments are standard for fierce deities; they include a garland of fifty severed heads, a live-snake brahman cord, snake bracelets, armbands and anklets, bone bead necklaces, and a five-skull diadem. Dark green jade and coral-colored gems are inset into his ornaments. A scarf flies lightly around him, emphasizing his vigorous stance. He tramples on the prostrate figure of his own emanation as the elephant-headed god Ganesha, who holds a skull bowl and is also ornamented with jewels inset with jade. A mass of twisting locks of flamelike red hair acts like a halo, serving as a foil for the magnificent skull crown. The huge mass of the head, with its large, well-defined features, becomes the real focus of the

work because of its stirring realism. Red coloring is used in effective accents in the eye sockets of the skulls, for his curling beard, flaring mustache, wide eyebrows, stretched lips, curled-up tongue, and his red-rimmed eyes, as well as for the blood in the skull bowls and for the hair of some of the severed heads. Other severed heads have black or blue hair. Black appears on the snake sliding through Mahakala's hair, and traces of dark green pigment remain on his large snake necklace. There is white on his teeth and on his tight necklace.

These colors all appear to be original and, when new, would have added striking complementary color accents to the inset gems. The shade of the colors and a number of elements of the style are similar to the Ford tangka of White Mahakala (No. 110). Because of the slightly soft appearance of the body and the smooth shaping of the line, this figure is likely to be a Mongolian or Chinese image, following the Tibetan prototypes. Its quality of solid, unstylized naturalism indicates a dating around the 17th century.

112

Six-Armed Mahakala

Central Regions, Tibet; probably Tsang

Late 17th century

Tangka; gouache on cotton

28 × 21½" (71.1 × 54.6 cm)

Robert Hatfield Ellsworth Private Collection

Lit.: Tucci, 1949, pp. 184–87.

This huge, lumbering, six-armed Mahakala, his entourage, and three Gelukpa lamas coexist in an ethereal world of black cosmic space and pastel flames. It is a masterpiece of the mystical black tangkas. The black color here reflects the ultimate reality, voidness, the Truth Body of enlightened beings. Beings enjoying the awareness of this reality are only moved to manifestation by compassion, which is the source of the striking beauty of their forms and surroundings. And yet these figures and their settings are gruesome and terrifying. They project an aura of overwhelming power in order to protect practitioners. They work to eradicate unwanted obstructions to the realization of the enlightened mind. According to Tucci, this form of Mahakala follows the evocation written by the yogi ascetic Shavaripa following his vision in a cemetery in South India. The lineage of this practice descended down from India to Tsong Khapa, the lama above the central deity.

The Great Black One is shown with six arms, the two uppermost hands holding the feet of a flayed elephant skin, at the same time holding a skull rosary in the right hand and a trident in the left. The middle right hand holds a *damaru* drum; the middle left holds a lasso. The two front hands hold a vajra chopper in the right and a skull bowl containing a heart in the left. He wears a brahman cord made of a large pale green snake twisted into loops over his belly. A garland of big severed heads is strung around his body, dramatically framed by an encircling floral print scarf with aqua lining. Other ornaments delicately and elegantly decorate his black form. His hair standing on end and the features of his wrathful face even appear elegant and refined (112.1). Underfoot is his own emanation in the form of Ganesha, the white elephant-headed Indian god. The top surface of the lotus pedestal has a hexagonal tortoise-

112.1

shell pattern, a type seen in other black tangka paintings of the late 17th to early 18th century (No. 107).

Mahakala's major attendants accompany him here. At the bottom center is Dugon Trakshad riding a black horse, holding a spear and a skull bowl, and wearing a long silk robe. To the left bottom is the ogre (*yaksha*) Kshetrapala on a black bear, holding a vajra chopper and a skull bowl. To the right is a two-armed Penden Lhamo on a wild ass, holding a notched wooden club and a skull bowl. Just under the lamas are the red ogre Jinamitra holding a drum and a skull bowl at the left, and the black Takkiraja holding a drum at the right. Like Mahakala, each of these figures has a glorious flame halo in pastel shades flickering with vivacious but controlled rhythms. In and around the spaces and clouds drift bits and pieces of skeletons, fantastic rocks, animals, birds, and other figures. At the top sits the lama Tsong Khapa and his two main disciples

depicted in splendidly pale yellow and orange with light green accents. They identify the painting as a work of the Geluk Order.

Tucci, who has discussed this painting in detail, writes that he acquired it in Gyantse from monks from the Tashi Lhunpo monastery, the famous monastery of the Panchen Lama near Shigatse in Tsang. It is a fully developed tangka of the black style. The strength of the drawing and its similarities with the Butön tangka of the late 17th century (No. 67), and with the drawing style, coloring, and certain figures in the manuscript (dated 1674–1681) of the Fifth Dalai Lama, clearly suggest a dating in the last quarter of the 17th century. The figure of Tsong Khapa is particularly close to the rendering of the same master in the Fifth Dalai Lama's manuscript (S. Karmay, 1988, fig. 8, on p. xi). It appears that the black tangkas were a well-developed style by the period of the Fifth Dalai Lama.

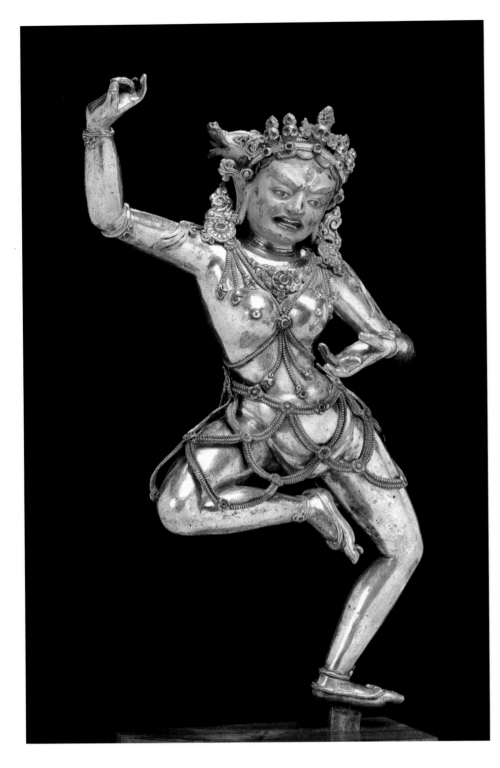

union form symbolizes wisdom and compassion indivisible as generosity, the opposite of greed.

In this dazzling silver image, Vajravarahi, the Diamond Sow, dances on the prostrate body of the deity of delusion, holding a vajra chopper and skull bowl (all missing here). Her sow's face is clearly seen jutting out on the right behind her bejeweled skull diadem. The pig is a common Buddhist symbol of delusion, and her having such a face symbolizes that wisdom's conquest of delusion does not merely suppress or destroy a part of the self. Wisdom tames the delusion of egotism and transmutes its energy into compassion and great bliss. The sow's face shows that nothing has been wasted. A popular yogini form, Vajravarahi appears both as an independent female Buddha and as a consort of Shamvara, the main male Heruka Buddha archetype of the Mother type of Unexcelled Yoga tantra. She is naked, but lavishly ornamented with sinuous, bell-tasseled strands of carved bone, which loosely encase her midsection in a heavy network and cover her chest. Her rich golden necklace and earrings are studded with turquoise, and thin gilded bands encircle her arms, wrists, ankles, and feet. The swaying strands of her ornaments reinforce the movements of her body and conjure the tinkling sounds of bone and bell that accompany her dramatic dance. Long strands of hair cover her back and hips. The strands are divided into strips resembling the hair on deities in some painted tangkas of the mid-17th century, such as Nos. 108 and 115. Her face, painted with cold gold paste and red and white pigments, is refined and yet wild with ecstasy. Despite the delicately curved eyes and sensitively formed mouth, there is a concentrated intensity in the arrowlike sharpness of the converging and expanding movements of her features. Her eyes and brows converge in one point at the base of her pointed nose, and her mouth expands with the stretch of her triumphant grin. A similar pincer movement of contraction and expansion occurs in the stunningly angular posture of the body: her right arm and left leg are energetically extended outward, while her left arm and right leg are drawn tautly inward. This creates one of the most excitingly complex yet balanced postures possible for a sculpted image. Sharp, almost abstract clarity, a vigorous spirit, and a touch of acerbic wildness characterize the distinctively Tibetan integration of the ideal and the real in this image. It has the elegance and naturalism seen in works of the 16th century, comparable to figures seen in tangkas Nos. 70 and 50.

113
Vajravarahi

Central Regions, Tibet

16th century

Silver, with gold, turquoise insets, and pigments

H. 12¾" (32.6 cm)

Collection of The Newark Museum, Newark, New Jersey. Purchase 1970, Mary Livingston Griggs and Mary Griggs Burke Foundation Fund

Lit.: Reynolds et al, 1986, pp. 107–08.

Vajravarahi is one of the female Buddha forms, also called Vajradakini (Diamond Skywalker) or Vajrayogini (Diamond Spiritual Athlete). These female archetype deities symbolically illustrate the Buddhist insight that enlightenment is beyond all sexual identity. There are archetypes that manifest Buddhahood in lone male forms, in male-female union forms, and in lone female forms. In the symbolic language of these archetypes, the male form symbolizes compassion, the opposite of hatred. The female form symbolizes wisdom, the opposite of delusion. And the male-female

Naro Dakini

Tibeto-Chinese

Early 18th century

Gilt brass; cast in several parts, with pigments

H. 6½" (16.5 cm)

The State Hermitage, Leningrad.
Prince Ukhtomsky Collection

Dakinis are skywalkers (T. *mkha' gro ma,* an angel, witch, or fairy who wanders in the air), in some cases celestial female beings, and sometimes earthly women who possess supernatural wisdom and powers. They have initiated, taught, and assisted many great Indian and Tibetan yogis in performing esoteric Vajrayana rituals. The Naro Dakini is a celestial female Budddha form associated with the *Paramasukha-Chakrasamvara Tantra* who manifested herself in an initiatory vision to the great Indian teacher and Mahasiddha Naropa (956–1040). Another name of the goddess is Sarvabuddhadakini, Dakini Quintessence of all Buddhas.

The Naro Dakini holds a vajra chopper in her right hand and a skull bowl in her left, and in the crook of her left elbow carries a *khatvanga* staff that rests across her shoulder. She wears a garland and a crown of human skulls, and tramples her own emanations, as the world deities Bhairava and Kalaratri, who are prostrate on the throne beneath her feet.

The sculpture is not overloaded with ornamentation or other details that are unconnected with the iconography. The decorations are rather simple and there are not many of them. The Dakini's body is almost naked, which helps to concentrate one's attention on the expressiveness of her movement.

One of the remarkable features of this image is the deep understanding of the proportions of a human body demonstrated by the sculptor. Without modeling muscles, and using only pure forms and volumes, the sculptor managed to create a perfect embodiment of the female energy of wisdom and balance, which plays such an important role in Vajrayana (Apocalyptic Vehicle) Buddhism.

G. Leonov

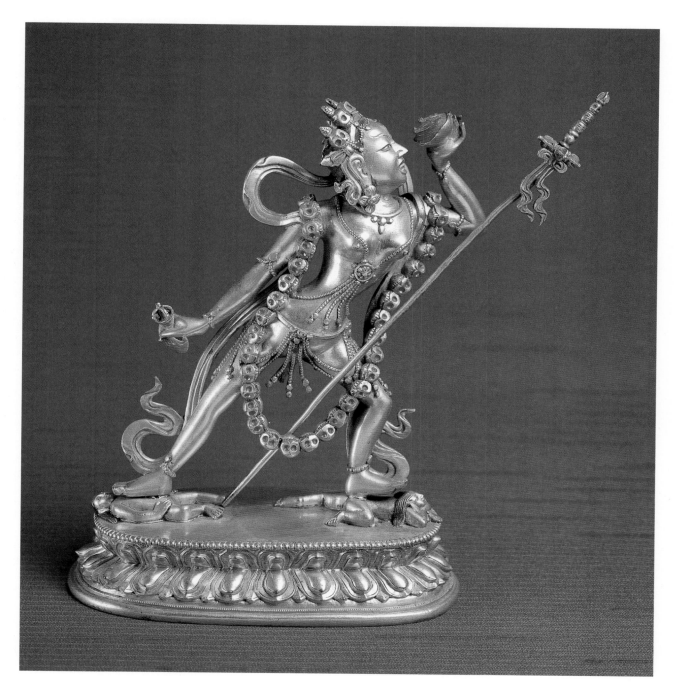

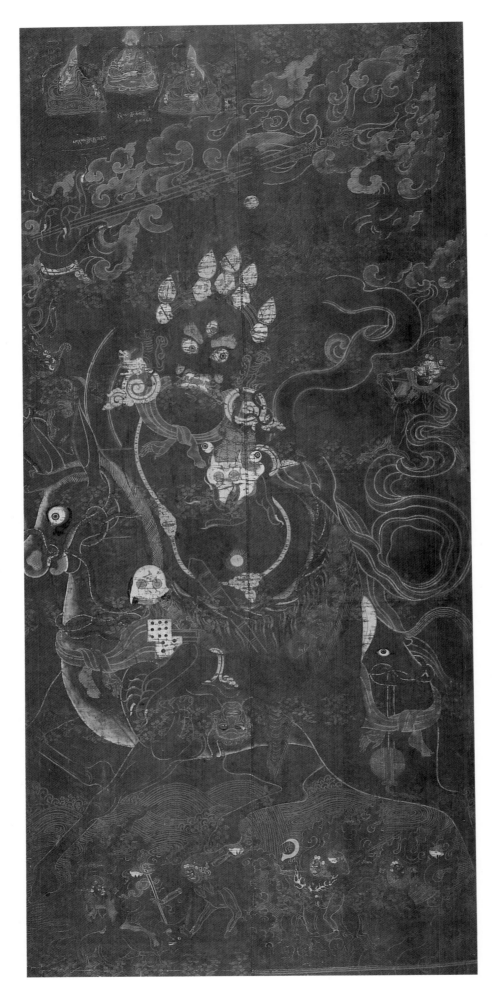

115
Penden Lhamo (Shri Devi)

Central Regions, Tibet

Circa 1630s (before 1642)

Tangka; gouache on brown silk damask

61¾ × 28¼″ (156.5 × 71.7 cm)

Mr. and Mrs. John Gilmore Ford

Penden Lhamo (Palden Lhamo) is one of the major protector deities in Tibetan Buddhism and the only female among the powerful group of the Eight Dharma Protectors (Dharmapalas). She is particularly favored by the Gelukpa, for whom she is a special protector of Lhasa and the Dalai Lama. She is known to appear at a mysterious lake, known as Lhamo Latso, about ninety miles southeast of Lhasa. This lake is renowned for revealing on its surface the reflections of the future. The Second Dalai Lama, Gendun Gyatso (1475–1542), founded the Chökorgyal monastery at the site in 1509. Since then it has been the custom for successive Dalai Lamas to make a special visit to this monastery and the magic lake each year. Penden Lhamo is Tibetan for Shri Devi, as she is the Tibetan vision of the terrific black goddess of India. Legends associate her with both Tara and Sarasvati. In Tibetan art since at least the 11th century, Penden Lhamo has appeared frequently as an entourage figure, particularly in paintings of Mahakala and Yama Dharmaraja. With her ascendancy under the Gelukpas as the personal protector of the Dalai Lamas, she attained an important independent status and became the primary subject of numerous paintings.

This painting of Penden Lhamo in the Ford collection is an extraordinary work on many levels. The unusually large, closeup, figure of Lhamo rides her wild mule through a sea of blood and fat. She is blue-black and haggish, with pendulous breasts, flaming eyebrows and mustache, and red hair standing on end. She brandishes a vajra-topped, long-handled club and a bowl made from the skull of a child of an incestuous union, which is filled with sense organs, including heart and plucked-out eyeballs. She sits astride her mount garbed only in the terrific ornaments of the fierce deities. A garland of freshly severed heads hangs around her body, snakes hold up her orange-streaked tiger-skin skirt, and five skulls topped with flaming jewels form her crown. A moon disc in her hair and a radiating sun disc at her navel are said to be gifts from the god

Vishnu, just as her other accoutrements are gifts from various other gods. Across the back of the mule lies the flayed skin of her own son, drawn in pink lines, the head hanging down in front of her and the hands and feet tied together to keep the skin in place. One of her legends recounts her existence as queen of the cannibal demons of Sri Lanka. She had vowed to slay her own son if she failed to convert her husband and their people from their evil ways of cannibalism and human sacrifice. When her husband refused to heed her warning, she fulfilled her vow, slew the child in front of the father, and assumed this awesome form of Lhamo (Getty, 1914, pp. 149–50).

Her wild mule is white in color and is outfitted with a harness of venomous snakes. Over the mule's front flank hangs a pair of dice used by Lhamo to determine the good or bad karmic fate of beings, a skull, and a black bag filled with diseases. Out of compassion, she swallowed all she could of the world's diseases. Those left over she stuffed into this bag. After casting the dice to determine the karmic situation, she breathes out these diseases, or lets them out of the bag to overcome the enemies of the Dharma. On the rear flank of the mule hangs a ball of magic thread, shown with crossing blue and red lines, said to have been made from rolled-up weapons. Nearby is the eye that formed when Lhamo pulled out the arrow shot at her by her husband, the cannibal king, as she fled Sri Lanka.

Small figures accompany Lhamo, Makaravaktra (Crocodile-Faced) Dakini leading her mule and Simhavaktra (Lion-Faced) Dakini behind her. Below, in the murky darkness surrounding the sea of blood, cavort four haggish goddesses who are also in her retinue. They are the goddesses of the four seasons. From left to right they are: 1) Vasanta Devi, the blue goddess of spring, who holds a sword and a skull bowl and rides a yellow mule; 2) Varsha Devi, the red goddess of summer, who holds a yellow staff and a skull bowl and rides on the back of a blue yak; 3) Sharad Devi, the yellow goddess of autumn, who holds a sicklelike knife and a

skull bowl and rides a stag with antlers; and 4) Hemanta Devi, the blue-black goddess of winter, who rides a camel and holds a notched stick and a skull bowl.

In the upper left corner are three Gelukpa lamas, each with an identifying inscription (115.1). According to these inscriptions, the central figure is Losang Chökyi Gyaltsen (later made the first Panchen Lama by the Fifth Dalai Lama), the lama to his right is the Fifth Dalai Lama, and the lama to his left is Tulku Drakpa Gyaltsen, another reincarnate lama of Drepung monastic university. Drakpa Gyaltsen was killed in mysterious circumstances, shortly before the Fifth Dalai Lama assumed responsibility for the secular government in 1642. This unusual circumstance enables us to date this tangka with certainty to before 1642. Because the Panchen Lama is in the center and Drakpa Gyaltsen is present, it is clearly before the death of the latter, and before the rise to eminence of the Fifth Dalai Lama in 1642, after which time he would have been given the central position.

This evidence establishes this painting as one of the oldest independent Penden Lhamo tangkas and also helps to ascertain the development of the black tangka style, of which it is a prime and early example. Tucci and other scholars have thought that the full-fledged black tangka style was not developed until the 18th century. Recently, in the work on the gold manuscript of the Fifth Dalai Lama, it became clear that this style was known at the time that this rare manuscript was executed. The manuscript was finished in 1674, and the illustrations were executed between 1674 and 1681 (H. Stoddard in S. Karmay, 1988, p. 19). Although the origins and development of the black tangka style are still being assessed and debated, this Ford tangka is a crucial work in establishing the clear existence of this type by ca. 1642.

In this masterwork, the forms are large and linear. The line is bold, assured, fluid, and sparingly used. It is quite different from the crisp, often thin and refined linear techniques of 15th- and 16th-century paintings. There is no stiffness in its movement and the forms take on a new

115.1

flexibility and naturalism by virtue of the line itself. It is a line that is comparable to the famous Tang dynasty naturalistic line. Shading only highlights certain areas and is not as dominant as line. Pale pinks, yellows, and blues coexist with orange, red, and a darker blue. Standing out above the other colors are the gold used for Lhamo's ornaments, the white areas of her three eyes, teeth, and crown, and other features, such as the skull bowl, the white snow lion on her right earring, the dice, the skull, the mule's eye, and the shading of its body. The orange flames of her fiery aura are broadly and simply portrayed. Sets of even, bold, parallel red lines describe frothy waves and whirlpools of blood. A floral pattern woven into the bluish brown silk damask, which serves as the ground for the painting rather than the customary sized cotton, can be seen in horizontal bands that become an

integrated part of the painting. This cloth, probably a rare piece, possibly of some garment associated with a special personage, also has a vertical seam running the entire length of the tangka near the center.

The unusual simplicity and untraditional size and placements of the groupings in the composition bespeak the early stages or new formulation of this deity as a central figure and as a black tangka genre. In later tangkas of this type the lamas are usually placed in a central position at the top, there are generally more attendants ranged along the sides as well as the bottom, and Lhamo herself is set back into the picture plane rather than looming so dominantly as she does in this work.

This tangka is clearly a remarkable and unusual work of great importance. Since it may be a product of a patron of the Panchen Lama, whose main monastery is

Tashi Lhunpo near Shigatse in Tsang, it may be thought to have originated from that area. According to Kongtrul's *Encyclopedia*, a 19th-century Tibetan text on the various styles of Tibetan art, the artist famed for initiating the New Menri style of painting was Chöying Gyatso (active 1620–1665). He was from Tsang and worked under the Panchen Lama before going to Lhasa in 1642 to work for the Fifth Dalai Lama (L. Chandra, 1970, p. 46 and note 82). It seems quite probable that the style seen in the Ford Lhamo tangka is New Menri. It is also possible, but not certain, that this masterful painting may even be by Chöying Gyatso himself. Certainly, the great power of line, not equaled in any other Tibetan painting style since the early 11th-century wall paintings of Tabo, can be considered as a new stylistic feature in Tibetan painting of the 17th century.

Penden Lhamo (Shri Devi)

Tibeto-Chinese

Late 17th to early 18th century

Gilt bronze, with pigment

H. 7½" (19 cm)

Rose Art Museum, Brandeis University, Waltham, Massachusetts. Gift of N. and L. Horch to the Riverside Museum Collection

Lit.: Nebesky-Wojkowitz, 1956, pp. 22–37.

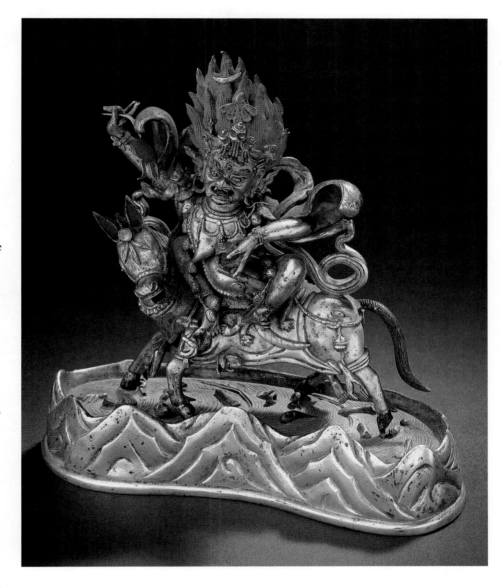

Penden Lhamo, as Shri Devi, represents the dark forces of the Great Mother aspect of life. In Buddhism she assumed a protective power, helping to vanquish the destructive forces of egotism. In Tibet in particular she may have replaced ancient female native deities associated with the Bon tradition. Following her introduction into Tibet she was placed in the entourage of other deities. She often appears as a member of the retinue of Mahakala. After her special propitiation by Gendun Gyatso, the Second Dalai Lama, and by the Fifth Dalai Lama, she acquired great prestige among the Gelukpa. Her images appear far and wide with the spread of Gelukpa influence into Western and Eastern Tibet, Mongolia, and China.

This wild and energetic sculpture of Lhamo captures all the vivacity and ferocity that descriptions of this deity conjure so vividly. She literally sparkles with electrifying movement as she sits hunched up on the back of her mule. With pointed fingers and spreading toes, flying sleeves and charged-up hair, she glowers and frowns, bares her fangs as she chews on a corpse, and emits wild "shouts of joy," to quote Nebesky-Wojkowitz, that "resemble roaring thunder." All the details of her form appear in this superb small statue. A crescent moon and a tiny peacock-feather umbrella appear in her clump of red hair. On her head is the five-skull crown, and she wears one lion and one snake earring. Her three eyes "flash like lightning," and her eyebrows and mustache blaze like fire. She brandishes a club (missing) and holds near her heart a skull bowl full of blood. There is a string

of fifteen severed heads around her body. Her breasts are pointed and a sun disc is at her navel. A sword is stuck into her belt and her body is smeared with "greasy finger prints" and with ashes "gathered in cemeteries." A garment of black silken patches billows behind her, and a flayed human skin is tied across her back. Her mount, the wild ass, is covered with yet another flayed human skin with, the hands and feet tied together and the head still attached. The wild ass turns its head around toward the shouting Lhamo as it gallops across the head-strewn sea of blood between the rows of Himalayan mountains. Some of the original jewel

insets and red lacquered pigment still remain on the statue.

This work relates to Tibeto-Chinese sculpture of the late 17th to early 18th century. The particular stylized, pointed form of mountain that is seen in the base commonly appears in Mongolian, Manchurian, and Chinese Buddhist sculpture of the 17th and 18th centuries. For comparison, it is interesting to note an earlier and even more fanciful form of mountain that appears in the Penden Lhamo depiction on the bottom of No. 129 from the Guge school of Western Tibet in the second half of the 15th century.

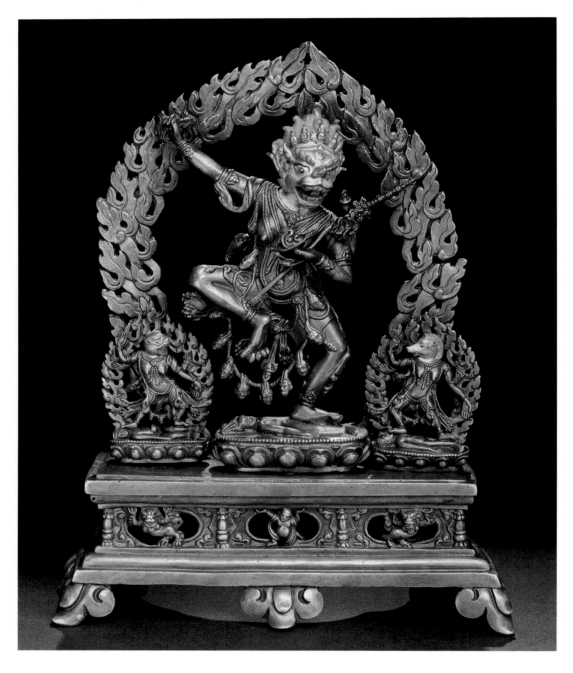

117

Simhavaktra

Tibet

Late 16th century

Brass; cast in several parts (the pedestal cast by mold in two parts), with cold gold paste and pigments

H. 8¼" (21 cm)

The State Hermitage, Leningrad. Prince Ukhtomsky Collection

This sculpture belongs to the same series as the Hermitage Mahakala Brahmanarupa (No. 72). The Lion-Faced Dakini is shown here dancing in the *ardhaparyankasana* pose, her left foot trampling a prostrate human figure. She holds a vajra chopper in her right hand and a skull bowl in her left hand. She wears a human skin on her shoulders and holds a *khatvanga* staff with her left arm. A *damaru* drum and a bell are attached to the *khatvanga* staff. The terrific goddess is surrounded by tongues of flame and is decorated with a long garland of severed human heads. She is accompanied by miniature images of her two attendants—the Dakinis Vyaghravaktra (Tiger-Faced) to her right and Rkshavaktra (Bear-Faced) to her left.

These three goddesses are depicted together in the album "Three Hundred Gods" (Pander, 1890), and were published by A. Grünwedel (1900, p. 174). His definition is supported by R. de Nebesky-Wojkowitz, who included these three Dakinis together with another goddess, Dredongma, "the goddess with the face of a yellow bear," in the group of four animal-faced goddesses (Nebesky-Wojkowitz, 1956, p. 51).

Simhavaktra's identification is clear; she definitely has a leonine face, and besides that, a Tibetan letter, *sa*, the first letter of her Tibetan name (Seng ge'i gdong ma), is cut on the inner side of the central leg of the pedestal of the sculpture. Vyaghravaktra's face looks like a "tiger" face, but the third deity in this sculpture has a fang in her mouth and a bristle on her head, which make it look more like a pig's head than a bear's head. But Tibetan artists often depicted bears in such a stylized way that they resembled pigs (see for example a drawing of a bear as Kshetrapala's *vahana*, a deity's animal mount, in Oldenburg, 1903, p. 78, no. 233).

G. Leonov

118

Vaishravana

Tibeto-Chinese

First half of the 18th century

Gilt brass, with chasing and pigments

H. 6¾″ (17.2 cm)

The State Hermitage, Leningrad.
Prince Ukhtomsky Collection

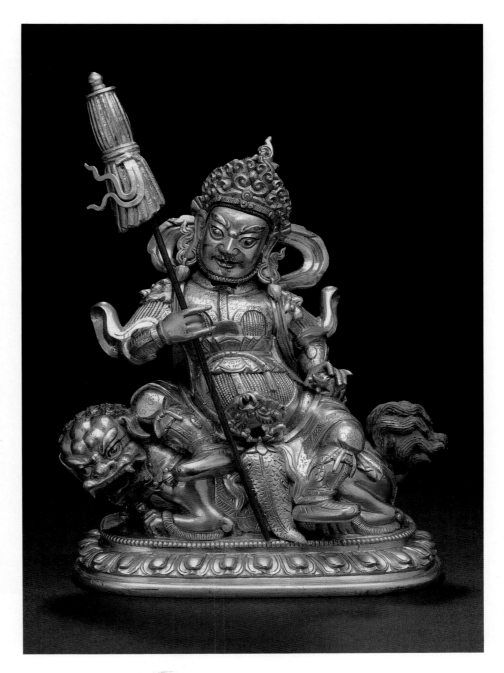

Vaishravana, the Guardian of the North, is shown here as a god of wealth. His iconography is traditional—he sits on a lion holding a victory banner in his left hand. This form of the deity is called Mahapita Vaishravana (Great Yellow Vaishravana). He is clad in a Chinese military costume executed with remarkable thoroughness. He wears chain-mail armor with breast- and back-protecting plates, a coat with lion-mask shoulders, and high boots.

A peculiar detail of Vaishravana's garment is the animal-head mask protecting his belly. It is turned upside down, and there is a ring in its nose and what appears to be the leaf of a plant attached to its horns. The ring connects the skin with the upper part of the garment by means of a belt. These two details may very likely have their origins in depictions of the skin of a predatory animal covering the loins of some deities of the heroic type. Later the two parts of the skin—its head and tail—had begun to be interpreted separately, and here the tail has been transformed into the shape of a plant leaf. Taking into consideration the Chinese origin of the sculpture, the leaf can stand here for a fan (Ch. *shan*), which is a homonym of another *shan* with the meaning of "good." It is interesting that there are Tibeto-Chinese images of Vaishravana and some other heroic deities where this leaf motif is even interpreted as a fish (Ch. *yu*), which is a homonym of "abundant," "rich" (Ch. *yu*). This last meaning coincides with the auspicious nature of Vaishravana. (See the sculpture of Vaishravana from the collection of Werner Schulemann in Toyka-Fuong, 1983, p. 146, n. B54. A fish is attached to the animal's head. Another example of a fish as a detail of a military costume

appears in the image of lCam-sring/Beg-tse in the same book, p. 138, n. B50.)

This sculpture is rather eclectic. It combines elements of both the Ming and Qing traditions of Tibeto-Chinese Buddhist art. The garment of the deity is closer to a Ming type. The same is true of a dotted spirallike design decorating Vaishravana's clothes above the breastplates and on his knees. At the same time other details of the image relate it to the Qing school: the design of the earrings and of the lotus petals, the decoration on Vaishravana's hair, characteristic flowers (seen on the textile lying on the lion's back

and on the back of Vaishravana's coat), and a specific triangular design that appears in many parts of the sculpture (on the crown, on the vertical strips of Vaishravana's boots, on his coat, and on the lion's collar). The mixed style of the image allows it to be dated to the first half of the 18th century, probably closer to the beginning. By about the middle of that century, Ming stylistic traditions in Chinese lamaist art had been almost completely replaced by the relatively simple styles of the mass-produced images of the Qing school.

G. Leonov

119
Vaishravana

Buryat, USSR

19th century

Wood-block carving

19⅝ × 16⅛ × 1⅜″ (50 × 41 × 3.5 cm)

The State Hermitage, Leningrad. Recent acquisition from the Ethnographic Expeditions

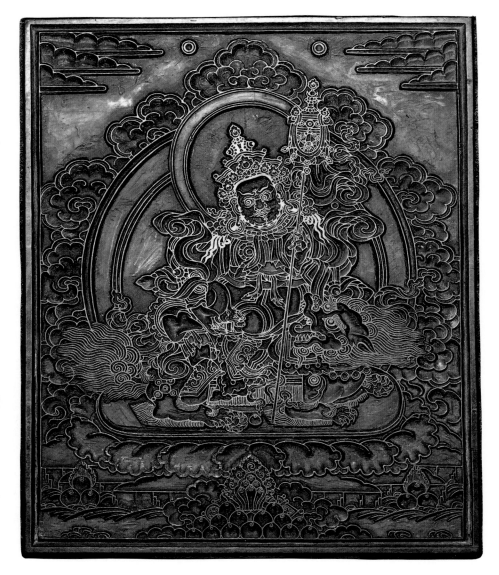

This wood block with an image of Vaishravana as the god of wealth belongs to a large collection of wood blocks preserved in the Hermitage. Vaishravana is shown here in his traditional iconography: he sits on a lion, holding a banner in his right hand and a jewel-spouting mongoose in his left hand.

The collection includes more than a thousand wood blocks brought to Leningrad from Aginski monastery, the main Buddhist printing house in Buryat (now in Chita region) in the early 1930s. This collection has about a hundred sets of wood blocks of Tibetan and Mongolian texts and a dozen wood blocks with mandalas, mantras, and images of deities. The collection was supplied with short notes on some of the objects. The following text is a summary of them.

To make a wood block, Buryat masters, who were, as a rule, laymen, used only soft wood, usually of trees growing on the banks of rivers, such as willow. First, pieces of wood were dried for six to ten months and only after that would they be used for making wood blocks. Having cut boards of one of the four prescribed sizes, a master planed it clean and took out all knots, filling the cavities with pieces of clear wood of corresponding sizes. Then a monk would draw lines on the surface of the board and write the text along them with black India ink, using a special wooden pen. The text was written in mirror reflection. In the 1920s, when the printing house in Aginski monastery was still operating and producing wood blocks, a skilled scribe could prepare up to ten wood blocks a day, and would be paid rather good money for them.

Monks checked the written text two to five times, reading it with the help of a mirror and correcting mistakes. They then gave the wood block to an engraver. Sometimes the engravers were monks, but as a rule they were lay people living not far from the monastery. To cut the text on both sides of a big wood block took about four days, and masters were given from one and a half to two rubles per block. After the text had been cut the monks checked it another five times, making prints and correcting mistakes first in the print and then in the wood block itself. Wrong or misspelled words or syllables were cut out and pieces of wood with written and cut text on them were inserted in their place and fastened with a special glue. This system of checking allowed them to eliminate mistakes almost completely. Then the final proofs, the wood blocks were boiled in butter in order to prevent warping. Monks used about one pound of butter for every ten wood blocks. When the butter started to boil, they put a few wood blocks in a pot with boiling butter and kept them there for one minute. Then the boiled wood blocks were taken away, cooled, dried, and finally cleaned of the dried butter with a special brush.

India ink for printing had to be prepared long before being used. A piece of dry ink was put into a pot and diluted with hot water. The pot was placed in a warm place and kept there for five to six months. Fresh warm water was added to compensate for the evaporation of liquid. During printing, a wood block was rubbed with ink, a sheet of paper of the corresponding size was put on the wood block and pressed onto it with a special horsehair brush. The process of making wood blocks with images of deities was essentially the same. The main difference was that sometimes a sheet of thin paper with a drawing of a deity was put on a board with its reverse side up and the contour of the image was perforated with a needle, for ease in transferring the image to the wood block.

G. Leonov

120
Begtse

Tibet

Early 17th century

Brass; cast in several parts, with cold gold paste and pigments

H. 9½″ (24 cm)

The State Hermitage, Leningrad.
Prince Ukhtomsky Collection

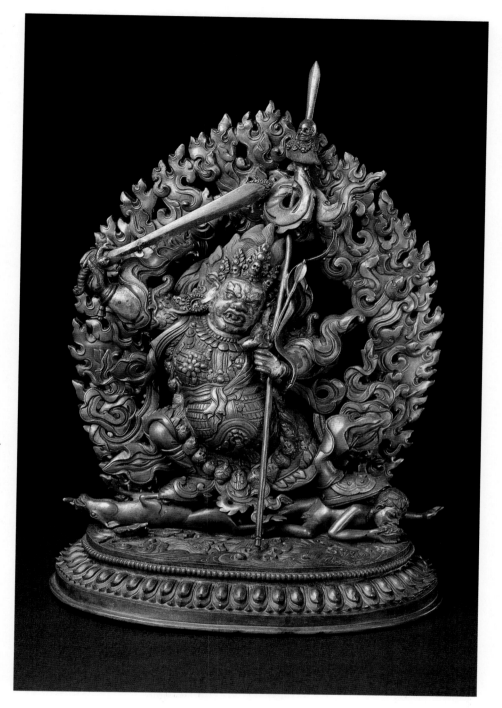

Begtse, literally, "hidden shirt of mail," or Begtsejen, "possessor of a hidden shirt of mail," is one of the eight famous protectors. This terrific deity is known also under his other name, Jamsing (Brother-Sister) because he is often depicted with his sister Rigpay Lhamo, who plays an important role in his cult.

The appearance of this deity in the Tibetan Buddhist pantheon goes back to the second half of the 16th century, and he seems to have been the last one to join the group of the Eight Dharma Protectors. According to a legend referred to by Grünwedel (1900, p. 81) and cited by Tucci (1949, p. 594) and Nebesky-Wojkowitz (1956, p. 88), Begtse was originally a pre-Buddhist Mongolian deity who tried in 1575 to prevent the journey to Mongolia of the Third Dalai Lama, Sonam Gyatso. Begtse was defeated, converted to Buddhism, and made to become its defender.

The description of this deity in a Tibetan text cited by de Nebesky-Wojkowitz coincides almost completely with the iconography of this image. Begtse is described as standing on top of a mountain that is situated in the middle of a lake formed by the blood of men and horses. He tramples a corpse of a man with his left foot and a carcass of a horse with his right foot. His limbs are thick and short. His mouth is wide open and warm blood bubbles in its corners. His tongue is rolled backward, as he bares his sharp copper fangs. His eyebrows and the hair of his face are flaming red. His three eyes are full of fury directed at the enemies of the Dharma. He brandishes a flaming sword of copper toward the sky with his right hand. His left hand holds the orange heart of an enemy near his mouth, clutching at the same time a bow and an arrow. In the crook of his left arm rests a stick of coral as well as a lance with a fluttering banner of dark red silk

attached to it. He wears a cuirass of copper, a garment of red silk, and a cloak made of the brownish skin of a billy goat. He carries a garland of fifty severed human heads, his feet are protected by high boots of red leather, and his whole figure is surrounded by purple flames (Nebesky-Wojkowitz, 1956, p. 90).

Even this detailed description leaves some details without explanation. For example, there is no mention in the text of the peculiar handle of the sword in the form of a scorpion. In addition, there is

not just "a man" under Begtse's left foot, but a man drinking blood from a skull bowl.

This sculpture is no doubt the creation of an outstanding artist. The deity's swift movement is limited by the circle of the flaming halo, and at the same time it is perfectly balanced with all the elements of the complex composition. All the minute details of Begtse's garments and equipment are carefully executed; each of the cut heads of the garland even has its own expression.

G. Leonov

121
Sertrap

Central Regions, Tibet, or Eastern Tibet

Late 18th to early 19th century

Tangka; gouache on cotton

56½ × 35½" (143.5 × 90.2 cm)

The Zimmerman Family Collection

Lit.: Nebesky-Wojkowitz, 1975, pp. 145–53.

Sertrap, literally "possessor of a golden cuirass," is the terrific form of the Dharma protector Tsangpa Drakpo, Fierce Brahma, who is peaceful and white, and wears a conch in his hair. In one text (Nebesky-Wojkowitz, 1975, p. 149) Sertrap is said to have been born from a ray of light emitted from Brahma's heart. Sertrap was apparently a favorite of the Kadam Order. This tangka has a lama figure, Ngog Loden Sherap, a Kadampa translator whose reincarnations are found as the lamas of the Dagyab monastic university near Chamdo in Kham, the highest Gelukpa reincarnation in Kham. Sertrap is thus the special protector of this monastery as also of the influential Nyagre college in Drepung university in Lhasa, where the Dagyab lamas go for their higher education.

Sertrap is described as being like a great goblin king, wild and red in appearance. He looms here as a giant figure riding a brown horse amid a swirling mass of orange-red flames. He flourishes a jewel-topped club in his right hand and in his left is a lasso to snare and tie up the evil opponents of Buddhism. He has a tough, bearded face of dark red color, against which his three rolling and gleaming white eyes and "sharp and glacial" white teeth stand out clearly. Atop his head is a golden helmet rimmed with the five-skull crown typical of fierce deities. Silken flags and a small canopy ornament with two peacock feathers stick out from the top of his helmet. His broad, massive body is distinguished by the cuirass of leather that is his emblem, portrayed here in gold.

Beneath this he wears garments of patterned turquoise silks that, like those adorning the horse, flutter and twist energetically. From his wide, jeweled girdle hangs a leopard-skin bow case and a sheathed sword.

He is shown with his fortress-palace compound, whose three concentric walls of red, yellow, and white describe an asymmetrical octagon. Inside the outer rim on a dark blue ground are different-colored dancing goblin-type figures, some brandishing swords. In the second space, on the pale, malachite green ground, goblins, warriors, and offering attendants dance among the jewels and trees. In the jewel-strewn, lapis lazuli ground of the large inner court are more goblins and the six main attendants of Sertrap, who ride their horses swiftly through clouds and smoke, each in front of his own palace compound surrounded by blue and green trees. These figures are emanations of Sertrap's body, speech, mind, excellence, and miraculous activities.

In the upper reaches of the painting, surrounded by clouds and trees against the dark blue sky, are the three golden roofs of the three-storied palace of Sertrap. His dominating figure occupies the first floor. On the roof of the second level of the central axis is a figure of Amitayus, flanked on the left by a lama (named as Loden Sherap by inscription), and on the right by a red Hayagriva. The roof of the third level of the palace is occupied by a figure of Amitabha. Outside, on the left, are two lamas of the Avalokiteshvara (compassion) lineage, with White Tara

below, and on the right two lamas of the Manjushri (wisdom) lineage, with Green Tara below. Along the lower border outside the fortification palace are offerings of a *torma*, a sacrificial offering cake, flanked by three skull bowls full of offerings on each side and the wealth gods Jambhala on the left and Vaishravana on the right.

The painting is handsome and dramatic. It is possibly the finest and richest painting yet known of this particular deity. The style is descended from the powerful paintings dominated by green and orange coloring of the late 17th century (No. 65), combined with some of the pale color effects and other details known especially from Eastern Tibetan painting. Although the emphasis on force and strength may favor a provenance in the central regions, the presence of Loden Sherap and the bright blue-green color frequently used in works from the Eastern Tibetan schools indicate that this may possibly be a work from the Chamdo region. This kind of formidable, generallike figure with its huge muscular body has its roots in the style of guardian protectors developed in Tang dynasty China and Central Asia from the 7th century. It is not a typically Indian protector form. The Tang style evolved into the even more herculean figures of the Song period (960–1279), and became generally formalized in that mode in the Ming and Qing periods. The Tibetan rendering is, however, a revitalization of this form and offers yet another magnificent major style development—one that stresses the beauty of colorful pattern with a wild and vigorous spirit.

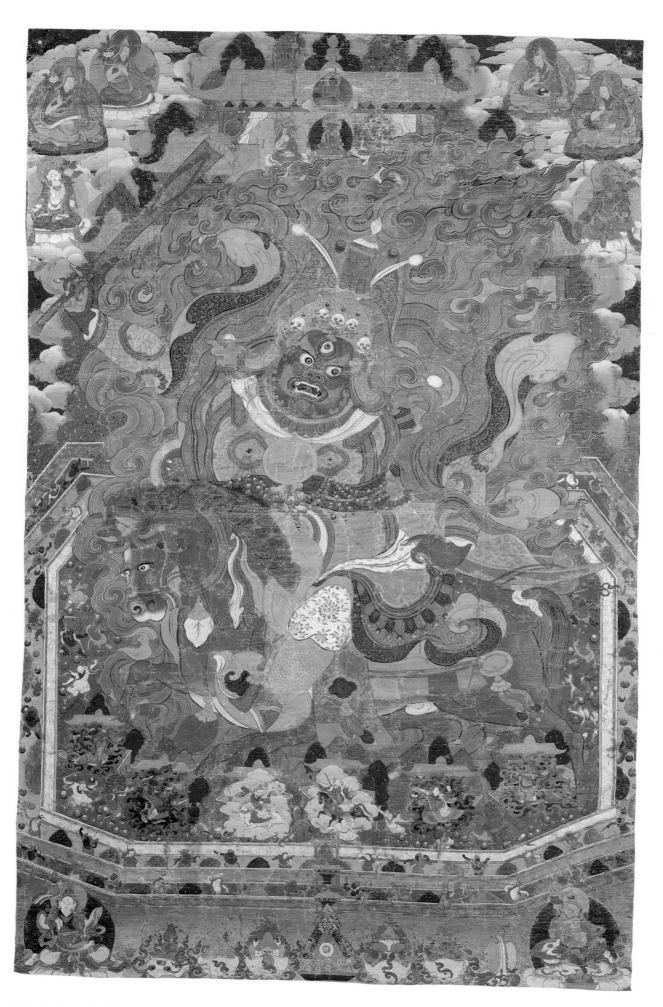

བོད་ལ་

ཕྱགས་པའི་

དགའ་ཞིང་

རྩམས།

TIBETAN PERFECTED WORLDS

Tibetans' faith in compassion has guided their history for more than a thousand years, and that same attitude shapes their cosmos in ways aimed to benefit all sentient beings. Tibetans are aware of the dangers to them of the unenlightened life, which is driven by the winds of delusion lifetime after lifetime. The individual, activated by the forces of greed, anger, and ignorance, cycles through the six realms of beings—hell, hungry ghosts, animals, humans, titans, and gods. This blind, compulsive existence is illustrated in "round of existence" paintings, which show the six realms of existence in a wheel held in the jaws of Yama, the Lord of Death, who personifies the universe's "judgment" on the aggregate of one's thoughts, words, and deeds. Tibetans also live in a close awareness of the immediacy of death, knowing that they can at any moment lose their comfortable hold on human life on earth and fly into the mouth of Yama.

Fortunately, they believe that the trajectory of the soul that leaves the body is determined by the state of mind, especially its degree of openness, throughout life and particularly at the time of death. Generosity is a virtue, as it is more open than avarice. Justice is more open than violence. Tolerance is more open than anger. Wisdom is more open than ignorance and prejudice. And, perhaps most important for the normal person, faith and trust are more open than suspicion and fear. Thus, vivid awareness of a dangerous universe and of the immediacy of death leads the Tibetan to invest the main energy of his or her life in the development of the openness of mind that is brought about by virtue and wisdom. And, in case they have not succeeded in developing very far, they can reach out through faith to get the help they need in moments of crisis. Many Tibetans continuously repeat OM MANI PADME HUM. This is the magic mantra that evokes the greater immediacy of compassion, the heart of Avalokiteshvara. Each syllable goes to one of the six realms—OM to the gods, MA to the humans, and so on. Each expresses compassion's universal energy that turns suffering to bliss, evil to goodness, darkness to light. Tibetans turn prayer wheels that are covered with the syllables on the outside and filled with scrolls that read OM MANI PADME HUM; they build MANI water and wind wheels, that are inscribed with the syllables and turned by natural forces; they carve the syllables on stones and mountainsides. They feel that even when driven by inanimate forces, the mantra is being articulated in the universe. They believe that by turning the wheels, by muttering the mantra, and by visualizing a MANI wheel of light turning in their hearts, they are creating a spiritual vehicle on which their souls can ride to the Pure Lands or Buddha field paradises of the great Bodhisattvas and Buddhas.

The Tibetans feel connected to a number of Pure Lands, which can be categorized as celestial, earthly, and microcosmic. The Universal Vehicle sutras refer to innumerable celestial Buddha lands in innumerable universes that are astronomical distances away in all directions. There are Buddha lands made of light, made of incense, made of jewels, made of flowers, and made of fine cloth, as well as those somewhat similar to our coarse world. Of all of these there are three that figure most importantly in the Tibetan imagination.

There is the celestial Western Pure Land, known as Sukhavati, the Blissful, created from the merits and vows of the Buddha Amitabha (Infinite Light). Anyone who prays wholeheartedly to go there at death is enfolded in the powerful laserlike light rays of Amitabha's great compassion and brought to rebirth in a lotus there. Avalokiteshvara himself is connected with that land, and his mythical vows are

taken there in the presence of Amitabha. There is the Eastern Pure Land, known as Abhirati, the Delightful, created and maintained by the Buddha Akshobhya (Unshakable). This is the land where Great Adepts like Vimalakirti and Milarepa often dwell. It is a less ethereal, more earthlike realm, but in a universe to the east, far beyond our own—as many universes to the east as there are grains of sand in sixty-two Ganges riverbeds (see No. 151).

There is also the Manorama paradise within Tushita Heaven, fourth heaven of the desire realm, where perfect Buddha emanations always spend a last celestial life teaching the Dharma to gods, angels, and sages before becoming a Supreme Emanation Buddha on earth. When Shakyamuni Buddha left there to come to our earth, the Bodhisattva Maitreya became regent, to rule and teach there until he too descends to earth in the future. But Maitreya is believed to be active in the world as a Bodhisattva even now, emanating as helping beings to work among us. The great master Asanga (ca. 4th century CE) was said to have met Maitreya in person, to have been taken up to Tushita with him, and to have received five sacred books there, which he brought back with him to India. These five books form the backbone of the curriculum of the great compassion teachings, the magnificent stage of the path to enlightenment. The famous monastery founded by Tsong Khapa near Lhasa in 1415 was named after Tushita Heaven (T. Ganden) to indicate its connection to the millennial hope of Maitreya's future presence on earth.

Tibetans believe they can be reborn in any of these three celestial Pure Lands, depending on which Bodhisattva or Buddha they can best envision and trust. Thus, the numerous icons and statues of the Five Transcendent Buddhas, the Tathagatas of the directions—popularly Akshobhya in the east, Vairochana in the center, Ratnasambhava in the south, Amitabha in the west, and Amoghasiddhi in the north—are everywhere in Tibetan temples, in texts and block prints, painted and carved on mountainsides, on giant bannerlike appliqué icons twenty stories high, sculpted in clay, or butter, or dough. Tibetans encounter their own pure celestial potential in seeing these paradigmatic deities.

On the earthly level, there are a number of Pure Lands hidden away in Tibet. In the south of India there is the Potalaka (Haven) Paradise, the mountain retreat of Avalokiteshvara and Tara, after which the Great Fifth Dalai Lama named his palace in Lhasa (text fig. 25). To the southwest, on another continent that seems to resemble Africa from its descriptions, there is the Glorious Copper Mountain Paradise of Padma Sambhava, where he dwells immortally and continues teaching his circle of adepts (No. 149). To the

northwest, hidden in the Pamirs or the Hindu Kush, there is the Uddiyana Dakini Paradise, where female Buddhas in Dakini embodiments preserve the Mother tantra teachings of the *Laughing Vajra* (*Hevajra*) *Tantra* and the *Supreme Bliss Wheel Integration* (*Paramasukha-Chakrasamvara*) *Tantra,* and whence they visit the outer world to inspire adepts' practice. In the east, in northwest China, there is the Five Mountain Paradise of the Bodhisattva Manjushri, where the pilgrim has a chance of meeting the Prince of Wisdom in person, and where the cultivation of transcendent wisdom is most advantageous. In the north, perhaps somewhere in the arctic regions, lies the hidden paradise of Shambhala, a vast nation of ninety-six provinces, where technology was already advanced twenty-five hundred years ago, and where the entire population dedicates its energies to the study and practice of the *Wheel of Time Tantra,* the *Kalachakra Tantra* (No. 155).

All of these Pure Lands are on this earth yet subtly hidden from the ordinary sight of ignorant people. One can go to the Five Mountain Paradise as a pilgrim and see only a beautiful landscape of green and misty mountains with flat, moist platformlike peaks. One could fly over the arctic, and not see the vast land of Shambhala, though northern Tibetan nomads might see its rooftops reflected in the aurora borealis. But Tibetans have legends of Great Adepts who visited these lands and brought back teachings. Even simple people visit them in their dreams at times. And they are yet another way by which the Tibetan imagination makes the full manifestation of enlightenment seem closer.

Finally, there are the microcosmic Pure Lands, through which the landscape of Tibet itself became transformed into a secondary Pure Land of Avalokiteshvara, who lives as its ruler in continuous reincarnations in the majestic Potala temple-palace-monastery (text fig. 26). These sacred microcosms are accessed by stupa monuments, *chötens,* by painted, colored-particle, or three-dimensional mandala constructions, by magical chants and rituals and dances, or most perfectly by the inner visualizations of the lama adepts, yogis, and yoginis. The subtle materials of the human imagination are the finest of all the artistic media by which these microcosmic Pure Lands are created. They are constructed in the stabilized visualizations of the adept lamas and reincarnations. Tibetans feel that to enter the presence of such a person is to enter a Pure Land; and all the places where adept lamas have spent time—their houses, monasteries, retreat caves, vehicles—become sacred environments, and the faithful can draw closer to liberation by entering such spaces. Through Tibet's seventeen-hundred-year association with the Buddha reality, the entire land of Tibet has become the closest place on earth to an actual Pure Land.

X.
Cosmic
Bodhisattvas

When Bodhisattvas achieve the stage of being able to manifest at will in the celestial realms, they never go to those domains merely to get away from the earthly or even the hellish planes of suffering. Instead, they use the vantage of the heavens to expand their range of great compassion and to intensify their powers of emanation to reach out more effectively to help all sentient beings become free and wise. Tibetan Buddhists believe that the heavens are planes of ever more subtle matter, where the mind can shape the body and environment at will to heighten the exercise of power and the enjoyment of bliss. In such planes, a Bodhisattva might express his or her will to reach out to many beings in many appropriate ways by growing many arms. A Bodhisattva with boundless compassion would thus reach out with boundless arms to boundless beings; the thousand arms of some Bodhisattvas are symbolic of infinite arms. A Bodhisattva who wished to see everything, to understand it all, and to communicate with all beings might express that by growing a thousand eyes and manifesting a thousand faces. The thousand eyes of such Bodhisattvas are symbolic of all-seeing vision; the thousand faces are symbolic of the ability to be all things truly necessary to all beings.

This part displays some spectacularly beautiful and rare tangkas and sculptures. The female Bodhisattva forms include an eight-armed fierce Green Tara, Ushnishasitatapattra, and Ushnishavijaya. The male figures are various forms of the Eleven-Faced Avalokiteshvara and the fierce and mild forms of Vajrasattva. A manuscript cover with Prajnyaparamita and a large *tsa-tsa* in clay of the Eleven-Faced Avalokiteshvara with a thousand arms are outstanding examples of their medium and type. The overall effect of these multiarmed cosmic deities is one of incomparable otherworldly beauty. They transport the viewer into their own sublime realms, which their compassion manifests both to delight and to enlighten all beings.

Manuscript Cover

Central Regions, Tibet; probably Tsang

13th century

Wood, with pigments
Carved (outer) side with Thirty-five Buddhas
of Confession

Painted (inner) side with Prajnyaparamita

L. 28¼ × W. 10½ × D. 1⅛″
(71.8 × 26.7 × 2.8 cm)

The British Museum, London

Lit.: Zwalf, 1985, p. 137; Pal and Meech-
Pekarik, 1988, pp. 163–64.

This splendid manuscript cover, one of the best surviving examples in early Tibetan art, is carved in relief on its outer surface and brilliantly painted on its inner surface. The outer, which is slightly convex, has a central rectangular panel containing thirty-one of the group of Thirty-five Buddhas of Confession, a group especially important in the initial stages of Tibetan Buddhist practice. In the center is Shakyamuni Buddha in the earth-witness gesture, seated on an Indian Pala-style throne with a lion base (containing a niche in the center, possibly for the insertion of an object), side panels with leogryphs standing on elephants, and an arch composed of *makara* sea monsters with their filigree tails and a *garuda* (the eagle of wisdom) at the apex (122.1). The throne is supported by a lotus pedestal, whose foliated branches curl left and right, forming the vine roundels of thirty seated Buddhas, who are positioned on the two sides in three rows of five Buddhas each. They are portrayed with five different hand gestures: contemplation, boon-granting, teaching, discerning, and earth-witness,

122.1

utilized in a varied pattern of alternation. The beautifully naturalistic pattern of the vines includes alternating flowers and animals in the interstices. Around this central panel are a pearl border and a double border of two styles of lotus petals. In the center of each side on the outermost row of petals are the four remaining Buddhas of the set of thirty-five. The style of the Buddha figures and the soft naturalism of the vines and animals seem to relate to sculpture of ca. the 11th to the 12th century and to representations seen in some manuscript paintings of the same period from India and Nepal.

The painted inner surface shows a central square panel with the four-armed goddess Prajnyaparamita, in a vivid orange color, holding a book and a vajra and making the teaching gesture with her two main hands (122.2, 122.3). She is simply but richly adorned and is seated in the

diamond posture on a multitiered lion throne. The animals on the sides and back of the throne are similar to the ones on Shakyamuni Buddha's throne on the other side, only in this case beauty of line and color replaces the three-dimensional quality of the relief carving. She is attended by two standing Bodhisattvas, one gold (holding a water vase on a lotus) and one white (holding a white lotus), most likely Maitreya and Avalokiteshvara, respectively. The solid red background is delightfully sprinkled with a simple repetitive pattern of flowers, and above the figures is a dark blue canopy decorated with linear designs, and a festoon hanging from each end.

Prajnyaparamita is the paradigmatic enlightened goddess in Buddhism. She is the transcendent wisdom of selflessness or freedom, the realization that liberates from all suffering. She is praised as the Mother

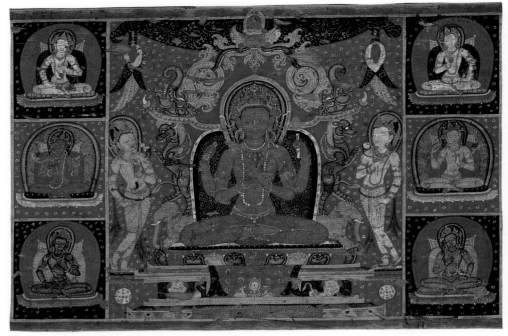

122.2

of all Buddhas. The Prajnyaparamita Sutras are the verbal expressions of her wisdom; they are basic to Universal Vehicle (Mahayana) Buddhism. These wisdom texts teach the freedom reality of voidness, the conception of the spirit of the enlightenment of love and compassion, the paths of the Bodhisattvas—everything needed for the attainment of liberation. They breathe a spirit of fervent devotion to the goddess herself.

Flanking the central panel on each side, and about equal in size and shape, is a set of squares, three rows wide and three rows high. They are ingeniously designed using alternating colors to create a vivid tapestry effect while maintaining the individuality of each section. Each square contains a seated figure with alternating red or green halo. The red and blue backgrounds, with their single, equally spaced flowers painted carefully around, are disposed in a

checkerboard fashion. The arrangement of figures is mostly symmetrical. Of the eighteen figures, eight are Bodhisattvas (four on each side: three are on the inner vertical row with the fourth one at the top of the middle row), and, except for one Mahasiddha on the left side, all the rest are lamas. The Bodhisattvas are probably the Eight Great Bodhisattvas and the lamas appear to be members of the Sakya Order. Each one has a distinct character, a slightly different pose, and a different robe color and style.

The colors are incredibly rich and saturated. The line is fairly soft and even. Pal has noted the typically Nepalese elements of the curtained background and the style of garments and ornaments. Although this style is strongly related to Indian and Nepalese manuscripts, especially of the 12th to 13th centuries (such as the 1207 manuscript in the Pritzker

collection, in Pal and Meech-Pekarik, 1988, pl. 26), this example is clearly a Tibetan book cover, as indicated by its large size and the presence of the Tibetan lamas. The lamas somewhat resemble the sculpted lama on the Twenty-one White Tara Stele (No. 22) and the lama portrait in the Ford collection (No. 95). Their short-waisted appearance and the use of bricklike patches in their robes are features that suggest a date in the late 12th or early 13th century for this work. The figural style of the standing Bodhisattvas is different from that seen in many 12th- and 13th-century Tibetan tangkas. Thus, this book cover shows yet another variation in the early schools of painting, a variation that seems related to the style of wall paintings from Narthang or Shalu monastery in Tsang (Liu, 1957, figs. 32, 27), and closely connected to some Nepalese paintings.

122.3

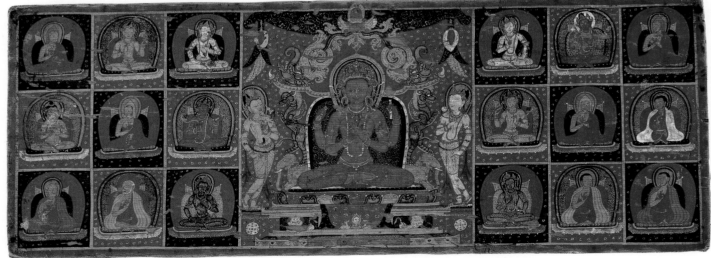

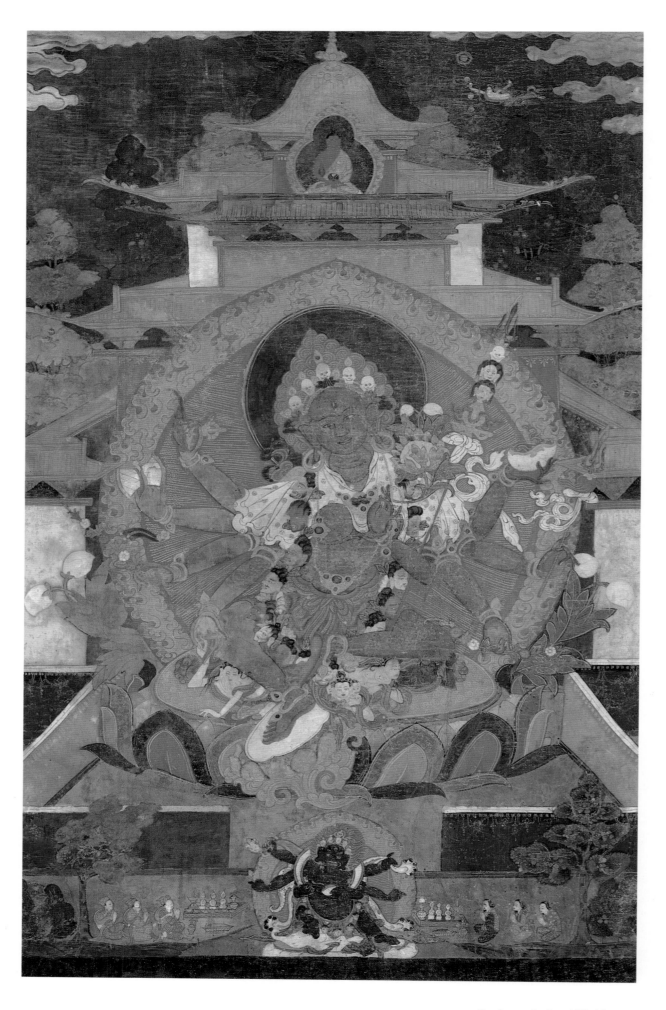

123
Eight-Armed Wrathful Form
of Green Tara

Eastern Tibet

17th century

Tangka; gouache on cotton

27 × 18″ (68.5 × 45.7 cm)

Robert Hatfield Ellsworth Private Collection

Lit.: Tucci, 1949, p. 539.

This sublimely beautiful painting, both peaceful and shocking, is of an apparently rare form of Green Tara, goddess of compassion, in her powerful, eight-armed emanation. She sits in the posture typical of Green Tara, with one leg pendant, the foot supported by a small lotus, and the other leg drawn up onto the large lotus seat, which is topped with a white moon disc. Her two main hands are also typical for Tara: her right hand makes the boon-granting gesture and her left hand holds a large yellow lotus with two white buds. Her other six arms hold familiar symbolic implements of power that are particularly decoratively and delicately fashioned. In her other right hands are a vajra chopper, a *damaru* drum, and a flowered arrow. In her other left hands there are a skull bowl, a trident, and a flowered bow. The trident-tipped *khatvanga* staff, festooned with a white silk ribbon below the tip, leans in the crook of her elbow. She wears some of the standard fierce deity ornaments—the five-skull crown and the garland of fifty freshly severed heads. Her hair, billowing lightly around her, is orange-red, and her lovely face is slightly wrinkled in a frown as she bares her tiny teeth. She wears a short white floral-printed, pink-lined silk blouse, which rises up over her breasts and falls loosely over her shoulders in light, rippling folds. Her tiger-skin skirt is tied with a gold-dotted red sash, and her gold and jewel ornaments are delicately plain but rich. The red henna decorating the

palms of her hands and the soles of her feet is a time-honored mark of beauty seen on the gods and goddesses of India. She sits comfortably on the supine bodies of the World Gods as a fiery arch of flames encompasses her radiant body halo and plain dark blue head halo.

Her lotus seat, composed of broad, simply delineated petals and framed on each side by two intertwined flower stems, each topped by a white bud, hovers in the courtyard before her palatial abode. The gateway is protected by a six-armed dark blue Mahakala. The donors kneel near their offering tables, under trees on either side in front of the entrance walls. The contemplative figure of her parent Buddha, Amitabha, sits in the topmost shrine of her multistoried, orange-, green-, and golden-roofed palace with its plain yellow, blue, and orange walls. Strangely wavy clouds float in from the corners, and there is a flying figure below the moon in the dark sky at the upper right. Several lofty, shadowy, dark blue and pale green trees at the sides of the palace suggest the forestlike nature of the peaceful setting.

The broad washes of subdued, deep, and also light colors create a mystical atmosphere—joyous, calm, and deeply satisfying. The subtle beauty of the form, dress, ornaments, and expression of the green-bodied Tara is the magnetic and brilliant center of the painting. The effects of a three-dimensional spatial setting created by the zigzag planes of the palace

walls, the slightly high view looking into the palace, and the soothing, symmetrical harmony of the judiciously balanced colors—all combine to entrance us and draw us into her realm. With charm and power she acts to destroy unwanted obstructions within the practitioner. The gentle yet powerful hand of the Great Compassionate One could be no more soothingly and gently administered. Her fierce medicine is made to seem sweet to the taste.

This is one of the most inspired of all paintings of this popular goddess, revealing the true genius of the Tibetan style in its later stages. It is successful in reflecting the truth of emptiness in the form of a deity who simultaneously seems completely in our world and completely of the purified realms. We can accept her as a real being who exists in our world, and we can also understand her relation to the perfection and power of the enlightened state. A comparison with such paintings as the Eleven-Faced Avalokiteshvara (No. 129) and Vajrasattva (No. 132) reveals the considerable difference between the earlier, strongly two-dimensional iconic style related to the Indo-Nepalese traditions and the later developments, mainly in the eastern schools of Tibet, of the spatial landscape as a natural setting for the deity. In this painting the simplicity of the planes and of the architectural and landscape elements suggests a dating probably in the first half of the 17th century.

124
Ushnishavijaya

Tibeto-Chinese

Late 17th to early 18th century

Gilt brass; cast in several parts, with chasing, cold gold paste, and pigments

H. 13½″ (34.2 cm)

The State Hermitage, Leningrad.
Prince Ukhtomsky Collection

Three-faced, ten-eyed, and eight-handed, Victorious Ushnisha—this is how her name is translated—is an emanation of Vairochana Buddha. She is one of the three longevity deities in the Tibetan Buddhist pantheon, along with Amitayus and White Tara. In this sculpture all the attributes of the goddess have been lost: a miniature Buddha image, a vajra cross, and an arrow that she would normally hold in her left hands, and a lasso, a bow, and a vase with the nectar of immortality that she would carry in her right hands.

Very little of the Ming style remains in this sculpture. The only link that connects the image with earlier Chinese lamaist sculptures is the row of lotus petals completely surrounding the throne, with no empty space at the back. However, a number of elements are sure signs of the Qing stage in the development of Tibetan-style art in China: a stiff design of the locks of her hair as they cover her shoulders, the ends of the shawl floating symmetrically to both sides of her waist, the simple design of the prongs of the crown, and the unelaborate jewelry ornamenting the goddess.

G. Leonov

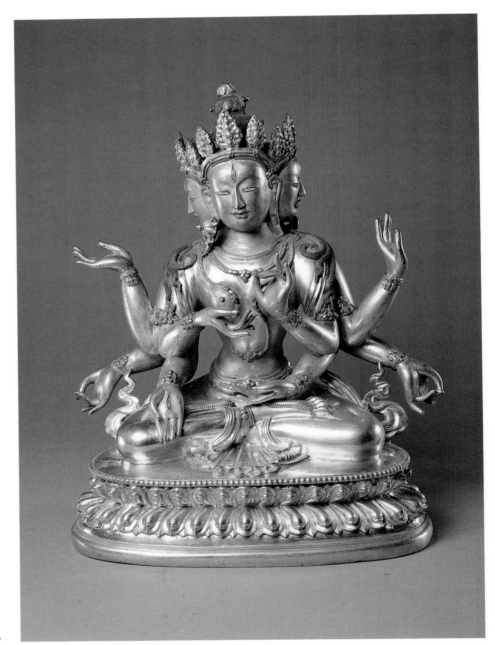

Ushnishasitatapattra

Eastern Tibet

First half of the 18th century

Tangka; gouache on cotton

30½ × 20½″ (77.5 × 52 cm)

The Zimmerman Family Collection

Lit.: Olson, 1974, p. 34.

Ushnishasitatapattra, the Goddess of the Victorious White Parasol, is a powerful independent deity. She manifests this power with her thousand faces, thousand arms, and thousand legs. Each face has three eyes, and the palm of each hand and the sole of each foot has its own eye. In this finely detailed painting, she displays them all in multiple rows, including a tall stack of heads in four different colors. Her impressive and awesome appearance is bolstered by her vigorous posture, emphasized by her wide billowing red and blue brocaded tentlike skirts and long, twisting, green scarves. Her slightly fierce mien does not outweigh the expressions of her lovely and benign nature—the beauty of her form, her white color, and the refinement of her small round face and tiny, idealized features.

Beneath the broad fan-shaped spread of her feet lie swarms of squirming bodies of the world's evil ones—demonic rulers, military men, and demigods—as well as dagger-spouting dragons, and flying rocks, bullets, and chains, all of which she keeps under control (125.1). All her left hands hold arrows and all her right hands hold the wheel of the Teaching. One of her left hands also holds her namesake, the staff of the white parasol of protection, seen silhouetted against the blue sky with many fluttering ribbons.

Ushnishasitatapattra is popular with the Geluk Order in particular. She is often given a prominent position among the wall paintings in Gelukpa monasteries, such as Drepung in Lhasa. The style of this painting favors an attribution to the Eastern Tibetan schools of painting. Its lovely green and blue coloring contrasts markedly with the strong orange-red and green that has been typical of the schools of the central regions since the second half of the 17th century.

Ushnishasitatapattra's entourage is large (thirty-eight deities) and powerful. Directly above her stacked heads is a cluster of sixteen seated Buddhas with an arch of flames above them. The Buddha at the very top of the central axis is

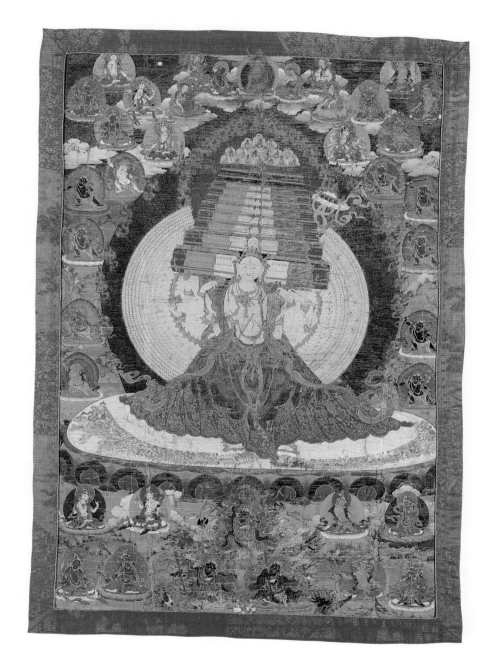

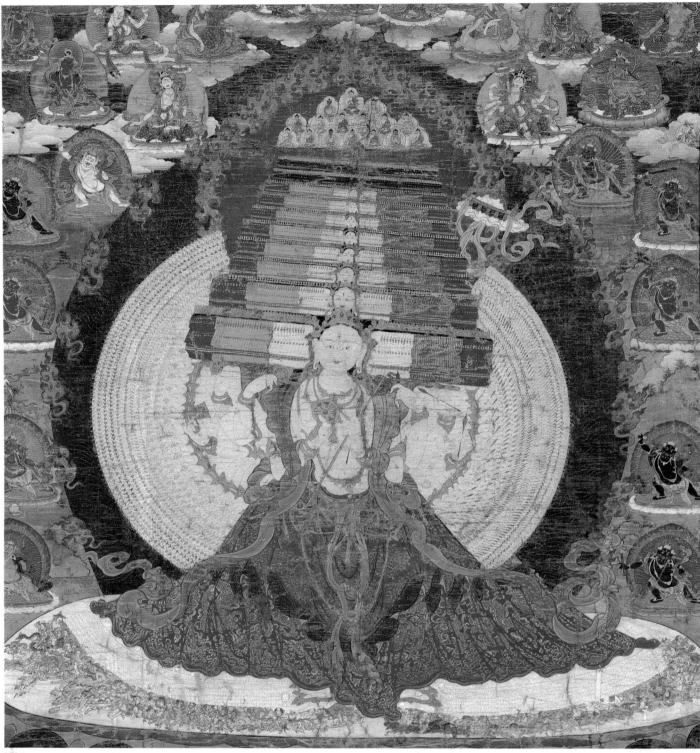

125.1

Shakyamuni, flanked by great philosophers, Great Adepts, and lamas of the Geluk Order. In the upper left corner are five female goddesses, including White Tara. At the upper right corner are five female deities, including Ushnishavijaya. On the sides are fierce protector deities, five on each side. Below, in the center, are three dark blue protectors in swirls of smoke and flames. Each is dressed in long robes, holds a *khatvanga* staff and a skull bowl, and tramples a prostrate body.

Groups of four fierce female deities in different colors sit in each corner. Parrots, crows, and other birds fly near the protectors and dot the landscape.

Delicate landscape elements create a naturalistic setting, but the profusion of deities and the dramatic beauty of the central figure focus our attention. The gold design in the main goddess's garments is exquisitely refined. The drawing of the tiny figures under her feet is done with incredible dexterity and precision. This

technical virtuosity with minute detail is a special feature of some painting styles during the period of the Sixth and Seventh Dalai Lamas around the late 17th to the first half of the 18th century, as can also be seen in tangkas Nos. 67 and 66. They all stress a style of perfected idealism that reaches its finest expression during the late 17th to the first half of the 18th century. The relative naturalism of this painting suggests a date near the turn of the 18th century.

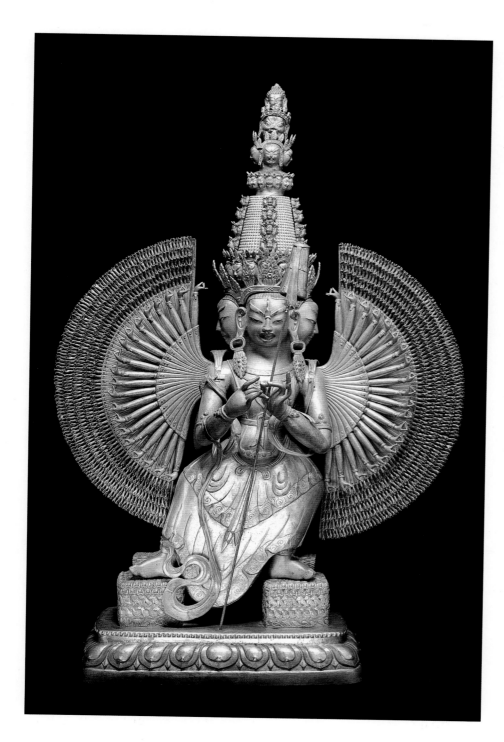

126
Ushnishasitatapattra

Tibeto-Chinese

Mid-18th century

Embossed brass, partly gilded; assembled
from several parts (hands cast separately),
with chasing and pigments, with turquoise,
coral, and smalt inlay

H. 40″ (102 cm)

The State Hermitage, Leningrad.
Prince Ukhtomsky Collection

Thousand-Armed Ushnishasitatapattra is a
special form of the goddess Tara, a female
counterpart of the thousand-armed form of
Avalokiteshvara. Her iconography is
probably one of the most complex in the
Tibetan Buddhist pantheon. The goddess
has as many heads and legs as she has
arms. She tramples on human beings,
birds, and animals. Pressed under her feet
into two cubes in this sculpture, they
symbolize egocentric existence. She holds a
victory banner in front of her chest in her
two main hands, although, according to
the iconographic canon, her main attribute
is an umbrella.

This sculpture has evidently been made
by a very skillful and experienced master.
He managed to execute each one of
Ushnishasitatapattra's thousand arms by
arranging them as a kind of six-tiered halo
surrounding the goddess. The thousand
heads and legs are rendered conventionally,
though over two hundred of the heads are
individually portrayed.

Sculptures of Ushnishasitatapattra, es-
pecially those of large size, are very rare in
Western collections. The difficulty of execu-
ting such a complex iconography in
sculpture may be one reason for the relative
scarcity of this icon in sculptural form.

G. Leonov

127

Eleven-Faced, Six-Armed Avalokiteshvara

Western Tibet; Kashmiri style

Mid-11th century

Brass, with copper and silver inlay

H. 15½″ (39.4 cm)

The Cleveland Museum of Art. Andrew R. and Martha Holden Jennings Fund. 75.100

Lit.: Klimberg-Salter, 1982, p. 105.

This image, which is a very powerful and popular form of Avalokiteshvara, the Bodhisattva of Compassion, is surely one of the most perfect and splendid sculptures of this deity in all Asian art. Certainly it is a rare surviving example of the Indo-Tibetan form, in which the faces are stacked like a pyramid. In this it is different from the prevailing East Asian style of presenting them in one row like a crown around the main head. These faces, marvelously portrayed with individuality, vigor, and sharp detail, reflect various aspects of this Bodhisattva. The main head and the two faces to either side are the peaceful Bodhisattva faces. The three in the next row are fierce and the three above, with gaping jaws and furrowed faces, are howlingly terrific. The single face above them is laughing, baring two rows of square teeth. The head of the Buddha Amitabha appears on the pinnacle. Each head, except that of the Buddha, has a small seated Amitabha Buddha in meditation on the front of its crown. Copper inlay appears on the lips of the main face, on the eyelids of the small heads, and on the tongues of the faces with open mouths. Silver is used for the eyes of the main face and for its *urna,* the hair curl between the eyes.

The figure of Avalokiteshvara is simply garbed in a thin cloth clasped by a single rosette ornament. A striped design in the fabric is indicated by delicately incised lines, while incised dots create a textural pattern of lines and geometric shapes. The cloth falls with a short drape over the left thigh, but nearly covers the right leg; its straight hem forms a stiff triangular point just above the ankle. A dotted antelope skin, suggestive of Avalokiteshvara's yogic activities, lies limply over his left shoulder, and a long double-stranded garland, clasped at intervals by rosette ornaments, passes around his shoulders and dips below his knees.

His top right hand originally probably held a wheel; the top left hand grasps a white lotus, beautifully portrayed here in full bloom. The middle right hand holds a rosary; the middle left hand should hold a bow and arrow, but they are lost. The lower right and left hands make the boon-granting gesture and hold a vase of the elixir of immortality, respectively. This image lacks the customary two hands in the prayer gesture (*anjali mudra*), held in front of his chest and clasping the wish-fulfilling jewel. The six-armed form of the Eleven-Faced Avalokiteshvara is rare; he is usually seen with eight arms, as in Nos. 34, 128, and 129.

This handsome figure, of tall and slender proportions, carries his remarkable array of heads with grace and composure. The slight sway of the stance, the smooth and sleek planes of the body, and the simple and restrained ornamentation and drapery all contribute to the impression of poised elegance. There is harmony and unity among the various parts, subtle modeling of the smoothly muscular torso, and skillful articulation of the individual heads, whose realistic volumes and fascinating details create an emphatic vitality. All of these elements, as well as the use of inlay, effectively produce a strong sense of naturalism in the image.

This style is directly related to the naturalism that flourished in the Kashmiri schools of sculpture from the 7th to the 10th centuries. The Kashmiri style played a major part in the Buddhist art of Western Tibet in the early decades of the period of the Second Transmission, especially from the late 10th to the 11th century, and this sculpture was probably made in Kashmir or in Western Tibet by a Kashmiri or Kashmiri-trained artist. The relatively unfinished back of the sculpture is typical of metal images made in Western Tibet. Three projections, one from the back of the head and one from the back of

each shoulder, are for securing a head and body halo, now lost. The back, and other parts of the image such as the lower right leg and the back of the ankle of the left leg, show clear evidence of patching, a practice frequently seen in Western Tibetan sculptures of this early period. Most of the patches are lost, but some still remain. These factors strongly suggest a Western Tibetan provenance.

Stylistically, this sculpture is closely related to the style of the wall paintings of ca. mid-11th century in the Dukhang at Alchi in Ladakh. Both have a similar degree of naturalistic modeling of the body, without the emphasis on tense musculature or abstractions of shape that appear slightly later in the style of the Alchi Sumtsek wall paintings of ca. the third quarter of the 11th century, and that are also seen in the wooden Buddha in No. 136. The Dukhang paintings and this Avalokiteshvara sculpture possess a quiet and gentle demeanor. In addition, there are numerous close parallels in certain details: the simple crown band with small-sized ornaments (Pal, 1982, D 14–18), the thin necklace, worn low, with a single simple fleur-de-lis type pendant (*ibid.,* D 25), the thin twisted strands of hair on the shoulders (*ibid.,* D 23, 25), earrings with a small pendant rather than the more usual big one (*ibid.,* D 24), the shape of the face, its long eyes, the sweeping slope of the eyebrows (*ibid.,* D 240), and so on. The hands, with attenuated sinuous fingers and long curved backs, are akin to the styles appearing in the wall paintings of both the Dukhang and Sumtsek. This masterful image clearly represents the splendid achievements in sculpture, just as the great cycles of wall paintings testify to the high accomplishments of painting during the 11th century in Western Tibet. Because of its size, spectacular beauty, and rarity, this work is a treasure of early Tibetan Kashmiri-style art.

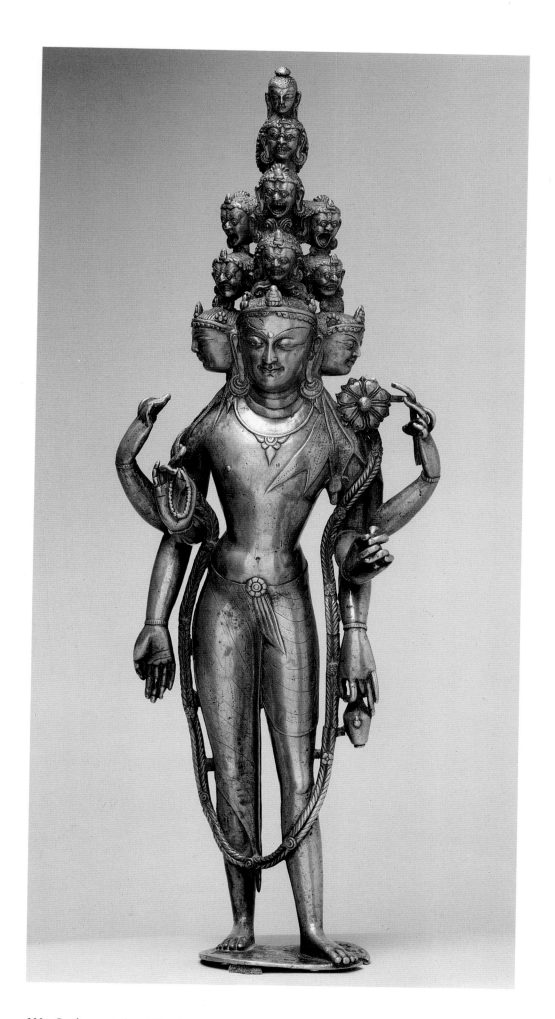

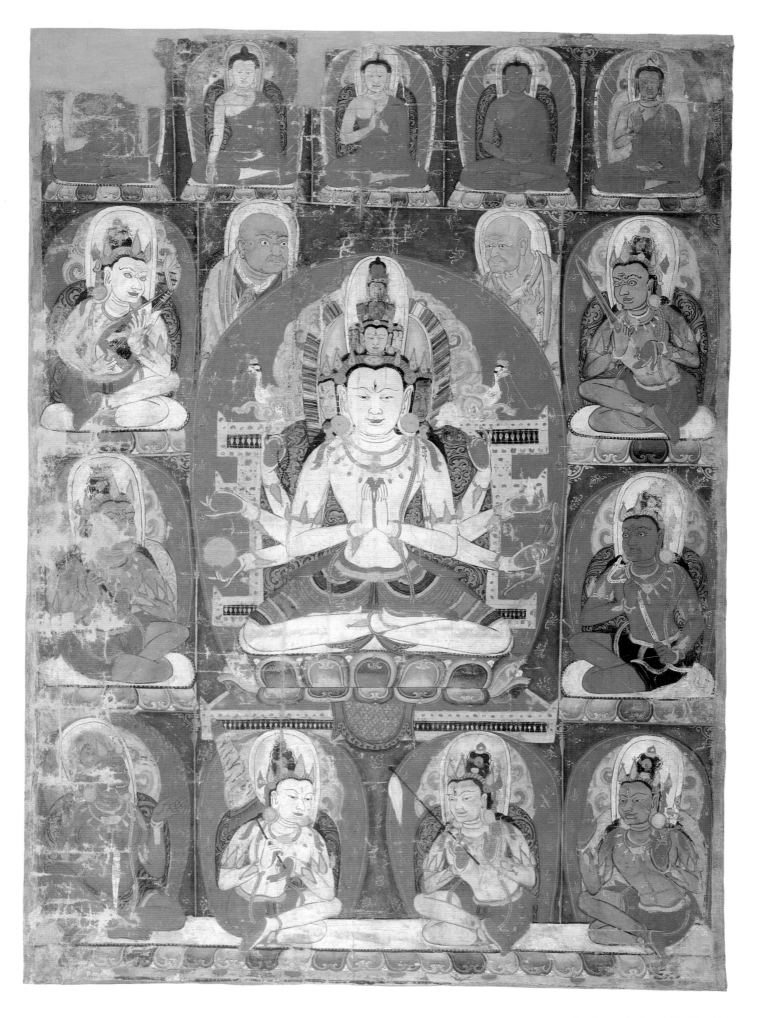

128
Eleven-Faced, Eight-Armed Avalokiteshvara

Khara Khoto, Central Asia

Before 1227

Tangka; gouache on cotton

52 × 37" (132 × 94 cm)

The State Hermitage, Leningrad

Lit.: Oldenburg, 1914; Béguin et al, 1977, no. 25.

This strong and vivid eleven-faced, eight-armed Avalokiteshvara sits in the diamond posture. His lotus throne has two rows of petals, and a small rug hangs off the front of the throne. A garment striped in blue, red, green, and gold covers his waist and thighs. His faces are arranged as a pyramid; there are three tiers with three faces each, and above them is a head with a terrific face. Crowning the whole pyramid is the red-faced, *ushnisha*-topped head of Amitabha. This image of Avalokiteshvara derives, as is well known, from chapter 24 of the Lotus Sutra. His two main hands are folded together in salutation, holding an almost invisible wish-fulfilling gem. His other right hands hold a rosary, make the boon-granting gesture, and hold a wheel of Dharma. His other left hands hold the stem of a white lotus, a vase of blessed water, and a bow and arrow. The iconography of the main deity as well as the form of the throne and the remaining personages derive from Indian and Nepalese traditions. The Five Transcendent Buddhas in the top row seem very Tibetan in style. The dark green background with flowers is often seen in icons from Khara Khoto (backgrounds may also be blue or red, but the flowers dispersed on them are identical). To the left and right behind Avalokiteshvara are two astonished-looking monks making the discerning gesture; possibly they are Ananda and Mahakashyapa (128.1).

Avalokiteshvara is surrounded by eight deities. The upper four, arranged symmetrically with two on each side, are Bodhisattva-like forms of the Four Heavenly Kings. To the upper left sits the white guardian of the east, Dhrtarashtra, with a lute. Under him green Vaishravana, lord of the north, is depicted holding a flag in his hands. Across from him on the upper right is the guardian of the south, blue Virudhaka, holding a sword in his hands (128.1). Below him is red Virupak-

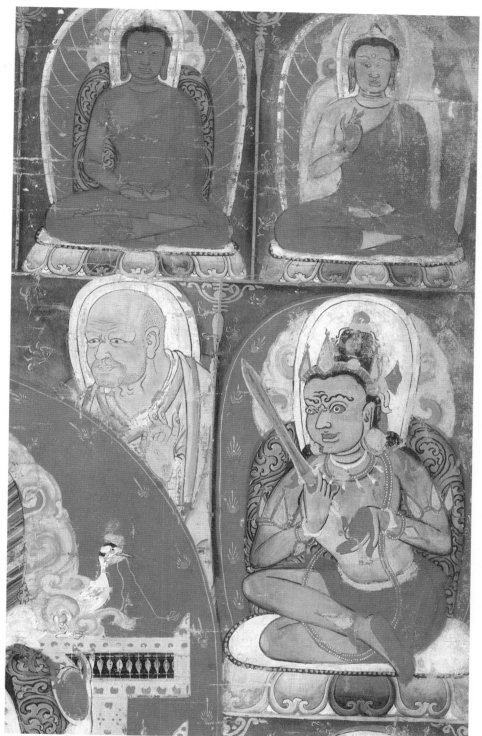

128.1

sha, guardian of the west, holding a white snake. The deities on the bottom row share a single lotus throne. On the left sits a red Hayagriva. Next to him sits white Sitatapattra with an umbrella in her hand, which, despite the name of the goddess, is not white but tiger-striped. Next there is yellow Marichi with a white fly whisk. At the bottom right sits Green Tara with a blue lotus. These four deities are clearly united in one group, but we are as yet unable to explain its meaning; some

evocations (*sadhanas*) of Avalokiteshvara include Hayagriva and Tara (de Mallman, 1975, pp. 107–10). Marichi may be the companion of Tara. However, the composition of this icon and its pantheon does not correspond to the one known evocation. The four guardians of the directions occupy places that do not match the cardinal points in the composition of the mandala, so the icon is not arranged on the principle of a mandala.

K. Samosyuk

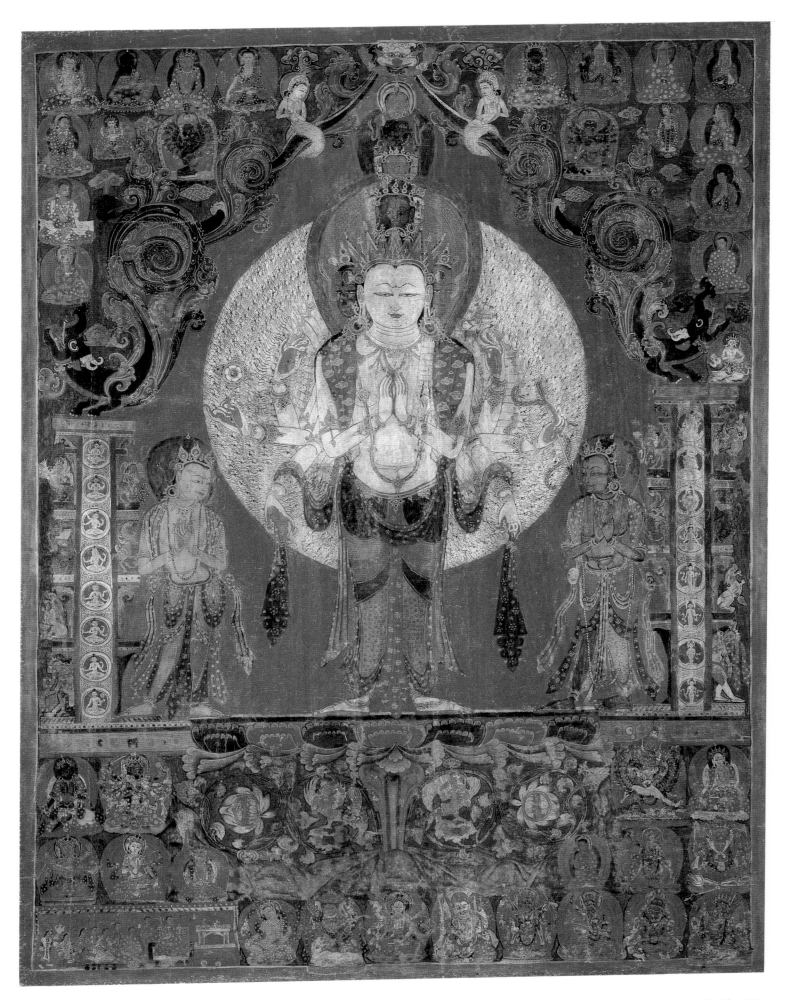

Eleven-Faced, Thousand-Armed Avalokiteshvara

Western Tibet; Guge

Second half of the 15th century

Tangka; gouache on cotton

38 × 28½" (96.5 × 72.4 cm)

Robert Hatfield Ellsworth Private Collection

Lit.: Tucci, 1949, pp. 361–63.

This supremely beautiful painting of the Bodhisattva of Compassion, Avalokiteshvara (Chenrezi to Tibetans), is one of the finest known in all Tibetan art. It portrays this incarnation of inconceivable mercy in his most powerful royal form, with eleven faces, one thousand eyes, and one thousand arms. He is saluted in a common Tibetan prayer as "The holy Avalokiteshvara, who has the thousand arms of the thousand universal monarchs, the thousand eyes of the thousand Buddhas of this good eon, and who manifests whatsoever is appropriate to tame whomsoever!"

The thousand arms extend his helping hands toward all beings. Each hand has an eye to see their sufferings in innumerable worlds. Ten of his faces indicate his attainment of the ten Bodhisattva stages, with the eleventh, the face of Amitabha, indicating his being the incarnation of the universal compassion of all Buddhas. The ten faces may also stand for his looking after beings throughout the ten directions of space, the eleventh face representing the all-encompassing Buddha wisdom. Texts relate that three of the heads are Bodhisattva heads, three are fierce, three are peaceful, one is a laughing head, and the final one is Avalokiteshvara's parent Buddha, Amitabha. Many texts and verses praise and expound on the qualities, nature, and activities of this sublime being, who is beloved by all Mahayana Buddhists, and considered by Tibetans the special protector of Tibet.

Avalokiteshvara stands frontally, forming the large pivotal axis of the painting. The array of arms resembles a large white halo encircling the gentle white body and contrasting with the dark red background of the shrine interior with its floral-scroll shadow patterning. The eight main arms hold the major symbols and perform the main gestures of the Bodhisattva. His right hands hold a rosary and a wheel of the Teaching, and make the boon-granting gesture. His left hands hold a white lotus, a bow and arrow, and a vase of elixir. In front of his heart his two hands are held in the prayer gesture, holding the wish-fulfilling gem. A red scarf with a white cloud design and a dark blue lining spreads around his shoulders and drapes in languid loops over his extended arms. A striped and patterned lower garment is held at the low waist by a golden girdle, and thin golden ornaments adorn his legs, chest, arms, and head. Over his left shoulder appear the delicate outlines of a white antelope skin, a reminder of the ascetic nature of this Bodhisattva. His face is peaceful and alert, gentle and serene; its full-moon shape is generous, beautiful, and radiant (129.1). His eyelids are lowered in an introspective gaze and a small third eye appears between his slightly furrowed, elegantly drawn eyebrows. His nose is long and thin, and his petal-shaped mouth makes a slight smile. A combination of power, beauty, calm, and wisdom pervades this face, which in its mildness completely welcomes the beholder.

Two attendants, one orange and one blue (129.2), half the size of the main figure, stand together with Avalokiteshvara, forming a triad within the spacious shrine. The relaxed and graceful, yet slightly awkward, postures of these two are in lively contrast to the steady central image. Beside them rise the pillars of the shrine. They are marvelously fashioned with a column of eight circles containing multiarmed figures—possibly other forms of Avalokiteshvara. On the projecting cornices are animals and beings from the celestial spheres. At each of the lower outer corners, a *yaksha* ogre leans against a pillar, grimacing as though lending all his strength to support the post. Dark blue *makara* sea monsters with red underbellies lift their gaping crocodile heads and unfurl their fancy filigree-feathered tails to create the archway of the shrine, which terminates in a "face of glory" (*kirtimukha*) at the apex. Near the top, two white dragon goddesses (Naginis)

129.1

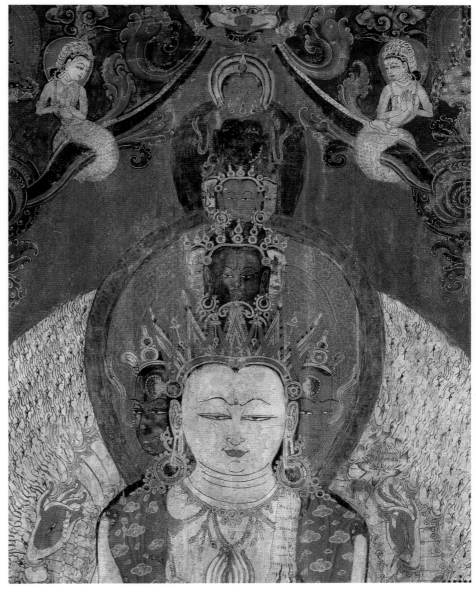

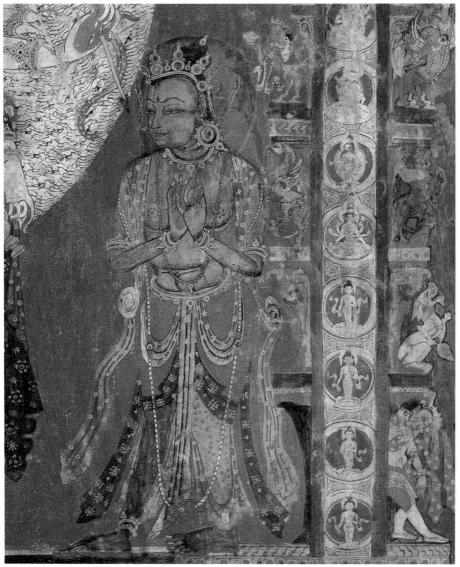

129.2

six-armed orange female deity, perhaps Mahapratisara, a two-armed white female deity, perhaps white Ushnishasitatapattra, Amitayus, a kneeling monk (or possibly a nun) with a halo, a Simhavaktra, and an orange Hayagriva; on the bottom row, after the donors and offerings, and Kubera and Vaishravana, there are: a White Ushnishavijaya, a four-armed Mahakala, a standing, six-armed Mahakala, a Penden Lhamo, a Lord of the Pavilion Mahakala, and a Yamaraja. Despite their small size, these figures in the lower area have a sparkling energy that, along with the other areas of the tangka, creates a flurry of small movements all around the painting. This movement contrasts with the static calmness of the white, pillarlike form of Avalokiteshvara, who remains the pivotal, stable center of the painting as well as of our samsaric world.

This tangka, originally part of the Tucci collection, is a rare Bodhisattva painting of the Guge renaissance group, dating around the second half of the 15th century. In style it is related to the wall paintings found in the Red and White Temples at Tsaparang in Western Tibet, though less manneristically developed than those of the White Temple, which dates into the first half of the 16th century. In color it utilizes the colors—dark red and blues, muted lavenders, bright orange, and pearl white—most typical of paintings from the early Guge renaissance period. The line is assured, a bit free and fanciful, yet firm and crisp. The drawing is related to styles known from the Nepalese drawing book of 1435 and from the Kumbum wall paintings at Gyantse of ca. the second quarter of the 15th century. There is little attention to space—only slight landscape elements, where the lotus pedestal springs from a mountainous area, possibly indicating Mount Potala, the mountain abode and Pure Land of Avalokiteshvara (129.3), also called the Potalaka (Haven) Paradise. The painting is nearly symmetrical and is formally organized. The dark and muted tones of color and the calm, even line create the dominant serious, deeply mystical mood, while the brilliant touches of white and orange, and the charming distortions of the postures and proportions of some figures enliven the scene and impart an earthy reality and delightful touch of humor to the painting. This is typical of the paintings of Western Tibet, in contrast to the joyfully heightened beauty engendered by the pale, bright colors and idealized landscapes and figures typical of the Eastern Tibetan style. It contrasts as well with the powerfully strong and rich styles of many schools of painting of the central regions.

wrap their thick, sinuous bodies around the arch and look adoringly at the Buddha face on top of Avalokiteshvara's pyramid of heads. Two archetype deities, Hevajra on the left and Shamvara (with Vajravarahi in the same unusual posture as seen in No. 69) on the right, immediately flank the shrine near the top. Auspicious symbols and clouds drift in the space around the arch. Tucked in near the sea monster at the right is a small Simhanada Avalokiteshvara on a snow lion.

In the upper left and right corners is a selection of deities and lamas. At the top of the central axis is the blue Vajradhara, the essence of all Buddhas. Interestingly, members of the Kagyu Order appear among the lamas on the left side (including Marpa, Milarepa, and Gampopa), and, on the top at the right, there are Gelukpa lamas (Tsong Khapa with book and sword, and two other lamas with yellow hats). Western Tibet had been strongly oriented to the Kagyu Order, but after the middle of the 15th century the area was assimi-

lating the Geluk Order; this painting seems to indicate a conscious, perhaps even a conciliatory, reference to both orders by the donors.

The lower area is clearly separated by the horizontal bottom of the shrine, which rests on the delicate, multicolored petals of the open lotus. Within the scrolling branches of the lotus are a male and a female Gandharva making salutations, and two open lotus flowers. In the lower left corner is a large group of donors, who are mostly female, and lamas making offerings (129.3). Immediately to the right along the bottom are the wealth and protector deities Kubera and Vaishravana. The remainder of the bottom area is devoted to exquisitely portrayed archetype and protector deities, painted in a minute, exacting manner with great verve and skill. From left to right across the painting they are (see 129.3, 129.4): on the upper row, Green Tara, Guhyasamaja, Yamantaka, and White Tara; on the middle row: an unidentified three-faced,

129.3

129.4

130
Tsa-tsa of the Eleven-Faced, Thousand-Armed Avalokiteshvara

Tibet

17th to 18th century

Clay

8½ × 6 × 1″ (21.6 × 15.2 × 2.5 cm)

Mr. and Mrs. John Gilmore Ford

Tsa-tsa are votive tablets made of clay. They are formed by pressing the clay into a mold that is carved with figures and inscriptions. They are commonly used by pilgrims as offerings at shrines. Stupas (*chötens*) and statues often contain large numbers of *tsa-tsa* as offerings. This unusually large example is a most extraordinary and rare work showing five images of the eleven-faced, thousand-armed Avalokiteshvara. This exceedingly complex image is handled with dexterity of detail in each of the five representations. They probably represent the Bodhisattva in the four cardinal directions and at the center, as encompassing all space. On the central axis above the Bodhisattva is Buddha Amitabha, the root Buddha of Avalokiteshvara, seated on a lion and lotus throne. Flanking the stupa below are two small deities: Manjushri, the Bodhisattva of Wisdom, with his sword and book, and Vajrapani, the remover of obstacles. Tibetan letters fill the spaces around all the figures, and a lotus pedestal supports the entire configuration. The whole cusped-arch rectangular shape is bordered by a raised rim, creating a protective frame, both of which are features seldom seen in the usual *tsa-tsa* representations.

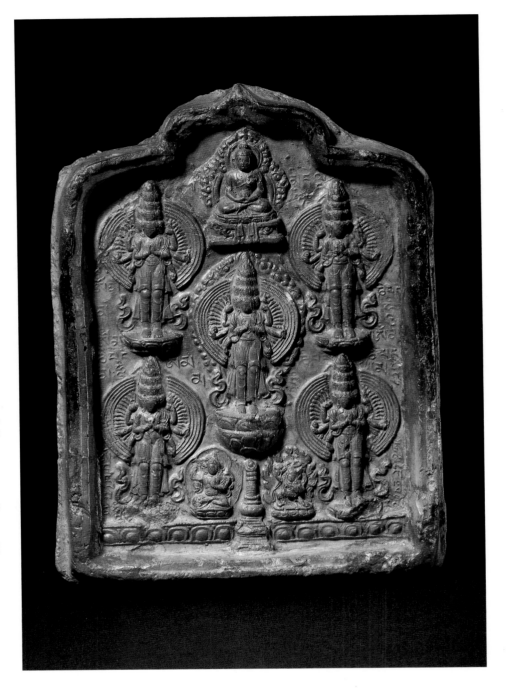

131
Vajrasattva

Western Tibet

First half of the 15th century

Brass; cast as one piece, with copper and silver inlay and jewel insets

H. 17⅞" (45 cm)

Collection of the Newark Museum, Newark, New Jersey. Purchase 1973. The Members' Fund and Membership Endowment Fund

Lit.: Reynolds et al, 1986, p. 96.

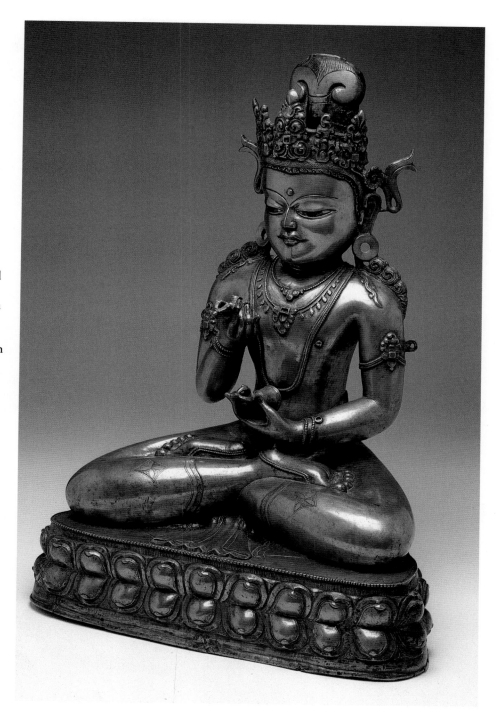

Vajrasattva is a tantric archetype deity. Like Manjushri, Avalokiteshvara, Tara, and the other celestial Bodhisattvas, he is a Buddha who persists in a Bodhisattva form to help beings on the path. *Sattva* means "spiritual hero or heroine," and *vajra* (diamond or thunderbolt) is associated with power and maleness. Vajrasattva might be considered a counterpart of Vajradhara, the quintessential tantric female Buddha form. They are connected with the vajra Buddha clan, associated with the Buddha Akshobhya, and with the ultimate-reality-perfection wisdom, developed from the transmutation of the poison of hate. Vajrasattva is the subject of many hymns and verses. He is supplicated in the special yoga of repentance that employs his special, well-known hundred-syllable mantra. He is usually blue in color and is generally represented seated, with a vajra held before his heart in his right hand and a bell in his left hand, which rests akimbo on the left thigh. The vajra and the bell are symbolic of compassion and wisdom, male and female, magic body and clear light, respectively, depending on the level of reference of the symbolism.

Vajrasattva's disproportionately large head and legs contrast with his rather narrow and short torso, creating a mildly strange, unrealistic effect that adds a mystical touch to the otherwise solid mass of the form. The jewels and hems of the garments provide a slightly decorative and colorful element. The heavy crown, the plain loops of his pulled-up hair, and the perforated disc earrings provide opposing textural elements as well as being rather uncommon in shape. The smooth planes of the lotus petals continue the play of light-reflecting surfaces so skillfully utilized throughout the sculpture.

The sculpture has a monumentality and a tough vigor similar to the colossal sculptures in the Kumbum at Gyantse in the central regions, dating ca. the second quarter of the 15th century, probably indicating a date of about that time (text fig. 18). With regard to provenance, however, certain elements, such as the distortions of proportion, suggest association with Western Tibet. Also, the smooth, curved hair loops on top of the head appear in the famous earlier image of the standing colossal Maitreya Bodhisattva carved in the cliff at Mulbek (between Kashmir and Ladakh), which at least suggests a precedent for this unusual motif in the Western Tibetan region. With its pristine condition and generous size, this sculpture of Vajrasattva is one of the most impressive and handsome Tibetan sculptures from the early 15th century in a Western collection.

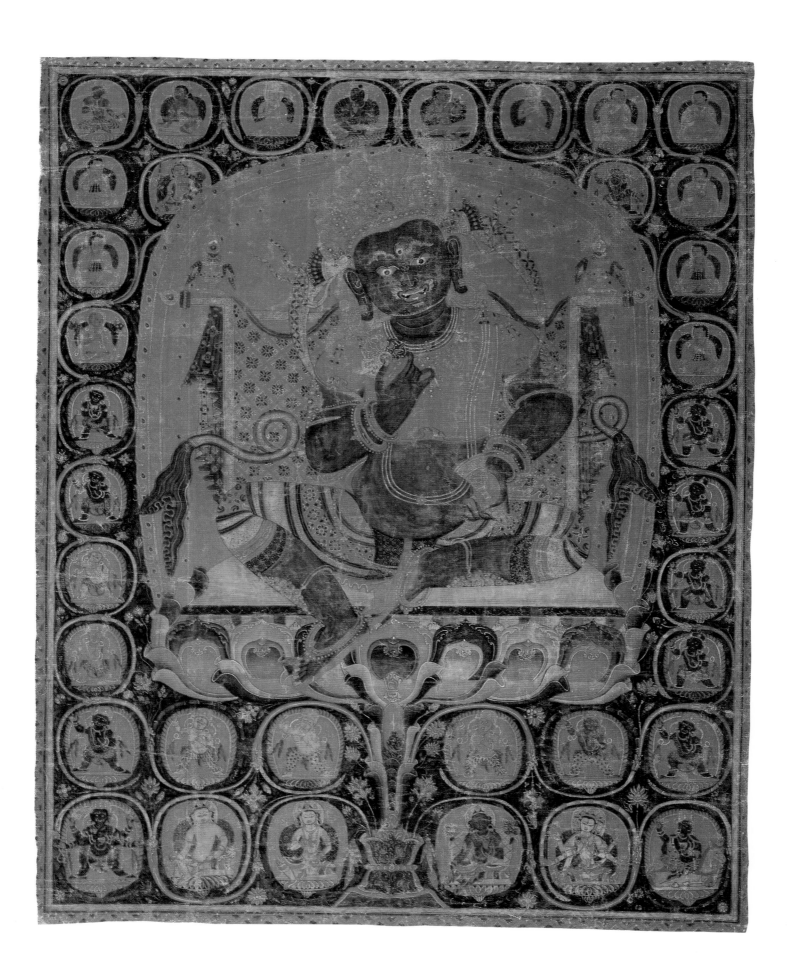

132

Vajrasattva (Wrathful Form)

Central Regions, Tibet

Second quarter of the 15th century

Tangka; gouache on cotton

22½ × 17½" (57.2 × 44.5 cm)

Robert Hatfield Ellsworth Private Collection

Lit.: Tucci, 1949, p. 584.

This tangka is a rare depiction of the fierce form of the Buddha or Bodhisattva Vajrasattva, here holding a vajra cross and a bell. Though the image is fierce and dark, the painting is most delightful, primarily because of the decorative beauty of the main figure and the sunny gold and orange colors, which are offset against the dark blue-black background. The subtle nuances of shading, especially as seen in the lotus petals, create a shimmering translucence. The orange-red of the garments and hair of the main image reverberate harmoniously against the darker red halo. Vajrasattva is positioned a bit high, imparting a slightly set-back impression, but the format is symmetrical, formal, and insistently two-dimensional, in the traditional Indo-Nepalese styles. The usage of the vine scroll to frame the separate deities associated with this form of Vajrasattva is an especially popular compositional configuration in tangkas of the 14th- to 16th-century period in both the central and western regions of Tibet. Here, however, the skillfully modulated shading of the vines, graded from pale blue-green to yellow and orange, and the extremely delicate flower sprays at each intersection are especially fine and distinct features. Equally superb is the varied and refined patterning of the textiles and the sparkling jewels on the main figure, whose eyes and teeth nevertheless outshine everything else (132.1).

At the center of the top are two Great Adepts flanked by two yellow-hatted lamas. In the upper corners are other la-mas without hats, and other Great Adepts. To the left and right, slightly behind Vajrasattva's large, plain red, flame-edged mandorla, are small figures of Manjushri and Vajrapani. Starting midway on each side and continuing along the upper row at the bottom of the painting are fourteen red, black, green, and white, fierce,

protective figures, ten male and four female. Tucci identifies the four females on the upper row at the bottom as forms of Parnashavari, a goddess propitiated to prevent epidemic diseases. On the bottom row, from left to right and separated in the middle by the stalk and base of the lotus, are a six-armed Mahakala, a wealth-deity Kubera, a peaceful white Vajrasattva, a Green Tara, an Ushnisha-vijaya, and a Penden Lhamo.

Several factors suggest a date around the second quarter or middle of the 15th century, and a provenance in the central regions, for this tangka. The style is especially close to some 15th-century

132.1

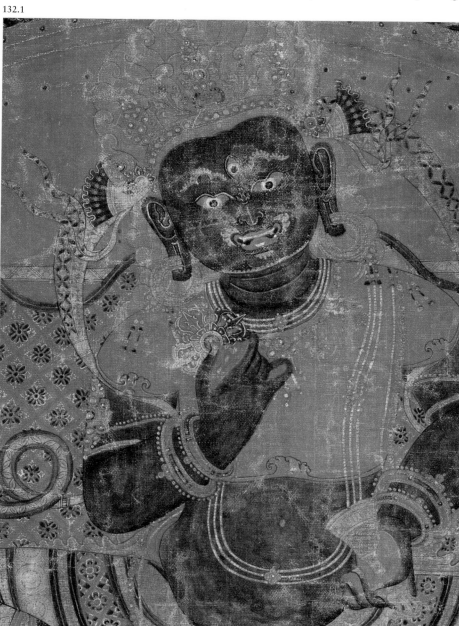

Nepalese paintings, in the highly stylized figures, and to the paintings from the Kumbum at Gyantse of the second quarter of the 15th century. Also, the rather simple format and the linear outlining of elements such as the lotus petals point to such a date. Although the delicacy and subtlety of the style may suggest a relation with the Guge school of Western Tibet in the mid-15th century, the figural style, the rich realism of the detail, and the specific style of the jewel ornamentation and floral decor appear to relate more closely to styles of the central regions. This is one of the most interesting and finely portrayed images of Vajrasattva in Tibetan painting.

XI.
Cosmic Buddhas

One of the titles of a Buddha is Tathagata, literally "one who has realized, or gone over into, suchness." Suchness (*tathata*) is the Buddhist term for the elusive, transcendent reality of all things. Thus, any thing, even one's fingertip before one's face, is not only what it seems to be. If it is investigated scientifically to the utmost degree, it simply dissolves under analysis: into skin and bones and blood and nerves, then into cells, then into molecules and atoms in empty spaces, and finally into quarks or other strange probabilities. A Buddha is one who has completed an inner scientific investigation even beyond the outer investigations of physicists and mathematicians. A Buddha has "gone beyond" and become transcendent to any world of appearance, and has also transcended any world of nothingness. So, from the ultimately immovable ground of transcendence, a Buddha can emerge in purified embodiments to reach out to beings and bring them into contact with their own realities.

In mystical Buddhism, a set of Five Transcendent Buddhas became popular over the centuries as symbolic of the purity of the five aggregates, the five elements, the five directions, the five colors, the five transmuted addictions, the five wisdoms, and the five Buddha clans. Akshobhya is the paradigm of the Dharma's ability to transmute all the hate of all beings into blue ultimate-reality-perfection wisdom; Vairochana transmutes delusion into white mirror wisdom; Ratnasambhava transmutes pride and avarice into yellow equality wisdom; Amitabha transmutes lust into red discriminating wisdom; and Amoghasiddhi transmutes envy into green all-accomplishing wisdom. The Medicine Buddha is a form that any Buddha can manifest by identifying with the Medicine Buddha in his Pure Land, and represents a Transcendent Buddha's ability to express himself as healing medicine for the benefit of ailing beings.

Four paintings represent the cosmic Buddhas in this part of the book, including two of the exceptional Khara Khoto tangkas: one of the Medicine Buddha (No. 133) and another of a Buddha, probably Shakyamuni at the moment of enlightenment (No. 135), seated in the diamond posture. This latter work is imbued with a tantric (Vajrayana) interpretation by the presence of the Five Transcendent Buddhas above Shakyamuni, and by the diamond vajra on the pedestal in front of the Buddha. Also, this representation could have

special meaning in the Khara Khoto context because it may also refer to the Avatamsaka (Garland) Sutra, which was popular at Khara Khoto during this period, as seen in many of the Chinese-style paintings from that site. It is said in the Mahayana tradition that Shakyamuni Buddha first preached the Avatamsaka Sutra after his enlightenment under the bodhi tree at Bodhgaya. It could be that this painting incorporates various aspects of Shakyamuni Buddha's enlightenment, including the interpretations of all three vehicles. The Medicine Buddha painting is particularly interesting for its depiction of a Black-Hat Karmapa Lama. This special hat is said to have been a visionary offering to the first Karmapa, Dusum Kyenpa (1110–1193), by the Dakinis at his moment of enlightenment when he was fifty years old (Thinley, 1980, p. 42). Probably the figure in this painting is the first Karmapa, which indicates a date for the painting after ca. 1160. Also, a disciple of the first Karmapa was invited by the Xi Xia king in 1159 and went to that kingdom that same year (see essay, "Tibetan Buddhist Art"). This confirms the presence of influential Karmapa lamas in the Xi Xia kingdom in the late 12th century. These Khara Khoto paintings provide important evidence of trends dating around the late 12th to early 13th centuries—before 1227 when the town was razed by the troops of Genghis Khan. They are also some of the most important paintings of the early Tibetan style, mainly associable with Tibetan painting of the Indo-Nepalese stylistic traditions from the central regions. (See text by K. Samosyuk below and at the end of the introduction to III. Bodhisattvas.)

The other two paintings are masterworks of their time and region. The monumental Amitayus in No. 145, from the flourishing period of the 15th century, is one of the few large tangkas in the West whose style is closely related to the elegant Kumbum wall paintings of the second quarter of the 15th century at Gyantse, in the Tsang region of Tibet. The Vajradhara in No. 148 dates from around the late 17th to early 18th centuries, probably from Eastern Tibet. It fully embodies the joyous, brilliant, and naturalistic qualities so frequently captured in the Eastern Tibetan schools of painting of that time.

In sculpture, which predominates in this part, there are two main groups represented. One is a group of sculptures dating

primarily from the 11th to 15th centuries, mostly associated with the Western Tibetan style. These offer in chronological sequence extraordinary examples of the Five Transcendent Buddhas, a Crowned Buddha (probably the Sambhogakaya form of Shakyamuni), and Vajradhara. The second group is a spectacular set of mid-18th-century Tibeto-Chinese sculptures from the Hermitage, comprising the inner circles of the mandala of the Medicine Buddha (No. 134). This extraordinary set of forty-nine pieces (one and a half pieces are missing), identified recently by G. Leonov, is the only currently known, virtually complete mandala in sculpture of this important Buddha in Western collections.

The preponderance of early art in this part reflects the particular popularity of the Five Transcendent Buddhas and the Medicine Buddha in the period around the 12th to the early 15th centuries in Tibet. The section closes with Vajradhara, the supreme essence of all Buddhas, as represented in two of the most beautiful examples known of this form, the ethereal gilt bronze sculpture from the collection of the Newark Museum and the gemlike painting in the Ellsworth collection.

M. Rhie and R. Thurman

The Khara Khoto materials in the Hermitage collection probably are the treasures of a monastery, buried in the famous *suburgan* (Mongolian for "stupa") discovered at Khara Khoto by Kozlov. It is difficult to say how fully the articles reflect Tangut culture. Buddhism was certainly one aspect of Tangut culture, but the governmental system, bureaucracy, and schools were modeled after the Chinese. In 1146 the cult of Confucius was officially brought to Xi Xia. Confucian works were translated into Tangut, examples of which can be seen in the collection of books in the Institute of Oriental Studies in Leningrad, and there are articles on Confucian representational art.

Two Buddhist *yanas* (vehicles) determined the nature of Tangut Buddhism: the Mahayana, which came from China, and the Vajrayana, which came from eastern India through Tibet. A Soviet researcher of the history of Central Asian culture, M. Vorobieva-Desiatovskaia, has come to the interesting conclusion that in East Turkestan (Central Asia) the logical-discursive level of Buddhism was entirely borrowed from India

without further development (Ph.D. dissertation synopsis, Leningrad, 1989). But the content of religious practice constantly changed, absorbing local beliefs and expanding the range of deities. For example, the Central Asian version of The Sutra of the Five Protections, which was one of the most popular in Tibet, has a pantheon of deities twice as large as in the original Pali version. There are more than thirty examples of this sutra in Tangut translations in the Hermitage collection of Khara Khoto books. The Central Asian origins of the Buddhanama Sutra, in which the names of the Buddha are praised, can be seen in several Khara Khoto works.

The deities appearing in the Tibetan stylistic group of icons show how the religion responded to the practical religious needs of Buddhist followers. The most popular of the Buddhas was the Buddha in *vajrasana,* the diamond posture; eleven works from the *suburgan* depict this Buddha, each with iconographic and compositional variations (No. 135). The next most popular was the Medicine Buddha, in five large tangkas (No. 133), followed by the teaching Buddha and the contemplative Buddha. Among the Bodhisattvas, eight tangkas depict Avalokiteshvara in three different iconographic forms (No. 128). Among the female deities, there is one tangka of Tara and three of Ushnishavijaya. However, the most prevalent among the female deities is Vajravarahi, with eight tangkas (No. 93). The most popular of the archetype deities is Chakrasamvara, who is depicted in nine tangkas (No. 92). Mahakala is the most popular of the Dharmapalas, the protectors of the Teaching, and Vaishravana is the favorite among the World Protectors. Interestingly, most of the icons in the "Chinese" part of the Khara Khoto collection are of Amitabha, Guanyin (Kuanyin, Avalokiteshvara), and planetary deities. These three most widespread cults show Tangut Buddhism to be a pragmatic religion serving the everyday needs of its believers. The practical role of Buddhism was interwoven with its role as a state ideology. A careful analysis shows the presence of several artistic schools within the Tibetan-style group of tangkas and identifies various artistic solutions. The proportions of the figures may be elongated or shortened and the manner of depicting eyebrows, ears, and drapery folds varies. The depictions of Buddha are executed according to Tibetan stylistic traditions.

K. Samosyuk

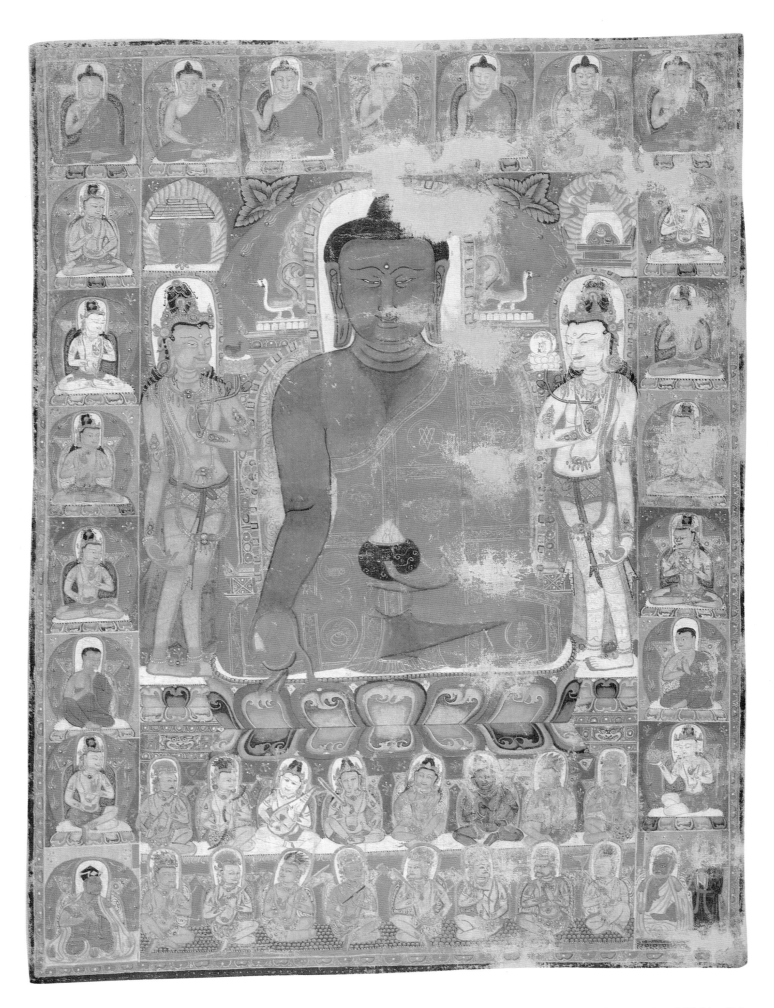

133

Bhaishajyaguru

Khara Khoto, Central Asia

Before 1227

Tangka; gouache on cotton

43⅜ × 23¼" (110 × 82 cm)

The State Hermitage, Leningrad

Lit.: Oldenburg, 1914; H. Karmay, 1975, pl. 7; Bèguin et al, 1977, p. 123.

133.1

Bhaishajyaguru, the Medicine Buddha, is depicted in traditional iconography wearing a bright red robe divided into squares of various sizes by wide brown bands decorated with gold floral ornamentation. This is a stylized depiction of monk's clothing, which, according to the rules of the first Buddhist communities in India, was to be sewn from pieces of old cloth. The Buddhist symbols of the Eight Lucky Emblems and a palace on Mount Meru, the cosmic mountain at the center of the universe, are depicted in fine gold lines within the squares.

In this icon Bhaishajyaguru's total retinue consists of thirty-nine figures. The central Buddha is one of a set of Eight Medicine Buddhas, and the other seven of the set occupy their usual places in the top row. The Bodhisattvas Suryaprabha and Chandraprabha stand on the right and left sides, respectively, of the principal Medicine Buddha. This is the only icon, of all the Khara Khoto icons of Bhaishajya-guru, in which these deities are placed this way in relation to the central figure. In addition to their color, the Bodhisattvas are identified here by their attributes, the traditional Chinese symbols of sun and moon: a red disc with a black, three-legged rooster, and a white disc with a hare preparing the elixir of immortality in a mortar. Above Suryaprabha is a table holding books, possibly sutras, and a pair of fly whisks. Above Chandraprabha is a stupa with the Three Jewels inside. Each is on a lotus pedestal and has a wide parallel-striped flame halo.

Eight Bodhisattvas are positioned in two vertical rows on the left and right edges of the icon, four in each row. The iconography of these deities is extremely vague and, in the present stage of study, cannot be identified with certainty. Below them, and third from the bottom in each of the side rows, are Buddhist monks wearing patched robes sewn with yellow stitches. Their robes are the same shade of brown as the borders of Bhaishajyaguru's

robe. Under them are two World Gods: four-faced Brahma to the right and Indra to the left.

Twelve *yakshas*, ogres, princes—or perhaps mythical medical *rishis*, Indian ascetic sages—and the Four Heavenly Kings are in the central part of the two bottom rows (133.1). The princes (or *rishis*) occupy all eight squares of the lower row and two of the side squares in the second row from the bottom. The remaining four squares in the middle of this row are occupied by the Four Heavenly Kings: white Dhrtarashtra holding a stringed instrument (east), blue Virudhaka holding a sword (south), red Virupaksha with a serpent (west), and green Vaishravana with a banner and a mongoose (north).

The depictions of the two lamas in the bottom corners of this icon are particularly interesting. Both are seated on cushioned thrones and each is haloed. In the left corner there is a lama wearing an orange vest with short sleeves, a brown patched inner robe with yellow stitching lines, and a yellow outer robe with a round medallion design (133.1). He has a mustache and a short, thin black beard framing his face, which has prominent cheekbones. He wears a black hat edged with a narrow band of yellow. On the front of the hat is a diamond-shaped yellow patch with a red vajra cross depict-ed on it. This is the hat of the Black-Hat

Karmapa, the patriarch of the Karmapas, a branch of the Kagyupas. Dusum Kyenpa (1110–1193), the first Black-Hat Karmapa Lama, may be the person represented here. The lama in the lower right corner is dressed in a brown coat with long sleeves, a white inner robe, and a yellow outer robe decorated with solid-color medallion shapes. He has a solid bluish-grey beard and holds a bell in his right hand. He appears to wear a yellow hat with short, pointed lappets. This lama cannot yet be identified; we can only surmise that he is somehow linked with the Karmapa Lama and/or the Indo-Tibetan medical traditions that flourished in the state of Xi Xia.

Behind this lama stands a man in a wide-sleeved black robe tied with a brown sash. His hands are folded in prayer in front of his chest. He has a black beard and straight black hair, both depicted with individual black lines. This image has been severely damaged—the entire layer of paint and much of the top and lower portion of the figure have been lost. However, his clothes suggest with a high degree of certainty that this is a Tangut layman, most likely the patron of this work. Noteworthy features of this icon are the ornamentation of the flaming gems on all the halos, the green trees above the Medicine Buddha, and the delicate red and white buds that fill in the free space around the depictions of the deities.

G. Leonov

134
Mandala of Bhaishajyaguru

Forty-nine of the fifty pieces of this mandala in the Hermitage collection are presented here. Not shown is U-1192, the one with a pedestal that lacks an image.

Tibeto-Chinese

Mid-18th century

Brass; some sculptures solid cast, others in several parts, with chasing, cold gold paste, and pigments

H. 5½ to 6¼″ (14 to 16 cm)

The State Hermitage, Leningrad. Prince Ukhtomsky Collection

It is quite likely that Prince Esper Ukhtomsky acquired these sculptures as an entire set. This is evident from Grünwedel's observation in the first description of the collection, published in 1905: "These bronzes make up a series of Buddhas, Bodhisattvas and other images surrounding a big central image, probably that of Shakyamuni" (Grünwedel, 1905, I, p. 82). At the same time, neither collector

Ukhtomsky nor Grünwedel realized that in fact this set was in fact the mandala of Bhaishajyaguru, the Medicine Buddha. If they did, this information would have found its place in Grünwedel's book. Later, during the many travels of the collection, these sculptures became scattered among the more than fifteen hundred Tibetan bronzes of the Hermitage (as witnessed by their different inventory

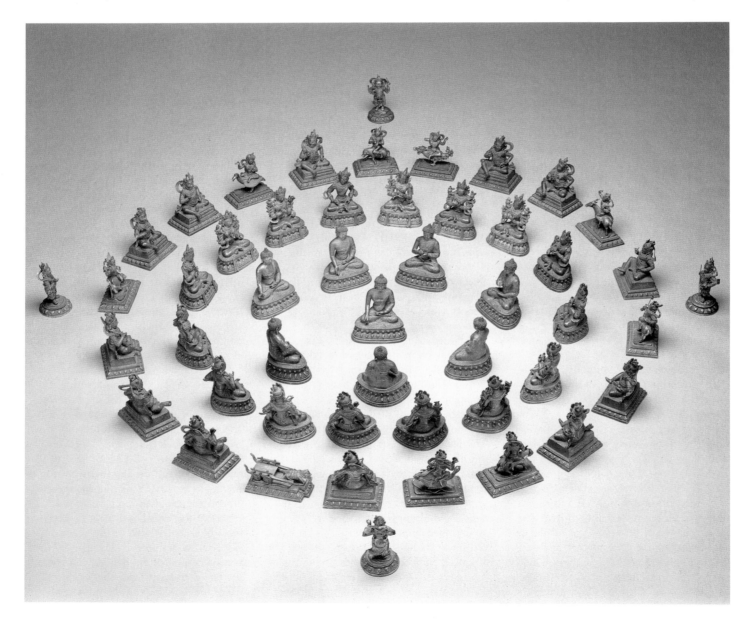

134.1

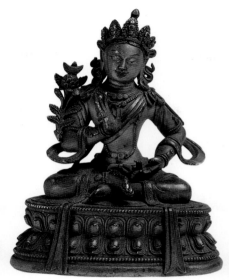

134.2

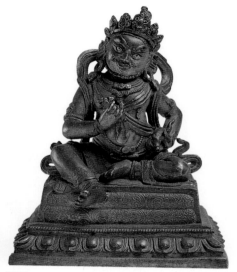

134.3

numbers), and the mandala "dissolved" into the collection. It was the evident similarity of the sculptures to each other that attracted attention and allowed them to be reassembled once again.

The date and the provenance of the images do not create any difficulties—they seem to be made by the same masters as the bronzes of the Baoxiang (Pao-hsiang) Lou pantheon. In addition, the Chinese origin of these images is confirmed by the presence of Chinese characters of numerical meaning cut on the bottom plates and on the lower edges of almost all the sculptures. The images form five iconographic groups: eight Buddhas, sixteen Bodhisattvas, twelve images of Jambhala, Ten World Gods sitting on different animals, and the Four Heavenly Kings.

Pieces of paper (in some cases, small fragments) with Chinese characters written in cursive script survive on the bottom plates of some sculptures. They read, for example, No. U-626, one of the Buddhas: "Number three, the third sculpture, starting from the west, behind the Buddha in the upper room" ("shang wu fo hoy si qi san cun san hao"); No. U-877, a Bodhisattva: "Number one, the first sculpture, starting from the east, in front of the Buddha in the middle room" ("shang wu fo hoy si qi yi cun yi hao"); and No. U-1195, a World God: "In front of the Buddha in the lower room" ("xia wu fo qian . . ."). Such inscriptions survived on only eleven sculptures, and it was impossible to reconstruct with only their information the system to which the entire fifty images originally belonged. On

the other hand, the mention of the points of the compass and of the three levels ("rooms") in the inscriptions made it clear that this system could only be a mandala. An attempt was made to determine the original order of the images with the help of the numbers cut on every sculpture. But nothing came of this, as these numbers did not coincide with the numbers on the paper labels. For example, one of the Buddhas (No. U-620), has "eight" (Ch. *ba*) cut on the lower edge and "two" (Ch. *er*) written in its label.

The original mandala was soon found, however. It was the Fifty-one-fold Bhaishajyaguru Mandala, the third one in the collection of 132 mandalas from the Sakya Ngor monastery (Vira and Chandra, 1967, part 13, no. 3). This set of mandalas is based on the collection of Tibetan ritual texts *Rgyud sde kun btus* ('Jam-dbyangs Blo-gter-dbang-po, ed., 1971, I, pp. 62–67). All the mandalas were reproduced as black-and-white drawings in this edition. Later, a full-color reproduction of the set was published (see Sonami and Tachikawa, 1983). On the whole, the Hermitage mandala coincides with both the tangka and the text almost completely.

The main deity of the mandala is Bhaishajyaguru, the Medicine Buddha. There are seven other Medicine Buddhas (134.1) and a four-armed Prajnyaparamita Goddess in the first circle (the "upper room"). There is no image of this goddess in the Hermitage collection at all and judging by Grünwedel's description it had not been bought by Ukhtomsky together with the other fifty images.

There are sixteen Bodhisattvas (134.2) in the second circle (the "middle room") and the Twelve Jambhalas, wealth deities (134.3), and the Ten World Gods (134.4) in the third circle (the "lower room"). The Four Heavenly Kings (134.5) occupy their places at the four gates of the mandala.

It turned out to be more difficult to deal with the individual iconography of the deities. The individual iconography of the Hermitage images does not coincide either with the text or with the tangka. The only exception is the group of the Four Heavenly Kings, whose iconography in the Hermitage sculptures is traditional, which allowed us to identify the four deities exactly.

The Twelve Jambhalas, as they are called, are an interesting group to examine. In *The Sutra of the Lord of Healing* (Beijing, 1936, Buddhist Scriptures Series, No. 1, p. 24), the Sanskrit names of these deities are: Kumbhira, Vajra, Mihira, Andhira, Majira, Shandira, Indra, Pajra, Makura, Sindura, Chatura, and Vikarala. (See also Birnbaum, 1989, p. 169.) The Tibetan names, as they are given in the evocation texts, do not seem to correspond exactly in all cases: "In the east, there are yellow Ji-'jigs [Jijig] with a vajra in his right hand, red rDo-rje [Dorje] with a sword, yellow rGyan-'dzin [Gyandzin] with a club. In the north, there are a light-blue gZa'-'dzin [Sadzin] with a club, red rLung-'dzin [Lungdzin] with a trident, smoky gNas-bcas [Neyjey] with a sword. In the west, there are red dBang-'dzin [Wangdzin] with a club, yellow bTud-'dzin [Tudzin] with a club, light red sMra-'dzin [Madzin] with an ax. In the south, there are yellow bSam-'dzin [Samdzin] with a rope, blue

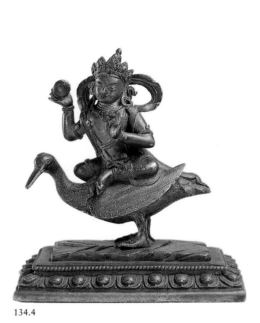

134.4

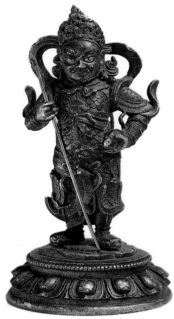

134.5

gYob-'dzin [Yobdzin] with a club, and red rDzogs-byed [Dzogjey] with a fighting discus. All these deities hold these implements in their right hands and a mongoose in their left hands."

All the Hermitage Jambhalas hold a mongoose in their left hands as well (134.3). As for their right hands, one Jambhala from the Hermitage mandala holds a vajra in his right hand (No. U-1158). So he is definitely Jijig. Six deities show the threatening gesture (the *tarjani mudra*) with their right hands, holding no implements. Four Jambhalas hold an object resembling the vajra handle of some attribute in their right hands. Two of these hands (Nos. U-1151, U-1155) have a small opening that can be used for inserting the upper part of an attribute into them. The last Jambhala (No. U-1148) holds his right hand at his breast with his palm turned upward and his fingers slightly bent. There is an opening in his palm for an implement.

A comparison of the iconography of the Ten World Gods with their images in the mandala is no less interesting (134.4). According to the text, in the east are yellow Tsangpa (Brahma), holding a wheel and sitting on a goose, and white Gyajin (Indra), holding a vajra and sitting on an elephant. In the southeast, there is a red Melha (Agni), holding a medicine cake and sitting on a goat. In the south, there is a blue Shinje (Yama), holding a mace and sitting on a buffalo. In the southwest, there is a dark red-black Sinpo (Rakshasa), holding a sword and sitting on a zombie (T. *rolang,* "risen corpse"). In the west,

there is a white Chulha (Varuna), holding a snake lasso and sitting on a sea monster. In the northwest, there is a smoky Lunglha (Vayu), holding a banner and sitting on a deer. In the north, there is a yellow Nöjin (Kubera or Yaksha), holding a mongoose and sitting on a horse. In the northeast, there is a white Wangden (Ishana), holding a trident and sitting on his bull, Nandi. Finally, in the west-southwest, there is a yellow Sailhamo (Prthividevi), holding a vase and sitting on a boar.

Only one of the Hermitage World Gods can be Brahma—No. U-1190. The four-faced god sits on a goose. According to the text, his implement is a wheel, but the Hermitage Brahma has no implements at all. One of the deities has been lost and its empty pedestal (No. U-1192) could belong to either Indra or Rakshasa. Anyway, one of these two deities is absent in the Hermitage mandala. No. U-1193 is Agni, who sits on a goat, holding what appears to be a vase with a spout instead of the usual medicine cake. Yama sits on a buffalo (No. U-1186), but holds a skull bowl instead of a mace. Varuna, as is said in the text, sits on a sea monster, his left hand empty and his right hand broken; he might easily have held a snake lasso in the broken hand. Vayu (No. U-1195) sits on a deer, and his hands are empty, while he should hold a banner. Besides a mongoose, the Hermitage Kubera (No. U-1189), who is sitting on a horse, holds a trident. No. U-1187 is probably Ishana. The deity in the Hermitage mandala sits on an unknown bird with a long flat beak. Whoever this deity may be, his implement

is not mentioned in the text: he holds a disc with the Chinese character *ri,* "the sun," cut into it. No. U-1191 is evidently Prthividevi. She sits on a pig with a vase in her left hand. The last sculpture in the Hermitage group of World Gods is a chariot with a horse (No. U-1195). It is unknown whether there was any deity in this chariot, but it cannot be Indra or Rakshasa. These various differences between the text and the Hermitage assemblage open the possibility that the sculptures originally represented the larger traditional group known as the Fifteen World Gods, which includes five more deities along with the above ten: Surya, the sun, who rides a horse-drawn chariot; Chandra, the moon; Vishnu, who rides a peacock and holds a discus; Ganesha, who rides a rat; and Vemachitra, who holds a sword and also rides a chariot.

The situation is the same with the eight Buddhas and the sixteen Bodhisattvas. Their descriptions in the text fail to help identify many of the images with certainty. The reason for all these differences is unclear. For the time being it can only be suggested that the Chinese masters who cast this set in the middle of the 18th century, probably under the supervision of the Jangkya Hutuktu, did not use the *Rgyud sde kun btus* text. It is possible that a Gelukpa text was used as the source for the iconography of the deities. Both the Fifth Dalai Lama and his regent, Desi Sanjay Gyatso, wrote about this mandala, and developed various modified arrangements.

G. Leonov

135

Shakyamuni Buddha in Vajrasana

Khara Khoto, Central Asia

Before 1227

Tangka; gouache on cotton

31½ × 20⅝″ (80 × 52.5 cm)

The State Hermitage, Leningrad

Lit.: Oldenburg, 1914, no. 1, pp. 96–97.

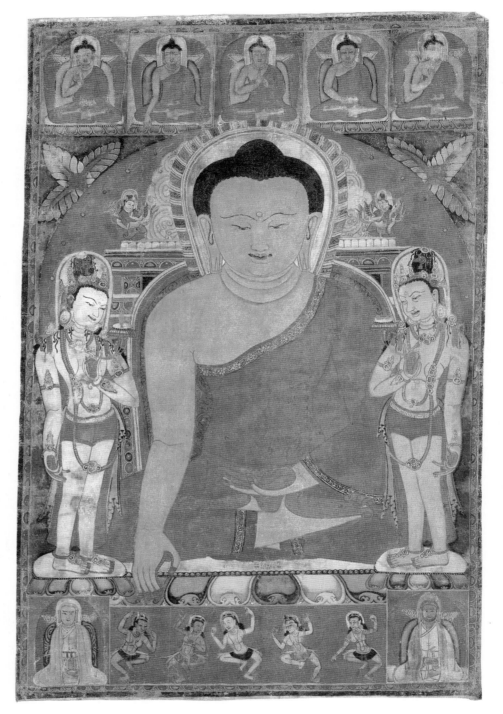

This icon depicts fifteen figures, represented in four iconographic groups. The central deity is most probably Shakyamuni Buddha, seated in the diamond posture, making the earth-witness gesture with his right hand, and holding his left hand flat on his lap in the contemplation gesture. The *ushnisha* protrusion of the Buddha is not topped by a red jewel (the layer of paint may have worn off), although the *ushnishas* of the five Tathagatas in the top row have such marks. The Buddha's robe is of one piece, not a monk's patched robe. It is edged with floral ornamentation (135.1). There are no wheel marks on the palms and feet of the Buddha. The Tathagata in the center of the top row is Vairochana, the paradigm Buddha of the Avatamsaka (Garland) Sutra. This recalls the tradition that Shakyamuni taught this sutra non-verbally to the gods and Bodhisattvas at Bodhgaya, during the time immediately after his supreme enlightenment, while manifesting himself as Vairochana.

On the Buddha's right side is the Bodhisattva Maitreya, holding his right hand down in the boon-granting gesture, and holding in his left hand the stem of a small white lotus that floats at his shoulder, with a tiny golden vase resting on it. On the Buddha's left side is a standing golden Bodhisattva, his left hand empty in the boon-granting gesture, and his right holding the stem of a white lotus floating over his shoulder, on which lies a small, golden vajra scepter (135.1). He may be a form of Avalokiteshvara (or else Vajrapani, or even Samantabhadra, the paradigm Bodhisattva of the Avatamsaka). Avalokiteshvara and Maitreya here do not differ overall from the forms of these Bodhisattvas in other icons from Khara Khoto. The only difference is Avalokiteshvara's implement. Here a golden vajra lies on the white lotus blossom, an unusual implement for Avalokiteshvara. The golden vase on Maitreya's lotus blossom is the standard symbol of this Bodhisattva (135.1). Half-bird half-human Gandharvas stand in symmetrical poses on either side of Buddha's head on

the upper crosspiece of the throne back. In the corners of the central portion of the icon, two green three-leaf plants with red cores are depicted.

There are five Tathagatas in the top row, the Five Transcendent Buddhas (135.1). They are all yellow and differ from one another only in the position of their hands. Their throne backs are alternately green and blue. Here the Buddhas are clearly identifiable, moving from left to right: the first Buddha holds his right hand at his chest making the fear-not gesture, and is Amoghasiddhi, the Tathagata of the north; the second is clearly Akshobhya, the Tathagata of the east, with his right hand

in the earth-witness gesture and his left hand in the contemplation gesture; the third, and the central Buddha in this tangka, is Vairochana, the Tathagata of the center, with both hands at his chest in the unity gesture (*vajra-jnyana mudra*), his right index finger raised, his left hand closed in a fist; next is Amitabha, the Tathagata of the west, with both hands in the contemplation gesture; and the last Buddha must be Ratnasambhava, the Tathagata of the south, with his right hand at his chest, palm inward, possibly a variant of the discerning gesture.

Five dancing goddesses are depicted in the lower row. All of them are without

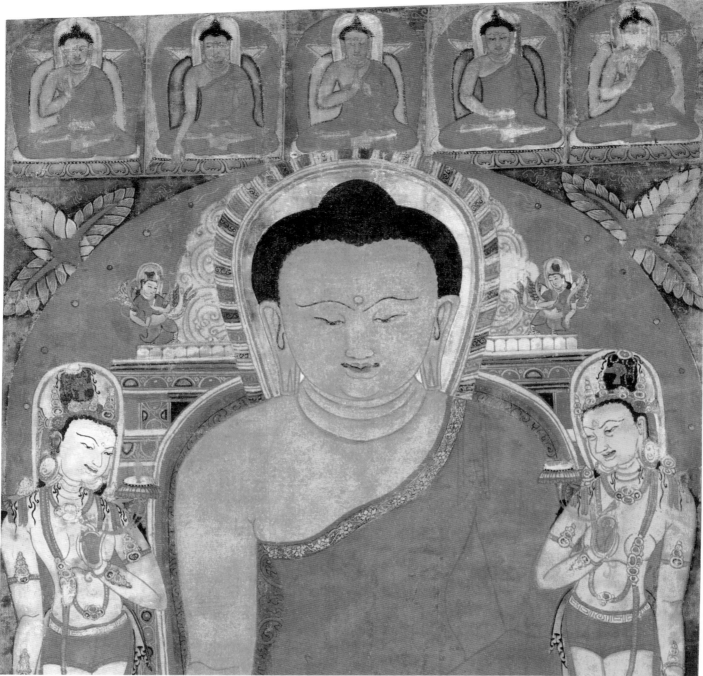

135.1

implements, their hands are held naturally, and their poses are symmetrical. It has not been possible to determine their names. They may be the five female Tathagatas: green Tara, red Pandara, yellow Vajradhatvishvari, white Lochana, and blue Mamaki, who are sometimes the consorts of Amoghasiddhi, Amitabha, Ratnasambhava, Vairochana, and Akshobhya, respectively. However, the placement of the goddesses does not correspond to the placement of the five Tathagatas, and their postures lack the dignity usually associated with the female Buddhas. Considering the absence of precise iconographic signs, the five goddesses might represent any group of

female deities, even five Earth goddesses, or possibly even the daughters of Mara. Oldenburg noted that "the exact same figures" are depicted on the fresco from the Turfan oasis. He refers to the fresco from the Tibetan caves of Turfan, which were brought to the USSR by Oldenburg's first Russian-Turkestan expedition and are now preserved in the Hermitage. The fresco portrays the daughters of Mara, who are tempting Shakyamuni Buddha with their dances at the moment he experiences enlightenment.

Two lamas are depicted in the bottom corners of the icon. Both depictions are extremely loose, nearly devoid of individual characteristics, and icono-

graphically vague. But it is clear that the artist tried to emphasize the difference between them. This was achieved primarily by alternating colors: dark greyish inner clothing and a yellow robe for one, and yellow inner clothing and a greyish blue robe on the other; light hair and dark hair; light face and dark face; a small dark grey mustache and beard on one lama and a large beard covering the entire face of the other. It is unlikely that these depictions are linked to any particular personages. By emphasizing these differences the artist was probably trying to indicate the continuity that linked the Tangut Vajrayana to India and Tibet.

G. Leonov

136
Seated Buddha

Western Tibet

Third quarter of the 11th century

Wood, with gold and pigments

H. 21½" (54.6 cm)

The Cleveland Museum of Art. Andrew R. and Martha Holden Jennings Fund. 86.6

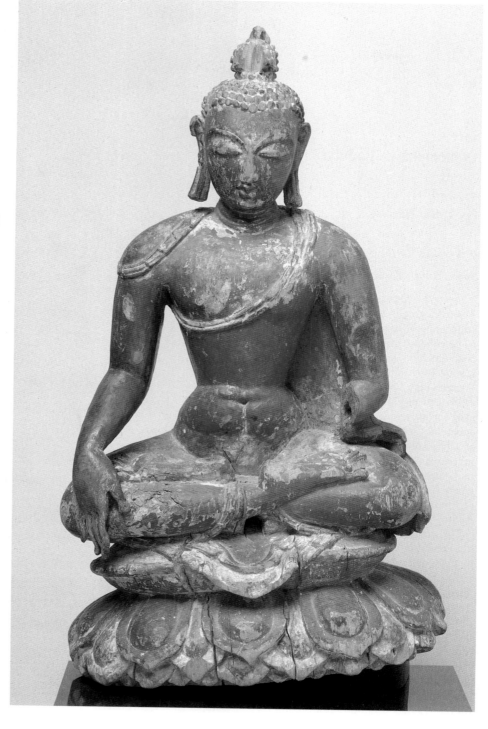

This Buddha, carved in wood and retaining much of its original pigment, is a spectacular sculpture from the early period of Buddhist art in Western Tibet; possibly it comes from Ladakh. The Buddha is tensely alert, seated in the diamond posture. His right hand is placed over his knee in the earth-witness gesture. Such a gesture usually connotes either the historical Buddha Shakyamuni at the time of his enlightenment (see No. 2) or the esoteric Tathagata Akshobhya, one of the Five Transcendent Buddhas (see No. 138). Only the tips of some fingers have been slightly restored in this graceful hand. The left hand, now missing, would have been in the contemplation gesture. The figure appears animated and vigorous, but his visage is introspective and calm. The shape of the body is youthfully strong, with wide shoulders, narrow waist, strong abdominal muscles, and well-shaped limbs. Inner strength seems to activate every part of the body, even though he is seated in a motionless, centrally controlled, rigid posture.

The sculpture is carved in the round, but the back is fairly flat and summarily carved, except for the head. Presumably it was originally intended to be set against a halo or wall. There are two small, square holes in the back for the purpose of attaching it to its backing. Crimson paint covers much of the surface of the Buddha's robe and appears on the lotus petals alternating with petals that apparently were once covered in gold. Gold seems also to have covered the face and chest of the Buddha, but little trace of it remains. Touches of white gesso underpainting still appear in places. Black lines once outlined the eyes, and were used for the eyebrows as well as for the hair, but these are barely visible now.

The style is compatible with that of wall paintings in the Sumtsek dating ca. the third quarter of the 11th century, at Alchi in Ladakh (see essay, "Tibetan Buddhist Art"). It is nearly identical in style to the Buddha in the depiction of the paradise of Ratnasambhava on the back wall of the second floor of the Sumtsek (Pal, 1982, S73), including the lotus seat with its pointed broad petals. The tension of the shapes, the stress on energetic curves and contours, and the balanced exaggeration of expanding and contracting masses seen in this sculpture characterize the style of the Sumtsek wall paintings as well. Details such as the double-rolled hem punctuated by folded pleats at regular intervals appear in many Buddha figures of the Sumtsek (*ibid.*, S19, 24, 26, 73). Also, the startlingly straight contours of the rib cage and the bulging muscular abdomen (*ibid.*, S18), the oval face with puffed-out cheeks, pursed mouth, long thin nose, widow's-peak hairline, and tiny round chin (*ibid.*, S37, 38, 63) are prevalent features in the Sumtsek figures.

Few wooden sculptures survive from Tibet, Nepal, or India from this period, although there was considerable wood decor in the temples of these regions and wood had always been a highly favored medium for religious icons. The scarcity of wooden images and the relatively intact condition of this statue, which retains much of its original paint, ensure its importance. Its radiant life and youthful vitality make this sculpture a particularly inspiring work from the early years of Buddhism in Western Tibet.

137
Contemplative Buddha

Western Tibet

Late 11th to 12th century

Brass, with silver and copper inlay

H. 12″ (30.5 cm)

Robert Hatfield Ellsworth Private Collection

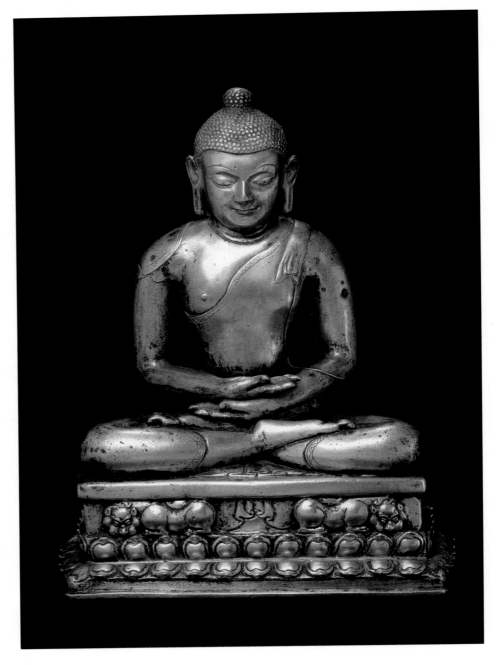

The iconography of this important early sculpture is debatable, but it would appear to be either Amitabha or Shakyamuni. The contemplation gesture is the distinguishing gesture for Amitabha, Buddha of the Western Pure Land and one of the Five Transcendent Buddhas. It is also commonly used for images of Shakyamuni, although apparently seldom seen in early Tibetan art. The lions in the pedestal generally indicate Shakyamuni, but there are also rare cases in the art of this early period where they appear in the pedestals of Amitayus (at Tabo), another form of Amitabha.

This sculpture, which has only recently become known, has some elements related to styles of both Kashmir and the central regions of Tibet, the latter mainly known through painting. For example, the long, straight shape of the legs is comparable to forms seen in some 12th-century tangkas from the central regions of Tibet, but features such as the tall dome of the cranium, the small size of the *ushnisha,* and the high and stiff positioning of the hands are more clearly related to some Kashmiri bronzes (Zwalf, 1985, no. 137), a major source of Western Tibetan sculpture. Also, the large, straight-lidded eyes inlaid with silver and the gently smiling mouth inlaid with copper are typical ingredients of the Western Tibetan style inherited from Kashmiri sources.

The rectangular pedestal, which is beautifully fashioned and complements the smooth, plain surfaces of the seated Buddha, seems to reflect the type commonly seen in tangkas of the central regions of Tibet of the 12th to 13th centuries; but there are distinctive differences in detail. Two crouching lions with small ears and lumpy bodies flank the central cloth overhang, a feature common to the central regional style. Two rows of smooth, small, and delicately swelling lotus petals decorate the rectangular levels between the plain lower and upper slabs, the upper "cushion" slab being a common motif in Kashmiri sculpture and also occurring in Western Tibetan examples. Typical of Western Tibetan statues in this early period are the plain back of the statue, lacking any definition of the pedestal or of the Buddha's robe, and the appearance of patching (occurring in the upper part of the Buddha's back).

Western Tibetan characteristics appear to dominate in this sculpture, including the somewhat awkward stiffness and the emphasis on a proportionately large head, which does, however, impart a warmly human essence to the sculpture, as is typical of the Western Tibetan style. The clear presence of some stylistic elements characteristic of the art of the central regions suggests that this work was made in Western Tibet during a period when some artistic influences were received from the central regions, while the relation with Kashmiri styles continued. A comparison with the Shakyamuni Buddha in No. 2, possibly of a comparable time and regional attribution, reveals the greater sophistication of the latter and its closer stylistic relation to the Pala Indian lineages. Nevertheless, this contemplative Buddha, probably from around 1100, has a genuine beauty in its innocence, and gentleness. It is an important sculpture for understanding the range and various complex aspects of the art of the early periods of the Second Transmission of Buddhism to Tibet.

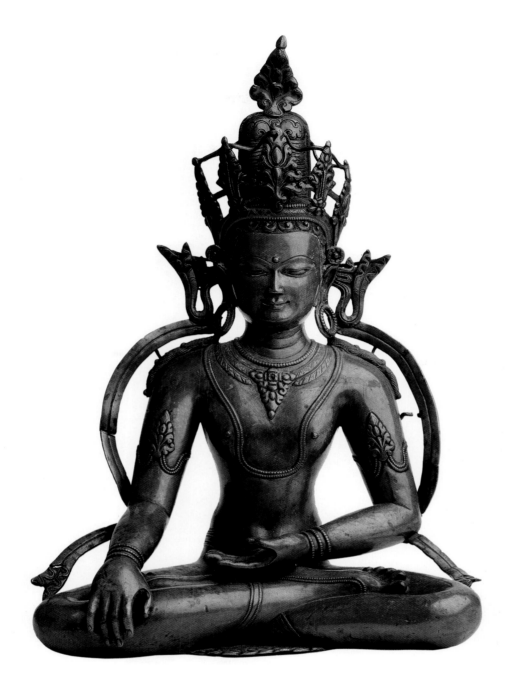

138

Akshobhya

Western Tibet or Central Regions, Tibet

13th century

Brass, with pigment and silver inlay

H. 16½″ (42 cm)

Robert Hatfield Ellsworth Private Collection

Akshobhya is one of the Five Transcendent Buddhas, the group of Cosmic Buddhas (sometimes referred to as Dhyani Buddhas, following Lama Govinda's, Getty's, and Bhattacharya's terminology). When represented in a mandala of a deity who is related to his clan, he is shown in the center. However, in the Action, Performance, and Yoga tantra mandalas where the Five Tathagatas first appear, most often he is represented in the eastern quarter, with Vairochana in the center. His color is blue and his clan is that of the vajra. As one of the five, he helps in overcoming the affliction of anger, one of the most potent obstructions to enlightenment and a dangerous affliction of human beings. He represents the transformation of anger into absolute perfection wisdom. Akshobhya is also the parent Buddha of such important

tantric manifestations as Hevajra. As cosmic, rather than historical Buddhas, these five are often depicted not in the robes of a Buddha, but with crown and jewel ornaments, like Bodhisattvas. Akshobhya is customarily depicted seated, with his right hand in the earth-witness gesture and his left hand in his lap.

This sculpture, as well as Nos. 139, 140, 142, and 143, belongs to a stylistic group generally associated with Western Tibet dating from ca. the 13th to the 15th century (von Schroeder, 1981, pp. 156–93). It is one of the most elegant, sophisticated, and refined of all the examples of this style, probably dating to the 13th century, before the heavier elaboration appears in the 14th century. Many elements of the figure, such as the subtle modeling of the slender torso, the

wide shoulders, the slim, rounded arms, and the long, smooth legs relate to figures in the famous paintings from the central regions of ca. late 12th to early 13th century, which also strongly suggests a provenance in the central regions. However, the brass and the technique of using struts to secure the crown and the encircling thin scarf are, as far as we know, more typical of Western Tibetan manufacture. The round, sweetly smiling face with fine lines and naturalistic modeling shows some relation to the style of the Shakyamuni Buddha in No. 2, also probably from Western Tibet. The eyes are inlaid with silver, and some red pigment remains in the necklaces, crown, and hair ornaments. It is certainly one of the largest and finest of the early Tibetan Buddha sculptures.

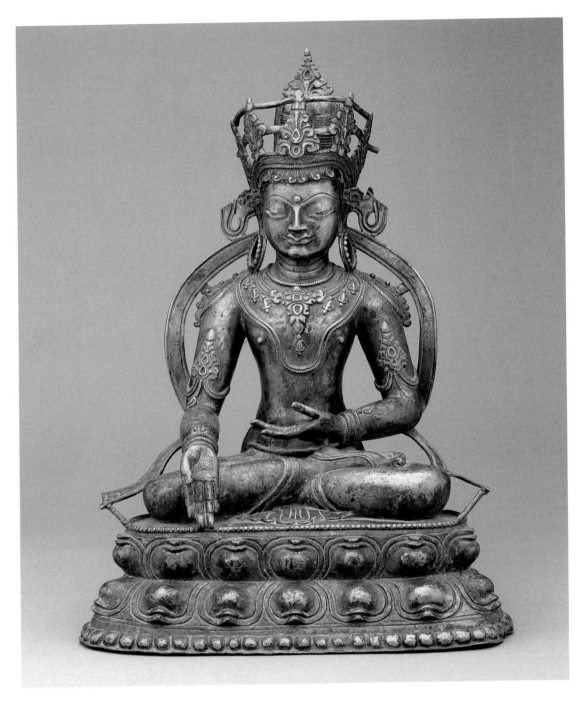

139

Ratnasambhava

Western Tibet

Late 12th to early 13th century

Brass, with pigments and jewels (missing)

H. 14" (35.5 cm)

The Zimmerman Family Collection

Ratnasambhava is one of the Five Transcendent Buddhas. He is associated with the southern direction and with the addictions of pride and avarice, which he helps the practitioner to transform into the wisdom of equanimity. His color is yellow and his clan is the jewel. Like the other Buddhas of this group, he is usually shown seated in the diamond posture. His identifying gesture is the boon-granting gesture, with right hand extended down, palm outward. He can wear the garments and ornaments of a Bodhisattva (which could in fact be the royal ornaments of a Beatific Body [Sambhogakaya] Buddha), as well as the monastic robes of a Buddha.

This statue is typically Western Tibetan, with the tall crown and the stiff circular scarf bound by the strutlike supports of the casting tubes. The circular pearl earrings, the sinuous double-stranded necklace, and the pearl bracelets and anklets are of the style seen in other Western Tibetan examples. Typical as well are the form-revealing lower garments edged with delicately decorated hems. This image has certain interesting details, such as the few incised flowers and lines on the ribbon-like scarf. It has rather large hands, with unusually long fingers, a style also seen in the Lotsawa Lhakhang wall paintings of ca. the late 12th century at Alchi in Ladakh. The large head, with broad, sensitively modeled features, imparts a strongly personalized character to the image. It has a tougher vigor than the Akshobhya in No. 138, and less stylistic association with the art of the central regions. The figure was cast with the pedestal, which has the smooth, bulging lotus petals common in images of the Western Tibetan group.

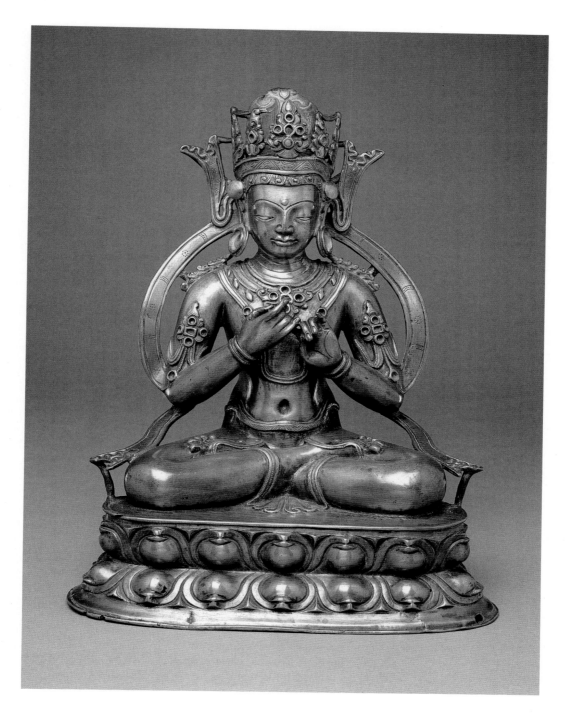

140
Vairochana

Western Tibet

14th century

Brass, with copper and silver inlay and jewel insets

H. 10″ (25.4 cm)

Trustees of The Victoria and Albert Museum, London. On loan from the MacPherson Family Collection

In all but the Unexcelled Yoga tantras, Vairochana is usually the Buddha seen as the central image in the mandala of the Five Transcendent Buddhas. When in the center, he is associated with the root addiction of hatred, which he transforms into ultimate-reality-perfection wisdom. According to the texts, his color is blue, when he is in the center, or white, when he is in the east. His symbol is the wheel, and he is depicted with his hands in the teaching gesture.

Although related in style to Nos. 138 and 139, this statue shows increased application of inlaid silver and copper, and the use of more inset jewels (most now missing). The form is sturdy and tight, the ornaments heavy and prominent. The waistband of the lower robes assumes a fanciful, clearly patterned relief shape echoing the curves of the jewels, and the earrings become thicker circles. These changes reflect developments moving toward the more monumental and decorative style of the early 15th century as seen in the Vajrasattva in the collection of the Newark Museum (No. 131). The fact that many elements similar to the previous several sculptures remain, such as the use of casting struts, the stiff circular scarf with incised lines and tiny floral designs, and the basically similar type of jewels, reveals the strong tenacity of tradition in the sculpture of Western Tibet. This sculpted image of Vairochana is particularly pleasing and colorful, with a sensitively realized feeling for the beauty of line and for its interesting, quite tactile contrasts of color and texture.

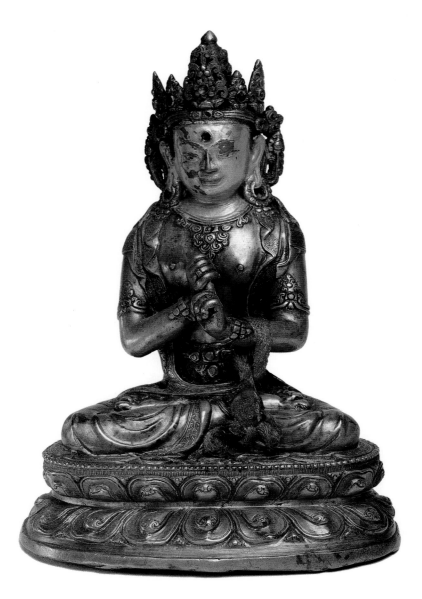

141

Vairochana

Tibetan, with Nepalese elements

Early 15th century

Brass, with turquoise and paste inlay, chasing, cold gold paste, and pigments

H. 7¼" (18.5 cm)

The State Hermitage, Leningrad.
Prince Ukhtomsky Collection

Vairochana is known from tantras such as the Vairochana-abhisambodhi as the central Tathagata, the first emanation of the Adi-Buddha Vajradhara and the head of the Buddha clan of the wheel. Sitting in the usual diamond posture, he clasps the index finger of his left hand with his right hand, making the gesture of the unity of all things in the context of ultimate reality (*vajra mudra* or *jnyana mudra*).

He is represented here with the royal outfit of a Bodhisattva (or a Beatific Body Buddha), richly decorated with all the ornaments and garments prescribed for these deities. An interesting addition to the usual set of ornaments is the ring, on the fourth fingers of each hand. It is difficult to say whether these rings have any symbolic meaning or are just a result of the master's ignoring the rigid limits of the canon with this personal touch.

On the whole, the sculpture produces an impression of being made by two masters. All the modeled parts of the sculpture (the points of the crown, the earrings, the necklace, the armbands, the belt, and the lotus petals on the throne) are decorated with a simple, ordinary chasing having nothing in common with the comparatively rich and elaborated ornamentation of Vairochana's garments. At the same time the modeling is rather interesting, especially that of the garments. The two ends of the scarf that covers Vairochana's shoulders fall down and, after crossing on the lap of the deity, hang over the back of the throne. It is quite probable that a later Qing tradition of two parallel ribbons hanging down along the front part of thrones takes its precedence in a style like this.

Two interesting details add to the singularity of this sculpture. One is a chased Sanskrit inscription on the back of the throne: "Om! Hail to Vairochana!" ("Om! Namo Vairochana!"). Each of the eight letters of the inscription is enclosed in a floral vignette. The other is a silk braid on Vairochana's left wrist, with a piece of some kind of sealing wax with a seal of a lama, probably the owner of the sculpture.

G. Leonov

142
Amoghasiddhi

Western Tibet

14th century

Bronze, with silver and copper inlay, chasing, and pigments

H. 10¾″ (27 cm)

The State Hermitage, Leningrad.
Prince Ukhtomsky Collection

The fifth Tathagata, Amoghasiddhi, is represented here as a royal, or Beatific Body, Buddha with long hair, crown, necklaces, armbands, and earrings. He does not hold his symbolic implement, a vajra cross, in his right hand, and can be recognized only by his hand gestures—the fear-not gesture of his right hand and the contemplation gesture of his left hand. Amoghasiddhi is the head of the action Buddha clan, and he symbolizes the practical realization of all the wisdom of the other four Tathagatas.

The style of the sculpture does not leave any doubts in establishing its date and provenance. There is no halo behind the figure of the deity, but instead it is surrounded by stalks of lotus flowers growing up from the pedestal. The head seems to be too large for the body, and the other proportions are not so regular either. The bottom edge of the pedestal is uneven, so the sculpture sways when placed on a level surface. The vertical axis of the sculpture is off line and the body of the deity seems to be inclined back and to the right. Rather typical for Western Tibetan bronzes of this period is the form and the number (usually seven to nine) of large lotus petals decorating the throne of the Buddha. Another characteristic feature of the 14th-century Western Tibetan style is a high flat knot of hair (*jatamukuta*) protruding above the crown, and narrow metal struts that connect the points of the crown with each other and with the rest of the sculpture. Western Tibetan sculptors needed such connecting tubes to allow the molten metal to fill the whole of the clay model.

Although sometimes a little clumsy, Western Tibetan bronzes preserve a touching purity of spirit that reflects the faith of their creators.

G. Leonov

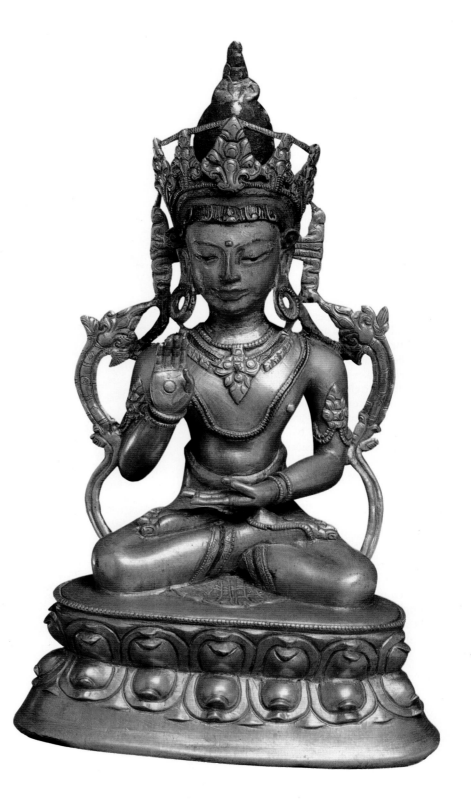

143
Ratnasambhava

Western Tibet

Late 14th to early 15th century

Bronze, with silver and copper inlay, chasing, and pigments

H. 12½″ (31.7 cm)

The State Hermitage, Leningrad.
Prince Ukhtomsky Collection

Ratnasambhava, associated as usual with the south, is the third Tathagata, or Transcendent Buddha. He is associated with the addictions of avarice and pride, transmuting them into the wisdom of equality. He is the head of the jewel clan of Buddhas. He has not been very popular in Tibet and his images are rather rare. Like the last few images, he is represented here as a Bodhisattva (or Beatific Body Buddha). He makes the boon-granting gesture with his right hand and the contemplation gesture with his left hand.

The style of the sculpture is similar to that of the Amoghasiddhi in No. 142. Still, some details allow consideration of a slightly later date for this work. First of all it must be noted that the proportions are much better balanced than in the previous image. The surface is more finished, the ornaments are more elaborate—even the ends of the lotus petals on the throne are decorated—the chasing is finer in all parts of the sculpture, and the lines of the face are purer and more exact. All these details may reveal a more stable tradition in producing such images, a tradition that requires several generations of masters to become developed to such a degree.

G. Leonov

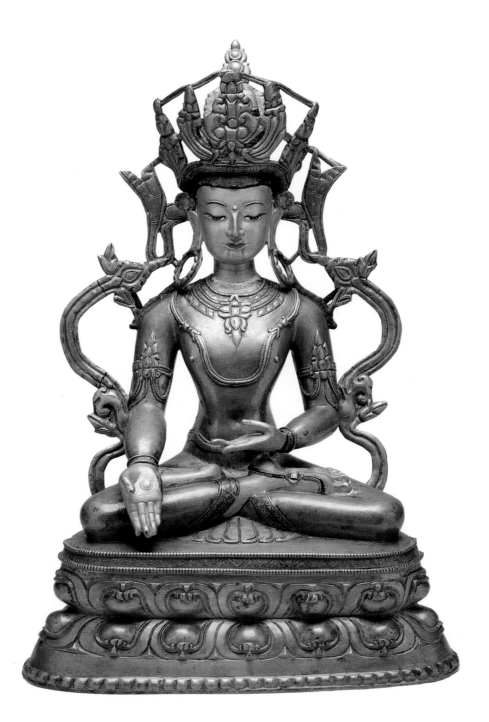

144
Amitayus

Samples of the consecrated relics from within the image are included

Nepalese, with elements of Western Tibetan stylistic tradition

Second half of the 14th century

Gilt brass, with chasing, cold gold paste, and pigments

H. 11″ (28 cm)

The State Hermitage, Leningrad. Prince Ukhtomsky Collection

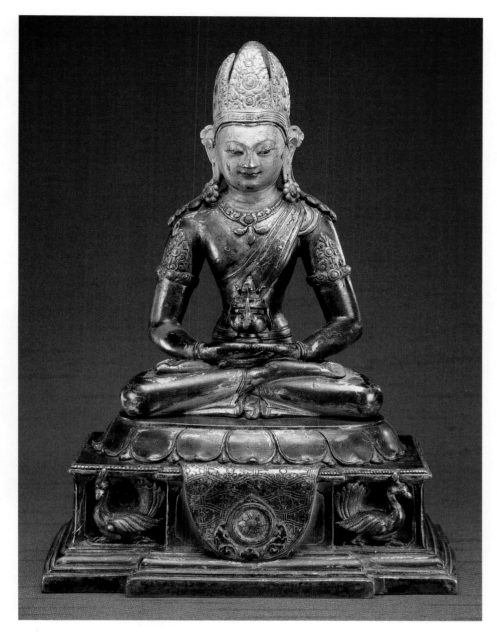

Amitayus, the Buddha of Infinite Life, is represented here in his traditional iconography. He sits in the diamond posture, with both hands flat in the contemplation gesture, holding a vase of elixir of immortality with a stylized "tree of life" on top of it. A textile decorated with an eight-petaled rosette hangs down over the rectangular pedestal from under the lotus seat. There are two peacocks in the niches flanking the overhanging textile.

It is difficult to establish the exact provenance of this image, but it can be called a Nepalese sculpture with elements of the Western Tibetan stylistic tradition. The lower part of the sculpture, with the combination of an oval lotus seat with large, flat petals and a rectangular pedestal, is without doubt of Nepalese origin. Some other details, such as the earrings and the three-petaled pendant of the necklace, can also be connected with the Nepalese tradition. At the same time, the Western Tibetan influence reveals itself in the high, flat knot of hair, in the type of crown, in the design of the armbands, and lastly in the massiveness of the figure.

The presence of two peacocks on the pedestal of the sculpture is rather interesting. The peacock is the vehicle of Amitabha, and the very presence of this bird in the sculpture may signal an early stage in the development of the cult of Amitabha/Amitayus. It may be that Amitayus was not yet considered a separate deity at this time, but was interpreted as a personification of one of the qualities of the Buddha of Infinite Light mentioned in his sutras, namely his eternal life. Later an independent cult of Amitayus emerged. At the same time, the presence of peacocks is not incompatible with the nature of Amitayus either—in Indian mythology this bird is considered immortal, as it is not affected by snake venom.

The sculpture is also interesting from another point of view. The copper plate

covering the bottom had been damaged before it was acquired by the Hermitage, and the relics with which the image had been consecrated were falling out of it. In order to prevent their dispersion, the plate was removed and the relics were taken out. A sizable collection of relics was hidden inside the two inner cavities of the sculpture. Among them there were sixty small packages of paper containing Tibetan inscriptions and relics inside. According to these inscriptions, the packages preserved relics of many persons prominent in the history of Tibetan Buddhism. Among the names mentioned in the inscriptions are Atisha, Marpa, the highest hierarchs of both Shamarpa and Karmapa lineages, and other persons. It is evident that some of the items found inside the sculpture can be dated to an earlier period than the image itself. Still, this does not contradict the date of the sculpture

because the practice of reconsecration of images commonly occurred in Tibetan Buddhism.

There are about fifteen hundred bronzes in the Hermitage collection. Over three hundred of them have been conserved unopened up to the present. Besides these, there are over two hundred full sets of relics from the same number of sculptures in the Hermitage collection. Each one of them has its own inventory number, correlated to the sculpture from which it has been removed. These two hundred sets were taken out of the sculptures for unknown reasons in the 1920s, when the Ukhtomsky collection was in the Russian Museum in Leningrad. The presence of these two hundred sets of relics in the Hermitage collection is very important, because it permits the study of relics without opening sealed images, except several damaged bronzes like the above-

144.1

mentioned image of Amitayus.

Such an approach to the material—studying available relics without opening new sealed images—proves to be justified at the present level of knowledge in the field. Some important details, such as the position of the objects inside an image in relation to the image itself, and the relation of items to each other, are inevitably destroyed when relics are removed. It has been impossible so far to work out a suitable method of establishing these details. In addition, studying relics already removed from a sculpture allows one to become more familiar with the basic material. Finally, the considerable quantity of relics conserved in the Herm-

itage (several thousand items in the two hundred sets mentioned above) allows systematization of relics from different sculptures and their study not according to sets, as has been done in a few publications on this subject (Schulemann, 1969; Hatt, 1980), but according to typological groups compiled of all the items of the same type—for instance, all printed protection wheels or all trees of life. It is most likely that this approach will lead to a greater understanding of the symbolic purpose of each item (see Leonov, 1989, pp. 117–131). A sample of the contents of this Amitayus sculpture is described below (144.1 and diagram).

a) An unfolded package
Manuscript on paper, black ink
2½ × 2¼″ (6.5 × 5.8 cm)
The State Hermitage (No. 30/1.2)
The text is written in two lines: 1) "rje mi bskyod rdoe'i," 2) "gdung thal." Translation: "Ashes of the reverend Mikyö Dorje." Mikyö Dorje (1507–1554/1556) was the eighth hierarch of the Black-Hat Karmapa school. Here the second part of his name is written in an abbreviated form, rdoe' i instead of rdo rje'i. The package was filled with small hard brownish particles. Very likely they are

sacred relics (T. ring bsrel), small particles that according to Tibetan tradition are found in the ashes after the cremation of important lamas.

b) An unfolded package
Manuscript on paper, black ink
2¼ × 2″ (5.9 × 5 cm)
The State Hermitage (No. 30/3.3)
Text: "Na ro pa'i rus brgyan." Translation: "Naropa's bone ornament." Naropa (d. 1040) was the famous Indian Great Adept who, along with Tilopa, is important to the Kagyupa transmission lineage through being the teacher of Marpa. There was a small piece of a bone in this package. It is most likely a fragment of a bone ornament, an earring, necklace, armband, bracelet, anklet, breast medallion, or apron made of human bone.

c) An unfolded package
Manuscript on paper, black ink
2½ × 2″ (6.2 × 5 cm)
The State Hermitage (No. 30/4.2)
The text is written in two lines: 1) "byang chub kyi," 2) "shi." Translation: "Bodhi tree." There was a small piece of wood in this package. A scientific analysis carried out in a laboratory confirmed that it really was a piece of bodhi tree, Ficus religiosa.

d) An unfolded package

Manuscript on paper, black ink
3¾ × 3½″ (9.8 × 9.1 cm)
The State Hermitage (No. 30/19.4)
The text is written in two lines: 1) "rgyal ba dkoog 'bangs," 2) "kyi dbu lo." Translation: "Hair from the head of victorious Konchok Bang." *Dkoog* is an abbreviation of *dkon mchog.* Konchok Bang (the full name is Dkon mchog gsum gyi 'bangs, Triratnadasa in Sanskrit) was an Indian teacher, and the author of four treatises included in the Tanjur. The exact dates of his life are unknown, but one of his works was translated into Tibetan by Loden Sherap (1059–1109) (Wylie, 1962, p. 148, n. 306). Thus, Konchok Bang lived not later than the 11th century. There was hair in the package.

e) A scroll
Manuscript on paper, black ink
7¾ × 1¼″ (19.5 × 3 cm)
The State Hermitage (No. 30/9)
The text is written in 3 lines: 1) "sbyin par bya ba'i chos 'di ma ha tsi na'i yul nas rab mchog theg pa chen po shri de wa ki rti zhes rab bdag gi pha dang ma dag," 2) "sngon du byas pa'i sems can mtha' dag gi bsod nams gyi ched y'ong." Translation: "This object to be donated was brought from the country of Mahachina by myself, the (monk of the) excellent Mahayana known as Shri Devakirti, for the sake of giving merit to all beings, with my father and mother at their head." So far no mention of the name Shri Devakirti has been found.

f) A *sogshing* with mantras
Wood
5½ × 1 × 1″ (13.8 × 1.3 × 1.3 cm)
The State Hermitage (No. 30/28)
The first item to be put inside a sculpture is a *sogshing,* a tree of life, the axis of the sculpture. Sometimes lamas first put a small scroll with *dharanis* (mnemonic spells) into the head of the image and then insert the axis itself. According to Tibetan manuals the *sogshing* is obligatory, but it was found in only thirty-nine sets of relics out of over two hundred. Most often a *sogshing* is a thin wooden stick, square at the bottom and narrowing to the top. Its length is usually about two-thirds of the total height of the sculpture. As a rule seed (*bija*) mantras, which are considered the quintessence of the deity, are written on its planed sides with black or red ink. Sometimes the famous mantra of Avalokiteshvara—OM MANI PADME HUM—is inscribed. The inscriptions are made as a rule in Sanskrit written in Tibetan script, and very rarely in Devanagari, the Sanskrit alphabet. In some cases there is no text on a *sogshing* and probably instead of this they tie several scrolls to the stick with silk threads or wrap one large scroll around the stick. The *sogshing* presented here is inscribed with seed mantras in Devanagari.

g) A paired mandala of Jambhala and Vasudhara
Manuscript on paper, black ink
5¾ × 2¾″ (14.5 × 6.8 cm)
The State Hermitage (No. 30/27)
At the end of the procedure of consecration, protection wheels (T. '*khor-lo*) are inserted. Such wheels were found in thirty-four sets of relics and their total number is one hundred ten. Protection wheels of Jambhala and Vasudhara, the god and goddess of wealth, are found in almost all the sets of relics with protection wheels, including wood-block prints and drawings. The former are usually printed on two separate pieces of paper put together with the circles inside. The latter are drawn on one piece of paper and folded over so the drawing is inside. Almost all these wheels consist of two circles, with the name of the main deity (Jambhala or Vasudhara), or his or her seed mantra, written in the central circle. The outer circle of each wheel is divided into eight petals, on which the names or seed mantras of the retinue deities are written. In almost all the wheels, the names or seed mantras of the deities are burned from the outside to join the two circles firmly together. This makes the paper very fragile, and it is difficult to unfold and to read the text. Folded protection wheels are often wrapped in yellow or orange silk or tied crosswise with silk threads.

The list of the retinue deities of Jambhala and Vasudhara can be found in mandalas Nos. 284, 285, and 289 of the *Sadhanamala,* one of the main sources on early Apocalyptic Vehicle (Vajrayana) iconography (de Mallmann, 1975, pp. 460–61). The names of all the deities in this paired mandala are written in Sanskrit, in Tibetan transliteration. Each name is preceded by a seed mantra OM and followed by the mantra MAMA DHANAM DEHI DEHI SVAHA ("To me, wealth—Give! Give! Hail!"). Their list and orientation to the points of the compass coincide with those of mandala No. 284 of the *Sadhanamala.* Deities of the west in both mandalas are situated above the principal deities of the mandalas.

The deities in the retinue of Vasudhara, seen in the second circle surrounding the center, are, moving clockwise from the top: 1) Sudatta, the west; 2) Devi, the northwest; 3) Arya, the north; 4) Sarasvati, the northeast; 5) Chandrakanti, the east; 6) Subhadra, the southeast; 7) Datta, the south; and 8) Gupta, the southwest. The deities in the retinue of Jambhala, again moving clockwise from the top, are:

1) Dhanada, the west; 2) Vichitrakundali, the northwest; 3) Purnabhadra, the north; 4) Kelimalin, the northeast; 5) Manibhadra, the east; 6) Charendra, the southeast; 7) Vaishravana, the south; and 8) Mukhendra, the southwest.

As mentioned above, protection wheels of Jambhala and Vasudhara are found folded together inside bronze sculptures. And it is in this folded state that they must be oriented to the points of the compass. Every deity from the retinue of Jambhala has his female counterpart in the retinue of Vasudhara. Thus, in the folded pair of wheels there must be Vaishravana and Arya in the north, Charendra and Sarasvati in the northeast, and so on. It is evident that if in the wheel of Vasudhara the deities (and the points of the compass) are arranged clockwise, that is, in the way they are arranged on maps, the deities in the wheel of Jambhala must be arranged counterclockwise. Otherwise the deities in one wheel will not coincide with their counterparts when they are folded together. In this arrangement, the Vasudhara wheel is on the bottom and the Jambhala wheel is folded over it.

We found this arrangement, with the Vasudhara wheel on the bottom, in eight pairs of wheels. Another type, with the Jambhala wheel on the bottom and the Vasudhara wheel on top, was found in seven pairs. In other words, in these examples we came across two systems of arranging sacred symbols; in one the male principle dominates, and in the other the female one. It is well known that there exist two trends of tantra; the left- and right-handed tantras. In the first of them the female principle plays a more important role, and in the other, the male principle. The two variants of deity arrangement in the mandalas of Jambhala and Vasudhara are no doubt connected with these two trends and it is probable that in the future it will become possible to gain fuller understanding of the symbolism of the mandalas in relics and to establish connections between the type of mandala and the image of the deity into which it is inserted.

h) A scroll
Manuscript on paper, black ink
30¼ × ¹⁴⁄₁₆″ (77 × 2.2 cm)
The State Hermitage (No. 30/5)
The text of this scroll presents a series of Sanskrit *dharanis* written in two lines in Devanagari. There is a short, three-syllable, Tibetan inscription (perhaps a shortened form of the title of the *dharani*) at the top left corner of the scroll. Six more scrolls with Sanskrit *dharanis* were inserted in this sculpture.

G. Leonov

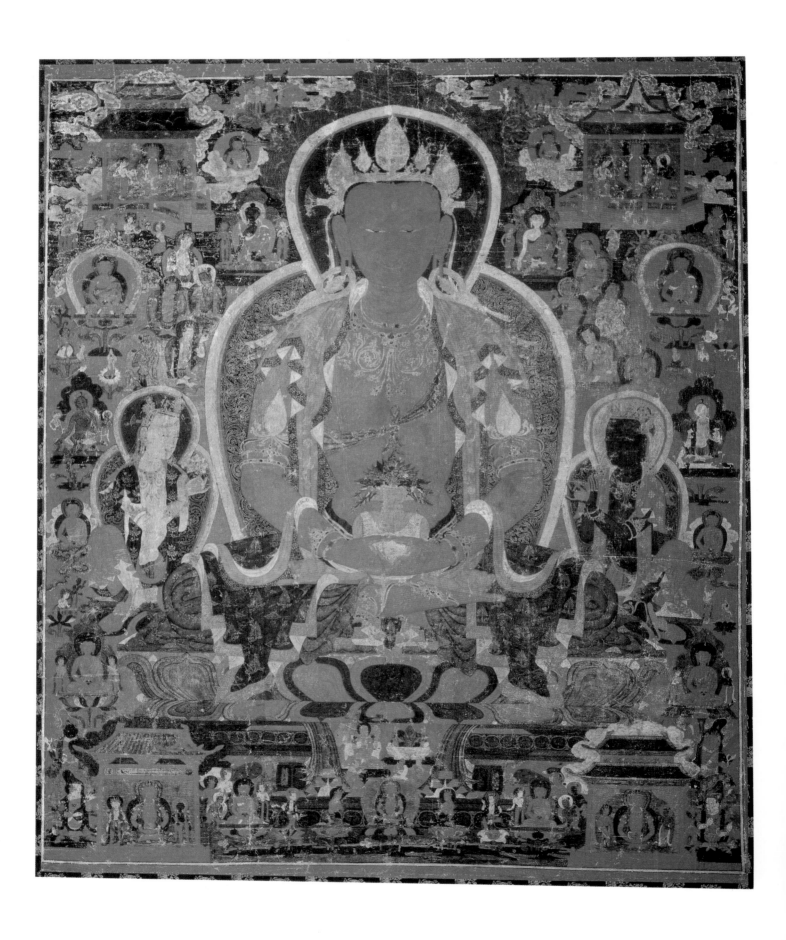

145
Amitayus

Central Regions, Tibet; probably Tsang

Second quarter of the 15th century

Tangka; gouache on cotton

54 × 45″ (137.2 × 114.2 cm)

Museum of Fine Arts, Boston.
Gift of John Goelet

Amitayus is the Buddha of Infinite Life, the counterpart of Amitabha, who is Infinite Light. Together they embody the Wisdom-Compassion Unity, and they are synonymous with each other. Amitayus, however, has special popularity and function as the Buddha for the attainment of long life. As one of the Five Transcendent Buddhas, Amitabha/Amitayus transforms the affliction of desire into discriminating wisdom. In most mandalas of the Five Transcendent Buddhas he is in the west. He is red in color and his Buddha clan is the lotus, whose symbol is the red lotus of compassion. He holds his hands in the contemplation gesture and, as Amitayus, usually holds the vessel of the elixir of eternal life. The paradise of this Buddha is called Sukhavati, the Land of Bliss, also known as the Western Pure Land. This Buddha has been greatly cherished among Buddhist peoples throughout Asian history, especially in East Asia in modern times.

This monumental painting of Amitayus is like a paradise and a mandala in one. A gentle yet magnificent red figure of Amitayus sits in splendor as the dominant center of an intricate configuration of images and shrines. He is flanked by his two main Bodhisattvas, Avalokiteshvara holding a lotus and Mahasthamaprapta (a form of Vajrapani) holding a vajra (145.1). At each of the four corners is a differently designed temple shrine containing a triad centering around Amitayus and reflecting in smaller scale the main triad in the center. Together they make a five-part repetition of Amitayus, covering the four quarters of space and the center, which is the nadir and the zenith combined. Clouds encircle the shrines, which are attended by various figures. To left and right on the upper levels are four major seated Buddhas, with an assembly of five seated Bodhisattvas (at the left) and five monks (at the right). The two lowest Buddhas are identical, each seated on a lotus with a long stalk and holding a bowl. The other two are the Medicine Buddha and Akshobhya. Midway in the painting are

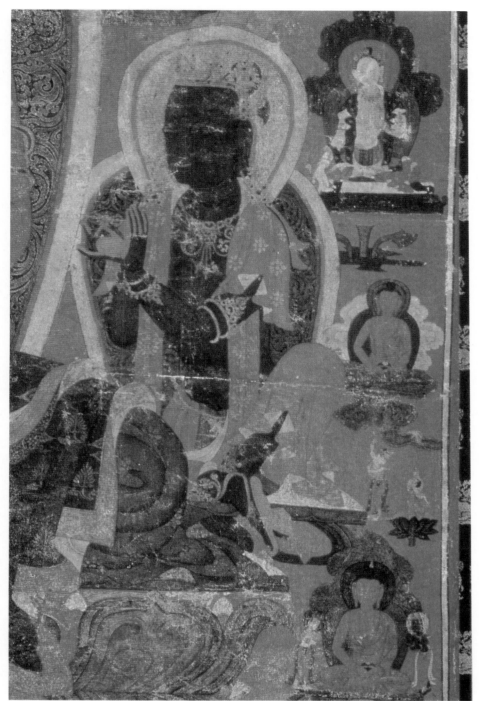

145.1

Green Tara and White Tara (left and right), then two more Buddhas of small size, seated and holding bowls. At the two lower corners are the Four Heavenly Kings and in the center at the bottom is Amitayus flanked by two more seated Buddhas with bowls. In the overhang of the main Buddha's throne cover are monks and an offering. The configuration is very symmetrical, but variations in color and the usage of cloud, landscape, and architectural elements create a sense of differentiation.

The color scheme is quite dark, but lavish amounts of gold in delicate patterns brighten the work. Patterns of scroll or-

naments, textiles, and jewelry all provide surpassingly fine linear detail, creating a rich surface. This, as well as the complex arrangements of the drapery on the main figures, finds its parallels with the wall paintings of the Kumbum and with the sculptures of the Peljor Chöde, both at Gyantse, and dating around the second quarter of the 15th century. The closeness of the styles suggests to us a generally similar dating and regional attribution for this splendid painting. Not only is it one of the largest and most magnificent tangkas of this period outside of Tibet, it is a rare, and probably the finest, Amitayus painting of this early date.

146
Crowned Buddha

China

Early 15th century

Gilt copper alloy, with pigment

H. 18½″ (47 cm)

Collection of The Newark Museum, Newark, New Jersey. Gift of Herman and Paul Jaehne, 1941

Lit.: Reynolds et al, 1986, pp. 92–94.

This image could be a Vairochana Buddha with the teaching gesture, but it is more likely to be the crowned form of Shakyamuni, a special form representing the Beatific Body (Sambhogakaya) form of subtle royal majesty. Among the Three Bodies of the Buddha, the Emanation Body (Nirmanakaya), the Beatific Body (Sambhogakaya), and the Truth Body (Dharmakaya), this represents the manifestation of the Buddha visible to those of greatly purified mind, such as tenth-stage Bodhisattvas. This form was made especially important in Tibet from the first Great Prayer Festival in 1409. During that celebration, Tsong Khapa transformed the Jokhang temple's Shakyamuni statue (the Jowo Shakyamuni)—an image venerated since its presentation to Tibet by the Chinese bride of the great Tibetan king Songtsen Gambo in ca. 640— by crowning and bejeweling it to represent the Beatific Body form (text fig. 2).

This sculpture is a large and beautiful example stylistically associable with the group of sculptures made during the Yongle period (1403–1425) in China. Several examples of the specifically inscribed Yongle sculptures appear in this book (Nos. 30, 76). The style of this Buddha strongly follows the Chinese tradition, particularly of the 12th century (the Jin period in the north), and is in marked contrast with the early Tibetan

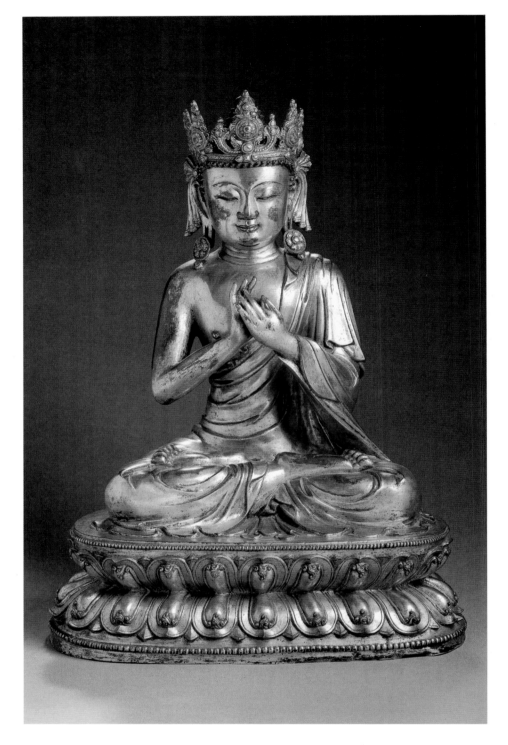

Buddha of Indian stylistic lineage such as the one in the Zimmerman collection (No. 2). Rather than a vigorous body with athletically shaped physique, as in the latter, this image seems gently shaped, with an almost feminine delicacy in its narrow shoulders and slender arms. The garment, unlike works of the Indian style, is loosely arranged over the form in thick but pleasingly mobile pleats. Rather than a strong tension of line coordinating with the muscular body to reflect the living energy of the image, as is typical of the Indian style, in this sculpture it is the fluid curves of the heavy folds that impart the

sense of a life substance within. The face is not the full, round face with slanting eyebrows, curved eyes, and sharply pointed nose typical of the Indian Pala lineage. Rather it is square, with arched eyebrows, slanted eyes, abstractly shaped nose, and a bow-shaped mouth clearly outlined with raised edges. The apparent ethereal lightness of the image offers another stylistic dimension in polar contrast with the vigorous naturalism of the Indian lineage style in No. 2. This splendid large image aptly represents another major, distinctly different, and influential tradition interacting with Tibetan art.

147
Vajradhara

Central Regions, Tibet

Late 15th to first half of the 16th century

Gilt copper, with turquoise and coral inlay, jewel insets, and pigments

H. 18¾″ (47.6 cm)

Collection of The Newark Museum, Newark, New Jersey. Purchase 1970. The Members' Fund

Lit.: Reynolds et al, 1986, p. 100.

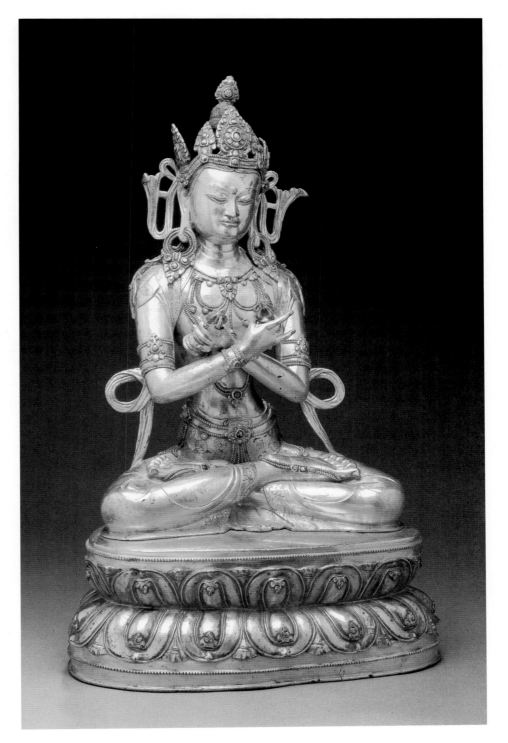

From the perspective of the Apocalyptic Vehicle, the Vajrayana, Vajradhara is the supreme essence of all Buddhas. Considered indivisible from the Truth Body of all Buddhas, he nevertheless manifests in the form of a royal Beatific Body Buddha or celestial Bodhisattva with crown and ornaments seated in the diamond posture, his hands holding a vajra and a bell crossed in front of his heart in the diamond HUM-sound gesture.

This shining gilt image perfectly exemplifies the mystical nature of Vajradhara. The tall, graceful body with its fittingly introspective demeanor seems transmuted beyond the mundane. The slight stiffness of the looped scarves and the judicious use of the turquoise blue, coral red, black, and jade green of the gems add an otherworldly splendor to the image, increased by the delicate refinement of the thin jewel chains.

Although there may be a hint of the Nepalese stylistic tradition in the sculptural style, the slim elongation seems distinctly Tibetan. The touches of curvilinear drapery folds relate to Chinese styles, especially as known in Tibet from the Yongle sculptures of the early 15th century and as assimilated in Tibetan works of the later 15th century. The pedestal also follows the general Yongle style, except that the lotus petals, unlike those of the early 15th-century Yongle works, do not completely encircle the pedestal in the back. These factors and the refinement of the style suggest a dating in the late 15th or first half of the 16th century. The tall, slender proportions of the torso and the ethereal appearance of the work relate to the style seen in the Padma Sambhava sculpture in No. 47 and to the statues of the White Temple at Tsaparang of the first half of the 16th century. The quality of sharp precision, imparting a pristine clarity to the form, is a special characteristic of Tibetan art. It is beautifully revealed in this work, one of the most splendid of Tibetan Vajradhara sculptures, and effectively heightens the image's essence of penetrating and mysterious reality.

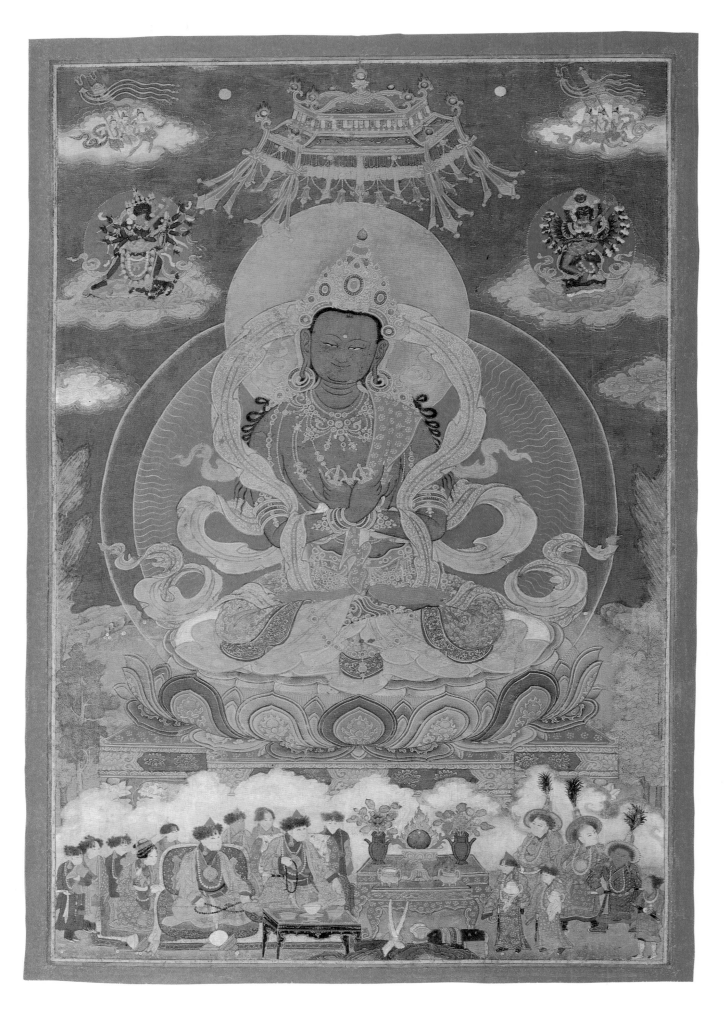

148
Vajradhara

Eastern Tibet

Late 17th century

Tangka; gouache on cotton

23 × 17½" (58.4 × 44.5 cm)

Robert Hatfield Ellsworth Private Collection

Lit.: Tucci, 1949, p. 537.

Against a deep, gem blue sky and pale, lavender-pink and rose red halos sits the quintessence of all Buddhas, Vajradhara. The intense blue of his body indicates his total communion with the ultimate reality of the infinite, eternal Truth Body of all Buddhas. The graceful sway of his lithe and powerful form suggests his perfect freedom to manifest out of compassion without diminishing that ultimacy. His legs are locked in the diamond posture, and his hands are crossed in the diamond HUM-sound gesture, holding a vajra in his right hand and a vajra-handled bell in his left hand. This embracing gesture symbolizes the union of compassion and wisdom in the form of the magic body and the clear light, the pure energy body and the pure wisdom mind commanded by a Buddha on the ultimate level of enlightenment. Vajradhara's body and head are bent in a graceful posture of movement. The smiling face, in a crisp and well-delineated style using white highlights, is reminiscent of the time-honored Pala style. Here Vajradhara appears more brilliant than the sky. The gold jewels and patterns on the garments in delicate shades of pink, lavender, rose red, and pale malachite green—colors drawn from Chinese inspiration but fully incorporated into the Tibetan repertoire by this time—contrast with the dark body and create an impression of subtle and ethereal light surrounding the figure. The light movements of the drapery, another distinctively Tibetan style derived from Chinese sources, and the swirling, drifting, pale, malachite green scarves impart the

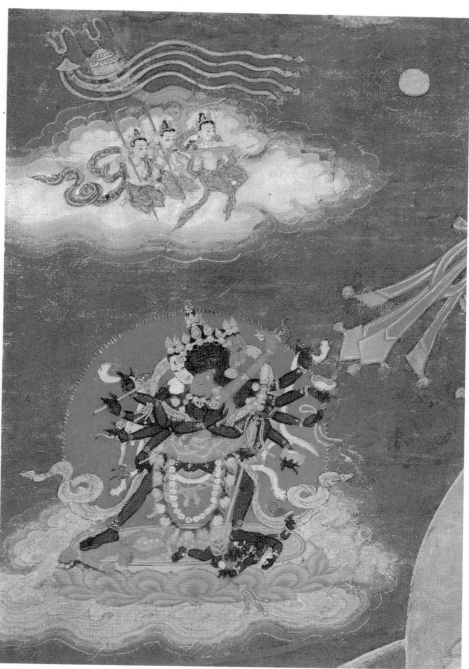

148.1

sense of a "self-generated" movement enveloping the figure.

Enhancing the otherworldly atmosphere of the painting are the strange, jagged, crystalline rocks, the fairyland trees of blue, gold, and green on both sides of the

main figure, and the six islands of pastel and white clouds drifting symmetrically in the vivid sky. On the middle clouds, Shamvara, to the left (148.1), and Hevajra, to the right, embrace their wisdom consorts against bright crimson halos. In

148.2

the two corners celestial offering angels kneel on the aqua-edged clouds, bearing offerings and long, floating banners. Above the main image is an openwork canopy whose light pendant fringe sways to the sides, contributing to the lively but delicate rhythms that infuse the whole painting.

A moderately spacious ground plane is clearly established by the stretch of the tree-covered rocky landscape with its definite horizon line, so the main figure appears set within a naturalistic world. Increasing this sense of the unity of the transcendent beings with the reality of the human world is the prominent row of

donors at the bottom, separated from the towering deity by a thick layer of white clouds (148.2). Piles of offerings of tusks, grain, and cloth, in front of two lacquer tables holding flowers and incense in Chinese-style tripod vessels, divide two groups of large figures comprising the donors—possibly a whole family. At the left sit a man and wife with gorgeous robes, jewels, and fur-trimmed, peaked hats. A seated young girl and some children stand next to and behind the main pair. To the right of the altar table are six standing figures, three wearing distinctive tall hats with wide brims and pipelike crowns, from which extend

feather plumes. Servant figures in front bring in tea pots. Tucci has identified the people from their clothing as being from the Minag area of Eastern Tibet.

Besides providing an interesting depiction of the peoples' appearance, this painting is a superb example from one of the Eastern Tibetan schools of painting from ca. late 17th century. It fully displays the characteristics of the use of bright, light colors and the incorporation of landscape to produce a sense of joyous intermingling of the transcendent and the mundane worlds. It is clearly one of the most perfect and splendid paintings of this date and region.

XII.
Pure Lands

When modern humans at last saw the whole earth from space as a little blue, white, and brown ball floating in the dark void of space, they found something in their own culture to enable them to understand Vimalakirti's famous illustration of the "inconceivable liberation" of the Bodhisattvas. Vimalakirti said, "Only those who can see and understand the miraculous putting of this entire planet, with its axis and its continents, into a mustard seed, without shrinking the planet and without enlarging the mustard seed—only they can understand the inconceivable liberation of the Bodhisattvas" (Thurman, 1976, p. 52). The Universal Vehicle vision of the cosmos is truly what we could call today "science fictional." The miraculous power of compassion is bounded only by the limits of the trained imagination. Thus, an enlightened being, a Bodhisattva or a Buddha, can reach into the subtlest energies of the universe, into the strongest forces within the atom, into the farthest reaches of the universe, even beyond the universe into other universes and dimensions entirely—all in order to find whatever is necessary to help and liberate suffering beings. Steeped in this Universal Vehicle literature for centuries, the Tibetans opened up to the presence of such Bodhisattvas all around them. They discovered Pure Lands around them on earth, invisible to the ordinary person. They developed the technology of artistically creating evocations of Pure Lands through the art of the mandala. And they opened up to the essential perfection and purity of their own land, the Land of Snows, Tibet, with its landscape of terrible magnificence. Here we present quintessential Tibetan paintings, heavenscapes, planetscapes, and sacred landscapes, before we move into the living art of the colored particle mandala.

Comprising mainly tangkas from the later periods (15th to 19th centuries), some of which are monumental in scale, this section presents the paradises (Pure Lands) of some of the Buddhas, Bodhisattvas, and great saints of Tibet, as well as Tibet itself, represented by its temples and monasteries. These paintings offer the book's final glimpse of the Accomplished Ones and reveal their realm to be entirely in this reality, simultaneous with their presence in the reality of complete liberation. Most of these paintings depict either landscape or architecture as the setting, in the fully developed forms of the 18th and 19th centuries. A huge painting of symbolic offerings and the gilt bronze, shrine-covered offering mandala accompany the Pure Lands to bring to a close the entire progress of the mandala configuration presented here.

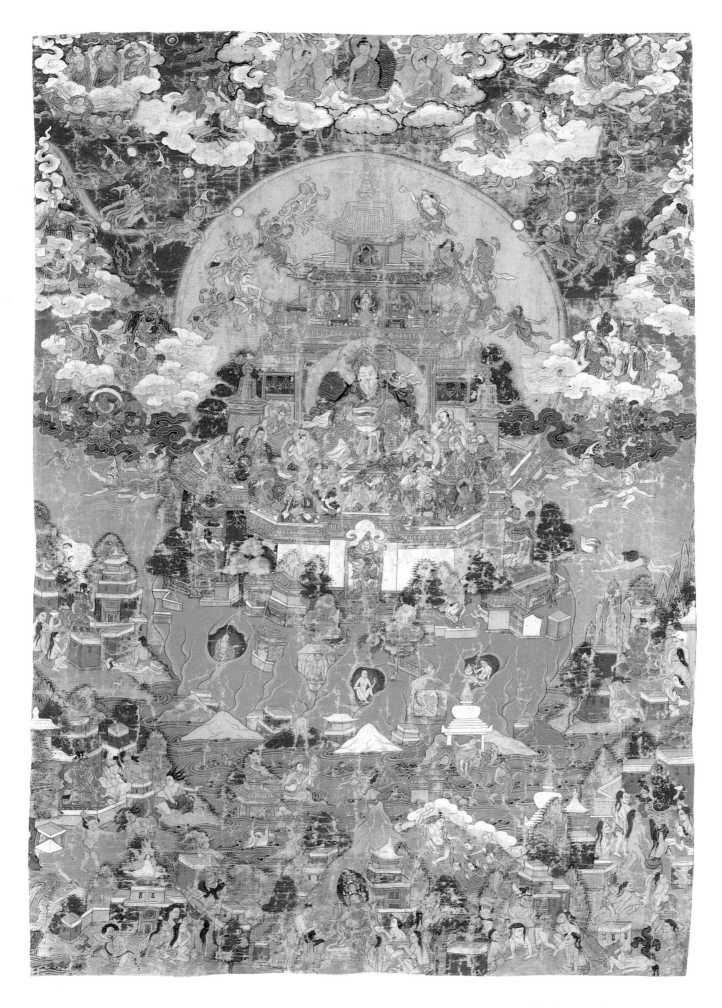

149
Padma Sambhava in the Palace of the Glorious Copper Mountain Paradise

Eastern Tibet (?)

Late 18th to early 19th century

Tangka; gouache on cotton

24¼ × 16¼" (61.6 × 41.3 cm)

Collection of The Newark Museum, Newark, New Jersey. Purchase 1969. The Members' Fund

Lit.: Reynolds et al, 1986, pp. 164–65.

The Glorious Copper Mountain Paradise is the Pure Land of Padma Sambhava, the yogi from Uddiyana considered an emanation of Amitabha and Avalokiteshvara. It is said to be located somewhere to the southwest, across the sea from India, perhaps in Madagascar or even Africa. It takes its name from the copper coloring of the mountain. Tibetans believe that Master Padma Sambhava retired there when he left Tibet, and that he dwells there to this day.

In this painting Padma Sambhava sits in front of his triple-storied palace together with his two consorts, some lamas, and others, including a Buddha. In the shrine on the second floor is Shadakshari Avalokiteshvara and his attendants; Amitabha Buddha occupies the topmost level under the hexagonal golden roof. Dancing Dakinis—female Buddhas—play around these upper stories within the encompassing arc of the large halo that surrounds the palace. A triad with Shakyamuni Buddha in the center is at the summit of the painting. Around them the sky and cloud clusters teem with celestial Dakinis, offering goddesses dancing and playing music, demonic creatures, and various protectors (149.1). Standing guard at the entrances in the golden-roofed hexagonal wall surrounding the palace are the Four Heavenly Kings of the directions. Below, in caves within the mountain, sit yogic ascetics, and in the moatlike sea around the mountain are the Nagas, the dragon deities, and their sunken, palatial shrines. On a thin bridge between two stupas, two ascetics cross the swirling waters. On the opposite shore, in the foreground, is the land of the *rakshasas*, cannibal demons, whom Padma Sambhava unceasingly works to civilize. They are depicted engaged in gruesome activities that contrast starkly with the celestial beings in the upper part of the painting.

149.1

This painting is a typical rendering of this popular theme, which had become standardized by the 18th century. Although particularly animated and complex, it is executed in a delicate style, probably of Eastern Tibet from the late 18th to the early 19th century. Along with the quiet center around Padma Sambhava, the rainbow-edged, peach-colored halo with its thin golden rays and the strong orange-red of the mountain seem to be the most stable factors. Otherwise the painting is crowded with figures, whose scattered placement and wild activities create an incessant, churning agitation that is reinforced by the somewhat nervous liveliness of the line. This type of depiction of Padma Sambhava's paradise, emphasizing the large mountain, is different from the representation in No. 50. It may be a type special to a particular region, such as Eastern Tibet, or perhaps represents a more general function than the type in No. 50.

Samye Monastery

Central Regions, Tibet, or Eastern Tibet;
obtained in Kham

Late 18th to early 19th century

Tangka; gouache on cotton

21 × 15″ (53.3 × 38.1 cm)

Collection of The Newark Museum, Newark,
New Jersey. Purchase 1920. Albert L. Shelton
Collection

Lit.: Reynolds et al, 1986, pp. 201–02.

Samye is the oldest Buddhist teaching monastery in Tibet. It was founded in ca. 779 by the great Tibetan Buddhist king Trisong Detsen. The second of the famous three Religious Kings, he ruled during the second half of the 8th century over an extended Tibetan empire that stretched from Persia into China. Following the advice of his Indian Buddhist master, Shantarakshita, the king invited the powerful tantric yogi Padma Sambhava of Uddiyana to come to Tibet to assist in "taming" and bringing under control the numerous adverse forces present there and impeding the development of Buddhism. These three, Trisong Detsen, Shantar-akshita, and Padma Sambhava, were said to have been linked in former lives to the building of the great Bodhnath Stupa in Kathmandu, Nepal; together they founded the monastery of Samye at a site about thirty miles southeast of Lhasa, in the level valley of the Tsangpo River, surrounded by huge sandy mountains.

Texts relate that Padma Sambhava drew a mandala of the Five Transcendent Buddhas on the ground and meditated on it for seven days. After that, despite op-position from demonic local deities who tried to tear down and stop the building, help was obtained from benign beings, and the monastery rose successfully upon the diagram of the mandala. Its outer circumference is, in fact, circular, and the main building is at the exact center, as in a mandala. Buddha sculptures in solid gold were made for the temple, and the first seven Tibetan monks were trained there. The monastery is also known for guarding the state treasure, secured by the power of Padma Sambhava and the various spiritual protectors he entrusted with the care and preservation of the site, the most notable being Pehar, a deity especially brought in the late 8th century from Khotan in Central Asia to guard this place.

Accounts relate that the styles of India, Tibet, and China are represented in the structure. Although the monastery has been greatly damaged in recent years, old photographs reveal its plan and some of the buildings, notably the central temple in three main stories, surrounded by a two-storied colonnaded courtyard with a large pylonlike entrance gate. Four large, differently shaped stupas appear at the four directional points within the encircled compound, and there are many other buildings scattered around the site. The monastery is said to have been modeled after the famous Buddhist monastery of Odantapuri in northeastern India.

This painting, a rare surviving portrait of this monastery, seems in general to depict Samye faithfully, as far as we can know from later photographs, although certain elements had undergone rebuilding in the interim. The high viewpoint in the painting distinctly reveals the details of the main monastery, with its courtyard and the golden hip and gable roof with sharply upturned rafters, a Chinese style. It also shows the red-painted columns of the courtyard and doors of the large two-storied gateway, which is flanked by two guardian lions. The four large stupas, said to have been donated originally by four ministers of state, are distinct variations of the stupa form. They are clearly portrayed here in red, black, blue, and white. A strange yet engaging double-zigzag wall, containing numerous temples within its boundaries and also forming the circular circumference wall, is not exact to reality but nevertheless creates the major enliven-ing, if somewhat confusing, rhythmic movements in the painting.

This may well be one of the earliest surviving tangkas of the genre of pure landscape and architecture in Tibetan art. This genre, utilized mainly to depict famous monasteries, which became like sacred Pure Lands on earth, was well established by the 19th century in Tibet. It had been a type known since the 9th century in the wall paintings of Dun-huang. The most famous example is the extensive depiction of Wutaishan in cave 61, dating from the mid-10th century. From the few glimpses available of the wall paintings and tangkas from various Tibetan monasteries such as Narthang, Shalu, and the Kumbum at Gyantse, the use of large-scale architecture seems to have been a part of compositions with figures from at least the 14th century. In this Samye painting, the consistent rendering of all the architectural compo-nents in a kind of perspective, albeit naïve and intuitive, is a clear development over the more frontal two-dimensional conceptions that appear in paintings of the second half of the 15th and the 16th centuries, such as Nos. 6 and 97 from Western Tibet and No. 7 from Eastern Tibet. In the late 17th century there is an increase in architectural components and in their presentation with some perspective, as seen in No. 65. Paintings of the type focusing primarily on architectural elements seem to have developed by the late 18th to the early 19th century. In fact, a series of wall paintings depicting several famous stupa sites is still at Samye. Probably dating from the 18th century, they appear presented in a generally similar way as in this Samye tangka, with high perspective and with plain pale washes for the landscape. The Newark Museum painting of Samye is one of the most satisfying of the architectural tangkas in that it has a certain complexity and sense of reality and yet is simple enough in its focus to have its own monumental and special character.

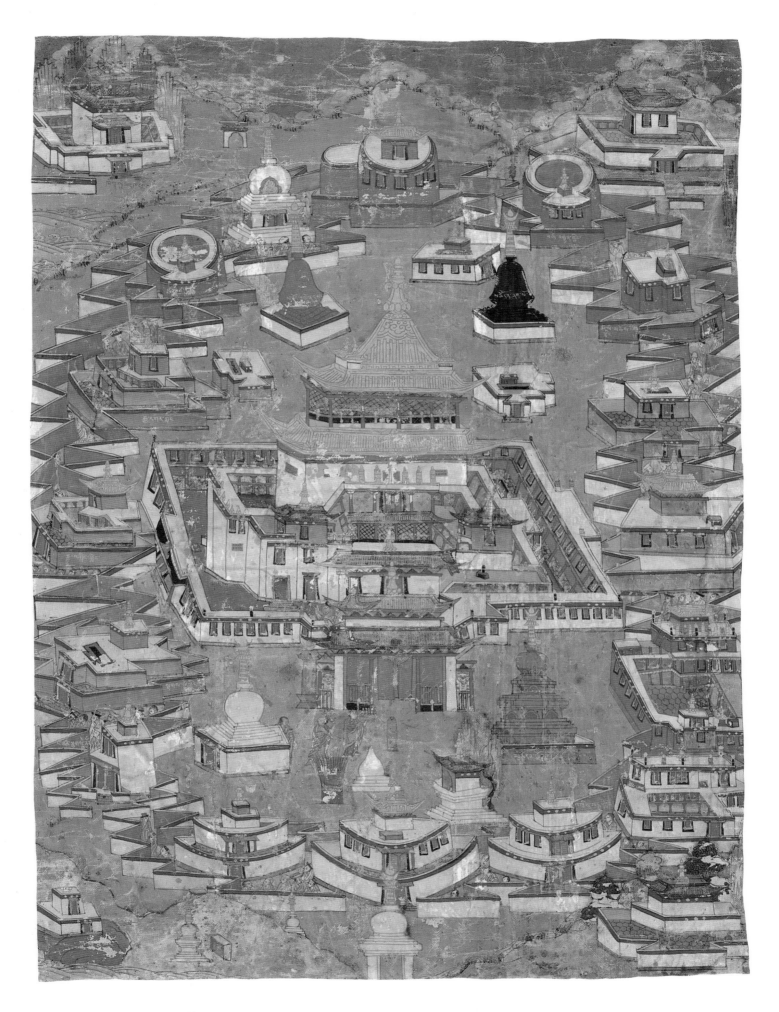

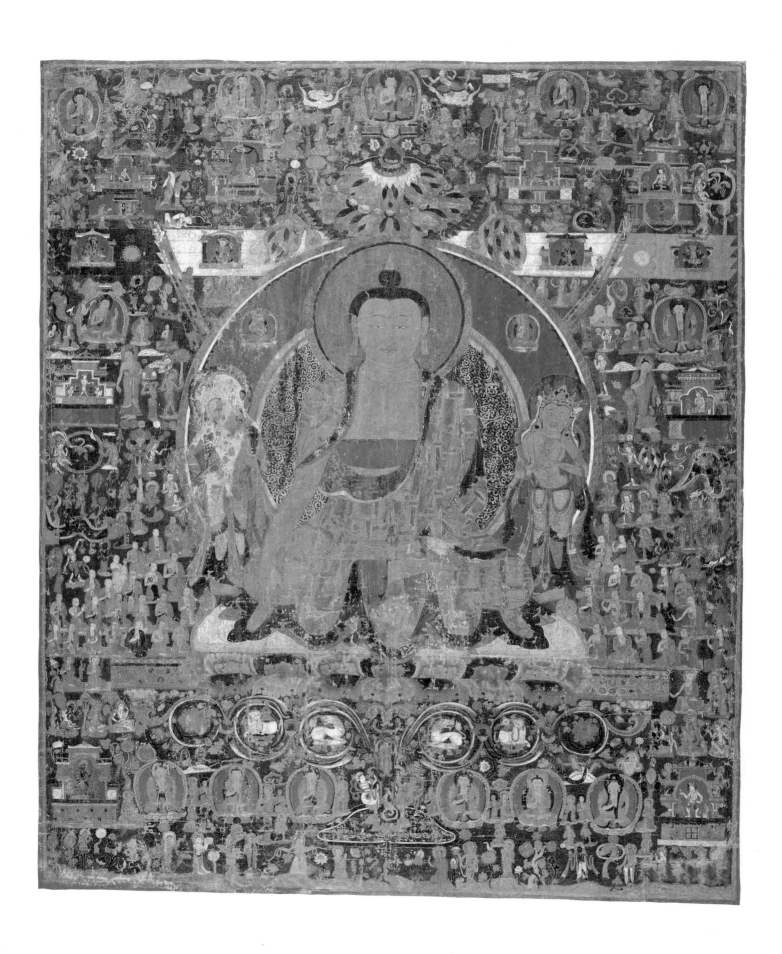

Akshobhya in Abhirati

Western Tibet; Guge

Second half of the 15th century

Tangka; gouache on cotton

59½ × 49¼″ (151.1 × 125.1 cm)

The Los Angeles County Museum of Art,
Los Angeles. From the Nasli and Alice
Heeramaneck Collection. Purchased with
funds provided by the Jane and Justin Dart
Foundation. M.81.90.3

Lit.: Tucci, 1949, pp. 347–48; Pal, 1983,
pp. 139–40; J. Huntington, 1972

The Buddha Akshobhya is one of the
Five Transcendent Buddhas in esoteric or
tantric (Mantrayana) Buddhism. He is
usually placed in the east in the Yoga
tantras, and in the center in the mandalas
of the Unexcelled Yoga tantras. He is
associated there with the transformation
of anger into ultimate-reality-perfection
wisdom, and is the lord of the vajra
Buddha clan. He is also a well-known
Buddha in exoteric Mahayana Buddhism.
His Eastern Pure Land of Abhirati was
mentioned in the Vimalakirti Sutra as the
place where Vimalakirti had come from.
At the end of that sutra, Vimalakirti
actually picks up the Pure Land in his
hands, brings it miniaturized into the
grove where the Buddha and his guests are
gathered, and displays it to all. His sutra
was one of the earliest to be translated
into Chinese in the Later Han period (23–
220 CE). In Tibetan literature, Milarepa's
disciple Rechungpa visits Abhirati in his
dream and is inspired by Akshobhya to
ask Milarepa to tell his life story. At
Milarepa's death, his crystal stupa and
magic relics are said to have been carried
to Abhirati by the Dakinis. In general,
Tibetans consider Abhirati a less celestial
and more earthly type of Pure Land, and
it is the one most often frequented by
departed Great Adepts and mystics.

Akshobhya is magnificently depicted in
Abhirati in this superb but slightly worn
painting from the Western Tibetan school
of the Guge renaissance period. A Buddha's
Pure Land is the pure manifestation of the
Buddha visible to those of pure and
elevated mind, such as Bodhisattvas. Some
of the characteristics of Akshobhya's
paradise are related to his vows to attain
Buddhahood, such as the one that in his
paradise women would have painless
childbirth. In this painting some women
holding babies appear just beneath the
Buddha's pedestal at left and right,
possibly a reference to this attribute of

his paradise. Another feature is the
presence of ladders extending from earth
to the Trayastrimsa Heaven, the Indian
counterpart to Olympus. The gods of
Trayastrimsa can descend on these flower
ladders to visit Akshobhya Buddha, and
the human beings of earth can ascend to
visit the celestial cities. In this painting the
ladders are shown in the upper part of the
painting, with gods and men ascending
and descending through the layers of other
heavens, such as that of the Four Heavenly
Kings, who are shown each in a shrine-
palace within the strangely slanted layers
that probably indicate the levels of Mount
Meru, the cosmic mountain. Also,
Abhirati is known to be a favorite of
Arhats, and in this painting a prominent
group of monks, each seated on individual
rugs, is shown in worshipful attendance on
either side of Akshobhya. Behind them are
clustered various Bodhisattvas. Other
features of his paradise include beautiful
jewel trees and lakes, shrines with teaching
Buddhas, and, near the bottom corners,
two large shrines of dancing Yogini
Buddhas. Above and below are rows of
seated Buddhas. Along the bottom on
wavy hills appear worshiping monks,
Bodhisattvas, and flowering trees. In the
upper reaches of the painting are elaborate
shrine-palaces, kneeling monks, jewel
trees, clouds, flying monks, and Bodhi-
sattvas, possibly depicting, as Pal suggests,
the realm of the Trayastrimsa Heaven,
above Mount Meru.

Akshobhya himself is a glorious figure
with full and graceful proportions. His
right hand makes the earth-witness
gesture, and in his left hand he holds an
upright blue vajra. His patched robe is
orange-red, with dark blue borders and a
blue-green lining that spreads with limpid
and fluid folds, complementing the curves
of his limbs, face, and dark hairline.
Charming Bodhisattvas stand shyly at his
side, bending with the awkward but

intriguing distortions characteristic of the
Western Tibetan school. The series of
halos, in shades of deep red, orange-red,
and blue, mostly filled with the intricate
lacy floral shadow pattern, provides a
block of solid color that puts the primary
focus on the central triad, amid the
ceaseless detail of the paradisiacal scene.
Despite the profusion of minute detail
however, there is a calmness to the entire
scene and a pristine clarity in the mostly
orange and flesh-colored figures against the
midnight blue of the spaceless background.

Stylistically, the main figures relate to
the paintings seen in the Serkhang of
Tabo monastery, a major Western
Tibetan monastery in present-day Spiti in
Himachal Pradesh. The relation of some of
these Guge tangkas with Tabo has been
recognized by John Huntington (1972, pp.
105–17). The main Buddha, in particular,
with his broad proportions and elegantly
curved drapery, relates to the Tabo variant
of the Guge renaissance style of the second
half of the 15th century. The serenely
ethereal effect of the thin and somewhat
brittle lines and subdued color planes, the
unwavering two dimensionality of the
composition, and a charming quality of
earthy humanness are characteristic of the
best painting of the Western Tibetan
school of this time. Although Pure Land
representations are known in the wall
paintings of the Sumtsek at Alchi from the
second quarter of the 11th century, the
examples in the Guge renaissance tangkas,
several of which are in the Los Angeles
County Museum, constitute the most
important group from the middle periods
of Tibetan art. These works offer a more
complete descriptive form of the Pure
Lands than the earlier paintings. In
subsequent centuries the Pure Land form
developed into a widely popular theme.
Tucci considered this tangka to be one of
the most interesting paintings in his
collection.

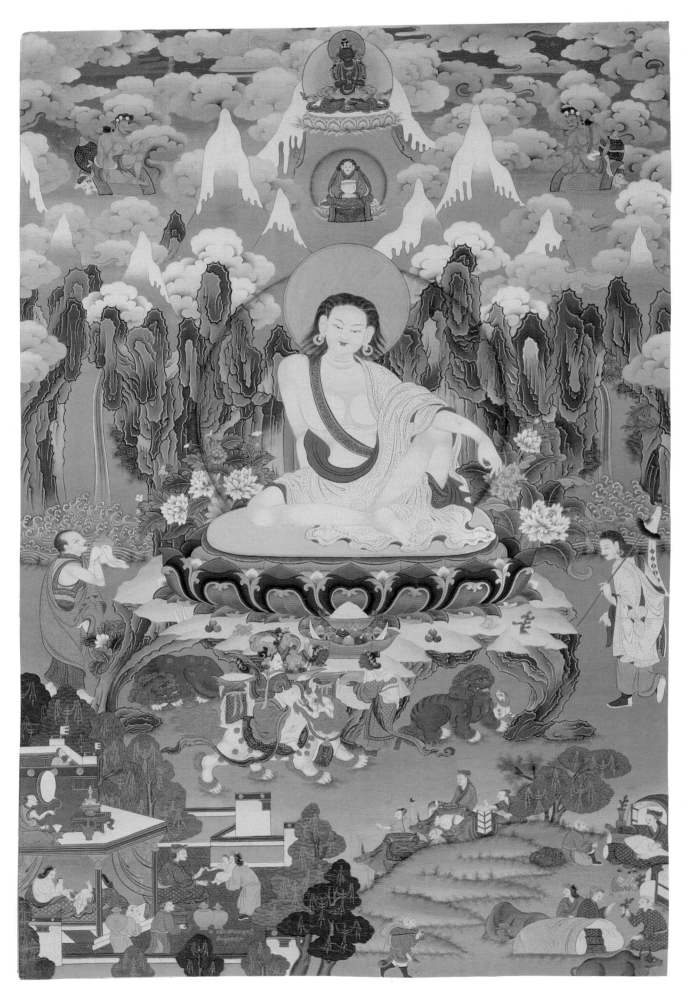

Milarepa and Scenes from His Life

Eastern Tibet

Late 18th to early 19th century

Tangka No. I in a series; gouache on cotton

32⅞ × 21⅞″ (83.5 × 55.5 cm)

Folkens Museum Etnografiska, Stockholm

Lit.: Schmid, 1952, pp. 30–31.

Milarepa, the "cotton-clad" yogi saint of Tibet, is shown here in his Pure Land of the Himalayan mountains, the location of his many ascetic abodes. Milarepa is considered by the whole Tibetan populace to be the first ordinary Tibetan to become a perfect Buddha in the Great Adept pattern, and this tangka is included in this section because the deeds it depicts and the life it symbolizes are firmly lodged in the memory of all Tibetans. Through Milarepa's suffering, effort, and eventual triumph, the Tibetan landscape itself became his Pure Land, within which his beloved Tibetans could begin to find their own way to Buddhahood.

Snow-covered peaks and blue-green rocky cliffs with tumbling waterfalls rise behind Milarepa as he sits at ease on a splendidly colorful lotus with his white robe loosely draped around him (152.1). Surrounding him are the main personages and deities of his life experience. On the central axis, above his head, which is beautifully framed by a lilac-colored halo, is the seated figure of Marpa, his teacher. Above Marpa is the dark blue Vajradhara, the supremely eminent Buddha. Tilopa, with the golden fish, and Naropa, with the skull bowl, the two Indian Great Adepts special to the lineage of Marpa and Milarepa, are to the left and right respectively, amid the profusion of clear-cut clouds. These figures are the spiritual lineage of the Kagyupa school; as Milarepa has said: "Great Dorje Chang is my origin, Wise good Tilo my ancestor, Great Pandit Naro my Grandfather, Marpa the Translator my honoured father, I myself am Milarepa" (Shmid, 1952, p. 15). On Milarepa's right is Rechungpa and to his left Gampopa, his two main, "moon and sun," disciples respectively. Below his lotus pedestal, which rests on a rocky plateau spread with offerings, are the five fierce flesh-eating Dakinis (Tseringma and her sisters), who threatened Milarepa with demonic visions during his meditation, but whom he conquered in the famous episode at Medicine Valley (Chang, 1977, I, pp.

296–311). Tseringma, chief of the sisters, rides an orange and white snow lion. Two dark blue and green snow lions lounge beside the group. In the lower left corner the birth of Milarepa is depicted. A messenger (lower middle) is shown going to get the father at the market place (lower right), who returns home to give his son the name Töpaga (return to lower left).

This painting is the first in a series of nineteen tangkas on the life of Milarepa, obtained in Beijing in 1930, of which Nos. 82 and 83 are two other examples. The paintings of this series come from the later period of Tibetan painting, which highly idealizes the colors and figures yet effectively utilizes a more three-dimensional landscape setting. The shadowless figures seem to exist in a very pure world, one that irrevocably draws the viewer into its lovely environment and intriguing scenes. The perfection of the style in this set of tangkas makes it one of the most important examples of later Tibetan painting, and its completeness makes it an especially cherished series on Milarepa.

152.1

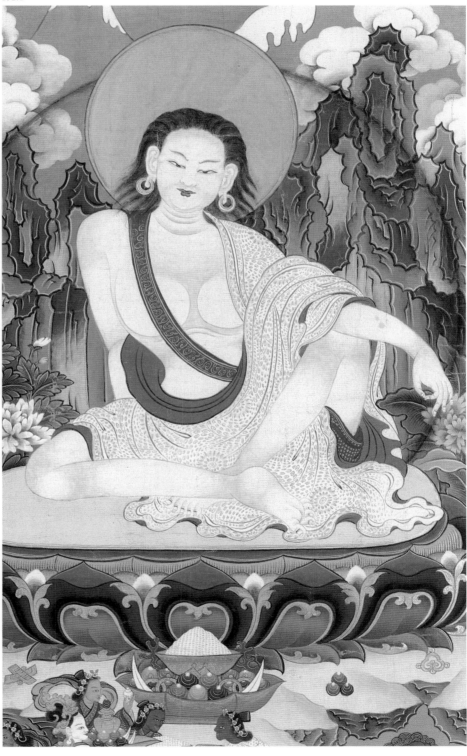

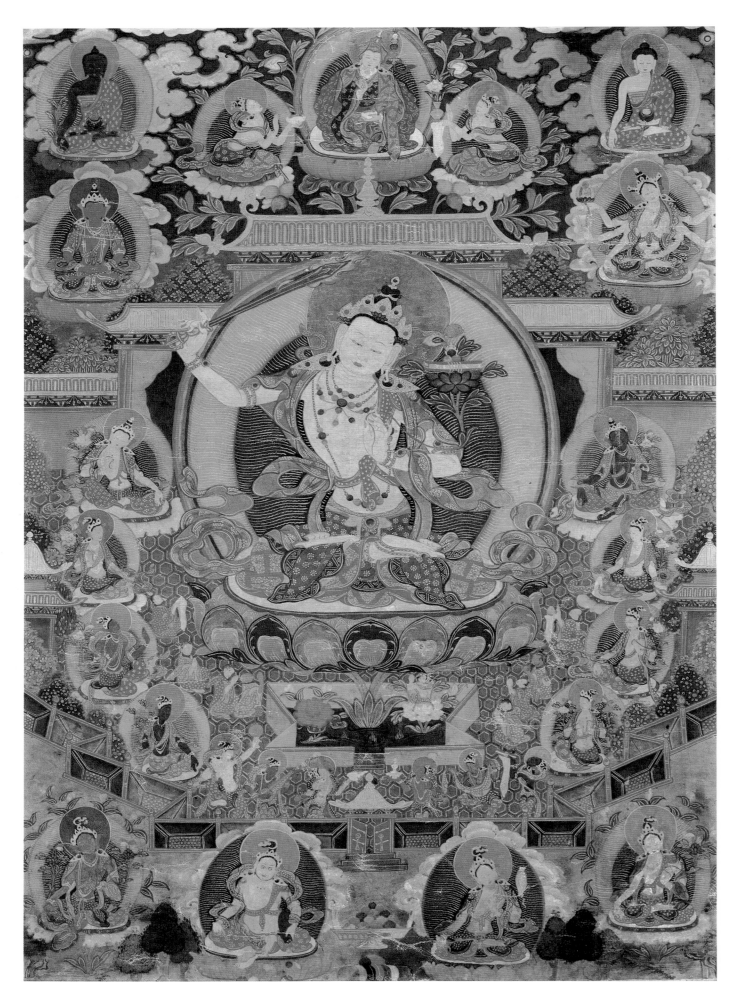

153
Pure Land of Manjushri

Eastern Tibet (?)

Late 18th to early 19th century

Tangka; gouache on cotton

29½ × 21¼" (74.9 × 53.3 cm)

Virginia Museum of Fine Arts, Richmond.
Gift of the Honorable and Mrs. Alexander W.
Weddell

Manjushri is the Bodhisattva of
Transcendent Wisdom. The youthful prince
carries with his right hand the double-
edged sword able to cut through illusion
and with his left hand a blooming lotus
that supports a volume of the Prajna-
paramita Sutra. He is depicted as a youth
of sixteen years (153.1) in order to convey
the Buddhist insight that wisdom is not a
matter of mere experience or years, but
results from the cultivation of intellectual
genius, which can penetrate directly to the
bedrock of reality. Wisdom is the most
honored virtue in Buddhism, called the
Mother of all Buddhas, since only wisdom
makes possible the great bliss of total
freedom from all suffering that is the goal
of all living beings. Thus, Manjushri is one
of the most important of all Buddhist
deities, the veritable god of wisdom and
herald of emancipation.

In the sutras, Manjushri has a Pure
Land in another universe, wherein he
manifests himself as the Buddha he
actually is. He is in fact a perfect Buddha
who vowed to emanate all over the
universe as a Bodhisattva to put the hard
questions to the Buddhas on the topics of
voidness, freedom, and the nature of the
self. But in the popular Tibetan
imagination, Manjushri has his earthly
Pure Land at the magical Five Mountain
Paradise (Ch. Wutaishan; T. Riwo Tsenga)
in northeast China, one of the most
important pilgrimage places for Tibetan,
Mongolian, and Chinese Buddhists. This
painting depicts the vision of Manjushri
and his Bodhisattva companions that, it is
said, can be seen there even to this day by
those of great purity of heart.

This painting depicts the same form
of Manjushri as the large statue in the
collection of the Folkens Museum
Etnografiska (No. 35). The Bodhisattva is
in his paradise, on his lotus seat in a
courtyard with a palatial structure and
walls behind. Beyond the golden roofs, the
diamond-pattern ground of the Pure Land
is seen, and various figures drift against
the dark sky. Among these, Padma Sam-
bhava is in the center, flanked by his two
consorts, who offer him food and elixir.

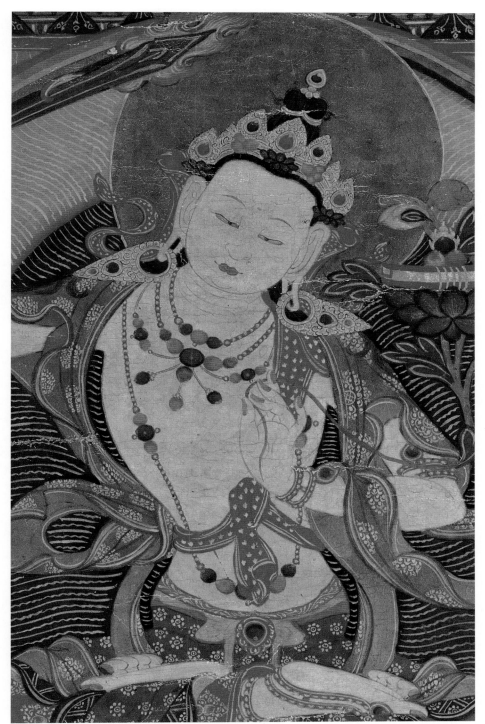

153.1

To the left and right are the Medicine
Buddha and Shakyamuni Buddha, and
below them are Amitayus and Ushnisha-
vijaya. On the lower part outside the
courtyard appear from left to right a
Green Tara, the god of wealth Kubera,
Vasudhara, and a White Tara. Within the
courtyard are five white and three dark
Bodhisattvas, seated on lotus pedestals.

A simply organized painting, it is neatly
patterned, and softly and harmoniously
colored in green, blues, and reds. It has a
sensitive, fluid, and precise line. It is a rare
example of Manjushri's Pure Land, which
is not commonly seen. The presence of

Padma Sambhava indicates its probable
connection with a Nyingma monastery or
patron. The style has developed from a
combination of idioms, such as those seen
in the eight-armed Green Tara (No. 123)
of the Eastern Tibetan school and the Los
Angeles County Museum Kunga Tashi
(No. 65) from the central regions. It also
has some relation with the Narthang
wood-block style of ca. the 1730s, but it
has a simpler and more fluid line that
relates it most closely with the Milarepa
paintings in Stockholm (Nos. 82, 83, 152),
and the Panchen Lama lineage painting
(No. 99).

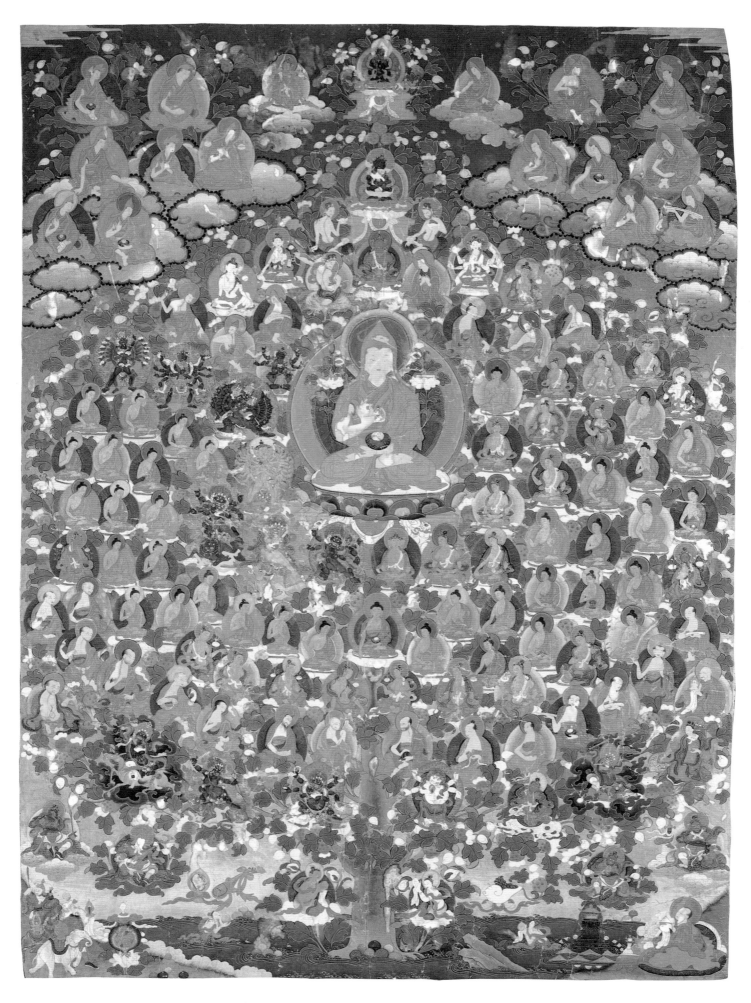

154
Tsong Khapa and the Gelukpa Refuge Tree

Eastern Tibet or Central Regions, Tibet

Late 18th to early 19th century

Tangka; gouache on linen

53 × 37⅞″ (134.6 × 96.2 cm)

Mead Art Museum, Amherst College, Amherst, Massachusetts. Gift of Mrs. George L. Hamilton. 1952.25

A large tree with a blue trunk grows out of a deep blue lake, on whose shores appear auspicious symbols and a praying lama. At the pinnacle of this amazing tree sits an image of Tsong Khapa in monk's robes, holding the stems of lotuses that support the sword of wisdom and the book of profound transcendence, the Prajnyaparamita Sutra. To Tsong Khapa's left is a cloud of lamas of the philosophical "lineage of the profound view of reality," descended from Manjushri and Nagarjuna. Another cloud on his right contains lamas of the ethical and contemplative "lineage of magnificent deeds," descended from Maitreya and Asanga. From above him descends the line of contemplative practice from Vajradhara and the Great Adepts. Near him to left and right are intricately detailed depictions of his major archetype deities: Yamantaka, Hevajra, Vajradakini, Guhyasamaja, Manjuvajra, Shamvara, Hayagriva, Kalachakra, various Taras, Avalokiteshvara, and many more (154.1). Below there are Buddhas, Bodhisattvas, Arhats, numerous historical masters, and a row of protector deities. The base of this great ensemble is supported by the tree and guarded by the Four Heavenly Kings.

This resplendent icon relates the whole religious, philosophical, cultural, and historical synthesis achieved by Tsong Khapa and embodied in the Geluk Order. To the practitioner, this entire vision of the Great Assembly Tree would be seen by the mind's eye in space, streaming forth a radiance of rainbow spiritual light. Such a vision creates a field of secure clarity and penetrating brilliance, in which a person may effectively contemplate the subject of his practice. This icon is thus a major tool of practice as well as an object of veneration and worship. The particular form of this representation, special to the Gelukpa, appears to have been developed by the 18th century, but more investigation needs to be done into its origins and development.

154.1

The style of this impressive tangka has evolved from a mixture of the atmospheric style of the Eastern Schools and the heavy, rich, orange-green style of the central regions. The strong tones of dark green and orange impart dramatic power to the painting, despite the tendency to idealize the human figures. Though many amazingly tiny figures are crowded into the painting, the clarity of the composition in major clusters keeps it comprehensible, while drawing the viewer's attention to the fascinating individual details. The strong outlining of the clouds is a technique well known since the 15th century, but it is particularly prevalent from the late 18th century. In general, the style is fairly close to the small tangka of the same iconography in the Museum of Fine Arts, Boston, dating by inscription to 1789 (Pal and Tseng, 1969, no. 17). The Mead Art Museum possesses another impressive tangka of this theme, which dates ca. mid-18th century (1952.24).

The Temples and Monasteries of Lhasa

Eastern Tibet or Mongolia

First half of the 19th century

Tangka; gouache on cotton

53¼ × 72¾″ (135.4 × 184.6 cm)

Royal Ontario Museum, Toronto.
The George Crofts Collection

Here we are offered a special and extra-ordinary view of the great monasteries and temples of Lhasa, the capital of Tibet. The scene is treated as a vision of a Pure Land here on earth, which is what Tibetans believe it to be. There are rolling hills, winding streams, jeweled trees, and pastel clouds, on a broad and tilted picture plane. The great Potala palace of the Dalai Lamas dominates the center, and around it are the three main monasteries of the Geluk Order: Drepung in the upper left, Sera to the right, and Ganden in the upper right corner. In the lower right corner is the Jokhang, the most sacred temple of Tibet (text fig. 1). Interspersed among these impressive monastic and temple complexes, readily recognizable by the accuracy of the building descriptions, are smaller buildings, people engaged in various activities, horses rolling on the ground, monks in the monasteries, and most interestingly, a fascinating procession with the Dalai Lama on a white horse, wearing his special yellow pandit's hat and robe, backed by a halo and covered with a canopy. Together with an entourage of officials and lamas, he is shown proceeding on horseback from the compound of the Jokhang and heading for the great *chöten*-shaped western entrance gate of Lhasa and the Potala beyond.

These buildings, so important in the history of Tibet, appear like a mandala of sacred centers of Buddhist doctrine in and near Lhasa. The Jokhang is the oldest, dating to around the 640s, in the reign of Songtsen Gambo, the first of the famous Religious Kings and the first to be converted to Buddhism—by his Nepalese and Chinese wives, it is said. The Jokhang was built to house the image of Akshobhya Buddha that his Nepalese queen brought to Tibet, but it later came to house the Shakya-muni Buddha statue that his Chinese queen brought from China. This Jowo Shakya-muni Buddha image (text fig. 2) remains the most sacred image in Tibet, and the Jokhang is still the center of national worship. The three monasteries of Dre-

pung, Sera, and Ganden were founded by Tsong Khapa (1357–1419) and two of his disciples. Ganden, or Tushita Heaven, where Maitreya waits to be born as the next Buddha, was built by Tsong Khapa in 1409, on the site of his favorite retreat. Located some fifteen miles northeast of Lhasa, it became his main teaching center near the end of his life. Drepung, or Rice Heap, named after the great stupa in South India where Shakyamuni Buddha is said to have revealed the *Kalachakra Tantra*, was built by Jamyang Chöjey in 1416. It later became the residence of the early Dalai Lamas, and eventually was the largest monastic university in the world; by the twentieth century it housed as many as twelve thousand monks. Sera, or Hailstorm of Wisdom, was built in 1419 by Jamchen Chöjey near a retreat house where Tsong Khapa wrote some of his greatest books. The great Potala, named after the Pure Land of Avalokiteshvara, was the last of these complexes to be built; it was founded on the ruins of Songtsen Gambo's palace on Marpori (Red Mountain) in Lhasa by the Fifth Dalai Lama in 1645. It took fifty years to come to completion, some thirteen years after the Great Fifth had died—in an incredible deception, the death of the Dalai Lama was kept secret until it could be completed. Today it still stands as one of the supremely captivating and monumental structures of the world (text fig. 26). It is a royal fortress, a monastery, a temple, a school of administration, and a seat of government. At the foot of the hill in front of its steep diagonal staircases and towering walls containing, it is said, one thousand windows, are the offices of governmental administration.

This painting represents a fully developed stage of architectural representation in Tibetan art, consistently utilizing the intuitive sense of perspective from a high vantage point and numerous landscape elements. The paintings Nos. 97, 65, and 150 show the earlier stages of this genre from around the late 16th, late 17th, and late 18th centuries respectively. This painting probably dates from the first half of the 19th century. It is very similar to two others in the Musée Guimet and one in the Musées Royaux in Brussels. Its style of landscape is descended from works datable to the Qianlong period in China (1735–1796). It shows the Potala prior to the large addition that is so prominent today, the red hall containing the Thirteenth Dalai Lama's tomb. The loose robes of the Dalai Lama and other figures in the painting seem to relate to Chinese or Mongolian style, suggesting a possible eastern provenance for this work.

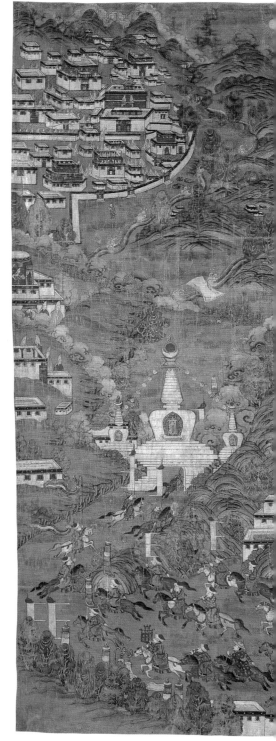

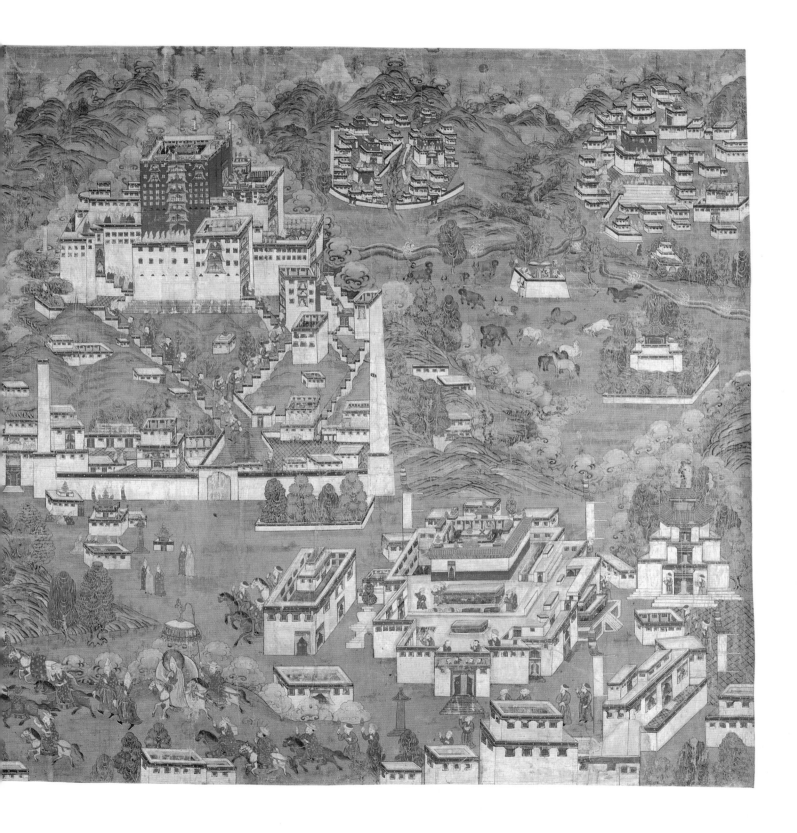

156
Kalachakra Mandala

Central Regions, Tibet

End of the 16th century

Tangka; gouache on cotton

32⅝ × 29¾″ (83 × 75.5 cm)

Musée Guimet, Paris

The Kalachakra mandala is extensively described in the *Nishpannayogavali* (no. 26). However, this painting in the Musée Guimet presents certain variations from the Sanskrit text. In the center of the mandala, in the first enclosure, is a multicolored Kalachakra. He has four faces, but only twenty-two arms instead of the twenty-four that he usually has. He dances in intimate union with his female consort, the eight-armed female deity Vishvamata. Around the couple, on each of the eight petals of a lotus flower, can be seen a female deity, each with four faces and eight arms. Their implements, however, are not shown.

The second enclosure contains eight couples seated in embrace. The males have three faces and six arms; their consorts are similar. In the Sanskrit text, four Transcendent Buddhas and their consorts are placed in the four cardinal directions, in the center of each side. In the corners, at the intermediate compass points, are the consorts, in union with the four Buddhas. The consorts are dominant in the corners as the Buddhas are dominant in the previously described pairs. The eight deity couples alternate with eight vases, against a dark blue background. The deities are placed in their proper canonical locations, and then a second time in the immediately following intermediate direction. For instance, a black Amoghasiddhi, rendered here in dark blue, in union with a yellow Lochana, orange-rose here, is represented in the east (in the lower section), and they appear again in the southeast (in the lower left corner).

The third enclosure is more complicated. It has four triumphal gates, each protected by a fierce deity in union with a female deity. On each side of the gates and in the angles are Bodhisattvas, twelve in all, embracing consorts; they represent the different senses. As in the second enclosure, there is a second couple of each Bodhisattva-consort pair, with the female dominant. The *Nishpannayogavali* describes the gates as having two columns. Their bases support the "female deities of the religion" at each cardinal point. Here, the triumphal gates have three stories, each with its own roof, and a fourth story, known as the wheel of the Dharma story, but there are no deities occupying these levels. The deities up to here are all included in the mind mandala-palace.

The fourth enclosure is called the speech mandala-palace (Vanmandala). A male and a female deity in close embrace, with the female dominant, are placed in the center of each of eight lotus flowers in full bloom—red with a red background at the cardinal points, and red with a white background at the intermediate points. The four lotuses placed in the cardinal directions would have been hidden by the multistoried gate of the third enclosure, but the artist has preferred to place them in a visible way, in front of the four-storied gates as if the gates were transparent. Each of the divinities within these lotus flowers has one head and four arms; their attributes are not portrayed. In the tantric text, eight four-armed speech goddesses are around each central couple, standing on each of the open lotus petals, making a total of sixty-four speech goddesses. There are sixty-four terrific male deities in the warrior posture in union with the speech goddesses. The gates of this enclosure have three stories, inhabited by small deities of undetermined sex. Each gate is guarded by a fierce deity couple mounted on top of a cart pulled by an animal.

The fifth and largest enclosure, or the third building, is the body mandala-palace (Kayamandala). It has twelve lotuses, representing the twelve months. Each lotus has a round center, occupied by a deity couple with the male as the dominant partner. Around the center are twenty-eight petals, each supporting a goddess of a day. The triumphal gates of this fifth enclosure are the largest and grandest of all the gates. The three stories are all occupied by deities; two of the roofs are crowned with vases, and the other two each with a fierce deity couple on a cart. The ring around the architectural aspects represents the four elements. It is the sixth enclosure, called the burning ground enclosure.

G. Béguin

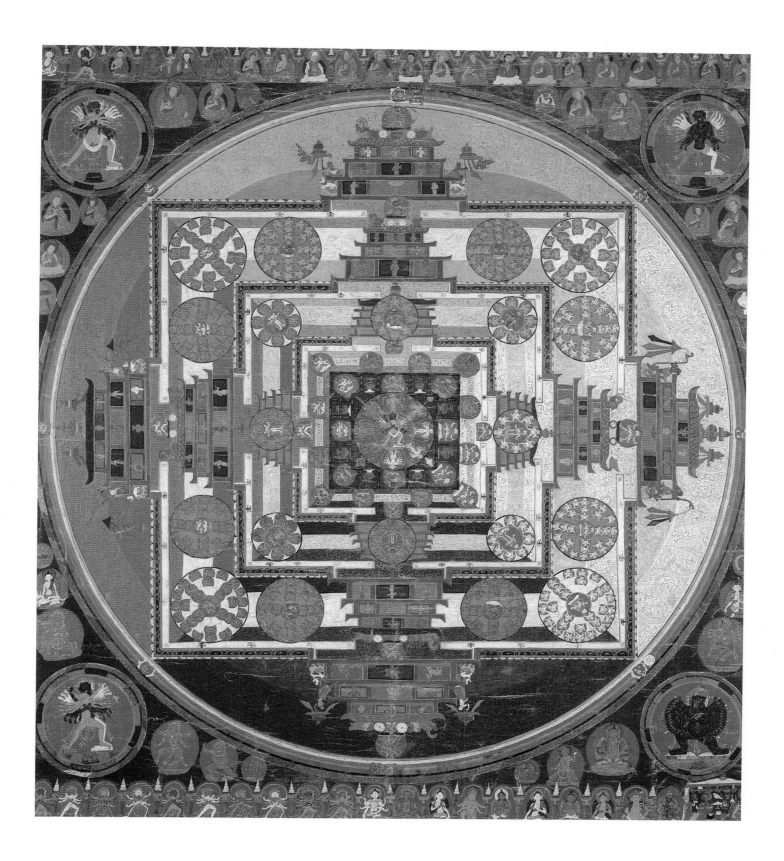

157
The Kingdom of Shambhala

Mongolia

19th century

Tangka; gouache on cotton

44 × 87½″ (112 × 222.5 cm)

Musée Guimet, Paris

An abundant literature in the West is dedicated to the subject of the mythical kingdom of Shambhala. James Hilton's novel *Lost Horizon,* published in 1933, romanticized and made this legend popular with a large Western public. In Tibet, various aspects of the legend were established by the third Panchen Lama (1737–1780).

This painting is compositionally divided into two sections. The right side depicts the mythical kingdom of Shambhala, a place dedicated to the glory of the archetype deity Kalachakra. This country, where devotees may be reborn, is situated by geographers somewhere in the north, maybe in Central Asia, separated from the rest of the world by the river Sita (perhaps the Tarim), seen here in the shape of a waterfall that divides the painting down the middle. Shambhala is surrounded by a double range of snow-covered mountains,

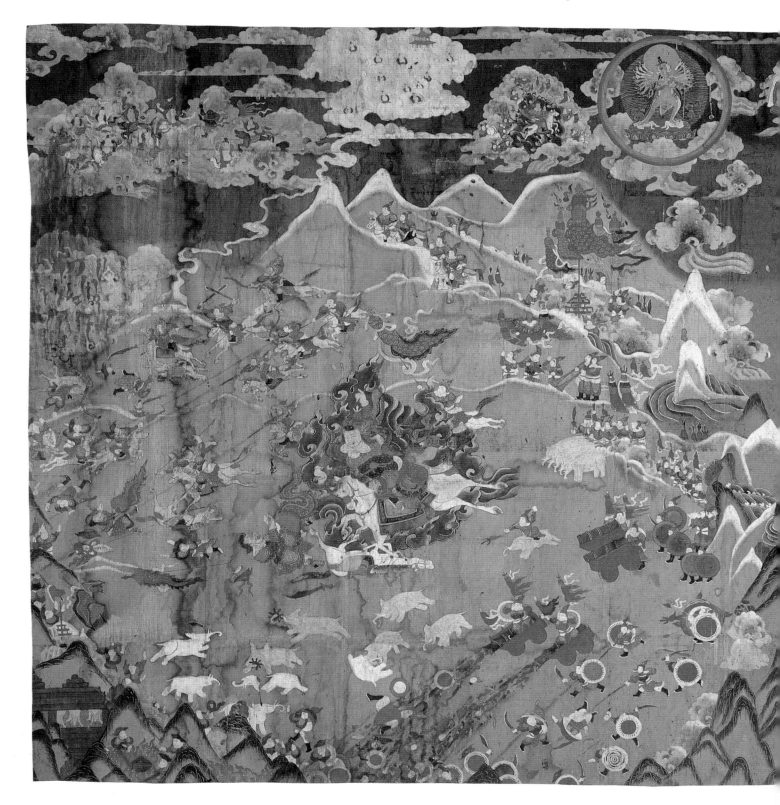

"pointed and sharp as teeth." In the center, the last king of Shambhala, Rudrachakrin, holds court in the palace of Kalapa. All around are represented the various palaces of the vassals, in this case numbering ninety-three.

On the top right side, nine of the kings of Shambhala are represented. Some are not easily identifiable, but one can recognize from right to left Manjushrikirti, Atibhadra, and Sumitra. The third one

from the right is possibly Sagaravijaya.

The left side of the painting represents the war at the end of the dark age of the world. Rudrachakrin will appear on his white horse, followed by his general Hanumanda. He will crush the barbarians in the west and will allow the Buddhist teachings to spread around the world. It is worth noting how the theme of this battle contains some curious parallels with the Hindu Vaishnavite tradition. At the top of

the composition Kalachakra appears inside a multicolored circle.

According to recent tradition, the Panchen Lamas themselves reincarnate as kings of Shambhala. In Mongolia and Tibet, the theme of this mythical northern kingdom was exploited for political reasons favorable to czarist Russia at the end of the 19th and the beginning of the 20th century.

G. Béguin

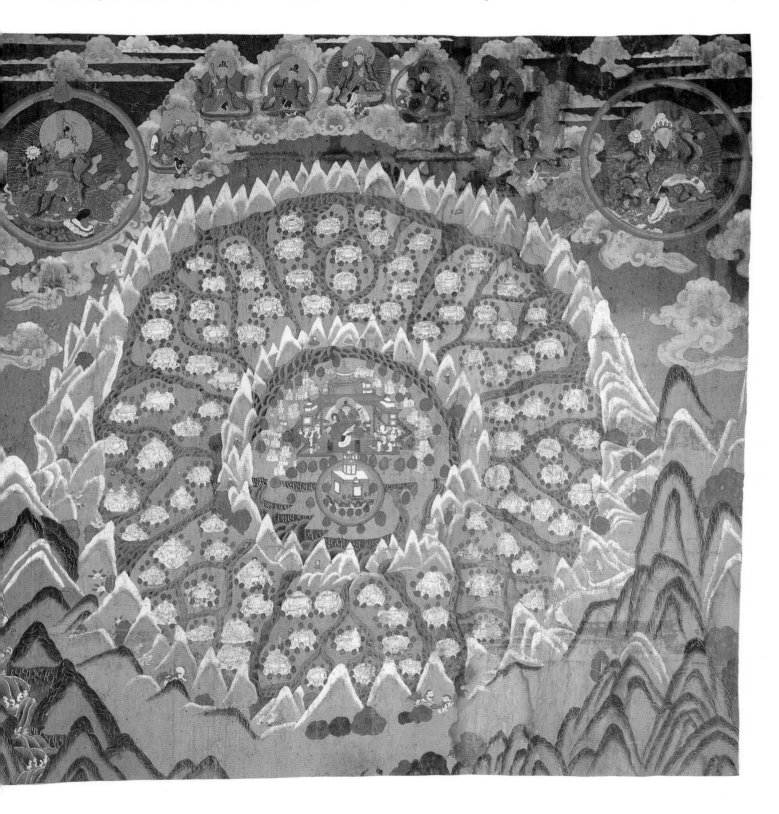

158
Offerings to Mahakala

Tibet

19th century

Tangka; gouache on cotton

39⅜ × 76¾" (100 × 195 cm)

Musée Guimet, Paris

This painting belongs to a specific iconographic genre called host of ornaments (T. *rgyan-tshogs*). These pieces were kept by monasteries in special protector chapels (*gonkang*) dedicated to the Dharmapalas. They represent the different offerings made to one or several of these deities during the special ceremonies designed to appease and propitiate them, particularly the fierce ones. In certain monasteries, rituals were periodically performed to renew the oath of submission of the local deities to Buddhism.

In these types of works the fierce deities are never represented. However, their attributes and attire allow us to identify them. Here, in the center of the

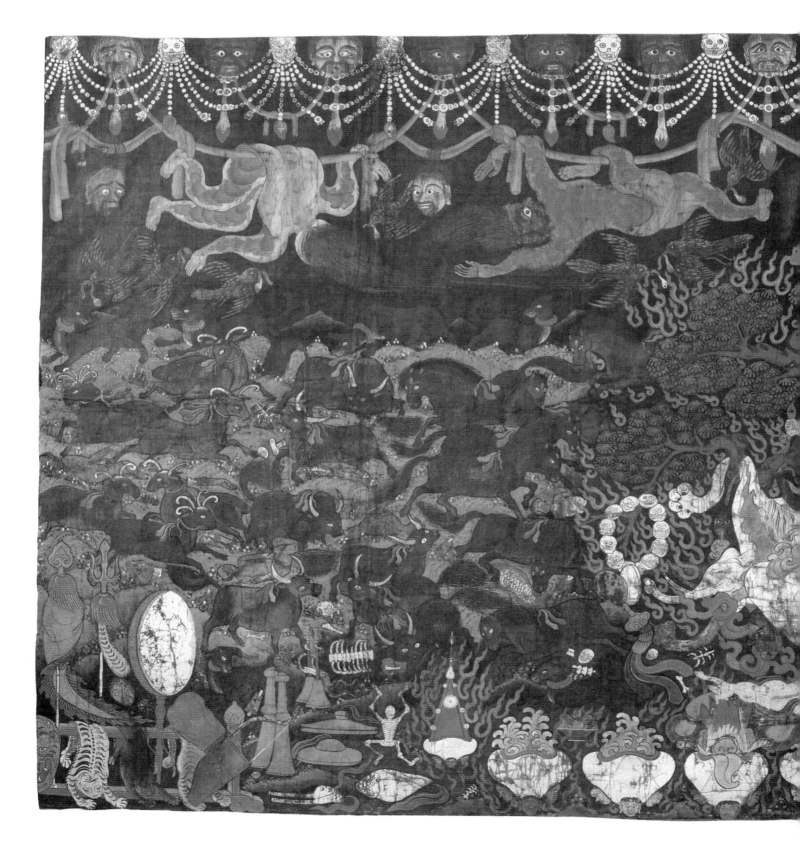

composition, are assembled attributes most often associated with Mahakala: vajra chopper and skull bowl, *damaru* drum, rosary of skulls, lasso and trident, unfurled elephant skin, outstretched Ganesha figure, and so on. Nine skull bowls are placed in the foreground. The two side cups contain sculpted offerings of butter and dough (*torma*). The seven larger ones in the middle are full of various gruesome offerings. The assorted musical instruments used during the ritual are arranged in the lower corners of the composition. On each side of the central configuration wild animals (horses, goats, yaks, and birds of prey), all in black, are part of the offerings presented to the deity. Skeletons and decomposing corpses are scattered on the ground of the charnel house inhabited by the deity. The upper section of the composition is decorated with severed heads and with heads in various stages of decay, which hold up an ornamental network made of flayed human skins and viscera, and pearls made of bone.

G. Béguin

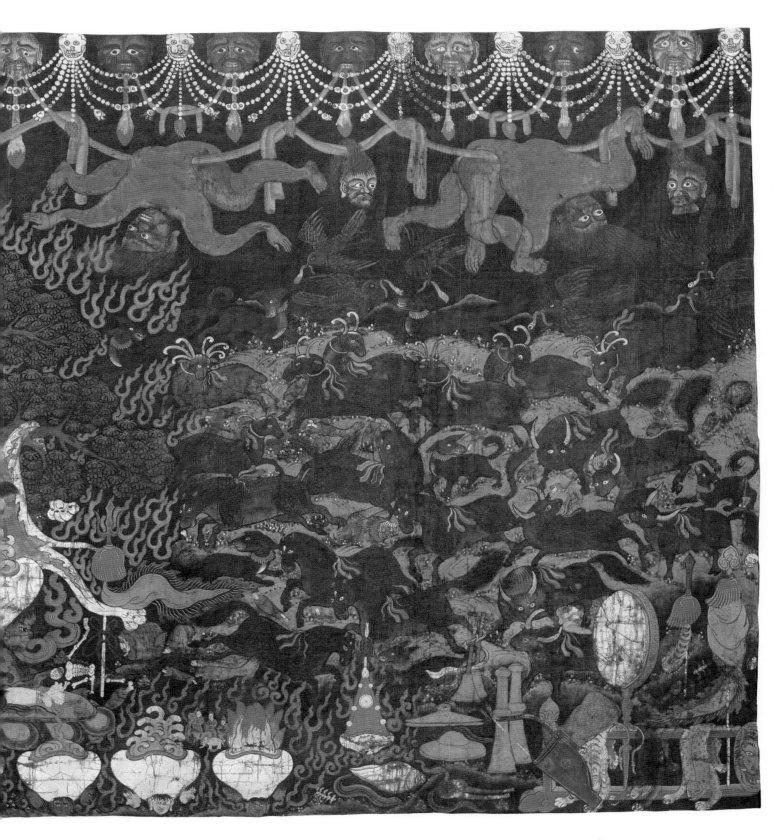

159
Offering Mandala

Northern China

18th century

Gilt brass

14¾ × 13¾″ (37.5 × 35.1 cm)

Musée Guimet, Paris

This model is the representation in durable material of configurations most often made of a variety of dough for the particular ritual of offering to Mount Meru and the entire universe. In Buddhist cosmography, Mount Meru stands in the center of the world. In certain monasteries this cere-mony takes place every morning. Of Indian origin, where it is known as *sumerumandalapuja,* similar images of Mount Meru have been described.

The ensemble, centered on an axis, is organized like a mandala, yet bears no relation to any esoteric ritual. In the middle stands Mount Meru crowned by a stupa containing the syllable OM. The first circle, on the upper level, is surrounded on each side by the sun, the moon, and six small dancing deities. In the second circle, the lower level, the eight auspicious signs of Tibetan Buddhism and several of the seven jewels of the Universal Monarch are laid out. Then, corresponding to the four directions, the four continents of the Indian cosmology are each represented by a group of three small pavilions. We find in succession: Purva Videha to the east, traditionally in the shape of a crescent; Jambudvipa in a triangular shape to the south; Apara Godaniya in a circular shape to the west; and finally, Uttara Kuru in a square shape to the north.

The shapes of the continents are engraved on the surface of the mandala. In the same way, wave designs are used to symbolize the oceans. The band around the drum is decorated with the eight auspicious signs, which alternate with the "face of glory" (*kirtimukha*) masks spitting garlands. An object similar to this can be found in the Palace Museum in Taipei.

G. Béguin

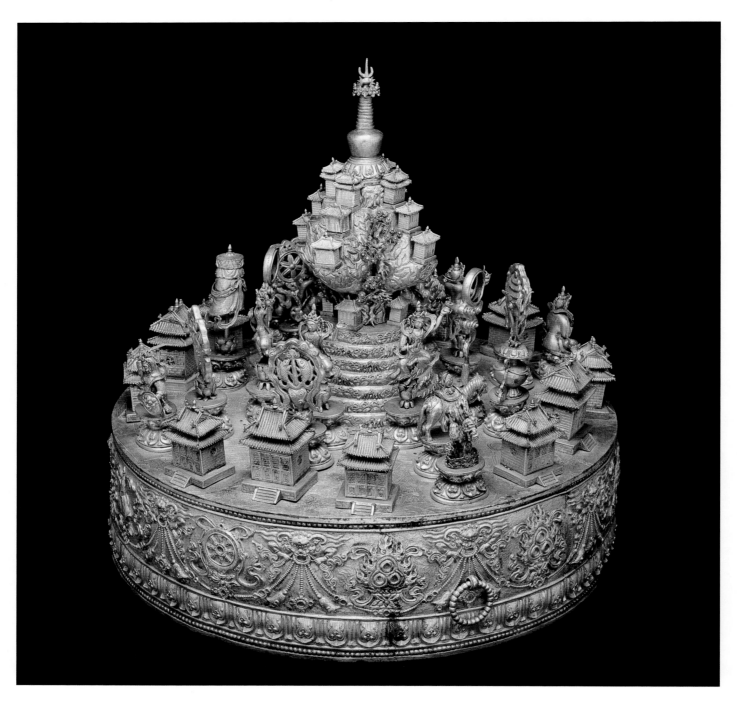

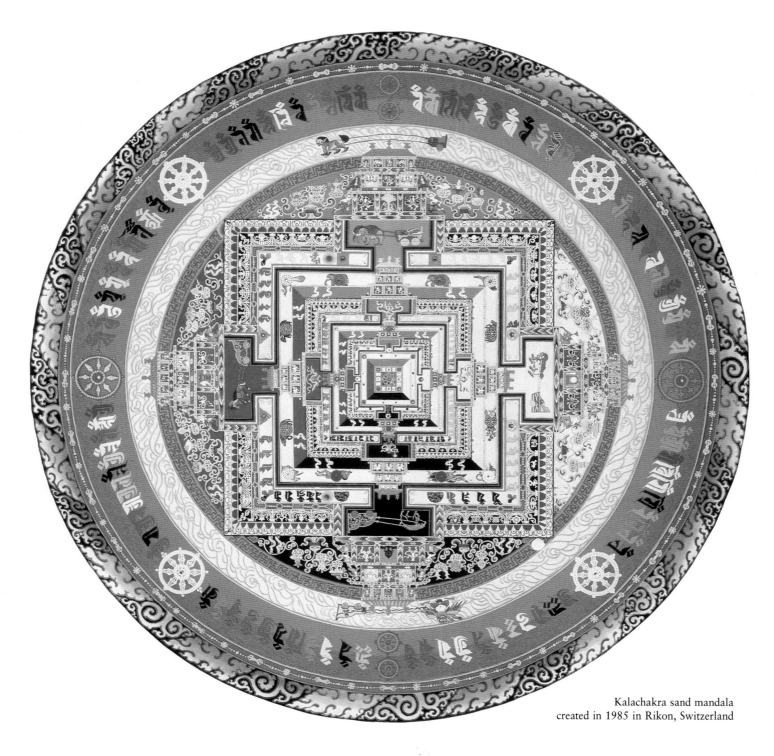

Kalachakra sand mandala
created in 1985 in Rikon, Switzerland

160
Particle Mandala of Kalachakra

Created by monk-artists of Namgyal Monastic
University, Dharamsala, India

Sand mixed with mineral pigments

Diameter about 84″ (213.4 cm)

Tibetans revere this ephemeral particle
mandala as a sacred object in itself. They
believe that it is healing to the ordinary
person, and is the subliminal trigger of the
visualization power of the initiate. They
believe that anyone who beholds it with
good will and faith will be reborn during
the Tibetan "New Age" time of fruition,
known as the Golden Age of Shambhala.
And, most generally, they believe that just
to behold it plants a genetic impulse
toward enlightenment in the mind stream
of any sentient being.

In texts, it is said that mandalas can
be painted, made of particles, made of
samadhi—of the subtle stuff of inwardly
visualized imagery—or made in the
visionary restructuring of the human
nervous system. The first two of these are
two-dimensional blueprints, and the latter
two are three-dimensional, imaginary
models of the spatial environment that is
the actual mandala. In the special case of
the Kalachakra, there is a fifth type of
mandala, the architectural, three-
dimensional mandala made of wood,
jewels, clay, or other substances. It is
believed that the two-dimensional
mandalas have a remarkable power to
intensify the power of the imagination of
the beholder, to stimulate the confident
creativity needed by the practitioner to
visualize the three-dimensional mandala.

In looking at such mandalas, it is
helpful to remember that they are models

for contemplative visualization practice. The adept develops the ability, through stabilized concentration and cultivated inner vision, to see him or herself as present within a perfected environment, a majestic palace made of pure jewel-light substance, surrounded by perfected companions, and completely secure from any ordinary disturbance or interference. This kind of ideal aesthetic environment is not considered an end in itself, but is only the physical situation needed for the perfection-stage yogas of unfolding the deepest inner sensitivities of the central nervous system.

Of the four main types of mandalas, the particle mandala is deemed most essential for the purpose of initiating or anointing practitioners, thus enabling them to engage in the study of the tantra. Tantric monastic universities in Tibet had to maintain the artistic traditions needed for making particle mandalas. The keys to the intentionally cryptic, precise geometrical instructions for the ground plan had to be memorized and transmitted from generation to generation. Monk-artists of talent had to be selected and trained. And the techniques had to be constantly refined.

While more research needs to be done on the early development of the particle mandala, it is likely that the earliest form in India was made by hand with colored chalks on the ground by a tantric guru as part of the ritual of initiation of his or her disciples. Sometimes it may have been a large, simple sacred circle, which would actually be entered during the ritual. Thus the actual forms of the mandalas must have been fairly crude, although the ritual itself infused each line with mystical energy and profound significance. The basic purpose is to create a sacred space within which the creative imagination can assert its power over substance. Within the world of the mandala, the guru is no ordinary human, but becomes indivisible with the Buddha paradigm, here the Buddha Kalachakra-Vishvamata couple. When initiants are brought in blindfolded, they are instructed to set aside the conventional imagination of the ordinary world and the ordinary self and to visualize themselves as the Kalachakra Buddha. The whole experience is enormously detailed, taking months to prepare and several days to perform, and

the initiant ideally should enter a prolonged contemplative retreat afterward.

At some point in the tradition in India, great masters such as the pandit Abhayakaragupta began the practice of making miniature mandalas, too small for persons actually to enter, but providing a vivid blueprint for a three-dimensional visualized mandala within which the ritual is imagined to be taking place. This miniature mandala, undisturbed by physical entrance, could be rendered in much greater detail, with much finer technique. It is fairly certain that this type of sand-particle painting was done with the fingers in India. Tibetan practitioners today demonstrate extraordinary skill in making delicate details using just their fingers. However, it seems that only in Tibet was the cone-shaped, fine-tipped funnel employed to make a line of extreme delicacy and flexibility. With this instrument and extreme patience and skill, Tibetan artists have been able to make these amazingly complex and vivid particle mandalas.

The Kalachakra mandala displayed here follows the same basic pattern as the Musée Guimet Kalachakra mandala painted on cloth (No. 156). In this Kalachakra mandala, the central chamber is a circle containing a vajra with an orange dot at the left, which symbolize Kalachakra and Vishvamata (Time Machine and All-Mother) archetype Buddhas. Around the circle are eight lotus petals, on which dots stand for the eight Shakti goddesses, symbolizing the compassionate energies of the enlightened heart. Other little flowers and dots refer to the other deities of the mind mandala-palace, the first of the three concentric buildings in the mandala. This building can be recognized by the three-storied arched gates that are depicted two-dimensionally, lying down outward from the actual doorways of the building. The next building, moving outward, is the speech mandala-palace, which has eight eight-petaled lotuses, on which stand the sixty-four speech goddesses, eight per lotus. Each group is ranged around a center, supporting a divine couple in which the female deity is the dominant partner. The third and outermost building, the body mandala-palace, has twelve, twenty-eight-petaled lotuses, on which the

three hundred sixty deities of the days of the years are dancing, each lotus supporting twenty-eight goddesses dancing around a deity couple in the center, with the male deity as the dominant partner. The lotuses represent the twelve months. Outside of that is a ring composed of various elements, on which eighty-eight mantric, Sanskrit seed syllables refer to eighty-eight deities associated with the planets, lunar mansions, zodiacal signs, and mythical pantheons common to a number of Asian civilizations. Sanskrit syllables standing in white galleries outside the walls of the speech and body palaces represent various offering deities. The entire mandala contains a divine community of seven hundred twenty-two deities, all of whom are emanations of the central archetype Buddha couple.

There are said to be three levels of interpretation of the Kalachakra symbolism, the "outer," the "inner," and the "other." The outer level relates to the entire universe as understood in ancient India, hence it incorporates many elements of Indian astronomy and astrology. Thus the mandala becomes a simulacrum of the universe, through which cosmic energies can be turned toward the good. The inner level relates to the subtle nervous system of the yogic practitioner, incorporating the inner landscape of nerve channels, energies, and essences. It thus serves as a template for the aesthetic restructuring of the enlightened sensitivity. The "other" level relates to the stages and practices of the path from ordinariness to Kalachakra Buddhahood.

The Kalachakra perfected universe or Buddha land is intended to provide the ideal symbolic environmental matrix, built from transcendent wisdom's five jewel-colored, laserlike energies, from which universal compassion can most effectively reach out to all sentient beings to nudge their histories in the direction of evolutionary progress toward complete enlightenment. As its name indicates, it is a Time Machine—the Sanskrit *chakra*, "wheel," is used by extension to mean "machine"—not in the science-fiction sense that it travels through time, but in the special sense that it is the artistic creation with which universal compassion turns time into a machine to produce the enlightenment of all sentient beings.

TECHNIQUES OF TIBETAN PAINTING AND SCULPTURE

Gilles Béguin

The area encompassed by Tibetan civilization has unique techniques of architecture, mostly conditioned by climate and available materials. They vary considerably from region to region, depending on the natural environment. In contrast, the visual arts, which are mostly at the service of the Buddhist faith, are heir to ancient traditions that arrived directly from the Indo-Gangetic plain or in stages from the kingdoms of Central Asia, Kashmir, and Nepal. Throughout all the periods of Tibetan Buddhist history, the inner decoration of monastic meeting halls and sanctuaries represents a major genre. In a descriptive or narrative form, Buddhist mural paintings and monumental sculptures make concrete for the devotee the fundamental theories of the religion, the doctrinal specificities of a religious order, and even the philosophical or apologetic traditions of a specific monastery. The smaller, more portable icons of the same themes that are made to hang on walls and to grace altars are the main forms of Tibetan art represented in Western collections.

The creation of a work of art is a religious act that brings merit not only to the one who commissions it but also to the artist himself. Each stage of creation is filled with assorted prayers and specific rituals of great length and complexity. The final ceremony of consecration, taken from ancient Brahmanic rituals, gives the work its final liturgical value. Sacred formulas, mantras, are often written on the backs of the paintings. And deposits of various grains, small scrolls of religious texts, and votive offerings of molded clay (*tsa-tsa*), among other things, are placed inside the statues.

The donor-patron must furnish all the necessary materials for the artist—for painters it is colored pigments, some of them having great value; for sculptors it is the required quantities and kinds of metal. Traditionally, the artist was not paid for his work; he could, however, receive presents. We know little about the organization of the workshops. A large number of the painters have been monks. Lay artists specializing in bronze work have had to travel according to the dictates of their commissions. The transportation of sacred images of all kinds, the donation of these to monasteries or their distribution among important people, the pious souvenirs brought back from pilgrimages, and the particular bonds uniting "mother houses" to their subsidiary branches brought about a great mixture of styles and techniques throughout the entire Tibetan world early in its development.

PAINTING AND TEXTILES

The evolution of mural painting in the Tibetan world can be followed from the end of the 10th century. The techniques seem to have changed very little over the centuries, although definite conclusions cannot be drawn in the absence of technical studies. Most of the mural paintings are executed over an earthen mixture. The wall receives several preparatory layers consisting of clay, chopped-up straw, and dung, each successive layer thinner than the previous one. This mixture has sometimes adhered badly to the wall and this weakness explains in part the deterioration of certain ancient painted murals. Drawings are prepared and mineral colors are applied *a secco* (to a dried wall surface) with methods identical to those used in portable paintings. From about the 15th century, details have been heightened by patterned gold leaf. Possibly from the 18th century on, a glossy lacquer has been applied to most of the panels. Another process, possibly of Chinese

origin, is used in Bhutan and Mongolia. There, the walls of sanctuaries are covered with huge canvases, their appearance in no way different from the traditional mural paintings executed directly on the dry plasterlike clay mixture.

In Tibetan, a painting that rolls up is called a tangka, "thing that one unrolls." Most of them are painted on a length of cotton, but one often finds rougher textiles such as hemp and linen (flax). When the artist does not have a single piece of cloth long enough for the desired painting, he sews on an additional strip, barely noticeable in the finished work. Cotton was often imported from India, and sometimes from China, as spun thread, and then woven into canvas at major centers such as Lhasa. Numerous examples reveal the local style of weaving to be close and even. Silk was used as a ground, a background support, only in Chinese monasteries practicing Tibetan Buddhism.

The tangka canvas is stretched tightly on a temporary but very sturdy framework by a system of crisscross lacing. The canvas is then prepared with sizing, to make the surface smooth. The composition of this sizing varies; it can contain gelatin, as well as other proteins and organic matter. When the surface of the canvas is of a suitable fineness, the following step is considered useful. The canvas receives a preparatory layer of chalk and of a more-or-less pure white porcelain (kaolin) clay, mixed into a paste with water and applied with a special knife. Once the surface dries, the painter polishes both the prepared side and the back with a small river-washed stone, or with a shell. He can then position the figures.

The painter first begins by tracing a network of fine geometric lines, diagonal and then secondary ones. He achieves this with the help of a thin string saturated with chalk and kept in a special leather pouch, or by use of a compass. The lines laid out on the painting surface correspond to diagrams specifically developed for each deity and for secondary figures. The proportions of the represented deities were codified by a tradition that was heir to ancient Sanskrit texts such as the *Aryamanjushrimulakalpa Tantra* and that was considerably enriched in Nepal and Tibet. There are two types of proportional measure: the large measures (*cha chen*) and small measures (*cha chung*), both related to specific parts of the human body. The drawing is executed with a graphite pencil; the weak adherence of the lines made this way allows for correcting mistakes and for making changes. For this part of the work the artist can be aided by anthologies of drawings or sketches. The oldest known one (now in a private collection in Calcutta), dating from 1435, is the work of a Nepali painter named Jivarama. As in paintings of Central Asia of the 5th and 6th centuries, certain repetitive images can be obtained by the use of pounced drawings (*tshags-par*), the desired silhouette being punctured through tiny holes. From about the 18th century, under the influence of China, entire compositions have been obtained by wood-block printing. The final drawing, redrawn in black or red, then disappears with the application of colors.

The pigments used are almost all of mineral extraction: blue from azurite, green from malachite, reds and yellows from cinnabar, vermilion, realgar (arsenic disulfide), and orpiment (king's yellow, arsenic trisulfide), orange from minium (red lead), white from chalk, and gold. Only black is of organic origin, made from carbonized wood or graphite. These pigments are ground in a small mortar, dissolved in water, and then linked by a colloidal substance. They are then applied by a whole series of paint brushes of differing sizes and textures to the ground, which in some cases is gold or black, rather than white. The painter creates volume for each of the parts by the application of lightened or adulterated tones. Blue from indigo and red from lacquer of insect origin are particularly used for this kind of work. On the whole this method is comparable to that of Western gouache. The technique is originally Tibetan and is related to other commonly used Tibetan techniques, while the principles of composition seem to be of Chinese origin.

The lines that contour the forms and the details, such as the motifs of the clothing, are executed at the end. The last operation consists of drawing the eyes of the figures. These are inscribed according to eight types of procedures. "Opening the eyes" (*spyan-dbye*) of the divine figures is an integral part of the consecration ritual.

Painted tangkas are the most common ones, but there are also tangkas executed with appliqué and embroidery, or with other textile techniques. The "embroidered application," more commonly known as "appliqué" (*dras-drab-ma, gos-sku*), is a particularly Tibetan style, as testified in pre-17th-century texts. Fragments of cloth—most often silks, traditionally imported from China or even from India—are cut into the desired shapes and colors and juxtaposed to form a kind of mosaic. The pieces are either sewn onto a background or to each other. Rigid bands of golden binding, made of leather or sometimes of horse or yak hair mixed with threads of gold, hide the seams and circle the contours. Certain details are embroidered or even painted on. A frame or border similar to those of painted tangkas gives further support for the finished work.

This procedure has been used for the preparation of both pious images and ornamental works, especially for the colossal tangkas hung on the occasion of certain celebrations over the facades of the monasteries and almost entirely covering them. In the absence of written materials, even relative dating of these works remains largely hypothetical. Most of the preserved pieces do not date earlier than the middle of the 18th century, and their place of manufacture is generally debatable. They were made in several places: in Gyantse and in other centers of southern Tibet, in Lhasa in the central regions of Tibet, in Sikkim, and in Bhutan. Also, this technique experienced some important developments in Mongolia.

Embroideries with Tibetan Buddhist subject matter were executed in the far eastern part of Tibet and in China and were exported. Their technique, often of great virtuosity, cannot be distinguished from other embroideries of Chinese manufacture. The silk tapestry or *kesi* (literally "engraved threads") is essentially a Chinese technique, often used for the preparation of ceremonial clothing or for the "mandarin squares" (*pufang*) that indicated the owner's rank. From the Song dynasty (960–1279) through the Yuan period (1279–1368) and the Ming dynasty (1368–1644), Buddhist tapestries of enormous size were made with this technique, often enhanced with gold and silver threads. In later works, the technique loses the virtuosity of the older *kesi*, which had up to 275 threads per inch of chainlike rib. Their huge size partly accounts for the slackening, as does the use of highlights of paint for certain details, which is quicker and less painstaking. This technique, frequently seen in works from the monasteries of northern China, is unknown in most of Tibet itself.

The divine image, once finished, can begin to fulfill its liturgical role. The earlier paintings, like the Indian or Nepali ones, probably had no framing. Some simple thin rods of wood allowed the tangka to be rolled up. To our knowledge no painting in this state has survived. Since the 14th century, it has been customary to sew a rectangular piece of cloth across the top and the bottom, thus allowing the tangka to be more easily rolled up. The lateral borders remained without frames but could be protected by a simple strip of cloth. The lower rod, longer on one side, could receive some inscriptions, allowing for an easy classification of the rolled-up paintings when kept stored on shelves.

Paintings earlier than the 16th century are of a square or rectangular format, always greater in height than in width. With time the format became more variable. The central section containing the icon is surrounded by two thin bands of yellow and orange-red silk representing the mystic rainbow (*ja-ser, dmar*) that emanates from the divinity depicted. This surrounding frame is sometimes just painted on instead, most probably as a way to economize. The whole is then framed in a setting made of cloth, often done with Chinese silks, and then backed with a thicker fabric. In some pieces, another piece of fabric appears on the lower section of the mounting. It is of different color and is called "the door of the tangka" (*tang-sgo*); it seems to play a certain role during meditation sessions. A tangka is hung by a fabric or leather string, and a thin veil (*zhal-khebs*), decorated with splashes of color and sewn on only at the top, protects it from dust and from the smoke of butter lamps. This cover is pulled up during ceremonies. A rod whose extremities are decorated with metal ferrules, and a second wooden rod are passed through the hems, allowing the tangka to be rolled up from bottom to top.

SCULPTURE

As with other artistic techniques, Tibetan sculpture is essentially inspired by religion. The variety of materials used includes *pisé* (compressed earth), clay, wood, stone, and metal, decorated with designs, paint, gold, and gems. As in the rest of Central or northern Asia, the Tibetans have made great use of molded earth, which is dried and then covered with a richly painted surface. The inside of these sculptures is made of a core of straw covered with layers of thinner and thinner *pisé* and clay. Most works made as architectural decor were made in this way up to the 17th century. Sacred seals (*tsa-tsa*), made out of clay from a particularly venerated site and sometimes covered with ashes of a holy person, are still made and used today.

Wood, a relatively costly material, was used primarily for the construction of certain richly carved architectural elements, such as the internal supports of buildings, and door and window frames. A number of small-sized statues in wood still exist, in particular, works inspired by well-known pieces, such as the Bodhisattva statues in the chapel of Lokeshvara in the Red Palace of the Potala, originally brought from India and Nepal.

Stone is used only marginally. Nevertheless, it is important to mention the sculpted bases and the head stones of the monumental steles from the period of the Religious Kings (7th to 9th century), as well as the monumental stone low reliefs of Western Tibet and Ladakh (ca. 10th to 16th century). The colored low reliefs that decorate some of the passes not far from Lhasa that are frequently traveled by pilgrims, and those that still cover the colossal rocks behind monasteries such as Sera or Drepung, show a certain lack of sophistication. Votive statues in very high relief have only recently become known, including several still preserved at Sakya monastery. Representing protector deities, Dharmapalas, and sometime female deities with Bodhisattva rank such as the Pancharaksha goddesses, they reveal a strong Nepalese influence and could date back to the 14th to 15th century. Another type of relief work is engraved pieces of slate or slabs of small size put into the masonry on the exterior of buildings, like the low reliefs found on the inside of the parapet that borders certain terraced roofs of the Potala dating from the 17th century. This kind of relief is also seen in Bhutan.

Metal has been the preferred material of Tibetan sculptors for centuries. The two techniques used primarily have been lost wax casting and repoussé, hammering and shaping. Most of the smaller statues are cast using the lost wax technique. The figure is initially sculpted in wax over a compact core. It is then carefully covered with clay and then with a heat-resistant clay. Molten metal is poured in through channels to the inside of the mold and takes the place of the wax, which melts and flows out through vent holes. The different elements of a statue—the stand, the pedestal, the figures, arms, multiple heads, and attributes—are made separately and fastened together with metal clasps, dovetails, or rivets. Pieces of lesser importance can be cast horizontally ("on the stomach") to allow the metal to spread itself out equally across the front of the statue. Certain "archaic" bronzes were made in one piece; the core was shaped around a metal armature, schematically reproducing the silhouette of the desired figure. Sometimes the casting channels and the exhaust vents were kept as structural bridges.

A Tibetan text studied by G. Tucci (see Tucci, 1959) uses a double classification for metal sculptures that mixes stylistic considerations with a typology based on the alloys (*li-ma*) used. This, however, is difficult to use as a basis for a coherent classification of Tibetan sculpture. One can distinguish Indian sculpture from Central Asian, Uighur, Tibetan, ancient Chinese, and modern Chinese styles.

The composition and the color of the alloys vary according to the provenance. The term "bronze" is often used for Tibetan cast sculptures, but it is incorrect in many cases. Bronze is normally an alloy of copper and tin, sometimes with a little zinc or another metal in addition, and occasionally almost exclusively copper. The Tibetan word *li* designates all sorts of metals and alloys. In fact, the most varied mixtures were used. Metals from diverse origins, more or less refined, were mixed with old metal objects, old jewelry, and sometimes old statues smelted for religious reasons. The heating at a relatively low temperature did not allow for a perfect mixture of the alloys. It is not rare to find significant variations in the proportions of the components in different parts of the same statue. Laboratory analyses, including some done at the British Museum (Oddy and Zwalf, 1981) and by the Laboratoire des Musées de France (Béguin and Liszak-Hours, 1982), have allowed us to better understand the Tibetan alloys. The studies, though sketchy, do not seem to support the Tibetan literary traditions. Brass, an alloy of copper and zinc, is largely used. By varying the amounts of zinc, the smelters obtained a variety of tones ranging from a light beige with a silvery reflection to a chocolate brown

called by the Tibetans *smug,* "liver color." Certain statues are made with a relatively pure copper, like many of the Nepali ones. Laboratory studies up to now have not revealed the use of particular sacred alloys; that is, the specific use of five or more metals. It is possible that, traditionally, several components were used symbolically. Small metal bars of different metals sandwiched together are known to have been made and attached to graters. When a religious sculpture was being cast, tiny particles of the bar's mixture would be grated into the primary alloy, infusing the finished work with the special properties attributed to each of those elements.

There are not enough studies of sculptures from the imperial workshops of the Beijing area to know precise details on their mode of fabrication. Complex alloys of a perfectly homogeneous composition were used for both the plinths and the movable figures. This suggests that both parts were made in the same workshop, even when there are variations of size or style. Three pieces from the Ming dynasty at the Musée Guimet contain about 15 percent zinc. This proportion becomes higher than 30 percent for most of the works made later than the 15th century. From the end of the 18th century the use of molds in the Beijing workshops increased with a more or less visible welded seam joining the front to the back of the statue.

Tibeto-Chinese and Mongolian bronzes are unusual because they have a more homogeneous metallic composition, regardless of their mode of manufacture. Their technology is much more evolved and more homogeneous than the pieces executed in Tibet itself. The Tibetan works are often of irregular thickness, frequently need repair, and often have infiltrations of metal in cracks in the core.

Larger works or those attached to architectural decor are executed in repoussé. Slabs of copper are either hammered from the inside or, more rarely, pounded out over wooden forms, then riveted and held together by supports. Reliefs and halos, as well as most of the metallic sections of the interior decoration of monasteries, are made this way, as are some large statues, which are held up by inner wooden frames.

Both cast and repoussé sculptures are finished with a chisel: the floral ornaments of the clothing and plinths, as well as facial expressions. In early works, the simplicity of the material belies the virtuosity of the techniques. Sculptures are ornamented by inlay damascening, by inlaying with niello, and by incrustation or inlaying of copper by hammering. These methods are originally from India, found in Pala and Sena art of the 8th to the 12th century, as well as in Kashmir.

Many statues are gilded. An early method (*tsang-ser*) consisted of using a brush to apply gold mixed with a resin or even, according to certain texts, with honey. It has not been established when gilding with mercury (amalgamated gilding, *tsa-ser*) was introduced in Nepal and Tibet, the process having been used earlier in China and India. Gilding over lacquer is found in certain Tibeto-Chinese works of northern China. In Mongolia, and also in Tibet, some metallic statues are completely painted, but usually just the face and hair are highlighted with paint. Some statues are inlaid with turquoise or other semiprecious stones, an influence from Nepalese practice. Most often hollow, the statues receive a consecrational deposit, sometimes relatively voluminous, kept in place by a piece of metal under the base and often decorated by two crossed vajras (*visvavajra*), marked with a stylized "auspicious" sign in the middle.

Glossary

Abhirati. One of the important Buddha lands or Pure Lands in Buddhist cosmology. It is described in the Vimalakirti Sutra, and is the abode of the Buddha Akshobhya.

adamantine. An adjective used to translate vajra, the Sanskrit word for thunderbolt, or diamond. It refers to something overwhelmingly powerful and durable, which can usefully symbolize ultimate reality and by extension direct knowledge of ultimate reality. *See also* vajra.

Akshobhya. Literally, Unshakable, he is the lord of the Vajra clan and occupies the eastern direction in many popular tantras, or the center in the advanced Unexcelled Yoga tantras (switching with Vairochana). Akshobhya represents the transmutation of delusion (or hate) into mirror wisdom (or reality wisdom), and the purity of the aggregate. His color is white (or blue). *See* Abhirati; Five Transcendent Buddhas.

Amitabha. Literally, Infinite Light, he is the Transcendent Buddha of the west, and lord of the Lotus clan. He represents the transmutation of lust into discriminating wisdom, and the purity of the conceptual aggregate. His color is ruby. Associated with the Buddha Amitayus (Infinite Life) and the Bodhisattva Avalokiteshvara, he is widely known outside of tantric Buddhism as the Buddha of the Blissful Pure Land in the west (Sukhavati), and is the object of devotion of the numerous Pure Land believers throughout Asia. *See also* Five Transcendent Buddhas; Sukhavati.

Amoghasiddhi. Literally, Unfailingly Accomplished, he is the Transcendent Buddha of the north, and lord of the Action clan. He represents the transmutation of envy into all-accomplishing wisdom, and the purity of the performance aggregate. His color is emerald. *See also* Five Transcendent Buddhas.

Apocalyptic Buddhism. *See* Three Vehicles.

archetype; archetype deity (T. *yi-dam*; S. *ishtadevata*). An embodiment of enlightenment, a Buddha form, used by a tantric practitioner in contemplation to model his or her emotions, insights, and vows into optimal function. Certain such forms were instrumental in the enlightenment experiences of many Great Adepts and have been developed for later use in groups of texts, also called tantras and tantric commentaries.

Arhat. A Buddhist saint, one who has fully realized selfless reality, thus being assured of attaining nirvana at death. This is the ideal type of the Buddhist Individual Vehicle, which does not focus on the distinction between Arhat and perfect Buddha.

asana. The Sanskrit word for pose, or posture. **Pratyalidhasana.** The warrior posture, as adopted by the fierce deities. **Bhadrasana.** The throne-sitting pose, called the benevolence posture, with two feet down on the ground, as is characteristic of the Bodhisattva Maitreya; his sitting style is called "good" (*bhadra*) as it represents his willingness to get up and go forth into the world for the benefit of beings. **Padmasana.** The lotus posture, the cross-legged sitting posture used in meditation. **Lalitasana.**

Posture of royal ease, with one leg drawn up akimbo, one leg relaxed and extended, as the princely Bodhisattvas sit. **Vajrasana.** The diamond posture, the same cross-legged meditation posture as above, but in particular that pose as adopted by the Buddha under the bodhi tree during the final day before his enlightenment.

Atisha. Born a prince of Bengal, in 982 CE, he was a famous Buddhist scholar and spiritual master. He is credited with a seminal contribution to the renaissance of Buddhism in Tibet in the mid-11th century. His disciple Drom Tonpa ('Brom sTon) was the founder of the Kadam Order, forerunner of the Geluk Order.

Avalokiteshvara (T. Chenrezi). The Bodhisattva of Compassion, he is one of the best-known deities in Asian Buddhism, and the patron deity or archangel of Tibet. Avalokiteshvara appears in many different forms, with varying numbers of limbs, sometimes mild and sometimes fierce.

Bardo. *See* between.

Beatific Body. *See* Three Bodies.

between (T. *bar-do*). Buddhists consider life to be continuous after death, with a between-state, a dreamlike realm in which the transmigrating soul has various experiences between death and subsequent rebirth.

Bhaishajyaguru. *See* Medicine Buddha.

bodhi. The Sanskrit word for enlightenment, a complete and precise understanding of the nature of reality and a total sensitivity to the condition of others; perfect wisdom and universal compassion. *Bodhichitta* is the spirit of, or will to, enlightenment. When a person develops the universal, messianic motivation of wishing to become someone who can perfectly satisfy the needs of all beings, he or she conceives this spirit, thereby becoming a Bodhisattva. A Bodhisattva is a person who lives by the spirit of enlightenment life after life, dedicated to becoming a Buddha for the sake of all beings. Sometimes even after reaching that goal, a Buddha will emanate incarnations into the world as Bodhisattvas, in order to get nearer to sentient beings and help them more effectively. The celestial Bodhisattvas such as Avalokiteshvara, Manjushri, Tara, Vajrapani, and Samantabhadra may be considered Buddhas acting as Bodhisattvas in order to help sentient beings.

Bon. The other major, organized religion in Tibet besides Buddhism. Based on pre-Buddhist religious ideas, some shamanistic, some perhaps of Iranian descent, Bon created a large literature, a complex institutional structure, and a systematic path of practice, all in close parallel with Tibetan Buddhism.

Buddha. One who has become perfectly enlightened. *See also* bodhi; Shakyamuni; Tathagata.

central regions of Tibet. The regions in south-central Tibet comprising the areas of Ü and Tsang.

Chakrasamvara. *See* Shamvara.

Chan. The Chinese Buddhist precursor of (J.) Zen, the contemplative tradition known for its sudden-enlightenment theory and practice.

Chögyal. *See* Dharma King.

chöten. See stupa.

compassion. Sensitivity to others' suffering and the will to alleviate it, it is the central virtue of Universal Vehicle Buddhism, the natural outgrowth of the wisdom of selflessness. The basic goodwill of all living beings, it has various degrees, as it is released by greater degrees of wisdom. Its highest degree is universal compassion, a loving will toward all beings as if each were one's only child.

Dakini. Dakas and Dakinis were originally fierce male and female angelic deities in popular Indian religion, associated with the goddess Kali in Hinduism and with the tantric adepts in Buddhism. In Indo-Tibetan Buddhism, the Dakinis are more prominent, with both mundane and transcendent types, and are associated with the female deities called Yoginis.

Dalai Lama. "Dalai" is Mongolian for "oceanic," and "Lama" is Tibetan for spiritual master. Sonam Gyatso, a reincarnate lama of Drepung monastery, was given this name as an honorific title by Altan Khan of the Mongols, and it was applied retroactively to his two immediately previous incarnations. From 1642, the Great Fifth Dalai Lama, Losang Gyatso, was invested with secular and spiritual authority over Tibet, which subsequent Dalai Lamas exercised until 1959, when the Fourteenth Dalai Lama fled into exile from the Chinese occupation. He still heads the Tibetan government-in-exile, in Dharamsala, India.

damaru (**S**). A small, double-faced hand drum with two clappers on strings that makes a rattling sound when it is rotated. A miniature form of a shaman's drum, its sound is a symbol of impermanence, an offering to all Buddhas and deities, and a celebration of the mystic teachings of the tantras.

Dharma. This ancient Sanskrit word has many meanings, ranging from thing, through religion, teaching, and truth, to ultimate reality and nirvana. Usually it refers to the Teaching that holds (S. *dhr*) beings apart from suffering—that is, the Buddha's Dharma.

Dharmakaya. The Truth Body of Buddha. *See* Three Bodies.

Dharma King (**S.** Dharmaraja; **T.** Chögyal). A Buddhist King who formally places Buddhism at the center of the life of his kingdom. It is a title of legitimation that Asian Buddhist kings and emperors made considerable effort to acquire. During the imperial period in Tibet, the three most famous Dharma Kings, called the Religious Kings, were the 7th-century Songtsen Gambo, the 8th-century Trisong Detsen, and the 9th-century Tri Relwajen.

Dharmapala (**S.**). Fierce deities who protect (S. *pala*) the Buddha Teaching, the Dharma. In Buddhist myth, most were once mundane, in the sense of egocentric, deities or demons. They were tamed by emanations of great Bodhisattvas, and their fierce powers were turned to the defense of the good. Mahakala, Penden Lhamo, Yamaraja, Pehar, and so forth are well-known

Dharmapalas. *See also* Mahakala; Penden Lhamo.

dorje. See vajra.

Drepung monastery. The largest monastery in Tibet, founded in 1416 by Chamchen Chöjey. The name comes from the Dhanyakataka stupa in southern India, where Buddha is believed to have first taught the *Kalachakra* system.

Dzogchen. The Tibetan name means Great Perfection. It is a specific meditation practice on the highest level of Buddhist tantra, and by extension a general name for the entire meditational system, usually associated with the Nyingma Order.

Eastern Tibet. The eastern regions of Tibet, comprising the areas of Kham and Amdo.

Emanation Body. *See* Three Bodies.

Esoteric Buddhism. *See* Three Vehicles.

Five Transcendent Buddhas. The group of Transcendent (Tathagata) Buddhas, known in the West as Dhyani (Contemplation) Buddhas, a term not used in the Indo-Tibetan tradition. They are the primary lords of the five Buddha clans: the Vajra, Buddha, Jewel, Lotus, and Action clans. The personifications of the five wisdoms, mild archetype deities heading the five Buddha clans. *See* Akshobhya; Amitabha; Amoghasiddhi; Ratnasambhava; and Vairochana.

Five Wisdoms. The five wisdoms are the primary energies or elements of the universe as understood by the enlightened mind. They are the ultimate-reality-perfection, mirrorlike clarity, equalizing, discriminating, and all-accomplishing wisdoms; the colors associated with them are blue, white, yellow, red, and green; their elements are ether, water, earth, fire, and air; and they are the transmuted poisons of hate, delusion, pride, greed, and envy.

Four Heavenly Kings. These are deities who live on the upper slopes of the axial mountain, Meru or Sumeru, in the ancient Buddhist cosmology. Sometimes called the Guardian Kings of the Directions, they are Virudhaka (king of the south), Virupaksha (king of the west), Vaishravana (king of the north), and Dhrtarashtra (king of the east). *See* Vaishravana.

Four Noble Truths. The basic facts about ignorance and enlightenment, suffering and freedom, set forth by Shakyamuni Buddha in his first teaching. They are the Noble Truths of 1) suffering, the misery of unenlightened living; 2) origination, the source of suffering in ignorance, the addictions, and negative action; 3) freedom, liberation from suffering through awakening to one's reality; and 4) the path, the way to freedom, consisting of the three spiritual educations—moral, meditative, and intellectual.

Ganden monastery. East of Lhasa, it was founded by Tsong Khapa in 1409.

Ganesha. An Indian deity of literary learning and also of wealth. The son of Shiva and Parvati, he has a human body and an elephant's head. *See also* World Gods.

Gautama. *See* Shakyamuni.

Geluk. The Tibetan Buddhist order commonly traced to Tsong Khapa's renaissance of the teachings of the Kadam Order. **Gelukpa.** A person or text, monastery, idea, and so on, belonging to the Geluk Order.

Great Adept. The ideal type to be achieved by the tantric practitioner, the Great Adept (in Sanskrit, Mahasiddha), is one who has become a perfect Buddha through the quick path of the tantras. He or she is believed to be unbound to any particular form of life and capable of manifesting anywhere in any way, yet still remaining in his or her coarse body to work for the benefit of local sentient beings.

Guge renaissance. A period of florescence of the Guge dynasty in Western Tibet, from the 15th to the mid-17th century, as influenced by the spread of the Geluk Order from the time of Tsong Khapa around 1400. There was an energetic wave of temple and monastery building with remarkable wall paintings and sculptures at Tabo, Tsaparang, and Tholing.

Guhyasamaja. The most important Father tantra in the Unexcelled Yoga tantra category, its study and practice was a specialty of Marpa and later of Tsong Khapa.

Gupta period. Ca. 320–500CE during the rule of the Gupta monarchs in Central India. A period of high cultural achievement that saw the flourishing of Buddhism and its arts.

Heruka. As a general term, it means a herculean, heroic deity form, adopted by Buddhas when they express their breaking through of ignorance as a fierce deed. It translates in Tibetan as Blood Drinker (*khrag-'thung*), which is explained as a personification of wisdom's consumption of the lifeblood of ignorance.

Hevajra. An important Mother tantra of the Unexcelled Yoga tantra category; it has been most favored by the Sakya Order.

Hinayana Buddhism. *See* Three Vehicles.

idealistic. A term used here in writing about art to describe the expression of the highest or ideal norm, generally implying perfection.

Indra. The Vedic god of war, storm, and thunder, holder of the vajra thunderbolt. In the Buddhist-Hindu period, he became known as king of the gods of the sense realm, ruling over a heavenly city atop the Indian analogue of Mount Olympus. *See also* vajra; World Gods.

ishtadevata. See archetype.

Jataka. Former life stories of the Buddha Shakyamuni, when he was still a Bodhisattva, presented in animal lives, among the gods, and as various kinds of humans.

Kadam. A Tibetan Buddhist order, founded by Atisha, that developed into the Geluk Order. **Kadampa.** A person or thing associated with that order.

Kagyu. A Tibetan Buddhist order founded by Marpa, Milarepa, and Gampopa, tracing its origins to the Indian Great Adepts Tilopa and Naropa. It developed four main orders and

eight suborders, including the Karma, the Drigung, the Druk, the Taklung, and the Pakmodru Kagyu orders. **Kagyupa.** A person or thing associated with that order.

Kalachakra. Literally, Wheel of Time or Time Machine, it is an important Mother tantra in the Unexcelled Yoga tantra category. It is unique among tantras in that it contains an elaborate cosmology, including an apocalyptic theory of history, referring to a great war at the end of history, and ending with the triumph of Shambhala, a mysterious land of Bodhisattvas. *See also* Shambhala.

Kanjur. A major section of the Tibetan Buddhist canon, consisting of the words of the Buddha, attributed directly to Shakyamuni, translated from Sanskrit, and collected in 108 volumes, including Vinaya (Discipline), Prajnyaparamita (Perfection of Wisdom), Avatamsaka (Ornament), Ratnakuta (Collection of Jewels), Sutra, Tantra, and so on. *See also* Tanjur.

kapala. A skull bowl used as a container of the elixir of immortality in tantric rituals and carried by tantric deities, it symbolizes enlightenment's power to transmute even death into infinite life.

Karma Gadri. A style of Tibetan painting said in Tibetan texts to have developed in the second half of the 16th century and to have flourished in the 17th and 18th centuries. It is noted for incorporating Ming dynasty painting styles. Most of the artists of this school were Karma Kagyupas in the Kham and Amdo regions of Tibet.

Karmapa. A suborder of the Kagyu Order of Tibetan Buddhism, and the reincarnate Lama who heads it. The first Karmapa was Dusum Kyenpa (Dus gSum mKhyen Pa), ca. 1110–1193, followed by Rangjung Dorje (Rang 'Byung rDo rJe) and Mikyö Dorje (Mi bsKyod rDo rJe). The Karmapa Lamas have been very influential in Tibetan history and continue today to be honored among the very highest incarnations.

kesi (Ch.). A silk tapestry weave using several colors. At each change of color, the threads are doubled back, creating a selvage border and a slitlike space surrounding each discrete color area. Known in Egyptian Coptic and Near Eastern works of Roman and Byzantine times, this technique reached a high point of development in the silk tapestries of China and Central Asia, especially from the 12th to the 14th century.

khatvanga (S.). A ceremonial staff carried by Mother tantra deities in particular, it is crowned by a carving of three human heads—fresh, dried, and a skull—symbolizing the conquest of the three poisons of lust, hate, and delusion. It is topped either by a vajra, symbol of compassion, or a trident, symbol of the mastery of the threefold central channels of the yogic subtle nervous system.

Kubera. An important Tibetan wealth god in his own right, he is sometimes in the retinue of Vaishravana and sometimes operates independently, which at times causes him to be confused with Vaishravana. *See* World Gods.

Lotsawa. Literally, "eye of the people," that is, a translator. The scholars who translated the Buddha's Teachings from Indian languages were highly honored by Tibetans, who gave them this title and cherished them as their very eyes to look out from Tibet into the higher culture of the holy land of India, where the Buddha had dwelt and taught his Dharma.

Mahakala. Originally a demon, he was tamed by Manjushri and Avalokiteshvara and turned into a fierce protector of Buddhism, popular among all Tibetans. He has many forms, the most common having one face and six arms.

Mahasiddha. *See* Great Adept.

Mahayana Buddhism. *See* Three Vehicles.

Maitreya. One of the foremost Bodhisattvas, Maitreya is believed to reside in Tushita (T. Ganden) Heaven, waiting until the time, far in the future, when he will incarnate on earth as a Buddha. In the meantime, he is believed to exercise his compassion in myriad ways to benefit beings.

mandala. Literally, a "sphere of nurturance of the essence," a mandala is a magical and sacred realm, created by the artistry of enlightened compassion in order to nurture beings' development toward enlightenment. Mandalas are the perfected environments of the Buddhas, built on the foundation of their perfect wisdom, just as the ordinary universe is built on the foundation of ignorance. Two-dimensional geometric mandalas in paint and sand are blueprints for three-dimensional architectural and cosmological environments.

mandorla. A large halo painted behind figures, encompassing the body and head haloes and conveying the overall spiritual aura of the figure or figures.

Manjushri. The Bodhisattva of Wisdom, he takes many forms. The most characteristic one is a sixteen-year-old youth, symbolizing that Buddhist wisdom is the clear knowledge of reality, critical and penetrating, not merely a venerable resignation or a heightened common sense accumulated from long experience. His attributes are the sword of wisdom and the Prajnyaparamita Sutra.

mantra. Literally, "protection of the mind," a mantra is a sacred letter-form and sound that contains the genetic essence of an entity and makes it accessible to the mind. It is the essence of the creative word, the primal sounds that give shape to the relative reality filling the ultimate reality of the void.

Medicine Buddha. According to a Mahayana sutra, the Buddha transformed himself into a deep blue Buddha, emanating healing rays of light, and taught a vast assembly of men and gods the science of medicine. The Buddhist orders valued medicine to alleviate suffering and prolong human life, to improve the human opportunity to attain enlightenment. The Medicine Buddha (Bhaishajyaguru) was worshiped in many Buddhist countries as the patron of medicine and healing and the archetype deity of all physicians.

Messianic Buddhism. *See* Three Vehicles.

Milarepa, Mila (1040–1123). The most popular Tibetan folk hero, he lived as a cotton-clad ascetic in the Himalayan heights. A singer of illuminating songs, he is believed to be the first ordinary Tibetan to have attained complete enlightenment in a single lifetime. He is famous for rejecting conventional modes of behavior.

Ming. A major native Chinese dynasty from 1368 to 1644.

Monastic Buddhism. *See* Three Vehicles.

mudra. The Sanskrit word for a sacred gesture symbolically expressing inner wisdom, in tantra it can also refer to a female consort for yogic practices that harness sexual energies to the path. *Abhaya mudra.* The gesture of fearlessness called the fear-not gesture, with the right hand held open in front, with palm forward and fingers pointing up. *Dharmachakrapravartana mudra.* The teaching gesture, each hand held with thumb and index fingers touching and the other three fingers upraised, usually with the two hands touching each other in front of the heart center. *Dhyana mudra.* The contemplation gesture, either one or both hands held flat in the lap, with palm up. *Trisharana mudra.* The Three Refuge gesture, using a hand position like the teaching or analytic gestures, with the emphasis on the three upraised fingers, representing the three refuges of Buddha, Dharma, and Sangha. *Tarjani mudra.* The threatening gesture, with either hand held forward in a fist, with the index and little fingers raised up. *Varada* (or *Vara*) *mudra.* The boon-granting gesture, the right hand held open, palm out, extended forward and pointing down, just like the giving gesture (*dama mudra*). *Vitarka mudra.* The discernment or analytical gesture, like a one-handed teaching gesture, with one hand held up with thumb and index finger forming a circle, the other three fingers pointing up.

Naga. Nagas and Naginis are mythical serpentlike or underwater dragonlike beings.

naturalism. In art, naturalism can be taken as the polar opposite of abstraction. It is the expression in sculpted or painted form that portrays general qualities of the natural world, such as weight, mass, volume, movement, regular proportions, and so forth, for figures, and three-dimensional space in settings. In general, naturalism may not denote exact details as much as does the term realism.

New Menri (Menri Sarma). A style of Tibetan painting said in Tibetan texts to have been developed from the old Menri style by the artist Chöying Gyatso (active ca. 1620–1665). It is noted for its stylized realism, rich coloration, elegant details and patterning, and graceful linear style.

Ngor. A division of the Sakya Order of Tibetan Buddhism founded by Kunga Sangpo (1382–1444) and centered at Ngor Evam Chöden monastery.

Nirmanakaya. The Emanation Body of Buddha. *See* Three Bodies.

nirvana. The Buddhist *summum bonum,* a state of perfect and eternal happiness that can be attained by human beings in becoming Buddhas. Some forms of Buddhism tend to present it as a transcendent place beyond the world. Mahayana Buddhism critiques that idea and advances the concept of unlocated nirvana, meaning that nirvana is a transcendence of suffering through wisdom, not requiring any change of place, achievable in the midst of life. *See also* parinirvana.

Nyingma Order. The oldest order of Tibetan Buddhism, it dates from the late 8th century CE, when Padma Sambhava, Shantarakshita, and Trisong Detsen established Samye monastery. During the 11th through the 16th centuries, it developed through interaction with the newer orders, while preserving the precious traditions from the ancient period. The Great Fifth Dalai Lama counted himself a Nyingmapa as well as a Gelukpa, and energetically supported the construction of Nyingma monasteries and the spread of their curriculum of study and practice. By the modern period the Nyingma had become the second largest order in Tibet. *See also* Samye monastery.

Padma Sambhava. An Indian Buddhist Great Adept from Uddiyana (Swat, Pakistan), he was invited in the late 8th century to Tibet to help convert the Tibetans to Buddhism. A major culture hero of all Tibetans, the teachings of Padma Sambhava are central in the practice of the Nyingmapas.

Pala period. From ca. mid-8th to mid-12th centuries under the rulers of the Pala dynasty in the Magadha region of Eastern India.

Panchen Lama. The first Panchen Lama was Losang Chökyi Gyaltsen (1570–1662), the teacher of the Fifth Dalai Lama. He was recognized by the Great Fifth as the reincarnation of Tsong Khapa's great successor Kedrup Gelek Pelsangpo, with various distinguished incarnations intervening. As the Dalai Lama was considered an incarnation of Avalokiteshvara, whose celestial teacher is Buddha Amitabha, the Panchen Lama, the Dalai Lama's teacher, became known as an incarnation of Amitabha. Up to the present, the Panchen Lamas have served as abbots of Tashi Lhunpo monastery.

parinirvana. Final nirvana, manifested by a Buddha at the time of death, as opposed to the nirvana attained under the bodhi tree; freedom from suffering without giving up the continuity of embodiment. *See also* nirvana.

Penden Lhamo (T. dPal lDan lHa Mo; S. Shri Devi). An important goddess for Tibetans, she is believed to have a special duty to protect the Dalai Lamas and the government of Tibet. She is associated with the male protectors Mahakala and Yama Dharmaraja.

Potala, or Potalaka. The earthly Pure Land abode of Avalokiteshvara, believed to be accessible from a mountaintop in southern India. It is also the name of the most famous monument in Tibet, the Potala palace in Lhasa, sometimes called the "second Potala," built by the Fifth Dalai Lama, starting around 1645, on the remains of the palace of the Dharma King Songtsen Gambo.

prajnya (S.). *See* wisdom.

Prajnyaparamita (S.). Perfect or Transcendent Wisdom. *See* wisdom.

Protector deity. *See* Dharmapala; World Gods.

purba (S.). A ritual stake or dagger, used to pin down demonic influences in the process of taming them and teaching them to reform their ways.

Qianlong. Emperor of China from 1735 to 1796, during the Qing dynasty; also, the period of his reign.

Qing. The Manchu dynasty in China, 1644 to 1908.

Ratnasambhava. Literally, Buddha of Precious Birth, he is the Transcendent Buddha of the southern direction and Lord of the Jewel clan. He represents the transmutation of pride and stinginess into the equality wisdom, and the purification of the aggregate of sensation. His color is gold. *See also* Five Transcendent Buddhas.

Ratreng ("Reting") monastery. A major Kadampa monastery north of Lhasa, founded by Drom Tonpa in 1057.

realism. The expression in art stressing exact detail, as in photographic images.

Religious King. *See* Dharma King.

Sakya. A Tibetan Buddhist order, named after a place in southwestern Tibet, where the Sakya monastery was founded in 1073. **Sakyapa.** A person or thing belonging to that order.

Sakya Pandita. One of the greatest of all Tibetan lamas, considered an incarnation of the Bodhisattva Manjushri, Kunga Gyaltsen (1182–1251) wrote numerous important books, set the curriculum of study and practice for the Sakyapa monasteries on a sound footing, attained important realizations, and served his country by negotiating skillfully with the Mongol rulers of Asia.

Samantabhadra. The embodiment of benevolence, he is an important Bodhisattva in the Garland Sutra. As a Buddha he holds a central place in the contemplations of the Nyingma Order.

Sambhogakaya. The Beatific Body of Buddha. *See* Three Bodies.

samsara. The life cycle that includes death and rebirth; worldly existence.

Samye monastery. The oldest monastery in Tibet, completed in 787. Tradition says Padma Sambhava chose the place, and Shantaraksita built it on the model of Odantapuri in Magadha, Bengal, designed to resemble a Buddhist mandala. It was the site of the famous Samye Debate in 792, between the Chinese Hvashang Mahayana of the Chan tradition, and the Indian Kamalashila, in the tradition of the Buddhist "gradual path" to enlightenment.

Sangha. One of the Three Jewels of refuge, it is the Buddhist community of monks and nuns and, by extension, lay initiates and practitioners. *See also* Three Jewels.

Shakyamuni. The historical Buddha was born in the Gautama clan in approximately 563 BCE, in the Shakya republic located on the present India-Nepal border. The young Prince Siddhartha renounced his kingdom, sought and found perfect enlightenment, and as a Buddha was called Shakyamuni, the Shakya Sage. After teaching extensively for over forty-five years, he attained parinirvana in approximately 483 BCE.

Shambhala. An ancient kingdom somewhere north of Tibet and Mongolia, it is magically hidden under a force field until the future moment of the Buddhist apocalypse. The king of Shambhala was believed to have requested the teaching of the *Kalachakra Tantra* from Shakyamuni, and the tantra has been widely practiced in his kingdom to this day. The Shambhala myth was the prototype for the idea of Shangrila, which so captured the Western imagination earlier in this century.

Shamvara. Literally, Supreme Bliss, it is the short form of the name of the *Paramasukha-Chakrasamvara Tantra,* major Mother tantra among the Unexcelled Yoga tantras, believed to contain all the essential teachings of the female Buddhas, the Vajradakinis, and Vajrayoginis. Also, Shamvara is an archetype deity.

Sino-Tibetan. A stylistic designation of Buddhist art that combines Chinese and Tibetan elements, whose iconographic and stylistic sources are predominantly in Chinese Buddhism and its arts. The majority of examples of true Sino-Tibetan art as thus defined consist primarily of the traditions of depictions of the Arhats. *See also* Tibeto-Chinese.

Songtsen Gambo. The Tibetan king responsible for the introduction of Buddhism to Tibet in the early 7th century.

stupa (T. *chöten*). Shakyamuni gave instructions before his death that his remains were to be interred in a funerary mount or monument, called a stupa. With square, triangular, round, and vertical forms symbolizing the primary elements, surmounted by the victory banners and parasols of enlightenment, stupas have come to symbolize the Truth Body reality of enlightenment, the all-pervasive mind of all Buddhas. Tibetans used stupas to transform the landscape of Tibet, placing these reminders of the omnipresence of enlightenment everywhere.

Sukhavati. Amitabha Buddha's Pure Land of bliss, in the western direction. It is vividly described in great detail in the Sukhavati Sutras. It is also the heavenly home of the Bodhisattva Avalokiteshvara. *See also* Amitabha.

sutra. A sacred text of Buddhism, especially associated with the Universal Vehicle.

tangka. The Tibetan portable icon, usually painted on cotton, framed by brocade, hence easily rolled up when transported from place to place.

Tanjur. The commentarial and related Buddhist literature in the Tibetan canon, translated from

the Sanskrit, comprising about two hundred and twenty-five volumes. *See also* Kanjur.

Tantra. Literally, "continuum," we can most accurately think of tantra as the high technology for building an enlightened world, mobilizing great bliss in the form of creative imagination. Tantra can refer to the Vehicle, specific texts, and systems of practice for developing these techniques. There are four classes of tantra: Action, Performance, Yoga, and Unexcelled Yoga. Unexcelled Yoga is divided into great, progressive, and ultimate yogas by the Nyingmapas, and into creation stage and perfection stage by the other orders.

Tara. Born from Avalokiteshvara's tears of compassion in one myth, and from her own vow to be enlightened in a woman's body in another, Tara is considered the archangelic and archetype deity Bodhisattva representing the miraculous activities of all Buddhas. The many emanations of Tara help beings overcome difficulties on the path to enlightenment.

Tathagata. An epithet for Buddhas, it means "one who has realized (literally, 'gone into') the ultimate reality of suchness." "Suchness" itself implies a reality transcendent to normal concepts and understandings, and thus this Buddha name can be translated Transcendent One. *See* Five Transcendent Buddhas.

Three Bodies (S. Trikaya). The state of Buddhahood, though an inconceivable reality beyond all categories of thought, is analyzed into Three Bodies: a Truth Body (Dharmakaya), a Beatific Body (Sambhogakaya), and an Emanation Body (Nirmanakaya). Though all are called "body," they represent the ultimate development of ordinary mind, speech, and body, respectively.

Three Jewels (S. Triratna). The Buddha, Dharma, and Sangha—the Teacher, the Teaching, and the Community of practitioners—are the jewels of rare and valuable refuge from the existential predicament of endless suffering in a meaningless cycle of lives and deaths. Taking refuge in these three is considered the beginning point of being a Buddhist.

Three Vehicles. The Three Vehicles are a way of classifying Buddhist teachings. The first is the monastic vehicle of early Buddhism, centered on the Four Noble Truths and the individual's freedom and enlightenment, which is here called the Individual Vehicle, rehabilitating the Sanskrit Hinayana without negative connotation. The second is the messianic vehicle of post-Ashoka social Buddhism, centered on emptiness and great compassion and all beings' freedom and enlightenment, here called Universal Vehicle, after the Sanskrit Mahayana. The third is the esoteric, tantric vehicle of post-Gupta tantric Buddhism, centered on the implementation of compassion as great bliss, the use of artistic imagination to reconstruct the self and the universe, and all beings' accelerated freedom and enlightenment. It is here called

Apocalyptic Vehicle after the lightning-swift and revelatory connotation of vajra.

Tibeto-Chinese. A stylistic designation of Buddhist art that combines Tibetan and Chinese elements, whose iconographic and stylistic sources are predominantly Tibetan Buddhism and its art. *See also* Sino-Tibetan.

Truth Body. *See* Three Bodies.

tsa-tsa (T.). Small clay sculptures of Buddhas and Bodhisattvas made in molds with clay in which the ashes of lamas, deceased relatives, or friends are mixed. These statues are then embedded in stupas, statues, or other spiritual environments.

Tsong Khapa (1357–1419). One of the greatest Tibetan lamas, he is believed to be the third great incarnation of Manjushri (after Longchenpa and Sakya Pandita) to have blessed Tibet with a major intellectual opus. He set the curriculum for the vastly expanded monastic institution that "industrialized" Tibet's production of enlightened persons from the renaissance of the 15th century. He founded the yearly Great Prayer Festival in Lhasa that expresses the millennial consciousness that has sparked the nation during the last five centuries.

Universal Vehicle. *See* Three Vehicles.

upaya. A Sanskrit Buddhist term for "art" in the widest sense: means or techniques of liberative manifestations that free and develop beings for enlightenment. It is the expression of compassion in dynamic action.

urna (S.). A small tuft of white hair that grows on the forehead of a Buddha, at the spot where a fierce deity has a third eye, it is one of the thirty-two major signs of a great being.

ushnisha (S.). The crown-protrusion on a Buddha's head, symbolizing the cosmic openness of the consciousness of an enlightened being. It is often confused with an arrangement of knotted or braided hair worn on top of the head.

Vairochana. Literally, Shining One, he is one of the Five Transcendent (Tathagata) Buddhas. He is the lord of the Buddha clan and occupies the center in many popular tantras and the eastern direction in the advanced Unexcelled Yoga tantras (switching places with Akshobhya). Vairochana represents the transmutation of hate (or delusion) into perfect reality, or mirrorlike, wisdom, and the purity of the consciousness (or form) aggregate. His color is blue (or white). *See also* Five Transcendent Buddhas.

Vaishravana. One of the Four Heavenly Kings, the guardian kings who became celestial Dharma Kings early on in Buddhist myth. King of the north, Vaishravana was greatly worshiped in Tibet as an important wealth deity. *See* Four Heavenly Kings.

vajra (T. *dorje*). A Sanskrit word, literally, "diamond" or "thunderbolt," the vajra symbolized

the supreme power of the divine Indra in Vedic India, used punitively by that god of war and storm. Universal Vehicle Buddhism transvalued it into a symbol of great compassion, the strongest power in the universe. In tantra the vajra, or vajra scepter, symbolizes compassion having become great bliss consciousness (its companion bell symbolizing the wisdom of the void), the male organ (the bell, the female), and the magic body (the bell, the clear light). *See also* adamantine.

Vajrapani. A famous celestial Bodhisattva, he represents the concentrated power of all Buddhas.

Western Tibet. The western region that is historically and culturally part of Tibet, including mainly the areas of Guge, Ngari, Ladakh, Spiti, and Zanskar.

wisdom (S. *prajnya*). Wisdom is the most important mental power in Buddhism, as it is only wisdom that can effect a being's liberation from suffering. It is defined as the perfect, experiential knowledge of the nature of reality, which is sheer relativity free of any intrinsically established persons or things. Prajnyaparamita is the Perfection of Wisdom, and is the title of a series of sutras. Perfect Wisdom can be personified as a goddess, the Mother of all Buddhas, or the female Buddha forms among the tantric archetype deities. *See also* Five Wisdoms; Prajnyaparamita.

World Gods, or World Protectors. (S. Lokapala), sometimes Direction Protector (S. Dikpala). These are a slightly varying group of ten, or sometimes fifteen, Indian deities, including Indra, Vishnu, Yama, Varuna, Kubera, Ganesha, Agni, Nairrti, Vayu, Shiva, Brahma, Surya, Chandra, Vemachitra, Prthividevi, Yaksha, and Garuda.

Xi Xia. A major Buddhist Tangut nation in Central Asia at the juncture of Tibet, Mongolia, and Song China, it flourished between 982 and 1227, and then was destroyed for trying to resist Genghis Khan. The example set by the destruction of Xi Xia was one cause of the Tibetans' quick surrender to the Mongol empire from 1244.

yaksha (S.). *Yakshas* are ancient Indian forest spirits, something between savages and elvish demons, often tamed by Buddhist masters in various myths. *See also* World Gods.

Yama. The Indian god of death and justice, tamed by Manjushri and made into a Buddhist protector. Tsong Khapa had a close personal connection with this deity, and he is the special protector of the Geluk Order.

Yamantaka (T. Shinjeshey). Literally, Death Terminator, this is the fierce form Manjushri adopted to conquer Yama, the Indian god of death. Vajrabhairava, the Diamond Terrorist, is the most ferocious of these fierce forms, Black Yamantaka the mildest, and Red Yamantaka medium fierce. *See also* Yama.

yidam. *See* archetype.

Bibliography

Books, articles, and essays cited in short form in the essays and catalogue entries appear below. In addition, there are a number of general books recommended as background reading. These are signaled by an asterisk.

Akiyama, Terukazu, et al
1969 *Arts of China, Buddhist Cave Temples.* Vol. 2. Tokyo: Kodansha International.
Aschoff, Jürgen
1989 *Tsaparang—Königsstadt in Westtibet.* Munich: MC Verlag.
Asher, Frederick
1980 *The Art of Eastern India, 300–800.* Minneapolis: University of Minnesota Press.
Avedon, John F.
*1984 *In Exile from the Land of Snows.* New York: Alfred A. Knopf.
Aziz, Barbara Nimri, and Matthew Kapstein
*1985 *Soundings in Tibetan Civilization.* London: Wisdom Publications.
Bachhofer, Ludwig
1947 *A Short History of Chinese Art.* London: B. T. Batsford.
Bartholemew, Terese Tse
1987 Tibetan *thangkas* relating to the abbots of Ngor and Shalu in the Asian Art Museum of San Francisco. *Orientations* 18, no. 2: 20–35.
Batchelor, Stephen
*1987 *The Tibet Guide.* London: Wisdom Publications.
Béguin, Gilles
1987 *Les arts du Népal et du Tibet.* Paris: Desclée de Brouwer.
1989 *Tibet, terreur et magie.* Brussels: Musées royaux d'art et d'histoire.
Béguin, Gilles, and L. Fournier
1986 Un sanctuaire méconnu de la région
/87 d'Alchi. *Oriental Art* 32, no. 4: 373–87.
Béguin, Gilles, and Juliette Liszak-Hours
1982 Objets himâlayens en métal du Musée Guimet. *Laboratoire de recherche des Musées de France.* Annales: 28–82.
Béguin, Gilles, et al
1977 *Dieux et démons de l'Himalaya.* Paris: Réunion des Musées Nationaux.
1984 *The Sixteen Netens.* Paris: Editions Sciaky.
Bell, Sir Charles
*1924 *Tibet Past and Present.* Oxford: Clarendon Press.
*1928 *The People of Tibet.* Oxford: Clarendon Press.
*1931 *The Religion of Tibet.* Oxford: Clarendon Press.
1946 *Portrait of a Dalai Lama: The Life and Times of the Great Thirteenth.* London: Wm. Collins. Reprint 1987, London: Wisdom Publications.
Bernbaum, Edwin
*1980 *The Way to Shambhala.* Garden City, N.Y.: Doubleday and Co., Anchor Press.
Beyer, Stephan
1973 *The Cult of Tara. Magic and Ritual in Tibet.* Berkeley: University of California Press.

Bhattacharyya, Benoytosh
1924 *The Indian Buddhist Iconography. Mainly Based on the Sadhanamala and Other Cognate Tantric Texts of Rituals.* London: Humphrey Milford/Oxford University Press.
1968 *The Indian Buddhist Iconography.* Calcutta: K. L. Mukhopadhyay.
Bhattacharyya, Benoytosh, ed.
1967 *Guhyasamâjatantra.* 2nd ed. reprint. Gaekwad's Oriental Series, no. 53. Baroda: Oriental Institute.
Biographie des . . .
1967 *Biographie des 1. Pekinger 1Can skya Khutuhtu Nag dban blo bzan c'os 1dan/verfasst von Nag dban c'os 1dan alias Ses rab dar rgyas; hrsg., übers; und kommentiert von Klaus Sagaster.* Asiatische Forschungen, Bd. 20. Wiesbaden: Otto Harrassowitz.
Birnbaum, Raoul
*1989 *The Healing Buddha.* Boston and London: Shambhala Publications.
Bryner, Edna
1956 *Thirteen Tibetan Thankas.* Indian Hills, Colo.: Falcon's Wing Press.
Cahill, James
1978 *Parting at the Shore.* New York: Weatherhill.
Chandra, Lokesh
1974 *Sadhanamala of the Panchen Lama.* 2 vols. New Delhi: International Academy of Indian Culture.
1987 *Buddhist Iconography.* Rev. and enl. ed. 2 vols. New Delhi: Aditya Prakashan.
Chandra, Lokesh, ed.
1970 *Kongtrul's Encyclopedia of Indo-Tibetan Culture.* Intro. E. Gene Smith. New Delhi: International Academy of Indian Culture.
Chandra, Pramod
1976 *Tuti-namah: Tales of a Parrot.* 2 vols. Graz Austria: Akademische Druck-u. Verlagsanstalt.
1985 *The Sculpture of India: 3000 B.C.–1300 A.D.* Washington, D.C.: The National Gallery of Art.
Chang, Garma C. C., trans.
1977 *The Hundred Thousand Songs of Milarepa.* 2 vols. Boulder, Colo.: Shambhala Publications.
Chapin, H. B., and A. C. Soper
1972 *A Long Roll of Buddhist Images.* Ascona, Switzerland: Artibus Asiae.
Chattopadhyay, A.
1981 *Atisa and Tibet.* New Delhi: Motilal Banarsidass.
Chayet, Anne
1985 *Les Temples de jehol et leurs modèles Tibetains.* Synthèse no. 19. Paris: Editions recherche sur les civilisations.
Chin, Hong
1983 *T'appa* (Pagodas). Vol. 6 of *Kukbo* (The National Treasures of Korea). Seoul: Yekyong Publishers, Ltd.
Chogay, Trichen Rinpoche
1983 *The History of the Sakya Tradition.* Trans. J. Stott. Bristol: Ganesha Press.
Clark, Walter Eugene
1937 *Two Lamaistic Pantheons.* Harvard-

Yenching Institute Monograph Series, Vols. 3 and 4. Cambridge, Mass.: Harvard University Press.

1965 Reprint of 1937 (above). New York: Paragon Books Reprint Corp.

Conze, Edward, trans.

1973 *The Perfection of Wisdom in Eight Thousand Lines and Its Verse Summary*. Bolinas: Four Seasons Foundation.

Conze, Edward, et al, eds.

1964 *Buddhist Texts Through the Ages*. New York: Harper & Row. Originally published 1954.

Copeland, Carolyn

1980 *Tankas from the Koelz Collection*. Ann Arbor: Center for South and Southeast Asian Studies, University of Michigan.

Council of Religious Affairs of His Holiness the Dalai Lama

*1982 *The World of Tibetan Buddhism*. Tokyo: Gyosei.

Cozort, Daniel

1986 *Highest Yoga Tantra: An Introduction to the Esoteric Buddhism of Tibet*. Ithaca, N.Y.: Snow Lion Publications.

Dargay, E. M.

1977 *The Rise of Esoteric Buddhism in Tibet*. New Delhi: Motilal Banarsidass.

Dargyay, Eva K.

*1982 *Tibetan Village Communities*. London: Wisdom Publications.

David-Neel, Alexandra

*1971 *Magic and Mystery in Tibet*. Reprint. New York: Dover Publications.

Dawa-Samdup, Lama Kazi

1969 *Tibet's Great Yogi Milarepa*. London: Oxford University Press.

de Mallmann, Marie-Thérèse

1964 *Étude iconographique sur Mañjushri*. École française d'Extrême-Orient. Paris: Librairie Adrien-Maisonneuve.

1975 *Introduction à l'iconographie du Tântraisme Bouddhique*. Bibliothèque du centre de recherches sur l'Asie centrale et la haute Asie. Vol. 1. Paris: Librairie Adrien-Maisonneuve.

de Visser, M. W.

1923 *The Arhats in China and Japan*. Berlin: Oesterheld.

Deng, Ruiling

1982 *The Potala Palace of Tibet*. Hong Kong: Joint Publishing Co.

Denwood, P.

1971 "The Tibetan temple—art in its architectural setting." In *Mahayanist Art after A.D. 900*. Ed. W. Watson. London: University of London.

Douglas, N., and M. White

1976 *Karmapa: The Black Hat Lama of Tibet*. London: Luzac.

Ekvall, Robert B.

1964 *Religious Observances in Tibet: Patterns and Function*. Chicago: University of Chicago Press.

Essen, Gerd-Wolfgang, and Tsering Tashi Thingo

1989 *Die Götter des Himalaya*. 2 vols. Munich: Prestel-Verlag.

Fisher, R.

1974 *Mystics and Mandalas*. Exh. cat. Tom and Ann Peppers Art Gallery,

University of Redlands, Calif.

Foucher, Alfred

1963 *The Life of the Buddha. According to the Ancient Texts and Monuments of India*. Abridged trans. Middletown, Conn.: Wesleyan University Press.

Genoud, Charles

1982 *Buddhist Wall Painting of Ladakh*. Trans. T. Tillemans, photog. Takao Inoue. Geneva: Editions Olizane.

Gerasimova, K. M.

1971 *Pamyatniki esteticheskoi mysli Vostoka. Tibetsky kanon proportsy*. (Monuments of the Aesthetic Thought of the East. Tibetan Canon of Proportions.) Ulan-Ude, USSR: Buryatian Publishing House.

Getty, Alice

1914 *The Gods of Northern Buddhism*. London: Oxford University Press. Rutland, Vt.: Charles E. Tuttle. Reprint 1962.

Gnoli, G., and L. Lanciotti

1985 *Orientalia Iosephi Tucci Memoriae*
–88 *Dicata*. Serie Orientale Roma 56. 3 vols. Rome: Istituto italiano per il medio ed estremo oriente.

Gordon, Antoinette K.

1939 *The Iconography of Tibetan Lamaism*. New York: Columbia University Press.

Govinda, Lama Anagarika

*1962 *Foundations of Tibetan Mysticism*. London: Rider. Reprint 1969, New York: Samuel Weiser.

Govinda, Li Gotami

*1979 *Tibet in Pictures*. 2 vols. Berkeley, Calif.: Dharma Publishing.

Griswold, A., C. Kim, and P. Pott

*1964 *Burma, Korea, Tibet*. Art of the World. Baden-Baden, Germany: Holle and Co. Verlag. and London: Methuen.

Grünwedel, Albert

1890 *See* Pander.

1900 *Mythologie des Buddhismus in Tibet und der Mongolei*. Leipzig.

1905 *A Review of the Collection of Lamaist Objects of Prince E. Ukhtomsky* [in Russian]. Bibliotheca Buddhica, 6. St. Petersburg.

Harrer, Heinrich

*1985 *Return To Tibet: Tibet after the Chinese Occupation*. New York: Schocken Books.

*1989 *Seven Years in Tibet*. Reprint of 1953 ed. Los Angeles: J. P. Tarcher.

Hatt, R.

1980 A thirteenth-century Tibetan reliquary. *Artibus Asiae* 42, no. 2/3: 175–220.

Henss, Michael

1981 *Tibet. Die Kulturdenkmäler*. Zurich: Atlantis.

Hilton, James

*1933 *Lost Horizon*. New York: William Morrow and Co.

Hirth, Friedrich

1896 *Über Fremde Einflusse in der chinesischen Kunst*. Munich and Leipzig: G. Hirth.

Hoffman, Helmut

*1961 *The Religions of Tibet*. Trans. E. Fitzgerald. New York: Macmillan.

Hopkins, Jeffrey

1983 *Meditation on Emptiness*. London: Wisdom Publications.

1987 *Emptiness Yoga*. Ithaca, N.Y.: Snow Lion Publications.

Huntington, John C.

1972 "Gu-ge bris: a stylistic amalgam." In *Aspects of Indian Art*. Ed. P. Pal. Leiden: Brill.

1975 *The Phur-pa, Tibetan Ritual Daggers*. Ascona, Switzerland: Artibus Asiae.

Huntington, Susan

1984 *The "Pala-Sena" Schools of Sculpture*. Leiden: Brill.

Huntington, Susan, and John C. Huntington

1989 Leaves from the bodhi tree: the art of Pala India (8th–12th centuries) and its international legacy. *Orientations* 20, no. 10: 26–46.

Jackson, David P., and Janice A. Jackson

1984 *Tibetan Thangka Painting: Methods and Materials*. London: Serindia Publications.

Jigmei, Ngapo Ngawang, et al

*1981 *Tibet*. New York: McGraw-Hill Publishing Co.

Karmay, Heather

1975 *Early Sino-Tibetan Art*. Warminster, England: Aris and Phillips.

Karmay, Samten

1988 *Secret Visions of the Fifth Dalai Lama*. London: Serindia Publications.

Klimburg-Salter, Deborah, et al

1982 *The Silk Route and the Diamond Path*. Los Angeles: UCLA Art Council.

Kychanov, Evgeny Ivanovich

1982 "The legal position of Buddhist communities in the Tangut State." In *Buddhism, the State and Society in the Countries of Central and East Asia in the Middle Ages*. Moscow: Oriental branch of Nauka Publishing House.

Lauf, Detlef Ingo

1976 a *Secret Revelation of Tibetan Thangkas*. Freiburg im Breisgau, Switzerland: Aurum Verlag.

*1976 b *Tibetan Sacred Art, the Heritage of Tantra*. Berkeley, Calif.: Shambhala Publications.

1979 *Eine Ikonographie des tibetischen Buddhismus*. Graz: Akademische Druck-u. Verlagsanstalt.

Leonov, Gennady

1989 The rite of consecration in Tibetan Buddhism [in Russian]. *Transactions of the State Hermitage* 27: 117–31.

Lessing, Ferdinand Diederich

1942 *Yung-Ho-Kung. An Iconography of the Lamaist Cathedral in Peking. With Notes on the Lamaist Mythology and Cult*. Reports from the Scientific Expedition to the Northwestern Provinces of China under the Leadership of Dr. Sven Hedin, VIII, Ethnography, 1. Stockholm.

Lhalungpa, Lobsang, trans.

*1977 *The Life of Milarepa*. New York: E. P. Dutton.

Liu, I-se, ed.

1957 *Xizang fojiaoishu* (Tibetan Buddhist Art). Beijing: Wenwu chubansha.

Liu, Lizhong
1988 *Buddhist Art of the Tibetan Plateau.* Ed. and trans. Ralph Kiggell. Hong Kong: Joint Publishing Co.

Lo Bue, E.
1981 "Casting of devotional images in the Himalayas: history, tradition and modern techniques." In *Aspects of Tibetan Metallurgy. See* Oddy and Zwalf 1981.

Lopez, Donald S., Jr.
1987 *A Study of Svatantrika.* Ithaca, N.Y.: Snow Lion Publications.

Lowry, John
1973 *Tibetan Art.* London: Her Majesty's Stationery Office.
1977 "A fifteenth-century sketchbook." In *Essais sur l'art du Tibet,* 83–118. *See* MacDonald and Imaeda 1977.

MacDonald, Ariane
1977 "Un portrait du cinquième Dalai-Lama." In *Essais sur l'art du Tibet, 119–156. See* MacDonald and Imaeda 1977.

MacDonald, Ariane, and Y. Imaeda, eds.
1977 *Essais sur l'art du Tibet.* Paris: Librairie d'Amérique et d'Orient.

Mullin, Glenn H., ed.
1980 *Six Texts Related to the Tara Tantra.* New Delhi: Tibet House.

Mullin, Glenn H., et al
*1981 *Selected Works of the Dalai Lama.* Vol. 1. Ithaca, N.Y.: Snow Lion Publications. Rev. ed. 1985.
*1982a *Selected Works of the Dalai Lama.* Vol. 2. Ithaca, N.Y.: Snow Lion Publications.
*1982b *Songs of Spiritual Change.* Ithaca, N.Y.: Snow Lion Publications. Rev. ed. 1985: *Selected Works of the Dalai Lama.* Vol. 7.

Nebesky-Wojkowitz, René de
1956 *Oracles and Demons of Tibet.* The Hague: Mouton and Co.
1975 *Oracles and Demons of Tibet.* Reprint. Graz, Austria: Akademische Druck-u. Verlagsanstalt.

Neven, A.
1975 *Lamaistic Art.* Brussels: Société générale de banque.

Nima, Tuguan Luosang Queji
1988 *Zhangjia guoshi Ruobi Duoji chuan* (Biography of Zhangjia guoshi Ruobi Duoji). Trans. Chen Qingying and Ma Lianlong. Beijing: Minzu chubansha.

Norbu, Thubten Jigme, and Colin M. Turnbull
*1968 *Tibet: Its History, Religion, and People.* New York: Simon and Schuster.

Normanton, Simon
*1989 *Tibet: A Lost Civilization.* New York: Penguin Books.

Oddy, W. A., and W. Zwalf, eds.
1981 *Aspects of Tibetan Metallurgy.* British Museum Occasional Paper No. 15. London: Trustees of the British Museum.

Oldenburg, Sergei Fedorovich
1914 "Matériaux pour l'iconographie bouddhique de Kharakhoto I." In *Matériaux pour l'éthnographie de la Russie,* vol. 2, 79–157 [in Russian]. St. Petersburg.

Oldenburg, Sergei Fedorovich, ed.
1903 *Sbornik izobrazhenyi 300 burkhanov.* Part 1. Bibliotheca Buddhica, 5. St. Petersburg.

Olschak, Blanche C., and Geshe Thupten Wangyal
1973 *Mystic Art of Ancient Tibet.* New York: McGraw-Hill Publishing Co.

Olson, Eleanor
1950 *Catalogue of the Tibetan Collections*
–71 *and Other Lamaist Articles in the Newark Museum.* 5 vols. Newark, N.J.: Newark Museum.
1974 *Tantric Buddhist Art.* New York: China House Gallery.

Pal, Pratapaditya
*1969 *The Art of Tibet.* New York: Asia Society.
1975 *Bronzes of Kashmir.* New York: Hacker Art Books.
*1978 *The Sensuous Immortals.* Los Angeles: Los Angeles County Museum of Art.
*1982 *A Buddhist Paradise: The Murals of Alchi.* Photog. L. Fournier. Basel: Ravi Kumar for Visual Dharma Publications Ltd., Hong Kong.
*1983 *Art of Tibet: A Catalogue of the Los Angeles County Museum of Art Collection.* Los Angeles: Los Angeles County Museum of Art. Expanded ed. 1990.
*1984a *Tibetan Paintings.* London: Ravi Kumar.
*1984b *The Light of Asia: The Buddha Sakyamuni in Asian Art.* Los Angeles: Los Angeles County Museum of Art.
*1985 *Art of Nepal: A Catalogue of the Los Angeles County Museum of Art Collection.* Los Angeles: Los Angeles County Museum of Art.
1987 Tibetan religious paintings, 1. *Arts in Virginia* 27, nos. 1–3: 44–65.
1990 The Arhats and Mahasiddhas in Himalayan art. *Arts of Asia* 20, no. 1: 66–78.

Pal, Pratapaditya, ed.
1986 *American Collectors of Asian Art.* Bombay: Marg Publications.

Pal, Pratapaditya, and Julia Meech-Pekarik
1988 *Buddhist Book Illuminations.* New York: Ravi Kumar.

Pal, Pratapaditya, and Hsien-ch'i Tseng
1969 *Lamaist Art.* Boston: Museum of Fine Arts.

Pander, Eugene
1890 *Das Pantheon des Tschangtscha-Hutuktu. Ein Beitrag zur Iconographie des Lamaismus.* Herausgegeben und mit Inhaltsverzeichnissen von Albert Grünwedel. Berlin.

Pathak, S. K., ed.
1986 *The Album of the Tibetan Art Collections.* Patna: Kashi Prasad Jayaswal Research Institute.

Pelliot, P.
1924 *Les Grottes de Touen-Houang.* Paris: Librairie Paul Geuthner.

Petech, Luciano
1977 *The Kingdom of Ladakh.* Serie Orientale Roma, 50. Rome: Istituto italiano per il medio ed estremo oriente.
1980 Ya-ts'e, Guge, Puran: a new study. *Central Asiatic Journal* 24, nos. 1–2: 85–111.

Pritzker, T.
1989 The wall paintings of Tabo. *Orientalis* 28, no. 2: 38–47.

Rahula, Walpola
*1962 *What the Buddha Taught.* New York: Grove Press.

Reedy, Chandra L.
1987 Determining the region of origin of Himalayan copper alloy statues through technical analysis. *Mārg* 39, no. 4: 75–98.

Reynolds, Valrae
1978 *Tibet: A Lost World.* New York: American Federation of the Arts.

Reynolds, Valrae, A. Heller, and J. Gyatso
1986 *Sculpture and Painting.* Vol. 3, Tibetan Collection. Newark, N.J.: Newark Museum.

Rhie, Marylin M.
1985 The Buddhist art of Tibet. *Arts of Asia* 15, no. 1: 82–95.
1988 "The statue of Songzen Gampo in the Potala, Lhasa." In *Orientalia Iosephi Tucci Memoriae Dicata,* Serie Orientale Roma 56, vol. 3: 1201–19. Rome: Istituto italiano per il medio ed estremo oriente.

Rhie, Marylin M., and Robert A. F. Thurman
1984 *From the Land of Snows: Buddhist Art of Tibet.* Exh. cat. Mead Art Museum, Amherst, Mass.

Rhys-Davids, C. A. F., and T. W. Rhys-Davids, trans.
1977 *The Dialogues of the Buddha.* Reprint of 1910, 1966. Vol. 3 in Sacred Books of the Buddhists. Pali Text Society. London: Luzac and Co.

Richardson, H. E.
*1962 *Tibet and Its History.* London: Oxford University Press.

Roerich, George N.
1925 *Tibetan Painting.* Paris: Paul Geuthner.
1988 *The Blue Annals.* New Delhi: Indological Publishers & Booksellers.

Ruegg, D. S.
1966 *The Life of Bu Ston Rin Po Che.* Rome: Istituto italiano per il medio ed estremo oriente.

Schmid, Toni
1952 *The Cotton-clad Mila.* Stockholm: Statens Etnografiska Museum.
1958 *The Eighty-five Siddhas.* Stockholm: Statens Etnografiska Museum.

Schulemann, Werner
1969 Der Inhalt eines Tibetisches mc'od Rten. *Zentralasiatische Studien* 3: 53–76.

Sekino, T., and T. Takeshima
1934 *Ryōkin jidai no kenchiku to sono*
–44 *butsuzō* (Architecture of the Liao and Chin Dynasties and Their Buddhist Images). 3 vols. Tokyo: Tōyō bunka gakuin Tokyo kenkyūjo.

Shakabpa, Tsepon W. D.
*1967 *Tibet, a Political History.* New Haven: Yale University Press. 3d ed. 1984, Potala.

Shih, Chin-po, et al, eds.
1988 *Xi Xia wen-wu.* Beijing: Wenwu chubansha.

Siren, Osvald
1958 *Chinese Painting, Leading Masters and Principles.* 7 vols. New York: Ronald Press.

Snellgrove, D. L.
*1957 *Buddhist Himalaya.* Oxford: Cassirer.
1959 *The Hevajra Tantra.* London: Oxford University Press.
1967 *The Nine Ways of Bon.* London: Oxford University Press.
1987 *Indo-Tibetan Buddhism. Indian Buddhists and Their Tibetan Successors.* 2 vols. Boston: Shambhala Publications.

Snellgrove, D. L., and H. E. Richardson
*1968 *A Cultural History of Tibet.* New York: Praeger.

Snellgrove, D. L., and T. Skorupski
1977 *The Cultural Heritage of Ladakh.* Vol. 1. Warminster, England: Aris and Phillips.
1980 *The Cultural History of Ladakh.* Vol. 2. *See above.*

Sonami, H., and M. Tachikawa, eds.
1983 *Tibetan Mandalas. The Ngor Collection.* [Text: Ngor Thar rtse mKhan pa bSod nams rgya mtsho.] 2 vols. Tokyo: Kodansha International.

Speyer, J. S., trans.
1982 *The Jatakamala or Garland of Birth-Stories of Aryasura.* New Delhi: Motilal Banarsidass. Originally published 1895.

Srivastava, K. M.
1990 Sculptures from Sanghol: a monumental discovery. *Arts of Asia* 20, no. 1: 79–91.

Stein, R. A.
*1972 *Tibetan Civilization.* Palo Alto, Calif.: Stanford University Press.

Stoddard, Heather
1985 A stone sculpture of mGur mGon-po, Mahakala of the Tent, dated 1292. *Oriental Art* 31, no. 3: 261, 278–82.

Tate, John
1989 The sixteen Arhats in Tibetan
–90 painting. *Oriental Art* 35, no. 4: 96–206.

Tenzin Gyatso, the Fourteenth Dalai Lama
*1983 *My Land and My People: Memoirs of the Dalai Lama.* London: Wisdom Publications.
1984 *Kindness, Clarity and Insight.* Ithaca, N.Y.: Snow Lion Publications.
*1988 *The Dalai Lama at Harvard.* Trans. and ed. J. Hopkins. Ithaca, N.Y.: Snow Lion Publications.
*1990 *Freedom in Exile: The Autobiography of the Dalai Lama.* New York: Harper Collins.

Thinley, Karma
1980 *The History of the Sixteen Karmapas of Tibet.* Boulder, Colo.: Prajna Press.

Thurman, Robert A. F.
1976 *The Holy Teaching of Vimalakirti.* University Park, Pa.: Pennsylvania State University Press.
1984 *Tsong Khapa's Speech of Gold in the Essence of True Eloquence.* Princeton: Princeton University Press.

Thurman, Robert A. F., ed.
1982 *Life and Teachings of Tsong Khapa.* Dharamsala: Library of Tibetan Works and Archives.

Tibet House Museum
1965 *Catalogue of the Inaugural Exhibition.* New Delhi: Tibet House Museum.
1966 *Second Exhibition of Tibetan Art.* Text Sonam Topgay Kazi. New Delhi: Tibet House Museum.

Tokyo National Museum
1975 *Chinese Paintings of the Yüan Dynasty in Buddhist and Taoist Figure Subjects* [in Japanese]. Tokyo: Tokyo National Museum.

Tonkō Bumbutsu Kenkyūjo, ed.
1980 *Chūgoku Sekkutsu: Tonkō Bakkō*
–82 *Kutsu* (The Grotto Art of China: The Mogao Grottoes of Dunhuang). 5 vols. Tokyo: Heibonsha.

Toyka-Fuong, Ursula
1983 *Die Kultplastiken der Sammlung Ernst Senner.* Vol. C of Ikongraphie und Symbolik des Tibetisches Buddhismus. Wiesbaden: Otto Harrassowitz.

Tsong-ka-pa
1977 *Tantra in Tibet.* Intro. H. H. the Dalai Lama, trans. and ed. J. Hopkins. London: Allen and Unwin.

Tsultem, Niamosorym
1982 *The Eminent Mongolian Sculptor—G. Zanabazar.* Ulan Bator, Mongolia: State Publishing House.
1986 *Development of the Mongolian National Style Painting "Mongol Zurag" in Brief.* Ulan Bator, Mongolia: State Publishing House.

Tucci, Guiseppe
1932 *Indo-Tibetica.* 4 vols. Rome: Reale
–41 Accademia d'Italia.
1934 Some glosses on the Guhyasamaja.
–35 *Mélanges chinois et bouddhiques* 3: 339–53.
1937 Indian paintings in Western Tibetan temples. *Artibus Asiae* 7: 191–204.
1949 *Tibetan Painted Scrolls.* 3 vols. Rome: La libreria dello stato.
1956 *To Lhasa and Beyond.* Rome: Istituto poligrafico della stato.
1959 A Tibetan classification of Buddhist images according to their style. *Artibus Asiae* 22, no. 1/2: 179–87.
1961 *The Theory and Practice of the Mandala.* London: Rider.
*1967 *Tibet: Land of Snows.* Trans. J. E. S. Driver. New York: Stein and Day.
1973 *Transhimalaya.* Geneva: Nagel Publishers.
1980 *The Religions of Tibet.* Trans. G.

Samuel. Bombay: Allied Publishers.
1989a *Gyantse and Its Monuments.* 3 vols. New Delhi: Aditya Prakashan.
1989b *The Temples of Western Tibet and Their Artistic Symbolism: Tsaparang.* New Delhi: Aditya Prakashan.

Tulku, Tarthang
1972 *Sacred Art of Tibet.* Berkeley, Calif.: Dharma Publishing. Rev. ed. 1988.

Vasiliev, V.
1857 *Buddhism, ego dogmaty istoria i literatura* (Buddhism, Its Dogmata, History, and Literature) [in Russian]. St. Petersburg.

Vira, Raghu, and Lokesh Chandra, eds.
1961 *A New Tibeto-Mongolian Pantheon.* New Delhi: International Academy of Indian Culture.

von Schroeder, Ulrich
1981 *Indo-Tibetan Bronzes.* Hong Kong: Visual Dharma Publications.

Vostrikov, Andrei Ivanovich
1962 *Tibetskaya istoricheskaya literatura* (Tibetan Historical Literature). Moscow: Oriental branch of Nauka Publishing House.

Waddell, L. A.
1972 *The Buddhism of Tibet or Lamaism.* New York: Dover. Reprint of 1895 ed.

Wayman, Alex
1973 *The Buddhist Tantras.* New York: Samuel Weiser.
1977 *The Yoga of the Guhyasamajatantra. The Arcane Lore of Forty Verses. A Buddhist Tantra Commentary.* New Delhi: Motilal Banarsidass.

Whitfield, Roderick
1982 *The Art of Central Asia.* Vol. 1. Tokyo: Kodansha International and the Trustees of the British Museum.
1983 *The Art of Central Asia.* Vol. 2. *See above.*
1985 *The Art of Central Asia.* Vol. 3. *See above.*

Willson, M.
1988 *In Praise of Tara Tantra.* London: Wisdom Publications.

Wylie, T. V.
1962 *The Geography of Tibet According to the 'Dzamgling rgyas-bshad.* Rome: Istituto italiano per il medio ed estremo oriente.

Xizang gongye qianchu kanze shejiyuan, ed.
1985 *Da Zhaosi.* Beijing: Zhongguo qianchu kongye chubansha.

Xizang zichigu wenwuguan weiyuanhui, ed.
1985 *Xizang Tangjia.* Beijing: Wenwu chubansha. (English edition: *Tibetan Thangkas,* 1987).

Zwalf, W.
1981 *Heritage of Tibet.* London: Trustees of the British Museum.

Zwalf, W., ed.
*1985 *Buddhism, Art and Faith.* London: Trustees of the British Museum.

Index

Page numbers are set in roman type; all illustrations are referred to by page numbers in *italic* type.

Mudras and postures are grouped under these headings and are not listed individually. Painting and sculpture entries are grouped under these headings chronologically by region, as well as being listed individually.

A

Abhayakaragupta, 275
Abhirati, 33, 312, 334, 367
Achala, 257; *256*
Aginski monastery (Buryatia, USSR), 306
 printing masters of, 306
Agni, 239, 340
Akshobhya Buddha, 33, 48, 49, 194, 334, 341, 345, 367–68
 Abhirati, paradise of, 312
Akshobhya (Ellsworth), 345; *345*
Akshobhya Buddha and Bodhisattvas, 48, 49; *48*
Akshobhya in Abhirati (LACMA, Los Angeles), 367–68; *366*
Alchi monastery (Ladakh), 43–44, 65 n. 2
 Dukhang and Sumtsek halls of, 43–44
 wall paintings, 43–44, 215, 322, 343; *44*
Altan Khan, 30, 60, 266
Amitabha Buddha, 33, 334, 341; *180*
 Padma Sambhava as, 169
 Panchen Lama as, 275
 peacock vehicle of, 351
 Sukhavati, paradise of, 311, 355
Amitayus, 169, 271, 351, 355
Amitayus (Hermitage), 351; *351*
Amitayus (MFA, Boston), 334, 355; *354*
Amitayus (Peljor Chöde, Gyantse), 56; *56*
Amoghasiddhi Buddha, 129, 334, 341, 349
Amoghasiddhi (Hermitage), 349; *349*
Amrtakundali, 132
Ananda, 99
Angaja (Arhat), 63, 102, 103, 117; *116*
Aniko (Nepali artist), 50
Apocalyptic Vehicle (Vajrayana), 15, 24–25, 146–47
 definition of, 147
 female energy in, 299
archetype deities, 15, 17, 171, 291
 gender and, 298
 Mother tantra, 257
architecture (Tibetan), 37, 385
 and landscape painting, 95, 208, 243, 271, 317, 364, 374; *209, 271, 365, 375*
Arhat(s), 24, 50, 52, 102–03
 eighteen Tibetan, 78, 86, 102–07
 landscape settings of, 103, 105
 ordering of, 78, 82, 87, 102
 sculptures of, 103, 112, 113; *112, 113*
 seventeen Chinese, 82, 102. *See also* Arhat images (Chinese)
 sixteen Indian, 78, 102, 103
 tarjani mudra, 108–09
 three major styles of, 102–03
 Yerpa representations, 102
Arhat (LACMA, Los Angeles), 52, 105–06; *104, 106*
Arhat Angaja (Ford), 63, 103, 117; *116*
Arhat Bhadra (Musée Guimet), 53, 112; *112*
Arhat images (Chinese), 50, 52, 79, 102–03, 106, 111, 113
 Guan Xiu and, 103, 106
 Li Gonglin and, 103, 106
 rock pedestals in, 113
 Yan Hui and, 52, 106
Arhat Kalika (LACMA, Los Angeles), 53, 113; *113*
Arhat Rahula (Musée Guimet), 103, 119; *118–19*
Arhat Vanavasin (Ellsworth), 52, 107–09; *107, 109*

Aryadeva (Great Adept), 146
Asanga, 146, 312
Atisha Dipamkara, 27, 29, 45, 124, 129, 146, 199, 213, 265
 Drom Tonpa and, 29, 45, 129, 212, 247, 265
 pandit's hat, 148, 149
Avalokiteshvara (Bodhisattva), 29–30, 34, 136–37, 138, 262, 311, 312, 322–29, 341
 Dalai Lama (Fifth) and, 29–30
 Hayagriva and, 189; *189*
 Potalaka Paradise of, 312
 White Lotus of Compassion Sutra and, 136
Avalokiteshvara (Ellsworth), 44, 136–37; *136, 137*
Avalokiteshvara (Zimmerman), 138; *138*
Avatamsaka (Garland) Sutra, 43, 334, 341

B

banner painting(s), 41–42, 122
Baoxiang Lou temple (Beijing), 240, 339
Bardo (between-state), 167, 198
 paintings, 167, 198; *198*
Bardo Thodol. See *The Tibetan Book of the Dead*
Baroque-Rococo style (European), 208, 211
Beatific Body (Sambhogakaya), 35, 39, 44, 72, 356; *356*
Begtse (Hermitage), 307; *307*
Béguin, Gilles, 13
Bell, Sir Charles, 32
Bhagavati Mahavidya (goddess), 227; *228*
Bhairava, the Terrifier, 278
Bhaishajyaguru (Hermitage), 59, 334, 337; *336, 337*
Bhaishajyaguru, 337, 338. *See also* Medicine Buddha
Bhavaviveka (philosopher), 275
black tangka style (T. *nagtang*), 61–63, 197, 213, 263, 289, 297, 301–02; *197, 288, 296, 302*
bliss-swirl motif (T. *gakyil*), 77, 172; *77*
Bodhidharma, 147, 150
Bodhisattva(s), 24, 25, 33, 120–21
 cosmic, 313
 early images of, 49
 eight main mudras/symbols of, 327
 ornaments of, 69
 See also Avalokiteshvara; Manjushri; Vajrapani
Bodhisattva (Jokhang), 47; *47*
Bodhisattva (Tabo monastery), 43; *43*
Bon religion, 21–22, 26
Brahma (World God), 18, 229, 232, 340
 severed head of, 18
Buddha(s)
 cosmic, 334–35
 definition of, 72, 334
 erotic/terrific forms of, 35–36
 Five Transcendent, 334
 land (Skt. *buddha-kshetra*), 33, 311. *See also* Pure Land(s) paradise(s)
 Medicine, 334, 336–39
 thirty-five, of confession, 73, 82, 87, 314; *81*
 thirty-two marks of, 73, 85
 three bodies of, 18, 35, 39, 44, 72, 356
Buddha (Iwang monastery), 46–47; *47*
Buddhahood, 25, 33, 72
Buddhanama Sutra (Central Asian), 335
Buddha Shakyamuni. See Shakyamuni Buddha
Buddhashri (Victoria & Albert), 249; *249*

Buddhism, 15, 22–26, 146
 Chan, 147, 150
 enlightenment as goal, 15, 23–25, 34–36
 evil in, 17, 72
 Indian, 22–23, 25–26, 32–34, 146, 335
 Mongolian, 32, 144, 263, 266, 269, 294
 Pure Lands of, 13, 32–36, 65, 311, 361
 selflessness/freedom/compassion in, 24, 230, 314–15
 suchness (Skt. *tathata*) and, 334
 Tangut, 49, 255, 334–35
 three vehicles of, 15, 24–25, 102, 146–47
 Turkic invasions and, 26
 Xi Xia dynasty, 49, 236, 255, 334–37
Buddhism (Tibetan), 12, 20, 22–32, 40, 42, 262, 266
 in Beijing, 50, 276
 death in, 35, 167, 198, 235, 291, 311
 four main orders of, 26–30, 165
 persecution of, 32, 42, 166
 Pure Lands of, 13, 34–36, 65, 311, 361
Buddhist art, 17, 34–36
 Khotanese, 45, 46–47, 53, 65 n. 7; *47*
 Mongolian, 64, 69, 141, 144–45, 263, 267, 294, 378–79, 388; *68, 141, 144–45, 267, 378–79*
 quintessential, 17
 See also regional listings
Buddhist art (Chinese), 46, 64, 112, 113, 143, 199, 208, 263, 267, 335, 356; *41, 356*
 Arhats in, 50, 52–53, 66 n. 12, 79, 102–03, 106, 111, 113, 119
 painting, 50, 52–53, 122, 143, 163; *122, 143, 162–63*
 rocky pedestals in, 113
 sculpture, 50, 112, 113, 139, 142, 240, 356; *112, 113, 139, 142, 240, 356, 382*
 traveling figures in, 115
 See also Chinese style(s)
Buddhist art (Tibetan), 12–13, 35–65
 aesthetics of, 39, 44, 65
 architecture, 37, 385
 characteristics of, 39, 44, 75, 105, 117
 creation/consecration of, 100, 353, 385, 386
 early, 39, 65, 218, 314–15
 Encyclopedia (Kongtrul) on, 302
 iconography of, 39
 incarnation as, 37
 literature, 35, 37
 mandalas, 37
 music, 37
 sculpture, 37
 visualization and, 37
 See also individual listings
Butön Rinchen Drup (AAM/San Francisco), 62, 213–14; *212, 214*

C

Central Asia:
 Khara Khoto, 47, 49–50, 120–21, 255, 335
 Tangut culture, 49, 121, 255, 335
 Xi Xia dynasty, 49, 121, 236, 255, 334–37
central regions (of Tibet) style, 45–57, 59, 60–63, 77, 129–32, 249, 265
 Orissan/Hoysalan influence, 50, 51
 Tsang, 54–57, 60, 61, 232
 Ü, 54, 60, 61
 See also painting (central regions); sculpture (central regions)

Chahar (Inner Mongolia), 69, 144, 266
Chakrasamvara, 215, 278
 iconography of, 279
 See also Paramasukha-Chakrasamvara; Shamvara
Chandrakirti (Great Adept), 146, 148–49
Chandrakirti (Hermitage), 148–149; *149*
Chemchok Heruka (archetype deity), 198
 Samantabhadra as, 198
Chemchok Heruka with Fierce and Tranquil Deities of the Bardo (Newark), 167, 198; *198*
Chinese style(s), 50, 52–53, 59, 65, 142, 143
 Chin, 356
 Karma Gadri style and, 59, 63, 96, 103, 152, 154, 236, 243, 245; *155, 242–45*
 Ming, 59, 60, 63, 97, 103, 111, 115, 119, 143, 163, 233, 277, 305
 naturalism in, 65, 111, 241, 253
 Qianlong, 64, 65
 Qing, 85, 142, 148, 305, 318
 Sino-Tibetan, 64
 Song period, 78, 103, 105, 308
 Tang, 309
 Wan-li period, 60, 90, 95
 yin-yang principle in, 95, 105–06, 113, 117, 211
 Yongle period, 61, 63–64, 120, 139, 233, 356, 357
 Yuan dynasty, 50, 52, 103, 105, 106, 108
 See also Tibeto-Chinese style
Chökorgyal monastery (at Lhamo Latso), 301
cold gold paste, 388
compassion, 17–19
 male principle as, 17, 192, 217, 298
 OM MANI PADME HUM mantra and, 311
 wisdom and, 17–19, 192, 217, 298
Contemplative Buddha (Ellsworth), 44, 344; *344*
Crowned Buddha (Newark), 356; *356*
crown of five skulls, 187, 259, 283; *260*

D

dagam (meditation robe), 201; *254*
Dakini(s), 18, 197, 198, 299, 312
 See also goddesses
Dalai Lama lineage, 30–32, 34, 60, 64, 101, 165, 213, 262, 266
Dalai Lama (Third, Sonam Gyatso), 30, 60
 Begtse and, 307
 between-state experience, 271
 Mongols and, 144, 263, 266, 269
Dalai Lama (Fifth, Losang Gyatso), 30–31, 61, 64, 208, 213, 262, 267, 272, 275, 301, 374
 Drakpa Gyaltsen and, 301
 gold manuscript of, 62, 197, 290, 301
 Mongols and, 30
 Nyingma Order and, 166
Dalai Lama (Fourteenth, Tenzin Gyatso), 32
 Chinese invasion of Tibet and, 32
 Nobel Peace Prize and, 32
damaru (drum), 18, 259, 279
depth psychology, 35
 Tibetan, 36
Dharikapa (Great Adept), 151–52; *151*
 Dharima and, 151–52
Dharma, 23
Dharma King(s), 22, 156–63
 Ashoka, 156

Four Heavenly, 156, 172, 181, 325, 337; *336*
 Gesar, 156
 Kubera, 162, 163
 Rudrachakrin, 156, 159
 Songtsen Gambo, 22, 40–41, 156; *41*
 thirty-two, of Shambhala, 156, 159
 Tri Relwajen, 41, 42, 156
 Trisong Detsen, 22, 26, 40, 156, 157, 166, 364
 Vaishravana, 163, 305
 See also individual listings
Dharmakirti (Great Adept), 146
Dharmapala(s). *See* protector deities
Dharmatala, 78, 82, 86, 102, 111, 115; *77, 83, 114*
Dharmatala (MFA, Boston), 59, 78, 103, 115; *114*
Dignaga (Great Adept), 146
Dombi Heruka (Great Adept), 155; *154*
drapery style(s), 185, 239
 Alchi, 43–44, 75, 343
 central regions (of Tibet), 76, 204
 Chinese, 50, 52, 55, 65, 78, 106, 108, 111, 154, 253, 356, 357, 359
 Dunhuang, 49, 111
 Indo-Nepalese, 50, 52
 Kashmiri, 100
 Khotanese, 46
 Kumbum (Gyantse), 55, 205
 Qing, 85
 Renaissance (European), 203
 Western Tibet, 83, 346
Drepung monastery, 29, 54, 309, 374
 wall paintings, 285–86
Drigung Kagyu (suborder), 28, 250
 Jigten Sumgon and, 28, 250
The Drigung Kagyu Lama Chetsang Rinpoche (Zimmerman), 60, 250–51; *251*
Drigung monastery (Ü), 28, 250
 sculptures, 53
 tangkas, 52
Drigung style, 60; *251*
Drokmi (translator), 200, 207
Drom Tonpa, 29, 45, 129, 247, 265
Druk Kagyu (suborder), 28, 248
 monasteries, 248
Drukpa Lama Gyalwa Gotsangpa Gonpo Dorje (Newark), 248; *248*
Dujom Rinpoche (Nyingma lama), 185
Dunhuang (China), 122
 banner paintings, 41–42, 122
 drapery style, 49, 111
 wall paintings, 41, 49–50, 77, 111; *37, 43, 44*
Dusum Kyenpa. *See* Karmapa (First)

E

Eastern Tibetan Lama, Shamarpa Kagyu (Musée Guimet), 63, 254; *254*
Eastern Tibet style, 59–60, 63, 66 n. 13, 115, 117, 151–52, 241, 250, 252, 319, 334, 371
 Chinese influence on, 59, 60, 95, 97, 115, 152, 241, 250
 Karma Gadri, 59, 63, 97, 103, 152, 155, 236, 243, 245; *135, 154, 242–245*
 See also painting (Eastern Tibet); sculpture (Eastern Tibet)
Eight-Armed, Eleven-Faced Avalokiteshvara (MFA, Boston), 143; *143*

Eight-Armed Wrathful Form of Green Tara (Ellsworth), 63, 317; *316*
eight cemeteries (Skt. *shmashana*), 257, 259–60
eight demon generals, 161, 162
Eight Dharma Protectors, 301
eight lucky symbols, 161, 200, 337
Eight Medicine Buddhas, 58, 337, 339; *58*
Ekajata, 130
elephant hide (attribute), 18, 192, 217, 220, 279
Eleven-Faced, Eight-Armed Avalokiteshvara (Hermitage), 325; *324*
Eleven-Faced, Six-Armed Avalokiteshvara (Cleveland Mus. of Art), 323; *322*
Eleven-Faced, Thousand-Armed Avalokiteshvara (Ellsworth), 58, 327–29; *326–29*
Emanation Body (Nirmanakaya), 35, 39, 44, 72, 356
 three forms of, 35, 72
embroidery/appliqué technique, 49, 101, 121, 126–27, 292, 386; *101, 126, 127, 292*
 See also *kesi* embroidery technique
emperor(s):
 Ashoka, 156
 Kangxi, 276
 Qianlong, 262–63, 276, 287
 Yongzhen, 276
Encyclopedia (Kongtrul, art text), 302
enlightenment, 15, 23–25, 34–36, 72
 Shakyamuni Buddha's, 23, 24, 73, 75, 88
 unconscious energy and, 35–36
European style(s):
 Baroque-Rococo, 208, 211
 Renaissance, 56, 203

F

face of glory (Skt. *kirtimukha*), 81, 126, 327
fan symbol (Ch. *shan*), 305
father-mother union (T. *yab-yum*), 12, 17, 51, 298
Feilaifeng carvings (Hangzhou, China), 50, 190
Female Power Deities (T. Wangchukma), 198; *198*
Fifteen World Gods, 229, 232, 340
 See also World Gods
figural styles:
 Alchi, Dukhang/Sumtsek, 43–44
 central regions, 77, 315
 Chinese influence, 52, 106, 111
 Indian/Pala, 49
 Kumbum wall paintings, 55, 111
 Renaissance (European), 203
 Western Tibet, 75
 Yuan dynasty, 52
Five Mountain Paradise (Ch. Wutaishan), 33, 312, 364
Five Pancharaksha Goddesses, 227, 229
Five Transcendent Buddhas, 49, 229, 341, 342, 345; *228, 229, 342*
 five wisdoms of, 277, 334
Four-Armed Manjushri (Hermitage), 61, 139; *139*
Four-Armed Vajrapani (Ellsworth), 61, 193–94; *193–95*
Four Heavenly Kings, 156, 172, 181, 337; *336*
Four Mandalas of the Vajravali (Zimmerman), 51–52, 227–29; *226, 228, 229*
"Further-eye" projection, 108, 203

G

Gampopa, Dakpo Lhajey, 27, 28, 165, 236, 237; *238*
Gampopa (Zimmerman), 247; *246*
Ganden monastery (Lhasa), 29, 312, 374
garland of severed heads, 187, 217, 283
garuda (wisdom eagle), 197, 314; *314*
Gayadhara (Kashmiri Adept), 200, 206; *207*
Geluk Order, 26, 29–30, 54, 165, 262–63, 266, 275, 373
 Dalai Lama lineage and, 30–32, 262–63, 266, 274, 374
 Guhyasamaja and, 277
 main archetype deities of, 263
 Manchu and, 31, 262, 267
 monasteries, 29, 54, 374
 Mongols and, 30, 60, 262
 Panchen Lamas and, 262, 275
 protector deities of, 262, 291
 Tsong Khapa and, 29, 165, 262
 Ushnishasitatapattra and, 319
 Yamantaka and, 287, 291
 yellow hats of, 266
Gelukpa style, 157, 263
Gesar of Ling, 156
Ghantapa (Great Adept), 147, 153
Glorious Copper Mountain Paradise, 33, 181, 183, 312; *180*
Gö, the Great Translator, 275
goddesses:
 four animal-faced, 197, 198, 218, 232, 304; *196*
 of four seasons, 301
 See also Dakini(s), Prajnyaparamita
Great Adept(s) (Skt. Mahasiddhas), 146–47, 260, 258; *259*
 Sufism and, 147
Great Adept Ghantapa and Consort (Victoria & Albert), 153; *153*
Great Adepts Shavaripa and Dharikapa (Ford), 59, 151–52; *151–52*
Great Adepts Virupa, Naropa, Saraha, and Dombi Heruka (MFA, Boston) 154; *155*
Great Perfection tantras (*Dzogchen*), 26, 27
great philosophers (Skt. Mahapanditas), 146
Great Prayer Festival (Lhasa), 237, 356
Green Khadiravani Tara (Ford), 47–48, 129–32; *128, 130–31*
Green Tara, 129
 Queen Bhrkuti and, 129
 verses (First Dalai Lama), 129, 130, 132
Green Tara (Cleveland Mus. of Art), 51; *51*
Green Tara (Hermitage), 126–27; *126–27*
Green Tara (ROM, Toronto), 133; *133*
Green Tara as Prajnyaparamita (Alchi), 43–44; *44*
Grünwedel, A., 85, 304, 307, 338
Guge dynasty (Tibet), 26, 42, 57, 166
Guge renaissance style, 58, 59, 81–82, 87–89, 91, 177–79, 269–71, 327–29, 367; *80, 83, 86, 88–89, 176, 178–79, 268–71, 326–29, 366*
Guhyasamaja (archetype deity), 277
Guhyasamaja Akshobhyavajra Father-Mother (AAM, San Francisco), 277; *277*
Guhyasamaja Tantra, 277
Gunaprabha (Great Adept), 146
Guru Drakpoche (Newark), 197; *196–97*
Gyantse Kumbum style, 55–56, 57, 61, 224
 See also Kumbum

H

halos (head/body), 99, 161, 176, 194, 197
 Chinese style, 101
 Dunhuang style, 77
 Guge style, 86, 207
 Indo-Nepalese style, 48, 51, 220
 Khara Khoto style, 132, 337
 Kumbum style, 55, 206
Hayagriva, 169, 189
Hayagriva (Zimmerman), 189; *189*
Hermitage Museum. See State Hermitage (Leningrad)
Heruka(s), 171, 197, 198
Hevajra Tantra, 27, 199
Himachal Pradesh influence, 42, 44
Hinayana Buddhism. See Individual Vehicle
Hvashang, 52, 78, 82, 86, 102, 111; *77, 110*
Hvashang (British Mus.), 52, 78, 111; *110*

I

icon(s), 35, 37, 71
 Emanation Body of Buddha as, 72
iconography, 39, 42, 43, 279
 of Bodhisattvas, 68
 of Chakrasamvara, 217, 279
 of cosmic Buddhas, 345
 "host of ornaments," 380
 Sadhanamala text on, 278, 353
 of Ushnishasitatapattra, 321
 Vairochana text on, 42
 of Vaishravana, 306
 of wrathful deities, 186, 283, 381
Indian Pandit Gayadhara (Zimmerman), 60, 64, 207; *206*
Individual Vehicle (Hinayana), 15, 24, 102, 146–47
 Arhats and, 102
Indo-Nepalese style, 42, 45, 48, 50, 51, 57, 58, 60, 65, 106, 108, 220, 229, 317, 325, 333–34
 Chinese style with, 52, 57, 61
Indra (World God), 229, 340
Indrabhuti Vajradakini (Musée Guimet), 50, 236, 261; *261*
international Tibetan style, 49, 62, 64, 68, 208, 211, 305, 318
Ishana (World God), 340
ishtadevata. See archetype deity; *yidam*
Iwang monastery (central regions of Tibet), 46–47

J

Jambhala(s), 161, 353; *340*
 jewel-vomiting mongoose of, 161, 340
 protection wheels of, 353
 retinue of, 353
 twelve, 339–40
Jamyang, Kyenrab (painter), 213, 214
Jangkya Hutuktu lineage, 276, 340
Jangkya Hutuktu I (Ngawang Chönden), 276
 text on Vajravali mandalas, 227
Jangkya Hutuktu II (Rolpay Dorje), 262, 276; *276*
 Emperor Qianlong and, 276
Jataka(s) (Former Life stories/Buddha), 35, 73, 97–99
 at Tabo monastery, 73

Jatakamala (Aryashura), 91, 97
jewelry style(s):
 Alchi, 215
 live snakes as, 187, 188, 295; *186*
 Ming, 233
 Orissan-Nepalese, 220
 Qing, 318
Jnyanadakini, 285
Jokhang temple (Lhasa), 40, 374; *40, 374*
 wall paintings, 47; *47*
Jowo Shakyamuni Buddha (Jokhang temple), 34, 38, 40, 54, 356; *41*
Juyong guan gate (Beijing), 50

K

Kadam Order, 29, 129
 Atisha and, 29
 monasteries of, 29, 45
Kagyu Order, 26, 28–29, 165, 236, 328, 369
 archetype deities of, 236
 Drigung, 28, 236
 Druk, 28, 248
 Marpa and, 165
 monasteries of, 28, 236
 Pakmodrupa rulers and, 28, 30, 50
 reincarnate lamas of, 165
 Shamarpa lineage, 247, 254
 Taklung, 28, 236, 247
Kalachakra (archetype deity), 159, 376, 384
 Vishvamata and, 376, 384
Kalachakra mandala, 13, 34, 376, 383–84
 Nispannayogavali text on, 376
 three levels of interpretation, 384
Kalachakra Mandala (Musée Guimet), 376; *377*
Kalachakra Tantra (Wheel of Time), 32, 159, 312
 Shambhala and, 156, 159
Kalaratri, 278
Kanakavatsa (Arhat), 105
Kanjur/Tanjur (Tibetan Buddhist canons), 146, 213, 227, 276
kapala. See skull bowl
Karma Gadri style, 59, 63, 97, 103, 152, 155, 236, 243, 245; *154, 242–45*
 duck pond motif, 250
 Great Adepts, 147
 Karmapa lineage and, 59, 236
 Ming influence, 97
Karma Kagyu (suborder), 29, 236
 Karma Gadri style and, 59, 236
 Karmapa lineage, 28, 29, 236
Karmapa (Black Hat) lineage, 28, 29, 34, 59, 236, 247
 Karma Gadri style and, 59, 236
 Ming emperors and, 29, 54, 254
 Xi Xia dynasty and, 49, 236, 334, 337
Karmapa (First, Dusum Kyenpa), 28, 29, 236, 247, 334, 337; *246, 337*
 black hat of, 50, 334, 337
Kashmiri style, 42–43, 46, 100, 120, 137, 188, 323, 344; *42, 100, 323*
 Western Tibet art and, 188, 323, 344
Kedrup Jey Pelsangpo, 275
kesi embroidery technique, 49, 121, 126–27, 292, 386; *126–27, 292*
Khara Khoto (Central Asia), 47, 49–50, 120–21, 255, 335
 kesi embroidery, 49, 121, 126–27; *101, 126–27*

painting, 123, 255–60, 325, 334, 337, 341–42; *123, 255, 256, 258–60, 324–25, 336–37, 341–42*
 suburgan (stupa), 49–50, 121, 335
 Xi Xia dynasty and, 49, 121, 255
khatvanga (staff), 18, 167, 169, 183, 187, 259, 279; *168*
Khon family (Sakya Orders), 27, 201
Khotan, 45, 46–47
Khotanese style, 45, 46–47, 53, 65 n. 7; *47*
 Iwang and Nesar monasteries and, 46–47
The Kingdom of Shambhala (Musée Guimet), 65, 378–79; *378, 379*
king(s), 21–22
 Lang Darma, 166
 Miwang Kunga Gyalpo, 172
 Namri Songtsen, 22
 Nyatri Zangpo, 21
 Rudrachakrin of Shambhala, 156, 159; *158*
 shamans and, 22
 Suchandra of Shambhala, 156
 symbols of, 21
 Yashas of Shambhala, 275
 Yeshe Ö, 27, 42
 See also Dharma Kings, Three Religious Kings
King Trisong Detsen (Musée Guimet), 157; *157*
King Trisong Detsen (Peljor Chöde, Gyantse), 56; *56*
Konchok Bang, relics of, 353
Korean landscape tiles, 49, 129; *49*
Kozlov, P. K., 49, 120–21
Kubera (World God), 163, 229, 340
Kubera (Musée Guimet), 163; *162*
Kumbum (Gyantse, Tsang), 54–55; *54*
 drapery style, 55, 205
 figural style, 55, 111
 scroll patterning, 206, 355
 sculptures, 55, 237
 wall paintings, 55, 89, 111, 203, 218
Kunga Lekpa, Lama Khedzun, 231–32
Kunga Sangpo, Gyalwa Dorje Chang, 56, 201
Kunga Tashi (LACMA, Los Angeles), 61, 62, 208; *209*

L

lakshanas (marks of Buddha), 73, 85
Lalitavajra (Great Adept), 147, 285
Lama (Hermitage), 252; *252*
A Lama (. . . Atisha or Early Kadam Lama) (Ford), 265; *264*
Lama Karma Dudzi (LACMA, Los Angeles), 61, 253; *253*
Lama (Portrait of a Monk) (Hermitage), 255, 265; *255*
landscape, 183, 239; *183*
 Chinese naturalistic, 59, 63, 64, 135, 211, 250, 254, 360
 evolved Tibetan, 96, 114, 117; *97, 115, 117*
 expressive, 239, 247
 figure in, 73, 95; *97*
 ideal naturalism, 39, 65, 154
 international style, 49
 Ming, 111, 114
 settings of Arhats, 103, 106, 111
landscape and architecture, 95, 208, 243, 271, 317, 364, 374; *209, 271, 365, 375*
 genre (Tibetan), 365
lasso, 18, 279, 308

leogryphs (Skt. *shardula*), 81, 265, 314
Longchen Rapjam Tsultim Lodrö, 27
Losang Gyatso. *See* Dalai Lama (Fifth)
Lotus Mandala with Paramasukha-Chakrasamvara (British Mus.), 280–81; *280, 281*
lotus seat(s):
 black tangka style, 297
 central regions of Tibet style, 185, 217, 230, 249
 Eastern Tibet style, 90
 Guge style, 80, 86
 Indo-Nepalese style, 48, 351
 Pala style, 130, 187
 Qing style, 148
 Western Tibet style, 248, 343, 344, 349, 350
 Yongle style, 357
Luyipa (Great Adept), 147, 260
 Sixty-Two Deity Shamvara Mandala of, 257

M

Machig Labdrön (Great Adept), 150
Mahachakra Vajrapani and Consort (Zimmerman), 191; *191*
Mahakala, 187, 223, 225, 293, 295, 297
Mahakala (Ellsworth), 187; *186*
Mahakala (ROM, Toronto), 295; *295*
Mahakala Brahmanarupa (Hermitage), 225; *225*
Mahakala Panjaranatha (Lord of the Pavilion) (Zimmerman), 60, 223–24; *222–24*
 gandi, gong of, 223
Mahaparinibbana Sutra, 99
Mahasiddha(s). *See* Great Adept(s)
Mahasiddha Nagpopa (Padampa Sangyey) (LACMA, Los Angeles), 53, 150; *150*
Mahayana Buddhism. *See* Universal Vehicle
Maitreya Bodhisattva, 81, 341
Maitreya Bodhisattva (Hermitage), 142; *142*
Maitreya Bodhisattva (Kumbum), 55; *55*
Maitreya Bodhisattva (Narthang monastery), 45; *45*
Maitreya Bodhisattva (Sackler, Harvard), 64, 141; *141*
Maitreya Buddha, 34, 312
Maitreya Buddha (Ford), 101; *101*
Maitreya, the Future Buddha (Hermitage), 100; *100*
makara(s), 81, 232, 271, 314, 327; *314*
Manchu empire, 31, 262, 266
mandala(s), 33, 312, 361, 383
 colored sand (particle), 13, 37, 383–84; *383*
 palace, 13, 232, 376, 384
 three-dimensional, 37, 383, 384
Mandala of Bhaishajyaguru (Hermitage), 338–40; *338–40*
Mandarava (Great Adept), 167, 169, 175, 177, 178; *168, 170, 174, 176, 181*
Manjushri (Bodhisattva), 27, 33, 34, 81, 371; *80*
 Five Mountain Paradise of, 312
 as Longchen Rapjam, 27
 as Rolpay Dorje, 276
 as Sakya Pandita, 211
 as Tsong Khapa, 266, 275
 as Yamantaka, 36, 235, 283, 287, 291
Manjushri (Stockholm), 144; *144*
Manjushri (Zimmerman), 63, 140; *140*
Manuscript Cover (British Mus.), 314–15; *314, 315*

Marichi (goddess), 130
Marpa, Lhodrak, 27–28, 245
 four major disciples of, 28
Maudgalyayana, 73, 76, 87; *77, 86*
Medicine Buddha(s), 58, 334, 337–39; *59*
 See also Bhaishajyaguru
metal sculpture, 387–88
 alloys for, 387–88
 connecting struts, 100, 323, 345, 346, 347,
 349
Mikyö Dorje, 352
 relics of, 352
Milarepa, 28, 147, 165, 236
 and the huntsman, 241
 and Marpa, 28, 245
 right-hand-to-ear gesture, 240
Milarepa (Hermitage), 240; *240*
Milarepa (LACMA, Los Angeles), 241; *241*
Milarepa (Zimmerman), 237; *237*
Milarepa and Scenes from His Life (LACMA,
 Los Angeles), 239; *238–39*
Milarepa and Scenes from His Life (I, Stock-
 holm), 65, 369; *368–69*
Milarepa and Scenes from His Life (III, Stock-
 holm), 65, 243; *242–43*
Milarepa and Scenes from His Life (IX, Stock-
 holm), 65, 245; *244–45*
Ming period, 28–29, 54, 254
 bronzes, 233. *See also* Yongle bronzes
 style, 59, 60, 63, 66 n. 15, 97, 103, 111,
 115, 119, 143, 163, 277, 305
Mongolian Buddhist art, 64
 painting, 378–79; *378–79*
 sculpture, 69, 141, 144–45, 263, 266, 294,
 388; *68, 141, 144–45, 267*
Mongol khans, 27, 30, 49–50, 60, 262, 266
monumental temple sculpture, 55–56, 64, 237,
 248, 267; *55–56*
Mount Meru, 32, 337, 382
mudra(s) (hand gestures), 73, 314
 boon-granting (*varada*), 133; *350*
 contemplation (*dhyana*), 73, 344; *341, 350*
 diamond HUM-sound (*vajrahumkara*), 193,
 215, 217, 357, 359; *357, 359*
 discerning (*vitarka*), 141, 248; *141, 252*
 earth-witness (*bhumisparsha*), 73, 75, 341,
 343; *342*
 fear-not (*abhaya*), 136; *136*
 prayer (*anjali*), 322
 right-hand-to-ear (Milarepa's), 240; *240*
 teaching (*dharmachakra-pravartana*), 73,
 142, 347; *150*
 threatening (*tarjani*), 108–09, 189, 190; *190*
 three refuge, 133
 unity-of-all (*vajra/jnyana*), 348; *348*
 See also posture(s)
Mughal painting, 106
mural painting (Tibetan), 385–86
 See also wall painting

N

Naga(s), 126, 191
Nagarjuna (Great Adept), 146–47
Nairatmya (LACMA, Los Angeles), 74, 230; *230*
Naro Dakini (Hermitage), 299
 Naropa and, 298; *298*
Naropa (Great Adept), 28, 146, 147, 155, 352;
 154
 relics of, 352

Narthang monastery (Tsang), 45
Narthang wood-block illustrations, 64, 66 n.
 20, 275
Nebesky-Wojkowitz, R. de, 304, 307
Nepalese style, 79, 315, 348
 Jivarama text on, 79, 328
 Newari sculpture, 277
 sculpture, 351–53; *351*
Nesar monastery (central regions), 46, 47
New Menri style, 61–62, 262, 286, 302
 Chöying Gyatso and, 61, 302
Ngawang Losang Gyatso, the Fifth Dalai Lama
 (Rose, Brandeis), 64, 272; *273*
Ngor monastery (Tsang), 56, 201
 Gyalwa Dorje Chang Kunga Sangpo, 200
Nyingma Lama (Ford), 185; *184*
Nyingma Order, 26–27, 165–66
 Great Perfection (Dzogchen) tantras, 26, 27
 Longchen Rapjam Tsultim Lodrö and, 27
 major *yidams* of, 167, 171
 monasteries, 166
 Padma Sambhava and, 165
Nyingmapa style, 167, 171, 175; *168, 174*

O

Offering Mandala (Musée Guimet), 382; *382*
Offerings to Mahakala (Musée Guimet), 65,
 380–81; *380–81*
OM MANI PADME HUM (mantra), 34, 136, 144,
 353
orchid flower line (painting style), 95
Orissan/Hoysalan styles, 50, 51
The Outer Yama Dharmaraja (Zimmerman),
 291; *290*

P

Padampa Sangyey (Great Adept), 46, 147, 150; *150*
 Shije Order and, 150
 See also *Mahasiddha Nagpopa*
Padma Lingpa, Tertön, 197, 198
Padma Sambhava, 26, 27, 33, 34, 40, 147,
 165, 166–67, 365
 Amitabha as, 169
 Glorious Copper Mountain Paradise, 181,
 312, 363
 twenty-five main disciples, 169, 171, 175
Padma Sambhava (Ford), 52–53, 169–71; *168,
 170–71*
Padma Sambhava (Zimmerman), 58, 172; *173*
Padma Sambhava and Scenes from His Life
 (Ellsworth), 63, 177–79; *176, 178–79*
Padma Sambhava and the Twenty-Five Adepts
 (Victoria & Albert), 175; *174–75*
*Padma Sambhava in the Palace of the Glorious
 Copper Mountain Paradise* (Newark), 363;
 362, 363
*Padma Sambhava in the Palace of the Glorious
 Copper Mountain Paradise* (Zimmerman),
 60, 181–83; *180–83*
Padmapani Bodhisattva (Hermitage), 50, 123;
 123
painting:
 18th–19th century developments, 64–65,
 157, 380–81; *157, 380–81*
 European Renaissance style and, 56, 203
 European Rococo style and, 211
 Khara Khoto, 49–50, 123, 255–60, 325,

334, 337, 341–42; *123, 255, 257, 258–60,
 324–25, 336–37, 341–42*
 Mongolian, 378–79; *378–79*
 Mughal, 106
 orchid flower line, 95
 Pala style, 48, 76, 199
 Rva Lotsawa form, 283; *282–83*
 tangka, techniques, 48, 386–87
 Tibeto-Chinese, 254, 292; *254, 292*
 See also regional listings; international
 Tibetan style
painting (central regions of Tibet), 47–50, 60–
 63
 11–12th centuries, 47–50, 129–32, 265;
 128, 130–31, 264
 13–14th centuries, 50–53, 105–08, 111,
 169–71, 217–19, 227–29, 231–32;
 *104–05, 107, 109, 110, 168, 170, 171,
 216, 218–19, 226, 228–29, 231–32*
 15th century, 54–57, 111, 161, 175, 201–03,
 220, 235, 283, 333; *110, 160–61, 174,
 200, 202–03, 221, 234, 282, 332–33*
 16th century, 59, 60–61, 76–79, 181–83,
 206, 223, 250, 355, 376; *77–79, 180–83,
 207, 222, 251, 354, 377*
 17th century, 61–63, 134, 185, 193–94,
 197, 208, 213–14, 253, 285, 291, 297,
 301–02; *185, 193–95, 197–98, 209, 212,
 214, 284–86, 290, 296, 300, 302*
 18th century, 64, 211, 247, 289, 309, 365;
 210, 246, 288, 308, 364
 19–20th centuries, 65, 99, 275; *98, 274, 57,
 380–81*
painting (Chinese), 50, 52–53, 106, 122, 143,
 163; *122, 143, 162–63*
 See also Buddhist art (Chinese); Chinese
 style(s); Sino-Tibetan style; Tibeto-Chinese
 style
painting (Eastern Tibet), 59–60, 63, 114, 117,
 250, 319, 334; *135, 369*
 15th century, 59
 16th century, 59–60, 91–95, 103, 115,
 151–52; *90, 92–93, 95, 114, 151–52*
 17–18th centuries, 63, 96, 117, 135, 293–
 94, 317, 359–60; *96, 116, 135, 293–94,
 316, 358–60*
 18–19th centuries, 64–65, 155, 159, 198,
 243, 245, 319–20, 363, 369, 371, 373,
 374; *154, 158–59, 198, 242–45, 319–20,
 362–63, 368–75*
 duck pond motif, 250
 Wanli period, 90, 95
painting (Western Tibet), 50, 57–59, 250, 367
 14th century, 50, 237, 349, 350; *349, 350*
 15th century, 57–59, 81–83, 87–89, 239,
 327–28, 367; *80, 83, 86–89, 236–39,
 366*
 16th century, 59, 250, 269–71; *268–71*
 17th century, 63, 176–79; *176, 178–79*
"palaces with lattice work," 108
 See also shrine-type throne
Pala dynasty style, 42, 45–46, 48, 75, 77, 100,
 120, 138, 199, 205, 225
Pala-Sena style, 45, 46
 stone sculpture, 125, 187
 See also Indo-Nepalese style
Panchen Lama(s), 213, 262, 275
Panchen Lama (First, Losang Chökyi Gyaltsen),
 274
Panchen Lama (Fourth, Losang Tenpay Nyima),
 274

Panchen Lama and His Reincarnation Lineage
(AMNH, New York), 274; *275*
Paramasukha-Chakrasamvara, 17, 57, 215,
217, 220, 278
Paramasukha-Chakrasamvara and Vajravarahi
(AAM, San Francisco), 278–79; *278–79*
Paramasukha-Chakrasamvara Father-Mother
(Ellsworth), 51, 217–19; *216, 218–19*
*Paramasukha-Chakrasamvara Father-Mother,
Luyipa Mandala* (Hermitage), 257; *256*
*Paramasukha-Chakrasamvara Father-Mother,
Variant Face Style* (Ellsworth), 57, 220; *221*
Particle Mandala of Kalachakra, 383–84; *383*
Pehar (protector deity), 365
Peljor Chöde monastery (Gyantse), 55, 56, 57,
249
sculptures, 56
Penden Lhamo, 263, 301, 303
Dalai Lamas and, 301, 303
Lhamo Latso and, 301
Penden Lhamo (Shri Devi) (Ford), 61, 263,
301–02; *300, 302*
Penden Lhamo (Shri Devi) (Rose/Brandeis),
303; *303*
period of the Religious Kings, 40–42, 156
period of the Second Transmission, 42, 50,
125, 165, 323, 344
pig symbol, 298
planetary deities (Indian), 227, 335; *228*
Portrait Statue of Songtsen Gambo (Potala), 41;
41
posture(s), examples of:
ardhaparyankasana, *304*
benevolence (*bhadrasana*), *142*
debate, 148; *149*
diamond (*vajrasana*), 335, 341, 359; *341,
343*
ease (*lalitasana*), 41, 126
inner heat (*dumo*), *150*
integration of wisdom and art (*prajnyopaya-
dvaya*), 129
thrice bent (*tribhanga*), 138
warrior's (*pratyalidha*), 68, 189, 190; *69,
189, 190*
Potala (Lhasa), 31, 34, 37, 41, 61–62, 157,
262, 272, 312, 374; *62, 375*
wall paintings, 62, 157, 208
Potalaka Paradise, 312
Prajnyaparamita (goddess), 43–44, 314, 339;
315
Prajnyaparamita (Tholing monastery), 57; *57*
Prajnyaparamita sutra(s), 315
A Protector (Drigung), 52; *52*
protector deities, 161, 175, 291, 335; *175*
female, 218, 227, 256
Prthividevi (goddess), 229, 340
purba (dagger), 159, 188
Pure Land of Manjushri (VMFA, Richmond),
371; *370–71*
Pure Land paradise(s), 13, 32–34, 65, 311, 361
Five Mountain (Ch.Wutaishan), 33, 312, 364
Glorious Copper Mountain, 33, 181, 183,
312; *180*
Joyous (Skt. Tushita) Heaven, 32–33, 312
Land of Bliss (Skt. Sukhavati), 33, 311
Land of Delight (Skt. Abhirati), 33
microcosmic, 312
Mount Meru, 32, 382
Potalaka, 312
Shambhala, 33, 312
Tibet as, 34

Q

Qianlong period, 31, 64, 65, 262
Qing period, 85, 262, 266, 305, 318
bronzes, 148

R

Rakshasa (World God), 340
rakshasas, 181
Raktayamari Father-Mother (Hermitage), 233;
233
Raktayamari Father-Mother (MFA, Boston),
235; *234*
Raktayamari Father-Mother (MFA, Boston), 62,
289; *288–89*
Raktayamari Mandala (Zimmerman), 51, 231–
32; *231–32*
Ratnasambhava Buddha, 334, 341
Ratnasambhava (Hermitage), 350; *350*
Ratnasambhava (Zimmerman), 346; *346*
Ratreng monastery, 265
Rechungpa, 236, 237; *238*
red style (tangkas), 185; *185*
Red Temple (Tsaparang), 57–58, 66 n. 11, 89;
58
Refuge Tree, 373
relics, 351–53; *352*
Buddha and dog's jawbone anecdote, 38
protection wheels in, 353
study of, 351–52
Renaissance style (European), 203
Rinchen Sangpo (translator), 42, 187
Rolpay Dorje, the Jangkya Hutuktu
(Hermitage), 276; *276*
Rudrachakrin, the Last King of Shambhala
(VMFA, Richmond), 159; *158–59*
Rva Lotsawa form (painting), 283; *282–83*

S

Sadhanamala (text on iconography), 278, 353
Sakya Lama (Peljor Chöde, Gyantse), 56, 57;
57
Sakya Lama Kunga Nyingpo (Ellsworth), 56,
201–03; *200, 202–03*
Sakya Lama Sasang Pakpa, 27, 225
Mahakala Brahmanarupa and, 225, 227
Sakya Lama Sonam Lhundrup (Zimmerman),
61, 205; *205*
Sakya Lama Sonam Tsemo (LACMA, Los An-
geles), 204; *204*
Sakya monastery, 27, 199, 201, 208
Khon Konchok Gyalpo, 27, 199
Sakya Order, 26, 27–28, 165, 199
archetype deities, 27, 199
Drokmi (Khon, founder), 27
Khon family, 27, 200
Mahakala Panjaranatha and, 223
monasteries, 27, 45, 199, 200
Mongols and, 27, 50
Sakya Pandita (Newark), 64, 211; *210*
Sakya Pandita Kunga Gyaltsen, 27, 199, 275
Mongols and, 211
Panchen Lamas and, 211
Sakyapa style, 51, 60, 81, 199, 207, 218, 223,
229; *221, 222, 226*
Samantabhadra, 198
Samye monastery, 22, 26, 40, 157, 166

Samye Monastery (Newark), 365; *364*
Sangha, 23
Saraha (Great Adept), 147, 155; *154*
Sarasvati (LACMA, Los Angeles), 63, 135; *135*
Sarnath style, 75
Scroll/shadow patterning, 106, 175, 206, 355
sculpture, 61, 334–35, 387–88
12–15th-century developments, 124–25,
186, 189, 191, 348; *124, 186, 348*
16–19th centuries, 153, 225, 261, 304, 307,
330, 380; *153, 225, 261, 304, 307, 330*
cold gold paste, 189, 191, 388
Indo-Nepalese style, 63, 134, 348; *348*
Kashmiri style, 42–43, 46, 100, 120, 137,
188, 322, 344; *42, 100*
metal, 387–388
Mongolian, 64, 69, 141, 144–45, 263, 266,
294, 388; *68, 141, 144–45, 267*
monumental temple, 64, 237, 248, 267
Nepalese/Newari, 277, 351–53; *351*
Pala style, 45–46, 75, 125, 138, 187, 225;
125, 138, 186, 225
repoussé, 261, 388
stone, 124–25, 187, 387; *124, 186*
techniques, 385, 387–88
tree of life (T. *sogshing*) in, 353
wood, 343, 387; *343*
sculpture (central regions of Tibet), 45–46, 53,
61, 249; *41, 45, 46, 47, 53, 55–57*
11–12th centuries, 45–47, 138, 188, 189,
215; *138, 188, 215*
13–14th centuries, 53–54, 150, 190, 237,
314–15; *150, 190, 237, 314–15*
15th century, 54–57, 150, 191, 204, 237,
249, 357; *191, 204, 237, 249, 357*
16th century, 61, 140, 192, 205, 230, 298,
357; *140, 192, 205, 230, 298, 357*
17th century, 64, 134, 241, 272; *134, 273*
Khotanese influence, 46, 47, 53; *47*
Pala influence, 120, 138; *138*
sculpture (Chinese), 112, 113, 142, 240; *41,
112, 113, 240, 382*
Qing, 85, 142, 148; *84, 142*
Yongle period, 61, 63–64, 120, 139, 233,
356; *139, 233, 356*
sculpture (Eastern Tibet), 63–64
15–16th centuries, 252, 253; *252, 253*
17th century, 241; *241*
sculpture (Tibeto-Chinese), 85, 133, 148, 190,
233, 277, 278–81, 287, 292, 335, 388; *190,
315*
15th century, 233, 277; *233, 277*
17–18th centuries, 85, 133, 148–49, 278–
81, 287, 295, 299, 303, 305, 318, 321,
338–40; *84, 133, 149, 278–81, 287, 295,
299, 303, 305, 318, 321, 338–40*
sculpture (Western Tibet), 44, 53–54, 58, 120,
172, 188, 323, 335; *42, 58*
11–12th centuries, 44, 75, 120, 136–37,
188, 189, 323, 335, 343, 344, 346; *74,
136, 137, 189, 322, 344*
13–14th centuries, 50, 53–54, 345, 347,
349, 350; *345, 347, 349, 350*
15th century, 58, 61, 172, 248, 331; *173,
248, 331*
16th century, 61
Kashmiri influence, 188, 323, 344
metal connecting struts, 100, 323, 345, 346,
347, 349
Seated Buddha (Cleveland Mus. of Art), 343;
343

Sera monastery, 29, 54, 374
Sertrap (Zimmerman), 65, 309; *308*
seven treasures, 161, 281
Shadakshari Avalokiteshvara (Stockholm), 144–
 45; *145*
Shakyamuni Buddha, 22–24, 32, 71, 72–73,
 341, 344, 356
 enlightenment of, 23, 24, 75, 88
 relics of, 99, *98*
 twelve deeds of, 73
Shakyamuni Buddha (Cleveland Mus. of Art),
 42; *42*
Shakyamuni Buddha (Hermitage), 85; *84*
Shakyamuni Buddha (Zimmerman), 44, 75; *74*
Shakyamuni Buddha and Two Bodhisattvas
 (VMFA, Richmond), 58, 81–83; *80, 83*
Shakyamuni Buddha Attaining Parinirvana
 (AAM, San Francisco), 65, 99; *98*
Shakyamuni Buddha in Vajrasana (Hermitage),
 334, 341–42; *341–42*
*Shakyamuni Buddha with Scenes of His Former
 Lives* (British Mus.), 60, 91–95; *90, 92, 93,
 95*
*Shakyamuni Buddha with Scenes of His Former
 Lives* (Ford), 97–98; *96, 98*
Shakyamuni Buddha with Scenes of His Life
 (Ellsworth), 58, 87–89; *86, 88, 89*
*Shakyamuni Buddha with Two Disciples and
 the Eighteen Arhats* (British Mus.) 77–79;
 76, 78–79
Shakyaprabha (Great Adept), 146
Shalu monastery (Tsang), 53, 213, 289
 Butön Rinchen Drup and, 213–14
shamanism, 20–22
 symbol of, 21
Shamarpa lineage, 247, 254
Shambhala, 32, 71, 159
 flag of, 159
 Kalachakra Tantra and, 378, 383
 kingdom of, 378–79
 pure land of, 33, 34
 thirty-two kings of, 156, 378
Shamvara (archetype deity), 17–19, 215, 217,
 220, 278
 forms of, 278
 with Vajravarahi, 215
 See also Paramasukha-Chakrasamvara
Shamvara Paramasukha-Chakrasamvara
 (Zimmerman), 215, *215*
Shantarakshita (Great Adept), 26, 27, 146, 165,
 166, 365
 as Arhat Rahula, 119
Shantideva (Great Adept), 146
Shariputra, 73, 77, 87; *76, 86*
Shavaripa (Great Adept), 151–52, 187, 297;
 151
shrine-type throne, 77, 81, 128, 168, 171, 175,
 207, 208; *76, 80, 129, 168, 174, 206*
Siddhartha, Prince, 22–23, 88
Simhavaktra (Hermitage), 304; *304*
Sino-Tibetan style, 64, 118–19, 276; *118–19,
 276*
Six-Armed Mahakala (Ellsworth), 62, 297;
 296–97
skull bowl (Skt. *kapala*), 18, 152, 153, 154,
 167, 168, 169, 186, 187, 235, 279, 309;
 168, 260
Sonam Gyatso. *See* Dalai Lama (Third)
*Sonam Gyatso, the Third Dalai Lama and
 Scenes from His Esoteric Biography*
 (Ellsworth), 59, 83, 269–71; *268–71*

Song period, 78, 103, 105, 308
Songtsen Gambo, King, 22, 40–41, 156
Standing White Mahakala (Ford), 293–94;
 293–94
State Hermitage (Leningrad), 85, 351
 Prince Esper Ukhtomsky and, 85
Sthiramati (Great Adept), 146
stupa(s) (T. *chöten*), 34, 35, 99, 121, 312
Subhuti, 274
suchness (Skt. *tathata*), 334
Sufism, 147
Supreme Bliss Wheel Integration Tantra
 (Mother Tantra), 215, 278
Sutra of Five Protections, 335,
 Central Asian version, 335
Sven Hedin, expedition, 68, 243, 266

T

Tabo monastery, 43, 367
 wall paintings, 43, 65 n. 1, 73, 89; *43*
Taklung Kagyu (suborder), 28, 247
Taklung monastery (Tsang), 249
Tang dynasty style, 309
 black, style (T. *nagtang*), 61–63, 197, 213,
 263, 289, 297, 301–02; *197, 288, 296,
 302*
tangka(s), 48, 386
 embroidered/appliquéd, 49, 101, 121, 126–
 27, 292, 386; *101, 126, 127, 292*
 red style, 185; *185*
tangka painting techniques, 48, 386–87
 background supports, 386
 gilded raised relief, 77, 105, 169, 201
 pigments, 386
Tangut culture, 121, 255, 335
 Buddhism and, 49, 255, 334–35
 State Hermitage (Leningrad) collection of,
 121
Tanjur. *See* Kanjur
Tantric Vehicle (Vajrayana), 24–25
 feminine principle in, 353
 four categories of, 25
 See also Apocalyptic Vehicle
Tara, 63, 83, 126, 312, 317
 See also Green Tara, *White Tara*
Tashi Lhunpo monastery (Shigatse, Tsang), 30,
 54, 274, 297
The Temples and Monasteries of Lhasa (ROM,
 Toronto), 65, 374; *375*
Ten World Gods. *See* World Gods
Tenzin Gyatso. *See* Dalai Lama (Fourteenth)
thigh bone trumpet, 223, 224; *225*
The Thirteen-Deity Yamantaka Father-Mother
 (Zimmerman), 61, 285–86; *284–86*
Thirty-five Buddhas of Confession, 73, 82, 86,
 314; *80*
thirty-two marks of Buddha, 73, 85
Tholing monastery (Western Tibet), 57
Three Bodies of Buddha, 35, 39, 44, 72, 356
 art theory and, 35
Three-Buddha-Body Mansion, 181
"Three Hundred Gods" (album), 276, 304
"Three Hundred Sixty Gods" (album), 276
Three Jewels (Skt. Triratna), 23–24
Three Religious Kings. *See* Songtsen Gambo;
 Tri Relwajen; Trisong Detsen
Three Vehicles of Buddhism, 15, 24, 102, 146–
 47
throne style(s), 58, 76–78, 80, 142

Indian, 48
Indo-Nepalese, 78, 81, 325
Khara Khoto, 126, 255
Pala, 100, 314
Qing (early), 85
shrine-type, 77, 81, 129, 168, 171, 175,
 207, 208
Tibet, 15, 20–22, 262
 ancient world views of, 21
 central regions of, 15
 Eastern, 15
 modernization of, 32
 monastic "revolution" in, 31
 northern plain (Jangtang), 20
 sacred history of, 71
 southern valleys, 20–21
 Western, 15
The Tibetan Book of the Dead, 167, 198
Tibetan international style, 62, 64, 69, 263,
 266
 See also international Tibetan style
Tibetan language, 15, 21
Tibeto-Chinese style, 64, 263, 292, 335
 Ming, 305
 painting, 292, 254; *254, 292*
 Qing, 85, 305, 318; *84, 318*
 sculpture, 85, 133, 148–49, 190, 233, 277,
 278–81, 287, 292, 295, 299, 303, 305,
 318, 321, 338–40, 388; *84, 133, 149,
 190, 233, 277, 278–81, 287, 295, 299,
 303, 305, 318, 321, 338,–40*
Tilopa (Great Adept), 147, 213
torma (offering cake), 309
Trakkiraja (protector deity), 297
trident, 18, 169, 279
Tri Relwajen, King, 41, 42, 156, 166
Trisong Detsen, King, 22, 26, 40, 56, 156,
 157, 166, 169, 365
Truth Body (Dharmakaya), 35, 39, 72, 356
tsa-tsa, 330
*Tsa-Tsa of the Eleven-Faced, Thousand-Armed
 Avalokiteshvara* (Ford), 330; *330*
Tsong Khapa, 29, 54, 83, 101, 213, 265, 266,
 275, 291
 "four major deeds" of, 29
 major disciples of, 29–30
Tsong Khapa and the Gelukpa Refuge Tree
 (Mead, Amherst), 373; *372–73*
Tsong Khapa (Stockholm), 266; *267*
Tsurpu monastery, 28, 29
Tucci, Guiseppi, 43, 57, 82, 89, 201, 269, 297
Tuhui Baochien (Chinese text), 121
Tushita Heaven/Paradise, 32–33, 312
Twelve Jambhalas, 339–40; *339*
Twenty-one Verses in Praise of Tara, 123–25
Twenty-one White Tara Stele (Irving), 45, 124;
 124

U

Ukhtomsky Collection (Hermitage), 85, 225,
 351
Ukhtomsky, Prince Esper, 85
Unexcelled Yoga tantra, 25
 Mother tantra class of, 215, 256
Universal Vehicle (Mahayana), 15, 24, 25, 33,
 35, 102, 146–47, 361
urna, 73, 85, 323
ushnisha, 73, 75, 85, 325, 341, 344; *74, 324*
Ushnishasitatapattra (Hermitage), 321; *321*

Ushnishasitatapattra (Zimmerman), 64, 319; *319–20*
Ushnishavijaya (goddess), 227, 318; *229*
Ushnishavijaya (Hermitage), 318; *318*

V

Vairochana Buddha, 43, 48, 58, 334, 341
 texts on iconography, 42
Vairochana (Gyantse Kumbum), 55; *55*
Vairochana (Hermitage), 348; *348*
Vairochana (Victoria & Albert), 347; *347*
Vairochana and Bodhisattvas (Cleveland Mus. of Art), 48, 49; *48*
Vairochana Buddha (White Temple, Tsaparang), 58, 61
Vaishravana (Guardian of North), 163, 305, 335
 leaf motif in images of, 305
Vaishravana (Ellsworth), 161; *160–61*
Vaishravana (Hermitage), 305; *305*
Vaishravana (Hermitage), 306; *306*
vajra (scepter), 18, 167, 190, 201; *190*
vajra bell, 18, 201, 279, 331
 and scepter, 18, 201, 277, 279, 331
Vajrabhairava, 36. *See also* Bhairava; Yamantaka
vajra chopper, 18, 187, 230, 235, 279
Vajradhara (Ellsworth), 359–60; *358–60*
Vajradhara (Newark), 61, 357; *357*
Vajradharma, 250; *251*
Vajrakila, 178
Vajrakumara (Vajrakila) (Ford), 192; *192*
Vajrakumara (Vajrakila) (Newark), 188; *188*
vajra lasso, 279
 See also lasso
Vajrapani, 34, 68, 122, 190
Vajrapani (British Mus.), 122; *122*
Vajrapani (Ford), 53, 190; *190*
Vajrapani (Stockholm), 68; *69*
Vajrasattva (Ellsworth), 333; *332–33*
Vajrasattva (Newark), 331; *331*
Vajravali (text), 227
 four mandalas of, 227–29; *226, 228–29*
Vajravarahi, 17, 18–19, 215, 220, 335; *220, 298*
 Shamvara and, 257; *256*
 sow's face crowning, 259, 298
Vajravarahi (Hermitage), 236, 257, 259–60; *258–60*
Vajravarahi (Newark), 61, 298; *298*
Vajravetali, 233; *233*
Vajrayana. *See* Apocalyptic Vehicle

Vajrayogini/Vajradakini, three main forms of, 261
Vajriputra (Arhat), 105
Varuna (World God), 229, 340
Vasubandhu (Great Adept), 146
Vasudhara (goddess of wealth), 227; *229*
 protection wheels of, 353
 retinue of, 353
Vayu (World God), 229, 340
victory banner, 305; *305*
Vikramashila monastery (India), 150, 199
Vimalakirti, 361, 367
Virupa (Great Adept), 27, 147, 155, 199, 201, 260; *154*
 Hevajra Tantra and, 27, 199
Virupa, 53; *53*
visualization(s), 25, 37, 312, 384

W

wall paintings, 41, 45, 50, 57–58, 89
 Alchi, 43–44, 215, 323, 343; *44*
 Drepung, 285–86
 Dunhuang, 41, 49–50, 77, 111; *43, 44, 47*
 Jokhang, 47; *47*
 Kumbum (Gyantse), 55, 89, 111, 203, 218; *55*
 Potala, 62, 157, 208
 Red Temple (Tsaparang), 57–58, 89
 Tabo, 43, 65 n. 1, 73, 89; *43*
 Tholing, 57; *57*
 Xi Xia, 105
Weber, Max (on secularization), 31
Wen Cheng, Princess, 125
Western Tibet style, 42–45, 50–54, 57–59, 61, 63, 75, 120, 250, 335
 Guge dynasty style, 42, 57, 80–83
 Guge renaissance style, 58, 59, 80–83, 86–89, 90, 177–79, 269–71, 327–29, 367; *80, 83, 86, 88–89, 176, 178–79, 268–71, 326–29, 366*
 Kashmiri influence, 172, 188, 323, 335, 344
 See also painting (Western Tibet); sculpture (Western Tibet)
Wheel of Time. *See* Kalachakra mandala
White Tara (Asia Society), 63, 134; *134*
White Temple (Tsaparang), 58, 59
wisdom(s), 17, 19, 371
 compassion and, 17–19, 25, 217, 298
 female principle as, 17, 192, 217, 298
 of five Buddha clans, 217, 277, 334
Wood-block carving, 306; *306*
 Aginski monastery and, 306
 print technique, 306

World Gods, 229, 232, 340; *228–29, 231, 340*
 Fifteen, 229, 232, 340
 Ten, 339, 340
Wutai shan (Five Mountain Paradise), 33, 312, 364

X

Xi Xia dynasty, 49, 236, 255, 334–35, 337
 three Buddhist sanghas in, 255
 wall paintings, 105

Y

yab-yum. *See* father-mother union
Yaksha(s), 227, 229, 297, 327, 337
Yama (Lord of Death), 36, 229, 235, 291, 311, 340
Yama Dharmapala (British Mus.), 292; *292*
Yamantaka (archetype deity), 36, 104, 231–35, 283–87, 291
 Jnyanadakini and, 385
 three main forms of, 283
 Vajravetali and, 285
Yamantaka Vajrabhairava Ekavira (Hermitage), 287; *287*
Yamantaka Vajrabhairava Ekavira (Rva Lotsawa Form) (LACMA/Los Angeles), 283; *282–83*
Yamaraja (dharmapala), 235, 291
 outer, inner, secret forms of, 290
 Tsong Khapa verses on, 291
Yarlung dynasty (Tibet), 21–22
Yeshe Tsogyal (Great Adept), 167, 169, 175, 177, 181; *168, 170, 174, 176, 181*
yidam (archetype deity), 15
 attributes of, 279
 definition of, 278
 See also archetype deities
yin-yang principle (in composition), 95, 105–06, 113, 117, 211
Yogi (Ellsworth), 46: *46*
Yongle bronzes, 61, 63–64, 120, 139, 233, 356, 357
Yuan dynasty style, 50, 52, 103, 105, 106, 108
Yungdrön Dorje Pel, 275

Z

Zanabazar, Lama (Mongolian sculptor), 64, 68, 141

Credits

The authors and publisher thank the following individuals, museums, and publishers for granting permission to reproduce or quote copyrighted materials in this book.

Illustrations:

Except as listed below or with text figures on pages 40–62, all illustrations are © 1991 John Bigelow Taylor; permission courtesy Tibet House, New York

Asian Art Museum of San Francisco (photographs by John Bigelow Taylor): pp. 98, 213, 214, 277, 278, 279

The Cleveland Museum of Art: pp. 323, 343

Ethnographic Museum of the University of Zurich (photograph by Peter Nebel and Martin Brauen): p. 383

Harvard University (photograph by John Bigelow Taylor): p. 141

Anita Karl and Jack Kemp: maps, front and back end-papers

The Venerable Lobsang Chögyen: Tibetan script, pp. 2, 6, 67, 70, 164, 310, back jacket (hardcover), back cover (museum edition)

Los Angeles County Museum of Art: pp. 104, 106, 150, 282, 283, 366

Museum of Fine Arts, Boston: pp. 115, 143, 155, 234, 235, 288, 289, 354, 355

The Newark Museum (photographs by John Bigelow Taylor): pp. 188, 196, 197, 198, 210, 248, 298, 331, 356, 357, 362, 363, 365

Marylin M. Rhie: diagrams on pp. 83, 86, 90, 96, 176, 200, 206, 208, 212, 217, 245, 259, 274, 352

The State Hermitage, Leningrad (photographs by John Bigelow Taylor): 84, 100, 126, 127, 139, 142, 225, 233, 240, 252, 254, 260, 276, 287, 298, 304, 305, 306, 307, 318, 321, 324, 325, 336, 337, 338, 339, 340, 341, 348, 349, 350, 351, 352

Stewart Zolotorow, Blakeslee-Lane: pp. 101, 116

Text:

Excerpt of 26 lines on p. 154 from *Buddhist Texts Through the Ages*, by Edward Conze et al. Originally published 1954 by Bruno Cassirer Publishers Ltd., Oxford, England

Excerpt of 15 lines on p. 21 from *A Cultural History of Tibet*, by D. L. Snellgrove and H. E. Richardson. Copyright 1968 by Praeger Publishers

Excerpt of 31 lines on p. 241 from *The Hundred Thousand Songs of Milarepa*, by Garma C. C. Chang. Copyright 1962 Oriental Studies Foundation. Published by arrangement with Carol Publishing Company

Excerpt of 42 lines on pp. 129, 130, and 132 from *In Praise of Tara: Songs to the Savioress*, by Martin Willson. Published by Wisdom Publications, Boston, 1988

SUPPLEMENT

The seventy-seven pages that follow contain eighty-one works of Tibetan art included in the 1996 *Wisdom and Compassion* exhibition at the Kunst- und Ausstellungshalle der Bundesrepublik Deutschland in Bonn, Germany.

None of the works in this Expanded Edition appeared in the original exhibition or in the first edition of the book published in 1991. Their addition here constitutes a significant contribution to the study and published corpus of Tibetan art.

This enlarged edition includes two hundred forty-one individual works. The numbering of objects in the Supplement begins with No. 161. Following each main number is a number in parentheses. Such a number indicates where the work belongs in the sequence of the original edition. Thus, Nos. 161 (2a), 162 (2b), and 163 (2c) are intended to be viewed and studied between Nos. 2 and 3 (on pages 75 and 76) of this book.

TIBETAN SACRED HISTORY

See page 71.

I. Shakyamuni Buddha: Life and Lives

For a general discussion of Shakyamuni Buddha, see pages 72–73.

161 (2a)
Shakyamuni Buddha

Central Regions, Tibet

11th century

Brass, with cold gold paste and pigments; sealed with relics inside

H. 19¹¹/₁₆" (50 cm)

Private Collection

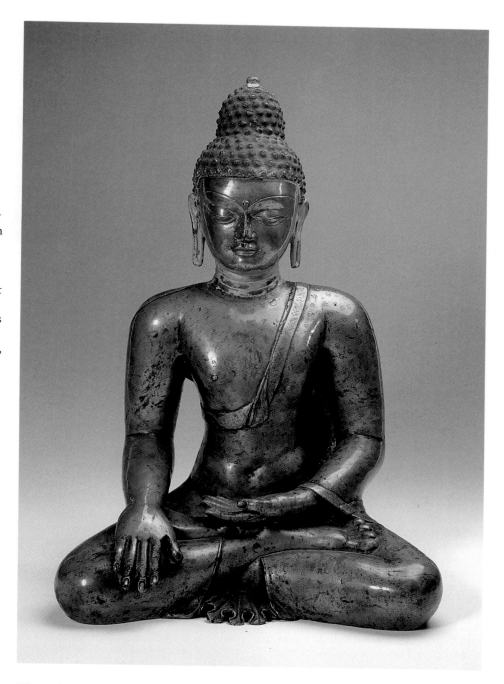

This is an impressive Buddha from early in the period of the Second Transmission of Buddhism to Tibet. The powerful body, slightly modulated in the torso, is stylistically similar to the Shakyamuni Buddha in the Defeat of Mara Chapel at Yemar (Iwang) of ca. mid-11th century and to the Buddhas in the wall paintings at Drathang monastery in eastern Tsang dated to about 1081–93 (Govinda, 1979, I, p. 49; Vitali, 1990, p. 58, pls. 29, 30). Thin hems over the legs, a few pleats of the robe spreading out from under the crossed feet, a wide band at the left wrist and over the chest, and a playful though unobtrusive loop of the under-garment over the hem across the chest all add linear interest to the skintight robe. A fine incised floral pattern consisting of a center circle surrounded by dots and a pattern of three dots in a triangle decorate the robe. The hems have linear border lines and a zigzag pattern of double lines with simple rosette flowers in the spaces and three-dot triangles. The face—handsome, large, and squared with high, domed cranium and big *ushnisha*—has features that relate it to the sculptures of the Kunrig chapel at Kyangphu (Vitali, 1990, figs. 9, 12), but especially with the Yemar Shakyamuni, both of ca. second quarter of the 11th century. The prominent eyes with their curving shape and raised rims and the dramatic arch of the eyebrows are nearly identical to the forms in the major sculptures of the Defeat of Mara Chapel at Yemar.

These elements strongly suggest a dating for this impressive sculpture around the early to mid-11th century and a provenance in the Tsang region. It must be counted as one of the rare early surviving Buddha sculptures so far known from the central regions. A large rectangular patch appears on the upper back, and the bottom is sealed with a copper plate (probably a later replacement, perhaps after a rededication) with an engraved design of a vajra cross.

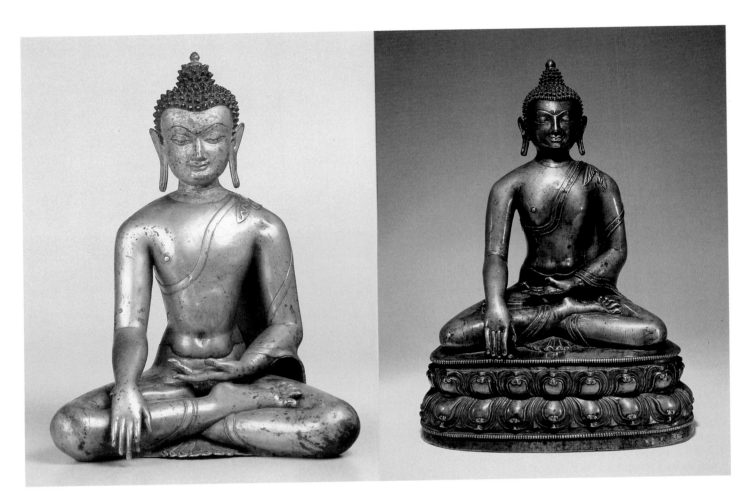

162 (2b)
Shakyamuni Buddha

Central Regions, Tibet

Early 13th century

Copper alloy, silver and copper inlay,
and pigments

H. 21⅝" (54.9 cm)

Private Collection, London

In comparison with Nos. 161 and 2,
this sculpture possesses less vigorous
form and line but has a gentle, relaxed
naturalism and elegant attenuation of
the torso and long face. This style
reflects some tendencies of naturalism
seen in some tangkas, probably of the
Tsang regions, of ca. late 12th to early
13th century, such as the one in text fig.
12. The limited use of inlay (copper lips
and fingernails; silver nipple and eyes) is
a foretaste of the development of more
lavish embellishment in the sculpture of
the central regions in the 14th century
(No. 163). Border folds, less wiry than
in No. 2, are subdued and flat, imparting
only a restrained energy to the figure;
they are also different from the stronger,
pearl-lined borders of some 14th-century
sculptures. The slow, measured curves
of eyebrows, eyes, and mouth reflect the
refinement of the well-known Pala forms
and also of earlier Tibetan expressions of
the Pala idiom, as seen in No. 161.

163 (2c)
Shakyamuni Buddha

Central Regions, Tibet; probably Tsang

First half of the 14th century

Brass with copper inlay

H. 15" (38.1 cm)

Doris Wiener Gallery and Nancy Wiener
Gallery, New York

This sculpture of Shakyamuni Buddha
in the earth-witness gesture is a prime
example of the image style of Shalu
monastery art in Tsang of ca. first half
of the 14th century. Copper inlay in the
borders of the robe and for the Buddha's
fingernails adds a richer coloration and
design component, as do the double and
triple rows of pearls, compared with the
earlier Buddha sculptures in Nos. 161,
2, and 162. The sharp, slightly angular
appearance of the facial features and the
tensely held body reveal a more conscious
tightening of form and decorative flair
than in the relative naturalism of the
early-13th-century Buddha in No. 162.

164 (5a)
Shakyamuni Buddha and Scenes from His Life

Central Regions, Tibet

14th century

Tangka; gouache on cotton

34 × 29¼" (86.4 × 74.3 cm)

The Zimmerman Family Collection

Attended by the two monks Shariputra and Maudgalyayana and eleven small seated lamas on each side, Shakyamuni Buddha sits in the earth-witness gesture, surrounded by scenes depicting episodes from his life. Clockwise from upper center the scenes are: 1) the conception, 2) informing the king, 3) the birth (right corner), 4) the prediction of Asita, 5) and 6) schooling, 7) clearing away the elephant that Devadatta had killed, 8) practicing archery (one arrow goes through seven trees and digs a well), 9) wrestling and throwing Devadatta, 10) enjoying himself in the palace (lower right corner), 11) going out of the palace and having the four encounters, 12) leaving home in the Great Renunciation, 13) cutting his princely hair (with stupa behind), 14) the defeat of Mara (below the main Shakyamuni), including a blue Mahakala in the center and a pair of Heavenly Kings at each end of the panel, 15), 16), 17), and 18) offerings to be made to the Buddha (left corner of the lower register), 19) offerings made by a dragon queen, 20) merging of the four begging bowls into one, 21) the first teaching at Sarnath, 22) the conversion of Kashyapa and the five hundred brahmans at Uruvela, 23) the offering of honey by the monkey, 24) the taming of Nalagiri, 25) the descent from Tushita Heaven (upper left corner), 26) the Parinirvana, and 27) the nirvana stupa.

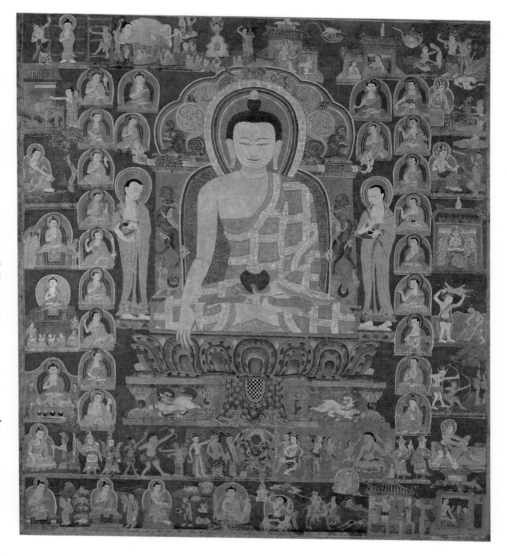

Although the solid, majestic style of the main figure and its magnificent patched robe generally relate to the styles of the Gyantse Kumbum wall paintings of the second quarter of the 15th century, as does the dominant color scheme of dark green and orange-red, this tangka appears to predate the Kumbum paintings. The small landscape scenes are simpler than those of the Kumbum wall paintings and such mid-15th-century tangkas as

No. 79. The style is more forthright and less embellished than the British Museum tangka (No. 3), which appears to have further developed the usage of raised gold decoration. This tangka represents an important style probably of ca. later 14th century that relates to the works at Shalu monastery and the Gyantse Kumbum but is a distinct and as yet unidentified style, likely from the central regions.

II. Arhats

For a general discussion of the Arhats, see pages 102–3.

165 (15a)
Arhat Rahula

Central Regions, Tibet; or Eastern Tibet

Late 14th to first half of the 15th century

Tangka; gouache on cotton

26¾ × 23" (67.9 × 58.4 cm)

Collection of Mr. and Mrs. John Gilmore Ford

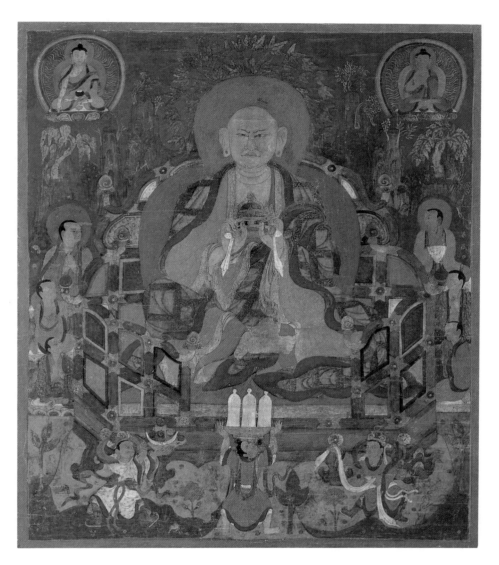

Seated within the ample space of a magnificent chair of wooden lattice and ornate fittings, a powerful and majestic Arhat holds up a crown—the distinguishing element of Rahula—in front of his chest. Robes of red, deep yellow, and green edged in dark blue flow loosely and elegantly over his large form. Decor in gold along the hems and for the borders of the patches does not lessen the sweeping movements of the folds, some lightly modeled and grouped in parallel configurations. The sturdy head, with its large ears, intently serious and penetrating eyes, full lips, and big nose, projects a forceful personality. Behind the Arhat a dense red head-and-body halo with an intricate foliate shadow pattern offsets the figure. Spiky green leaves project from behind the red head halo like rays. In the background wavy green peaks with a few highly individualistic trees and tiny creatures present a landscape with a greater naturalistic nuance and sense of space than the landscapes of the early Arhat paintings that are probably from the central regions in the 14th to early 15th century (Nos. 12–14). Though related to these paintings, this tangka represents a different stylistic group that incorporates clearer Chinese stylistic elements and is generally more naturalistic in portrayal. These differences may reflect a distinct regional difference, such as Eastern Tibet, perhaps the Kham area, but this must remain in the realm of speculation until more evidence is available.

On the predominantly green foreground, figures in lively postures offer plates of food, three large white offering cakes, and a large white scarf as various monks and lay figures attend the great Arhat behind his throne. Shakyamuni Buddha at the upper left and a Buddha in the teaching mudra at the upper right sit on lavender and green lotus seats and have round halos with rainbow rims and wavy radiant lines similar to the patterns on some of the wall paintings of the Gyantse Kumbum (Ricca and Lo Bue, 1993, fig. 14), with which this painting has a number of elements in common, especially the robe depiction and throne type. It is a major early work in the tradition of Tibetan Arhat painting.

166 (16a)
Arhat Kanakavatsa

Central Regions, Tibet

Mid-16th century

Tangka; gouache on cotton

51 × 20½" (129.5 × 52.1 cm)

Collection of Shelley and Donald Rubin

This mythic Arhat, one of the group of sixteen
immortal saints, is probably Kanakavatsa,
usually depicted holding a necklace of beads
and a jewel (here a bowl of jewels) that were
offered to him by dragons (nagas) in grati-
tude for his teachings. The Arhat offers a
commanding presence with his brown body,
a light, rippling red robe with a white lining,
and a vividly expressive face with finely drawn
features. The white circular halo around his
head draws further attention to his head and
the red-bordered white rug with its exquisite
floral vine pattern sets up an equally inter-
esting foil for the body and robe. Head and
halo, with their more abstract circular shapes,
contrast with the rug and robe with their
irregular shapes; the brown body harmon-
iously links these two opposing groups.
A fancy canopy of red tassels and the yellow
and green foliage of a tree provide further
contrasting shapes and colors, while the
upper and lower parts of the unusually tall,
vertical tangka provide areas of broad color
washes for the sky and the light green ground.
A lama—probably Sakyapa—the Buddha
deity Vajradhara, and the Great Adept Virupa
float above amid some wavy red clouds. In
the foreground is an offering table before the
Arhat and various donor figures approaching
from right and left making offerings. In the
center area is a blue-robed royal figure in an
enclosure surrounded by a wall with various
attendants: he faces forward but is looking
up over his shoulder at the giant Arhat in the
center. One suspects this is something more
than the standard patron figure; rather, the
suggestion here is that this is a lay ruler
and Dharma teacher and patron who is an
emanation of the Arhat, himself associated
with Virupa and the Sakya Order.
 The simple landscape and moderate degree
of naturalism reflect the changes occurring in
paintings in the central regions around the
middle of the 16th century, as also seen in No.
87. In these, landscape plays a less dominant
role than in the Arhat tangkas of the same
period from Eastern Tibet, as in No. 167, a
characteristic of the regional distinctions in
paintings of the 16th to 17th century. This
tangka is an important representative of the
Arhat painting styles emerging in the Sakyapa
schools of the mid-16th century.

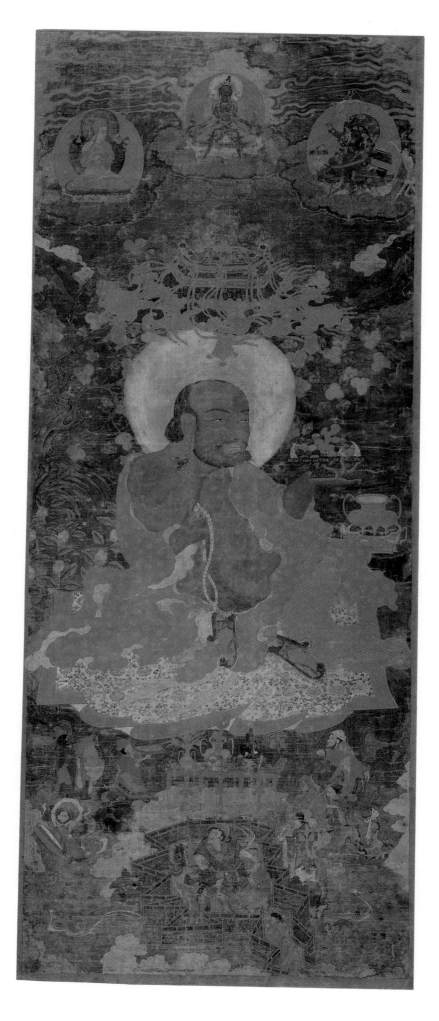

167 (16b)
Arhat Kalika

Eastern Tibet

16th century

Tangka; gouache on cotton

40 × 23" (101.6 × 58.4 cm)

Collection of Shelley and Donald Rubin

This Arhat is probably Kalika, holding an earring (see No. 16), but it could be Rahula, holding a crown. He sits on a flat-topped rock, his shoes in front of him on a smaller rock. An attendant lights incense in a large golden bowl, and Amitayus, Buddha of Infinite Life, appears in the upper left corner. The main figures are placed in the near mid-ground of a rocky and forested landscape executed in the blue-green tradition typical of some Chinese painting. The scale of the main figure, his placement beneath a large, realistic, yet decorative tree, the refinement of the details, and the close view of the rocky cliffs all bespeak the Ming style of the late 15th to early 16th century. Even though the overlapping planes of the cliffs suggest recession, the clear patterning and sharp line tend to flatten out the effects—a characteristic not only of Ming painting, but also of Tibetan paintings in the Ming style. Such devices to suggest space, the elegance of proportion, and refinements of line are clearly more evolved than the style of the early-15th-century Arhat painting in No. 14. Tibetan Arhat paintings based on Chinese models were a major factor in the introduction and development of landscape in Tibetan painting; even so, the bastion of landscape seems to have remained the Eastern Tibetan schools, especially the Karma Gadri, with their closer proximity to Chinese sources. This work clearly relates to other known paintings of Arhats in Ming style landscape (see Pal, 1984, pls. 58, 59).

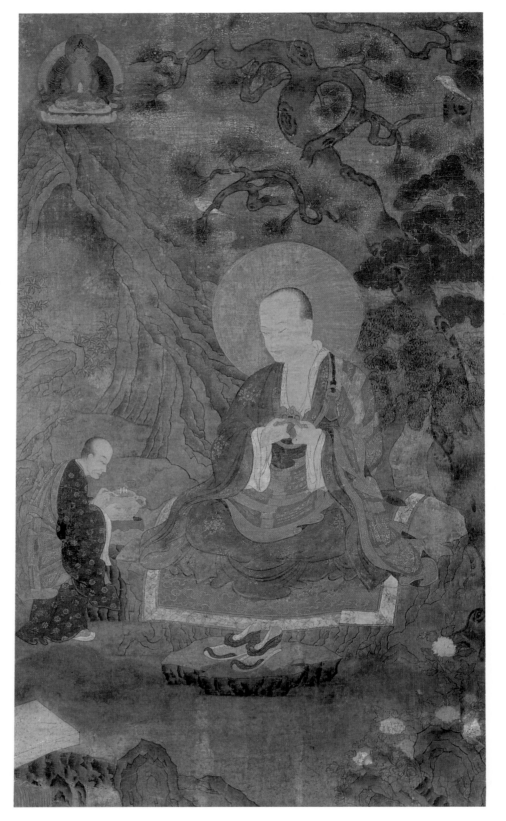

168 (16c)
Arhat Abheda

Central Regions, Tibet

First half of the 16th century

Brass

H. 6½" (16.5 cm)

Collection of G. W. Essen, Hamburg

Lit.: Essen and Thingo, 1989, I-29

This extremely expressive sculpture of a legendary Buddhist Arhat originally had a stupa of enlightenment on the scarf held in his hands. It is said that Shakyamuni Buddha gave a stupa to the Arhat Abheda when he was about to go into the snowy mountains of the Himalaya to teach the wild ogres there.

Here we see the Arhat Abheda sitting in a relaxed posture on a throne, clad in a lotus-decorated monk's robe. He is accompanied by two smaller figures: at the left by a king, identifiable by his turban, and at the right by an old man dancing joyfully. Each is standing on a lotus flower, which means that they have achieved dispassion and spiritual purity. The king holds out an offering mandala, which is crowned by a flaming pearl.

The representation of Arhats in Tibetan art often shows elements of Chinese style, which may derive from a tradition that the Arhats were invited to China by a Chinese emperor and that their portraits were painted while they were living there. Tibetan artists may have painted the Arhats with Chinese features with this legend in mind, despite the fact that the Arhats, who lived during Buddha's lifetime, came, like him, from North India.

G. W. Essen and T. T. Thingo

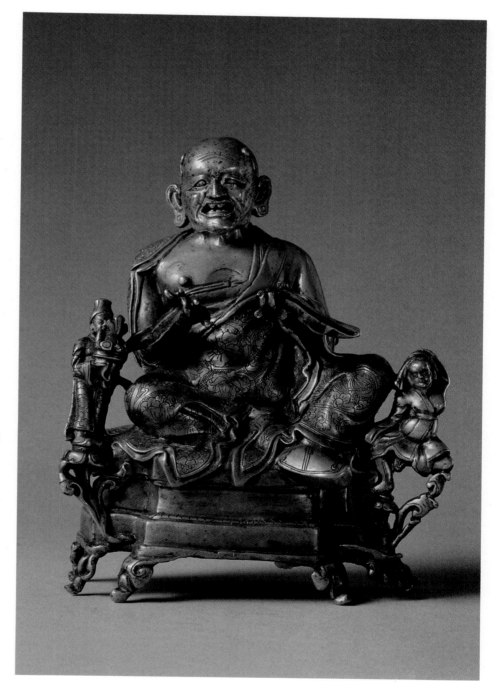

III. Bodhisattvas

For a general discussion of Bodhisattvas, see page 120.

169 (19a)
Bodhisattva

Central Regions, Tibet

Yarlung dynasty, circa first half of
the 9th century

Copper alloy with insets, cold gold paste,
and pigments

H. 25⅜" (64.5 cm)

Private Collection

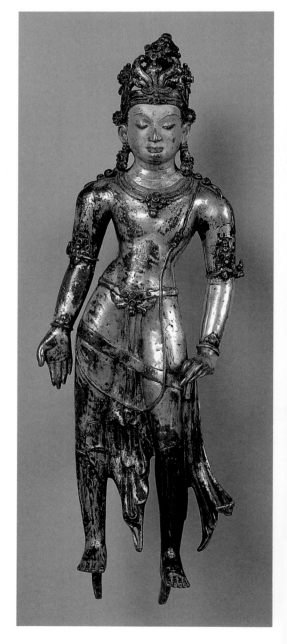

Despite the coppery sheen on much of the surface, this sculpture, probably Avalokiteshvara, is likely a rare survival from the latter part of the Yarlung dynasty. It has the character of a Tibetan creation following well-established Nepalese forms. Every aspect of the work points to a date ca. 9th century rather than later. The body has a solid, substantial, naturalistic mass consonant with the Tang-period sculptures of China and Central Asia (7th–9th century) and is related to the sculptures of Kachu monastery of ca. the second quarter of the 9th century (Vitali, 1990, p. 22, pls. 5–10). Although it has more muscular definition than the Kachu Bodhisattva sculptures, which are closer to the forms of the 9th-century Dunhuang Bodhisattvas in the well-known group of banner paintings (of which No. 20 is one) than to Nepalese sculpture, the degree of dense solidity of form—distinctly different from the greater emphasis on shape in later sculptures—is the important distinguishing factor in all these 9th-century examples, including this rare Bodhisattva.

Though fashioned after the graceful stance of Nepalese images of similar type, this Bodhisattva has a stiffness most relatable to the Kachu sculptures. It lacks the refinements generally seen in later Tibetan sculpture, such as the Narthang Maitreya Bodhisattva of ca. 1093 shown in text fig. 7, and the weighty mass is without emphasis on the beauty of shape and slightly inflated form characteristic of Tibetan sculptures of the 11th century and later. The loose movement in the riblike hem folds of the dhoti between the legs and in the long ends of the *uttariya* (the chest shawl, which is shown here reduced to a flat band that has been tied and has slipped down low on the thighs) relates to Nepalese examples datable to ca. the 7th to 9th century, such as the Bodhisattvas in the stone stupa at Dhvaka Baha in Kathmandu. The shape of the face, the eyes, eyebrows, nose, and mouth are all similar to the Padmapani of the stone stupa at Sigha Baha in Kathmandu of ca. 8th century. However, rather than the sweet, relaxed expression of the Nepalese style, this Tibetan statue has a tight, serious, slightly stern expression, echoing in a subtle degree the "sour" expression known in mid- to late-Tang Buddhist sculptures of the 8th and 9th centuries.

Neither hair nor crown is overly large. The crown design with double pearl band close to the forehead and curling flat tendrils supporting a five-gemmed ornament are forms relatable to the jewels of 9th-century Nepalese statues (Pal, 1975, fig. 69). The earrings are compact and heavy and the ears lack the attenuation of later styles, even those of the 11th century, as seen in No. 28 and text fig. 7. The usage of small pearls in the necklace is a trait of the Kachu sculptures; the insets relate well to examples in Nepalese sculpture of ca. 9th century and appear as well in the 9th-century banner painting figures from Dunhuang already mentioned.

The image appears at present to be a rare metal Buddhist sculpture from the Yarlung dynasty and, as such, can be regarded as a cherished treasure of the early Tibetan civilization.

170 (26a)
White Tara (Sitatara)

Eastern Tibet

17th century

Tangka; gouache on cotton

14 × 9⅜" (35.6 × 23.8 cm)

American Museum of Natural History,
New York

In a charming portrayal of White Tara,
this uncomplicated, small painting
presents her as a figure of utmost purity,
guileless simplicity, and calm repose.
An unusual element of her iconography
here is the fact that the lotus floating at
her left shoulder supports a scripture,
undoubtedly the Perfection of Wisdom,
making explicit Tara's association with
the goddess Prajnyaparamita, Mother of
All Buddhas. The tangka, along with the
one of Sarasvati in No. 27 that may be
from the same set, is an early example
of a particular style of Eastern Tibetan
painting, probably related to the Karma
Gadri school, that evolves by the 18th
century into a pristine, highly sophis-
ticated, and more fully abstract style
(Xizang, 1985, pls. 28, 29). Here a sense
of the natural world is instilled along
with the focus on the intense beauty
of certain elements, like the pure white
lotus and the body of Tara, both beauti-
fully contrasting with shades of green in
the scarf, ribbons, rim, and leaves. The
landscape, presented as a unified ground
of subtle washes, is further defined by
lyrical touches here and there of plants
and animals: elephants (one dark and
one white), birds, aquatic flowers, and
faraway, slightly fantastic peaks. The
red robes of the three lamas (including
the red-hat Shamarpa) located in the
upper part of the atmospherically shaded
sky provide, along with the pink flowers,
just enough balance with the orange-red
skirt and light golden halo of Tara. Her
face, round and deftly defined, and her
gracefully held right arm with hand in
the boon-granting gesture are but a few
of the delightful elements in this disarm-
ingly subtle painting.

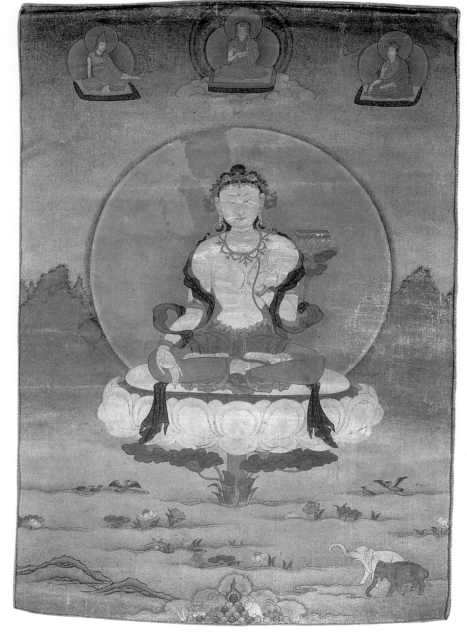

171 (27a)
Avalokiteshvara

Central Regions, Tibet

Early 11th century

Bronze, with silver and copper inlay and insets

H. 50" (127 cm)

Courtesy of Spink and Son, Ltd., London

This extraordinary bronze sculpture is a masterpiece from the early years of the Second Transmission of Buddhism in Tibet. Other than some breakage and repair to parts of the abdomen and neck and a new right hand, the image is in remarkable condition. It presents a marvel of taut yet sinuous planes, rich embellishment, and a stunning and unusual inlay on the garments, with motifs of animals and figures cavorting among leafy vine-*rinceau* patterns. Stylistically, it is close to the now-destroyed sculptures of the Kunrig chapel on the upper floor of Kyangphu monastery in southern Tsang, introduced by Tucci and more recently discussed by Vitali as dating from the early 11th century (Vitali, 1990, pp. 56–61; fig. 12). Although the technique, with generous amounts of copper and silver inlay, could suggest a Western Tibetan provenance, its strongly Pala stylistic connections appear to relate it to the central regions of Tibet. In any case, it is one of the most important sculptures to survive in the legacy of early Tibetan Buddhist art. For Avalokiteshvara in general, see pages 120–21 and Nos. 28 and 34.

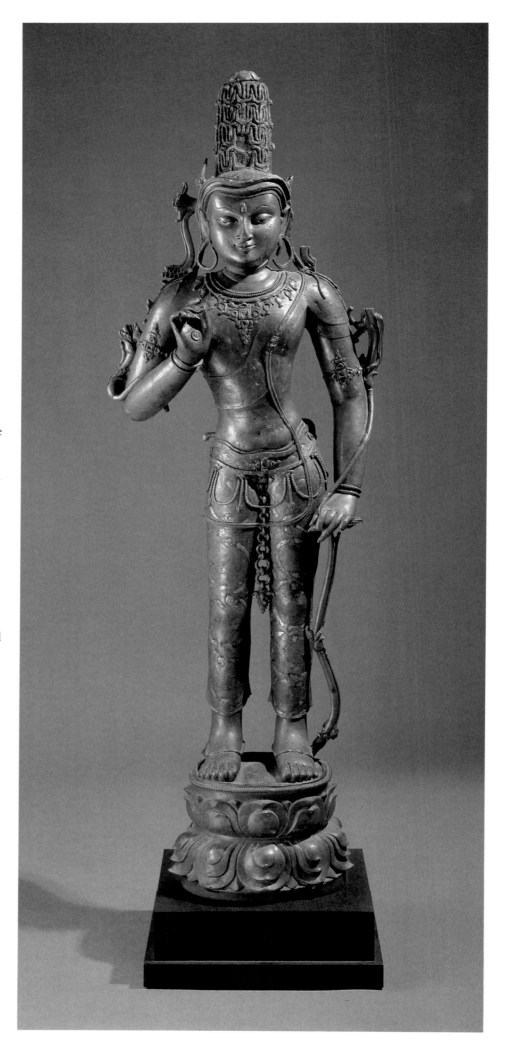

172 (29a)
Shadakshari Avalokiteshvara

Central Regions, Tibet

14th century

Brass, with insets, copper fingernails,
cold gold paste, and pigments

H. 26½" (67.3 cm)

Courtesy of A. and J. Speelman, Ltd., London

Though lacking its rosary and lotus, the
characteristic pose of the Shadakshari
(Six-Syllable One; see pp. 144–45) form
of Avalokiteshvara clearly identifies
this sculpture. Its rather large size is
heightened by the proportionately large
head, which gives the figure a sedate
demeanor. The slim shaping of the torso
and limbs imparts a slightly wistful,
ethereal aspect to the image, which is
sparsely ornamented except for the crown
with its upright leaf-shaped projections
and floating ribbons. The delicate lines
of the jewelry and incised lines on the
dhoti only slightly reduce the dominance
of smooth planes, which is the main
feature of this style. It seems related to
14th-century sculptures in the Tsang
region, such as some at Shalu, and would
appear to predate the bolder, heavier
style of the 15th century as represented
by the Gyantse Kumbum sculpture and
such Western Tibetan sculptures as the
Newark Vajrasattva (No. 131).

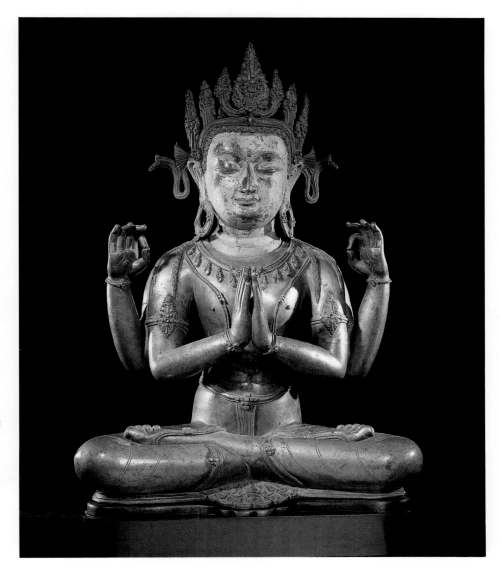

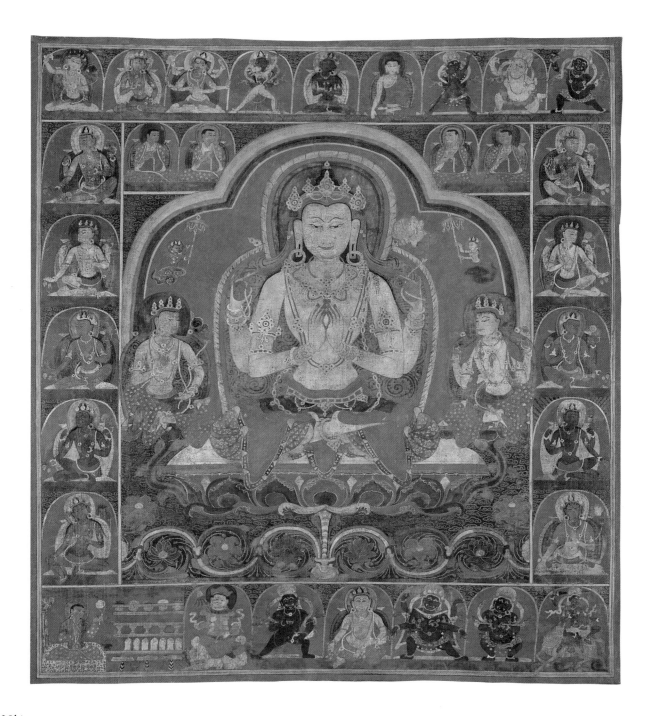

173 (29b)
Shadakshari Avalokiteshvara

Central Regions, Tibet

Second half of the 13th to first half
of the 14th century

Tangka; gouache on cotton

22¼ × 19¾" (56.5 × 50.2 cm)

The Zimmerman Family Collection

The white, four-armed Shadakshari
Avalokiteshvara, holding rosary, lotus,
and the wish-fulfilling gem, wearing
robes of dark red, green, and blue, and
adorned with strikingly bold gold

ornaments, sits on a lotus whose stem
sprouts a scrolling floral *rinceau*. To
either side within the large red mandorla
sit a two-armed golden Bodhisattva and
a four-armed white Bodhisattva. Two
lamas, possibly Kadampa, sit on each
side above. Along the uppermost border
are, from left to right: Manjushri,
Vajravidarana, Ushnishavijaya, two-
armed Kalachakra, Vajrasattva (in the
center), Shakyamuni, two-armed
Hevajra, white Acala, and blue
Vajrapani. The side borders from the
top have four-armed white, yellow, red,
and blue Bodhisattvas seated facing
outward away from the main image.
Green Tara (left side) and White Tara
(right side) complete the ensemble at the

sides. Across the bottom row from the
left are the donor and various protec-
tor and wealth deities: Vaishravana,
Acala, Jambhala, six-armed Mahakala,
Mahakala as Lord of the Pavilion, and
Penden Lhamo. All the small figures
appear within red niches with golden
rims, and a fine red linear cloud pattern
fills all the spaces around them. The
style, which has both grace and vigor, is
related to No. 231, but has more loosely
portrayed robes. Similar floral scroll
designs appear in late-13th-century
tangkas and in the early-14th-century
wall paintings at Shalu. Though the
provenance of this style is not yet clear,
it is a major style possibly associated
with styles from Eastern Tibet.

174 (29c)
Shadakshari Avalokiteshvara

Central Regions, Tibet; or Eastern Tibet

17th century

Tangka; gouache and gold on cotton

35½ × 24⅛" (90.2 × 61.3 cm)

Private Collection

Here the four-armed Shadakshari is presented together with scenes of the eight dangers, from which Avalokiteshvara is the savior. Each scene, graphically and engagingly illustrated, is specifically accompanied by a standing Bodhisattva. In clockwise order from the upper right the scenes show: rescue from lions and pride, snakes and envy, the six poisons and avarice, robbers and fanatical views (lower right), wild elephants (lower left), fire and hatred, demons and devils, and in the upper left corner, floods and lust. The three deities on the central axis, Vajradhara above, Shadakshari in the center, and Padma Sambhava below, represent the Truth, Beatific, and Emanation Bodies of Buddhahood. A pair of standing Bodhisattvas holding blossoming lotus flowers attend the main image.

This is a stunning example of a red-ground tangka with generous usage of gold and touches of yellow, orange, blue, and white. The mountainous landscape, waterfalls, trees, and houses, all drawn with striking realism and perfection, seem to exist in a strange red world made all the more interesting and intense by the gold. The style is close to that of No. 214, perhaps suggesting that this tangka dates from the period of the Fifth Dalai Lama.

The inscription on the back reads: "This tangka of the noble Avalokiteshvara who saves from eight dangers is the excellent, genuine painting of Tse Wang Drakpa, chief son of the great discoverer Ratna Lingpa. I like it better than five gold coins!" We would like to think that this inscription expresses a father's delight in the high accomplishment of his son.

175 (29d)
Manjushri

Central Regions, Tibet

13th century

Tangka; gouache on cotton

22 × 16" (55.9 × 40.6 cm)

Private Collection

Lit.: Rossi and Rossi, 1994, no. 12

The main image, a form of Manjushri, Bodhisattva of Wisdom, is seated within a shrine with multiple roofs and a crowning shrine containing a standing Buddha. His golden body with its long face bends gracefully as he makes the giving gesture (*dana mudra*) with his right hand, which also holds the stem of a blue lotus—symbolizing the teachings of the Buddha—that supports a small sword of wisdom. His raised left hand in the discernment gesture (*vitarka mudra*) holds the stem of another blue lotus that supports the Prajnyaparamita (Perfect Wisdom) Sutra. To each side stands a willowy attendant Bodhisattva: green Vajrasattva to his left and white Padmapani to his right. All have trilobed arched openings in their respective shrines. Two small forms of Manjushri, each holding a sword and book, float between the roofs of the main and attendant shrines. Aligned along the bottom are five forms of Manjushri. From left to right they are Manjushri on a lion, a four-armed Manjushri, two with six arms, and a red Manjushri carrying sword and vajra. On the top register stand the seven Manushi Buddhas of the past and Maitreya Bodhisattva, each accompanied by a tree. The configuration of this tangka is both interesting and unusual, as there are relatively few early tangkas of Manjushri. Jane Casey Singer is no doubt correct in her insight that the tree motif occurring in this tangka suggests that this Manjushri is present in the Bodhgaya temple of great enlightenment (Rossi and Rossi, 1994, no. 12, p. 29).

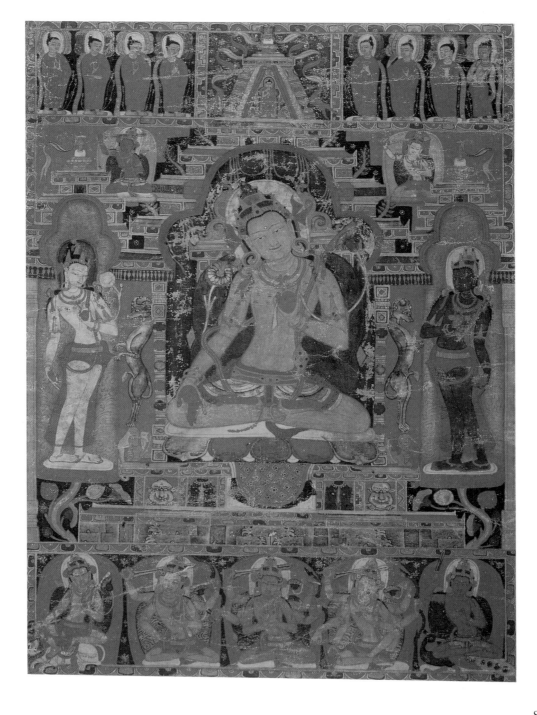

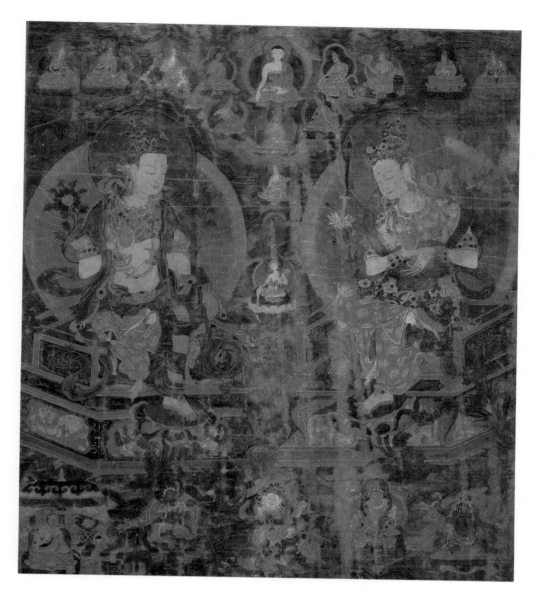

176 (31a)
Manjushri and Maitreya

Central Regions, Tibet; probably Tsang

Mid-16th century

Tangka; gouache on cotton

31½ × 27" (80 × 68.6 cm)

Trustees of the Victoria and Albert Museum, London

Manjushri and Maitreya in discourse was a theme favored by Atisha, the Indian master who came to Tibet in the mid-11th century and whose chief disciple, Drom Tonpa (later retro-actively honored as the first Dalai Lama incarnation in Tibet), was the founder of the Kadampa Order. They represent respectively the profound wisdom view and the magnificent compassion deeds that constitute the path of enlightenment. The two Bodhisattvas

are portrayed in this painting seated in elaborate lacquer chairs surrounded by numerous smaller figures. Their elegant white bodies, turned slightly toward each other, contrast with the subdued tones of their garments and the overall dark atmosphere in which they seem almost to be drifting. Along the vertical central axis from top to bottom are Shakyamuni Buddha and the famous group of Indian masters known as the "Six Ornaments and Two Superiors," who are arranged on two sides of him and in a semicircle below him, including Nagarjuna and Asanga close by on either side. A pair of Tibetan lama figures occupies each upper corner. In the very center of the composition sits a tiny white Padmapani Avalokiteshvara, with one foot down in the posture of royal ease, suggesting the inspired speaker of the Perfect Wisdom Heart-Essence Sutra. On the bottom row, there is a monk-donor figure in the lower left corner, and then four protector deities,

a Green Tara, a standing Vaishravana, a seated Jambhala, and a standing four-armed Mahakala.

The clothing of the two main Bodhisattvas is loose and fluid in the Chinese style and their ornamentation is elegant. The degree of Ming-period style in the garments and chairs and the prevalence of dark coloration point to some possible relation with the Khyenri style, which, judging from the wall paintings of the Gongkar Chöde monastery by Jamyang Khyentse Wangchuk, founder of the Khyenri school, incorporates a lyrical freedom of line and subdued, somewhat dark color tonality. The halo form in the tangka is also distinctive, with widely spread zigzag golden lines, different from the fine, narrowly spaced golden lines used ca. late 16th century (see No. 7). Unlike the rich, brilliant color of many earlier paintings, this painting style emphasizes the elegant beauty of line and a spatial component in the placement of figures.

177 (31b)
Maitreya Bodhisattva

Central Regions, Tibet

16th century

Tangka; gouache on cotton

35 × 27" (88.9 × 68.6 cm)

Collection of Shelley and Donald Rubin

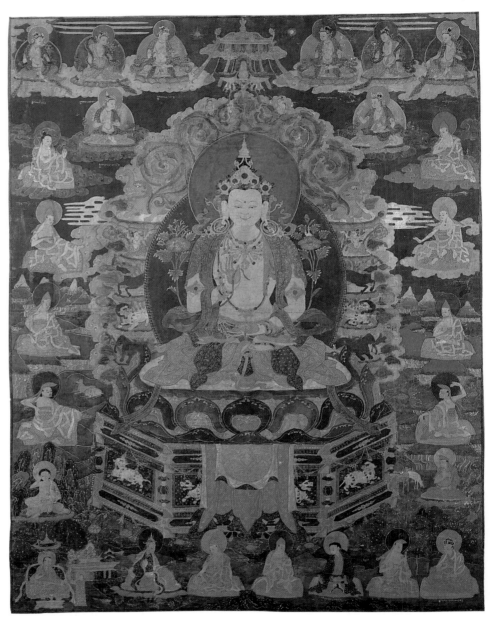

This is a charming vision of the future Buddha, whose name means Friendly Love, seated in a stylized presentation of his Sudharma teaching palace located in the Tushita Heaven. He is identified by the stupa in his crown, the vase on the lotus held over his left shoulder (the vase signifying his anointment as crown prince of Dharma by Shakyamuni Buddha before the latter's emanation down to the earth), and the kesara tree (the tree associated with Maitreya) on the lotus over his right shoulder. His left hand manifests the contemplation gesture while holding the stalk of the floating lotus; his right is raised in the fear-not gesture, holding the stalk of the other lotus. The dark green and blue halos afford a strong backing for the handsome, full-bodied image and contrast with the lovely details of the throne, including spritely animals and leafy vines, all quite differently portrayed from earlier types and showing the new freedom in forms probably influenced, at least to a degree, by the developments of the Menri and Khyenri styles of the late 15th–16th century. A variety of deities and lamas, including Milarepa and the Black-Hat Karmapa, seem to be more or less anchored on a ground plane that has a consistent indication of depth—a feature that begins to appear with some prevalence in 16th-century works in the central regions. Other figures float on pink and green clouds in the darker blue sky.

Above Maitreya to the right and left are the Eight Great Bodhisattvas, from Sarvanivaranaviskambhi through Akashagarbha, including Manjushri and another form of Maitreya, left and right on the second level. Below Maitreya are the Six Ornaments and Two Superiors; on the right are four of the great Indian philosopher-saints, Asanga, Vasubandhu, Gunaprabha, and Dignaga; and below Manjushri on the left are Nagarjuna, Aryadeva, Shakyaprabha, and Dharmakirti. Below Dharmakirti on the left sits Milarepa, and below Dignaga, Gampopa. Along the bottom sit, left to right, a donor, Padma Sambhava, Shantarakshita, Atisha, Drom Tonpa, a lama whose inscription is illegible, and a Karmapa lama wearing his famous black hat. There is an inscription on the very bottom that is mostly illegible, except at the end, where one can just make out "this was commissioned through the spiritual inspiration of Ngawang Namgyel . . . in order to attain Buddhahood" (sangs rgyas thob phyir du/ dus ngag dbang rnam rgyal gyi lhag pai bsam pa rnam par dag pas bzhengs).

IV. Great Philosophers and Great Adepts

The general discussion of these figures is on pages 146–47.

178 (38a)

Great Adept Krishnacharya (Kanhapa)

Central Regions, Tibet; probably Tsang

Second quarter of the 15th century

Dark bronze

H. 14½" (36.8 cm)

Collection of Dr. Wesley and Carolyn Halpert

Krishnacharya is one of the most popular of the eighty-four Indian Great Adepts. One of the three main founders of the Mother, or Yogini, tantra teaching, centering on the Supreme Bliss Wheel (Chakrasamvara) and related tantras, he was also an extraordinary poet. This marvelous large sculpture portrays him as a muscular, chubby, naked figure, bound with a finely decorated meditation strap and sitting jauntily but heavily on an antelope hide draped over a patterned cushion. He is only scantily adorned with a necklace and a few slender strings of jewels that crisscross his chest. The whole figure, with its square head, massive coil of hair, and thick, rolling, broadly modeled masses, is the embodiment of realism. This realism as well as its inherent monumentality relate the sculpture to the Great Adept images in the Peljor Chöde monastery at Gyantse, dating about the second quarter of the 15th century. This style shows a development from the monumental, more abstract forms with elaborate jewels of the late 14th century, as seen in No. 196.

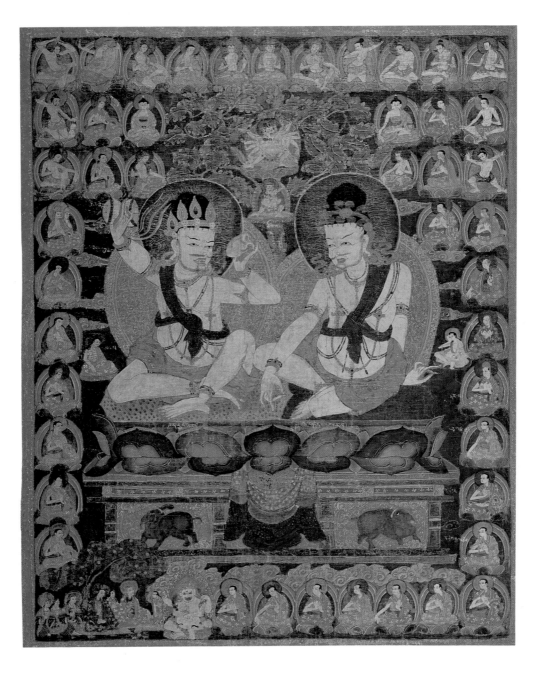

179 (38b)
Two Great Adepts, Tilopa and Naropa

Central Regions, Tibet

Second half of the 15th to early 16th century

Tangka; gouache on cotton

31½ × 23½" (80 × 59.7 cm)

Doris Wiener Gallery and
Nancy Wiener Gallery, New York

These two Great Adepts present a rather bizarre pair with their Pinocchio noses and slightly incongruously shaped limbs. If they are indeed Tilopa and Naropa, they are the human founders of the Kagyu Order oral traditions of tantric yoga that came down into Tibet through Marpa and Milarepa. Tilopa holds a drum and skull bowl, with a jewel crown, and Naropa holds his empty hands in the discernment or analytical gesture, with flowers in his hair. Some doubt of their identity arises due to the fact that faintly scrawled inscriptions identify the left-hand figure as "Damarupa," and the right hand one as "Sa gdung . . . pa," which is not attested as a name of one of the Eighty-Four Great Adepts, though by some stretching "Dengipa" is a possibility. Other adepts and masters of the Kagyu lineage, many labeled, not including Tilopa and Naropa, surround the main pair. Small figures of Marpa and Milarepa flank the main pair. Vajradhara is in the center of the row above, flanked by Saroruha Vajra on the right and Vajrapani on the left. Twelve-armed and two-armed Chakrasamvara Father-Mother deities are in the tree behind the main pair. A donor group and a four-armed, seated white Mahakala appear in the lower left corner. The red shadow-filling pattern in the halos is similar to that in Nos. 70 and 71, both from the Tsang regions, the former ca. second half of the 15th century and the latter ca. first half of the 16th century. Another painting of a pair of adepts, in the Zimmerman Collection, is stylistically close to this one (Pal, 1991, no. 95). Although earlier paintings of the Great Adepts are known, the format using paired groups seems to have become popular in the central regions as a series of tangkas around the late 15th–early 16th century.

180 (41a)
Four Great Adepts (Ajita, Savaripa, Parbuse, Bhayani)

Eastern Tibet

18th century

Tangka; gouache on cotton

33 × 22" (84 × 56 cm)

Collection of G. W. Essen, Hamburg

Lit.: Essen and Thingo, 1989, I-53

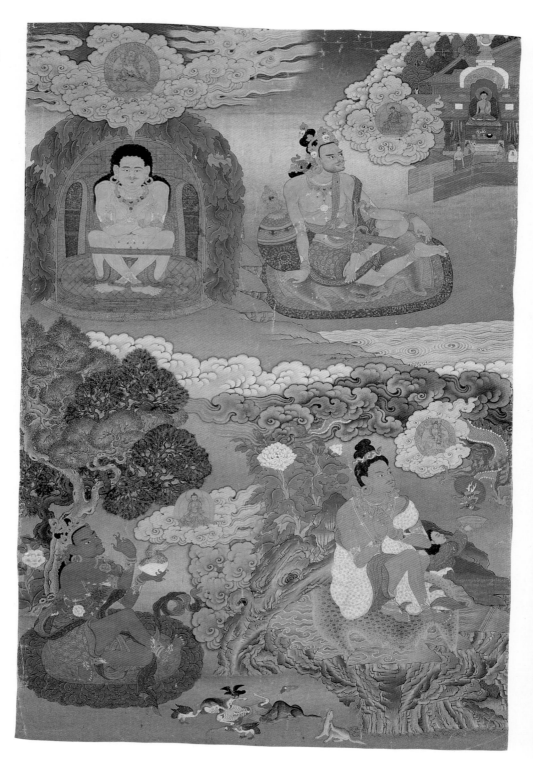

This tangka originally belonged to a series of twenty-one tangkas with four Mahasiddhas painted on each one. The series, grouped around a central painting of Vajradhara, the primordial Buddha, as the spiritual master, shows the eighty-four famous Mahasiddhas and pandits, the mediators of the Indian tradition of Vajrayana Buddhism. A short biographical verse from the Tanjur is written for each Mahasiddha in the series, to which the tangka in No. 41, now in the Museum of Fine Arts, Boston, also belongs.

At the upper left in a hut of leaves a yogi sits in meditation, his legs held by a meditation strap. Above in a cloud appears an initiation deity riding a bull. The inscription reads: "He has been blessed by a vision of Red Yamantaka in Eastern Bengal. His name is Kalalibhe. I bow before the lama."

At the upper right, sitting on a tiger-skin–covered cushion, the yogi Savaripa receives a vision. In the background he appears together with some yogis making an offering to a Buddha, who sits in a stupa. The inscription says: "He was an ascetic from Bengal. He had a vision in Bodhgaya. His name is Savaripa. I bow down before the lama."

At the lower right a yogi appears in a mountain landscape with the scene of a burial ground in front of him. The yogi sits on a leopard skin, wearing a white cotton robe. While meditating on the transitoriness of existence he has a vision of Vajrayogini. At the same time a dragon appears, wrapped in a dark cloud, and a servant holds up a golden bowl. The inscription states: "In a burial ground in Udyana he achieved highest Siddhahood through a vision of Vajrayogini. His name is Parbuse. I bow down before the lama."

At the lower left the yogi Bhayani sits under two elaborately detailed sandalwood trees, where he attains a vision of Khasarpani Avalokiteshvara, to whom he ritually offers ambrosia in a skull bowl. According to the inscription: "He was an ascetic living in a sandalwood forest. Khasarpani appeared to him. His name is Bhayani. I bow down before the lama."

G. W. Essen and T. T. Thingo

V. Dharma Kings

For a general discussion of these figures, see page 156.

181 (43a)
Vaishravana

Central Regions, Tibet; probably western Tsang

Circa 1400

Tangka; gouache on cotton

38¾ × 32⅝" (98.4 × 82.9 cm)

Collection of Michael McCormick

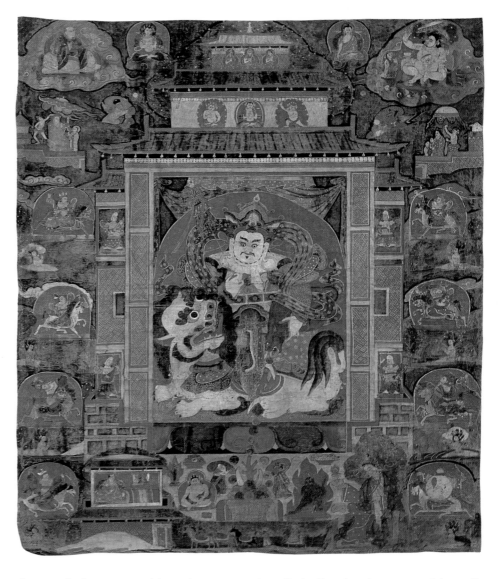

Vaishravana, guardian of the north and god of wealth, sits on a jaunty white snow lion inside the palace of his Pure Land. In the middle story are three deities, and in the upper shrine are three lamas, two with yellow hats. In the two side projections of the palace appear a total of four guardians, presumably of the four directions. Around the structure are scenes placed in a simple landscape. To the sides and silhouetted by red halos are the eight barbarian (*yaksha*) generals in the entourage of Vaishravana. A small adoring dragon appears with each of the eight generals, signifying their control over the eight dragons who guard the inexhaustible treasuries of the earth. Above, against a blue mountain and sky, are two royal figures, probably Padma Sambhava attended by Mandarava on the left and queen Yeshe Tsogyal on the right, one on each side under an umbrella. In the upper corners are a seated lama in elegant clothing of royal colors (upper left), perhaps a Sakya hierarch, and a Virupa-like adept (upper right). Near the roof of the palace a winged deity empties a bag of jewels on the left and a *garuda* does the same on the right. Flanking the top of the palace left and right are a small Vajradhara and Shakyamuni. In the register directly below the main palace are various figures, including white and black Kuberas facing forward, and a man and a horse-headed Kinnara making offerings to the palace. Around this is wrapped a dramatic scene: on the left is a small two-story building with a lama on the second story with a bowl of jewels before him (possibly Shantarakshita); across from him is a royal figure (possibly Trisong Detsen) sitting beneath a tree holding a wealth vase; between them at the bottom a red-hatted gentleman appears riding a horse across a landscape from the king to the lama, in the company of an attendant and three pack horses. The combination of this scene and the Padma Sambhava and Yeshe Tsogyal scene above indicates that this may portray the story associated with the wealth cult of Vaishravana, to the effect that Master Padma taught Trisong Detsen the special rituals of Vaishravana, with which the king raised a large fortune to fund his sponsorship of Samye monastery and all its scholarly and religious activities. This set the pattern for later Tibetan rulers and monastic orders to propitiate Vaishravana for the support of the sangha.

This tangka is of special note as it is stylistically related to some of the wall paintings at Jonang and Gyang stupas in western Tsang, such as the scenes in chapel 9 at Jonang (Tucci, 1949, I, fig. 56) probably of ca. last quarter of the 14th century. The dark outlining that occurs in this tangka to some degree and also is used in the late-14th-century tangkas of Kunga Lekpa (Nos. 75 and 200) appears in the early wall paintings at the Jonang stupa and continues in the paintings at Gyang stupa of ca. early 15th century, as well as in Riwoche stupa of ca. mid-15th century, all three in western Tsang and grouped as the "La.stod" school by Vitali (1990, p. 133). Certainly this tangka is one important example of this style, which may well be associated with the western part of Tsang.

TIBETAN BUDDHIST ORDERS

See page 165.

VI. Nyingma Order

A general discussion of the four Tibetan Buddhist orders and Nyingma in particular is on pages 165–67.

182 (48a)
Padma Sambhava

Central Regions, Tibet; or Eastern Tibet

Second half of the 16th to early 17th century

Gilt bronze

H. 12⅝" (32.1 cm)

Museum Rietberg Zurich,
Berti Aschmann Foundation

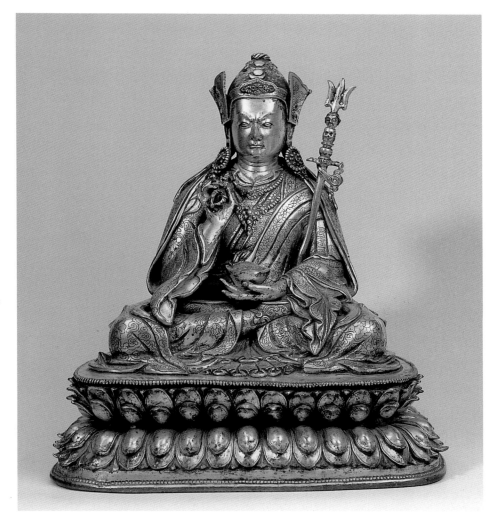

A young, gentle Padma Sambhava with slightly furrowed brow is presented in this beautiful gilt bronze sculpture. The *khatvanga*, vajra, and skull bowl, as well as his distinctive hat and robes, clearly identify the great tantric master and important historical figure for Tibet. Over a full, firm body, the royal robes and outer cloak form strong and somewhat erratic masses of interestingly mannered folds, richly chased with floral patterns. The dense quality and heavy weight of the robes convey a naturalism enlivened by the many-creased hems and folds, which lend an aura of emanating energy that contrasts with the calm inner strength and sublimely idealistic face. The angular folds and mannered tendencies of late-17th-century sculpture as seen in the Rose Art Museum's Fifth Dalai Lama statue (No. 98) are not as developed in this work, which appears to be about a century earlier. An inscription on the back of the base reads: "As soon as you set foot in Tibet you established the Buddha's teachings that wash away all sins. May the Great Master of Uddi-yana, conqueror of the hordes of demons, obtain the unalterable Buddha body! May he overpower with virtuous weapons all illusions, such as the strength of Shiva, Indra, the treasure of the ocean and lives of the kalpas, the host of beings in samsara and nirvana! May the sweet melody of the conch that spirals to the right, its color unrivaled by moonlight, resound until the end of the world!" (translation by Amy Heller). It affords a striking contrast with No. 47.

183 (51a)
Adi Buddha Samantabhadra Father-Mother

Central Regions, Tibet

Second half of the 16th century

Tangka; gouache on cotton

34 × 28" (86.4 × 71.1 cm)

Collection of Shelley and Donald Rubin

The deep blue primal Buddha Samantabhadra (Universal Goodness) and his pure white Wisdom Consort Samantabhadri together represent the blissful essence of the Truth Body of all Buddhas, the most profound, ultimate reality of the universe, unwittingly experienced by all beings, but known consciously only by the enlightened. For the unenlightened to use icons such as this to find faith in the underlying and overwhelming goodness of reality itself is considered essential for their evolutionary and spiritual well-being. Behind the central deities, the glowing white halo creates an aura that sets them off from the dark surrounding landscape of subdued sky and clouds and overlapping series of gold-outlined blue hills and snow-capped mountains that is viewed as a deep recessive plane from a high point of view. The juxtaposition of numerous smaller Buddhas, deities, and protectors as independent entities overlaying the landscape establishes a clear relationship between the naturalistic and the mystical that successfully evokes the world of the Between (*bardo*), the experiential realm between death and rebirth, with which this tangka is probably associated. Though this type of tangka is usually linked with the Nyingma tradition, a tiny figure of Milarepa on the right side could suggest that this painting was made for a Kagyupa practitioner. Stylistically, the painting is similar to the Zimmerman tangka in No. 50 (also probably related to the Between practice), dates to the same period and probably comes from the same local region.

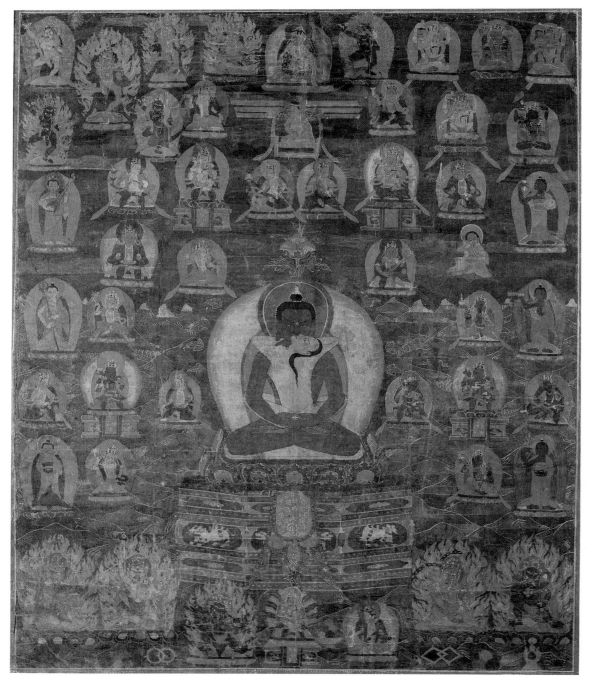

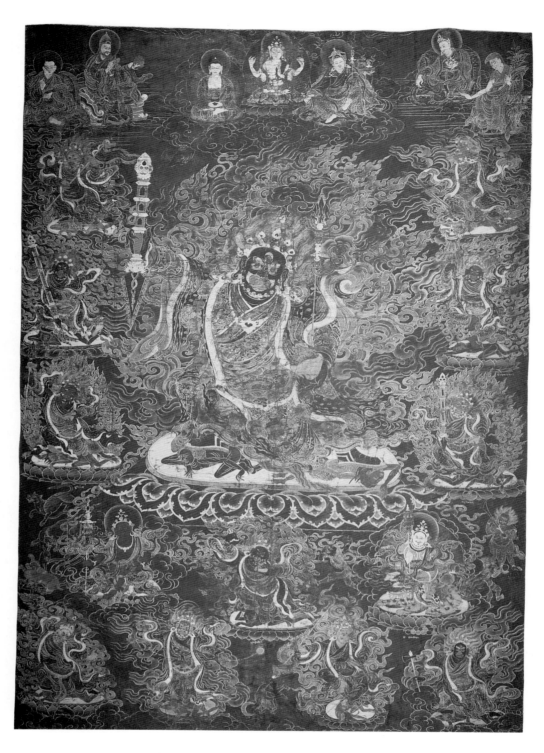

184 (59a)

Mahakala as Gonpo Beng Terma

Central Regions, Tibet; or Eastern Tibet

Late 17th to early 18th century

Tangka; gouache on cotton

42⅞ × 29⅛" (108.9 × 74 cm)

Musée Guimet, Paris; Gift of Mr. Lionel Fournier (under condition of usufruct)

Lit.: Béguin, 1990, no. 74

In a dazzling display of gold and golden-red colors on the mystical black ground, the fierce Gonpo (Savior) form of Mahakala majestically commands the central space. He holds an enormous mystic dagger (*purba*) in his outstretched right hand, his left hand holding a skull bowl containing a raw heart, as a *khatvanga* power-scepter leans in the crook of his elbow. The surrounding space is emblazoned by his entourage of deities (all labeled, see Béguin, 1990, no. 74) and presided over by lamas and kings and a central triad of Amitabha, Shadakshari Avalokiteshvara, and Padma Sambhava

(representing the three Buddha Bodies). Below are the wealth deities Jambhala and Vaishravana.

With precision and unfailing sense of coordinated movement and design, the master painter of this tangka lays out one of the most energized, refined, and splendid of all black tangkas. Stylistically, it is related to tangkas of the Sakyapa made around the turn of the century (see Nos. 67, 107, 201), but it projects a different aura, created by the predominating golden coloring and the increased refinement of line. For general reflections on the "black tangka" style, see No. 59.

185 (59b)
Padma Sambhava as Guru Dragmar

Tibet

17th century

Gold, iron, and wood with pigments

H. 23¼" (59.1 cm)

Musée Guimet, Paris; Gift of Mr. Lionel Fournier (under condition of usufruct)

Lit.: Béguin, 1990, no. 46

In this dramatic representation, Padma Sambhava takes the form of the mystic ritual dagger (*purba*). He holds a vajra and a large scorpion; elephant and human skins hang from his back; and his blue wings are spread open. A snake drapes around his neck, and the face of the sea-monster peeks out above his severed-head garland, the triangular dagger blade projecting from its mouth. The figure is surrounded by a flaming aureole, and the point of the triangular dagger is sunk into a triangular base of flames. Despite the powerfully bold depiction—a rare example of such graphic portrayal—the finely detailed, ferocious face emits a cheerful joy that allows for human interaction with the work. Stylistically, it relates to some sculptures in the Lhasa area of the 17th century.

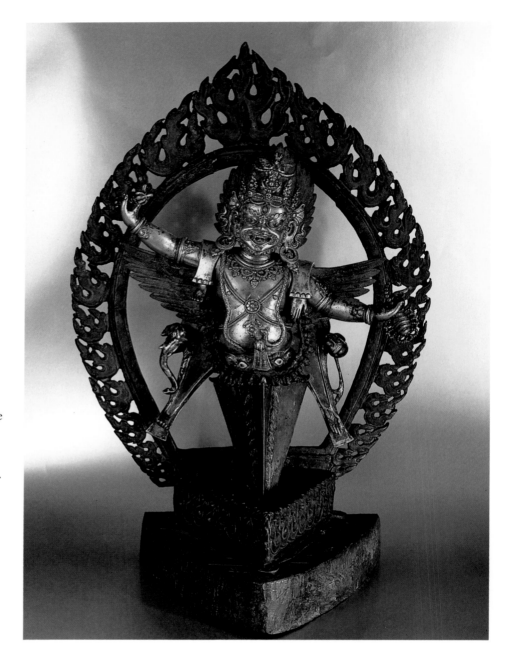

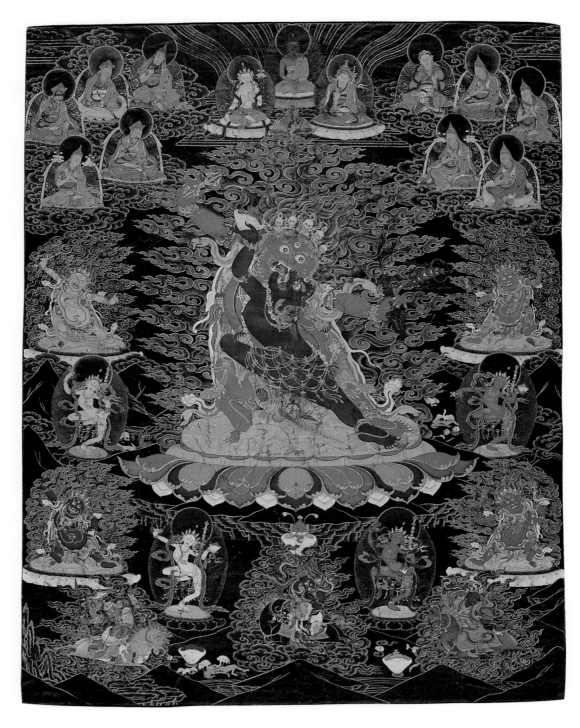

186 (59c)
Guru Drakpoche Father-Mother

Central Regions, Tibet; or Eastern Tibet

18th century

Tangka; gouache on cotton

23 × 19" (58.5 × 48.2 cm)

Collection of Shelley and Donald Rubin

This well-preserved tangka with its original brocade mounting depicts the wrathful archetype deity form of Padma Sambhava, Guru Drakpoche Father-Mother, holding a vajra and triangular dagger (*purba*), with his trademark blue scorpion hanging on to the handle of the dagger. Four smaller fierce deities, identified, clockwise from the yellow one on the upper left, as yellow Yama, red Hayagriva, brown Agnishri (usually Takkiraja), and blue Vajrapani, alternate with beautiful dancing red, green, white, and yellow Dakini angels, these eight deities probably being the door guardians and consorts of his mandala palace. On the central axis above sits a central triad, with Buddha Amitayus in the center, flanked by Padma Sambhava and White Tara. In the upper corners sit two sets of five lamas and yoginis, identified (higher to lower) as Vairo, Terchen, Rinchen Namgyal, Tenzin Chogyal, and Kangtrul on the left, and Yeshe Tsogyal, Padma Gyurme Gyatso, Lochen, Tutob Namgyal, and Rabjam on the right. Below, male and female red and blue protector deities ride on horseback, perhaps Machen Bomra on the left and Yudronma on the right. Though small, this tangka is exquisite in its detail and color, which is especially brightened by the sprinkling of red, orange, and bright green. The flame patterns are a maze of intricate swirling lines, possibly a style assignable to the first half of the 18th century.

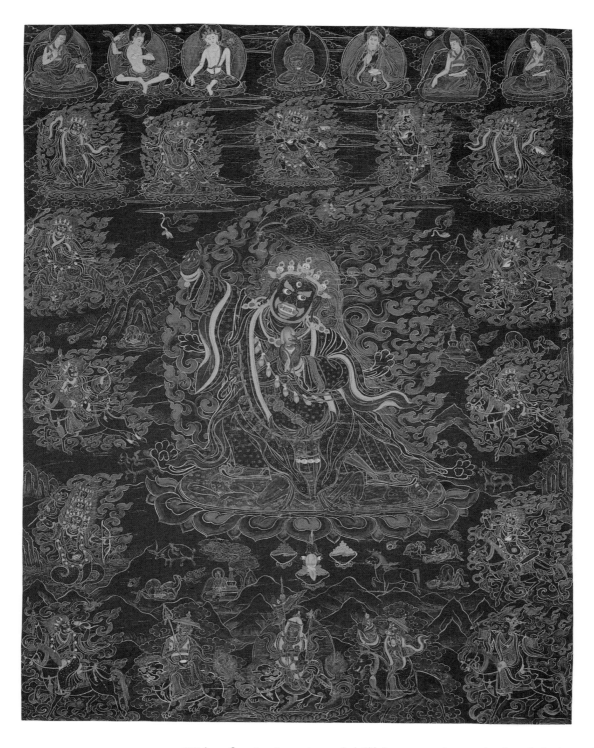

187 (59d)

Gonpo Bernagjen

Central Regions, Tibet; or Eastern Tibet

Late 18th to early 19th century

Tangka; gouache on cotton

27⅝ × 21⅝" (70.2 × 54.9 cm)

Private Collection

With unflagging intensity and skillful draftsmanship this painting presents the Black-Cloaked Mahakala (*mGon po Ber nag can,* a form of Mahakala) surrounded by his wild attendants, peaceful deities, and lamas. Gonpo holds a banner in his upraised right hand and a heart together with a lasso in his left hand. Besides the garland of severed human heads, connoting his conquest of the fifty-odd negative emotions and concepts, and a huge sword in his belt, he wears a necklace of human hearts, symbolizing his ability to conquer all forms of egotism. Among his flowing robes one also catches a glimpse of skulls and snakes, and a flayed elephant skin is draped over his shoulders. Interspersed among the ferocious attendants, calm lamas, Padma Sambhava, Buddhas, and Bodhisattvas are little scenes of corpses being scavenged by animals, skull bowls full of organs, fiery skulls, streaking clouds, yogis meditating near stupas, and mountainous landscapes, all portrayed against the particularly dense black ground of the mystical black tangka. The strong, rather than translucent, quality of the black and the simple yet boldly powerful drawing suggest a dating around the second half of the 18th century.

188 (59e)
Vajrakila Father-Mother

Central Regions, Tibet

18th century

Tangka; gouache on cotton

20⅛ × 15" (51.1 × 38.1 cm)

Musée Guimet, Paris; Gift of Mr. Lionel Fournier (under condition of usufruct)

Lit.: Béguin, 1990, no. 84

A sparkling, dizzying array of emanations, mystic dagger deities, entourage figures, protectors, and dancing skeletons (*citipatti*) surround the main pair, a Vajrakila Father-Mother, major archetype deity of the Nyingma tradition. This archetype deity relates to the triangular dagger (*kila* or *kilaya*) itself, which represents the ultimate reality of the three doors of liberation—voidness, signlessness, and wishlessness—and the unity of the Three Bodies of Buddha-hood, mobilized here into a one-pointed force for conquering evil and transmuting it into goodness (see also Nos. 53, 57). Above center appears the primal Buddha Samantabhadra Father-Mother, Vajrasattva, and Padma Sambhava. Probably slightly later in date than No. 59, there is a marked amplitude of detail that lifts the work into an ethereal, incorporeal realm of pure line and color, almost resembling a modern abstract painting.

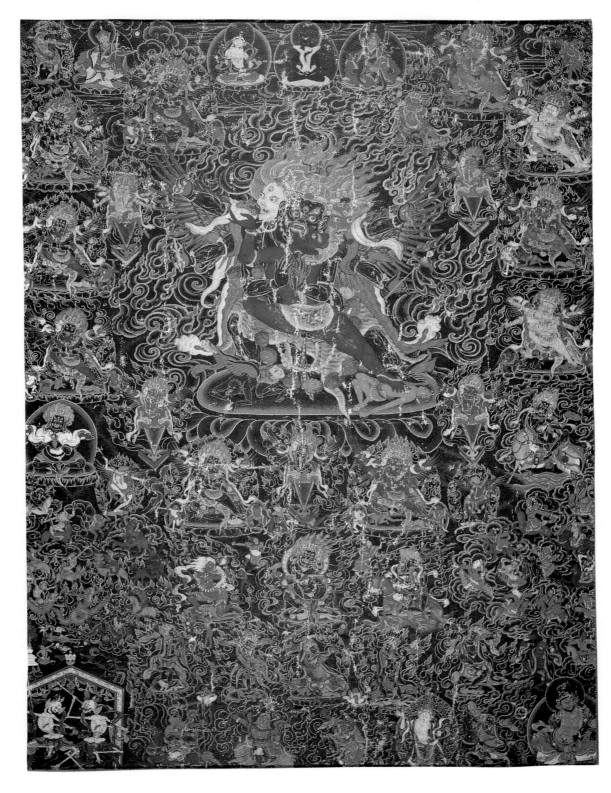

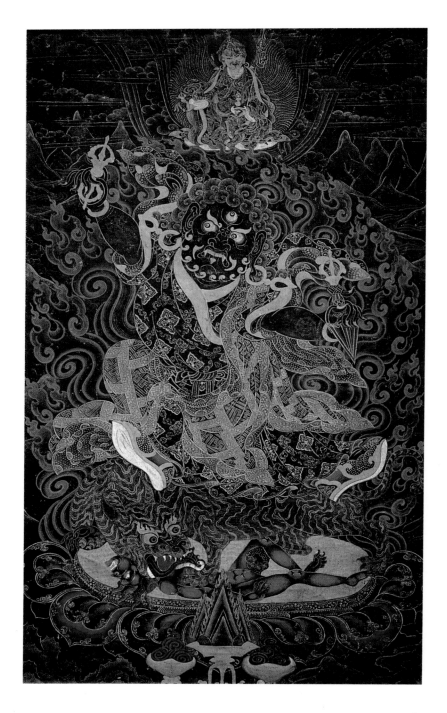

189 (59f)

Padma Sambhava
as Dorje Drölö

Central Regions, Tibet; or Eastern Tibet

Late 18th to early 19th century

Tangka; gouache on cotton

25⅝ × 14½" (65.1 × 36.8 cm)

Musée Guimet, Paris; Gift of Mr. Lionel Fournier (under condition of usufruct)

Lit.: Béguin, 1990, no. 87

A gorgeous, typically arrayed Padma Sambhava sits at the apex of this tangka above the splendid, burly, Herculean form of himself as Dorje Drölö, subduer of demons (see No. 232). This Vajra Big Belly is one of the eight main forms of Padma Sambhava, a fierce form he adopted at the Tiger's Lair (Tagtsang) cave in Bhutan, where he subdued demons that were troubling the people. Dorje Drölö grasps vajra and dagger and with unusual vigor seems to float on the back of a strikingly striped tigress with enormous jaws who strides over and pins down the blue corpse of a demon. A *torma* offering cake and skull bowls full of red and blue demon-blood elixir appear at the bottom.

A surreal landscape of mountains, rivers, prickly rocks, clouds, and rainbow lights is glimpsed at the edges, but all focus reverts to the powerful central brown-black figure with its huge face, curly locks, golden teeth and beard, and stunningly patterned robes that miraculously seem to harmonize with the patterns of the orange-red flames to create a strongly focused painting. Paintings such as this and No. 187 testify to the vitality of the Nyingma tradition in the late 18th to early 19th century.

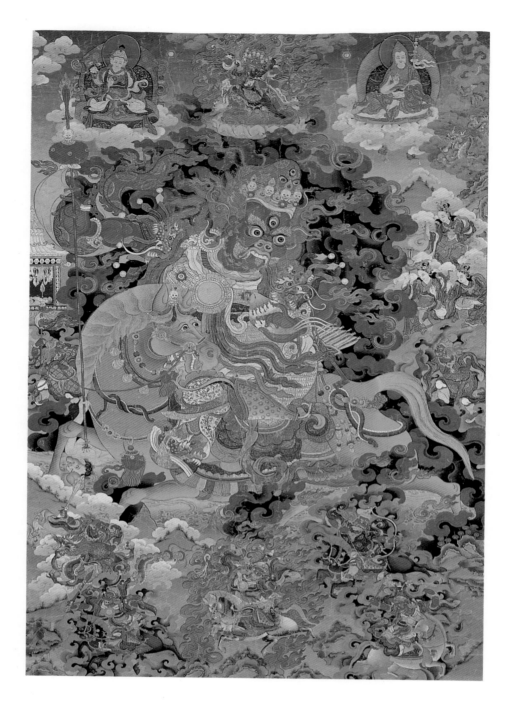

190 (59g)
Begtse

Central Regions, Tibet; or Eastern Tibet

Late 18th to early 19th century

Tangka; gouache on cotton

38 × 26" (96.5 × 66 cm)

The Zimmerman Family Collection

Lit.: Béguin, 1977, no. 224

Begtse, a wrathful red protector deity, is associated with the Nyingma and Geluk orders, the latter of which developed strong associations with Begtse during the times of the Second, Third, and especially Fifth, Dalai Lamas. In conjunction with the black female deity Penden Lhamo, he emerges from the 1570s as a major protector deity of the Dalai Lamas (see No. 216 and A. Heller, 1988 and 1989). Here he appears with Padma Sambhava, clearly indicating the Nyingma linkage central in his myth. He was previously thought to be a later addition to the ranks of Tibetan protector deities from Mongolian sources, but Amy Heller has written persuasively on his probable early origins in the 11th century as a Tibetan rather than Mongolian protector (Heller, 1988). Begtse is presented here somewhat differently from usual, riding on a spirited pink horse wrapped with green snakes and holding a sword and skull cup with organs. This tangka, probably late 18th to early 19th century, depicts the red Begtse in a flurry of armor (his name means "shirt of mail"), silken robes, and dark smoke. An equally energetic retinue accompanies him: five kings, below; several pages and groups of fierce goddesses, at the sides; above appear the religious king Songtsen Gambo at the left, Vajrakila Father-Mother in the center, and Padma Sambhava at the right. The bright green landscape, following styles well developed by the 17th century, and the light coloration suggest a possible Eastern Tibetan provenance for this lively, rare depiction of Begtse.

VII. Sakya Order

A general discussion of the order is on pages 165 and 199.

191 (60a)
The Great Translator Rinchen Sangpo

Central Regions, Tibet; or Western Tibet

Late 11th to first half of the 12th century

Tangka; gouache on cotton

33⅛ × 27⅝" (84.1 × 70.2 cm)

Private Collection

A verse inscription in black ink behind the main figure on the back of this tangka reads: "You, the peerless great Translator, appear to me like a second Buddha, your wisdom and realization inseparable, a veritable Lord Dharmatala —I bow with respect to you!" Almost certainly this refers to the translator and major early propagator of Buddhism in Western Tibet, Rinchen Sangpo (958–1055). Rinchen Sangpo was sponsored by the kings of Western Tibet to study in Kashmir and India, where he spent a total of seventeen years, and then to translate a large number of important Buddhist texts, tantras and technical treatises as well as scriptures. He was one of the leading figures in the Second Transmission of Buddhism in Tibet. The author of the eulogy calls him a "Second Buddha," high praise indeed, and compares him to the mythic saint and translator Dharmatala, a figure modeled on the Chinese monk Xuan Zang, who traveled to India to find the scriptures and then brought them home to Tang-dynasty China to translate.

Rinchen Sangpo sits making a teaching gesture and is attended by two small Bodhisattvas, probably white Padmapani and yellow Maitreya. The iconographic scheme is complex and contains more than 140 figures. Above his shoulders are the Herukas, two-armed Chakra-samvara *yab-yum* and Vajravarahi; above them is a line of nine horizontal divisions, with a white stupa on the far left followed by eight primary figures, five seated and three standing, most

with attendants and halo, two with canopies rather than a shrine-niche setting. The primary figures all appear to wear a large, flared, truncated yellow hat. Above in the central space, which is smaller than that for the main lama, is a lama similar to the main figure and probably his lineage master. He is attended by two standing monks and two barely distinct seated figures. Flanking the sides are six figures, two each in three rows to each side, including a Shakyamuni Buddha (upper left), a lama in yellow pointed pandit hat (possibly Atisha), another stupa, and various Indian adepts. Across the top of the tangka are eleven archetype deities: from the left, three standing twelve-armed Chakrasamvara Father-Mothers, yellow, white, and blue; then five seated Guhyamanjuvajra (three-faced, six-armed) Father-Mother archetype deities, yellow, white, blue, red, green; and again three standing, red, green, and blue. Below the top row, to each side in columns three figures wide and eleven figures long (to the bottom of the central register) are Buddhas, Bodhisattvas, and lamas, but mostly Siddhas. The top two rows on each side seem to be Buddhas and Bodhisattvas, giving twelve of these. The inner rows, nine down on each side, are lamas with yellow pandit hats. The outer two rows on each side, nine down, are adepts, giving thirty-six on the sides. Below the line of the bottom of the throne are two rows of thirteen figures (all but two of which are Siddhas). The bottom row is damaged and the far left corner, possibly containing a donor, is torn away and lost, though there were fifteen figures in all, perhaps five World Gods at each corner, and five standing, six-armed, lone hero Father tantra terrifics in the center, yellow, white, blue, red, and green. The end deity in the second row up is either Indra or Ishvara, and probably the end deity on the other side is also a World God, completing the customary number of twelve (sometimes fifteen).

This tangka probably dates from ca. late 11th to first half of the 12th century. The great translator is depicted with a large face, light beard and mustache, and smiling, full mouth (known to be a characteristic of Rinchen Sangpo). The long eyebrows are thin and placed above the lightly modeled, bony shape of the eye socket, a manner seen in early paintings and sculptures (No. 219). The "further eye" has a wavy contoured projection, very similar to the depiction in the Sakya lama pair of portraits said to date 1039 (Liu, 1957, pl. 17) and used with more forceful patterning in the pair of lamas now in the Cleveland Museum collection dating ca. late 12th century (Czuma, 1992–93). The mouth is depicted with sensitive naturalistic drawing and modeling in one of the finest portrayals in early Tibetan painting. The bold *rinceau*, patch, and border designs of his robe have strength and simplicity and lack the ornate sophistication of many robe patterns of the 12th and 13th centuries. To some degree the central portion of this tangka resembles the late-11th-century painting of Atisha in the Kronos Collection and the hierarch portrait in the Metropolitan Museum of Art (Singer, 1994, figs. 16 and 17a). However, the line and color are softer and more delicate. The face has a realism lacking in the harder-lined portraits of Atisha and the Metropolitan's hierarch portrait. In coloration the work is relatively similar to the Halpert painting (Huntington and Huntington, 1990, no. 106) and the McCormick collection's Akshobhya (No. 221), both probably of the 11th or first half of the 12th century. The two attendant Bodhisattvas are early style, but perhaps more similar to the one photographed by Tucci at Yemar (Vitali, 1990, fig. 15) than to later ones of the 12th century of this type, which persists through the 13th century. It is an important addition to the small corpus of early paintings, especially notable for the expressive rare portrait of Rinchen Sangpo and for containing such number of figures.

192 (61a)
Vajradhara and Vajradharma

Western Tibet; Guge

Mid-15th century

Tangka; gouache on cotton

35⅛ × 29⅜" (89.2 × 74.6 cm)

Collection of Michael McCormick

Lit.: Rossi and Rossi, 1994, no. 29

Thematically, this painting is almost unique, expressing the unification of the Father tantra and Mother tantra lineages of Unexcelled Yoga tantra in the Sakya Order, possibly in the person of Ngorchen Kunga Sangpo (1383–1457), who may be the unidentified hierarch making the teaching gesture in the upper middle center of the painting, flanked by a dark blue, Indian buffalo–headed, two-armed Yamantaka Lone Hero on the left and a red Yamantaka Father-Mother on the right (Yamantaka considered an archetype Buddha incorporating elements of Father and Mother tantras). The message of the painting is that this lama is, in visionary reality, both the dark blue Vajradhara Buddha Guru on the left, prime Buddha of the Father tantras such as Guhyasamaja, Yamantaka, and so on, and also the red Vajradharma Buddha Guru, prime Buddha of the Mother tantras, such as Chakrasamvara, Vajrayogini, and so forth. Vajradhara holds his trademark vajra and vajra-handled bell, and Vajradharma holds *damaru* drum, skull bowl, and trident-tipped *khatvanga* power-scepter. At the level of the lama's head stand slightly larger roundels with Chakrasamvara Father-Mother on the right and Hevajra Father-Mother on the left (Hevajra apparently associated with Father tantra here, though usually clearly a Mother tantra). In the topmost row of figures from left to right are Sakya Pandita, Konchok Gyalpo, Sachen Kunga Nyingpo, Sonam Tsemo, the Adept Virupa, Vajradhara, Vajranairatmya, Saraha, Nagarjuna, Luyipa, and Naropa. Down the left side runs a series of pandits and lamas; down the right, a lineage of nine adepts, headed by Ghantapa and Kanhapa; and at the bottom, two rows of lamas, adepts, and protectors, with a detailed lama and lay donor offering scene.

This is one of the most important paintings of this kind to surface since Tucci's tangkas from Western Tibet

(see Nos. 4, 6, 129, 151) of the Guge renaissance style. It stylistically predates those as well as the wall paintings of the Red Temple at Tsaparang of ca. the third quarter of the 15th century (see pp. 57–58; Aschoff, 1989, pp. 107–22). The style of the lama conforms to that current in the Sakya paintings of the central regions ca. mid- to second half of the 15th century, which raises the intriguing issue of the region of origin not only of this elegant, aristocratic style, but of this tangka itself, which appears to be one of the earliest of the Guge renaissance group, and to be associated with the Sakyapa. The donor scene includes women wearing turquoise beaded headdresses of the same style seen in the women donors of other Guge renaissance tangkas (No. 129, see detail 129.3). The throne and niche designs are well known in paintings of the central regions of the 15th century, but these are somewhat different in the fanciful elaboration of the pillars and scroll work. The coloring is quite

limited—mainly to a dark blue and green, and shades of red and orange—much as seen in Nos. 4 and 132 and most commonly in Western Tibetan paintings of the Guge renaissance group, which have in general a more earthy palette with fewer of the greens and light colors typical of Eastern Tibetan tangkas of the same period.

The artistry of this work is superior and shows the hand of a great master. All the thrones of the figures along the upper row are different; the vine is restrained yet elegant; interesting details abound, including the presence of OM AH HUM on the throne cloth of Vajradhara, and the Kalachakra HAM KSHAH MA LA VA RA YA monogram on that of Vajradharma. The whole painting emits a deeply profound aura, clearly demonstrating the comprehensive synthesis of styles and the artistic sophistication of the 15th century—truly a Tibetan renaissance that included all the orders, their great individuals, and burgeoning institutions.

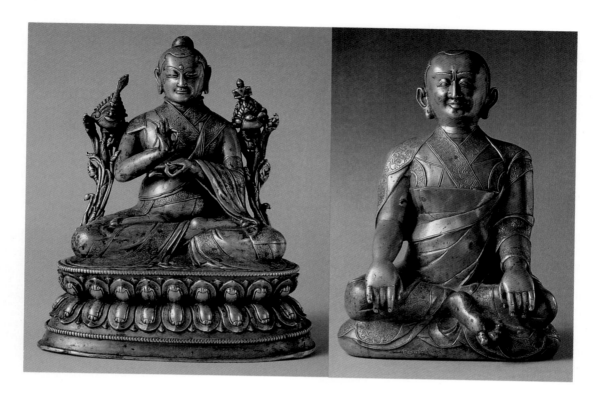

193 (62a)
Sakya Pandita

Central Regions, Tibet; probably Tsang

15th century

Brass

H. 7¾ (19.7 cm)

Collection of G. W. Essen, Hamburg

Lit.: Essen and Thingo, 1989, I-73

Sakya Pandita, the Sakya scholar Kunga Gyaltsen (1182–1251), was not only a lama of great ability, but also a politically important person. Master of several languages, he was also well educated in various contemporary teachings. His philosophical treatise on logic was translated into Sanskrit during his lifetime. Aside from religious books he wrote an anthology of epigrammatic sayings, *Sapen Legshey,* which became very popular. He generously sponsored the arts, bringing many artists from Nepal to decorate and enlarge the Sakya monasteries. Together with his nephew Pakpa, Sakya Pandita developed a Mongolian alphabet from the Uighur script, making it possible to translate Buddhist texts into Mongolian, thereby spreading Buddhism among the Mongolians.

Sakya Pandita played an important political role in dealing with Tibet's northern neighbors, the Mongolians; by swiftly offering tribute, he succeeded in preventing the Mongolian emperor

Genghis Khan (1155–1227) from looting Tibet. Subsequently, the high Sakya abbots continued to enjoy the confidence of the Mongolians, soon becoming honored spiritual advisers at the courts of the progressively more tolerant Mongol emperors. The Sakyapas thus succeeded for the first time in uniting spiritual and secular power in Tibet, which established the ascendancy of the Sakya over the other Tibetan orders.

Here, Sakya Pandita sits cross-legged on a high, double-lotus throne. His hands make the gesture symbolizing teaching, turning the wheel of Dharma. His head shows a small crown dome or *ushnisha,* an *urna* hair-tuft mark at the forehead, and long ears—all standard signs of a Buddha. On the high lotus flowers are the sword of knowledge and the Perfection of Wisdom Sutra, the symbols of Manjushri, of whom Sakya Pandita is considered to be an incarnation.

G. W. Essen and T. T. Thingo

194 (62b)
Drokmi

Central Regions, Tibet; probably Tsang

Second half of the 15th century

Brass

H. 15" (38.1 cm)

Collection of G. W. Essen, Hamburg

Lit.: Essen and Thingo, 1989, I-71; 1977, no. 288

The Tibetan scholar Drokmi (992–1072) was the disciple of the Indian Adept Gayadhara (see No. 64). During his studies in Bengal and Nepal, Drokmi was specially initiated into the *Hevajra Tantra* and the teachings of the Path and Fruition, a tradition that organizes the whole path of Mahayana Buddhism into a system that leads to mastery of the *Hevajra Tantra.* Drokmi was a famous translator of Indian Buddhist literature into Tibetan. The inscription on the cushion calls him Lachen Drokmi (T. *bla-chen-'brog-mi*), "the great Lama Drokmi." He is the spiritual ancestor of the Sakya Order of Tibetan Buddhism. In 1073, his disciple Khon Konchok Gyalpo (1034–1102) founded the monastery The Gray Ground (literal meaning of *sa-skya*) in southern Tibet, which became the main residence of the Sakya Order. It developed into a famous center of scholarship, the arts, and poetry.

Drokmi sits on a cushion in meditation, holding his hands in the mind-refreshing (*sems nyid ngal gso*) gesture. Surprisingly, his features seem portraitlike. Probably the artist used ancient patterns; he succeeded in imparting to this sculpture of the lama a powerful and calm appearance; his composed and kind features express humanity and dignity (see also p. 199).

G. W. Essen and T. T. Thingo

195 (66a)
Sakya Lama, probably
Ngorchen Kunga Zangpo

Central Regions, Tibet

Late 15th to early 16th century

Tangka; gouache on cotton

36½ × 31½" (92.7 × 80 cm)

Collection of Shelley and Donald Rubin

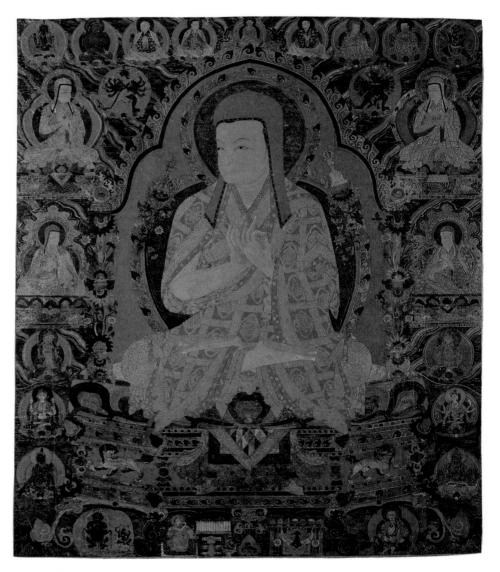

In a dazzlingly portrayed robe and red hat a Sakya lama sits with his hands in the teaching gesture, with vajra and bell on lotuses floating over his shoulders (one identifying clue), his head turned slightly to the side. The lama is most probably Ngorchen Kunga Zangpo (1382–1457), the Sakya hierarch who founded Ngor monastery. Though retaining some of the magnificent decorative elements of halos and pedestal associated with the Gyantse Kumbum wall paintings of the second quarter of the 15th century, this work transforms the style with imaginative variations, vivid accents of malachite green, and hints of landscape. The startling wavy rays of rainbow lights set against a pattern of delicate gold-lined clouds in the dark sky create a flurry of movement in the upper areas of the painting. Across the top is the Sakya lineage from Vajradhara, including Virupa, Sachen Kunga Nyingpo, Sonam Tsemo, a small Shakyamuni above the row, Drakpa Gyaltsen, Sakya Pandita, and Pakpa, with the goddess Vajranairatmya in the right corner. Beside the main lama are two large lama figures, the upper with a yellow hat and the lower a red hat, next to a Chakrasamvara deity figure on the left; two other, similar lamas are next to a Hevajra deity. These four lamas may be Konchokpel, Dakpukba, Penden Lama, and Penden Tsultrim, who often come between Pakpa and Ngorchen in lineages, as in the lineage depicted in No. 64. Down the side on the left are Maitreya, four-armed Lokeshvara, and Green Tara; down on the right are Manjushri, Ushnishavijaya, and a green Vajravidarana holding a vajra cross. On the bottom, there is a small Panjaranatha Mahakala with a diminutive Shridevi on the left, and a white Kubera on the right. In the bottom center is a lama donor, with elaborate offering arrangements. In comparison with the Sachen Kunga Nyingpo lama painting of ca. 1429 in No. 61, here we can appreciate the dramatic changes occurring between the second quarter of the 15th century and ca. 1500, even with regard to a traditional subject and iconographic format. This painting is a superb and important example of the developments of the Sakya lama class of paintings in the central regions around 1500.

196 (67a)
Virupa

Central Regions, Tibet

Circa 1400

Dark bronze with copper inlay and traces
of pigment

H. 16" (40.6 cm)

Courtesy of A. and J. Speelman, Ltd., London

Virupa, the Great Adept and lineage
master of the Sakya Order, gestures with
his finger to stop the sun. He is portrayed
here as a stately figure, handsomely
coiffured like a wealthy aristocrat. Double
strands of beads clasped in front and
back by a circular buckle with pendants
crisscross his chest. Similar jewels
encircle his arms, waist, and neck, and
he wears a tiger skin whose tiny paws
drape engagingly over his legs and the
back of the pedestal. The tour-de-force
of the image is the loosely plaited mound
of hair, bound by a jeweled headdress
with a seated Buddha in the front and a
cloth kerchief in back. Dignified yet
energetic, this Virupa gazes at us with
sharply outlined eyes, a wry smile,
stylish mustache, and firmly modeled
features. The pedestal is complete with
finely molded, closely spaced lotus petals;
the plain lower band of the pedestal has
a delicate cavorting lion on either side
of a flaming pearl, all in low relief.
Elements of the style, such as the sense
of realism and the elegance of the
jewelry, relate to the Gyantse Kumbum
images of the second quarter of the 15th
century, but the crisp line and elaborate
sophistication of the jewels suggest a
date perhaps a little earlier, ca. 1400,
before the style represented by No. 178.

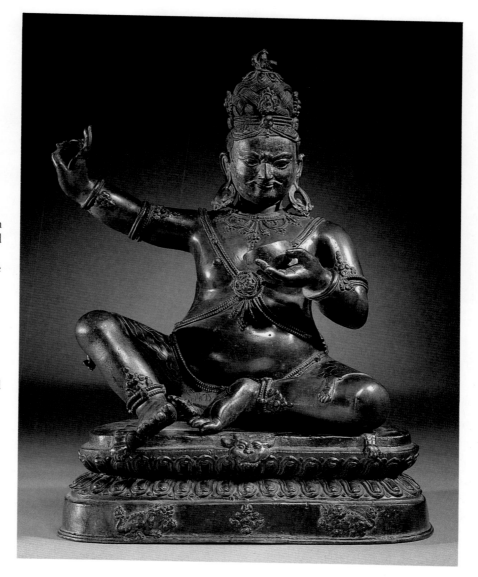

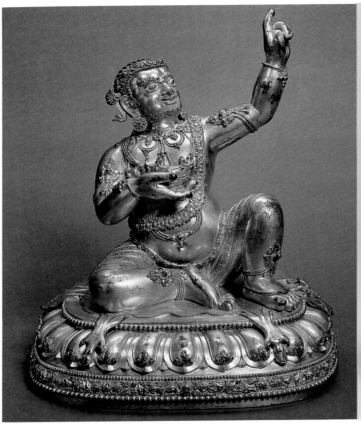 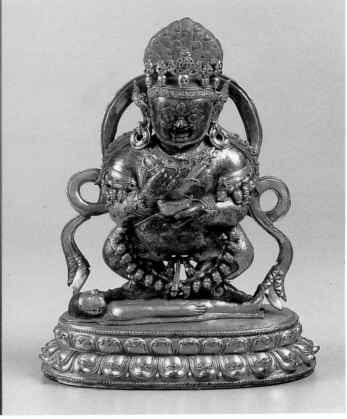

197 (67b)
Virupa

China; Tibeto-Chinese

Yongle period (1403–25), by inscription

Gilt brass

H. 17¼" (43.8 cm)

The Cleveland Museum of Art; Gift of Mary B. Lee, C. Bingham Blossom, Dudley S. Blossom III, Laurel B. Kovacik, and Elizabeth B. Blossom in memory of Elizabeth B. Blossom

A visually brilliant sculpture, this work is also one of the largest works among the known group of inscribed Yongle bronzes (see Nos. 30 and 76). Here Virupa, the Great Adept favored by the Sakyapa, has a gentle, mild appearance despite the large volumes of his stout form. The ponderous figure, seated in his customary posture with one finger pointed to stop the sun, is nevertheless given an ethereal radiance by the shining beauty of the totally gilded surface. It is perhaps the most elaborate sculpture known of Virupa. (See pp. 146–47 and No. 41.)

198 (67c)
Mahakala Panjaranatha (Lord of the Pavilion)

Central Regions, Tibet

14th century

Copper alloy with insets, parcel gilt, and pigments

H. 15⅞" (40.3 cm)

Collection of Mr. and Mrs. Willard G. Clark

Lit.: Rossi and Rossi, 1994, no. 27

This two-armed Mahakala, grinding up negativities in a skull bowl with his vajra chopper, presents quite a fancy appearance despite his wrathful countenance. A narrow, stiff scarf loops around him, symmetrically framing his chubby body as it stands half squatting on a prostrate demon atop a lotus pedestal. Gilded ornaments, including fine beading of his necklace, crown, and armbands and a garland of tightly strung heads hanging close to his body, contrast with the coppery surface of his fleshy form. Insets and the red pigment of his thickly curled hair add yet more color to the figure. The features of his face are tight and precise, similar to the faces of some wrathful deities in the early-14th-century wall paintings at Shalu in Tsang (Vitali, 1990, pl. 48), one indication of the date of this fine sculpture.

199 (67d)
Vajrapani

Central Regions, Tibet; probably Tsang

Second half of the 14th to early 15th century

Tangka; gouache on cotton

33 × 30" (83.8 × 76.2 cm)

Collection of Michael McCormick

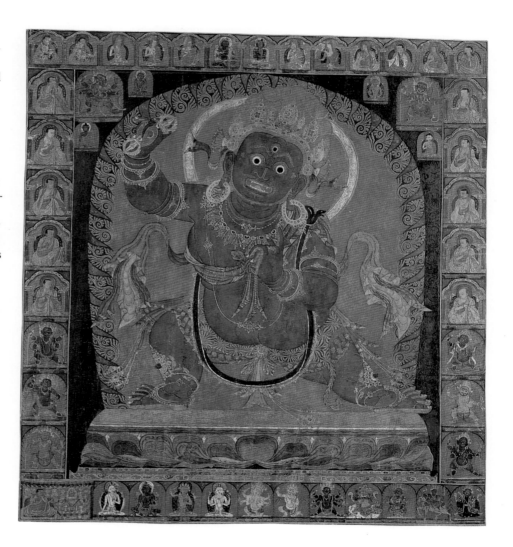

The corpulent, dark-blue Vajrapani, destroyer of obstacles, wears an orange-striped tiger skin, a flower-print loin-cloth, finely pleated ties, and a scarf and sports a rich assortment of delicately detailed jewels as he holds a golden pronged vajra aloft. He presents a magnificent figure against the strong red of his halo, which is lightly figured with scrolling floral patterns and bordered by stylized flames outlined in black. The taut, fleshy limbs and torso of the powerful Vajrapani give a sense of rounded mass and dimension to the form, similar to the techniques of the British Museum Hvashang (No. 14). The engaging details of his large square face have the vigor of a living being in their sharp, delicate, vibrant execution. A trio of images fills the upper corners of the main space: at the left Mahachakra Vajrapani with a Buddha and Akshobhya; at the right Vajrapani with a Buddha and Amitayus. In jeweled niches along the upper edge and upper part of the side borders are splendidly and individualistically robed lamas, including those of the Sakya lineage, which identify the order of the practitioner and donor of this tangka, seen in the lower left corner. Other forms of Vajrapani and fierce protectors appear with red halos in the lower areas at both sides, and a variety of deities, including White and Green Tara, Manjushri, forms of Acala, Vaishravana, Mahakala, Lhamo, and Gonpo complete the bottom row.

The style of this tangka appears to be more developed than that of the early-14th-century Shalu wall paintings (Vitali, 1990, pl. 48), but it is earlier than the more formalized styles of the Gyantse Kumbum wall paintings of ca. second quarter of the 15th century (Ricca and LoBue, 1993, pl. 38). In beauty of detail and monumental mass, this tangka and the Speelman Virupa statue (No. 196) are similar; in overall style it is also closely related to No. 69. This Vajrapani tangka is a rare and splendid example in the finest Sakyapa tradition, reflecting the important wall painting traditions of Tsang in this period; it is possibly related to the magnificent tangkas associated with Narthang monastery, of which we as yet have only the barest glimpse (Liu, 1957, figs. 19, 23).

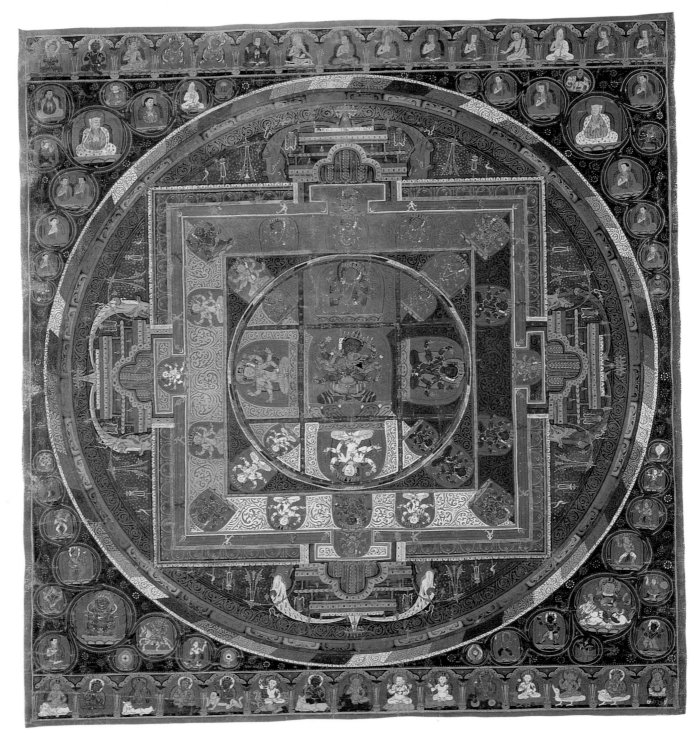

200 (75a)
Thirty-two Deity Guhyasamaja Mandala

Central Regions, Tibet; probably Tsang

Late 14th century

Tangka; gouache on cotton

36 × 32¾" (91.4 × 83.2 cm)

The Zimmerman Family Collection

This mandala is of Guhyasamaja, known as the King of Tantras and the archetypal matrix of the Father tantra class. In the center the six-armed, three-headed, seated dark-blue Akshobhyavajra clasps his six-armed light-blue consort. They are surrounded by the other four cosmic Buddhas at the cardinal directions and by the four Mother Buddhas at the intermediate directions. Outside the

protected circle of the celestial realm, there are lamas and Great Adepts in the upper parts of the tangka, and major protectors, World Gods, and symbols below. An inscription on the back mentions the same Lama Khedzun Kunga Lekpa as in No. 75. Both are important works in defining a style of painting ca. late 14th century in the Tsang region associated with the Sakyapa.

201 (77a)
Mahakala Brahmanarupa

Central Regions, Tibet; probably Tsang

Late 17th century

Tangka; gouache on cotton

58 × 38" (147.3 × 96.5 cm)

The Zimmerman Family Collection

Brahmanarupa ("having the form of a Brahman") is a special form of Mahakala particularly associated with the Sakya Order, whose lineage lamas are arranged in the upper parts of this splendid black tangka: moving left to right from the third down from the left corner, Kedrub Sangyey Puntsok, Konchok Penden, Nyen Lotsawa (upper left corner), Chökyi Gyaltsen, Nagarjuna, the deity Guhyamanjuvajra atop the central axis of the tangka, Risul Yogini, a lama without inscription, Drakpa Gyaltsen, Doring Kunzang Chökyi Nyima, and Penden Chökyong. The finely modeled black Brahmanarupa Mahakala, sitting on a prostrate white corpse, holds a thighbone trumpet adorned with tasseled streamers in his right hand and balances a demon-blood–filled skull bowl in his left hand, as his skull-bone rosary flips around his wrist and a spear is propped in the crook of his elbow. A pink-and-white flayed human skin drapes over his shoulders, a sword and a vase with a vajra-handled chopper appear beside his right knee, and a silken banner decorated with stylized Chinese "long life" ideograms floats from the spear over his left shoulder. Cavorting to either side of Brahmanarupa are the black fierce female deities in his retinue, Kalachandi, Heruki, Kali, and Singali, according to their inscriptions, which include little verses about their power in accomplishing the four magical activities, in punishing demons, in preventing disunity, and in prospering the virtuous. Below, there is a fine image of the warrior deity Begtse, flanked by the wolf-riding Asanga and the bear-riding female Jamdrel. In the lower right corner Vaishravana rides a snow lion. In the lower left corner, there is an elaborately detailed scene of a lama with attendants, practicing Brahmanarupa's ritual evocation rather than making the usual offering tableau.

This is the finest and largest tangka yet to surface of Brahmanarupa, and probably dates to the late 17th century.

Its similarities with the paintings of the secret book of the Fifth Dalai Lama (S. Karmay, 1988) also suggest a date of ca. late 17th century, about the time of Nos. 67 and 107 from Shalu, all of which, in fact, may belong to the same group since many elements are very similar between them.

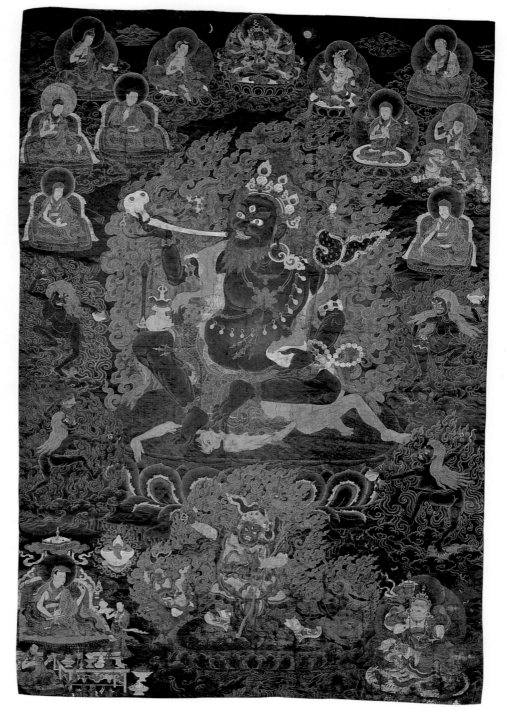

VIII. Kagyu Order

General discussions of the order are on pages 165 and 236.

202 (78a)
Milarepa

Western Tibet

Second quarter of the 15th century

Brass, with silver and copper inlay

H. 11" (27.9 cm)

Courtesy of A. and J. Speelman, Ltd., London

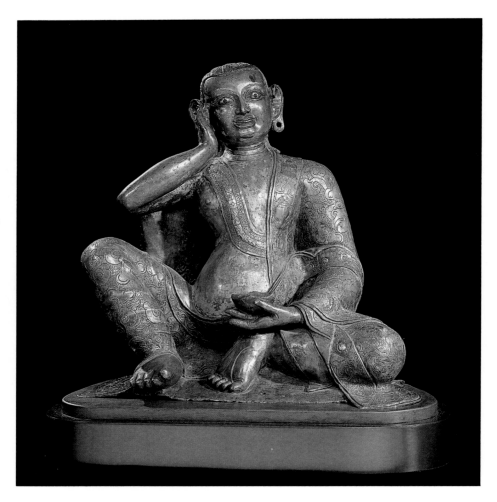

With right hand to his ear, left hand holding the caked shell of boiled thistles, and lips parted as though singing his poetic Dharma songs, this Milarepa statue presents one of the most compelling and powerful Tibetan images of the beloved yogi, one of the Tibetan progenitors of the Kagyu Order. The full body, the massive limbs, and the swelling volumes of the torso portray an impressive figure stylistically very close to the Newark Museum's Drukpa Lama (No. 85), which is probably from Western Tibet (Ladakh). The similarity also extends to the flat, heavy cloth of the robes, the effective usage of bands of copper and silver inlay, and the rather bold floral pattern chasing. Interesting details, such as the layered hair with its series of curled ends, the irregular creases on the right leg, and the expressive wide eyes and silver teeth, all contribute to the charismatic force of this sculpture.

With its powerful mass, monumental design, and sophisticated usage of pattern and line relatively similar to the Gyantse Kumbum sculptures of ca.

the second quarter of the 15th century, this image can probably be dated to approximately the same general period or a little later. If indeed from Western Tibet, this sculpture, along with No. 85, clearly demonstrate a highly original

local style of superb creative artistry from that region just prior to the great sculptures of the Red Temple at Tsaparang of ca. second half of the 15th century. For Milarepa in general, see Nos. 78–83.

203 (84a)
Taklung Lama Thangpa Chenpo

Central Regions, Tibet; probably Ü

First half of the 13th century

Tangka; gouache on cotton

12½ × 9¾" (31.8 × 24.8 cm)

Collection of Michael McCormick

Taklung Lama Thangpa Chenpo (1142–1210) was the first abbot of the Taklung monastery, seat of the Taklung sect of the Kagyu Order, which he founded in 1185. Among a number of ca. 13th-century paintings of this lama (see Singer, 1994), this one is among the finest for its perfection, rich and precise coloring, and skillful, firm drawing. With his hands in a teaching gesture and a slight smile on his round, neatly bearded face, the abbot gazes directly out at us dressed in robes of brilliant color whose sharp distinctions create fluid, flat shapes of great lyrical beauty that are enhanced by the bold designs in gold. The fresh coloring of the ornate throne, the strongly stylized mountain peaks, and the various deities and lamas arranged in formal rows framing the main lama conjure up a sparkling, well-controlled, and orderly world.

The figures along the top row of the painting are, left to right, Naropa, Tilopa, Vajradhara, Phagmodrupa (atop the central axis), Marpa, Milarepa, and Gampopa. In the mountain peaks framing the central Lama Chenpo appear a crowned, white yogi figure, perhaps Maitripa, and Lord Atisha—a reference to the Kadampa links of the Taklung. Along each side are lamas and deities; on the right from the top are four-armed Lokeshvara, an Indrabhuti Vajrayogini, a lama, and Ushnishavijaya, and on the left are Shakyamuni Buddha, a two-armed Chakrasamvara Father-Mother, a lama, and a white Vajrasattva. Across the bottom from the left are the donor; Vajrapani; a four-armed Mahakala; white Jambhala holding a vase and staff; red, four-armed Vajraganesha; Kurukulla; and Vajravarahi. A monastery with stupas and various halls with monks inside is depicted below the throne of Lama Chenpo and is undoubtedly Densatil, the monastery founded at the site of the grass meditation hut of Phagmodrupa (1110–1170), a main disciple of Gampopa and the teacher of

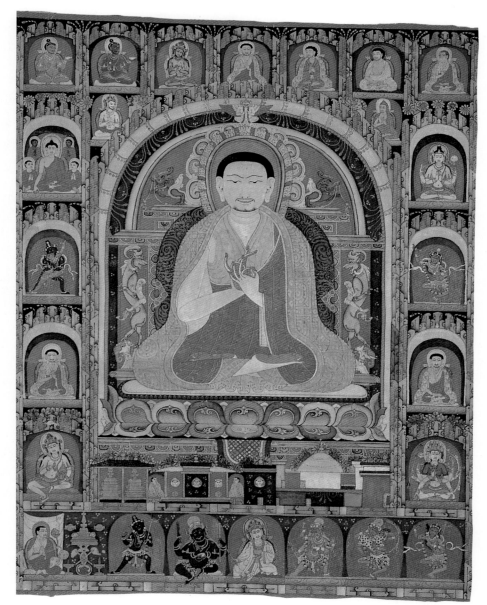

Thangpa Chenpo. Lama Chenpo seems to have been involved in a struggle for succession with other disciples of Phagmodrupa (see Singer, 1994, pp. 116–17, 121–22).

The mounting is original, and the tangka has a consecration inscription on the back by Sangyey Won (also known as Lama Rinpoche Wonpo, 1251–1296), the fourth abbot of Taklung, who

remained in office for one year (1272–73), after which, forced from the post, he founded Riwoche in Kham in 1276 (Singer, 1994, p. 132; Roerich, 1988, pp. 610–52). From the style, the painting is likely to have been painted earlier, ca. first half of the 13th century, and conse-crated later, a factor observed by Jane Casey Singer with regard to other tangkas consecrated by Lama Wonpo (*ibid.*, p. 132).

204 (84b)
Taklung Lama
Sangyey Yarjonpa

Central Regions, Tibet; probably Ü

Last quarter of the 13th century

Tangka; gouache on cotton

9 × 7" (22.9 × 17.8 cm)

Collection of Dr. Wesley and Carolyn Halpert

Sangyey Yarjonpa (1203–1272) was the third abbot of Taklung, a subsect of the Kagyu Order founded by Lama Thangpa Chenpo (see No. 203). The lama is distinguished by his long, fine-featured face, recognizable from other paintings (Singer, 1994, fig. 27). Masters of the Kagyu and Kadam orders fill the top and sides. Along the top border from left to right are Naropa, Tilopa, Vajradhara, a lama (possibly a disciple of Atisha), Atisha in the yellow pandit's hat, and a lama dressed in layman's clothing, doubtless Drom Tonpa, main successor of Atisha. Down the left side is the Kagyu lineage of Marpa: Milarepa, Gampopa, probably Phagmodrupa, and another lama, possibly Lama Chenpo. Down the right side may be the Kadampa lineage. At the lower left is the donor, two other lamas, a Manjushri, White Tara, and a green Vajravidarana. Stylized jewels and mountains in alternating pastel colors frame the borders and each individual segment.

On the reverse side of the painting are inscriptions: the usual OM AH HUMs behind the subordinate figures, and a series of mantras and badly spelled dedicatory verses written in the outline of the main figure's body, beginning with a salutation that mentions the lama by name, including the ubiquitous verse about how tolerance is the supreme asceticism, and concluding with good luck blessings for all. At the top is a sentence: "Here is the dedication of the precious, glorious lama, the master of Taklung."

Clearly in the painting tradition of other Taklung lama portraits such as

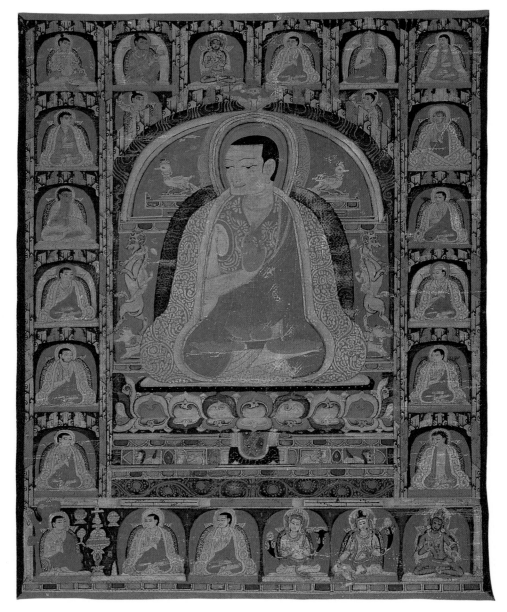

No. 203, it is evident that at least for several generations the Taklung had an identifiable artistic school of tangka painting, of which both No. 203 and this tangka are masterful examples, though by different hands. This school is characterized by a forthright simplicity in overall design and detail, with a strong sense of precise order and harmoniously brilliant coloring, which is dense and compact rather than ethereal, liquid, or thin, thus imparting

a tough, assertive, and almost playful richness that transcends the bold credibility engendered by the insistently strong colors. The color, which is a major component in creating the credibility of the depiction, is at the same time the element that transcends that reality to suggest an ideal world beyond it—one of the most successful styles in Tibetan painting to express simultaneously what we normally think of as two extremes, realism and transcendency.

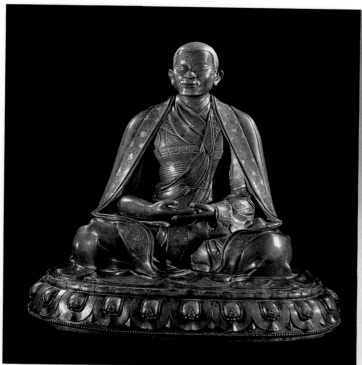

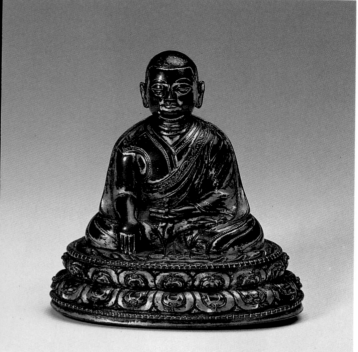

205 (85a)
Dusum Kyenpa, the First Karmapa Lama

Central Regions, Tibet; or Eastern Tibet

14th century

Brass, with gold, silver, and lapis lazuli inlay

H. 13" (33 cm)

Courtesy of A. and J. Speelman, Ltd., London

206 (87a)
Drigung Lama Jigten Sumgon

Central Regions, Tibet; probably Ü

13th century

Dark bronze with gilding; sealed with relics inside

H. 4⁹⁄₁₆" (11.6 cm)

Private Collection

The striking portrait quality of this extraordinary statue indicates that it is the first Karmapa, Dusum Kyenpa (1110–1193), a foremost disciple of Gampopa and the first in the reincarnation line known as the Karmapa lamas. There is a strong likeness to paintings of the master (Xizang Tangjia, 1985 pl. 57). The physiognomy is notably distinctive: high cheekbones, a square jaw, a slightly receding, strongly wrinkled forehead, a low nose, bright blue eyes (inlaid lapis lazuli), and a trim goatee. Silver inlay heightens the hair, mustache, and beard. The figure, with its tall torso, is magnificently draped in monastic robes embellished with a varied yet highly selective array of inlaid gold and silver floral and linear patterns. The heavy robes crease with a mannered life of their own, creating touches of a nervous yet restrained rhythm around the calm and firm inner core of the body, which is positioned in meditation.

Comparable examples are scarce, but stylistically this image can be related to the early Arhat paintings of the 14th century, such as those in Nos. 12 and 13. Both this statue and the Arhat in No. 13 have strongly featured faces with blue eyes, low noses, and attention to the rather soft contouring of the hair. The pronounced, unnatural force of the line, such as in the forehead wrinkles, is similarly portrayed in the No. 12 Arhat, and the rigidly held body and stiffly held long arms relate to similar depictions in these two Arhat paintings as well. Though the drapery is not precisely the same, the Arhats wear gorgeous robes with a degree of interesting creases and slightly mannered folds generally consonant with those of this Karmapa statue. The pedestal has an uncommon design, with a row of tiny petals above the elegant larger petals. The work, clearly a magnificent example of early Tibetan portrait sculpture, is likely to be from the central regions like the Arhat paintings, although a provenance from Eastern Tibet may also be possible.

Jigten Sumgon (1143–1212) is the primary founder of the Drigung branch of the Kagyu Order. Drigung monastery was built in 1179 to the northeast of Lhasa and had become a major center by the 13th century, when it engaged in rivalries with the Taklung branch of Kagyu and with the powerful Sakya. These rivalries had adverse effects, the most disastrous being the burning of Drigung monastery in 1290 by a combined force of the Sakya and Mongols.

The founder's statue, a rare early example of this important lama, is small but presents a compact, engaging image. The full face, with round, heavily lidded eyes and gently smiling countenance, has a calm poise. The drapery is smooth, tight, and has an unpretentious but lyrical rhythm to its folds. Lines of tiny pearls edge some folds, a technique seen in 13th–14th-century sculpture in particular (Nos. 227, 239). The statue is sealed on the bottom and marked with a lotus containing an abstract, simply represented vajra cross in the center.

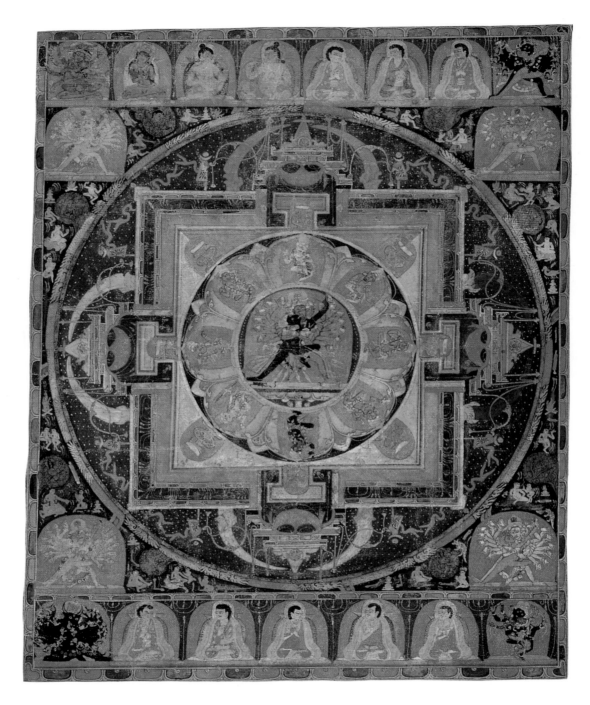

207 (92a)

Hevajra Mandala

Central Regions, Tibet

First half of the 13th century

Tangka; gouache on cotton

13½ × 11" (34.3 × 28 cm)

Collection of Michael McCormick

In the center of his mandala palace, a light blue Hevajra holding a white skull bowl in each of his sixteen hands clasps his dark blue "wisdom" consort, Nairatmya. The eight goddesses of his retinue of varied colors and directions dance on the red petals of the pink, red, and light yellow lotus that surrounds the main core. Four vases filled with elixirs mark the intermediate directions at the meeting of the quadrants of space between the circle center and the square outer walls of this palace domain. The gates, delicately embellished with jewels, drifting banners, and huge tusklike arches of differing colors for each direction, jut into the black space dotted with stars and encased by circular rims of vajras and flowers. Outside are adepts and World Gods in the landscapes of the eight death-grounds (shmashana) that represent the world of egotistic deficiencies. Four contemplative Buddha Father-Mothers in white, yellow, red, and green Hevajra forms occupy the four corners; clockwise from the lower left are Vairochana Hevajra, Ratnasambhava Hevajra, Amitabha Hevajra, and Amoghasiddhi Hevajra (the central figure is associated with Akshobhya). Above is a row of the Kagyu lineage masters: Guhyasamaja Father-Mother, Vajradhara, Tilopa, Naropa, and three lamas, and a Chakrasamvara Father-Mother in the upper right corner. Below from the lower left corner are a Lone Hero Yamantaka, five lamas, and a four-armed Hevajra Father-Mother. Though small, this mandala is a gem with its spirited energy and striking coloration.

208 (92b)
Hevajra Father-Mother Buddha

Eastern Tibet

First half of the 16th century

Tangka; gouache on silk

31⅛ × 22" (79.1 × 55.9 cm)

Musée Guimet, Paris

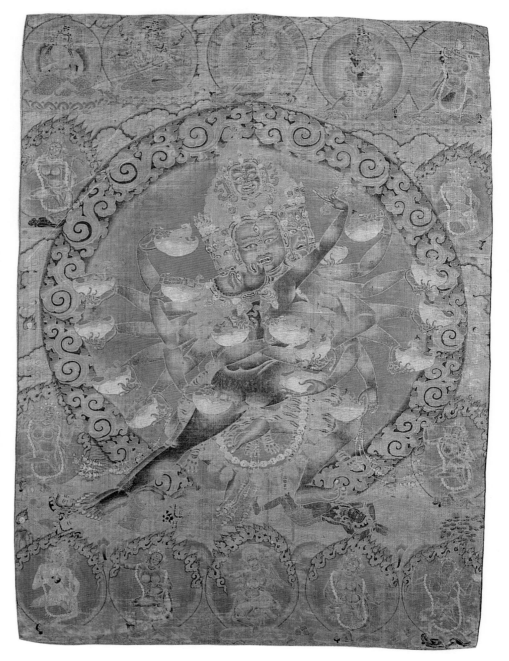

The eight-headed, four-legged Hevajra Buddha, light blue and holding a large skull bowl in each·of his sixteen hands, clasps his dark blue partner, Nairatmya, who holds a chopper in her outstretched right hand. Hevajra is the most important archetype deity of the Sakya Order; the *Hevajra Tantra* is considered the basic Mother tantra, and its contemplation is particularly excellent in creating the conditions for the blazing of the inner fury-fire *(tummo)* so important to Himalayan yogis, such as Milarepa. Encountering Hevajra Buddha, one recalls the Shiva Nataraja in Hindu iconography, but in Buddhism there is no question of destroying the living universe—only the world of egotistic suffering should be consumed in the supernova flames.

Though this is one of the most delicate and ephemeral representations of this popular tantric deity, an intense kinetic energy issues from the central figures, enhanced by the orange-red glow behind them. An unusual stylized scroll-design halo frames the pair. Everything around them seems to fade into burning, flickering, vaporous zones, all occupied on the sides and bottom by dancing yoginis. Along the top are, from left to right, Vajrasattva, Guhya-samaja, a two-armed Hevajra Father-Mother, a two-armed Chakrasamvara Father-Mother, and a Naro Vajrayogini. The central Father-Mother deity is surrounded by nine goddesses—the eight goddesses of his mandala, Gauri, Shavari, Chauri, Chandali Vetali, Dombi, Ghasmari, Pukkasi, and a lone heroine form of Vajranairatmya, his female form, below the central axis of the painting.

Since the tangka is painted on silk, it is likely to be from Eastern Tibet, but it is interesting to note that the style of the figures, with their extreme torsion, dramatically stretching *alidha* (warrior) posture, and slim and shapely limbs, appears in the figures of the wall paintings of the White Temple at Tsaparang in Western Tibet dating ca. the first half of the 16th century.

209 (94a)
Tseringma

Central Regions, Tibet; or Eastern Tibet

17th century

Tangka; gouache on cotton

27½ × 19¾" (69.9 × 50.2 cm)

Musée Guimet, Paris; Gift of Mr. Lionel Fournier (under condition of usufruct)

Lit.: Béguin, 1990, no. 75

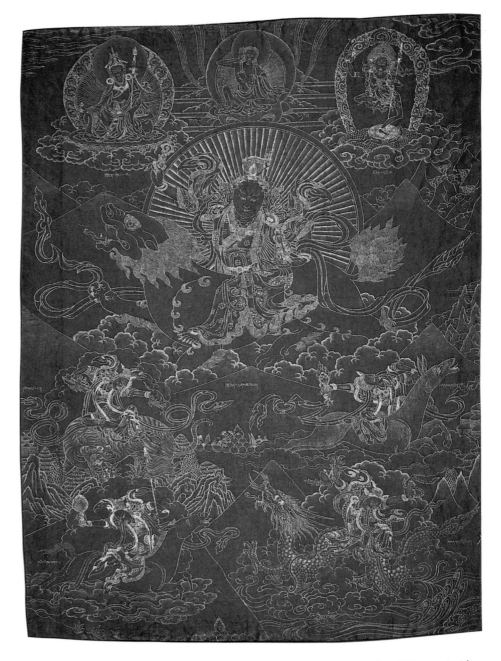

The Himalayan goddess Tseringma (Auspicious Lady of Long Life) and her four sisters represent the formidable spiritual power held in the towering peaks of that range. In the eighth century, the Great Adept Padma Sambhava was said to have tamed them to the extent of demonstrating for them the supremacy of the Buddha Dharma, its teaching of wisdom and love holding the spiritual key to the evolutionary purpose of divine as well as human life. By the eleventh century, the great yogi Milarepa was confronted by them once again, as they put him to the test of his principles to see whether he was motivated by wisdom and altruism or by selfish ambition. When he finally responded to their aggressive attacks by offering his own body as a sacrifice to nourish them, they were persuaded of his authenticity

and renewed their pledge to protect the Dharma and its practitioners (all this is described in the *Hundred Thousand Songs of Milarepa,* Chang, 1977, pp. 322–23 and stories 28, 29, and 31).

In this beautiful black tangka, the powerful Tseringma appears holding a vajra and the long-life vase and riding a blue-eyed lion with red and gold mane and tail. She sweeps across clouds and mountains, a halo with spokes like an umbrella framing her upper body. Above appear Padma Sambhava, Milarepa in the center, and a dancing Vajrayogini. Below are depicted her four sisters, each riding a different animal and holding their offerings to Milarepa. Clockwise from the lower left they are: Tingeyalzunma (Fair Lady of the Blue Face) riding a wild ass and offering a mirror and a banner; Miyo Longzunma

(Immutable Fair Lady of Heaven) riding a tiger and offering a mongoose and a dish of food; Jeuben Drinzunma (Crowned Lady of Good Voice) riding a mule and offering a sack and a flaming jewel; and Degar Drozunma (Fair Lady of Virtue and Action) riding a dragon and holding a snake and a bundle of shrubs, possibly as the offering for increasing livestock.

The style is delicate and the lines like threads of gold impart an embroidered effect. The hazy tones, like a soft mist, add further mystery and a twilight evocativeness to the painting, a lovely example of this rarely portrayed subject. This tangka may have been part of a series (see Béguin, 1990, nos. 76–78), to which the black tangka of Penden Lhamo in the Ford Collection is also stylistically related (No. 215).

IX. Geluk Order

A general discussion of the order is on pages 165 and 262–63.

210 (96a)
Tsong Khapa with Gyaltsab and Kedrup

Central Regions, Tibet

Second half of the 15th century

Tangka; gouache on cotton

30⅜ × 22⅞" (77.2 × 58.1 cm)

Collection of Michael McCormick

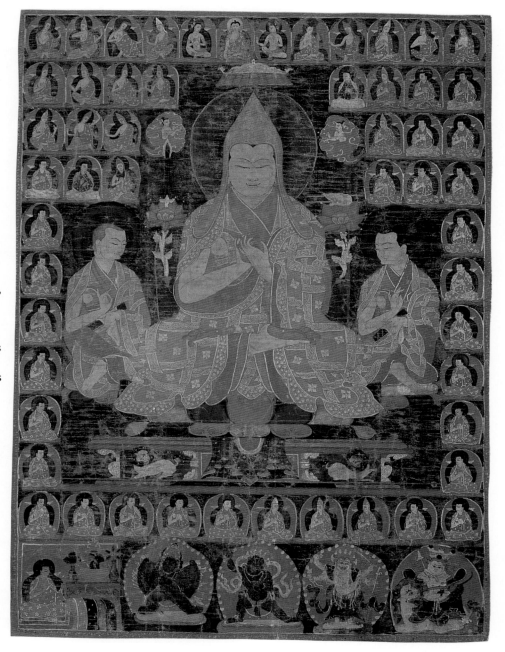

In this rich and energetic painting, Tsong Khapa is attended by his two main disciples, left to right, Gyaltsab and Kedrup, who followed Tsong Khapa in succession as throne-holder of Ganden monastery. Founded in 1409, Ganden was the center of the Geluk Order, a revival of the Kadam Order founded by Atisha and Drom Tonpa. This may be one of the earliest depictions of this combination of figures, which became standard in many later portrayals of Tsong Khapa. As in No. 211, Tsong Khapa sits on a lotus throne placed on a lion pedestal, but the style of the throne, the lotus stalks, and the figures is different, with greater simplicity given to the objects in the setting, and greater lightness and movement imparted to the draperies, which seem to have the fine yet voluminous character notable in some Sakyapa lama paintings from the Tsang region ca. second half of the 15th to early 16th century. The faces of the two attendant lamas also have the sharp, clear linearity observable in some paintings of the central regions of that time and earlier. However, the painting does not follow the Sakyapa school type of elaborate arches; instead, the plain dark blue background supports only fastidious rows of small lamas. The top row has twelve niches, with, left to right, four Indian master sages; a Great Adept, probably Tilopa; Shakyamuni; another Great Adept, probably Naropa; Nagarjuna; and four other Indian sages, undoubtedly including Atisha. Below this on the right and left, down to the level of the shoulder lotuses that support

the trademark sword and the Perfection of Wisdom Sutra, there are two clusters of ten lamas each, who represent Tsong Khapa's Tibetan predecessors and teachers, including two lay lamas, the one on the right surely Drom Tonpa, and the one lower on the left perhaps Lhodrak Namkha Gyaltsen. Two columns of six lamas each go down the two sides, probably Tsong Khapa's

immediate disciples and colleagues, and ten lamas form a row below the lotus throne, probably his other major successors after the two main disciples. There is a large area at the bottom with the lama donor on the left, and four major terrific deities: left to right, Yamantaka, Vajrapani, a white four-armed Mahakala, and a Vaishravana on his white snow lion.

211 (96b)
Tsong Khapa

Central Regions, Tibet

Last quarter of the 15th century

Tangka; gouache on cotton

37½ × 28⅜" (95.3 × 72.1 cm)

Collection of Michael McCormick

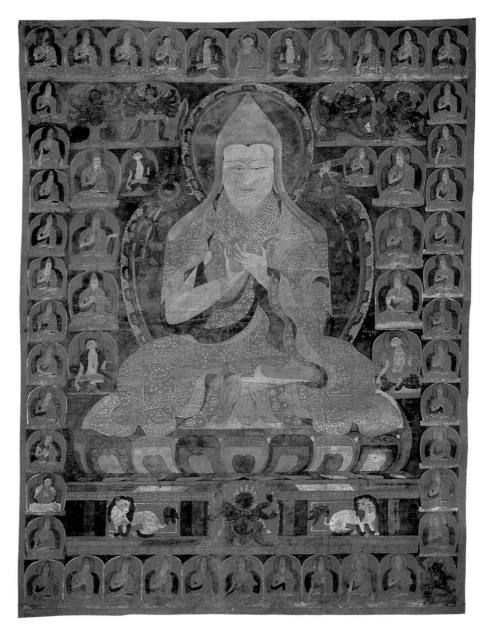

The Precious Master, Jey Rinpoche Tsong Khapa, sits alone in a teaching gesture, with the sutra book and sword, symbols of wisdom and the discriminating mind that understands true wisdom, carried unpretentiously on the lotus blossoms above his shoulders. His face is large, with refined features. He is arrayed in his yellow hat and his robes are decorated in gold floral patterns. The degree of looseness in the depiction of the robes, the still clearly defined shape of the torso, and the style of the halo and pedestal indicate a dating ca. second half of the 15th century. The subdued coloration, especially of dark blue, brown, and dark green, is unlike the bright colors often seen in paintings of the Sakyapa schools in the 15th century, and seems to connote some inclusion of the Khyenri style (after the artist Jamyang Khyentse Wangchuk, ca. mid-15th century), judging from that style as represented by the wall paintings at the Gongkar Chöde monastery. Even the form of the lotus shows some link to the vine style in these wall paintings.

In the top row above sit, left to right, four Indian sages, including Nagarjuna; the Bodhisattva Maitreya; Shakyamuni in the center; Manjushri; and four more Indian sages. Below them, there are four Father-Mother archetype deities flanking Tsong Khapa's halo (from left to right, Guhyasamaja, Chakrasamvara, Yamantaka, and Mahachakra Vajrapani). There is a small Manjushri near the sword, an Atisha near the book, and White and Green Taras at his right and left knees. The lama above the Green Tara on our right is labeled Gedun Drubpa, later named the First Dalai Lama. The inclusion of Gedun Drubpa, who died in 1471, indicates that this tangka was probably made after that date; his prominent position suggests it may have been made close to his lifetime. There are a six-armed Mahakala in the center of the pedestal base and an Outer Yama on a buffalo in the lower right corner. All the other surrounding figures are lamas, fourteen on each side and ten in a row on the bottom, most named by faded inscriptions. On the reverse of the painting, in addition to the usual OM AH HUM and OM YE DHARMA and similar mantras, there is an inscription of the famous verse, "I bow to the feet of Losang Drakpa, who is Lokeshvara, great treasure of inconceivable love, Manjushri, lord of taintless wisdom, the Lord of Secrets, conqueror of all devils, Tsong Khapa, crown jewel of sages of the Land of Snows!" This painting is important in documenting the early Gelukpa paintings, of which only a very few from the 15th century are known.

212 (96c)
Tsong Khapa and Scenes from His Life

Central Regions, Tibet

17th century

Tangka; gouache and gold on cotton

33¼ × 24⅛" (84.5 × 61.3 cm)

Private Collection

This splendid gold-on-red tangka depicts the great master lama of Tibet Tsong Khapa, surrounded by a selection of scenes from his life. From upper right in clockwise order the scenes are, according to the inscriptions: 1) "He initiated the prayer festival at Lhasa during the miracle season, setting beings in maturity and freedom, offering heartfelt offerings; he saw revelations in the sky of the ten-direction Buddhas and Bodhisattvas; and he offered the golden crown to Jowo Rinpoche." 2) "In Yarlung Namgyal monastery Tsogchenpa and Jildingpa served as abbot and instructor and gave full ordination before the right number of faithful monks, thus making the Buddha teaching bright as sunrise." 3) "Having first gone to Dewajen monastery he refreshed his mind in Transcendent Wisdom teachings." 4) "In Sera, he taught many teachings such as Guhyasamaja, Mother tantras, Perfection Stage and extensive commentary on the *Introduction to the Central Way*." 5) "In Gadong, he heard many teachings of tantra and philosophy from Manjushri, with Lama Umapa serving as translator. In Drepung, to one thousand scholars he taught many teachings, such as *Stages of the Path of Enlightenment, Six Yogas of Naropa, Guhyasamaja,* and so on." 6) "Having taught many scholars in Skyormolung teachings of Kalachakra, Prajnyaparamita, and so forth, master and disciples went in a boat." 7) "In the Potala, he taught many teachings concerning the Guhyasamaja to many sages of monasteries such as Panden, Skyormolung, and Zi."

On the back is written: "This tangka is offered to the fortunate community of Loseling, college of many sages, in Glorious Drepung, the great Dharma institution, by the faithful Trayshong Chödzay (T. *bKras gZhong Chos mDzad*). With a pure sense of high responsibility, I dedicate this work that Buddha's teaching may flourish and all mother beings may soon attain the

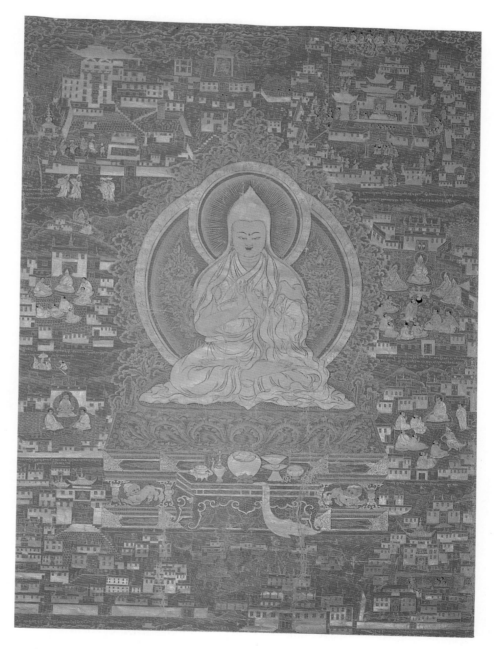

exaltation of omniscience!"

The lavish use of gold in flat, abstract planes for the architectural elements, in the fine line drawing for the details of flowers, clouds, light rays, lotus petals, and so on, all executed with precision, and a sense of the elements as living entities, make this a masterwork of its

kind. The spatial awareness in the setting shows the maturity of 17th-century styles in the central regions, more fully developed than the mid-16th-century Third Dalai Lama painting (No. 97), but possibly earlier than the Kunga Tashi painting of the last quarter of the 17th century (No. 65).

213 (96d)
Tsong Khapa with Gyaltsab and Kedrup

Central Regions, Tibet

Late 18th century

Tangka; silk appliqué tapestry

84½ × 56¾" (214 × 144 cm)

Collection of William M. Hitchcock, Houston

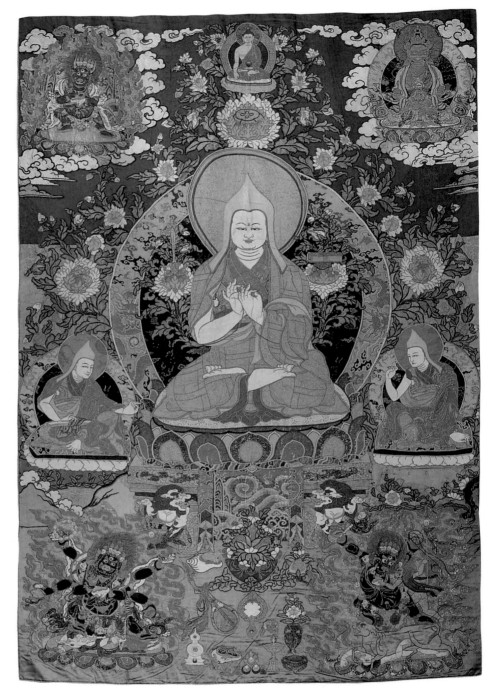

Its large size makes this tapestry an extraordinary example of the Tibetan tapestry tradition; it is also a finely executed work of majesty and skill. The main figure is Lama Tsong Khapa, his two hands in the teaching gesture while holding two lotuses that support the sword of wisdom and the scripture of the Perfection of Wisdom. He is accompanied by two smaller figures of his main disciples, Gyaltsab on the left and Kedrup on the right. Above him on the upper left is an Indian buffalo–headed, two-armed, grinning Yamantaka Lone Hero figure, the fiercest emanation of Manjushri Bodhisattva, of whom Tsong Khapa is believed to be the incarnation. Above him on the left is a red Amitayus, Buddha of Boundless Life, holding a begging bowl topped by a small sculpted stupalike tower that indicates it is filled with the elixir of immortality. In the lower left corner is a six-armed Mahakala protector deity, and in the lower right, Manjushri's special protector, Yamaraja, with his consort Chamundi, standing together on the back of his fierce Indian buffalo mount.

On the upper back of the tangka tapestry a large yellow label with an inscription is sewn. First, the tangka is named "Silk Tangka of the Lama Worship," indicating that the painting was commissioned as an icon used to visualize the personal mentor during the performance of the famous lama worship ritual compiled in the 17th century by the first Panchen Lama. Then the verse says, "This wondrous creation adorned by the famous name of that Losang Drakpa with his sons, he who is the second Victor, emanated from the heart of the invincible Savior Maitreya, lord of the tenth stage, is offered during the summer retreat of the Water Ox year

(1673, 1733, 1793, 1853, 1913), by the wealthy novice *(getsul)* Gelek Chötrak. May the ocean of the mass of merit of this deed of commissioning this chief of icons be increased, may he never be apart from the Manjushri Savior Lama in all his future lives, and may he become a Buddha, a supreme leader of all mother living beings!"

This finely executed silk damask and brocade appliqué tapestry probably dates ca. 1793. It has many elements in common with other tapestries of ca. second half of the 18th century, including the fabrics used (*Xizang Tangjia*, 1987, pl. 96). Stylistically, it is very close to a late 18th-century tangka of the third Panchen Lama, who died in 1780 (*ibid.*, pl. 80). The lively and rather elaborate deity figures, the elegant draperies of the lamas, and the firm red outlining produce a magnificent ensemble of figures against the brilliant colors of the background in one of the finest large surviving tapestries.

214 (98a)
Fifth Dalai Lama with Hand Prints and Footprints

Central Regions, Tibet; or Eastern Tibet

Mid-17th century

Tangka; gouache and gold on silk

23½ × 17½" (59.7 × 44.4 cm)

Collection of Mr. and Mrs. John Gilmore Ford

Large golden palm prints and footprints, marks of an especially sacred tangka, frame the seated figure of the Fifth Dalai Lama holding a book and a flowering plant. His features are fine and he appears youthful, with a light mustache. To either side stands a Bodhisattva, and two seated monks kneel below at an altar. In a circle above the Dalai Lama sits a yogi with long black hair. Three golden lines of nectar flow from the vase in his left hand to the head of the Dalai Lama. He is likely to be the Nyingma master Terdag Lingpa, the mystic teacher of the Dalai Lama. Surrounding the major figures, all executed with simplicity and warmth with a fluid line, is a strikingly delicate and ephemeral drawing of landscape trees and mountains and the protector Penden Lhamo on her wild mule in the lower front. On the back of this unusual painting appear two natural palm prints, likely to be those of the Fifth Dalai Lama (1617–1682) himself, a factor that would date this tangka to around the middle or third quarter of the 17th century, if not earlier.

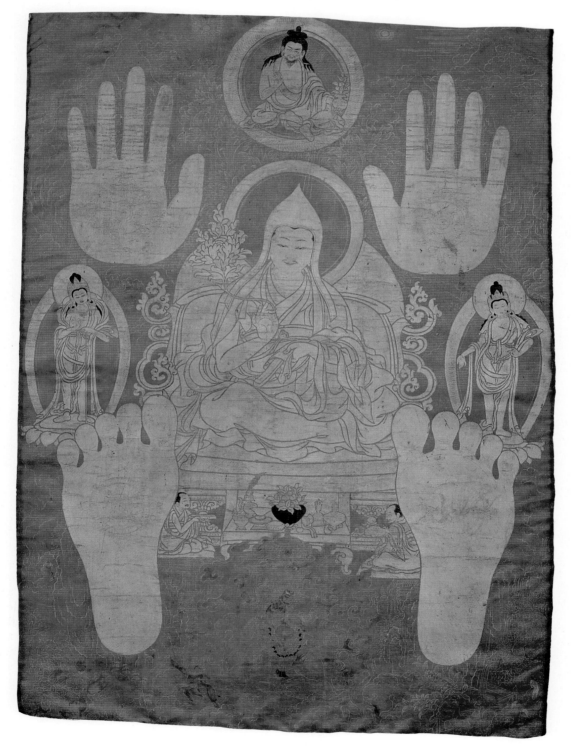

215 (116a)
Penden Lhamo

Central Regions, Tibet; or Eastern Tibet

17th century

Tangka; gouache on cotton

28½ × 19¾" (72.4 × 50.2 cm)

Collection of Mr. and Mrs. John Gilmore Ford

With little color except a few touches of pale blue, pink, and white, this painting conjures up the ghostly dark world of Penden Lhamo. Refined lines and shading in gold, deftly drawn with the lightest touch, evoke an ephemeral ambience as light and changing as the mists of her mountain-lake abode.

The style is similar to that in the series of black tangkas in the Musée Guimet Fournier collection (No. 209), all probably dating in the 17th or early 18th century. Inscriptions accompany most of the figures, identifying them as the demon attendants of Lhamo's entourage (see No. 115).

216 (120a)
Begtse

Central Regions, Tibet; or Eastern Tibet

Late 18th to early 19th century

Tangka; gouache on cotton

33 × 22¾" (85 × 58 cm)

Collection of G. W. Essen, Hamburg

Lit.: Essen and Thingo, 1989, I-140; H. Uhlig, *Tantrische Kunst des Buddhismus*, 149.

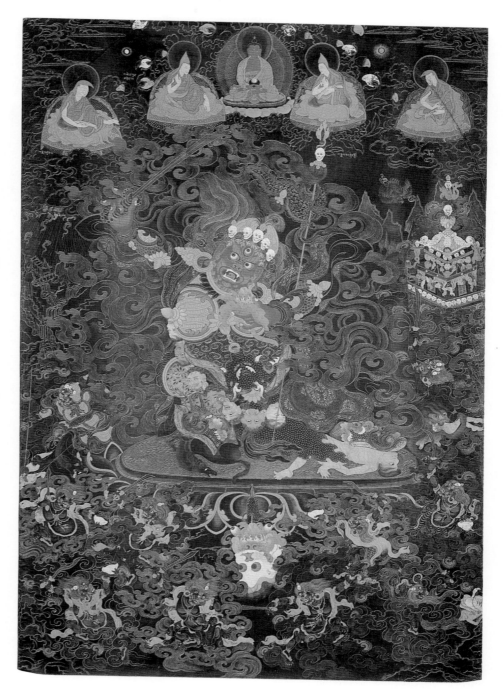

The Dharma protector Begtse originally was considered Lord of War in Central Asia, as indicated by his name, meaning Copper Shirt of Mail, and his clothing. He was taken to be the son of a demon *(yaksha)* and a goblin *(rakshasi)*. Unlike some other protectors, Begste is reckoned as a lower protector because he did not achieve complete liberation; hence a Buddhist cannot take refuge with him but can urge him to perform the good work of protecting institutions and practitioners of the Dharma.

Begtse appears surrounded by flames and smoke, accompanied by his demoniac attendants, the Eight Knife-holders *(gri-thog)*, who cut corpses to pieces on the battlefield. In warrior posture he tramples the carcass of a horse and the corpse of a man. The dark lotus on which they lie is covered with a lake of blood. Begtse is of compact appearance; his red face looks furious and he wears a richly embellished cuirass and Mongolian boots. With his right hand he swings a sword with a scorpion handle; in the crook of his left arm he holds a bow and arrow and a spear with a banner. His left hand holds a human heart near his mouth so he can devour it with his boarlike fangs. At the left he is attended by Sogdag riding a wolf, at the right by his man-eating, red-faced sister Dongmarma. At the upper left we see a dragon spitting fire and hail. At the upper right, nestled in the mountains, is Begtse's residence, the skull palace Marutse, ornamented with body-part trophies. The upper scene indicates the origin of the painting; it shows four hierarchs of the Geluk Order sitting around the red Amitabha. Their names are (from left to right): Jetsunpa; Sera Kunkhyen; the Second Dalai Lama, Gyalwa Gedun Gyatso (1475–1542); and the Third Dalai Lama, Gyalwa Sonam Gyatso (1543–1588).

The tankga in its gloomy, agitated atmosphere is not specially painted for meditation, but rather projects destruction and death. Its function is not to inspire fear and dread but to warn about lost, senseless lives and to appeal for liberation from hatred and passion. In Tibet Begtse is no longer worshiped as Lord of War, but as Mediator of Peace.

G. W. Essen and T. T. Thingo

TIBETAN PERFECTED WORLDS

See pages 311–12.

X. Cosmic Bodhisattvas

Pertinent general discussions are on pages 120 and 311–13.

217 (123a)
Ushnishavijaya

Central Regions, Tibet

14th century

Tangka; gouache on cotton

33 × 26⅜" (83.8 × 67 cm)

Musée Guimet, Paris. Gift of Mr. Lionel Fournier (under condition of usufruct)

Lit.: Béguin, 1990, no. 22.

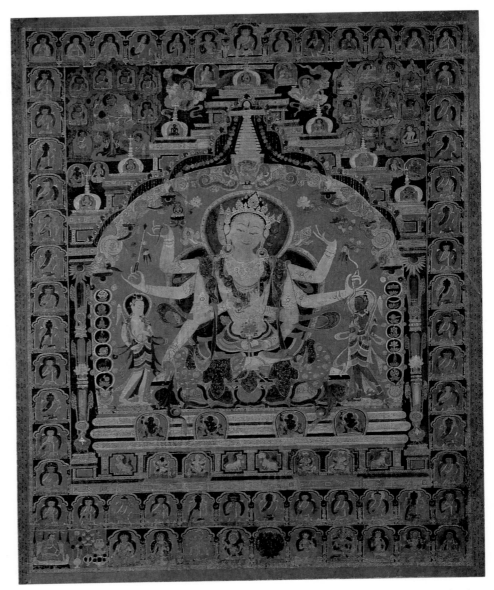

In possibly the finest painting of this subject, the goddess Ushnishavijaya tilts her head and smiles sweetly and engagingly from within the dome of a large stupa. White, three-faced, and eight-armed, she is the goddess of long life, of the Buddha's *ushnisha* crown-dome, and of his enlightenment. Her robes are light, colorful, and fresh, with delicate modeling, loose, fluttering edges, and varied designs. The red background imparts a richness to her domain, where she is attended by two standing Bodhisattvas (a white Lokeshvara and a blue Vajrapani). Her shrinelike stupa is decorated with scroll motifs, vertical rows of the seven lucky signs and of the seven royal emblems of a universal monarch, both sprouting from vases of plenty. At the base are four dark blue fierce deities, and below that, the four Heavenly Kings and four lions. Delicately wrought colorful pillars rising from vases of plenty support the gilded terraces of her stupa, represented at the sides with a small stupa at each corner, each containing a Buddha or a deity. To the left, within a rocky massif, is an ensemble surrounding Virupa, main adept of the Sakyapa. This is balanced at the right by the group of adepts surrounding the Great Adept Saraha, all presented in cavelike niches in the stylized rocky mountain. The thirty-five

Buddhas of Confession appear at the sides and below the throne of the main stupa. Along the top of the tangka are Sakyapa hierarchs with Shakyamuni Buddha in the center and Manjushri on his right. The lowest row contains the donor with his offerings, deities, and Bodhisattvas (see Béguin, 1990, no. 22, p. 58, for specific identification).

Though with clear Nepalese stylistic antecedents, the painting is sharp, fresh, and bright in this Tibetan rendering. The elaborate composition and rich style may relate it to paintings said to have been in Narthang, a major Sakyapa monastery in Tsang (Liu, 1957, fig. 19), and it appears to be a precursor of the bolder and stronger style of the Gyantse Kumbum wall paintings of the second quarter of the 15th century.

218 (128a)
Eleven-faced, Thousand-armed Avalokiteshvara

Central Regions, Tibet

Late 14th to first half of the 15th century

Tangka; gouache on cotton

32¼ × 28¼" (81.9 × 71.8 cm)

The Zimmerman Family Collection

With an array of yellow-hatted lamas, bareheaded lamas, Buddhas, Bodhisattvas, and protector deities forming a grid pattern on all sides, the image of the white eleven-faced, thousand-armed Avalokiteshvara stands as a single large figure amplified by the large circle of his thousand arms. Directly above is Amitabha. At the image's feet stand two small attendants and the seated figures of White and Green Taras. Along the bottom are various protector deities: from left to right, black-robed Bernagjen; blue standing Mahakala; white, six-armed standing Mahakala; two figures in the retinue of Mahakala, including the bear-riding Kshetrapala; the large main blue Mahakala; two more figures in his retinue; Hayagriva; Penden Lhamo; red Hayagriva; and a peaceful Shri Devi. Red-outlined blue clouds fill the spaces on the dark blue background.

The lively and free linear drawing of scarves and robes with vigorous curves and arcs and the intensity of the dark blues, greens, and red create a fresh, vigorous style linked to that of the Gyantse Kumbum wall paintings of ca. second quarter of the 15th century. It is distinct from the refined, more delicate and restrained style of the Western Tibetan Guge renaissance paintings of ca. late 15th to the first half of the 16th century, as seen in No. 129. The modeling relates to the techniques employed in the 14th-century Arhat paintings, such as Nos. 12 and 13. The style of this image is more vigorous than that of the 14th-century Metropolitan Museum figure of the same iconography (Singer, 1994, fig. 31). A derivative of this style appears in Ladakh, in the cave

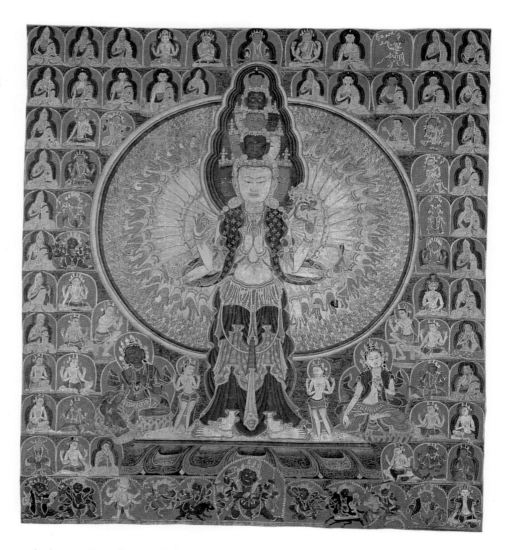

paintings at Saspol around the mid-15th century (Genoud, 1982, Saspol fig. 1). Though the specific lamas in the Zimmerman painting are difficult to identify, they may be associated with the Geluk Order, established around the early 15th century. This tangka, along

with several others in the Zimmerman Collection (Nos. 164 and 220) are important for defining a particular style in tangka painting that is relatively similar to the Gyantse Kumbum wall paintings, possibly predating or contemporary with them.

219 (130a)
Vajrasattva

Western Tibet; or Central Regions, Tibet

11th–12th century

Bronze, with copper and silver inlay,
cold gold paste, and pigments

H. 27¼" (69.2 cm)

Courtesy of A. and J. Speelman, Ltd., London

This statue, one of the finest early
Tibetan images of Vajrasattva, is in the
standing position commonly seen in
early examples of this deity (Essen and
Thingo, 1989, fig. II-44; Béguin, 1977,
fig. 40). Holding vajra and bell, the
figure is a complex and charming mix-
ture of elements. Though the upper
torso has considerable muscle definition,
the limbs appear more fragile and timid.
The face, made larger by the mass of
stacked hair, has a benign, gentle expres-
sion, its large, soft features somewhat
reminiscent of the faces in the early wall
paintings at Shalu of ca. 1045 (Vitali,
1990, pl. 50). Garments and jewels
create a gorgeous, though somewhat
unexpected, richness in the figure, and
one is captivated by the unnatural yet
restrained movements of the hems,
sashes, belts, and ribbons. Somewhat
heavy chasing for the textile designs adds
to the linear complexity of the lower
garment (dhoti), which has a series of U-
shaped, narrow, raised pleats, known in
Indian art but perhaps more typical of
Chinese and Central Asian styles. The
tight, curling hems are a feature notable
in many figures of 11th–12th-century
tangkas from the central regions.
Though the exceptionally large eyes
with silver inlay, the muscular torso,
the summary modeling of the back, and
the casting quality could suggest a
provenance in Western Tibet, it is most
likely from the central regions from
around the 11th to 12th century.

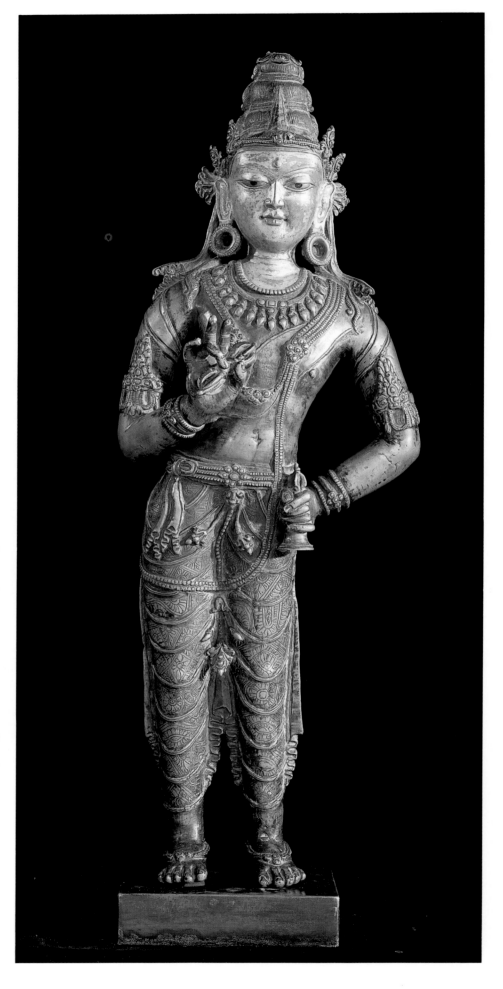

XI. Cosmic Buddhas

A general discussion is on pages 334–35.

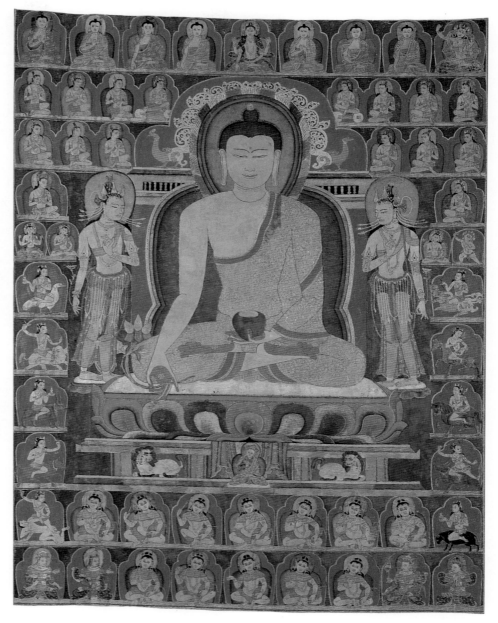

220 (133a)
Bhaishajyaguru

Central Regions, Tibet

14th century

Tangka; gouache on cotton

39½ × 30½" (100.3 × 77.5 cm)

The Zimmerman Family Collection

The Medicine Buddha holds a bowl in his left hand and a myrobalan plant with three fruits in his lowered right hand. He is splendidly garbed in robes with a gold decorated floral pattern. Raised gold decorates the edges of his robe and the golden flames of his halo. The white—rather than the more common blue—body of the Buddha is starkly revealed against the dark green and blue halos. The lintel of the throne back with repetitive vertical lines is a type recurring from as early as the 11th–12th century (see Nos. 191 and 221). Similarly, the two standing Bodhisattvas, probably Suryaprabha on the left and Chandra-prabha on the right, wear diaphanous dhotis and girdles with vertically hanging pendants also seen on a number of early figures (No. 222). These and other elements appear to be in the expanded repertoire of styles current in the 14th to first half of the 15th century, as seen in the great variety of dress and ornamentation used in the Shalu wall paintings of ca. early 14th century and more elaborately expounded in the Gyantse Kumbum wall paintings of ca. second quarter of the 15th century. However, along with Nos. 164, 173, 218, 225, and 234, this tangka helps to define a distinct style group different not only from the Sakya styles of Nos. 73 and 75 of similar period and from the Shalu and Gyantse Kumbum wall paintings, but also from the wall paintings of the Jonang, Gyang, and Riwoche stupas in western Tsang of ca. mid-14th, early 15th and mid-15th century respectively (coined the Latö [La.stod] group or style by Vitali, 1990, pp. 132–33).

Completing the grouping around the Buddha are a top row of the seven Medicine Buddhas, a four-armed Lokeshvara atop the central axis, and Manjushri in the upper right corner. Below them on the two sides are the sixteen Indian masters of the medical tradition (eight on each side); four small deities, probably Lokeshvara, White Tara, Manjushri, and Vajrapani (two on each side); the ten World Gods on their mounts (five down each side); and, directly below the Buddha's pedestal, two rows with the twelve barbarian *yakshas* (each holding a mongoose) in the retinue of the Medicine Buddha (see No. 133). Terminating the bottom at both corners are a pair of the four Guardian Kings. In front of the cloth overhang of the Buddha's pedestal is Padma Sambhava, possibly associated with the Medicine Buddha by virtue of his role in propagating the medicine books in Tibet, burying them as treasure teachings to be discovered in later times. On the back of this handsome painting, one of the finest early Tibetan depictions of the Medicine Buddha, is the black outline of a large stupa with red inscriptions stating the Buddhist creed and a phrase that "tolerance is the best asceticism." Similar inscriptions occur on Nos. 173, 203, 221, 223 and on a small painting of Shakyamuni in the Rossi collection of ca. 13th century (Rossi and Rossi, 1994, fig. 5). The syllables OM AH HUM appear behind each individual figure.

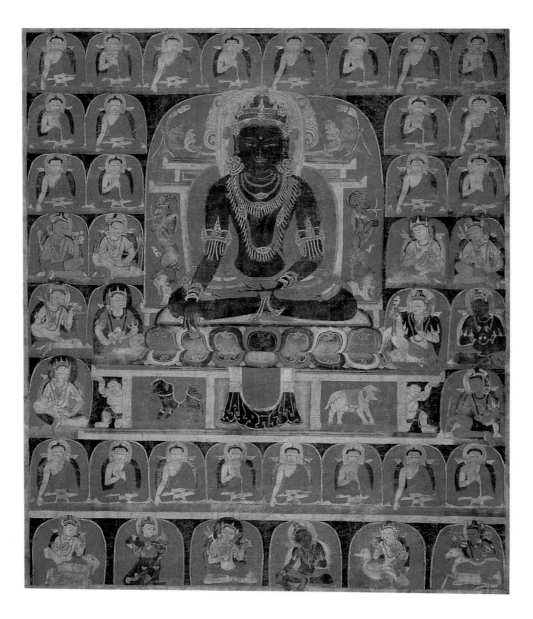

221 (137a)
Akshobhya

Central Regions, Tibet

11th to first half of the 12th century

Tangka; gouache on cotton

21 × 17⅜" (53.3 × 44.1 cm)

Collection of Michael McCormick

The blue Akshobhya Buddha, holding a golden vajra in his right hand in the earth-witness mudra, sits cross-legged on a multicolored lotus pedestal supported by a base containing a white and black elephant, the animal vehicle of Akshobhya. Two burly golden *yakshas* support the ends of the base; blue leogryphs on the back of a pink elephant support the sides of the throne back, and pink *makaras* with golden foliate tails grace the top slabs of the throne. Above and to the upper sides of the central configuration are sixteen seated Buddhas with alternating earth-witness and teaching gestures. The ten celestial Bodhisattvas from Akshobhya's retinue in the Pure Land of Abhirati—five on each side—fill the center of each side. The lower part contains a row of another eight seated Buddhas, with alternating earth-witness and teaching gestures, and below that are World Gods and a Tara: from left to right, Indra, perhaps Kuvera, Shiva, Green Tara, Brahma, and Agni. The delicate line and simplicity of the forms impart a fragility and lightness to the work.

This tangka is similar in style to, and possibly a companion of, the Vairochana Buddha in the Halpert collection (identified by Huntington and Huntington, 1990, no. 106 and pp. 313–16 as Vajradhatu Vairochana of the yoga tantras and dated to ca. 1065–85). Stylistically, this tangka appears to belong early in the period of the Second Transmission. The Akshobhya figure relates to the sculptures from the second floor of Khyangphu monastery in Tsang of ca. early to mid-11th century (Vitali, 1990, fig. 9; Govinda, 1979, I, pp. 41–43), though it is slightly simpler in ornamentation. The simplicity of the figure style has some similarity to the early paintings of the Jokhang (text fig. 10). Perhaps most convincing for attributing a ca. 11th-century dating for the tangka is the particular form of the seated Buddhas: the angular right arm position, rather full body and face, and shallow hair with pointed *ushnisha* seem to relate this work to the wall paintings of Yemar (Iwang) monastery of ca. early 11th century (Vitali, 1990, fig. 13), a style that appears later in more developed form in some of the Khara Khoto tangkas (Nos. 133, 135). This tangka appears to predate the style of No. 222.

222 (139a)
Vairochana and Bodhisattvas

Central Regions, Tibet

Second half of the 12th century

Tangka; gouache on cotton

43¾ × 28¾" (111.13 × 73 cm)

The Cleveland Museum of Art.
Mr. and Mrs. William H. Marlatt Fund

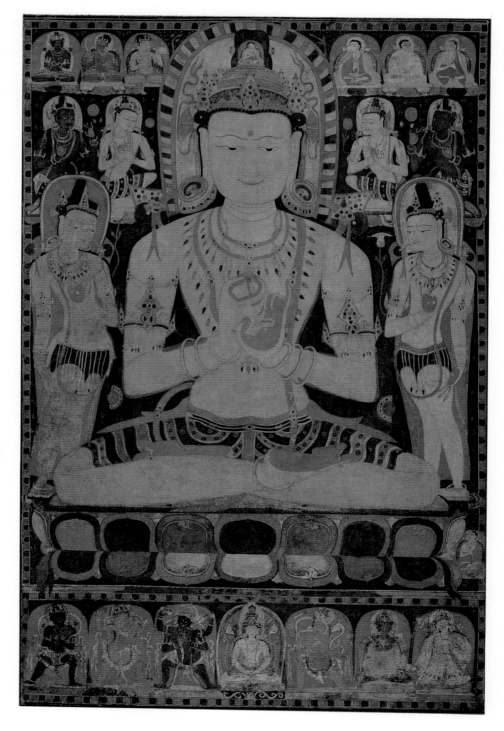

A seated cosmic Vairochana Buddha, garbed as a royal figure, his hands in a form of the enlightenment summit *(bodhyagri)* gesture, looms large with broad and smiling face as the main focus of this painting. He is elegantly adorned, with large earrings, tiny pearl strings with hanging jewel pendants, thumb rings, and so forth, and he holds a tiny vajra, symbol of his clan, between the thumb and index finger of his right hand. His two main attendant Bodhisattvas, with long torsos and gauzy dhotis, stand gracefully at each side. Just above are a pair of seated Bodhisattvas and along the top is the main lineage of the Kagyupa: Vajradhara, Tilopa, Naropa, Marpa, Milarepa, and Gampopa. A lama, possibly Phagmodrupa (1110–1170) as suggested by Jane Casey Singer (Singer, 1994, pp. 115–17), appears as a rare occurrence in the crown of Vairochana. On the bottom, left to right, a two-armed Vajrapani, a Vajrayogini, a four-armed Mahakala, a seated, eleven-faced Avalokiteshvara, a standing four-armed Hayagriva, a seated, blue Vajrasattva (partially effaced), and a standing warrior-donor figure complete the ensemble, which, in this large tangka, presents a majestic, sublime vision.

 The subdued, dark color tones of the background pleasingly offset the light tones of the figures. The line is particularly delicate and the ornamentation restrained yet elegant. Stylistically, the work is related to the well-known Amitabha and Ratnasambhava tangkas in the Los Angeles County Museum of Art (see Pal, 1983, nos. P1 and P2), the former datable to ca. 1180, the likely period of this tangka as well.

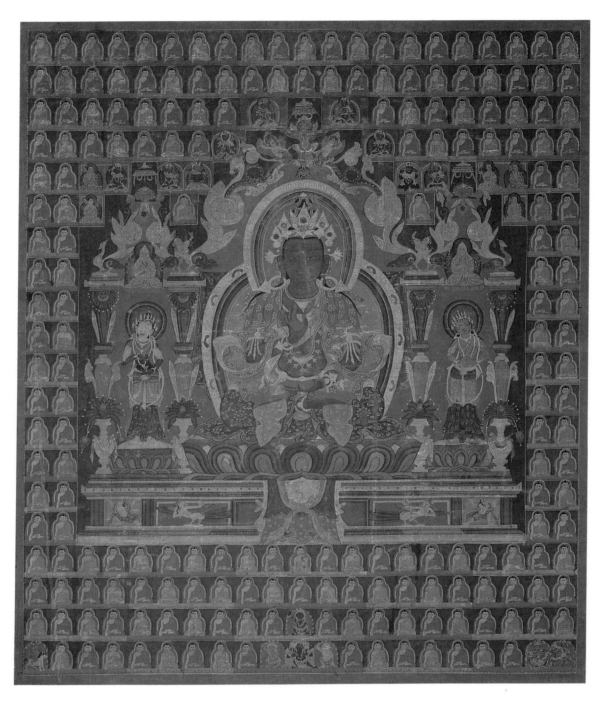

223 (142a)
Amoghasiddhi

Central Regions, Tibet

Second quarter of the 15th century

Tangka; gouache on cotton with raised gold

31¼ × 26⅝" (79.4 × 67.6 cm)

Private Collection

The cosmic Buddha Amoghasiddhi, green in color, holding the right hand in the fear-not gesture and the left in the contemplation gesture, sits beneath a shrine attended by two standing female Bodhisattvas, probably Green Tara on the left and Yellow Tara on the right, each in her own side shrine supported by elaborately carved pillars with a vase-of-plenty base. An image of Tsong Khapa appears at the top of each side shrine, clearly indicating that this was a Gelukpa tangka probably made after 1419, the date of Tsong Khapa's death. Stylistically, the work closely relates to the wall paintings of the Gyantse Kumbum of ca. 1427–45 (See Ricca and LoBue, 1993, figs. 4, 6, 20, 26, etc.) and can thereby be dated to about the same time or possibly slightly later. This is one of the earliest tangkas clearly associated with the Geluk Order, newly established in the early 15th century.

Raised gold adorns the main figure and parts of the shrine; the colors are rich, like the Kumbum palette, not as brilliant as some of the Sakyapa tangkas of this period (Nos. 73, 237). The dramatic power of the forms and the bold, free line are completely consonant with the Gyantse Kumbum style.

Around the upper edges of the shrine are various Buddhas and Bodhisattvas. The remainder of the painting is devoted to the one thousand Buddhas of this "golden eon." In the lower left corner is a protector on a horse; in the center are four protector deities; at the lower right are Vaishravana and a female protector, Shri Devi Remati. On the back is a single inscription in cursive that gives the usual mantras and the verse on tolerance as the highest asceticism.

224 (144a)
Amitayus

Central Regions, Tibet; or Eastern Tibet

14th century or earlier

Gilt bronze with insets (mostly recent),
cold gold paste, and pigments (mostly recent)

H. 10¹⁄₁₆" (25.5 cm)

Private Collection

This sculpture is distinctive for its
beauty, refinement, and delicacy. Though
once generously bejeweled, it has lost
most of its insets. Nevertheless, the
combination of fine jewels and delicately
creased and patterned chest shawl and
dhoti provide a harmonious interplay
of line on the slim, rather elongated,
and stiffly fashioned figure. The facial
features are tiny and exquisite, imparting
still further ethereality to this interpre-
tation of Amitayus, the Buddha of
Infinite Life. The pedestal has elaborate
petals encircling the entire base, as does
the inscription, which is the Amitayus
mantra written in Lantsa script.

The overall style of this elegant work
seems consonant with some sculptural
styles of the Song period in China. The
U-shaped folds of the shawl over the
arms are a motif that appears as early
as the early 11th century in the sculp-
tures of the Central and Amitayus
chapels at Yemar (Iwang) monastery
(Vitali, 1990, pls. 19, 21). Even the stiff
body and jewel belts are similar. The U-
shaped folds and narrow creases of the
scarf occur in bolder form in the Gyantse
Kumbum wall paintings and Pelchor
Chöde sculptures of ca. second quarter
of the 15th century, but in general this
sculpture appears to predate these as
well as the Yongle-period bronzes. It is
possible that the work is as early as the
11th century, and probably no later than
the 14th century. It may come from the
eastern regions; little is known about
early-period work from there.

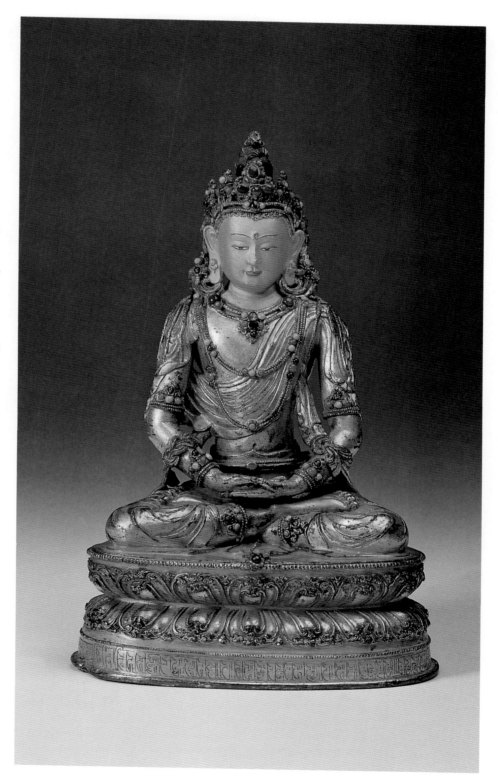

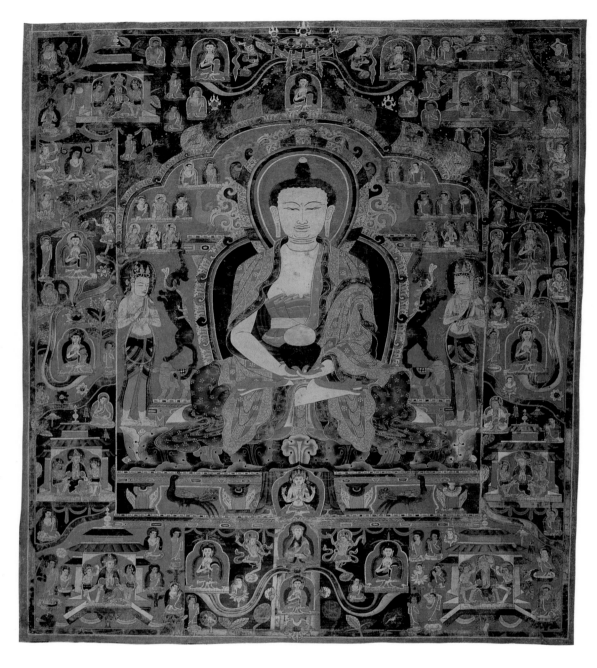

225 (144b)
Amitayus in Sukhavati

Central Regions, Tibet; or Eastern Tibet

Second half of the 14th to early 15th century

Tangka; gouache on cotton

25¼ × 19¼" (64.1 × 48.9 cm)

Collection of Shelley and Donald Rubin

In this handsome painting the Buddha of Infinite Life (a form of the Infinite Light Buddha, Amitabha) is surrounded by scenes of his Pure Land, Sukhavati, presented as upheld on the trunk of a massive cosmic tree that grows up from the earth. There are six palace scenes with royal figures within, in the four corners and on the lower right and left, probably indicating the heavenly abodes of the ancient Dharma kings of Tibet. On the bottom of the tree trunk is a Shakyamuni figure, with a Padma Sambhava and four-armed Avalokiteshvara above him, the Emanation and Beatific Body forms that proceed from Amitabha as a Truth Body Buddha. Above Amitayus are three small Buddhas in teaching gesture.

This majestic work possesses the strong, deep coloring typical of some paintings around the second half of the 14th to the early 15th century that appear in the wall paintings of the Gyantse Kumbum. The line drawing is firm and sharp. The modeling of parts of the Buddha's robes is reminiscent of techniques seen, for example, in the robes of the Arhat in No. 13, but it is presented here in a more luxuriant, slightly mannered way. The array of scenes, each with its own rivers, trees, shrines, and worshiping figures, creates a splendid, clearly organized yet rich and complex painting. It is a major painting that seems to bridge the time between the wall paintings of Shalu monastery of the early 14th century and the more fully developed styles of the Gyantse Kumbum wall paintings of the second quarter of the 15th century, and it is one of the earliest examples of the Sukhavati theme in Tibetan tangka paintings. Similar to the Karmapa sculpture in No. 205, it may represent a school from Eastern Tibet, but at present this is difficult to confirm.

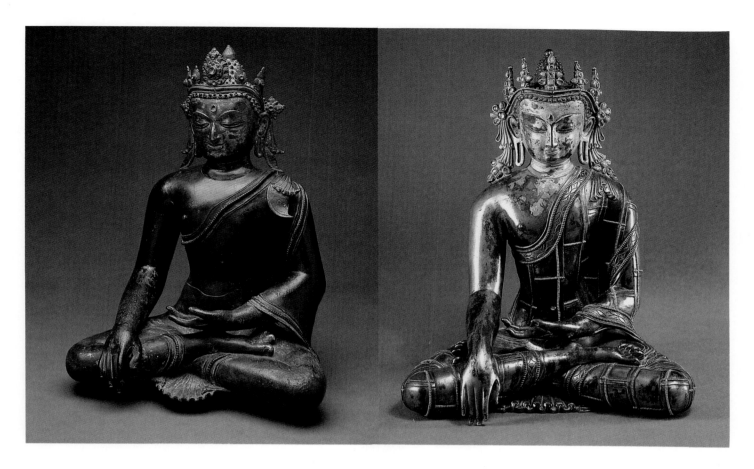

226 (146a)
Crowned Buddha

Central Regions, Tibet

11th century

Dark bronze with traces of gilding on the face

H. 14⅜" (36.5cm)

Collection of Mr. and Mrs. John Gilmore Ford

This powerful bronze crowned Buddha in earth-witness gesture may date as early as the 11th century. It has a number of features in common with the early-11th-century sculptures from the upper floor of Kyangphu monastery in Tsang, with the sculpture of Shakya-muni in the Defeat of Mara at both Kyangphu and Yemar (Iwang) of ca. mid-11th century, as well as with the wall paintings at Drathang monastery dating ca. 1081–93 (see Vitali, 1990, figs. 9, 12 and pl. 30; Govinda, 1979, I, p. 49). The similarities include the powerful and solid shaping of the body; the careful, slightly stiff but strong quality of the lineaments; and hands and feet that are set abruptly, without the elegant transitions, attenuation, and modeled nuances typical of late 13th–14th century sculptures such as the crowned Buddha in No. 227 of ca. 1300.

The full, square face resembles that of the Buddhas of the Drathang wall paintings, as does the line at the waist, which, like other elements of this style, does not show fleshy modeling but a sharp delineation on the smooth, solid surface. The robe is plain except for the delicate yet stiff line of pearls that divides the hems. Usage of pearls as part of the garment decor is known as early as the Yemar and Kyangphu early 11th-century sculptures, and the stiff manner of portrayal in the Ford Collection Buddha is consonant with this early 11th-century style. This feature, as well as the crown ribbons, becomes con-siderably more elaborate by the end of the 13th century, as witnessed in No. 227. The thin and delicate shape of the earlobes and the unusual teardrop-shaped *urna* of the Ford collection Buddha also occur in the Kyangphu sculptures of early 11th century. Cast with the image and probably meant for insertion into a now-lost pedestal is a flangelike projection, not as wide as the image's legs, which project over the edges. This technique and the unusually heavy weight may be factors of the early date of this extraordinary sculpture.

227 (146b)
Crowned Buddha

Central Regions, Tibet

Circa 1300

Silver, with insets, cold gold paste, gilding, and pigments

H. 9" (22.9 cm)

Robert Hatfield Ellsworth Private Collection

Made of silver, this Buddha is likely to be a crowned Shakyamuni, but it could also be a crowned Akshobhya (see No. 138). The patched robe is beaded with lines of pearls, and an incised leaf pattern very similar to the patterning used in some of the early-14th-century wall paintings at Shalu decorates the borders. The crown ribbons cascade to the shoulders in two-tiered clusters of tight pleats, a fashion observable in scarfs and ribbons portrayed in sculptures and paintings of the 13th and 14th centuries. A sweetly smiling mouth adds to the youthful impression given by the strong body with its cinched waist, long limbs, and large hands and feet. It is a highly sophisticated image of great beauty and vitality, related to the vigor-ous styles of the early-14th-century Shalu wall paintings.

228 (146c)
Tathagatha (One of the Thirty-five Buddhas of Confession)

Eastern Tibet

17th century

Tangka; gouache on cotton

45½ × 29¾" (115.6 × 75.6 cm)

Private Collection

Against a landscape of large conical mountains, receding blue rivers and yellow cliffs, and a sky filled with blue, green, pink, and white clouds, rainbow lights, and groups of teaching Buddhas and worshipers, are a Tathagatha and his two elegantly garbed Bodhisattvas. With right shoulder bared, the Buddha teaches. Lively creases and fine gold patterning enliven his robe. Behind is a rainbow-rim halo and a gorgeous array of dense, scrolling foliage, finely modeled in blue, green, yellow, pink, and white, in which cavort two large dragons holding pearls. The robes of the Buddha's right attendant are astonishingly mannered, with fluttering hems reminiscent of Central Asian or Chinese forms, the so-called Khotanese style. The prevalent usage of landscape, the touches of Chinese-related stylistic elements, and the relatively light palette all suggest an Eastern Tibetan provenance, possibly Amdo. The naturalistic qualities of the landscape and the tonality of the colors support a dating of ca. 17th century, before the more radical stylization and brighter coloring of later times. Although with our present state of knowledge it is not possible to pinpoint the probable locale of this style, this fine tangka clearly represents an important but as yet undefined painting style occurring within the Eastern Tibetan region.

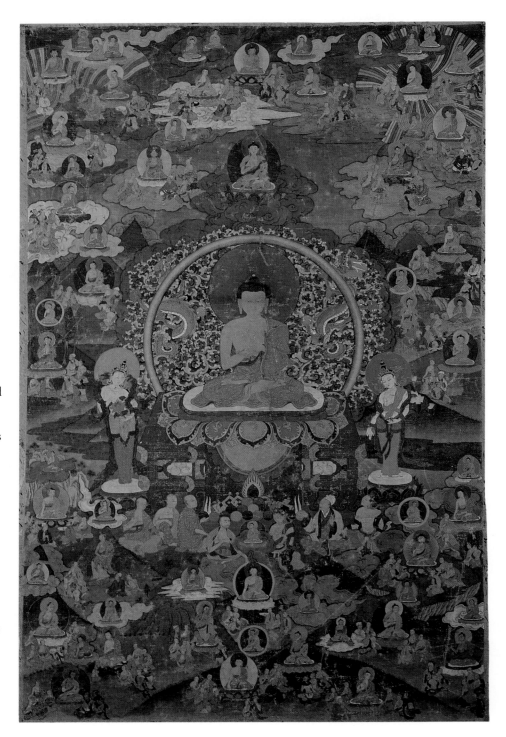

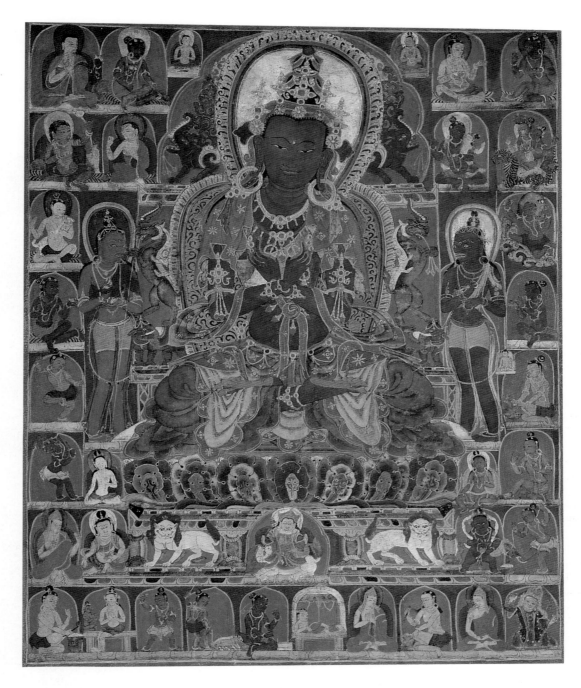

229 (146d)
Vajradhara

Central Regions, Tibet

Late 14th to early 15th century

Tangka; gouache on cotton

23¼ × 19¾" (59.1 × 50.2 cm)

Collection of Mr. and Mrs. John Gilmore Ford

This handsome, dark blue Vajradhara is richly arrayed with loose robes and starkly bold, heavy jewels, mostly in raised gold. The variety of color, skillful modeling in the robes, and flowery lotus petals make it an exceptionally vibrant style. Similarly rich and bold designs not only for the robes and jewelry but also in the halo relate closely to many examples in the Kumbum wall paintings (Ricca and LoBue, 1993, figs. 15, 16, 19) and may represent a variant regional style. The intriguing and as yet unanswered question is whether this style is contemporary with the Gyantse Kumbum in the second quarter of the 15th century or possibly predates it. Some early features, such as the style of the surrounding and attendant figures (which may have been executed by a different hand from the main figure), may be an indication of ca. late 14th- to early-15th-century dating, or they may be a conservative element if the painting dates ca. second quarter of the 15th century. These issues remain to be resolved, but this tankga and others of related style (Nos. 173, 217, 223, and 225) comprise a new and distinct stylistic group whose exact provenance is still undetermined.

Vajradhara is attended by a fierce form of blue Vajrasattva on his left and a fierce red Bodhisattva on his right. Registers above and to the sides and bottom contain Buddhas, lamas, adepts, and protectors; and in the bottom center is a Parinirvana Buddha. Close to the main image are White and Green Tara, Kubera, Vaishravana, and a blue Kubera with a mongoose. A tiny golden Shakyamuni appears near the blue Vajrasattva attendant. The figures are all individualistically rather than repetitively portrayed and have carefully executed, interesting details.

230 (147a)
Vajradhara and Prajnyaparamita Father-Mother

Central Regions, Tibet

First half of the 16th century

Brass and copper alloy

H. 15⅛" (38.4 cm)

Collection of G. W. Essen, Hamburg

Lit.: Essen and Thingo, 1989, I-3; von Schroeder, 1981, no. 132A; H. Uhlig, *Tantrische Kunst des Buddhismus*, no. 63.

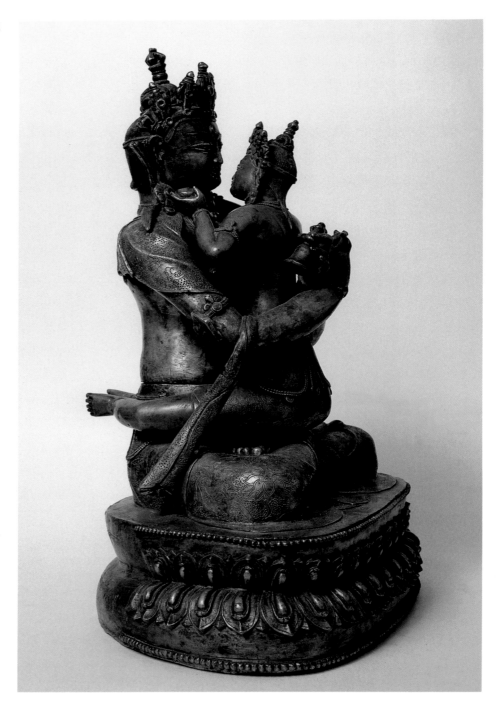

On a double lotus throne we see the primal Buddha Vajradhara, Holder of the Diamond Scepter. He is the incarnation of the diamond, symbolizing the uncreated and indestructible nature of Truth. In all of the New Translation-based orders (except the Nyingma), he is worshiped as the primordial Buddha holding the first rank in the Buddhist pantheon. Vajradhara is sitting in the father-mother union posture with his female consort. This posture is typical for many Tibetan deities; here it is not to be understood only as an ecstatic sexual union, as is also found with the fierce deities. Like Vajradhara's ritual gesture of embrace, the union symbolically means the union of compassion and wisdom. Vajradhara's consort symbolizes transcendent wisdom *(prajnyaparamita)*. The goddess holds a ceremonial knife in her right hand in order to exterminate the fundamental evil of ignorance, while with her left hand offering her mate a skull bowl filled with ambrosia, symbolizing the purification of ignorance. She looks deeply into his eyes and he returns her smile. Their faces reflect the highest harmony. Prajnyaparamita is regarded as mother of all Buddhas, because those who walk in transcendent wisdom reach enlightenment.

This beautifully fashioned and engraved religious sculpture, composed of three parts, was a lady's generous donation, as we learn from the inscription on the back of the base, in which she is called a Bodhisattva as an honorific title because of her religious merits. The inscription reads: "The true personification of [the lama] Namdol Zangpo as Vajradhara. Donated to him in adoration by the great Bodhisattva Konchok Zangmo. Made by the masters, father and son, Lhadon Poncho." Unfortunately we cannot draw any historical conclusion from this inscription. However, the high respect afforded this Tibetan lama is instructive: because he is considered as Adibuddha Vajradhara, we learn that Vajradhara himself is at the same time the archetype of all lamas.

G. W. Essen and T. T. Thingo

XII. Pure Lands

A general discussion of Pure Lands is on page 361.

231 (148a)
Shakyamuni with Buddhas, Bodhisattvas, and Lamas

Central Regions, Tibet

Mid-13th century

Tangka; gouache on cotton

39 × 31½" (99 × 80 cm)

Private Collection, Switzerland

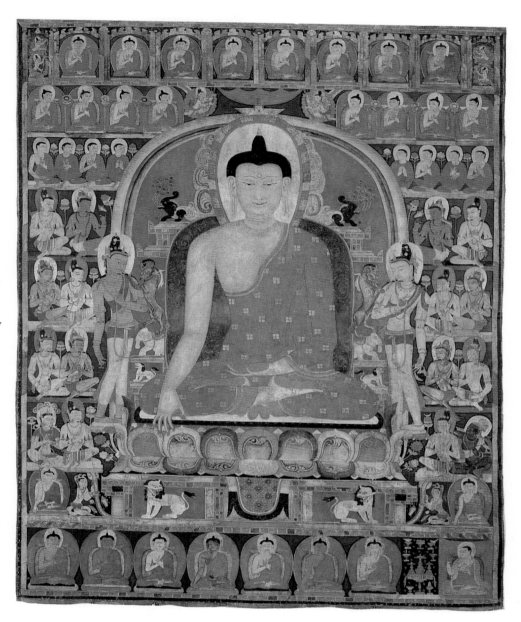

The Buddha, probably Shakyamuni, in the earth-witness gesture and wearing a brilliant red robe sparingly decorated with golden four-part square designs, is master of this splendid tangka, in which he is surrounded by rows of Buddhas, Bodhisattvas, and lamas and attended by two standing Bodhisattvas. Exquisitely refined and controlled modeling of the face and body of the Buddha is complemented by finely tuned planes of color and a varied yet simple and unerring line. The dominance of red, the strong arc of the shrine, and the shaping of the figures relate this tangka to the style of the vertical banner (Rossi and Rossi, 1994, fig. 2), though the hand is clearly different and other factors, such as the greater restraint of the jewelry, could suggest a different school or monastic center. Some stylized mountain shapes appear at the top, a prominent feature in a number of tangkas from as early as the 11th century. In this tangka they are far less pronounced than in the early versions (No. 24) or in some of the 13th-century tangkas of the Taklung school (Nos. 203 and 204) and some of the Khara Khoto works (Piotrovsky, 1993, nos. 9–11), both of which are roughly contemporaneous with this tangka, thus indicating different traditions in this respect as well. Floral sprays at the base of the standing Bodhisattvas are less developed than those of the early 14th-century wall paintings at Shalu, but this feature and the style of the three-quarter faces of the Bodhisattvas seem to prefigure the Shalu wall-painting style.

The Buddha is accompanied by sixteen Buddhas in two rows at the top, eight seated lamas below, and at the sides by four pairs of seated Bodhisattvas, each pair on a separate register. A small Buddha in earth-witness gesture like the main Buddha flanks each side of his large lion pedestal. Next to these is a naga holding the stalk of a lotus that supports the registers of the paired Bodhisattvas. Along the bottom are seven Buddhas, including the Medicine Buddha, and the donor monk with his offerings. Lotus flowers appear between most of the figures, except the Buddhas of the top and bottom rows. The overall composition of figures is more complex than many works of the late 12th century (No. 222) and is akin to that known in some works from Narthang, probably of around the same mid-13th-century period (Liu, 1957, pl. 19). Clearly a painting by a master artist, this tangka, possibly related to the Kagyupa, serves to affirm a major style of ca. mid-13th century that continued to have repercussions well into the 14th century (Nos. 164 and 220).

232 (149a)
Padma Sambhava in the Palace of the Glorious Copper Mountain Paradise

Central Regions, Tibet

18th century

Tangka; gouache on cotton

30⅛ × 18⅜" (76.5 × 46.7 cm)

Collection of G. W. Essen, Hamburg

Lit.: Essen and Thingo, 1991, no. 14, pp. 128–30; Tucci, 1949, pls. 221–23.

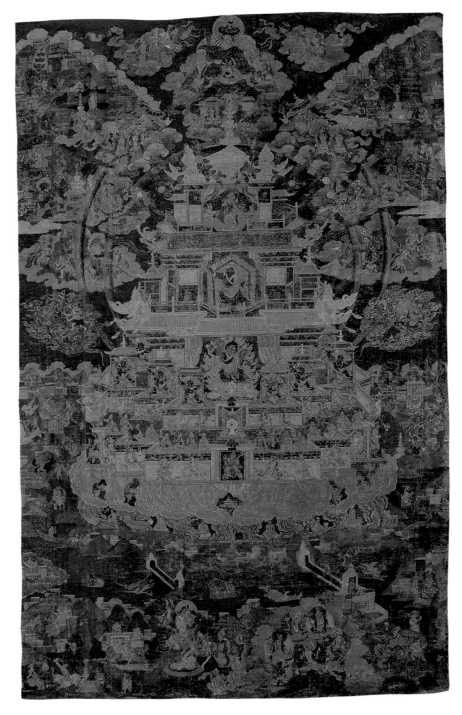

This tangka contains many inscriptions that have their source in the Nyingmapa canon, namely in the *Seven Chapter Prayer* (T. le'u-bdun-ma) and in the *Pemakathang* (T. padma-bka'-than), Padma Sambhava's hagiography. In these texts the locality of the paradise in the southwest is described in detail; certainly the geography is mythical and the celestial palace an ideal construction.

The entrance for contemplating the tangka is a small scene depicted at the bottom center of the painting, where Padma Sambhava is parting from his temporal existence and from his disciples and departing for the heavenly fields of Copper Mountain Pure Land (Zandog Palri). Padma Sambhava dances as a winged Heruka on a lotus flower holding a *damaru* drum in his raised right hand. His left hand, giving blessing to his most intimate consort, Yeshe Tsogyal, rests on her head. Looking in the southwest direction of his paradise, Padma Sambhava recites a prayer of farewell to his attentive disciples, who are deeply moved.

The painter leads the viewer's line of sight from Tibet to the far mighty peak, the Glorious Copper Mountain (Zandog Palri). It is located on an island, surrounded fanlike by eight other islands that are spread according to the eight directions and protected by the eight protectors of the heavenly directions. These islands are important places for meditation. On each of them we see a burial ground with a stupa and wisdom holders in meditation or in the process of civilizing demons. These wisdom holders have transmitted their secret knowledge to Padma Sambhava. The main island with the holy mountain, at the foot of which hermits live in caves, is separated from the continent by a dark lake. Here is the domain of the cannibal *rakshasas,* wild, dark-skinned men, who seem engaged in some kind of protecting as well as in carrying corpses.

It is said in the *Seven Chapter Prayer* that the reddish shining mountain is formed like a human heart, that it penetrates deep into the domain of the nagas, touches the domain of the dakinis in its middle section, and extends its peak to the sphere of the Gods. There we see the four-faced Brahma in his palace, while from all sides heavenly dakinis appear in bands on clouds. Gods and goddesses hold banners and ceremonial umbrellas, playing music and giving offerings. Celestial dancers *(ging)* with drums welcome Padma Sambhava, while flowers fall from the sky like rain. The triple-storied palace

on top of the mountain, with its curved golden roofs, rich decoration, small steeples, and balconies, looks like a Chinese pagoda. Horizontally seen, it forms a mandala resting on a four-colored crossed vajra and oriented to the four main directions—as are the gates of the palace, which are guarded by the four protectors of the directions. The Measureless Mansion is completely transparent, resembling the celestial Jerusalem in the revelation of St. John. It consists of jewels—white rock-crystal, yellow beryl, red garnet, and blue lapis lazuli—which make it shine in the cosmic symbolic colors of the mandala. Like the

mountain itself the palace is encircled by a colored rainbow. In the surroundings of the palace wish-fulfilling trees are said to grow, while ambrosia streams from the springs in the niches of the rock.

The meditator passes through the middle eastern gate, which is guarded by Dhrtarashtra, the lute-playing Lord of the East. On top of the gate the eight-spoked golden wheel of Dharma reminds one of the eightfold path leading to liberation. After passing the gate, the meditator enters an interior courtyard encircled by a crowd of dancing gods and offering goddesses where sixteen of Padma Sambhava's disciples are assembled. Through another half-opened door the meditator finally reaches the interior of the palace and meets eight mighty Herukas as incarnations of the eight tantras. In the lower hall Padma Sambhava appears as Dorje Drölö, the Guru of Consolation and Subduer of Demons, riding a female tiger. The eight categories of gods and spirits covered in flames and serving the tantric master appear at the same time at both sides of the palace. In the upper hall Padma Sambhava stands in the form of a king of cannibal *rakshasas*. In warrior pose he stands on four demons, who are extended in a vajra-cross form. This appearance of Padma Sambhava is also called Fierce Karma Guru.

In the uppermost hall Padma Sambhava sits enthroned, attended by his two wives, the tantric consorts Mandarava and Yeshe Tsogyal. The Tibetan text says: "His lotus throne stands on an octagonal jewel, covered by sun and moon. His figure is more impressive than Mount Meru, his radiation brighter than a thousand suns." For the meditating person, to enter the celestial palace means not only to have a great visionary experience but also to turn within. For that reason the holy mountain possesses the form of a heart, which the meditating person must experience as his or her own. By this meditation practice one hopes to be reborn in Padma Sambhava's paradise and to attain liberation there.

At the top of the painting, clad like a black-hat dancer and flying in reddish clouds, is Landro Konchok Jungnay, a famous disciple of Padma Sambhava. This special conception of the Copper Mountain Pure Land (Zandog Palri) traces its origins back to this disciple. On the back of this tangka is a long, remarkable dedication inscription written by a Karmapa hierarch in verse using Tibetan cursive.

G. W. Essen and T. T. Thingo

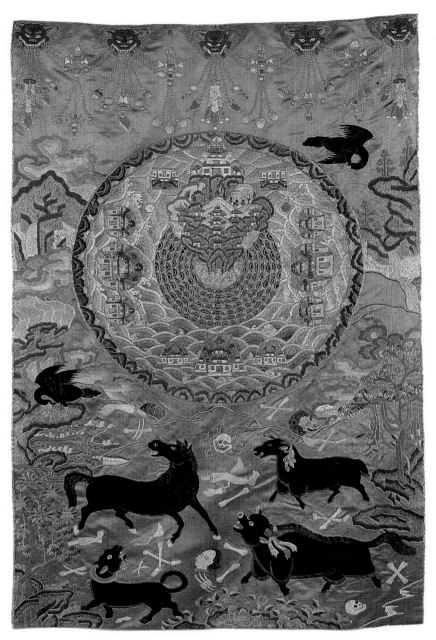

233 (149b)
Mount Meru

China; Tibeto-Chinese

17th century

Tangka; brocade on silk tapestry

32¾ × 21½" (83.2 × 54.6 cm)

Collection of Mr. and Mrs. John Gilmore Ford

The cosmic world mountain, Mount Meru (Sumeru), rises from the oceans within the mandalalike circle of the universe, bordered by a rim of mountains. Castles representing the major "continents" (of which ours is the southern) face the four directions. A large castle tops the rocky mass of Mount Meru, whose lower slopes are the realms of the gods. Surrounding the mandala of the universe is a landscape composed of bright blue sky and water, stylized and outlined rocks and mountains, pink, yellow, and orange clouds, bright flowers and trees, four four-footed animals playing in the water, and two crows. All the creatures are black and are posed in lively postures. Drifting around the waters are parts of skeletons and dismembered bodies, and above, a spirited banner of grinning skulls with jewel festoons hanging from their toothy jaws completes this refined and exquisitely composed tapestry made brilliant by gold piping around many elements. The original silk brocade mounting in subdued and pastel colors with a shocking sliver of dark blue harmoniously complements the unusually sensitive tangka, which appears to be ca. 17th century or earlier.

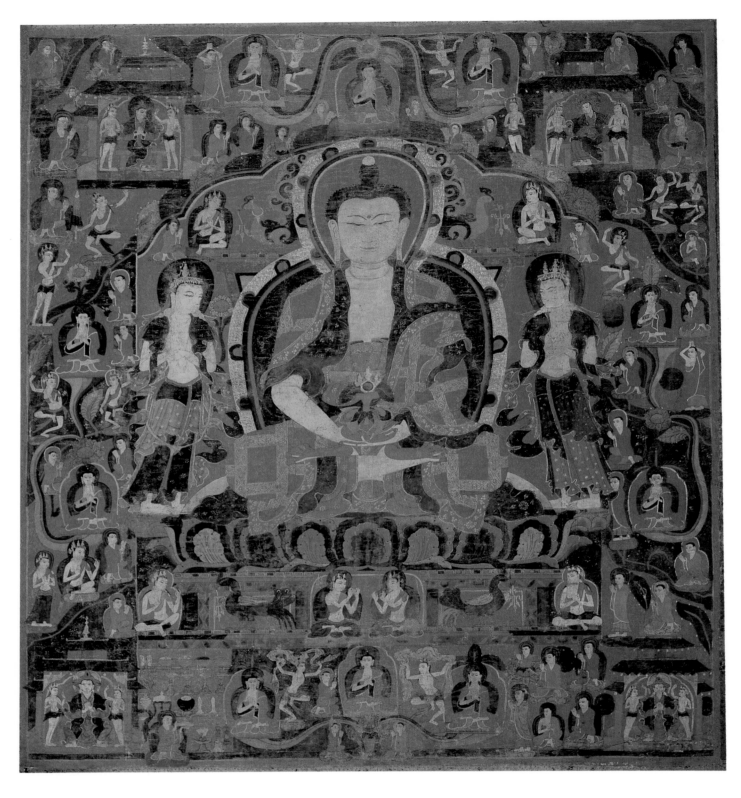

234 (150a)
Amitayus in Sukhavati

Central Regions, Tibet; or Eastern Tibet

Second half of the 14th to first half of the 15th century

Tangka; gouache on cotton

26 × 22" (66 × 55.9 cm)

Collection of Michael McCormick

Amitayus, Buddha of Boundless Life, holding in his hands the long-life vase, is attended by his two great Bodhisattvas, Mahasthamaprapta and Avalokiteshvara. Though heavily golden, the tangka abounds in red, the family color of Amitabha-Amitayus. The stark limitation of color to mainly dark green, red, and gold creates a rather unusual, strongly contrasting painting. Little sense of space appears in this work, which augurs for a relatively earlier dating, probably in the late 14th to early 15th century. The loose shapes and fluid merging between areas shows, however, a breaking down of the rigid formalities of the earlier phases of Tibetan painting. The raised gold is effectively used in the halo and even in the patches of the monastic robe, which appear as boldly solid areas, drawing the main focus of attention to the center of the painting. The line drawing is particularly fine and is related to that of No. 225. The donor, with rows of offerings, appears near the lower left corner; a few figures have inscriptions.

235 (153a)
Pure Land of Naro Dakini

Central Regions, Tibet; or Eastern Tibet

Second half of the 17th to first half
of the 18th century

Tangka; gouache on cotton

52 × 34" (132 × 86.4 cm)

Private Collection, New York

The Naro Dakini, or Naro Vajrayogini,
is named for the great Adept Naropa,
since he first reported the detailed vision
of her paradise. She is the same archetype
Buddha as the male-appearing deity
Chakrasamvara, either lone-hero or
Father-Mother union forms, who is the
chief archetype Buddha of the Mother
tantras. She sometimes manifests herself
as a lone heroine, a lone female with the
khatvanga power-scepter symbolizing
her male counterpart. It is said that the
central palace of the Supreme Bliss
(Paramasukha or Samvara) mandala
stands in space above Mount Kailash,
the mythic axial mountain, residence of
Shiva and Uma in the Hindu mythology.
It is said to remain always open, thus
enabling the Great Adepts of this
difficult age to contemplate it and to
attain enlightenment swiftly within the
short human life-span of this era. The
purely female form of this Buddha deity
is considered especially powerful and
swift, operating efficaciously on the
subtle and unconscious level, since the
female is symbolic of ultimate wisdom
(the male symbolizing compassion).

Here the Naro Dakini, holding a
chopper, balancing a *khatvanga* staff
on her left shoulder, and drinking blood
from a skull bowl, dances in warrior
pose on a pastel-colored lotus within her
magnificent Palace in the Angelic Pure
Land of Uddiyana. Dancing yoginis fill
the courtyard; *citipatti* (dancing skele-
tons) and Brahmanarupa occupy side
shrines. Lamas appear with a two-armed
Chakrasamvara and a goddess in the
upper stories. Arching over the palace is
a stream of celestial dakinis riding the
rainbow halo decorated with an
exquisitely detailed festoon of flowers.
Mahakala guards the entrance and more
dancing figures fill the forecourt. The
dark green and blue background allows
the primarily orange palette of the palace
and the lively figures within, especially
the energetic, beautiful, and superbly
rendered red Naro Dakini with her flame-
bordered halo, to appear as a luminous
vision in one of the most delightfully

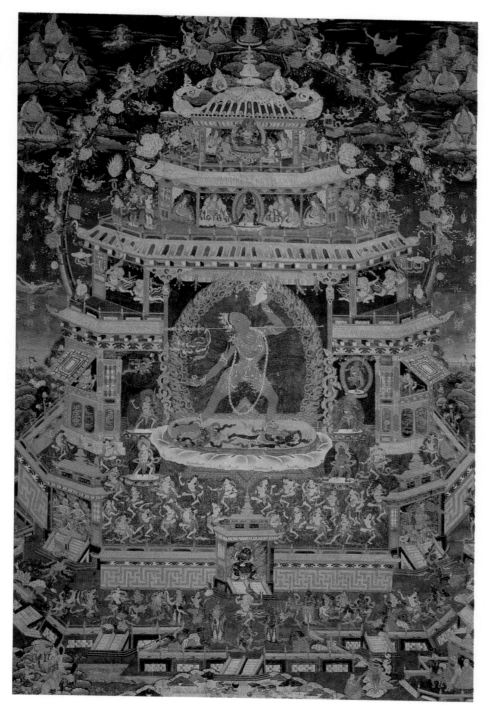

detailed examples of this theme. Elements
of Chinese architectural design suggest
this may be a work from the eastern
regions of Tibet, possibly Amdo.

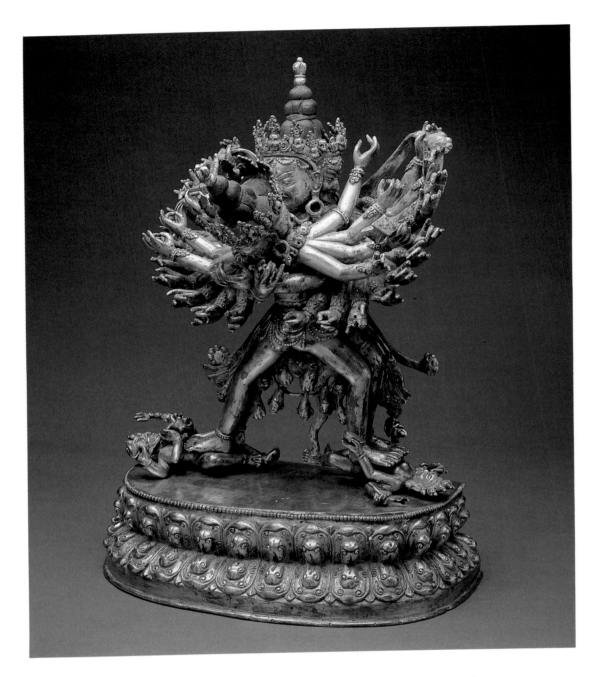

236 (156a)
Kalachakra and Vishvamata Father-Mother

Central Regions, Tibet

15th century

Gilt bronze

H. 16" (40.6 cm)

Collection of Mr. and Mrs. John Gilmore Ford

This is a rare early Tibetan sculpture of Kalachakra, one of the major tantric Buddhas. The slender forms of the two figures, the fanlike cluster of the multiple arms, and the simply fashioned bound hair suggest a relatively early dating, probably ca. 15th century. The faces of the deities are fierce and have the sharp, penetrating quality of a Tibetan artistic hand. Later examples have more openly displayed arms (von Schroeder, 1981, figs. 116e–f, 120b). A flayed elephant skin with head and tail intact that was cast together with the figure drapes over the back of Kalachakra, and a tiger skin, its head covering his hips, is worn as a loincloth. The pedestal is unusual in several respects: it is completely plain and straight in the back, and has an uncommon design of commalike curls decorating the lotus petals. These factors could mean a relatively earlier dating and to a provenance other than the central regions.

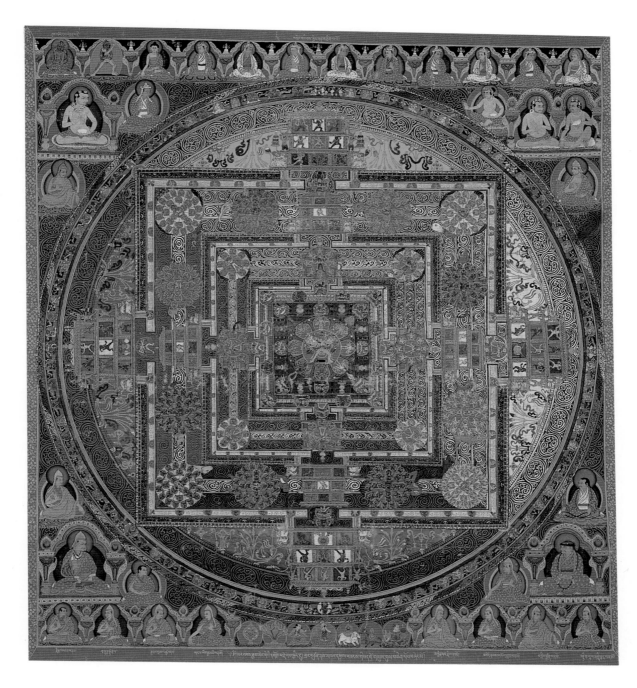

237 (156b)
Kalachakra Mandala

Central Regions, Tibet; probably Tsang

Second half of the 15th to early 16th century

Tangka; gouache on cotton

21½ × 19½" (54.6 × 49.5 cm)

Private Collection

This is an extremely fine example of the Kalachakra mandala, whose iconography is described in No. 156. The work retains its original mount: light green silk sewn with red threads. It contains many inscriptions, including the identification of all the figures outside the mandala circle. The main

inscription in the center of the bottom margin reads: "For the occasion of the decease of Vajradhara Sangyey Sengey, the Reverend Namkha Pelsang commissioned [this tangka] with full reverence of body, speech, and mind."

Across the top from left to right are: Vajradhara, Kalachakra, Shakyamuni, Suchandra, Devendra, Tejashri, Somadatta, Deveshvara, Vishvarupa, Devendra, Manjushrikirti, and Pundarika. All the name inscriptions throughout are preceded by the phrase "Reverence to." At the upper left, reading downward, are the Manjushri Emanation, Pandita Acharya, and Manjukirti. At the upper right are Tsilu Acharya, Duzhab Chechung, and Samantashri. At the lower left are Ra Chosay, Bumseng, and Sherab Sengey.

At the lower right are Yeshey Sengey, Ga Lotsawa, and Penden Sengey. Across the bottom, left to right, are Dorje Gyaltsen, Zhalu Butön, Thugsey Lotsawa, Sharpa Sherab Gyatso, the seven symbols of the world conqueror, Khyenrabjey, Sonam Chogdrub, Tashi Gyaltsen, and Pandita Arjanashribhadra. Around the rim of the mandala circle are numerous deities.

The painting is skillfully drawn and brilliantly colored in one prominent style of the Sakyapa tradition, of which No. 73 is an early example. The more fluid drawing of the robes and the expanded palette, including pastels, indicate a dating for this work probably in the second half of the 15th or early 16th century. It is one of the most beautiful of the few known early Kalachakra mandalas to survive.

238 (157a)
The Kingdom of Shambhala and the Buddhist "Armageddon"

Eastern Tibet

18th century

Tangka; gouache on cotton

69 × 77½" (175.3 × 196.9 cm)

The Zimmerman Family Collection

Presided over by Shakyamuni Buddha between the sun and moon, the icicle-rimmed, snowy mountain circle protects the kingdom of Shambhala, whose ninety-six mountainous regions occupy the center of this large tangka. From the heart of the kingdom the last king of Shambhala oversees the countries of his realm. Outside, green mountains, silhouetted against pink and white clouds, form a background for the horrific warfare taking place in the foreground, where the forces of good from the Shambhala kingdom are fighting the forces of evil that have taken over the world, centuries in the future. Phalanxes of soldiers mass for battle, great carts stuffed with hordes of Lilliputian soldiers are being drawn into battle by huge white elephants, laserlike guns shoot their devastating fire, and fantastic elephantlike animals herd together and fight below the glowing circle of the kingdom. The extensive use of landscape and credible spatial depiction are indicative of the Eastern Tibetan schools, probably ca. 18th century or a little later.

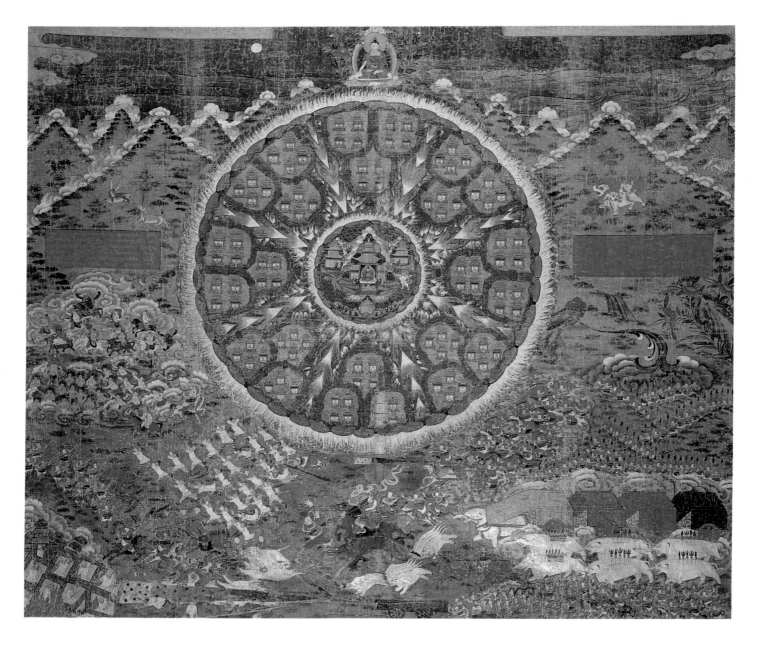

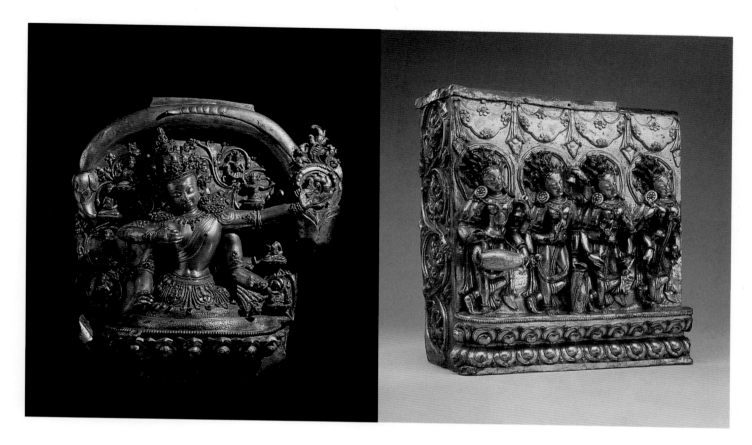

239 (157b)
Rahu

Central Regions, Tibet; Ü
(from Densatil monastery)

Second half of the 14th to early 15th century

Gilt bronze with insets

21 × 20" (53.3 × 50.8 cm)

Doris Wiener Gallery and
Nancy Wiener Gallery, New York

This fragment was once part of large gilded funerary reliquaries at Densatil monastery on the north bank of the Tsangpo River, not far from Samye. Densatil was founded in the late 12th century around the thatch-roof meditation hut of the Kagyu Lama Phagmodrupa, but suffered during the rivalry for succession after his death and later during the Mongol invasions. The large stupas, broken during the Chinese Cultural Revolution and dispersed, were probably made during the second half of the 14th to early 15th century, when the monastery was under the patronage of the prominent Lang

family (Rossi and Rossi, 1994, p. 51).

This powerful sculptural fragment—providing a mere glimpse of the complete assemblage—shows the demon-god Rahu with his snake body, four arms, and stack of heads. He is richly ornamented, and delicate pearls line the edge of his chest scarf and his girdle. His muscular body is similar to that of the crowned Buddha in No. 227. Various figures appear in the vignettes created by the small vine *rinceaux* within the larger one, whose magnificently wrought curling tendrils can still be appreciated in the remaining portions of this fragment.

240 (157c)
Celestial Goddesses

Central Regions, Ü (from Densatil monastery)

Second half of the 14th to early 15th century

Gilt bronze with insets

15½ × 14¾" (39.4 × 37.5 cm)

Collection of Mr. and Mrs. John L. Eastman

This fragment presents a row of celestial four-armed goddesses with drums, vajras, and bells. They stand on a lotus base with a festive banner decorating the wall above. In brilliant gilt and with jewel insets, they must have presented an even more dazzling effect "en masse" in their original setting, probably as part of the great funerary reliquaries at Densatil, as known from a few rare photographs taken by P. Mele in the 1940s (von Schroeder, 1981, p. 462). Other fragments of this group have surfaced (ibid., no. 113G; Rossi and Rossi, 1994, nos. 23, 24), and No. 239 among them. The goddesses possess a sturdy form and simplicity of line that increases their sense of regal beauty.

241 (159a)
Stupa

China; Tibeto-Chinese

18th century

Gilt bronze

43.3 × 22.4" (110 × 57 cm)

The State Hermitage Museum, St. Petersburg

This large gilded stupa is finely embellished and chased with ornamental designs and relief figures. The octagonal stepped base has various geometric and floral patterns and a large row of lotus petals. A recessed section with eight panels shows detailed scenes in relief from the Avatamsaka Stupa, said to be the sutra first given by Shakyamuni Buddha after his enlightenment. Separate sculptures of yakshas at each juncture of the panels support the upper levels of the octagonal base, which in turn holds the four stepped, four-sided levels of the base of the main part of the stupa. Each side of the steps is decorated with eight small sitting Buddhas. The *anda* or dome of the main portion of the stupa is circular with a sloping shoulder. The shoulder has a niche with three Buddhas in front, and eight relief sculptures of standing Bodhisattvas encircle the sides and back. The ornate top of the stupa includes thirteen levels of umbrellas topped by two lotus buds. The craftsmanship suggests a dating ca. late 17th to 18th century, a period when China had a significant relationship with Tibetan Buddhism, notably during the lifetime of the second Jangkya Hutuktu, Rolpay Dorje (see No. 100).

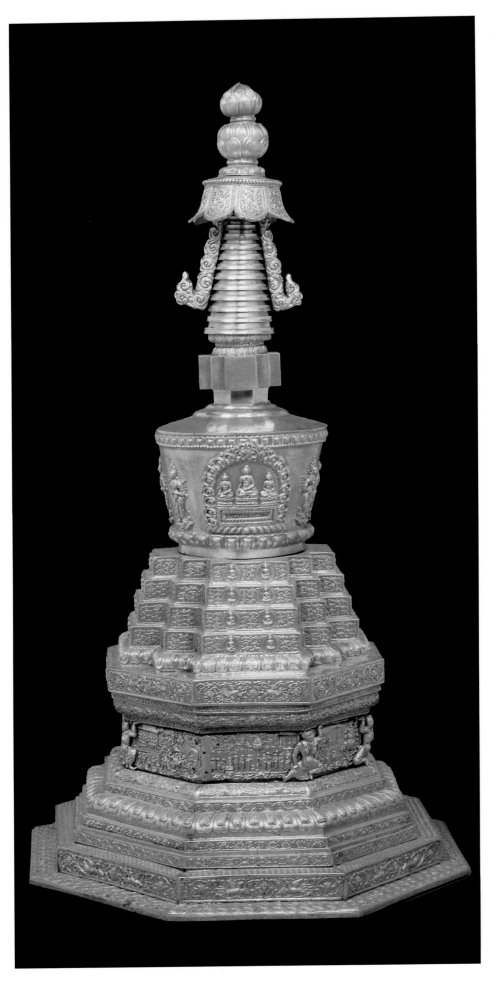

Bibliography

Books, articles, and essays cited in short form in the catalogue entries appear below. In addition, there are a number of general books recommended as background reading. These are signaled by an asterisk.

Alsop, Ian
1994 The Metal Sculpture of the Khasa Malla Kingdom. *Orientations* 25, no. 6: 61–68.

Aris, Anthony, ed.
1992 *Tibetan Medical Paintings*. 2 vols. Trans. Y. Parfinovitch, F. Meyer, and G. Dorje. New York: Harry N. Abrams, Inc.

Aris, Michael, and Aung San Suu Kye, eds.
1980 *Tibetan Studies in Honour of Hugh Richardson*. Warminster, England: Aris and Phillips.

Aschoff, Jurgen C.
1989 *Tsaparang-Konigstadt in Westtibet*. Munich: MC Verlag.

Bartholomew, Terese Tse
1991 Sino-Tibetan Art of the Qianlong Period from the Asian Art Museum of San Francisco. *Orientations* 22, no. 6: 34–45.
1995 The Legacy of Chinggis Khan. *Orientations* 26, no. 6: 46–52.

Berger, Patricia
1995 "A Buddha from Former Times": Zanabazar and the Mongol Renaissance. *Orientations* 26, no. 4: 53–59.

Berger, Patricia, and Terese Tse Bartholomew
*1995 *Mongolia: Legacy of Chingghis Khan*. New York: Asian Art Museum of San Francisco and Thames and Hudson.

Béguin, Gilles
1990 *Art ésotérique de l'Himalaya: La Donation Lionel Fournier*. Paris: Réunion des Musées Nationaux.

Béguin, Gilles, and Sylvie Colinart
1994 Vaisravana, Dieu des Richesses, Dieu des Armées, a propos d'un *Thang-ka* du Musée Guimet. *Artibus Asiae* 54, no. 1/2: 137–55.

Czuma, Stanislaw
1992 Some Tibetan and Tibet-Related Acqui-
–93 sitions of the Cleveland Museum of Art. *Oriental Art* 38, no. 4: 231–43.

Denwood, Philip
1994 Sacred Architecture of Tibetan Buddhism: The Indwelling Image. *Orientations* 25, no. 6: 42–47.

Dye, Joseph M., III
1992 Chinese Influences on Tibetan Paintings in the Virginia Museum of Fine Arts. *Orientations* 23, no. 9: 61–66.

Essen, Gerd-Wolfgang, and T. T. Thingo
1991 *Padmasambhava*. Cologne: DuMont Buchverlag.

Goepper, Roger
*1984 *Alchi: Buddhas, Goddesses, Mandalas*. Photog. Jaro Poncar. Cologne: DuMont Buchverlag.
1990 Clues for a Dating of the Three-Storeyed Temple (Sumtsek) in Alchi, Ladakh. *Asiatische Studien* 44, no. 2: 159–69.
1993 The "Great Stupa" at Alchi. *Artibus Asiae* 53, no. 1/2: 111–43.

Heller, Amy
1988 Early Textural Sources for the Cult of Beg-ce. *Tibetan Studies*, 185–95. Zurich.
1992 Historic and Iconographic Aspects of the Protective Deities Srung-ma dmar-nag. Ed. Ihara and Yamaguchi. *Tibetan Studies* I, 479–92. Narita.
1994 Early Ninth-Century Images of Vairochana from Eastern Tibet. *Orientations* 25, no. 6: 74–79.
1994 Ninth-Century Buddhist Images Carved at lDan-ma-brag to Commemorate Tibeto-Chinese Negotiations. *Tibetan Studies*, 335–49, appendix 12–19. Oslo.

Henss, Michael
1994 A Unique Treasure of Early Tibetan Art: The Eleventh-Century Wall Paintings of Drathang Gonpa. *Orientations* 25, no. 6: 48–53.

Huntington, Susan L., and John C. Huntington
*1990 *Leaves from the Bodhi Tree*. Seattle: The Dayton Art Institute in association with the University of Washington Press.

Jing, Anning
1994 The Portraits of Khubilai Khan and Chabi by Anige (1245–1306), a Nepali Artist at the Yuan Court. *Artibus Asiae* 54, no. 1/2: 40–86.

Klimburg-Salter, Deborah
1985 The Tucci Archives Preliminary Study, I: Notes on the Chronology of Tapho "Du Khan." *East and West* 35: 11–41.
1994 A Decorated *Prajnaparamita* Manuscript from Poo. *Orientations* 25, no. 6: 54–68.

Kossak, Steven
*1994 The Arts of South and Southeast Asia. *The Metropolitan Museum of Art Bulletin*. Spring.

Leoshko, Janice
*1989 The Noble Path: Buddhist Art of South Asia and Tibet. *Orientations* 20, no. 9: 73–83.

Linrothe, Robert N.
1994 The Murals of Mangyu: A Distillation of Mature Esoteric Iconography. *Orientations* 25, no. 11: 92–102.

Neumann, Helmut F.
1994 The Wall Paintings of the Lori Gonpa. *Orientations* 25, no. 11: 79–91.

Pal, Pratapaditya
1975 *Nepal, Where the Gods are Young*. New York: The Asia Society in association with John Weatherhill.
1991 *Art of the Himalayas: Treasures from Nepal and Tibet*. New York: Hudson Hills Press.

Piotrovsky, Mikhail, ed.
1993 *Lost Empire of the Silk Road: Buddhist Art from Khara Khoto (X–XIIIth Century)*. Milan: Electa.

Pritzker, Thomas J.
1992 Notes on the Evolution of Tabo's Monastic Complex. *Orientations* 23, no. 6: 81–86.

Ricca, Franco, and Eberto Lo Bue
1993 *The Great Stupa of Gyantse*. London: Serindia Publications.

Rossi, Anna Maria, and Fabio Rossi
1993 *Tibetan Painted Mandalas*. London: Anna Maria Rossi and Fabio Rossi Publications.
1994 *Selection 1994*. London: Anna Maria Rossi and Fabio Rossi Publications.

Singer, Jane Casey
1994 Painting in Central Tibet, c. 950–1400. *Artibus Asiae* 54, no. 1/2: 87–136.

Stoddard, Heather
1994 Restoration in the Lhasa Tsuglagkhang and the Fate of Its Early Wall Paintings. *Orientations* 25, no. 6: 69–73.

Thurman, Robert A.F.
*1994 *The Tibetan Book of the Dead*. New York: Bantam Books.

Uhlig, Helmut
1981 *Tantrische Kunst des Buddhismus*. Berlin.

Vitali, Roberto
1990 *Early Temples of Central Tibet*. London: Serindia Publications.

Zhongguo bihua zhuanji bianji weiyuanhui, ed.
1989 *Zhongguo bihua zhuanji: Tsang chwan siyuan bihua, 1 (in Zhongguo meishu fenlai zhuanji)*. Tiantsin: Tiantsin renmin chubansha.
1991 *Zhongguo bihua zhuanji, 32: Tsang chwan bihua, 2 (in Zhongguo meishu fenlai zhuanji)*. Tiantsin: Tiantsin renmin chubansha.

Index

Page numbers are in roman type; all illustrations are referred to by page numbers in *italic* type.

Mandala(s), *mudra(s)*, and posture(s) entries are grouped under these headings. Text accompanies illustration except where noted. Painting, sculpture, and tangka(s) entries are grouped under these headings chronologically by region; text accompanies illustration except where noted.

A

Adi Buddha Samantabhadra Father-Mother (Rubin), 430; *430*
Akshobhya (McCormick), 439, 466; *466*
Amitayus in Sukhavati (McCormick), 478; *478*
Amitayus in Sukhavati (Rubin), 470, 478; *470*
Amitayus (Private), 469; *469*
Amoghasiddhi (Private), 468; *468*
Arhat Abheda (Essen), 415; *415*
Arhat Kalika (Rubin), 414; *414*
Arhat Kanakavatsa (Rubin), 413; *413*
Arhat Rahula (Ford), 412; *412*
Arhat(s), 412–15
Atisha
 Indian master, 423, 455
Avalokiteshvara
 bodhisattva, 416, 418, 419, 420, 421, 463
Avalokiteshvara (Spink and Son), 418; *418*

B

Begtse (Essen), 461; *461*
Begtse (Zimmerman), 437; *437*
Bhaishajyaguru (Zimmerman), 465; *465*
Bodhisattva (Private), 416; *416*
Bodhisattva(s), 416–24
 cosmic, 462–64
Buddha(s)
 cosmic, 446, 465–74
Buddhism
 Mahayana, 441
 Mongolian, 441, 451

"tolerance" creed inscriptions, 420, 449, 465, 466, 468

C

Celestial Goddesses (Eastman), 483; *483*
Compassion
 male symbol, 474, 479
Crowned Buddha (Ellsworth), 471; *471*
Crowned Buddha (Ford), 471; *471*

D

Densatil monastery, 449, 483; *449*
Dharma Kings, 428
Drathang monastery (Tsang)
 wall paintings, 409, 471
Drepung monastery (Loseling), 457
Drigung Lama Jigten Sumgon (Private), 451; *451*
Drigung monastery (Ü), 451
Drokmi (Essen), 441; *441*
Drom Tonpa
 First Dalai Lama reincarnate, 423, 455
Dunhuang
 banner paintings, 416
Dusum Kyenpa, the First Karmapa Lama (Speelman), 451, 470; *451*

E

Eleven-faced, Thousand-armed Avalokiteshvara (Zimmerman), 463; *463*

F

Fifth Dalai Lama with Hand Prints and Footprints (Ford), 459; *459*
Four Great Adepts (Ajita, Savaripa, Parbuse, Bhayani) (Essen), 427; *427*
Four Magical Activities, 447

G

Gampopa, Dakpo Lhajey, 449, 451
Ganden monastery (Lhasa), 455
Gedun Drubpa
 First Dalai Lama, 456
Geluk Order, 437, 455–61
 lineage, 456, 461
Genghis Khan
 Mongolian emperor, 441
Gongkar Chöde monastery
 wall paintings, 423, 456
Gonpo Bernagjen (Private), 434; *434*
The Gray Ground monastery, 441
Great Adept Krishnacharya (Kanhapa) (Halpert), 425; *425*
Great Philosopher(s) and Great Adept(s), 425–27
The Great Translator Rinchen Sangpo (Private), 439; *438*
Guhyasamaja (King of Tantras), 446; *446*
Guru Drakpoche Father-Mother (Rubin), 433; *433*
Gyaltsab
 disciple of Tsong Khapa, 455, 458; *455, 458*
Gyang stupa (Tsang)
 wall paintings, 428, 465
Gyantse Kumbum (Tsang)
 sculptures, 419, 443, 448
 wall paintings, 411, 442, 445, 462, 463, 465, 468, 469, 470, 473

H

Heller, Amy, 437
Hevajra Father-Mother Buddha (Musée Guimet), 453; *453*
Hevajra Mandala (McCormick), 452; *452*
Hevajra Tantra, 441, 453

J

Jamyang Khyentse Wangchuk
 painter, 423
Jigten Sumgon
 Drigung lama, 451; *451*
Jokhang temple (Lhasa)
 paintings, 466
Jonang stupa (Tsang)
 wall paintings, 428, 465

K

Kachu monastery
 sculptures, 416
Kadam Order, 423, 450, 455
Kagyu Order, 448–54
 lineage, 467
 tantric yoga, 426
Kalachakra and Vishvamata Father-Mother (Ford), 480; *480*
Kalachakra Mandala (Private), 481; *481*
Karmapa sect, 424, 451, 477
Kedrup
 disciple of Tsong Khapa, 455, 458; *455, 458*
Khyangphu monastery (Tsang)
 sculptures, 466
The Kingdom of Shambhala and the Buddhist "Armageddon" (Zimmerman), 482; *482*
Kunga Gyaltsen
 Sapen Legshey, 441
Kunga Lekpa, Lama Khedzun, 428, 446
Kunga Sangpo, Ngorchen, 440, 442
Kyangphu monastery (Tsang)
 sculptures, 409, 418, 471

L

Landro Konchok Jungnay
 disciple of Padma Sambhava, 477; *476*

M

Mahakala as Gonpo Beng Terma (Musée Guimet), 431; *431*
Mahakala Brahmanarupa (Zimmerman), 447; *447*
Mahakala Panjaranatha (Lord of the Pavilion) (Clark), 444; *444*
Mahasiddha(s). *See* Great Philosopher(s) and Great Adept(s)
Maitreya Bodhisattva (Rubin), 424; *424*
Mandala(s), *446, 452, 477, 481*
Manjushri and Maitreya (V&A, London), 423; *423*
Manjushri (Private), 422; *422*
Milarepa
 Kagyu yogi, 448, 454
Milarepa (Speelman), 448; *448*
Mount Meru (Ford), 477; *477*
Mudra(s) (hand gestures)
 analytical. *See* discernment
 boon-granting, *417*

contemplation, *424, 468*
discernment (*vitarka*), *422, 426*
earth-witness, *410, 411, 466, 471, 475*
enlightenment summit (*bodhyagri*), *467*
fear-not, *424, 468*
giving (*dana*), *422*
mind-refreshing (*sems nyid ngal gso*), *441*
teaching, *412, 438, 440, 441, 442, 449, 456, 458, 466, 470*

N

Nairatmya
"wisdom" consort of Hevajra, 452, 453; *452, 453*
Naropa
Great Adept, 426, 479; *426*
Narthang monastery (Tsang)
paintings, 445, 462, 475
Ngor monastery (Tsang), 442
Nyingma Order, 429–37
lineage, 437
Seven Chapter Prayer, 476

P

Padma Sambhava
Great Adept, 428, 433, 437, 454, 465
Padma Sambhava as Dorje Drölö (Musée Guimet), 436; *436*
Padma Sambhava as Guru Dragmar (Musée Guimet), 432; *432*
Padma Sambhava in the Palace of the Glorious Copper Mountain Paradise (Essen), 476–77; *476*
Padma Sambhava (Museum Rietberg), 429; *429*
Painting
Arhat, 451, 463, 470
Between (*bardo*) practice, 430
Chinese elements, 472, 479
coloring, 439, 440, 449, 450, 467, 472, 477, 479, 481
"further eye" projection, 439; *438*
Gelukpa school, 455–61, 463, 468
Guge renaissance style, 440, 463
Kagyupa school, 448–54, 475
Karma Gadri school, 414, 417
Khara Khoto style, 466, 472, 475
Khyenri school, 423, 424, 456
landscape, 412, 413, 414, 417, 421, 430, 436, 437, 472, 477, 482
"La.stod" school, 428
Menri style, 424
Ming style, 414, 423
Nepalese style, 462
Nyingmapa school, 429–37
Sakyapa school, 413, 431, 439–47, 455, 456, 465, 468, 481
Taklung school, 449, 450, 475
throne and niche designs, 440, 449
tree motif, 422
visualization icons, 458
Painting (central regions of Tibet)
11–12th centuries, 439, 464; *438, 466, 467*
13th century, *422, 449, 450, 452, 475*
14–15th centuries, *411–13, 428, 442, 445, 446, 455, 456, 462, 463, 465, 468, 470, 473, 478, 481*
16th century, *412, 413, 423, 424, 426, 430, 442, 481*
17th century, 460; *421, 431, 447, 454, 457,*

459, 479
18–19th centuries, 476–77; *431, 433–37, 458, 461, 476, 479*
Painting (Chinese)
17th century, *477*
Painting (Eastern Tibet)
14–15th centuries, *412, 414, 470, 478*
16th century, *412, 414, 453*
17th century, *417, 421, 431, 454, 459, 460, 472, 479*
18–19th centuries, *427, 431, 433, 434, 436, 437, 461, 479, 482*
Painting (Tibeto-Chinese)
17th century, *477*
Painting (Western Tibet)
11–12th centuries, 439; *438*
15th century, *440*
Peljor Chöde monastery (Gyantse)
sculptures, 425, 469
Penden Lhamo
black female deity, 437, 460
Penden Lhamo (Ford), 454, 460; *460*
Phagmodrupa
Kagyu lama, 449, 467, 483
Posture(s)
father-mother union, 474; *474*
royal ease, 423; *423*
stop-the-sun, 443, 444; *443, 444*
warrior (*alidha*), 453, 461, 477, 479; *453, 461, 476, 479*
Prajnyaparamita (Mother of All Buddhas), 417, 474; *474*
Pure Land of Naro Dakini (Private), 479; *479*
Pure Lands, 424, 470, 475–84

R

Rahu (Wiener and Wiener), 483; *483*
Red Temple (Tsaparang)
sculptures, 448
wall paintings, 440
Rinchen Sangpo
translator, 439; *438*
Riwoche stupa (Kham), 449
wall paintings, 465

S

Sakya Lama, probably Ngorchen Kunga Sangpo (Rubin), 442; *442*
Sakya Order, 439–47, 451, 453
lineage, 442, 445, 447
Sakya Pandita (Essen), 441; *441*
Samye monastery, 428
Sangyey Yarjonpa
Third Taklung abbot, 450; *450*
Sapen Legshey (Kunga Gyaltsen), 441
Saspol (Ladakh)
cave paintings, 463
Sculpture
Chinese elements, 415, 469
Nepalese style, 416
Pala idiom, 410, 418
pearl usage, 451, 471; *451, 471*
pedestals, 471, 480
throne and niche designs, 484
Yarlung dynasty, 416
Yongle period, 444, 469; *444*
Sculpture (central regions of Tibet)
9th century, *416*
11–12th centuries, *409, 418, 464, 471*

13–14th centuries, *410, 419, 420, 443, 444, 451, 469, 471, 483*
15th century, *425, 441, 443, 480, 483*
16–17th centuries, *415, 429, 432, 474*
Sculpture (Chinese)
15th century, *444*
18th century, *484*
Sculpture (Eastern Tibet)
14th century, *451, 469*
16–17th centuries, *429*
Sculpture (Tibeto-Chinese)
15th century, *444*
18th century, *484*
Sculpture (Western Tibet)
11–12th centuries, *464*
15th century, *448*
Shadakshari Avalokiteshvara (Private), 421; *421*
Shadakshari Avalokiteshvara (Speelman), 419; *419*
Shadakshari Avalokiteshvara (Zimmerman), 420; *420*
Shakyamuni Buddha
life and lives, 409–11, 465, 482, 484
Shakyamuni Buddha and Scenes from His Life (Zimmerman), 411; *411*
Shakyamuni Buddha (Private)
11th century, 409; *409*
13th century, 410; *410*
Shakyamuni Buddha (Wiener and Wiener), 410; *410*
Shakyamuni with Buddhas, Bodhisattvas, and Lamas (Private), 475; *475*
Shalu monastery (Tsang), 411
sculptures, 410
wall paintings, 420, 444, 445, 447, 464, 465, 470, 471, 475
Sigha Baha (Kathmandu)
stone stupa, 416
"Silk Tangka of the Lama Worship." *See Tsong Khapa with Gyaltsab and Kedrup* (Hitchcock)
Singer, Jane Casey, 422, 449, 467
Stupa (Hermitage Museum), 484; *484*

T

Taklung Lama Sangyey Yarjonpa (Halpert), 450, 475; *450*
Taklung Lama Thangpa Chenpo (McCormick), 449, 475; *449*
Taklung sect, 449, 450, 451
Tangka(s)
banner style, 475
black, *431, 434, 447, 454, 460*
brocade on silk tapestry
17th century, *477*
gold-on-red, *457*
gouache and gold on cotton
17th century, *457*
gouache on cotton
11–12th centuries, 439; *438, 466, 467*
13th century, *420, 422, 449, 450, 452, 475*
14th century, *411–14, 428, 445, 446, 462, 463, 465, 470, 473*
15th century, *412–14, 428, 440, 442, 445, 455, 456, 463, 465, 470, 473, 481*
16th century, *412–14, 423, 424, 426, 430, 442, 481*
17th century, *417, 421, 431, 447, 454, 460, 472, 479*
18–19th centuries, 476–77; *427, 431, 433–37, 461, 476, 479, 482*

gouache on cotton with raised gold
 14–15th centuries, *468, 478*
gouache on silk
 16–17th centuries, *453, 459*
red, *421*
series, 426, 427, 454, 460
silk appliqué tapestry
 18th century, *458*
Tashi Lhunpo monastery (Shigatse), 468
Tathagatha (One of the Thirty-five Buddhas of Confession) (Private), 472; *472*
Thangpa Chenpo
 Taklung lama, 449, 450
Thirty-two Deity Guhyasamaja Mandala (Zimmerman), 446; *446*
Three Bodies of Buddhahood, 421, 430, 435, 470
Three Doors of Liberation, 435
Tilopa
 Great Adept, 426; *426*
Tseringma (Musée Guimet), 454, 460; *454*
Tse Wang Drakpa
 painter, 421
Tsong Khapa, Jey Rinpoche, 468; *468*
Tsong Khapa and Scenes from His Life (Private), 457; *457*
Tsong Khapa (McCormick), 455, 456; *456*
Tsong Khapa with Gyaltsab and Kedrup (Hitchcock), 458; *458*
Tsong Khapa with Gyaltsab and Kedrup (McCormick), 455; *455*
Two Great Adepts, Tilopa and Naropa (Wiener and Wiener), 426; *426*

U

Ushnishavijaya (Musée Guimet), 462; *462*

V

Vairochana and Bodhisattvas (Cleveland Museum), 466, 467; *467*
Vaishravana (McCormick), 428; *428*
Vajradhara and Prajnyaparamita Father-Mother (Essen), 474; *474*
Vajradhara and Vajradharma (McCormick), 440; *440*
Vajradhara (Ford), 473; *473*
Vajrakila Father-Mother (Musée Guimet), 435; *435*
Vajrapani (McCormick), 445; *445*
Vajrasattva (Speelman), 439, 464; *464*
Virupa (Cleveland Museum), 444; *444*
Virupa (Speelman), 443, 445; *443*

W

White Tara (Sitatara) (AMNH, New York), 417; *417*
White Temple (Tsaparang)
 wall paintings, 453
Wisdom
 female symbol, 474, 479
World Gods, 439, 452; *438, 452*

Y

Yemar monastery (Iwang)
 sculptures, 409, 439, 469, 471
 wall paintings, 466

Photographic Credits

The author and publisher wish to thank the libraries, museums, galleries, and private collectors for permitting the reproduction of works of art in their collections and for supplying the necessary photographs. Photographs from other sources are gratefully acknowledged below.

G. W. Essen, Hamburg: pp. 415, 427, 441 (upper left and upper right), 461, 474, 476; Peter James Gates, London: pp. 419, 443, 448, 451 (upper left), 464; Richard Goodbody, Inc., New York: p. 483; Shin Hada, New York: p. 471 (upper right); Robert Mates, New Jersey: pp. 417, 428, 440, 449, 452, 455, 456, 458, 466, 479; Maggie Nimkin, New York: pp. 410 (upper right), 426; Peter Oszvald, Bonn: pp. 409, 416, 421, 434, 438, 451 (upper right), 457, 468, 469, 472, 481; Réunion des Musées Nationaux, Paris: pp. 431, 432, 435, 436, 453, 454; George Roos, New York: pp. 413, 414, 424, 430, 433, 442, 470; Rossi & Rossi Ltd., London: pp. 410 (upper left), 422, 444 (upper right); M. Spink, London: p. 418; John Bigelow Taylor, New York: pp. 411, 420, 425, 437, 446, 447, 450, 463, 465, 482; Michael Ward, Baltimore: pp. 412, 459, 460, 471 (upper left), 473, 477, 480

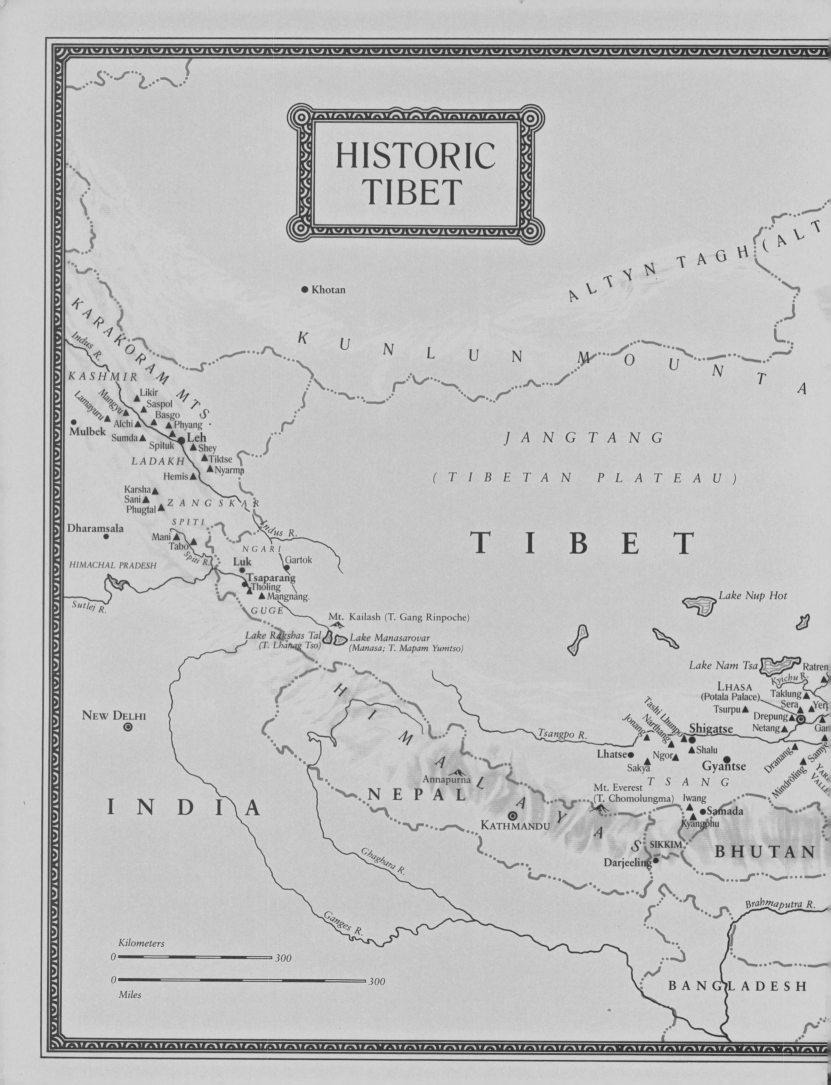

HISTORIC TIBET

ALTYN TAGH (ALT

KUNLUN MOUNTA

• Khotan

KARAKORAM MTS.

Indus R.

KASHMIR

Lamayuru
Mangyu ▲ Likir
 Alchi ▲ Saspol
Mulbek • Basgo Phyang ·
 Sumda ▲ Spituk ▲ Leh
 Shey
LADAKH ▲ Tiktse
 Hemis ▲ Nyarma

 Karsha ▲
 Sani ▲ ZANGSKAR
 Phugtal ▲

 SPITI
Dharamsala • Mani
 Tabo ▲ NGARI
HIMACHAL PRADESH Spiti R.
 Luk Gartok •
 Tsaparang
 Tholing
Sutlej R. ▲ Mangnang.
 GUGE

 Mt. Kailash (T. Gang Rinpoche)

Lake Rakshas Tal
(T. Lhanag Tso) Lake Manasarovar
 (Manasa; T. Mapam Yumtso)

JANGTANG

(TIBETAN PLATEAU)

TIBET

Lake Nup Hot

Lake Nam Tsa Ratren
 LHASA Kyichu R. ▲
 (Potala Palace) Taklung
 Tashi Lhumpo Sera ▲
 Tsurpu ▲ Yert
 Jonang Narthang Drepung ▲
Tsangpo R. ▲ Netang ▲ Gan
 Lhatse • Ngor Shigatse
 Sakya ▲ Shalu
 NEW DELHI ◎ Gyantse Dranang
 Mindröling ▲ Samye
 YARE
 TSANG VALLE

 Mt. Everest
 (T. Chomolungma) Iwang
 Kyangphu • Samada

HIMALAYA

Annapurna

NEW DELHI ◎

INDIA NEPAL

KATHMANDU ◎

 Ghaghara R.

 S SIKKIM
 Darjeeling •

 BHUTAN

 Brahmaputra R.

Ganges R.

Kilometers
0 —————————— 300

0 —————————— 300
Miles

BANGLADESH